OAK PARK PUBLIC LIBRARY

For Cathy

Acknowledgments

Once again thanks to the folks at Cengage Learning PTR, who have pioneered publishing digital imaging books in full color at a price anyone can afford. Special thanks to product team manager, Kevin Harreld, who always gives me the freedom to let my imagination run free with a topic, as well as my veteran production team including project editor Jenny Davidson and series technical editor Mike Sullivan. Also thanks to Bill Hartman, layout; Katherine Stimson, indexing; Sara Gullion, proofreading; Mike Tanamachi, cover design; and my agent, Carole Jelen, who has the amazing ability to keep both publishers and authors happy. I'd also like to thank the Continents of Europe and Asia, without which this book would have a lot of blank spaces where illustrations are supposed to go.

About the Author

With more than two million books in print, **David D. Busch** is the world's #1 selling digital camera guide author, and the originator of popular digital photography series like *David Busch's Compact Field Guides*, *David Busch's Pro Secrets*, and *David Busch's Quick Snap Guides*. He has written more than 100 hugely successful camera-specific guidebooks, compact guides, and general digital photography books on topics ranging from infrared and macro photography to electronic flash and lighting techniques. As a roving photojournalist for more than 20 years, he illustrated his books, magazine articles, and newspaper reports with award-winning images. He's operated his own commercial studio, suffocated in formal dress while shooting weddings-for-hire, and shot sports for a daily newspaper and upstate New York college. His photos and articles have appeared in *Popular Photography, Rangefinder, Professional Photographer*, and hundreds of other publications. He's also reviewed dozens of digital cameras for CNet and *Computer Shopper*. His advice has been featured on National Public Radio's *All Tech Considered*.

When About.com named its top five books on Beginning Digital Photography, debuting at the #1 and #2 slots were Busch's *Digital Photography All-In-One Desk Reference for Dummies* and *Mastering Digital Photography*. During the past year, he's had as many as five of his books listed in the Top 20 of Amazon.com's Digital Photography Bestseller list—simultaneously! Busch's 100-plus other books published since 1983 include bestsellers like *David Busch's Quick Snap Guide to Using Digital SLR Lenses*.

Busch is a member of the Cleveland Photographic Society (www.clevelandphoto.org), which has operated continuously since 1887. Visit his website at http://www.dslrguides.com/blog. There you'll find news, tips, and an errata page with typo alerts from sharp-eyed readers.

Contents

Preface	xiv
Introduction	XV
	i e i
PART I: BASIC MIRRORLESS TEC	CHNOLOGY
Chapter 1	
The Incredible Transformation	3
Amazing New Features Sensor Sensations	
Chapter 2	
Inside Your Mirrorless Camera	15
Key Components of Your Mirrorless Camera Sensors Up Close Capturing Light Noise and Sensitivity Dynamic Range	
Controlling Exposure Time How We Get Color Infrared Sensitivity Using Interchangeable Lenses	
Lens Interchangeability	

Viewfinders	34
Storage	35
Choosing the Camera That's Right for You	36
Questions to Ask Yourself	37
Chapter 3	
Dealing with Dust and Storage	43
Protecting the Sensor from Dust	43
Whither Dust	44
Dust vs. Dead Pixels	
Protecting Sensor from Dust	49
Fixing Dusty Images	50
Cleaning the Sensor	50
Key Considerations for Choosing a Memory Card	55
Large Card or Multiple Smaller Cards?	55
Working with RAW and Other File Formats	
Format Proliferation	
JPEG	
TIFF	
RAW	
Image Size, File Size, Image Quality, and File Compression	60
JPEG, RAW, or TIFF?	63
Advantages of Shooting RAW+JPEG	64
Advantages of Shooting RAW Only	65
Advantages of Shooting JPEG Only	65
Chapter 4	
Mastering Your Exposure Controls	67
Exposure Basics	68
Exposing for Middle Tones	69
Exposing for Dark Tones	70
Exposing for Light Tones	
Tonal Range	73
Introducing Histograms	75
Understanding Histograms	
What Affects Exposure	

Choosing an Exposure Mode	
Programmed and Full Auto Exposures	
Adjusting Exposure with ISO Settings	
Semi-Automatic and Manual Exposure Modes	
Aperture-Priority	
Shutter-Priority	
Program Mode	
Manual Exposure	
Exposure Metering	
Bracketing	
Bracketing and Merge to HDR	100
Chapter 5	
Mastering the Mysteries of Focus	103
Manual Focus	104
Manual Focus Aids	
Autofocus	
Autofocus Considerations	
Autofocus Modes	
When to Focus	
Where to Focus	
How Focus Works	
Contrast Detection	
Phase Detection	
Other Focus Options	
Face Detection and Focus Tracking	
Fine-Tuning the Focus of Your Lenses	
and a second of a	
Chapter 6	
Working with Lenses	117
Welcome to Lens Lust	
Lenses and Mirrorless Interchangeable Lens Cameras	
Digital Differences	
Lens Designs	
If It Ain't Bokeh, Don't Fix It	$\dots\dots124$

Understanding Lens Requirements	126
Image Quality	126
Variability	127
Construction/Build Quality	127
Zoom Lenses	
Lens "Speed"	
Constant Aperture	129
Video Considerations	130
Focusing Distance/Speed	
Add-On Attachments	
Adapters	
What Lenses Can Do for You	
Zoom or Prime?	134
Wide-Angle/ Wide-Zoom Lenses	
Using Telephoto and Tele-Zoom Lenses	136
Typical Upgrade Paths	
Image Stabilization	139
The Bane of Image Blur	140
Causes of Camera Shake	141
Diagnosing Camera Shake	
Preventing Camera Shake	144
Using Image Stabilization	146
C1 7	
Chapter 7	4.54
Working with Light	151
Two Types of Light	151
Continuous Lighting Essentials	153
Electronic Flash Essentials	
Understanding Flash Sync	157
Lighting Equipment	162
Working with Existing Light	163
Working with Electronic Flash	165
Painting with Light	166

PART II: EXPLORING NEW TOOLS

Chapter 8	
Shooting Movies	171
Capturing Video/Sound	
More on Video Resolution	174
Selecting a Frame Rate	174
Progressive Scan vs. Interlaced Scan	
Tips for Shooting Better Video	176
Depth-of-Field and Video	177
Zooming and Video	178
Keep Things Stable and on the Level	179
Shooting Script	179
Storyboards	179
Storytelling in Video	180
Composition	180
Lighting for Video	184
Audio	186
Chapter 9	
Exploring GPS and Wi-Fi	189
What's Geotagging?	
Using GPS	191
Eye-Fi Upload	
Built-in Wi-Fi	
Chapter 10	
Using Apps	195
Smart Platforms	
What Can They Do?	
Camera-Specific Apps	201
Another Great Device	202

Chapter 11	
Great Gadgets	203
Taking Pictures by Remote Control	
Underwater Housings	
Light and Measuring Aids	
The Three Qs of Filter Buying: Quality, Quality, Quality	
Filters to Protect Your Lenses	
Polarizing Filters	212
Neutral Density Filters	
Graduated Neutral Density Filters	
Color Control and Special Effects Filters	218
Special Effects Filters	219
PART III: EXPAND YOUR SHOOTING WO	ORLD
	225
Travel Photography	
Foreign Photography Field Trips—Fun and Affordable	
What to Take	
My "Domestic" Kit	
My Air Travel Kit	
The Backup Question	
Tips for Getting Great Travel Images	
Photographing People	
Photographing Monuments and Architecture	
Getting Permission	
Have Fun!	

Chapter 13	
People Photography	253
Home Studio—or Nature's Studio?	254
Setting Up Your Studio	
What You Need	
Your Portrait Camera	257
Backgrounds	258
Visible Means of Support	260
Make Light Work for You	262
Gadgets	266
Portrait Basics	268
The Nature of Light	269
Direct versus Soft	270
Balancing Light	271
Using Multiple Light Sources	273
Main Light	273
Fill Light	275
Background Light	275
Hair Light	277
Lighting Techniques	277
Short Lighting	277
Broad Lighting	279
Butterfly Lighting	279
Rembrandt Lighting	282
Side Lighting	282
Outdoor Lighting	282
A Touch of Glamour	286
Portraits on the Street	294
Vary Your Shots	298
Chapter 14	
Photographing Concerts and Performances	301
Brushes with Greatness	302
Arming for Battle	309
Getting Into Position	313
Interesting People	
Techniques	

Chapter 15 Scenic, Wildlife, and Nature Photography	325
Scenic Photography	
Scenic Essentials	326
Eight Simple Rules for Composing Your Landscapes	327
Simplicity	329
Front and Center	330
Landscape "Portraits"	
Rule of Thirds	332
Using Lines	
Balance	
Framing	
Fusion/Separation	
Color and Texture	
Key Types of Landscapes	
Mountains	
Sunsets/Sunrises/Dawn/Dusk	344
Sea and Water Scenes	
Changing Seasons	349
Infrared Landscape Photography	351
What You Need	
Taking IR Photos	
Wildlife Photography	
Stalking Your Prey Made Easy	
Scouting Prime Locations	358
Chapter 16	
Capturing Action	361
Sports in a Nutshell	362
The Importance of Position	362
Key Sports: Play by Play	365
Continuous Shooting Basics	370
Selecting Your Shooting Mode	
Choosing Your Lenses	
Zoom or Prime Lens?	374
Focal Lengths Needed	376

Action Exposure Concerns	378
Attaining Focus	
Selecting an ISO Speed	
Using a Tripod or Monopod	383
Basics of Freezing Action	383
Motion and Direction	
Action-Stopping Techniques	
Stopping Action with Panning	
Freezing Action Head On	
Freezing Action with Your Shutter	
Freezing Action with Electronic Flash	
Freezing Action at Its Peak	
When Blur Is Better	
Some Final Tips	391
Chapter 17	
<u>.</u>	202
Close-Up Photography	393
Macro Terminology	393
Magnification	
Perspective	
Depth-of-Field	
Getting Practical	
Macro or General-Purpose Lens?	
_	102
Close-Un Gear	
Close-Up Gear	404
Close-Up Gear	404

Preface

Let David Busch—the mentor who helped you learn how to use your new mirrorless interchangeable lens camera through his comprehensive guidebooks—give you the inside knowledge of how your camera can be used to master the tools and techniques for capturing the best images of your life. You won't find one word telling you how to overcome your digital camera's shortcomings in Photoshop. There are lots of great Photoshop books that can do that. The best part about the new breed of mirrorless cameras is that they have exciting new capabilities that will let you take great pictures in the camera, if you know how to use the tools at your fingertips. This book emphasizes digital photography. It shows you how to take compelling pictures and make great images using imaging technology, while taking into account the special strengths of mirrorless interchangeable lens cameras. Whether you're a snap-shooting tyro, or a more experienced photographer moving into the interchangeable lens realm, you'll find the knowledge you need here. Every word in this book was written from the viewpoint of the serious photographer.

Introduction

The world of digital photography has changed incredibly in the past few years. Only a few years ago, fixed lens "super-zoom" cameras and low-end digital SLRs dominated the market among avid photographers who were upgrading from point-and-shoot models. For more advanced shooters, middle- and high-end digital SLR cameras were the only option.

Then mirrorless interchangeable lens cameras burst on the scene. They've gone from being a more compact alternative to the dSLR camera to one of the two predominant platforms for serious photographers. Today, anyone who is an avid photographer can afford a mirrorless camera and lenses and other accessories for it. Those who need basic instruction for the most popular cameras can find the get-started information they need in one of the *David Busch's Guides* series. But for those of you who are looking for a deeper grounding in photographic concepts and techniques, the information you need is between these covers.

Here are some of the latest innovations you'll want to learn about:

- Full-frame cameras are becoming more affordable and increasing in popularity.
- High-definition movie making has become standard in new cameras.
- Features like image stabilization, built-in high dynamic range (HDR) features, and even touch-screen LCDs are common.
- Wireless links to Flickr and other websites are available, directly from the camera, using built-in Wi-Fi and accessories like the Eye-Fi card.
- GPS tagging has become an integral part of camera technology.
- iPhone/iPad/iPod Touch apps help owners of mirrorless cameras on-the-go.

All these exciting advances will appeal to those of you who want to expand your knowledge through this book. This book will be compelling for anyone new to the world of digital photography, who wants to exercise their creativity, enrich their lives, or do their jobs better.

What's in This Book?

It's interesting that a camera platform that we couldn't quite hang a name on has matured so quickly. Initially, these mirrorless models were referred to as *electronic viewfinder interchangeable lens* (EVIL) cameras. However, not all of them had electronic viewfinders, with many models relying solely on the back-panel LCD monitor for preview, review, and menu navigation. All had interchangeable lenses, however, so the industry seems to have settled on the nomenclature *interchangeable lens camera* (ILC) for the whole lot. Indeed, Sony has applied the term to its latest Alpha line of mirrorless cameras, dubbing them with model names like Sony Alpha ILCE-6000 (the E stands for E lens mount) in most countries (but Alpha a6000 in North America).

These mirrorless models have special advantages, special features, and special problems that need to be addressed and embraced. In addition, those of you who work with these cameras tend to expect more from their photography, and crave the kind of information that will let you wring every ounce of creativity out of their equipment.

Some of your questions involve the equipment. What are the best and most cost-effective accessories for mirrorless cameras? What are the best lenses for portrait photography, or sports, or close-ups? Is it possible to use lenses and accessories accumulated for a previous version of the same vendor's cameras?

Other questions deal with photography, and how to apply the advanced capabilities of ILC cameras to real-world picture taking. What are the best ways to use exposure features creatively? How can pictures be better composed with a mirrorless camera? Selective focus is easier with mirrorless cameras than with other point-and-shoot models; how can it be applied to improve compositions? Now that digital cameras with almost zero shutter lag are available, what are the best ways to capture a critical moment at an exciting sports event? How can you make your family portraits look professional? What's the best way to create a last-minute product shot in time to get it on your company website? You'll find the answers in *David Busch's Mastering Mirrorless Interchangeable Lens Photography*.

This isn't a general digital camera book. It's a book about digital *photography*: how to take great pictures with the newest cameras and make great images that leverage the strengths of computer technology, while taking into account the special needs of digital cameras. Minutes after cracking the covers of this book, you'll be able to grab action pictures that capture the decisive moment at a sports event; create portraits of adults, teens, and children that anyone can be proud of; and understand how to use the controls of your camera to optimize your images even before you transfer them to your computer. This is the book that will show you how to explore the fascinating world of photography with digital technology.

The heavy hardware discussions enrich the introductory material in the first few chapters, giving the basic information needed to choose and use a digital camera, and to satisfy curiosity about what goes on inside. Readers don't need to understand internal combustion to drive a car, but, even so, it's a good idea to know that an SUV may roll over during hairpin turns. The nuts-and-bolts portions of this book won't teach readers about internal combustion, but will help them negotiate those photographic hairpins.

What Cameras Are Covered?

This book covers the features, controls, and options that are, for the most part, common to all mirrorless interchangeable lens cameras. Whether a model is produced by Canon, Fujifilm, Panasonic, Nikon, Olympus, Pentax, Samsung, or Sony, all of them feature detachable lenses that can be swapped for others. Each includes automatic exposure and autofocus features that are much like those of the other cameras in this class. High-definition movie making is a universal capability, and growing numbers of ILC models include built-in GPS, Wi-Fi, or touch screen features. So, no matter which mirrorless model you own, you'll find helpful information on virtually all of the features of your camera.

Of course, each vendor implements those features in a slightly different way. Lens mounts may allow only for use of the manufacturer's lenses; or accept a variety of lenses using adapters, or supplied by third parties. Sensor sizes differ. Various capabilities are activated in different ways. For camera-specific information, you'll want to consult one of my guides written for particular camera models. But everything else in this book applies broadly to all interchangeable lens mirrorless models.

The emphasis is on cameras from the vendors with the largest market share, listed above. However, because of their specialized nature or limited installed base, I don't provide coverage of Leica M-mount mirrorless cameras (both Leica and Epson models), nor the Ricoh GXR modular camera design.

Why This Book?

I've aimed this book squarely at digital camera buffs and business people who want to go beyond point-and-shoot snapshooting and explore the world of photography to enrich their lives or do their jobs better. For anyone who has learned most of a digital camera's basic features and now wonders what to do with them, this is a dream guide to pixel proficiency. Of course, once you've read this book and are ready to learn more, you might want to pick up one of my other guides to digital photography. I'm listing them here not to hawk my other books, but because a large percentage of the e-mails I get are from readers who want to know if I've got a book on this topic or that. Again, that's only for the benefit of those who want to delve more deeply into a topic. My other guides offered by Cengage Learning PTR include:

David Busch's Guides to Digital Photography

I've written individual guidebooks for specific cameras, including the most popular models from Nikon, Canon, Sony, and Olympus. If you want to learn more about your camera's specific features and how to apply them to photography, check out one of my camera guides. Some of the same topics covered in this book are included, such as use of lenses and electronic flash, but everything is related directly to your specific model.

David Busch's Compact Field Guides

Throw away your command cards and cheat sheets! The basic settings suggestions and options for many specific cameras have been condensed from my comprehensive guides into these spiral-bound, lay-flat, pocket-sized books you can tuck in your camera bag and take with you anywhere. Available for an expanding line of camera models, there are also totable *Compact Field Guides* for topics including Close-Up/Macro Photography, Electronic Flash Photography, Movie Making, and Portrait/People/Street Photography.

David Busch's Quick Snap Guide to Using Digital SLR Lenses

A bit overwhelmed by the features and controls of lenses, and not quite sure when to use each type? This book explains lenses, their use, and lens technology in easy-to-access two- and four-page spreads, each devoted to a different topic, such as depth-of-field, lens aberrations, or using zoom lenses.

David Busch's Quick Snap Guide to Lighting

This book tells you everything you need to know about using light to create the kind of images you'll be proud of, including some of the most common lighting setups for portraiture.

Who Am I?

After spending years as the world's most successful unknown author, I've become slightly less obscure in the past few years, thanks to a horde of camera guidebooks and other photographically oriented tomes. You may have seen my photography articles in *Popular Photography* magazine. I've also written about 2,000 articles for magazines including *Rangefinder*, *Professional Photographer*, and dozens of other photographic publications. But, first, and foremost, I'm a photojournalist and commercial photographer and made my living in the field until I began devoting most of my time to writing books.

Although I love writing, I'm happiest when I'm out taking pictures, which is why I invariably spend several days each week photographing landscapes, people, close-up subjects, and other things. I spend a month or two each year traveling to events, such as Native American "powwows," Civil War re-enactments, county fairs, ballets, and sports (baseball, basketball, football, and soccer are favorites). I wrote much of this book during a month I spent in the Florida Keys, photographing the scenery, wild life and wild people I found there. I can offer you my personal advice on how to take photos under a variety of conditions because I've had to meet those challenges myself on an ongoing basis.

Like all my digital photography books, this one was written by someone with an incurable photography bug. I've worked as a sports photographer for an Ohio newspaper and for an upstate New York college. I've operated my own commercial studio and photo lab, cranking out product shots on demand and then printing a few hundred glossy 8 × 10s on a tight deadline for a press kit. I've served as a photo-posing instructor for a modeling agency. People have actually paid me to shoot their weddings and immortalize them with portraits. I even prepared press kits and articles on photography as a PR consultant for a large Rochester, N.Y., company, which was a dominant force in the industry at the time, but is now a mere shadow of its former self. My trials and travails with imaging and computer technology have made their way into print in book form an alarming number of times.

But, like you, I love photography for its own merits, and I view technology as just another tool to help me get the images I see in my mind's eye. And, also like you, I had to master this technology before I could apply it to my work. This book is the result of what I've learned, and I hope it will help you master your mirrorless camera, too.

I hope you visit me at David D. Busch Photography Guides on Facebook, or at my blog at www.dslrguides.com/blog. There is an E-Mail Me tab, and an Errata page listing any goofs and typos spotted by sharp-eyed readers. If you see something in these pages that needs improvement, let me know!

Part I Basic Mirrorless Technology

The manual packaged with your camera lists what each and every control, button, and dial does. But unless you understand *why* you need to use each setting and adjustment, you really can't put them to work improving the technical quality of your images. In this book, I'm going to help you understand *why* and *when* you should use each of the tools at your disposal, and to do that, you need to understand some of what's going on under the hood.

For example, it's not enough to learn that high ISO sensitivity settings are "bad" and low ISO settings are "good"—because that's simply not true. Once you understand how the camera's sensor captures images, and what boosting ISO sensitivity does to that image, you'll understand the tradeoffs. Yes, using a higher ISO setting may give you more visual noise in your image, but the photo may be, overall, much sharper because you were able to use a faster, blur-canceling shutter speed or an f/stop that produces a sharper image. You'll also understand that settings like "noise reduction" may cancel some of that visual noise—but at the cost of some image detail. Armed with a deep understanding of how your camera works, you will be better equipped to choose the best settings for any situation.

This first Part offers a detailed look at the most important aspects of how your mirrorless camera's technology works. You don't have to be a gear-head to enjoy learning these things; I've put together some examples that I think will make everything clear and easy to absorb.

The Incredible Transformation

It was the snapshot heard 'round the world. Eventually.

Roughly 40 years ago, few people were aware that the planet's first digital camera had been successfully tested—even within Eastman Kodak Company, where Kodak engineer Steven Sasson spent the better part of a year developing an 8-pound prototype that was the size of a small toaster (Figure 1.1.). The first photograph taken by this first digital camera in December 1975, was in black-and-white and contained only 10,000 pixels—one hundredth of a megapixel. Each image took 23 seconds to record to magnetic media (tape!) and a similar amount of time to pop up for review on a television screen.

But the age of digital photography had begun and, ironically, the dominance of the largest company devoted to fostering the photographic arts, was coming to an end. Kodak, which developed the first successful image scanners and pioneered development of the

Figure 1.1 Steve Sasson invented the digital camera in 1975.

first megapixel sensor (and coined the term "megapixel" to describe it), never fully exploited the innovations that came out of its research labs. The company failed to reap the rewards of innovating the first "Photo" CD-ROMs, the first widely used consumer digital camera (the Apple QuickTake 100, developed by Kodak's Chinon subsidiary), and the first digital SLRs (built on Nikon and, later, Canon film bodies).

Instead, you and I have been the happy beneficiaries of the digital camera revolution. Even though the transition from film to digital took a long time, by 2008 it was essentially completed. The first digital cameras that could partially replace their film counterparts were expensive, relatively lowresolution devices suitable for specialized applications such as quickie snapshots you could send by e-mail or post on a web page (at the "low," \$1,000 end) to news photographs of breaking events you could transmit over telephone lines to the editorial staff in minutes (at the stratospheric \$30,000 price point).

Then, in 2003-2004, Canon and Nikon finally made interchangeable lens digital cameras affordable with the first low-cost digital SLRs: Canon EOS Digital Rebel and Nikon D70 models, which cost around \$1,000—with lens. Advanced digital cameras had been available for years—but now, for the first time, the average photographer could afford to buy one. The migration from film to digital SLR to, for some, mirrorless interchangeable lens cameras, had begun.

But enough history. Many of the readers of this book have never shot film at all. So, this initial chapter provides a summary of where the interchangeable lens camera is today and how it works, as an introduction to the technology that will help you avoid the pitfalls in your path, and put your tools to work most effectively. You don't need to understand Ohm's Law to operate a toaster or Newton's Laws of Motion to drive a car, but it's helpful to understand why you shouldn't use a fork to retrieve a waffle, or make a hairpin turn at high speed when driving a vehicle with a high center of gravity.

In later chapters, I'll show you how to use your digital and optical tools to raise the bar on image quality and improve your creative vision. By the time we're done, you'll be well on the road to mastering your digital camera. From time to time I will mention a parallel technology—that found in so-called digital SLR cameras—but only to compare them with the models that are the heart of this book. If you are interested in learning how to use digital SLR cameras, you might want to pick up a companion to this book, David Busch's Mastering Digital SLR Photography. While both books cover much of the same territory, each concentrates on the advantages and use of their respective technologies. This one will have a special emphasis on the characteristics of mirrorless models, from the Pentax K and Q series, through the Nikon 1 and Micro Four Thirds models from Panasonic and Olympus, up to APS-C and full-frame cameras offered by Sony, Samsung, Fujifilm, and Canon.

Amazing New Features

Photography has changed more in the last five years than it did in the previous half-century. Indeed, in my case, film cameras and lenses I purchased while still in college were my main tools for several decades. While my equipment wasn't really state-of-the-art, the functional differences between my original film gear and later, more electronic film cameras, were slight.

But now, consider the incredible array of new features found in the latest crop of digital cameras—and promised for future models that are just around the corner. Cameras that are scarcely five years old are considered obsolete (although they still take the same fine pictures they always did), and, for most photographers, the urge to gain new, exciting features through an equipment upgrade happens much more frequently.

I'll explain each of the innovations that are sweeping over the photographic arena in more detail later in the book, but, for now, just take a look at the new capabilities that have helped make the mirrorless camera the fastest growing segment of the photography market. The list is long, and can be divided into three segments: improvements in the sensor/sensor assembly; improvements in the other camera hardware/software components; and improvements in software used to manipulate the digital images we've captured.

Sensor Sensations

I'll cover each of these breakthroughs in more detail later in this chapter and elsewhere in this book, but if you want a quick summary of the most important improvements to the sensor and its components, here's a quick list:

■ Full frame isn't just for pros anymore. So-called "full-frame" cameras—those with 24mm × 36mm sensors sized the same as the traditional 35mm film format—are becoming more common and affordable. Sony was the first to offer full-frame mirrorless cameras: the Sony Alpha A7, A7r, and A7s—all rather expensive in the \$2,000 and up price range, with lens. During the life of this book, I expect several more full-frame models, although which vendors will be offering them is a little sketchy. Canon, Pentax K, Samsung, and Fujifilm offer mirrorless models that use APS-C sensors (smaller than full frame at roughly 15-16mm × 22-24mm), while Nikon, Olympus, and Panasonic are firmly entrenched in using even smaller sensors of 8.8mm × 13.2mm (Nikon) and 13mm × 17mm (Olympus/Panasonic). Pentax Q cameras use the smallest sensors of all, the so-called 1/2.3 inch and 1/1.7 inch image grabbers. Only the top-of-the-line Leica M9 series, which I don't cover in this book, offer full-frame imagers to rival the current Sony A7 series.

As you'll learn later in this book, full-frame mirrorless cameras are prized for their low-noise characteristics, especially at higher ISOs, and the broader perspective they provide with conventional wide-angle lenses.

■ Resolution keeps increasing. Vendors vie to up the resolution ante to satisfy consumers' perception that more pixels are always better. In practice, of course, lower resolution cameras often produce superior image quality at higher ISO settings. So, the megapixel race has been reined in, to an extent, by the need to provide higher resolution, improved low-light performance, and extended dynamic range (the ability to capture detail in inky shadows, bright highlights, and every tone in-between).

While there are a few stragglers stuck at 16MP (chiefly the Micro Four Thirds camp), every other consumer mirrorless camera has 18-24MP of resolution. The lone new exception is the Sony A7s, a 12.2MP model really intended for video production. The new plateau, if you can call it that, is 36MP, found in Sony's full-frame model line. Nevertheless you can expect more hi-res cameras in the future.

■ ISO sensitivity skyrocketing. Larger and more sensitive pixels mean improved performance at high ISO settings. Do you really need ISO 51,200 or above? The Sony A7s offers extended sensitivity to ISO 409,600. Certainly, if those ridiculous ratings mean you can get acceptable image quality at ISO 6400. For concerts and indoor sports events, I've standardized on ISO 3200, and have very little problem with visual noise. In challenging lighting conditions, ISO 12,800 isn't out of the question, and ISO 25,600 (which allows 1/1,000th second at f/8 or f/11 in some of the gyms where I shoot) is practical.

Figure 1.2 shows a recent shot of guitarist Lee Silvis, taken at 1/1,000th second and f/6.3 at ISO 6400 on a full-frame camera with a measly 20MP of resolution. At left is the complete, uncropped frame, and at right is an enlargement of roughly 5 percent of the image, indicated by the yellow box at left. Although fine detail is invariably masked by the printing process, I can assure you that there is almost no visible noise.

■ Professional full HDTV video is possible with a mirrorless camera. To date, many professional video productions have been captured using mirror-equipped digital SLR cameras, but this is changing. The opening title sequences of *Saturday Night Live* were shot in HDTV by Alex Buono with Canon dSLR cameras. The award-winning film *Act of Valor*, directed by Mike McCoy and Scott Waugh was shot by cinematographer Shane Hurlbut using a Canon 5D Mark II.

But the dSLR's "edge" is vanishing, which makes sense when you realize that, during video shooting, a digital SLR's mirror is flipped up out of the way, and its live view is roughly the equivalent of mirrorless capture, anyway. Models like the Sony A7s, so-called 4K ultra-high-definition video ($4,096 \times 3,072$ pixels versus $1,920 \times 1,080$ pixels with high-definition video) is possible. Indeed, the A7s can output uncompressed 4:2:2 UHD 4K video to an optional external recorder over the HDMI port. Plus, the A7s's built-in electronic viewfinder can be used to monitor capture, if desired, while dSLR video shooters must use the back panel LCD or a larger external monitor.

Figure 1.2 Today's sensors can impart almost no visible noise at ISO settings of 6400 or even higher.

Nor are the HDTV capabilities of the latest mirrorless cameras just a camcorder replacement. If you're a wedding photographer, you can use them to add video coverage to your stills; photojournalists can shoot documentaries; and amateur photographers can come home from their vacation with once-in-a-lifetime still photos and movies that won't put neighbors to sleep.

■ Live view is now standard. Only a few years ago, the ability to preview your images on an LCD screen was a point-and-shoot feature that most digital SLR users could see no need for. Today, of course, live view is an essential part of movie shooting, but improvements like "face detection" (the camera finds and focuses on the humans in your image), "subject tracking" (the camera is able to follow focus specific subjects shown on the screen as they move), and zoom in (to improve manual focusing on the LCD screen) can be invaluable in certain situations. Something as simple as the ability to focus at any point in the frame (rather than just at the few fixed focus points marked in the optical viewfinder) can be very helpful. While dSLRs offer

this live view as an optional mode, with mirrorless cameras it's *standard operating procedure*. You can monitor your shot on the back panel LCD, or use the built-in or add-on electronic viewfinder, ensuring that what you see is always what you get.

The latest innovation is embedding special autofocus sensors *right in the sensor*, making full-time, full-speed phase detection autofocus possible during still shooting and movie making. In the past, once the mirror of a conventional dSLR camera flipped up, its faster phase detect AF was lost, and the camera had to rely on slower contrast detect autofocus. Today, mirrorless cameras offer some of the fastest AF speeds available. (You'll find more on autofocus technology and techniques in Chapter 5.)

■ Image stabilization. Camera movement contributes to blurry photographs. Optimizing antishake compensation by building it into a lens means you have to pay for image stabilization (IS) in every lens you buy. So, some vendors are building IS into the camera body in the form of a sensor that shifts to counter camera movement. Unfortunately, "one-size-fits-all" image stabilization doesn't work as well with every lens that can be mounted on a camera, but vendors are learning to adjust the amount/type of in-camera IS for different focal lengths.

Other Camera Hardware Improvements

Of course, the great strides forward in digital SLR technology (and digital photography in general) aren't limited to sensor breakthroughs. Other components of the cameras, including lenses and accessories, have seen significant improvements, too. Here are some of the most important:

- Digital Signal Processing (DSP) chips. As sensors grab more and better data, sophisticated signal processing chips have to be developed to convert the analog data captured to digital format, while optimizing it to produce better images. Faster frame rates (driven partly by the need to shoot more full-resolution images for action/sports, and by the requirements of movie making at 24/30/60 fps) call for beefier processing power. Some high-end cameras have *two* DSP chips to boost throughput even more. Vendors give their chips powerful-sounding names, such as EXR (Fujifilm), TruPic (Olympus), Venus Engine (Panasonic), EXPEED (Nikon), DIGIC (Canon), or BIONZ (Sony), but the end results are similar: better pictures, processed more rapidly.
- Built-in high dynamic range (HDR) photography. One of the limitations of digital sensors is their inability to record details in both the brightest highlights and darkest shadows simultaneously. Most vendors have developed cameras with the ability to snap off several exposures in a row, and then combine them to produce an optimized, "HDR" image. This effectively extends the tonal range (dynamic range) of the sensor. Within a few more years, I expect that sensors will improve to the point where built-in HDR isn't necessary.

- Global positioning system (GPS) tagging. Just about any mirrorless camera can be fitted with some sort of external GPS tagging accessory, and an increasing number have the feature built right into the camera. There are so many reasons why marking each photo with data on where and when it was taken is useful (I'll explain some of them later in this book), that GPS tagging should be a standard feature in *all* cameras within five years, as well.
- Wider Wi-Fi. Built-in Wi-Fi is becoming standard in mid entry-level cameras (those a notch above the true beginner models). Virtually all of the rest support inexpensive plug-in Wi-Fi add-ons, or include menu setup options to activate Wi-Fi features included in some SD memory cards (from Eye-Fi, Transcend, and others). Today, you can upload your pictures instantly to Flickr or Facebook (among other sites) instantly, as you shoot, if you're located near a Wi-Fi hotspot. When "tethering" becomes more widespread, your camera will piggyback onto the instant Wi-Fi hotspots that will be provided by your tablet computer, smartphone, Mi-Fi gadget, or other device no matter where you are. Canon has a cool feature that allows you to link compatible Canon cameras to share images directly.
- Bits and pieces. Mirrorless cameras are becoming smaller in size. More cameras have swiveling LCDs that let you adjust your angle of view for live view shooting, movie making, or image review. LCDs have higher resolution for better detail (although the size seems to have stabilized at about 3.2 inches diagonally). More cameras feature touch screens that you can use to select menu items, specify the area within a frame where the camera should focus, and even take a photo by tapping the screen. During playback, these cameras allow scrolling among images with a swipe of a finger, and zooming in and out of a display with pinching gestures—just like the typical smartphone.
- Rise of the mirrorless camera. Mirrorless ILCs are replacing dSLR cameras for most applications where compact size is prized. Because these cameras do not have a mirror, they can be extra compact and use smaller lenses.
 - Olympus has been wildly successful with its OM-D lineup of mirrorless camera-lookalikes in the Micro Four Thirds format, with their more compact interchangeable lens PEN cameras, with fewer features, not gaining as much traction in the marketplace. At their introduction, Sony's Alpha A7, A7s, and A7r (the latter with a 36MP sensor) were the smallest full-frame cameras on the market, and the company has done well with its other mirrorless ILC models. Panasonic also sells Micro Four Thirds cameras with interchangeable lenses, but the company offers a confusing number of variations on the theme. The Panasonic mirrorless models are known for their excellent movie-making features. The simplified light path of the traditional digital SLR and the new mirrorless cameras is shown in Figure 1.3. I'll explain the other components of the light path in more detail in Chapter 2.

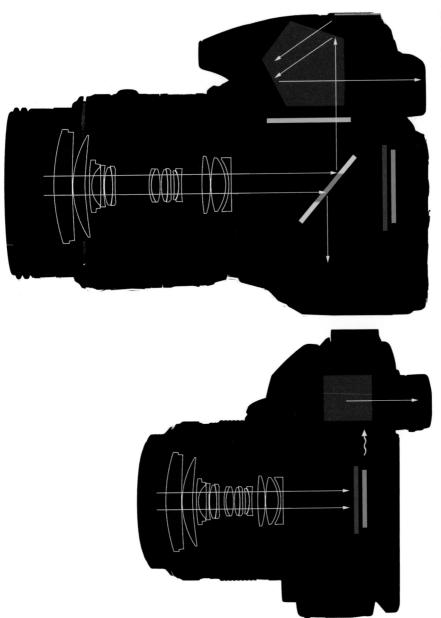

Figure 1.3
In a traditional dSLR camera (top), light is reflected up to an optical viewing system by a mirror that flips up and out of the light path when an exposure is made. A mirrorless camera (bottom) has an electronic viewfinder.

Software Innovations

Software products have seen improvements, too, albeit on a slower schedule, because the impetus among software developers is to bunch upgrades into stable software releases every 12 to 18 months—just often enough to convince you that you really need to pay up to a third of the original price for your software to gain the new features (whether you really need them or not). Here are some supposed software innovations—and, what I feel, is the one true breakthrough.

■ Photoshop gets bigger—more expensive. Photoshop, and its cousins, Photoshop Elements and Lightroom, continue to add sufficient features, some of which are actually needed, to make each, basically, impossible to completely master. The one real breakthrough feature for photographers in recent years has to be Content-Aware Fill, which, if properly used, lets you quickly and virtually invisibly remove those tiny, inevitable defects that appear in many photos. Vexed by a few scraps of paper on the grass, or an ugly, withered leaf or two in your landscape photo? Need to quickly retouch a portrait of someone with a less-than-perfect complexion? Content-Aware Fill can save you hours.

The problem for advanced photographers who are amateurs, or who don't make significant amounts of money from their work, or who are not rich is that Elements, while automated and easy to use, isn't a true substitute for Photoshop CS6. Neither is Lightroom a good Photoshop replacement. Unfortunately, Adobe has more or less discontinued its most advanced tool—CS6—in favor of its expensive Creative Cloud subscription model, discussed next.

Photoshop retouches, color corrects, does an amazing job of compositing, and can tame noise and create animations. Lightroom has some limited image-editing features similar to some of the pixel manipulation tools in Photoshop. However, the intent of Lightroom is to function as a workflow management application. Photoshop can do just about anything, except help you manage 100,000 different images effectively. Lightroom *can't* do everything, but it excels at giving you a way to manage tens or hundreds of thousands of images easily.

Buying both can be expensive, now that Adobe has essentially discontinued the standalone licensed version of Photoshop, freezing its feature set at Photoshop CS6. At this writing, all future upgrades will be in the form of Adobe Creative Cloud (CC) subscriptions, for which you will pay a monthly or annual fee to use Photoshop or any of the other applications in the Creative Cloud Suite (such as Adobe InDesign or Adobe Illustrator). The software still physically resides on your computer, but periodically "phones home" to Adobe over the internet, and if your subscription has expired, so does your access to Photoshop CC and your other tools. For corporations, professional photographers, and avid amateurs who use Photoshop day in and day out, the Creative Cloud subscription is a modest cost. But for those who don't need every single upgraded feature, and who had tended to happily skip Photoshop generations—jumping from CS4 to CS6 for example—the Photoshop CC model is an unnecessary or difficult to justify expense.

Adobe has said that Lightroom will retain both standalone and CC versions, and remains an option for those who don't like subscribing to software. Photoshop Elements also remains on

the standalone track, but lacks some of the capabilities that owners of an advanced camera requires, such as the ability to use all tools with 16-bit images.

- Stop-gap applications. We've seen remarkable growth of applications that do nothing but fix limitations of the camera. HDR software has become a fad and a cottage industry, and will certainly—in the long run—be much less significant when sensors gain the ability to capture longer dynamic ranges, or HDR is built into more cameras. Other stop-gap applications include resampling software that enables you to make bigger prints (at least until in-camera resolution reaches the point of diminishing returns), and any kind of RAW conversion software.
- iOS/Android smart device apps. The true innovation in software has been the growth of photography apps that can be downloaded and run on your phone, tablet, phablet, or other personal device when you're out shooting pictures. Tuck a tiny iPod or phone the size of half a deck of cards in your pocket, and you can pull it out and access any of hundreds of useful utilities and reference guides. You can have depth-of-field or exposure estimator tables at your fingertips, display a level to orient your camera, or keep a digital copy of your camera manual

(or this guidebook) at hand. For example, I've developed a few "companion" apps for specific cameras that include settings guides, and videos of my personal self explaining how to use some of the most under-used features, select the best accessories for the job at hand, or how to clean your sensor manually. I also have an absolutely free app, *David Busch's Lens Finder* to help you decide what optics to add to your collection. (See the screen capture in Figure 1.4 for a shameless plug.) As mirrorless cameras become better able to shoot great pictures in the camera, with less need for image editing, apps like those already available for smart devices will become the most useful software modules for digital photography.

And, many cameras come with their own smart device apps that allow you to operate your camera by remote control (and preview the exact image seen through the camera lens on your phone or tablet). Take time-lapse photos, if you like. Apps allow you to upload photos from your camera to your device through the camera's built-in or add-on Wi-Fi connection. Although some think smartphone cameras will replace digital point-and-shoot cameras, it's becoming obvious that at the higher end, there's no need to beat 'em: join 'em.

Figure 1.4 Portable apps like this one from iTunes provide guidance and enhancements for your mirrorless camera.

The Future

In his 1888 utopian novel *Looking Backward*, 2000-1887, Edward Bellamy made some remarkable predictions—including the first description of what we today call credit and debit cards. But he also predicted that by the turn of the 21st century, music would be available in every household, emanating from speakers connected by telephone lines to live concert halls around the globe. Did he miss the boat, or just leap over phonograph records, CDs, and MP3 players to Pandora? Other seers predicted the automobile, but not one of them foresaw traffic jams, road rage, and smog. It's been said that the chief outcome of predictions has been amusement for our ancestors.

The future of digital photography is equally murky. It seems obvious that, as I mentioned earlier, smartphones will replace low-end digital cameras. They've already supplanted landline phones, standalone MP3 players, hand-held video games, many GPS devices, stopwatches, and alarm clocks (as well as wristwatches, for that matter). It's a wonderful technology, the joke goes, that allows us to hold all the knowledge of the world in our hand, look at pictures of cats, and get into arguments with people we don't know.

But, are smartphones, tablets, or phablets a threat to the mirrorless ILC? I think not—at least in the short to medium term—because enthusiasts are willing to give up the small size of the typical smart device in order to gain the versatility that mirrorless cameras offer in the way of features and add-ons like interchangeable lenses, electronic flash, and other accessories. The 41MP phones of today still can't do things that the least expensive mirrorless model can do.

Still, we can expect mirrorless cameras to get smaller and more compact, even among the professional models. The dramatic rise in popularity of mirrorless cameras demonstrates that, given two cameras with roughly equal capabilities, photographers would like to opt for the smaller one. Other changes outlined in this chapter—higher resolution, better sensors, improved software tools, and enhanced connectivity—are coming, too. While each of these may have points of diminishing returns, we haven't come close to reaching them.

In 2012, the Cleveland Photographic Society, which has been in continuous operation since 1887, "buried" a time capsule destined to be opened in 75 years. It contained an assortment of artifacts from our era, including a copy of one of my books. (I was told that burying it for 75 years was an excellent idea.) The note I enclosed made no predictions of what I thought photography would be like three-quarters of a century hence, lest I be thought a total idiot. Instead, I provided a detailed listing of the state of the technology today, my personal contribution to the amusement of our ancestors. As for the *art* of photography, nothing needed to be said. It's always been that great images don't depend on technology, and the images of the Westons, Cartier-Bressons, Langes, Adamses, and their more recent counterparts, will survive on their own.

Inside Your Mirrorless Camera

To belabor my analogy at the beginning of the last chapter, you truly don't need to know anything about internal combustion to operate an automobile, and you really don't need to understand digital technology to use a point-and-shoot digital camera, either. Both devices are so automated these days that there's not a lot for the driver/shooter to do other than point the machinery in the right direction and press the gas pedal or shutter release. Even if you decide to use manual controls, the only things you *must* understand are that this button makes the picture lighter or darker, that one helps freeze action, and this other button changes the way the camera focuses.

However, if you really want to master a mirrorless, you can benefit from understanding exactly how the camera's components provide you with a much finer degree of control over your images than the typical point-and-shoot camera. Unlike digital snapshot photography, where it's almost impossible to adjust depth-of-field (the range of acceptable sharpness), and usable ISO ratings range from ISO 100 to ISO 100 (just kidding!), the technology built into a mirrorless camera *does* allow you to make a difference creatively and technically, if you know what you're doing. And for the average serious photographer, that's what taking pictures is all about.

With a mirrorless, it's easy to use depth-of-field to manipulate your images, but you need to understand how digital cameras work with lenses and their apertures. The "graininess" of your pictures is under your control, too, but it depends heavily on things like the size of the sensor, the sensitivity setting you're using, and what kind of noise reduction technology is built into your camera, and how you choose to apply it. If noise is bad, then noise reduction must be good, right? Yet, when you

really delve into how your camera works, you'll understand that noise reduction can rob your image of sharpness and detail. There are certain types of pictures in which *less* noise reduction is a better bet, even at a cost of a bit of "grain" in your image.

Or, would you like to take a picture in which a runner is frozen in time, but a streaky blur trails behind him like The Flash in comic books? You'd better understand the difference between front-sync and rear-sync shutter settings. Interested in using a super-long telephoto lens without a tripod or switching to high shutter speeds? Step up and learn about image stabilization.

If you're who I think you are, you don't see understanding mirrorless technology as a daunting task, but as an interesting challenge. By the time someone is ready to use all the features of their digital camera, he or she is looking forward to taking greater control over every aspect of the picture-taking process.

The most comforting thing about mirrorless technology is that, for the most part, these cameras were designed by engineers who understand photography. Many of the point-and-shoot digital cameras I have used appear to have been designed by a techie who was creating cell phones last week, and then moved over to digital cameras this week. They operate like computers rather than cameras, have features that nobody in their right mind actually needs, and often are completely impractical for the kinds of photography for which they are intended.

For example, one alarming trend is toward pocket-sized digicams that have *no eyelevel viewfinder at all*. With those models, it's necessary to frame every picture using the back-panel LCD, which, unfortunately, can wash out in bright sunlight, and often forces you to hold the camera at arm's length, almost guaranteeing that powerful image stabilization features are going to be required to nullify camera shake.

In contrast, while some lower-end mirrorless cameras lack an eyelevel viewfinder, for the most part higher-end mirrorless models are designed by people who understand the needs of avid photographers. They often have, for example, large high-resolution eyelevel electronic viewfinders. These provide a reasonable display of approximate depth-of-field, and such viewfinders can be used under a variety of lighting and viewing conditions. The designers of these models have been creating such cameras for many years and know from the feedback they receive what photographers want. So, learning mirrorless technology will be rewarding for you, because you'll come to understand exactly how to use features that have been designed to help you be a better and more creative photographer.

This chapter explains that technology, and will help you when you're shopping for your next mirrorless. You'll have a better understanding of the kinds of technology you should be looking for in your camera. If you already own a dSLR, after reading this chapter, you'll know how to put those features to work.

Key Components of Your Mirrorless Camera

I'm not going to spend a lot of time in this chapter on the mechanical aspects of mirrorless cameras. Examine Figure 2.1 (with corresponding numbered list), which shows light entering a lens, evading capture by the diaphragm, wending its way to the sensor, and thence to the back-panel LCD or electronic viewfinder. You'll realize that you probably already know that stuff. Here's a quick review with brief descriptions of the main components (by no means comprehensive; I'll have more detail on some of them later in the book).

- 1. **Light path.** The yellow arrows represent an overly simplified path for the light entering the lens and making its way to the viewfinder and sensor. In reality, the light (1) is refracted at angles as it passes through the lens elements, and heads toward the shutter.
- 2. Lens elements. Lenses contain a varying number of elements (2) made of glass, plastic, or another material. These elements are fixed in place, or can move in relation to other elements to focus or zoom the image, or, in an image-stabilized lens, shifted to compensate for camera movement.

Figure 2.1
The light path inside
a mirrorless looks
something like this,
but there's a lot more
to know.

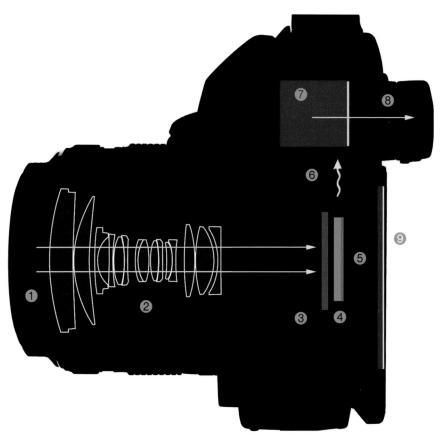

- 3. **Shutter.** In a mirrorless camera, the shutter (3) can be a physical component, consisting of a pair of vertically traveling curtains that open consecutively to create a gap for light from the lens to pass through during the exposure. Some cameras use an electronic shutter, in which the sensor remains active gathering light (such as for a live preview), until just before the exposure. Then, the camera "dumps" the image on the sensor electronically and captures a new image for the time specified by the shutter speed. It's possible for a camera to have a traditional physical shutter, an electronic shutter, and a hybrid shutter. The latter speeds the picture-taking process by electronically blanking the sensor at the start of an exposure, then using only the second physical shutter curtain to end the exposure. The process eliminates the need for the first shutter curtain to open and travel across the sensor plane. This process is called *electronic first curtain shutter* and I'll explain how it works in Chapter 7.
- 4. **Sensor.** The sensor (4) contains light-sensitive photosites that record the image and pass it off to the camera's analog-to-digital signal processing chip, and then to a memory card for storage. With mirrorless cameras, the sensor provides a live image for the LCD/electronic viewfinder, and is used for autofocus and exposure measurement.
- 5. **Sensor movement platform.** The sensor is not necessarily fixed in place. Instead, it resides on a platform (5) that can serve several functions. As a sensor-cleaning feature, the platform can vibrate the sensor very quickly to shake off dust and artifacts that have collected on the image-collecting surface. In cameras that use in-camera image stabilization, the sensor can be subtly moved to zero out camera motion that would otherwise cause image blur.
- 6. **Electronic connection to viewing system.** The live sensor image is conveyed electronically to the electronic viewfinder (if present) (6) or back-panel LCD.
- 7. **Electronic viewfinder.** Provides a high-resolution eyelevel view (7), often with 1.4 to 2.8 megapixels of resolution—several times more detail than found in a typical back-panel LCD.
- 8. **Viewfinder window.** This magnifier enlarges the EVF image, and includes diopter correction to adjust the view for the user's eyesight.
- 9. **Rear LCD.** Can display the live preview image, plus menus, and review images of pictures taken.

Sensors Up Close

In the broadest terms, a digital camera sensor is a solid-state device that is sensitive to light. When photons are focused on the sensor by your mirrorless camera's lens, those photons are registered and, if enough accumulate, are translated into digital form to produce an image map you can view on your camera's LCD and transfer to your computer for editing. Capturing the photons efficiently and accurately is the tricky part.

There's a lot more to understand about sensors than the number of megapixels. There are very good reasons why one 20-megapixel sensor and its electronics produce merely good pictures, whereas a different sensor in the same resolution range is capable of sensational results. This section will help

you understand why, and how you can use the underlying technology to improve your photos. Figure 2.2 shows a composite image that represents a typical sensor.

There are two main types of sensors used in digital cameras, called CCD (for charge coupled device) and CMOS (for complementary metal oxide semiconductor), and, fortunately, today there is little need to understand the technical differences between them, or, even which type of sensor resides in your camera. Early in the game, CCDs were the imager of choice for high-quality image capture, while CMOS chips were the "cheapie" alternative used for less critical applications. Today, technology has advanced so that CMOS sensors have overcome virtually all the advantages CCD imagers formerly had, so that CMOS has become the dominant image capture device for digital cameras, with only a very few cameras using CCDs remaining. CCDs are still found in some point-and-shoot models and in electronic movie cameras, because of their ability to capture an entire frame at once (the so-called "global shutter") rather than a line at a time ("rolling shutter") like CMOS sensors.

Figure 2.2 A mirrorless sensor looks something like this.

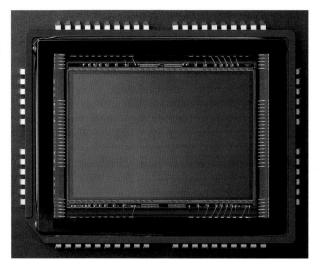

Capturing Light

Each sensor's area is divided up into picture elements (pixels) in the form of individual photo-sensitive sites (photosites) arranged in an array of rows and columns. The number of rows and columns determines the resolution of the sensor. For example, a typical 21-megapixel digital camera might have 5,616 columns of pixels horizontally and 3,744 rows vertically. This produces 3:2 proportions (or *aspect ratio*) that allow printing an entire image on 6 inch by 4 inch (more typically called 4×6 inch) prints.

While a 3:2 aspect ratio is most common on mirrorless cameras, it is by no means the only aspect ratio used. So-called Four Thirds and Micro Four Thirds cameras from vendors like Olympus and Panasonic use a 4:3 aspect ratio. Some cameras have a "high-definition" *crop mode* for still photos

that uses the same 16:9 aspect ratio as your HDTV. Figure 2.3 shows the difference between these different proportions.

Digital camera sensors use microscopic lenses to focus incoming beams of photons onto the photosensitive areas on each individual pixel/photosite on the chip's photodiode grid, as shown in Figure 2.4. The microlens performs two functions. First, it concentrates the incoming light onto the photosensitive area, which constitutes only a portion of the photosite's total area. (The rest of the area, in a CMOS sensor, is dedicated to circuitry that processes each pixel of the image individually. In a CCD, the sensitive area of individual photosites relative to the overall size of the photosite itself is larger.) In addition, the microlens corrects the relatively "steep" angle of incidence of incoming photons when the image is captured by lenses originally designed for film cameras. Lenses designed specifically for digital cameras are built to focus the light from the edges of the lens on the photosite; older lenses may direct the light at such a steep angle that it strikes the "sides" of the photosite "bucket" instead of the active area of the sensor itself.

As photons fall into this photosite "bucket," the bucket fills. If, during the length of the exposure, the bucket receives a certain number of photons, called a *threshold*, then that pixel records an image at some value other than pure black. If too few pixels are captured, that pixel registers as black. The more photons that are grabbed, the lighter in color the pixel becomes, until they reach a certain

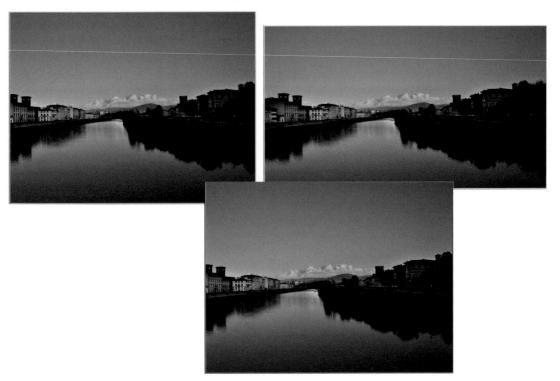

Figure 2.3 Typical sensor aspect ratios include 3:2 (upper left), 16:9 (upper right), and 4:3 (lower right).

level, at which point the pixel is deemed white (and no amount of additional pixels can make it "whiter"). In-between values produce shades of gray or, because of the filters used, various shades of red, green, and blue. (See Figure 2.5.)

If too many pixels fall into a particular bucket, they may actually overflow, just as they might with a real bucket, and pour into the surrounding photosites, producing that unwanted flare known as *blooming*. The only way to prevent this bucket from overfilling is to drain off some of the extra photons before the photosite overflows, which is something that CMOS sensors, with individual circuits at each photosite, are able to do.

Figure 2.4
A microlens on each photosite focuses incoming light onto the active area of the sensor.

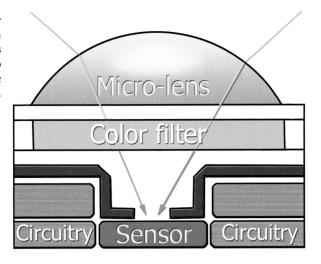

Figure 2.5
Think of a photosite as a bucket that fills up with photons.

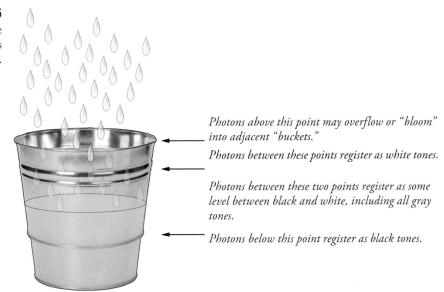

Of course, now you have a bucket full of photons, all mixed together in analog form like a bucket full of water. What you want though, in computer terms, is a bucket full of ice cubes, because individual cubes (digital values) are easier for a computer to manage than an amorphous mass of liquid. The first step is to convert the photons to something that can be handled electronically, namely electrons. The analog electron values in each row of a sensor array are converted from analog ("liquid") form to digital (the "ice cubes"), either right at the individual photosites or through additional circuitry adjacent to the sensor itself.

Noise and Sensitivity

One undesirable effect common to all sensors is visual noise, that awful graininess that shows up as multicolored specks in images. In some ways, noise is like the excessive grain found in some high-speed photographic films. However, while photographic grain is sometimes used as a special effect, it's rarely desirable in a digital photograph.

Unfortunately, there are several different kinds of noise, and several ways to produce it. The variety you are probably most familiar with is the kind introduced while the electrons are being processed, due to something called a "signal-to-noise" ratio. Analog signals are prone to this defect, as the amount of actual information available is obscured amidst all the background fuzz. When you're listening to a CD in your car, and then roll down all the windows, you're adding noise to the audio signal. Increasing the CD player's volume may help a bit, but you're still contending with an unfavorable signal-to-noise ratio that probably mutes tones (especially higher treble notes) that you really wanted to hear.

The same thing happens during long time exposures, or if you boost the ISO setting of your digital sensor. Longer exposures allow more photons to reach the sensor, increasing your ability to capture a picture under low-light conditions. However, the longer exposures also increase the likelihood that some pixels will register random phantom photons, often because the longer an imager is "hot" the warmer it gets, and that heat can be mistaken for photons. This kind of noise is called *long exposure noise*.

There's a second type of noise, too, so-called *high ISO noise*. Increasing the ISO setting of your camera raises the threshold of sensitivity so that fewer and fewer photons are needed to register as an exposed pixel. Yet, that also increases the chances of one of those phantom photons being counted among the real-life light particles, too. The same thing happens when the analog signal is amplified: You're increasing the image information in the signal but boosting the background fuzziness at the same time. Tune in a very faint or distant AM radio station on your car stereo. Then turn up the volume. After a certain point, turning up the volume further no longer helps you hear better. There's a similar point of diminishing returns for digital sensor ISO increases and signal amplification, as well.

Regardless of the source, it's all noise to you, and you don't want it. Mirrorless cameras have noise reduction features you can use to help minimize this problem.

Dynamic Range

The ability of a digital sensor to capture information over the whole range from darkest areas to lightest is called its *dynamic range*. You take many kinds of photos in which an extended dynamic range would be useful. Perhaps you have people dressed in dark clothing standing against a snowy background, or a sunset picture with important detail in the foreground, or simply an image with important detail in the darkest shadow. Or, perhaps you want to capture the snow on mountain peaks in a distant vista that also includes much darker fir trees (see Figure 2.6). If your digital

Figure 2.6
A broad array of tones, such as snow-capped peaks and dark forest foliage, is beyond the capabilities of digital cameras with a narrower dynamic range (top).
A wide dynamic range allows you to capture both (bottom).

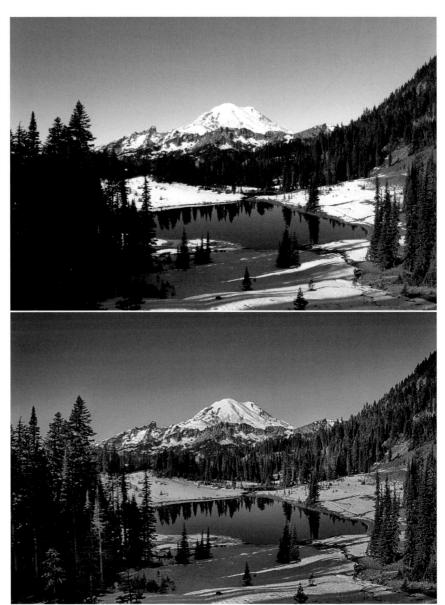

camera doesn't have sufficient dynamic range or built-in HDR (which combines multiple exposures into a single, extended range image), you won't be able to capture detail in both areas in one shot without resorting to some tricks like Photoshop's Merge to HDR Pro (High Dynamic Range) feature.

Sensors have some difficulty capturing the full range of tones that may be present in an image. Tones that are too dark won't provide enough photons to register in the sensor's photosite "buckets," producing clipped shadows, unless you specify a lower threshold or amplify the signal, increasing noise. Very light tones are likely to provide more photons than the bucket can hold, producing clipped highlights and overflowing to the adjacent photosites to generate blooming. Ideally, you want your sensor to be able to capture very subtle tonal gradations throughout the shadows, midtones, and highlight areas.

Dynamic Range and Sensitivity

One way to do this is to give the photosites a larger surface area, which increases the volume of the bucket and allows collecting more photons. In fact, the jumbo photosites in larger sensors (so-called *full-frame* models) allow greater sensitivity (higher ISO settings), reduced noise, and an expanded dynamic range. In the past few years, a metric called *pixel density* has provided an easy way to compare the size/density of pixels in cameras, even those with different absolute resolutions. For example, consider two cameras from one vendor share the same 24-megapixel resolution, such as the Sony A7 and Sony a6000. The former has a full-frame sensor measuring about 24mm × 36mm, and roughly 277,778 pixels packed into each square centimeter of sensor area. The latter uses a typical APS-C sensor size (more on that later) measuring about 16mm × 24mm, and with less room on its smaller sensor, has to squeeze 625,000 pixels into each square centimeter of sensor area in order to equal the 24MP resolution of the full-frame camera. Clearly, the camera with the larger sensor has larger pixels that are more sensitive to light, as you can see in Figure 2.7. Those larger pixels can gather more light, allowing better image quality, particularly at higher ISO settings. (I'll explain the reason for those red, green, and blue rectangles later in this chapter.)

Figure 2.7
A full frame
24mm × 36mm
sensor (left) uses
larger pixels than
an APS-C sensor
measuring about
16mm × 24mm
(right) of the exact
same resolution.

Dynamic Range and Tonal Values

While we're always interested in the amount of detail that can be captured under the dimmest lighting conditions, the *total* dynamic range of tones that can be grabbed is also important. Dynamic range can be described as a ratio that shows the relationship between the lightest image area a digital sensor can record and the darkest image area it can capture. The relationship is logarithmic, like the scales used to measure earthquakes, tornados, and other natural disasters. That is, dynamic range is expressed in density values, D, with a value of, say, 3.0 being ten times as large as 2.0.

As with any ratio, there are two components used in the calculation, the lightest and darkest areas of the image that can be captured. In the photography world (which includes film; the importance of dynamic range is not limited to digital cameras), these components are commonly called Dmin (the minimum density, or brightest areas) and Dmax (the maximum density, or darkest areas).

Dynamic range comes into play when the analog signal is converted to digital form. As you probably know, digital images consist of the three color channels (red, green, and blue), each of which has, by the time we begin working with them in an image editor, tonal values ranging from 0 (black) to 255 (white). Those 256 values are each expressed as one 8-bit byte, and combining the three color channels (8 bits × 3) gives us the 24-bit, full-color image we're most familiar with.

However, when your mirrorless converts the analog files to digital format to create its RAW (unprocessed) image files, it can use more than 8 bits of information per color channel, usually 12 bits, 14 bits, or 16 bits. These extended range channels are usually converted down to 8 bits per channel when the RAW file is transferred to your image editor, although some editors, like Photoshop, can also work with 16-bit and even 32-bits-per-channel images.

The analog to digital converter circuitry itself has a dynamic range that provides an upper limit on the amount of information that can be converted. For example, with a theoretical 8-bit A/D converter, the darkest signal that can be represented is a value of 1, and the brightest has a value of 255. That ends up as the equivalent of a maximum possible dynamic range of 2.4, which is not especially impressive as things go.

On the other hand, a 10-bit A/D converter has 1,024 different tones per channel, and it can produce a maximum dynamic range of 3.0; up the ante to 12 or 16 bits (and 4,094 or 65,535 tones) in the A/D conversion process, and the theoretical top dynamic ranges increase to values of D of 3.6 and 4.8, respectively.

These figures assume that the analog to digital conversion circuitry operates perfectly and that there is no noise in the signal to contend with, so, as I said, those dynamic range figures are only theoretical. What you get is likely to be somewhat less. That's why a 16-bit A/D converter, if your camera had one, would be more desirable than a 12-bit A/D converter. Remember that the scale is logarithmic, so a dynamic range of 4.8 is *many* times larger than one of 3.6.

The brightest tones aren't particularly difficult to capture, as long as they aren't *too* bright. The dark signals are much more difficult to grab, because the weak signals can't simply be boosted by amplifying them, as that increases both the signal as well as the background noise. All sensors produce some noise, and it varies by the amount of amplification used as well as other factors, such as the temperature of the sensor. (As sensors operate, they heat up, producing more noise.) So, the higher the dynamic range of a digital sensor, the more information you can capture from the darkest parts of a slide or negative. If you shoot low-light photos or images with wide variations in tonal values, make sure your camera has an A/D converter and dynamic range that can handle them. Unfortunately, specs alone or published reviews won't tell you in so many words; to really see if a camera will do the job for you, you'll need to take some pictures and see if the camera is able to deliver. (Which is another good reason to buy your camera locally, even if you have to take your test shots in the store, rather than purchase a pig in a poke from a mail-order or Internet vendor.)

Controlling Exposure Time

This wonderful process of collecting photons and converting them into digital information requires a specific time span for this to happen, known in the photographic realm as *exposure time*. Film cameras have always sliced light into manageable slivers of time using mechanical devices called shutters, which block the film until you're ready to take a picture, and then open to admit light for the period required for (we hope) an optimal exposure. This period is generally very brief, and is measured, for most pictures taken with a hand-held camera, in tiny fractions of a second.

Digital cameras have shutters, too. They can have either a mechanical shutter, which opens and closes to expose the sensor, or an electronic shutter, which simulates the same process. As I mentioned earlier, many digital cameras have used *both* types of shutter, relying on a mechanical shutter for relatively longer exposures (usually 1/500th second to more than a second long), plus an electronic shutter for higher shutter speeds that are difficult to attain with mechanical shutters alone. (That's why you'll find a [very] few digital cameras—aside from a couple mirrorless models from Nikon and Panasonic—with shutter speeds as high as 1/16,000th second: they're electronic.) Electronic shutters and hybrid electronic/mechanical shutters are also used to speed up a camera's response time in live view mode. These modes avoid the time needed to close the mechanical shutter, dump the image on the sensor, and then re-open the mechanical shutter to begin the actual exposure. Instead, the exposure can commence immediately by blanking the sensor electronically, and then "opening" the electronic shutter.

Shutters can work with any kind of sensor. One important thing to remember about a mirrorless's mechanical shutter is that its briefest speed usually (but not always) determines the highest speed at which an electronic flash can synchronize. That is, if your camera syncs with electronic flash at no more than 1/160th second, that may be the highest mechanical shutter speed available. Some special flash systems can synchronize with electronic shutters at higher speeds, but I'll leave a detailed discussion of syncing for Chapter 7.

How We Get Color

So far, I've ignored how sensors produce color. In one sense, digital camera sensors are color blind. They can register the brightness, or *luminance*, of an image, but have no notion of the color of the light at all. To do that, most sensors (excepting a special type called Foveon, used in some Sigma cameras, and explained below) overlay the photosites with a set of color filters. Each pixel registers red, green, or blue light, and ignores all the others. So, any particular pixel might see red light (only), while the one next to it might see green light (only), and the pixel below it on the next row might be sensitive to blue light (only).

As you might guess, in the normal course of events, a pixel designated as green-sensitive might not be lucky enough to receive much green light. Perhaps it would have been better if that pixel had registered red or blue light instead. Fortunately, over a large pixel array, enough green-filtered pixels will receive green light, red-filtered pixels red light, and blue-filtered pixels blue light that things average out with a fair degree of accuracy. To compensate for this shortcoming, the actual color value of any particular pixel is calculated through a process called *interpolation*. Algorithms built into the camera's circuitry can look at surrounding pixels to see what their color values are, and predict with some precision what each pixel should actually be. For the most part, those guesses are fairly accurate.

For reasons shrouded in the mists of color science, the pixels in a sensor array are not arranged in a strict red-green-blue alternation, as you might expect to be the case. Instead, the pixels are usually laid out in what is called a Bayer pattern (named after Kodak scientist Dr. Bryce Bayer), shown in Figure 2.8, which shows just a small portion of a full sensor array. One row alternates green and red pixels, followed by a row that alternates green and blue filters. Green is "over-represented" because of the way our eyes perceive light: We're most sensitive to green illumination. That's why monochrome monitors of the computer dark ages were most often green-on-black displays.

The process of interpreting the pixel values captured and transforming them into a more accurate representation of a scene's colors is called *demosaicing*. With good algorithms, the process is accurate, but faulty demosaicing can produce unwanted artifacts in your photo (although, almost by definition, artifacts are generally always unwanted).

Of course, use of a Bayer pattern means that a great deal of the illumination reaching the sensor is wasted. Only about half of the green light is actually captured, because each row consists of half green pixels and half red or blue. Even worse, only 25 percent of the red and blue light is registered. Figure 2.9 provides a representation of what is going on. In our 36-pixel array segment, there are just 18 green-filtered photosites and 9 each of red and blue. Because so much light is not recorded, the sensitivity of the sensor is reduced (requiring that much more light to produce an image), and the true resolution is drastically reduced. Your digital camera, with 10 megapixels of resolution, actually captures three separate images measuring 5 megapixels (of green), 2.5 megapixels (of blue), and 2.5 megapixels (of red).

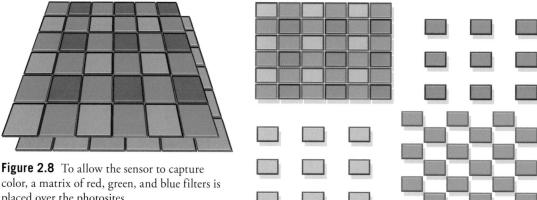

placed over the photosites.

Figure 2.9 There are twice as many green pixels in a raw captured image as red and blue pixels.

FOVEON SENSORS

Foveon sensors are found in several Sigma digital cameras, but no ILC mirrorless models to date. The Foveon imager works in a quite different way. It's long been known that the various colors of light penetrate silicon to varying depths. So, the Foveon device doesn't use a Bayer filter mosaic like that found in other sensors. Instead, it uses three separate layers of photodetectors, which are shown in Figure 2.10, colored blue, green, and red. All three colors of light strike each pixel in the sensor at the appropriate strength as reflected by or transmitted through the subject. The blue light is absorbed by and registers in the top layer. The green and red light continue through the sensor to the green layer, which absorbs and registers the amount of green light. The remaining red light continues and is captured by the bottom layer.

So, no interpolation (called *demosaicing*) is required. Without the need for this complex processing step, a digital camera can potentially record an image much more quickly. Moreover, the Foveon sensor can have much higher resolution for its pixel dimensions, and, potentially, less light is wasted. The reason why Foveon-style sensors haven't taken over the industry is that technical problems limit the pixel dimensions of this kind of sensor. However, outside the theoretical world, cameras using the Foveon sensor are not yet regarded as the leading edge in sharpness, color fidelity, or much of anything else. However, don't write off this technology until it has been explored fully.

The Foveon sensor

Figure 2.10

has three layers, one for each primary color of light. At left, a representation of colored light penetrating the array; at right, a cross section of a typical photosite, measuring about 7 microns wide by 5 microns thick.

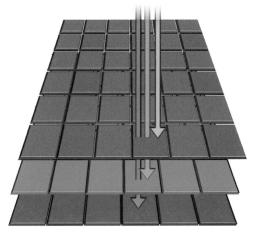

Infrared Sensitivity

The final aspect of sensor nuts and bolts that I'm going to mention is infrared sensitivity. Sensors, in particular, are inherently quite sensitive to non-visible, infrared light. Imaging this extra light can produce colors that are not realistic, and therefore inaccurate. For example, a green leaf (which reflects a lot of infrared) might not look the same shade as a non-infrared-reflecting green automobile that, to our eyes, appears to be the exact same hue. So, most camera vendors install infrared blocking filters in front of sensors, or include a component called a hot mirror to reflect infrared to provide a more accurate color image. (If your camera has one, this may be the only "mirror" it contains.) Luckily (for the serious photographer) enough infrared light sneaks through that it's possible to take some stunning infrared photos with many digital cameras. There are easy ways to determine whether your camera can shoot infrared photos. Point your TV's remote control at the lens with the room lights dimmed, and take a picture while a button is depressed; if a light dot that represents the invisible infrared beam appears, your camera has some infrared sensitivity.

There are lots of things you can do with infrared, especially if you're willing to manipulate the photo in an image editor. For example, swapping the red and blue channels, as was done for Figure 2.11, can produce an infrared photo in which the sky regains its dark blue appearance for a strange and wonderful effect. If you want to learn more about digital IR photography, you might want to check out my book David Busch's Digital Infrared Pro Secrets, from Course Technology/PTR.

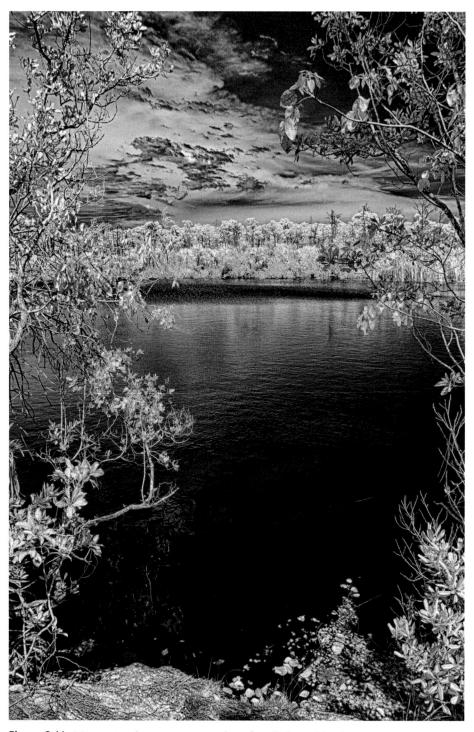

Figure 2.11 Many mirrorless cameras can take infrared photos like this one.

Using Interchangeable Lenses

The next most important component of a mirrorless camera is the lens—or, more properly, lenses—because, unlike non-interchangeable lens cameras, which may use add-on lens adapters, the lens of a mirrorless camera is fully interchangeable. I'm not going to tell you much about how lenses work. Most of the rest of this section will deal with practical matters relating to interchangeable lenses on a camera. The only things you really need to know about lenses are these:

- Lenses consist of precision-crafted pieces of optical glass (or plastic or ceramic material) called *elements*, arranged into *groups* that are moved together to change the magnification or focus. The elements may be based on slices of spheres, or not (in which case they are *aspherical*), and given special coatings to reduce or eliminate unwanted reflections.
- Lenses contain an iris-like opening called a diaphragm that can be changed in size to admit more or less light to the sensor. In addition to adjusting the amount of light that passes through the lens, the diaphragm and its shape affect things like relative overall sharpness of an image, the amount of an image that is in focus, the brightness of your view through the electronic viewfinder or seen on the LCD, and even the shape and qualities of out-of-focus highlights in your image. I'll describe these aspects in more detail as they come up.
- Lenses are mounted in a housing that keeps the elements from rattling around and provides a way to move them to adjust focus and magnification. The lens housing can include a microprocessor, a tiny motor for adjusting focus (and, in some cameras, for zooming), and perhaps a mechanism for neutralizing camera shake (called *vibration reduction*). Also included are threads or a bayonet mount for attaching filters, a fitting that attaches to your camera, and various levers and electronic contacts for communicating with the camera body. You might find a switch or two for changing from autofocus to manual focus, locking a zoom lens so it doesn't extend accidentally while the camera is being carried, and a macro lock/lockout button to limit the seeking range of your autofocus mechanism so your lens won't seek focus from infinity to a few inches away every time you partially depress the shutter release.

Everything else is details, and we'll look at them in this and later chapters of this book.

Lens Interchangeability

The ability to remove a lens and swap it for another is one of the key advantages of the mirrorless camera. Interchangeable lenses make a very cool tool because they expand the photographer's versatility in several ways:

■ Swapping lenses lets you change the "reach" of a camera, from wide-angle to medium telephoto to long telephoto. The zoom lenses on non-ILC models provide some of this flexibility, but they can't provide the magnification of the longest telephotos and telephoto zooms, nor the wide-angle perspective of the shortest focal lengths found in some interchangeable lenses and zooms. Figures 2.12, 2.13, and 2.14 illustrate just how much the right lenses can change your view of a single subject.

Figure 2.12
With the zoom set to 14mm, and with a vertical perspective, the sheer depth of a broad expanse of the Grand
Canyon is visible.

Figure 2.13
At 70mm, a lone hiker becomes a point of interest.

Figure 2.14
A 150mm lens crops the image to the hiker and a glimpse of the vista in front of him.

- Interchangeable lenses let you choose a lens optimized for a particular purpose. Do-everything zooms are necessarily a compromise that may perform fairly well in a broad range of applications, but excel at none of them. Using an ILC mirrorless model lets you choose a lens, whether it's a zoom or a fixed focal length lens (called a *prime* lens), that does a particular thing (such as capture images with a large maximum aperture, or focus especially close) very well indeed. For example, a lens with a zoom range extending from wide-angle to long telephoto may be plagued with distortion at one end of the range or another (or both!). A multi-purpose lens is probably much slower than an optimized optic, perhaps with an f/4.5 or f/5.6 maximum aperture. With the availability of interchangeable lenses, you can select a very fast, f/1.4 lens when you need one, or choose a lens that's particularly good in a given zoom range (say, 12-24mm). Choose another lens for its exquisite sharpness, or because it provides a dreamy blurry effect that's perfect for portraiture. Use zooms when you need them and prime, fixed focal length lenses when they are better suited for a job.
- Lens swaps make it easy for those with extra-special needs to find some glass that fits their specialized requirements. Fisheye lenses, those with perspective control shifts, macro lenses for a bug's eye view of that prize flower, or hyper-expensive super-long telephoto optics with built-in correction for camera shake are available to anyone who can afford them.

As you know, however, lenses aren't infinitely interchangeable. Lenses designed to fit on one particular vendor's brand of camera probably won't fit on another vendor's camera (although there are exceptions), and it's highly likely that you'll discover that many lenses produced by the manufacturer of your mirrorless can't be used with current camera models. Unfortunately, I can't provide a comprehensive lens compatibility chart here, because there are hundreds of different lenses available, but you might find some of the guidelines in this section useful.

The first thing to realize is that lens compatibility isn't even an issue unless you have older lenses that you want to use with your current digital camera. If you have no lenses to migrate to your new camera body, it makes no difference, from a lens standpoint, whether you choose a Nikon, Canon, Sony, Olympus, Samsung, Panasonic, Pentax, or another camera. You'll want to purchase current lenses made for your camera by the vendor, or by third parties such as Tokina, Sigma, or Tamron, to fit your camera. One exception might be if you had a hankering for an older lens that you could purchase used at an attractive price. In that case, you'll be interested in whether that older lens will fit your new camera.

You also might be interested in backward compatibility if you own a lot of expensive optics that you hope to use with your new camera. That compatibility depends a lot on the design philosophy of the camera vendor. It's easier to design a whole new line of lenses for a new camera system than to figure out how to use older lenses on the latest equipment. Some vendors go for bleeding-edge technology at the expense of compatibility with earlier lenses. Others bend over backwards to provide at least a modicum of compatibility.

Viewfinders

The next key component of a digital camera is its viewfinder. The viewfinder is, along with lens interchangeability, one of the distinguishing features between many ILC models and point-and-shoot models. Your choices include:

- View on the back-panel LCD display. These viewing panels, which operate like miniature laptop display screens, show virtually the exact image seen by the sensor. The LCDs measure roughly 2.7 to 3.2 inches diagonally, and generally display 98 percent or more of the picture view seen by the lens. An LCD may be difficult to view in bright light. Point-and-shoot digital cameras use the LCD display to show the image before the picture is taken, and to review the image after the snapshot has been made. Some of these have no optical viewfinder at all, so the only way to compose a shot is on the LCD. There are even fairly advanced mirrorless interchangeable lens cameras available from Canon, Nikon, Sony, Panasonic, and Olympus with no eyelevel viewfinders. In a camera, the back-panel LCD is used for reviewing pictures that have been taken and for previewing using the live view features, and for viewing movies as they are taken.
- View through an electronic viewfinder (EVF). The EVF operates like a little television screen inside the digital camera. You can view an image that closely corresponds to what the sensor sees, and it is easier to view than the LCD display, but until recently, didn't have nearly the quality of an SLR viewfinder. Sony has pioneered sensational EVFs with roughly twice the detail of earlier electronic viewfinders, so the gap is narrowing. Many EVF cameras are more compact than dSLRs, and are available both with interchangeable lenses (such as the Olympus and Panasonic Micro Four Thirds cameras, or E-Mount models in the Sony Alpha series).

There are several other important aspects of eyelevel viewfinders that you need to keep in mind:

- Vision correction. All mirrorless cameras have diopter correction to allow for near/far sightedness. However, if you have other vision problems that require you to wear glasses while composing photos, make sure your digital camera lets you see the entire image with your eyeglasses pressed up against the viewing window. Sometimes the design of the viewfinder, including rubber bezels around the frame, can limit visibility.
- Eyepoint. The distance you can move your eye away from the viewfinder and still see all of the image is called the eyepoint, and it's important to more than just eyeglass wearers, as described above. For example, when shooting sports, you may want to use your other eye to preview the action so you'll know when your subjects are about to move into the frame. Cameras that allow seeing the full image frame even when the eye isn't pressed up tightly to the window make it easy to do this. In the past, manufacturers of some cameras have even offered "extended eyepoint" accessories for sports photographers and others.
- Magnification. The relative size of the viewfinder image affects your ability to see all the details in the frame as you compose an image. It's not something you might think about, but if you compare cameras side by side, you'll see that some provide a larger through-the-lens view than others. Bigger is always better, but it is likely to cost more, too.

Working with viewfinders will come up again a few times later in this book, but if you remember the basic information presented in this chapter, you'll understand most of what you need to know.

Storage

Once you've viewed your image through the viewfinder, composed and focused it with your lens, and captured the photons with the sensor, the final step is to store the digital image semi-permanently so it can be transferred to your computer for viewing, editing, or printing. While the kind of storage you use in your camera won't directly affect the quality of your image, it can impact the convenience and versatility of your camera, so storage is worth a short discussion.

Once converted to digital form, your images first make their way into a special kind of memory called a buffer, which accepts the signals from the sensor (freeing it to take another picture) and then passes the information along to your removable memory card. The buffer is important because it affects how quickly you can take the next picture. If your camera has a lot of this very fast memory, you'll be able to take several shots in quick succession, and use a burst mode capable of several pictures per second for five or six or ten consecutive exposures. The buffer stores the images in the camera until it can write them to your memory card. If you take pictures faster than the camera can offload them to the card, the buffer will eventually fill up temporarily. Many mirrorless cameras provide a viewfinder readout showing either how many pictures can be stored in the remaining buffer or, perhaps, a flashing bar that "fills" as the buffer fills, and gets smaller as more room becomes available for pictures. When your buffer is completely full, your camera stops taking pictures completely until it is able to offload some of the shots to your memory card.

The memory card itself has its own speed, which signifies how quickly it can accept images from the buffer. There's no standard way of expressing this speed. Some card vendors use megabytes per second. Others label their cards as 80X, 120X, 233X, 400X, and so forth. Some vendors prefer to use word descriptions, such as Standard, Ultra II, Ultra III, or Extreme. With Secure Digital cards, the nomenclature Class 4, Class 6, or Class 10 can provide an indication of how quickly the card can move data. I'm not going to tell you which particular brands of cards are fastest here, because memory card technology and pricing is changing with blinding speed.

For standard shooting, I've never found the speed of my digital film to be much of a constraint, but if you shoot many action photos, sequences, or high-resolution (TIFF or RAW) pictures, you might want to compare write speeds carefully before you buy. A card that's been tested to write more quickly can come in handy when you don't have time to wait for your photos to be written from your camera's buffer to the memory card. What I always recommend is to buy the fastest memory card you can afford in a size that will hold a decent number of pictures. Then, purchase additional cards in larger sizes at bargain prices as your backups.

For example, if you've got a lot of money to spend, you might want to buy a 32GB or "ultra" card as your main memory card for everyday shooting, and stock up on slower, but dirt-cheap 16GB cards to use when your main card fills up. Or, if your budget is limited and you don't need

a high-speed card very often, spend your money on a larger standard card, and treat yourself to high-speed media in a more affordable size. That way, if you do need the extra-fast writing speed of an ultra card, you'll have it without spending a bundle on a high-speed/high-capacity memory card. And you'll have plenty of capacity in your standard digital film at an economical price.

In the past we saw marginal use of memory card formats like xD cards or Memory Sticks, and specialized cards like the XQD cards used only in the Nikon D4, D4s dSLRs, and some video cameras; today, the Secure Digital format dominates.

The SD format overtook Compact Flash as the most popular memory card format years ago. Most other vendors had long since converted their non-pro digital cameras to SD card, reserving CF for larger, "pro" cameras. The postage-stamp-sized SD cards allow designing smaller cameras, are available in roughly the same capacities as Compact Flash, and cost about the same. A new specification, SDHC (Secure Digital High Capacity) had to be developed to allow cards larger than 2GB (up to 32GB) to be offered for devices (including cameras) that are compatible with the standard. Today, SDXC offers the potential for memory cards up to 2TB (2,000GB) in size.

Choosing the Camera That's Right for You

You might have studied the explanations of mirrorless technology in this chapter because you're pondering which camera to buy. Because technology changes so rapidly, it's unlikely that the camera you buy today will be your last. On the other hand, even the least expensive ILC model is a significant investment for most of us when you factor in the cost of the lenses and accessories you'll purchase. You want to make the right choice the first time. Mirrorless camera decision makers often fall into one of five categories:

- Serious photographers. These include photo enthusiasts and professionals who may already own lenses and accessories belonging to a particular system, and who need to preserve their investments by choosing, if possible, a camera that is compatible with as much of their existing equipment as possible. That is, if you own Sony A-mount lenses or Canon EF/EF-S lenses, you might want to consider a mirrorless camera that can use those lenses, even if an adapter is required.
- **Professionals.** Pro photographers buy equipment like carpenters buy routers. They want something that will do the job and is rugged enough to work reliably despite heavy use and mistreatment. That holds true even when they are considering an ultra-compact mirrorless model. They don't necessarily care about cost if the gear will do what's needed, because their organizations or clients are ultimately footing the bill. Compatibility may be a good idea if an organization's shooters share a pool of specialized equipment, but a pro choosing to switch to a whole new system probably won't care much if the old stuff has to fall by the wayside.

- Well-heeled enthusiast photographers. Many buyers exhibit a high turnover rate, because they buy equipment primarily for the love of having something new and interesting. Some actually feel that the only way they will be able to take decent (or better) pictures is to own the very latest gear. I'm happy to let these folks have their fun, because they are often a good source of mint used equipment for the rest of us. I purchased several of my favorite lenses for \$900–\$1,300 each in mint condition from a "churn"-happy photographer. Each of them sells for \$1,500–\$2,000 brand new.
- Serious newcomers. Many mirrorless ILC models are sold to fledgling photographers who are buying their first digital camera or who have been using a point-and-shoot camera model. These buyers don't plan on junking everything and buying into a new system anytime soon, so they are likely to examine all the options and choose the best system based on as many factors as possible. Indeed, their caution may be why they've waited this long to purchase a mirrorless camera in the first place.
- Casual newcomers. As prices for mirrorless models dropped to the \$500 level and below, I noticed a new type of buyer emerging: those who might have purchased a point-and-shoot camera at the same price point in the past, but now have the notion that an ILC model would be cool to have and/or might provide them with better photos. Many of these owners aren't serious about *photography*, although they might be serious about getting good pictures of their family, travels, or activities. A large number of them find that a basic mirrorless camera with its kit lens suits them just fine and never buy another lens or accessory. It could be said that an ILC is overkill for these casual buyers, but most will end up very happy with their purchases, even if they aren't using all the available features.

Questions to Ask Yourself

Once you decide which category you fall into, you need to make a list of your requirements. What kind of pictures will you be taking? How often will you be able to upgrade? What capabilities do you need? Ask yourself the following questions to help pin down your real needs.

How Much Resolution Do You Need?

This is an important question because, at the time I write this, models are available with resolutions from about 16 megapixels to 24 megapixels (with a small number of high-end models with up to 36MP of resolution). Even more interesting, not all mirrorless cameras of a particular resolution produce the same results. It's entirely possible to get better photos from a 16-megapixel camera with a sensor that has low noise and more accurate colors than with a similar 24-megapixel model with an inferior sensor (even when the differences in lens performance is discounted).

Looking at resolution in general, you'll want more megapixels for some types of photography. If you want to create prints larger than 8×10 inches, you'll be happier with a camera having 20-24 megapixels of resolution or more. If you want to crop out small sections of an image, you may definitely

need a camera with 24MP or more. On the other hand, if your primary application will be taking pictures for display on a web page, or you need thumbnail-sized photos for ID cards or for a catalog with small illustrations, you may get along just fine with the lowest-resolution camera you can find. However, keep in mind that your needs may change, and you might later regret choosing a camera with lower resolution.

Full Frame or Cropped Frame?

Throughout this chapter I've mentioned some of the differences between *full-frame* sensors and *cropped* sensors, although, at this writing, the number of full-frame mirrorless cameras is very limited. Even if you're new to the interchangeable lens camera realm, from time to time you've heard the term *crop factor*, and you've probably also heard the term *lens multiplier factor*. Both are misleading and inaccurate terms used to describe the same phenomenon: the fact that some cameras (generally the most affordable mirrorless cameras) provide a field of view that's smaller and narrower than that produced by certain other (usually much more expensive) cameras, when fitted with exactly the same lens.

Figure 2.15 quite clearly shows the phenomenon at work. The outer rectangle, marked 1X, shows the field of view you might expect with a 28mm lens mounted on a "full-frame" (non-cropped) camera, like the Sony Alpha A7r. The area marked 1.5X shows the field of view you'd get with that 28mm lens installed on an APS-C form factor camera. Canon uses a very similar 1.6X crop, which is virtually identical and also called by the APS-C nomenclature. All Four Thirds/Micro Four Thirds cameras use a 2X crop factor, represented by the next rectangle. Inside that is the 2.7X crop offered by the Nikon 1 cameras, and the 5.6X crop produced by the Pentax Q system. You can see from the illustration that the 1X rendition provides a wider, more expansive view, while each of the inner fields of view is, in comparison, *cropped*.

The cropping effect is produced because the "cropped" sensors are smaller than the sensors of the full-frame cameras. These sensors do *not* measure 24mm \times 36mm; instead, they spec out at roughly 24mm \times 16mm, or about 66.7 percent of the area of a full-frame sensor, as shown by the red boxes in the figure. You can calculate the relative field of view by dividing the focal length of the lens by .667. Thus, a 100mm lens mounted on an APS-C camera has the same field of view as a 150mm lens on a full-frame camera. We humans tend to perform multiplication operations in our heads more easily than division, so such field of view comparisons are usually calculated using the reciprocal of .667—1.5—so we can multiply instead. (100 / .667=150; 100 \times 1.5=150.)

This translation is generally useful only if you're accustomed to using full-frame cameras (usually of the film variety) and want to know how a familiar lens will perform on a digital camera. I strongly prefer *crop factor* over *lens multiplier*, because nothing is being multiplied; a 100mm lens doesn't "become" a 150mm lens—the depth-of-field and lens aperture remain the same. Only the field of view is cropped. But *crop factor* isn't much better, as it implies that the 24mm × 36mm frame is "full" and anything else is "less." I get e-mails all the time from photographers who point

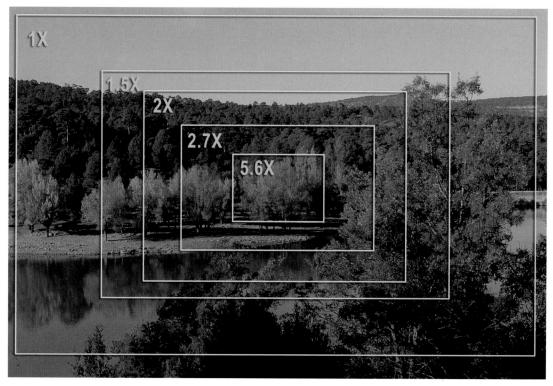

Figure 2.15 Crop "factors" provide different fields of view.

out that they own full-frame cameras with 36mm × 48mm sensors (like the Mamiya 645ZD or Hasselblad H3D-39 medium-format digitals). By their reckoning, the "half-size" sensors found in full-frame cameras are "cropped." Probably a better term is *field of view conversion factor*, but nobody actually uses that one.

If you're accustomed to using full-frame film cameras, you might find it helpful to use the crop factor "multiplier" to translate a lens's real focal length into the full-frame equivalent, even though, as I said, nothing is actually being multiplied.

How Often Do You Want to Upgrade?

Photography is one field populated by large numbers of technomaniacs who simply must have the latest and best equipment at all times. The digital photography realm rarely disappoints these gadget nuts, because newer, more sophisticated models are introduced every few months. If remaining on the bleeding edge of technology is essential to you, a mirrorless *can't* be a long-term investment. You'll have to count on buying a new camera every few years, because that's how often the average vendor takes to replace a current model with a newer one. Some upgrades are minor ones.

Fortunately, the typical mirrorless replacement cycle is a bit longer schedule than you'll find in the digital point-and-shoot world, where a particular top of the line camera may be replaced every six months or more often. Mirrorless cameras typically are replaced no more often than every 12 to 24 months—12 months for the entry-level models, and 24 months or longer for the intermediate and advanced models. Sony tends to be the most aggressive about changing/replacing camera models, as was seen in its transition from the NEX product line to the new aXXXX mirrorless cameras.

TRADE IN—OR KEEP?

Typically, come upgrade time, your old camera will be worth more as a hand-me-down to another user than as a trade-in. That's why I'm already looking forward to using my current favorite mirror-less ILC model as a second or third camera body when I do upgrade to the next generation. An extra body can come in handy. When I leave town on trips, I generally take one extra body simply as a backup. Still, I end up using the backup more than I expected when I mount, say, a telephoto zoom on my "main" camera and a wide-angle zoom on my backup so I don't have to switch lenses as often.

On the other hand, perhaps you're not on a never-ending quest for a shiny new gadget. You just want great pictures. Once you acquire a camera that does the job, you're not likely to upgrade until you discover there are certain pictures you can't take because of limitations in your current equipment. You'll be happy with a camera that does the job for you at a price you can afford. If your desires are large but your pocketbook is limited, you may want to scale back your purchase to make those inevitable frequent upgrades feasible.

Is a Compact Camera Important to You?

Compared to point-and-shoot digital cameras, all mirrorless models are a bit larger. But all mirrorless ILC models are still smaller than most digital SLRs, even when you add optional "power grips" like those Olympus has made available for its OM-D lineup. Before you lay down a large hunk of change for a digital camera, play with it to make sure it's a size that you'll be comfortable lugging around with you. The difference in weight alone can be significant if you're walking around all day with a camera strap around your neck. If you're the sort of photographer who would have been happy with a small, lightweight, virtually silent Leica rangefinder camera (which nevertheless produced superb pictures), you might also prefer a smaller camera. Heck, you might even want the Leica M9, a mirrorless model that looks and handles like a rangefinder film camera, but produces 18 MP digital images (and will set you back up to \$7,000, plus lots more for lenses).

In that vein, don't forget to take into account the size of the lenses you'll be using, too. While many lenses designed for mirrorless models are quite compact, others are adapted directly from lenses originally designed for digital SLRs. In addition, you might be using larger lenses that you already own on your mirrorless camera with an adapter. If you need a compact mirrorless camera, check out the size and weight of the lenses you are likely to use at the same time you examine the heft of the camera body itself.

Do You Want to Share Lenses and Accessories?

Are you an old-timer who still has lenses left over from the days of film, along with perfectly serviceable flash units and other accessories? Old Canon, Nikon, Minolta, and Olympus "legacy" lenses can easily be used on those vendors' mirrorless models with the correct adapter.

Or, perhaps you own an ancient camera that has seen better days. You may be able to justify a particular digital camera built around a camera body similar to the one used by your previous model. The list of compatible gadgets that can be shared is long, ranging from electronic flash units through filters, close-up attachments, tripods, and so forth. I have a huge stockpile of glass filters and accessories that fit my existing cameras. I'm able to use some of them using step-up and step-down rings in common sizes. Make sure that the adapter rings don't cause vignetting of the corners of your image (common with wide-angle lenses) and that your filters have both front and back filter threads so you can stack them. (Some filters, particularly polarizers, may not have a front thread.) You'll pay extra for "thin" adapter rings that keep your filters from projecting out too much in front of your lens, but the premium will be worth it. As an alternative, you may be able to simply zoom in a bit to eliminate those vignetted corners.

What Other Features Do You Need?

Once you've chosen your "must have" features for your digital camera, you can also work on those bonus features that are nice to have, but not essential. All mirrorless cameras share a long list of common features, such as manual, aperture-priority, and shutter-priority exposure modes. All have great autofocus capabilities. Many (but not all) have built-in flash units that couple with the exposure system, and which can control external, off-camera flash units as well (especially useful when using multiple units). Beyond this standard laundry list, you'll find capabilities available in one camera that are not found in others. You'll have to decide just how important they are to you as you weigh which system to buy. Here are some of the features that vary the most from camera to camera.

- Movie making. The trend today is toward full 1,920 × 1,080 HDTV movie-making capabilities. If video shooting is important to you, make sure your camera has the ability to plug in a microphone, preferably a stereo microphone. In-camera editing features let you trim clips that run too long, easing the editing process later.
- Burst mode capabilities. If you shoot lots of sports, you'll want the ability to shoot as many frames per second as possible for as long as possible. Some cameras shoot more frames per second, and others have larger buffers to let you capture more shots in one burst. For example, one model grabs 4 fps for 32 JPEG images in one burst, or 11 RAW images. Another camera from the same vendor ups the ante to 5 fps, but can capture only 23 JPEG images in one blast. If you've got deep pockets, one top-of-the-line action model blazes through sports photography at an 11 fps clip for 100 or more images.

- Image stabilization/dust removal. Some cameras, such as those from Olympus, may have vibration reduction built into the camera. Other vendors, like Sony, Samsung, Fujifilm, or Panasonic, may ask you to buy image-stabilized lenses, or may not have that capability at all. If you want to hand-hold your camera at low shutter speeds, or need to take rock-steady telephoto shots without a tripod, regardless of shutter speed, you'll want to consider this capability. Cameras that have internal anti-shake capabilities often use the ability to move the sensor quickly to provide an anti-dust removal system. You'll also find dust cleaning capabilities in most other digital cameras these days. But some work better than others, as I'll explain in Chapter 3.
- **Higher and lower ISO ratings.** Some cameras offer sensitivities as low as ISO 50 and as high as ISO 6400 and beyond (ISO 104600 is not out of the question, and one model puts its upper limit in the ISO 409600 stratosphere). The need for these depends on what kind of photos you intend to take, and how good the results are at the ISO extremes.
- Playback/review features. You'll find used mirrorless cameras only a few years old with backpanel LCDs as small as 2.7 inches diagonally, but virtually every new model has a 3.0-inch or larger LCD. All same-sized LCDs are not created equal. Some have more pixels and finer detail, and may be brighter and easier to view in direct sunlight or from an angle. Some systems let you zoom in 3X to 4X on your LCD image, while others offer 10X or more zoom. If reviewing your images in the field is critical, take a close look at how a camera's LCD panel performs.
- Maximum shutter speed. Some cameras top out at 1/4,000th second; others go as high as 1/8,000th second. In real life, you'll rarely need such brief shutter speeds to freeze action. It's more likely that the high speeds will come in handy when you want to use wider lens openings at your lowest ISO setting. For example, if you want to use f/2.8 on a bright beach or snow scene in full daylight, if your camera's lowest ISO setting is ISO 200, you'll probably need to use a shutter speed of 1/8,000th second. If you don't have such fast shutter speeds, you'd better hope you have a neutral-density filter or two handy. In practice, however, such high shutter speeds aren't really needed; the fastest shutter speed I use regularly is 1/2,000th second, and I don't recall ever using my camera's 1/8,000th second setting, other than to test it.

Dealing with Dust and Storage

If you're accustomed to working with a point-and-shoot digital camera, or even with an advanced model using an electronic viewfinder, you'll find that mirrorless cameras have their own particular set of advantages and quirks that you must learn. The ILC mirrorless camera is a different type of animal when it comes to dealing with dust and artifacts on your images and selecting the right memory card on which to store those images.

While the design of mirrorless cameras solves many of the problems that may have vexed you with other types of cameras, every silver lining can be cloaked in a troublesome cloud. They are prone to collect dust on their sensors—including stubborn artifacts that the built-in sensor-shaking dust removal systems found in virtually all modern cameras with interchangeable lenses can't handle. This chapter will clear up some of the confusion around dealing with dust, and help you decide which memory cards are best.

Protecting the Sensor from Dust

Photographers have had to surmount dirt and dust problems for more than 150 years. Dust can settle on film or photographic plates, marring that one picture. Dust can reside on the front or back surfaces of lenses and, if the specks are numerous enough, affect the image. Dirt can even get *inside* the lens. Dirty electrical contacts could conceivably affect the ability of your flash memory cards to store information or hinder the operation of an external electronic flash.

These ills infected film cameras in the past, and most of them apply to digital cameras as well. However, the interchangeable lens camera adds a new wrinkle: dirty sensors. In non-ILC models, the sensor is sealed inside the camera and protected from dust. Unfortunately, your removable-lens digital camera invites the infiltration of dust or worse, every time you swap lenses. Dust will inevitably creep inside and come to rest. Some of it will lie in wait for the shutter protecting your sensor

to open for an exposure and then sneak inside to affix itself to the imager's outer surface. No matter how careful you are and how cleanly you work, eventually you will get some dust on your camera's sensor. This section explains the phenomenon and provides some tips on minimizing dust and eliminating it when it begins to affect your shots.

Whither Dust

Like it or not, unless you live in a clean room or one of those plastic bubbles, you're surrounded by dust and dirt. It's in the air around you and settles on your digital camera's works without mercy. When you remove a lens to swap it for another, some of that dust will get trapped inside your camera. Dust can infiltrate even if you *don't* remove the lens; certain lenses are notorious for sucking in dust as their barrels move during zooming or focusing, and then propelling the dust backward toward the lens mount. None of this dust ends up inside the optics of the lens—it's directed toward the interior of your camera.

But, in the end, all is for naught. Dust *will* get inside your camera. Dust that hasn't settled on the sensor shouldn't affect your pictures. The real danger lies in the dust particles that cling to the insides of the camera. They're likely to be stirred up by the motion of the shutter curtain and waft their way onto the sensor. (See Figure 3.1.) Taking a photo with the camera pointed upward will enlist the law of gravity against you.

Eventually, though, the dust settles on the outer surface of the sensor, which is a protective filter (often a low-pass, anti-aliasing filter, found in many—but not all—recent models), rather than the sensor itself. Today, all vendors make an effort to ensure that the dust doesn't take up

Figure 3.1 The sensor of a mirrorless camera is accessible at all times.

permanent residence. Even so, some cameras are more susceptible to dust on the sensors than others, and some cameras do a better job of removing it than others. Over time, however, most will succumb and exhibit some sensor dust that isn't removed by the camera's self-cleaning features. I owned my latest camera for two weeks and had removed the lens perhaps three or four times before I noticed I had my first dust problem.

You may have dust on your sensor right now and not know it. Because the grime settles on a surface that's a tiny fraction of an inch above the actual sensor, it often will not be visible at all at wider lens apertures. If you shoot at f/2.8-f/5.6 most of the time, the dust on your sensor is probably out of focus and not noticeable, particularly if the particles are small. Stop down to f/16 or f/22, and those motes suddenly appear, in sharp relief. (See Figure 3.2 for a pair of photos at two different lens

apertures.) The actual particles may be too small to see with the unaided eye; a dust spot no larger than the period at the end of this sentence (about .33mm in diameter) could obscure a block of pixels 40 pixels wide and 40 pixels tall with a typical sensor. If a dust spot creates a dark blotch against a light background, a spot as small as 4 pixels wide is likely to stick out like a sore thumb.

Clearly, you do not want to have your images suffer from this plague.

Figure 3.2
At f/4 (top), the sensor dust on this small portion of a larger image is less visible. At f/22 (bottom), the artifacts are painfully obvious.

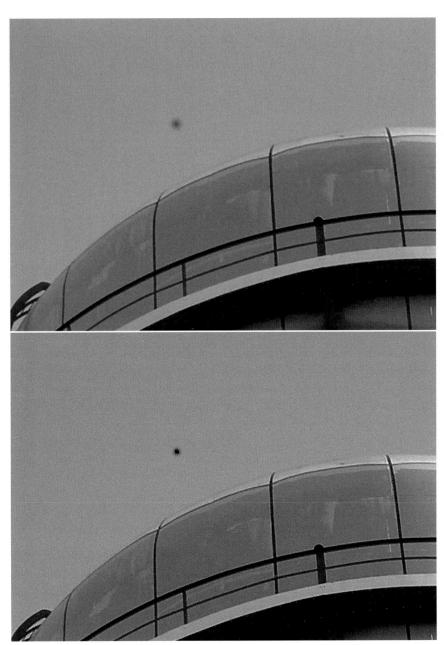

Dust vs. Dead Pixels

New owners who find spots that show up in the same place on a series of images may wonder whether they're looking at a dust spot or a defective pixel in their sensor. Dead pixels aren't as deadly as you might think. A technique called *pixel mapping* can locate non-functioning pixels and permanently lock them out, so the camera will substitute information from surrounding pixels for future images. Some cameras have sensor pixel mapping built into the camera, which can be automatically or manually applied (depending on how the camera is designed).

You should be aware that some models have a type of pixel mapping that works *only* for the color LCD monitor, removing defective pixels from the display, either during live view or picture review. Those bad pixels reside in the display alone, and are not in the image you captured. This type of pixel mapping does nothing for hot or dead pixels on the *sensor*, which don't show up on the LCD until picture review, after the image has been captured. Other cameras need a firmware upgrade to take care of sensor pixel mapping, or require sending the camera back to the vendor for adjustment. This fix is typically free while the camera is under warranty.

So, how do you tell whether you have a dust bunny or a bad pixel to deal with? Just follow these steps.

- 1. Shoot several blank frames of both dark- and light-colored backgrounds (so you can see both light and dark pixel anomalies). Do not use a tripod. You do not want the frames to be identical. You want bad pixels, which are always in the same place, to appear regardless of how the subject is framed.
- 2. Shoot variations of dark and light frames using both your maximum (largest) f/stop and your minimum (smallest) f/stop, such as f/2.8 and f/22.
- 3. Transfer the images to your computer and then load them into your favorite image editor.
- 4. Copy one of the dark frames and paste it into another dark frame image as a new layer. Make sure you include frames taken at both minimum and maximum apertures. Repeat for another image containing several light frames.
- 5. Zoom in and examine the images for dark and light spots.
- 6. If you locate a suspect spot, make the current layer invisible and see if the spot is in the same position in the other layers (from different shots). If that is the case, then the bad pixel(s) are caused by your imager, and not by your subject matter.
- 7. Use the guidelines below to determine whether the spots are caused by dust or bad pixels.

Bad pixels may be tricky to track down, because they can mask themselves among other components of an image. A hot pixel may be obvious in a clear blue sky, but scarcely noticeable in an image with lots of detail in the affected area. Figure 3.3 (top) shows a best-case (or worst-case) scenario: a hot pixel (actually a cluster of *four* pixels) lurking in a speckled image of some crayons. It's lurking in the third row, but you'll never find it with the naked eye. Figure 3.3 (bottom) shows the little

devils isolated. They were identified by comparison with a completely different picture, which showed the same hot pixels in the same position. Although the crayons have speckles and dust motes of their own, these hot pixels are objectionable because the crayons in question are supposed to be out of focus, without a razor-sharp hot spot. In Figure 3.4, you can see that the four bad pixels are surrounded by other pixels that are incorrectly rendered because demosaicing was unable to interpolate their proper values correctly due to the hot spot caused by the bad pixel.

Figure 3.3
Four bad pixels are lurking here (top).
Enlargement reveals their location (bottom).

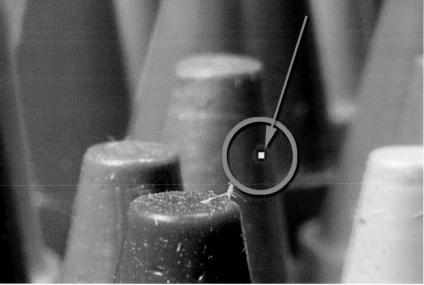

Figure 3.4
The bad pixels will cause an ugly blotch like this in every photo taken.

When you've identified spotty areas in your images, figure out their cause by going through this checklist. If you pinpoint a dust spot, use the cleaning methods described later in this chapter. If it's a bad pixel, activate your camera's pixel-mapping feature, if available (either built-in, or through a software utility). If no such remedy is built into your camera or software, you can usually ignore a bad pixel or two. However, if you discover a half-dozen or more, contact your vendor.

Note that if you shoot RAW, the RAW conversion process as you import the image into your image editor may eliminate bad pixels automatically. I discovered this phenomenon when I noticed that when shooting with my camera's RAW+JPEG mode, the errant pixels appeared only in the JPEG version, and not in an image imported from RAW. Bad pixels tend to be most noticeable when they appear within areas of contrasting tone. In an image with many subtle shades, the defective pixel may be massed. I tend to notice them most when shooting concerts, when the vast areas of black surrounding the performers cause anomalous light colored pixels to stick out like a sore thumb. Finally, bad pixels *can* be intermittent, appearing and disappearing as your sensor heats up or shifts into higher ISO settings that seem to accentuate bad pixels. You can use the remedial methods described in the next section to fix bad spots that appear in existing images.

- **Light pixel.** If the spot is light in color when viewed against an area that is overall dark in color, it's probably caused by one or more pixels that are permanently switched on. This is known as a *stuck* pixel.
- **Dark pixel.** If the spot is dark in color when viewed against an area of lighter pixels, it may be a pixel that is permanently off (known as a *dead* pixel), or it may be a dust spot (if it's fuzzy). A dark pixel that is rectangular (perhaps a black pixel surrounded by pixels of decreasing density) is probably a dead pixel. The additional bad pixels are usually caused by the effects of interpolating surrounding pixels from the dead one.

- Now you see it/Now you don't pixel. If a spot seems to come and go and you determine that it only happens when using longer exposures, it is likely to be a *hot* pixel, produced when the sensor heats up. You may find that your camera's noise reduction features see hot pixels as noise and remove them for you automatically.
- Blurry/sharp pixels. A set of dark pixels that shows up in the frames shot at the smallest f/stop, but which vanishes or becomes out of focus in the wide-open frames is certainly a dust spot, as you can see in Figure 3.2, shown earlier.

Protecting Sensor from Dust

The easiest way to protect your sensor from dust is to prevent it from entering your camera in the first place. Here are some steps you can take:

- **Keep your camera clean.** Avoid working in dusty areas if you can do so. Make sure you store your camera in a clean environment.
- Clean your lenses, too. When swapping lenses, use a blower or brush to dust off the rear lens mount of the replacement lens first, so you won't be introducing dust into your camera simply by attaching a new, dusty lens. Do this before you remove the lens from your camera, and then avoid stirring up dust before making the exchange.
- Minimize the time your camera is lensless and exposed to dust. That means having your replacement lens ready and dusted off, and a place to set down the old lens as soon as it is removed, so you can quickly attach the new lens.
- Face the camera downward. When the lens is detached, point the camera downward so any dust in the mirror box will tend to fall away from the sensor. Turn your back to any breezes or sources of dust to minimize infiltration. Some camera vendors recommend having the base of the camera downward when *cleaning* the sensor, because their designs employ sticky areas on the floor of the sensor area to grab dust.
- **Protect the detached lens.** Once you've attached the new lens, quickly put the end cap on the one you just removed to reduce the dust that might fall on it.
- Clean the mirror area. From time to time, remove the lens while in a relatively dust-free environment and use a blower bulb (*not* compressed air or a vacuum hose) to clean out the inner vestibule area. A bulb blower is generally safer than a can of compressed air, or a strong positive/ negative airflow, which can tend to drive dust further into nooks and crannies.
- Clean soon and often. Your camera's built-in sensor cleaning system is not perfect, even if you have set it to clean both when the camera is switched on and powered down. And remember that many cameras allow turning off automatic sensor cleaning (some find the "buzz" annoying, or think they are saving power by disabling the feature). So, manual inspection and cleaning can be important. If you're embarking on an important shooting session, it's a good idea to make sure your sensor is clean *now* using the suggestions you'll find below, rather than coming home with hundreds or thousands of images with dust spots caused by flecks that were sitting on your sensor before you even started.

Fixing Dusty Images

You've taken some shots and notice a dark spot in the same place in every image. It's probably a dust spot (and you can find out for sure using my instructions above), but no matter what the cause, you want to get it out of your photos. There are several ways to do this. Here's a quick checklist:

- Clone the spots out with your image editor. Photoshop and other editors have a clone tool or healing brush you can use to copy pixels from surrounding areas over the dust spot or dead pixel. This process can be tedious, especially if you have lots of dust spots and/or lots of images to be corrected. The advantage is that this sort of manual fix-it probably will do the least damage to the rest of your photo. Only the cloned pixels will be affected.
- Use your image editor's dust and scratches filter. A semi-intelligent filter like the one in Photoshop can remove dust and other artifacts by selectively blurring areas that the plug-in decides represent dust spots. This method can work well if you have many dust spots, because you won't need to patch them manually. However, any automated method like this has the possibility of blurring areas of your image that you didn't intend to soften.
- Try your camera's dust reference feature. Some cameras have a dust reference removal tool that compares a blank white reference photo containing dust spots that you shoot for comparison purposes with your images, and uses that information to delete the corresponding spots in your pictures. However, such features generally work only with files you've shot in RAW format, which won't help you fix your JPEG photos. Dust reference subtraction can be a useful after-the-fact remedy if you don't have an overwhelming number of dust spots in your images.

Cleaning the Sensor

Should you clean your sensor? That depends on what kind of cleaning you plan to do, and whose advice you listen to. Some vendors countenance only dust-off cleaning, through the use of reasonably gentle blasts of air, while condemning more serious scrubbing with swabs and cleaning fluids. These same manufacturers sometimes offer the cleaning kits for the exact types of cleaning they recommended against, for sale in Japan only, where, apparently, your average photographer is more dexterous than those of us in the rest of the world. These kits are similar to those used by the vendor's own repair staff to clean your sensor if you decide to send your camera in for a dust cleaning.

Removing dust from a sensor is similar in some ways to cleaning the optical glass of a fine lens. It's usually a good idea to imagine that the exposed surfaces of a lens are made of a relatively soft kind of glass that's easily scratched, which is not far from the truth (although various multi-coatings tend to toughen them up quite a bit). At the same time, imagine that dust particles are tiny, rough-edged boulders that can scratch the glass if dragged carelessly across the dry surface. Liquid lens cleaners can reduce this scratching by lubricating the glass as a lens cloth or paper is used to wipe off the dust, but can leave behind a film of residue that can accumulate and affect the lens's coating in another fashion. Picture the lens wipes as potential havens for dust particles that can apply their own scratches to your lenses.

You can see why photographers who are serious about keeping their lenses new and bright tend to take preventive measures first to keep the glass clean. Those measures often include protective UV or skylight filters that can be cleaned more cavalierly and discarded if they become scratched. If all else fails, the experienced photographer will clean a lens's optical glass carefully and with reverence.

Most of this applies to sensors, with a few differences. Sensors can be affected by dust particles that are much smaller than you might be able to spot visually on the surface of your lens. The filters that cover sensors tend to be fairly hard compared to optical glass. Cleaning a sensor that measures 24mm or less in one dimension within the tight confines behind the mirror can be trickier and require extra coordination. Finally, if your sensor's filter becomes scratched through inept cleaning, you can't simply remove it yourself and replace it with a new one.

In practice, there are three kinds of cleaning processes that can be used to vanquish dust and gunk from your mirrorless camera's sensor, all of which must be performed with the shutter locked open:

- Air cleaning. This process involves squirting blasts of air inside your camera with the shutter locked open. This works well for dust that's not clinging stubbornly to your sensor.
- **Brushing.** A soft, very fine brush is passed across the surface of the sensor's filter, dislodging mildly persistent dust particles and sweeping them off the imager.
- Liquid cleaning. A soft swab dipped in a cleaning solution such as ethanol is used to wipe the sensor filter, removing more obstinate particles.

You should work as quickly as possible to reduce the chance that even more dust will settle inside your camera. Have a strong light ready to illuminate the interior of your camera. If you happen to have one of those headband illuminators that blasts light anywhere you happen to be gazing, so much the better.

The next few sections will describe each of these methods in a little more detail.

Air Cleaning

Cleaning by air is your first line of defense. If you do it properly, it's difficult to overdo. An extra gentle blast of air isn't going to harm your sensor in any way, unless you stir up dust that re-deposits on the sensor.

Of course, the trick is to use air cleaning properly. Here are some tips:

- Use only bulb cleaners designed for the job. Good ones, like the Giottos Rocket shown in Figure 3.5, have one-way valves in the base so that air always enters from the rear of the bulb and never the front (which would allow dust from the sensor to be sucked inside, then sprayed out again with the next puff). Smaller bulbs, like those air bulbs with a brush attached sometimes sold for lens cleaning or weak nasal aspirators may not provide sufficient air or a strong enough blast to do much good.
- **Do not use compressed air-in-a-can.** The propellant inside these cans can permanently coat your sensor if you goof.

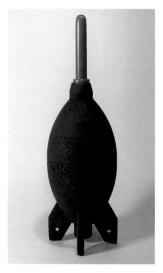

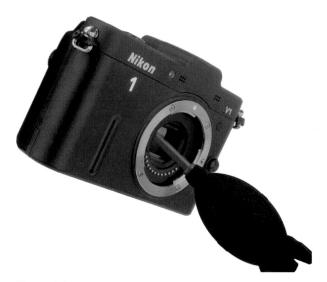

Figure 3.6 A few puffs of air should clean your sensor.

- **Do not use commercial compressed air compressors.** Super-strong blasts of air are as likely to force dust into places you don't want it to be, including under the sensor filter, as they are to remove it.
- Hold the camera upside down and look up into the mirror box as you squirt your air blasts. This increases the odds that gravity will help pull the expelled dust downward, away from the sensor. You may have to use some imagination in positioning yourself. If your vendor recommends holding the camera so the base is downward, try that, too, but I prefer my method. (See Figure 3.6.)

Brush Cleaning

If your dust is a little more stubborn and can't be dislodged by air alone, you may want to try a brush, like the Sensor Brush sold at www.visibledust.com. Ordinary brushes are much too coarse and stiff and have fibers that are tangled or can come loose and settle on your sensor. The Sensor Brush's fibers are resilient and described as "thinner than a human hair." Moreover, the brush has a wooden handle that reduces the risk of static sparks.

Another good, if expensive, option is the Arctic Butterfly sold at www.visibledust.com. A motor built into the brush is used to "flutter" the tip for a few seconds prior to cleaning (see Figure 3.7, left), charging the brush's anti-static properties. Then, the motor is turned off (Figure 3.7, right) and the brush tip is passed above the surface of the sensor. (It's not necessary to touch the sensor.) The dust particles are attracted to the brush fibers and cling to them.

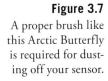

The dust is removed by another quick flutter once you've withdrawn the brush from the interior chamber. A cheaper, inanimate, sensor cleaning brush can be purchased at www.copperhillimages.com. You need a version sized to fit your camera's sensor. It can be stroked across the short dimension of your camera's sensor. You should clean the brush with compressed air before and after each use, and store it in an appropriate air-tight container between applications to keep it clean and dust free. Although these special brushes can be expensive, one should last you a long time. They are offered in various sizes to fit different sensor widths. You can also use a brush to dust off the surfaces inside the mirror box.

Liquid Cleaning

The most persistent dust spots may be combined with some grease or a liquid that causes them to stick to the sensor filter's surface. In such cases, liquid cleaning with a swab may be necessary. You can make your own swabs out of pieces of plastic (some use fast food restaurant knives, with the tip cut at an angle to the proper size) covered with a soft cloth. However, I recommend buying commercial sensor cleaning swabs, such as those sold by Photographic Solutions, Inc. (http://photosol.com/product-category/sensor-swabs/) to get the best results. (Some folks get good results using homemade swabs and the Pec-Pad cleaning pads sold by Photographic Solutions, but the company itself does not recommend using these pads for this application.) Vendors selling these swabs will recommend the right size for your particular camera.

You want a sturdy swab that won't bend or break so you can apply gentle pressure to the swab as you wipe the sensor surface. Use the swab with methanol (as pure as you can get it; other ingredients can leave a residue), or the Eclipse solution also sold by Photographic Solutions. A couple drops of solution should be enough, unless you have a spot that's extremely difficult to remove. In that case, you may need to use extra solution on the swab to help "soak" the dirt off.

Once you overcome your nervousness at touching your camera's sensor, the process is easy. You'll wipe continuously with the swab in one direction, then flip it over and wipe in the other direction. You need to completely wipe the entire surface; otherwise, you may end up depositing the dust you collect at the far end of your stroke. Wipe; don't rub.

You can make your own swabs out of pieces of plastic (some use fast food restaurant knives, with the tip cut at an angle to the proper size) covered with a soft cloth or Pec-Pad, as shown in Figure 3.8. However, if you've got the bucks to spend, you can't go wrong with good-quality commercial sensor cleaning swabs, such as those sold by Photographic Solutions, Inc.

If you want a close-up look at your sensor to make sure the dust has been removed, you can pay \$50-\$100 for a special sensor "microscope" with an illuminator. Or, you can do like I do and work with a plain old Carson MiniBrite PO-55 illuminated 5X magnifier, as seen in Figure 3.9. It has a built-in LED and, held a few inches from the lens mount with the lens removed from your Alpha, provides a sharp, close-up view of the sensor, with enough contrast to reveal any dust that remains. If you want to buy one, you'll find a link at www.dslrguides.com/carson.

Figure 3.8 You can make your own sensor swab from a plastic knife that's been truncated. Carefully wrap a Pec-Pad around the swab.

Figure 3.9 The Carson Mini-Brite is an inexpensive illuminated magnifier you can use to examine your sensor.

Key Considerations for Choosing a Memory Card

Here are some of the things to consider when choosing memory card storage for your camera:

- Capacity. Don't expect one format or another to retain a capacity advantage for very long, but at the time I write this, cards that hold 64GB or more are available at reasonable prices. If maximum capacity is important to you, keep track of the latest developments among the vendors, realizing that the top capacity cards are likely to be the most expensive.
- Cost. The secret is to find the "sweet spot" in the pricing, so that you're paying about the same per gigabyte of storage, regardless of the size of the card. That is, a 32GB card should cost about twice as much as a 16GB card of the same speed. If not, you're paying a premium for the extra capacity. Right now, I am still using 32GB cards in my cameras, but I also buy 64GB cards, because some good brands are available at less than twice the cost of two 32GB cards.
- Speed. When choosing a card, evaluate your needs and the write speed of the card you're considering. For most kinds of photography, the write speed of the card has little effect on your picture taking. Most memory cards can accept data from single shots as quickly as you can shoot them. An exception might be if you're shooting sports sequences, or if you're shooting RAW files and your camera is particularly slow in saving these files. You'll pay more for the higher-speed cards, perhaps with no discernable benefit during shooting. However, when it comes time to transfer your images from a memory card to your computer, that extra speed can come in handy. If you have a FireWire or fast USB 2.0/USB 3.0 card reader, a slow card can be a bottleneck, and transferring a large number of images can take many minutes. The cards I buy tend to be labeled 600X or 800X, although I do have a few 1000X and 1100X cards for demanding applications.

Large Card or Multiple Smaller Cards?

Opting for large memory cards over several smaller ones does more than reduce your costs on a per-megabyte basis (a 32GB card is usually less expensive than 4 cards of 8GB capacity). You're also increasing your exposure to loss of images if you lose a card or the media becomes unreadable. Some photographers like to pop in a single card and then shoot all day without the need to switch to a different card. Others prefer to swap out cards at intervals, and keep the exposed memory extra safe. (If all your eggs are in one basket, watch that basket very carefully!)

From a security standpoint, there is little difference between using fewer high capacity cards or a larger number of lower capacity memory, although I tend to see the bigger cards as safer. Working with two 8GB cards instead of a single 16GB card means you double your chances of losing one. You also double your chances of damage to your camera caused by frequent insertions/removals.

True, you could *potentially* lose more pictures if a 16GB card fails, than if an 8GB card fails, but who says that your memory card will become corrupted only when it's full? A 4GB card, 8GB card, or 16GB card could each fail when they had 3GB worth of images on them, costing you the same amount of pain in each case. When you and your family go on vacation by car, do you drive in two separate vehicles? Assuming you don't have a very large family, the answer is probably no. However, auto accidents are much more common than memory card failure, and I imagine you value your family members a lot more than you value the photos you shoot.

Of course, there are other reasons for using multiple memory cards. Using multiple cards is a good way to segregate your images by topic or location. If you're on vacation in Europe, you can use a new card for each city (just as you might shoot one or two rolls of film in each location). Or, photograph cathedrals on one card, castles on a second, landscapes on a third, and native crafts on a fourth.

But, for the most part, I prefer to use larger cards to minimize the number of swaps I need to make while shooting. With a typical camera, I can shoot several thousand photos in RAW format per 64GB card (a lot more than I got with 36-exposure rolls of film!), and I don't need to swap media very often except when I'm shooting sports, which can eat up an entire 16GB or 32GB card in an hour or two. I often segregate several days' shooting by creating new storage folders on the same card. I might put all June 1 images in a folder named 601, and then create a new folder called 602 for the next day. Things get a little more complicated after September each year, but I manage.

Working with RAW and Other File Formats

If you upgraded to a mirrorless ILC model from a point-and-shoot camera, you might have been surprised at the new choices you had to make in terms of what file format to select when setting up to take photos. The snapshot crowd generally needs only to choose from among quality settings with names like Super Fine, Fine, or Standard (each step down sacrificing a little quality in order to squeeze more shots on a memory card). Casual photographers may also switch from their camera's maximum resolution to a lower resolution from time to time, usually to produce a more compact image suitable for e-mailing or posting on a web page. For the most part, with a point-and-shoot camera, selecting a file format and resolution is a no-brainer.

That's not quite the case with mirrorless cameras. You, too, get to select a quality level for JPEG images (actually "compression level"—the amount of information discarded in order to make the image file smaller). You can also opt for a different resolution to save some additional storage space with some loss of quality. But you also have other decisions that the majority of point-and-shoot owners don't need to make. Should you shoot only JPEG images, or should you record your photos using the "unprocessed" format known as RAW? Perhaps you'll want to opt for a setting that stores *two* images on your memory card for each shot, one of them JPEG (using one of the three different quality levels available) and the other RAW. A few allow you to specify either *compressed*

or *uncompressed* RAW, and an even smaller number (generally only the rare top-of-the-line cameras) give you an additional file format option: TIFF (explained below).

The most interesting aspect related to the file format dilemma is that serious photographers, unlike snapshooters, probably won't select an image format based on how many extra photos can be crammed into a memory card. Any photographer serious enough to purchase an ILC model has purchased at least enough memory cards to serve most picture-taking situations this side of an extended vacation. Instead of choosing a format solely to save space, the digital shooter often selects one option over another because of the extra quality that might be provided, or the additional control, or, perhaps, how quickly the format can be stored to the memory card. It's a little like selecting a film that features a particular kind of rendition—saturated and contrasty, or muted and accurate—to produce a particular result. For most owners, choice of file format is the primary tool for providing as much power over your photos as possible.

Format Proliferation

The Universe must love standards, because there are so many of them. It's no secret why formats have proliferated. Vendors always think they can do something better than their competitors, or, at the very least, hope that you'll think so. As a result, they invent a new file format with a few extra features that tweak the capabilities a tad.

Fortunately, JPEG and Adobe's Photoshop-standard PSD formats have become the most common file formats used for image editing. Adobe's DNG is another format that the company is promoting as a standard, but it has been met with less enthusiasm. Of course, your digital camera can't read or produce PSD files at all (nor DNG files, either, except in the case of some oddball cameras from Pentax). PSD can't handle the kinds of information that digital cameras can record, such as a specific white balance, sharpness, variable tonal curves, and other data. When you take a picture, a host of this kind of picture information is captured in a raw form, and then immediately processed using settings you've specified in your camera's menus. After processing, the image is stored on your memory card in a particular format, usually JPEG (TIFF, described later, is also available in some pro cameras). After that's done, any changes must be made to the *processed* data. If you decide you should have used a different white balance, you can no longer modify that directly, even though color balance changes in your image editor might provide a kind of fix.

So, digital camera vendors provide an alternative file format, generically called RAW to encompass them all, but in practice given other names, such as NEF (Nikon), CRW/CR2 (Canon), or ARW (Sony). (I'll explain more about RAW later in this chapter.) The different names reflect the fact that each of these RAW formats is different and not compatible with each other. You'll even find differences between RAW formats used by the same vendor. For example, while the RAW files produced by several Canon cameras all have a CR2 extension, they each need their own RAW converter to import the files into a standard format. To date, there are more than 100 different "RAW" formats.

WHITHER DNG?

To complicate things, a few years ago Adobe Systems introduced its new DNG (Digital Negative) specification, which purports to translate RAW files from any camera type to a common RAW format compatible with any software. Of course, the specification allows adding what Adobe calls "private metadata" to DNG files, "enabling differentiation," which is another word for non-standard/non-compatible. If DNG is adopted, *most* of the data from your camera's RAW images can be converted to the new standard, but there's no guarantee that all of it will be. Because Photoshop can already handle the most common types of RAW files we use (although there is a lag between the introduction of a new RAW version and its compatibility with Photoshop), most camera owners are likely to be underwhelmed by this initiation for the foreseeable future.

Of course, the reason for individual RAW formats is not to lock you into a particular camera system. The vendor has already done that by using a proprietary lens mount design. Ostensibly, the real reason is the one I outlined earlier: to do the job better than the other folks. Of course, a particular RAW format provides an unadulterated copy of the (relatively) unprocessed data captured by the CCD or CMOS imager. I say *relatively* because the analog information captured by the camera's sensor is certainly processed extensively as it's converted to digital form for storage as a RAW file.

There are advantages to each of the main format types, as well as a few pitfalls to avoid.

JPEG

JPEG is the most common format used by digital cameras to store their images, as it was designed specifically to reduce the file sizes of photographic-type images. It provides a good compromise between image quality and file size, and it produces images that are suitable for everyday applications. Those who work with point-and-shoot digital cameras may use nothing else but JPEG, and even many ILC model owners find that the default JPEG settings offer quality that's good enough for ordinary use. Indeed, on a sharpness basis, it can be difficult to tell the difference between the best-quality JPEG images and those stored in RAW or TIFF formats. But, as you'll see, there are additional considerations that come into play.

As you probably know, the JPEG format allows dialing in a continuous range of quality/compression factors, even though digital cameras provide only a fixed number of settings. However, in image editors, you'll find this range shown as a quality spectrum from, say 0 to 10 or 0 to 15. Sometimes, very simple image editors use sliders labeled with Low, Medium, or High quality settings. Those are just different ways of telling the algorithm how much information to discard.

Advanced cameras, on the other hand, lock you into a limited number of quality settings with names like Super Fine, Extra Fine, Fine, Normal/Standard, or Basic, and don't tell you exactly

which JPEG quality settings those correspond to. The names for the quality settings aren't standardized, and a particular setting for one camera doesn't necessarily correspond to the same quality level with another camera.

You'll usually find no more than three JPEG compression choices with any particular digital camera. Some cameras, for example, offer Fine, Normal, and Basic. If you're concerned about image quality, and want to use JPEG, you should probably use the best JPEG setting all the time, or alternate between that and RAW setting. Your choice might hinge on how much storage space you have. When I'm photographing around the home where I have easy access to a computer, I use RAW. When I travel away from home, I switch to JPEG if I think I'm going to be taking enough pictures to exceed the capacity of the memory cards I carry around with me at all times.

That might be the case when shooting many sports sequence shots. It's easy to squeeze off a burst of 6 to 8 shots on any given play, and a dozen plays later notice you've exposed gigabytes of RAW photos in a relatively short period of time. Although memory cards are relatively inexpensive, even if you carry a clutch of 4GB or 8GB cards, you'll find that Busch's Corollary to Parkinson's law applies to digital photography: Photos taken expand to fill up the storage space available for them.

Most cameras are able to store photos to the memory card more quickly in JPEG format rather than in RAW, so that is another consideration for sequence shots. If quality isn't critical, then use lower-quality JPEG settings with your camera to fit more images on the available storage.

TIFF

Pure TIFF, one of the original lossless image file formats, is found very seldom in the digital camera world, most often in the higher-end cameras. Most of the non-pro models offer only JPEG and RAW, or, commonly a JPEG+RAW mode that stores the same image in both formats (usually with your choice of JPEG compression ratio). A few still offer TIFF, but their numbers are small.

The original rationale for using TIFF at all was that it provided a higher-quality option in a standard format, without the need for the vendor to develop a proprietary RAW format. Today, the additional advantages of RAW when it comes to tweaking images make RAW well worth the trouble.

TIFF, or Tagged Image File Format, was designed in 1987 by Aldus (later acquired by Adobe along with Aldus's flagship product, PageMaker) to be a standard format for exchange of image files. It's become that, and was at one time supported by virtually all high-end digital cameras as a lossless file option, even though its use has diminished today. However, because TIFF supports many different configurations, you may find that one application can't read a TIFF file created by another. The name itself comes from the *tags* or descriptors that can be included in the header of the file, listing the kinds of data in the image.

TIFF can store files in black/white, grayscale, 24-bit, or 48-bit color modes, and a variety of color gamuts, including RGB, L*a*b, and CMYK. If you've used Photoshop, you know that TIFF can store your levels and selections (alpha channels) just like Photoshop's native PSD format. It uses a variety of compression schemes, or no compression at all. Most applications can read TIFF files stored in any of these compression formats. You might find TIFF useful for image editing, but you'll rarely use it with a digital camera, even if your model offers that option, because storing TIFF files in a camera can take many seconds—per file!

RAW

As applied to digital cameras, RAW, as mentioned earlier in this chapter, is not a standardized file format. RAW is a proprietary format unique to each camera vendor, and, as such, requires special software written for each particular camera. Each RAW format stores the original information captured by the camera, so you can process it externally to arrive at an optimized image.

Some RAW formats, such as those employed by Nikon and Canon for their high-end cameras, are actually a sort of TIFF file with some proprietary extensions. That doesn't mean that an application that can read standard TIFF files can interpret them, unfortunately. Usually, special software is required to manipulate RAW files. If you're lucky, your camera vendor supplies a special RAW processing application that is easy to use and powerful.

But Adobe Camera Raw, available with both Adobe Photoshop and Photoshop Elements, handles RAW files from just about every camera (although in Elements, not all features are available). The problem with Adobe Camera Raw (ACR) is that the latest versions, needed for the newest digital cameras, may not work with your edition of Photoshop. If you're using Adobe Photoshop CS3, for example, and buy a new camera, you may find that the most recent version of ACR that works with your image editor doesn't support your camera. Adobe wants you to upgrade to Photoshop CS6 or Photoshop CC to use the ACR version that does work with your camera's RAW files.

Image Size, File Size, Image Quality, and File Compression

One of the original reasons digital cameras offered more than one file format in the first place was to limit the size of the file stored on your memory card. If a digital camera had unlimited memory capacity and file transfers from the camera to your computer were instantaneous, all images would probably be stored in RAW or TIFF format. TIFF (which I'll describe later in this section) might even have gained the nod for convenience and ease of use, and because not all applications can interpret the unprocessed information in RAW files. Both RAW and TIFF provide no noticeable loss in quality, but modern cameras store RAW files a little more slowly to the memory card, and the few that still support TIFF (explained earlier) take a *lot* more time to save image files. So JPEG now gets the nod for most general-purpose applications.

JPEG was invented as a more compact file format that can store most of the information in a digital image, but in a much smaller size. This smaller size is, naturally, quicker to write to a memory card, too. JPEG predates most digital cameras, and was initially used to squeeze down files for transmission over slow dialup connections.

Alas, JPEG provides smaller files by compressing the information in a way that loses some information. JPEG remains the most viable digital camera file alternative because it offers several different quality levels. At the highest quality level you might not be able to tell the difference between the original RAW file and the JPEG version, even though the RAW file occupies, say, 14MB on your memory card, while the high-quality JPEG takes up only 4MB of space. You've squeezed the image 3.5X without losing much visual information at all. If you don't mind losing some quality, you can use more aggressive compression with JPEG to store 14 times as many images in the same space as one RAW file.

RAW exists because sometimes we want to have access to all the digital information captured by the camera, before the camera's internal logic has processed it and converted the image to a JPEG. RAW doesn't save as much space as JPEG. What it does is preserve all information captured by your camera *before* the settings you've made for things like white balance or sharpening have been applied. Think of your camera's RAW format as a photographic negative, ready to be converted by your camera or, at your option, by your RAW-compatible image-editing/processing software.

You can adjust the image size, file size, and image quality of your digital camera images. The guide-books and manuals don't always make it clear that these adjustments are three entirely different things. However, image size affects file size and image quality, and image quality affects file size. File size, while it's dependent on the other two, has no direct effect on image size or quality. No wonder it's confusing! It's a good idea to get these three terms sorted out before we move on so that we're all talking about exactly the same thing. Here's a quick summary:

- Image size. This is the dimensions, in pixels, of the image you capture. For example, if you have an 18MP camera, it may offer a choice of 5,184 × 3,456, 3,456 × 2,304, and 2,592 × 1,728 resolutions (or, 18, 13, and 4.5 megapixels, respectively). Each reduction in resolution reduces the size of the file stored on your memory card.
- File size. This is the actual space occupied on your memory card, hard disk, or other storage medium, measured in megabytes. The size of the file depends on both the image size (resolution) and image quality (compression) level. You can reduce the file size by reducing the image size or using a lower-quality/higher-compression setting.
- Image quality. This is the apparent resolution of the image after it's been compressed and then restored in your image editor. The RAW format offers a simple form of compression with no loss of image quality, but JPEG compression reduces the image quality (although the lost quality may be barely visible) for reasons that will become clear shortly.

How JPEG Compression Works

Ordinary compression schemes look for multiple occurrences of strings of numbers in a file, places them in a table, and then provides a pointer to the location of that string of numbers in the table, rather than repeating the numbers each time they appear. With long strings, the savings in file size can be significant. JPEG images also use this kind of encoding to shrink the size of the images. But, as transfer of image files over telecommunications lines became popular (this was even before the public Internet), a consortium called the Joint Photographic Experts Group (JPEG) developed a compression scheme particularly for continuous tone images that is efficient, and still retains the most valuable image information. JPEG uses three different algorithms, a numeric compression method like the one I just described, plus two more schemes with mind-boggling names like "discrete cosine transformation (DCT)" and "quantization."

However, even an ordinary mortal can grasp the basic principles. JPEG first divides an image into larger cells, say 8×8 pixels, and divides the image information into two types of data: luminance values (brightness) and chrominance (color) values. In that mode, the JPEG algorithm can provide separate compression of each type of data. Because luminance is more important to our eyes, more compression can be applied to the color values. The human eye finds it easier to detect small changes in brightness than equally small changes in color.

Next, the algorithm performs a discrete cosine transformation on the information. This mathematical mumbo-jumbo simply analyzes the pixels in the 64-pixel cell and looks for similarities. Redundant pixels—those that have the same value as those around them—are discarded.

Next, quantization occurs, which causes some of the pixels that are nearly white to be represented as all white. Then the grayscale and color information is compressed by recording the differences in tone from one pixel to the next, and the resulting string of numbers is encoded using a combination of math routines. In that way, an 8×8 block with 24 bits of information per pixel (192 bytes) can often be squeezed down to 10 to 13 or fewer bytes. JPEG allows specifying various compression ratios, in which case larger amounts of information are discarded to produce higher compression ratios.

Finally, the codes that remain are subjected to a numeric compression process. This final step is lossless, as all the information that is going to be discarded from the image has already been shed. Because it discards data, the overall JPEG algorithm is referred to as "lossy." This means that once an image has been compressed and then decompressed, it will not be identical to the original image. In many cases, the difference between the original and compressed version of the image is difficult to see.

Compressed JPEG images are squeezed down by a factor of between 5:1 and 15:1. The kinds of details in an image affect the compression ratio. Large featureless areas such as areas of sky, blank walls, and so forth compress much better than images with a lot of detail. Figure 3.10 shows an image at a low compression setting (top) and high compression (bottom).

Figure 3.10

Low compression
(top) produces a
smooth look, with
artifacts visible only
under this high
magnification. High
compression (bottom) yields a much
more blocky
appearance.

This kind of compression is particularly useful for digital camera files. Unfortunately, more quality is lost every time the JPEG file is compressed and saved again, so you won't want to keep editing your digital camera's JPEG files. Instead, save the original file as a PSD or another lossless file format, and edit that, reserving the original as just that, an original version you can return to when necessary. In fact, it's a good idea to backup your RAW digital "negative" (say, on a DVD) so you can go back to your original file at any time in the future, no matter how much you've butchered (or improved) the image since.

JPEG, RAW, or TIFF?

Of the three file formats, which should you use? Actually, your choices are just two, because TIFF isn't a practical in-camera option for most people. Between JPEG and RAW, you'll find that JPEG files are the most efficient in terms of use of space, and can be stored in various quality levels, which depend on the amount of compression you elect to use. You can opt for tiny files that sacrifice detail or larger files that preserve most of the information in your original image. JPEG really allows you to tailor your file size for the type of photos you're planning to take.

However, as I noted, JPEG files have had additional processing applied by the camera before they are stored on your memory card. The settings you have made in your camera, in terms of white balance, color, sharpening, and so forth, plus compression, are all applied to the image. You can

make some adjustments to the JPEG image later in an image editor like Photoshop, but you are always working with an image that has *already been processed*, sometimes heavily.

The information captured at the moment of exposure can also be stored in a proprietary, native format designed by your camera's manufacturer. These formats differ from camera to camera, but are called RAW. You might think of RAW as a generic designation rather than a specific format, just as the trade name Heinz applies to all 57 varieties instead of just one.

A RAW file can be likened to a digital camera's negative. It contains all the information, stored in 10-bit, 12-bit, 14-bit, or 16-bit channels (depending on your camera), with no compression, no sharpening, no application of any special filters or processing. In essence, a RAW file gives you access to the same information the camera works with in producing a 24-bit JPEG. You can load the RAW file into a viewer or image editor, and then apply essentially the same changes there that you might have specified in your camera's picture-taking options.

Advantages of Shooting RAW+JPEG

My personal preference is to shoot both RAW and my camera's highest quality JPEG setting simultaneously (for example, RAW+JPEG FINE), but, oddly enough, I end up using the JPEG version 80 to 90 percent of the time. If you've made your camera settings intelligently, the JPEG version will not only be good enough for many applications, it can be given minor tweaks in an image editor that will optimize it. Relying on the JPEG file most of the time lets me avoid the need to import the RAW file and perform time-consuming post processing. Yet, I have the RAW file available if I need to perform some image-editing magic like fine-tuning white balance or using Photoshop's Merge to HDR Pro command.

Using RAW+JPEG consistently allows some other tricks. You can set your camera to its black-and-white mode when you want to explore the creative possibilities of monochrome images, and thus not need to bother with making tricky color-to-black-and-white conversions in your image editors. You'll shoot black-and-white JPEGs, yet still be able to go back to the RAW image at any time to restore the color if you need it, or want to create a particular monochrome rendition, such as sepia tone or cyanotype.

You can also "miraculously" shoot using two color spaces at once by setting your camera to, say, sRGB (Standard RGB) to produce JPEGs with a color gamut optimized for monitor or web display. Should you find you need an image with the Adobe RGB gamut for printing, you can easily create such a version from your RAW file.

Inexpensive solid state media make it entirely practical to shoot RAW+JPEG most of the time, particularly if you're staying close to home and will be able to offload your photos to your computer frequently, or you have a backup system, such as a personal storage device (PSD) or a laptop. Of course, shooting both will slow down your camera's continuous shooting capabilities (especially important when shooting sports), and consume more memory card space.

Advantages of Shooting RAW Only

Some photographers shoot RAW exclusively. I do this myself when I am on long trips, in order to maximize my available storage space. I'll shoot RAW, back up my files to one or two PSDs, and be able to make what I think is the best use of my available capacity. I could cram more pictures onto the same storage space if I used JPEG exclusively, but I tend to use my travel photos in my work and want the best possible quality available in every single shot. So, if I have to choose just one format, I end up shooting RAW.

When I get home, there are utilities that will create JPEG files from every single RAW image if I feel I need them. The process is slow when you're creating JPEGs for a lot of files (which is why RAW+JPEG is usually the better choice for dual-format shooting), but I can let a batch run overnight if I need to.

RAW-only is also a good choice for those who plan to do a lot of post-processing and have no significant need for JPEGs produced in the camera.

Advantages of Shooting JPEG Only

I've touted how great RAW is so much in this chapter you might wonder if there are any advantages at all to shooting nothing but JPEG images. Huge numbers of photographers rely on JPEG images for a lot of their work, and there are solid reasons for choosing that format and eschewing the joys of RAW images.

Indeed, many professional photojournalists, sports, wedding, and event photographers shoot nothing but JPEG, and it's not because they want to squeeze every last byte out of their memory cards. Each type of shooter has different reasons for using JPEG exclusively, most of them relating to technical issues or workflow. Here's a quick summary of the rationales:

■ Sheer volume. Wedding photographers may shoot 1,000 to 1,500 photographs (or even more) during, before, and after the nuptials. Even though a relatively small number of photos are included in bound albums, having alternative images and shots of virtually every guest and relative can lead to additional prints, sales of a DVD, and so forth. Event photographers can easily take thousands of photos in a short period of time. Photojournalists and sports photographers also burn through many pictures. I can't recall a sports event recently at which I didn't take 1,100 to 1,200 photos, many of them with my camera set on 5 to 8 fps continuous bursts. Nobody, especially pros, wants to wade through a thousand pictures doing post-processing on even a small proportion of them. The solution is to make sure the camera settings are optimized, and then produce uniformly good JPEG images that require no twiddling after the dust settles.

- 66
 - Sheer speed. Digital cameras generally take longer to store RAW files, or RAW+JPEG combos to a memory card. For most types of photos, the camera's buffer will absorb those images and dole them out to the card about as fast as you can press the shutter release. But if you're shooting sports or other activities in quick bursts, it's easy for the buffer to become overwhelmed with large files. You may be able to take only 5 or 6 RAW files in a row at 5 fps, but double or triple that number of shots if you're using JPEG exclusively.
 - Faster transfer. Because they are several times larger, RAW files *will* take longer to transfer from your camera or memory card to your computer. If you're in a big hurry (say, to meet a deadline), the extra wait can be frustrating. So, when time is short, you'll want to use JPEG images and the fastest transfer method available, such as a card reader that is USB 2.0/USB 3.0 or FireWire compatible.

Mastering Your Exposure Controls

You may know what all the controls of your mirrorless camera are, but do you really understand what they are used for, how to select their options, and exactly when to use them? The manual furnished with your camera is not much help. It has a few black-and-white illustrations with labels for every button, dial, and switch on the camera, along with multiple cross-references that force you to jump back and forth to many different pages just to discover what a particular control does. You still have to decide why and when to put them to work.

The various controls that adjust exposure are among the most confusing. This chapter explains the basics for every kind of camera, and when you finish it, you'll have a basic mastery of your mirror-less camera's exposure controls. If you want to know more, I've written individual camera guides and compact references for many of the major models—but this chapter isn't designed to sell you one of those. I think you'll find a lot of what you need right here. I'm going to answer the most common questions.

You'll learn about automated exposure modes, using histograms, working with f/stops and shutter speeds, and selecting the right "scene" options. I'll also cover some of the quirks of working with automatic focus systems, too. I'm not going to waste pages on some of the easier controls, like the shutter release, or on setup options such as white balance settings you make using your menu system. The emphasis here will be on the most important physical controls you use for everyday shooting.

Exposure Basics

After composition, one of the most important aspects of getting a great photograph is zeroing in on the correct exposure. Your camera can take care of exposure for you automatically—most of the time. When exceptions occur, it's time for you to step in and use your camera's controls to fine-tune your images. This section deals with exposure.

Correct exposure is a necessity because, as you'll recall from Chapter 2, no digital camera sensor can capture detail at every possible light level. In very dark portions of a scene, there will be too few photons to register in the individual photosites. Shadows that should have some detail will be rendered as black.

At the other end of the exposure spectrum, if part of the scene is very light, the pixel "wells" will overflow or the excess photons will be drained off, and that photosite will stop collecting additional information. If some of the excess spill over onto adjacent pixels, you'll see an unwanted blooming effect in your image. Having superfluous photons lost or totally ignored renders areas that should be "almost-white" as completely white, and, again, important details can be lost.

Given the fixed limitations of the sensor to record both very dark and very light areas, the goal of setting exposure is to either *increase* the number of photons available to register details in dark areas (by boosting the exposure) or to *decrease* the number of photons flooding the photosites in the light areas (by reducing the exposure). Sensors are unable to handle high-contrast situations in which there is a large variation in brightness between the dark and light areas. The degree to which a sensor can handle such variations is called its *dynamic range* and was explained in Chapter 2. However, even a sensor with a broad dynamic range won't handle the most extreme lighting conditions, so the "correct" exposure is likely to be a compromise that preserves detail at one end of the brightness scale at the expense of detail at the other end.

Generally, that means avoiding the clipping off of highlight detail caused by overexposure. As I noted, once a pixel bucket is "full," that pixel is rendered as pure white with no detail at all. There is no point in collecting additional photons and doing so can spoil the image in surrounding pixels because of spillover. On the other hand, information can often be retrieved from darker areas of an image even if those areas are underexposed, usually by multiplying the data that is there by increasing the ISO sensitivity setting. That's because, even in the darkest areas of the image *some* photons will be collected, even if too few are captured to pass the threshold level where image details start to become visible.

Of course, exposing strictly for the middle tones, while often a good idea, is no panacea; you may still end up with whites that are overexposed, and shadows that lack detail. Nor is exposing for one end or the other of the tonal range the answer, as I am about to show you.

Exposing for Middle Tones

Figure 4.1 shows an example of an image of Michaelangelo's Pietà. Inset at upper right is a set of patches (which I have added for illustrative purposes and do not actually appear on the wall at St. Peter's Basilica). The left patch is black, the center one a middle gray tone, and the right patch renders as white. The image represents what you'd get if you measured exposure from the middle gray patch, which, for the sake of illustration, we'll assume reflects approximately 12 to 18 percent of the light that strikes it. Lacking a strip of patches, you could also meter from a similar mid-tone area in the scene, in this case one of the shadow areas of the Carrara marble figures.

When you measure exposure using a middle tone, the camera's exposure meter sees an area that it assumes is a middle gray, calculates an exposure based on that, and the patch in the center of the strip is rendered at its proper tonal value. Best of all, because the resulting exposure is correct, the black patch at left and white patch at right are rendered properly as well.

When you're shooting pictures with your camera, and the meter happens to base its exposure on a subject that averages roughly the same as that "ideal" middle gray, then you'll end up with similar (accurate) results. The camera's exposure algorithms are concocted to ensure this kind of result as often as possible, barring any unusual subjects (that is, those that are backlit, or have uneven illumination).

Note that, despite what you may have been taught in photography classes or read in other books, your camera is *not* "calibrated" for 18 percent gray. Most mirrorless cameras are actually calibrated for a value that's closer to 12 to 14 percent gray, depending on the vendor. The 18% gray myth is

Figure 4.1
When exposure is calculated based on the middle-gray tone in the center of the card, the black and white patches are rendered accurately, too, and the sculpture is properly exposed.

HAND-HELD METERS

It's not possible for the user to change the calibration of a camera, although, with some cameras it is easy to make a global adjustment so that all images are uniformly "overexposed" or "underexposed" by a set amount. You can also temporarily add or subtract some exposure temporarily using a process called *exposure compensation*, which I will describe later. However, hand-held light meters can be calibrated to a new value, so, if you're still using one of these it may indeed be calibrated to 18 percent gray, or some other value of your choosing.

said to have begun after a 1970s-era revision of Kodak's instructions for its E-27Q gray cards (which continue to be sold today by other vendors) omitted the advice to open up an extra half stop from the exposure metered off the card. An entire generation of shooters grew up thinking that a measurement off a gray card could be used as-is. The proviso returned to the instructions by 1987, it's said, but by then it was too late. In most cases, the discrepancy is too small to matter much, but if you want to be 100 percent accurate in calculating exposures with a gray card you should do the following:

- For subjects of normal reflectance, *increase* the indicated exposure by 1/2 stop.
- For light subjects use the indicated exposure; for very light subjects, *decrease* the exposure by 1/2 stop.
- If the subject is dark to very dark, *increase* the indicated exposure by 1 to 1-1/2 stops.

Exposing for Dark Tones

Figure 4.2 shows what would happen if the exposure were calculated based on metering the left-most, black patch. The light meter sees less light reflecting from the black square than it would see from a gray middle-tone subject, and so figures, "Aha! I need to add exposure to brighten this subject up to a middle gray!" That lightens the "black" patch, so it now appears to be gray.

But now the patch in the middle that was *originally* middle gray is overexposed and becomes light gray. And the white square at right is now seriously overexposed and loses detail in the highlights, which have become a featureless white. Our marble sculpture is similarly overexposed, and a lot of detail is lost in the lightest areas.

Exposing for Light Tones

The third possibility in this simplified scenario is that the light meter might measure the illumination bouncing off the white patch, and try to render *that* tone as a middle gray. A lot of light is reflected by the white square, so the exposure is *reduced*, bringing that patch closer to a middle gray tone. The patches that were originally gray and black are now rendered too dark, and Michaelangelo's masterpiece is similarly underexposed. Clearly, measuring the gray card—or a substitute within the scene that reflects about the same amount of light—is the only way to ensure that the exposure is correct. (See Figure 4.3.)

Figure 4.2
When exposure is calculated based on the black square at upper right, the black patch looks gray, the gray patch appears to be a light gray, and the white square is seriously overexposed.

Figure 4.3
When exposure is calculated based on the white patch on the right, the other two patches, and the photo, are underexposed.

So, as you can see, the ideal way to measure exposure is to meter from a subject that reflects 12 to 18 percent of the light that reaches it. If you want the most precise exposure calculations, the solution is to use a stand-in, such as the evenly illuminated gray card I mentioned earlier. The standard Kodak gray card reflects 18 percent of the light that reaches it, what is considered to be a middle gray. But, as I said earlier, your camera is probably calibrated for a somewhat darker tone than that middle gray, roughly 12 to 14 percent gray, so you would need to *add* about one-half stop *more* exposure than the value metered from the card.

Another substitute for a gray card is the palm of a human hand (the backside of the hand is too variable). But a human palm, regardless of ethnic group, is even brighter than a standard gray card, so instead of one-half stop more exposure, you need to add one additional stop. That is, if your meter reading is 1/500th of a second at f/11, use 1/500th second at f/8 or 1/250th second at f/11 instead. (Both exposures are equivalent.)

If you actually wanted to use a gray card, place it in your frame near your main subject, facing the camera, and with the exact same even illumination falling on it that is falling on your subject. Then, use your camera's Spot metering function to calculate exposure. Of course, in most situations, it's not necessary to do this. Your camera's light meter will do a good job of calculating the right exposure. But, I felt that explaining exactly what is going on during exposure calculation would help you understand how your camera's metering system works.

The best exposure may be the one in which some of the white areas lack detail, providing closer to a true white, and some shadow details are lost as a trade-off to allow a better overall tonal range for the image. Image-processing algorithms can often do a good job of making these calculations, using, in some cases, the auto lighting optimizer/dynamic range lighting processing provided by many mirrorless cameras.

If you want to see how this works at a primitive level, load a photo into your image editor and then play with the brightness control. Moving the brightness slider to the right lightens shadow areas enough that you may be able to see details that were previously cloaked in darkness. However, moving the same slider to the left to darken overexposed highlight areas won't produce additional detail—it will only turn the white blocks into a featureless gray.

Digital camera autoexposure systems are optimized to attempt to preserve highlight detail (which is otherwise lost forever) at the expense of shadow detail (which can sometimes be retrieved). Any changes in how exposure is made that you make will simply be aimed at improving the relationship between the actual brightness levels in a scene and what is captured by your camera.

Tonal Range

The tonal range of an image is the range of dark to light tones, from a complete absence of brightness (black) to the brightest possible tone (white), and all the middle tones in between. Because all values for tones fall into a continuous spectrum between black and white, it's easiest to think of a photo's tonality in terms of a black-and-white or grayscale image, even though you're capturing tones in three separate color layers of red, green, and blue.

Because your images are digital, the tonal "spectrum" isn't really continuous: it's divided into discrete steps that represent the different tones that can be captured. Figure 4.4 may help you understand this concept. The gray steps shown range from 100 percent gray (black) at the left, to 0 percent gray (white) at the right, with 20 gray steps in all (plus white). The middle tone in the center represents 50 percent gray. I've also marked the approximate gray values of an 18 percent gray card, and the 12–14 percent gray that your camera is calibrated for.

Along the bottom of the chart are the digital values from 0 to 255 recorded by your sensor for an image with 8 bits per channel. (8 bits of red, 8 bits of green, and 8 bits of blue equal a 24 bit, full-color image.) The actual scale may be "finer" and record say, 0 to 4,094 for an image captured using 12 bits per channel. Any black captured would be represented by a value of 0, the brightest white by 255, and the middle gray by 128.

Grayscale images (which we call black-and-white photos) are easy to understand. Or, at least, that's what we think. When we look at a black-and-white image, we think we're seeing a continuous range of tones from black to white, and all the grays in between. But, that's not exactly true. The blackest black in any photo isn't a true black, because *some* light is always reflected from the surface of the print, and if viewed on a screen, the deepest black is only as dark as the least-reflective area a monitor can produce. The whitest white isn't a true white, either, because even the lightest areas of a print absorb some light (only a mirror reflects close to all the light that strikes it), and, when viewing on a monitor, the whites are limited by the brightness of the display's LCD or LEDs picture elements. Lacking darker blacks and brighter, whiter whites, that continuous set of tones doesn't cover the full grayscale tonal range.

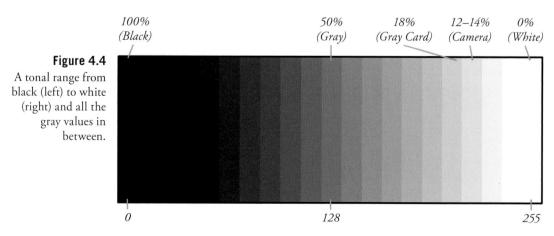

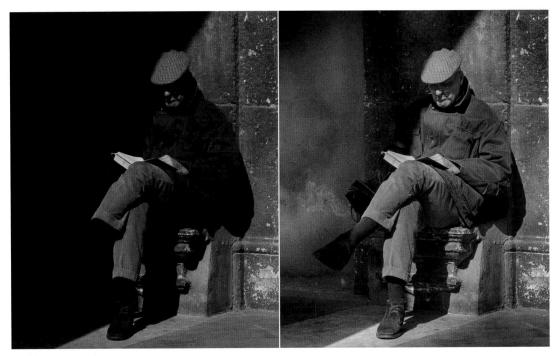

Figure 4.5 Detail exists in the highlights and shadows (left), even though a digital camera isn't always able to capture that information without special techniques like HDR (right).

The full scale of tones becomes useful when you have an image that has large expanses of shades that change from one level to the next, such as areas of sky, water, or walls. Consider the image shown at left in Figure 4.5, picturing a man reading a book, in sunlight and partially in shadow. All the tones that make up the details we can see of his face, hands, coat, and slacks are compressed into one end of the brightness spectrum, the lighter end.

Yet, there's more to this scene than the figure of the man. There is a lot of detail cloaked in the shadows of this image. These are illuminated by the softer light that bounces off the surrounding surfaces. If your eyes become accustomed to the reduced illumination, you'll find that there is a wealth of detail in these shadow images, as you can see in the version at right.

This scene would be a nightmare to reproduce faithfully under any circumstances. If you are an experienced photographer, you are probably already wincing at what is called a *high-contrast* lighting situation. (Today, a special kind of processing called *High Dynamic Range* (HDR) imaging—available in some cameras or by using special software—can be used to produce a final image similar to the one shown at right. I'll explain HDR later on.) Some photos may be high in contrast when there are fewer tones and they are all bunched up at limited points in the scale. In a low-contrast image, there are more tones, but they are spread out so widely that the image looks flat. Your digital camera can show you the relationship between these tones using something called a *histogram*.

Introducing Histograms

Your camera may have "live" histograms available, unlike a traditional SLR, which may present histograms only during image review, where they can be superimposed somewhere next to or overlaid on the image you've already taken. The "live" histogram displayed in shooting mode is probably the most useful, because you can consult it and adjust your exposure before you actually take a shot. A typical histogram is shown in Figure 4.6, which I'll use to show you exactly how they work.

Histograms are simplified displays of the relative numbers of pixels at each of 256 brightness levels, from 0 to 255, producing an interesting mountain range effect. Although separate charts may be provided for brightness (luminance) and the red, green, and blue channels, when you first start using histograms, you'll want to concentrate on the brightness histogram, which represents the tones available in white.

- Tonal shape. The white "mountain range" in this brightness/luminance histogram represents the distribution of all the tones in the image, from black on the left (0 brightness) to white (255 maximum brightness) on the right. The vertical axis represents the number of pixels at each point along the brightness scale. The higher the peak at any given point, the more pixels there are with that value in an image. Shallow valleys represent a relatively low number of pixels at that particular brightness level.
- **Brightness values.** This scale represents the darkest shadow areas of the image (at the left) to the brightest highlights (on the right). Although traditionally this scale runs from 0 (completely black) to 255 (completely white).
- Darkest tones. The darkest pixels are represented at the area at the left in the histogram. Any pixels that venture into the area marked with the blue bar will register as totally black and will be completely lost. By increasing exposure, you can move these pixels toward the right, preserving their detail.
- **Mid tones.** The number of pixels in the middle gray range are represented here. Increasing or decreasing exposure doesn't change the number of these pixels, but, instead moves them to the right or left, making them lighter or darker.

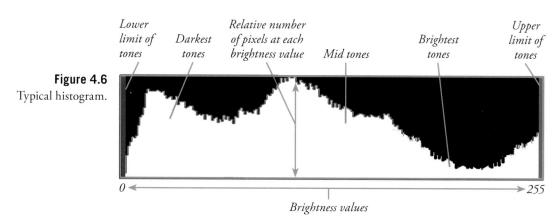

■ **Brightest tones.** The lightest pixels are represented at the area at the right in the histogram. Any pixels that venture into the area marked with the blue bar will register as totally white and will be lost. Decreasing exposure moves these pixels toward the left, keeping them from becoming "blown out." Optimizing exposure involves arriving at settings that preserve the most important tones in your images, whether they reside in the highlights or shadows.

Many cameras can show you a non-live histogram that represents the tonal values of an image that has already been taken, as in Figure 4.7. This histogram shows brightness/luminance values as well as separate values for the red, green, and blue channels of your image.

The sample brightness histogram of the riverside scene of Ft. Matanzas National Monument in Florida at bottom left in Figure 4.7 shows that most of the pixels are spread fairly evenly across the grayscale "spectrum," with some peaks of lighter colored pixels at the right side, representing the brighter clouds, water, and rocks. This histogram represents a fairly good exposure, because only a little image information is being clipped off at either end. With an image of normal contrast and typical subject matter, the bars of the histogram will form a curve of this sort. You can actually compare the curve shapes to evaluate the contrast range of an image.

For example, Figure 4.8 shows an image with fairly normal contrast. See how the bars of the histogram create a curve across most of the width of the grayscale? We can see from this histogram that the mask itself has very few black tones. That spike at the left side of the histogram represents the true blacks in the mask. Otherwise, there would be almost no tones at all at the far left.

With a lower-contrast image, like the one shown in Figure 4.9, the basic shape of the histogram will remain recognizable, but gradually will be compressed together to cover a smaller area of the gray spectrum. The squished shape of the histogram is caused by all the grays in the original image being represented by a limited number of gray tones in a smaller range of the scale.

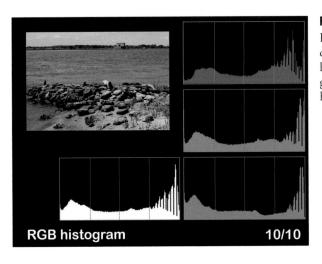

Figure 4.7 Playback histogram display with separate luminance, red, green, and blue histograms.

Instead of the darkest tones of the figurine reaching into the black end of the spectrum and the whitest tones extending to the lightest end, the blackest areas of the figurine are now represented by a light gray, and the whites by a somewhat lighter gray. The overall contrast of the image is reduced. Because all the darker tones are actually a middle gray or lighter, the mask in this version of the photo appears lighter as well.

Going in the other direction, increasing the contrast of an image produces a histogram like the one shown in Figure 4.10. In this case, the tonal range is now spread over a much larger area. When you stretch the grayscale in both directions like this, the darkest tones become darker (that may not be possible) and the lightest tones become lighter (ditto). In fact, shades that might have been gray before can change to black or white as they are moved toward either end of the scale.

Figure 4.8
This image has fairly normal contrast, even though, except for some black features in the mask, there are few true blacks showing in the histogram.

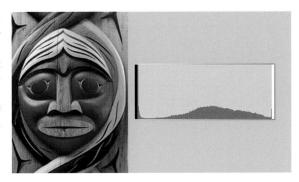

Figure 4.9
This low-contrast image has all the tones squished into one end of the grayscale.

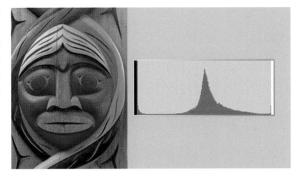

Figure 4.10
A high-contrast image produces a histogram in which the tones are spread out.

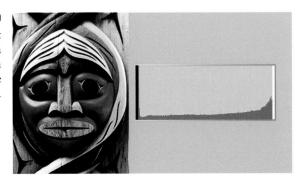

The effect of increasing contrast may be to move some tones off either end of the scale altogether, while spreading the remaining grays over a smaller number of locations on the spectrum. That's exactly the case in the example shown. The number of possible tones is smaller and the image appears harsher.

Understanding Histograms

The important thing to remember when working with the histogram display in your camera is that changing the exposure does *not* change the contrast of an image. The curves illustrated in the previous three examples remain exactly the same shape when you increase or decrease exposure. I repeat: The proportional distribution of grays shown in the histogram doesn't change when exposure changes; it is neither stretched nor compressed. However, the tones as a whole are moved toward one end of the scale or the other, depending on whether you're increasing or decreasing exposure. You'll be able to see that in some illustrations that follow.

So, as you reduce exposure, tones gradually move to the black end (and off the scale), while the reverse is true when you increase exposure. The contrast within the image is changed only to the extent that some of the tones can no longer be represented when they are moved off the scale.

To change the contrast of an image, you must do one of three things:

- Change your digital camera's contrast setting using the menu system. You'll find these adjustments in your camera's Picture Controls or Picture Styles menus.
- Use your camera's shadow-tone "booster." Many mirrorless cameras have a feature, which may be called Automatic Lighting Optimizer, or Active D-Lighting, or some other term. These options use algorithms to process each image (either at the time it is taken, or during in-camera post-processing from a "retouching" menu) to change the relationship between the shadow details and the highlights of a single image. Some cameras have an in-camera HDR feature that accomplishes something similar, but by taking two to three or more consecutive different exposures and combining the shadow and highlight details of each. There's a delay while this process is underway, but the results can be excellent.
- Alter the contrast of the scene itself, for example by using a fill light or reflectors to add illumination to shadows that are too dark.
- Attempt to adjust contrast in post-processing using your image editor or RAW file converter. You may use features such as Levels or Curves (in Photoshop, Photoshop Elements, and many other image editors), or work with HDR software to cherry-pick the best values in shadows and highlights from multiple images.

Of the four of these, the third—changing the contrast of the scene—is the most desirable, because attempting to fix contrast by fiddling with the tonal values is unlikely to be a perfect remedy. However, adding a little contrast can be successful because you can discard some tones to make the image more contrasty. However, the opposite is much more difficult. An overly contrasty image rarely can be fixed, because you can't add information that isn't there in the first place.

What you *can* do is adjust the exposure so that the tones *that are already present in the scene* are captured correctly. Figure 4.11 shows the histogram for an image that is badly underexposed. You can guess from the shape of the histogram that many of the dark tones to the left of the graph have been clipped off. There's plenty of room on the right side for additional pixels to reside without having them become overexposed. So, you can increase the exposure, either by changing the f/stop or shutter speed or by adding an exposure compensation (EV) value to produce the corrected histogram shown in Figure 4.12.

Figure 4.11
A histogram of an underexposed image may look like this.

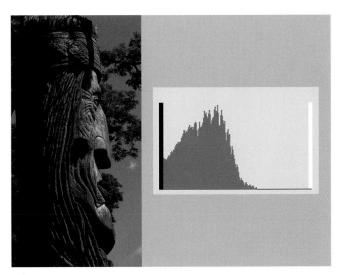

Figure 4.12
Adding exposure will produce a histogram like this one.

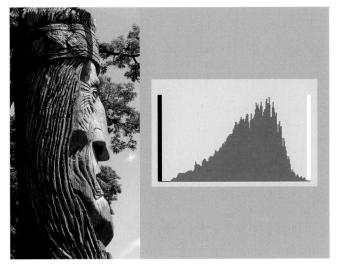

In addition to a histogram, your camera may also have an option for color coding the lightest and darkest areas of your photo during playback, so you can see if the areas that are likely to lose detail are important enough to worry about. Usually, such coding will involve flashing colors (often called "blinkies") in the review screen. Areas that are extremely overexposed may flash white, while areas that are very underexposed may flash black. Depending on the importance of this "clipped" detail, you can adjust exposure or leave it alone. For example, if all the dark-coded areas in the review are in a background that you care little about, you can forget about them and not change the exposure, but if such areas appear in facial details of your subject, you may want to make some adjustments.

Alternatively, an image may be overexposed, generating a histogram like the one shown in Figure 4.13. Reducing the exposure a stop or two will create the more optimized histogram you saw in Figure 4.12. One common term for optimizing exposures using a histogram is to "expose to the right." The rule proposes increasing exposure to push your tones to the right side of the histogram, as far as you can without clipping them off (converting the brightest tones to utter white).

The rationale behind this is that once pixels have been exposed to the extent that they become completely white, the information has been lost forever; whereas moving some dark pixels into the dark gray zone during this shift to the right doesn't eliminate picture data. Moreover, visual noise is more easily seen in dark areas, so reducing the amount of dead black can be beneficial if you have a camera that is prone to noise effects. This technique is actually a holdover from the days of color transparencies (positive film/color slides, for those of you who have never seen one). It was better to underexpose a slide, because you could always pump more light through it to retrieve shadow detail (when, say, making a print from that slide), while blown highlights were beyond retrieval.

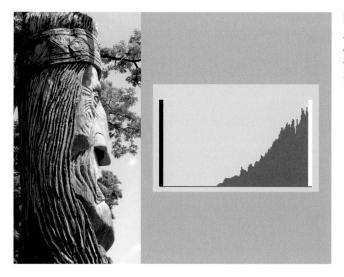

Figure 4.13
A histogram of an overexposed image will show clipping at the right side.

WHAT'S EV?

EV stands for Exposure Value, and it is a shortcut for representing changes in exposure regardless of whether they are made using the aperture or shutter speed controls. As you know, changing the settings from 1/125th second at f/8 to 1/60th second at f/8 doubles the exposure because the shutter speed has been made twice as long. Similarly, opening up the f/stop while leaving the shutter speed alone (making the exposure 1/125th second at f/5.6) also doubles the exposure. Sometimes you won't care which method is used, because the shutter speed will still be fast enough to freeze whatever action is present, and the aperture will still provide adequate depth-of-field. In those cases, if you're using a programmed exposure mode (in which the camera selects both shutter speed and aperture), you'll find it easiest to use your camera's EV adjustment to add or subtract EV from the exposure. The camera will choose which parameter to change to provide the requested modification. EV values can be added in half-stop or third-stop increments (or some other value, depending on your camera). Dialing in a +1/2 EV change will increase exposure by one-half f/stop/shutter speed value. Setting a -1/2 EV change will reduce exposure by the same amount.

Of course, digital images aren't like film transparencies. The trailing "toe" of the curve seen in color slides is relatively slow in contrast, while the transition of a digital image from little detail to no detail at all is quite abrupt. So, if you choose to expose to the right, be careful that important highlights don't venture *too* close to the cutoff point at the right side of the histogram (which may be difficult to interpret on a 3.2-inch LCD in any case), and avoid wasting precious tones from your maximum of 256 per channel by leaving the left side of the histogram empty.

What Affects Exposure

To control exposure, you need to understand what elements affect it. As a photographer, you probably have an innate sense of what these elements are, but the list that follows may bring them into focus, so to speak, for the discussions that follow.

In the most basic sense, exposure is all about light. Exposure can make or break your photo. Correct exposure brings out the detail in the areas you want to picture, providing the range of tones and colors you need to create the desired image. Poor exposure can cloak important details in shadow, or wash them out in glare-filled featureless expanses of white. However, getting the perfect exposure requires some intelligence—either that built into the camera or the smarts in your head—because digital sensors can't capture all the tones we are able to see. If the range of tones in an image is extensive, embracing both inky black shadows and bright highlights, we often must settle for an exposure that renders most of those tones—but not all—in a way that best suits the photo we want to produce.

You might be aware of the traditional "exposure triangle" of aperture (quantity of light passed by the lens), shutter speed (the amount of time the shutter is open), and the ISO sensitivity of the sensor, which all work proportionately and reciprocally to produce an exposure. The trio is itself affected by the amount of illumination that is available to work with. So, if you double the amount of light, increase the aperture by one stop, make the shutter speed twice as long, or boost the ISO setting 2X, you'll get twice as much exposure. Similarly, you can increase any of these factors while decreasing one of the others by a similar amount to keep the same exposure.

Working with any of the three controls involves trade-offs. Larger f/stops provide less depth-of-field, while smaller f/stops increase depth-of-field and, with higher resolution cameras can decrease sharpness through a phenomenon called diffraction. Shorter shutter speeds do a better job of reducing the effects of camera/subject motion, while longer shutter speeds make that motion blur more likely. Higher ISO settings increase the amount of visual noise and artifacts in your image, while lower ISO settings reduce the effects of noise. (See Figure 4.14.) The factors affecting exposure include:

- Intensity of the light. Indoors, we can turn lights on and off, move them around, and perhaps control their intensity with a dimmer switch. We can add auxiliary lighting equipment. Outdoors, we may have less control over the amount, direction, and quality of the light—although sources like electronic flash, reflectors, and light blockers can add or subtract light from a scene.
- **Duration.** Light may be continuous during an entire exposure, or, as in the case of an electronic flash, may be intermittent and last for only part of the time the shutter is open.

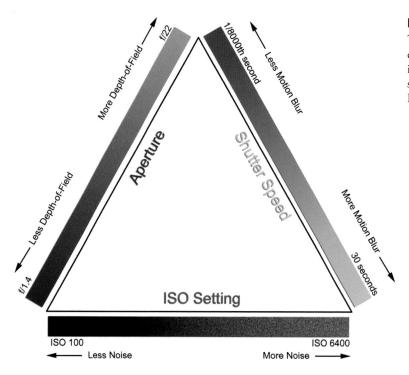

Figure 4.14
The traditional exposure triangle includes aperture, shutter speed, and ISO sensitivity.

- Amount of light reflected, transmitted, or emitted. Cameras record only light that bounces off our subjects, or is transmitted through them (say, from translucent objects that are lit from behind), or emitted (perhaps by a campfire or LCD screen).
- **Light traveling through the camera's lens.** Some of the light from our subject can be filtered out or reduced by the variable-sized lens opening, or aperture of the lens. Changing this *f/stop* provides one of the primary ways we control exposure.
- Light admitted by the shutter. The sensor can capture light only for the duration that the shutter is open, generally from 30 seconds to as high as 1/8,000th second if we are using the typical camera's automatic shutter speed controls, or for longer if we choose the Bulb setting (which locks the shutter open until we manually release it).
- **Captured photons.** The discussion of sensors earlier explained how individual photosites either record or do not record the photons that fall into their "buckets."

These six factors all work proportionately and reciprocally to produce an exposure. If you double the *intensity* of the light; lengthen its *duration* by 2X (either at the source or using the shutter); cause twice as much to be *reflected*, *transmitted*, or *emitted*; or double the number of photons recorded (say, by boosting the ISO setting 2X), you end up with twice as much exposure. Similarly, you can *increase* any one of these factors while *decreasing* one of the others in the same proportion to keep the same exposure.

F/STOPS AND SHUTTER SPEEDS

Each of my books always has a few readers who are totally new to photography, so it's always necessary to recount how f/stops and shutter speeds are described.

The time-honored way to explain an f/stop or lens aperture is to describe it as a ratio, much like a fraction. That's why f/2 is "larger" than f/4, just as 1/2 is larger than 1/4. However, f/2 is actually *four times* as large as f/4, because the ratio is calculated from the square root of two: 1.4.

Lenses are usually marked with intermediate f/stops that represent a size that's twice as much/half as much as the previous aperture. So, a lens might be marked:

f/2, f/2.8, f/4, f/5.6, f/8, f/11, f/16, f/22, with each larger number representing an aperture that admits half as much light as the one before.

Shutter speeds are actual fractions (of a second), but the numerator is omitted, so that 60, 125, 250, 500, 1,000, and so forth represent 1/60th, 1/125th, 1/250th, 1/500th, and 1/1,000th second. To avoid confusion, virtually all camera vendors use quotation marks to signify longer exposures: 2", 2"5, 4", and so forth representing 2.0, 2.5, and 4.0 second exposures, respectively.

You can change from one exposure to an equivalent exposure using a different f/stop and shutter speed, by making one value larger, while reducing the other value by an equivalent amount. So, 1/30th second at f/22 is the same as 1/60th second (half the duration) at f/16 (twice the aperture size).

Choosing an Exposure Mode

Digital SLRs typically have a mixture of fully automated, semi-automated, and manual exposure modes that can choose a correct (or close to correct) exposure for you, or let you have some (or all) control over how the camera exposes the photograph. The ability to choose an exposure mode affects the amount of creativity you can put into the image. You can elect to have the camera make most of the decisions for you, or you can tailor the settings yourself to achieve a particular effect or look.

Programmed and Full Auto Exposures

Digital cameras have modes that select the f/stop and shutter speed for you. Some are fully automatic (you can make few or no adjustments to the settings the camera chooses) or "programmed" (the camera selects settings, but you can modify them for a special effect). Although vendors call these by different names, they generally perform similar functions, as described in this list:

- **Full auto.** This mode, usually marked with a green camera or rectangle icon on the selection control (often a *mode dial*), directs the camera to make all the exposure decisions for you, with virtually no options for the photographer. The camera may also choose how to focus the image, whether to pop up the flash, and other parameters. This is the mode you'd use when you stop an honest looking stranger on the street and ask him to take your picture posing by that big glass pyramid in front of the Louvre.
- Full auto (no flash). Once you proceed *inside* the Louvre, you might want to switch to this setting to turn off your electronic flash and work with available light. (Tip: they don't like you to take pictures at all of the Mona Lisa, but there are always about 1,000 tourists doing it anyway at any given time.) This setting, usually marked with a lightning bolt symbol with a diagonal line through it, also works at religious ceremonies, concerts, or any other venue where flash is disruptive or useless.
- **Programmed.** With the typical camera, programmed or programmed auto is an automatic mode that makes basic settings for you, but allows a great deal of fine-tuning. While in P mode, you can change exposure combinations (switching to a faster or slower shutter speed and letting the camera choose the appropriate aperture—or a different f/stop, with the camera selecting the right shutter speed). P mode also allows adding or subtracting exposure from the calculated reading (*exposure compensation*), switching to a different Picture Control or Picture Style, or performing other adjustments. Many photographers like to use P mode when they encounter a photo-worthy situation and don't have the time to think about what semi-automatic or manual setting to use. Some—even more than a few professional photographers—use P almost all the time, because modern cameras do an excellent job of choosing settings for many typical types of pictures.
- Scene modes. These are fully automatic modes (although some may allow a few adjustments) tailored for specific types of shooting, such as landscapes, night portraits, sports, or close-ups. Beginners love these, because they don't require much experience or knowledge. There are dozens of different scene modes, and I'll explain a typical selection of them next.

Entry-level and intermediate mirrorless cameras may have from a half-dozen to two dozen scene modes, including some that I consider silly, such as "food" (increased saturation to make the food look better) and "museum" (locks out the flash even in low light, so you won't get kicked out of the venue), because there are other ways to achieve the same effect. Scene modes generally make some settings for you, and may limit the other settings you can make by blocking out your override capabilities for focus, exposure, brightness, contrast, white balance, or saturation.

I don't know any advanced camera users who work with scene modes regularly, but they're handy if you're a neophyte and fear that the basic programmed exposure modes or semi-automatic/manual modes won't do the job. If a split-second photo opportunity arises, such as a pet unexpectedly doing something cute, if you can't remember what settings you've adjusted on your camera, switch into an appropriate scene mode. You'll get your picture even if it turns out the camera was set in manual mode for a 30 second fireworks exposure the night before.

Note that some mirrorless cameras may have a basic complement of scene modes on the mode dial, with an additional setting (often called SCN) that provides access to a dozen or more additional scene modes. A few cameras have yet another mode dial setting that provides special effects retouching modes, including fisheye effects, that are applied as you take the picture. Here are some of the common scene/effects modes found in mirrorless cameras, and the typical parameters used by them. No single camera will have all of these; I'm presenting only a selection of some that are offered with some cameras:

- **Portrait.** This scene mode uses a large f/stop to throw the background out of focus and generally sets the flash (if used) for red-eye reduction mode.
- **Night.** Reduces the shutter speed to allow longer exposures without flash, and to allow ambient light to fill in the background when flash is used.
- **Night portrait.** Uses a long exposure, usually with red-eye flash, so the backgrounds don't sink into inky blackness.
- **Night vision.** This effect gives you a monochrome image recorded at high ISO under very low light conditions. Because the light is so dim, autofocus is available only in live view mode. You can use manual focus. You'll probably want to use a tripod, because this mode can use longer shutter speeds that accentuate camera movement. (See left, Figure 4.15.)
- **Beach/Snow.** May slightly overexpose a scene to counter the tendency of automatic metering systems to overcompensate for very bright settings.
- **Sports.** Uses the highest shutter speed available to freeze action, and, in some cameras, may choose spot metering to expose for fast-moving subjects in the center of the frame. This mode may boost the ISO sensitivity to capture more light in dim conditions, or to permit that faster shutter speed.
- Landscape. Generally selects a small f/stop to maximize depth-of-field, and may also increase the saturation setting of your camera to make the landscape more vivid.

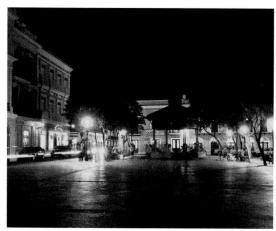

Figure 4.15 Special effects/scene modes can include night vision (left) and silhouette (right).

- Macro. Some cameras have a close-up scene mode that shifts over to macro focus mode, which defaults to a smaller f/stop (to provide increased depth-of-field), favors higher shutter speeds to help make close-up photos sharp, and adjusts how your camera selects focus.
- Kids & pets. An "action" scene mode for capturing fast-moving pets and children without subject blur. The camera may boost the ISO to a higher level than normal to allow a fast shutter speed.
- Silhouette. Produces silhouettes against bright backgrounds, and flash is disabled. (See Figure 4.15, right.)
- Super vivid. This setting increases the saturation of the colors in a scene, making them appear much richer and more intense than normal. Use it for dramatic effect, but you'll probably want to use this one sparingly, because it could wear out its welcome rapidly.
- **Poster effect.** This setting, like the previous one, is not intended for a specific type of scene; rather, it imposes a particular type of processing on the image. In this case, it provides a degree of "posterization," increasing contrast with bright color effects.
- Color accent/Selective color. Creates a special effect: Choose one color on the LCD, and all the other colors in an image are converted to black-and-white.
- Color swap. Changes one color to another. If you want to see Kentucky bluegrass that's *really* blue, this is the mode for you.
- HDR. This setting is found on a few cameras, and used for producing in-camera processing of a High Dynamic Range image, by taking three pictures in one sequence at different exposures, and then combining them into a final product that uses the most clearly exposed portions of the different shots to give you better combination of highlights, shadows, and middle tones than you could get with just one exposure.

- **Nostalgic.** This setting lets you ramp down the saturation of the colors in your images, giving the appearance of a faded, antique photograph.
- Fisheye effect. This setting simulates the bulging, distorted view produced by an extreme wide-angle "fisheye" lens.
- Miniature effect. This setting lets you select a portion of the image to be shown clearly, while blurring the top and bottom, resulting in an effect like viewing a miniaturized model.
- Underwater. This setting is intended specifically for use under the surface of water (many cameras have optional waterproof cases). It removes bluish color casts and reduces the intensity of the flash. The camera may use a high ISO setting to compensate for the reduced amount of light underwater.
- Foliage. Another saturation-rich setting for shooting trees and leaves, with emphasis on bright and vivid greens.
- Fireworks. Offers vivid photos of fireworks with a longer exposure to capture an entire burst.
- **High key.** Creates bright scenes. This effects tool, like the low key effect described next, can't work miracles. It won't produce a high-key image from a low-key subject. But if you have a scene that is filled with bright light, this effect will accentuate that, as seen at left in Figure 4.16.
- Low key. Gives you dark, foreboding images. You'll need contrasty lighting to achieve this effect, but given the right subject, you can end up with an image like the one at right in Figure 4.16.

Figure 4.16 Other effects include high key (left); and low key (right).

Adjusting Exposure with ISO Settings

Most photographers use two primary ways of adjusting exposure: changing the shutter speed or aperture, but may also resort to modifying the amount of light illuminating the scene (most often by adding a source, such as a lamp or electronic flash). However, a less-used way of adjusting exposures is by changing the ISO sensitivity setting. Sometimes photographers forget about this option, because the common practice is to set the ISO once for a particular shooting session (say, at ISO 200 for bright sunlight outdoors, or ISO 800 when shooting indoors) and then forget about ISO. That's because ISOs higher than ISO 200 or 400 are seen as "necessary evils." However, changing the ISO is a valid way of adjusting exposure settings, particularly with cameras that have relatively low light levels at settings as high as ISO 1600, ISO 3200, or higher.

ISO adjustment is a convenient alternate way of adding or subtracting EV when shooting in manual mode, and as a quick way of choosing equivalent exposures when in program or shutter-priority or aperture-priority modes. For example, select a manual exposure with suitable f/stop and shutter speed using, say, ISO 200. You can then change the exposure in increments (1/3, 1/2, or whole stops). The difference in image quality/noise at the base setting of ISO 200 can be negligible when you change to ISO 320 to increase exposure. You end up with your preferred f/stop and shutter speed, but still are able to adjust the exposure.

Or, perhaps, you are using shutter-priority/Tv mode and the metered exposure at ISO 200 is 1/500th second at f/11. If you decide to use 1/500th second at f/8, you can change the sensitivity to ISO 100. It's a good idea to monitor your ISO changes, so you don't end up at ISO 6400 accidentally.

ISO settings can, of course, also be used to boost or reduce sensitivity in particular shooting situations. Most cameras can also adjust the ISO automatically as appropriate for various lighting conditions. You may even be able to specify the minimum shutter speed where automatic ISO changes kick in. Perhaps you feel you can hand-hold an image at 1/30th second, so you prefer that ISO not be boosted until the camera is forced to use 1/15th second, instead. Most cameras also allow you to specify the highest ISO setting that will be used in Auto ISO mode, so, you can "top out" the adjustments at, say, ISO 3200 if your particular model doesn't do a good job at higher sensitivity settings (as described in Chapter 1).

Semi-Automatic and Manual Exposure Modes

All mirrorless cameras have these, although the names may differ slightly among cameras from various vendors. You'll generally choose the mode you want from a mode dial that also includes the fully automatic and scene modes at other detents. Your choice of which is best for a given shooting situation will depend on things like your need for lots of (or less) depth-of-field, a desire to freeze action or allow motion blur, or how much noise you find acceptable in an image. Each of these exposure methods emphasizes one aspect of image capture or another. This section introduces you to all three.

Aperture-Priority

This setting is called aperture-priority, aperture preferred, or aperture value mode, depending on the vendor, and is usually abbreviated either A or Av. In aperture-priority mode, you specify the lens opening used, and the camera selects the shutter speed. This mode is especially good when you want to use a particular lens opening to achieve a desired effect. Perhaps you'd like to use the smallest f/stop possible to maximize depth-of-field in a close-up picture. Or, you might want to use a large f/stop to throw everything except your main subject out of focus, as in Figure 4.17. Maybe you'd

Figure 4.17
Use aperturepriority to "lock in"
a large f/stop when
you want to blur the
background.

just like to "lock in" a particular f/stop because it's the sharpest available aperture with that lens. Or, you might prefer to use, say, f/2.8 on a lens with a maximum aperture of f/1.4, because you want the best compromise between speed and sharpness.

Aperture-priority can even be used to specify a *range* of shutter speeds you want to use under varying lighting conditions, which seems almost contradictory. But think about it. You're shooting a soccer game outdoors with a telephoto lens and want a relatively high shutter speed, but you don't care if the speed changes a little should the sun duck behind a cloud. Set your camera to A or Av, and adjust the aperture until a shutter speed of, say, 1/1,000th second is selected at your current ISO setting. (In bright sunlight at ISO 400, that aperture is likely to be around f/11.) Then, go ahead and shoot, knowing that your camera will maintain that f/11 aperture (for sufficient DOF as the soccer players move about the field), but will drop down to 1/750th or 1/500th second if necessary should the lighting change a little.

An indicator in the viewfinder or LCD (frequently of the blinking variety) will show when the camera is unable to select an appropriate shutter speed at the selected aperture and that over- and underexposure will occur at the current ISO setting. That's the major pitfall of using aperture-priority: you might select an f/stop that is too small or too large to allow an optimal exposure with the available shutter speeds. For example, if you choose f/2.8 as your aperture and the illumination is quite bright (say, at the beach or in snow), even your camera's fastest shutter speed might not be able to cut down the amount of light reaching the sensor to provide the right exposure. Or, if you select f/8 in a dimly lit room, you might find yourself shooting with a very slow shutter speed that can cause blurring from subject movement or camera shake. Aperture-priority is best used by those with a bit of experience in choosing settings. Many seasoned photographers leave their cameras set on A/Av all the time. The exposure indicator scale in the status panel and viewfinder typically indicate the amount of under- or over-exposure, so you can make adjustments as required.

When to use aperture-priority:

- General landscape photography. Aperture-priority is a good tool for ensuring that your land-scape is sharp from foreground to infinity, if you select an f/stop that provides maximum depth-of-field.
 - If you use A mode and select an aperture like f/11 or f/16, it's your responsibility to make sure the shutter speed selected is fast enough to avoid losing detail to camera shake, or that the camera is mounted on a tripod. One thing that new landscape photographers fail to account for is the movement of distant leaves and tree branches. When seeking the ultimate in sharpness, go ahead and use aperture-priority, but boost ISO sensitivity a bit, if necessary, to provide a sufficiently fast shutter speed, whether shooting hand-held or with a tripod.
- Specific landscape situations. Aperture-priority is also useful when you have no objection to using a long shutter speed, or, particularly, *want* the camera to select one. Waterfalls are a perfect example. You can use A mode, set your camera to ISO 100, use a small f/stop, and let the

camera select a longer shutter speed that will allow the water to blur as it flows. Indeed, you might need to use a neutral-density filter to get a sufficiently long shutter speed. But aperture-priority mode is a good start.

- Portrait photography. Portraits are the most common applications of selective focus. A medium large aperture (say, f/5.6 or f/8) with a longer lens/zoom setting (in the 85mm-150mm range) will allow the background behind your portrait subject to blur. A *very* large aperture (I frequently shoot wide open with my 85mm f/1.4 lens) lets you apply selective focus to your subject's *face*. With a three-quarters view of your subject, as long as their eyes are sharp, it's okay if the far ear or their hair is out of focus.
- When you want to ensure optimal sharpness. All lenses have an aperture or two at which they perform best. That's usually about two stops down from wide open, and thus will vary depending on the maximum aperture of the lens. My 45mm f/1.8 is good wide open, but it's even sharper at f/2.8 or f/4; I shoot my 14-40mm f/2.8 wide open at concerts, but, if I can use f/4 instead, I'll get better results. Aperture-priority allows me to use each lens at its very best f/stop.
- Close-up/macro photography. Depth-of-field is typically very shallow when shooting macro photos, and you'll want to choose your f/stop carefully. Perhaps you need the smallest aperture you can get away with to maximize DOF. Or, you might want to use a wider stop to emphasize your subject. A mode comes in very useful when shooting close-up pictures. Because macro work is frequently done with the camera mounted on a tripod, and your close-up subjects, if not living creatures, may not be moving much, a longer shutter speed isn't a problem. Aperture-priority (Av mode) can be your preferred choice.

Shutter-Priority

Shutter-priority/shutter preferred/time value exposure (S or Tv) is the inverse of aperture-priority: you choose the shutter speed you'd like to use, and the camera's metering system selects the appropriate f/stop. Perhaps you're shooting action photos and you want to use the absolute fastest shutter speed available with your camera; in other cases, you might want to use a slow shutter speed to add some blur to a sports photo that would be mundane if the action were completely frozen. (See Figure 4.18.) Shutter-priority mode gives you some control over how much action-freezing capability your digital camera brings to bear in a particular situation.

You'll also encounter the same problem as with aperture-priority when you select a shutter speed that's too long or too short for correct exposure under some conditions. Like A/Av mode, it's possible to choose an inappropriate shutter speed. If that's the case, the display will show an indicator, which varies depending on the camera model.

Figure 4.18 Lock the shutter at a slow speed to introduce blur into an action shot, as with this panned image of a relay race.

MAKING EV CHANGES

Sometimes you'll want more or less exposure than indicated by the camera's metering system. Perhaps you want to underexpose to create a silhouette effect, or overexpose to produce a high-key look. All cameras have an exposure compensation system, generally accessible by pressing a button on the camera with a plus/minus mark. Hold down the button and adjust the appropriate dial, wheel, or other control.

The EV change, usually plus or minus three to five stops, remains for the exposures that follow, until you manually zero out the EV setting. An exposure compensation icon or indicator is easy to miss, so don't forget to cancel the change when you're done.

When to use shutter-priority:

- To reduce blur from subject motion. Set the shutter speed of the camera to a higher value to reduce the amount of blur from subjects that are moving. The exact speed will vary depending on how fast your subject is moving and how much blur is acceptable. You might want to freeze a basketball player in mid-dunk with a 1/1,000th second shutter speed, or, as I mentioned earlier, use 1/250th second to allow the spinning wheels of a motocross racer to blur a tiny bit to add the feeling of motion.
- **To add blur from subject motion.** There are times when you want a subject to blur, say, when shooting those waterfalls or rivers with the camera set for a one- or two-second exposure in shutter-priority mode.
- **To add blur from camera motion when** *you* **are moving.** Say you're panning to follow a relay runner, as illustrated earlier in Figure 4.18. You might want to use shutter-priority mode and set the camera for 1/60th second, so that the background will blur as you pan with the runner. The shutter speed will be fast enough to provide a sharp image of the athletes.
- To reduce blur from camera motion when *you* are moving. In other situations, the camera may be in motion, say, because you're shooting from a moving train or auto, and you want to minimize the amount of blur caused by the motion of the camera. Shutter-priority is a good choice here, too.
- Landscape photography hand-held. If you can't use a tripod for your landscape shots, you'll still probably want the sharpest image possible. Shutter-priority can allow you to specify a shutter speed that's fast enough to reduce or eliminate the effects of camera shake. Just make sure that your ISO setting is high enough that the camera will select an aperture with sufficient depth-of-field, too.
- Concerts, stage performances. I shoot a lot of concerts with a telephoto zoom lens, and have discovered that, when image stabilization is taken into account, a shutter speed of 1/180th second is fast enough to eliminate the effects of camera shake from hand-holding the camera with this lens, and also to avoid blur from the movement of all but the most energetic performers. I use shutter-priority and set the ISO so the camera will select an aperture in the f/4-5.6 range.

Program Mode

Program mode/programmed auto (P) uses the camera's built-in smarts to select both the correct f/stop and shutter speed using a database of picture information that tells it which combination of shutter speed and aperture will work best for a particular type of photo. If the correct exposure cannot be achieved at the current ISO setting, your camera may provide an indicator. You can then boost or reduce the ISO to increase or decrease sensitivity and bring the camera's settings back into "range."

The camera's recommended exposure can be overridden if you want. Use the EV setting feature (also described later, because it also applies to S and A modes) to add or subtract exposure from the metered value. And, as I mentioned earlier in this chapter, you can change from the recommended setting to an equivalent setting that produces the same exposure, but using a different combination of f/stop and shutter speed.

When to use program mode priority:

- When you're in a hurry to get a grab shot. The camera will do a pretty good job of calculating an appropriate exposure for you, without any input from you.
- when you hand your camera to a novice. Set the camera to P, hand the camera to your friend, relative, or trustworthy stranger (someone you meet in front of the Eiffel Tower who does not already have three or four cameras and is not wearing track shoes), point to the shutter release button and viewfinder, and say, "Look through here, and press this button." While you can also use the auto mode found on many cameras as a novice-friendly mode, P gives you the option of making some exposure adjustments before turning your camera over to the other person.
- When no special shutter speed or aperture settings are needed. If your subject doesn't require special anti- or pro-blur techniques, and depth-of-field or selective focus aren't important, use P as a general-purpose setting. You can still make adjustments to increase/decrease depth-of-field or add/reduce motion blur with a minimum of fuss.

Manual Exposure

Manual exposure can come in handy in some situations. You might be taking a silhouette photo and find that none of the exposure modes or EV correction features give you exactly the effect you want. Set the exposure manually to use the exact shutter speed and f/stop you need. Or, you might be working in a studio environment using multiple flash units. The additional flash are triggered by slave devices (gadgets that set off the flash when they sense the light from another flash unit, or, perhaps from a radio or infrared remote control). Your camera's exposure meter doesn't compensate for the extra illumination, so you need to set the aperture manually.

Because, depending on your proclivities, you might not need to set exposure manually very often, you should still make sure you understand how it works. Fortunately, most cameras make setting exposure manually easy, usually by rotating a main/back-panel command dial for shutter speed, and a front/sub-command or other dial for aperture. You might also use the same dial for both, and press a button to switch back and forth.

Manual exposure mode is a popular option among more advanced photographers who know what they want in terms of exposure, and want to make the settings themselves. Manual lets you set both shutter speed and aperture.

There are several reasons for using manual exposure:

- When you want a specific exposure for a special effect. Perhaps you'd like to deliberately underexpose an image drastically to produce a shadow or silhouette look. You can fiddle with EV settings or override your camera's exposure controls in other ways, but it's often simpler just to set the exposure manually.
- When you're using an external light meter in tricky lighting situations or for total control. Advanced photographers often fall back on their favorite hand-held light meters for very precise exposure calculations. For example, an incident meter, which measures the light that falls on a subject rather than the light reflected from a subject, can be used at the subject position to measure the illumination in the highlights and shadows separately. This is common for portraits, because the photographer can then increase the fill light, reduce the amount of the main light, or perform other adjustments. Those enamored of special exposure systems, like the marvelously effective and complex Zone System of exposure developed by Ansel Adams, might also want the added control an external light meter provides.
- When you're using an external flash that's not compatible with your camera's TTL (through-the-lens) flash metering system. You can measure the flash illumination with a flash meter, or simply take a picture and adjust your exposure in manual mode.
- When you're using a lens that doesn't couple with your digital camera's exposure system. Several mirrorless camera models can use older lenses not designed for the latest modes of operation, although they must be used in manual focus/exposure mode. I have several specialized older lenses that I use with my camera in manual focus/manual exposure mode. They work great, but I have to calculate exposure by guesstimate or by using an external meter. My camera's exposure system won't meter with these optics under any circumstances.

Exposure Metering

Regardless of whether you're using fully automatic, programmed, aperture-/shutter-priority, or manual mode using your camera's exposure indicators as a guideline, you'll want to choose a metering method that suits your situation.

Mirrorless cameras use the sensor itself to measure the light passing through the lens. In the early days of interchangeable lens photography, cameras of that era frequently captured exposure information through clumsy photocells mounted on the *outside* of the camera body. The alternative was to use a hand-held meter. Such systems were relatively low in sensitivity, and you had to be incredibly lucky or well-seasoned in interpreting meter readings for the light captured by the meter to have some correspondence with the illumination that actually reached the film. Of course, if you used a filter or other add-on, all bets were off. Photographers were delighted when cameras were introduced that actually measured light destined for the film itself.

Of course, we now take TTL (through-the-lens) metering for granted. Digital SLRs and mirrorless cameras alike use much more refined methods of metering light, too, compared to the earliest through-the-lens models that captured an amorphous blob of light without much regard to where it originated in the image. Modern metering systems can be divided into several categories:

- Center-weighting. While early cameras had a form of averaging metering, in which light from all portions of the viewfinder was captured, in truth they tended to emphasize the center portion of the frame. This bug was turned into a feature and center-weighted averaging was born. Most of the exposure information is derived from the middle of the frame. Figure 4.19 shows, roughly, the typical area emphasized by a center-weighted metering system. (The green shading does *not* appear in the electronic viewfinder or LCD!)
- **Spot metering.** This method gathers exposure information only from a central portion of the frame. You may be able to choose from a 6mm or 8mm spot, or larger. Light outside the spot area is ignored. Figure 4.20 shows a typical center spot arrangement, with the sensitive area in green. Some cameras allow you to change the spot metered area from the center, usually to one of the locations indicated by the focus area brackets (in red in the figure).
- Matrix/evaluative metering. Exposure information is collected from many different positions in the frame, and then used to calculate the settings using one of several calculation routines. Figure 4.21 shows the matrix/evaluative metering zones used by an Olympus mirrorless camera.

Once the camera's metering system has captured the amount of illumination passing through the lens, the information is evaluated and the correct exposure determined. How that exposure is calculated can vary from camera to camera. One vendor's camera may calculate center-weighted exposure based on an average of all the light falling on a frame, but with extra weight given to the center. Others may use a modified spot system with a really large, fuzzy spot, so that light at the periphery of the frame is virtually ignored, even though the system is *called* center-weighting.

Similarly, spot metering can vary depending on the size of the spot, and what the camera elects to do with the spot of information, and how much flexibility the photographer is given over the process. For example, as I mentioned, you might be able to choose the size of the spot. Or, you may be allowed to move the spot around in the viewfinder using your camera's cursor controls, so that you meter the subject area of your choice, rather than a central area forced on you by the camera. You'll find this option especially useful for backlit subjects or macro photography.

In modern multipoint matrix metering systems, hundreds or thousands of different points might be measured. Matrix metering enables the camera to make some educated guesses about the type of picture you are taking, and choose an exposure appropriately. For example, if the camera detects that the upper half of the frame is brighter than the bottom half, it may make a reasonable assumption that the image is a landscape photo and calculate exposure accordingly.

Figure 4.19
Center-weighting gathers most of its exposure information from the center of the frame, but it also includes data from the rest of the image.

Figure 4.20
Spot metering collects exposure information only from a small area in the frame.

Figure 4.21
Matrix/evaluative
metering gathers
exposure information from an array of
areas within the
frame.

Brightness patterns from a large number of metering zones in the frame are collected, and then compared against a large database of sample pictures compiled by the camera manufacturer. Your camera is not only capable of figuring out that you're shooting a landscape photo, it can probably identify portraits, moon shots, snow scenes, and dozens of other situations with a high degree of accuracy.

These highly sophisticated evaluation systems use a broad spectrum of information to make exposure decisions. In addition to overall brightness of the scene, the system may make changes based on the focus distance (if focus is set on infinity, the image is more likely to be a landscape photo); focus or metering area (if you've chosen a particular part of the frame for focus or metering, that's probably the center of interest and should be given additional weight from an exposure standpoint); the difference in light values throughout the frame (effectively, the contrast of the image); and, finally, the actual brightness values encountered.

It's often smart to build in some bias toward underexposure, because incorrectly exposed shadows are easier to retrieve than blown highlights. Evaluative metering systems use that kind of bias and other factors to calculate your exposure. For example, in dark scenes, the tendency is to favor the center of the photo. In scenes with many bright values, extra attention is given to the brightest portions, especially if the overall contrast of the image is relatively low. Your best bet is to become familiar with how your own camera's exposure systems work in the kinds of photo situations you favor.

EXPOSURE LOCK

Mirrorless cameras often include an exposure lock/focus lock button you can use to capture the current exposure settings without the need to continuously hold down the shutter release. The exposure and/or focus remains locked until you take the next picture, allowing you to reframe or do other things before you actually depress the shutter release to capture the image.

Bracketing

Another control you might find handy is the bracketing option, which automatically provides settings with less and additional exposure (clustered around your base exposure), using an increment (such as 1/3 or 1/2 stop) that you select. More advanced systems can bracket conventional exposure, flash exposure, or both, and perhaps other values, such as white balance. By using bracketing to shoot several consecutive exposures at different settings, you can improve the odds that one will be exactly correct, or that one will be "better" from a creative standpoint. For example, bracketing can supply you with a normal exposure of a backlit subject, one that's "underexposed," producing a silhouette effect, and a third that's "overexposed" to create yet another look. (See Figure 4.22.) Not all cameras have built-in bracketing in any form, but you can always shoot successive images at different exposures with manual adjustments.

Figure 4.22 Bracketing can give you three different exposures of the same subject.

I use bracketing a great deal, not because I lack confidence in my camera's exposure metering or my ability to fine-tune it. Some pictures just can't be reshot if the exposure is not exactly right, and under conditions where lighting is constantly changing, or a scene has a mixture of bright sunny areas and dusky shadows, a range of exposures can be useful. So, I'll set the camera to shoot in three-shot brackets, either with a 1/3 stop or 2/3 stop increment, depending on how widely the lighting conditions vary. (With a broader range of lighting, I'll use a larger increment to increase the chances that *one* of my shots will be spot-on.) Then, I'll use continuous shooting mode and bang off a triplet of shots with one press of the shutter button.

Depending on the type of camera you are using, you might have some decisions to make in setting up bracketing:

- Choose type of bracketing. Your camera may allow you to bracket exposure only, flash exposure only, or both, plus white balance only.
- Select number of bracketed exposures. Some cameras, particularly entry-level models, shoot a fixed number of bracketed shots (say, three); others may allow you to choose from 0 (which turns bracketing off), or 2, 3, 5, 7, or 9 bracketed shots. You'll find a higher number of shots useful when shooting images for later HDR processing, as more images provide a larger span of exposures on which the HDR software can perform its magic, as explained next.
- Choose bracket increment. You can select 1/3 stop brackets (for minor fine-tuning), as well as 2/3 or 1 stop adjustments for a broader range of exposures. Some cameras may allow you to choose even larger bracket increments.

- Set zero point. Some cameras allow you to move the zero point for bracketing from the metered exposure to a higher or lower value. That way, you can create a set of bracketed exposures that are clustered around the metered exposure, or which are all underexposures or overexposures.
- Frame and shoot. As you take your photos the camera will vary exposure, flash level, white balance, or other setting for each image. In single shot mode for exposure bracketing, you'll need to press the shutter release button the number of pictures in your bracketed set. In continuous shooting mode, all will be taken in one burst if you continue to hold down the shutter release.
- Turn bracketing off. When you're finished bracketing shots, remember to cancel bracketing. If you've been using single shot mode and forget you're still bracketing, you may be puzzled why your exposures differ from shot to shot.

Bracketing and Merge to HDR

HDR (High Dynamic Range) photography is all the rage right now, with entire books devoted to telling you how, using software, you can partially correct for your sensor's inability to record an unrealistically long dynamic range. I'm joking, in part, because the most common use for HDR seems to be to produce fantasy-world images that couldn't possibly be seen by the eyes of humans. They're most often vertically oriented landscapes (so as to encompass the maximum amount of sky and foreground in the same image), shot with ultra-wide-angle lenses (for the same reason), with dramatic skies and fine details stretching from immediately in front of the photographer to infinity. Enjoy viewing and taking these images while you can, because, like cross-processing techniques (if you'll recall those weird colors that dominated fashion photography five to ten years ago), they will soon fall from favor.

Yet, HDR does have uses for improving images in less extreme ways, providing a photo that looks more like the scene did to your unaided eye. High dynamic range photography involves shooting two or three or more images at different manually or automatically bracketed exposures, giving you an "underexposed" version with lots of detail in highlights that would otherwise be washed out, an "overexposed" rendition that preserves detail in the shadows, and several intermediate shots. These are combined to produce a single image that has an amazing amount of detail throughout the scene's entire tonal range.

Suppose you encountered a colonnaded structure such as the one in the Gaudí-designed Park Güell in Barcelona. Exposing for the foreground columns leaves the open park area at the end overexposed, as you can see in Figure 4.23. If you expose for the park seen through the columns—a difference of more than 7 f/stops—the columns themselves appear dark and dingy. (See Figure 4.24.) But taking several exposures and combining them into one shot gives you an image like the one in Figure 4.25, which more or less resembles what the scene actually looks like to the eye.

When you're using Merge to HDR, a feature found in Adobe Photoshop (similar functions are available in other programs, including Photomatix [www.hdrsoft.com; free to try, \$99 to buy]),

you'd take several pictures. As I mentioned earlier, one would be exposed for the shadows, one for the highlights, and perhaps several more for the midtones. Then, you'd use the Merge to HDR Pro command (or the equivalent in other software) to combine all of the images into one HDR image that integrates the well-exposed sections of each version.

The images should be as identical as possible, except for exposure. So, it's a good idea to mount the camera on a tripod, use a remote release, and take all the exposures in one burst. You should use aperture-priority to fix the aperture at a single f/stop—otherwise the focus and depth-of-field will change and make merging the photos more difficult. Or, you can bracket manually and remember to change only the shutter speed.

If you don't have the opportunity or inclination, or skills to create several images at different exposures of the original scene, you may still be able to create an HDR photo. If you shoot in RAW format, import the image into your image editor several times, using the RAW import utility (such as Adobe Camera Raw) to create multiple copies of the file at different exposure levels. For example, you'd create one copy that's too dark, so the shadows lose detail, but the highlights are preserved. Create another copy with the shadows intact and allow the highlights to wash out. A third copy would optimize the middle tones. Then, you can use your HDR software to combine the three and end up with a finished image that has the extended dynamic range you're looking for.

Figure 4.23 Exposing for the foreground overexposes the area seen through the columns.

Figure 4.24 Adjust the exposure for the far background, and everything else is underexposed.

Figure 4.25 Combining several exposures using HDR techniques yields one optimized image.

Mastering the Mysteries of Focus

Correct focus is another critical aspect of taking a technically optimized photograph. You want your main subject to be in sharp focus generally (there are exceptions), and may want other parts of the image to be equally as sharp, or you may want to let them become blurry to use selective focus techniques.

If you're coming from the point-and-shoot camera world, focus was probably no big deal for you. These models have tiny sensors and short focal length lenses, with, say, a 6-36mm true zoom range (but billed as a 28-168mm "equivalent"). So, virtually everything may be in sharp focus, except when shooting macro (close-up) photos. That extensive depth-of-field can be either a good thing or a bad thing, depending on whether you wanted to use focus creatively.

Mirrorless cameras, on the other hand, have larger sensors. Those larger sensors use longer focal lengths, and aren't necessarily susceptible to this problem/advantage. Focus really matters. You can choose to focus the image yourself, manually, let the camera focus for you, or step in and fine-tune focus after the camera has done its best. There are advantages and disadvantages to each approach. To help you understand your focusing options, this chapter will first explain the basics of focus, to help you understand what the focus controls and settings available on your camera do. Then, I'll dive a little more deeply into exactly how focusing works, which will enable you to fine-tune how you choose to put your camera's focusing capabilities to work.

Manual Focus

Although autofocus has been with us since the 1980s (this was when images were captured on film, not solid-state sensors), prior to that breakthrough focusing was always done manually. Even though viewfinders were bigger and brighter than they are today, special focusing screens, magnifiers, and other gadgets were often used to help the photographer achieve correct focus. Imagine what it must have been like to focus manually under demanding, fast-moving conditions such as sports photography.

I don't have to imagine it. I did it for many years. I started my career as a sports photographer, and then traveled the country as a roving photojournalist for more years than I like to admit. Indeed, I was a hold-out for manual focus right through the film era, even as AF lenses became the norm and autofocus systems in cameras were (gradually) perfected. I purchased my first autofocus lens back in 2004, at the same time I switched from non-SLR digital cameras and my film cameras to digital SLR models.

Manual focusing was problematic because our eyes and brains have poor memory for correct focus, which is why your eye doctor must shift back and forth between sets of lenses and ask "Does that look sharper—or was it sharper before?" in determining your correct prescription. Similarly, manual focusing involves jogging the focus ring back and forth as you go from almost in focus, to sharp focus, to almost focused again. The little clockwise and counterclockwise arcs decrease in size until you've zeroed in on the point of correct focus. What you're looking for is the image with the most contrast between the edges of elements in the image.

Manual focus, often activated with an AF/M switch on the lens or camera body, or, sometimes through a function screen or menu setting, allows you to twist the focus ring on your lens until the image you want pops into sharp focus. For some who are new to digital photography, this may be an almost forgotten skill, because most camera lines have had autofocusing capabilities built in for at least 20 years. However, manual focusing is a skill that's easy to learn. Some points to consider about manual focus are these:

- **Speed.** Manual focus takes more time, compared to the speedy operation of autofocus systems. If you're shooting contemplative works of art, portraits in which your subjects will generally stay put for a period of time, or close-up pictures, the speed of manual focus may be no consideration at all. For action photography, however, you may not be able to change focus quickly enough to keep up.
- Your bad memory. The eye (the brain actually) doesn't remember focus very well. That's why you must jiggle the focus ring back and forth a few times using smaller and smaller movements until you're certain the image is sharply focused. You never really know if optimal focus is achieved until the lens starts to de-focus. So, manual focus may actually be a trial-and-error experience.

- Difficulty. Focusing is most easily done when the image is bright and clear, the depth-of-field of the image being viewed is shallow, and there is sufficient contrast in the image to make out details that can be brought in and out of focus. Unfortunately, you'll frequently encounter scenes that are dim and murky, with little contrast, and be using a slow lens that compounds the problem.
- Accuracy. Only you—not the camera—know precisely which subject in the frame you want to be in sharpest focus. So, tweaking focus manually is the best way to ensure that the exact portion of the image you want to be sharp and clear *is* sharp and clear. If you're using selective focus creatively, manual focus is the only way to go.
- **Following action.** Today's autofocus systems are sophisticated enough that they can often use *predictive focus* to track moving subjects and keep them in focus as they traverse the frame. Even so, it may be easier to manually focus on a point where you know the action is going to be, and trip the shutter at the exact right moment. The human brain still has some applications.

Manual Focus Aids

Manual focus tends to be used more with mirrorless ILC models than with their dSLR counterparts, because the full-time live view of the mirrorless camera (either through an EVF or using the back-panel LCD monitor) means that you're always viewing the same image that is currently being captured by the sensor. You can thus manually focus with more confidence. The *range* of sharpness, or *depth-of-field* shown may not be exactly the same as what will be grabbed in the final image; but you can preview that range using the depth-of-field button or control found on most mirrorless cameras.

A second reason why manual focus has increased popularity with mirrorless cameras is the variety of focusing aids that the technology offers. Most cameras allow you to zoom in on the EVF/LCD image at various magnifications, more easily focusing on an enlarged image of your subject, as shown in Figure 5.1. In this example, the magnification (5X) is shown, along with arrows that indicate you can move the enlarged area around within the frame, using the navigation inset at lower right as a guide. When precise focus is critical, especially in close-up photography—many photographers use this magnified view to focus manually. With a conventional dSLR, magnifier attachments are required for the optical viewfinder, or, the dSLR owner can resort to live view, just like their mirrorless counterparts.

Another manual focusing aid is called *focus peaking*. When this feature is activated, the camera processes the preview image, examining the edges of the subject for contrast, and highlighting those edges in a color, such as yellow, white, or red. (See Figure 5.2.) As you rotate the focus ring, the color contrast increases and decreases, allowing sharp focus to "pop" into view. You can usually change the highlight color to suit your subject; you wouldn't want red highlighting when focusing on a red rose, for example.

Figure 5.1 Magnification makes manual focus easier.

Figure 5.2 Focus peaking highlights edges in color.

Autofocus

When your camera is set in autofocus mode, it will use one of several different methods to collect focus information and then evaluate it to adjust the correct focus for your image. These generally work by examining the image as the lens elements are moved back and forth to change focus. The image will be in sharp focus when the camera "lines up" matching portions of the image as detected by special pixels embedded in the sensor (using a technology available with some cameras, called *phase detection* and explained later in this chapter); or when the image on the sensor has its highest contrast (when using live view in *contrast detection* mode, also explained later). In either case, an autofocus system may rely on the ambient illumination on the subject, or use a special autofocus assist light source built into the camera to improve the lighting under dim conditions.

Autofocus Considerations

No matter how autofocus is accomplished, there are a host of things to keep in mind when using this feature. I outlined a few of them in the section on manual focus. Here are some more points to ponder.

- Autofocus speed. The speed at which your autofocus mechanism responds to focusing directives issued by the camera can be critical. With all mirrorless camera systems, the autofocus motor is built into the lens itself, which makes focusing dependent on the type of miniature motor used. Simply put, some lenses focus more quickly than others.
- Autofocus technology. Different digital cameras use different autofocus systems. These differences can involve the type and number of sensors used to calculate focus (when phase detection is used), or the areas of the image on the sensor that are evaluated to determine correct focus. Plus, you may be able to specify which sensor or areas within the frame are used to calculate focus, using your camera's cursor keys or other controls.
- **Autofocus evaluation.** How and when your camera applies the autofocus information it calculates can affect how well your camera responds to changing focusing situations. As with exposure metering systems, your camera may use the focus data from the various points differently, depending on other factors and settings. For example, the camera may be set to focus priority on the *nearest* subject to the camera, or may use a pattern of focus sensors to choose the correct point. More sophisticated cameras offer more autofocus evaluation options, but also make it more complicated for you to choose which settings to use in a given situation.

Autofocus Modes

To save battery power, your camera usually doesn't start to focus the lens until you partially depress the shutter release or other "AF start" control. (Some cameras can be set to seek focus all the time, which uses more battery power, and may be reserved for special situations, such as shooting movies.) But, autofocus isn't some mindless beast out there snapping your pictures in and out of focus with no feedback from you after you activate it. There are several settings you can make that return at

least a modicum of control to you. The three basic parameters to be concerned about when shooting still images are as follows:

- When does the camera lock in focus? That is, does the camera focus once and then ignore any additional movement in the frame? Or does the camera continually re-focus if your subject moves? Each approach has advantages and disadvantages, listed in the next section.
- What portions of the frame are used to determine focus? Does the camera focus on the subject in the center of the frame, or does it choose another portion of the image to evaluate? Can you change from one focus zone to another? I'll explain that in the following sections.
- What takes priority? Under certain autofocus conditions, your camera may refuse to take a picture until sharp focus has been achieved. This is called *focus priority*, and is often a good idea for everyday shooting, because it eliminates taking an out-of-focus picture. Focus priority can also be extremely frustrating if an important moment (say, a game-winning touchdown) is unfolding in front of you and your camera is still seeking focus at the exact moment you want to take a picture. In such situations, an option called *release priority* may be preferable. You can take a picture a fraction of a second before perfect focus is achieved, at a point when focus may well be good enough, at the exact moment you prefer, rather than when the camera decides it's ready. Some cameras allow you to specify focus priority or release priority for particular autofocus modes. If yours doesn't allow setting this parameter, it's a good idea to learn which priority it uses, anyway, to avoid unexpected disappointment.

When to Focus

The *when to focus* question is answered by your choice of *autofocus mode*. The three main modes are as follows:

- Single autofocus (AF-S). This mode is also called single focus, single servo, or one-shot AF, depending on the vendor. In this mode, once you begin to press the shutter release, focus is set once, and remains at that setting until the button is depressed, taking the picture, or you release the shutter button without taking a shot. For non-action photography, this setting is usually your best choice, as it minimizes out-of-focus pictures (at the expense of spontaneity). The drawback here is that you might not be able to take a picture at all while the camera is seeking focus; you're locked out until the autofocus mechanism is happy with the current setting.
- Continuous autofocus (AF-C). This mode is also called continuous AF, or AI servo by some vendors. Once the shutter release is partially depressed, the camera sets the focus, but continues to monitor the subject, so that if it moves or you move, the lens will be refocused to suit. This setting may be your best bet for fast-moving subjects and sports. The chief drawbacks of this system are that it's possible to take an out-of-focus picture if your subject is moving faster than the focus mechanism can follow, it uses more power, and makes a distracting noise.

One important consideration in using continuous autofocus is the system's *lock on* timing. That is, how quickly does the focus change when a moving subject is detected. You might assume that a quick reaction time is preferable, but that's not always so. What if you're on the sidelines

at a football game and focusing on a receiver who is ready to catch a pass. Another player or a referee runs in front of the camera momentarily. In that case, you'd want the camera to ignore the interloper for a brief period, and not change focus. The very best cameras allow you to set the lock on timing so that the system quickly refocuses on the new movement (if that's what you want) or ignores the movement for a short period so you can shoot your original subject.

■ Automatic autofocus (AF-A). This mode is also called AI focus AF, and is found on an increasing number of cameras. It offers the best compromise between the two previous modes. The camera alternates between AF-C and AF-S modes, depending on whether the subject remains stationary or it begins moving.

Your camera may have additional focus modes in addition to these. Olympus's OM-D lineup, for example, includes a single AF+MF mode, that allows you to tweak focus manually, and continuous AF+tracking, which locks onto a subject and changes focus to follow it as it moves around in the frame, say, when shooting action. All mirrorless cameras have modes like these, plus others, such as face tracking, which allows the camera to recognize faces (and, sometimes, even *particular* registered faces of your friends, family, or colleagues) and give preference to focusing on those visages as you frame the image.

Where to Focus

Your camera will choose a focus zone to evaluate in one of two ways: by selecting a zone automatically and dynamically, or by using a particular focus area that you specify. All mirrorless cameras will give you these two options. Most common is a switch or menu setting that sets either automatic zone selection or manual zone selection. In manual selection mode, you will be able to change from among the available focus points using a dial, cursor keys, or other control. Some entry-level cameras have as few as three focus zones in a horizontal row roughly in the center of the screen. Intermediate cameras usually have seven to 11 different focus zones, while pro cameras can have 45 to 61 different focus zones. When using a camera with a large number of focus zones, you may be able to specify how many of the zones are active at any time (say, 21 or 11 zones instead of the full 51).

That's because more focus areas is not always better. You (or the camera's automatic zone system) can waste a lot of time shifting from one zone to another. Indeed, when shooting action and sports with relatively large subjects darting around the frame, I switch to automatic focus zone selection using just 11 focus zones, to reduce the amount of time my camera spends switching around among available focus areas.

There are other settings you can use to adjust how your camera focuses. Not all of these are available on every camera, but the most common parameters include:

■ Dynamic focus area. Because your camera has more than one focus area available in a frame, it may shift among them as focus is calculated. With dynamic area autofocus, the camera may automatically switch from using one area to a different area if it detects subject motion.

- User-selected focus area. You switch from one focus area to another using the camera's cursor pad or directional keys. Autofocus systems frequently use the same general zones applied by the autoexposure system, and use a single on-screen set of indicators to show them. The focus area in use will often be indicated by highlighting, as you can see in Figure 5.3.
- **Nearest subject.** In this mode, the autofocus system looks for the subject matter that's closest to the camera, no matter where it is located in the frame, and focuses on that.
- Focus lock. Your camera has a focus locking button, often marked with an AE-L/AF-L (autoexposure lock/autofocus lock) label. That button lets you fix the focus at the current point until you take a picture. With most cameras, you can also press the shutter release halfway to lock focus.
- Focus override. Cameras and lenses generally have an AF/M or similar button you can use to switch between autofocus and manual. Some let you use a mode that focuses automatically, but which can be fine-tuned manually with no danger of grinding gears or gnashing teeth.
- Macro lock/lockout. Some cameras and lenses have a provision for locking the lens into macro position so focus can be achieved only within the narrower close-up range. Or, you might find a macro lockout feature, which keeps the autofocus mechanism from trying to focus closer than a given distance. That can come in handy when you're shooting distant subjects, because the lens won't bother seeking close focus, which can be time-consuming.
- Autofocus assist lamp. This is an optional feature that can improve autofocus operation in low-light situations. The light, which is most often either white or red, is rarely strong enough to be of much help beyond a few feet, tends to be annoying to your human or animal subjects, and uses enough power to drain your battery a bit.

Figure 5.3
When you switch from one autofocus zone to another, the focus priority area often will be indicated with highlighting.

How Focus Works

Until recently, mirrorless cameras worked with only one sort of autofocus technology: contrast detection, which used the image on the sensor to evaluate focus. The other technology, phase detection, required special, separate autofocus sensors. It wasn't until sensor designers began building phase detection pixels into the image capture sensors themselves that mirrorless ILC models added hybrid AF systems that were able to use contrast detection and phase detection simultaneously. Sony offers several adapters that let you use phase detection AF with their mirrorless cameras, not with their mirrorless cameras' native E-mount lenses; the system is designed to work only with A-mount lenses designed for their "mirrored" SLT models.

Contrast Detection

Contrast detection is the original focus technology used by mirrorless cameras. Contrast detection is easy to understand and is illustrated by Figure 5.4. When the image is brought into focus (top), the transitions are sharp and clear. At the bottom of the image, the transitions between pixels are soft and blurred. Although this example is a bit exaggerated so you can see the results on the printed page, it's easy to understand that when maximum contrast in a subject is achieved, it can be deemed to be in sharp focus.

Contrast detection works best with static subjects, because it is inherently slower and not as well-suited for tracking moving objects as phase detection. Indeed, contrast detection works less well than phase detection in dim light, because its accuracy is determined not by the length of the baseline of phase detection's rangefinder focus system (described next), but by its ability to detect variations in brightness and contrast. You'll find that contrast detection works better with faster lenses, too, not as with phase detection (which gains accuracy because the diameter of the lens is simply wider), but because larger lens openings admit more light that can be used by the sensor to measure contrast.

Phase Detection

Digital SLRs have an advantage of sorts in that they can use an optical viewfinder and mirror system to preview an image (that is, when not in live view mode). In that mode, the camera calculates focus using what is called a *phase detection* system.

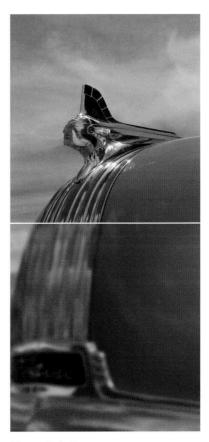

Figure 5.4 Focus in contrast detection mode evaluates the increase in contrast in the edges of subjects, producing a sharp, contrasty image (top) from a soft, blurry, low contrast image (bottom).

112

Parts of the image from two opposite sides of the lens are directed down to the floor of the camera's mirror box, where an autofocus sensor array resides; the rest of the illumination from the lens bounces upward toward the optical viewfinder system and the autoexposure sensors. With Sony's SLT lineup of cameras, the light path is somewhat different. Some 30 percent of the illumination is reflected upward to the autofocus sensors, and the remaining 70 percent continues through the mirror to the sensor, where the exposure is calculated. With either dSLR or SLT models, a portion of the illumination is reflected downward or upward (respectively) to the autofocus sensor array, which includes separate autofocus "detectors." Phase detection operates by allowing the camera to "line up" the pairs of images until they converge, as shown in Figure 5.5.

As with any rangefinder-like function, accuracy is better when the "base length" between the two images is larger, so the two split images have greater separation. (Think back to your high school trigonometry; you could calculate a distance more accurately when the separation between the two points where the angles were measured was greater.) For that reason, phase detection autofocus is more accurate with larger (wider) lens openings than with smaller lens openings, and may not work at all when the f/stop is smaller than f/5.6. Obviously, the "opposite" edges of the lens opening are farther apart with a lens having an f/2.8 maximum aperture than with one that has a smaller, f/5.6 maximum f/stop, and the base line is much longer. The camera is able to perform these comparisons and then move the lens elements directly to the point of correct focus very quickly, in milliseconds. In digital SLRs, the phase detection sensors may be linear (horizontal or vertical arrays), or crosstype (arranged like a plus sign) to allow them to better detect edges of the subject running in vertical, horizontal, or diagonal directions.

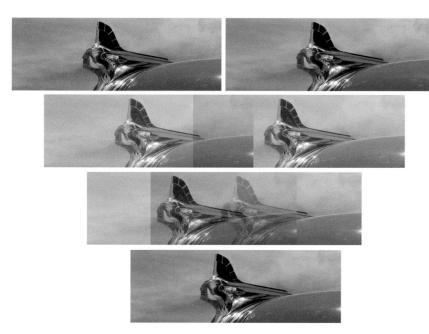

Figure 5.5
Phase detection uses rangefinder-like technology to quickly line up pairs of image pixels.

Because of the speed advantages of phase detection, makers of mirrorless cameras are adding onchip phase detect points to their sensors. Sony, for example, uses a 25-area contrast detection system for autofocus with several of its recent cameras, but includes up to 179 phase detect pixels embedded in the sensor, covering 92 percent of the frame. This hybrid system is more adept at tracking moving subjects, producing what Sony claimed at the introduction of its Alpha a6000 "the fastest autofocus system in the world." During the life of this book, I expect virtually all mirrorless cameras to adopt some sort of combined contrast detection/phase detection system.

Other Focus Options

Some cameras have additional focusing options. Here's a quick summary.

- Avoiding endless focus hunting. If you frequently photograph subjects that don't have a lot of detail (which complicates focus) or use very long telephoto lenses (which may be difficult to autofocus because of their shallow depth-of-field and smaller maximum apertures), you may find the camera constantly seeking focus unsuccessfully. Some cameras have a function that tells the camera what to do when it is having difficulty focusing. You can order the camera to keep trying (if that's what you really want), or instruct the camera to give up when the autofocus system becomes "lost," giving you the opportunity to go ahead and focus manually.
- Show/hide AF zones in the viewfinder. If the camera is selecting the focus zones, you may find the constant display of the selected zone distracting. Some cameras allow you to specify whether the AF points, the grid, and other elements are illuminated in the viewfinder with red highlighting under low light levels. Some people find the glowing red elements distracting and like to disable the function. You can select auto (highlighting is used in low light levels), enable (highlighting is used at all times), or disable (red highlighting is never used).
- Specify arrangement of focus zones. Many cameras allow you to choose which focus zones are used, or to select an individual focus zone manually.
- Activate/deactivate the autofocus assist lamp. The autofocus assist lamp may be useless in some cases (when your subject is more than about six feet from the camera) or distracting in others (say, at a concert or religious ceremony). Your camera probably has a feature that determines when the AF assist lamp or bursts from an electronic flash are used to emit a pulse of light that helps provide enough contrast for the camera to focus on a subject. You can select enable to use an attached electronic flash to produce a focus assist beam. Use disable to turn this feature off if you find it distracting. (Keep in mind that some cameras use the same lamp or a flash burst for red-eye reduction.)

Face Detection and Focus Tracking

Some cameras are able to find faces in your scene and lock focus in on them. They also may allow you to select a subject, press a button, and then have the camera continue tracking that subject as it moves around the screen.

Face Detection

In this mode, the camera will try to identify any human faces in the scene. If it does, it will surround each one (from eight to 35, depending on the camera model) with a white frame. If it judges that autofocus is possible for one or more faces, it will create the frames around those faces. When you press the shutter button halfway down to autofocus, the frames will turn green or yellow once they are in focus. The camera will also attempt to adjust exposure (including flash, if activated) as appropriate for the scene.

These cameras may allow you to register certain faces so they will be more quickly recognized the next time the camera encounters them, and you may be able to assign a priority to them. That is, if your spouse or child's face is found, the camera will give preference to that face over, say, your brother-in-law. (See Figure 5.6.)

Tracking Focus

Another AF magic trick is called *tracking focus*. You can choose a moving subject to lock focus on, and as it moves around the frame, the camera will attempt to retain focus on that subject. Changes in lighting, lack of contrast with the background, extra small or extra large subjects, and anything moving very rapidly can confuse tracking focus, but it generally does a good job. In either face detection or tracking focus modes, your camera may be able to "remember" the subject selected, so if the subject disappears from the frame and then returns, the camera locks in on that object again. (See Figures 5.7 and 5.8.)

Figure 5.6Face detection finds and locks focus onto faces.

Figure 5.8
The camera will maintain focus on the object as it moves.

Fine-Tuning the Focus of Your Lenses

Several mirrorless cameras have a feature called *autofocus fine tuning* or *AF microadjustment*, which I hope you never need to use, because it is applied only when you find that a particular lens is not focusing properly. If the lens happens to focus a bit ahead or a bit behind the actual point of sharp focus, and it does that consistently, you can use the adjustment feature that can "calibrate" the lens's focus.

Why is the focus "off" for some lenses in the first place? There are lots of factors, including the age of the lens (an older lens may focus slightly differently), temperature effects on certain types of glass, humidity, and tolerances built into a lens's design that all add up to a slight misadjustment, even though the components themselves are, strictly speaking, within specs. A very slight variation in your lens's mount can cause focus to vary slightly. With any luck (if you can call it that), a lens that

doesn't focus exactly right will at least be consistent. If a lens always focuses a bit behind the subject, the symptom is *back focus*. If it focuses in front of the subject, it's called *front focus*.

You're almost always better off sending such a lens in to the vendor to have them make it right. But that's not always possible. Perhaps you need your lens recalibrated right now, or you purchased a used lens that is long out of warranty. If you want to do it yourself, the first thing to do is determine whether your lens has a back focus or front focus problem.

For a quick-and-dirty diagnosis (*not* a calibration; you'll use a different target for that), lay down a piece of graph paper on a flat surface, and place an object on the line at the middle, which will represent the point of focus (we hope). Then, shoot the target at an angle using your lens's widest aperture and the autofocus mode you want to test. Mount the camera on a tripod so you can get accurate, repeatable results.

If your camera/lens combination doesn't suffer from front or back focus, the point of sharpest focus will be the center line of the chart. If you do have a problem, one of the other lines will be sharply focused instead. Should you discover that your lens consistently front or back focuses, it needs to be recalibrated. Unfortunately, it's only possible to calibrate a lens for a single focusing distance. So, if you use a particular lens (such as a macro lens) for close focusing, calibrate for that. If you use a lens primarily for middle distances, calibrate for that. Close-to-middle distances are most likely to cause focus problems, anyway, because as you get closer to infinity, small changes in focus are less likely to have an effect.

Focus calibration is done differently for each different type and brand of camera, so it's not possible to outline the methods in this book. I provide more specific directions in my comprehensive guides to particular cameras that have that feature. If you want to attempt calibration on your own, you can obtain a focus test chart (you can download your own copy of my chart from www.dslrguides.com/FocusChart.pdf). (The URL is case sensitive.) Then print out a copy on the largest paper your printer can handle. (I don't recommend just displaying the file on your monitor and focusing on that; it's unlikely you'll have the monitor screen lined up perfectly perpendicular to the camera sensor.) Then, place your camera on a tripod, level it, and take several photographs at slightly different focus distances. Then follow the directions for your camera to fine-tune your camera for that lens.

Working with Lenses

There's an old saying: camera bodies come and go; lenses are forever.

That was a rock-solid adage in the digital SLR era, but now that we have mirrorless interchangeable lens cameras, many with brand-new lens mounts not entirely compatible with earlier lenses, the saying is not entirely accurate. You could often migrate your old SLR lenses—even those from the ancient, pre-digital film camera epoch—to the latest digital single lens reflex cameras, unless you decided to switch from one platform to another. Mirrorless cameras have introduced a new fly into the ointment.

Yes, you can use your old A mount Sony/Minolta lenses on your new Sony mirrorless camera. If you own Olympus Four Thirds lenses, they can be used with your Micro Four Thirds mirrorless model. Many Nikon autofocus lenses designed for digital SLRs can be used with Nikon 1 mirrorless cameras. But you'll need an adapter in each case, and your results, particularly in the case of autofocus performance, may not be optimum. Then, we have Fujifilm's X mount, Pentax K and Q mounts, and Samsung's NX lens mount system, which also can be fitted with a variety of adapters that provide functionality with some lenses. While you may be able to use your existing lenses with your mirrorless camera, your best bet will probably be to purchase lenses designed specifically for your particular camera. This chapter will help you make your choices.

Welcome to Lens Lust

Most mirrorless models are available with a decent array of lenses, although, as I write this, the selection of full frame E-Mount lenses for Sony's growing full frame mirrorless line is a bit sparse. But, believe it or not, there are large numbers of casual photographers who purchase a digital camera with versatile kit optics and then never, ever buy another lens. I won't say anything bad about these

snapshooters, who are obviously deliriously happy with the camera they bought. But, my guess is that most of the readers of this book suffer from a singular disease: Lens Lust, defined as the urge to add just one more interchangeable lens to your repertoire in order to make it possible to shoot wider, longer, closer, sharper, or in less available illumination.

I didn't make that term up. You'll find references to Lens Lust all over the Internet, in user groups, and any gathering that includes two or more photographers. Lens Lust isn't a new phenomenon. I've fallen victim to it myself. I worked for two years as the manager of a camera store, and a hefty chunk of what I earned was diverted to my favorite vendor's personal purchase program, as well as to acquiring good used equipment brought to me for trade-in. I ended up with 16 different lenses, including *two* fisheye lenses, a perspective-control lens, and other specialized optics. Of course, all but one of those lenses were fixed focal length (prime) lenses, so I wound up "upgrading" when I began accumulating zoom lenses.

If the symptoms are familiar, you should read this chapter. It will tell you more than you need to know about lenses, but, then, you're probably going to acquire more lenses than you need anyway. There's a little bit more detail on how lenses work (which will help you in selecting your next optics) and some advice for choosing the right lens for the job.

I can't promise a remedy for Lens Lust. I can promise you that I will *not* refer to lenses in this book as "glass," as in "I'm really loaded up on Nikon glass" or "I find Sigma glass to be better than Tamron glass." Using that term as a generic substitute for "lens" is probably confusing and potentially inaccurate. Lens elements aren't necessarily glass, in any case, as very good lens elements can be made using other materials, including quartz and plastic (although the manufacturers will probably call it "optical resin" instead of plastic), and at least one vendor has introduced a point-and-shoot camera with a transparent ceramic lens. If I happen to mention "glass" in this book, I'll be referring to amorphous silica, not a lens. If I need a synonym to keep from using the word *lens* three times in one sentence, I'll substitute *optics*.

Lenses and Mirrorless Interchangeable Lens Cameras

As recently as ten years ago, there were many photographers making the transition from film-based SLR cameras to digital SLRs, and these migratory shooters often wanted to bring the lenses they used to shoot film with them to the digital realm. Today, virtually everyone who has planned to make the transition has already done so, and most today have either converted from film to digital or started out using digital cameras in the first place and never used a film SLR. Today, the most common migration is from digital SLR to mirrorless ILC model. Although mirrorless cameras have a lot of catching up to do, the selection for mature platforms, like Sony's APS-C E-mount system, is growing, and Olympus and Panasonic are not far behind. New lenses for Nikon 1 cameras, and those for Fujifilm's XF, Samsung's NX, or Pentax K/Q mounts are appearing all the time. (See Figure 6.1.)

Figure 6.1
Typical Olympus
Micro Four Thirds
(left), Sony
E-Mount (center),
and Nikon 1 lenses
(right).

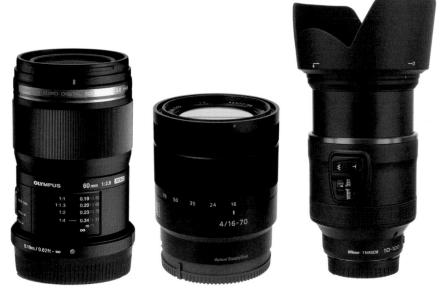

Digital Differences

Vendors claim that some of their lenses are "optimized" for digital photography. Exactly what kind of optimization is possible for "digital only" lenses? The answer is interesting. Although lenses designed for film and digital use all operate on the same basic principles, sensors react to the light transmitted by those lenses in different ways than film does. Digital lens designs need to take those differences into account. Here are some of the key digital differences.

Some Sensors Are Smaller Than Traditional "Full" Frame

You should remember this difference from the brief discussion in Chapter 2. As I noted, many sensors are smaller than the 24mm × 36mm standard frame that digital systems inherited from the film era. When mounted on a camera with a smaller sensor, lenses of a particular focal length produce what is actually just a cropped version of the same image. No "magnification" takes place; you're just using less than the full amount of optical information captured by the lens.

The most obvious result is the infamous *lens multiplier factor*. Fortunately, this incorrect term is dying out, and it is being replaced by the more accurate and descriptive *crop factor*. The "multiplication" concept came into play because the easiest way to calculate how much a given lens was cropped in relation to the same lens on a full-frame camera is to multiply the lens's focal length by the factor, so that a 100mm lens mounted on a camera with am APS-C (advanced photo system, version C) 1.5X crop factor "becomes" a 150mm lens in terms of field of view.

Currently, there are five (or six, depending on how you count Pentax's K and Q mounts) formats used with the leading mirrorless cameras. They are illustrated in Figure 6.2, and include:

- Full frame. As I write this, Sony offers the only popular full-frame mirrorless cameras, producing a 1X "crop" factor with its (approximately) 24mm × 36mm frame. Of course, the Leica M9 is also full frame and very popular (at least among Leica enthusiasts and admirers), but I don't cover M-mount cameras in this book. In the figure, the full-frame sensor size is represented by the outer green rectangle.
- APS-C. Using a sensor measuring roughly 22–23mm × 15–16mm, and a 1.5/1.6X crop factor, APS-C mirrorless models are offered by Canon EOS-M, Fujifilm XF, Pentax K, Samsung NX, and Sony NEX/Alpha. The yellow rectangle in Figure 6.2 represents the APS-C sensor size.
- Micro Four Thirds. Used by both Olympus and Panasonic, these sensors measure about 13mm × 17mm, and have a nice, round 2X crop factor. The magenta rectangle represents the Micro Four Thirds sensor size.
- CX. The Nikon 1 cameras are the only ILC models using the Nikon CX lens mount system, with an 8.8mm × 13.2mm sensor and 2.7X crop factor. See the orange rectangle in the figure for a size comparison.
- Q. Pentax offers several Q mount cameras and lenses, with 4.55mm × 6.17mm and 5.58mm × 7.44mm sensors, for 4.74X and 5.84X crop factors. They are represented by the white and cyan rectangles in the figure.

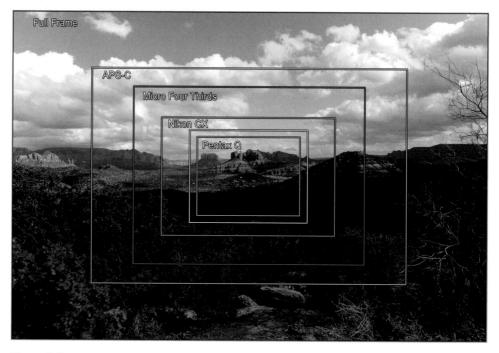

Figure 6.2 Cameras with sensors smaller than 24mm × 36mm provide cropped views.

Extreme Angles

Another difference in how digital cameras work with lenses derives from dissimilar ways film and silicon capture photons. Film's "sensors" consist of tiny light-sensitive grains embedded in several different layers. These grains respond in roughly the same way, whether the light strikes them head on or from a slight or extreme angle. The angle makes a small difference, but not enough to degrade the image.

As you learned in Chapter 2, sensors consist of little pixel-catching wells in a single layer. Light that approaches the wells from too steep an angle can strike the side of the well, missing the photosensitive portion, or stray over to adjacent photosites. This is potentially not good, and can produce light fall-off in areas of the image where the incoming angles are steepest, as well as moiré patterns with wide-angle lenses.

Fortunately, the camera vendors have taken steps to minimize these problems. The phenomenon is more acute with lenses with shorter distances between the back of the lens and the sensor, such as wide angles. Because the rear element of the lens is so close to the sensor, the light must necessarily converge at a much sharper angle. Lens designs that increase the back-focal distance (more on this later) alleviate the problem. With normal and telephoto lenses that have a much deeper back-focal distance anyway, the problem is further reduced.

Another solution, discussed earlier in this book, is to add a microlens atop each photosite to straighten out the optical path, reducing these severe angles. Figure 6.3 shows how such a microlens operates. Newer cameras employ such a system, which do a good enough job that you can use modern lenses designed for either film or digital use without much worry.

Figure 6.3
A pattern of microlenses above each photosite corrects the path of the incoming photons.

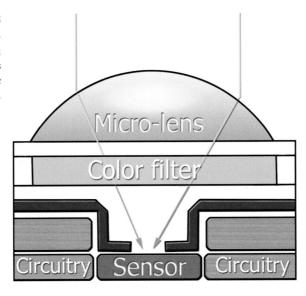

Reflections

If you've ever looked at film (your local camera club may have some samples in their archives or museum), you noticed that the "dull" emulsion side—the side that is exposed to light—has a relatively matte surface, due to the nature of the top antiabrasion coating and the underlying dyes, and a light-catching anti-halation layer at the bottom. Take a glance at your sensor, and you'll see a much shinier surface. It's entirely possible for light to reflect off the sensor, strike the back of the lens, and end up bouncing back to the sensor to produce ghost images, flare, or other distortions. While lens coatings can control this bounce-back to a certain extent, digital camera lenses are more prone to the effect than lenses used on film cameras.

Lens Designs

In the "more than you probably wanted to know" department, you can understand why designing lenses for mirrorless cameras can become extremely complex if you investigate how lenses are created. Although typical interchangeable lenses contain many elements in several groups, I'm going to explain some basic principles using a minimal number of pieces of glass. Bear with me: someday you can amaze all your friends with this arcane knowledge.

Figure 6.4 shows a simple lens with one positive element. This is known as a *symmetrical* lens design because both halves of the lens system are mirror images. The optical center of this lens is in the center of the single element, and the distance from the center to the focal plane (in this case, the sensor) is the same as the focal length of the lens. Assuming it's a 75mm lens, that distance, the back-focus distance, would be 75mm, or about 3 inches. All you'd need to do to use this configuration would be to design a lens that positioned the single lens element at 75mm to bring the lens into sharp focus.

Things get more complicated when you start designing a longer lens. With a 500mm optic, you'd need to design the lens so the optical center was 20 inches from the sensor. That would be quite a long lens! Indeed, so-called *mirror lenses* exist that use a series of reflecting surfaces to fold this long optical path to produce a lens that is much shorter for its particular focal length.

But there's another way—through the use of an *asymmetrical* lens design. Place a negative lens element *behind* the positive element, spreading the incoming light farther apart again, causes the photons to converge farther from the optical center than they would otherwise, as you can see in Figure 6.5. The negative element has the effect of lengthening the effective focal length and moving the optical center in front of the front element of the lens. The result: a "shorter" telephoto lens.

With wide-angle lenses, we have the reverse problem. The photons focus too close to the rear of the lens, creating a back-focus distance that's so short that even with a mirrorless camera with a rather thin body, large portions of the lens might have to extend far into the camera body. The key parameter is the *flange to sensor* distance, which varies by camera design. For the majority of mirrorless cameras, this distance is about 17-18mm (Canon EOS, Fujifilm, Nikon 1, Sony) to 20mm (Olympus, Panasonic). Only Pentax K (45.5mm) and Samsung NX (25.5mm) offer generous amounts of space between the lens mount and sensor. (That creates the opportunity to build some

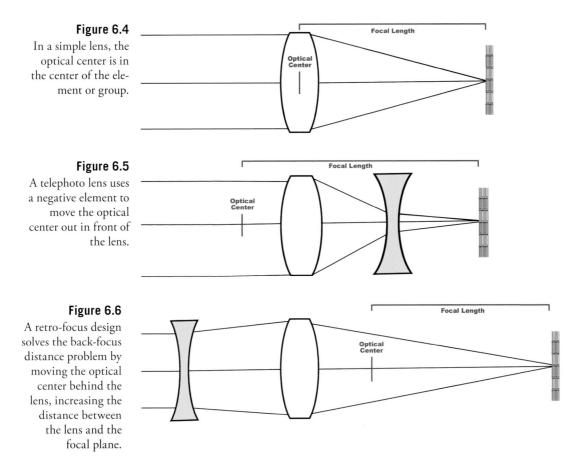

interesting adapters for lenses not designed for a particular mirrorless camera, as I discuss later in this chapter.)

The solution is to create an inverted telephoto lens, usually called *retro focus*, which inserts the negative lens element ahead of the positive element, spreading the beam of light so that when the positive lens element focuses it again on the sensor, the focal point is much farther back than it would be otherwise. The optical center has been moved *behind* the center of the lens, as you can see in Figure 6.6.

You can see that an inverted telephoto design helps digital camera lens designers produce wide-angles that are physically "longer" than their focal lengths, just as the traditional telephoto configuration produced lenses that were physically "shorter" than their focal lengths. Unfortunately, these more complex lens designs lead to undesired effects in both telephoto and wide-angle lenses. A primary symptom is *chromatic aberration*, or the inability of a lens to focus all the colors of light at the same point, producing a color fringing effect. This color effect is caused by the glass's tendency to refract different colors of light in different ways, much like a prism. There are actually two types of chromatic aberration: *axial* (in which the colors don't focus in the same plane) and *transverse*, in

which the colors are shifted to one side. The partial cure is the use of low diffraction index glass (given an ED code by Nikon and Sony, and UD by Canon), which minimizes the effect.

Other ailments include barrel distortion, which is a tendency for straight lines to bow outward, and various spherical aberrations. Lens designers have countered with *aspherical* lens elements. As you might guess, aspherical optics are lenses with a surface that is not a cross-section of a sphere. These lenses are precisely ground or molded to the required shape, and do a good job of correcting certain kinds of distortion.

If It Ain't Bokeh, Don't Fix It

Lens Lust isn't the only malady that can befall a new mirrorless owner. Another illness is the search for the perfect bokeh. The term has almost become a buzzword, and it is used to describe the aesthetic qualities of the out-of-focus parts of an image, with some lenses producing "good" bokeh and others offering "bad" bokeh. *Boke* is a Japanese word for "blur," and the h was added to keep English speakers from rhyming it with *broke*.

You've probably noticed that out-of-focus points of light become disks, which are called *circles of confusion*. These fuzzy discs are produced when a point of light is outside the range of an image's depth-of-field. Often, circles of confusion appear most vividly in close-up images, particularly those with bright backgrounds, as shown at left in Figure 6.7. The circle of confusion is not a fixed size, nor is it necessarily always a perfect circle. The viewing distance and amount of enlargement of the image determine whether we see a particular spot on the image as a point or as a disc. The shape of the lens's diaphragm can determine whether the circle is round, nonagonal, or some other configuration.

Evenly illuminated discs, or, worst of all, those with lighter edges, are undesirable. The bokeh characteristics of a lens are most important when you are using selective focus (say, when shooting a

Figure 6.7 Out-of-focus areas produce noticeable blobs of light with lenses that have poor bokeh characteristics (left). At right, the unfocused areas are less noticeable.

portrait) to de-emphasize the background, or when shallow depth-of-field is a given because you're working with a macro lens, long telephoto, or with a wide-open aperture. Figure 6.7, right, shows improved bokeh. There are fewer bright highlights in the image to begin with, so the circles of confusion are smaller and less numerous. The out-of-focus discs blend together to form an unobtrusive background.

Good bokeh and bad bokeh derive from the fact that some of these circles are more distracting than others. Some lenses produce a uniformly illuminated disc. Others, most notably *mirror* or *catadioptric* lenses, produce a disc that has a bright edge and a dark center, producing a "doughnut" effect, which is the worst from a bokeh standpoint, as shown in Figure 6.8. Lenses that generate a bright center that fades to a darker edge are favored because their bokeh allows the circle of confusion to blend more smoothly with the surroundings. In Figure 6.9, I've isolated three typical circles of confusion to show you what good, neutral, and bad discs look like.

Figure 6.8 Specular highlights exhibit the donut-shaped bokeh typical of the 500mm f/8 mirror lens used for this shot.

Figure 6.9
Discs that create good bokeh (left), neutral bokeh (middle), and bad bokeh (right).

Understanding Lens Requirements

You've got a little background in lenses now, and you're ready to learn exactly what you should be looking for when choosing lenses for your camera. After all, the lenses you own affect the quality of your images as well as the kinds of pictures you can take. The most important factors in choosing a lens are the quality of the lens, the resolution of the images it produces, the amount of light it can transmit (that is, its maximum lens opening), its focusing range (how close you can be to your subject), and the amount of magnification (or zooming, in a zoom lens) that it provides. Here are some of the things you should consider.

Image Quality

If you're graduating from a digital point-and-shoot camera, one of the first things you notice is how concerned your colleagues are over lens sharpness. Most point-and-shooters don't worry about it that much because there is little they can do about it, anyway, other than purchasing another camera. The lens on a non-interchangeable lens camera is what it is; it may be sharp or it may be less sharp, and that's it. The situation is similar to the horsepower question in an econobox automobile. You didn't purchase the vehicle for its horsepower. You'd be more interested in engine power if you had a sports car that, perhaps, could be souped up a little with some aftermarket components.

Lenses are the mirrorless ILC model's primary aftermarket component (after all, that's how the designation *interchangeable lens* became so important). If you frequent the newsgroups and forums, you'll notice the attention paid to how sharp a particular lens is. Visit any such venue and you'll find multiple postings inquiring about the resolution of this lens or that lens, and whether it has good or bad bokeh. A good rule of thumb is that most general-purpose lenses produce good enough image quality for general-purpose shooting. When you start to get into specialized areas—ultrawide lenses, extra-long telephotos, super-fast optics with large f/stops—the compromises necessary to produce those expensive toys sometimes involve compromises in image quality. If you're contemplating one of these lenses, it's a good idea to read the magazines and websites that have formalized, standard testing, and check around among your friends, colleagues, and others who can provide you with tips and advice.

The traditional ploy of shooting a brick wall or a newspaper pinned up on a bulletin board probably won't work reliably. There are too many variables, even if you use a tripod to steady the camera. For example, you may or may not set up your camera properly with the sensor plane parallel to the plane of your target. It's unlikely you'll be able to tell the difference in sharpness among several pictures at different f/stops. Can you focus repeatedly on the same spot? Do you know a sharp picture when you see one? If so, where is it sharp—in the center, at the edges, corners? Can you differentiate between different types of lens defects, including several varieties of chromatic aberration? You're almost better off just going with the reputation that a particular lens has established, based on reviews and comments in user groups, rather than trying to do your own tests for image quality.

Variability

One thing to keep in mind is lens variability from sample to sample within a particular lens model. When you peruse For Sale listings of lenses, you'll frequently see the note that this is "a good copy." That generally means that the previous owner has found the lens to be more than satisfactorily sharp, and may imply that other samples of this lens have been found lacking by others. Variability becomes a concern because not all examples of a particular lens model are created equal, both in terms of sharpness as well as *build quality*, which I discuss later.

One on-going debate you'll discover as you attempt to cure your Lens Lust is whether this vendor or that makes the "best" lenses. It's easiest to stick with the lenses produced by the maker of your camera, as Olympus, Pentax, Fujifilm, Samsung, Nikon, Canon, and Sony all have rigorous standards that each and every lens they offer for sale must meet. You'll find that the optical and mechanical variability of camera maker lenses is very slight. However, even among the major manufacturers you'll find slight variations in quality from sample to sample. Moreover, not every lens a camera manufacturer produces is the absolute best in its focal length range for a particular camera.

I've found that variability between samples most often comes into play with third-party lenses, such as those from Sigma, Tamron, Samyang, and others who are now catering to the mirrorless market. You're most often likely to find "good copy" notations for lenses from these vendors. My advice is to take pictures with any lens you plan to purchase, or ask for return privileges (widely available from online retailers), and then keep only the lenses you are well satisfied with.

Construction/Build Quality

A related consideration when choosing a lens is the quality of its construction, also called *build*. See if the key lens components are made of metal or plastic. Believe it or not, an increasing number of lower-cost lenses have mounts that are made of non-metallic components. They're less sturdy, and more likely to wear if you attach and detach them from your camera often, but they'll perform perfectly well under moderate use by the average non-professional photographer.

Also check for play in the focusing and zooming mechanisms. You don't want any looseness, stickiness, odd noises, or other qualities that signify cheap or poor construction. Your investment in lenses will probably exceed your cost for your digital camera body after a few months, so you want your lenses to hold up under the kind of use and abuse you'll subject them to.

Remember that, most likely, the lenses you purchase after each bout with Lens Lust will probably work just as well with your *next* camera as with your current model, so you can consider them a long-term investment. I have lenses that I purchased early in my career that are still in use a dozen camera bodies later. So, don't be afraid to spend a little more for lenses that are constructed well and have all the features you need. I own more than one lens that originally cost more than my camera body (which isn't difficult if you're buying one of the exquisite Zeiss lenses offered for mirrorless cameras), and I don't consider the expenditure extravagant.

Zoom Lenses

A zoom lens is a convenience for enlarging or reducing an image without the need to get closer or farther away. You'll find it an especially useful tool for sports and scenic photography or other situations where your movement is restricted. Only the least-expensive digital non-SLR cameras lack a zoom lens. Some offer only small enlargement ratios, 4:1, in which zooming in closer produces an image that is four times as big as one produced when the camera is zoomed out. More-expensive cameras have longer zoom ranges, from 12:1 to 18:1 and beyond.

Mirrorless ILC models, of course, can be fitted with any zoom lens that is compatible with your particular camera, and you'll find a huge number of them in all focal length ranges and zoom ratios. There are wide-angle and wide-angle-to-short telephoto zooms, which cover the range of about 18mm to 105mm, short telephoto zooms from around 70mm to 200mm, high-power zooms in the 80mm to 400mm range, and lenses that confine their magnifications to the long telephoto territories from about 200mm and up.

Lens "Speed"

If you're a veteran photographer, you know all about lens apertures. If not, you need to know that the lens aperture is the size of the opening that admits light to the sensor, relative to the magnification or focal length of the lens. A wider aperture lets in more light, allowing you to take pictures in dimmer light. A narrower aperture limits the amount of light that can reach your sensor, which may be useful in very bright light. A good lens will have an ample range of lens openings (called f/stops) to allow for many different picture-taking situations.

You generally don't need to bother with f/stops when taking pictures in automatic mode, but we'll get into apertures from time to time in this book. For now, the best thing to keep in mind is that for digital photography a lens with a maximum (largest) aperture of f/1.4 to f/2.8 is "fast" while a lens with a maximum aperture of f/6.3 is "slow." If you take many pictures in dim light, you'll want a camera that has a fast lens.

Zoom lenses tend to be slower than their prime lens (non-zooming) counterparts. The most commonly used digital optics are almost always zoom lenses, and zoom lenses tend to have smaller maximum apertures at a given focal length than a prime lens. For example, a 28mm non-zoom lens might have an f/2 or f/1.4 maximum aperture. Your digital camera's zoom lens will probably admit only the equivalent of f/2.8 to f/3.5, or less, when set for the comparable wide-angle field of view.

The shorter actual focal length of digital camera lenses when used with cameras that have a lens crop factor also makes it difficult to produce effectively large maximum apertures. For example, the equivalent of a 28mm lens on a full-frame camera with a camera having a smaller 1.6X multiplier sensor is an 18mm lens. There's a double-whammy at work here. Although providing the same field of view as a 28mm wide-angle, the 18mm optic has the same depth-of-field as any 18mm lens (much more than you'd get with a 28mm lens). Worse, the mechanics of creating this lens complicates producing a correspondingly wide maximum f/stop. So, while you might have used a 28mm f/2 lens with your film camera with a workable amount (or lack) of depth-of-field wide open, you'll be lucky if your 28mm (equivalent) digital camera lens has an f/stop as wide as f/4. That increases your depth-of-field at the same time that the actual focal length of your wide-angle (remember, it's really an 18mm lens) is piling on even *more* DOF.

What about the minimum aperture? The smallest aperture determines how much light you can block from the sensor, which comes into play when photographing under very bright lighting conditions (such as at the beach or in snow) or when you want to use a long shutter speed to produce a creative blurring effect.

Digital cameras don't have as much flexibility in minimum apertures as film cameras, partly because of lens design considerations and partly because the ISO 100 speed of most sensors is slow enough that apertures smaller than f/22 or f/32 are rarely needed. A digital camera's shutter can generally reduce the amount of exposure enough. So, your lens probably won't have small f/stops because you wouldn't get much chance to use them anyway. If you do need less light, there are always neutral-density filters.

Of course, while smaller apertures increase depth-of-field, there are some limitations. In practice, a phenomenon known as *diffraction* reduces the effective sharpness of lenses at smaller apertures. A particular lens set at f/22 may offer significantly less overall resolution than the same lens set at f/5.6, even though that sharpness is spread over a larger area.

Constant Aperture

You'll note that in describing various zoom lenses in this book, I've often referred to their apertures using terms like "f/2.8-4.0" or "f/4-5.6." The "range" specification is required because the effective aperture (and sometimes even the focus plane) of a lens may vary as the zoom setting/magnification changes, because the elements of a lens are moving around in strange and mysterious ways. A lens that has an f/2.8 maximum aperture at its wide-angle setting may provide only the amount of light admitted by an f/4.5 lens at the tele position.

Lenses that keep the same aperture regardless of zoom setting are called *constant aperture* lenses, and generally are larger and more expensive than their counterparts with varying maximum apertures. For example, when I purchased my Sony Alpha A7r, it was available with either a Zeiss Vario Tessar T* 24-70mm F4 ZA OSS constant aperture mid-range zoom or a variable aperture Sony 28-70mm F3.5-F5.6 OSS zoom. As much as I lusted after the Zeiss lens, it cost \$1,200 and, considering the big bucks I'd just laid out for the camera body, the \$500 zoom with f/3.5-5.6 aperture was my choice.

Aperture change is likely to be a factor while you're shooting with a lens that doesn't have a constant aperture. Suppose you're taking photos with my 28-70mm f/3.5-5.6 zoom lens, with the zoom set to 28mm and using an exposure of 1/60th second at f/4. Then, you zoom in to the 70mm setting, and because the camera adjusts exposure automatically, you may be unaware that you're now taking photos at the *equivalent* (technically) exposure of 1/30th second at f/5.6. Unfortunately, while a shutter speed of 1/60th second is likely to be fine with a 28mm focal length in the hands of a steady shooter, it's unlikely that 1/30th second will be fast enough to account for camera shake magnified by the (approximately) 2X zoom factor at 70mm. The result (even though my lens has image stabilization built in) is likely to be an image suffering from camera/lens shake.

Video Considerations

Focus can change, too, so when you focus at, say, the wide-angle position and then zoom in to a telephoto view, the original subject may not technically still be in sharpest focus (although the huge amount of depth-of-field provided by digital camera lenses at smaller f/stops may make the difference more difficult to detect). When shooting stills, you'd notice the differences only when using the camera in manual exposure or focusing mode, anyway. When set to autofocus and autoexposure, your camera will provide the optimum setting regardless of zoom magnification.

However, that's not the case when shooting video. Zooming while capturing a clip is not generally a good idea (unless you're working on a kung-fu movie), but it can be used artistically, if done carefully. Constant and linear automatic focus is a good idea in such situations. But wait, there's more. Sophisticated video shooters may want to *follow focus* to track a subject as it moves closer to or farther from the camera during a shot. Or, it may be desirable to quickly switch selective focus from a nearby subject to the background, or vice versa, again for artistic reasons. (We've all seen these techniques used in movies and TV shows, whether we're aware of them or not.)

A new generation of video-friendly lenses have been created by some manufacturers that include linear focus (and zoom) characteristics, so that when you zoom in or out, or change focus, the shifts are smooth rather than jerky. Such lenses, like the 16-50mm f/3.5-5.6 lens I use, may also have ultra-quiet autofocus motors, and built-in near-silent power zooming (available at the press of a button or switch) to minimize sound disruptions that can occur when the camera's microphone picks up noises emanating from the lens. Such sounds are most pronounced when using a camera's

built-in microphone(s), but can also be obtrusive when using an external microphone that's physically attached to the camera.

Focusing Distance/Speed

The ability to focus close is an important feature for many digital camera owners. One of the basic rules of photography is to get as close as possible and crop out extraneous material. That's particularly important with digital cameras because any wasted subject area translates into fewer pixels available when you start cropping and enlarging your image. So, if you like taking pictures of flowers or insects, plan to photograph your collection of Lladró porcelain on a tabletop, or if you just want some cool pictures of your model airplane or stamp collections, you'll want to be able to focus up close and personal.

What's considered close can vary from model to model; anything from 12 inches to less than an inch can be considered "close-up," depending on the vendor. Fortunately, those short focal length lenses found on digital cameras come to the rescue again. Close focusing is achieved by moving the lens farther away from the sensor (or film) and an 18mm wide-angle lens doesn't have to be moved very far to produce an image of a tiny object that fills the viewfinder. You'll find more about macrophotography in Chapter 17.

Autofocus speed is another important factor. Some lenses focus noticeably faster than others, which can be important when tracking fast-moving subjects for sports photography, or shots of young children. Most of the difference can be traced to the focusing mechanism used by the lens. Because not all autofocus systems are created equal, you may need to do a little homework before buying an add-on lens to make sure its focus speed will meet your requirements.

Add-On Attachments

Photographers have been hanging stuff on the front of their lenses to create special effects for a hundred years or more. These include filters to correct colors or provide odd looks, diffraction gratings and prisms to split an image into pieces, pieces of glass with Vaseline smeared on them to provide a soft-focus effect, and dozens of other devices. These range from close-up lenses to microscope attachments to infrared filters that let you take pictures beyond the visible spectrum. Add-on wide-angle and telephoto attachments are also available, along with slide-copy accessories and other goodies. If you're serious about photography, you'll want to explore these options.

Unfortunately, digital cameras come with lenses that have all different sizes of filter threads. You're likely to need 62mm accessories for some of your lenses, probably will require 67mm add-ons for many of them, and needn't be surprised if your faster lenses, longer zooms, and widest optics require 72mm or 77mm filters. Some vendors have standardized as much as possible; my own lenses fall into two groups: the least expensive consumer-type zooms that use 62mm or 67mm filters, and my "pro" lenses that all require 77mm filters.

Of course, you won't want to choose a lens based on its filter thread, but it's a good idea to look at how you plan to use your lenses before purchasing filters. If only one of your lenses requires a 72mm filter, but the lenses you use most use 62mm and 67mm filters, you might want to standardize on 67mm filters and use a step-down ring to mount those 67mm filters on the lenses that accept 62mm accessories. (A set of stepping rings is shown in Figure 6.10.) Buy only those 72mm filters you actually need. Filters are so much more expensive in the larger sizes that you probably won't need much prompting to make your plans carefully.

Figure 6.10 Step-up and step-down rings allow you to use filters on lenses with several different thread sizes.

Adapters

Because the flange-to-sensor distance of the typical mirrorless camera is small (due, primarily, to the lack of a need to allocate space for a mirror), some interesting adapters are available that allow you to use "foreign" lenses on your camera, with varying degrees of success. In many cases, the oddball lens will mount on your camera properly, but you'll lose autofocus capabilities, and, usually, autoexposure. It may be possible to use aperture-priority, with the camera selecting a shutter speed, and using the foreign lens either wide open or stopped down manually with a control provided on the adapter. Fotodiox and others make the simplest adapters, for a variety of mirrorless models, with Voigtlander or Novoflex making expensive varieties with the greatest precision and most features.

Some adapters are offered by your camera vendor for its own lenses. For example, Nikon 1 mirror-less models can use many Nikon AF-S lenses, with full autofocus, metering, and, often, vibration reduction/image stabilization features intact. Olympus sells a series of adapters that allow using legacy Four Thirds lenses (designed for Olympus' older E-series digital SLRs) on its Micro Four Thirds mirrorless cameras with autofocus and autoexposure. Because some of Olympus's best, "professional" lenses are of the Four Thirds type, the adapters not only allow those who already own older lenses to preserve their investment. Shooters who aren't already invested in Four Thirds optics can use the adapters when they need focal lengths, speeds, and features that current Micro Four Thirds lenses don't have.

Sony sells its EA-LA series of adapters that allow using A-mount Sony/Minolta lenses on E-mount mirrorless models. These actually include a mirror (of the SLT fixed, translucent variety), giving you fast phase detect autofocus even if your Sony camera lacks sensor-embedded AF pixels as discussed in Chapter 5. Both APS-C and full-frame adapters are available. The APS-C version is less

expensive, but the more costly full frame EA-LA4 adapter works fine on both full-frame and APS-C Sony E-mount cameras, so you might want to consider paying extra for the top-of-the-line adapter if you think you might upgrade in the future.

Sony/Minolta A-mount lenses are available in both APS-C types (generally for newer Sony and Konica Minolta digital cameras) and as full-frame models (originally designed for Minolta film cameras). Keep that in mind when purchasing lenses for use on your mirrorless camera, especially if you will be using a Sony full-frame model in the Alpha A7 series. Both E-mount and A-mount (with adapter) APS-C optics can be used with E-mount full-frame cameras, but must be operated in "crop" mode, which gives you an image of 15MP, 10MP, and 5MP with the A7r, A7, and A7s cameras, respectively.

Third parties offer adapters for most mirrorless cameras, and most "foreign" lenses you can imagine. You can mount Canon, Nikon, Minolta A-mount, and older Minolta MD mount lenses on many different mirrorless ILC models. There are even C-mount-to-mirrorless adapters that let you use cine lenses on your camera. I purchased 25mm f/1.4, 35mm f/1.4, and 50mm f/1.4 C-mount lenses—each for less than \$40—and have used them on Nikon 1, Sony, and other mirrorless models. They are manual focus/manual aperture lenses, of course, and may not cover the full APS-C frame in all cases, and some of them have what is best described as "strange" bokeh, but for \$40 it's hard to go wrong and these lenses are a lot of fun.

Another unusual option is the "focal reducer" adapters offered by Lens Turbo and Metabones. Like some other more conventional adapters, they include optics that give them some special characteristics. For example, the Mitakon Lens Turbo II adapter (less than \$200) for Sony and Fujifilm mirrorless cameras have a 0.726x reverse magnification and increase the effective aperture by 1 full stop—transforming, say, a 100mm f/2.8 lens into a 73mm f/2 lens. Thus adjusted, an APS-C lens can cover a full-frame sensor, too. Metabones Speedbooster has similar specs, but a heftier cost (\$400–\$600). You'll find them for Micro Four Thirds, Sony, Fujifilm, and other mirrorless cameras, in mounts that accept Canon EF, Canon FD, Nikon F, Minolta MC/MD, Pentax K/PK, Leica, Olympus OM, Yashica, and other mounts. (The variations are daunting.) You may have to hunt around eBay to find some of these, and it may be necessary to import them directly from China, but B&H Photo/Video (www.bhphotovideo.com) seems to carry the largest selection in the United States. If you're wondering why it's possible to justify building so many combinations, keep in mind that "mirrorless" video cameras are also popular and use the same lens mounts as mirrorless still cameras (such as Sony E-mount), and videographers have the budgets and creative bents that make these kinds of adaptations attractive.

What Lenses Can Do for You

No one can afford to buy even a percentage of the lenses available. The sanest approach to expanding your lens collection is to consider what each of your options can do for you and then choose the type of lens and specific model that will really boost your creative opportunities.

- Wider perspective. Your mild wide-angle lens has served you well for moderate wide-angle shots. Now you find your back is up against a wall and you *can't* take a step backward to take in more subject matter. You need an ultra-wide lens or zoom with a broader view.
- **Bring objects closer.** A long lens brings distant subjects closer to you, offers better control over depth-of-field, and avoids the perspective distortion that wide-angle lenses provide. They compress the apparent distance between objects in your frame.
- Bring your camera closer. Macro lenses allow you to focus to within an inch or two of your subject, as I'll explain in Chapter 17.
- Look sharp. Many lenses are prized for their sharpness and overall image quality. While your run-of-the-mill lens is likely to be plenty sharp for most applications, the very best optics are even better over their entire field of view (which means no fuzzy corners), are sharper at a wider range of focal lengths (in the case of zooms), and have better correction for various types of distortion.
- More speed. Your inexpensive 75-150mm f/4.5-5.6 telephoto zoom lens might have the perfect focal length and sharpness for sports photography, but the maximum aperture won't cut it for night baseball or football games, or, even, any sports shooting in daylight if the weather is cloudy or you need to use some ungodly fast shutter speed, such as 1/4,000th second. You might be happier to gain a full f/stop with a (non-zooming) prime lens or faster zoom.

Zoom or Prime?

When selecting between zoom and prime lenses, there are several considerations to ponder. Here's a checklist of some important factors:

- **Logistics.** As prime lenses offer just a single focal length, you'll need more of them to encompass the full range offered by a single zoom. More lenses mean additional slots in your camera bag, and extra weight to carry.
- Image quality. Prime lenses usually produce better image quality at their fixed focal length than even the most sophisticated zoom lenses at the same magnification.
- Maximum aperture. Because of the same design constraints, zoom lenses usually have smaller maximum apertures than prime lenses, and, as mentioned previously, the most affordable zooms have a lens opening that grows effectively smaller as you zoom in.
- Working speed. Using prime lenses takes time and slows you down. It takes a few seconds to remove your current lens and mount a new one, and the more often you need to do that, the more time is wasted.

Wide-Angle/ Wide-Zoom Lenses

Wide-angle lens considerations:

- More depth-of-field. Practically speaking, wide-angle lenses offer more depth-of-field at a particular subject distance and aperture. You'll find that helpful when you want to maximize sharpness of a large zone, but not very useful when you'd rather isolate your subject using selective focus (telephoto lenses are better for that).
- Stepping back. Wide-angle lenses have the effect of making it seem that you are standing farther from your subject than you really are. They're helpful when you don't want to back up, or can't because there are impediments in your way.
- Wider field of view. While making your subject seem farther away, as implied above, a wideangle lens also provides a larger field of view, including more of the subject in your photos.
- **More foreground.** As background objects retreat, more of the foreground is brought into view by a wide-angle lens. That gives you extra emphasis on the area that's closest to the camera.
- Super-sized subjects. The tendency of a wide-angle lens to emphasize objects in the fore-ground while de-emphasizing objects in the background can lead to a kind of size distortion that may be more objectionable for some types of subjects than others. Very wide-angle lenses, like the fisheye used to capture the black-and-white shot in Figure 6.11, make this effect even more dramatic.
- Perspective distortion. When you tilt the camera so the plane of the sensor is no longer perpendicular to the vertical plane of your subject, some parts of the subject are now closer to the sensor than they were before, while other parts are farther away. So, buildings, flagpoles, or NBA players appear to be falling backward.
- Steady cam. You'll find that you can hand-hold a wide-angle lens at slower shutter speeds, without need for vibration reduction, than you can with a telephoto lens. The reduced magnification of the wide-lens or wide-zoom setting doesn't emphasize camera shake like a telephoto lens does.
- Interesting angles. Many of the factors already listed combine to produce more interesting angles when shooting with wide-angle lenses. Raising or lowering a telephoto lens a few feet probably will have little effect on the appearance of the distant subjects you're shooting. The same change in elevation can produce a dramatic effect for the much closer subjects typically captured with a wide-angle lens or wide-zoom setting.

Figure 6.11 A fisheye wide-angle lens produces dramatic distortions.

Using Telephoto and Tele-Zoom Lenses

Telephoto lenses also can have a dramatic effect on your photography.

- Selective focus. Long lenses have reduced depth-of-field within the frame, allowing you to use selective focus to isolate your subject. You can open the lens up wide to create shallow depth-of-field, or close it down a bit to allow more to be in focus. The flip side of the coin is that when you want to make a range of objects sharp, you'll need to use a smaller f/stop to get the depth-of-field you need. Like fire, the depth-of-field of a telephoto lens can be friend or foe.
- **Getting closer.** Telephoto lenses bring you closer to wildlife, sports action, and candid subjects, allowing you to capture memorable moments while retaining enough distance to stay out of the way of events as they transpire.
- Reduced foreground/increased compression. Telephoto lenses have the opposite effect of wide angles: they reduce the importance of things in the foreground by squeezing everything together. This compression even makes distant objects appear to be closer to subjects in the foreground and middle ranges. The photographer in Figure 6.12 was on a hill almost 25 yards from the breaking waves in the background.

Figure 6.12 Telephoto lenses provide a compression effect, making elements seem closer together.

- Accentuates camera shakiness. Telephoto focal lengths hit you with a double whammy in terms of camera/photographer shake. The lenses themselves are bulkier, more difficult to hold steady, and may even produce a barely perceptible see-saw rocking effect when you support them with one hand halfway down the lens barrel. Telephotos also magnify any camera shake. It's no wonder that vibration reduction is popular in longer lenses.
- Interesting angles require creativity. Telephoto lenses require more imagination in selecting interesting angles, because the "angle" you do get on your subjects is so narrow. Moving from side to side or a bit higher or lower can make a dramatic difference in a wide-angle shot, but raising or lowering a telephoto lens a few feet probably will have little effect on the appearance of the distant subjects you're shooting.

Typical Upgrade Paths

Many mirrorless cameras are purchased with a lens, either because the buyer doesn't already own a suitable lens or because the particular camera is available only in a "kit" that includes a basic zoom lens. So, the humble kit lens may be the start of a great collection of lenses. But, to paraphrase Malvolio, reading Maria's letter aloud in *Twelfth Night*, "Some collections are born great, some achieve greatness, and some have greatness thrust upon them."

However, even if that starter lens in your collection is thrust upon you, it's likely you'll have choices in your mandatory kit lens. Virtually all non-professional digital cameras today can be purchased with a basic 18-55mm f/3.5-5.6 lens that's wide enough at the wide end (the equivalent of 27mm on a "full-frame" 35mm film camera) and long enough at the telephoto end (82.5mm—both after calculating a 1.5X "crop" factor) to be useful for anything short of architecture (wide) or field sports (long). However, other lenses in other kits are also available.

Unless you have specific reasons for not wanting it, the basic kit lens is often a wise purchase. The 18-55mm versions usually add less than \$100 to the price of the camera body (if it's available) and so are very economical even if you don't plan to use them much. When I recently bought a supercompact entry-level camera for family use, I went ahead and purchased the 18-55mm kit lens, too, even though I had a better 18-70mm lens already in my collection. The kit price was only \$70 more than the camera body alone and, equipped with a "protective" glass filter (which I don't normally use), it could be entrusted to the hands of the youngest budding photographer.

These basic lenses are likely to be very sharp for their price, too, because the vendors crank out hundreds of thousands of them and are able to give you a very high-quality optic for not very much money. Back in the film era, the 50mm lens furnished with a camera was likely to be dollar for dollar, the sharpest, most versatile, and least expensive lens a camera owner had. The same is true with most kit lenses. They have a useful zoom range (at least for a beginning photographer), an adequate aperture speed of f/3.5 at the wide-angle end and acceptable f/5.6 at the telephoto setting, compact size, and fast autofocusing.

The next step on the upgrade path will depend on the kind of photography you want to do. Someone interested in sports may decide they need a 55-200mm zoom lens to pull in distant action. Those with a hankering to shoot landscapes or architecture may be interested in a 12-24mm or 10-20mm wide-angle. Bug or wildflower photographers may want a close-up, or *macro*, lens to provide more magnification of tiny subjects. One, or, maybe, two more lenses may be all you need. That is, until Lens Lust raises to a fever pitch and you find that there is *always* one more lens you must have—not to make you a better photographer, of course; lenses and gadgets won't improve your skills and creativity.

But, that extra lens will let you shoot a particular picture that just can't be captured with your existing optics. For example, I shoot concert photos with an 85mm f/1.4 lens at 1/160th second and ISO 800 using a monopod to steady the camera. Such photos simply wouldn't be the same with a 55-200mm zoom set at 85mm and f/4.5 and 1/30th second—even with the monopod: the performers move too quickly, and a faster shutter speed at ISO 3200 would dissolve my crisp image in grainy noise.

Image Stabilization

Image stabilization, which counteracts camera shake, is a feature built into some lenses. It's also built into the bodies of many cameras, but I'm going to cover it in this chapter, because the intent and effect is the same: to reduce the blurring in photographs caused by camera motion during exposure.

There are actually three types of image stabilization, and it goes by many names. Vibration reduction. Anti-shake. Optical image stabilization. All these describe several types of technology that help eliminate blur from camera and photographer movement during an exposure. Camera waver is probably the number one cause of blurry photos, and one of the banes of photography at all levels. It doesn't matter whether you're a tyro, a serious photo enthusiast looking to express bottled-up creativity with photography, or a seasoned pro who should know better: Over the entire spectrum of users, as many images are "lost" through camera-induced blur as through poor exposure or bad focus.

The many names applied to image stabilization all fit, because there are many causes of camera shake, and several different technologies used to counter that movement. The three main types of IS are as follows:

■ Electronic image stabilization. This type is most often used in video cameras. It's applied using a simple trick. The image captured by the sensor is slightly larger than the image stored as part of a continuous video of 24/25 or 30 frames per second (depending on the video system you use). So, if the camera moves slightly between frames, shifting, say, the equivalent of three pixels to the left and two pixels down, compared to the previous frame, the camera's electronics detect that and grab an image that's in "register" from the sensor, three pixels to the right and two pixels up, and stores that instead of the shifted frame.

- Optical image stabilization. Tiny motors built into the lens shift lens elements at high speed to compensate for the motion that detectors in the lens measure in real-time as you shoot. This type of IS is commonly used by Canon, Fujifilm, Samsung, Nikon, Sony, and Panasonic in select lenses.
- In-camera image stabilization. The entire sensor is shifted slightly to adjust for motion that occurs during exposure. This system is used by Olympus and Pentax.

The Bane of Image Blur

Amateurs bring me their photographs asking how they can make them "sharp and clear" and a quick evaluation of their shooting technique is enough for me to tell them not to "punch" the shutter button. I've seen examples of camera shake so egregious it was possible to tell whether an aggressive downward stroke on the shutter release was vertical or slightly diagonal. You'd think automated cameras would set a shutter speed high enough to prevent these blurry pictures, but, as you'll see, that's not always possible. As light levels drop, so do shutter speeds, and blur is an inevitable result.

Camera shake can result from a combination of a too-slow shutter speed and something as mundane as the photographer breathing, from attempting to shoot from a moving vehicle even at higher shutter speeds, or from using long lenses that are "front-heavy" and cause camera wobble. There are several different ways of counteracting this movement, ranging from putting certain elements of the lens in motion to stabilize the optical path to moving the sensor in sync with the camera jitter. Some video cameras even provide stabilization electronically.

Photographers who don't have access to any of these image stabilization technologies, and who can't switch to a higher shutter speed, often rely on their imagined ability to hand-hold their cameras and get sharp images at 1/30th second or slower. But even the steadiest hand is sometimes shocked at how much sharpness is actually lost when they compare their hand-held shots with those taken at the same settings using a tripod or other steadying aid. Of course, a hand-held shot may be good enough for its intended use, or even *better* for artistic or practical reasons than one taken with a tripod.

For example, Figure 6.13, left, was taken hand-held at 1/2 second, producing a blurred rendition that captures the movement of the energetic blues guitarist Bo Ramsey. There are many reasons to prefer this shot over the more static one shown in Figure 6.13, right, taken a few seconds later at 1/200th second, with the sensor's sensitivity cranked up to a noise-inducing ISO 1600. Most creative efforts reside somewhere between the very blurry and the very sharp, and image stabilization gives you the option to choose your techniques to suit the photograph you want to take.

Figure 6.13 Left: With an exposure of 1/2 second, this image is very blurry, but still an interesting portrait of the guitarist. Right: An image taken a few seconds later using a shutter speed of 1/200th second and a high ISO setting shows the guitarist's attitude, but little of the excitement of his playing.

Causes of Camera Shake

Sharpness-robbing camera shake is insidious because it can come from so many sources. As I mentioned earlier, punching the shutter release, as rank amateurs (as well as careless photographers with more experience) do, can jar the entire camera, often producing motion in a downward or diagonal direction sufficient to blur the image when slow shutter speeds are used. A more gentle finger on the release can eliminate some of the worst problems.

The normal, inevitable motion of the hand during a longer exposure can also produce camera shake. Some people have an almost imperceptible amount of tremor in their grips that is not caused by serious problems in the brain, my neurologist assures me. But the steadiest hands will tremble slightly, and the results will show in photographs taken with a normal or wide-angle lens at 1/30th second, or even, amazingly, at 1/125th second.

Shakiness can be exacerbated by several other factors. A camera or camera/lens combination that is poorly balanced is prone to additional camera shake. Turning the camera from a horizontal to a vertical orientation can produce more shake if the rotated grip is uncomfortable, or if there is no second "vertical" shutter release and the photographer's hand is forced into an awkward position.

Camera shake is magnified by longer focal lengths. It's bad enough that a long telephoto will induce vibration by making the camera front-heavy. But vibrations that are almost imperceptible when shooting photos with a 25mm lens will be seemingly magnified 10X at 250mm. The rule of thumb that suggests using a minimum shutter speed that's the reciprocal of the focal length of the lens (e.g., 1/250th second with a 250mm lens) is a good one, even if it doesn't go far enough. Enlarging a small section of a photo in an image editor, or the magnification produced by a non-full frame camera's crop factor, can also magnify the effects of camera shake.

Diagnosing Camera Shake

The big shocker for many experienced photographers is that the "recommended" minimum shutter speed suggested by the popular rules of thumb is not a panacea. The only true way to eliminate camera shake is to prevent the camera from shaking. If that's not possible, one of the image stabilization technologies available from camera vendors will probably help.

Most photographers are surprised to learn just how much camera shake they fall victim to even at "high" shutter speeds. Even the steadiest hands are likely to see some camera shake in their photos at 1/125th second, or even higher, if only under extreme magnification. It may be virtually invisible in normal picture-taking circumstances, but it's there.

Very serious camera shake is easy to diagnose. There are four possible causes for a blurry photo (and don't forget that some pictures can contain elements of all four causes):

- The picture is out of focus. If you or your camera's autofocus mechanism goofed, some of your subject matter, or in the worst cases *all* of it, will be out of focus and blurry. You can spot this kind of blur by looking at pinpoints of light in your image. Absent camera shake or subject movement, fixed spots of light will be enlarged and blurry, but will maintain their shape. Figure 6.14 shows an image that is simply out of focus. The camera had been manually focused on an object fairly close to the camera, and not adjusted when the lens was pointed at the Ferris wheel that was, effectively, at infinity.
- The subject was moving. You can tell if subject movement is the main cause of image blur if the subject itself is blurry, but the background and surroundings are not. Figure 6.15 shows the same Ferris wheel, this time with the camera on a tripod and the wheel is moving. Spots of light in the image will be blurred in the direction of the subject's travel, in this case producing an interesting blur effect.
- You zoomed during the exposure. Racking the zoom lens in or out during a long exposure is a time-honored special effect, but it's easy to do it accidentally. You're zooming in on an interesting subject and happen to press the shutter release on impulse before the zoom is finished. If your zoom movement is fast enough, you can see this effect in exposures as long as 1/60th second. Points of light will move inward toward the center of the image or outward as the magnification decreases or increases while you zoom. Figure 6.16 shows an intentional zoom during exposure. The Ferris wheel was also moving, so a combination of zoom and movement blurs result.
- Your camera shook. The final primary cause of a blurry photo is camera shake. You can spot this kind of blur by looking at spots of light or other objects in the picture. They'll be deformed in the direction of the camera shake: up and down, diagonally, or, in the worst cases, in little squiggles that show that the camera was positively trembling. Figure 6.17 shows an example of camera shake.

Figure 6.14 Blur caused by an out of focus image.

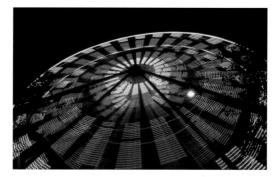

Figure 6.15 Blur caused by subject movement.

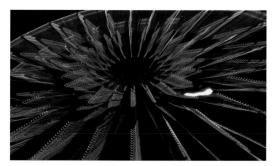

Figure 6.16 Light trails caused by zooming during exposure.

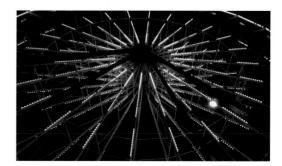

Figure 6.17 Camera shake causes distinctive blur patterns.

If you want a measurable way of seeing just how badly camera shake affects your own photos, it's easy to construct a diagnostic tool. Get yourself a large piece of aluminum (aluminum foil will do in a pinch) and poke some tiny holes in it using a pattern of your choice. I prefer a cross shape because that simplifies seeing blurs in horizontal, vertical, and diagonal directions; the cross pattern doesn't interfere with the blurs you produce.

Then mount the sheet 10 to 20 feet away and back-illuminate it so the tiny holes will form little dots of light. The correct distance will depend on the focal length of the lens or zoom you'll be testing. You want to fill the frame with the testing sheet. Focus carefully on the sheet, and then take a series of exposures at various shutter speeds, from 1/1,000th second down to 1 full second. Repeat your test shots using various methods of steadying yourself. Brace the camera against your body with your arms. Take a deep breath and partially release it before taking the photo. Try different ways of holding the camera.

Then, examine your test shots. As the shutter speed lengthens, you'll notice that the tiny circles in the aluminum sheet will become elongated in the vertical, horizontal, or diagonal directions, depending on your particular brand of shakiness. You may even notice little wavering trails of

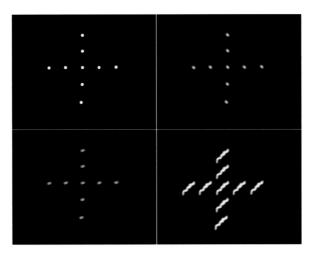

Figure 6.18
These backlit test patterns were photographed at 1/1,000th second (upper left); 1/30th second (upper right); 1/4th second (lower left); and 1 second (lower right).

light that indicate that you weren't merely shaking but were more or less quivering during the exposure.

You'll probably be shocked to discover some discernable camera shake at shutter speeds you thought were immune. With a normal lens, you might find some blur with hand-held shots at 1/125th second; with short telephotos, blur can be produced at 1/250th second or shorter exposures. Figure 6.18 shows some typical results.

Preventing Camera Shake

The least expensive way of countering camera shake is to hold your camera steady. You probably don't want to carry a tripod around with you everywhere, but there are alternative devices that are easier to transport, ranging from monopods to the C-clamp devices that fasten to any convenient stationary object. I carry mine with me everywhere; it fits in an outside pocket of my camera bag and can be used to convert anything from a fence post to a parking meter into a tripod-like support. It even has a sturdy screw fitting so you can attach it to utility posts or other wooden objects. (Please don't kill trees!) Once, when I was nursing a gimpy hip, I coupled this clamp with a walking cane to create a handy instant monopod. Most of the Ferris wheel photos earlier in this chapter were all taken with this clamp and a handy railing.

Lacking any special gear, you can simply set your camera on any available surface and use your self-timer to take a shake-free picture. The two versions shown in Figure 6.19 were taken with the camera hand-held (top) and with the camera resting on top of a trash receptacle (bottom). Sometimes you can rest a long lens on a steadying surface to reduce the front-heavy effect. Veteran photographers carry around beanbags they can place on an object and use to cradle their long lens. Another trick is to attach a strong cord to the tripod socket of your lens (most telephotos have them) with a tripod fitting, loop the other end of the cord around your foot, and pull it taut, adding some stability to your camera/lens combination.

Figure 6.19 Steady a hand-held shot by placing the camera on a handy object (bottom).

You can also follow any of the well-known prescriptions for holding your body more steady, such as regulating your breathing, bracing yourself, and, above all, *not punching the shutter release*.

Using Image Stabilization

Your camera may be able to help stabilize your images. One of the most popular features of some current cameras and lenses is hardware stabilization of the image. By countering the natural (or unnatural) motion of your camera and lens, IS can provide you with the equivalent of a shutter speed that is at least four times faster, effectively giving you two extra stops to work with. That can be important under dim lighting conditions.

For example, suppose you're shooting in a situation with a 400mm lens that calls for a shutter speed of 1/500th second at f/2.8 for acceptable sharpness. Unfortunately, you're using a zoom lens with a maximum aperture at that particular focal length of only f/5.6. Assume that you've already increased the ISO rating as much as possible, and that a higher ISO either isn't available or would produce too much noise. Do you have to forego the shot?

Not if you're using a camera or lens with IS. Turn on your IS feature, and shoot away at the equivalent exposure of 1/125th second at f/5.6. If the image stabilizer works as it should, blur caused by camera shake should be no worse than what you would have seen at 1/500th second. Your picture may even be a little sharper if your lens happens to perform better at f/5.6 than at f/2.8 (which isn't uncommon).

There are some things to keep in mind when using image stabilization:

- **IS doesn't stop action.** Image stabilization mimics the higher shutter speed *only* as it applies to camera shake. It will neutralize a wobbly camera, but it won't allow you to capture fastermoving objects at a slower shutter speed. If you're shooting sports with IS-enabled gear, you'll still need a shutter speed that's fast enough to freeze the action. Figure 6.20 shows a concert photo of a fiddler in Celtic rock band Enter the Haggis. It was taken hand-held with a zoom lens at the 200mm zoom setting and a 1/60th second shutter speed. The vibration reduction feature stopped camera shake just fine, but the slow shutter speed still allowed the animated musician's hands (especially) to blur.
- **IS can degrade tripod shots.** Some older image stabilizers produce *worse* results if used while you're panning or using a tripod. The intentional camera movement of panning may confuse the IS, or provide only partial compensation, so you'll end up with a picture that is not as good as if IS were switched off. Use of image stabilization when the camera is on a tripod leads to wasted use of the feature, or, worse, unneeded compensation that adds to the blur. Not all equipment suffers from this problem, however. Newer image stabilization systems can recognize horizontal motion as panning, and interpret extraordinarily low levels of camera movement as tripod use, and disable themselves when appropriate. Your camera or lens may have a special "active" mode that can be selected when shooting from a moving car or other vibration-heavy environments.

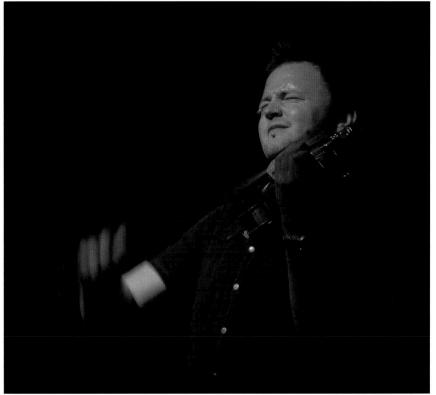

- IS slows camera response. Image stabilization can slow down your camera a little. The IS process takes some time, just as your autofocus and autoexposure do, but unlike either of those, does not necessarily cease when you partially depress the shutter release. Image stabilization can produce the equivalent of shutter lag, and, oddly enough, may not work as well as you think for sports photography. IS is great for nature photography, long-range portraits, close-ups, and other work with subjects that aren't moving at a high rate of speed, but less suitable for fast action.
- **IS not limited to telephoto or close-up applications.** Remember that image stabilization can be used for applications besides long-range telephoto or close-up photography, and it doesn't require macro or tele settings to be of benefit. For example, if you find yourself in an environment where flash photography is not allowed, such as a museum or concert, IS can be a life-saver, letting you shoot with normal or wide-angle settings at shutter speeds as slow as 1/4th second. I've found its image stabilization features helpful even when using the wide-angle range of the zoom. Many vendors now offer IS lenses in the wide-angle zoom range and, of course, IS is available at any focal length for cameras with the feature built into the body.

Despite my final caveat, image stabilization can be used effectively for sports photography, particularly if you're careful to catch peak moments. Figures 6.21 and 6.22 show two different shots of a base runner diving back to first base, both taken with 400mm long lenses at about 1/500th second. In both pictures, subject motion isn't really a problem. The sliding base runner has already skidded to a halt, and the first basewoman has caught the ball and prepares to make the tag (too late), in Figure 6.21, or is waiting for the ball to arrive (in Figure 6.22). The 1/500th second shutter speed was sufficient to stop the action in either case.

However, camera shake proved to be the undoing in the first example, but image stabilization saved the day in the second photo.

How It Works

As I mentioned earlier, there are several ways of achieving image stabilization. Some electronic video cameras use an electronic form of IS by capturing an image that's slightly larger than the final frame and shifting the pixels in the proper direction to counter the motion of the camera, then saving the displaced pixels as the final image for that frame, repeating the process many times each second. This works, but it is not the ideal method.

Optical image stabilization built into the lens is better. Several piezoelectric angular velocity sensors operate like tiny gyroscopes to detect horizontal and vertical movement, which are the usual sort of camera shake you'll experience—up-and-down or side-to-side shaking, rather than rotation around the optical axis, which is difficult to do accidentally while taking an ordinary photo. Once motion is detected, the optical system uses prisms or adjustments in several "floating" lens elements to compensate. The glass can be shifted along the optical axis to cancel undesired lens movement and vibration. Lenses that can be adjusted to compensate only for up and down motion can successfully use image stabilization even when you're panning.

There are also some disadvantages to either type of image stabilization. When IS is built into each and every lens, you must purchase special image-stabilization-capable optics to get this feature. Canon offers its most popular zoom lens types both with and without IS, and Nikon seems to be on a campaign to convert just about all of its zoom lenses—both professional and consumer grade—to their vibration reduction features. Building IS into lenses allows vendors to offer new and improved technology simply by upgrading the capabilities of their lenses.

While you don't have to purchase special IS lenses for your camera with internal image stabilization, you do have to contend with a single point of failure: if the anti-shake feature of your camera breaks, you have to send the entire camera in for repair, which is likely to be less convenient and more expensive than if you were able to ship off just a lens. Many photographers who have tried both types of systems like being able to see lens-based IS at work; you can see the image being stabilized right through the viewfinder as you partially depress the shutter release to lock in focus. In-camera IS provides no such feedback, so you need to trust your camera and hope that the feature is doing its job.

It's safe to say that image stabilization is a technology that's destined to become a standard feature on all lenses and/or digital cameras within the lifespan of this book.

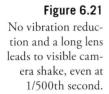

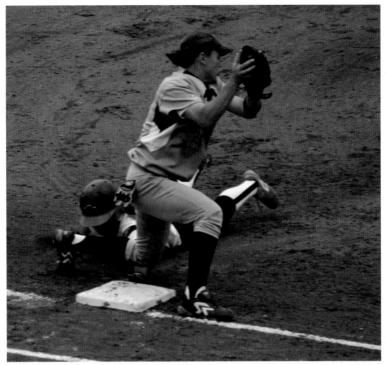

Figure 6.22
The same shutter speed works fine with image stabilization.

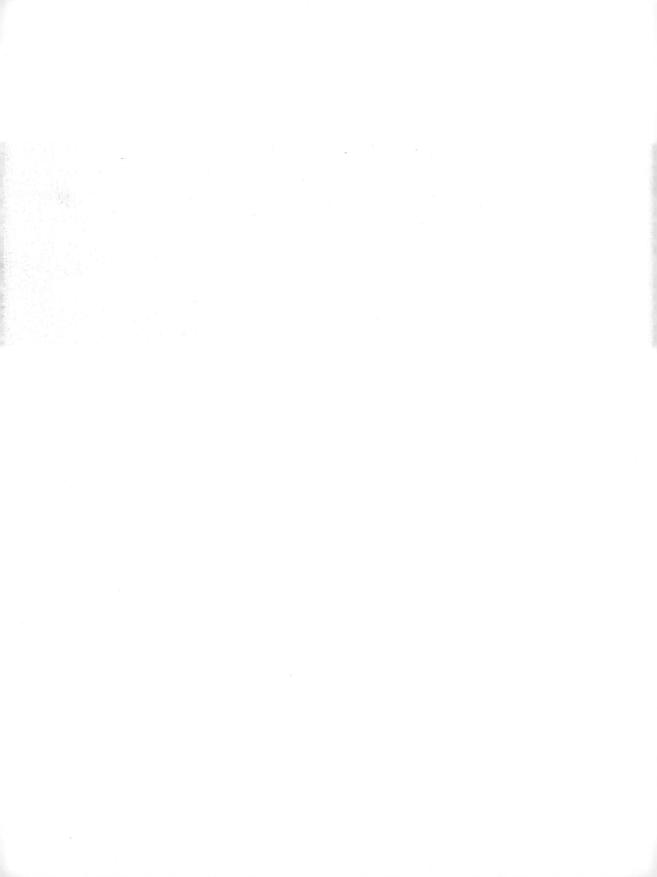

Working with Light

Photography, like all forms of visual art, uses light to create shape and form. But, unlike artists who create drawings and paintings, photographers have less control over the direction, quality, and effects of light. Some artists may paint from life and may prefer to choose a setting like the portraitists' legendary "northlight studio," but others are free to paint from their imaginations, and maintain absolute control over the attributes of the illumination that fills their canvases.

For the photographer, even awesome Photoshop skills won't be able to fix an image captured under poor, difficult, or unflattering lighting conditions. Photographers need to learn how to use the qualities of light to shape their pictures, and how to adapt and modify the light that's available to achieve the image they are trying to capture.

Two Types of Light

There are two main categories of illumination available to photographers: continuous lighting, such as daylight, moonlight, and artificial lighting indoors or outdoors; as well as electronic flash, supplied by the camera's built-in electronic flash unit, or external units that are generally triggered by the camera at the moment of exposure.

Table 7.1 compares the two forms of illumination. Some points in the table will receive some additional explanation later in the chapter.

Table 7.1 Attributes of Light Sources		
Attribute	Continuous Illumination	Electronic Flash
Intensity	Plentiful in full daylight; generally less early or late in the day, or at night, or indoors, unless strong supplemental lighting is used.	Often stronger than continuous light sources at a location, and intensity can be increased by adding stronger or multiple units.
Range	Daylight fills a scene, but with less illumination in shade. Supplemental continuous light sources can be limited in range.	Particularly vulnerable to the <i>inverse</i> square law. A flash unit that is twice as far away from a subject provides only one-quarter the illumination, for example.
Exposure calculation	The camera's metering system easily can measure the illumination in a scene, even when different areas have differing levels of light. Spot metering can zero in on a specific zone, if desired.	The camera can measure and adjust exposure only for the camera's built-in flash, and dedicated flash units designed for metering by the camera. Exposure for other types of flash must be calculated using a flash exposure meter, or by estimate when viewing test images or histograms.
Lighting preview	What you see is what you get.	For the most precise preview of lighting, the flash must have a <i>modeling light</i> or function that provides continuous illumination for a short period.
Action stopping	Your shutter speed determines whether action is frozen, so there must be sufficient illumination to allow using the shutter speed you need.	The slice of time captured is generally determined by the duration of the flash, which is usually in the 1/1,000th second range, or briefer. However, the actual camera shutter speed may be slow enough to allow a secondary, "ghost" image.
Cost	Daylight is free; supplementary lights (except for professional studio lighting equipment) are relatively inexpensive.	Most mirrorless cameras have a flash built in. Supplementary external flash units can cost \$150-\$500 (or more) each, depending on their power and features.

Continuous Lighting Essentials

While continuous lighting and its effects are generally much easier to visualize and use than electronic flash, there are some factors you need to take into account, particularly the color temperature of the light. (Color temperature concerns aren't exclusive to continuous light sources, of course, but the variations tend to be more extreme and less predictable than those of electronic flash.)

Color temperature, in practical terms, is how "bluish" or how "reddish" the light appears to be to the digital camera's sensor, and is measured using the *Kelvin* scale, on which the light we see in our illumination generally ranges from 2,800K to around 6,000K. Indoor illumination is quite warm, at 2,800K to about 3,400K, comparatively, and appears reddish to the sensor. Dawn and dusk can also venture into this warm range.

Full daylight, from about 5,000K to 6,000K, in contrast, seems much bluer to the sensor. Our eyes (our brains, actually) are quite adaptable to these variations, so white objects don't appear to have an orange tinge when viewed indoors, nor do they seem excessively blue outdoors in full daylight. Yet, these color temperature variations are real and the sensor is not fooled. To capture the most accurate colors, we need to take the color temperature into account in setting the color balance (or white balance) of the camera—either automatically using the camera's features or manually, using our own knowledge and experience. The chief types of light you'll be working with include:

- Daylight. Outdoors, daylight is pervasive (even at night, when light bounced off the sun may be called *moonlight*)—direct, bright, and harsh, or indirect, soft, and diffused (by clouds or bouncing off objects like walls or filtered by shade). Under these varied conditions, daylight's color temperature can vary quite widely. It is highest (most blue) at noon when the sun is directly overhead, because the light is traveling through a minimum amount of the filtering layer we call the atmosphere. The color temperature at high noon may be 6,000K. At other times of day, the sun is lower in the sky and the particles in the air provide a filtering effect that warms the illumination to about 5,500K for most of the day. Starting an hour before dusk and for an hour after sunrise, the warm appearance of the sunlight is even visible to our eyes when the color temperature may dip below 4,500K. Figure 7.1 shows an image shot outdoors at midday. It has a slight bluish cast, but it's really barely noticeable, because this rendition is what we expect to see at this time of day.
- Incandescent/Tungsten light. These lights consist of a glass bulb that contains a vacuum, or is filled with a halogen gas, and contains a tungsten filament that is heated by an electrical current, producing photons and heat. Although the exact color temperature of this type of illumination varies, it can be precisely calculated and used for photography without concerns about color variation (at least, until the very end of the lamp's life). Figure 7.2 shows an outdoors shot from a wedding shoot in Valencia, Spain. The camera's white balance was set for the incandescent lights that were used, so the bride and groom appear with very little color cast. However, the other illumination in the plaza was quite a bit warmer, giving an orange tint to the fountain and background.

Figure 7.1 This shot in full daylight has the rich colors and slight blue cast we expect at midday.

Figure 7.2 Although the white balance was set correctly for the incandescent lighting illuminating the bride and groom, the warmer incandescent lights that lit the rest of the plaza produced a warmer rendition.

■ Fluorescent light/Other light sources. Fluorescent light has some advantages in terms of illumination, but some disadvantages from a photographic standpoint. This type of lamp generates light through an electro-chemical reaction that emits most of its energy as visible light, rather than heat, which is why the bulbs don't get as hot. The type of light produced varies depending on the phosphor coatings and type of gas in the tube. So, the illumination fluorescent bulbs produce can vary widely in its characteristics. Different types of lamps have different "color temperatures" and fluorescent lamps have a discontinuous spectrum of light that can have some colors missing entirely. A particular type of fluorescent tube can lack certain shades of red or other colors, and other alternative technologies such as sodium-vapor illumination can produce truly ghastly looking human skin tones. Their spectra can lack the reddish tones we associate with healthy skin and emphasize the blues and greens popular in horror movies. Your camera probably has several different fluorescent color balance settings to choose from. Figure 7.3 shows an image taken in a college gym under fluorescent lighting, with the camera's color balance set to correct for the color rendition.

Figure 7.3 If you choose the right fluorescent color balance setting, colors will look natural.

Electronic Flash Essentials

Electronic flash illumination is produced by a burst of photons generated by an electrical charge that is accumulated in a component called a *capacitor* and then directed through a glass tube containing xenon gas, which absorbs the energy and emits the brief flash. The typical electronic flash provides a burst of light that lasts about 1/1,000th second.

An electronic flash is triggered at the instant of exposure, during a period when the sensor is fully exposed by the shutter's pair of curtains. When the exposure begins, the first curtain opens and moves to the opposite side of the frame, at which point the shutter is completely open. The flash can be triggered at this point (so-called *1st curtain sync*), making the flash exposure. Then, after a delay that can vary from 30 seconds to 1/250th second for most modern cameras (depending on the camera's fastest *sync speed*), a second curtain begins moving across the sensor plane, covering up the sensor again. If the flash is triggered just before the second curtain starts to close, then *2nd curtain sync* is used. In both cases, though, the sync speed is the fastest shutter speed that can be used to take a photo. I'll explain flash sync in a little more detail later in this chapter.

If you're using your camera's built-in flash or a compatible clip on or dedicated flash, the camera will automatically adjust the shutter speed downward to the sync speed if you accidentally set it higher. The exception is when you're using high-speed sync, described in the sidebar that follows.

CUT-OFF IMAGES

Shutter speeds briefer than the top sync speed are produced by launching the second curtain before the first curtain has finished its journey, so the second curtain chasing the first creates a slit that's narrower than the full frame, and thus exposes only part of the sensor at a time as the opening moves. If you use a faster shutter speed (say, because you're using a non-dedicated or studio flash unit that doesn't communicate with your camera), only part of the image—corresponding to the width of the slit—will be exposed during the moment the flash fires. (See Figure 7.4.) Some camera/flash unit combinations offer a *high-speed sync* option, in which the electronic flash fires at a reduced output level for the entire duration of the moving slit's travel across the sensor surface. All of the sensor is exposed to the flash illumination, but at a much lower level. Thus, high-speed sync is best reserved for close-up photos, where the weaker flash output is still sufficient to make an exposure.

Understanding Flash Sync

Perhaps you haven't fiddled much with your camera's flash sync settings, because the default setting probably works well for most photos. That's not necessarily true with action photography, particularly if you're looking to reduce or enhance the ghosting effect produced by intentional/unintentional double exposures from flash and ambient light. Now's a good time to learn just how flash sync settings can affect you.

As you learned earlier in this book, mirrorless cameras generally have two kinds of shutters, a mechanical shutter that physically opens and closes, much like the focal plane shutter on a film camera, and an electronic shutter, which controls exposure duration by limiting the time during which the sensor can capture pixels. It's often most efficient to use a mechanical shutter for "slower" shutter speeds (from 30 seconds up to around 1/250th second) and switch to an electronic shutter for the really fast speeds (up to 1/16,000th second on a very few models).

An electronic flash unit's duration is often much briefer than any of these, typically 1/1,000th second to as short as 1/50,000th second with some models at some power settings. So, as far as the electronic flash is concerned, the shutter speed of your camera is irrelevant as long as the shutter is completely open during the time the flash fires. If you've used flash with a camera at a shutter speed that was too high, you probably noticed that your exposed image was only one-quarter, one-eighth, or some other fraction of the full frame. That's because the focal plane shutter (which moves immediately above the sensor plane) was open only partially as it traveled across the film, and that opening was exposed by the flash, as described in the sidebar and shown in Figure 7.4.

Your digital camera has a maximum flash sync speed, which can be as slow as 1/125th second or as fast as 1/500th second (with some older cameras). Even higher speeds can be used when working with high-speed sync, mentioned in the previous sidebar, because that interval is the shutter speed at which the sensor is fully exposed and ready to capture a brief flash.

Figure 7.4
With a non-dedicated flash unit connected, it's possible to use a shutter speed that's higher than a camera's fastest sync speed, producing a "shadow" of the shutter on the frame.

The next fly in the ointment is the ghost image mentioned earlier in this chapter. Because the shutter is open for a longer period than is needed to record the flash alone, you'll end up with that ghost image caused by a secondary exposure from ambient light. If the subject is moving, the ghost will trail or precede the flash image. If you're holding the camera unsteadily, the ghost image may even be jerky due to camera movement.

If you don't want ghost images, use the highest shutter speed practical to reduce the impact of ambient light, without producing a completely black background. Experiment until you find a shutter speed that eliminates ghosting, but still allows the background to be illuminated a bit.

Here are the most common synchronization options found on digital cameras:

■ Front sync. In this mode (also called *front-curtain sync*), the flash fires at the beginning of the exposure. If the exposure is long enough to allow an image to register by existing light as well as the flash, and if your subject is moving, you'll end up with a streak that's in front of the subject, as if the subject were preceded by a ghost. Usually, that's an undesirable effect. Unfortunately, front-curtain sync is generally the default mode for most ILC models. You can be suckered into producing confusing ghost images without knowing the reason why. Figure 7.5 shows an example of a photograph taken using front-sync flash.

In the figure, the dancer is moving from the right side of the frame to the left. The flash, located to the left and slightly in front of her, was triggered as soon as the shutter opened. The shutter remained open for about 1/30th second, so the ambient light on the stage produced a ghost image in front of her as she moved to the left. The ghost partially obscured the dancer—which is not what I wanted.

- Rear sync. In this mode (known as *rear-curtain sync*), the flash doesn't fire until the *end* of the exposure, so the ghost image is registered first, and terminates with a sharp image at your subject's end position, with the well-known streak (like that which followed The Flash everywhere) trailing behind. That can be a bad thing or a good thing, depending on whether you want to use the ghost image as a special effect. Figure 7.6 shows the improved effect you get when you switch to rear sync when using a slow shutter speed. In this shot, the dancer was swiveling her body and leg, and the ghost image was recorded as she made this movement. Then, the flash was triggered, creating a sharp image at the end of the movement. That rendition looks much more natural to the eye.
- Slow sync. This mode sets your camera to use a slow shutter speed automatically, to record background detail that the flash, used to expose a subject closer to the camera, fails to illuminate. This mode can improve your flash images if you hold the camera steady and the subject is not moving. So, slow sync is best reserved for non-sports images, non-moving subjects, or photographs in which the subject is approaching the camera. Otherwise, you can almost guarantee ghost images.

On one trip, I wanted to take a black-and-white photo of the cathedral in Segovia, Spain, but the foreground was too dark. Mounting my camera on a tripod, I used slow sync and an external flash, ending up with an exposure of 1/15th second at f/16. Because the image was captured in monochrome, the mixed lighting—warm incandescent background and cool foreground illuminated by the flash—was not a problem. (See Figure 7.7, top.) The original mixed lighting version is shown at bottom.

Figure 7.5 With front-curtain sync, the blur precedes the sharp flash image.

Figure 7.6 With rear-curtain sync, the blur trails the sharp flash image and looks more natural.

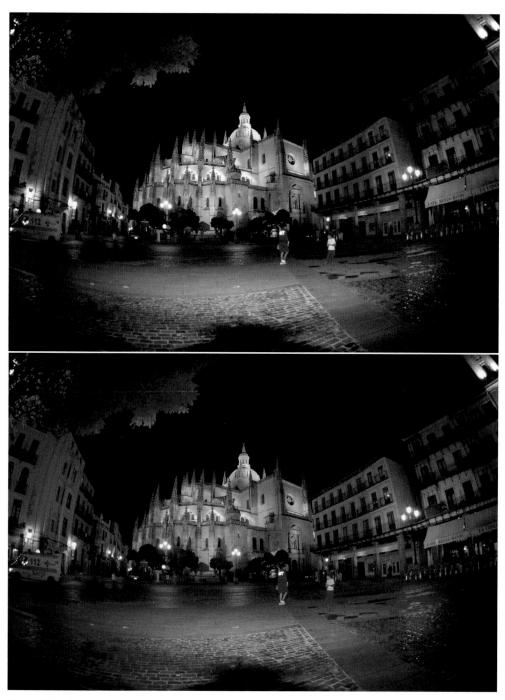

Figure 7.7 Slow sync allows mixing flash (in the foreground) with ambient light (the background) using slow shutter speeds when the camera is mounted on a tripod. Top, monochrome version; bottom, original mixed-lighting color version.

Calculating Exposure

As I noted earlier, digital cameras can calculate exposure for electronic flash automatically when you're using the built-in flash or a dedicated flash designed for that camera. This is accomplished by firing the flash twice. The initial burst is a *pre-flash* that can be measured by the camera and used to adjust the intensity of the main flash that fires a split-second later. If you're using one or more dedicated flash units, the camera is able to calculate the total exposure for a scene from the pre-flashes that all of them emit when directed to do so by the main or "commander" flash. The commander can be your camera's built-in flash, an auxiliary flash unit, or a special triggering device specifically used to set off your strobes (often using infrared signals rather than a visible flash).

Manual flash exposure can also be calculated, roughly, using the guide number (GN) supplied for that flash unit. Just take the GN for that flash at the ISO setting you are using, and divide by the approximate distance to your subject. For example, if your camera were set at ISO 100 and a particular flash has a GN of 80 for that ISO, with a subject at 10 feet, you'd use f/8 (80 divided by 10=8). At 14 feet, you'd use f/5.6 (80 divided by 14=5.6). Because there are other, more accurate options today (primarily your camera's flash metering capabilities), guide numbers are used chiefly to compare the relative power of two flash units. One with a GN of 110 would be twice as powerful as one with a GN of 80, for example.

Flash meters are a third alternative for calculating flash exposure. These can be used with dedicated or non-dedicated flash alike; they are pointed at the subject (in reflective mode) or, more commonly, held at the subject and pointed toward the light source (this is called incident mode) and the light is measured when the flash unit(s) are triggered. One advantage of using a flash meter is that in studio and other situations where multiple flash is used, each unit can be fired individually and the illumination measured to help you evaluate or set lighting ratios.

Choosing a Flash Exposure Mode

Vendors apply fancy names to their dedicated flash units, such as d-TTL, or i-TTL, or Creative Lighting System, so you'll know that your camera contains massive technology innovation. However, this nomenclature can be confusing. Learn what your flash unit's most common exposure modes do, and how they can help you. Here are some typical options:

- TTL (through the lens) metering. With this type of exposure, the camera measures the flash illumination that reaches the sensor (often by diverting some of the light elsewhere) and adjusts the exposure to suit. If you're photographing a subject that reflects or absorbs a lot of light, the exposure setting may not be accurate.
- **Pre-flash metering.** The camera fires a pre-flash and uses that information only to calculate exposure. This is the best mode to use when your exposure is "non-standard" in some way, as when you put a diffuser on the flash, a darkening filter on your lens, or use an external flash unit.

- Integrated metering. The camera triggers a pre-flash just before the exposure, measures the light that reflects back, and then integrates that information with distance data supplied by your camera's focus mechanism. The camera knows roughly how far away the subject is and how much light it reflects, and can calculate a more accurate exposure from that.
- Manual control. In this mode, the flash fires at whatever power setting you specify for the flash (full power, half power, and so forth) and you calculate the manual exposure yourself, using a flash meter or various formulas using guide numbers (values that can be used to calculate exposure by dividing them by the distance to the subject).

Electronic flash units may have firing modes, too, in addition to exposure modes. The most common modes you'll encounter are these (not all are available with every digital camera, and some models may have additional modes):

- **Always flash.** Any time you flip up the electronic flash on your camera, or connect an external flash, the flash will fire as the exposure is made.
- Autoflash. The flash fires only when there isn't enough light for an exposure by available light.
- Fill flash. The flash fires in low light levels to provide the main source of illumination, and in brighter conditions such as full sunlight or backlighting, to fill in dark shadows.
- Red-eye flash. With some mirrorless models, a pre-flash fires before the main flash, contracting the pupils of your human or animal subjects, and reducing the chance of red-eye effects. (Others use an AF-assist lamp on the camera itself.)
- **Rear sync/front sync.** As described earlier, these options control whether the flash fires at the beginning or end of an exposure.
- Wireless/remote sync. In this mode, the camera triggers an external flash unit using a wireless sync unit. As with all such remote controls, a selection of perhaps four or more channels are available so you can choose one that's not in use by another nearby photographer who also happens to be using wireless control. Unless you're covering a major event, you probably won't experience many conflicts when using wireless control. Some remote control/slave flash setups trigger by optical means: the camera's flash is detected and sets off the remote flash. You may be able to set the camera flash to low power so the main illumination comes from the remote.

Lighting Equipment

You can choose from the existing light (modified with reflectors if need be), electronic flash units (or incandescent illumination such as photoflood lights), high intensity lamps, or other auxiliary lighting. If you want to be pedantic, you can also shoot close-ups with light emitted by the subject itself, so if you have some lighted candles or lightning bugs to capture, knock yourself out.

Working with Existing Light

The existing light that already illuminates your subject may be the most realistic and easy to use option for close-up photos, as long as you're prepared to manipulate the light a bit to achieve the best effect. That's particularly true when you're shooting on location or outdoors. Making the most of the existing light means not having to set up special light sources or possibly locating a source of electrical power (not always an option outdoors).

Available light can be contrasty, providing enough illumination for the highlights of your subject, but with not enough light to open up the shadows. It might also be too dim overall, or too bright. You can usually fix these failings with a variety of reflectors and light blockers. You can buy these tools if you like, but it's often just as easy to make your own in the exact shape and size that you need. As a bonus, you can use reflectors and light attenuating accessories with your electronic flash units, too.

The next sections detail some recommended tools and what you can do with them.

White Cardboard

The best and most versatile light tool is a piece of white posterboard. It's cheap, disposable, and you can do dozens of things with it. Here are a few ideas on using white cardboard:

- Portability. Fold it up into quarters to make it more compact. Having a few creases won't hinder your cardboard's utility as a reflector in the least. You can unfold only as much as you need for your photograph.
- Go colorful. Use white shades, but mix in some colors. Most of the time you'll want a neutral white board, but you can carry orange and light-blue versions to warm up or cool down the shadows of your picture. You might find, for example, that the highlights of an object are illuminated by diffuse sunlight, but the shadows are filled in by reflections off a bluish object. An orange reflector can balance the color quickly. Poster boards can double as a background, too.
- **Block the light.** Use the cardboard to block light, too. While you'll generally use the cardboard to reflect light onto your subject, you'll find you can use it to block direct sunlight and create soft shadows where none existed before.
- Use your cookies. Cut holes in the cardboard for special effects. Motion-picture lighting often uses "cookies" to create special lighting shapes and effects. What? You thought those shadows on the wall were cast by *real* Venetian blinds? Use your imagination and cut some holes in your cardboard to create a halo around your subject or some other effect. Move the cardboard closer to the subject to make the highlight harder, and farther away to soften it.

Foamboard

Foamboard can make a great soft-light reflector, especially when you're shooting in your home studio. Those ultra-light boards of plastic foam sandwiched between paper or plastic sheets are commonly used to mount photos or to construct exhibits. They make great reflectors, too, especially if you need larger sizes that are rigid but also light in weight. They don't fold easily, and are probably more useful for portraits and group pictures, but if you have a small hunk of foamboard, keep it handy.

Aluminum Foil

Aluminum foil provides a bright, contrasty reflection that can sharpen up soft lighting (if that's what you need). Tape aluminum foil to a piece of white cardboard (use the reverse side of your main cardboard reflector if you want). If you need lighting with a little less snap, just reverse the cardboard to expose the non-aluminum side. Be sure to crinkle the aluminum foil so it will reflect the light evenly; you don't want shiny hot spots.

Mylar Sheets

Those space blankets can do more than keep you warm at your campsite or in an emergency. They can be used as a handy high-contrast reflector, yet still folded up and carried in a pocket of your gadget bag. Every photographer should get two: one for the emergency kit in the trunk of your car, and another for photographic purposes. Windshield sun shades make good reflectors, too. They usually have a silver reflective side, a darker/matte side, and fold up for portability.

Umbrellas

Photographic umbrellas are used in the studio, and available in white, gold, or silver surfaces. You can buy them with a black outer covering, which keeps light from being "wasted" by passing through the umbrella, away from your subject. However, the translucent type, often called "shoot through" umbrellas, are useful, too, as you can turn them around to serve as an extra-soft diffuser. While conventional photographic umbrellas are compact enough to carry with you on outside close-up shooting expeditions, outside the studio environment I favor white purse-sized rain umbrellas, like the one shown in Figure 7.8, that telescope down to six or eight inches in length, yet unfold to a respectable size. You can use these as a reflector to bounce light onto your subject, or as a translucent diffuser to soften the light that passes through them (perfect for use in bright sunlight when you can't find any open shade). And if it rains, you won't get wet!

Tents

If you're photographing a very shiny object, a light tent may be the best tool to even out your lighting. Photographic tents are usually made of a translucent material and are placed right over the object you're photographing. Illuminate the tent from all sides, shoot through a hole in the tent provided for that purpose, and you can get soft, even lighting without bright spots, even with relatively shiny subjects. Figure 7.9 shows the view inside a typical small lighting tent.

Figure 7.8 Purse- or pocket-sized umbrellas are perfect for macro shooting in the field.

Figure 7.9 Tents are great for photographing shiny objects, like this glazed ceramic container.

Black Cardboard or Cloth

Sometimes you need to block light from a glaring source to produce softer illumination. A sheet of black poster board works, although even black board reflects some light. For extra light absorption, consider a small piece of black velour. If you're trying to take photos of seashells in their natural habitat, a black cloth will help.

Working with Electronic Flash

The electronic flash built into your digital camera may work fine for quick and dirty pictures, but sometimes it will provide illumination that is too bright, too harsh, and might not cover your subject completely. This is because built-in flash is typically "aimed" to light subjects that are at least a few feet away from the camera. It's more difficult to visualize how electronic flash illumination will look in the finished picture. While available light provides an automatic "preview," with electronic flash, what you get may be a total surprise. On the plus side, the short duration of electronic flash will freeze any moving subject this side of a hummingbird if it is the predominant light source and you are close enough to the subject to minimize lighting from other sources.

Electronic flash is most applicable to macro work indoors, especially if you plan to work with several lights and set them up on stands. Outdoors, you might be limited to one or two battery-operated flash units. Here are your choices for electronic flash used for close-up photography:

■ Built-in flash. This is the flash unit built into your digital camera. You'll find that in extreme close-ups, the light it produces will look unnatural and may not illuminate your subject evenly. You probably can't aim the built-in flash in any meaningful way, and you may find that the lens casts a shadow on your close-up subject.

- External flash units. Many digital cameras have a connector for attaching an external flash unit. These can be inexpensive flash units designed for conventional film cameras, or more elaborate (and more costly) studio flash devices with modeling lights, which are extra incandescent lamps that mimic the light that will be emitted by the flash. These external flash units don't have to be physically connected to the camera; Canon, Nikon, and Sony all offer wireless operation, either using a camera's built-in flash (if it has one) to trigger off-camera units, or with an external flash mounted on or connected to the camera and then used to trigger the additional flash. Wireless flash works differently for each brand, but you'll find information to get you started in each of my guidebooks written for your specific camera.
- Slave flash. These are electronic flash units with light-detecting circuitry that automatically trigger them when another flash goes off. You can also purchase add-on slave detectors that set off any flash. Slaves are useful when you want to use two or more electronic flash. Keep in mind that you may need to disable your main flash's pre-flash feature to avoid tripping the slave too early. Some slave triggers have a so-called "digital" mode, which tells them to wait for the main flash burst before firing, and to ignore the pre-flash.
- Ringlights. These are specialized electronic flash units made especially for close-up photography. They have circular tubes that fit around the outside of a camera lens, providing very even lighting for close-ups. Ringlights are generally a professional tool used by those who take many close-ups, particularly with interchangeable lens cameras. If you can afford them, and do enough close-up work to justify a ringlight, they make a great accessory.

REFLECTORS

If you're forced to use your camera's built-in flash, you still may be able to achieve acceptable lighting. Try placing a reflector or two just outside the picture area at the back and sides of the subject. A piece of white cardboard or even a handkerchief might be enough. The reflector bounces light from the camera's flash back onto the subject, providing a more even, softer light than you'd get with the main flash alone.

Painting with Light

I think you'll find this project a lot of fun, because there are lots of different effects you can achieve. You can use either electronic flash for this (probably best for "large" paintings) or an incandescent source as small as a flashlight (better for painting smaller subjects and scenes).

Painting with light is just that: using a light source to daub illumination over a dark subject during a time exposure. You can use this technique to provide good lighting for architectural subjects that are too large or too dark even for a long exposure with your camera mounted on a tripod.

Here's a quick description of how to paint with light:

- 1. **Select a suitable subject in a dark environment.** Choose a subject that has insufficient illumination, or which is illuminated unevenly. If possible, select an environment that has few, if any, strong lights pointed directly at the camera. External security lights on the building, for example, should be doused if they're pointing toward the lens. Some light sources, such as city lights in the background, won't hurt anything and may even add interest. For the photo shown in Figure 7.10, I didn't have any choice; the lights illuminating the county courthouse weren't under my control. My main problem was that the lights illuminated only the middle portion of the building. The two ends were rather dimly lit. It helped that there was no breeze, too, so the flags in the photo weren't blurred during the long exposure.
- 2. **Set up on a tripod.** I mounted my camera on a tripod and composed the photograph.
- 3. **Shoot some test exposures.** You don't want to have to repeat the "painting" step too many times! After some tests, I set the aperture of the lens so it was appropriate for a two-minute time exposure. Make sure your camera has this capability! In my case, the maximum preset time exposure my camera allows is 30 seconds, so I had to use the locking capability of a plug-in remote control. Your camera may have an infrared remote control, which allows clicking once to open the shutter, which then remains open until you click the remote control a second time. (This is called a "bulb" exposure in photo parlance.) You may have to experiment with the right f/stop, but you'll want a fairly long exposure in order to give you time to do your painting. Ten to 20 seconds to a minute or two is the exposure to shoot for. I used two minutes. Setting your camera to a lower ISO rating (ISO 64 to 100) will let you use longer exposures but, of course, will reduce the amount of exposure from your external flash units.

Figure 7.10
Painting with light
can evenly illuminate a photo that
would otherwise be
murky in spots.

- 4. **Begin the time exposure.** When everything was set, I started the time exposure. I had waited until the dead of night, minimizing the chance of passing car headlights intruding on the painting procedure.
- 5. **Begin painting.** Then, I had an assistant move into the scene. Because the light from the building's main illumination was relatively bright, my helper had to move quickly and *keep* moving. Otherwise, his body would have been imaged in the photo just from the available light. You'll find that with a two-minute time exposure, a rapidly moving person won't register at all as long as you keep spill light from your electronic flash from hitting the person.
- 6. **Use repeated flashes.** Keeping the photo "painter's" body between the camera and external electronic flash, I had the assistant trip the flash to expose the left part of the building for several flashes, then race over to the other side to add another flash to the right side. If you try this, move around and expose other parts with additional flash exposures. Because your camera's lens is open, it will register each of these exposures.

TIP FROM THE PROS: HANDLING MIXED COLORS

Because part of the exposure was made from the existing illumination, which is considerably warmer in color than the illumination from the electronic flash, I had to use a special orange filter over the flash head. You can buy these ready-made for some electronic flash units, or you can make one of your own using orange filter material. If you can find a filter equivalent to a Wratten #85B filter, you're all set. If you can reduce the ambient illumination so it doesn't contribute to the exposure at all, you won't need the orange filter. Or, you can even go for an interesting mixed-light effect with both the bluish flash and orange-tinted incandescent lighting in the same image.

- 7. When the painting was finished, I closed the shutter, ending the time exposure.
- 8. Check your results on your camera's LCD screen and repeat the process, making appropriate changes to improve your photo. You might want to use a longer exposure, more flashes, or work harder to keep yourself or your assistant from showing up in the picture.

There are many variations on this theme. Here are a few to play with:

- Alternate flashes using multi-colored gels over your unit, painting your building with a rainbow of different colored lights.
- Paint only part of the structure, allowing the rest to remain in shadow. This is a good way of disguising the less-photogenic portions of a building.
- Instead of an electronic flash pointed *away* from the camera, use a flashlight pointed *toward* the camera, and "write" with it. Small beams, such as those provided by penlights, work best. Trace the outline of a portion of the building, draw a human figure, or create any other kind of light writing you want.

Part II

Exploring New Tools

170

No feature discussed in the next three chapters even existed in a form the average photographer could use five years ago. Live previewing of images was something that point-and-shoot cameras did routinely, but was impossible with any camera in the dSLR world. Now, mirrorless interchangeable lens cameras offer live view all the time, whether through an electronic viewfinder or a backpanel LCD. If you wanted movies, you tucked a camcorder in your camera bag alongside your mirrorless camera, and both Wi-Fi and GPS tagging were pro features that required specialized equipment. If you had a particular application that helped you with your photography, you had to lug a laptop computer and endure the slow boot-up process each time you wanted to use it. Now, these features are available with mirrorless cameras.

In this next part, I'm going to devote a trio of very short chapters to introducing these new features. In Chapter 8, you'll discover some things about movie making that you might not have thought of. Chapter 9 introduces you to some of the things you can do with Wi-Fi and GPS, while Chapter 10 concentrates on the newest technologies of all—smartphone/tablet computer apps that can travel with you anywhere. In Chapter 11, you'll find information about some great gadgets that expand the capabilities of your mirrorless camera.

Shooting Movies

Point-and-shoot cameras have always had live preview to accompany their (generally) poor optical viewfinders—and today, many of these cameras offer only the live view option and lack an optical viewfinder entirely. Initially, live view was slow to catch on among experienced SLR users (especially those dating from the film era). Mirrorless cameras—with the full-time live view not possible with dSLR cameras—have conquered all the problems users of interchangeable lens cameras have had with live view and movie shooting.

Current cameras typically offer a 100-percent view of the sensor's capture area. Large LCDs (see Figure 8.1) and high-resolution electronic viewfinders allow manual focusing, and some mirrorless

Figure 8.1
Swiveling/tilting
LCDs allow shooting movies from
multiple viewpoints.

models have sensors with special pixels embedded that allow fast phase detect focusing for stills or movies, as described in Chapter 5.

The most recent mirrorless cameras can shoot full HDTV movies with monaural sound at $1,920 \times 1,080$ resolution. Your camera may also be able to shoot stereo sound using built-in stereo microphones, or, if only a monaural mic is built in, cameras may allow you to plug in an accessory stereo microphone. In some ways, the camera's movie mode is closely related to the mirrorless camera's live view still mode. In fact, mirrorless cameras use live view type imaging to show you the video clip on the LCD as it is captured. Many of the functions and setting options are the same, so the functions and setting options discussed elsewhere in this book will serve you well as you branch out into shooting movies with your camera.

You'll want to keep the following things in mind before you start:

- Choose your resolution. The typical movie-capable mirrorless camera can capture movies in full high definition (1,920 × 1,080 pixel) resolution, standard HD (1,080 × 720 pixel) resolution, and, sometimes, other resolutions such as 720 × 480 pixel resolution. A few of the latest models have added so-called 4K movie-shooting (ultra HD) capabilities, with twice the resolution of Full HD at 3,840 × 2,160 pixels, and four times the number of pixels per frame.
- You can still shoot stills. With most cameras, you can press the shutter release all the way down at any time while filming movies in order to capture a still photo. Still photos are usually stored as separate files from the movie clips.
- Use the right card. You'll want to use a fast memory card to store your clips; slower cards may not work properly. Choose a memory card with at least 4GB capacity (8GB or 16GB are even better). If the card you are working with is too slow, a five-level thermometer-like "buffer" indicator may appear at the right side of the LCD/EVF, showing the status of your camera's internal memory. If the indicator reaches the top level because the buffer is full, movie shooting will stop automatically.
- Use a fully charged battery. Typically, a fresh battery will allow about one hour of filming at normal (non-Winter) temperatures.
- Image stabilizer uses extra power. If your lens has an image stabilizer, it will operate at all times (not just when the shutter button is pressed halfway, which is the case with still photography) and use a considerable amount of power, reducing battery life. You can switch the IS feature off to conserve power. Mount your camera on a tripod or monopod, and you don't need IS anyway.
- Silent running. You can connect your mirrorless camera to a television or video monitor while shooting movies, and see the video portion on the bigger screen as you shoot. However, the sound will not play—that's a good idea, because, otherwise, you could likely get a feedback loop of sound going. The sound will be recorded properly and will magically appear during playback once shooting has concluded.

MOVIE TIME

I've standardized on 16GB memory cards when I'm shooting movies; these cards will give you 49 minutes of recording at $1,920 \times 1,080$ full HD resolution. (Figure 330MB per minute of capture.) A 4GB card, in contrast, offers just 12 minutes of shooting at the full HD setting. With many cameras, the actual size of a single video clip may be limited to 2GB and 29 minutes, 59 seconds, for technical reasons.

Capturing Video/Sound

To shoot movies with your camera, just follow these typical steps:

- 1. **Set movie recording size.** Choose 1,920 × 1,080 (full HD) quality, or another resolution.
- 2. Place external microphone (if used). You can attach an external microphone (Figure 8.2) to your camera, or place it elsewhere in your scene or near your subject for better sound.
- 3. **Focus.** Use the autofocus or manual focus techniques for your camera to achieve focus on your subject.
- 4. **Begin filming.** Press the movie button or other control to begin shooting. A red dot or similar indicator will appear on the LCD screen to show that video/sound are being captured. (See Figure 8.3.) The memory card access lamp also flashes during shooting.

Figure 8.2 A microphone can be attached to the top of your camera, or mounted elsewhere.

- 5. Stop filming. Press the movie control again to stop filming.
- 6. **Start playback.** Press the playback button to review thumbnails of the stills and movies you've captured. Movie clips show up the same as still photos, but with an icon to indicate that it is a video clip. With most cameras, a series of video controls appear at the bottom of the frame. You can choose options like play, slow motion, first frame, previous frame, next frame, last frame, or exit.
- 7. **View your clip.** Once you've highlighted a clip you'd like to review, press your camera's movie activation button and the clip begins. An indicator will show the progress/time elapsed for the clip. Press the activation button again to stop at any time.

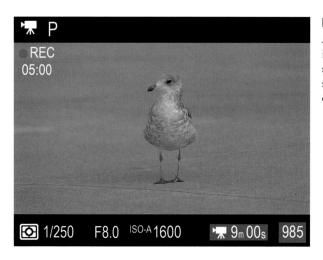

Figure 8.3
A lot of information is shown on the screen as you begin shooting a movie clip.

More on Video Resolution

As I noted earlier, there are three key resolutions for video:

- HD Video 720. This is a high-definition video standard that has dimensions of 720 × 1,280 pixels. This is approximately equivalent to a 1 megapixel still photo in resolution, and produces smaller video files.
- HD Video 1080. This is a high-definition video standard that has dimensions of 1,080 × 1,920 pixels. This is approximately equivalent to a 2 megapixel still photo in resolution. You will not see a huge difference between 1080 and 720 resolutions on a standard HD television set.
- **SD Video.** Standard definition video was the traditional video before high-definition video. SD video has a resolution of 720 × 480 pixels in the U.S. and other countries that use what is called the NTSC standard. Other countries use slightly different standards, such as PAL, that may include a slight increase in resolution.

Selecting a Frame Rate

Frame rate refers to how many frames or fields per second are captured while you are recording video. The common standard for video in the United States is 30 frames/fields per second (fps), although the European standard is 25 frames/fields per second. Because of this difference, people sometimes refer to the US standard as NTSC high-definition video and the European standard as PAL high-definition video, but this is incorrect as those standards only refer to standard definition video and technically don't apply to HD.

You will typically find up to three different frame rates for shooting video:

- 30 fps. This has long been a standard for video. Technically, broadcast video is at 29.97 fps, and many cameras will give precisely that. For the average photographer shooting video, that technicality is not going to make much of a difference. A rate of 30 frames per second is exactly that—30 individual frames shot per second of video. A rate of 30 frames per second gives you an appearance that definitely looks like video that you would see on television.
- 24 fps. Theatrical movies are shot both with film and video typically at 24 frames per second. This has long been a standard for the film that was used for movies. This has a slightly different look than 30 fps, and many people feel this tends to give video more of the look of a movie. Where you will see this is in the way that motion is recorded. Higher frame rates record motion more smoothly, but it is that less smooth recording of movement of movies that some people like and so choose 24 fps.
- 60 fps. The higher frames per second of 60 fps gives an even smoother movement to video, but it comes at a cost. Remember that this means 60 individual little pictures are being shot and recorded per second which is a lot of data to go through the camera and record to the memory card. Because of this, 60 fps is often only available at 720 HD resolution. Some people like to shoot 60 fps and then use it at 30 fps when they edit the video. This creates a bit of a slowmotion effect because it shows everything at half speed.

Progressive Scan vs. Interlaced Scan

As you probably know, video images as you see them on your TV or monitor consist of a series of lines which are displayed, or *scanned*, at a fixed rate. When captured by your camera, the images are also grabbed, using what is called a *rolling shutter*, which simply means that the image is grabbed one line at a time at the same fixed rate that will be used during playback. (There is a more expensive option, not used in the camera, called a *global shutter* that captures all the lines at one time.)

Line-by-line scanning during capture and playback can be done in one of two ways. With *interlaced scanning*, odd-numbered lines (lines 1, 3, 5, 7,... and so forth) are captured with one pass, and then the even-numbered lines (2, 4, 6, 8,...and so forth) are grabbed. With the AVCHD 60i format, roughly 60 pairs of odd/even line scans, or 60 *fields* are captured each second. (The actual number is 59.94 fields per second.) Interlaced scanning was developed for and works best with analog display systems such as older television sets. It was originally created as a way to reduce the amount of bandwidth required to transmit television pictures over the air. Modern LCD, LED, and plasma-based HDTV displays must de-interlace a 1080i image to display it. (See Figure 8.4.)

Newer displays work better with a second method, called *progressive scanning* or *sequential scanning*. Instead of two interlaced fields, the entire image is scanned as consecutive lines (lines 1, 2, 3, 4, ... and so forth). This happens at a rate of about 60 frames per second (not fields). (All these numbers apply to the NTSC television system used in the United States, Canada, Japan, and some other countries; other places use systems like PAL, where the nominal scanning figures are 50 fps.)

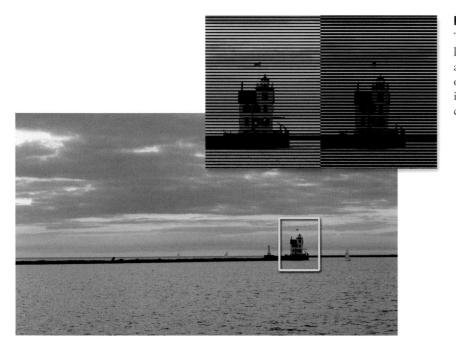

Figure 8.4
The inset shows how lines of the image alternate between odd and even in an interlaced video capture.

One problem with interlaced scanning appears when capturing video of moving subjects. Half of the image (one set of interlaced lines) will change to keep up with the movement of the subject while the other interlaced half retains the "old" image as it waits to be refreshed. Flicker or *interline twitter* results. That makes your progressive scan options of 60p or 24p a better choice for action photography.

Which to Choose?

If you're shooting a relatively static image, you can choose 60p 28M for the best combination of resolution and image quality, if you can accept the high demands of a 28 Mbps transfer rate, and have a TV that can display 60p video (otherwise the video will be converted before output to the television). Use 60i 24M or 60i 17M if you know you'll be mixing your video with existing 60i footage, or if you happen to be shooting for NBC, CBS, or The CW. (Ha!)

Tips for Shooting Better Video

Producing good-quality video is more complicated than just buying and using good equipment. There are techniques that make for gripping storytelling and a visual language the average person is very used to, but also pretty unaware of. While this book can't make you a professional videographer in half a chapter, there is some advice I can give you that will help you improve your results with the camera.

Depth-of-Field and Video

Have you wondered why professional videographers have gone nuts over still cameras that can also shoot video? The producers of *Saturday Night Live* could afford to have Alex Buono, their director of photography, use the niftiest, most expensive high-resolution video cameras to shoot the opening sequences of the program. Instead, Buono opted for a pair of mirrorless cameras. One thing that makes digital still cameras so attractive for video is that they have relatively large sensors, which provide improved low-light performance and results in the oddly attractive reduced depth-of-field, compared with most professional video cameras.

Figure 8.5 provides a comparison of the relative size of sensors. The typical size of a professional video camera sensor is shown at lower left, next to the sensor of a point-and-shoot camera. The APS-C sensor used in many mirrorless cameras is shown just northeast of both, with Micro Four Thirds and full-frame sensors above them. Compared with the sensors used in many pro video cameras and the even smaller sensors found in the typical consumer camcorder, the typical mirrorless model's image-grabber is much larger.

A larger sensor calls for the use of longer focal lengths to produce the same field of view, so, in effect, a larger sensor has reduced depth-of-field. And *that's* what makes these cameras attractive from a creative standpoint. Less depth-of-field means greater control over the range of what's in focus. Your camera, with its larger sensor, has a distinct advantage over consumer camcorders in this regard, and even does a better job than many professional video cameras.

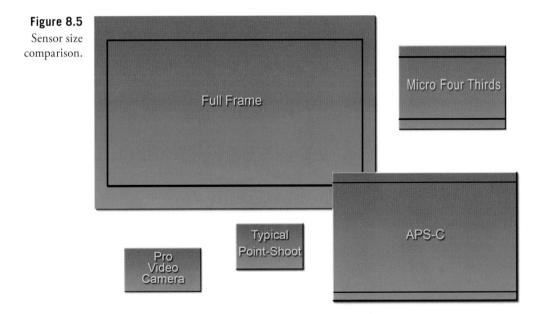

Zooming and Video

When shooting still photos, a zoom is a zoom. The key considerations for a zoom lens used only for still photography are the maximum aperture available at each focal length ("How *fast* is this lens?), the zoom range ("How far can I zoom in or out?"), and its sharpness at any given f/stop ("Do I lose sharpness when I shoot wide open?").

When shooting video, the priorities may change, and there are two additional parameters to consider. The first two I listed, lens speed and zoom range, have roughly the same importance in both still and video photography. Zoom range gains a bit of importance in videography, because you can always/usually move closer to shoot a still photograph, but when you're zooming during a shot, most of us don't have that option (or the funds to buy/rent a dolly to smoothly move the camera during capture). But, oddly enough, overall sharpness may have slightly less importance under certain conditions when shooting video. That's because the image changes in some way many times per second (24/30/60 times per second), so any given frame doesn't hang around long enough for our eyes to pick out every single detail. You want a sharp image, of course, but your standards don't need to be quite as high when shooting video.

Here are the remaining considerations:

- Zoom lens maximum aperture. The speed of the lens matters in several ways. A zoom with a relatively large maximum aperture lets you shoot in lower light levels, and a big f/stop allows you to minimize depth-of-field for selective focus. Keep in mind that the maximum aperture may change during zooming. A lens that offers an f/3.5 maximum aperture at its widest focal length may provide only f/5.6 worth of light at the telephoto position.
- Zoom range. Use of zoom during actual capture should not be an everyday thing, unless you're shooting a kung-fu movie. However, there are effective uses for a zoom shot, particularly if it's a "long" one from extreme wide angle to extreme close-up (or vice versa). Most of the time, you'll use the zoom range to adjust the perspective of the camera *between* shots, and a longer zoom range can mean less trotting back and forth to adjust the field of view. Zoom range also comes into play when you're working with selective focus (longer focal lengths have less depth-of-field), or want to expand or compress the apparent distance between foreground and background subjects. A longer range gives you more flexibility.
- Linearity. Interchangeable lenses may have some drawbacks, as many photographers who have been using the video features of their mirrorless cameras have discovered. That's because, unless a lens is optimized for video shooting, zooming with a particular lens may not necessarily be linear. Rotating the zoom collar manually at a constant speed doesn't always produce a smooth zoom. There may be "jumps" as the elements of the lens shift around during the zoom. Keep that in mind if you plan to zoom during a shot, and are using a lens that has proved, from experience, to provide a non-linear zoom. (Unfortunately, there's no easy way to tell ahead of time whether you own a lens that is well-suited for zooming during a shot.)

Keep Things Stable and on the Level

Camera shake's enough of a problem with still photography, but it becomes even more of a nuisance when you're shooting video. While an in-camera or in-lens image-stabilization feature can help minimize this, it can't work miracles. Placing your camera on a sturdy tripod will work much better than trying to hand-hold it while shooting.

Shooting Script

A shooting script is nothing more than a coordinated plan that covers both audio and video and provides order and structure for your video. A detailed script will cover what types of shots you're going after, what dialogue you're going to use, audio effects, transitions, and graphics.

Storyboards

A storyboard is a series of panels providing visuals of what each scene should look like. While the ones produced by Hollywood are generally of very high quality, there's nothing that says drawing skills are important for this step. Stick figures work just fine if that's the best you can do. The storyboard just helps you visualize locations, placement of actors/actresses, props and furniture, and also helps everyone involved get an idea of what you're trying to show. It also helps show how you want to frame or compose a shot. You can even shoot a series of still photos and transform them into a "storyboard" if you want, such as in Figure 8.6.

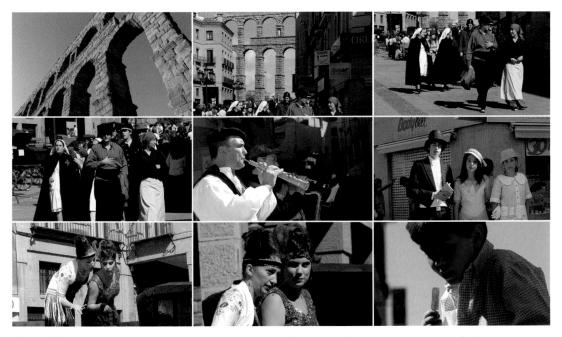

Figure 8.6 A storyboard is a series of simple sketches or photos to help visualize a segment of video.

Storytelling in Video

Today's audience is used to fast-paced, short-scene storytelling. In order to produce interesting video for such viewers, it's important to view video storytelling as a kind of shorthand code for the more leisurely efforts print media offers. Audio and video should always be advancing the story. While it's okay to let the camera linger from time to time, it should only be for a compelling reason and only briefly.

It only takes a second or two for an establishing shot to impart the necessary information. For example, many of the scenes for a video documenting a model being photographed in a Rock and Roll music setting might be close-ups and talking heads, but an establishing shot showing the studio where the video was captured helps set the scene.

Provide variety too. Change camera angles and perspectives often and never leave a static scene on the screen for a long period of time. (You can record a static scene for a reasonably long period and then edit in other shots that cut away and back to the longer scene with close-ups that show each person talking.)

When editing, keep transitions basic! I can't stress this one enough. Watch a television program or movie. The action "jumps" from one scene or person to the next. Fancy transitions that involve exotic "wipes," dissolves, or cross fades take too long for the average viewer and make your video ponderous.

Composition

In movie shooting, several factors restrict your composition, and impose requirements you just don't always have in still photography (although other rules of good composition do apply). Here are some of the key differences to keep in mind when composing movie frames:

- Horizontal compositions only. Some subjects, such as basketball players and tall buildings, just lend themselves to vertical compositions. But movies are shown in horizontal format only. If you want to show how tall your subject is, it's often impractical to move back far enough to show him full-length. You really can't capture a vertical composition. Tricks like getting down on the floor and shooting up at your subject can exaggerate the perspective, but aren't a perfect solution.
- Wasted space at the sides. What do you do when you want to capture the 2,080-foot Tokyo Sky Tree, the world's second-tallest structure (behind the 2,717-foot Burj Kalifa in Dubai)? If you zoom in as outlined by the yellow box in Figure 8.7 you're still forced to leave a lot of empty space on either side. Even zooming out a bit doesn't do justice to the enormous tower. You have to be creative, back off even further, or pan to capture really tall subjects.
- Seamless (or seamed) transitions. Unless you're telling a picture story with a photo essay, still pictures often stand alone. But with movies, each of your compositions must relate to the shot that preceded it, and the one that follows. It can be jarring to jump from a long shot to a tight close-up unless the director—you—is very creative. Another common error is the "jump cut"

in which successive shots vary only slightly in camera angle, making it appear that the main subject has "jumped" from one place to another. (Although everyone from French New Wave director Jean-Luc Goddard to Guy Ritchie—Madonna's ex—have used jump cuts effectively in their films.) The rule of thumb is to vary the camera angle by at least 30 degrees between shots to make it appear to be seamless. Unless you prefer that your images flaunt convention and appear to be "seamy."

■ The time dimension. Unlike still photography, with motion pictures there's a lot more emphasis on using a series of images to build on each other to tell a story. Static shots where the camera is mounted on a tripod and everything is shot from the same distance are a recipe for dull videos. Watch a television program sometime and notice how often camera shots change distances and directions. Viewers are used to this variety and have come to expect it. Professional video productions are often done with multiple cameras shooting from different angles and positions. But many professional productions are shot with just one camera and careful planning. You can do just fine with your mirrorless camera.

Figure 8.7

Movie shooting requires you to fit all your subjects into a horizontally oriented frame.

Here's a look at the different types of commonly used compositional tools:

- Establishing shot. Much like it sounds, this type of composition, as shown in Figure 8.8, establishes the scene and tells the viewer where the action is taking place. Let's say you're shooting a video of your offspring's move to college; the establishing shot could be a wide shot of the campus with a sign welcoming you to the school in the foreground. Another example would be for a child's birthday party; the establishing shot could be the front of the house decorated with birthday signs and streamers or a shot of the dining room table decked out with party favors and a candle-covered birthday cake. Or, in Figure 8.8, I wanted to show the studio where the video was shot.
- **Medium shot.** This shot is composed from about waist to head room (some space above the subject's head). It's useful for providing variety from a series of close-ups and also makes for a useful first look at a speaker. (See Figure 8.9.)
- Close-up. The close-up, usually described as "from shirt pocket to head room," provides a good composition for someone talking directly to the camera. Although it's common to have your talking head centered in the shot, that's not a requirement. In Figure 8.10 the subject was offset to the right. This would allow other images, especially graphics or titles, to be superimposed in the frame in a "real" (professional) production. But the compositional technique can be used with videos, too, even if special effects are not going to be added.
- Extreme close-up. When I went through broadcast training, this shot was described as the "big talking face" shot and we were actively discouraged from employing it. Styles and tastes change over the years and now the big talking face is much more commonly used (maybe people are better looking these days?) and so this view may be appropriate. Just remember, your mirrorless camera is capable of shooting in high-definition video and you may be playing the video on a high-def TV; be careful that you use this composition on a face that can stand up to high definition. (See Figure 8.11.)
- "Two" shot. A two shot shows a pair of subjects in one frame. They can be side by side or one in the foreground and one in the background. (See Figure 8.12.) This does not have to be a head to ground composition. Subjects can be standing or seated. A "three shot" is the same principle except that three people are in the frame.
- Over-the-shoulder shot. Long a composition of interview programs, the "over-the-shoulder shot" uses the rear of one person's head and shoulder to serve as a frame for the other person. This puts the viewer's perspective as that of the person facing away from the camera. (See Figure 8.13.)

Figure 8.8 An establishing shot sets the stage for your video scene.

Figure 8.9 A medium shot is used to bring the viewer into a scene without shocking them. It can be used to introduce a character and provide context via their surroundings.

Figure 8.10 A close-up generally shows the full face with a little head room at the top and down to the shoulders at the bottom of the frame.

Figure 8.11 An extreme close-up is a very tight shot that cuts off everything above the top of the head and below the chin (or even closer!). Be careful using this shot since many of us look better from a distance!

Figure 8.12 A "two-shot" features two people in the frame. This version can be framed at various distances such as medium or close up.

Figure 8.13 An "over-the-shoulder" shot is a popular shot for interview programs. It helps make the viewers feel like they're the one asking the questions.

Lighting for Video

Much like in still photography, how you handle light pretty much can make or break your videography. Lighting for video can be more complicated than lighting for still photography, since both subject and camera movement is often part of the process.

Lighting for video presents several concerns. First off, you want enough illumination to create a useable video. Beyond that, you want to use light to help tell your story or increase drama. Let's take a better look at both.

Illumination

You can significantly improve the quality of your video by increasing the light falling in the scene. This is true indoors or out, by the way. While it may seem like sunlight is more than enough, it depends on how much contrast you're dealing with. If your subject is in shadow (which can help them from squinting) or wearing a ball cap, a video light can help make them look a lot better.

Lighting choices for amateur videographers are a lot better these days than they were a decade or two ago. An inexpensive incandescent video light, which will easily fit in a camera bag, can be found for \$15 or \$20. You can even get a good-quality LED video light like the one shown in Figure 8.14, for less than \$100. Some electronic flashes have built-in video lights, like the Canon flash shown in Figure 8.15. Work lights sold at many home improvement stores can also serve as video

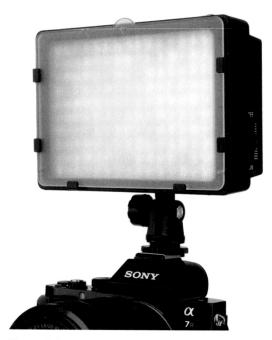

Figure 8.14 Inexpensive LED video lights can provide fill-in illumination.

Figure 8.15 Some electronic flash units have LED video lights built-in.

lights since you can set the camera's white balance to correct for any color casts. You'll need to mount these lights on a tripod or other support, or, perhaps, to a bracket that fastens to the tripod socket on the bottom of the camera.

Much of the challenge depends upon whether you're just trying to add some fill-light on your subject versus trying to boost the light on an entire scene. A small video light will do just fine for the former. It won't handle the latter.

Creative Lighting

While ramping up the light intensity will produce better technical quality in your video, it won't necessarily improve the artistic quality of it. Whether we're outdoors or indoors, we're used to seeing light come from above. Videographers need to consider how they position their lights to provide even illumination while up high enough to angle shadows down low and out of sight of the camera.

When considering lighting for video, there are several factors. One is the quality of the light. It can either be hard (direct) light or soft (diffused). Hard light is good for showing detail, but can also be very harsh and unforgiving. "Softening" the light, but diffusing it somehow, can reduce the intensity of the light but make for a kinder, gentler light as well.

While mixing light sources isn't always a good idea, one approach is to combine window light with supplemental lighting. Position your subject with the window to one side and bring in either a supplemental light or a reflector to the other side for reasonably even lighting.

Lighting Styles

Some lighting styles are more heavily used than others. Some forms are used for special effects, while others are designed to be invisible. At its most basic, lighting just illuminates the scene, but when used properly it can also create drama. Let's look at some types of lighting styles:

- Three-point lighting. This is a basic lighting setup for one person. A main light illuminates the strong side of a person's face, while a fill light lights up the other side. A third light is then positioned above and behind the subject to light the back of the head and shoulders.
- Flat lighting. Use this type of lighting to provide illumination and nothing more. It calls for a variety of lights and diffusers set to raise the light level in a space enough for good video reproduction, but not to create a particular mood or emphasize a particular scene or individual. With flat lighting, you're trying to create even lighting levels throughout the video space and minimize any shadows. Generally, the lights are placed up high and angled downward (or possibly pointed straight up to bounce off of a white ceiling).
- "Ghoul lighting." This is the style of lighting used for old horror movies. The idea is to position the light down low, pointed upward. It's such an unnatural style of lighting that it makes its targets seem weird and "ghoulish."

■ Outdoor lighting. While shooting outdoors may seem easier because the sun provides more light, it also presents its own problems. As a general rule of thumb, keep the sun behind you when you're shooting video outdoors, except when shooting faces (anything from a medium shot and closer) since the viewer won't want to see a squinting subject. When shooting another human this way, put the sun behind her and use a video light to balance light levels between the foreground and background. If the sun is simply too bright, position the subject in the shade and use the video light for your main illumination. Using reflectors (white board panels or aluminum foil covered cardboard panels are cheap options) can also help balance light effectively.

Audio

When it comes to making a successful video, audio quality is one of those things that separates the professionals from the amateurs. We're used to watching top-quality productions on television and in the movies, yet the average person has no idea how much effort goes in to producing what seems to be "natural" sound. Much of the sound you hear in such productions is actually recorded on carefully controlled sound stages and "sweetened" with a variety of sound effects and other recordings of "natural" sound.

Tips for Better Audio

Since recording high-quality audio is such a challenge, it's a good idea to do everything possible to maximize recording quality. Here are some ideas for improving the quality of the audio your camera records:

- Get the camera and its microphone close to the speaker. The farther the microphone is from the audio source, the less effective it will be in picking up that sound. While having to position the camera and microphone closer to the subject affects your lens choices and lens perspective options, it will make the most of your audio source. Of course, if you're using a very wide-angle lens, getting too close to your subject can have unflattering results, so don't take this advice too far.
- Use an external microphone. Many cameras have an external microphone port that accepts a stereo mini-plug from a standard external microphone, allowing you to achieve considerably higher audio quality for your movies than is possible with the camera's built-in microphones (which are disabled when an external mic is plugged in). An external microphone reduces the amount of camera-induced noise that is picked up and recorded on your audio track (The action of the lens as it focuses can be audible when the built-in microphones are active.)

The external microphone port can provide plug-in power for microphones that can take their power from this sort of outlet rather than from a battery in the microphone. Sony provides optional compatible microphones such as the ECM-ALST1 and the ECM-CG50; you also may find suitable microphones from companies such as Shure and Audio-Technica.

- Turn off any sound makers you can. Little things like fans and air handling units aren't obvious to the human ear, but will be picked up by the microphone. Turn off any machinery or devices that you can plus make sure cell phones are set to silent mode. Also, do what you can to minimize sounds such as wind, radio, television, or people talking in the background.
- Make sure to record some "natural" sound. If you're shooting video at an event of some kind, make sure you get some background sound that you can add to your audio as desired in postproduction.
- Consider recording audio separately. Lip-syncing is probably beyond most of the people you're going to be shooting, but there's nothing that says you can't record narration separately and add it later. It's relatively easy if you learn how to use simple software video-editing programs like iMovie (for the Macintosh) or Windows Movie Maker (for Windows PCs). Any time the speaker is off-camera, you can work with separately recorded narration rather than recording the speaker on-camera. This can produce much cleaner sound.

External Microphones

The single most important thing you can do to improve your audio quality is to use an external microphone. Most internal stereo microphones mounted on the front or top of the camera will do a decent job, but have some significant drawbacks, partially spelled out in the previous section:

- Camera noise. There are plenty of noise sources emanating from the camera, including your own breathing and rustling around as the camera shifts in your hand. Manual zooming is bound to affect your sound, and your fingers will fall directly in front of the built-in mics as you change focal lengths. An external microphone isolates the sound recording from camera noise.
- **Distance.** Anytime your camera is located more than 6–8 feet from your subjects or sound source, the audio will suffer. An external unit allows you to place the mic right next to your subject.
- Improved quality. Obviously, a camera manufacturer isn't going to install a super high-quality microphone on a (relatively) budget-priced camera. An external microphone will almost always be of better quality.
- Directionality. The camera's internal microphone generally records only sounds directly in front of it. An external microphone can be either of the directional type or omnidirectional, depending on whether you want to "shotgun" your sound or record more ambient sound.

You can choose from several different types of microphones, each of which has its own advantages and disadvantages. If you're serious about movie making with your camera, you might want to own more than one.

Common configurations include:

- **Shotgun microphones.** These can be mounted directly on your camera, although, if the mic uses an accessory shoe mount, you'll need the optional adapter to convert the camera's shoe to a standard hot shoe. I prefer to use a bracket, which further isolates the microphone from any camera noise.
- **Lapel microphones.** Also called *lavalieres*, these microphones attach to the subject's clothing and pick up their voice with the best quality. You'll need a long enough cord or a wireless mic (described later). These are especially good for video interviews, so whether you're producing a documentary or grilling relatives for a family history, you'll want one of these.
- Hand-held microphones. If you're capturing a singer crooning a tune, or want your subject to mimic famed faux newscaster Wally Ballou, a hand-held mic may be your best choice. They serve much the same purpose as a lapel microphone, and they're more intrusive—but that may be the point. A hand-held microphone can make a great prop for your fake newscast! The speaker can talk right into the microphone, point it at another person, or use it to record ambient sound. If your narrator is not going to appear on-camera, one of these can be an inexpensive way to improve sound.
- Wired and wireless external microphones. This option is the most expensive, but you get a receiver and a transmitter (both battery-powered, so you'll need to make sure you have enough batteries). The transmitter is connected to the microphone, and the receiver is connected to your camera. In addition to being less klutzy and enabling you to avoid having wires on view in your scene, wireless mics let you record sounds that are physically located some distance from your camera. Of course, you need to keep in mind the range of your device, and be aware of possible signal interference from other electronic components in the vicinity.

WIND NOISE REDUCTION

Always use the wind screen provided with an external microphone to reduce the effect of noise produced by even light breezes blowing over the microphone. Both the camera and many mics include a low-cut filter to further reduce wind noise. However, these can also affect other sounds. With many cameras, you can disable the low-cut filters for the camera's internal microphones. Some external mics have their own low-cut filter switch.

Exploring GPS and Wi-Fi

When you think of GPS and Wi-Fi, you may be thinking of using your vehicle's GPS system to help you find the nearest coffee shop where you can connect your laptop to the Internet. But, today, both GPS and Wi-Fi have many more applications. You can mark your photographs with location information, so you don't have to guess where a picture was taken. And, you can upload your photos directly to your computer or—if you're in that coffee shop or another Wi-Fi hotspot—to online picture sharing services like Facebook and Flickr. This chapter will help you discover some of the things you can do with these tools, which have been available as add-on accessories for some time, and which now are built right into an increasing number of mirrorless cameras.

What's Geotagging?

For photographers, geotagging is most important as a way to associate the geographical location where the photographer was when a picture was taken, with the actual photograph itself. This is done using a GPS (global positioning system) device that calculates the latitude and longitude, and, optionally, the altitude, compass bearing, and other location information. Geotagging can be done automatically, through a device built into the camera (or your smartphone or other gadget) or manually, by attaching geographic information to the photo after it's already been taken.

Automatic geotagging is the most convenient. Many point-and-shoot cameras and smartphone cameras have included built-in geotagging for some time. The feature has more recently become available for mirrorless cameras, currently found in only a couple models, such as the Nikon 1 AW1 and several models from Samsung, such as the Samsung Galaxy NX. Sony has included GPS built into a number of its SLT models, and there is hope that the feature will make its way into their mirrorless models as well.

A swarm of satellites in geosynchronous orbits above the Earth became a big part of my life even before I purchased a GPS-capable mirrorless camera. I use the GPS features of my iPhone and iPad and the GPS device in my car to track and plan my movements. When family members travel without me—most recently to Europe—I can use the Find my iPhone feature to see where they are roaming and vicariously accompany them with Google Maps' Street View features. And, since the introduction of GPS accessories and built-in features, GPS has become an integral part of my shooting regimen, too, when I use a camera that offers it.

Any GPS device makes it easy to tag your images with the same kind of longitude, latitude, altitude, and time stamp information that is supplied by the GPS unit you use in your car. (Don't have a GPS? Photographers who get lost in the boonies as easily as I do *must* have one of these!) The geotagging information is stored in the metadata space within your image files, and can be accessed by software that comes with the camera or GPS unit, or by online photo services such as mypicture-town.com and Flickr.

Geotagging can also be done by attaching geographic information to the photo after it's already been taken. This is often done with online sharing services, such as Flickr, which allow you to associate your uploaded photographs with a map, city, street address, or postal code. When properly geotagged and uploaded to sites like Flickr, users can browse through your photos using a map, finding pictures you've taken in a given area, or even searching through photos taken at the same location by other users. Of course, in this day and age it's probably wise not to include GPS information in photos of your home, especially if your photos can be viewed by an unrestricted audience.

Having this information available makes it easier to track where your pictures are taken. That can be essential, as I learned from a trip out West, where I found the red rocks, canyons, and arroyos of Nevada, Utah, Arizona, and Colorado all pretty much look alike to my untrained eye. I find the capability especially useful when I want to return to a spot I've photographed in the past and am not sure how to get there. I can enter the coordinates shown into my hand-held or auto GPS (or an app in my iPad or iPhone) and receive instructions on how to get there. That's handy if you're returning to a spot later in the same day, or months later.

All operate on the same principle: using the network of GPS satellites to determine the position of the photographer. (Some mobile phones also use the location of the cell phone network towers to help collect location data.) As mentioned earlier, the GPS data is automatically stored in the photo's EXIF information when the photo is taken. A connected GPS will generally remain switched on continuously, requiring power, and will then have location information available immediately when the camera is switched on.

Most mirrorless cameras don't contain a built-in GPS receiver, but you can still use them to tag photos by using an external GPS device. You can take the picture normally, without GPS data, and then special software can match up the time stamps on the images with time stamps recorded by an external GPS device, and then add the coordinates to the EXIF information for that photo.

(Obviously, your camera's date/time settings must be synchronized with that of the GPS for this to work.) This method is time consuming, because the GPS data is added to the photograph through post processing.

You can also add location information to your photographs manually. This is often done with online sharing services, such as Flickr, which allow you to associate your uploaded photographs with a map, city, street address, or postal code. When properly geotagged and uploaded to sites like Flickr, users can browse through your photos using a map, finding pictures you've taken in a given area, or even searching through photos taken at the same location by other users.

Using GPS

You can expect many future mirrorless cameras to include geo-tagging built-in, as with the Samsung Galaxy NX, or available as an external option, such as the Samsung WGS84 add-on unit. Once attached or activated, GPS is very easy to use. You need to activate the camera's GPS capabilities in the GPS choice within its setup menu. An internal GPS can be activated in much the same way.

The next step is to allow the GPS unit to acquire signals from at least three satellites. If you've used a GPS in your car, you'll know that satellite acquisition works best outdoors under a clear sky and out of the "shadow" of tall buildings. It may take about 40-60 seconds for the camera GPS to "connect." A blinking LED, viewfinder/LCD indicator, or other signal means that GPS data is not being recorded; a green blinking LED or similar acknowledgement in the viewfinder or on the LCD signifies that the unit has acquired three satellites and is recording data.

You may have the option to run the GPS unit all the time, or only when you manually turn it on. Always On assures that the camera doesn't go to sleep while you're using the GPS unit. Of course, in this mode the camera will use more power (the meters never go off, and the GPS draws power constantly), but you don't want to go through the 40–60-second satellite acquisition step each time you take a picture. You're all set. Once the unit is up and running, you can view GPS information using photo information screens available on the color LCD with most cameras offering GPS features.

Tracking Logs

Some internal or external GPS units have the capability of recording the camera's position at preset intervals and saving that information to a track log file that can be viewed using software. This capability can be useful in tracking your wanderings separately from the actual pictures you take. You can turn the log on and off, and the camera will continue to access satellite data when available and will continue logging even if the camera has been powered off. Logging will stop when the battery is depleted, so make sure your battery is fully charged, and it's smart to have an extra one available because your battery will run out more quickly than if you hadn't been using GPS or logging. In Nikon's case, the camera creates a folder on your memory card. These logs can be copied to your computer just like image or movie files. Their format conforms to the NMEA (National Marine Electronics Association) protocols, but may not be compatible with all utilities or devices.

Assisted GPS

If you want to increase the speed with which your camera's built-in GPS determines position, cameras may include an optional feature called *assisted GPS*. GPS Assist (also known as A-GPS) services use network data connections to improve accuracy and shortens what is called "time to first fix" (which can be slow if the unit has difficulty accessing satellite data). To use this feature, download the latest A-GPS file according to the instructions supplied by your camera vendor, copy the data to a memory card, insert in the camera, and load the data into your camera's GPS memory. The file you've downloaded will be valid for about two weeks, at which point the camera will ignore it. If you try to update using an outdated A-GPS file, an error message will be displayed. If you elect to continue using assisted GPS, you'll need to update the camera's files at intervals to maintain valid data.

Eye-Fi Upload

Affordable Wi-Fi connectivity has to be one of the most exciting options to come to digital photography in years. It's been available for some time, but only through expensive add-on devices for pro cameras, typically at costs of \$700 or more for the transmitter. I'm not even going to discuss those pricey devices in this book—the professionals who need them already know about them. Normal people like you and me need an affordable solution, like the built-in Wi-Fi found in an increasing number of mirrorless cameras, and memory-card based solutions that add Wi-Fi to other cameras, like the cards offered by Eye-Fi (www.eye.fi).

The Eye-Fi card is an SDHC memory card with a wireless transmitter built in. You insert it in your camera just as with any ordinary card (see Figure 9.1), and then specify which networks to use. You can add as many as 32 different networks. The next time your camera is on within range of a speci-

fied network, your photos and videos can be uploaded to your computer and/or to your favorite sharing site. During setup, you can customize where you want your images uploaded. The Eye-Fi card will only send them to the computer and to the sharing site you choose. Upload to many popular sharing websites, including Flickr, Facebook, Picasa, MobileMe, Costco, Adorama, Smugmug, YouTube, Shutterfly, or Walmart. Online Sharing is included as a lifetime, unlimited service with all X2 cards.

Newer mirrorless cameras have a menu option for enabling or disabling Wi-Fi access, but I've found that the card works with cameras that don't have direct support for Wi-Fi—the Eye-Fi card, in effect, is "on" all the time. You control its behavior, such as which Wi-Fi networks to use, from the Eye-Fi Center software.

Figure 9.1 Just insert the Eye-Fi card in an SD slot.

When uploading to online sites, you can specify not just where your images are sent, but how they are organized, by specifying preset album names, tags, descriptions, and even privacy preferences on certain sharing sites.

If you frequently travel outside the range of your home (or business) Wi-Fi network, an optional service called Hotspot Access is available, allowing you to connect to any AT&T Wi-Fi hotspot in the USA. In addition, you can use your own Wi-Fi accounts from commercial network providers, your city, even organizations you belong to such as your university.

The card has another interesting feature called Endless Memory. When pictures have been safely uploaded to an external site, the card can be set to automatically erase the oldest images to free up space for new pictures. You choose the threshold where the card starts zapping your old pictures to make room. Eye-Fi currently offers a number of different models, in both the latest Mobi and Pro X2 models, in 8GB to 32GB capacities, ranging in price from around \$50 to about \$100. Some versions can add geographic location labels to your photo (so you'll know where you took it), and free you from your own computer network by allowing uploads from more than 10,000 Wi-Fi hotspots around the USA. Very cool, and the ultimate in picture backup. The company also offers an Eye-Fi app for the iPhone that allows you to upload your photos directly to your computer or websites.

Built-in Wi-Fi

These days, built-in GPS and Wi-Fi capabilities work together with your camera in interesting new ways. Wireless capabilities allow you to upload photos directly from your camera to your computer at home or in your studio, or, through a hotspot at your hotel or coffee shop back to your home computer or to a photo sharing service like Facebook or Flickr. You can use your smartphone as a remote control for your camera, and preview your live view images right on your Android or iOS phone's screen. Your Wi-Fi-compatible camera has its own Wi-Fi capabilities, and works in conjunction with a Wi-Fi app for your smartphone or tablet (using either iOS or Android operating systems).

The traditional methods for transferring photos and videos to a computer work well and they're familiar to most everyone, but in this high-tech era there are wireless alternatives. Your camera may be equipped with a built-in Wi-Fi system that can be used for transferring files to a networked computer or to a networked HDTV or to a smartphone or tablet computer. There's also an option (with an app) to use the smart device as a remote controller for the camera.

These aspects of Wi-Fi are available with an increasing number of digital cameras but some cameras pile on additional features. For example, after making Wi-Fi connectivity from the camera to a network or hotspot, you can instruct the camera to download apps (free or for \$4.99 or \$9.99 in the US) from a website for increased versatility. An app can expand existing features with extra options or add entirely new functions. For example, one app enables you to retouch JPEGs to improve them while two others allow for direct uploading (via Wi-Fi) from the camera to certain social media sites on the Internet.

Depending on your camera model, you may be able to link to other Wi-Fi-compatible cameras or connect directly to a smartphone or tablet to preview and take pictures remotely (see Figure 9.3, left). Sony's Near Field Communications (NFC) capabilities allows your camera to connect directly to your smartphone without the need for an external Wi-Fi network to serve as an intermediary (Figure 9.2, right). You can also link to your computer, print directly to a wireless printer, or view your images on an intelligent high-definition television. Printing from your camera is particularly convenient. Some models, for example, show you a screen you can use to select, resize, transmit, or print images one at a time or in batches.

The trickiest part of connecting your camera using Wi-Fi is setting up the connection for the first time. You may have to wend your way through multiple screens to choose a network, enter a password (if required), and select a name for your camera on the network. However, once you've done that, connecting is usually automatic.

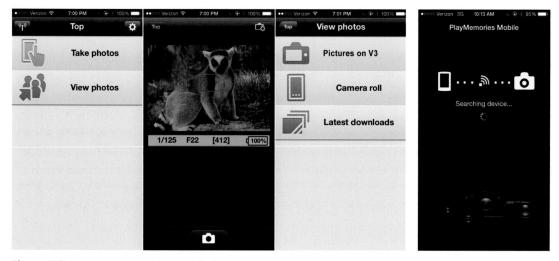

Figure 9.2 Communicate with multiple devices.

Using Apps

In the past, the most important add-on accessory for your mirrorless camera was probably your second lens, a tool that, as you learned in Chapter 6, expands your perspective, brings you closer to your subject, or allows you to shoot in more challenging environments. Of course, depending on the type of subjects you shoot, that MVP (most valuable purchase) might be a tripod or close-up accessory. By the time the next edition of this book is published, however, the hands-down winner for most useful accessory will be your smart device (phone, tablet, phablet, or other portable gadget), and the apps it can run. That's because, of all the technologies discussed in this book, that of the portable application—or app—is the one that is still truly in its infancy, and which will grow dramatically in importance. Quite simply, in the future, smart devices and related electronics will be one of the most important accessories you can have for your digital mirrorless camera, if it isn't already. We're only now seeing the beginnings of the trend.

Think of all the products that have effectively been made obsolete by a device that's small enough to slip into a pocket or purse:

■ Point-and-shoot cameras. Millions of pocket cameras are still sold each year, primarily because they have a few features that are not yet universal in smart phones, such as zoom lenses. Yet, the adage goes, "The best camera is the one you have in your hand" and while even the most avid snapshooter doesn't tote their P & S camera everywhere they go, when they venture out they're more likely to forget a wallet than a smartphone. When phone cameras catch up to the best point-and-shoots in terms of features, the latter will become an endangered species.

- **GPS.** It's true, as I explained in Chapter 9, that GPS built into cameras is becoming an important technology for photographers. However, other types of global positioning system units will eventually join the endangered species list along with point-and-shoot cameras. Many people are already using their smart device GPS for route information and finding particular points of interest (i.e., where's the nearest gas station?). Hand-held GPS, used by hikers, and in-vehicle GPS units are less crucial. Did you think it was cool that your latest automobile had an in-dash GPS system? How thrilled will you be in five years when you still own that car and realize your obsolete GPS unit can't be updated every two years like your phone?
- Landlines. People started phasing out home landlines when they disconnected their fax machines and dial-up Internet connections a decade ago. I don't even *know* anybody who has an actual landline, unless you consider one of those Internet-based voice over IP (VOIP) systems that use a standard telephone. They may be magic, Jack, but we use our mobile phone a lot more.
- Wrist watches. Today, most wrist watches are a fashion accessory rather than a useful device. If you really need to know the time, glancing at your phone's screen takes only a second longer than looking at your wrist—and the display will likely tell you about the weather, too.
- Voice calls. A lot of people, especially the younger set, don't even make many voice calls with their phones. Texting can be faster, can be responded to (or not) at your convenience without interrupting what you're doing, and provides a non-paper trail of a conversation so you don't have to take notes. If you really need to communicate with someone in realtime, Skype or FaceTime are frequently more useful.

And I didn't even include standalone MP3 players or pocket calculators in this list. The next sections will look at how electronic accessories—including smart devices—are becoming essential tools for the digital mirrorless camera photographer.

Smart Platforms

In the past, wireless carriers have subsidized the cost of the smart device in order to attract your business and tie you to their mobile system. Because we're paying only \$200 or less for a phone that costs, in reality, \$600, the tendency is to upgrade to the latest and greatest models as often as every two years. Some carriers have even eliminated long-term contracts and allow you to purchase your devices on an installment plan. In some ways, committing to a given operating system/platform is a lot like choosing a camera brand. Once you've select Nikon, Canon, Sony, or some other vendor, and start investing in lenses and accessories, you're locked in until you decide to jump ship and reinvest in an entirely new platform/brand. So, as in choosing a camera brand, it's important to select your platform carefully.

The relevant platforms are these (see Figure 10.1):

- Old-style smartphones. Cell carriers call these "Basic Phones," and they are only somewhat smart. They can run apps designed specifically for them, and have a few features beyond making phone calls. With Blackberry increasingly out of the picture, I include in this category all smartphones that are not based on Apple's iOS, Microsoft's Windows Phone, or Google's Android operating systems. You can buy lots of interesting apps for these non-iOS/Windows/ Android phones, although not many applications specifically for photography. This type of phone should be on its way out, too, simply because it's easier to write applications for the iPhone's iOS and Android than to create them for multiple "old" smartphone platforms. Carriers keep selling them because there are people who basically use their phones primarily for making phone calls.
- Android smartphones. There are already more Android-based smart phones on the market than for all other types, including iOS. Although Apple had a head start, the number of Android applications is rapidly catching up. You'll find lots of photo applications, GPS apps, and other great utilities.
- iPhones. The sale of iPhones took off once Apple stopped supplying them exclusively to AT&T, and began offering them through dozens of carriers, including all the majors in the United States, including Verizon, T-Mobile, and Virgin Mobile. The iPhone is supported in Canada, too, through carriers like Rogers, and throughout Europe and Asia. Apple's iOS leads in number of applications, especially for photography apps. When my first camera-specific app was developed, it appeared for the iOS platform first, and my free *David Busch's Lens Finder* app remains available only through the Apple App Store. Apps from camera vendors like Nikon, Canon, and Sony are always available for iOS.

Figure 10.1 The iPad, iPod, and other devices open a whole world of useful apps to the photographer.

- iPod Touch. The main reason why Apple is able to continue to sell iPods is that, in the case of the iPod Touch, the product is basically just an iPhone that can't make phone calls. (Although there are some hacks around that limitation.) Virtually all of the apps that run on the iPhone under iOS also run on the iPod Touch. You need a Wi-Fi connection to access features that use network capabilities, but, these days, Wi-Fi hot spots aren't that difficult to find. Tethering and Mi-Fi (which allow another device to serve as a hot spot for non-connected gadgets like the Touch) and *automobiles* that include built-in Wi-Fi (!) make connectivity almost universal. In my travels through Europe in the last year, I found free Wi-Fi connections in the smallest towns. (Indeed, the only time I was asked to pay for it was when staying in an upscale hotel.) So, for many who are tied to a non-iPhone cell phone, the iPod Touch is a viable alternative.
- iOS tablets. I was welded to my iPad since I bought it the first day they became available in January, 2010. I resisted Apple's annual upgrades until Apple's lack of OS support for their original model nudged me into my current iPad Air and iPad Mini models. Because of the large number of iOS apps I have, and my preference for some of the features found in the various iPads, I'll continue using them as a key tool for photographic and personal use.
 - However, iPad tablets are far from the perfect tool for photographers. As I write this, they lack memory card slots or any way to plug in additional external storage (other than through clever wireless add-on hard drives), so you're stuck with no more than 128GB of storage. Loading your images onto the iPad is best done with Apple's Camera Connection Kit, or third-party clones, or by connecting the iPad to your computer through a USB cable. With iOS 8, though, Apple did introduce some interesting photography-oriented features, although they aren't geared to mirrorless camera owners. You now get a time-lapse mode, separate control of exposure and focus with the iPhone camera app, an iPhone camera self-timer with 3- and 10-second delays, an instant burst mode, and improved panorama features.
- Android Tablets/Phablets. The range of tablets and combined phone/tablet products ("phablets") is amazing, and spans the gamut from \$79 basic models to the higher-end devices like the Samsung Galaxy and Amazon Kindle models priced in the \$500 range once dominated by Apple's pricey iPads.
 - Depending on the model you select, you can find Android devices with memory card slots, USB ports, and other hardware upgrades, including a selection of different screen sizes. Like iPad models, these are available with internal 3G/4G support, or can rely solely on Wi-Fi connections. Of course, different vendors install slightly different "flavors" of the Android OS on their tablets, so not every app runs on every device. I've been using a Kindle Fire for some time, but not for photography, for the most part. The Kindle Fire interfaces more smoothly than my iPads with Amazon's Prime movie streaming service, and is more convenient for downloading and reading books (compared to the full-size iPad Air).

An Android phablet proved especially useful during a six-week visit to Asia. A kiosk at Bangkok's international airport sold SIM (mobile connection) cards with one month's unlimited use for a modest amount, allowing uploading and e-mailing many photos without worrying about the meter ticking.

■ Windows Phone/Surface Tablets. Microsoft continues to try to break into the phone/tablet market, but has a lot of catching up to do to overtake iOS or Android. I tend to lag behind Microsoft's technological "breakthroughs" until it becomes obvious that they've put together a winner (Windows 7) or a loser (Microsoft Zune). I must admit that I do have heavily customized versions of Windows 8 smoothly running on my laptop (which I used in Florida to write the first half of this book), and one desktop computer, but my "main" desktop (that I'm using right now) relies on a mature copy of Windows 7.

Should you try out Windows Phone or Surface products? Microsoft and Nokia have given the photography aspects of the Windows Phones a priority, so, if you want to use your phone as a camera, you'll be pleasantly surprised. If you like Windows (i.e., you're not a Mac user), the Windows Phone and Surface operating systems will seem familiar to you. However, the number of apps designed specifically to take advantage of these products lags behind. For example, while Windows Phone has come with basic Microsoft Office applications, in early 2014 a version for iPads was made available, too.

What Can They Do?

Many of these devices can serve as a backup for your memory cards. I've got Apple's camera connection kit, and can offload my pictures to my iPad's 64GB of memory, then upload them to Flickr or Facebook, or send to anyone through e-mail. (I'll show you a way to transmit your images directly to your home television from a distant vacation spot later in this chapter.) My iPad also makes a perfect portable portfolio, too. I have hundreds of photos stored on mine, arranged into albums (see Figure 10.2) ready for instant display, either individually or in slide shows. I have the same photo library on my iPod Touch, and more than a few pictures available for showing on my smartphone.

Figure 10.2
Display your photos in albums, anywhere.

But the real potential for using these devices comes from specialized apps written specifically to serve photographic needs. Here are some of the kinds of apps you can expect in the future. (I'm working on more than a few of them myself.) Google any of these topics to locate current apps that perform these functions.

- Camera guides. Even the inadequate manual that came with your camera is too large to carry around in your camera bag all day. I'm converting many of my own camera-specific guides to app form, while adding interactive elements, including hyperlinks and videos. You can already put a PDF version of your camera manual on your portable device and read it, if you like. You should be able to read any of the more useful third-party guides anywhere, anytime.
- Photo editors. In these days of Instagram, there are literally hundreds of apps that manipulate your photos to provide a retro look, correct color balance, bend pixels, make stereoscopic images, convert shots to high dynamic range (HDR) versions, add text, or compile collages.
- Lens selector. Wonder what's the best lens to use in a specific situation? Enter information about your scene, and your app will advise you. Or, you can use my *David Busch's Lens Finder* app, currently available for iOS.
- How a mirrorless camera works. Curious about how your camera works? Find an app with a 3D model of your mirrorless camera with internal components labeled and captioned with their functions.
- Exposure estimator. Choose a situation and the estimated exposure will be provided. Useful as a reality check and in difficult situations, such as fireworks, where the camera's meters may falter.
- **Shutter speed advisor.** The correct shutter speed for a scene varies depending on whether you want to freeze action, or add a little blur to express motion. Other variables include whether the subject is crossing the frame, moving diagonally, or headed toward you. The photographer also needs to consider the focal length of the lens, and presence/absence of image stabilization features, tripod, monopod, etc. This app will allow you to tap in all the factors and receive advice about what shutter speed to use.
- Hyperfocal length calculator. In any given situation, set the focus point at the distance specified for your lens's current focal length setting, and everything from half that distance to infinity will be in focus. But the right setting differs at various focal lengths. This app tells you, and is a great tool for grab shots.
- Accessory selector. Confused about what flash, remote control, battery grip, lens hood, filter, or other accessory to use with your camera or lens? This selector lists the key gadgets, which ones fit which cameras, and explains how to use them.
- **Before and after.** Images showing before/after versions of dozens of situations with and without corrective/in-camera special effects applied.

- Fill light. Pesky shadows on faces from overhead lighting indoors? This turns your iPod/iPhone or (best of all) iPad into a bright, diffuse fill light panel. Choose from white fill light, or *colors* for special effects. Makes good illumination for viewing your camera's buttons and dials in dark locations, too.
- Level. Set your device on top of your camera and use it to level the camera, with or without a tripod.
- **Gray card.** Turn your i-device into an 18-percent gray card for metering and color balance.
- **Super links.** If you don't find your answer in the Toolkit, you can link to websites, with more information.
- **How It's Made.** A collection of inspiring photos, with details on how they were taken in camera—or manipulated in Photoshop (if that's your thing).
- Quickie guides. Small apps that lead you, step-by-step, through everything you need to photograph lots of different types of scenes (similar to what I have for you in Part III of this book). Typical subjects would be sports, landscape photography, macro work, portraits, concerts/performances, flowers, wildlife, and nature.

As you can see, the potential for apps is virtually unlimited. You can expect your smartphone, tablet computer, or other device to be a mainstay in your camera bag within a very short time. Although point-and-shoot cameras are on the way out, mirrorless cameras will benefit from these applications.

Camera-Specific Apps

Each mirrorless camera model capable of communicating with a smart device has an Android or iOS app available for download. You can also find camera control software that runs on your desktop or laptop computer, too. Several third-party companies, such as Breeze Systems, produce similar software at reasonable prices.

With any of these, you can use your computer (linked to the camera wirelessly or over a USB cable) or smart device (connected wirelessly) to make camera settings, adjust picture styles, upload firmware updates, or, most importantly, operate the camera remotely. You can preview the live view image on your monitor or device's LCD, change exposures or just about any other setting, and actually take a picture in single shot, continuous, or time-lapse mode. The image you've just shot is transferred directly to your computer or phone/tablet, and you can then upload it to a destination of your choice. I explained the various options of wireless connectivity in Chapter 9.

Some recent mirrorless models, particularly those from Sony, have an Applications menu that allows you to find and download great applications for your camera. (See Figure 10.3.) Many are free, others cost from \$4.99 to \$9.99. Available apps include one for capturing star trails, a time-lapse photography app, photo retouching software, facilities for adding special effects beyond those available in the camera, and noise reduction tools.

Figure 10.3
A variety of applications are available for some mirrorless cameras.

Another Great Device

Imagine shooting pictures on vacation (or on assignment) and having them show up immediately on the television in your home or office—thousands of miles away. All you need is a smart device (phone, tablet, phablet) connected to a Wi-Fi or cellular network, or, a Wi-Fi-equipped camera. Then, use a connecting box like the new Amazon Fire TV (\$99) to link your device to any high-definition television with a spare HDMI port. Introduced in April, 2014, the Amazon Fire TV is an alternative to Google Chromecast/Roku/Apple TV devices, with a couple features photographers will love.

I appreciate the ability to remotely view images, as they are shot. The first step is to set your camera to upload pictures to your Amazon Cloud Drive over any available Wi-Fi network. Amazon gives you 5GB of cloud storage for free, but you can upgrade to 20GB to 1TB at extra cost. (\$20 to \$500 a year as I write this.) Alternatively, if a Wi-Fi network isn't available, you can upload from your camera to your smart device (phone, etc.) and use the device's connection to upload the images to the Amazon Cloud Drive.

Once in cloud-land, your shots are immediately available for viewing on your Fire TV-equipped television. Friends/colleagues can view what you shoot as quickly as you can upload the images, even if you're thousands of miles away. Or, you can view your own shots in your home, office, or studio. Any photos in the cloud can be viewed on your television using this device.

As a bonus, Fire TV also does television! And games. My HDTV already has built-in connectivity to YouTube, Netflix (so I was able to watch *House of Cards* non-stop on a big screen), and a few other services. The Fire TV lets me view my Amazon Prime videos as well (I binged on 10 episodes of *Orphan Black* over two nights), Hulu Plus for current TV shows, and can be used to play games with an optional controller. We've gone from game consoles that let you watch Netflix and other streaming video to video links that let you play games—and share your photos automatically.

Great Gadgets

Don't fret if your dream digital SLR is something that you can only dream about. The camera you own right now may be capable of doing a lot more than you think, with the addition of just a few accessories. It's easy to get excited over a newly introduced model with killer features, until you realize that there are very, very few pictures that the most advanced camera can take that are beyond the reach of an unadorned basic entry-level mirrorless camera. Other than higher resolution (and do any of us really *need 36* MP or so?) and better performance at lofty ISO sensitivity settings (how much available darkness photography do you do?), the only thing a fancier camera is likely to give you is *convenience*. Built-in HDR, Wi-Fi, or GPS, as well as features like sophisticated multiple exposure capabilities or lightning-fast autofocus are all conveniences, and most of them can be replaced by external tools or clever shooting techniques.

And, most important of all, you can often add these nifty features to your existing camera with a few well-selected accessories or add-ons. In this chapter, I'm going to summarize a few of the most popular.

Taking Pictures by Remote Control

Sometimes you want to trip your shutter without being anywhere near your camera. It's not out of laziness; sometimes you just don't want to be anywhere near what you're photographing because it's scared of you (small birds and animals) or you're scared of it (big animals, your in-laws). While you can set the self-timer and run, that only gets you one shot, or, perhaps, a short series with most cameras and doesn't really work when you're trying to capture wildlife (see Figure 11.1).

A wireless triggering system is simpler to rig and easier to use. Cheaper systems are available for specific camera lines for less than \$100 (sometimes a lot less) and often rely on infrared light to signal the camera to fire. While pro versions will cost a good deal more, the good news is a pro

Figure 11.1
Remote control shot of a butterfly.

wireless triggering system can also be used for firing a flash wirelessly too. The systems that provide the greatest range use radio waves which are stronger than infrared, not prone to failure in bright sunshine, and bounce around enough to transmit through obstacles. The cheap ones are good for about 150 feet or so, while the pro setups can be good for well over a thousand feet. A cable-based approach can only manage about 100 feet at best, and only if you have an expensive, long cable. Your camera's manufacturer undoubtedly offers a remote for your mirrorless camera, whether it's a wired remote like the Olympus RM-UC1, or a wireless system like the Sony RMTDSLR2.

- At the cheap end. There are several low-cost camera remote systems available these days from \$30 and up. An extension cable adds to the cost. Optika and Phottix (www.phottix.com) supply remotes for many mirrorless models.
- **Pro versions.** Higher-end remote transmitters can trigger their receiver longer distances of more than a thousand feet and send their signals through walls and around corners. They can also be used to fire remote flashes as well. Pocket Wizard makes a variety of transmitters and receivers (including units that can do both). You need two units plus a cord to plug into the camera's digital connection. Setting up the pair would run you from \$300 to close to \$600 (the company offers several different units, hence the price range). The accessory cable for the camera would add from \$20 to \$60 or more. You'd need another cord to hook up the receiver with the strobe (more on this in the section on working with flash units).
- Infrared remotes. At the low end of the price range (\$29.99) are infrared remotes. These will trigger the camera but may not have the range of radio signal-based devices. Higher-end versions can cost upwards of \$100 but offer more features and greater range (more than 300 feet). These are line-of-sight remotes, meaning you can't have anything blocking the signal for them to work.

Underwater Housings

Underwater photography is both challenging and rewarding. Once you slip below the water's surface, a wide range of opportunities and problems greet you. Most pressing of course is how to keep your valuable camera equipment safe and dry. If you're operating a camera just a foot or two under the surface, the main problems facing underwater photography—water pressure and loss of certain color wavelengths—are minimized. Even light falloff is inconsequential at that depth, so all you really have to worry about is safety, protecting your camera from moisture.

It's a different story when you put on scuba gear or try to take your camera deeper than five or 10 feet. As you descend deeper into the water, the pressures that build up on whatever's protecting your camera increase drastically and the consequences of even a tiny leak become magnified under the greater pressure. The amount of light penetrating the water decreases significantly the farther down you go and certain color wavelengths also become weaker, meaning your photos take on a pronounced bluish cast.

This is expensive gear, but there are good reasons for it. Once you're at depth, you can't just make a quick run to the surface if something goes wrong (at least not if you're diving to a depth that requires decompression stops on the way back up). Equipment failures when you're diving past snorkeling depths risk your equipment and can blow your shoot.

At this writing, only the Nikon 1 AW is suitable for underwater photography *without* the need for a special housing, down to about 49 feet. Several companies, including Meike, Polaroid, and MegaGear make housings for some Sony mirrorless models. Olympus offers its own for some of its cameras, with other companies, including Opteka, selling compatible housings. Specialist vendors also provide suitable housings for underwater photography:

- Ewa-Marine. Ewa-Marine has been making underwater camera housings for a long time now. The company offers a soft, baglike housing. These housings offer certain advantages over the hard housing approach. They pack smaller for travel, cost less, and can be a little more adaptable when it comes to using different lenses. Its D-B, D-A, and D-AX models are sold for mirrorless cameras.
- **Ikelite.** Ikelite is another company that has specialized in underwater housings. This company offers a variety of units including polycarbonate models designed for specific cameras, including one for the Panasonic DMC-GH3.

Light and Measuring Aids

Digital photography has made photography easier in many ways. Savvy photographers can glean a lot of information from the feedback the camera's LCD screen provides. From being able to see the image itself and judge its exposure and color to being able to read the histogram, this information is incredibly valuable.

Even so, as important as it is, such feedback alone doesn't guarantee the results you need. For critical exposure and for color accuracy, there are certain accessories that help you achieve the quality you need. It sounds kind of old fashioned to be carrying a hand-held light meter or color meter, but there's nothing old fashioned about the modern versions of these tools.

Color meters can provide precise color information, and gray cards and tools such as the Expo disc can help photographers make sure they get the most accurate color possible. While Photoshop can fix a lot of problems, it's still easier to get it right in the camera than it is to fix it later. Plus, if you're running or thinking about running an event photography business (which produces a high volume of images), having to spend a lot of time working in Photoshop is time that can be better spent doing other things.

- Light meters. While your camera comes with a built-in light meter, it's not as accurate as a hand-held unit, many of which can also double as flash meters. Light meters are particularly important when you have unusual conditions. Remember, camera light meters are calibrated to roughly 13-18 percent gray. If you're shooting a lighter or darker scene, your camera meter can be thrown off. With a hand-held light meter you can measure the light falling on the scene rather than the light reflected off the scene, a more accurate method under such conditions. Light meters can cost from about \$100 to more than \$1,400. The difference in price reflects things such as digital versus analog technology, and additional capabilities such as being able to measure flash output, and control wireless remotes such as Pocket Wizards.
- Spot meters. These are light meters with a very narrow field of view so you can take readings from a distance. You use this to take several light meter readings of the scene to determine the best overall exposure. Zone System proponents in particular find spot meters useful (the Zone System is a very precise exposure control system made famous by Ansel Adams), but landscape photographers in general like them. Spot meters generally cost between \$300 and \$800 but often you can find a hand-held light meter that has a spot meter attachment (\$100 or more as an add-on accessory) so you don't have to buy both.
- Color meters. Similar to a light meter, but it measures color temperature instead (generally in degrees Kelvin). As long as your camera can accept input in degrees Kelvin, it provides for very accurate color. Color meters cost from \$150 to \$1,400.
- Flash meters. Usually better quality light meters can also trigger flash units (either via PC cord or Pocket Wizard) and read their light output, but if you don't need a multi-purpose light meter or yours doesn't have a flash meter capability, you might consider a flash meter. Flash meters run about \$100 to \$1,300.
- **Gray cards.** Since camera light meters are theoretically calibrated to 18-percent gray (it's actually closer to 13-14 percent gray), using a gray card to help achieve correct exposure and color works fairly well. You hold the gray card under the light your subject is under and activate the camera's light meter. This gives you the best exposure as long as you've got the card under the same light as your subject. You might want to use about one-half stop *more* exposure, because your camera is probably calibrated for a slightly lighter tone. You can also use the gray card to

set your white balance under the camera's custom white balance feature (the method varies from camera to camera so check your owner's manual to see how). These run from \$5 to \$50, but the more expensive versions are usually made from plastic or resin rather than cardboard and may include a color chart or some other color correction tool.

■ Expo Disc. The Expo Disc is a white diffuser-like dome that fits over your camera lens. You point it at your subject area and create an exposure. You then load the image into your custom white balance setting and as long as your lighting conditions don't change, you can then work from that white balance. If your lighting conditions change (or you move to an area with different lighting conditions, such as indoors from the outside or vice versa) then you need to create another Expo Disc exposure. If you're shooting at this location on a repeat basis, you can always use the Expo Disc exposure all over again, but you should be sure the lighting conditions haven't actually changed. Expo Disc prices are based on filter size for your camera and cost from \$70 to \$170.

The Three Qs of Filter Buying: Quality, Quality, Quality

Filters come in two varieties: cheap and fairly expensive. The cheap filters are the ones that you receive for free from your grateful photo dealer, or as part of a "bargain" bundle (which is likely to include a cheap tripod and some other useless gear). You may also *buy* cheap filters for prices of \$5 to about \$20. Bargain-basement filters are not a total waste of money. They make great lens caps. You can smear them with petroleum jelly to create a dreamy soft-focus effect.

But for serious applications, I use serious filters. If you buy a decent one in the first place, you'll have little need to replace it over the next few decades—until you reach a point that you no longer own a lens that fits that particular filter size. Or, if you shoot in sandstorms a lot or your filter

encounters an unidentified flying object, it's possible that the filter will be damaged and need replacement. But, in most cases, spending a few extra dollars to get a good filter will pay off, because your filter will last a long, long, time. If you're interested in experimenting with things like infrared photography, a good IR filter, such as the one shown in Figure 11.2, is essential to achieve effects like you see in Figure 11.3.

Figure 11.2 Infrared photography is one pursuit that absolutely demands the use of a filter.

Here are some things to think about when considering buying filters:

■ Good filters filter what they are supposed to—and nothing else. Filters are intended to *remove* something from the light path, unless they are close-up attachments or clear glass filters designed for "protection" (more on that later). The best filters are made from high-quality glass or resin and should be either completely neutral in color or precisely the exact color they're supposed to be. Inexpensive filters may have a slight color-cast, and may cause unwanted optical effects, such as flare.

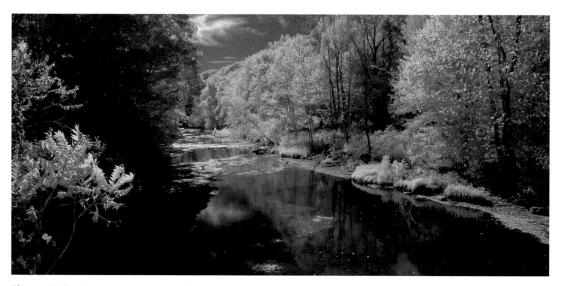

Figure 11.3 High-quality infrared filters aren't cheap, but they can be your gateway to a new outlet for your creativity.

- Glass or gels. Glass is generally better, but there are a couple of ways that glass filters are constructed. The better way is for the glass to be made with the ingredients that give it its effect added while the glass is still molten. The other approach, sandwiching multiple pieces of glass around a colored gel and then fusing the sandwich together makes for cheaper, less durable glass filters. Gels are flimsy; in fact, they're usually used in special mounts at the rear of certain lenses (usually extreme wide-angle lenses or very long telephotos) instead of the front of the lens.
- Larger filters cost more. One type of filter I prefer costs \$35 in a 52mm screw-in mount (that is, the filter has male threads that screw into matching female threads around the perimeter of a camera lens). I use that size on a 105mm macro lens, several 50mm f/1.8 lenses, and some older optics that I still use. Most of my best lenses use a 77mm thread, standardized by the lens manufacturer as a mercy to us cash-strapped photographers. The exact same brand and model filter costs \$85 in the 77mm size. You'll want to keep that in mind when planning your own filter arsenal. If all your lenses use the same size filter (so you don't have to duplicate your set), and that size is modest (say, 62mm or 67mm), you can afford more filters, and will have fewer to carry around.
- Brass or aluminum frame. Circular filters are usually made with either a brass or aluminum frame. In this case there are advantages and disadvantages to each material. Brass is harder, so it's less likely to lock to your lens, but it's also more likely to break a glass filter because it won't absorb shock. Aluminum, on the other hand, isn't as hard as brass, so it's more likely to bind to your lens. It won't transmit shock to the filter as readily though, so it's less likely to cause your filter to crack if it receives a hard tap. I tend to panic at the thought of my lens or filter receiving a "hard tap," so I may be more careful than most, as well as insistent on always having a protective lens hood mounted to my lens.

- Thickness. Another reason I prefer my brass filters (B+W brand, the version made in Germany) is that these particular filters are a bit thinner than any aluminum filters I've used. They can be mounted on fairly wide-angle lenses without the filters themselves intruding into the picture area (as described shortly). You may be able to "stack" several thinner filters together, so you can use more than one at once. (However, not all filters, especially the very thinnest ones, have a front female thread to allow attaching additional filters.) I don't recommend stacking filters, because additional layers of glass will eventually affect your images, no matter how good the filter is, but it's a useful creative option nevertheless.
- Coating. Ideally, a filter will adjust only the photons it is supposed to, and won't add any. But when light strikes the front surface of a filter, it's possible that some of those photons will go awry, and bounce around on their way to the sensor, causing a phenomenon known as *flare*. Flare robs your image of sharpness while reducing contrast. It can cause those little globs of light, distracting "rays," and other visual artifacts that nobody wants (unless they *do* want it, for "effect," and add using an image editor's Lens Flare filter). Fortunately, many filters (and virtually all lenses) receive one or more coating layers that greatly reduce unwanted reflections. More expensive filters usually have the most effective coatings. Coatings can also be used to make an optical surface harder and more scratch resistant, which is one reason why you can carefully clean filters and lenses with the right kind of cloth, tissues, or other tools.
- **Square or round.** Filters can be mounted to your camera several ways. Most common are round filters that screw into the front of your lens; also popular are rectangular filters, like the Cokin System, which slide into an adapter mounted on the front of your lens.

Once you've chosen the brand, type, and size filter you want, there are even more things to watch out for.

- One size does not fit all. Attachments designed with a specific diameter won't fit lenses with other diameters without use of a step-up or step-down ring. For example, to mount a 67mm filter on a lens with a 62mm filter thread, you'd need to use a 62mm-to-67mm adapter ring. Step-up and step-down adapter rings can allow you to use the same filter on multiple lenses with different diameter threads. They have a male thread of one size to screw into a specific lens diameter, and a female thread of a different size to accept a filter of another diameter. These adapters can cost \$10-\$20 and are well worth the cost.
- Vignetting. As I noted earlier, a filter or other add-on may intrude into the picture area, particularly when used with wide-angle lenses, at smaller apertures (which have greater depth-of-field), and when shooting close-ups (which brings the plane of focus closer to the front of the lens). The result is darkened corners.
- Lens/filter conflicts. Some lens barrels *rotate* during focusing (while others use *internal focusing* and may not change length or rotate). This rotation can cause problems when using a filter that needs to be used in a specific orientation, such as a polarizer (which is rotated until the desired degree of reflection-removal is achieved), gradient filters (which have a particular

density and/or color in one portion, and a different density/color in another), and when using certain special effects attachments (such as "kaleidoscope" lenses that change rendition as they are rotated).

■ Lens/lens hood conflicts. If you're using a lens hood that fastens to the filter thread rather than to a bayonet on the lens barrel, certain unpleasantries can occur. One of them is vignetting (described above), which is almost inevitable with wide-angle lenses when you attach the filter first and then screw in the lens hood (which is now moved farther away from the front element of the lens, and potentially visible in the picture area). A lens hood may interfere with your ability to adjust a filter, such as a polarizer or star filter, which must be rotated to the orientation you want. Another drawback of this configuration is that each time you decide to switch filters, you must remove the lens hood first. It's also easy to screw a lens hood into a filter thread too tightly, making it difficult to remove. Some attachments have no matching filter thread on their front rim (polarizers frequently don't) so you have no way of attaching a lens hood in the first place.

Filters to Protect Your Lenses

Do you need to use a filter to protect your lens? I have a definitive answer: yes, no, and maybe. There are three schools of thought when it comes to using filters to help protect your lenses. The first says it's smart to use an inexpensive filter to help protect your expensive glass from dust and scratches. The second says why stick a cheap filter in front of an expensive piece of glass? I subscribe to the third school of thought: I put an *expensive* filter in front of an expensive piece of glass, but virtually always remove it before shooting. Five of my best lenses each have an \$85 B+W UV filter on the front, and, as I mentioned earlier in the chapter, I can snap off the lens cap and shoot a grab shot with the filter in place if I need to. And if an evil wind, misty rain, or a gritty sandstorm is afoot, I can still fire away. (Although, when I am not doing photojournalism, wind, rain, and sand usually are enough to send me packing.) The second and third alternatives don't put much stock in the "protective" qualities of filters, except when shooting under dire environmental conditions.

Each of the three sides' arguments can be persuasive. No matter how careful you are, if you're not using a filter, some dust, mist, or other foreign substances can get on your lens. If you know how to clean your lens properly, that's not a problem. But, if you don't know how to clean a lens, or don't have the proper tools, the more often you have to clean your lenses, the greater the likelihood of leaving cleaning marks or clumsily rubbing off some of the vital multi-coating that helps prevent lens flare. Yet, there are other ways to protect your lens. First off, a good quality lens shade, properly matched to a particular lens, will help protect your expensive glass. Coupled with a lens cap and reasonable care when shooting, you can minimize the risk of dust and accidents.

I suppose it comes down to what your shooting style is like. Are you a careful and deliberate photographer who can take the time to set up each shot and treat your equipment as carefully as possible or are you more frenetic? I'm cautious when I am shooting landscapes, wildlife, and architecture, and almost never need a protective filter under favorable environmental conditions.

As with most controversies, there are pros and cons for each side. You'll find many photographers who have never used a protective filter and who have suffered no mishaps in 30 to 40 years that a lens hood wouldn't counter. A significant percentage of those who are most adamant about using a protective filter have tales of woe about smacking or dropping a lens or two that was "saved" by the filter. I don't know if the non-filter users are more careful and/or lucky, or whether the filter proponents are clumsy, careless, or unfortunate. The real bottom line: if you're convinced you need a filter to protect your lens, you *really* need one. Otherwise, you're sure to have an accident and regret it for the rest of your life.

Here are the relevant pros and cons. First, the no-filter-required arguments:

- No filtering required. It's known that general-purpose UV and skylight filters have no effect in the digital world. However, strongly yellow UV filters, such as a Haze2A or UV17 can reduce chromatic aberration. If you're not using a lens plagued with this defect, you really don't need to be filtering anything. A piece of clear glass (an "optical flat") would provide the same effect—good or bad.
- Varying performance. Lower-quality filters can cause problems with autofocus and can degrade the image. That means if you use a protective filter at all, you should use one of high quality. A \$20 filter might do more harm than good. A very good filter, on the other hand, can cost \$70 to \$100 or more in larger filter sizes (and don't forget you'll need one of these for each and every lens).
- Cost. If you are using a \$1,500 lens, an \$85 filter might make sense to you. But an \$85 filter for a \$180 lens makes little sense. But, oddly enough, that cheap lens might have little quality to spare and would, ironically, benefit more from a pricey filter than the expensive lens that is so sharp you won't notice a little degradation.
- **Softer images.** Adding another element can degrade image quality due to aberrations and flare. Why reduce the quality of every image you take to guard against an accident that may never happen?
- Damage from a broken filter. A badly broken filter can scratch the optical glass element behind it. For every lens "saved" by a protective filter, you may find one that's really been whacked, sufficiently that the filter is cracked, crushed, and the pieces driven into the glass behind it. In some cases, the damage might have been less had the protective filter not been in place.
- Lens hoods provide better protection. I don't use protective filters most of the time, and have never had an accident where one would have helped. However, I've gently bumped the front of my lens up against objects, and my lens hood prevented any damage every time. The insidious thing about filters is that when one is being used, the camera owner may actually be less likely to use a lens hood—which should always be your first line of defense.

And on the other side of the fence:

- Protection from small sharp and blunt objects and falls. If the lens is dropped, the filter may well suffer scratches or breakage instead of the front lens element. Small pointy things can sneak past a lens hood and strike the front of your lens. A lens hood is great at blocking a door that opens unexpectedly, but will not help if the first thing that hits your lens is a doorknob.
- Reduced cleaning. One can clean the filter frequently without having to worry about damaging the lens coatings; a filter scratched by cleaning is much less expensive to replace than a lens. I must admit, though, that this rationale applies most to those who don't know how to clean their lenses properly.
- Makes a good lens cap. I keep mentioning this, because most people tend to forget about this alternative. A protective filter can do its job and still not interfere with image quality. Keep a screw-on filter mounted on your lens at all times—without a lens cap protecting the filter. Then, if an impromptu opportunity for a picture appears without warning, you can flip your camera on (if necessary), sight through your viewfinder, and take a picture. There is no time lost fumbling for the lens cap. If you have more time, *take the filter off.* I usually don't care if one of my "grab" shots with filter in place is not as sharp as it could have been. It's a grab shot, an opportunity that would have been lost entirely.

Polarizing Filters

Polarizing filters are useful in many ways—most of which are impossible to recreate in Photoshop. Light becomes polarized (and therefore susceptible to the effects of a polarizing filter) when it is scattered by passing through a translucent medium. So, light from a clear-blue sky becomes polarized when it passes through the dust-laden atmosphere. Light striking, passing through, and reflecting off water also becomes polarized. The same is true of many other types of objects, including foliage, and the partially transparent paint on an automobile body (think about it: that's why cars need several coats of paint). Nontransparent or translucent objects, like the chrome *trim* on the automobile, aren't transparent, and don't polarize the light. *However*, if the light reflecting from the metal has already been partially polarized (that is, it is reflected skylight), you still might be able to see a reduced amount of glare reduction with a polarizing filter.

How does it work? A polarizer contains what you can think of as a tiny set of parallel louvers that filter out all the light waves except for those vibrating in a direction parallel to the louvers. The polarizer itself consists of two rings; one is attached to the lens, while the outer ring rotates the polarizing glass. This lets you change the angle of the louvers and selectively filter out different light waves. You can rotate the ring until the effect you want is visible. The amount of glare reduction depends heavily on the angle from which you take the photograph, and the amounts of scattered light in the reflections (which is determined by the composition of the subject). Polarizers work best when the sun is low in the sky and at a 90-degree angle from the camera and subject (that is, off to your left or right shoulder). Blue sky and water, which can contain high amounts of scattered light,

can be made darker and more vibrant as glare is reduced. You can also reduce or eliminate reflections from windows and other nonmetallic surfaces.

As you might expect, polarizing filters solve problems and enhance images in several ways. Let's look at them:

- Reduce or eliminate reflections. Polarizing filters can reduce or eliminate reflections in glass, water, lacquer-coated objects, non-conducting surfaces, and plastic. They don't have any effect on reflections on metallic surfaces.
- Increase contrast. A polarizing filter is the only filter that can increase contrast in color imagery by eliminating those pesky reflections.
- Darken pale skies. Polarizing filters block a lot of light (as much as two f/stops), and because the effect is strongest when dealing with polarized light (such as light in the sky), this can help darken pale skies considerably. At the same time, it will also make clouds stand out more strongly, as you can see in Figure 11.4.

When considering a polarizer, there are some important considerations. First off—linear or circular? This one's easy: if you're using an autofocus camera, you want a *circular polarizer*, usually abbreviated CPL. Now, keep in mind, when we're talking about linear and circular, we're not talking about the shape of the filter. All polarizers are furnished in a circular frame for easy rotation. While both types transmit linearly polarized light that is aligned in only one orientation, a circular polarizer has an additional layer that converts the light that remains into circularly polarized light that doesn't confuse the metering and autofocus sensors in digital SLRs.

Figure 11.4
Using polarizing filters can get rid of reflections, increase contrast, and turn pale skies bluer.

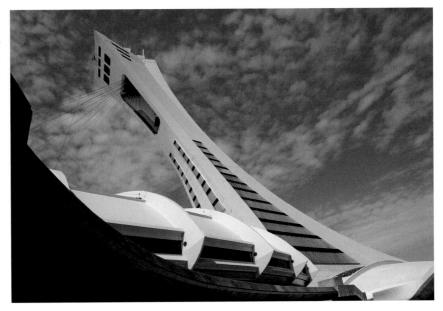

The second thing to watch out for is the use of polarizers with wide-angle lenses. Such filters produce uneven results across the field of view when using lenses wider than the equivalent of about 28mm (which would be a 17-18mm lens on a camera with a 1.5X to 1.6X crop factor). Polarizers work best when the camera is pointed 90 degrees away from the light source, and provides the least effect when the camera is directed 180 degrees from the light source, as when the light source is behind you. The field of view of normal and telephoto lenses is narrow enough that the difference in angle between the light source and your subject is roughly the same across the image field.

But an extra-wide-angle lens may have a field of view of about 90 degrees. It's possible for subjects at one side of the frame to be oriented exactly perpendicular to the light source, while subject matter at the opposite side of the frame will actually face the light source (at a 0-degree angle). Everything in between will have an intermediate angle. In this extreme case, you'll get maximum polarization at one side of your image, and a greatly reduced polarization effect at the opposite edge. Use caution when using a polarizer with a very wide lens. This phenomenon may not even be a consideration for you: many polarizers will intrude into the picture area of wide-angle lenses, causing vignetting, so photographers tend to avoid using them entirely with the very widest lenses.

Neutral Density Filters

There are times when you can have too much light. When reducing ISO and closing down the aperture aren't enough to get the desired shutter speed, you need a neutral density filter to block additional light. ND filters, as they're known, come in a variety of "strengths," and vendors use somewhat confusing nomenclature to define how much of the light is blocked. You'll see neutral density filters from one manufacturer labeled according to something called a *filter factor*, while others, from different vendors, are labeled according to their *optical density*. There are actually no less than *four* variations of naming schemes, all equally cryptic; and even if you understand the difference you still probably won't know which is which, or why.

For example, one of the ND filters I own of a particular value is labeled, by different manufacturers, with the following names: ND8, 8X, ND 0.9, and "Three Stop." All three monikers mean that the filter reduces the amount of illumination by three full f/stops. If the correct exposure were 1/500th second at f/8 without any filter at all, you'd need an exposure of 1/60th second at f/8 with the filter in place. (Or, if your goal were to use a larger f/stop instead, you could shoot at 1/500th second at f/2.8 with the filter attached.) Only the last terminology ("Three Stop") actually explicitly tells you what you want to know.

While you might see stronger or weaker neutral density filters available, the basic ND2, ND4, and ND8 set will handle most situations, because they can be stacked and used together to provide higher light-stopping values. Stacking filters does increase the chances of noticeable image degradation, color shift (because neutral density filters are rarely 100% color-neutral, despite their name), and/or vignetting.

Here are some of the things you can use neutral density filters for:

- Slower shutter speeds. Many digital SLRs have ISO 200 as their lowest ISO setting; others have a minimum of ISO 100, and only a very few go as low as ISO 50. The average lens has f/22 as its smallest f/stop. So, outdoors in bright daylight you may find it impossible to use a shutter speed longer than 1/50th or even 1/100th second. If your mountain stream is not in bright sunlight, it's still unlikely you'll be able to use a shutter speed any longer than about 1/30th to 1/15th second. That's a shame when you have a beautiful waterfall or crashing ocean waves in your viewfinder and want to add a little creative motion blur. An ND8 filter can give you the 1/2 second to several-second exposures you'll need for truly ethereal water effects, as shown in Figure 11.5.
- Larger f/stops. Frequently there is too much light to use the large f/stop you want to apply to reduce depth-of-field. The wide-open f/stop you prefer for selective focus applications might demand shutter speeds of 1/4,000th second or higher. With a 2X or 4X ND filter, the apertures f/2.8 or f/2 are available to you. ND filters are often used to avoid a phenomenon called diffraction, which is the tendency of lenses to provide images that are less sharp at very small f/stops, such as f/22 or f/32. If the shutter speed you want to use calls for such a small f/stop, you can add a neutral density filter and shoot the same image at f/16 or f/11.
- **Split the difference.** If creative or practical needs dictate, you can *split* the effects among all the exposure factors: an ND8 filter's three-stop light-blocking power will let you use a shutter speed that is half as fast, an f/stop that is twice as large, and an ISO setting that is twice as sensitive, all in the same photograph if that's what you want.

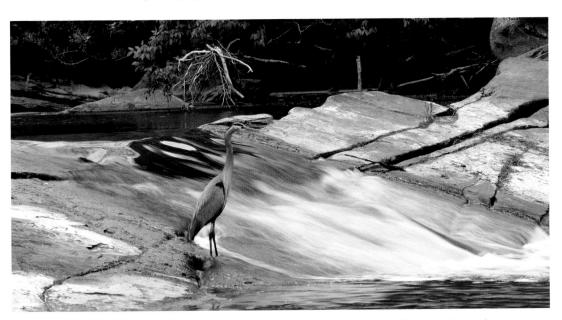

Figure 11.5 Neutral density filters reduce light striking the lens making it possible to use slower shutters speeds and get much longer exposures.

- Countering overwhelming electronic flash. I have several older manual studio flash units that are simply too powerful for *both* my available range of f/stops and ISO settings, even when switched from full power to half power. Newer units generally offer 1/4, 1/8, 1/16, and 1/32 power options and may be continuously variable over that or an even larger range. But lower power may not be the ideal solution. It's common for the color temperature of electronic flashes to change as the power is cranked way down. An ND filter, instead, allows me to shoot flash pictures with these strobes at my camera's lowest ISO setting and apertures larger than f/22, reducing the need to shoot at a lower power setting.
- Vanishing act. Create your own ghost town despite a fully-populated image by using a longer shutter speed. With an ND8 filter and shutter speeds of 15 to 30 seconds, moving vehicular and pedestrian traffic doesn't remain in one place long enough to register in your image. With enough neutral density, you can even make people and things vanish in full daylight.
- **Sky and foreground balance.** A special kind of neutral density—the split ND or graduated ND filter, is a unique tool for landscape photographers. In the average scene, the sky is significantly brighter than the foreground and well beyond the ability of most digital camera sensors to capture detail in both. An ND filter that is dark at the top and clear at the bottom can even out the exposure, restoring the puffy white clouds and clear blue sky to your images. There are other types of split and graduated filters available, as you'll learn from the next section.

Graduated Neutral Density Filters

Graduated neutral density filters are a special type of ND filter, one that's almost indispensable for landscape photography. They are particularly important in digital photography for a couple of reasons. The first is that digital cameras often have trouble capturing high-contrast light. The second is that they can have difficulty recording detail with overcast skies.

Digital imaging sensors have gotten a lot better at handling high contrast light than they were just a few years ago, but they're still not capable of handling typically contrasty conditions you frequently run into when shooting under extreme lighting conditions. That's one reason for the current High Dynamic Range (HDR) photography fad among avid users of image editors and utilities like Adobe Photoshop and Photomatix.

Graduated neutral density filters come in a variety of shapes, sizes, densities, and even area of coverage. These filters are so useful that pro landscape photographers may own a half dozen or more. You can find round ones and square ones, but rectangular ones that are longer than they are wide are the best choice. Here's what you need to know about them:

■ **Soft edge or hard.** You can find these filters transitioning from dark to light ending in either a soft transition to a clear area (as shown top left in Figure 11.6) or ending in a hard transition to clear area (shown at top right in Figure 11.6). The center bottom filter is a split-color filter, discussed in the next section.

Figure 11.6
Graduated neutral density filters can have a soft transition (top left), hardedged transition (top right), or fade from one color to another (bottom).

- Reverse graduated neutral density filters. The typical graduated neutral density filter is darkest at one of the outside edges and gradually gets lighter. The folks at Singh Ray responding to requests from landscape photographers created a filter where the transition moves from clear at the outer edge to darker in the middle of the filter then back to clear at the other edge. This filter is a good choice for sunset and sunrise photography when the brightest part of the image is the sun right on the horizon with the foreground and sky both being darker than the center of the image.
- Cost range. GNDs, as they're known, can vary greatly in price from \$22 for smallish resin versions to upwards of \$150 for high-quality glass versions. This is a case where you get what you pay for and if your budget allows for it, a good quality glass version will do a better job. Still, it's better to have and use a GND, even a resin one, than it is to not use one.
- Filter length. The most versatile GNDs are rectangular and longer than they are wide. These can be shifted up and down in the filter holder to best match up the effect with the portion of the sky that needs holding back.
- **Software approaches.** It's possible to simulate the effect of a GND in image-editing programs, some of which even have a specific software filter to mimic the effect. The problem is you're dealing with overexposed highlight areas where no information has been recorded by the imaging sensor. These software approaches will darken a too-bright area, but won't restore any detail (clouds that might have been recorded) because there is no record of it.

Here's a quick summary of the things you need to know to use a graduated neutral density filter or split-density filter:

- Choose your strength. Some vendors offer graduated/split ND filters in various strengths, so you can choose the amount of darkening you want to apply. This capability can be helpful, especially when shooting landscapes, like the one shown in Figure 11.7, because some skies are simply brighter than others. Use an ND2 or ND4 (or 0.3 or 0.6) filter for most applications.
- **Don't tilt.** The transition in the filter should match the transition between foreground and background, so you'll want to avoid tilting the camera—unless you also rotate the filter slightly to match.
- Watch the location of your horizons. The ND effect is more sharply defined with a split ND filter than with a graduated version, but you need to watch your horizons in both cases if you want to avoid darkening some of the foreground. That may mean that you have to place the "boundary" in the middle of the photograph to properly separate the sky and foreground. Crop the picture later in your image editor to arrive at a better composition.
- Watch the shape of your horizons. A horizon that's not broken by trees, mountains, buildings, or other non-sky shapes will allow darkening the upper half of the image more smoothly. That makes seascapes a perfect application for this kind of neutral density filter. However, you can use these filters with many other types of scenes as long as the darkening effect isn't too obvious. That makes a graduated ND filter a more versatile choice, because the neutral density effect diminishes at the middle of the image.

Color Control and Special Effects Filters

Sometimes you want color with just a little more oomph, and sometimes you want color that should be there, but isn't. Fortunately, there's a whole class of filters designed to help with those problems.

While you can certainly tweak image colors in an image-editing program such as Photoshop, it's still frequently easier to get the effect you want out in the field by using a filter. The advantage to this is you are in a position to check the result either via your camera's LCD screen or through a portable hard drive/view or laptop computer. This approach gives you the chance to try again if the resulting effect isn't to your liking. If you wait until you get home, you may not be able to get the effect you want on your computer and then, you're stuck.

Here are some of the choices available:

■ Intensifiers. Sold under several different names (intensifiers, enhancers, Didymium filters), they serve to intensify just one or two colors while not affecting any others. A "redhancer" for instance, will make the reds in a scene stronger without influencing any other colors. These filters can be useful for landscape or fall foliage photos. There are a wide variety of these filters on the market (one camera store lists 10 different versions in the 77mm size alone).

- Split color. These filters follow the same approach as split-graduated neutral density filters except they're not neutral and are more concerned with adding a color-cast than blocking light (although the darker part of the filter will rob you of some light). These filters are useful for changing the color of the sky while leaving the foreground unaffected. Sepia, tobacco, and orange versions of this filter are popular (a certain cable TV channel seems to use them for all their documentaries) but they are also available in other colors such as blue, green, red, brown, and yellow. One such filter is shown at the bottom in Figure 11.6. They may have a transition from one color, such as amber, brown, red, cyan, or blue, to clear, or from one color to another contrasting hue. For example, filters that have a ruddy sunset glow on one half, and a blue tone on the other can simulate sunrise or sunset effects, or simply add an interesting color scheme, as in Figure 11.7. There are dozens of graduated filters available to provide the looks you want. Because the density in these filters can cancel out overly bright portions of the image and bring those areas within the dynamic range of your sensor, the effects you get with graduated/split filters can be superior to the same treatments applied in an image editor.
- Sunrise/sunset filters. While it's possible to use an orange or red split color filter to get a sunset/sunrise like result, such an image rings a bit hollow because while the sky looks like it was shot when the sun was low in the sky, the foreground doesn't. For years photographers would use a rectangular filter holder and position a stronger color filter in the top half of the holder and a weaker version upside down in the bottom half to create a more realistic sunset/sunrise image. Cokin eventually came up with a sunrise/sunset filter that gradually transitions from a light orange to a darker orange so you only have to carry one filter for that effect these days.

Special Effects Filters

Special effects filters can do a variety of things from creating star-like effects to double images to multi-color images and more. While some of these effects can be created in software, some can't, and as always, there are certain advantages to achieving an effect in the field where you can make adjustments to exposure and camera positioning if need be.

- Cross screen filter. This filter, sometimes called a star filter, gives light sources a star-like effect. You can achieve a similar result by stretching a black nylon stocking over a lens or holding a piece of window screening in front of the lens. (See Figure 11.8.)
- **Soft FX filter.** Helps soften small blemishes and wrinkles without degrading other elements of the photo.
- **Split field filter.** This filter is half diopter, half clear. It's used in situations where you want to have a close-up element and a distant element and need both to be in focus.

Figure 11.7 A variety of filters, like the split color filter used for this shot, exist to help you make colors more intense or get Mother Nature to cooperate with your photographic needs.

- Radial zoom filter. A clear center spot doesn't affect your subject in the center, while everything else in the frame is turned into a zoom effect.
- Multi-image filter. Takes whatever's in the center of the frame and creates multiple versions of it. There are 5, 7, 13, and 25 models, which multiply the subject by the number of the filter.
- Rainbow filter. Puts a rainbow into your image. While it's an interesting idea, it seems to be very difficult to get a natural-looking effect with this filter.
- Mirage filter. Creates a reflection of your subject similar to a reflecting pool.

Figure 11.8 A star/cross-screen filter effect.

Part III Expand Your Shooting World

If you ignore (for the moment) the cost of airfare to your destination, the other costs for an overseas trip (food, transportation, admissions, hotels, misc.) can be remarkably affordable. I once spent a full week in Toledo, Spain, photographing that city's ancient treasures for a total expenditure of \$600. Another time, I spent two weeks in Europe for \$1,200, about half of that spent on transportation because I rented a car and paid the equivalent of \$5.60 a gallon for diesel fuel. Last year, it was nine days for \$965, for all expenses. All these, as I noted, don't include airfare.

If you do as I do, and pay many routine expenses (groceries, gasoline, utility payments) with a credit card that grants airline mileage points for every dollar spent, it's easy to pick up one free round-trip overseas plane ticket per year (but, if you are able to pay fewer bills with your credit card, most can manage a free trip every two years, tops). If you *have* to pay for a plane ticket, it usually adds to the price of your photo expedition around \$600–\$1,000 (and up, depending on where you live, and where you are going).

How do you get into travel photography on the cheap? Just follow these tips.

- Travel like a native, not like an American. In Europe, I stay in the same hotels and eat in the same restaurants Europeans do, while my fellow Americans are often sequestered at the Hilton. Public transportation is far better than we have in the United States, easy to understand, fast, and cheap. While Americans are eating in touristy restaurants, I am dining on much better food a couple blocks away at one-quarter the price.
- Avoid tours. I stay away from the packaged tours; I'm visiting to take pictures, not simply to be shown the sights by bored locals. A two-week, \$4,000 (per person) guided tour can cost you half or one third as much if you're willing to spend a little time on Google discovering the major things of interest in the places you want to visit—or even to determine what those places are. I do use Orbitz to pick up non-guided packages, such as airfare/car rental (a week in Ireland for \$500 was nice!) or sometimes airfare/hotel when I'm staying put and don't want to choose my own lodging.

Certainly there is a place for guided tours with one-day-per-city itineraries, especially if a trip to Europe is a once-in-a-lifetime event for you. But you can transform that single visit into three or four, for the same cost, if you choose to visit Europe like the Europeans do.

■ Don't worry about language barriers. Guides make their money based on your belief that you need someone who "speaks the language." Tourism is big business in most countries these days, and anyone you encounter in hotels, restaurants, or on the street will have vast experience in dealing with English speakers. Indeed, I found a recent trip to Barcelona very frustrating, because it was almost impossible to use my college Spanish, generally because the natives I dealt with had learned that speaking to Americans in English helps avoid confusion. So, in a restaurant I'd order "pollo asado con patatas bravas y un agua mineral sin gas," and the server would repeat back, "chicken and fries and a bottle of water, right?" The situation was much the same during visits to Vienna, Krakow, Budapest, Paris, and Brussels. I had more difficulty being understood in Ireland than in Prague.

- Choose your hotels carefully. When I searched travel websites for hotels for a trip to Valencia, even the "cheap" and "special deals" hotels were ridiculously expensive (usually a couple hundred dollars a night) and located in the business and commercial centers, or on the beach, none of which had anything I wanted to photograph. Instead, I researched further and stayed in a quiet, tiny 18-room hotel nestled deep in the cobblestoned spider web streets of the ancient quarter of the city, within a hundred yards of the cathedral. Although the hotel's 18th century building was older than the USA, it was freshly remodeled, had air-conditioning, Wi-Fi, and a friendly family-run staff. My cost? \$66 a night.
- Eat right. Enjoying—and photographing—the local food while you travel is part of the fun. But keep in mind that those restaurants near the tourist attractions don't have to please you, because they don't depend on repeat business. In Valencia, the "Menu of the Day" offerings are usually the cheapest way to have a tasty meal at any restaurant, but I found that the tourist traps were charging 20 to 25 Euros for these meals (\$29 to \$37 at the time, which is not really out of line for a good dinner anywhere). But I found better food and service at the restaurants favored by Valencians, at 10 Euros (\$14.88). I even found a *buffet libre* that let me sample a variety of dishes for 8.95 Euros.

In countries like Thailand, Cambodia, and Vietnam, excellent food costs so little that some city apartments for residents of those countries don't even include a traditional kitchen. Eating out, inexpensively, is a way of life. You can even kill three birds with one stone by signing up for a cooking lesson offered in major cities in many different countries. You'll eat well, learn how to prepare an exotic new dish or two, and discover some excellent photo opportunities, (See Figure 12.1.)

Figure 12.1
When visiting a new locale, take a one-day class, learn something new, and find photo opportunities!

- Travel right. In Asia and parts of South America and Africa, tuk-tuks (a kind of three-wheeled auto rickshaw) afford much better photographic perspectives than taxis—if you're traveling with no more than two companions. Because they are only partially enclosed, you will be able to take photos as you pass through crowded streets.
 - In Europe, self-driving is an option—albeit an expensive one considering the price of fuel. On my last trip, I paid the equivalent of \$5.60 a gallon. But, it was worth it to be able to spend a week driving through the mountains and along the Mediterranean coast, stopping and photographing anywhere I pleased. Car rental/fuel ended up accounting for about half my costs on that trip. But if you really want to get to know a destination, you'll stay put in one spot for a few days, using your feet or local transportation to explore photo opportunities. Bus routes will take you from village to village with ease and comfort, and at very low cost. For one recent trip, I traveled from Madrid to Valencia by high-speed rail, and used a double-decker tourist ("hopon/hop-off") bus the first two days I was there (\$13 a day) to get an overview of the city. The bus had two completely different routes ("historic" and "maritime") and I was able to get on and off at any point, explore a particular area on foot completely, and then catch the next bus, which arrived at 30 minute intervals. Although in Europe most of the places of interest will be in the old town quarters, larger cities have efficient subways and bus systems. I used "10-trip" and "bonobus" passes to move through Madrid and Valencia effortlessly.
- Mix it up. Riding local transportation, staying in modest hotels, and eating in restaurants favored by the natives means you'll be shoulder-to-shoulder with the people who really know the city best. As I said earlier, language is no barrier. I speak enough Spanish and French to amuse the Spaniards and annoy the French, can read and sometimes understand Italian, and struggle along with English, but have never had any problems communicating—even in the Czech Republic. Those Europeans who are not multi-lingual still have lots of experience dealing with those from other lands, and are eager for the chance to show off their countries.
 - Some of the best travel/photo tips I've gotten have come from the people who live in the countries I visit. One recent October I signed up for some classes at a college in Salamanca, Spain, and the instructors there were a treasure trove of information about what to see and where to take pictures.

What to Take

Travel photography is no more equipment- or gadget-intensive than ordinary scenic or architectural photography. If anything, it is less so, because, if you're traveling by air, you'll probably want to travel light. Fortunately, you can take some great pictures with only basic equipment. I expand my kit only for domestic trips where I want to experiment with new techniques, new gadgets/cameras, and interesting lenses. This section will introduce you to my recommendations for both types of kits.

My "Domestic" Kit

At one end of the spectrum is the "basic" equipment I tote along when I am traveling to my destination by car. Last winter's weather was particularly nasty in my Midwest base of operations, so I loaded up my vehicle and took refuge in the Florida Keys for a month to photograph Key deer, pelicans, and the fascinating denizens of Key West. My goal was to familiarize myself with some new equipment, and work on techniques I'd been trying to perfect. This section will be brief, and chiefly to compare a "bulk and weight is no object" collection with my more manageable "Air Travel" kit. The gear I took included the following tools:

- Several cameras. While one good camera and a backup of some sort is essential for any trip, an excursion by motor vehicle allows taking along several cameras. I equipped myself with my (current) favorite 16MP camera and a second high-resolution model for landscapes. I also packed a third camera, a dSLR that had been permanently converted to infrared operation, allowing me to experiment with photos like the IR image shown in Figure 12.2.
- More lenses than I really needed. Because size/weight was not a concern, I took along all the lenses that I *thought* I might need. I ended up doing some tabletop product photography during the trip, and the mid-range zoom proved to be amazingly good as a "macro" lens. I also took along a 500mm f/8 telephoto, a 16-35mm f/4 zoom, a 15mm f/2.8 fisheye, and a Lensbaby "distortion" optic. You'll find descriptions of what each of these types of lenses can do for you earlier in Chapter 6.
- Full-size tripod and monopod. The wildlife photography I planned called for a sturdy full-size carbon fiber tripod and a monopod, both with versatile ballheads. They fit nicely in the trunk of my car, along with a swiveling collapsible camp stool I could sit on while awaiting my prey.
- Upgraded computer. I always take a laptop or ultrabook on trips, but for driving excursions I often add a 24-inch LED monitor that disassembles into a compact screen/base package. I also took along a full-size keyboard and mouse, and several 2TB USB 3.0 hard drives. I was able to view and edit my images on two screens (the monitor and the laptop's LCD) just as if I were using my desktop in my office.

My Air Travel Kit

Of course, most of my travel is by air. Experienced air travelers will tell you one thing: Travel light, because once you leave home, everything you take will have to be carried with you everywhere you go. You'll want to take everything you absolutely need, but *nothing* else. I didn't always believe this, especially when venturing some place I'd never been before, eager to capture every possible detail with every possible piece of equipment I owned. I'll never do that again. Since I tend to be at the extreme end of the travel-light spectrum, I'm going to show you exactly what I take on a typical 7-to-14-day overseas trip, and then explain some more realistic options for normal people.

Figure 12.2 A quiet lake, given a blue cast through the magic of infrared photography.

Here are the core items I carry with me:

- Main carry-on. Most airlines allow you a main carry-on suitcase, plus one smaller "personal" item. (Check before you go; not all adhere to this allowance.) My "main" bag is a rather small backpack with wheels and a handle. The only thing that goes inside the backpack is my camera bag and all my equipment. There's method to the madness. The rolling backpack can be used to wheel itself (with my camera bag inside) and the "personal item" around the airports, trains, or other means of transportation until I reach my first hotel. Then the camera bag comes out, the clothing is rinsed out and dried wrinkle-free, and then toted around in the backpack for the rest of the trip. A single carry-on item becomes two pieces once I've arrived.
- **Personal carry-on item.** This may be a laptop case, large purse, briefcase, or similar. Mine is a compact 16 × 12 × 5 inch tote bag into which I squeeze my most important items, including a Gitzo Traveler tripod, and all clothing that I won't be wearing onto the plane (generally three pairs of slacks, three shirts, underwear, socks) plus toiletries. The clothing is mix-and-match (one pair of slacks has zip-off legs, turning it into a pair of shorts) and squeezed down to an amazingly compact size using those vacuum-seal travel bags. ScotteVest (www.scottevest.com) supplies much of my travel apparel, including the vest and jacket I wear on the plane (both supplied with plentiful pockets for an iPad, travel documents, etc.).
- Camera bag. I use several different camera bags, depending on the length of my trip and how many locations I will be visiting. I tend to favor backpacks and sling bags, but can use a shoulder bag if I know I won't need to set down my bag often in locations where it might "wander" off.
- Main camera. Although I don't find a heavy "pro" camera objectionable most of the time, when I am traveling light, I prefer a smaller camera, because it's going to be around my neck all day long. That makes a mirrorless camera perfect. I once carried a top-of-the-line pro dSLR camera around Barcelona for a week, and it felt like a boat anchor.
- Backup camera. It's really embarrassing to come home with no pictures or fewer pictures because your camera failed. That's never *happened* to me, but, considering that most of my trips are not as a tourist but as a photographer who is there specifically to shoot pictures, I want a backup. My most frequent traveling companion uses the same camera system I do, so I can "borrow" her camera if I need to. She serves as my second shooter, anyway, wandering off to grab pictures of interesting subjects while I concentrate on my primary subject. However, I travel alone quite frequently, and when I do I either take a second camera body that uses the same lenses (and it may spend most of the trip in the hotel room's safe), or a pocket-sized camera. Fortunately for us travelers, camera manufacturers are meeting pressure for smaller and smaller cameras by introducing even smaller models. Figure 12.3 shows a dSLR-like mirrorless camera at left that compares somewhat favorably to the super-compact model from the same vendor shown next to it. It's a bit taller and thicker, and its lens is larger, but the compact version is small enough to make an excellent backup—or main—camera.

Figure 12.3 Use a backup camera for emergencies, or when you want to leave your main camera back in the hotel, and as a second camera, say, for shooting wide-angle shots when you have a telephoto mounted on your main camera.

■ Two or three lenses. I usually take just two primary lenses, and shoot almost everything with those. If I am using a full-frame camera, those two lenses are almost always a 24-70mm zoom and any one of several longer full-frame telephoto zooms, both with image stabilization. I use the fast wide-angle zoom for more than half my shots, as it's suitable for architecture, available light street scenes at night, interiors, and even close-ups. The tele zoom comes in handy when I need longer focal lengths. I use it for a lot of street photography, as it allows me to shoot people discreetly at a distance using a focal length of 200mm and, at that focal length and an f/8 aperture, I can get sharp images and selective focus to isolate my subjects.

If I'm using a cropped sensor camera, I substitute a 12-40mm f/4 zoom for the full-frame wide angle. No matter what type of camera I am using, I often throw in a "fun" lens, either a 15mm f/2.8 fisheye (for a full-frame camera) or 10-17mm f/3.5-4.5 fisheye zoom for a cropped sensor camera.

■ More memory cards than I need. I take a minimum of five 32GB memory cards, and, if my trip will be for longer than a week, I tote along my "old" arsenal of five 16GB and five 8GB cards. (Each time I upgrade to the next largest size, I retain the old cards as backups.)

The lesson here is that *every* piece of equipment must justify being packed for your trip, based on exactly how much you can comfortably carry. At one extreme, there is a trip taken by motor home or a roomy vehicle with enough space to hold everything you want to carry, as I did on my trip to the Keys. At the other extreme are hiking or bicycle journeys when every ounce must be carried on your back or saddlebags the whole way. In the middle are trips by plane, bus, or other transport that require you to schlep everything into each hotel, then out again when you move on. No matter how you travel, you won't want to take along some gadget or accessory that you never really use.

Other than your camera, lenses, memory cards, and, probably, a tripod or monopod (preferably a small carbon-fiber model that collapses down to a small size), what else do you need to take? Here are some suggestions:

- Battery charger with adapters. Unless your camera takes easily found batteries, such as AA cells (not many models do), you'll need to take along your charger and, if you're traveling outside your home country, an adapter that will let you plug your charger into local electrical outlets. Most newer chargers are the universal type that work with both 110 and 220 volts, but their plugs might not fit the sockets overseas. If your adapter is not a universal type, you'll need a current converter, as well. Take some socket converters so your plugs will fit in the sockets of the countries you visit.
- Plastic bags. Take plastic bags with you everywhere, even when you're not planning to shoot photos. You can buy foods or snacks, dump the packaging, and carry your equipment around in the plastic bags. The bags can protect your equipment from humid climes or help you separate exposed from unexposed memory cards. (Write EXPOSED on one of the clear bags.) A gallon-sized clear bag makes a good raincoat for your camera. Cut a hole in it and you can take pictures even if it's wet outside.
- Camera bag. I happen to own a LowePro bag that holds two camera bodies and six or seven lenses, plus all the filters and other accessories I need. I usually take everything with me when I am traveling close to home, because you never know when you might need that infrared filter. On longer trips when I am traveling lighter, the large bag stays at home and I use one of several
 - smaller bags, each sized to take only the equipment that is going with me. All I care about are a few resizable compartments so I can stow each item individually, without needing separate cases for them, or worrying that they will dent each other as I move around. A sturdy strap, the ability to open the bag quickly, and surefire protection from the elements are also important. It doesn't matter whether your bag is a backpack, belt pack, chest bag, or shoulder bag. Use what feels comfortable to you. An all-weather cover, like the one shown in Figure 12.4, proved invaluable one day I spent shooting in Prague in a drenching downpour.

Figure 12.4 A camera bag with an all-weather cover can be invaluable to protect your gear against rain, snow, or sand.

■ Other stuff. I usually find room in even the smallest bag for a cleaning cloth, a Giottos Rocket blower for removing dust from the camera or sensor, a Carson Mini-Brite illuminated magnifier for *finding* the dust, one of those plastic rain ponchos that fold down to the size of a pack of playing cards (I got mine on *The Maid of the Mist*), and maybe a roll of gaffer tape. You never know when you might need to tape something down or up, or otherwise require gaffing. While your camera's self-timer can help prevent user-induced camera shake when shooting long exposures off a tripod, an infrared or wired remote release is also handy to have.

MY FAVORITE GADGET COSTS \$69

Although it's not a photographic gadget, the best value, ounce for ounce, of any device I tote along with me overseas is a \$69 phone from Mobal Communications (www.mobal.com). I found it even more useful than my Garmin GPS, which did well with the winding European streets, but had problems pronouncing names like *Staromestské námestí*. But even if you have a GSM phone that works in Europe and are willing to purchase a SIM card when you arrive, the Mobal phone is better.

It's a fairly full-featured Samsung 3G phone, with all the useful apps you might expect. You buy (*not* lease or rent) this phone for \$69, and then own it (and your international phone number) for life. You never pay another penny, other than for the calls you actually make, which cost \$1.95 or so per minute. It works in more than 190 countries, including the USA. At the time I wrote this a more basic \$29 model was also available, and you could upgrade to a \$199 Android smartphone.

My "second shooter" and I used these phones to keep in touch as we wandered around separately, called back to the United States once or twice a day for updates, and used them to confirm reservations locally. Totally invaluable. Certainly, you can buy a SIM card for your current GSM phone in Europe, but you may need a different one for each country you visit (your incoming phone number *changes* each time you plug in a new card), and these cards expire. The Mobal SIM card never expires, and works in every country you visit. (So far, we've used ours in France, Holland, Belgium, Ireland, Spain, Austria, Poland, the Czech Republic, Thailand, Cambodia, and Vietnam.) There are no monthly charges or minimums. When you get back home, throw the Mobal in a drawer and take it out again the next time you travel. If you really want to use your current phone, Mobal will sell you a SIM card for your unlocked GSM phone (assuming it uses the right frequencies for the country you visit) for \$9. I think it's easier to just buy their phone.

The Backup Question

Earlier, I mentioned I always have a backup camera available should I run into an equipment problem, and I take along many, many memory cards. (I took twenty 32GB cards to the Keys for a month, and that proved to be a bit of overkill.) But that backup isn't sufficient when you're traveling far from home. The number of memory cards you have on hand is rarely a limitation when shooting close to home. Most of us own enough cards to shoot all the pictures we care to until we get a chance to download them to our computers. Unless I am immersed in a major project, I rarely shoot more than 1,000 pictures in a single day and can fit all those photos on a few memory cards. The picture changes dramatically once you leave home with no chance to return to your personal computer for a few days or a few weeks. You'll find your memory cards fill up faster than Yankee Stadium on Bat Day. So, what do you do?

Here are a few possibilities:

- Take a laptop. If you have a laptop computer and want to lug it around on a trip, you can tote it with you and download your photos to its hard drive at the end of a shooting session. I don't know about you, but I sit in front of a computer all day, and when I travel for fun, the last thing I want to carry with me is a computer. If you are insane enough to want to take the computer anyway, it makes a sensible choice for moving your photos from your camera. You can copy them to your laptop's hard drive, burn the pictures onto a DVD, maybe mail them home so that you'll still have your pictures even if your laptop's hard drive crashes, you lose it, or it's stolen.
- Take an ultrabook/netbook. I haven't taken my full-size laptop overseas in ages. But I do sometimes take along a compact MacBook Air ultrabook, or old Asus netbook that serves the same purpose. Like a laptop, an ultrabook/netbook has built-in Wi-Fi capabilities (and Wi-Fi is ubiquitous overseas), and a built-in hard-drive (of the solid-state persuasion in the MacBook Air). There's no built-in DVD burner, but you can attach a tiny hard drive the size of a deck of cards and have a second or third backup of your memory cards' content. (See Figure 12.5.) You can also use the computer's keyboard for e-mail or even editing documents or images. To be honest, since I got my iPad (see Chapter 10), I don't always carry the MacBook Air. With Apple's camera connection kit, I can copy memory cards to the iPad's 64GB of storage space if I need to.
- Take a portable storage device. A lightweight, battery-operated standalone personal storage device (PSD) might be easier to carry with you than a laptop, although, with the advent of ultrabooks, these devices have fallen from favor. They have built-in readers for memory cards; some have screens for viewing images, and they are very, very fast in transferring photos. The chief disadvantage is that the average PSD costs as much or more as an ultrabook or netbook, but are still two-thirds the size of their more full-featured rivals.

Figure 12.5
Ultrabooks can be used for backup—
plus you can send e-mail and surf the web from a Wi-Fi hotspot.

- Visit a hot spot. It's difficult to find a city of any size that doesn't have a free Wi-Fi hot spot or cyber café nearby. An increasing number of hotels offer Wi-Fi and/or a computer guests can use, even if it means a trip to the lobby. On my last trip overseas, virtually every city of any size had a McDonald's with free Wi-Fi, too (and this was in Europe). The first thing I noticed while spending two weeks in Salamanca was the large number of young people clustered on the steps of a building across a narrow street from a McDonald's—they were all taking advantage of the free Wi-Fi service.
- Use a camera with dual card slots. An increasing number of cameras offer two memory card slots. This is the solution I favor above all others. I typically carry enough memory cards that I can shoot an entire trip on one set of cards, and still have enough cards left over to copy all (or most) of my pictures over to a spare card. I may come home with three copies of each image: one on the original memory card, one on a backup card, and one on my portable hard drive or iPad.

Tips for Getting Great Travel Images

While most of what you learn elsewhere in this book about getting great photographs also applies to travel photography, here are some additional things to keep in mind as you rove about, camera in hand. If you follow these guidelines, you can come home with some magnificent pictures. Here are some tips:

- Think like a movie director. You're telling a story with your travel photography, just as a movie director spins a yarn on the big screen. Use an overall photograph of a scene or city (an "establishing shot" in movie parlance) to establish the location and mood. Then capture some images at medium range, and finish off with close-ups that concentrate on local color and life. For example, if you're charmed by a particular square in a European town, you might grab an overall shot, at night, when there are few people about, as in Figure 12.6. During the day, you could grab an image of some interesting architectural details (see Figure 12.7), before zeroing in on some street photography close-ups that show how older cultural ways have remained (see Figure 12.8) even as newer trends impinge (see Figure 12.9). All these images were captured in Old Town Square (Staroměstské náměstí) in Prague.
- Shoot details. The biggest mistake neophyte photographers make is not getting close enough. You're a veteran shooter, so you'll want to get in close and capture details that really show the differences in culture. Sometimes, the best way to picture a building or other memorable sight is to capture individual snippets of its design. Indeed, parts of some buildings or monuments may be more interesting than the structure as a whole. Doorways, entrances, roofs, and decorations all make interesting photographs. Best of all, you can often use a telephoto or normal lens to capture details. I thought the glass sculpture in Figure 12.10 was interesting, and you probably wouldn't have guessed that the image is an extreme close-up of just part of the work.

Figure 12.6 Set the stage for your travel story with an establishing shot.

Figure 12.7
Capture some images from a medium distance to show the character of the place.

In other situations, a detail may tell a little story about the structure you're photographing. The gaping holes and crumbling stones you might capture in a shot of a wall of a crumbling castle weave a tale of assaults, sieges, and Medieval warfare, even if the destruction happens to have been caused by natural erosion rather than combat. Cobblestones worn by the incessant pounding of human feet, weathered siding on an old barn, or even the shiny perfection of a slick new glass office tower can express ideas better than any caption.

■ Stop to smell the roses—and view the scenery. Scenic photography is sometimes problematic in a travel environment, because there is sometimes a need to meet your schedule and get on to the next city. If traveling by car, you might pull over, gawk at an impressive lake or mountain vista, then hurry to get back into the car and move on after taking a few pictures. You certainly don't have the time to maneuver to the perfect position, or to stick around until sunset so you can capture the waning light of day. When day wanes, you need to be checked into your hotel room! Travel with a tour group in a bus is likely to be even more hurried.

So, you'll have to make a special effort to stop and smell the roses or, at least, take their photo. You may never pass this way again, so take the time to scope out your scenic view, find the best angle, and shoot it first. That way, if you're forced to move on you'll at least have a good basic shot. Then, take the remaining time to look for new angles and approaches. Use a wide angle to emphasize the foreground, or a telephoto to pull in a distant scene. (See Figure 12.11.)

Figure 12.8 Then concentrate on details that show how cultural elements survive...

Figure 12.9 ...even as their replacements become more popular.

Figure 12.10 You'd never guess this was blown glass sculpture.

Figure 12.11
Even when traveling between big cities, you may spot a scenic image to capture.

Photographing People

Some of my favorite types of travel photography are street photos, taken of people going about their daily lives. People can be among the most interesting subjects of your travel photographs, especially if you've traveled to a foreign land where clothing, cultures, or even the packaging of common products that people use, like soft drinks or candy bars, can be different from what we are used to. Your photographs of people can evoke the lifestyles, working environment, and culture or in the act of working on their crafts, as shown in Figure 12.12, or simply going about their daily lives, as in Figure 12.13.

Figure 12.12 Artisans, like this metalworker, make excellent subjects.

Figure 12.13 Capture ordinary people in their daily lives for some special memories of your visit.

There are a few things to keep in mind when photographing people during your travels.

- Don't gawk. I once watched a group of camera-toting foreign visitors in a California supermarket giggling and snapping picture after picture of an American woman doing her shopping while wearing a full set of immense hair curlers. The tourists thought she was very amusing, but the poor woman was rightly annoyed. She was out about her business and was not an exhibit on display for the enjoyment of travelers from another country where, apparently, curlers are not so casually worn outside the home. As exotic as the folks from a country where you are a guest may appear to you, they aren't circus performers, and you should treat them with respect. The fellow dressed in his tribe's native costume in Figure 12.14 was pleased to be photographed—those weren't his everyday clothes, and he was proud of his heritage.
- Ask permission. In the same vein, it's good to ask permission to shoot, even if you only nod your head in the person's direction before taking the picture to see if they smile or glower. That approach works even when there is a language barrier, because photography and taking pictures is a universal language. Once you've gotten the okay, suggest, even if only by gesture, that your subject resume their normal activities so your photos will look natural. When photographing children, you should always ask their parents first, as I did for the photo shown in Figure 12.15.
- Offer thanks after shooting. Let them know how much you appreciate the favor. If your subject is interested, you can show him or her the results of your shooting on your camera's LCD. You can offer to mail a print or e-mail the photo, if appropriate. When photographing street musicians and other performers, it's only polite to leave them a tip in exchange for capturing their art in a photo.
- Be aware of taboos and legal restrictions. Some cultures frown on photographic images of people. Photographing women (or even a man asking a woman for permission to shoot) can cause problems. You may get into trouble photographing soldiers, military installations, airports, or even some public buildings. Try to learn about these restrictions in advance, if you can.

Figure 12.14 This fellow was there to be photographed, and happy to oblige, as long as he was treated with respect.

Figure 12.15 When photographing children, always ask their parents' permission.

Photographing Monuments and Architecture

Every place you visit, whether overseas or in the good old USA, has sights that you absolutely *must* capture, if only to prove you've been there. Perhaps you need to grab a good shot of a city's skyline (see Figure 12.16) or, if you must, the Eiffel Tower. Photographic monuments, castles, ancient places of worship, ruins, and other sights can be rewarding and exciting. Some of the most dramatic architectural photos are taken at night, so you'll want a camera capable of long time exposures without excessive noise. A time exposure setting, useful for the infamous "painting with light" technique (described in Chapter 7) is another important capability.

Lens selection is especially important when shooting this type of subject. For many scenes, you'll need a wide-angle lens and, up to a point, the wider the better.

Figure 12.16 A city skyline is a traditional—and worthy—photographic subject.

There are several reasons for needing a wide lens or zoom setting:

- Emphasis. Wide angles help you include foreground details, such as landscaping, that are frequently an important part of an architectural shot, or to provide extra emphasis to that foreground. The street leading to the palace in the background wasn't nearly as wide and long as it appears in Figure 12.17. A wide-angle lens exaggerated the foreground.
- Interiors. For interior shots, you'll need a wide setting to capture most rooms or spaces. Unless you're shooting inside a domed stadium, cathedral, or other large open space, you'll find yourself with your back to the wall sooner or later. A wide-angle lens helps you picture more of a room in one image. Figure 12.18 shows a cistern in a home designed by *modernisme* architect Antoni Gaudí. Grabbing this shot called for an ultra-wide 16mm zoom lens setting (on a full-frame camera).
- Exteriors. Exterior photos often require a wide-angle setting for the same reason. The structure you're shooting is surrounded by other buildings, and you can back up only so far. A wide angle is required to grab an image from the best (or only available) vantage point. For Figure 12.19, there was literally only one place I could stand to capture the "crooked house" framed by the archway of the village gate in Albarracín, Spain. The shot required a wide-angle lens, a tripod to allow precise positioning of the camera, and a good deal of patience while I waited for a break in the passersby who were strolling through the gate and up the streets.

Figure 12.17
The wide-angle perspective emphasized the foreground in this shot.

Figure 12.18 This small room could only be captured with a wide-angle lens.

Figure 12.19 A wide-angle lens allowed the only vantage point possible for this shot.

Figure 12.20 Distant subjects may require a telephoto lens.

A lens with a wide f/stop is also desirable for nighttime and interior photos. Even if you want to use the smallest f/stop possible to increase depth-of-field, there will be times when you want to shoot wide open in very dim conditions. A "wide-open" setting of f/2.8 is to be much preferred over one that's on a lens that can open only as wide as f/4 or f/5.6.

Telephoto lenses have their application in travel photography, too. I was actually not very close to the muddy scene shown in Figure 12.20 (thank goodness); I actually had to zoom to 200mm (on a full-frame camera) to get the photo. Teles will let you reach out and grab the subjects you want, even if they are located down a muddy road, behind fences or otherwise inaccessible.

Getting Permission

Your first challenge in photographing some well-known sights might be to discover whether you're allowed to shoot a picture of a particular subject in the first place. The good news is that most of the time you don't need permission to photograph the outside of a building or structure, especially those edifices that, on some level, exist expressly as a photographic opportunity. So, you don't have to ask if you can photograph the Pyramids of Egypt, the Eiffel Tower, or the Chrysler Building in New York City. The Pyramids are historical monuments; *la Tour Eiffel* has come to symbolize The

City of Lights (and all of France); and the architecture of the Chrysler Building was deliberately designed to call attention to the success of the automotive company.

Groups of buildings, such as city skylines, require no permission. Nor do you usually need permission to photograph ordinary office buildings or even private homes, at least in the United States, as long as they are on what is called "permanent public display" and can be photographed from public places. If you have to take a photograph while standing on private property, you may need the permission of the property owner. Interior photos of non-public buildings may require permission, as well. Shooting photographs inside public buildings can be restricted, or there may be some limitations on whether you can use a tripod or electronic flash. Museums may limit flash photography.

Towns may prohibit use of tripods in the public buildings or parks. Police in Paris have been known to disapprove of the use of tripods, which are considered a "professional" tool, without getting a permit. That's a shame, because a tripod is especially helpful for photographing monuments and architectural subjects. Certainly, indoor photos will often be taken using long exposures under the natural lighting present in the room or space, so a tripod is essential for holding the camera steady. Outdoors, a tripod makes a steady base for the camera so you can compose your shot carefully, and is also useful for making panoramic exposures. If you photograph a building at night, you'll want a tripod to hold the camera for exposures that can take a second or two.

Security forces at many manufacturing plants will offer to take custody of your cameras while you're on site. Secure facilities such as federal buildings, military installations, financial institutions, or airports may have guards who will automatically be suspicious of anyone attempting to take pictures. I was innocently taking family photographs of my kids at Heathrow Airport in London a while back, when I was approached by a British policeman who informed me in the most apologetic way that what I was doing was prohibited. I'm glad I didn't try to whip out a tripod and set up for a more formal shot!

Use of the photographs you create is another matter entirely. Private and editorial use, as in books like this one, generally requires no special permission. However, if you want to use a photograph of someone's home in an advertisement or other marketing application, you'll want to get the owner's permission, what is called a "property release" (and similar in many ways to a model release).

Have Fun!

The most important thing to remember is that travel photography is fun. For many of us, visiting exotic locations is our final frontier, and, as photographers, our voyages provide us with an ongoing mission: to explore strange new worlds, to seek out new life forms and new civilizations, to boldly photograph where no one has photographed before.

People Photography

Some digital photographers specialize in one kind of picture or another, such as landscapes, sports, or close-ups. But everyone who uses a camera enjoys taking pictures of people, even if their main efforts are concentrated elsewhere. Unless you're a hermit, you love to photograph your friends, family, colleagues, and even perfect strangers. Human beings are the most fascinating subjects of all.

The person you photograph today may look completely different tomorrow, or might even adopt several different looks in a single afternoon with a quick change of clothing or hairstyle. Change the environment and surroundings, and you can change the way you capture your subject's personality. Modify the lighting, and a person can be pictured as sinister, powerful, or glamorous. It's your choice.

Photographs such as the lively celebrity photography of Richard Avedon, or Yousuf Karsh's powerful portrait of Winston Churchill, are some of the greatest images ever captured. The value we place on photographs we take of each other can be measured by the number of people who say the one object they'd grab on their way out of a burning home would be the family photo album. After all, photographs of our friends and family are a way of documenting our personal histories, and the best way we have of preserving memories. The fact that there are so many different categories of people-oriented pictures, from fashion photography to portraiture, demonstrates the depth of this particular photographic field.

Each individual brand of people picture deserves an entire book of its own. You'll find lots of good books on family photography, group portraiture, wedding photography, photojournalism, or figure photography. Most of the digital photography books you see try to cram little snippets of information about a broad range of these categories into a single chapter or two. I'm going to take a different approach. This chapter will concentrate on just one variety of people picture, the individual

portrait, and will cover it in a bit more depth. I'm going to give you some guidelines on lighting that are glossed over by most other books. What you learn here about posing and lighting applies broadly to other kinds of photography, so my goal is to get you interested enough that you try some other types, whether you opt for weddings or Little League team photos.

Home Studio—or Nature's Studio?

For many years, most portraits were created in a studio of some sort. This custom pre-dates photography by a handful of centuries, because, unless you were royalty and were able to do exactly as you pleased, it was more common to venture to the artist's studio, where the lighting, background, props, and other elements could be easily controlled. That soft and flattering "north light" used to illuminate portraits could be best guaranteed by painting in a space designed for that purpose.

Studio portrait sittings remained the norm after the invention of photography, because photos often took minutes to create. Traveling photographers sometimes carried along tents that could be used as portable darkrooms or studios. Even after more portable cameras and faster films and lenses freed photographers to capture documentary images and insightful candid pictures anywhere, portraits were still most often confined to studio settings.

The social unrest and anti-establishment feelings of the late '60s and early '70s placed a new premium on natural, less formal photography that emphasized realism, an emphasis that has remained today in this age of smart phone photography, "selfies," and Instagram. When "candid" wedding photography became sought-after, professional photographers were eager to set up lights in your living room to create family portraits in your own habitat. Before long, what was labeled as "environmental" portraiture became common, posed photographs with scenic backgrounds, such as the one shown in Figure 13.1. Enterprising pros either set up "natural" settings in their own studio backyards or compiled a list of parks, seashores, and other sites that could be used for these informal portraits.

The most interesting part of the whole phenomenon was that this new kind of professional portraiture didn't change much, except the setting for the photograph. Consumers then and now love casual snapshots for their immediacy, but still prefer professional portraits to be well-posed portraits, using flattering lighting, attractive backgrounds, and the other qualities they came to expect from formal studio portraiture in the old days. What consumers wanted was a studio-quality portrait taken in a less formal setting, usually with more casual dress and less rigid posing. Environmental and home portraits incorporate the professional's skills, even if they needn't be taken in a studio.

While the portraiture industry hasn't come full circle, an updated version of time-honored portrait photographic techniques has returned to favor, and studio work commands much of the respect it traditionally has had. Portraits are still taken outdoors, but many are captured indoors in the studio. There may be more props, more latitude in dress, and variety in poses now, as anyone who's seen

the kind of pictures high school seniors covet for their yearbooks knows. So, as a digital photographer, you'll probably find yourself taking people pictures in *both* kinds of settings. It's helpful to be comfortable with both.

Studio portraits are usually more formal. With a professional-looking backdrop or a "serious" background such as those omnipresent shelves of professional journals you see in so many executive portraits, a studio portrait can have a formal or official appearance. Even the crazy Mylar backgrounds and wacky props they're using for high school portraits these days retain a sense of "this is a professional portrait" in the finished product.

Location portraits, on the other hand, end up having a casual air no matter how hard you try to formalize them. The most carefully staged photo of the Speaker of the House posed on the steps of the U.S. Capitol will still look less formal than a relaxed portrait of the same legislator seated in a studio with only the American flag and shelves of law books in the background.

My feeling is that you should master both studio and location portraiture. You'll want a studio-style picture for a newspaper head shot or for mounting over the mantel, but will probably prefer an environmental picture to hang above the couch in the family room or use for your holiday greeting cards. It's great to have an option.

Figure 13.1 Today, portraits are rarely confined to studio settings.

Figure 13.2 The same flattering lighting techniques learned in the studio can be applied outdoors, too.

It's probably best to learn studio work first, because all the lighting and posing techniques you learn for your home studio can be applied elsewhere, as you can see in Figure 13.2. You may be using reflectors rather than flash units for your portraits out in the park, but the principles of putting light to work for you are the same. The following section will get you started working in your own home studio.

Setting Up Your Studio

Any convenient indoors space can be transformed into a mini-studio for use in capturing both portraits and close-up photos of objects. Of course, people pictures require more room than photographs of your ceramic collection, and few homes have space that can be devoted to studio use on a full-time basis. Two of my last three homes had large semi-finished attic space that I was able to commandeer as a studio. When I had an office addition built for my current residence, I had the choice of having a crawl space underneath or a full basement. I opted for a basement room with high ceilings, so I ended up with a 24×16 -foot multipurpose room that can be used as a studio.

Those of you with newer homes *sans* attic, or who live in parts of the country where basements are not common, probably don't have an extra room for a studio. Even so, I'll bet you have space that can be pressed into service from time to time. A garage makes a good location, especially if you live in warmer climes or are willing to confine your studio work to warmer weather. Some garages can be heated efficiently for year 'round use, too. Just back your vehicle out of the garage and you have space to shoot. I know several part-time professional photographers who work exclusively from rooms that were originally the garage. Their studios don't much resemble a garage today, but that's how they started off.

Of course, a garage studio is impractical in California, and a few other places where the denizens pay more for living space than the rest of us make. Generally, such space is used permanently for storage, practice space for your kid's band, or maybe even as living quarters. In big cities like New York, many people don't even own cars, let alone garages. Try suggesting to someone who dwells in a studio apartment in the Big Apple that, say, 200 square feet should be set aside for a home studio.

If space is limited, see if enough space can be cleared in your family room, living room, or other indoor location to set up a few lights, a background, and perhaps a tripod on a temporary basis. You want a place that can be used without disrupting family activities (which is why even the largest kitchen is probably a poor choice) and where you can set up and tear down your studio as quickly as possible. You'll use your home studio more often if it isn't a pain to use.

What You Need

The next section will list the basic items you need to have on hand. There's enough overlap that if you're well-equipped for macro photography, you've got most of what you need for individual portraits, too.

Your Portrait Camera

There are few special requirements for a digital camera that will be used for portraiture. Here's a list of the key things that make a mirrorless camera ideal for portraiture.

- Lots of megapixels. Portraiture is one type of photography that places a premium on resolution. Even if you plan on making prints no larger than 5 × 7 inches, you'll find a 21 to 24 megapixel (or more) camera useful, because those extra pixels come in handy when you start retouching your portraits to make your subjects look their best. I think you'll find it hard to resist making 8 × 10 and larger prints of your best efforts, too, so you'll be glad you sprung for a few million more megapixels when you bought your camera.
- A modest zoom lens (at least). For the most flattering head-and-shoulders pictures, you'll want a lens that has a zoom setting in the 80mm to 105mm (on a full-frame camera) or 50mm to 75mm range (on a cropped sensor camera). Shorter focal lengths often produce a kind of distortion, with facial features that are closer to the camera (such as noses) appearing much larger in proportion than features that are farther away from the camera (such as ears), as you can see in Figure 13.3. By the time you zoom in to the 135mm to 200mm (or longer) telephoto settings, the reverse effect happens: The camera's perspective tends to flatten and widen the face, bringing nose and ears into the same plane. The 80mm to 105mm settings are just about perfect.
- Some way to use multiple light sources. If you want the most control over your lighting, you'll want to use several light sources. Electronic flash is often the best option, so your camera should have a way of triggering one or more external flash units that are used separate from the camera. You may be able to connect extra flash units with a standard PC/X connector (the PC is said to stand for Prontor-Compur, two early shutter manufacturers, not "personal computer"), a hot shoe connector that can accommodate either an external flash or an adapter you can plug an external flash into. Some more advanced cameras should be able to work with flash triggered wirelessly. (See Chapter 7 for more on using external flash.)

Figure 13.3

The wide-angle setting (left) emphasizes subject matter (such as a nose) that is closer to the camera. A more natural look comes from a telephoto setting (right).

Backgrounds

Backgrounds are an important consideration for more formal portraits. You can get great casual pictures with the gang posed on the couch in the living room, and, in fact, you should try some of the lighting techniques discussed later in this chapter in that sort of an environment. Good lighting can elevate the family room portrait well above the snapshot category. However, if you want a true studio portrait, you're going to have to arrange for a more formal background. Luckily, that's easy to do.

Seamless paper, available in 9- and 12-foot widths and around 36 feet long, is another good choice. A paper backdrop can be easily damaged, becoming wrinkled with handling and dirty as people walk on it. When a piece becomes soiled, you just rip it off and roll off some more. If you can, avoid using seamless paper on thick carpets. They don't provide enough support for the paper, so it rips more easily. A wood or tiled floor may be a better choice.

You've probably admired those abstract backgrounds with, perhaps, a cloud effect, or stippled blotches of paint, like the one shown in Figure 13.4, although the "blotchy" backgrounds are rapidly becoming somewhat dated. They are still handy to have for more formal portraits. Painted backdrop canvases are available for big bucks from professional photography supply houses (\$99 to \$300 and up), but you can easily make your own, as I did.

Figure 13.4 Dabbing with a sponge and paint on a piece of canvas can create a workable backdrop for portraits.

TIP FROM THE PROS: HOW WIDE IS A YARD OF CLOTH?

If you answered "36 inches," you lose and don't get to advance to Final Jeopardy. A yard of cloth is 36 inches *long*, but the width of the bolt can vary. Some are as narrow as 18 inches. Other types of cloth come in 45 inch or larger widths. I've had great luck with velour cloth backdrops. For portraiture, the key is to purchase cloth that is wide enough and long enough to allow posing one or more people full-length. Find a bolt that is 54 to 60 inches wide. Purchase a piece that is a lot longer than you think you need. Six yards isn't too much when you want to stretch the cloth up to the ceiling, then drape it down on the floor. Make sure your fabric is easily washable, because it will get soiled from people walking on it. Buy as many different colors as you can afford.

While professional photographers won't blink an eye at purchasing backdrops they can use repeatedly, most don't hesitate to create their own props and backgrounds to give their photography a customized, personal flavor.

When my studio was in operation professionally, I used the reverse side of 4×8 sheets of paneling to create dozens of backgrounds for individual portraits. Of course, I had a permanent studio in which to store them. You're probably better off using sheets of awning canvas. The secret is to use a sponge to paint them with colors. You'll be surprised at the results, even if you're not the artistic type. Start painting using lighter colors in the center and work your way toward the edges with darker pigments. The sponge will give the surface an arty splotchy effect that will look great, especially when it's out of focus. Browns and earth colors are recommended for men; brighter colors, especially blues, work well for women and children. Remember, if you make any mistakes or don't like your initial results, you can always paint over them.

Here are some ideas that you can use for getting a simple background:

- Look for a blank wall. Take down photos on the wall if you need to in order to make the wall blank. But be careful of picture hangers that can create distractions in the background. You might be able to position your subject so that those things are blocked.
- Put up a sheet. Use a plain, freshly ironed sheet and hang it on a wall, across some windows, over a bookcase, or anywhere that you can hold it up. Small clamps that you can get from a hardware store can help you position and hold the sheet.
- **Get some foam board.** Go to an art supply store and pick up a big sheet of foam board (or Fomecor). You can get these with white or black surfaces, either one of which can be effective as a simple background.
- Consider a formal photo muslin background. Many camera stores carry muslin backgrounds that are designed specifically for photographers. You can also get stands and other accessories to help you hold up such a background. Be wary of getting highly patterned or very colorful muslin backgrounds because most photographers find their novelty wears off quickly.
- Get a painter's cotton drop cloth from a painting store. Painting stores, and painting sections of large hardware stores, will have cotton drop cloths available for painters. These typically come in a tan or white color and can be excellent for backgrounds. You may need to get some stands from a camera store in order to hold it up.
- Make your own photo cloth background. Get a painter's drop cloth and some cans of gray, black, and off-white paints, then spray soft blobs of tone across the drop cloth for a simple background. Go for subtle and gentle patterns so as not to distract from your subject.
- Try some seamless background paper. Larger camera stores will have rolls of seamless paper that you can hold up with a couple of stands. You then pull the paper down from the roll for a simple background behind your subject. A 53-inch wide roll that's 12 yards long can cost \$25 or less.

Visible Means of Support

You'll need stands for your background, lighting, and camera, although there are many portrait situations in which you'll want to dispense with a tripod (such as when you're taking photos by electronic flash). Unlike macro photographs, portraits are often taken from a variety of angles and distances from the same basic setup.

Whether you're using cloth backdrops, seamless paper, or another background, you'll need some sort of framework to support it. I prefer sturdy light stands for lightweight backgrounds, and ceiling supports for heavier paper rolls. You may not be able or willing to nail anything to your ceiling (this is one instance when having a basement or attic is great), but you can still build some sort of easily disassembled framework to hold your backdrop.

Light stands make good supports, and are a once-in-a-lifetime investment. Unless you manage to lose one, they'll last forever. You'll need to add clamps or other fasteners to fix your lights and, perhaps, umbrellas to the stands.

A tripod is not essential for people photography, particularly if you're using motion-stopping electronic flash, and in many cases a tripod can be detrimental. You'll want to be able to roam around a little to get various angles, move in and out to change from full-length or three-quarters portrait to close-up. For Figure 13.5, I posed my subject against a brightly lit wall, held a flash with a diffuser at arm's length to my right, and, with no tripod to encumber me, was able to move around to get the shot I wanted.

The only time you'll really need a tripod for portraits is when you need to lock down the camera to get a precise composition, or when you're working with relatively low light levels and need the tripod to steady the camera. For example, you might be shooting a series of head shots for your company and would like each photo to be taken from the exact same distance and angle. Or, you may be taking pictures using diffused window light or with household lamps as your illumination. In both cases a tripod can be useful as a camera support.

RIGHT OF SPRINGS

You can purchase spring-loaded vertical supports that fit tightly between your floor and ceiling, but can be released and stored when not in use. These work well with sturdy ceilings, or those with overhead beams. You can try making your own: cut a 2×4 a few inches shorter than your ceiling height. Pad one end of the 2×4 so it won't damage your ceiling, then put the end that rests on the floor in a coffee can with a spring mechanism of your choice. (Actually, I've used sponges as a cheap substitute for springs.) Press the 2×4 down to get enough slack to slide it in place, then release to allow your spring to hold it firmly in a vertical position. The spring must be strong enough to resist the downward pull of your backdrop material.

Figure 13.5 Electronic flash and a hand-held camera lead to spontaneous poses.

Make Light Work for You

Lighting is one of the most important tools for creative portraiture. The way you arrange your illumination can have a dramatic effect on the mood of a photo. Lighting can focus interest on your subject. You can even use lighting techniques to improve the looks of a subject with less-than-perfect features. You'll find that portrait lighting is a great deal more complex than the lighting you might use for many other types of subjects. Close-ups need to be lit carefully, and your scenic and architectural pictures will look better if the illumination is just so. For sports photography, much of the time you won't have control over the kind of light you use. Portraiture, on the other hand, looks best when the lighting is carefully crafted.

As a result, while very good portraits can be taken with just one light source, you'll find that mastering multiple light sources opens new creative avenues. But note that I said multiple light *sources*. You don't have to clutter your home or office studio with dozens of different lighting fixtures. Often, a skylight, window, or reflector can serve as an effective light source. Outdoors, you may work with the light from the sun, supplemented by reflectors or electronic flash. You'll learn how to use these light sources later in this chapter.

Here are your choices:

- Incandescent photo light bulbs. Years ago, you could go in any photo store and find photo bulbs, including those with a blue tone that matched the color balance of daylight films. They were commonly screwed into an inexpensive reflector and used for lighting people. Incandescent photo bulbs are still available though hard to find. They are very inexpensive and put out a lot of light. They come in blue for daylight white balance and white for tungsten balance. However, their color temperature can shift over time, they are relatively fragile, and they tend not to have a very long life.
- Fluorescent photo light bulbs. Photo light bulbs are now available as compact fluorescent lamps (CFL). They are relatively inexpensive and put out a reasonable amount of light without getting hot. However, their color temperature can shift as they age, they are relatively fragile, and they have a shorter life than other CFLs. If the fluorescent lamps aren't balanced for daylight illumination, you'll need to set your camera's color balance to match that of the fluorescents, or shoot RAW and adjust the white balance in your image editor.
- Photo quartz lights. Quartz lights have a very good reputation for putting out a lot of very consistent light at a specific color temperature. They have a long life, are fairly rugged (as long as you don't bang them around when they are hot), and are an inexpensive type of photo light for their output and life. You can buy them with very specific housings that are designed to meet photographers' needs. They have a color temperature that will match the Tungsten white balance on your camera. Their biggest disadvantage is that they get very hot.

- Hardware store quartz lights. One way to try out quartz lights is to go down to your hardware store and get some work lights that use a quartz light. They have the same advantages and disadvantages of the photo quartz lights except that their housings are not as convenient for photographers and they often have a protective grill over them that must be removed or it will cause shadows on your subject. But they are very inexpensive.
- Photo fluorescent lights. A number of companies like Westcott (www.fjwestcott.com) make special lighting fixtures that use fluorescent lights specifically designed for photography. These tend to be physically large light fixtures that are not always very portable, and they can be expensive. They do put out a consistent light with a consistent color balance that will match either Tungsten or Daylight white balance on your camera. And they don't get hot. The bulbs in these units are more fragile than quartz lights.
- Hardware store fluorescent lights. You can buy work lights that use fluorescent light bulbs. These won't have as much power as the ones that are designed for photography, but you can increase your camera's ISO sensitivity to compensate. They are relatively inexpensive. However, their color balance will vary from unit to unit and you may need to use your camera's manual or custom white balance to match them.
- Photo LED lights. The newest type of continuous light source is the LED photo light. These fixtures are made up of rows of tiny LED lights that work together to create light for your subject. LED lights are very rugged, use very little power, and are never hot. They can be balanced for either Daylight or Tungsten white balance. Their disadvantages: they are lower powered than any other continuous light source and are quite expensive for the amount of power they create.
- Hardware store LED lights. Once again, you can try out LED lights from your hardware store or home improvement center. Look for LED work lights that have many rows of these small lights. You'll need lots of LEDs to provide enough power to actually be useful. These lights are less expensive than the photo LED lights, but will usually be bigger for the same amount of power and you will be limited as to how much power you can get. Their color balance can vary from unit to unit and you may need to use your camera's manual or custom white balance to match them.
- Small flash units. You can get small, accessory flashes that can attach to your camera. Many of these units today will also work wirelessly with your camera so that you can use multiple flash away from the camera. These units offer excellent autoexposure capabilities, have very fast durations, and are always daylight balanced. They are easily packed into a camera bag and they will never overheat your subject. Disadvantages include: the short flash duration means that you cannot see the light on your subject, the more powerful of these units can be expensive, and even the most powerful of these is limited in the amount of light it can put on your subject.

■ **Studio flash.** Studio flash, including *monolights* (studio strobes with flash and power pack in a single unit), are large flash that put out a lot of illumination. These are designed specifically for photographic use. You may need extra gear in order to sync a group of them with your camera. You will need a flash meter for setting exposure manually, or you will have to resort to trial and error testing, as the camera's flash metering system cannot accurately gauge the output of studio flash.

These units have brief flash durations (effective, "short" shutter speeds), are always daylight balanced, and will never overheat your subject. They come with modeling lights that can be left on to help you see where the flash will be affecting your subject. Disadvantages include: the strong and short burst of light from the flash can be disturbing to some subjects, units can be expensive, and modeling lights are sometimes not strong enough to give you a clear indication of what the flash is going to look like.

Existing Light

The existing light indoors or outdoors can be perfect for good people pictures. Rembrandt reportedly cut a trapdoor in the ceiling of his studio and used that to illuminate many of his portraits. If you have a room with a skylight, you may find that suitable for portraits at certain times of day. Some memorable pictures have been taken using only the soft light that suffuses from a window. Indeed, you'll find references to "north light" (a window orientation that produces diffuse light from dawn to dusk) throughout painting and photographic literature.

Just because the lighting is already there doesn't mean you can't modify it to your advantage. You can lower the blinds part way to reduce or soften window light. You can use reflectors to bounce light around in interesting ways.

Electronic Flash

Electronic flash is often the best choice for indoor portraiture. The short duration of flash captures a moment in a fraction of a second, without danger of blur from a slow shutter speed. The high intensity of flash means you can use small f/stops if you want, so all of your subject will be in sharp focus. Flash can be reduced in intensity, as well, giving you the option of using selective focus, too. Flash can be harsh and direct, or soft and diffuse.

The chief problem with electronic flash is that it is difficult to preview how flash illumination will appear in the final picture. Fortunately, there are ways to overcome this limitation, as I'll show you later in this section. A second problem is that many digital cameras don't have a connector that lets you plug in an external flash, as I mentioned earlier. A shoe mount adapter with a connector for an external flash usually costs less than \$30.

Electronic flash comes in many forms, from the built-in flash on your digital camera to external battery-powered units to "studio" flash that operate from AC power or large battery packs. Unless you're moving into portraiture in a big way, you don't need studio flash units. If you do decide to make the investment, there are some surprisingly economical AC-powered studio flash setups for

serious amateurs and pros on a budget. A single-unit (flash head and power supply in one module) "monolite" can cost less than \$200.

Some add-on flash units have a built-in device called a slave sensor that triggers the flash when the sensor detects another unit firing. These can be safely used with any camera, as they have no direct connection to the camera. You can also purchase detectors that attach to any flash unit, turning it into a slave flash. As I mentioned in Chapter 7, look for a slave unit with a digital mode that can be set to ignore the pre-flash of your camera's built-in flash unit.

If you use your electronic flash on stands, you may be able to rig an incandescent light along each side to give you some indication of what your lighting looks like. These "modeling" lights work especially well if your electronic flash is pointed at a reflector such as an umbrella. That's because the softening effect of the umbrella reduces the variation in illumination that results when the flash and incandescent lamp aren't in precisely the same position.

The ability to see the exact light you're going to get can be very important. For Figure 13.6, I carefully manipulated the lights so the model's hat fell into shadow, and most of the right side of her face was in shadow as well, except for the dangling earring. You can't achieve lighting effects like this on a hit or miss guesstimate basis.

Figure 13.6
Careful lighting can produce effects like this, in which the earring stands out sharply from the shadows.

Incandescent Lights

You'll find that incandescent lights are inexpensive—even the halogen models that replaced the older tungsten models—easy to set up, and make it simple to preview your lighting effects. You never have to worry about what your lighting will look like if you use incandescent lamps.

Unfortunately, lamps are not as intense as flash and may not provide enough illumination for good hand-held exposures at short shutter speeds. Or, if the lamps are intense enough, they may be too hot to pose under for long periods of time. In addition, incandescent lamps are much redder than the illumination provided by daylight or electronic flash, so you may have to change your camera's white-balance control to compensate. (Many digital models have automatic white-balance control, but it's not foolproof.)

While you can use just about any light, you might want to investigate incandescent lamps made especially for photography, available from your local camera shop or online photo retailer. They aren't overly expensive, and are easier to buy hardware for, such as mounting clamps, umbrella adapters, and so forth.

Gadgets

There are dozens of different gadgets and accessories associated with portraiture. The best news is that you can make many of them yourself, so you don't have to pay a lot of money to spice up your portrait-shooting arsenal. Here are some versatile gadgets you might want to consider.

Flat Reflectors

Reflectors bounce some of the illumination from other light sources onto your subject, serving as a low-cost secondary light source in their own right. Large sheets of foamboard (which you can stand up and lean against things at the proper angle), poster board, Mylar sheets, or anything that reflects light can be used.

Soft Boxes and Diffusers

Soft boxes use diffuse white material, such as cloth, to create a soft lighting effect. Soft boxes can simulate window light and create a diffuse, flattering illumination suitable for photography of women, children, teens, and any adult men who aren't tenacious about preserving those craggy furrows they think of as facial character lines. A kind of mini soft box can be purchased for electronic flash units that are normally used on the camera, to diffuse the light. There's no reason why one of these units, shown in Figure 13.7, can't be used with an off-camera flash, too.

Gobos and Cookies

Gobos and cookies are the opposite of a reflector. They can be a black drape or sheet placed between a light source and the subject to block some light, and are handy when you have an unwanted light source, such as a window, that's spoiling the effect you want. These items are actually more of a tool for video and cinema photographers and for stage productions, because they can include cutouts that let some light through to produce an interesting combination of light and shadows, such as window frames, trees, or logos. However, still photographers should know about them and use them when appropriate.

Barn Doors/Snoots

These are devices that limit where the light from a flash or lamp goes. A barn door has two or four hinged flaps you can move into or out of the path of the light. Subtle adjustments can be made to "feather" the light on your subject. Snoots are conical devices that focus the light down to a narrow spot. They are excellent for creating a light that illuminates a small area, such as the hair of the subject.

You can easily make your own barn doors or snoots out of cardboard or tin (which is a better choice for accessories used near hot incandescent lamps). Spray paint them with black heat-resistant barbeque grill paint. Or, use purchased units, like those shown in Figure 13.8.

Figure 13.7 Flash diffusers are a sort of mini soft box.

Figure 13.8 Barn doors let you direct the light carefully.

Umbrellas

A good set of umbrellas is the best investment you can make for portrait photography. Umbrellas soften the light in ways you can control and use for artistic effect. You can bounce light off an umbrella onto your subject, or, in the case of translucent white umbrellas, shine your illumination through the fabric for an especially diffuse effect. In either mode, a soft-white umbrella provides very diffuse illumination, but you can also purchase umbrellas with opaque shiny silver or gold interiors that provide a broad light source that still has snap and contrast. Umbrellas produced for professional photographers are compatible with various lighting clamp systems that make them easy to set up and manipulate.

GOING FOR THE GOLD

Gold umbrellas, in particular, are prized for the warm illumination they provide. They are used extensively for fashion and glamour photography because of the flattering skin tones their light produces. Silver umbrellas have more contrast and snap than soft-white models. The edges of the illumination provided by silver umbrellas are more sharply defined, so you can angle the umbrella to "feather" the light on your subject (placing strong light on some parts, while fading to less light on others).

However, you can also use ordinary umbrellas of the type people take out into the rain. I found a source selling white umbrellas that collapse down to less than a foot in length for about \$5 each. I really liked these when I was a traveling photojournalist who was unable to travel light (two or three cameras, five or six lenses, and two electronic flash units were my minimum kit), but tried to trim weight whereever I could. I picked up a dozen and found I could hold the umbrella and flash unit in my left hand and shoot with the camera held in my right hand. You can jury-rig clamps to hold them to light stands or other supports. Collapsible umbrellas usually have small diameters and must be used relatively close to get a soft, wrap-around lighting effect. Larger sizes are needed to provide illumination from greater distances (say, 10 to 12 feet).

Portrait Basics

Here are some things to think about for portrait composition:

■ **Headroom.** Never compose your shot with the subject's head in the middle of the picture. That puts too much space or headroom over the top of your subject. That is wasted space in the composition. Keep a small amount of headroom over your subject.

- Full body compositions. When using the whole body of your subject in a portrait, use a wraparound background that extends onto the floor toward the camera so that the subject can stand on it. That simplifies the overall image. In addition, never cut off a person's body at the ankles. That is very uncomfortable place for the edge of the frame.
- Half-body compositions. Move in closer and you emphasize the top half of your subject. A half-body composition shows off the person's torso, arms, head, and hair.
- **Head-and-shoulder composition.** Move in closer and you show the upper part of the person's body and his head. This can really show off the personality of your subject. This framing does not show the arms, but does show off the head, shoulders, and hair. This is a traditional formal portrait composition.
- **Tight face composition.** Move in closer so that only the face is used in the composition. This means cutting off the top of the head so that you don't see it. By eliminating things like the top of the head, you force the viewer to really focus in on the subject's face, especially the eyes.

The Nature of Light

Lighting is the palette you'll be using to paint your photographic portraits. The next two sections will introduce you to some basic techniques, using some diagrams I've put together that will help you set up professional-looking lighting on your first try. However, you don't need to stick to the setups I'm going to describe anymore than you'd want to paint using only one shade each of red, blue, green, yellow, orange, or other colors. Once you understand how various types of lighting affect your portrait, you'll want to expand on the basic techniques to achieve special looks of your own devising. This section covers some basics.

The character of the light you use is just as important as the direction it comes from. As a photographer, you probably already know that light can be hard and harsh, or soft and gentle. Neither end of the spectrum is "good" or "bad." Each type of light, and all the gradations in between, has its own advantages and disadvantages.

A spotlight or a lamp in a reflector, or an electronic flash pointed directly at a subject is highly directional and produces a hard effect. Hard light is harsh because all the light comes from a relatively small source. This kind of light can be good if you want to emphasize the texture of a subject, and are looking for as much detail and sharpness as possible. In fact, many kinds of photographic projection and optical gear take advantage of point-source lighting to maximize sharpness.

Most portrait subjects benefit from a softer light, like that used in Figure 13.9. You can soften this light in many ways, using umbrellas, diffusers, and other techniques. It's even possible to add a little softness in Photoshop, as I did with this particular photo.

Figure 13.9 Soft illumination works best for many subjects, including women.

Direct versus Soft

As I've noted, direct light is not as good a choice for portraiture. People rarely look their best under a direct light, because even a baby's skin is subject to imperfections that we don't see under home illumination (which is deliberately designed to be non-harsh). Only in direct sunlight are we likely to look our worst. Figure 13.10 shows how a direct light focuses a sharp beam on a human subject.

Most portraits are made using softer illumination, such as that produced by bouncing light off an umbrella. As the light strikes the umbrella (or other soft reflector), the light scatters. It bounces back toward the subject and appears to come from a much larger source—the umbrella itself rather than the bulb or flash unit that produced it. Figure 13.11 shows a much softer beam of light bounced onto the subject from an umbrella. Of course, the light is bouncing in all directions and spreading

Figure 13.10 A direct light forms a sharp beam of high-contrast light on your subject.

Figure 13.11 Bouncing light from an umbrella produces a much softer light source.

Figure 13.12 Moving the light in closer provides an even broader, softer effect.

out, but my illustration shows just the cone of light falling on the subject. The blunt "apex" of this cone gets smaller the farther away you move the light, and larger the closer it gets.

But you probably already guessed by now that the distance of the light source from the subject also has a bearing on the quality of light. In Figure 13.11, the umbrella is fairly far from the subject, so the light source seems to come from a relatively small area, even though it's bouncing off an umbrella. The effect is less harsh than direct light, of course, but still not as good as we can achieve.

For Figure 13.12, I moved the umbrella in much closer to the subject, making the blunt end larger. The apparent source of the light is now much broader, relatively, and correspondingly softer. You'll need to keep this characteristic in mind as you set up your lights for portraiture. If you need to move a light back farther from the subject, you'll also need to take into account the changing nature of the light. A larger umbrella may help keep the lighting soft and gentle. Or, you simply might want to have slightly "edgier" lighting for your subject. As long as you are aware of the effect, you can control it.

Balancing Light

As you'll see in the next section, you'll often be using multiple illumination sources to light your portraits. It's important to understand some of the principles that go into balancing light from several different sources in a single photograph. Here are some tenets to work by:

That Inverse Square Law Again

As I first mentioned in Chapter 7, moving a light source twice as far away reduces the light by 4X (not 2X). In photographic terms, that translates into two f/stops, not one f/stop, to compensate. For example, a light source placed 8 feet from your subject will provide *one-quarter* as much illumination as the same source located just 4 feet from the subject. After moving the light twice as far away, you'd have to open up two f/stops to keep the same exposure.

You can make the inverse square law work for you. If you find a source is too strong, either by itself or relative to other light sources you're using, simply moving it twice as far away will reduce its strength to one-quarter its previous value. Or, should you need more light, you can gain two f/stops by moving a light source twice as close. (Keep in mind that the softness of the light is affected by the movement, too.)

There are times when you won't want to adjust the light intensity entirely by moving the light because, as you've learned, the farther a light source is from the subject, the "harder" it becomes. In those cases, you'll want to change the actual intensity of the light. This can be done by using a lower power setting on your flash, switching from, say, a highly reflective aluminum umbrella to a soft white umbrella, or by other means.

Using Ratios

When lighting a subject, the most common way to balance light is to use ratios, which are easy to calculate by measuring the exposure of each light source alone (either with your camera's exposure meter or using an external flash meter). Once you have the light calculated for each source alone, you can figure the lighting ratio.

For example, suppose that the main light for a portrait provides enough illumination that you would use an f/stop of f/11. The supplementary light you'll be using is less intense, is bounced into a more diffuse reflector, or is farther away (or any combination of these) and produces an exposure, all by itself, of f/5.6. That translates into two f/stops' difference or, putting it another way, one light source is 4 times as intense as the other. You can express this absolute relationship as the ratio 4:1. Because the main light is used to illuminate the highlight portion of your image, while the secondary light is used to fill in the dark, shadow areas left by the main light, this ratio tells us a lot about the lighting contrast for the scene. (I'll explain more about main and fill lights shortly.)

In practice, a 4:1 lighting ratio (or higher) is quite dramatic and can leave you with fairly dark shadows to contrast with your highlights. For portraiture, you probably will want to use 3:1 or 2:1 lighting ratios for a softer look that lets the shadows define the shape of your subject without cloaking parts in inky blackness.

If you use incandescent lighting or electronic flash equipped with modeling lights, you will rarely calculate lighting ratios while you shoot. Instead, you'll base your lighting setups on how the subject looks, making your shadows lighter or darker depending on the effect you want. If you use electronic flash without a modeling light, or flash with modeling lights that aren't proportional to the light emitted by the flash, you can calculate lighting ratios. If you do need to know the lighting ratio, it's easy to figure by measuring the exposure separately for each light and multiplying the number of f/stops difference by two. A two-stop difference means a 4:1 lighting ratio; two-and-a-half stops difference adds up to a 5:1 lighting ratio; three stops is 6:1; and so forth.

Figure 13.13 shows an example of 2:1, 3:1, 4:1, and 5:1 lighting ratios.

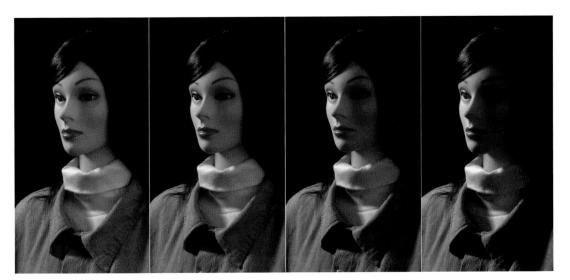

Figure 13.13 Left to right: Lighting ratios of 2:1, 3:1, 4:1, and 5:1.

Using Multiple Light Sources

As I warned you in the previous section, the best portrait lighting involves at least two, and often three or more light sources. The light sources don't always have to be incandescent lights or electronic flash. Figure 13.14, for example, was shot using window light (from the side and behind the subject), supplemented by light bounced from a flat reflector to the left side of the image. This section will introduce you to each type of light source and the terminology used to describe it.

Main Light

The main light, or key light, is the primary light source used to illuminate a portrait. It may, in fact, be the only light you use, or you may augment it with other light sources. The main light is often placed in front of the subject or slightly behind, and on one side of the camera or the other. Some kinds of lighting call for the main light to be placed relatively high, above the subject's eye-level, or lower at eye-level. You usually won't put a main light lower than that, unless you're looking for a monster/crypt-keeper effect. Figure 13.15 shows a portrait with the main light positioned to provide the most illumination on the side of the face that's turned away from the camera. (This is called *short lighting*, and will be explained later in the chapter.)

Placed to the side, the main light becomes a side light that illuminates one side or the profile of a subject who is facing the light. Placed behind the subject, the main light can produce a silhouette effect if no other lights are used, or a backlit effect if additional lighting is used to illuminate the subject from the front. I'll show you how to create lighting effects using the main light shortly.

Figure 13.14 Only window light and reflectors were used for this portrait.

Figure 13.15 The main light is off to the right and slightly behind the subject, illuminating the side of the face that's turned away from the camera.

You'll usually position the main light at roughly a 45-degree angle from the axis of the camera and subject. The main light should be placed a little higher than the subject's head—the exact elevation determined by the type of lighting setup you're using. One thing to watch out for is the presence or absence of catch lights in the subject's eyes. You want one catch light in each eye, which gives the eye a slight sparkle. If you imagine the pupils of the eyes to be a clock face, you want the catch lights placed at either the 11 o'clock or 1 o'clock position. You might have to raise or lower the main light to get the catch light exactly right.

You most definitely do not want *two* catch lights (because you're using both main and fill lights) or no catch light at all. If you have two catch lights, the eyes will look extra sparkly, but strange. With no catch light, the eyes will have a dead look to them, as in Figure 13.16. For this example, I used the same photo so you could see the difference (removing one, then both of the original catch lights), but you won't normally get identical shots with different catch light effects in them. Sometimes you can retouch out an extra catch light, or add one with Photoshop, but the best practice is to place them correctly in the first place.

Figure 13.16 Two catch lights (left) or no catch light at all (middle) look bad. One catch light (right) looks great.

Fill Light

The fill light is usually the second most powerful light used to illuminate a portrait. Fill light lightens the shadows cast by the main light. Fill lights are usually positioned on the opposite side of the camera from the main light.

The relationship between the main light and fill light determines, in part, the contrast of a scene, as you learned in the section on calculating lighting ratios. If the main and fill are almost equal, the picture will be relatively low in contrast. If the main light is much more powerful than the fill light, the shadows will be somewhat darker and the image will have higher contrast. Fill lights are most often placed at the camera position so they will fill the shadows that the camera "sees" from the main light. Figure 13.17 shows a main light and fill light in a typical lighting setup. In Figure 13.18, the fill light is to the left of the camera and is lighting up the shadows on the side of the face closest to the camera. I'll show you the effects of using main and fill lights in the sections that follow.

Background Light

A light illuminating the background is another common light source used in portraits. Background lights are low power lights that provide depth or separation in your image. Place the background light low on a short light stand about halfway between your subject and the background, so that the subject hides the actual light from view. This light can also provide interesting lighting effects on the background when used with colored gels or cookies. You can even turn the background light toward the back of the subject, producing a halo or back light effect.

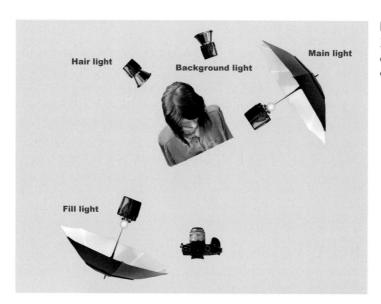

Figure 13.17
Main and fill lights complement each other.

Figure 13.18

Both a hair light and background light were used here to provide separation from the background.

Hair Light

A hair light is usually a small light directed at the hair of the subject to provide an attractive high-light. Often, a snoot or barn door is used to keep the hair light from spilling down on the subject's face. A hair light must be controlled carefully so it doesn't form an overexposed hot spot on the subject's head. A low-power light like the background light, the hair light also provides separation from the background, which can be very important if your subject has dark hair and is posed against a dark background. Place the hair light in a high position shining down on the subject's head, then move it forward until the light spills over slightly onto the subject's face. At that point, tilt the light back again until it is no longer illuminating the subject's face. You can see a hair light at work in Figure 13.18.

Lighting Techniques

Although I'll describe each of the most common lighting techniques, you'll want to set up some lights and see for yourself exactly how they work.

Short Lighting

Short lighting and broad lighting (discussed next) are two different sides of the same coin. Together, they are sometimes referred to as "three-quarter lighting," because in both cases the face is turned to one side so that three quarters of the face is turned toward the camera, and one quarter of the face is turned away from the camera.

Short lighting, also called narrow lighting, is produced when the main light illuminates the side of the face turned away from the camera, as shown in the bird's-eye view in Figure 13.19. Because three-quarters of the face is in some degree of shadow and only the "short" portion is illuminated, this type of lighting tends to emphasize facial contours. It's an excellent technique for highlighting those with "interesting" faces. It also tends to make faces look narrower, because the "fat" side of the face is shadowed, so those with plump or round faces will look better with short lighting. Use a weak fill light for men to create a masculine look.

This is a very common lighting technique that can be used with men and women, as well as children.

In Figure 13.20, our subject is looking over the photographer's left shoulder. The main light is at the left side of the setup, and the fill light is at the photographer's right. Because the fill light is about twice as far from the subject as the main light, if both lights are of the same power, the fill light will automatically be only one-quarter as intense as the main light (thanks to the inverse-square law). If the shadows are too dark, move the fill light closer, or move the main light back slightly. If your light source allows "dialing down" the power, that's an even better choice, because moving the light sources changes the character of the light slightly.

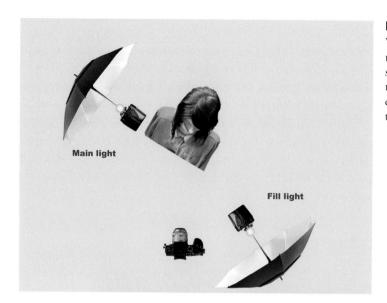

Figure 13.19
With short lighting, the main light source comes from the side of the face directed away from the camera.

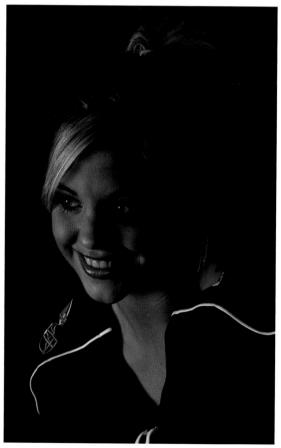

Figure 13.20 A typical portrait illuminated using short lighting looks like this.

Broad Lighting

In many ways, broad lighting, the other three-quarter lighting technique, is the opposite of short lighting. The main light illuminates the side of the face turned toward the camera. Because most of the face is flooded with soft light (assuming you're using an umbrella or other diffuse light source, as you should), it de-emphasizes facial textures (teenagers may love this effect) and widens narrow or thin faces. Figure 13.21 is the lighting diagram used to produce the image shown in Figure 13.22, which pictures the same subject as above, but with broad lighting instead. Broad lighting may not be the best setup for this young lady, because she has a broad face, but styling her hair so it covers both sides of her face reduces the effect. That let me use broad lighting and its feature-flattering soft light.

Butterfly Lighting

Butterfly lighting was one of the original "glamour" lighting effects. The main light is placed directly in front of the face above eye-level and casts a shadow underneath the nose. This is a great lighting technique to use for women, because it accentuates the eyes and eyelashes, and emphasizes any hollowness in the cheeks, sometimes giving your model attractive cheekbones where none exist. Butterfly lighting de-emphasizes lines around the eyes, any wrinkles in the forehead, and unflattering shadows around the mouth. Women love this technique, for obvious reasons. Butterfly lighting also tends to emphasize the ears, making it a bad choice for men and women whose hairstyle features pulling the hair back and behind the ears.

Butterfly lighting is easy to achieve. Just place the main light at the camera position, and raise it high enough above eye-level to produce a shadow under the nose of the subject. Don't raise the light so high the shadow extends down to his or her mouth. The exact position will vary from person to person. If a subject has a short nose, raise the light to lengthen the shadow and increase the apparent length of the nose. If your victim has a long nose, or is smiling broadly (which reduces the distance between the bottom of the nose and the upper lip), lower the light to shorten the shadow.

You can use a fill light if you want, also placed close to the camera, but lower than the main light, and set at a much lower intensity, to reduce the inkiness of the shadows. Figure 13.23 is the diagram for applying butterfly lighting (without a fill light), while Figure 13.24 shows the final result. Notice that the ears aren't a problem with this portrait, because they are hidden behind the model's hair. Because this young woman has blonde hair, I've toned back on the use of hair light in all the photos.

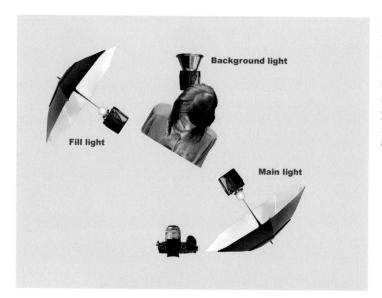

Figure 13.21
This diagram shows how the lights are arranged for a typical broad lighting setup. Remember, you can also use a mirror image of this arrangement.

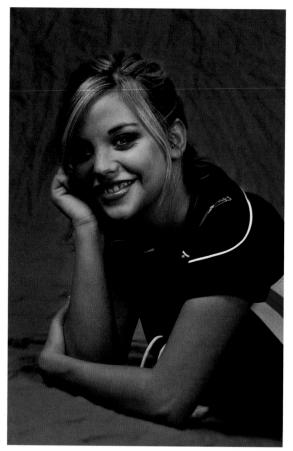

Figure 13.22 A portrait made using broad lighting de-emphasizes facial textures.

Figure 13.23
This diagram shows the basic arrangement for butterfly lighting.

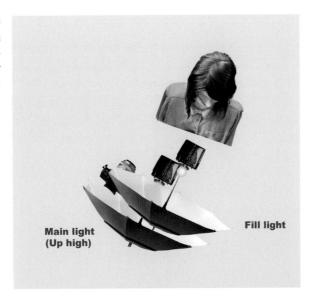

Figure 13.24
Butterfly lighting is a great glamour lighting setup.

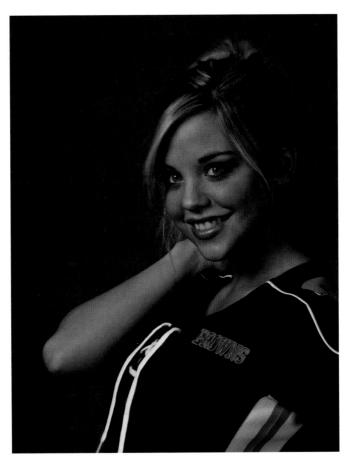

Rembrandt Lighting

Rembrandt lighting is another flattering lighting technique that is better for men. It's a combination of short lighting (which you'll recall is good for men) and butterfly lighting (which you'll recall is glamorous, and therefore good for ugly men). However, it also works for women, as shown in Figure 13.25. The main light is placed high and favoring the side of the face turned away from the camera, as shown in the figure. The side of the face turned toward the camera will be partially in shadow, typically with a roughly triangular shadow under the eye on the side of the face that is closest to the camera. For Rembrandt lighting, place the light facing the side of the face turned away from the camera, just as you did with short lighting, but move the light up above eye-level. If you do this, the side of the face closest to the camera will be in shadow. Move the light a little more toward the camera to reduce the amount of shadow, and produce a more blended, subtle triangle effect, as shown in Figure 13.26. Eliminate or reduce the strength of the fill light for a dramatic effect, or soften the shadows further with fill light.

Side Lighting

Side lighting is illumination that comes primarily directly from one side, and is good for profile photos. You can use it for profiles or for "half-face" effects like the Fab Four on the much copied/parodied cover of *Meet the Beatles/With the Beatles*. The amount of fill light determines how dramatic this effect is. You can place the main light slightly behind the subject to minimize the amount of light that spills over onto the side of the face that's toward the camera. Figure 13.27 shows you how to set up a light for side lighting, and Figure 13.28 shows the results. Note that a subject with long hair that covers the cheeks may have most of her face obscured when sidelit in this way. Either comb the hair back or go for a mysterious look.

Outdoor Lighting

You can apply virtually all the techniques you learned in the studio to your outdoors portraits. Once you've mastered short lighting, broad lighting, butterfly lighting, and the rest of the basic setups, you can use them outdoors by being flexible enough to work with the less controllable lighting you find there.

For example, you might have to position your subject to take advantage of the position of the sun as a "main" light, and use reflectors to create your fill. A search for some shady spot might be required to provide a soft enough light source. The sun might end up as your hair light. Figure 13.29 shows an outdoor portrait lit entirely with available light, using reflectors to fill in the shadows.

Figure 13.25
Arrange your main light high when working with a Rembrandt lighting effect.

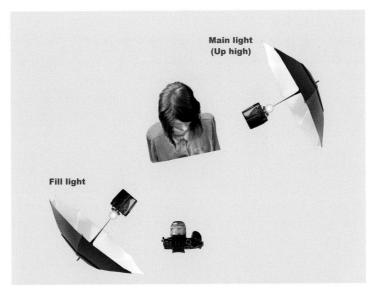

Figure 13.26
Rembrandt lighting lends an Old Masters' touch to portraiture.

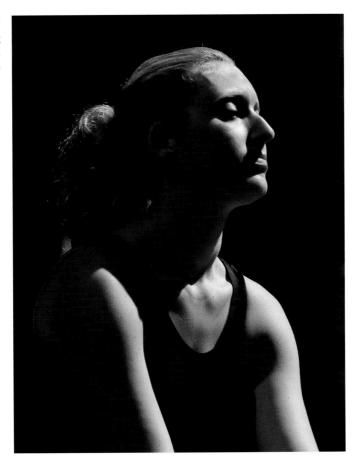

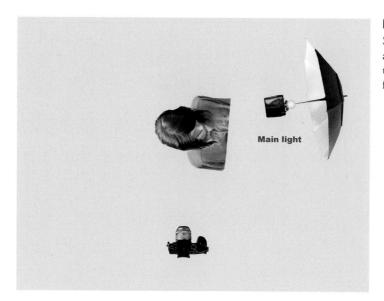

Figure 13.27 Side lighting is applied with most of the light coming from one side.

Figure 13.28
Side lighting can create dramatic profile photos.

Figure 13.29 Using sunlight, reflectors, and other aids, you can duplicate good studio lighting, such as this portrait, outdoors.

A Touch of Glamour

Glamour photography is another topic that's worth a book or two of its own. But, there's no reason why you can't add a touch of glamour to your own people pictures, whether you're shooting young and attractive male or female models, or attempting to make your Aunt Tillie look as good as possible. Although this next section *will* concentrate on some young and attractive subjects I've been lucky enough to photograph, you can easily apply all these concepts to any individual or group portrait you shoot. I'm using these particular subjects for the same reason that the commercials for workout videos use buff, athletic spokespeople, rather than folks who look like me (and who *really* need to work out). Viewing the kind of results you *can* get under ideal conditions with ideal subjects can be inspiring and motivational.

I'm going to provide a list of quick tips you can use in this section, but your best bet is to experiment with different techniques and poses and find some that you like. Work with those at first, try some variations, and add more poses as you become comfortable. Just keep in mind that your goal is not to use your subject as a mannequin that you can bend and twist any way you like. It's better to let the subject assume a pose that he or she is comfortable with. Then, you can make slight adjustments that reposition awkward limbs or produce better facial expressions.

CHOOSING POSES

There are an infinite number of good poses, but you're interested in starting with just a few. Your best bet is to clip photos from magazines with poses that you like, or purchase a posing guide with hundreds or thousands of different poses included. After you've worked with these canned poses for a while, you'll be more comfortable working with your subject for poses on your own.

The important thing is that your subject(s) must be relaxed and comfortable. The days when portrait subjects had to be immobilized in head braces for their daguerreotypes are long past. Don't make them stand for anything other than a full-length portrait. Stools make a great seat because they discourage slouching. An individual can sit tall in a stool, alert and ready to take your direction. Because they have no backs, stools won't intrude upon your picture, either. But don't be afraid to use other kinds of resting places, or from incorporating them into the photo.

If you're photographing an individual, you can try different poses as you work. For group pictures, you'll probably want to try and arrange everyone in a pleasing way and take several sets of pictures with each pose before moving on. Use basic compositional rules to arrange your subjects. For example, if photographing two or more people, don't have all your subjects' heads on roughly the same level, as at left in Figure 13.30. Instead, vary their height. The pose at right in Figure 13.30 forms a classic pyramid shape, one that should be a basic compositional element in any portrait or glamour shot.

When shooting individuals, you can vary the camera's viewpoint slightly to portray your subject in a more flattering way. For example, raise the camera slightly above eye-level if you want to elongate

Figure 13.30 Avoid having all the heads at the same level (left); vary the positions, instead (right.)

a nose or narrow a chin, broaden a "weak" forehead, or de-emphasize a prominent jaw line. If your subject has a wide forehead, long nose, or weak chin, lower the camera a little. If you encounter someone with a strong jaw and long nose, however, you're in a heap of trouble.

Nobody's perfect, and a portrait is a bad time to discover exactly where an individual's imperfections lie. Here are some general tips to keep in mind to minimize defects:

- The eyes have it. The eyes are the most important component of any portrait, as they will always be the center of attention. They must be sharp and lively, even if you're going for a softer look in the rest of the portrait. (See Figure 13.31.)
- Watch the feet. The edges of hands are more attractive than the backs or palms of hands. The bottoms of feet are downright ugly, but you can sometimes get away with side views if the feet are young enough and there are other things to look at in the photo.
- You can minimize shiny craniums. Bald heads are pretty cool these days (if you're a male) but if your subject is sensitive about a bare pate, elevate your victim's chin and lower your camera slightly.
- Minimize noses and ears. For long, large, or angular noses, try having your subject face directly into the camera. To minimize prominent ears, try shooting your subject in profile, or use short lighting so the ear nearest the camera is in shadow.

- Soft is better. If you want to minimize wrinkles or facial defects such as scars or a bad complexion, use softer, more diffuse lighting; take a step backward and photograph your subject from the waist up to reduce the relative size of the face; keep the main light at eye-level so it doesn't cast shadows; and consider using a diffusing filter (or add diffusion later in your image editor).
- Watch for reflections. If your subject is wearing glasses, be wary of reflections off the glass. Have him raise or lower his chin slightly, and make sure your flash is bouncing off the face at an angle, rather than straight on.
- **Diffuse for a romantic look.** Diffusion is a great way to add a soft, romantic look to a portrait. You can purchase diffusion filters, or make your own by smearing a little petroleum jelly around the edges of the plain glass skylight filter. Or, you can add diffusion within your image editor, as was done with Figure 13.32.
- Reflectors are your friends. Outdoors, you don't have access to main and fill lights like you do in the studio, but large reflectors can be just as good, as you can see in Figure 13.33. If your subjects are accompanied by a friend or parent, ask them to hold the reflector for you. I always manage to convince my helper to hold the reflector in front of his own face so he can't see the model. That's the best way I've found to keep the companion from offering lame suggestions that ruin the session.
- **Go for the gold.** A healthy golden glow can be beneficial to any type of portraiture, but when it comes to glamorous images, it's hard to overdo it. The image in Figure 13.34 was shot at sunset, with a gold reflector used to illuminate the model's face for an overall look that's heavy on warmth.
- **Get some movement.** Ask your subject to jump, and capture him in mid-air. Have him moving around, and grab your best shots when your subject is relaxed and thinking about his activity rather than the fact that he is being photographed. If you have a remarkably cooperative model (payment is the best way I've found to encourage cooperation), you can get some killer shots. For Figure 13.35, my model repeatedly dipped her hair into the chilly waters of Lake Erie, and then flung her head back to create a cascade of water droplets. She had to repeat the action a dozen times, but I was very patient, considering that I was dressed warmly and completely dry during the shoot.

EYES WIDE SHUT

If you're using flash for your individual or group portraits, you'll find that people may blink during a flash exposure, and you'll end up with a photo showing their eyelids instead of their eyes. The problem is particularly troublesome when shooting groups: The more people in the picture, the better the odds one of them will have her eyes closed. While you can review each shot on your LCD, a faster way is simply to ask your subjects to watch for the flash and then tell you whether it was red or white after the picture was taken. If the flash was red, they viewed it through closed eyelids and that particular picture, at least, is no good.

Figure 13.31 The eyes are the most important component of any portrait shot.

Figure 13.32 Diffusion is a great technique, and you can apply it during the exposure or later, in your image editor, as was done here.

Figure 13.33 Reflectors can brighten inky shadows outdoors.

Figure 13.34 A golden glow adds to the glamour look.

Figure 13.35 Your glamour shots can come alive if you incorporate a little movement.

You'll want to take lots of photos to capture various expressions and angles. Keep talking with your subject, and not just to provide her with instructions on where to place her arms and legs, or tilt her head. Mention how great she's doing; tell her how much she is going to like these photos.

Over time you'll develop a breezy line of patter that keeps your models relaxed. When working with amateurs, I use some funny stock phrases like, "Oh, I see you've done this before," or "Sorry, but we have to keep doing this until I get it right." You don't have to be *that* corny, but you'll soon collect a stockpile of jokes and phrases that will put your subjects at ease. And, if everybody is having fun, you'll find your people pictures are a lot more enjoyable for everyone involved.

Portraits on the Street

Photographing on city (or village) streets is a traditional type of photography, more akin to photo-journalism than portraiture, as you can see in Figure 13.36, taken from a moving tuk-tuk. One exciting aspect of this kind of work is that you may be photographing people you don't even know, including those who are so busy at just being themselves that they may only be barely aware that you are taking their picture. Although we all have privacy concerns these days, unless you're a professional photographer, or want to use a street photo in advertising, as long as you're polite and not operating in a clandestine manner, you really have few legal aspects to worry about. Street portraits are a lot of fun. (See Figure 13.37.)

You will feel uncomfortable photographing on the street if people are constantly looking at you. In addition, that can make it harder to get truly candid and effective photographs. Anything you can do to blend into your location will help you take better pictures. Sometimes that is as simple as just being relaxed and casual about your photography. Wear clothing that is appropriate to the location. Even if you are not going to wear clothing that matches the locals, you can wear clothing that is closer in color and tone. For example, if you are in an area where no one wears shorts, then if you wear shorts, you are going to stand out.

Here are some other ideas to help you blend in as you shoot:

- **Keep your gear simple.** If you are carrying a lot of gear, including multiple cameras around your neck, people will notice you. If you keep your gear simple so that it does not dominate your person, you will become more like the other people on the street.
- Know your gear. Nothing draws more attention than a photographer who is fumbling and struggling with his or her gear. Big, colorful camera bags, especially those with your camera name boldly displayed, are absolute giveaways that you are a photographer and will make it difficult to blend in. Keep your camera in a bag until you are ready to shoot, and fewer people will pay attention to you.
- **Keep your settings simple.** Before you start photographing, pick a lens that you expect will work best; set a white balance for the conditions; and choose an aperture.

Figure 13.36 The streets of any city in the world offer excellent opportunities for dramatic and interesting photography.

Figure 13.37 Simple compositions clearly show off your subject.

- Shoot with live view. Often you do have to bring your camera up to your face to photograph, but if you can shoot without doing that by using live view, especially with a tilting LCD, you will attract less attention and be able to see what is going on around you as you shoot.
- Shoot from locations out of the flow of the crowd. If you start photographing out in the middle of the street, people will notice you and may react unfavorably. Find places that are casual and out of the flow of things so that you can photograph unobtrusively. A sidewalk café just off the main square of a European city, for example, would be a good place to start. This does not mean you should hide because that is going to look suspicious.
- Smile a lot. A smile goes a long way when you are photographing on the street.

Be ready to shoot your street portrait at all times. By photographing quickly, you can respond immediately to interesting things that are happening, and people often won't notice that you are photographing, or if they do, they won't react too much to it because it seems so casual.

Here are some ways that you can shoot quickly and efficiently:

- Know your shot before you bring your camera up. This is probably the number one way to shoot quickly. Scan the location and visualize your shot before you pull your camera up to shoot. You want to be able to bring your camera up, point it at the subject, and shoot immediately.
- Be sure your camera is ready to go. Your camera must be set and ready to go if you are to shoot quickly. You need to bring your camera up to shooting position and squeeze the shutter knowing the camera is going to be taking the picture you want. Be sure your camera has not gone to sleep.
- **Preset your zoom.** With practice, you can figure out an approximate framing of a subject and your zoom setting. If you can preset your zoom to that framing, that's one less thing to do when you are ready to shoot. One way of doing this is to preframe your shot with something nearby, but not your actual subject.
- **Prefocus.** Prefocusing is like presetting your zoom. The easiest way to do this is to find something nearby that is about the same distance away from you as your subject is. Use your autofocus to focus on that point or use manual focus. You can lock focus with autofocus, but you don't have to—just having your lens at an approximate focus distance will help your autofocus work better.
- Practice bringing your camera up to shooting position. You need to bring your camera to a shooting position in a comfortable and quick way. That really only happens with practice.

Remember that a good photograph is more than just a subject. Street photography can result in very confusing compositions if you are not careful. Constantly focus your mind on keeping your compositions clear and direct. Many of the ideas for composition on the go from the last chapter also work here. Here are some modifications to those ideas to help you specifically with city street photography:

- **Be simple.** Simple compositions tend to be clear and direct. Think about how you can simplify a composition before you bring your camera to shooting position.
- Fill the viewfinder. Get in close so the subject fills up your viewfinder. This might not be possible in all situations, or it may make you uncomfortable to get physically close to your subject. In that case, use your telephoto zoom to ensure that you are visually close in the photograph.
- Check your LCD. It is easy to get distracted by the tensions of city street photography so that you lose track of how well you're doing with your compositions. The way to get yourself back on track is to check those compositions on your LCD at least once in a while as you shoot.
- Be aware of backgrounds. Backgrounds will often make or break a street photograph. Watch backgrounds as you are approaching your subject, even before you shoot. Find a camera position that will minimize problem backgrounds. Be aware of what the background is doing to affect your subject.
- Watch for distractions. Distractions crop up when you are shooting on the street. Once again, become aware of the possibility of distractions slipping in along the edges of your picture. Look for potential distractions before you bring your camera to shooting position, such as brightly lit background areas that will draw the eye away from your subject.

Vary Your Shots

Often when photographers are walking through a street taking photos, their pictures start to look the same because they are using the same focal length, they're shooting at the same distance from the subject, and they're not varying their shots. They are capturing different subjects, and sometimes that might be all that is needed. However, it can be interesting to photograph a city street location when you start looking for different shot types.

Hollywood does this all the time when creating a movie. Wide shots show off the location where a scene is taking place. Move in closer to get a medium shot to feature interactions between actors. Going in closer yet, Hollywood filmmakers will use a close shot to show off details and an extreme close shot to emphasize a very specific detail. This variety of shots makes the movie more interesting and more watchable. Looking for a variety of shots like this can help your street photography as well. Here are some things to look for when using these shot types for city street photography:

- A wide shot is about how much you see around your subject. A wide shot does not mean that you are using a wide-angle lens, although it might. A wide shot simply refers to how much you are seeing of a scene—how wide the view is around your subject, not the lens you're using. (See Figure 13.38.)
- Wide shots capture the feeling of a location. A wide shot of a city street showing the people on it can be an effective way of capturing the personality and feeling of a location.

Figure 13.38 A wide shot emphasizes your subject's surroundings.

- Wide shots show setting and environment. That's why you use them. When you get close to your subject, you might not see details of the location.
- Avoid centering your subject in a wide shot. Use the space around your subject to show interesting interaction of the subject to its surroundings. Centering your subject tends to make for rather dull street photographs because viewers will only look at what is in the center of the picture and not spend as much time with the image.
- A medium shot is about interaction. Medium shots mean that you tighten up your frame around your subject so that you emphasize the interaction of the subject with nearby people or objects. It is possible to see other interactions, but a medium shot means that you are close enough that you only see the subject and its immediate environment.
- **Medium shots can be done with any focal length.** Just as in a wide shot, a medium shot is more about the framing than it is about the focal length.
- A close shot is about details. When you tighten up your composition so that you are basically only seeing a single subject and the details of that subject, you are getting a close shot (Figure 6.8).
- Close shots are not just about close-ups. A close shot is simply a way of emphasizing details. If you are after the details of a person, you don't have to get right on top of them with a close-up to do that. All you are doing is framing in tightly to emphasize important details.
- Extreme close shots emphasize and dramatize a single detail. When you frame up really tight to a subject so that you only see a small detail, such as a close-up of a street person's tattoo, you have an extreme close-up that will often have a strong impact on a viewer. However, such extreme close-ups will miss a lot of details about the person or location that can also be important. That's why photographers rarely shoot extreme close-ups.

Photographing Concerts and Performances

We can't all be Bob Gruen or Annie Leibovitz and capture the pulse of rock music in our photographs. We can't even aspire to equal lesser known, but equally respected photographers of other types of performances, such as dance photographers Lois Greenfield or David Cooper. But our use of mirrorless ILC models does give us an advantage over many other aspiring performance photographers: we're armed with compact, (relatively) quiet cameras that are less intrusive and yet fully equipped to grab sensational images of the show. So, even if we're not ready for the cover of the *Rolling Stone*, we can all enjoy photographing concerts, festivals, plays, ballets, and many other types of presentations at local venues. I've been shooting these events for most of my photographic life, and continue to enjoy perfecting my skills three or more times each month.

In one sense, concert and performance photography is a type of photojournalism. The goal is to capture a moment or series of moments and tell a story, just as we do when practicing the art of photojournalism. With that in mind, I always tell new performance/concert shooters that two time-honored rules of photojournalism apply quite well to this type of photography:

- 1. If your pictures aren't good enough, you're not close enough. -- Robert Capa
- 2. F/8, and be there. -- Unknown (possibly Weegee)

If you keep these two rules in mind, everything else is just detail. Capturing the flying fingers of a legendary guitar hero like Tab Benoit, as in Figure 14.1, always trumps the very best photo you could possibly take from the 27th row of the upper balcony. In this chapter, I'm going to show you how you can get up close and personal with performers, and what to do when you get there.

Figure 14.1 If your performance photos aren't good enough, you probably weren't close enough.

Brushes with Greatness

Those who can, do. Those who cannot, sometimes end up taking pictures of those who can. As a failed musician, I instead turned to photography and photojournalism as a career. (This is why my band, *The Babylonian Disaster Squad* does not appear in your CD or MP3 collections.) I actually began photographing future Rock and Roll Hall of Famers while still in high school, not knowing at the time that my contemporaries Gerald Casale (at left center in Figure 14.2) and Joe Walsh (at far right in the figure) would have more successful careers with Devo and The Eagles (respectively), than I would as an aspiring (in my dreams) *Rolling Stone* photographer. Jerry and Joe are shown performing at the West Main Elementary School gymnasium in my home town, roughly at the time all three of us enrolled at nearby Kent State University.

Two years later, I was still using awful direct flash techniques to photograph B.B. King, and the bug had bitten me. I was wrestling my way to the foot of the stage to photograph Janis Joplin, Country Joe and the Fish, Jose Feliciano, and dozens of other performers you may or may not have heard of.

So, can you expect to find yourself front-and-center to photograph Bruce Springsteen at his next Super Bowl performance, or perhaps capture intimate shots of the Joffrey Ballet in *The Nutcracker?* Frankly, no. But there are lots of ways you can get great shots of nationally known performers as well as local acts without resorting to false credentials or a backstage pass.

Figure 14.2 Future Devo and Eagles stalwarts Gerald Casale and Joe Walsh were early victims.

Figure 14.3 Here's B.B. King in another (obviously) non-digital photograph.

Here are some tips:

- Volunteer your time. One local folk music venue—which hosts Grammy-winning acts several times a month—has a staff that is mostly volunteers. I help out there with my photography to gain better access at shows. One local dance troupe also makes use of unpaid help. By agreeing to set up a studio in their practice space and shoot images for their brochures, I was able to capture some excellent posed images, like the one shown in Figure 14.4, with the bonus of a professional choreographer on hand to direct the shoot.
- Attend dress rehearsals and sound checks. For plays, dances, concerts, and other types of performances, you may be able to gain access to a dress rehearsal or sound check. It's important not to disturb the practice/tune-up session. By staying out of the line of sight of the choreographer or director, you can usually shoot to your heart's content from some of the choice seats

Figure 14.4 Volunteer to provide studio shots for publicity.

stage right or left. Verb Ballets is a nationally respected professional dance company in Cleveland, and I've photographed many of their dress rehearsals. The company used the image in Figure 14.5 as a poster for their Fresh Inventions/Danceworks 10 production.

■ Look for side projects/nostalgia tours in small venues. Surely you've heard of Paul McCartney and Wings; Crosby, Stills, and Nash; Tom Petty & the Heartbreakers; Badfinger; Traffic; Toad the Wet Sprocket; J. Geils Band; The Moody Blues; or Bootsy Collins? You're unlikely to be able to photograph any of these arena acts in a large venue. But Denny Laine (of Wings and the Moody Blues), Stephen Stills, Benmont Tench (Tom Petty keyboardist), Peter Wolf, and other members of the aforementioned groups have all played in side projects at a local 600-seat theater where I have a regular aisle seat in Row 2. Nostalgia tours are great for those old enough to have developed a solid hankering for the Good Old Days. Dave Mason, shown in a black-and-white capture in Figure 14.6, survived playing in Traffic, accompanied Jimi Hendrix on guitar for the recording of *All Along the Watchtower*, and says he could live quite well from the royalties off Joe Cocker's version of his *Feelin' Alright*. Yet, I was able to photograph him from eight feet away as he toured small venues recently. Thanks to my photographic efforts, my official Bacon Number is 1.0, after meeting the actor while shooting him and his band, The Bacon Brothers.

Figure 14.5 This two-second exposure (timed so it would end when the center dancer stopped moving) ended up as a poster.

Figure 14.6 Living legends like Dave Mason often tour small venues.

■ Shoot up-and-coming bands. I have no way of knowing whether the Cleveland band "Jackie," featuring electrifying songstress Jackie LaPonza will make it big nationally, but the group's lack of a recording contract doesn't make the band any less exciting to shoot, as you can see in Figure 14.7. And if local talent does score on the national scene, you'll have some photos to really brag about.

Figure 14.7
Local bands can be just as exciting to photograph as nationally known acts.

- Photograph tribute bands. It's about 45 years too late to be photographing the Beatles, but cover and tribute bands with look-alike personalities and sound-alike repertoires are plentiful, as shown in Figure 14.8. Select the right angles, and your pictures could—almost—be the real thing. Indeed, Tim Owens, a singer who grew up six miles from me, ended up transferring directly from frontman for local tribute band British Steel to replace Rob Halford in Judas Priest. You never know.
- Take pictures for charity. Last summer, I was lucky enough to be the "official" photographer for Rock United, a fundraiser for United Way of Cleveland, which gave me "all access" (and free admission!) in exchange for some photographs supplied on DVD to the sponsors. Community service is a great way to get up close for the best pictures.
- Explore genres. I started out photographing rock and blues bands, because that's the type of music I played as a failed musician. (I also played in a jazz/big band combo, but never aspired to make a living at that.) I *liked* other types of music, but it was really a revelation when I began photographing folk artists like Loudin Wainwright III, Western/swing bands like Riders in the Sky and Asleep at the Wheel, and bluegrass artists like Ralph Stanley and the Gibson Brothers. After photographing blues legend James Cotton (see Figure 14.9) and Celtic rock virtuosos Enter the Haggis in the same month, I discovered that "alternate" acts were just as interesting to photograph. You can expand your musical and photographic horizons simultaneously.

Figure 14.8 Tribute bands are the next best thing to the real act.

Figure 14.9 I was lucky enough to photograph Howlin' Wolf and Muddy Water's harp player James Cotton when he was a young man 35 years old, then again, last year for this photo.

Arming for Battle

I am fond of reassuring aspiring photographers that you can take almost any picture with almost any camera. You don't need a fancy pro camera to shoot concerts and performances. Even a simple point-and-shoot camera can be pressed into service. However, the right gear *does* make it possible to take certain photographs easily that are difficult to shoot without certain equipment. And, in other cases, particular features make grabbing the picture you want somewhat easier and more convenient. But, in all cases, the most important tools you have are your feet and your brain. Maneuver yourself into the right spot and shoot creatively, and you'll end up with a winning photograph regardless of what equipment you have available.

That said, this section will list some of those "conveniences" that particularly lend themselves to photography of concerts and performances. Don't fret if you're missing some of these: you still have your feet and brain to rely on.

■ A fast zoom lens. A fast, sharp zoom lens that can be used wide open will simplify your life tremendously. I shoot 90 percent of my concerts with a mid-range zoom lens with an f/2.8 maximum aperture and image stabilization. Most vendors offer something similar (Sony has introduced a 70-200mm f/4 OSS [optical image stabilization—IS in the lens itself] for its

full-frame mirrorless cameras.) I love the results I get. I use the lens hand-held at 200mm and f/4 with the ISO of my camera set at 3200, and get shots like the one in Figure 14.10 of bluesman Robert Cray. You can get by with optics that are not quite as fast (see the tips that follow this one), but a similar lens makes your life simpler.

- Low light performance. Most stages are illuminated by spots and other lights, so you can usually get by with ISO settings of ISO 800 to ISO 1600. Those are well within the "low noise" performance range of most modern cameras. I use ISO 6400 and higher only because my camera does a particularly good job at that setting, and it lets me bump up the shutter speed a notch when I want to freeze those flying fingers. I captured bassist Jack Casady (from Jefferson Airplane and Hot Tuna) at ISO 12800 with very good results, as seen in Figure 14.11. But if you have a camera that produces good images at ISO 800 to ISO 1600, you're in good shape, particularly since a little noise in a concert or performance photograph is not usually very objectionable. Noise tends to show up worst in backgrounds, and, in stage performances, the backgrounds are dimly lit, either masking the noise or making it easy to remove with noise reduction or simple blurring techniques in your image editor.
- Image stabilization or a monopod. At one time, I photographed many concerts using a monopod. You'll find that a monopod (as opposed to a tripod) can be used without interfering with the other paying customers' enjoyment of the performance, as long as you don't sling it around like a weapon. (And the venue allows you to use one.) More recently, I've left the monopod at home and relied on image stabilization. The bulk of my concert photos are taken at 1/180th second at f/2.8 or f/4 and ISO 3200. I can slow down the shutter to 1/60th to 1/15th or even a full second if I want to incorporate subject motion in my shot, as with Figure 14.12. But, even if you want to allow the subject to blur, it's generally a good idea for the camera itself to be steady, so everything else in the shot is sharp and clear. Either a monopod or image stabilization will provide the steadiness you need.
- Certain camera features. There's no denying that certain camera features not found in every model can expand your creative opportunities. For example, if your camera has built-in double-exposure capabilities, you can grab pictures like the one shown in Figure 14.13. Sweep Panorama or Easy Panorama, found in some models, lets you capture interesting extra-wide-view shots. Rapid-fire characteristics of some mirrorless models (a recent Sony model is capable of 12 frames per second) can not only help you capture a critical moment, but, you'll find, will produce sharper images in the center of the sequence, because camera motion may be damped after the first few images are captured. If your camera has full HD capabilities, you can even come home with a sound video of your favorite band. (Don't overdo this; most bands ban movie recording. I usually grab a video clip of one song, or part of a favorite song for my personal enjoyment. It's likely that the smartphone recordings being captured all around me are the ones that make it to YouTube.)

Figure 14.10 A zoom lens, shot at the maximum aperture of f/2.8, captured this emotion-filled moment.

Figure 14.14 Shoot from the sides of the stage, as well as the front.

Figure 14.15 Side views let you isolate one performer creatively.

Figure 14.16 If you can get backstage, you'll find other interesting views.

Interesting People

The more you shoot, the more you'll discover that performers are flat-out interesting people, at least from a photographic standpoint. Costumes are an important part of a musician's image, an actor's character, and a dancer's repertoire. Add in some attitude, an interesting face, and a few quirky mannerisms, and you've got a prime subject for an interesting portrait—entirely separate from the individual's performance.

My portrait of the country guitarist didn't need a guitar or any of the accourtements of his stage persona to make for the interesting shot you see in Figure 14.17. The bass player in Figure 14.18 reeked of menace as his band played some ominous tune, although in real life he was a cheerful, engaging fellow. As you shoot concerts and other events, go beyond the music to explore the character of the performers, and I think you'll be pleased with the results.

Figure 14.17 I photographed this fellow as the good 'ole boy he was in real life, not the musician who generated excitement on stage with his music.

Figure 14.18 Dark moods can make for interesting portraits of musicians.

I cornered the actor shown in Figure 14.19 after a performance and asked him to pose for a picture. He immediately went back into character, every part of his body assuming the essence of the Renaissance fellow he was portraying, and cracked a wicked grin. As he posed and I snapped away, all I could say was, "I see you've done this before!"

Figure 14.19
Talk to actors after a performance; you'll find they make excellent portrait subjects.

Techniques

I'm going to finish off this chapter with a compendium of a few of my favorite techniques for photographing performances. This is one type of photography where creativity is given a premium, and there is no penalty for going over the top. The most extreme techniques you can dream up just might be the ones that make it to the cover of a CD or end up gracing a poster.

■ Selective focus to blur backgrounds. Indoors on stages, you'll rarely have to worry about backgrounds. Outdoors, especially at festivals like the one pictured in Figure 14.20, you'll find lots of distractions that can intrude on your photo. Bad backgrounds can be especially detrimental when you've got a musician performing while some gawker behind them sucks down a cotton candy. For this picture, I used a large aperture to blur the tents behind the violinist as much as I could.

Figure 14.20 Blur the background to reduce distractions.

■ Continuous shooting secrets. I love using continuous shooting at performances for several reasons. First, I've found that, even with image stabilization and an acceptably fast shutter speed, some camera blur still creeps in. That's often the case when I swivel the camera to reframe slightly, or am less than gentle when I press the shutter release. With the camera set on 5 fps or faster burst mode, I often find that one of the *center* pictures is the sharpest, because it's captured after the initial movement has subsided. Continuous shooting also captures a variety of different shots of performers who are playing their instruments quite rapidly. A difference of as little as 1/20th of a second can make a big difference in the final image of a fast-fingered violinist, leaping ballerina, or ukulele virtuoso Jake Shimabukuro, shown in Figure 14.21.

Figure 14.21
Use continuous shooting to capture the critical moment.

■ Telephoto compression. A long lens can be used to compress the distance between objects in the frame, as was the case with Figure 14.22. Drummers, who generally sit at the back of the stage, are notoriously hard to photograph anyway (unless they're seated on a raised platform). So, a long lens and a bit of compression caused by a telephoto focal length can give you a special shot.

Figure 14.22 Use a telephoto to compress distances.

■ Use framing. Carefully composing your image so that one subject is framed by another is an effective technique for tying together different members of a group, as I did with Figure 14.23. You can also see the effect of telephoto compression in this shot.

Figure 14.23 Framing helps unite several performers in one shot.

■ Blown highlights? No problem! I tend to shy away from recommending image editors to fix problems that should have been corrected in the camera, but am willing to make exceptions for concert photography. Rock music, in particular, has a long history of special effects, dating back to Frank Zappa's signature solarized photo on the cover of his 1966 album *Freak Out!* So, faced with blown highlights, I didn't hesitate to apply some posterization effects to create an entirely new image for Figure 14.24. Try to capture your image in the camera first, but don't be afraid of applying creativity in your image editor, too.

Figure 14.24
Sometimes, manipulating an image in an editor can provide a new look you couldn't get in real life.

■ **Reflections.** I have a few dozen shots I like in which reflections form an important part of the image, but chose this one, seen in Figure 14.25. I really did capture a reflection of Chris Sherman (aka Freekbass) in the sunglasses of his guitarist T-Sly, but made one small tweak to the image to make it better (in my opinion). Hint: Freekbass is *not* left-handed.

Figure 14.25Reflections can be interesting.

■ Mood lighting. A recent show I shot with Todd Rundgren featured constant backlighting, lasers, and smoke. Again, no problem! The weird colors are part of the mood of the performance, so I shot what I saw and didn't worry about making color or exposure corrections. (See Figure 14.26.)

Figure 14.26
Stage lighting adds to the mood.

■ Multiple exposures. If your camera has built-in double exposure capabilities, you can use it to produce interesting images like the one shown in Figure 14.27. The dancers performed the routine once at the beginning of the dress rehearsal, and when they ran through it a second time, I was ready for this moment. The dark background found in many stage performances simplifies using multiple exposure techniques.

Figure 14.27 Double exposures can convey a feeling of movement in an otherwise static shot.

Scenic, Wildlife, and Nature Photography

One of the cool things about photography is that so many of the most interesting creative avenues run parallel to each other, criss-cross, or even meander down the same path from time to time. Once you get outdoors and begin shooting, the whole world is your subject. Animals, plants, and scenic vistas all beg to be captured and enjoyed. This chapter will help you deal with the world of nature—basically, anything that does *not* include humans.

As a result, you'll find tips here for photographing wildlife of all sorts—but not, for example, people riding horses. Scenic photography can include human-made structures, such as the charming old barns often found in rural landscapes. Nature photographs can include flowering plants, trees, and other flora, but, generally, not photographs of formal flower gardens. However, photographing plant life most often incorporates elements of close-up and macro photography, so I'm not going to explore that topic in this chapter. You'll find what you need to know to photograph subjects close to the lens in Chapter 17.

I've found that mirrorless cameras are ideal for outdoors photography. Their biggest advantage is their light weight. Most of the best locations for shooting scenery, wildlife, and nature are located either off the beaten path, or *on* the beaten path. Both imply that, unless you're driving an off-road vehicle, you can't approach many ideal outdoor venues by automobile. Most of this type of photography that I do requires driving to a parking spot or pull-over space, getting out of my vehicle, and loading everything I need to shoot onto my shoulder, back, or arms.

Even when I'm traveling light, this gear will include a camera or two, three lenses, a tripod, a folding camp stool, water for hydration, and, possibly, outerwear to protect from unexpected (or expected) foul weather. Mirrorless ICL photography pares a significant amount of weight from the load I carry

while hiking through woods, fording waterways, or climbing hills. Not only are mirrorless cameras smaller than their dSLR counterparts, their lenses and accessories (such as filters) tend to be more compact as well. My whole camera kit can weigh less than my pro dSLR with a single telephoto lens. Coupled with a lightweight carbon fiber tripod, a backpack intended for hiking, and other intelligently-designed tools, a trek to capture nature can be an adventure rather than a chore. I've seen birders toting 600mm or 800mm lenses that cost more than my car. They must love nature photography (they must!), but as they lumber past me their faces look like they're just one mile short of completing the New York City Marathon.

Scenic Photography

I've put scenic photography first because it is as old as photography itself. The first known permanent photograph, taken in 1826 by French chemist Joseph Nicèphore Nièpce, is a view of the courtyard outside his laboratory. Because early photographs required exposures that were extremely long (Nièpce's scenic required an eight-hour time exposure in full daylight), stationary subjects like trees and mountains were perfect pictorial fodder. When early photographers weren't strapping our ancestors into chairs for painfully tedious portraits, they were creating scenic photographs.

Of course, we've come a long way since then, both in the way photographs are taken, and the esteem in which they are held. That first photograph was made using a pewter plate coated with asphalt, and when Nièpce submitted the "heliograph" to England's King George IV and the Royal Society, it was rejected. Today, the same photo could be exposed onto a solid-state sensor in 1 1/8,000th of a second (the fastest shutter speed on the latest high-end digital cameras), and photographs are more highly valued. For example, a signed 16×20 print of Ansel Adams' "Monolith, Face of Half Dome" will set you back \$37,000 at the Ansel Adams Gallery (www.anseladams.com, if you'd rather have the photograph than a new SUV).

This section focuses on several different varieties of scenics and offers some tips for getting some interesting shots of landscapes, sunsets/sunrises, fireworks, and other types of scenic images.

Scenic Essentials

Scenic photography isn't particularly equipment- or gadget-intensive. Your digital camera and its standard zoom lens will be fine in most cases, as long as your lens has a sufficiently wide focal length to take in expansive vistas. If you're planning to include night photography in your scenic repertoire, particularly if you're going after fireworks pictures, you'll want a digital camera that can capture long exposures at boosted ISO ratings without introducing excessive noise into the picture. All mirrorless cameras have special noise reduction features that are able to separate actual image detail from random noise by comparing two separate photographs and then, in effect, deleting anything that doesn't look like picture information.

A main concern when selecting a camera for scenic photography will be the lens. A wide zoom range, extending from a true wide-angle perspective to a decent telephoto setting gives you the flexibility you need to photograph wide-open spaces or focus in on a distant mountain. Choice of focal length is important when shooting scenics, because it's not always practical to drive a few miles closer to a mountain, and it may be impossible to back up any further for a wider view (thanks to a cliff, forest, ocean, or other impediment at your back). Telephotos can bring distant subjects closer, and de-emphasize things in the foreground that you don't want in the picture. Wide angles, in contrast, make distant objects look as if they are farther away while emphasizing the foreground, as you can see in Figure 15.1.

If you think landscapes aren't hard-wired into our thinking, the next time you print a photograph, check out the name applied to the "wide" orientation in your printer's Setup dialog box. You may be printing an abstract image, a photo of a football game, or even a group portrait, but the name applied to a picture or document that's wider than it is tall is *landscape*. Scenics have been a favorite subject for artists throughout history, from Da Vinci to Dali to Daguerre.

Eight Simple Rules for Composing Your Landscapes

Landscape photos, in particular, are an opportunity for you to create thoughtful and interesting compositions. Those mountains aren't going anywhere. You're free to move around a bit to get the best angle, and, unless you're including people in your pictures for scale, you don't have to worry about an impatient subject. If you can't pull all the elements of a scenic photograph together to create a pleasing composition, you're not trying hard enough.

In one sense, good composition is the most important aspect of landscape photography. Certainly an action photo or a portrait needs to be composed well for maximum effect, but if you've captured a once-in-a-lifetime moment in an important sports contest, no one is going to complain because the football needed to be a little more to the left. And, to be honest, do you really care about how well a close-up photo of Angelina Jolie or Brad Pitt is composed? Yet, mountains are everywhere, seashores look pretty much alike the world around, and nice-looking amber waves of grain are not especially distinctive. How you arrange the elements in photographs of these subjects can make all the difference.

There are eight simple rules for composing photos effectively. I'll review each of them in this section. In brief, they are as follows:

- Simplicity. This is the art of reducing your picture only to the elements that are needed to illustrate your idea. By avoiding extraneous subject matter, you can eliminate confusion and draw attention to the most important part of your picture.
- Choosing a center. Always have one main subject that captures the eye.
- The rule of thirds. Placing interesting objects at a position located about one-third from the top, bottom, or either side of your picture makes your images more interesting than ones that place the center of attention dead center (as most amateurs tend to do).

Figure 15.1
To emphasize the foreground, use a wide-angle lens or zoom setting.

- Lines. Objects in your pictures can be arranged in straight or curving lines that lead the eye to the center of interest, often in appealing ways.
- **Balance.** We enjoy looking at photographs that are evenly balanced with interesting objects on both sides, rather than everything located on one side or another and nothing at all on the other side.
- **Framing.** In this sense, framing is not the boundaries of your picture but, rather, elements in a photograph that tend to create a frame-within-the-frame to highlight the center of interest.
- Fusion/separation. When creating photographs, it's important to ensure that two unrelated objects don't merge in a way you didn't intend, as in the classic example of the tree growing out of the top of someone's head.
- Color and texture. The hues, contrasts between light and dark, and textures of an image can become an important part of the composition, too. The eye can be attracted to bright colors, lulled by muted tones, and excited by vivid contrasts.

Simplicity

Let nothing intrude into your photograph that doesn't belong there, and your viewer will automatically focus on the information you intended to convey. In scenics, extraneous subject matter can include busy backgrounds, utility wires, ugly buildings, or even stray people who interfere with the natural setting. Striving for simplicity is one of the reasons for excluding humans from landscape photographs, even if human-constructed buildings appear in your idyllic canvas. When we spot a person in a photograph, our eye tends to gravitate to the human form, and the vista we wanted to present becomes secondary.

Avoiding humans is one way to simplify your image. Indeed, some photographic competitions explicitly prohibit evidence of "the hand of man" (or, more properly, "the hand of humans") in certain categories of scenic and wildlife photography. That can be a challenge, at times, because human influence in an otherwise natural scene may be subtle to the untrained eye. For example, does Figure 15.2 show a pristine beach on a remote tropical isle—or do the carefully trimmed palms and manicured sand reveal a shoreline that's been prepped for human enjoyment? (It's actually a beach next to a State park in the Florida Keys, and the sand was trucked in, as all the sand on the reef-laden Atlantic coast of the Keys has long ago fled to Bermuda.)

Of course, you can still achieve a simple composition without eradicating all traces of human beings. But, aspects for achieving simplicity may not be simple even when you embrace the presence of the human race. For example, you probably won't have much choice in your background. The clouds, mountains, or ocean off in the distance aren't going to change their colors or move to suit you. However, you can make a background work for you by shooting on a day with a cloudless sky (if a plain blue background suits your composition) or one with abundant fluffy clouds, if that's what you're looking for.

Figure 15.2 Your scenic vistas might not be as natural as you think, even if they are still charming.

Crop out unimportant objects by moving closer, stepping back, or using your zoom lens. Remember that a wide-angle look emphasizes the foreground, adds sky area in outdoor pictures, and increases the feeling of depth and space. Moving closer adds a feeling of intimacy while emphasizing the texture and details of your subject. A step back might be a good move for a scenic photo; a step forward might be a good move for a scenic that includes a person.

Remember that with a digital camera, careful cropping when you take the picture means less trimming in your photo editor, and less resolution lost to unnecessary enlargement. Finally, when eliminating "unimportant" aspects of a subject, make sure you truly don't need the portion you're cropping. For example, if you're cropping part of a boulder, make sure the part that remains is recognizable as a boulder and not a lumpy glob that viewers will waste time trying to identify. And cutting off the heads of mountains can be just as bad as cutting off a person's head in a portrait!

Front and Center

Next, you should decide on a single center of interest, which, despite the name, needn't be in the center of your photo. Nor does it need to be located up front. No matter where your center of interest is located, a viewer's eye shouldn't have to wander through your picture trying to locate something to focus on. You can have several centers of interest to add richness and encourage exploration of your image, but there should be only one main center that immediately attracts the eye. Think of Da Vinci's Last Supper, and apply the technique used in that masterpiece to your scenic photography. There are four groups of Apostles that each form their own little tableaux, but the main focus is always on the gentleman seated at the center of the table. The same is true of scenic photos. One huge mountain with some subsidiary crests makes a much better starting point than a bunch of similarly sized peaks with no clear "winner."

Figure 15.3 A photograph without a center of interest is boring (left); the center of interest need not be in the center of the photograph (right).

Figure 15.3 shows two images shot on the Mediterranean coast on the same morning from roughly the same spot. At left are some waves crashing over rocks. There's no real center of interest, and no real reason to look at one particular rock or rivulet of water instead of another. At right, the rocks have become the center of interest and clearly dominate the image, even though an island at upper left and the risen sun at upper right balance the image vertically.

The center of interest should always be the most eye-catching object in the photograph; it may be the largest, the brightest (our eyes are drawn to bright subjects first), or most unusual item within your frame. Shoot a picture of a beautiful waterfall, but with a pink elephant in the picture, and the pachyderm is likely to get all of the attention. Replace the waterfall with some spewing lava, and the elephant may become secondary. Gaudy colors, bright objects, large masses, and unusual or unique subjects all fight for our attention, even if they are located in the background in a presumably secondary position. Your desired center of attention should have one of these eye-catching attributes, or, at least, shouldn't be competing with subject matter that does.

Avoid having more than one center of attention. You can certainly include other interesting things in your photograph, but they should be subordinate to the main subject. A person can be posed in your scenic photograph to provide scale, but if the person is dangling by a tree branch over a precipice, viewers may never notice the Grand Canyon in the background.

In most cases, the center of interest should *not* be placed in the exact center of the photograph. Instead, place it to one side of the center, as shown at right in the figure. We'll look at subject placement in a little more depth later in this chapter.

Landscape "Portraits"

The orientation you select for your picture affects your composition in many different ways, whether your photo uses a landscape (horizontal) layout or a portrait (vertical) orientation. Beginners often shoot everything with the camera held horizontally. If you shoot a tall building in that mode, you'll

end up with a lot of wasted image area at either side. Trees, tall mountains shot from the base, and images with tall creatures (such as giraffes) all look best in vertical mode.

Recognize that many landscapes call for a horizontal orientation, and use that bias as a creative tool by deliberately looking for scenic pictures that fit in the less used vertical composition. Some photos even lend themselves to a square format (in which case you'll probably shoot a horizontal picture and crop the sides).

Figures 15.4, 15.5, and 15.6 illustrate the kind of subject matter that can be captured in all three modes, each presenting a different view of the same scene, the Cliffs of Moher in County Clare, Ireland. Figure 15.4 emphasizes a panoramic view that shows how far the majestic cliffs project out into the Atlantic Ocean. Cropped vertically, as in Figure 15.5, the 700-foot (plus) height of the cliffs becomes the focus. The square composition of Figure 15.6 provides a more static look that's less interesting than the horizontally and vertically oriented views. When capturing or cropping to a square (which is sometimes necessary because of intrusive or unwanted elements at the sides and top/bottom of the frame, try to include curves and lines that draw the viewer's eye into and around the image. In Figure 15.6, the sea and sky provide a partial frame for the cliffs and help give the image a little more life.

Rule of Thirds

You'll see the idea of dividing your images into thirds referred to as the rule of thirds quite a bit, and this is one case in which I'm not obsessive about avoiding hard-and-fast rules. It really is a good idea to arrange your pictures using this guideline much of the time, and when you depart from it, it's a great idea to know exactly why.

Earlier, I mentioned that placing subject matter off-center is usually a good idea. Things that are centered in the frame tend to look fixed and static, while objects located to one side or the other imply movement, because they have somewhere in the frame to go, so to speak.

The rule of thirds works like this: Use your imagination to divide your picture area with two horizontal lines and two vertical lines, each placed one-third of the distance from the borders of the image, as shown in Figure 15.7. (Some cameras provide a rule-of-thirds grid in the viewfinder to help you.) The intersections of these imaginary lines represent four different points where you might want to place your center of interest. The point you choose depends on your subject matter and how you want it portrayed. Secondary objects placed at any of the other three points will also be arranged in a pleasing way.

Horizons, for example, are often best located at the upper third of the picture, unless you want to emphasize the sky by having it occupy the entire upper two-thirds of the image. Tall subjects may look best if they are assigned to the right or left thirds of a vertical composition. Figure 15.7 shows a vista at the edge of the Grand Canyon arranged into thirds. Notice how the horizon is roughly at the one-third mark, while the dominant tree at right is located at the intersection of vertical and horizontal one-third lines. While this image illustrates the application of the rule of thirds, it also

Figure 15.4 Some scenes look best in a horizontal format, especially when they lend themselves to a panoramic perspective.

Figure 15.5 Subjects can be vertically oriented if you want to emphasize height.

Figure 15.6 Take care when composing square pictures to avoid a static look. Include lines or curves, or other elements that lead the eye through the composition.

Figure 15.7 The rule of thirds is a good starting place for creating a pleasing composition.

Figure 15.8 Depart from the rule when a different composition is better.

shows its fallibility. Unless you're documenting the foliage that grows at the rim of the Grand Canyon, the most exciting view would have been to move a bit closer to show the depth and breadth of the canyon itself, whether or not the composition could have been divided neatly into thirds. Figure 15.8 shows a more interesting view of the Grand Canyon, and doesn't allow the rule of thirds to dictate exactly where the main elements are placed.

One important thing to consider is that if your subject includes an animal, a vehicle, or anything else with a definable "front end," it should be arranged in a horizontal composition so that the front is facing into the picture. If not, your viewer will wonder what your subject is looking at, or where the animal is going, and may not give your intended subject the attention you intended. Add some extra space in front of potentially fast-moving objects so it doesn't appear as if the thing is just about to dash from view.

Oddly enough, it's not important to include this extra space in vertical compositions for anything that doesn't move. A tree can butt right up to the top of an image with no problems. We don't expect the object to be moving, therefore we don't feel the need for a lot of space above it. If your scenic was taken at Cape Kennedy and a booster rocket intrudes, it would be best positioned a bit lower in the frame.

Using Lines

Viewers find an image more enjoyable if there is an easy path for their eyes to follow to the center of interest. Strong vertical lines lead the eye up and down through an image. Robust horizontal lines cast our eyes from side to side. Repetitive lines form interesting patterns. Diagonal lines conduct our gaze along a gentler path, and curved lines are the most pleasing of all. Lines in your photograph can be obvious, such as fences or the horizon, or more subtle, like a skyline or the curve of a flamingo's neck.

As you compose your images, you'll want to look for natural lines in your subject matter and take advantage of them. You can move around, change your viewpoint, or even relocate cooperative subjects somewhat to create the lines that will enhance your photos.

Lines can be arranged into simple geometric shapes to create better compositions. Figure 15.9 shows an image with a variety of lines. The strongest line is the curve of the main path, which leads our gaze through the picture to the Cathedral Rock formation in the background. The path's broad swathe is crossed by the shadows of the trees. The vertical lines of the trees along the path lead our eyes toward the top of the photo. This is the sort of picture that engages the viewer's attention, luring them into spending more than a few seconds exploring everything it contains.

Figure 15.9 The curved lines of the path interact with the horizontal shadows and the vertical lines of the trees.

Balance

Balance is the arrangement of shapes, colors, brightness, and darkness so they complement each other, giving the photograph an even, rather than lopsided, look. Balance can be equal, or symmetrical, with equivalent subject matter on each side of the image, or asymmetrical, with a larger, brighter, or more colorful object on one side balanced by a smaller, less bright, or less colorful object on the other.

Figure 15.10 shows an image at top that on first glance has a balance of sorts. The light tones of the castle image at the far right are more or less offset by the darker foliage on the left side. However, because the castle is clearly intended to be the center of interest for this photo, the more you look at it, the more you get the feeling the picture is a bit lopsided.

By taking a step back, we can include more of the road and wall leading to the castle, and a bit more of the structure on the right side, as shown in the middle version. This cropping does several things. It balances the picture, while moving the center of interest closer to one of the "golden" intersections defined by the rule of thirds. The walls and road provide converging lines that attract our eye to the castle.

Even so, there's still something wrong with this picture. The tree branches at the right side aren't connected to anything. They appear to be growing out of the side of the picture frame. We can crop most of them out and improve the balance of the image, as you can see in the bottom version.

Figure 15.10 Top: The large light and dark masses on the right and left sides of the picture don't really balance each other as they should. Middle: Cropping less tightly provides a better balanced picture with converging lines that draw our eyes to the castle. Bottom: Removing the tree branches improves the picture even further.

Framing

Framing is a technique of using objects in the foreground to create an imaginary picture frame around the subject. A frame concentrates our gaze on the center of interest that it contains, plus adds a three-dimensional feeling. A frame can also be used to give you additional information about the subject, such as its surroundings or environment.

You'll need to use your creativity to look around to find areas that can be used to frame your subject. Windows, doorways, trees, surrounding buildings, and arches are obvious frames. Figure 15.11 shows a classic "environmental" frame, with the tree branches in the foreground framing the upperhalf of the photo.

Frames don't even have to be perfect or complete geometric shapes. Figure 15.12 shows how rocks in the foreground form a frame for the vista above. Generally, your frame should be in the foreground, but with a bit of ingenuity you can get away with using a background object, such as a bridge, as a framing device.

Figure 15.11 Trees are a classic prop used to construct frames for scenic photographs.

Figure 15.12 Frames just need to provide a space for the image to reside within, as in this photo in which the foreground rocks frame the vista above.

Fusion/Separation

Our vision is three-dimensional, but photographs are inherently flat, even though we do our best to give them a semblance of depth. So, while that tree didn't seem obtrusive to the eye, in your final picture, it looks like it's growing out of the roof of that barn in your otherwise carefully composed scenic photograph. Or, you cut off the top of part of an object, and now it appears to be attached directly to the top of the picture.

You always need to examine your subject through the viewfinder carefully to make sure you haven't fused two objects that shouldn't be merged, and that you have provided a comfortable amount of separation between them. When you encounter this problem, correct it by changing your viewpoint, moving your subject, or by using selective focus to blur that objectionable background.

Figure 15.13 is a good example of an undesired fusion. The scene from the edge of this lake actually looked interesting in real life, with the fallen tree extending out into the water toward the distant shore. (Take my word on this.) Unfortunately, the slight telephoto lens setting I had to use to

Figure 15.13 Watch your compositions so that individual objects don't merge or fuse together.

capture the image from my vantage point compressed the near and distant subject matter together, making a big mess. You can't really tell how far the fallen tree and the opposite shore are from each other, and the details blend together. A slightly higher view would have been better, clearly putting the foreground tree into the foreground and opening up some clear water between it and the far shore, but that viewpoint wasn't physically possible in this case.

Your best defense for side-stepping fusion problems of this sort is to be aware that it can happen, and to recognize and avoid mergers as you compose your images.

Color and Texture

Color, texture, and contrasts are an important part of the composition in Figure 15.14. The warm sunset colors, the deep blue of the Mediterranean Sea, and the rough texture of the rocks in the foregrounds provide sharply contrasting elements that attract the eye and leads it through the picture from the brightest area (which typically attracts the eye first) to the foreground. When shooting in color, the hues in the photo are an important part of the composition. Texture and contrasts in tones can be effective in both color and black-and-white photos.

Figure 15.14 Imaginative use of color and texture can add interest to a landscape photo.

Key Types of Landscapes

This section will provide you with a little advice on how to shoot the most common type of scenic photographs, including mountain scenery, sunsets, sea and water scenes, panoramas, and fireworks. All of them are easy to picture, but there are a few tricks you'll want to pick up to get the best shots.

Mountains

Although I label this category "Mountains," this kind of scenic photography really encompasses any broad expanses of nature unencumbered by large numbers of buildings. The same concepts apply whether you're in Idaho or Iowa.

Your main decision is a choice of lens or zoom setting. A wide-angle setting makes distant objects appear to be farther away, emphasizing the foreground of your photo. A longer telephoto setting brings faraway objects like mountains closer, but compresses everything in the foreground.

Although digital camera sensors aren't especially sensitive to ultraviolet light (thus eliminating the need for a "UV" filter most of the time), a useful tool for photographing distant objects is a skylight or haze filter, which filters out some of the blue light that cloaks mountains and other objects located far from the camera.

Mountain scenes lend themselves to panorama photographs. Panoramas are another cool effect that give you wide-screen views of very broad subjects. There are several ways to shoot panoramas. Some cameras have a built in panorama feature: you sweep the camera from one side to another during a continuous serious of exposures that are patched together internally. But the simplest way is to simply crop the top and bottom of an ordinary photo so you end up with a panoramic shot like the one extracted from the full-frame picture in Figure 15.15.

You'll get even better results if you plan ahead and shoot your original image so that no important image information appears in the upper and lower portions. By planning ahead of time, you can crop your image and get a more natural-looking panorama.

Another way to shoot a panorama is to stitch together several individual photos. Your digital camera might have a panorama mode, like the "sweep panorama" feature found in several cameras, which takes several images and combines them automatically. However, the most common mode doesn't actually shoot a panorama for you. You take the first picture and the camera shows you the edge of that picture in the LCD viewfinder, so you can use the semi-transparent review version to line up your second or third shot in the panorama series. Then, the individual pictures are stitched together using an image editor. Photoshop and Photoshop Elements have a panorama-stitching feature.

When shooting panoramas, you might find it useful to use a tripod so you can smoothly pan from one shot to the next overlapping picture. Strictly speaking, the pivot point should be under the center of the lens, rather than the usual tripod socket location on the digital camera, but you should still be able to stitch together your photos even if you don't take the picture series absolutely correctly from a technical standpoint.

Figure 15.15 Crop a full-frame photo to produce a panorama.

Sunsets/Sunrises/Dawn/Dusk

Sunsets and sunrises are popular subjects because they're beautiful, colorful, and their images often look as if a lot of thought went into them, even if you just point the camera and fire away. The dawn hours just before or after sunrise, and the evening hours clustered around sunset are also prime shooting times. Some photographers specialize in these times.

I prefer sunsets for a couple technical reasons. With a sunrise, you're always chasing the clock, trying to capture prize images before the sun transitions into full daylight. Sunset photography is more relaxed, because the lighting at dusk just gets better and better as you shoot, culminating in that wonderful glow that comes after the sun has sunk below the horizon.

Second, I am not usually awake in time to see a sunrise. Third, at the latitude where I live, for much of the year, it's a lot warmer at sundown than at sunrise, and I don't particularly like cold weather. Finally, it's more difficult to scout out your location for a sunrise shot than it is for a sunset shot. Sunset follows a period of lightness (called "daytime"). You can spend hours looking for just the right spot and use the waning daylight to decide exactly where to stand to capture the sunset as the sun dips below the horizon. Dawn, in sharp contrast, occurs after a really dark period, and you may have difficulty planning your shot in the relatively short interval just before sunrise.

Here are some tips for shooting photos during the "golden hours":

- Adjust white balance and exposure for sunrise/sunset. If your camera has an automatic white balance control that can be overridden, see if you have a Sunset/Sunrise white balance setting as well as a Sunset/Sunrise programmed exposure mode. The former will let you avoid having the desired warm tones of the sunset neutralized by the white balance control, and the latter can allow you to get a correct exposure despite the backlighting provided by the sun. With sunset photos, you generally *want* a dark, silhouette effect punctuated by the bright orb of the sun. This is a good time to experiment with manual exposure, too, as I did for Figure 15.16, a sunset scene of Lake Erie from high atop the Terminal Tower in Cleveland, Ohio. It was deliberately underexposed, and the white balance set for daylight to produce an even warmer image tone.
- Don't stare at the sun, even through the viewfinder. I usually compose my sunset photos with the sun slightly out of the frame, then recompose just before taking the photo.
- Avoid splitting your photo in half with the horizon in the middle. Your picture will be more interesting if the horizon is about one-third up from the bottom (to emphasize the sky) or one-third down from the top (to emphasize the foreground). Remember the rule of thirds.
- Sunrises or sunsets don't have to be composed horizontally! Vertically oriented shots, like the one shown in Figure 15.17, can be interesting. In that photo, I broke several "rules" by using vertical orientation for a "landscape" photo, and didn't limit myself to the actual dawn hours. It was captured high up in the Montserrat chain near Barcelona at around eight in the morning, well past sunrise, but before the sun had a chance to burn away the morning fog. I deliberately underexposed the photo to create an image that evoked sunrise, even though it was several hours later.

Figure 15.16 Manipulate your white balance and exposure to get the most dramatic effects.

Figure 15.18 Water scenes can be calm and cool...

Figure 15.19 ...or water scenes can portray movement.

Changing Seasons

If you live in an area where the seasons change, you'll have the opportunity to photograph interesting landscapes under a variety of conditions without the need to stray far from home. It's always rewarding to go back and revisit favorite scenes at different times of the year to get a new perspective. Figure 15.20 shows a scene captured at Western Reserve high school campus in the Fall (left), and then again a few months later when Winter arrived.

Winter is particularly challenging. Photographing in snow is a lot like photographing at the beach: You have to watch out for glare and overexposures. Otherwise, snow scenics can be captured much like other landscape-type photographs. There are a few things to watch out for however. One of them is cold. Batteries of all types put out less juice in cold temperatures, and those in your digital camera are no exception. Keep your camera warm if you want it to perform as you expect.

Figure 15.20 The same scene, in Fall (left) and Winter (right).

Also, watch out for condensation on and within the camera, particularly on the lens, which can occur when you bring your cold camera into a warmer, humid environment, even if only for a few moments. (Perhaps you're ducking in and out of the shelter of a car between shots, as I often do in colder climes.) Then, when you go back out in the cold, you've got a moist camera in your hands. If you don't have time to let your camera slowly adjust to temperature variations, consider using a skylight filter that you can clean off with a soft cloth as necessary. These filters are tougher than the glass of your lens and cheaper to replace if they get scratched.

Figure 15.21 shows a typical snowy scene. It took me a long time to get back into the swing of shooting winter scenes. After living for a few years in Rochester, NY (which has nine months of winter and three months of bad skiing), I moved elsewhere specifically to reduce my opportunities for photographing in snow. Now I've grown to love them again.

Figure 15.21 Be careful to avoid underexposure under the bright conditions found in snow scenes.

Infrared Landscape Photography

If you have a digital camera that can handle it, infrared (IR) landscape photography can be a lot of fun. By photographing an image primarily using the infrared light that bounces off your subject matter, you end up with eerie monochrome photographs featuring white foliage and dark skies, like the image shown in Figure 15.22. Because everyday objects reflect infrared in proportions that differ sharply than that of visible light, the tonal relationships are wildly unexpected.

Scenic photos lend themselves to the IR treatment for a number of reasons. People photographed by infrared light often look pale and ghastly. Landscapes, on the other hand, take on an otherworldly look that's fascinating. You'll need to do some work and buy some add-ons to get started with infrared photography, but this section should get you started in the right direction.

What You Need

To shoot infrared photos, you need several things. One of them is a digital camera that can capture pictures by infrared illumination, as well as a filter that blocks virtually all light except for near infrared (NIR) illumination.

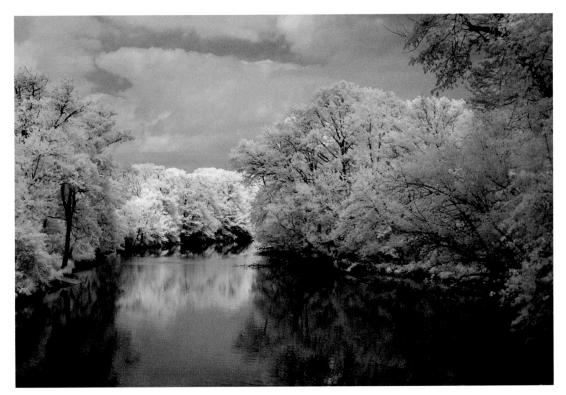

Figure 15.22 Infrared photography produces weird black-and-white landscape photos.

The sensors found in digital cameras generally are very sensitive to infrared light in the range of 700-1200 nanometers, which is a good thing if you want to take infrared pictures, and not so good if you don't want infrared illumination to spoil your non-infrared photographs. Accordingly, many digital cameras now include a filter or "hot mirror" that specifically blocks IR light from the sensor (yes, your "mirrorless" camera may include something *called* a mirror). A few enterprising souls have opened their cameras and removed the filter so they could take IR photographs, replacing it with a piece of glass to preserve the camera's autofocus capabilities. Those were invariably older cameras; modern cameras with integral moving sensor platforms for dust removal and image stabilization would likely be damaged by such treatment.

Some digital cameras have no IR-blocking filter or hot mirror at all (you may have to special order these, or have the camera converted), or have filters that block only part of the IR light, so you might be able to take infrared photos with your camera without needing to dismantle it and remove the IR filter manually. An easy way to check for IR capability is to photograph your television remote control. Point the remote at your camera in a darkened room, depress a button on the remote, and take a picture. If your camera can register IR light, a bright spot will appear on the photograph of the remote at the point where the IR light is emitted.

You'll also need an IR filter to block the visible light from your sensor. Find a Wratten #87 filter to fit your digital camera. You can also use a Wratten 87C, Hoya R72 (#87B), or try #88A and #89B filters. A simpatico camera store may let you try out several filters to see which one works best with your camera. These filters aren't necessarily cheap, easily costing \$60 to \$100, depending on the diameter. Some can be purchased for less than \$30, however.

Taking IR Photos

Once you're equipped, you have to learn to contend with the quirks and limitations of IR photography. These include:

- **Light loss.** The IR filter blocks the visible illumination, leaving you with an unknown amount of infrared light to expose by. Typically, you'll lose 5 to 7 f/stops, and will have to boost your exposure by that much to compensate. A tripod and long exposures, even outdoors, may be in your future.
- **Difficulty metering.** Exposure systems are set up to work with visible illumination. The amount of IR reflected by various subjects differs wildly, so two scenes that look similar visually can call for quite different exposures under IR.
- **Difficulty seeing.** Because the visual light is eliminated, you'll be in a heap of trouble trying to view an infrared scene. The LCD view may be a little weird, too.
- Focus problems. Infrared light doesn't focus at the same point as visible light, so your autofocus system might or might not work properly. You may have to experiment to determine how to best focus your camera for infrared photos. If you're shooting landscapes, setting the lens to the infinity setting probably will work (even though *infrared infinity* is at a different point than visible light infinity).

- **Spotty images.** Some removable lenses include an anti-IR coating that produces central bright spots in IR images. A few lenses fall into this category. Test your lens for this problem before blaming the artifacts on your filter or sensor.
- Color mode. Even though your pictures will be, for the most part, black-and-white, or, rather, monochrome (usually magenta tones or a color scheme described as "brick and cyan"), you still need to use your camera's color photography mode.

You'll find lots more information on the Internet about digital infrared photography, including the latest listings of which cameras do or do not work well in this mode. If you ever tire of conventional scenic photography, trying out digital IR can respark your interest and give you a whole new viewpoint.

Wildlife Photography

Photographing animals, especially if you seek to do so in their natural habitats, is one of the most challenging types of photography. In few other picture-taking pursuits is it necessary for you to first painstakingly locate your subjects, sneak up on them, take their photograph under (sometimes) harsh conditions, under the constant threat that your subject may flee, attack you, or otherwise become uncooperative. Child photography is the only other similar category I can think of.

Here are some of the things you'll need to consider if photographing wildlife is one of your favored activities.

- You'll need a long lens. The longer the better. If you're photographing actual creatures in the wild (rather than domesticated animals, those in preserves, or in zoos), a 200mm lens or equivalent is the absolute minimum. That's the focal length I used to capture the timid frog in Figure 15.23. Dedicated wildlife photographers are usually seen toting 400mm or longer lenses.
- A fast lens won't hurt. If you're out tromping through the woods or a field and light levels are low, a fast 300mm lens will be a lot more useful to you than a slow 400mm lens. Fast lenses let you use higher shutter speeds that will help you freeze Bambi's father as he scampers through the underbrush. Those fast shutter speeds (and image stabilization) will help if you choose to hand-hold your optical bazooka.
- Forget about hand-holding. The best wildlife photographs are taken with a long lens (see above), securely mounted to a sturdy tripod. The tripod reduces potential camera shake, and lets you line up your distance shot accurately. For Figure 15.24, I used a 500mm f/8 mirror lens (a catadioptric lens that uses internal mirrors, like that found in reflector telescopes, to reduce the length of the lens to a more manageable size). The camera and lens were firmly mounted on a tripod. Even with a high shutter speed (say, 1/2000th second) I wouldn't have achieved such a sharp image (despite the compact size and light weight of the mirror lens) without a tripod. Note: Mirror lenses are somewhat rare these days, due to the "doughnut" shaped blurs ("bokeh"—see Chapter 6 for more on that) in out-of-focus highlights. I've found, however, if you're shooting a subject, like the heron in the figure, posed against a background with few highlights, the doughnuts are not numerous or objectionable.

Figure 15.23 A long lens will help you capture wildlife even if it's relatively close at hand.

Figure 15.24
A long lens mounted on a tripod is your best weapon for capturing distant wildlife.

- Use continuous shooting mode. Think of wildlife photography as a type of action photography. Your subjects may be moving fast, and firing off a quick burst of shots may mean the difference between just missing a shot, and getting a stellar series.
- Think like a hunter. Indeed, most of the "safaris" in Africa these days consist of photographers hunting and tracking down vanishing wildlife species. You can do the same when foraging for photographic subjects closer to home. If you have some hunting experience, so much the better, as you'll know how to find your quarry without alarming them, and how to deal with woodland creatures (bears, etc.) that don't like being interrupted.

Stalking Your Prey Made Easy

Of course, you don't need to sign up for a photo safari in Africa, or tromp through the woods for days on end to locate suitable subjects. Here are some tips that will let you ease into wildlife photography painlessly.

■ Stay home. Even if you live in an urban apartment, you'll probably find wildlife right at your doorstep or windowsill. The young cardinal shown in Figure 15.25 fell in love with his reflection in my kitchen window and would perch on a branch just outside for hours, alternately looking into the house, or flying at the window trying to convince the "other" bird to move. You'll likely find interesting wildlife close to home, too, especially if you live in a suburban or rural environment where creatures share your space.

Figure 15.25 Wildlife can be photographed right from your home.

■ Visit a preserve or sanctuary. The owl shown in Figure 15.26 has an injured wing, and had taken up temporary residence at a bird rescue facility near me. Although he was truly wild, he'd gotten used to human presence enough to pose for pictures without much of a fuss—as long as I remained 15 to 20 feet away and photographed him through a long lens. The telephoto lens and relatively wide aperture I used blurred the background to isolate the owl in the frame.

Figure 15.26 This fellow resided at a bird rescue facility.

- Visit a zoo. For those who live in snowy climes, the local zoo is a secret destination that only photographers can fully appreciate. Every zoo has an indoor display where animals can be photographed in warmth and comfort. I'm a member of a zoo that's a wonderful refuge in Winter, as the reptile house, an indoor aquarium (including a display of backlit jellyfish), and a heavenly tropical rainforest exhibit await me on icy cold days.
 - The chief problem I have with zoos is that the photographs tend to look like they were taken in a zoo, not out in the wild, bringing to mind the "like shooting fish in a barrel" simile. Proper wildlife photography should be *hard* and involve stalking and at least a modicum of inconvenience and/or pain. In zoos, the backgrounds and "environment" tend to look a bit phony, as you can see in the shot of the meerkat in Figure 15.27. Moreover, for most of us, shots of exotic animals are *always* captured in zoos, unless we're fortunate enough to go on a safari. So, as nice as your photograph of that giraffe is, the first thing a viewer is going to do when looking at it is wonder in what zoo it was taken.
- Go where the wildlife is. If you know where to look, and are patient, the wildlife may come to you. There's a park near me, only a few miles from one of the largest urban areas in my state, with a nature preserve that includes a raging river, waterfalls, and teems with wildlife. A few hundred yards from a freeway, I can set down my camera bag, set up my tripod, and wait for truly wild creatures to show up.

Figure 15.27 Zoos can be a great location to photograph "wild" life.

Scouting Prime Locations

If shooting in the wild is your goal, scouting great locations, local or farther afield, should be your strategy. Perhaps you live near a National or State Park, a preserve, a rookery, or other area that abounds with wildlife. If you know a field or meadow where butterflies hang out, you can easily snag pictures of *lepidoptera* like the one in Figure 15.28.

Although I travel around the world looking for interesting subjects, once a year I schedule a trip to Florida, which seems to have attracted more than its fair share of interesting wildlife. One stop is always Merritt Island on the Atlantic Space Coast, where, as you can see in Figure 15.29, there are more birds than you can shake a stick at (and stick-shaking is probably illegal, anyway). The nearby Viera Wetlands are also worth a visit, especially during nesting/hatching season.

Last Winter, I spent four weeks shooting in the Florida Keys, where there were lizards, iguanas, alligators, and other wildlife that are a bit exotic for us Northerners (See Figure 15.30.) I also encountered the endangered Key deer on Big Pine Key, as pictured in Figure 15.31.

Figure 15.28 Take along a short tele or macro lens to shoot butterflies.

Figure 15.29 Birds of a feather flock together with birds of yet another feather.

Figure 15.30 You won't have to hunt reptiles; they'll often find you when you least expect them.

Figure 15.31 Key deer can be timid, but may be easily photographed by non-aggressive photographers.

Capturing Action

The essence of all still photography is to capture a moment in time. That's never more true than when you're photographing action, whether it's your kids' Little League or soccer teams, a volleyball game at your company picnic, a bowling tournament, or a quick snap of a fast-moving ride at an amusement park. Whether the action is frozen or blurred (perhaps intentionally), it's apparent that the photograph has sliced off a little piece of motion. Mirrorless interchangeable lens cameras are great at capturing those moments, particularly if you own one capable of shooting at a fast frame rate.

Other types of photography also isolate a moment, although it may not appear to be so at first glance. Architectural photos freeze a moment, but a structure can sit stolidly for decades or centuries and change very little. Photographs taken from a certain hilltop location outside Toledo, Spain look very much like the vista captured in El Greco's 16th century masterpiece *View of Toledo*.

Still-life photos and portraits also capture a moment in time. That bowl of fruit you photographed may become a snack an hour later or over-ripe if left for a week. You'll recognize nostalgically that a particular instant is represented in a portrait of your child years later when the child has grown to adulthood. Even so, there's something special about action photography. I think it's because a good action picture provides us with a view of an instant that we can't get in ordinary life. A snap of a hummingbird frozen in mid-air lets us study the fast-moving creature in a way that isn't possible in nature. A picture of a home run ball the moment it is struck by the bat offers a perspective of a home run that even the umpire never gets to see.

This chapter will concentrate on techniques for capturing action with a mirrorless camera. I'll explain some of the key tricks of the trade here, concentrating on the special capabilities of mirrorless camera photography in this chapter, and will cast my net far outside the sports arena when fishing for action-shooting opportunities.

Sports in a Nutshell

Before we take a closer look at specific action-shooting techniques, we might as well get some of the special aspects of sports photography out of the way. That's because several of the keys to getting good sports photos have nothing to do with photography *per se*. In some ways, it's just as important to know where to stand during a sports event as it is to understand the finer points of using your camera. Indeed, it probably won't surprise you that knowing how to position yourself and learning where to point the camera, and deciding the exact moment to press the shutter can be as important to your success as understanding the right ways to expose and compose your picture.

If you stop to think about it, sports action is a continuous series of moments, each a little different from the last, all leading up to *the* decisive moment, when the bat strikes the ball, the power forward releases the basketball at the apex of a jump, or when the puck slides past the goalie into the net. A decisive moment can follow the peak action, too, as when a pitcher slumps in defeat after giving up a walk-off home run. The best sports photography lies in capturing the right moment and the right subject, under the right circumstances. You don't want a technically perfect shot of a third-string receiver catching a football at the tail end of a 57-0 blowout (unless he's your kid). You want to capture the hero of the game at the turning point of the contest.

To see how far we've come, check out my first published photo as a professional photographer in Figure 16.1. It's one of those classic "basketball instead of a head" shots, taken with flash back in the dark ages prior to digital photography when action shots with inky-black backgrounds were acceptable. This particular picture was published partially because of the basketball/head juxtaposition, and partially because it showed a local college basketball hero blocking a shot (or committing a foul, depending on your bias). Lacking one of those two elements, it probably wouldn't have been printed at all, because it didn't illustrate a truly decisive moment in the game, and it suffered from more than one technical problem.

Stark flash photos are no longer acceptable, nor do you see much in the way of black-and-white action photography. Today, you're more likely to see a photo like Figure 16.2. Digital cameras have sensors that are fast enough to capture action indoors or out, in full color, and in sequences that show the unfolding story of a play or an individual's efforts.

The Importance of Position

Where you position yourself at a sports event can have a direct bearing on your photo opportunities. If you're up in the stands, your view of the game or match is likely to be limited and fixed. You'll have better luck if you are able to move down close to the action, and, preferably, given the option of moving from one position to another to take a variety of shots.

After you've taken a few sports photographs, you'll find that some places are better than others for both opportunities and variety. In or near the pits at an auto race provides a great view of the track as well as close-ups of the incredible pressure as crews service vehicles. At football games, you'll get

Figure 16.1 An unusual viewpoint and star power got this otherwise mundane photo published.

Figure 16.2 Today, full-color action photos are easily taken indoors, without flash.

one kind of picture at the sidelines, and another from the end zone. Soccer matches seem to revolve around the action at the net. Golf is at its most exciting on the greens (although you'll encounter limitations on your photography at pro matches). Each sport has its own "hot" spots.

You probably won't gain access to these locations at professional or major college-level contests. However, unless you're a pro sports photographer, you'll find that shooting lower-level events can be just as exciting and rewarding. If you want to get a good spot at a high school or college match, start out with some of the less mainstream or more offbeat sports. You're more likely to be given field access at a Division I-A lacrosse match than at a Division I-A (now called Football Bowl Subdivision) football game. However, at Division II and III levels you might still be able to get the opportunities you need if you call ahead and talk to the sports information director. I shoot a half-dozen basketball games each year at the college pictured in Figure 16.2; I just show up and shoot—the school doesn't even sell tickets to its home games. One Division III school near me has been NCAA champions in football 11 times since 1993, and had a 110-game regular-season winning streak. Yet, the folks at this mini-powerhouse can be quite accommodating to visiting photographers. Ask, and ye shall photograph a receiver!

Key Sports: Play by Play

Every sport is a little different when it comes to coverage. With some, like football, the action is sporadic, punctuated by huddles and time-outs, but lightning-fast when underway. Others, such as soccer, may have things going on all the time. Golf sometimes seems like it consists mostly of walking, interrupted by a few moments of intense concentration. You'll do best with sports that you understand well, so take the time to learn the games. Simply knowing that if a football team is down by 14 points with six minutes left in the game and it's third down with 20 yards to go, you probably aren't going to see a running play, can be an advantage.

Here are some quick guidelines for shooting some of the most popular sports.

- Football. Get down on the sidelines and take your pictures 10 to 20 yards from the line of scrimmage. It doesn't really matter if you're in front of the line of scrimmage or behind it. You can get great pictures of a quarterback dropping back for a pass, handing off, or taking a tumble into the turf when he's sacked. Downfield, you can grab some shots of a fingertip reception, or a running back breaking loose for a long run, or crushing forward for a gain of a yard or two (see Figure 16.3). Move to one side of the end zones or a high vantage point to catch the quarterback sneaking over from the one-yard line, or the tension on the kicker's face when lining up for a field goal.
- Arena Football. I shot my first arena football game while writing this book, and found it to be a special case among "field" sports. You can't really get down on the "field," because it's fenced off from the spectators, basically just like a hockey game, but without the glass. On the one hand, you lose the ability to range up and down the sidelines, changing your shooting angle

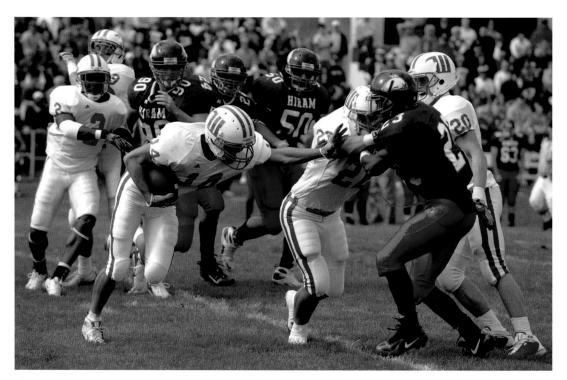

Figure 16.3 Football, soccer, and other field sports lend themselves to shots taken from the sidelines.

at will. On the other hand, if you get good seats, in the lower level of rows, your perspective is just as good as if you were on the sidelines—except you can't change positions readily. You'll have to wait for the action to come to you. I had special access at the corners of the arena, at field level by the end zone, but behind a partition. A slightly elevated position may be desirable so you are shooting down at the players, rather than across the field at the spectators.

As you select your seat or position, keep in mind that there is a lot of scoring in arena football. There is no punting, and, unless there is a fumble, interception, or score, you get a minimum of four full downs of excitement per possession. Most of the action takes place near the goal lines.

■ Soccer. You can follow the action up and down the sidelines, or position yourself behind the goal to concentrate on the defender's fullbacks and goalie and the attacking team's wings and strikers. I don't recommend running up and down the field to chase the action as possession changes. Soccer games usually last long enough that you can patrol one end of the field during the first half, then remain there when the teams switch goals in the second half to cover the other team. However, if a game is one-sided, you'll discover that most of the action takes place around the goal that the overmatched team will be constantly defending. Figure 16.4 shows some soccer action.

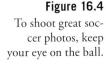

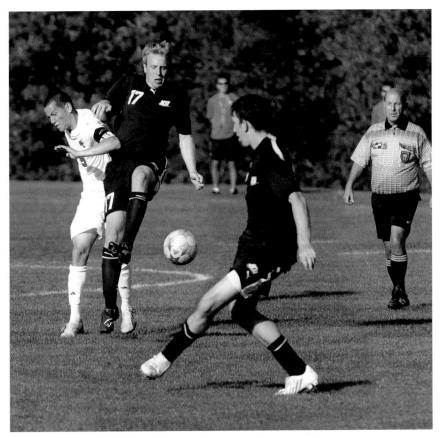

- Baseball. Everyone wants a seat behind home plate, but that's not where you'll want to shoot your pictures. Although the grimaces on the pitcher's face are interesting, the backstop netting will tend to diffuse your photos somewhat. I take a lot of photos at professional baseball and softball games, and, lacking press privileges, I try to buy seats in the front row next to the visitor or home team's dugouts. Those vantage points let you photograph the batters at work, get good shots of the pitchers, plus the action at the bases. There tends to be more going on at the first base side, and that's a good choice if you want to photograph a right-handed pitcher after the ball is delivered. (You'll see the pitcher's back during the wind-up.) Reverse sides for a left-handed pitcher.
- Basketball. One of the advantages of basketball is that the sport is more compact. The majority of the action will happen around the backboards. High angles (from up in the stands) are generally not very good, and low angles (perhaps seated in the first row) are less than flattering for an array of very tall people. Shots from almost directly under or above the rim can be an exception to these rules, however. If you can shoot from eye-level close to the basket, you'll get the best shots.

- Golf. Golf is one of the most intimate of sports, because it's entirely possible to position yourself only a few feet from world-famous athletes as they work amidst a crowded gallery of spectators. Distracting a golfer before a shot will get you booted from the course quickly, and mirrorless cameras, unlike their point-and-shoot brethren, don't have fake shutter click noises that can be switched off. That clunk you hear when the shutter trips is the real thing! A camera with an electronic shutter is a real advantage here. You might want to move back, use a telephoto lens, remain as quiet as a mouse, and remember to time your photography to minimize intrusion. Remember, this is one sport where even the commentators on television whisper during a putt.
- Wrestling/Martial Arts. Unless you have a ringside seat and are prepared to dodge flying chairs (in the pro version), wrestling is often best photographed from a high, hockey-like perspective. Amateur wrestling and martial arts are best when shot right at the edge of the mat. (See Figure 16.5.)

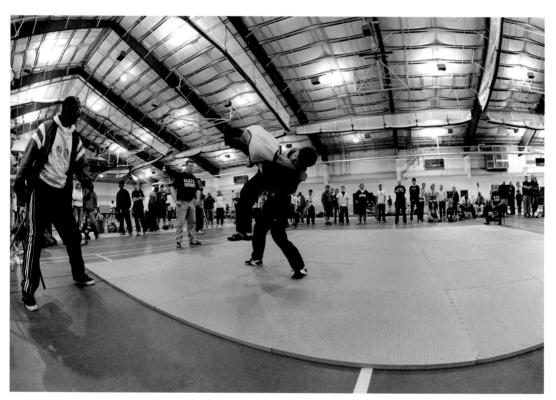

Figure 16.5 Wrestling and martial arts are best captured from the edge of the mat.

- Hockey. This form of warfare-cum-athletic event can look good from a high vantage point, because that perspective makes it easier to shoot over the glass, and the action contrasts well with the ice. However, if you can sit in the front row, you'll find a lot of action taking place only a few feet from your seat. You might want to focus manually if your camera's autofocus tends to fixate on the protective glass rather than the players.
- **Skating.** Skating events also take place in ice arenas, but eye-level or low-angles and close-ups look best. Catch the skaters during a dramatic leap, or just after.
- **Gymnastics.** Look for shots of the athlete approaching a jump or particularly difficult maneuver, or perhaps attempting a challenging move on the parallel bars or rings.
- Swimming. Some great shots are possible at swimming events, particularly if you are able to use a fast enough shutter speed to freeze the spray as the swimmer churns through the water. You'll get good pictures from the side if you can get down very low and close to water level. At the end of the pool, turns are fairly boring, but you can get some exciting head-on shots at the finish.
- Track and Field. There are so many different events that it's hard to classify track and field as a single sport. If you can get under the bar at a pole vault, or position yourself far enough behind the sand pit to shoot a long jumper without being distracting, you can come up with some incredible shots. Or, move next to the starting blocks of a dash or relay.
- Motor sports. Racing action will challenge your action-stopping capabilities. If you shoot these events as a car or motorcycle is headed down the straightaway toward you, a slower shutter speed can do the job. On one hand, the action can be a bit repetitive. But that can be an advantage because you have lap after lap to practice and fine-tune your technique to get the exact photo you want. Motocross and motorcycle stunt jumping can provide some especially exciting moments.
- Horseracing. Sports action and beautiful animals all in one sport! What could be better? As in motor sports, you might get the best pictures shooting head-on or as the steeds make a turn. Finish line photos are likely to look like those automated finish line photos used for instant replays, but if you get the opportunity, try a low angle for an interesting perspective.
- Rodeo. More sports action and powerful animals, although the snorting bulls and broncs and their snorting riders are typically more rugged than beautiful. I favor rodeos where for a small additional fee (actually double the base admission price), you can grab a table set up next to the fence and get an eye-level view of the action only a short telephoto lens away. In the background, cowboys waiting to ride, and the "bullfighters" and clowns who help fallen riders add to the interest. (See Figure 16.6.)
- **Skiing.** It's unlikely you'll be out all over the slopes taking photos during the race, but if you can find an interesting turn or good angle at the finish line, go for it. Remember to keep your camera and batteries warm between shots and watch out for condensation on the lens when you and your camera pass from icy cold to warm conditions.

Figure 16.6 Rodeos are non-stop action.

Continuous Shooting Basics

In the past, sports photographers used motor drives on their film cameras, which let them shoot an entire 36-exposure roll of film in about 12 seconds at a 3 fps clip. Today, the digital equivalent of the motor drive is called continuous shooting or burst mode, and mirrorless technology makes this technique much more practical. Instead of being limited to 36 shots (or 250 shots if you used a special motor drive with bulky 33-foot film cassettes), you can take hundreds of photos without "reloading," depending on compression, file size, and image format. Best of all, digital bursts don't waste film. If your sequence shots turn out to be duds, you can erase them and take more pictures using the same media. Nor do you need a special accessory for your digital "motor drive." All mirrorless cameras and most digital point-and-shoots have the capability built in.

One important thing to keep in mind is that continuous shooting is not a cure-all for poor timing. The typical mirrorless camera can fire off 3 to 12 frames per second for as long as the camera's buffer holds out. A few cameras write to their filmcards so quickly that in some modes the buffer never really fills, so you can shoot continuously until your card reaches its capacity. Even so, you still might not capture the decisive moment in your sequence. The action peak can still happen *between* frames, or, if your camera is limited to bursts of a few seconds in length, after your buffer fills and

the camera stops firing sequence shots. A brawny burst mode is no replacement for good timing and a bit of luck. Clicking off a picture at exactly the right moment will almost always yield better results than blindly capturing a series of frames at random. Figures 16.7 and 16.8 show a pair of pictures, one taken a fraction of a second too late, and the other at just the right moment. If you're shooting at 5 frames per second, a 90 mph fastball will travel 26 *feet* between frames.

Figure 16.7 The shutter fired only 3/100ths of a second too late to capture the ball as it passed the batter.

Figure 16.8 Perfect timing (actually luck) accounts for this shot of a ball striking the bat.

Choosing Your Lenses

With money matters, it may be all about the Benjamins, but with cameras boasting interchangeable lenses, the topic always seems to focus on optics. Of course, the ability to *choose* which lens you use is one of the undeniable advantages of the ILC camera in the first place. That's why you'll find so much coverage of lenses in this book.

Now we're taking a closer look at action photography, and it's time to talk about lenses once again. Indeed, lenses are one of the *key* aspects of action photography. When you're taking portraits, you'll probably use (or wish you could use) a prime lens of a focal length considered ideal for portraits, but then settle for a zoom lens of the appropriate range. For close-up pictures, you'll want a special micro/macro lens if you can afford one, or will make do with what you have. There really aren't that many choices. There are a few lenses and focal lengths that are best for portraits, macro photography, and other applications, but selecting the one you use won't take weeks out of your life.

Not so with action photography. The online forums I frequent are rife with never-ending discussions on the best lenses for action photos, with criteria ranging from focal length, maximum aperture, bokeh, or presence/lack of vibration reduction placed under the magnifying glass. This section explains some of the factors to consider.

Zoom or Prime Lens?

Until the 1990s, zoom lenses simply didn't offer sufficient quality for everyday use for the serious photographer. The only real exception was for sports photography, because a zoom lens can be the most efficient way to follow fast-moving action. Reduced image quality came with the territory, and non-zoom, prime lenses were still the preferred optic. Early zoom lenses were extremely slow in terms of maximum aperture, often didn't focus very close, and frequently changed both focus and f/stop as you zoomed in and out.

Things have changed! Today's zoom lenses can provide excellent quality. Some of them are sharp enough and focus close enough that they can be used for macro photography. Modern autofocus and autoexposure systems make focus and aperture shifts largely irrelevant. However, one thing hasn't changed: zooms that normal people can afford to buy are still relatively slow. Affordable zooms typically have f/3.5 or f/4.5 maximum apertures at the widest setting, and f/5.6 or worse in the telephoto position. That can be a drawback for available light action photography at night, indoors, or outdoors on very cloudy days, unless you choose to use a higher ISO setting and risk visual noise in your image.

If you're shooting outdoors in full daylight most of the time, a zoom may be your ideal lens. A 28mm-200mm lens on a camera with a 1.5X crop factor gives you the equivalent of a 42mm to 300mm zoom lens, which from the sidelines of a football game will take you from the bench to the opposite side of the field. A 75mm-300mm zoom sacrifices a little of the wide-angle view in favor

of a really long telescopic perspective. Zooms can be great. Unfortunately, *fast* zooms can be expensive. The 70-200mm f/4 zoom I prefer for outdoor sports costs more than \$1,500, and the 24-70mm f/2.8 zoom I use for indoor sports is only a few hundred dollars cheaper. To afford such lenses you either need to be a professional, a well-heeled amateur with lots of money to spend on a hobby, or (like me), lucky enough to find mint-condition used lenses at a distress sale at a considerable discount.

Prime lenses can be a slightly less expensive option if you want the absolute sharpest image, or will be shooting under very demanding lighting conditions. I have an 85mm f/1.4 lens that, through

the magic of the digital crop, gives me the equivalent of a 128mm f/1.4 telephoto that's perfect for low-light action photography. My 105mm f/2 lens has only a little less reach than a very expensive 180mm f/2 optic. Because of my lens's speed, I'm able to get shots like the one shown in Figure 16.10, taken using a wide aperture to throw the background out of focus.

Remember that a fast telephoto lens lets you use higher shutter speeds to stop action or reduce the effects of camera shake, without needing to resort to boosted ISO, which can increase the amount of noise in your picture. Also keep in mind that truly fast telephotos cost an arm and a leg. One vendor's 300mm f/2.8 prime lenses cost almost \$6,000; 500mm or 600mm f/4's top \$10,000; and the same manufacturer's 400mm f/2.8 can set you back close to \$10,000. So, your quest for a fast, superlong telephoto lens may be brought quickly to Earth by incredible price tags. Prime lenses may offer better quality and faster maximum aperture, but can get pricey, unless you opt for manual focus models. Zooms are usually economical in the 70mm to 300mm range, even if they're a bit slow.

Figure 16.10 A fast prime lens lets you get in close; use a higher shutter speed, and get images like this one.

WHAT'S THE BEST F/STOP?

To get the sharpest images, you'll almost always want to stop down one or two f/stops from the widest available aperture your lens provides. That is, an f/2.8 lens often produces its best results at f/5.6. Unfortunately, with action photography, a high shutter speed is often desirable, so you'll find yourself shooting wide open more than you'd like.

In that case, the maximum aperture of your lens can be important when shooting action in low-light situations. A "slow" lens can limit the maximum shutter speed you can use, thus affecting your ability to freeze action. For example, if your lens opens no wider than f/8 (a limitation for longer lenses and zoom settings), the best you can do with your camera set to ISO 100 in full daylight is 1/500 at f/8. Your camera may have a 1/1,000 or briefer setting, but you can't use it without increasing the ISO setting to 200 or higher, thus increasing your chances of detail-robbing noise in your photos. If daylight is waning or you're shooting indoors, an f/8 lens may limit you to sluggish 1/250th or 1/125th second speeds.

So, a larger maximum aperture is better, assuming that the lens performs well wide open; an optic that is a bit fuzzy at its maximum aperture is no bargain. Keep in mind that the maximum opening of some zoom lenses varies, depending on the focal length setting. That is, a lens that rates an f/4.5 aperture at the 28mm setting may provide only the equivalent of f/6.3 or slower when zoomed all the way to the telephoto position.

Focal Lengths Needed

For most action photos, the longest zoom setting is more important than the shortest. Few sports other than basketball near the baseline require a really wide-angle lens. Most of the time you can't get as close to the action as you'd like. Many benefit from the equivalent of a 135mm to 150mm telephoto optic, particularly if you're unable to patrol the sidelines and must shoot from the stands. Sports like basketball and volleyball do call for shorter focal lengths and wider angles, because you may be literally on top of the action.

For indoor sports, your best focal lengths might range from 35mm to 105mm. Outdoors, you'll probably need 70mm to 200mm or 300mm, unless you're forced to shoot from up in the stands. Non-sports action photography may still limit where you can stand to make your shot, as you can see in Figures 16.11 and 16.12. Don't forget that as your lens gets longer, you'll need to use higher shutter speeds or a tripod to reduce or eliminate blur from camera/lens shake (or use a vibration reduction lens/camera to compensate).

Those using some mirrorless cameras can benefit from using lenses designed for 35mm cameras with a sensor that's smaller than the $24\text{mm} \times 36\text{mm}$ full frame. As you've learned, when mounted on a non-full-frame camera, the focal length of a lens is multiplied, so a 200mm tele actually produces the same field of view as a 320mm long lens (when used with one particular digital camera with a 1.6X crop factor).

Figure 16.11
At the short tele position, your zoom can take in the big picture.

Figure 16.12

Zoom in and you're right in the middle of the action.

Action Exposure Concerns

You'll find a more complete discussion of exposure modes and features in Chapter 4. However, for action photography, you'll want to choose the right exposure mode for the job at hand. Here's a quick recap of the kind of options you may have, and how they relate to action pictures.

- Fully automatic. Serious photographers don't use fully automatic mode very much, particularly for action photography. It's usually not wise to let the camera's logic choose both shutter speed and aperture using its built-in rules, simply because the camera has no way of knowing what it's being pointed at. For example, the camera may elect to shoot at f/8 using whatever shutter speed provides the correct exposure until the exposure becomes long enough to encourage hand-held blurring (at, say 1/30th second). Then it will switch to a wider f/stop, as necessary. This is not the best mode for action photography.
- **Programmed automatic.** Mirrorless cameras have more sophisticated programming that takes into account the shooting environment when deciding exposure settings. For example, if photographs are being taken in dim light, the camera assumes that you're indoors; in bright light, it assumes that you're outdoors. Lens openings and shutter speeds are selected based on typical shooting situations in these environments. In program mode, unlike full auto, you may be able to bump the shutter speed up or down from the recommended setting, and the camera will change the aperture to compensate. This is something like a dumber version of shutter-priority, discussed shortly.
- Programmed scene modes. Your digital camera has selective programs you can choose for automatic exposure under specific conditions. The one you want to opt for is the action/sports setting. In such cases, the camera will try to use the shortest shutter speed possible. It might even automatically boost the ISO rating (if you've set ISO to auto) or use other tricks to optimize your exposure for fast-moving subjects. If you must use fully automatic exposure, this may be your best choice. At least the camera can be "told" that it's shooting action pictures and be trusted to compensate a bit.
- **Aperture-priority.** In this mode, called either A or *Av* mode, you set the lens opening, and the camera automatically chooses a shutter speed to suit. Use this if you want to select a specific f/stop, say to increase/decrease depth-of-field. Because aperture-priority offers little control over shutter speed, you probably won't use it frequently for sports photos.
- Shutter-priority. In this mode, called either S or Tv mode, you choose a preferred shutter speed, and the camera selects the lens opening. That lets you select 1/500th or 1/1,000th second or shorter to stop action, yet retain the advantages of automatic exposure. This is the mode to use if you're taking photos under rapidly changing light conditions. I use it for outdoor sports on partly cloudy days in which a playing field may alternate between bright sunlight and overcast within the space of a few minutes, depending on how the clouds move. It's also a good choice for photos taken as the sun is setting, because the camera automatically compensates for the decreasing illumination as the sun dips below the horizon.

■ Manual exposure. I end up using manual exposure for some of my action photographs. Indoors, the illumination doesn't change much. Most sports arenas, gymnasiums, and other sites have strong overhead illumination that allows taking pictures at 1/250th second at f/2.8 using ISO 400 or 800 settings. I might also use flash indoors. Outside, I carefully watch the lighting and change exposure to suit.

Attaining Focus

With action photography, the speed and accuracy of automatic focus can be crucial. Manual focus is frequently impractical when you're trying to capture subjects that may be racing toward you, away from you, or across your field of vision. The autofocus of most mirrorless cameras operates quickly enough for action photography that the operation doesn't introduce massive shutter lag delays into the picture-taking equation.

Here are some tricks you can use to optimize your results:

- Select your mode. Choose your autofocus mode carefully to suit the kind of action you're capturing. Your mirrorless camera probably gives you a choice between multi-point, spot, or user-selectable focus. If your subject will usually be in the center of the frame, spot focus may be your best bet. If your fingers are fast and your brain is faster, and you can train yourself to choose a focus point as you shoot, you can sometimes select the autofocus area as you compose the picture. Some cameras offer the option to lock in on the object closest to the camera, which can work well for action (assuming the closest subject is the one you want to capture, and not, say, a referee).
- **Disable macro.** Your lens might have a lock feature that disables macro focus distances. That keeps the lens from seeking focus all the way from infinity down to a few inches away. When you're shooting action, it's unlikely that your subject will be closer than a few feet, so go ahead and lock out the macro range to speed up autofocus.
- Override focus. Some lenses/cameras have an autofocus/manual override setting, which uses the autofocus mechanism first, but allows you to manually refocus if you need to. That can come in handy to fine-tune focus if you have time or can think quickly.
- **Prefocus.** You might be able to prefocus on a specific point where you expect the action to take place if you partially depress the shutter button. Some cameras also have a focus lock/exposure lock button that fixes either or both settings at the value selected when you depress the shutter release. With locked focus, you can take the photograph quickly by depressing the shutter button the rest of the way when your subject is where you want within the frame. For Figure 16.13, I prefocused on second base, and captured the runner just after he was forced out.

- Use manual focus. Manual focus might be a good choice when you know in advance where the action will be taking place (for example, around the hoop in a basketball game) and can help your camera operate more quickly than in autofocus mode. Manual focus works especially well with shorter lenses and smaller apertures, because the depth-of-field makes precise focus a little less critical.
- Selective focus. Manual focus also works when you're concentrating on a specific area, or want to control depth-of-field precisely. For example, at baseball games I may decide to take a series of shots of the batter, pitcher, or first baseman. I can prefocus on one of those spots and shoot away without worrying about autofocus locking in on someone moving into the field of view. My focus point is locked in. Selective focus can also concentrate attention on the subjects in the foreground.

Figure 16.13 Prefocus on a point where you expect the action to take place.

Selecting an ISO Speed

By now you're aware that the lower the ISO setting on your digital camera, the less noise you'll get and, usually the better the quality. But low ISO settings and action photography don't mix well. If you're trying to freeze action, you'll want to use the highest shutter speed possible, while retaining a small enough f/stop to ensure that everything you want to be in focus will be in focus. When available light isn't especially available, the solution may be to increase your mirrorless camera's ISO setting, as was done for the shot of the amusement park ride in Figure 16.14.

Fortunately, ISO speeds are another area in which mirrorless cameras often excel. Because of their larger sensors, a mirrorless camera can usually function agreeably at higher ISO settings without introducing too much noise. Many mirrorless cameras produce good results at ISO 3200, and may still offer acceptable images at ISO 6400 or above.

Your digital camera may automatically set an appropriate ISO for you, bumping the value up and down even while you're shooting to provide the best compromise between sensitivity and image quality. Or, you can set ISO manually. The easiest way to settle on an ISO rating is to measure (or estimate) the amount of illumination in the venue where you'll be working, and figure some typical exposures (even though your camera's autoexposure mechanism will be doing the actual calculation for you once you're shooting).

Outdoors, the ancient "Sunny 16" rule works just fine. In bright sunlight, the reciprocal of an ISO rating will usually equal the shutter speed called for at an f/stop of f/16. The numbers are rounded to the nearest traditional shutter speed to make the calculation easier. So, at f/16, you can use a shutter speed of 1/100-1/125th second at ISO 100; 1/200-1/250th second with an ISO rating of 200; 1/400-1/500th second at ISO 400; and perhaps up to 1/1,000th second at ISO 800. Select the ISO setting that gives you the shutter speed you want to work with. If the day is slightly cloudy (or really cloudy), estimate the exposure as one-half or one-quarter what you'd get with Sunny 16.

Indoors, the situation is dimmer, but you'll find that most venues are illuminated brightly enough to allow an exposure of f/4 at 1/125th second at ISO 800. For a faster shutter speed, you'll need either a higher ISO setting or a brighter venue. In modern facilities, you probably will have more light to work with, but it's always safe to use a worst-case scenario for your pre-event estimates. Don't forget to set your white balance correctly for your indoor location. If one of your camera's manual choices doesn't produce optimal results, consider running through your system's custom white balance routine to create a specially tailored balance for your venue.

Figure 16.14 You don't have to stop shooting action when the sun sets: just boost your ISO setting.

Using a Tripod or Monopod

You may think you don't need a tripod or monopod for action photography when using a compact mirrorless interchangeable lens camera. However, it's a new ball game when you mount a telephoto lens on your shooter. Indeed, most big, long lenses, even those with image stabilization built in, have a tripod socket for mounting the camera and lens combination on a support (or, if they don't, should). A tripod, or its single-legged counterpart the monopod, steadies your camera during exposures, providing a motion-damping influence that is most apparent when shooting with long lenses or slow shutter speeds. By steadying the camera, a tripod/monopod reduces the camera shake that can contribute to blurry photos. Although tripods are used a bit less at sports events these days, they can still be an important accessory.

You might not want to use a tripod at events where you need to move around a lot, because they take up a bit of space and are clumsy to reposition. Tripods are most useful for sports like baseball, where the action happens in some predictable places, and you're not forced to run around to chase it down. Monopods are a bit more portable than tripods, but don't provide quite as much support. Some action photographers rely on chestpods that brace the camera against the upper torso, but today the trend is toward image stabilization lenses and cameras that accommodate and correct for slight camera movement.

How much camera shake can you expect? One rule of thumb is that if you're not using antivibration equipment, the minimum shutter speed you can work with is roughly the reciprocal of the focal length of the lens. That is, with a 200mm lens, if you're not using a tripod you should be using 1/200th second as your slowest shutter speed. Step up to a 500mm optic, and you'll need 1/500th second, and so forth. Your mileage may vary, because some lenses of a particular focal length are longer and more prone to teetering, and some photographers are shakier than others. I tend to double the rule of thumb with shorter lenses to be safe, and quadruple the recommendation with longer lenses. For example, if I am not using a monopod, I shoot my 500mm lens at a shutter speed no slower than 1/2,000th second.

Basics of Freezing Action

To freeze or not to freeze? That is a question? Actually, for many types of action photos, totally freezing your subjects can lead to a static, uninteresting image. Or, as you can see in Figure 16.15, completely stopping the action can produce an undesirable effect. A little selective motion blur can add to the feeling of movement. Motor racing photographers, for example, always select a shutter speed that's slow enough to allow the wheels of a vehicle to blur; otherwise, the vehicle looks as if it were parked. However, including a little, but not too much blur in your pictures is more difficult and challenging than simply stopping your subjects in their tracks. Some of the best action pictures combine blur with sharpness to create a powerful effect. This section will show you how to put the freeze and partial freeze on your action subjects.

Figure 16.15
No, this helicopter's rotors haven't stopped, and no crash is impending. They were frozen in mid-spin by a fast shutter speed.

Motion and Direction

From your mirrorless camera's perspective, motion looks different depending on its speed, direction, and distance from the camera. Objects that are moving faster produce more blur at a given shutter speed if the camera remains fixed. Subjects that cross the field of view appear to move faster than those heading right toward the camera. Things that are farther away seem to be moving more slowly than those in our immediate vicinity. You can use this information to help apply the amount of freeze you want in your image.

■ Parallel motion. If a subject is moving parallel to the back of the camera, in a horizontal, vertical, or diagonal direction, it will appear to be moving fastest and cause the highest degree of blur. A high pop fly that's dropping into the infield will seem to be moving faster than one that's headed out of the ball park (away from the camera) for a home run, even though, in reality, Barry Bonds can probably propel a baseball *much* faster than the impetus the laws of gravity will apply to a falling popup. A racing car crossing the frame is likely to appear to be blurry even if you use a high shutter speed.

- Head-on motion. Motion coming toward the camera, like the hurdler shown in Figure 16.16, appears to move much slower, and will cause much less blur. That same race car headed directly toward you can be successfully photographed at a much longer shutter speed.
- Motion on a slant. Objects moving diagonally toward the camera will appear to be moving at a rate that's somewhere between parallel and head-on motion. You'll need a shutter speed somewhere between the two extremes. Motion coming toward the camera on a slant (perhaps a runner dashing from the upper-left background of your frame to the lower-right foreground) will display blur somewhere between the two extremes.
- Distant/close motion. Subjects that are closer to the camera and larger within the frame blur more easily than subjects that are farther away and smaller in the frame, even though they're moving at the same speed. That's because the motion across the camera frame is more rapid with a subject that is closer to the camera and appears larger in the viewfinder.

Figure 16.16 Motion coming toward the camera produces much less blur, and can be stopped with a slower shutter speed.

Figure 16.17 Panning the camera with this distance runner stopped the action at a relatively low 1/125th second shutter speed.

■ Camera motion. Blur is relative to the camera's motion, so if you pan the camera to follow a fast-moving object, as in Figure 16.17, the amount of blur of the object you're following will be less than if the camera remained stationary and the object darted across the frame. On the other hand, if the camera motion isn't smooth, but is jittery and not in conjunction with the movement of the subject, it can detract from the sharpness of the image.

Action-Stopping Techniques

This section will summarize the basic techniques for stopping action under the most common types of shooting situations. Your particular photo opportunity may combine elements from more than one of these scenarios, and you're free to combine techniques as necessary to get the best results.

Stopping Action with Panning

The term *panning* originated in the motion-picture industry, from a camera swiveling motion used to follow action as it progresses from one side of the frame to the other. Derived from the term *panorama*, a pan can be conducted only in a horizontal direction. The vertical equivalent is called a *tilt*, which is why your tripod's camera mount may be called a *pan and tilt* head. You'll rarely need to "pan" vertically, unless you're following a rocket as it takes off for outer space.

Suppose a marathon runner is racing across your field of view. If she's close enough and moving fast enough, even your highest shutter speed may not be able to stop the action. So, instead, you move the camera in the same direction that the runner is moving. Her apparent speed is much slower,

relative to the camera, so a given shutter speed will be able to freeze the action more readily, as you can see in Figure 16.17. Blur from subject motion is reduced. Yet, the background will display more blur, due to camera motion.

Panning can be done with a hand-held camera (just plant your feet firmly and pivot at the waist), or with a camera mounted on a tripod that has a swiveling panorama (pan) head. The more you practice panning, the better you'll get at following the action. You might find that if your panning speed closely matches the subject's actual speed, a shutter speed as slow as 1/60th to 1/125th second can produce surprisingly sharp images. Use of a lower shutter speed causes the background to appear blurrier, too.

To pan effectively, you should try to move smoothly in the direction of the subject's movement. If your movement is jerky, or you don't pan in a motion that's parallel to the subject's motion, you'll get more blurriness than you anticipate or want. Take a step back, if you can. The farther the subject is from the camera, the longer you'll have to make your pan movement, improving potential sharpness.

Panning is a very cool effect because of the sharpness of the subject, the blurriness of the background, and some interesting side effects that can result. For example, parts of the subject not moving in the direction of the overall pan will be blurry, so your runner's body may be sharp, but her pumping arms and legs will blur in an interesting way, as you saw in Figure 16.17.

Freezing Action Head On

Another way to stop action is to photograph the subject as it heads toward or away from you. A runner who is dashing toward the camera can be effectively frozen at 1/250th or 1/125th second, but would appear hopelessly blurred when crossing the frame (if you're not panning). Head-on shots can be interesting, too, so you might want to use this angle even if you're not trying to boost your effective shutter speed. The water skier and boat in Figure 16.18 were moving at a pretty good clip, but because they were headed away from the camera (albeit at a slightly diagonal angle), it was possible to freeze the action at 1/125th second. The fact that the water spray is a little blurry probably adds to the picture, rather than detracting from it.

Freezing Action with Your Shutter

A third way to stop motion is to use the tiny time slice your shutter can nip off. A fast shutter speed can stop action effectively, no matter what the direction of the motion. The trick is to select the shutter speed you really need. A speed that is too high can rob you of a little sharpness because you've had to open the lens aperture a bit to compensate, or use a higher ISO rating that introduces noise. There are no real rules of thumb for selecting the "minimum" fastest shutter speed. As you've seen, action stopping depends on how fast the subject is moving, its distance from the camera, its direction, and whether you're panning or not.

Figure 16.18 Movement toward or away from the camera can be captured at lower shutter speeds.

Many cameras include shutter speeds that, in practice, you really can't use. The highest practical speed tops out at around 1/2,000th second. With a fast lens and a higher ISO rating, you might be able to work with 1/4,000th second under bright illumination. Yet, there are digital cameras available that offer shutter speeds as brief as 1/16,000th of a second. So, the bottom line is usually that, to freeze action with your shutter speed alone, you'll probably be using a speed from 1/500th second to 1/2,000th second, depending on the illumination and what your camera offers.

Freezing Action with Electronic Flash

Electronic flash units, originally called "strobes" or "speedlights," are more than a great accessory for artificial illumination. The duration of an electronic flash is extremely brief, and if the flash provides the bulk of the illumination for a photograph, some great action-stopping results. One of the earliest applications of electronic flash was by Dr. Harold Edgerton at MIT, who perfected the use of stroboscopic lights in both ultra-high-speed motion and still (stop-motion) photography capable of revealing bullets in flight, light bulbs shattering, and other phenomena.

Some flash units have a duration of 1/50,000th second or less, which is very brief, indeed. One way of controlling an automated flash unit is to vary the duration of the flash by using only part of the stored energy that's accumulated in the unit's capacitors.

If the subject is relatively far away, the entire charge is fed to the flash tube, producing the longest and most intense amount of illumination. If the subject is relatively close, only part of the charge is required for the photograph, and only that much is supplied to the flash tube, producing an even briefer flash. Yet, even the longest flash exposure is likely to be shorter than your camera's shutter speed, so electronic flash is an excellent tool for stopping action.

The chief problem with electronic flash is that, like all illumination, it obeys that pesky inverse-square law. As you'll recall, light diminishes relative to the inverse of the square of the distance. So, if you're photographing a subject that's 12 feet away, you'll need *four* times as much light when the subject is twice as far away at 24 feet, not twice as much. Worse, if an athlete in your photograph is 12 feet away when you snap a picture, anything in the background 24 feet away will receive only one quarter as much light, giving you a dark background.

That generally means that a digital camera's built-in electronic flash is probably not powerful enough to illuminate anything two-dozen feet from the camera. You might be able to use your camera's flash at a basketball game, but not at a football game where the distances are much greater. A more powerful external flash unit might be called for.

However, flash is especially adept at stopping close-up action, as shown by Figure 16.19, which illustrates what happens when attempting to use a cryogenically frozen hammer to smash a light bulb. Of course, the exact effect shown in the figure is virtually impossible to achieve, except on April 1, and only with significant help from Photoshop or another image editor, but I decided not to run the traditional bullet-piercing-balloon or hammer-smashing-bulb photo, which we've all seen a million times. My e-mails will tell me which of my readers were paying attention here.

Figure 16.19
Electronic flash can
freeze close-up
action.

Freezing Action at Its Peak

The final method for freezing fast motion is simple: wait for the motion to stop. Some kinds of action include a peak moment when motion stops for an instant before resuming again. That's your cue to snap a picture. Even a relatively slow shutter speed can stop action during one of these peak moments or pauses. Figure 16.20 shows a motocross jumper at the exact peak of his leap, performing a daring stunt before his motorcycle resumes its downward trajectory.

Figure 16.20 Capture action at its peak and you can use a slower shutter speed.

The end of a batter's swing, a quarterback cocking his arm to throw a pass, a tennis player pausing before bringing a racket down in a smash. These are all peak moments you can freeze easily. Other peaks are trickier to catch, such as the moment when a basketball player reaches the apex of a leap before unleashing a jump shot. If you time your photograph for that split second before the shooter starts to come down, you can freeze the action easily. If you study the motion of your action subjects, you'll often be able to predict when these peak moments will occur.

When Blur Is Better

Some kinds of action shouldn't be frozen at all, as we saw in the helicopter photo earlier in this chapter. Better yet, you can use blur as a creative effect to show movement without freezing it. Figure 16.21 shows a 1/15th second exposure of a basketball player moving down the court. Panning wasn't enough to stop the action of his moving arms and legs, or the motion of the ball and other players, making a much better image than a static shot.

Some Final Tips

I know this chapter has you psyched up to take some great action photos, but there are a few additional points to consider before you embark on your photo assignment. As with any other kind of shoot, it's always best to be well prepared. There are things you should never leave home without, and not all of them are your MasterCard.

Figure 16.21 Some subjects are more interesting in a long exposure.

Make yourself a checklist like this one:

- Take spares. One of the first things I learned as a professional is that excuses like, "My flash cord didn't work!" won't fly. I used to carry at least three of everything, including camera bodies and key accessories. I duplicated only the most essential lenses, but I always had a spare along that would suffice in a pinch, such as an f/1.4 normal lens as well as an f/1.4 35mm wideangle. You don't need to be a pro to have a lot invested in your pictures. Don't let your vacation or once-in-a-lifetime shot be ruined. Take along extra batteries, extra digital film cards, and perhaps a backup flash unit. You might not be able to afford a spare body, but you can always squeeze an extra point-and-shoot digital camera into your gadget bag to use if all else fails.
- Charge your batteries. Some mirrorless cameras can shoot 1,000 to 2,000 pictures on a single charge, but those figures can be achieved only if you're starting out with a fully charged battery. Modern batteries can be recharged at any time without causing any detrimental side-effects, so you'll want to give all your batteries a fresh jolt just before embarking on any important photo journey. Have a spare battery if you think you might be taking more pictures than your original set will handle. And remember that if you expect to use your flash a lot, battery life will be reduced significantly.
- Offload your photos and reformat your memory cards. You don't want to grab a new card, get ready to take a crucial picture, and then discover that the card contains older photos that you haven't transferred to your computer yet. Nothing is more painful than having to decide whether to preserve some junky but interesting photos currently residing on your memory card, or to erase them so you'll have some space for new pictures. Transfer your old pictures to other storage, and then reformat the card so it's fresh and ready to go.
- Review your controls. Perhaps you want to take some pictures using rear-sync. Do you know how to activate that mode? Can you switch to burst mode quickly, particularly if the light isn't great? Do you know how to use shutter-priority mode, or select a fast shutter speed? Practice now, because the pressures of trying to get great pictures of fast-moving action can prove confusing.
- Set up your camera before you leave. If you're planning on using a particular ISO method, want to change from your camera's default focusing mode, or intend to use a particular exposure scheme, make those settings now, in calmer surroundings. In the excitement of the shoot, you may forget to make an important setting. I once shot a whole batch of action photos in full daylight not remembering that I'd manually set white balance to tungsten for some tabletop close-ups the night before. If you're shooting in RAW format, you can fix goofs like that, but if you're not, you can't provide perfect correction, even with an advanced image editor like Photoshop.
- Clean and protect your equipment. Unless you're looking for a soft-focus look, you'll want to make sure your lenses and sensor are clean. If you expect rain or snow, use a skylight filter. If necessary, make a "raincoat" for your camera out of a resealable sandwich bag with a hole cut in it for the lens to stick out.

Close-Up Photography

Many of the most enjoyable types of digital photography are, unhappily, seasonal. If you love to shoot baseball or football sports action, you'll have to wait until baseball or football season kicks off. Should your passion be shooting autumn colors as the leaves change after summer's end, you'll have to wait until September and October of each year. Wildlife and nature photography isn't impossible during the winter months, but it's usually more exciting during the spring. Architectural photos often look their best with leaves on the surrounding trees. Weddings seem to proliferate in June. Just when you get really involved in a particular type of photography, the "season" for it ends.

But close-up photography is a photographic pursuit you can enjoy all year long. Each April, I'm out there chasing down blossoming flowers and looking for interesting bugs to capture on digital film. In July, I end up at the beach shooting shells and shore creatures. Come late September, I grab close-up shots of leaves. And during the long winters, I have my macro tabletop set up so I can shoot pictures of anything that captures my fancy. Indeed, close-up photography and portraits are what I photograph most during the cold months.

I'm hoping this chapter will encourage you to try out macrophotography yourself because digital SLRs are the perfect tool for this kind of picture taking. You'll discover whole new worlds in a water drop, teeming life under any bush or tree, and fascinating patterns in common household objects.

Macro Terminology

It's easy to get confused over some of the terms applied to macrophotography. Even the name itself is sometimes misunderstood. Macrophotography is *not* microphotography, which involves microfilm and other miniature images; nor is it photomicrography, which is taking pictures through a microscope. Nor, necessarily, is it close-up photography, which, strictly speaking, applies to a tight shot in cinematography. Macrophotography is generally the production of close-up photos, usually

taken from a foot or less. Because the terms macrophotography and close-up photography are nevertheless used interchangeably these days, I'll do so in this book.

There are several other terms that cause confusion. I'll clarify each of them for you.

Magnification

In macrophotography, the amount of magnification is usually more important than how close you can get to your subject. For example, if you're photographing a coin and want it to fill the frame, it makes little difference whether you shoot the coin using a 50mm lens from 4 inches away or with a 100mm lens from 8 inches away. Either one will produce the same magnification. Because of this, close-up images and the macro capabilities of cameras and lenses are usually described in terms of their magnification factor, rather than the camera/subject distance. Moderate close-ups may involve 1:4 or 1:3 magnifications. Normal close-up photography requires 1:2 or 1:1 magnifications. Larger-than-life-size images may involve 2:1 or 4:1 (or 2X or 4X) magnifications. The small stone carving in Figure 17.1 was photographed at approximately a 1:4 ratio.

Figure 17.1
Sometimes getting up close and photographing a detail of a larger subject, such as this two-inchwide section of a stone carving, provides an interesting perspective.

Yet, the newcomer to macro photography invariably wants to know "how close can I get?" That's a logical question. If you're used to taking pictures of subjects that are located from six feet to infinity, the desire to get close, preferably as close as possible, takes on special significance. However, if you think about it, the distance between your lens and the subject isn't the most important thing. You want a bigger view of your subject, so the size of the subject on your sensor (or film) is the key factor. Instead of focusing on distance, think *magnification*.

It's easy to see why, through a simple thought experiment. You don't even have to whip out your camera. Imagine taking a photograph of a coin from your coin collection from 8 inches away, with your camera set to its widest zoom setting, say, the equivalent of a 35mm lens. Now, move the camera back so it's 12 inches away from the coin, but zoom in to your camera's maximum telephoto setting, say, 200mm. (Not all cameras can focus close at all zoom settings, but, fortunately, this is a thought experiment.) Which photograph will have the larger image? Which will be a more satisfactory close-up of your coin?

Figure 17.2 shows an aloe vera plant photographed from about 2 feet away using the equivalent of a 28mm wide-angle lens. For Figure 17.3, I moved back to about 5 1/2 feet and shot at the 80mm zoom setting. Note that the magnification of each image is exactly the same (at least, in terms of the flowerpot), even though one photo was taken at a distance that's nearly three times as far.

There are other differences in the photos, which I'll point out in the Perspective section.

In macro photography, it's not how close you can focus, but the final size, or magnification, of the image that is important. A lens that focuses very close only at the wide-angle setting will not produce the same results as one that focused close at both wide-angle and telephoto settings. Indeed, there are situations in which you'd want to use one or the other, because both wide-angle and

Figure 17.2 This photo was taken using a 28mm zoom setting from about 2 feet away.

Figure 17.3 This picture was taken using the 80mm zoom setting from 5 1/2 feet away.

telephoto settings can produce distortions in your final image, depending on the subject matter and how close you are to it. Subject distance can be important for some types of close-up photography: if you're shooting a skittish critter such as an insect or frog, you might prefer to use a longer lens at a greater distance, still keeping the same image size because the magnification of the longer lens is greater, as I'll explain shortly.

Because final image size depends on both the lens focal length and distance to the subject, magnification is the most useful way of expressing how an image is captured with macro photography. If your magnification is 1X, the object will appear the same size on the sensor (or film) as it does in real-life, completely filling the frame. At 2X magnification, it will be twice as big, and you'll only be able to fit half of it in the frame. At .5X, the subject will be half life-size and will occupy only half the width or height of the frame. These magnifications are most commonly referred to as ratios: 1X is 1:1, 2X is 2:1, .5X is 1:2, and so forth. As you work with close-up photography, you'll find using magnifications more useful than focusing distances.

Focal Length and Magnification

Focal length determines the working distance between your camera/lens and the macro subject at a given magnification. As with most real-world decisions, the choice of focal length is necessarily a

compromise. For example, if you want a life-size photo (1:1) of a tree frog, you could shoot it from a few inches away with a 50mm lens, or twice as far away (which should make the frog less apprehensive) with a 100mm lens.

To focus more closely, the lens elements of a general-purpose or macro lens must be moved farther away from the sensor, in direct proportion to the magnification. (To simplify things, I'm going to assume we're using a fixed-focal-length, or *prime* lens, rather than a zoom lens.) So, the optical center of a 60mm lens must be moved 60mm from the sensor (about 2.4 inches) to get 1:1 magnification. That's a relatively easy task with a 60mm lens. To get the same magnification with a 120mm lens, you'd have to move the optical center much farther, 120mm (or almost 5 inches), to get the same 1:1 magnification. (As I mentioned in Chapter 6, the "optical center" can be somewhere other than the physical center of the lens; with a long lens, the optical center may be close to the front element of the lens.)

For this reason, most so-called "macro" zoom lenses actually produce 1:4 or 1:5 magnifications. There are specialized macro prime lenses for digital cameras in the 60mm, 80mm, 105mm, and 200mm range, but these are special optics and tend to be expensive. Figure 17.4 shows a 60mm Micro Four Thirds prime lens. A true macro might be a better choice for you if you do a lot of close-up photography.

Figure 17.4 A 60mm macro lens for Micro Four Thirds cameras.

That's because of the increased working distance the longer lenses offer. For example, the 60mm lens shown has a full-frame "equivalent" focal length of 120mm when used on a Micro Four Thirds camera. At extreme magnifications, a shorter lens may have the front element less than an inch from the subject. That introduces perspective problems and makes it difficult to get some light in there to illuminate your subject. Your camera may be so close to the subject that there isn't room to light the front of the subject. Forget about your built-in flash: It is probably aimed "over" the subject and either won't illuminate it at all or will only partially illuminate it, and may even be too powerful. Or, your lens may cast a shadow on the subject.

So, your choice of focal length may depend on the desired working distance and whether a particular focal length produces the perspective you need.

Perspective

As you just learned, close-up pictures can be taken from a relative distance (even if that distance is only a few feet away) with a telephoto lens or long zoom setting. The same magnification can also be achieved by moving in close with a shorter lens. The same apparent perspective distortion that results from using a wide-angle lens close to a subject and the distance compression effects of a telephoto apply to close-up and macrophotography. Figure 17.5, captured with a fish-eye lens from less than a foot away from the grille of a custom car, looks like nothing you've ever seen before.

So, if you have a choice of tele/wide-angle modes for macrophotography, you'll want to choose your method carefully. Relatively thick subjects without a great deal of depth and those that can't be approached closely can be successfully photographed using a telephoto/macro setting. Subjects with a moderate amount of depth can be captured in wide-angle mode. If you find that a wide setting tends to introduce distortion, settle for a focal length somewhere in between wide and telephoto.

Figure 17.5 Wide-angle lenses, including the fish-eye used for this image, provide an interesting perspective for close-up shots.

Figure 17.6 shows an image I produced one day when I had nothing to photograph. I decided to do some "figure studies" of a shapely miniature jug, using close-up techniques. I used light and a telephoto zoom set to macro mode to capture images of portions of the jug.

The most important types of subjects affected by perspective concerns are tabletop setups such as architectural models and model railroad layouts. Use the right perspective, and your model may look like a full-scale subject. With the wrong perspective, the model looks exactly like what it is, a tiny mock-up.

Figure 17.6 A telephoto perspective and a creative use of light make this photo of part of a jug interesting.

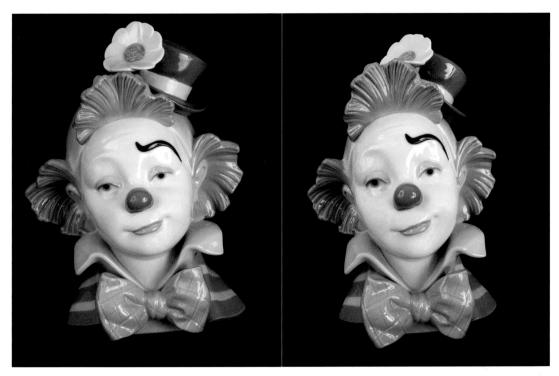

Figure 17.7 The telephoto shot (left) has a different perspective than the wide-angle picture (right).

You may be able to detect the difference perspective makes by comparing the images in Figures 17.2 and 17.3 shown earlier, or, more easily, by examining the two versions of the porcelain clown shown in Figure 17.7. The version on the left was shot with a longer lens, a short telephoto, while the version on the right was shot with a wide-angle lens, with the camera moved in closer to produce the same image size for the clown. Objects that are closer to the camera, such as the clown's nose, appear proportionately larger in the wide-angle shot at right, while objects that are farther away, such as his ears and his flowered hat, appear proportionately smaller. At any given magnification, you'll want to choose the focal length of your lens carefully to provide the kind of perspective that you're looking for.

Depth-of-Field

The depth of sharp focus with three-dimensional subjects can be a critical component in macrophotography. You'll find that depth-of-field is significantly reduced when you're focusing close. Although the relatively short focal length of the lenses used with digital cameras provides extra depth-of-field at a given magnification, it still may not be enough. You'll need to learn to use smaller apertures and other techniques to increase the amount of sharp subject matter. A lens that has a wider range of f/stops, with, perhaps stops as small as f/32 or even smaller, can be helpful to increase depth-of-field. Of course, you need to know that any DOF gains made with smaller f/stops can be

lost to a phenomenon known as *diffraction*, which crops its ugly head as you stop down. (Diffraction is why most lenses produce their best results one or two f/stops from wide open, and actually lose a bit of sharpness as you stop down, even while depth-of-field increases.)

Figure 17.8 shows three different versions of a photo of an array of crayons, taken with a 60mm macro lens. In all three cases, focus was on the yellow-green crayon in the upper middle of the frame. The image on the left was shot at f/4, the middle version at f/11, and the one at right at f/22. You can easily see how the depth-of-field increases as the lens is stopped down.

You'll also need to learn how to *use* your available depth-of-field. Typically, the available DOF (which, as you've just seen, varies by f/stop) extends two-thirds behind the point of sharpest focus and one-third in front of it. Figure 17.9 shows the same crayons in a slightly different arrangement, all taken at f/4. In the version at left, I've focused on one of the crayons in the front row. The middle shot, taken at the same f/stop, was focused on the middle crayon. The version at the right was focused on the rear-most row. With the lens almost wide open, depth-of-field is so shallow that only the crayon focused on is sharp. I could use that creatively to apply selective focus, or I could have stopped the lens down, focused on the center crayon, and perhaps brought all of them into focus.

I also could have increased depth-of-field by changing angles so that more crayons were approximately the same distance from the lens. For Figure 17.10, I cranked the tripod up a little higher and shot down from a different angle. The f/stop is still f/4, but more of the crayons are in focus.

Figure 17.8 Depth-of-field increases as the f/stop is changed from f/4 (left) to f/11 (middle) and f/22 (right).

Figure 17.9 See how depth-of-field changes when the lens is focused on the crayon in front, middle, or back rows.

Figure 17.10 Raising the viewing angle spreads the depth-of-field over a broader area than shooting head-on.

Getting Practical

Of course, macrophotography isn't all about terms and definitions. You need to understand how to apply these concepts to your picture taking. This section will look at some of the practical aspects of shooting close-up images.

Macro or General-Purpose Lens?

The selection of a lens for macrophotography can be important because not all lenses do a good job of taking close-up pictures. Some, particularly zoom lenses with a long range, may not focus close enough for practical macro work. Others may not be sharp enough, or might produce distortion, color aberrations, or other image problems that become readily apparent in critical close-up environments. Or, you might find that a particular lens or focal length is not suitable because, to get the magnification you want, the lens itself must be so close to the subject that it intrudes on properly lighting the setup. Here are some things to think about:

Many general-purpose lenses can be pressed into service as close-up optics and do a fine job if they have sufficient sharpness for your application and are relatively free of distortion. If you frequent the photography forums, you'll see paeans of praise for this lens or that when used for macro shots. It's entirely possible to work with a lens you already own and get good results.

I was shooting architecture with a wide-angle zoom lens when I encountered this flower amidst the plantings around a plaza. This particular lens focuses down to 1 foot at its 35mm zoom setting, so I was able to take the photo shown in Figure 17.11. I would have liked to have gotten even closer, but I didn't really need to. Simply enlarging the center portion of the frame in an image editor gave me the true macro image you can see in Figure 17.12.

Of course, if you do a lot of close-up work, you'll be happier with a lens designed specifically for that job, like the 30mm f/2.8 optic seen in Figure 17.13. I already owned this macro lens for my mirror-equipped Sony cameras, but am able to use it on several different mirrorless Sony models using the EA-LA4 A-mount to E-mount adapter shown. Similar adapters are available that let you use Four Thirds lenses on Micro Four Thirds cameras, Nikon F-mount lenses on a Nikon 1 camera, and virtually any lens from any manufacturer on Sony, Nikon, Canon, Fujifilm, Pentax, and Micro Four Thirds models.

Dedicated macro lenses will be exquisitely sharp and built to focus close enough to produce 1:1 or 1:2 magnification without any add-on accessories. Macro lenses are optimized for shooting at close focus distances. The typical non-macro lens is designed with the expectation that the distance between the subject and the optical center of the lens will be much *greater* than the distance from the optical center to the sensor plane. However, when shooting close-ups, it's frequently the case that the distance from the subject to the optical center of the lens is only a few inches, or even much less, while the distance to the sensor plane is more or less fixed at a couple inches. Macro lenses designed for this "backward" orientation can produce sharper results. (And this is exactly the reason

Figure 17.11 A wide-angle lens that focused down to 1 foot served as a "macro" lens for this shot.

Figure 17.12 Enlarging the center portion of the frame produced a dramatic close-up.

Figure 17.13
A true macro lens is your best bet for close-up photography.

why a non-macro lens can give you sharper images if you *reverse* it, using an adapter, so that the front filter thread end is now facing the sensor, to give it the "backward" orientation of the typical extreme close-up photo.)

Close-Up Gear

In addition to a macro lens, there are other pieces of equipment that can come in handy for macro-photography, ranging from special close-up attachments that fit on the front of the lens, lens "extenders" that move the optical center of the lens farther away from the sensor, and accessories like ring lights that make illuminating your subject easier.

Close-Up Lenses/Attachments

Close-up lenses and attachments, which screw onto the filter thread of a lens, are the least expensive macro equipment you're likely to find. Close-up "lenses" differ from macro true lenses, despite their confusingly similar names. Macro lenses are prime lenses or macro zoom lenses designed to focus more closely than an ordinary lens. The add-ons that have traditionally been called close-up lenses are actually screw-on, filter-like accessories that attach to the front of your camera's prime or zoom lens.

These accessories are useful when you want to get even closer than your camera's design allows. They provide additional magnification like a magnifying glass, letting you move more closely to the subject. Close-up lenses, like the one shown in Figure 17.14, are generally labeled with their relative "strength" or magnification using a measure of optical strength called "diopter." A lens labeled

Figure 17.14
A close-up lens attachment can bring you even closer than your camera's minimum focusing distance.

"No. 1" would be a relatively mild close-up attachment; those labeled "No. 2" or "No. 3" would be relatively stronger. Close-up lenses are commonly available in magnifications from +0 diopter to +10 diopters. You can stack multiple close-up lenses to achieve more magnification, although it's best to use no more than two at once to avoid optical degradation of the image.

The actual way close-up magnification is calculated is entirely too complicated for the average math-hating photographer, because there's little need to apply mumbo-jumbo like *Magnification at Infinity=Camera Focal Length/(1000/diopter strength)* in real life. That's because the close focusing distance varies with the focal length of the lens and its unenhanced close-focusing capabilities.

However, as a rule of thumb, if your lens, a telephoto, say, normally focuses to one meter (39.37 inches; a little more than three feet), a +1 diopter will let you focus down to one-half meter (about 20 inches); a +2 diopter to one-third meter (around 13 inches); a +3 diopter to one-quarter meter (about 9.8 inches); and so forth. A +10 diopter will take you all the way down to about two inches—and that's with the lens focused at infinity. If your digital camera's lens normally focuses closer than one meter, you'll be able to narrow the gap between you and your subject even more.

In the real world, the practical solution is to purchase several close-up lenses (they cost roughly \$20 each and can often be purchased in a set) so you'll have the right one for any particular photographic chore. You can combine several close-up lenses to get even closer (using, say, a +2 lens with a +3 lens to end up with +5), but avoid using more than two close-up lenses together. The toll on your sharpness will be too great with all those layers of glass. Plus, three lenses can easily be thick enough to vignette the corners of your image.

One of the key advantages of add-on close-up lenses is that they don't interfere in any way with the autofocus or exposure mechanism of your mirrorless camera. All of your lenses will continue to work in exactly the same way with a close-up lens attached. There are some disadvantages, too. As with any filters, you must purchase close-up lenses in sizes to fit the front filter threads of your lenses. You'll either need close-up lenses for each filter size appropriate for the optics you want to use them with or use step-up/step-down adapter rings to make them fit.

Finally, close-up lenses come with a sharpness penalty, especially when you start stacking them together to achieve higher magnifications. A photo taken with a close-up lens will be a little less sharp than one taken without.

Extension Tubes and Bellows

One of the coolest things about interchangeable lens cameras is that if you can't move the lens far enough away from the sensor to get the magnification you want, you can pop off the lens and insert gadgets that provide that extension for you. The simplest variety is called *extension tubes*, as seen in Figure 17.15.

These are nothing more than hollow tubes with a fitting on the rear similar to that on the back of a lens, and which connects to the lens mount of your camera. The front of the extension tube has a lens mount of its own, and your lens is attached to that. Automatic extension tubes are not made for every type of mirrorless camera, however. They do nothing but what their name says: extend. Extension tubes are available in multiple sizes, often as a set, with, say, 8mm, 12.5mm, and 27.5mm tubes that can be used alone or in combination to produce the amount of extension needed.

Some tubes may not couple with your camera and lens's autofocus and autoexposure mechanisms. That doesn't preclude their use because you may be focusing manually anyway when you're in macrophotography mode, and setting the f/stop and shutter speed manually (the tube may include a lever to stop down your lens to the aperture used to take the picture) may not be much of an inconvenience, either. Newer sets are compatible with your lens's full set of features, except, possibly, image stabilization, making them even more convenient to use.

A bellows is an accordion-like attachment that moves along a sliding rail to vary the distance between lens and camera continuously over a particular range. Where extension tubes each provide a fixed amount of magnification, bellows let you produce different magnifications, as much as 20:1 or more. I favor an older bellows attachment, used with a correspondingly ancient macro lens. It has a tilt and shift mechanism on the front column, which allows you to vary the angle between the lens and the back of the camera (where the sensor is). This shifting procedure can help you squeeze out a little more depth-of-field by tilting the sharpness "plane" in the same direction your subject matter "tilts" away from the camera.

A bellows attachment, like the one shown in Figure 17.16, frequently has a rotating mechanism that allows you to shift the camera from horizontal to vertical orientation. Some bellows have two rails: one for adjusting the distance of the lens from the camera, and a second that allows moving the

Figure 17.15 A lens can be mounted on these extension tubes to turn it into a close-focusing macro lens.

Figure 17.16 A bellows with slide and tilt capabilities lets you tweak a little extra depth-of-field out of your extreme close-up photos.

whole shebang—bellows, camera, and all—closer or farther away from the subject. That allows it to function as a "focusing rail." Once you've moved the lens out far enough to achieve the magnification you want, you can then lock the camera/bellows distance and slide the whole assembly back and forth to achieve sharpest focus.

Be careful when attaching bellows or extension tubes to your camera to avoid damaging your lens mount or camera body. Even if a bellows is nominally compatible, you may have to attach an extension tube to the camera body first and then fasten the bellows to the extension tube to allow the mechanism to clear projecting parts of the camera. Remember that, since you'll be manually focusing, and the distance between the lens and sensor is important only in terms of magnification, you can mix and match lenses, bellows, and cameras among vendors. For example, a Nikon bellows can be mounted on a non-Nikon camera with the proper adapter, and then, using another adapter, you can mount Nikon, Canon, Sony, or other lenses on the front of the bellows. Indeed, my favorite combination is just about any mirrorless camera coupled to a Nikon bellows (less than \$100) and used with an old Nikon macro lens with aperture ring (another \$100 or less).

Of course, bellows, extension tubes, and similar attachments designed specifically for your camera can be expensive (although there are many bargains available in pre-owned equipment), so you won't want to make the investment unless you do a lot of close-up photography. Another downside is that the farther you move the lens from the sensor, the more exposure required. You can easily lose 2 or 3 f/stops (or much more) when you start adding extension. Fortunately, your camera's through-the-lens exposure system can calculate the correct exposure for you.

Tripods

You'll probably need a tripod to support your camera during macrophotography sessions. Tripods steady the camera for the longer exposures you might need and allow consistent and repeatable positioning, which might be necessary if you were, perhaps, taking pictures of your toy soldier collection one figure at a time. Get a sturdy tripod with easily adjustable legs, sure-grip feet, and a center column that lets you change the height over a decent range without the need to fiddle with the legs again. A center column that's reversible is a plus because you can use it to point the camera directly down at the flower or shoot from low angles that are less than the minimum height of the tripod. A ball head, which lets you rotate the camera in any direction, is easier to use and more versatile than the tilt-and-swing type tripod head shown in the illustration.

A good tripod not only frees you from needing to have three or four different hands, but it makes it easier to focus and frame an image through a digital camera's LCD screen. A tripod is also a consistent and repeatable support, so if you're taking photographs of your model train collection, the camera can remain the same distance from your rolling stock picture to picture and session to session.

You'll quickly discover that not just any tripod is suitable for close-up photography. Some models are little better than camera stands and the worst of them wobble more than you do. Digital cameras are so small (many weighing only a few ounces) that you might be tempted to go with an equally petite tripod. Don't succumb to the temptation! Although you might not need a heavy-duty studio tripod like the one I use, you still need something that's rigid enough not to sway while you compose your image, and heavy enough to remain rock-solid during a long exposure. There are smaller tripods available that don't flex under tiny amounts of pressure, and resist swaying with every gust of wind or other minor environmental shakes.

Here are some things to look for in a tripod used for close-up photography:

- Quick adjustable legs. Look for legs that adjust easily so you can change the height of the tripod quickly. You'll need to make some altitude adjustments while taking pictures, of course. However, you'll find that you frequently need to set up a tripod on uneven surfaces, from stairs (indoors) to a sloping hill (outdoors). Legs that adjust quickly make it easy to set each leg at a different appropriate length for a steady mount on a less-than-flat surface.
- Sure-grip "feet." Rubberized feet at the end of each leg are good for gripping slippery surfaces. Some tripods have feet that can be adjusted to use spiky tips that can dig into dirt, grass, or other iffy surfaces.
- An adjustable center column. You'll need one that's long enough to let you move the camera up or down by a foot or two without the need to adjust the legs.
- A center column that's reversible. This feature comes in handy when you need to point the camera directly down at the floor for some close-ups.
- A versatile head. The traditional tilt and swing head or ball head that flips in horizontal and vertical directions may be found on older and less expensive tripods. More common are *ball heads* that swivel in all directions, so you can quickly change the camera angle. With some

professional tripods, heads are a component that's purchased separately. Figure 17.17 shows a typical ball head from Photo Clam (http://wp.photoclamusa.com/) and its key components.

- **Solid support.** Cross-bracing that holds the legs of a lightweight tripod rigid even when extended fully can be useful. Sturdier tripods might not need any cross-bracing.
- Lightweight. If you're taking your tripod out in the field, you might want an extra light model that can be toted around conveniently, but which doesn't sacrifice rigidity. Tripods built of carbon fiber or carbon fiber and magnesium, or basalt, typically weigh one-third less than aluminum models, yet are just as sturdy.

If you take pictures of small, flat objects (such as stamps, coins, photographs, or needlepoint), you might want to consider a special kind of camera support called a *copystand*. These are simple stands with a flat copyboard and a vertical (or slanted) column on which you fasten the camera. The camera can be slid up or down the column to adjust the camera-subject distance. A slanted column is best, because it ensures that the camera remains centered over a larger subject area as you move the camera up. Copystands provide a much more convenient working angle for this type of photography, particularly if your digital camera allows swiveling the lens and viewfinder in different directions.

DON'T CARRY THAT WEIGHT

When you're shooting in the field, take along one of those mesh bags that oranges come in. You can fill it up on-site with rocks, tie it to the center support of your tripod, and use it to add extra hill-hugging weight to a light-weight camera support.

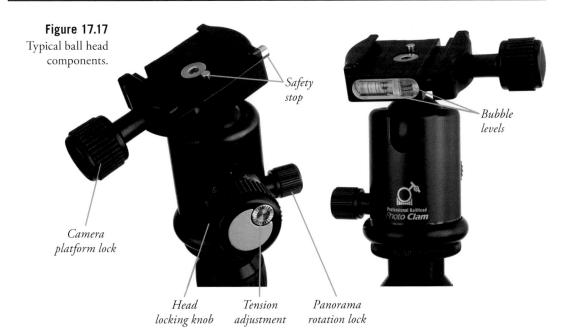

Other Gear

Although you can work with existing light, you'll find your creative possibilities are broader if you use external light sources. Macro subjects other than living creatures will usually sit still for long exposures, so incandescent lighting—perhaps something as simple as a pair of desktop gooseneck lamps—may suffice.

Or, you can use electronic flash to freeze action. As I mentioned earlier, your mirrorless camera's built-in electronic flash isn't ideal for macro work, so you should investigate external, off-camera flash units. Frequently, your camera's internal circuitry may be able to trigger the same vendor's external flash attachments by radio control. Or, you can set your internal flash to its very lowest power setting and use that to set off an external flash through a triggering device called a *slave unit*, described in Chapter 7. In that case, the internal flash may provide nothing more than a little fill on your subject, with most of the illumination coming from the external flash.

There is also a device called a ring light, which is a circular light shaped like a round fluorescent tube (and may in fact be one in its incandescent incarnation). A ring light can solve your close-quarters illumination problems by providing an even, shadow-free light source at short camera/subject distances.

Consider using reflectors, umbrellas, and other light modifiers to optimize your lighting effects. A simple piece of white cardboard can work well and can double as a background. Aluminum foil or Mylar sheets can provide a bright, contrasty reflection source. I also use pure-white pocket rain umbrellas that cost me \$5, but which unfold to 36 inches or more to create great, soft-light reflectors. If you want diffuse, omni-directional lighting for photographing things like jewelry, nothing beats a tent, which is an enveloping structure of translucent material that fits over your subject, with a hole to fit the lens through. Light can then be applied to the outside of the tent to illuminate your picture. You can make your own "tent" using something as simple as a plastic milk bottle.

Some Shooting Tips

You're ready to start shooting close-ups. I'm ready to give you some helpful tips. Try this mixed bag of tricks on for size (to coin a mixed metaphor) as you shoot your first macros.

■ Focus carefully. Some cameras allow switching autofocus to a center-oriented mode or spot mode or let you choose which focus sensor to use. Use those features if your subject matter is indeed in the middle of the picture or somewhere within one of the focus zones. Or, switch to manual focus if your camera offers it. Use a large f/stop if you want to work with selective focus, as shown in Figure 17.18. At left is an image in which the camera was focused on the cup in front. Because the lens was almost wide open, the jug in back is out of focus. At right, focus was on the jug in back, throwing the cup in front out of focus.

Figure 17.18 Focus on the front (left) and back (right).

You might want to use aperture-priority mode and select the *smallest* f/stop available to *increase* the depth-of-field. And keep in mind what you learned about how depth-of-field is arranged: Two-thirds is allocated to the area in front of the plane of sharpest focus, and only one-third to the area behind it. Figure 17.19 shows a dandelion shot with the widest f/3.5 lens aperture, so only the closest portion of the flower is in focus. Figure 17.20 shows the same dandelion captured using f/22.

- Use focus peaking (if available). Many mirrorless cameras have a feature called *focus peaking*, which makes manual focus a snap. When activated, colored highlighting appears at the edges of greatest contrast, indicating that edge is in sharp focus. Most models allow you to choose a specific color (white, yellow, red, or blue, for example) to provide greatest visual contrast. Figure 17.21 shows a white blossom with white focus peaking; selecting red or blue probably would have been a better idea.
- Take advantage of selective focus. You don't always want to have maximum depth-of-field. You can use a wide open aperture to isolate your subject, as in Figure 17.22. The wider aperture also allows using a higher shutter speed, which can be necessary when shooting plant life outdoors, because the slightest breeze can cause your subject to waver or flutter in the wind.
- Watch alignment. If you're shooting your subject head-on, check to make sure the back of the camera (where the sensor is located) is parallel to the plane in which your main subject lies. That's the plane you'll be focusing on and where the maximum amount of sharpness lies. If the camera is tilted in relation to the plane of the main subject, only part of the subject will be in sharp focus.

Figure 17.19
With the lens wide open, only the closest portion of the dandelion is in focus.

Figure 17.20
If you stop down the lens to a smaller aperture, the depthof-field increases.

Figure 17.21 Focus peaking provides highlighting to make manual focus easier.

Figure 17.22 Use large apertures and selective focus to isolate your subject from its background.

- Stop that jiggle! If your subject is inanimate and you're using a tripod, consider using your digital camera's self-timer or remote control to trip the shutter after a delay of a few seconds. Even if you press the shutter release button cautiously, you may shake the camera a little. Under incandescent illumination with a small f/stop, your camera will probably be using a slow shutter speed that is susceptible to blurring with even a little camera shake. Use of the self-timer or remote control will let the camera and tripod come to rest. (You may also want to lock up your mirror.)
- Bring models to life. One cool use for close-up photography is to make miniatures look lifesize through careful selection of perspective and focus. Set your camera at a height proportional to the position that might be used to shoot the "real" object, and you can get results like the shot of the toy train in Figure 17.23.
- Find new worlds in common objects. Figure 17.24 shows a pile of ordinary cast-iron cannon balls. Their rusted exteriors make an interesting close-up shot, but when you zoom in *really* close, as in Figure 17.25, the relics become something mysterious. You can shoot macro photos of everything from grains of sand to drops of water to create compelling and mysterious images.
- Carry a spray bottle of water. If you're shooting plants, you can spritz some ready-made "dew" on the leaves and petals for a glistening look. (See Figure 17.26.) If you're not, you can readily hydrate as you work.
- Stop, look, listen! Wait a few seconds after you hear the camera's shutter click before doing anything. You might have forgotten that you're taking a long-time exposure of a couple seconds or more! The click might have been the shutter opening, and the camera may still be capturing the picture. If you have picture review turned on, wait until the shot shows up on the LCD before touching the camera.

Figure 17.23 Choose your camera angle carefully to make a model appear to be full size.

Figure 17.24 A pile of cannonballs makes an interesting subject...

Figure 17.25 ...that can become mysterious when captured close up.

Figure 17.26 When shooting flowers, carry a spray bottle to spritz the blossoms with water droplets.

Index

A (Aperture-priority) mode for macrophotography, 411 for sports photography, 378 working with, 89–91 A/D converters and dynamic range, 25–26 A-GPS files, 192 accessories selector apps for, 200 sharing between cameras, 41 accuracy, MF (manual focus) and, 105 Act of Valor, 6 action photography, 361–392. See also freezing action; sports photography exposures for, 378–379 focus for, 379–382 ISO sensitivity for, 381–382	Adobe Photoshop/Photoshop Elements. See also Adobe Camera Raw contrast, adjusting, 78 Creative Cloud, 11 Dust & Scratches filter, 50 improvements in, 11–12 Merge to HDR Pro feature, 24, 100–102 mountain photography, panorama-stitching for, 342–343 PSD format, 57 TIFF format with, 60 Adorama, uploading from Eye-Fi cards to, 192 AE-L/AF-L lock, 98, 110 AF-A (auto-servo AF), 109 AF-assist lamp, 110 activating/deactivating, 113 AF (autofocus), 103–116. See also focus modes considerations for using, 107
tripods/monopods for, 383 action-stopping. See freezing action Active D-Lighting, 78	evaluation of, 107 explanation of, 111–116
Adams, Ansel, 206 adapters for lenses, 132–133 Adobe Camera Raw HDR (High Dynamic Range) with, 101 RAW files with, 60 Adobe DNG format, 57–58 Adobe Illustrator, 11 Adobe InDesign, 11 Adobe Lightroom, innovations in, 11–12	phase detection, 111–113 working with, 107–110 AF-C (continuous-servo AF), 108–109 AF/MF switch, 104 overriding focus with, 110 AF-S (single-servo AF), 108 air blowers. See blower bulbs air cleaning sensors, 51–52 air travel kit, 229–234 aluminum foil, 164 for macrophotography, 410

aluminum frame filters, 208	architectural photography. See also
always flash mode, 162	macrophotography
Amazon	permissions for, 252
Cloud Drive, 202	travel, photographing architecture in, 247-252
Fire TV, 202	Arctic Butterfly, 52-53
Kindle, 198	arena football, photographing, 365–366
Prime movies, 198, 202	ARW format, 57
analog signals, 22	Asleep at the Wheel, 308
dynamic range and, 25	aspect ratio, 19-20
Android devices. See also smart devices	aspherical lenses, 31, 124
phones, 197	assisted GPS, 192
angles	Asus netbook for travel photography, 234
in landscape photography, 327	asymmetrical lens design, 122–123
lenses and, 121	AT&T
movies, camera angles for, 180	iPhones and, 197
for studio portraits, 260	Wi-Fi hotspots, 193
with telephoto lenses, 138	audio. See also microphones
with wide-angle lenses, 135	capturing, 173
animals. See also wildlife photography	separately recording, 187
Kids & Pets mode, 86	silently running movies, 172
in landscape photography, 335	tips for recording, 186–188
aperture. See also maximum aperture	Auto Lighting Optimizer, 78
constant aperture lenses, 129-130	autoflash mode, 162
exposure triangle and, 82–83	autofocus (AF). See AF (autofocus)
speed of lenses and, 128-129	AVCHD format, 175
Aperture-priority (A) mode. See A (Aperture-	Avedon, Richard, 253
priority) mode	axial chromatic aberration, 123
Apple. See also iPads; iPhones	
App Store, 197	В
QuickTake 100, 4	
apps, 12, 195-202	back focus, 116
camera-specific apps, 201-202	angles and, 121
Eye-Fi app for iPhones, 193	with wide-angle lenses, 122
with Mobal Communications phones, 234	backgrounds
types of, 200–201	ideas for using, 259
Wi-Fi and, 193–194	in street photography, 298
APS-C sensors, 4, 120	for studio portraiture, 258–259
adapters for lenses, 132-133	backing up and travel, 231–232, 234–236
crop factor of, 38	The Bacon Brothers, 305
dynamic range and, 24	balance in landscape photography, 336–337 bald heads in glamour photographs, 287

ball heads on tripods, 408	blurry pixels, 49
barn doors for studio portraits, 267	bokeh, 124-126
barrel distortion, 124	in wildlife photography, 353
base length between images, 112	bracketing, 98–102
baseball, photographing, 367	continuous shooting and, 373
basketball, photographing, 367	decisions for setting up, 99-100
batteries	and Merge to HDR, 100-102
in cold temperatures, 349	brass frame filters, 208
extra batteries, 392	brightness
for movies, 172	histograms showing, 75-76
battery chargers, 392	measurement of, 27
in air travel kit, 233	working with controls for, 72
Bayer, Bruce, 27	broad lighting for portraits, 279–280
Bayer pattern, 27–28	brush cleaning sensors, 51-53
Beach/Snow mode, 85	buffer, 35
before and after apps, 200	for continuous shooting, 370-372
Bellamy, Edward, 13	movies and, 172
bellows for macrophotography, 406-407	build of lenses, 127-128
Benoit, Tab, 301-302	built-in flash
BIONZ chips (Sony), 8	with continuous shooting, 373
black-and-white. See also IR (infrared)	for studio portraits, 264-265
photography	working with, 165
RAW+JPEG format and, 64	bulb blowers. See blower bulbs
texture with, 341	bulb exposures, 167
tonal range and, 73	Buono, Alex, 6, 177
Blackberry phones, 197	butterfly lighting for portraits, 279, 281
blackboards, 165	B+W brand filters, 209
blinkies, 80	B&W photography. See black-and-white
blooming, 21-22	
blower bulbs. See also Giottos Rockets	C
for air cleaning sensors, 51–52	_
in air travel kit, 233	C-clamp devices, 144
mirror area, cleaning, 49	C-mount-to-mirrorless adapters, 133 calibration of focus, 116
blown highlights in performance photography,	
321	camera bags, 231
blurring. See also camera shake; selective focus	for air travel, 233
freezing action with, 391	camera guide apps, 200
S (Shutter-priority) mode for reducing, 93	

in water photography, 347

camera shake, 139–149. See also image	CFLs (compact fluorescent lights), 262
stabilization (IS)	charity, taking pictures for, 308
and action photography, 383	children, permission for photographing, 244
causes of, 141	246
diagnosing, 142–144	Chinon subsidiary, Kodak, 4
example of, 142–143	chromatic aberration with telephoto lenses,
lenses and, 31	123–124
macrophotography and, 415	Churchill, Winston, 253
and movies, 179	circles of confusion and bokeh, 124-126
prevention of, 144–146	circular polarizers, 213
problems with, 140–141	cleaning. See also sensor cleaning
and sports photography, 383	equipment, 392
with telephoto lenses, 138	filters and, 211
with wide-angle lenses, 135	mirror area, 49
cameras	Cleveland Photographic Society, 13
compact cameras, 40	clipping and pixels, 68
future of mirrorless cameras, 13	close-up lenses, 134
rise of mirrorless cameras, 9-10	for macrophotography, 404-405
selecting, 36–37	close-ups. See also macrophotography
upgrading, 39–40	Av (Aperture-priority) mode for, 91
candid photography, 254	image stabilization (IS) for, 147
Canon	lenses for, 134
CRW/CR2 format, 57	in movies, 182–183
DIGIC chips, 8	in street photography, 299-300
full-frame cameras, 4	with telephoto lenses, 136
video lights in cameras, 184	in travel photography, 236, 238
Capa, Robert, 301	cloth backgrounds, 258
card readers, 55	CMOS sensors, 19
carry-on luggage, 231	photons and, 20
Carson MiniBrite magnifiers, 54	Cocker, Joe, 305
in air travel kit, 233	Cokin sunrise/sunset filters, 219
Casady, Jack, 310, 312	college sports, photographing, 365
Casale, Gerald, 302-303	Color accent/Selective color mode, 86
catadioptric lenses	color fringing with telephoto lenses, 123-124
bokeh and, 125	color meters, 206
for wildlife photography, 353	Color swap mode, 86
catch lights in portraits, 274-275	color temperature
CCD sensors, 19	continuous light and, 153–155
photons and, 20	of fluorescent light, 155–156
center-weighted metering, 96–97	of incandescent/tungsten light, 153–155
- 0	

contrast detection, 111 colors cookies Bayer pattern and, 27-28 creating, 163 explanation of, 27–29 for studio portraits, 267 filters for controlling, 218–219 Cooper, David, 301 in landscape photography, 341 copystands, 409 posterboard colors, working with, 163 split color filters, 219-220 cost of continuous light, 152 compact cameras, 40 of filters, 208, 211 composition of flash, 152 landscape photography, rules for, 327-342 of graduated neutral-density (ND) filters, 217 for movies, 180-183 of travel, 226-227 for street photography, 294, 296 Costco, uploading from Eye-Fi cards to, 192 for studio portraits, 268-269 Cotton, James, 308-309 for sunset/sunrise photography, 344, 346 Country Joe and the Fish, 302 computers. See also tablet computers Cray, Robert, 310-311 backing up images on, 234 Creative Cloud, Adobe Photoshop/Photoshop in domestic travel kit, 229 Elements, 11 transferring images to computer and JPEG crop factor, 119-120 formats, 66 of cameras, 38-39 concert photography. See performance crop mode for images, 19 photography constant aperture lenses, 129-130 cropped frame cameras, need for, 38-39 cropping in landscape photography, 330 construction of lenses, 127-128 cross screen filters, 219, 221 continuous light CRW/CR2 format, 57 existing light, working with, 163–165 flash compared, 152 CX lenses, 120 working with, 153-156 continuous shooting D bracketing and, 373 Da Vinci, Leonardo, 330 built-in flash with, 373 dark pixels, 48 continuous advance mode, 372–373 dark tones high-speed continuous advance mode, 373 exposing for, 70 for performance photography, 318 histograms showing, 75 single-frame advance mode for, 372 David Busch's Digital Infrared Pro Secrets, 29 and sports photography, 370-373 David Busch's Lens Finder app, 12, 197, 200 time-lapse/interval mode for, 373 David Busch's Mastering Digital SLR for wildlife photography, 355 Photography, 4 contrast dawn/dusk in landscape photography, changing contrast of image, 78–79 344-347 histograms for fixing, 76–77 in landscape photography, 341

polarizing filters increasing, 213

with wide-angle lenses, 135

daylight	double exposures for performance
for movies, 186	photography, 310, 312, 324
for portraits, 282, 285	doughnut effect, 125-126, 353
working with, 153-154	dress rehearsals, attending, 304–305
degrees Kelvin, 153	dusk in landscape photography, 344–347
color meters measuring in, 206	dust. See also sensor cleaning
demosaicing, 27	cloning out dust spots, 50
Foveon sensors and, 28	dead pixels and, 46–49
depth-of-field (DOF). See DOF	identifying, 46
(depth-of-field)	protecting sensors from, 43-45, 49-50
Devo, 302	reference removal tool, 50
diaphragm of lenses, 31	dynamic focus area, 109–110
Didymium filters, 218–219	dynamic range, 23–26, 68. See also HDR
diffraction	(High Dynamic Range)
low diffraction index glass, 124	ISO sensitivity and, 24
and macrophotography, 400	and tonal values, 25–26
speed of lenses and, 129	
diffused light	E
in glamour photography, 288, 290	
for studio portraits, 266–267	The Eagles, 302
DIGIC chips (Canon), 8	ears in glamour photographs, 287
digital processing (DSP) chips, 8	Eastman Kodak Company, 3–4
diopter correction, 34	Easy Panorama mode for performance
direct light for portraits, 270	photography, 310
directionality of microphones, 187	Eclipse solution, 54
dissolves in movies, 180	ED (low diffraction index class), 124
distance	Edgerton, Harold, 388
lenses and focusing distance, 131	editing
microphones, setting up, 187	apps for photo editing, 200
distortion	movies, 180
barrel distortion, 124	18-percent gray cards. See gray cards
with wide-angle lenses, 135	El Greco, 361
DNG format, Adobe, 57–58	electronic first curtain shutter, 18
DOF (depth-of-field)	emitted light, 83
apertures and, 129	enhancer filters, 218–219
apps for finding, 12	Enter the Haggis, 308
bokeh, 124–126	establishing shots
exposure triangle and, 82-83	in movies, 182–183
and macrophotography, 399–401	in travel photography, 236–237
manipulating images with, 15	EV (exposure compensation), 70
MF (manual focus) and, 105	adjusting, 92
and movies, 177	explanation of, 81

evaluative metering, 96–97	extra equipment and batteries, 392
event photography. See performance	extreme close-ups
photography	in movies, 182–183
EVF (electronic viewfinder), viewing on, 34	in street photography, 300
Ewa-Marine underwater housings, 205	Eye-Fi cards, 9, 192–193
EXIF information, 190	Endless Memory feature, 193
EXPEED chips (Nikon), 8	Online Sharing with, 192
Expo Disc, 207	eyepoint, 34
exposing to the right rule, 80	eyes
exposure. See also bracketing; EV (exposure	blinking, reducing, 288
compensation); histograms; ISO	catch lights and, 274-275
sensitivity; long exposures; overexposure;	in glamour photography, 287, 289
underexposure	red-eye reduction mode for, 172
apps for estimating, 200	•
basics of, 68-74	F
continuous light, calculation with, 152	
controlling, 26	f/stops
dark tones, exposing for, 70	exposure, adjusting, 79
duration of light and, 82	exposure triangle and, 82–83
elements of, 81–83	with neutral-density (ND) filters, 215
flash, calculation with, 152, 161	shutter speed and, 83
intensity of light and, 82	speed of lenses and, 128-129
for IR (infrared) photography, 352	for sports photography, 376
light tones, exposing for, 70-71	Facebook, uploading from Eye-Fi cards to, 192
MF (manual flash), calculation with, 161	faces
middle tones, exposing for, 69-70	face detection mode, 113–114
performance photography, multiple exposures	tight face composition in portraits, 269
in, 310, 312, 324	FaceTime, communication with, 196
in sunset/sunrise photography, 347	feet in glamour photographs, 287
tonal range of image, 73–74	Feliciano, Jose, 302
for water photography, 347	field of view with wide-angle lenses, 135
exposure compensation (EV). See EV (exposure	file compression, 60-61. See also JPEG
compensation)	formats
exposure triangle, 82-83	file size, 60–61
EXR chips (Fujifilm), 8	fill flash/fill light, 162
extension tubes for macrophotography,	for portraits, 275–276
406–407	smart devices for, 201
exterior shots, 248, 250	in sunset/sunrise photography, 347
external flash	filter factor, 214
M (Manual) mode with, 95	filter threads on lenses, 131–132
small accessory flash lights, 263	
working with, 166	

filters, 131, 207–210. See also IR (infrared)	neutral-density (ND) filters and, 216
filters; neutral-density (ND) filters coating on, 209	red-eye reduction mode, 162
color control with, 218–219	for studio portraits, 264–265
	wireless flash, 162, 166
compatibility issues, 209	working with, 156–162, 165–166
damage from, 211	flash meters, 161, 206
graduated neutral-density (ND) filters, 216–218	Flash Off mode, 84
	flat lighting for movies, 185
as lens caps, 212	flicker with movies, 176
lenses and, 209–212	Flickr
low-cut filters, 188	Eye-Fi cards, uploading with, 192
for mountain photography, 342	GPS information with, 190–191
no-filter arguments, 211	fluorescent light, 155-156
for painting with light, 168	for studio portraits, 262–263
polarizing filters, 212–214	foam board, 164
pro-filter arguments, 212	as studio portrait background, 259
special effects filters, 219–221	focal lengths
split color filters, 219–220	apps for calculating, 200
sunrise/sunset filters, 219	camera shake and, 141
thickness of, 209	image stabilization (IS) and, 147
tips for buying, 207–210	for landscape photography, 327
fine-tuning focus of lenses, 115-116	and macrophotography, 396–397
Fire TV, Amazon, 202	sensor size and, 103
FireWire card readers, 55	speed of lenses and, 129
first-curtain sync, 16, 156, 162	for sports photography, 376–377
electronic first curtain shutter, 18	for wildlife photography, 353–354
working with, 158-159	focal planes and sync speed, 157
Fisheye effect, 87	focal reducer adapters, 133
fisheye lenses, 33	focus, 103–116. See also AF (autofocus); MF
for macrophotography, 397	(manual focus); selective focus
wide-angle lenses, 135-136	for action photography, 379-382
flange to sensor distance, 122-123	calibration of, 116
flare	explanation of, 111–116
blooming, 21–22	fine-tuning focus of lenses, 115–116
filters and, 209	for IR (infrared) photography, 352
flash. See also built-in flash; external flash; fill	movies and, 130–131
flash/fill light; sync speed; wireless flash	retro focus, 123
continuous light compared, 152	for sports photography, 379–382
exposure calculation with, 152, 161	in sunset/sunrise photography, 347
firing modes, 162	focus charts, 116
freezing action with, 388–389	focus hunting avoiding 113

focus hunting, avoiding, 113

focus modes, 107–108	with shutter speed, 387–388
AF-A (auto-servo AF), 109	slant, freezing motion on, 385
AF-C (continuous-servo AF), 108–109	techniques for, 386–391
AF-S (single-servo AF), 108	front-curtain sync. See first-curtain sync
focus peaking, 105–106	front focus, 116
in macrophotography, 411, 413	Fujifilm
focus priority, 108	EXR chips, 8
focus tracking, 114–115	full-frame cameras, 4
focus zones, 109–110	Mitakon Lens Turbo II adapters for, 133
showing/hiding in viewfinder, 113	X mount lenses, 117
Foliage mode, 87	XF lenses, 118
football, photographing, 365	Full Auto mode, 84
foregrounds	full body composition for portraits, 269
with neutral-density (ND) filters, 216	full-frame cameras, 4–5
with telephoto lenses, 136-137	determining need for, 38-39
with wide-angle lenses, 135	dynamic range and, 24
Fotodiox adapters, 132	for movies, 177
Four Thirds lenses/cameras, 117	sensors for, 119-120
adapters for, 132	fusion in landscape photography, 340-341
aspect ratio of, 19	future of digital photography, 13
crop factor for, 38-39	
Foveon sensors, 27–29	G
frame rates	Garmin GPS, 234
digital processing (DSP) chips and, 8	Gariffi Gr 3, 234 Gaudí, Anatoni, 248–249
for movies, 174–175	gel filters, 208
framing	
in landscape photography, 338-339	genres, exploring, 308 geotagging, 189–191. <i>See also</i> GPS devices
in performance photography, 320	ghost images, 158
"Freak Out!" (Zappa), 321	with first-curtain sync, 158–159
Freekbass (Chris Sherman), 322	with rist-curtain sync, 150–155 with second-curtain sync, 159
freezing action, 383-386	ghoul lighting for movies, 185
with blur, 391	Gibson Brothers, 308
camera motion and, 386	Giottos Rockets, 51–52
with continuous light, 152	in air travel kit, 233
distant/close motion and, 385	glamour photography, 286–294
with flash, 152, 388-389	defects, tips for minimizing, 287–288
head-on motion and, 385, 387-388	poses for, 286
image stabilization (IS) and, 146	two subjects, poses of, 286–287
with panning, 386–387	glass filters, 208
parallel motion and, 384	global shutter, 19
at peak of motion, 390-391	GN (guide numbers), 161
	G11 (8 mm - mm - mm), 101

gobos for studio portraits, 267 Goddard, Jean-Luc, 181 gold reflectors for glamour photography, 288,	HD Video 720 standard, 174 HD Video 1080 standard, 174 HDMI/HDMI cables, 6
292	HDR (High Dynamic Range), 24, 86
gold umbrellas for portraits, 268	as fad, 12
golf, photographing, 368	improvements in, 8
Google	Merge to HDR, 100–102
Android operating system, 197	tonal range and, 73–74
Maps' Street View feature, 190	HDTV. See also movies
GPS devices, 189-191	Fire TV, Amazon, 202
assisted GPS, 192	improvements in, 6–7
Garmin GPS, 234	head-and-shoulder composition for portraits,
improvements in, 9	269
smart devices as, 196	headroom in portraits, 268
tracking logs, 191	Hendrix, Jimi, 305
working with, 191–192	High Dynamic Range (HDR). See HDR (High
graduated neutral-density (ND) filters,	Dynamic Range)
216–218	high ISO noise, 22
horizons and, 218	High Key mode, 87
soft/hard edge filters, 216–217	high school sports, photographing, 365
strength of, 218	high-speed sync, 157
tilting and, 218	highlights in performance photography, 321
gray cards	histograms, 75–81
dark tones, exposing for, 70	blinkies and, 80
light tones, exposing for, 70	contrast and, 76–77
middle tones, exposing for, 69	explanation of, 78–79
smart devices as, 201	exposing to the right rule, 80
types of, 206–207	hockey, photographing, 369
working with, 72	horizons
Greenfield, Lois, 301	with graduated neutral-density (ND) filters,
Gruen, Bob, 301	218
guide numbers (GN), 161	in sunset/sunrise photography, 344
gymnastics, photographing, 369	horse racing, photographing, 369
	hot mirror, 29
Н	hot pixels, 49
hair light for portraits, 276–277	hot shoe for studio flash, 257
	Hot Tuna, 310
half body composition for portraits, 269 Halford, Rob, 308	hotels, choosing, 227
	How It's Made app, 201
hand-held microphones, 188	Howlin' Wolf, 309
hard light for movies, 185	Hoya R72 (#87B) filters, 352
HD capabilities and performance	Hulu Plus, 202
photography, 310	Hurlburt, Shane, 6

	inverse square law, 152
Ikelite underwater housings, 205	and freezing action with flash, 389
image editors. See also Adobe Photoshop/	for studio portraits, 271–272
Photoshop Elements	invisible people with neutral-density (ND)
brightness, working with controls for, 72	filters, 216
dust spots, fixing, 50	iOS operating system, 197. See also smart
infrared light, working with, 29–30	devices
image quality, 60–61	tablets with, 198
filters and, 211	iPads, 197
JPEG compression and, 63	GPS features, 190
lenses and, 126–127	iPhones, 197–199
of prime lenses, 134	Eye-Fi app for, 193
of zoom lenses, 134	GPS features, 190
image stabilization (IS), 8, 16, 139–149	iPods, 12, 197–198
cameras with, 42	IR (infrared) filters, 207–208
disadvantages of, 148	for landscape photography, 351
electronic image stabilization (IS), 139	IR (infrared) photography, 229–230
in-camera image stabilization (IS), 140	landscape photography and, 351–353
for movies, 172, 179	remotes for, 204
optical image stabilization (IS), 140	sensors and, 29–30
for performance photography, 310	IS (image stabilization). See image
working with, 146–149	stabilization (IS)
iMovie, 187	ISO sensitivity for action photography, 381–382
incandescent/tungsten light	adjusting exposure with, 99
lighting ratios with, 272	dynamic range and, 24
for studio portraits, 262, 266	
working with, 153–155	high ISO noise, 22 improvements in, 6
infrared infinity, 352	for painting with light, 167
infrared photography (IR). See IR (infrared)	for performance photography, 310, 312
photography	range of ISO ratings, 42
integrated metering, 162	for sports photography, 381–382
intensifier filters, 218-219	Sunny 16 rule, 381
intensity of light, 152	iTunes, 12
interior shots, 248-249	Trunes, 12
interlaced scan for movies, 175-176	•
interline twitter, 176	,
Internet, apps for uploading to, 193	"Jackie," 307
interpolation, 27	Jefferson Airplane, 310
Foveon sensors and, 28	Joint Photographic Experts Group (JPEG), 62.
interval photography with continuous	See also JPEG formats
shooting, 373	Joplin, Janis, 302

cropping images in, 330

dawn/dusk in, 344-347

essentials of, 326-327

framing in, 338–339

graduated neutral-density (ND) filters for, 216

fusion in, 340-341

adapters for, 132-133 add-on attachments and, 131-133 in air travel kit, 232 angles and, 121 apps for selecting, 12, 200 build of, 127-128 capabilities of, 134

in cold temperatures, 350
compatibility issues, 33
designs for, 121–122
detached lens, protecting, 49
diaphragm of, 31
in domestic travel kit, 229
elements of, 17, 31
filters and, 209-212
fine-tuning focus of, 115–116
focusing distance and, 131
image quality and, 126–127
interchangeability of, 31-33
for landscape photography, 327
M (Manual) mode and, 95
protective filters, 210–212
reflections and, 122
sharing lenses between cameras, 41
speed of, 128-129, 131, 134
for travel photography, 246-251
upgrade paths for, 138-139
variability and, 127
for wildlife photography, 353
Zeiss lenses, 128

Liebovitz, Annie, 301

light, 151–168. See also continuous light; exposure; fill flash/fill light; flash; fluorescent light; incandescent/tungsten light; studio portraits

duration of, 82
emitted light, 83
equipment for lighting, 162
existing light, working with, 163–165
exposure triangle and, 82–83
intensity of, 82
IR (infrared) photography and, 352
for macrophotography, 410
movies, lighting for, 184–186
painting with, 166–168
for portraits, 269–273
reflected light, 83
sensors capturing, 19–22
shutter, light admitted by, 83
transmitted light, 83

light meters, 206

M (Manual) mode and, 95
light path of camera, 17
light stands for studio portraits, 260
light tones, exposing for, 70–71
lighting ratios for portraits, 272–273
linear polarizers, 213
lines in landscape photography, 335–336
liquid cleaning sensors, 51, 53–54
live performances. See performance
photography

live view, 171. See also movies

improvements in, 7–8 for street photography, 297

location portraits, 255

long exposures

and noise, 22
in sunset/sunrise photography, 347
for water photography, 347–348

Looking Backward (Bellamy), 13
lossless compression, 62–63
lossy compression, 62
low-cut filters, 188
low diffraction index glass, 124
Low Key mode, 87
LowePro camera bags, 233
luggage for air travel, 231
luminance. See brightness

M

M (Manual) mode

for sports photography, 379 working with, 94–95

MacBook Air for travel photography, 234 macro lenses

for macrophotography, 402–404 zoom lenses, 396

macro lock/lockout feature, 110 Macro mode, 86

macrophotography, 393-418. See also	McCoy, Mike, 6
close-ups	medium shots
alignment considerations for, 411	in movies, 182–183
bellows for, 406–407	in street photography, 300
camera shake and, 415	in travel photography, 236, 238
careful focusing for, 410-412	MegaGear underwater housings, 205
close-up lenses for, 404–405	megapixels, 4. See also resolution; sensors
common objects and, 415, 417–418	for studio portraiture, 257
copystands for, 409	Meike underwater housings, 205
DOF (depth-of-field) and, 399-401	memory cards, 35-36. See also buffer; Eye-Fi
equipment for, 404–410	cards
extension tubes for, 406–407	in air travel kit, 232
focal lengths and, 396-397	capacity of, 55
focus peaking for, 411, 413	considerations for selecting, 55–56
general-purpose lenses for, 402-404	for continuous shooting, 370–372
lens attachments for, 404–405	cost of, 55
lifelike models, creating, 415-416	dual card slots for travel photography, 236
macro lenses for, 402-404	for movies, 172
magnification in, 394-397	multiple cards, working with, 56
perspectives and, 397–399	reformatting, 392
selective focus for, 411, 413	size of card, considerations for, 55-56
shooting tips for, 410–418	speed of, 35, 55
spray bottles of water for, 415, 418	Merge to HDR Pro feature, 24, 100-102
terminology for, 393–394	Metabones focal reducer adapters, 133
tripods for, 408–409	metering modes, 95–97
magnification	MF (manual flash)
in macrophotography, 394–397	exposure calculation with, 161
sensor cleaning, magnifiers for, 54	guide numbers (GN) with, 161
of viewfinder image, 34	MF (manual focus)
main light for portraits, 273-274	aids for, 105-106
manual flash (MF). See MF (manual flash)	for sports photography, 380
manual focus (MF). See MF (manual focus)	working with, 104–106
manual mode (M). See M (Manual) mode	Mi-Fi devices, 9
martial arts, photographing, 368	Michaelangelo, 69
Mason, Dave, 305-306	Micro Four lenses/cameras, 4, 117, 119, 120
matrix metering, 96–97	adapters for, 132
maximum aperture	aspect ratio of, 19
movies and, 178	crop factor for, 38–39
of prime lenses, 134	macro lens for, 396-397
for sports photography, 376	resolution of, 6
of zoom lenses, 134	microlenses, 20
maximum burst, 41	angles and, 121

microphones	motor drive. See continuous shooting
capturing audio with, 173	motor sports, photographing, 369
noise and, 187–188	mountains, photographing, 342-343
tips for recording with, 186-188	movies, 171-188. See also audio
types of, 188	camera shake and, 179
wind noise reduction, 188	cameras for taking, 41
microphotography, 393	capturing, 173–174
Microsoft	composition for, 180–183
Movie Maker, 187	creative lighting for, 185
Office applications, 199	DOF (depth-of-field) and, 177
Windows Phones, 197	focus and, 130-131
Zune, 199	frame rates for, 174-175
middle tones	horizontal composition in, 180
exposing for, 69–70	image stabilization (IS) for, 172, 179
histograms showing, 75	interlaced scan for, 175-176
Miniature effect, 87	lighting for, 184–186
mirage filters, 221	memory cards for, 172
mirror lenses, 122	progressive scan for, 175-176
bokeh and, 125	resolution for, 172, 174
Mitakon Lens Turbo II adapters, 133	reviewing clips, 173
Mobal Communications phones, 234	sensor size and, 177
Mobi cards, 193	shooting scripts for, 179
MobileMe, uploading from Eye-Fi cards to,	shot types for, 182–183
192	side space in, 180–181
modeling light, 152	storyboards for, 179
lighting ratios with, 272	storytelling in, 180
for studio portraits, 265	styles of lighting for, 185–186
monopods, 144	time dimension in, 181
for action photography, 383	time limits on, 173
in domestic travel kit, 229	tips for shooting, 176–183
for performance photography, 310	transitions in, 180–181
for sports photography, 383	zooming in/out in, 130, 178
monuments, photographing, 247–252	Muddy Waters, 309
mood lighting in performance photography,	multi-image filters, 221
323	multiple exposures for performance
moonlight, 153	photography, 310, 312, 324
motion. See also blurring	musicians. See performance photography
camera shake and, 142	Mylar sheets for macrophotography, 410
in glamour photography, 288, 293	mypicturetown.com, GPS information with,
S (Shutter-priority) mode and, 93	190

high ISO noise, 22

N	landscape photography and, 326
narrow lighting for portraits, 277	long exposure noise, 22
National Parks for wildlife photography, 358	manipulating, 15-16
natural light. See daylight	microphones and camera noise, 187
	wind noise reduction, 188
natural portraits, 254	north light for studio portraits, 264
natural sounds in movies, 187	noses in glamour photographs, 287
nature photography, 325. See also landscape	Nostalgic mode, 87
photography; wildlife photography	Novoflex adapters, 132
ND (neutral-density) filters. See neutral- density (ND) filters	NTSC video standard, 174–175
Near Field Communication (NFC), Sony, 194	
near infrared (NIR) illumination, 351	0
nearest subject, focusing on, 110	ocean photography. See water photography
NEF format, 57	Olympus
netbooks, backing up images on, 234	adapters for lenses, 132
Netflix, linking television to, 202	Micro Four Thirds cameras, 4
neutral-density (ND) filters, 214-216	new lenses, 118–119
graduated neutral-density (ND) filters,	OM-D cameras, 9
216–218	RM-UC1, 204
for water photography, 347	TruPic chips, 8
Night mode, 85	underwater housings, 205
Night Portrait mode, 85	OM-D cameras, Olympus, 9
Night Vision mode, 85-96	optical density, 214
Nikon	optical image stabilization, 148
adapters for lenses, 132	Optika
CX lenses, 120	remote system, 204
EXPEED chips, 8	underwater housings, 205
geotagging with, 189	orange filters, 168
NEF format, 57	
new lenses, 117–119	outdoor light. <i>See</i> daylight over-the-shoulder shots in movies, 182–183
Q camera, 4	
underwater equipment, 205	overexposure, 70–71
NMEA (National Marine Electronics	bracketing and, 98–99
Association) protocols, 191	histogram showing, 79
No Flash mode, 84	Merge to HDR and, 100–102
noise	overriding focus, 110
apps for reducing, 201	Owens, Tim, 308
dark areas of image and, 80	
explanation of, 22	

P	ISO sensitivity and, 6
P (Program) mode, 84	JPEG formats for, 65
for sports photography, 378	low light/low noise performances, 310
working with, 93–94	mood lighting in, 323
painting with light, 166–168	multiple exposures in, 324
PAL video standard, 174–175	positioning for, 313–314
pan and tilt head, 386	reflections, use of, 322
Panasonic	S (Shutter-priority) mode for, 93
Ikelite underwater housings for cameras, 205	selective focus for, 313–314, 317
Micro Four Thirds cameras, 4	techniques for, 317–324
new lenses, 118	telephoto lenses for, 319
Venus Engine chips, 8	tips for taking, 304–309
panning, freezing action with, 386–387	permissions
panoramas. See also sweep panorama feature	for architecture/monument photography,
Easy Panorama mode for performance	251–252
photography, 310	children, permission for photographing, 244,
for mountain photography, 342–343	246
Park Güell, Barcelona, 100–101	personal storage devices (PSDs) for travel
parks for wildlife photography, 357	photography, 235
PC/X connectors, 257	perspectives lenses for, 134
Pec-Pad swabs, 53-54	for macrophotography, 397–399
Pentax	phablets, 198–199
K mount lenses, 117–118	phase detection, 111–113
K series cameras, 4	photo cloth backgrounds, 259
Q mount lenses, 117-118, 120	Photographic Solutions
Q series cameras, 4–5	cleaning swabs, 53
people photography, 253-300. See also	Eclipse solution, 54
portraits; street photography; studio	Photomatix, Merge to HDR with, 100
portraits	photons, 20–22. See also filters
considerations for photographing, 244	captured photons and, 83
invisible people with neutral-density (ND)	exposure and, 68
filters, 216	photosites, 20–22
in travel photography, 242–246	Phottix remote system, 204
performance photography, 301–324	Picasa, uploading from Eye-Fi cards to, 192
blown highlights in, 321	Pietà, Michaelangelo, 69
continuous shooting for, 318	piezoelectric angular velocity sensors, 148
equipment for, 309–313	pixel density, 24
framing, use of, 320	pixel mapping, 46–47
interesting people, portraits of, 315-316	r

pixels. See also histograms; resolution; sensors	prime lenses, 33
Bayer pattern, 27–28	for action photography, 374-375
blurry pixels, 49	for macrophotography, 396
clipping and, 68	speed of, 129
colors and, 27	zoom lenses compared, 134
dark pixels, 48	printers/printing, Wi-Fi connections for, 194
dead pixels, 46-49	Pro X2 cards, 193
hot pixels, 49	professionals, cameras for, 36
photons and, 20-21	Program (P) mode. See P (Program) mode
quantization of, 62	progressive scan for movies, 175-176
stuck pixels, 48	property releases, 252
plastic bags in air travel kit, 233	PSD format, 57
Pocket Wizard	
light meters controlling, 206	Q
remote transmitters, 204	
point-and-shoot cameras, 195	quartz lights for studio portraits, 262–263
polarizing filters, 212-214	quickie guide apps, 201
Polaroid underwater housing, 205	n
Portrait mode, 85	R
portrait orientation in landscape photography,	radial zoom filters, 221
331–333	rain ponchos in travel kit, 233
portraits. See also glamour photography;	rainbow filters, 221
performance photography; street	Ramsey, Bo, 140-141
photography; studio portraits	rangefinder system and phase detection, 112
A (Aperture-priority) mode for, 91	RAW formats. See also RAW+JPEG format
composition of, 268–269	advantages of using, 65
headroom in, 268	for continuous shooting, 372
light for, 264, 269–273	dead pixels, eliminating, 48
outdoor lighting for, 282, 285	DNG format and, 58
Poster effect, 86	dynamic range and, 25
posterboard, 163	HDR (High Dynamic Range) with, 101
power. See also batteries	JPEG formats compared, 63-64
for studio flash, 264–265	memory cards for shooting in, 35
pre-flash, 161	pros and cons of, 61
predictive focus, 105	quality level, selecting, 56
prefocusing for sports photography, 379–380	TIFF format compared, 63-64
preserves for wildlife photography, 356	types of, 57
previewing	working with, 56–58, 60
with continuous light, 152	RAW+JPEG format
with flash, 152	advantages of using, 64
studio portraits, flash for, 264	for continuous shooting, 372
	dead pixels, eliminating, 48

rear-curtain sync. See second-curtain sync	Rogers, iPhones from, 197
red-eye reduction and flash, 162	round filters, 209
redhancer filters, 218	rule of thirds in landscape photography,
reflected light, 83	331–335
reflections	Rundgren, Todd, 323
in glamour photography, 288	
lenses and, 122	S
in performance photography, 322	
polarizing filters reducing, 213	S (Shutter-priority) mode for sports photography, 378
in water photography, 347–348	
reflectors, 162	working with, 91–93
with built-in flash, 166	Samsung full-frame cameras, 4
in glamour photography, 288, 291	Galaxy, 198
for macrophotography, 410	•
studio portraits, flat reflectors for, 266	geotagging products, 189 Mobal Communications phones, 234
release priority, 108	NX mount lenses, 117
Rembrandt lighting for portraits, 282–283	sanctuaries for wildlife photography, 356
remote control, 203–204	Sasson, Steven, 3
types of systems, 204	Scene (SCN) modes, 84–87
repeating flash for painting with light, 168	for sports photography, 378
resolution	scenic photography. See landscape
determining need for, 37–38	photography
improvements in, 6	SD Video standard, 174
for movies, 172, 174	SDHC memory cards, 36
restaurants, choosing, 227	sea photography. See water photography
retro focus, 123	seamless paper backgrounds, 259
reverse graduated neutral-density (ND) filters,	seasons, photographing, 349–350
217	second-curtain sync, 16, 156, 162
reviewing images	working with, 159
cameras for, 42	Secure Digital cards, 35
movie clips, reviewing, 173	selective focus
Riders in the Sky, 308	bokeh and, 124–125
ring lights, 166	for macrophotography, 411, 413
for macrophotography, 410	for performance photography, 313-314, 317
Ritchie, Guy, 181	for sports photography, 380
RM-UC1, Olympus, 204	with telephoto lenses, 136
RMTDSLR2, Sony, 204	self-timer
Rock United, 308	and camera shake, 144
rodeo, photographing, 369–370	for wildlife photography, 203-204

Sensor Brush, 52	shutter speed, 26. See also sync speed
sensor cleaning, 50-54	apps for advice on, 200
air cleaning, 51–52	Av (Aperture-priority) mode and, 90
brush cleaning, 51–53	cameras with maximum speed, 42
cameras including, 42	exposure triangle and, 82-83
liquid cleaning, 51, 53-54	f/stops and, 83
magnifiers for, 54	freezing action and, 387-388
sensors, 5, 18. See also APS-C sensors; CCD	with neutral-density (ND) filters, 215
sensors; CMOS sensors; dust; noise;	of studio flash, 264
sensor cleaning	Shutterfly, uploading from Eye-Fi cards to
description of, 18–22	192
embedding AF sensors, 8	side lighting for portraits, 282, 284
fir IR (infrared) photography, 352	side projects, attending, 305
flange to sensor distance, 122-123	Sigma products, 33
focal lengths and, 103	Foveon sensors, 27–29
Foveon sensors, 27–29	variability and, 127
infrared sensitivity, 29–30	signal-to-noise ratio, 22
light and, 19–22	Silhouette mode, 86
movies, sensor size and, 177	silhouettes
piezoelectric angular velocity sensors, 148	M (Manual) mode for, 95
reflections from, 121	main light for, 273
separation in landscape photography, 340–341	in sunset/sunrise photography, 347
sequential scanning for movies, 175–176	silver umbrellas, 268
shakiness. See camera shake	Silvis, Lee, 6-7
sharpness	SIM (mobile connection) cards, 198
Av (Aperture-priority) mode for, 91	for Mobal Communications phones, 234
lenses for, 134	sizing/resizing
MF (manual focus) and, 105	file size, 60–61
sheets as backgrounds, 259	filter size, cost and, 208
Sherman, Chris (Freekbass), 322	image size, 60-61
Shimabukuro, Jake, 318	skating, photographing, 369
shooting scripts for movies, 179	skies
short lighting for portraits, 273, 277-278	with neutral-density (ND) filters, 216
shorter telephoto lenses, 122	polarizing filters and, 212-213
shotgun microphones, 188	skiing, photographing, 369
shutter, 18	Skype, communication with, 196
controlling exposure and, 26	slave flash, 166
global shutter, 19	slave triggers for studio flash, 265
light admitted by, 83	slow sync, 159-160
Shutter-priority (S) mode. See S (Shutter-	
priority) mode	

smart devices, 196–199. See also apps; iPads;	sound. See audio
iPhones	sound checks, attending, 304-305
fill flash/fill light with, 201	spare batteries, 392
television, linking to, 202	special effects filters, 219-221
smartphones. See also iPhones	speed. See also shutter speed; sync speed
Android phones, 197	AF (autofocus) and, 107
Blackberry phones, 197	image stabilization (IS) and, 147
Microsoft Windows Phone, 197	JPEG formats and, 66
Mobal Communications phones, 234	of lenses, 128-129, 131, 134
Smugmug, uploading from Eye-Fi cards to,	of memory cards, 35, 55
192	MF (manual focus) and, 104
snoots for studio portraits, 267	of prime lenses, 134
snow	of zoom lenses, 134
Beach/Snow mode, 85	spherical aberration, 124
winter photography, 85, 349	split color filters, 219–220
soccer, photographing, 366–367	split field filters, 219
sodium-vapor light, 155–156	Sports mode, 85
soft boxes for studio portraits, 266–267	sports photography, 362-370. See also freezing
soft FX filters, 219	action
soft light	burst capabilities and, 41
in glamour photography, 288	continuous shooting and, 370-373
for movies, 185	exposures for, 378-379
for portraits, 264, 270–271	f/stops for, 376
umbrellas for, 268	focal lengths for, 376-377
software. See also Adobe Photoshop/	focus for, 379-382
Photoshop Elements	image stabilization (IS) for, 148-149
graduated neutral-density (ND) filters,	ISO sensitivity for, 381–382
simulation of, 217	JPEG formats for, 59
innovations in, 11–12	lenses for, 374–377
Sony	positioning, importance of, 362-365
A7 cameras, 6	prime lenses for, 374–375
adapters for lenses, 132–133	tripods/monopods for, 383
apps from, 201–202	zoom lenses for, 374–375
APS-C lenses, 118–119	spot meters, 96–97, 206
ARW format, 57	spring-loaded vertical supports for studio
BIONZ chips, 8	portraiture, 260
E-Mount lenses, 117	square filters, 209
full-frame cameras, 4–5	stage performances. See performance
Mitakon Lens Turbo II adapters for, 133	photography
Near Field Communication (NFC), 194	Stanley, Ralph, 308
RMTDSLR2, 204	star filters, 219, 221
underwater housing for cameras, 205	star trails, app for capturing, 201

State Parks for wildlife photography, 358 ratios of light for, 272–273 Rembrandt lighting for, 282-283 stepping back effect with wide-angle lenses, 135 setting up studio, 256 Stills, Stephen, 305 short lighting for, 273, 277–278 stills and movies, shooting both, 172 side lighting for, 282, 284 stopping action. See freezing action snoots for, 267 storage, 35-36. See also memory cards soft light for, 264, 270-271 personal storage devices (PSDs) for travel supports, use of, 260 photography, 235 types of light for, 257, 262-266, 269-273 storyboards for movies, 179 umbrellas for, 268 storytelling subject tracking, 7 in movies, 180 sun shades as reflectors, 164 in travel photography, 236–238 Sunny 16 rule for ISO sensitivity, 381 street photography, 294-300 sunrises/sunsets composition for, 294, 296 filters for, 219 equipment for, 294 in landscape photography, 344-347 varying shots in, 298-300 super link apps, 201 wide shots in, 298-300 Surface tablets, 199 stuck pixels, 48 sweep panorama feature studio flash for mountain photography, 342-343 neutral-density (ND) filters and, 216 for performance photography, 310 for studio portraits, 264 swimming, photographing, 369 studio portraits, 254-268 symmetrical lens design, 122–123 background light for, 275 sync speed, 26, 156-162. See also first-curtain backgrounds for, 258-259 sync; second-curtain sync balancing light for, 271-273 high-speed sync, 157 barn doors for, 267 slow sync, 159-160 broad lighting for, 279-280 butterfly lighting for, 279, 281 Т cameras for, 257 T-Mobile, iPhones from, 197 catch lights in, 274-275 T-Sly, 322 composition of, 268-269 tablet computers, 198-199 cookies for, 267 Surface tablets, 199 direct light for, 270 taboos on photographing people, 244 existing light for, 264 Tamron products fill flash/fill light for, 275-276 lenses, 33 flat reflectors for, 266 variability and, 127 gobos for, 267 telephones. See also iPhones; smartphones hair light for, 276-277 land telephone lines, 196 incandescent/tungsten light for, 266

main light, working with, 273-274

telephoto lenses	transferring images to computer and JPEG
chromatic aberration with, 123	formats, 66
image stabilization (IS) and, 147	transitions in movies, 180–181
inverted design for, 123	transmitted light, 83
for macrophotography, 397-399	transportation and travel, 228
for performance photography, 319	transverse chromatic aberration, 123
shorter telephoto lenses, 122	travel photography, 225-252
for sports photography, 375	air travel kit, 229–234
in travel photography, 251	architecture, photographing, 247–252
working with, 136–138	backup cameras for, 231–232
television. See also HDTV	backups for, 234-236
smart devices linking to, 202	details, shooting, 236, 239
Tench, Benmont, 305	domestic travel kit, 229
tents	equipment/gear for, 228–236
for macrophotography, 410	hotel tips, 227
working with, 164–165	lenses for, 247-252
texting, 196	memory cards for, 236
texture in landscape photography, 341	monuments, photographing, 247-252
third party adapters for lenses, 133	people, photographing, 242-246
three-point lighting for movies, 185	restaurant tips, 227
three shots in movies, 182	scenic photography, 239–241
threshold, 20	security issues and, 252
TIFF format, 57	storytelling in, 236–238
JPEG formats compared, 63-64	telephoto lenses for, 251
memory cards for shooting in, 35	tips for, 226-228, 236-242
RAW formats compared, 63-64	transportation tips, 228
working with, 59–60	tribute bands, photographing, 308
time exposure for painting with light, 168	tripods. See also monopods
time-lapse photography	for action photography, 383
apps for, 12, 201	camera shake, prevention of, 144
with continuous shooting, 373	in domestic travel kit, 229
Tokina products, 33	image stabilization (IS) and shots with, 146
variability and, 127	for macrophotography, 408-409
tonal range, 73-74	for painting with light, 167
dynamic range and, 25–26	prohibitions on use of, 252
histograms showing, 75-76	recommendations for, 408-410
track and field, photographing, 369	for sports photography, 383
tracking focus, 114-115	for studio portraits, 260
trading in cameras, 40	for water photography, 347–348
Traffic, 305	for wildlife photography, 353-354

TruPic chips (Olympus), 8

TTL (through the lens) metering, 95–96
working with, 161
tungsten light. See incandescent/tungsten light
12-percent gray cards. See gray cards
two shots in movies, 182–183

U

ultrabooks, backing up images on, 234 umbrellas

for macrophotography, 410 for studio portraits, 265, 268, 270–271 working with, 164–165

underexposure, 70-71

bracketing and, 98–99 histogram showing, 79 Merge to HDR and, 100–102 metering modes and, 98 in snow scenes, 350

underwater photography, 87, 205 United Way of Cleveland, 308 up-and-coming bands, photographing, 307 upgrading

cameras, 39–40 lenses, upgrade paths for, 138–139 USB cables, 55 user-selected focus area, 110

٧

variability and lenses, 127
Venus Engine chips (Panasonic), 8
Verb Ballets, 305
Verizon, iPhones from, 197
vertical supports for studio portraiture, 260
vibration reduction. See image stabilization
(IS)
video. See movies
"View of Toledo" (El Greco), 361

viewfinders, 16, 34-35

electronic connection to, 18 EVF (electronic viewfinder), viewing on, 34 focus zones, showing/hiding of, 113 street photography, filling viewfinder in, 298 window, 18

vignetting and filters, 209
Virgin Mobile, iPhones from, 197
voice telephone calls, 196
Voigtlander adapters, 132
volunteering and performance photography, 304

W

Wainwright, Loudin III, 308
Walmart, uploading from Eye-Fi cards to, 192
Walsh, Joe, 302–303
water photography, 347–348
underwater photography, 87, 205
waterfalls/cascades, photographing, 347–348
Waugh, Scott, 6
WB (white balance)
with continuous light, 153
for indoor sports photography, 381
in sunset/sunrise photography, 344–345
wedding photography
candid wedding photography, 254

candid wedding photography, 254 JPEG formats for, 65

white balance (WB). See WB (white balance) white posterboard, 163 white umbrellas, 268 Wi-Fi, 193–194

built-in Wi-Fi, 193–194
Eye-Fi cards and, 192
improvements in, 9
multiple devices, communicating with, 194
television, linking smart devices to, 202
travel photography, backing up, 236

wide-angle lenses

for architecture/monument photography, 247-250

back focus with, 122

chromatic aberration with, 123

considerations for, 135

fisheye wide-angle lenses, 135-136

for macrophotography, 397-398, 403-404

polarizing filters with, 214

wildlife photography, 325, 353-360

scouting locations for, 358-360

self-timer for, 203-204

stalking "prey" for, 355-357

tripods/monopods for, 229

wind noise reduction, 188

window light for studio portraits, 264

Windows. See Microsoft

winter, photographing, 349

wipes in movies, 180

wired/wireless microphones, 188

wireless flash, 162

working with, 166

Wolf, Peter, 305

work lights for movies, 184-185

Wratten #85B filters, 168

Wratten #87C filters, 352

wrestling, photographing, 368

wrist watches, 196

X

xD memory cards, 36

Y

YouTube

Eye-Fi cards uploads to, 192 HDTV linked to, 202

Z

Zappa, Frank, 321

Zeiss lenses, 128

Zone System, spot meters with, 206

zoom lenses, 33, 128

for action photography, 374-375

image stabilization (IS) with, 148

macro zoom lenses, 396

for movies, 178

for performance photography, 309-310

prime lenses compared, 134-135

speed of, 129

for studio portraiture, 257

zooming in/out

camera shake and, 142

in movies, 130, 178

radial zoom filters, 221

in street photography, 297

zoos for wildlife photography, 357

NEED HELP SELECTING A LENS? LET DAVID BUSCH HELP!

The new **FREE** David Busch Lens Finder app for iPhone/iPad is now available for download from the Apple app store. The app will help you learn more about camera lenses and how to select the right ones for various cameras and shooting situations!

Download Barid Busch's Lens Finder now!

Contents

PARI	1. FOREWORD	1
	2. REFERENCES AND DESIGN MANUALS	5
	References and Design Manuals	6
2.02	Building Codes	. 11
PART	3. DEFINITIONS	13
3.01	General	14
3.02	Systems	20
3.03	Contract Documents	23
3.04	Contractors/Manufacturers/Authorities	26
PART	4. PROFESSIONAL SOCIETIES AND TRADE ORGANIZATIONS	29
PART	5. EQUATIONS	35
5.01	Cooling and Heating Equations	36
	R-Values/U-Values	36
	Water System Equations	37
	Air Change Rate Equations	37
5.05	Mixed Air Temperature	37
5.06	Ductwork Equations	37
5.07	Fan Laws	38
5.08	Pump Laws	38
5.09	Pump Net Positive Suction Head (NPSH) Calculations	39
5.10	Air Conditioning Condensate	39
5.11	Humidification	40
5.12	Humidifier Sensible Heat Gain	40
	Expansion Tanks	40
5.14	Air Balance Equations	41
5.15	Efficiencies	42
5.16	Cooling Towers and Heat Exchangers	42
5.17	Moisture Condensation on Glass	42
5.18	Electricity	42
5.19	Calculating Heating Loads for Loading Docks	43
	Ventilation of Mechanical Rooms with Refrigeration Equipment	44
	Equations for Flat Oval Ductwork	44
5.22	Pipe Expansion Equations	45

iv	Contents
14	

	5.23	Steam and Condensate Equations	46
	5.24	Steam and Steam Condensate Pipe Sizing Equations	47
	5.25	Psychrometric Equations	48
	5.26	Swimming Pools	49
		Domestic Water Heater Sizing	49
	5.28	Domestic Hot Water Recirculation Pump/Supply Sizing	50
		Relief Valve Vent Line Maximum Length	50
	5.30	Relief Valve Sizing	50
		Steel Pipe Equations	53
		English/Metric Cooling and Heating Equations Comparison	53
		Cooling Tower Equations	55
		Motor Drive Formulas	55
F	PART	6. COOLING LOAD RULES OF THUMB	57
	6.01	Offices, Commercial	58
	6.02	Banks, Court Houses, Municipal Buildings, Town Halls	58
	6.03	Police Stations, Fire Stations, Post Offices	58
	6.04	Precision Manufacturing	59
	6.05	Computer Rooms	59
	6.06	Restaurants	59
	6.07	Kitchens (Depends Primarily on Kitchen Equipment)	59
		Cocktail Lounges, Bars, Taverns, Clubhouses, Nightclubs	60
	6.09	Hospital Patient Rooms, Nursing Home Patient Rooms	60
		Buildings w/100% OA Systems	60
	6.11	Medical/Dental Centers, Clinics, and Offices	60
	6.12	Residential	61
	6.13	Apartments (Eff., 1 Room, 2 Room)	61
		Motel and Hotel Public Spaces	61
		Motel and Hotel Guest Rooms, Dormitories	61
	6.16	School Classrooms	61
	6.17	Dining Halls, Lunch Rooms, Cafeterias, Luncheonettes	62
		Libraries, Museums	62
		Retail, Department Stores	62
		Drug, Shoe, Dress, Jewelry, Beauty, Barber, and Other Shops	62
		Supermarkets	63
		Malls, Shopping Centers	63
		Jails	63
	6.24	Auditoriums, Theaters	63
		Churches	64
	6.26	Bowling Alleys	64
		All Spaces	64
		Cooling Load Calculation Procedure	64
	6.29	Cooling Load Peak Time Estimate	66
1	PART	7. HEATING LOAD RULES OF THUMB	67
	7.01	All Buildings and Spaces	68
	7.02	0	68
	7.03		68
	7.04		68
	7.05		68
	7.06	Floors Below Grade (Heat Loss at Outside Air Design Condition)	69

Contents	*	V
----------	---	---

7.07	Heating System Selection Guidelines	69
	Heating Load Calculation Procedure	69
PART	8. INFILTRATION RULES OF THUMB	73
	Heating Infiltration (15 mph wind)	74
	Cooling Infiltration (7.5 mph wind)	74
	No Infiltration Losses or Gains for Rooms Below Grade or Interior Spaces	74
	Buildings Which Are Not Humidified Have No Latent Infiltration Heating	
	Load	74
8.05	Winter Sensible Infiltration Loads Will Generally Be 1/2 to 3 Times the	
	Conduction Heat Losses (Average 1.0–2.0 Times)	74
PART	9. VENTILATION RULES OF THUMB	75
	Outdoor Air	76
	Indoor Air Quality (IAQ)—ASHRAE Standard 62-1989	77
	Effects of Carbon Monoxide	78
	Toilet Rooms	78
	Electrical Rooms	79
	Mechanical Rooms	80
9.07	Combustion Air	82
9.08	Hazardous Locations	83
DART	10. HUMIDIFICATION RULES OF THUMB	87
	Window Types and Space Humidity Values	88
	Proper Vapor Barriers	88
	Human Comfort	88
	Electrical Equipment, Computers	88
	Winter Design Relative Humidities	88
	Energy Code Winter Design Relative Humidities	88
	Optimum Relative Humidity Ranges for Health	89
	Moisture Condensation on Glass	89
PART	11. PEOPLE/OCCUPANCY RULES OF THUMB	97
	Offices, Commercial	98
	Banks, Court Houses, Municipal Buildings, Town Halls	98
	Police Stations, Fire Stations, Post Offices	98
	Precision Manufacturing	98
	Computer Rooms	98
11.06	Restaurants	98
11.07	Kitchens	98
11.08	Cocktail Lounges, Bars, Taverns, Clubhouses, Nightclubs	98
11.09	Hospital Patient Rooms, Nursing Home Patient Rooms	98
11.10	Hospital General Areas	99
11.11	Medical/Dental Centers, Clinics, and Offices	99
11.12	Residential	99
	Apartments (Eff., 1 Room, 2 Room)	99
	Motel and Hotel Public Spaces	99
	Motel and Hotel Guest Rooms, Dormitories	99
	School Classrooms	99
	Dining Halls, Lunch Rooms, Cafeterias, Luncheonettes	99
11.18	Libraries, Museums	99

ii		Contents
//		

	11.19	Retail, Department Stores	99
	11.20	Drug, Shoe, Dress, Jewelry, Beauty, Barber, and Other Shops	100
	11.21	Supermarkets	100
	11.22	Malls, Shopping Centers	100
	11.23	Jails	100
	11.24	Auditoriums, Theaters	100
	11.25	Churches	100
	11.26	Bowling Alleys	100
	PART	12. LIGHTING RULES OF THUMB	101
		Offices, Commercial	102
		Banks, Court Houses, Municipal Buildings, Town Halls	102
		Police Stations, Fire Stations, Post Offices	102
		Precision Manufacturing	102
		Computer Rooms	102
		Restaurants	102
		Kitchens	102
		Cocktail Lounges, Bars, Taverns, Clubhouses, Nightclubs	102
		Hospital Patient Rooms, Nursing Home Patient Rooms	102
		Hospital General Areas	102
,		Medical/Dental Centers, Clinics, and Offices	103
		Residential	103
	12.13	Apartments (Eff., 1 Room, 2 Room)	103
		Motel and Hotel Public Spaces	103
		Motel and Hotel Guest Rooms, Dormitories	103
	12.16	School Classrooms	103
	12.17	Dining Halls, Lunch Rooms, Cafeterias, Luncheonettes	103
	12.18	Libraries, Museums	103
	12.19	Retail, Department Stores	103
	12.20	Drug, Shoe, Dress, Jewelry, Beauty, Barber, and Other Shops	103
	12.21	Supermarkets	104
	12.22	Malls, Shopping Centers	104
	12.23	Jails	104
	12.24	Auditoriums, Theaters	104
	12.25	Churches	104
	12.26	Bowling Alleys	104
	PART	13. APPLIANCE/EQUIPMENT RULES OF THUMB	105
		Offices and Commercial Spaces	106
		Computer Rooms	106
		Telecommunication Rooms	106
		Electrical Equipment Heat Gain	106
		Motor Heat Gain	107
		Miscellaneous Guidelines	108
	DADT	14. COOLING LOAD FACTORS	109
		Diversity Factors	110
		Safety Factors	110
		Cooling Load Factors	110
		ASHRAE Standard 90.1-1989	111

Contents				vii
----------	--	--	--	-----

PART	15. HEATING LOAD FACTORS	113
15.01	Safety Factors	114
15.02	Heating Load Credits	114
	Heating System Selection Guidelines	114
15.04	ASHRAE Standard 90.1-1989	115
PART	16. ENERGY CONSERVATION AND DESIGN CONDITIONS	117
	The 1989 CABO Model Energy Code	118
	ASHRAE Standard 90A-1980, Energy Conservation in New Building Design	119
	ASHRAE Standard 90A-a-1987, Energy Conservation in New Building Design	122
16.04	$ASHRAE\ Standard\ 90.1\text{-}1989,\ Energy\ Efficient\ Design\ of\ New\ Buildings\ Except$	
	Low-Rise Residential Buildings	123
16.05	Fuel Conversion Factors	132
PART	17. HVAC SYSTEM SELECTION CRITERIA	135
17.01	HVAC System Selection Criteria	136
17.02	Heating System Selection Guidelines	138
PART	18. AIR DISTRIBUTION SYSTEMS	139
18.01	Ductwork Systems	140
18.02	Duct Construction	141
18.03	Kitchen Exhaust Ducts and Hoods	142
18.04	Louvers	144
18.05	Volume Dampers	145
	Fire Dampers	145
	Smoke Dampers	146
	Combination Fire/Smoke Dampers	146
	Smoke Detectors	146
	Sound Attenuators	147
	Terminal Units	148
18.12	Process Exhaust Systems	150
	19. PIPING SYSTEMS	153
	Water (Hydronic) Piping Systems	154
	Steam Piping Systems	170
	Refrigerant Systems and Piping	183
	Glycol Solution Systems	189
	Air Conditioning (AC) Condensate Piping	191
	Valves	192
	Expansion Loops	196
	Strainers	196
	Expansion Tanks and Air Separators	197
	Galvanic Action	214
	Piping System Installation Hierarchy (Easiest to Hardest to Install)	214
19.12	ASME B31 Piping Code Comparison	215
	20. CENTRAL PLANT EQUIPMENT	225
	Air Handling Units, Air Conditioning Units, Heat Pumps	226
	Coils	228
20.03	Filters	232

viii	Contents
VIII	

20.04	Chillers	237
20.05	Cooling Towers (CTs)	242
	Air Cooled Condensers and Condensing Units (ACCs and ACCUs)	244
	Evaporative Condensers and Condensing Units (ECs and ECUs)	244
20.08	Installation of CTs, ACCs, ACCUs, ECs, and ECUs	244
20.09	Heat Exchangers	245
20.10	Boilers, General	246
20.11	Hot Water Boilers	251
20.12	Steam Boilers	257
20.13	Makeup Water Requirements	264
20.14	Water Treatment and Chemical Feed Systems	265
	Fuel Systems and Types	270
20.16	Automatic Controls	272
PART	21. AUXILIARY EQUIPMENT	281
21.01	Fans	282
21.02	Pumps	289
21.03	Motors	293
21.04	Starters, Disconnect Switches, and Motor Control Centers	312
21.05	Adjustable (Variable) Frequency Drives (AFDs or VFDs)	321
21.06	NEMA Enclosures	322
21.07	Humidifiers	322
21.08	Insulation	323
21.09	Firestopping and Through-Penetration Protection Systems	326
PART	22. EQUIPMENT SCHEDULES	329
22.01	General	330
22.02	Air Balance Schedule	330
22.03	Air Compressors	331
22.04	Air Cooled Condensers	331
22.05	Air Cooled Condensing Units	332
	Air Conditioning Units	332
	Air Filters (Pre-Filters, Filters, Final-Filters)	333
22.08	Air Handling Units—Custom, Factory Assembled, Factory Packaged,	
	or Field Fabricated	334
22.09	Air Handling Units—Packaged	334
22.10	Boilers, Hot Water	335
22.11	Boilers, Steam	335
22.12	Cabinet Unit Heaters	335
	Chemical Feed Systems	336
22.14	Chillers, Absorption	336
22.15	Chillers, Air Cooled	337
22.16	6 Chillers, Water Cooled	338
22.17	Coils, Direct Expansion (DX)	338
22.18		339
22.19	O Coils, Steam	339
22.20) Coils, Water	339
22.21	Condensate Pump and Receiver Sets	340
	2 Convectors	340
22.23	3 Cooling Towers	341

Contents		i.
		İX
		1/1

22.24	D	
	Deaerators	341
	Design Conditions	341
	Electric Baseboard Radiation	342
	Electric Radiant Heaters	342
	Evaporative Condensers	342
	Expansion Tanks	343
22.30		343
	Fan Coil Units	343
	Finned Tube Radiation	344
	Flash Tanks	345
	Fluid Coolers/Closed Circuit Evaporative Coolers	345
	Fuel Oil Tanks	345
	Gas Pressure Regulators	346
	Gravity Ventilators	346
	Heat Exchangers, Plate and Frame	346
	Heat Exchangers, Shell and Tube, Steam to Water (Converter)	347
	Heat Exchangers, Shell and Tube, Water to Water	347
	Heat Pumps, Air Source	348
	Heat Pumps, Water Source	348
	Humidifiers	349
	Motor Control Centers	350
	Packaged Terminal AC Systems	350
	Pumps	351
	Radiant Heaters	351
	Steam Pressure Reducing Valves	351
	Steam Pressure Relief Valve	352
	Sound Attenuators (Duct Silencers)	352
	Terminal Units, Constant Volume Reheat	352
	Terminal Units, Dual Duct Mixing Box	353
	Terminal Units, Fan Powered	353
	Terminal Units, Variable Air Volume (VAV)	354
	Unit Heaters	355
22.56	Water Softeners	355
PART	23. EQUIPMENT MANUFACTURERS	357
23.01	Central Plant Equipment	358
	Air System Equipment and Specialties	359
	Water System Equipment and Specialties	360
	Steam System Equipment and Specialties	362
	Terminal Equipment	363
23.06	Miscellaneous Equipment	363
PART	24. BUILDING CONSTRUCTION BUSINESS FUNDAMENTALS	365
	Engineering/Construction Contracts	366
	Building Construction Business Players	367
PART	25. ARCHITECTURAL, STRUCTURAL, AND ELECTRICAL	
	RMATION	371
25.01	Building Structural Systems	372
	Architectural and Structural Information	373
		5,505

		Contents
v		Contents
X		

25.03	Electrical Information	374
25.04	Mechanical/Electrical Equipment Space Requirements	374
25.05	Americans with Disabilities Act (ADA)	376
PART	26. CONVERSION FACTORS	379
26.01	Length	380
26.02	Weight	380
26.03	Area	380
26.04	Volume	380
26.05	Velocity	380
	Speed of Sound in Air	381
	Pressure	381
26.08	Density	381
	Energy	381
	Flow	382
26.11	HVAC Metric Conversions	. 382
PART	27. PROPERTIES OF AIR AND WATER	383
27.01	Properties of Air/Water Vapor Mixtures	384
27.02	Properties of Air	392
27.03	Properties of Water	399
27.04	Glycol Systems	411
PART	28. GENERAL NOTES	413
28.01	General	414
28.02	Piping	416
	Plumbing	418
28.04	HVAC/Sheet Metal	419
28.05	Fire Protection	421
PART	29. APPENDIX A: DUCTWORK	423
29.01	Ductwork Systems	424
PART	30. APPENDIX B: HYDRONIC PIPING SYSTEMS	459
30.01	Hydronic Piping Systems	460
30.02	Glycol Systems	470
30.03	Air Conditioning (AC) Condensate Piping	471
PART	31. APPENDIX C: STEAM PIPING SYSTEMS	473
	Steam Systems	474
	Steam Condensate Systems	520
PART	32. APPENDIX D: PIPE MATERIALS, EXPANSION, AND SUPPORT	701
	Pipe Properties	702
	Pipe Expansion	709
	Pipe Support	716
PAR	7 33. APPENDIX E: SPACE REQUIREMENTS	719
	Space Requirements	720

Conte	nts	
PART	34. APPENDIX F: MISCELLANEOUS	725
34.01	Airborne Contaminants	726
34.02	Miscellaneous	730
DADT	APPENDIX C. DECIONEDIO CUEDOS LOS	
	35. APPENDIX G: DESIGNER'S CHECKLIST	747
33.01	Boilers, Chillers, Cooling Towers, Heat Exchangers, and Other Central	
25.02	Plant Equipment	748
33.02	Air Handling Equipment—Makeup, Recirculation, and General Air	
25.02	Handling Equipment	748
	Piping Systems—General	749
	Steam and Condensate Piping	751
	Low Temperature Hot Water and Dual Temperature Systems	752
	Chilled Water and Condenser Water Systems	752
	Air Systems	753
	Process Exhaust Systems	756
	Refrigeration	757
	Controls	758
	Sanitary and Storm Water Systems	759
	Domestic Water Systems	761
	Fire Protection	762
	Natural Gas Systems	763
35.15	Fuel Oil Systems	764
35.16	Laboratory and Medical Gas Systems	765
	General	765
35.18	Architect and/or Owner Coordination	768
35.19	Structural Engineer Coordination	769
35.20	Electrical Engineer Coordination	770

χi

Foreword

1.01

The heating, ventilation, and air conditioning (HVAC) equations, data, rules of thumb, and other information contained within this reference manual were assembled to aid the beginning engineer and designer in the design of HVAC systems. In addition, the experienced engineer or designer may find this manual useful as a quick design reference guide and teaching tool. The following pages compile information from various reference sources listed in Part 2 of this manual, from college HVAC class notes, from continuing education design seminars and classes, from engineers, and from personnel experience. This document was put together as an encyclopedic type reference in contract specification outline format where information could be looked up quickly, in lieu of searching through volumes of text books, reference books and manuals, periodicals, trade articles, and product catalogs.

1.02

Rules of thumb listed herein should be used considering the following:

- A. Building loads are based on building gross square footage.
- B. Building loads generally include ventilation and make-up air requirements.
- C. Building loads should be calculated using the ASHRAE Handbook of Fundamentals or similar computational procedure in lieu of using these rules of thumb for final designs. When calculating heating and cooling loads, actual occupancy, lighting, and equipment information should be obtained from the Owner, Architect, Electrical engineer, other design team members, or from technical publications such as ASHRAE. These rules of thumb may be used to estimate system loads during the preliminary design stages of a project.

1.03

Code items contained herein were included more for comparison purposes than for use during design. All code items (i.e., BOCA, SBCCI, UBC, NFPA) are subject to change, and federal, state, and local codes should be consulted for applicable regulations and requirements. The following codes were used unless otherwise noted:

- A. 1990 Building Officials and Code Administrators International, Inc., (BOCA) The Basic/National Building Codes
- B. 1993 Building Officials and Code Administrators International, Inc., (BOCA) The Basic/National Building Codes
- C. 1988 Southern Building Code Congress International, Inc., (SBCCI) The Standard/ Southern Building Codes
- D. 1988 International Conference of Building Officials, (ICBO) The Uniform Building Codes
- E. 1991 National Fire Protection Association (NFPA) Codes

1.04

A special thanks to the following:

- A. The Pittsburgh Chapter of ASHRAE Education Committee Members involved in developing the HVAC Design Class.
- B. The students in the HVAC Design Class sponsored by the Pittsburgh Chapter of ASHRAE.
- C. The engineers at Henry Adams, Inc., in Baltimore, MD.
- D. The engineers at Baker and Associates in Pittsburgh, PA.
- E. The engineers at Industrial Design Corporation in Pittsburgh, PA.

References and Design Manuals

2.01 References and Design Manuals

A. The references listed in the paragraphs to follow form the basis for most of the information contained in this manual. In addition, these references are excellent HVAC design manuals and will provide expanded explanations of the information contained within this text. These references are recommended for all HVAC engineers' libraries.

B. American Society of Heating, Refrigerating and Air-Conditioning Engineers (ASHRAE) Handbooks, Standards, and Manuals

- ASHRAE. ASHRAE Handbook, 1998 Refrigeration Volume, Inch-Pound Edition. Atlanta, GA.: ASHRAE, 1998.
- ASHRAE. ASHRAE Handbook, 1997 Fundamentals Volume, Inch-Pound Edition. Atlanta, GA.: ASHRAE, 1997.
- ASHRAE. ASHRAE Handbook, 1996 HVAC Systems and Equipment Volume, Inch-Pound Edition. Atlanta, GA.: ASHRAE, 1996.
- ASHRAE. ASHRAE Handbook, 1995 HVAC Applications Volume, Inch-Pound Edition. Atlanta, GA.: ASHRAE, 1995.
- ASHRAE. ASHRAE Handbook, 1994 Refrigeration Volume, Inch-Pound Edition. Atlanta, GA.: ASHRAE, 1994.
- ASHRAE. ASHRAE Handbook, 1993 Fundamentals Volume, Inch-Pound Edition. Atlanta, GA.: ASHRAE, 1993.
- ASHRAE. ASHRAE Handbook, 1992 HVAC Systems and Equipment Volume, Inch-Pound Edition. Atlanta, GA.: ASHRAE, 1992.
- ASHRAE. ASHRAE Handbook, 1991 HVAC Applications Volume, Inch-Pound Edition. Atlanta, GA.: ASHRAE, 1991.
- ASHRAE. ASHRAE Handbook, 1990 Refrigeration Volume, Inch-Pound Edition. Atlanta, GA.: ASHRAE, 1990.
- ASHRAE. ASHRAE Handbook, 1989 Fundamentals Volume, Inch-Pound Edition. Atlanta, GA.: ASHRAE, 1989.
- ASHRAE. ASHRAE Handbook, 1988 Equipment Volume, Inch-Pound Edition. Atlanta, GA.: ASHRAE, 1988.
- ASHRAE. ASHRAE Handbook, 1987 HVAC Systems and Applications Volume, Inch-Pound Edition. Atlanta, GA.: ASHRAE, 1987.
- ASHRAE. ASHRAE Handbook, 1986 Refrigeration Volume, Inch-Pound Edition. Atlanta, GA.: ASHRAE, 1986.
- ASHRAE. ASHRAE Handbook, 1985 Fundamentals Volume, Inch-Pound Edition. Atlanta, GA.: ASHRAE, 1985.
- ASHRAE. ASHRAE Handbook, 1984 Systems Volume. Atlanta, GA.: ASHRAE, 1984.
- ASHRAE. ASHRAE Handbook, 1983 Equipment Volume. Atlanta, GA.: ASHRAE, 1983.
- ASHRAE. ASHRAE Handbook, 1982 Applications Volume. Atlanta, GA.: ASHRAE, 1982.
- ASHRAE. ASHRAE Handbook, 1981 Fundamentals Volume. Atlanta, GA.: ASHRAE, 1981.
- ASHRAE. ASHRAE Handbook, 1980 Systems Volume. Atlanta, GA.: ASHRAE, 1980.
- ASHRAE. ASHRAE Standard 15-1992, Safety Code for Mechanical Refrigeration. Atlanta, GA.: ASHRAE, 1992.
- ASHRAE. ASHRAE Standard 55-1992, Thermal Environmental Conditions for Human Occupancy. Atlanta, GA.: ASHRAE, 1992.
- ASHRAE. ASHRAE Standard 62-1989, Ventilation for Acceptable Indoor Air Quality. Atlanta, GA.: ASHRAE, 1989.
- ASHRAE. ASHRAE Standard 90A-1980, Energy Conservation in New Building Design. Atlanta, GA.: ASHRAE, 1980.

- ASHRAE. ASHRAE Standard 90A-a-1987, Addenda to Energy Conservation in New Building Design. Atlanta, GA.: ASHRAE, 1987.
- ASHRAE. ASHRAE Standard 90.1-1989, Energy Efficiency Design of New Buildings Except Low-Rise Residential Buildings. Atlanta, GA.: ASHRAE, 1989.
- ASHRAE. ASHRAE Standard 90.2-1993, Energy Efficient Design of Low-Rise Residential Buildings. Atlanta, GA.: ASHRAE, 1993.
- ASHRAE. ASHRAE Standard 111-1988, Practices for Measurement, Testing, Adjusting, and Balancing of Building Heating, Ventilation, Air-Conditioning, and Refrigeration Systems. Atlanta, GA.: ASHRAE, 1988.
- ASHRAE. ASHRAE Guideline 1-1989, Guideline for Commissioning of HVAC Systems. Atlanta, GA.: ASHRAE, 1989.
- ASHRAE. ASHRAE Guideline 3-1990, Reducing Emission of Fully Halogenated Chlorofluorocarbon (CFC) Refrigerants in Refrigeration and Air-Conditioning Equipment and Applications. Atlanta, GA.: ASHRAE, 1990.
- ASHRAE. Design of Smoke Control Systems for Buildings. 1st Ed., Atlanta, GA.: ASHRAE, 1983.
- ASHRAE. Pocket Handbook for Air Conditioning, Heating, Ventilation, Refrigeration. Atlanta, GA.: ASHRAE, 1987.

C. American National Standards Institute (ANSI) and American Society of Mechanical Engineers (ASME)

- ANSI/ASME. ANSI/ASME A13.1 Scheme for the Identification of Piping Systems. New York, NY: ANSI/ASME, 1988.
- ANSI/ASME. ANSI/ASME B31.1 Power Piping, 1998. New York, NY: ANSI/ASME, 1998.
- ANSI/ASME. ANSI/ASME B31.3 Process Piping, 1996. New York, NY: ANSI/ASME, 1996.
- ANSI/ASME. ANSI/ASME B31.5 Refrigerant Piping, 1987. New York, NY: ANSI/ASME, 1987.
- ANSI/ASME. ANSI/ASME B31.9 Building Services Piping Code 1996. New York, NY: ANSI/ASME, 1996.
- ANSI/ASME. ANSI/ASME Boiler and Pressure Vessel Code. New York, NY: ANSI/ASME, 1989.

D. Bell and Gossett Manuals

- ITT Corporation. Pump and System Curve Data for Centrifugal Pump Selection and Application. Morton Grove, IL.: ITT Corporation, Training and Education Department, Fluid Handling Division, 1967.
- ITT Corporation. *Pump Data Book*. Morton Grove, IL.: ITT Corporation, Training and Education Department, Fluid Handling Division, 1970.
- ITT Corporation. *Parallel and Series Pump Application*. Morton Grove, IL.: ITT Corporation, Training and Education Department, Fluid Handling Division, 1965.
- ITT Corporation. *Principles of Centrifugal Pump Construction and Maintenance*. Morton Grove, IL.: ITT Corporation, Training and Education Department, Fluid Handling Division, 1965.
- ITT Corporation. *Cooling Tower Pumping and Piping*. Morton Grove, IL.: ITT Corporation, Training and Education Department, Fluid Handling Division, 1968.
- ITT Corporation. Variable Speed/Variable Volume Pumping Fundamentals. Morton Grove, IL.: ITT Corporation, Training and Education Department, Fluid Handling Division, 1985.
- ITT Corporation. *Heat Exchangers, Application and Installation*. Morton Grove, IL.: ITT Corporation, Training and Education Department, Fluid Handling Division, 1965.
- ITT Corporation. *Primary Secondary Pumping Application Manual*. Morton Grove, IL.: ITT Corporation, Training and Education Department, Fluid Handling Division, 1968.

- ITT Corporation. One Pipe Primary Systems, Flow Rate and Water Temperature Determination. Morton Grove, IL.: ITT Corporation, Training and Education Department, Fluid Handling Division, 1966.
- ITT Corporation. *Primary Secondary Pumping Adaptations to Existing Systems*. Morton Grove, IL.: ITT Corporation, Training and Education Department, Fluid Handling Division, 1966.
- ITT Corporation. *Dual Temperature Change Over Single Zone*. Morton Grove, IL.: ITT Corporation, Training and Education Department, Fluid Handling Division, 1967.
- ITT Corporation. Single Coil Instantaneous Room by Room Heating-Cooling Systems. Morton Grove, IL.: ITT Corporation, Training and Education Department, Fluid Handling Division, 1965.
- ITT Corporation. *Equipment Room Piping Practice*. Morton Grove, IL.: ITT Corporation, Training and Education Department, Fluid Handling Division, 1965.
- ITT Corporation. Pressurized Expansion Tank Sizing/Installation Instructions for Hydronic Heating/Cooling Systems. Morton Grove, IL.: ITT Corporation, Training and Education Department, Fluid Handling Division, 1988.
- ITT Corporation. Snow Melting System Design and Problems. Morton Grove, IL.: ITT Corporation, Training and Education Department, Fluid Handling Division, 1966.
- ITT Corporation. *Hydronic Systems Anti-Freeze Design*. Morton Grove, IL.: ITT Corporation, Training and Education Department, Fluid Handling Division, 1965.
- ITT Corporation. *Air Control for Hydronic Systems*. Morton Grove, IL.: ITT Corporation, Training and Education Department, Fluid Handling Division, 1966.
- ITT Corporation. Basic System Control and Valve Sizing Procedures. Morton Grove, IL.: ITT Corporation, Training and Education Department, Fluid Handling Division, 1970.
- ITT Corporation. *Hydronic Systems: Analysis and Evaluation*. Morton Grove, IL.: ITT Corporation, Training and Education Department, Fluid Handling Division, 1969.
- ITT Corporation. *Circuit Setter Valve Balance Procedure Manual*. Morton Grove, IL.: ITT Corporation, Training and Education Department, Fluid Handling Division, 1971.
- ITT Corporation. *Domestic Water Service*. Morton Grove, IL.: ITT Corporation, Training and Education Department, Fluid Handling Division, 1970.

E. Carrier Manuals

- Carrier Corporation. Carrier System Design Manuals, Part 1—Load Estimating. Syracuse, NY.: Carrier Corporation, 1972.
- Carrier Corporation. Carrier System Design Manuals, Part 2—Air Distribution. Syracuse, NY.: Carrier Corporation, 1974.
- Carrier Corporation. Carrier System Design Manuals, Part 3—Piping Design. Syracuse, NY.: Carrier Corporation, 1973.
- Carrier Corporation. Carrier System Design Manuals, Part 4—Refrigerants, Brines, Oils. Syracuse, NY.: Carrier Corporation, 1969.
- Carrier Corporation. Carrier System Design Manuals, Part 5—Water Conditioning. Syracuse, NY.: Carrier Corporation, 1972.
- Carrier Corporation. Carrier System Design Manuals, Part 6—Air Handling Equipment. Syracuse, NY.: Carrier Corporation, 1968.
- Carrier Corporation. Carrier System Design Manuals, Part 7—Refrigeration Equipment. Syracuse, NY.: Carrier Corporation, 1969.
- Carrier Corporation. Carrier System Design Manuals, Part 8—Auxiliary Equipment. Syracuse, NY.: Carrier Corporation, 1966.
- Carrier Corporation. Carrier System Design Manuals, Part 9—Systems and Applications. Syracuse, NY.: Carrier Corporation, 1971.

- Carrier Corporation. Carrier System Design Manuals, Part 10—Air-Air Systems. Syracuse, NY.: Carrier Corporation, 1975.
- Carrier Corporation. Carrier System Design Manuals, Part 11—Air-Water Systems. Syracuse, NY.: Carrier Corporation, 1966.
- Carrier Corporation. Carrier System Design Manuals, Part 12—Water and DX Systems. Syracuse, NY.: Carrier Corporation, 1975.

F. Cleaver Brooks Manuals

- Cleaver Brooks. The Boiler Book, A Complete Guide to Advanced Boiler Technology for the Specifying Engineer. 1st Ed., Milwaukee, WI.: Cleaver Brooks, 1993.
- Cleaver Brooks. *Hot Water Systems, Components, Controls, and Layouts.* Milwaukee, WI: Cleaver Brooks, 1972.
- Cleaver Brooks. Application . . . and Misapplication of Hot Water Boilers. Milwaukee, WI: Cleaver Brooks, 1976.

G. Johnson Controls Manuals

- Johnson Controls. Fundamentals of Pneumatic Control. Milwaukee, WI: Johnson Controls. Johnson Controls. Johnson Field Training Handbook, Fundamentals of Electronic Control Equipment. Milwaukee, WI: Johnson Controls.
- Johnson Controls. *Johnson Field Training Handbook, Fundamentals of Systems*. Milwaukee, WI: Johnson Controls.

H. Honeywell Manual

Honeywell. Engineering Manual of Automatic Control for Commercial Buildings, Heating, Ventilating and Air Conditioning. Inch-Pound Edition, Minneapolis, MN.: Honeywell, 1991.

I. Industrial Ventilation Manual

American Conference of Governmental and Industrial Hygentists. *Industrial Ventilation, A Manual of Recommended Practice.* 21st Ed. Cincinnati, OH.: American Conference of Governmental and Industrial Hygentists, 1992.

J. SMACNA (Sheet Metal and Air-Conditioning Contractors' National Association, Inc.) Manuals

- SMACNA. Fibrous Glass Duct Construction Standards. 5th Ed., Vienna, VA.: SMACNA, 1979. SMACNA. Fire, Smoke and Radiation Damper Installation Guide for HVAC Systems. 4th Ed., Vienna, VA.: SMACNA, 1992.
- SMACNA. HVAC Air Duct Leakage Test Manual. 1st Ed., Vienna, VA.: SMACNA, 1985.
- SMACNA. HVAC Duct Construction Standards—Metal and Flexible. 1st Ed., Vienna, VA.: SMACNA, 1985.
- SMACNA. HVAC Systems—Duct Design. 2nd Ed., Vienna, VA.: SMACNA, 1981.
- SMACNA. HVAC Systems—Testing, Adjusting and Balancing. 1st Ed., Vienna, VA.: SMACNA, 1986.
- SMACNA. Rectangular Industrial Duct Construction Standards. 1st Ed., Vienna, VA.: SMACNA, 1989.
- SMACNA. Round Industrial Duct Construction Standards. 1st Ed., Vienna, VA.: SMACNA, 1989.
- SMACNA. Seismic Restraint Manual Guidelines for Mechanical Systems. 1st Ed., Vienna, VA.: SMACNA, 1991.
- SMACNA. Thermoplastic Duct (PVC) Construction Manual. 1st Ed., Vienna, VA.: SMACNA, 1974.

K. Trane Manuals

The Trane Company. Trane Air-Conditioning Manual. LaCross, WI.: The Trane Company, 1988.

The Trane Company. Psychrometry. LaCross, WI.: The Trane Company, 1988.

L. United McGill Corporation

United McGill Corporation. Engineering Design reference Manual for Supply Air Handling Systems. Westerville, OH.: United McGill Corporation, 1989.

United McGill Corporation. *Underground Duct Installation (No. 95)*. Westerville, OH.: United McGill Corporation, 1992.

United McGill Corporation. Flat Oval vs Rectangular Duct (No. 150). Westerville, OH.: United McGill Corporation, 1989.

United McGill Corporation. Flat Oval Duct—The Alternative to Rectangular (No. 151). Westerville, OH.: United McGill Corporation, 1989.

United McGill Corporation. *Underground Duct Design (No. 155)*. Westerville, OH.: United McGill Corporation, 1992.

M. Manufacturers Standardization Society of the Valve and Fitting Industry

Manufacturers Standardization Society of the Valve and Fitting Industry. Standard Marking System for Valves, Fittings, Flanges and Unions (Standard SP-25-1988). Vienna, VA.: Manufacturers Standardization Society of the Valve and Fitting Industry, 1988.

Manufacturers Standardization Society of the Valve and Fitting Industry. *Pipe Hangers and Supports—Materials, Design and Manufacturers (Standard SP-58-1988).* Vienna, VA.: Manufacturers Standardization Society of the Valve and Fitting Industry, 1988.

Manufacturers Standardization Society of the Valve and Fitting Industry. *Pipe Hangers and Supports—Selection and Application (Standard SP-69-1983)*. Vienna, VA.: Manufacturers Standardization Society of the Valve and Fitting Industry, 1983.

Manufacturers Standardization Society of the Valve and Fitting Industry. *Pipe Hangers and Supports—Fabrication and Installation Practices (Standard SP-89-1985)*. Vienna, VA.: Manufacturers Standardization Society of the Valve and Fitting Industry, 1985.

Manufacturers Standardization Society of the Valve and Fitting Industry. *Guidelines on Terminology for Pipe Hangers and Supports (Standard SP-90-1986)*. Vienna, VA.: Manufacturers Standardization Society of the Valve and Fitting Industry, 1986.

Manufacturers Standardization Society of the Valve and Fitting Industry. *Guidelines for Manual Operation of Valves (Standard SP-91-1984)*. Vienna, VA.: Manufacturers Standardization Society of the Valve and Fitting Industry, 1984.

Manufacturers Standardization Society of the Valve and Fitting Industry. *MSS Valve User Guide (Standard SP-92-1987)*. Vienna, VA.: Manufacturers Standardization Society of the Valve and Fitting Industry, 1987.

Manufacturers Standardization Society of the Valve and Fitting Industry. *Guidelines on Terminology for Valves and Fittings (Standard SP-96-1986).* Vienna, VA.: Manufacturers Standardization Society of the Valve and Fitting Industry, 1986.

N. Miscellaneous

Armstrong. Steam Conservation Guidelines for Condensate Drainage. Three Rivers, MI.: Armstrong Machine Works, 1976.

Avallone, Eugene A. and Baumeister, III Theodore. Mark's Standard Handbook for Mechanical Engineers. 9th Ed., New York, NY.: McGraw-Hill Book Co., 1986.

Bolz, D. and Tuve, George L. CRC Handbook of Tables for Applied Engineering Science. 2nd. Ed., Boca Raton, FL.: CRC Press, Inc., 1980.

- Clough, Richard H. Construction Contracting. 4th Ed., New York, NY.: John Wiley and Sons, Inc., 1981.
- Dryomatic, Div. Airflow, Co. Dehumidification Engineering Manual. Frederick, MD.: Dryomatic, Div. Airflow, Co., 1965.
- Haines, Roger W. Control Systems for Heating, Ventilating and Air Conditioning. 4th Ed., New York, NY.: Van Nostrand Reinhold Company, 1987.
- Hansen, Erwin G. Hydronic System Design and Operation A Guide to Heating and Cooling with Water. New York, NY.: McGraw-Hill Companies, Inc., College Customs Series, 1996.
- Harris, Norman C. *Modern Air Conditioning Practice*. 3rd Ed., New York, NY.: Glencoe Div. of Macmillan/McGraw-Hill, 1992.
- Hauf, Harold D. *Architectural Graphic Standards*. 6th Ed., New York, NY.: John Wiley and Sons, Inc., 1970.
- Heald, C. C. Cameron Hydraulic Data. 17th Ed., Woodcliff Lake, NJ: Ingersoll Rand, 1988. Leslie Control, Inc. Steam Pressure Control Systems. Tampa, FL.: Leslie Controls, Inc.
- The Marley Cooling Tower Co. *Cooling Tower Fundamentals*. 2nd Ed., Kansas City, MO.: The Marley Cooling Tower Co., 1985.
- McGuinness, William J. Mechanical and Electrical Equipment for Buildings. 6th Ed., New York, NY.: John Wiley and Sons, Inc., 1980.
- Nayyar, Mohinder L. Piping Handbook. 6th Ed., New York, NY: McGraw Hill, Inc. 1992.
- The Singer Company. Designing the Installation of the Electro-Hydronic Energy Conservation System. Auburn, NY.: The Singer Company, Climate Control Div., 1978.
- Spence Engineering Co. Steam Pressure Reducing Station Noise Treatment. Walden, NY.: Spence Engineering Co.
- Spirax/Sarco. Design of Fluid Systems, Steam Utilization. Allentown, PA.: Spirax/Sarco, 1991. Spirax/Sarco. Design of Fluid Systems, Hook-ups. Allentown, PA.: Spirax/Sarco, 1992.
- Strock, Clifford. *Handbook of Air Conditioning, Heating and Ventilating*. 1st Ed., New York, NY.: The Industrial Press 1959.
- Systecon, Inc. Distributed Pumping (Pressure Gradient Control) for Chilled Water and Hot Water Systems. Cincinnati, OH.: Systecon, Inc., 1992.

2.02 Building Codes

A. Building Officials and Code Administrators International, Inc. (BOCA)

BOCA. The BOCA National Building Code, 1990. Country Club Hills, IL.: BOCA, 1990.

BOCA. The BOCA National Mechanical Code, 1990. Country Club Hills, IL.: BOCA, 1990.

BOCA. The BOCA National Building Code, 1993. Country Club Hills, IL.: BOCA, 1993.

BOCA. The BOCA National Mechanical Code, 1993. Country Club Hills, IL.: BOCA, 1993.

B. Council of American Building Officials (CABO)

CABO. Model Energy Code. Falls Church, VA.: CABO, 1989.

C. International Conference of Building Officials (ICBO)

ICBO. *Uniform Building Code*. Whittier, CA.: ICBO, 1988. ICBO. *Uniform Mechanical Code*. Whittier, CA.: ICBO, 1988.

D. National Fire Protection Association (NFPA)

NFPA. NFPA 10 Portable Fire Extinguishers. Quincy, MA.: NFPA, 1994.

NFPA. NFPA 13 Installation of Sprinkler Systems. Quincy, MA.: NFPA, 1994.

NFPA. NFPA 13 Installation of Sprinkler Systems Handbook. Quincy, MA.: NFPA, 1994.

NFPA. NFPA 14 Installation of Standpipe and Hose systems. Quincy, MA.: NFPA, 1993.

NFPA. NFPA 20 Installation of Centrifugal Fire Pumps. Quincy, MA.: NFPA, 1993.

NFPA. NFPA 30 Flammable and Combustible Liquids Code. Quincy, MA.: NFPA, 1990.

NFPA. NFPA 45 Fire Protection for Laboratories Using Chemicals. Quincy, MA.: NFPA, 1991.

NFPA. NFPA 52 Compressed Natural Gas (CNG) Vehicular Fuel Systems. Quincy, MA:: NFPA, 1992.

NFPA. NFPA 54 National Fuel Gas Code. Quincy, MA.: NFPA, 1992.

NFPA. NFPA 54 National Fuel Gas Code Handbook. Quincy, MA.: NFPA, 1992.

NFPA. NFPA 58 Storage and Handling of Liquefied Petroleum Gases. Quincy, MA.: NFPA, 1992.

NFPA. NFPA 70 National Electrical Code. Quincy, MA.: NFPA, 1993.

NFPA. NFPA 70 National Electrical Code Handbook. Quincy, MA.: NFPA, 1993.

NFPA. NFPA 75 Protection of Electronic Computer/Data Processing Equipment. Quincy, MA.: NFPA, 1992.

NFPA. NFPA 88B Repair Garages. Quincy, MA.: NFPA, 1991.

NFPA. NFPA 90A Installation of Air Conditioning and Ventilating Systems. Quincy, MA:: NFPA, 1990.

NFPA. NFPA 90B Installation of Warm Air Heating and Air Conditioning Systems. Quincy, MA.: NFPA, 1990.

NFPA. NFPA 91 Installation of Exhaust Systems for Air Conveying of Materials. Quincy, MA:: NFPA, 1992.

NFPA. NFPA 92A Smoke Control Systems. Quincy, MA.: NFPA, 1993.

NFPA. NFPA 92B Smoke Management Systems in Malls, Atria, Large Areas. Quincy, MA.: NFPA, 1991.

NFPA. NFPA 96 Ventilation Control and Fire Protection of Commercial Cooking Operations. Quincy, MA.: NFPA, 1994.

NFPA. NFPA 99 Health Care Facilities. Quincy, MA.: NFPA, 1990.

NFPA. NFPA 101 Safety to Life in Buildings and Structures. Quincy, MA.: NFPA, 1994.

NFPA. NFPA 110 Emergency and Standby Power Systems. Quincy, MA.: NFPA, 1993.

NFPA. NFPA 211 Chimneys, Fireplaces, Vents and Solid Fuel Burning Appliances. Quincy, MA.: NFPA, 1992.

NFPA. NFPA 214 Water Cooling Towers. Quincy, MA.: NFPA, 1992.

NFPA. NFPA 318 Cleanrooms. Quincy, MA.: NFPA, 1992.

NFPA. NFPA 910 Libraries and Library Collections. Quincy, MA.: NFPA, 1991.

NFPA. NFPA 911 Museums and Museum Collections. Quincy, MA.: NFPA, 1991.

NFPA. NFPA 912 Places of Worship. Quincy, MA.: NFPA, 1993.

NFPA. NFPA 913 Historic Structures and Sites. Quincy, MA.: NFPA, 1992.

NFPA. NFPA 914 Fire Protection in Historic Structures. Quincy, MA.: NFPA, 1990.

E. Southern Building Code Congress International, Inc. (SBCCI)

SBCCI. Standard Building Code, 1988. Birmingham, AL.: SBCCI, 1988.

SBCCI. Standard Mechanical Code, 1988. Birmingham, AL.: SBCCI, 1988.

F. Miscellaneous

The American Institute of Architects Committee on Architecture for Health. *Guidelines for Construction and Equipment of Hospital and Medical Facilities*. Washington, D.C.: The American Institute of Architects' Press, 1993.

Definitions

3.01 General

- A. Furnish. Except as otherwise defined in greater detail, the term furnish is used to mean "supply and deliver to the project site, ready for unloading, unpacking, assembly, installation, and similar operations" as applicable to each instance.
- B. *Install*. Except as otherwise defined in greater detail, the term *install* is used to describe operations at the project site including actual "unloading, unpacking, assembly, erection, placing, anchoring, connecting, applying, working to dimension, finishing, curing, protecting, testing to demonstrate satisfactory operation, cleaning and similar operations" as applicable in each instance.
- C. *Provide*. Except as otherwise defined in greater detail, the term *provide* means to furnish and install, complete and ready for intended use and successfully tested to demonstrate satisfactory operation as applicable in each instance.
- D. Remove. Except as otherwise defined in greater detail, the term remove means to disassemble, dismantle, and/or cut into pieces in order to remove the equipment from the site and to properly dispose of the removed equipment and pay for all associated costs incurred.
- E. Replace. Except as otherwise defined in greater detail, the term replace means to remove the existing equipment and to provide new equipment of the same size, capacity, electrical characteristics, function, etc., as the existing equipment.
- F. Relocate. Except as otherwise defined in greater detail, the term relocate means to carefully remove without damaging item and to install where shown on the contract documents and/or as directed by the Engineer and/or Owner.
- G. Shall. Shall indicates action which is mandatory on the part of the Contractor.
- H. Will. Will indicates action which is probable on the part of the Contractor.
- I. Should. Should indicates action which is probable on the part of the Contractor.
- J. May. May indicates action which is permissible on the part of the Contractor.
- K. Indicated. The term indicated is a cross-reference to graphic representations, details, notes, or schedules on the drawings; to other paragraphs or schedules in the specifications; and to similar means of recording requirements in the Contract Documents. Where terms such as shown, noted, scheduled, and specified are used in lieu of indicated, it is for the purpose of helping the reader locate the cross-reference, and no limitation is intended except as specifically noted.
- L. Shown. The term shown is a cross-reference to graphic representations, details, notes, or schedules on the Contract Drawings and to similar means of recording requirements in the Contract Documents.
- M. Detailed. The term detailed is a cross-reference to graphic representations, details, notes, or schedules on the Contract Drawings and to similar means of recording requirements in the Contract Documents.
- N. Specified. The term specified is a cross-reference to paragraphs or schedules in the specifications and to similar means of recording requirements in the Contract

Documents. The specifications include the General Provisions, Special Provisions, and the Technical Specifications for the project.

- O. *Including,* Such as. The terms *including* and *such as* shall always be taken in the most inclusive sense, namely "including, but not limited to" and "such as, but not limited to"
- P. Supply, Procurement. The terms supply and procurement shall mean to purchase, procure, acquire, and deliver complete with related accessories.
- Q. At no additional cost. The phrase "at no additional cost" shall mean at no additional cost to the Owner and at no additional cost to the Engineer or Construction Manager.
- R. Approved, Accepted. Where used in conjunction with the Engineer's response to submittals, requests, applications, inquiries, reports, and claims by the Contractor, the meaning of the terms approved and accepted shall be held to the limitations of the Engineer's responsibilities to fulfill requirements of the Contract Documents. The terms approved and accepted shall also mean to permit the use of material, equipment, or methods conditional upon compliance with the Contract Documents.
- S. Approved Equal, Approved Equivalent. The terms approved equal and approved equivalent shall mean possessing the same performance qualities and characteristics and fulfilling the same utilitarian function and approved by the Engineer.
- T. Directed, Requested, Required, etc. Where not otherwise explained, terms such as directed, required, authorized, selected, approved, accepted, designated, prescribed, ordered, and permitted mean "directed by the Engineer," "requested by the Engineer," and similar phrases. However, no such implied meaning will be interpreted to expand the Engineer's responsibility into the Contractor's area of construction supervision.
- U. Review. The term review shall mean limited observation or checking to ascertain general conformance with design concept of the Work and with information given in the Contract Documents. Such action does not constitute a waiver or alteration of the Contract Document requirements.
- V. Suitable, Reasonable, Proper, Correct, and Necessary. Such terms shall mean as suitable, reasonable, proper, correct, or necessary for the purpose intended as required by the Contract Documents, subject to the judgement of the Engineer or the Construction Manager.
- W. Option. The term option shall mean a choice from the specified products, manufacturers, or procedures which shall be made by the Contractor. The choice is not "whether" the Work is to be performed, but "which" product, "which" manufacturer, or "which" procedure is to be used. The product or procedure chosen by the Contractor shall be provided at no increase or additional cost to the Owner, Engineer, or Construction Manager and with no lessening of the Contractor's responsibility for its performance.
- X. Similar. The term similar shall mean generally the same but not necessarily identical; details shall be worked out in relation to other parts of the work.

- Y. Submit. The term submit shall mean, unless otherwise defined in greater detail, transmit to the Engineer for approval, information, and record.
- Z. Project Site, Work Site. The term project site shall be defined as the space available to the Contractor for performance of the Work, either exclusively or in conjunction with others performing other Work as part of the project or another project. The extent of the project site is shown on the drawings or specified and may or may not be identical with the land upon which the project is to be built. The project site boundaries may include public streets, highways, roads, interstates, etc., public easements, and property under ownership of someone other than the Client and are not available for performance of Work.
- AA. Testing Laboratories. The term testing laboratories shall be defined as an independent entity engaged to perform specific inspections or tests of the Work, either at the project site or elsewhere, and to report and, if required, interpret the results of those inspections or tests.
- BB. Herein. The term herein shall mean the contents of a particular section where this term appears.
- CC. Singular Number. In all cases where a device or part of equipment or system is herein referred to in the singular number (such as fan, pump, cooling system, heating system, etc.) it is intended that such reference shall apply to as many such items as are required by the Contract Documents and to complete the installation.
- DD. No Exception Taken. The term no exception taken shall mean the same as approved.
- EE. Approved as Noted, Make Corrections Noted, or Revise–No Resubmittal Required. The terms approved as noted, make corrections noted, and revise–no resubmittal required shall mean the submittal essentially complies with the Contract Documents except for a few minor discrepancies that have been annotated directly on the submittal that will have to be corrected on the submittal and the Work correctly installed in the field by the Contractor.
- FF. Revise and Resubmit. The term revise and resubmit shall mean the Contractor shall revise the submittal to conform with the Contract Documents by correcting moderate errors, omissions, and/or deviations from the Contract Documents and resubmit it for review prior to approval and before any material and/or equipment can be fabricated, purchased, or installed by the Contractor.
- GG. Disapproved/Resubmit. The term disapproved/resubmit shall mean the Contractor shall revise the submittal to conform with the Contract Documents by correcting serious errors, omissions, and/or deviations from the Contract Documents and resubmit it for review prior to approval and before any material and/or equipment can be fabricated, purchased, or installed by the Contractor.
- HH. Disapproved or Rejected. The terms disapproved and rejected shall mean the Contractor shall discard and replace the submittal because the submittal did not comply with the Contract Documents in a major way.
- II. Submit Specified Item. The term submit specified item shall mean the Contractor shall discard and replace the submittal with a submittal containing the specified items because the submittal contained improper manufacturer, model number, material, etc.

- JJ. Acceptance. The formal acceptance by the Owner or Engineer of the Work, as evidenced by the issuance of the Acceptance Certificate.
- KK. Contract Item, Pay Item, Contract Fixed Price Item. A specifically described item of Work which is priced in the Contract Documents.
- LL. Contract Time, Time of Completion. The number of Calendar Days (not working days) set forth in the Contract Documents for completion of the Work.
- MM. Failure. Any detected inability of material or equipment, or any portion thereof, to function or perform in accordance with the Contract Documents.
- NN. Substantial Completion. Substantial completion shall be defined as the sufficient completion and accomplishment by the Contractor of all Work or designated portions thereof essential to fulfillment of the purpose of the Contract, so the Owner can occupy or utilize the Work or designated portions thereof for the use for which it is intended.
- OO. Final Completion, Final Acceptance. Final completion or final acceptance shall be defined as completion and accomplishment by the Contractor of all Work including contractual administrative demobilization Work, all punch list items, and all other Contract requirements essential to fulfillment of the purpose of the Contract, so the Owner can occupy or utilize the Work for the use for which it is intended.
- PP. Pre-Final Inspection or Observation. The term pre-final inspection or observation shall be held to the limitations of the Engineer's responsibilities to fulfill the requirements of the Contract Documents and shall not relieve the Contractor from Contract obligations. The term pre-final inspection shall also mean all inspections conducted prior to the final inspection by the Owner, the Engineer, or both, verifying that all the Work, with the exception of required contractual administrative demobilization work, inconsequential punch list items, and guarantees, has been satisfactorily completed in accordance with the Contract Documents.
- QQ. Final Inspection or Observation. The term final inspection or observation shall be held to the limitations of the Engineer's responsibilities to fulfill the requirements of the Contract Documents and shall not relieve the Contractor from Contract obligations. The term final inspection shall also mean the inspection conducted by the Owner, the Engineer, or both, verifying that all the Work, with the exception of required contractual administrative demobilization work, inconsequential punch list items, and guarantees, has been satisfactorily completed in accordance with the Contract Documents.
- RR. Reliability. The probability that a system will perform its intended functions without failure and within design parameters under specified operating conditions for which it is designed and for a specified period of time.
- SS. Testing. The term testing may be described as the inspection, investigation, analysis, and diagnosis of all systems and components to assure that the systems are operable, meet the requirements of the Contract Documents, and are ready for operation. Included are such items as:
- 1. Verification that the system is filled with water and is not air bound.
- Verification that expansion tanks of the proper size are connected at the correct locations and that they are not water logged.

- 3. Verification that all system components are in proper working order and properly installed. Check for proper flow directions.
- 4. Checking of all voltages for each motor in the system.
- 5. Checking that all motors rotate in the correct direction and at the correct speed.
- 6. Checking all motors for possible overload (excess amperage draw) on initial start-up.
- 7. Checking of each pump for proper alignment.
- 8. Checking all systems for leaks, etc.
- 9. Checking all systems and components to assure that they meet the Contract Document requirements as far as capacity, system operation, control function, and other items required by the Contract Documents.
- TT. Adjusting. The term adjusting may be described as the final setting of balancing devices such as dampers and valves, in addition to automatic control devices, such as thermostats and pressure/temperature controllers to achieve maximum system performance and efficiency during normal operation. Adjusting also includes final adjustments for pumps by regulation of motor speed, partial close-down of pump discharge valve or impeller trim (preferred over the partial close-down of pump discharge valve).
- UU. Balancing. The term balancing is the methodical regulation of system fluid flow-rates (air and water) through the use of workable and industry accepted procedures as specified to achieve the desired or specified flow quantities (CFM or GPM) in each segment (main, branch, or sub-circuit) of the system.
- VV. Commissioning. The term commissioning is the methodical procedures and methods for documenting and verifying the performance of HVAC systems so that the systems operate in conformity with the design intent. Commissioning will include testing; adjusting; balancing; documentation of occupancy requirements and design assumptions; documentation of design intent for use by contractors, owners, and operators; functional performance testing and documentation necessary for evaluating the HVAC systems for acceptance; adjusting the HVAC systems to meet actual occupancy needs within the capability of the systems. Commissioning does not include system energy efficiency testing or testing of other building systems such as envelope, structure, electrical, lighting, plumbing, fire protection, and life safety. The purpose of commissioning of HVAC systems is to achieve the end result of a fully functional, fine-tuned HVAC system.

WW.Functional Performance Testing. The term functional performance testing shall mean the full range of checks and tests carried out to determine if all components, sub-systems, systems, and interfaces between systems function in accordance with the contract documents. In this context, function includes all modes and sequences of control operation, all interlocks and conditional control responses, and all specified responses to abnormal emergency conditions.

XX. Confined Spaces. Confined spaces (according to OSHA Regulations) are spaces which must have these three characteristics:

- The space must be large enough and configured to permit personnel to enter and work.
- 2. The space is not designed for continuous human occupancy.
- 3. The space has limited or restricted means of entry and exit.

There are two categories of confined spaces:

- 1. Non-Permit Required Confined Spaces (NRCS). Spaces which contain no physical hazards that could cause death or series physical harm, and there is no possibility that it contains any atmospheric hazards.
- 2. Permit Required Confined Spaces (PRCS). Spaces which contain or may contain a hazardous atmosphere (atmospheric hazards—oxygen deficiency or enrichment 19.5% acceptable minimum and 23.5% acceptable maximum; flammable contaminants; and toxic contaminants—product, process, or reactivity); a liquid or finely divided solid material such as grain, pulverized coal, etc., that could surround or engulf a person; or some other recognized serious safety or health hazard such as temperature extremes or mechanical or electrical hazards (boilers, open transformers, tanks, vaults, sewers, manholes, pits, machinery enclosures, vats, silos, storage bins, rail tank cars, process or reactor vessels).

YY. Hazardous Location Classifications

- 1. Hazardous locations are those areas where a potential for explosion and fire exist because of flammable gases, vapors, or dust in the atmosphere, or because of the presence of easily ignitable fibers or flyings in accordance with the National Electric Code (NEC—NFPA 70).
- Class I Locations. Class I locations are those locations in which flammable gases or vapors are or may be present in the air in quantities sufficient to produce explosive or ignitable mixtures.
 - a. Class I, Division 1 Locations. These are Class I locations where the hazardous atmosphere is expected to be present during normal operations. It may be present continuously, intermittently, periodically, or during normal repair or maintenance operations. Division 1 locations are also those locations where a breakdown in the operation of processing equipment results in the release of hazardous vapors while providing a source of ignition with the simultaneous failure of electrical equipment.
 - b. *Class I, Division 2 Locations*. These are Class I locations in which volatile flammable liquids or gases are handled, processed, or used, but in which they can escape only in the case of accidental rupture or breakdown of the containers or systems. The hazardous conditions will occur only under abnormal conditions.
- 3. *Class II Locations*. Class II locations are those locations that are hazardous because of the presence of combustible dust.
 - a. Class II, Division 2 Locations. These are Class II locations where combustible dust may be in suspension in the air under normal conditions in sufficient quantities to produce explosive or ignitable mixtures. This may occur continuously, intermittently, or periodically. Division 1 locations also exist where failure or malfunction of machinery or equipment might cause a hazardous location to exist while providing a source of ignition with the simultaneous failure of electrical equipment. Included also are locations in which combustible dust of an electrically conductive nature may be present.
 - b. Class II, Division 2 Locations. These are Class II locations in which combustible dust will not normally be in suspension in the air and normal operations will not put the dust in suspension, but where accumulation of the dust may interfere with the safe dissipation of heat from electrical equipment or where accumulations near electrical equipment may be ignited by arcs, sparks, or burning material from the equipment.
- 4. Class III Locations. Class III locations are those locations that are hazardous because of the presence of easily ignitable fibers or flyings, but in which the fibers or flyings are not likely to be in suspension in the air in quantities sufficient to produce ignitable mixtures.

- a. *Class III*, *Division 1 Locations*. These are locations in which easily ignitable fibers or materials producing combustible flyings are handled, manufactured, or used.
- Class III, Division 2 Locations. These locations are where easily ignitable fibers are stored or handled.

3.02 Systems

- A. Mechanical Systems. The term mechanical systems shall mean for the purposes of these Contract Documents all heating, ventilating, and air conditioning systems and all piping systems as specified and as shown on the Mechanical Drawings and all services and appurtenances incidental thereto.
- B. *Plumbing Systems*. The term *plumbing systems* shall mean for the purposes of these Contract Documents all plumbing fixtures, plumbing systems, piping systems, and all fire protection systems as specified and as shown on the Plumbing and/or Fire Protection Drawings and all services and appurtenances incidental thereto.
- C. *Ductwork*. The term *ductwork* shall include ducts, fittings, flanges, dampers, insulation, hangers, supports, access doors, housings, and all other appurtenances comprising a complete and operable system.
 - Supply Air Ductwork. The term supply air ductwork shall mean for the purposes of these Contract Documents all ductwork carrying air from a fan or air handling unit to the room, space, or area to which it is introduced. The air may be conditioned or unconditioned. Supply air ductwork extends from the fan or air handling unit to all the diffusers, registers, and grilles.
 - 2. Return Air Ductwork. The term return air ductwork shall mean for the purposes of these Contract Documents all ductwork carrying air from a room, space, or area to a fan or air handling unit. Return air ductwork extends from the registers, grilles, or other return openings to the return fan (if used) and the air handling unit.
 - 3. Exhaust Air Ductwork. The term exhaust air ductwork shall mean for the purposes of these Contract Documents all ductwork carrying air from a room, space, area, or equipment to a fan and then discharged to the outdoors. Exhaust air ductwork extends from the registers, grilles, equipment, or other exhaust openings to the fan and from the fan to the outdoor discharge point.
 - 4. *Relief Air Ductwork*. The term *relief air ductwork* shall mean for the purposes of these Contract Documents all ductwork carrying air from a room, space, or area without the use of a fan or with the use of a return fan to be discharged to the outdoors. Relief air ductwork extends from the registers, grilles, or other relief openings to the outdoor discharge point or from the return fan discharge to the outdoor discharge point.
 - 5. Outside Air Ductwork. The term outside air ductwork shall mean for the purposes of these Contract Documents all ductwork carrying un-conditioned air from the outside to a fan or air handling unit. Outdoor air ductwork extends from the intake point or louver to the fan, air handling unit, or connection to the return air ductwork.
 - 6. *Mixed Air Ductwork*. The term *mixed air ductwork* shall mean for the purposes of these Contract Documents all ductwork carrying a mixture of return air and outdoor air. Mixed air ductwork extends from the point of connection of the return air and outdoor air ductwork to the fan or air handling unit.
 - 7. Supply Air Plenum. The term supply air plenum shall mean for the purposes of these Contract Documents all ductwork in which the discharges of multiple fans or air handling units connect forming a common supply header or all ductwork or ceiling con-

- struction forming a common supply box where supply air ductwork discharges into the box at limited locations for air distribution to supply diffusers which are directly connected to the plenum.
- 8. Return Air Plenum. The term return air plenum shall mean for the purposes of these Contract Documents all ductwork in which the suctions of multiple return fans or the discharges of multiple return fans connect forming a common suction or discharge return header or the space above the architectural ceiling and below the floor or roof structure used as return air ductwork.
- 9. Exhaust Air Plenum. The term exhaust air plenum shall mean for the purposes of these Contract Documents all ductwork in which the suctions of multiple exhaust fans or the discharges of multiple exhaust fans connect forming a common suction or discharge exhaust header or the ductwork formed around single or multiple exhaust air discharge openings or louvers to create a connection point for exhaust air ductwork.
- 10. *Relief Air Plenum*. The term *relief air plenum* shall mean for the purposes of these Contract Documents all ductwork in which multiple relief air ductwork connections are made forming a common relief air header.
- 11. Outdoor Air Plenum. The term outdoor air plenum shall mean for the purposes of these Contract Documents all ductwork in which the suctions of multiple fans or air handling units connect to form a common outside air header or the ductwork formed around single or multiple outside air openings or louvers to create a connection point for outside air ductwork.
- 12. *Mixed Air Plenum*. The term *mixed air plenum* shall mean for the purposes of these Contract Documents all ductwork in which multiple return air and multiple outdoor air ductwork connections are made forming a common mixed air header.
- 13. Vents, Flues, Stacks, and Breeching. The terms vents, flues, stacks, and breeching shall mean for the purposes of these Contract Documents ductwork conveying the products of combustion to atmosphere for safe discharge.
- D. *Piping*. The term *piping* shall include pipe, fittings, valves, flanges, unions, traps, drains, strainers, insulation, hangers, supports, and all other appurtenances comprising a complete and operable system.
- E. Wiring. The term wiring shall include wire, conduit, raceways, fittings, junction and outlet boxes, switches, cutouts, receptacles, and all other appurtenances comprising a complete and operable system.
- F. *Product.* The term *product* shall include materials, equipment, and systems for a complete and operable system.
- G. *Motor Controllers*. The term *motor controllers* shall be manual or magnetic starters (with or without switches), individual push buttons, or hand-off-automatic (HOA) switches controlling the operation of motors.
- H. Control Devices. The term control devices shall be automatic sensing and switching devices such as thermostats, float and electro-pneumatic switches controlling the operations of mechanical and electrical equipment.
- I. Work, Project. The terms work and project shall mean labor, operations, materials, supervision, services, machinery, equipment, tools, supplies, and facilities to be performed or provided including Work normally done at the location of the project to accomplish the requirements of the Contract including all alterations, amendments, or extensions to the Contract made by Change Order.

- J. Extra Work. The term extra work shall be any item of Work not provided for in the awarded Contract as previously modified by change order (change bulletin) or supplemental agreement, but which is either requested by the Owner or found by the Engineer to be necessary to complete the Work within the intended scope of the Contract as previously modified.
- K. Concealed. The term concealed shall mean hidden from normal sight; includes Work in crawl spaces, above ceilings, in chases, and in building shafts.
- L. Exposed. The term exposed shall mean not concealed.
- M. Below Ground. The term below ground shall mean installed under ground, buried in the earth, or buried below the ground floor slab.
- N. Above Ground. The term above ground shall mean not installed under ground, not buried in the earth, and not buried below the ground floor slab.
- O. Conditioned. The term Conditioned shall mean for the purposes of these Contract Documents rooms, spaces, or areas that are provided with mechanical heating and cooling.
- P. Un-Conditioned and Non-Conditioned. The terms un-conditioned and non-conditioned shall mean for the purposes of these Contract Documents rooms, spaces, or areas that are not provided with mechanical heating or cooling.
- Q. Heated. The term heated shall mean for the purposes of these Contract Documents rooms, spaces, or areas that are provided with mechanical heating only.
- R. Air Conditioned. The term air conditioned shall mean for the purposes of these Contract Documents rooms, spaces, or areas that are provided with mechanical cooling only.
- S. Unheated. The term unheated shall mean for the purposes of these Contract Documents rooms, spaces, or areas that are not provided with mechanical heating.
- T. Ventilated Spaces. The term ventilated spaces shall mean for the purposes of these Contract Documents rooms, spaces, or areas supplied with outdoor air on a continuous or intermittent basis. The outdoor air may be conditioned or unconditioned.
- U. Indoor. The term indoor shall mean for the purposes of these Contract Documents items or devices contained within the confines of a building, structure, or facility and items or devices which are not exposed to weather. The term indoor shall generally reference ductwork, piping, or equipment location (indoor ductwork, indoor piping, indoor equipment).
- V. *Outdoor.* The term *outdoor* shall mean for the purposes of these Contract Documents items or devices not contained within the confines of a building, structure, or facility and items or devices which are exposed to weather. The term *outdoor* shall generally reference to ductwork, piping, or equipment (outdoor ductwork, outdoor piping, outdoor equipment).
- W. Hot. The term hot shall mean for the purposes of these Contract Documents the temperature of conveyed solids, liquids, or gases which are above the surrounding ambient temperature or above 100°F. (hot supply air ductwork, heating water piping).

- X. Cold. The term cold shall mean for the purposes of these Contract Documents the temperature of conveyed solids, liquids, or gases which are below the surrounding ambient temperature or below 60°F. (cold supply air ductwork, chilled water piping).
- Y. Warm. The term warm shall mean for the purposes of these Contract Documents the temperature of conveyed solids, liquids, or gases which are at the surrounding ambient temperature or between 60°F. and 100°F. (condenser water piping).
- Z. Hot/Cold. The term hot/cold shall mean for the purposes of these Contract Documents the temperature of conveyed solids, liquids, or gases that can be either hot or cold depending on the season of the year (heating and air conditioning supply air ductwork, dual temperature piping systems).
- AA. Removable. The term removable shall mean detachable from the structure or system without physical alteration or disassembly of the materials or equipment or disturbance to other construction.
- BB. *Temporary Work*. Work provided by the Contractor for use during the performance of the Work, but which is to be removed prior to Final Acceptance.
- CC. Normally Closed (NC). The term normally closed shall mean the valve, damper, or other control device shall remain in or go to the closed position when the control air pressure, the control power or the control signal is removed. The position the device will assume when the control signal is removed.
- DD. Normally Open (NO). The term normally open shall mean that the valve, damper, or other control device shall remain in, or go to, the open position when the control air pressure, the control power, or the control signal is removed. The position the device will assume when the control signal is removed.
- EE. Traffic Level or Personnel Level. The term traffic level or personnel level shall mean for the purposes of these Contract Documents all areas, including process areas, equipment rooms, boiler rooms, chiller rooms, fan rooms, air handling unit rooms, and other areas where insulation may be damaged by normal activity and local personnel traffic. The area extends vertically from the walking surface to 8'-0" above walking surface and extends horizontally 5'-0" beyond the edge of walking surface. The walking surface shall include floors, walkways, platforms, catwalks, ladders, and stairs.

3.03 Contract Documents

- A. Contract Drawings. The terms contract drawings and drawings shall mean all drawings or reproductions of drawings pertaining to the construction or plans, sections, elevations, profiles, and details of the Work contemplated and its appurtenances.
- B. Contract Specifications. The terms contract specifications and specifications shall mean the description, provisions, and other requirements pertaining to the method and manner of performing the Work and to the quantities and qualities of materials to be furnished under the Contract. The specifications shall include the general provisions, the special provisions, and the technical specifications.

- C. Contract Documents. The term contract documents shall include Contract Drawings, Contract Specifications, Addendums, Change Orders, shop drawings, coordination drawings, General Provisions, Special Provisions, the executed Agreement and other items required or pertaining to the Contract including the executed Contract.
- D. Addendums. Addendums are issued as changes, amendments, or clarifications to the original or previously issued Contract Documents. Addendums are issued in written and/or drawing form prior to acceptance or signing of the Construction Contract.
- E. Change Orders (Change Bulletins). Change orders (change bulletins) are issued changes or amendments to the Contract Documents. Change orders are issued in written and/or drawing form after acceptance or signing of the Contract.
- F. Shop Drawings. The term shop drawings shall include drawings, diagrams, schedules, performance characteristics, charts, brochures, catalog cuts, calculations, certified drawings, and other materials prepared by the Contractor, Sub-Contractor, Manufacturer, or Distributor which illustrates some portion of the Work as per the requirements of the Contract Documents used by the Contractor to order, fabricate and install mechanical and electrical equipment and systems in a building.

The corrections or comments annotated on a shop drawing during the Engineer's review do not relieve the Contractor from full compliance with the Contract Documents regarding the Work. The Engineer's check is only a review of the shop drawing's general compliance with the information shown in the Contract Documents. The Contractor remains responsible for continuing the correlation of all material and component quantities and dimensions, coordination of the Contractor's Work with that of other trades, selection of suitable fabrication and installation techniques, and performance of Work in a safe and satisfactory manner.

- G. *Product Data.* Illustrations, standard schedules, performance charts, instructions, brochures, diagrams, and other information furnished by the Contractor to illustrate a material, product, or system for some portion of the Work.
- H. Samples. Physical examples which illustrate material, equipment, or workmanship and establish standards to which the Work will be judged.
- I. Coordination Drawings. The terms coordination drawings and composite drawings are drawings created by the respective Contractors showing Work of all Contractors superimposed on the sepia or mylar of the basic shop drawing of one of the Contractors to coordinate and verify that all Work in a congested area will fit in an acceptable manner.
- J. Contract. A set of documents issued by the Owner for the Work, which may include the Contract Documents, the Advertisement, Form of Proposal, Free Competitive Bidding Affidavit, Affidavit as to Taxes, Certification of Bidder, Buy America Requirements, Disadvantaged Business Enterprise Forms, Bid Bond, Agreement, Waiver of Right to File Mechanics Lien, Performance Bond, Labor and Materialman's Bond, Maintenance Bond(s), Certification Regarding Lobbying, Disclosure Form to Report Lobbying, and other forms that form part of the Contract as required by the Owner and the Contract Documents.

- K. Labor and Materialman's Bond. The approved form of security furnished by the Contractor and its Surety as a guaranty to pay promptly, or cause to be paid promptly, in full, such items as may be due for all material furnished, labor supplied or performed, rental of equipment used, and services rendered in connection with the Work.
- L. Maintenance Bond. The approved form of security furnished by the Contractor and its Surety as a guaranty on the part of the Contractor to remedy, without cost to the Owner, any defects in the Work which may develop during a period of twelve (12) months from the date of Substantial Completion.
- M. Performance Bond. The approved form of security furnished by the Contractor and its Surety as a guaranty on the part of the Contractor to execute the Work.
- N. Working Drawings. Drawings and calculations which are prepared by the Contractor, Sub-Contractor, Supplier, Distributor, etc., and which illustrate Work required for the construction of, but which will not become an integral part of, the Work. These shall include, but are not limited to, drawings showing Contractor's plans for Temporary Work such as decking, temporary bulkheads, support of excavation, support of utilities, groundwater control systems, forming and false-work, erection plans, and underpinning.
- O. Construction Drawings. Detailed drawings which are prepared by the Contractor, Sub-Contractor, Supplier, Distributor, etc., and which illustrate in exact and intricate detail, Work required for the construction Contract. These drawings often show hanger locations, vibration isolators, ductwork and pipe fittings, sections, dimensions of ducts and pipes, and other items required to construct the Work.
- P. Project Record Documents. A copy of all Contract Drawings, Shop Drawings, Working Drawings, Addendum, Change Orders, Contract Documents, and other data maintained by the Contractor during the Work. The Contractor's recording, on a set of prints, of accurate information and sketches regarding exact detail and location of the Work as actually installed, recording such information as exact location of all underground utilities, Contract changes, and Contract deviations. The Contractor's information is then transferred to the original Contract Documents by the Engineer for the Owner's permanent record unless otherwise directed or specified.
- Q. Proposal Guaranty. Cashier's check, certified check, or Bid Bond accompanying the Proposal submitted by the Bidder as a guaranty that the Bidder will enter into a Contract with the Owner for the performance of the Work indicated and file acceptable bonds and insurance if the Contract is awarded to it.
- R. *Project Schedule.* The schedule for the Work as prepared and maintained by the Contractor in accordance with the Contract Documents.
- S. Certificate of Substantial Completion. Certificate issued by the Owner or Engineer certifying that a substantial portion of the Work has been completed in accordance with the Contract Documents with the exception of contractual administrative demobilization work, inconsequential punch list items, and guarantees. The Certificate of Substantial Completion shall establish the Date of Substantial Completion, shall state the responsibilities of the Owner and the Contractor for security,

maintenance, heat, utilities, damage to the Work, and insurance, and shall fix the time within which the Contractor shall complete the items listed therein. Warranties required by the Contract Documents shall commence on the Date of Substantial Completion of the Work or designated portion thereof unless otherwise provided in the Certificate of Substantial Completion or the Contract Documents.

- T. Certificate of Final Completion (Final Acceptance). Certificate issued by the Owner or Engineer certifying that all of the Work has been completed in accordance with the Contract Documents to the best of the Owner's or Engineer's knowledge, information, and belief, and on the basis of that person's observations and inspections including contractual administrative demobilization work and all punch list items. The Certificate of Final Completion shall establish the Date of Owner acceptance. Warranties required by the Contract Documents shall commence on the Date of Final Completion of the Work unless otherwise provided in the Certificate of Substantial Completion or the Contract Documents.
- U. Acceptance Certificate. Certificate to be issued by the Owner or Engineer certifying that all the Work has been completed in accordance with the Contract Documents.
- V. Award. The acceptance by the Owner of the Bid from the responsible Bidder (sometimes the lowest responsible Bidder) as evidenced by the written Notice to Award to the Bidder tendering said bid.
- W. Bid (Proposal). The Proposal of the Bidder for the Work, submitted on the prescribed Bid Form, properly signed, dated, and guaranteed, including Alternates, the Unit Price Schedule, Bonds, and other bidding requirements as applicable.
- X. Certificate of Compliance. Certificate issued by the Supplier certifying that the material or equipment furnished is in compliance with the Contract Documents.
- Y. Agreement. The instrument executed by the Owner and the Contractor in conformance with the Contract Documents for the performance of the Work.
- Z. Field Order. A notice issued to the Contractor by the Engineer specifying an action required of the Contractor.
- AA. Request for Information (RFI). A notice issued to the Engineer or Owner requesting a clarification of the Contract Documents.
- BB. Notice to Proceed. A written notice from the Owner to the Contractor or Engineer directing the Contractor or Engineer to proceed with the work.
- CC. Advertisement, Invitation to Bid. The public or private announcement, as required by law or the Owner, inviting Bids for the Work to be performed, material to be furnished, or both.

3.04 Contractors/Manufacturers/Authorities

A. Contractor. The term contractor shall mean the individual, firm, partnership, corporation, joint venture, or any combination thereof or their duly authorized representatives who have executed a Contract with the client for the proposed Work.

- B. Sub-Contractor or Trade Contractor. The terms sub-contractor and trade contractor shall mean all the lower tier contractors, material suppliers, and distributors which have executed a contract with the Contractor for the proposed Work.
- C. Furnisher, Supplier. The terms furnisher and supplier shall be defined as the "entity" (individual, partnership, firm, corporation, joint venture, or any combination thereof) engaged by the Contractor, its Sub-Contractor, or Sub-Sub-Contractor, to furnish a particular unit of material or equipment to the project site. It shall be a requirement that the furnisher or supplier be experienced in the manufacture of the material or equipment they are to furnish.
- D. Installer. The term installer shall be defined as the "entity" (individual, partner-ship, firm, corporation, joint venture, or any combination thereof) engaged by the Contractor, its Sub-Contractor, or Sub-Sub-Contractor to install a particular unit of Work at the project site, including installation, erection, application, and similar required operations. It shall be a requirement that the installer be experienced in the operations they are engaged to perform.
- E. *Provider.* The term *provider* shall be defined as the "entity" (individual, partnership, firm, corporation, joint venture, or any combination thereof) engaged by the Contractor, its Sub-Contractor, or Sub-Sub-Contractor to provide a particular unit of material or equipment at the project site. It shall be a requirement that the provider be experienced in the operations they are engaged to perform.
- F. Bidder. An individual, firm, partnership, corporation, joint venture, or any combination thereof submitting a Bid for the Work as a single business entity and acting directly or through a duly authorized representative.
- G. Authority Having Jurisdiction. The term authority having jurisdiction shall mean federal, state, and/or local authorities or agencies thereof having jurisdiction over Work to which reference is made and authorities responsible for "approving" equipment, installation, and/or procedures.
- H. Surety. The corporate body which is bound with and for the Contractor for the satisfactory performance of the Work by the Contractor, and the prompt payment in full for materials, labor, equipment, rentals, and services, as provided in the bonds.
- I. Acceptable Manufacturers. The term acceptable manufacturers shall mean the specified list of manufacturers considered acceptable to bid the project for a specific piece of equipment. Only the equipment specified has been checked for spatial compatibility. If the Contractor elects to use an optional manufacturer from the acceptable manufacturers list in the specifications, it shall be the Contractor's responsibility to determine and ensure the spatial compatibility of the manufacturers equipment selected.

Professional Societies and Trade Organizations

ASQC

4.01 Professional Societies and Trade Organizations

Associated Air Balance Council AABC American Automatic Control Council AACC American Boiler Manufacturers' Association **ABMA ACCA** Air Conditioning Contractors of America American Conference of Governmental and Industrial Hygienists **ACGIH** American Concrete Institute ACI American Ceramic Society ACS American Chemical Society ACS American Congress on Surveying and Mapping **ACSM** American with Disabilities Act ADA ADA Accessibility Guidelines for Buildings and Facilities **ADAAG** Air Diffusion Council ADC Association of Energy Engineers AEE Architectural Engineering Institute AEI American Fan and Bearing Manufacturers' Association **AFBMA** AFS American Foundrymen's Society American Gas Association **AGA** American Gear Manufacturers Association **AGMA** American Institute of Architects AIA American Insurance Association AIA American Institute of Consulting Engineers AICE American Institute of Chemical Engineers **AIChE** American Industrial Hygiene Association AIHA American Institute of Industrial Engineers, Inc. AHE American Institute of Plant Engineers **AIPE** American Institute of Steel Construction **AISC** Association of Iron and Steel Engineers AISE American Iron and Steel Institute AISI Air Movement and Control Association International, Inc. **AMCA** American National Standards Institute **ANSI** Air Pollution Control Association **APCA APFA** American Pipe and Fittings Association American Public Health Association **APHA** American Petroleum Institute API **APWA** American Public Works Association ARI Air-Conditioning and Refrigeration Institute Acoustical Society of America ASA American Society of Civil Engineers ASCE American Society of Certified Engineering Technicians ASCET **ASEE** American Society for Engineering Education American Society of Heating, Refrigerating and Air Conditioning **ASHRAE** Engineers American Society of Lubricating Engineers ASLE American Society of Mechanical Engineers International ASME American Society for Non-Destructive Testing **ASNT** ASPE American Society of Plumbing Engineers

American Society of Quality Control, Inc.

ASSE American Society of Safety Engineers; American Society of Sanitary ASTM American Society for Testing and Materials Architectural and Transportation Barrier Compliance Board ATBCB **AWS** American Welding Society **AWWA** American Water Works Association, Inc. **BCMC** Board for the Coordination of Model Codes (a Board of CABO) BEPS **Building Energy Performance Standards BOCA Building Officials and Code Administrators** Basic/National Building, Mechanical, Plumbing, and Fire Codes **Building Research Institute** BRI British Standards Institute **BSI** Council of American Building Officials CABO CAGI Compressed Air and Gas Institute CANENA North American Electro/Technical Standards Harmonization Council Consulting Engineers Council of the United States CEC **CEN** European Standards Organization CENELEC European Committee for Electro/Technical Standardization **CGA** Compressed Gas Association, Inc. **CISPI** Cast Iron Soil Pipe Institute **CSA** Canadian Standards Association CSI **Construction Specifications Institute** CTI Cooling Tower Institute DER Department of Environmental Resources DOE Department of Energy Engineers' Council for Professional Development **ECPD** EF **Engineering Foundation EIC** Engineers' Joint Council Expansion Joint Manufacturers' Association EIMA **EPA Environmental Protection Agency ETL Testing Laboratories** ETL FM Factory Mutual System **FPS** Fluid Power Society HEI Heat Exchange Institute Hydraulic Institute HI Heat Transfer and Fluid Mechanics Institute HTFMI **Hydronics Institute** HYDI **IAPMO** International Association of Plumbing and Mechanical Officials IBR Institute of Boiler and Radiator Manufacturers' International Conference of Building Officials **ICBO** Uniform Building, Mechanical, Plumbing, and Fire Codes International Code Council (BOCA, CABO, ICBO, and SBCCI combined) **ICC** International Mechanical and Plumbing Codes

Institute for the Certification of Engineering technicians **ICET IEC** International Electro/Technical Commission

IEEE Institute of Electrical and Electronics Engineers

IES Illuminating Engineering Society

IESNA Illuminating Engineering Society of North America

IFCI International Fire Code Institute IFI Industrial Fasteners Institute

IIAR	International Institute of Ammonia Refrigeration
IRI	HSB Industrial Risk Insurers; Industrial Research Institute, Inc.
ISA	Instrument Society of America
ISO	International Organization for Standardization
MCAA	Mechanical Contractors Association of America
MSS	Manufacturers' Standardization Society of the Valve and Fittings Industry
NACE	National Association of Corrosion Engineers
NAE	National Academy of Engineering
NAIMA	North American Insulation Manufacturers Association
NAPE	National Association of Power Engineers, Inc.
NAPHCC	National Association of Plumbing-Heating-Cooling Contractors
NAS	National Academy of Sciences
NBFU	National Board of Fire Underwriters
NBS	National Bureau of Standards
NCEE	National Council of Engineering Examiners
NCPWB	National Certified Pipe Welding Bureau
NCSBCS	National Conference of States on Building Codes and Standards
NEBB	National Environmental Balancing Bureau
NEC	National Electric Code
NEMA	National Electrical Manufacturers' Association
NEMI	National Energy Management Institute
NFPA	National Fire Protection Association
NFSA	National Fire Sprinkler Association
NICE	National Institute of Ceramic Engineers
NICET	National Institute of Certified Engineering Technicians
NIOSH	National Institute for Occupational Safety and Health
NIST	National Institute of Standards and Technology
NRC	National Research Council
NRCA	National Roofing Contractors' Association
NRCC	National Research Council of Canada
NSAE	National Society of Architectural Engineers
NSF	National Sanitation Foundation International
NSPE	National Society of Professional Engineers
NUSIG	National Uniform Seismic Installation Guidelines
OSHA	Occupational Safety and Health Administration
PADER	Pennsylvania Department of Environmental Resources
PDI	Plumbing and Drainage Institute
PFI	Pipe Fabrication Institute
RESA	Scientific Research Society of America
SAE	Society of Automotive Engineers
SAME	Society of American Military Engineers
SAVE	Society of American Value Engineers
SBCCI	Southern Building Code Congress International;
	Southern/Standard Building, Mechanical, Plumbing, and Fire Codes
SES	Solar Energy Society
SFPE	Society of Fire Protection Engineers
SMACNA	Sheet Metal and Air Conditioning Contractors' National Association
SPE	Society of Plastics Engineers, Inc.
SSPC	Structural Steel Painting Council
SSPMA	Sump and Sewage Pump Manufacturers' Association

SWE Society of Women Engineers

TEMA Tubular Exchanger Manufacturers Association
TIMA Thermal Insulation Manufacturers' Association

UL Underwriters' Laboratories, Inc.
WPCF Water Pollution Control Federation

Equations

5.01 Cooling and Heating Equations

 $H_S = 1.08 \times CFM \times \Delta T$

 $H_S = 1.1 \times CFM \times \Delta T$

 $H_L = 0.68 \times CFM \times \Delta W_{GR}$

 $H_L = 4840 \times CFM \times \Delta W_{LB}$

 $H_T = 4.5 \times CFM \times \Delta h$

 $H_T = H_S + H_L$

 $H = U \times A \times \Delta T$

 $SHR = \frac{H_S}{H_T} = \frac{H_S}{H_S + H_L}$

 $LB. \ STM/HR = \frac{BTU/HR}{H_{FG}}$

H_S = Sensible Heat (Btu/Hr.) H_L = Latent Heat (Btu/Hr.)

 H_T = Total Heat (Btu/Hr.)

 ΔT = Temperature Difference (°F.)

 $\Delta W_{GR.}$ = Humidity Ratio Difference (Gr.H₂O/Lb.DA) $\Delta W_{LB.}$ = Humidity Ratio Difference (Lb.H₂O/Lb.DA)

 Δh = Enthalpy Difference (Btu/Lb.DA)

CFM = Air Flow Rate (Cubic Feet per Minute)

U = U-Value (Btu/Hr. Sq. Ft. °F.)

A = Area (Sq. Ft.) SHR = Sensible Heat Ratio

 H_{FG} = Latent Heat of Vaporization at Design Pressure (1989 ASHRAE

Fundamentals)

5.02 R-Values/U-Values

$$R = \frac{1}{C} = \frac{1}{K} \times Thickness$$

$$U = \frac{1}{\Sigma R}$$

R = R-Value (Hr. Sq. Ft. °F./Btu.)

U = U-Value (Btu./Hr. Sq. Ft. °F.)

C = Conductance (Btu./Hr. Sq. Ft. °F.)

K = Conductivity (Btu. In./Hr. Sq. Ft. °F.) $\Sigma R = Sum of the Individual R-Values$

5.03 Water System Equations

$$H = 500 \times GPM \times \Delta T$$

$$GPM_{EVAP} = \frac{TONS \times 24}{\Lambda T}$$

$$GPM_{COND.} = \frac{TONS \times 30}{\Lambda T}$$

H = Total Heat (Btu/Hr.)

GPM = Water Flow Rate (Gallons per Minute)

 ΔT = Temperature Difference (°F.) TONS = Air Conditioning Load (Tons)

GPM_{EVAP} = Evaporator Water Flow Rate (Gallons per Minute) GPM_{COND} = Condenser Water Flow Rate (Gallons per Minute)

5.04 Air Change Rate Equations

$$\frac{AC}{HR} = \frac{CFM \times 60}{VOLUME}$$

$$CFM = \frac{\frac{AC}{HR} \times VOLUME}{60}$$

AC/HR. = Air Change Rate per Hour

CFM = Air Flow Rate (Cubic Feet per Minute)

VOLUME = Space Volume (Cubic Feet)

5.05 Mixed Air Temperature

$$T_{\mathit{MA}} = \left(T_{\mathit{ROOM}} \times \frac{\mathit{CFM}_{\mathit{RA}}}{\mathit{CFM}_{\mathit{SA}}}\right) + \left(T_{\mathit{OA}} \times \frac{\mathit{CFM}_{\mathit{OA}}}{\mathit{CFM}_{\mathit{SA}}}\right)$$

$$T_{MA} = \left(T_{RA} \times \frac{CFM_{RA}}{CFM_{SA}}\right) + \left(T_{OA} \times \frac{CFM_{OA}}{CFM_{SA}}\right)$$

 $CFM_{SA} = Supply Air (CFM)$

 $CFM_{RA} = Return Air (CFM)$

 CFM_{OA} = Outside Air (CFM)

 T_{MA} = Mixed Air Temperature (°F)

 T_{ROOM} = Room Design Temperature (°F)

 T_{RA} = Return Air Temperature (°F)

 T_{OA} = Outside Air Temperature (°F)

5.06 Ductwork Equations

$$TP = SP + VP$$

$$VP = \left[\frac{V}{4005}\right]^2 = \frac{(V)^2}{(4005)^2}$$

$$V = \frac{Q}{A} = \frac{Q \times 144}{W \times H}$$

$$D_{EQ} = \frac{1.3 \times (A \times B)^{0.625}}{(A+B)^{0.25}}$$

TP = Total Pressure

SP = Static Pressure, Friction Losses VP = Velocity Pressure, Dynamic Losses

V = Velocity, Ft./Min.

Q = Flow through Duct (CFM) A = Area of Duct (Sq. Ft.) W = Width of Duct (Inches)

H = Height of Duct (Inches)

 D_{EQ} = Equivalent Round Duct Size for Rectangular Duct (Inches)

A = One Dimension of Rectangular Duct (Inches)
B = Adjacent Side of Rectangular Duct (Inches)

5.07 Fan Laws

$$\frac{CFM_2}{CFM_1} = \frac{RPM_2}{RPM_1}$$

$$\frac{SP_2}{SP_1} = \left[\frac{CFM_2}{CFM_1}\right]^2 = \left[\frac{RPM_2}{RPM_1}\right]^2$$

$$\frac{BHP_2}{BHP_1} = \left[\frac{CFM_2}{CFM_1}\right]^3 = \left[\frac{RPM_2}{RPM_1}\right]^3 = \left[\frac{SP_2}{SP_1}\right]^{1.5}$$

$$BHP = \frac{CFM \times SP \times SP.GR.}{6356 \times FAN_{EFE}}$$

$$MHP = \frac{BHP}{M/D_{EFE}}$$

CFM = Cubic Feet/Minute RPM = Revolutions/Minute

SP = In. W.G.

BHP = Break Horsepower

Fan Size = Constant Air Density = Constant

SP.GR. (Air) = 1.0

 $\begin{array}{lll} {\rm FAN_{EFE}} & = & 65\text{--}85\% \\ {\rm M/D_{EFE}} & = & 80\text{--}95\% \\ {\rm M/D} & = & {\rm Motor/Drive} \end{array}$

5.08 Pump Laws

$$\frac{GPM_2}{GPM_1} = \frac{RPM_2}{RPM_1}$$

$$\frac{HD_2}{HD_1} = \left[\frac{GPM_2}{GPM_1}\right]^2 = \left[\frac{RPM_2}{RPM_1}\right]^2$$

$$\frac{BHP_2}{BHP_1} = \left[\frac{GPM_2}{GPM_1}\right]^3 = \left[\frac{RPM_2}{RPM_1}\right]^3 = \left[\frac{HD_2}{HD_1}\right]^{1.5}$$

$$GPM \times HD \times SPGR$$

$$BHP = \frac{GPM \times HD \times SP.GR.}{3960 \times PUMP_{EFE}}$$

$$MHP = \frac{BHP}{M/D_{EFE}}$$

$$VH = \frac{V^2}{2g}$$

$$HD = \frac{P \times 2.31}{SP.GR.}$$

GPM = Gallons/Minute RPM = Revolutions/Minute

 $HD = Ft. H_2O$

BHP = Break Horsepower

Pump Size = Constant Water Density = Constant

SP.GR. = Specific Gravity of Liquid with Respect to Water

g = Acceleration due to Gravity $(32.16 \text{ Ft./Sec}^2)$

5.09 Pump Net Positive Suction Head (NPSH) Calculations

 $NPSH_{AVAIL} > NPSH_{REQ'D}$

$$NPSH_{AVAIL} = H_A \pm H_S - H_F - H_{VP}$$

NPSH_{AVAIL} = Net Positive Suction Available at Pump (Feet) NPSH_{REO'D} = Net Positive Suction Required at Pump (Feet)

H_A = Pressure at Liquid Surface (Feet—34 Feet for Water at Atmospheric

Pressure)

 H_s = Height of Liquid Surface Above (+) or Below (-) Pump (Feet)

 H_F = Friction Loss between Pump and Source (Feet)

 H_{VP} = Absolute Pressure of Water Vapor at Liquid Temperature (Feet—1989)

ASHRAE Fundamentals)

5.10 Air Conditioning Condensate

$$GPM_{AC\ COND} = \frac{CFM \times \Delta W_{LB.}}{SpV \times 8.33}$$

$$GPM_{AC\ COND} = \frac{CFM \times \Delta W_{GR.}}{SpV \times 8.33 \times 7000}$$

GPM_{AC COND} = Air Conditioning Condensate Flow (Gallons/Minute)

CFM = Air Flow Rate (Cu.Ft./Minute)

SpV = Specific Volume of Air (Cu.Ft./Lb.DA)

 ΔW_{LB} = Specific Humidity (Lb.H₂O/Lb.DA) ΔW_{GR} = Specific Humidity (Gr.H₂O/Lb.DA)

5.11 Humidification

$$GRAINS_{REQ'D} = \left(\frac{W_{GR}}{SpV}\right)_{ROOMAIR} - \left(\frac{W_{GR}}{SpV}\right)_{SUPPLYAIR}$$

$$POUNDS_{REQ'D} = \left(\frac{W_{LB.}}{SpV}\right)_{ROOMAIR} - \left(\frac{W_{LB.}}{SpV}\right)_{SUPPLYAIR}$$

LB.
$$STM/HR = \frac{CFM \times GRAINS_{REQD} \times 60}{7000} = CFM \times POUNDS_{REQD} \times 60$$

GRAINS_{REQD} = Grains of Moisture Required (Gr.H₂O/Cu.Ft.) POUNDS_{REQD} = Pounds of Moisture Required (Lb.H₂O/Cu.Ft.)

CFM = Air Flow Rate (Cu.Ft./Minute)

SpV = Specific Volume of Air (Cu.Ft./Lb.DA)

 $W_{GR.}$ = Specific Humidity (Gr.H₂O/Lb.DA) $W_{LB.}$ = Specific Humidity (Lb.H₂O/Lb.DA)

5.12 Humidifier Sensible Heat Gain

$$H_{S} = (0.244 \times Q \times \Delta T) + (L \times 380)$$

 H_S = Sensible Heat Gain (Btu/Hr.)

Q = Steam Flow (Lb.Steam/Hr.)

 ΔT = Steam Temperature – Supply Air Temperature (F.)

L = Length of Humidifier Manifold (Ft.)

5.13 Expansion Tanks

$$CLOSED \ V_T = V_S \times \frac{\left[\left(\frac{\mathbf{V}_2}{\mathbf{V}_1} \right) - 1 \right] - 3\alpha\Delta T}{\left[\frac{P_A}{P_1} - \frac{P_A}{P_2} \right]}$$

OPEN
$$V_T = 2 \times \left\{ \left(V_S \times \left[\left(\frac{\mathbf{v}_2}{\mathbf{v}_1} \right) - 1 \right] \right) - 3\alpha \Delta T \right\}$$

DIAPHRAGM
$$V_T = V_S \times \frac{\left[\left(\frac{\mathbf{v}_2}{\mathbf{v}_1}\right) - 1\right] - 3\alpha\Delta T}{1 - \left(\frac{P_1}{P_2}\right)}$$

Equations 41

 V_T = Volume of Expansion Tank (Gallons)

 V_s = Volume of Water in Piping System (Gallons)

 $\Delta T = T_2 - T_1 (^{\circ}F)$

 T_1 = Lower System Temperature (°F)

Heating Water $T_1 = 45-50^{\circ}F$ Temperature at Fill Condi-

tion

Chilled Water T_1 = Supply Water Temperature

Dual Temperature $T_1 = Chilled Water Supply Temperature$

 T_2 = Higher System Temperature (°F)

Heating Water T_2 = Supply Water Temperature

Chilled Water $T_2 = 95^{\circ}F$ Ambient Temperature (Design

Weather Data)

Dual Temperature T_2 = Heating Water Supply Temperature P_A = Atmospheric Pressure (14.7 Psia)

P₁ = System Fill Pressure/Minimum System Pressure (Psia)

P₂ = System Operating Pressure/Maximum Operating Pressure (Psia)

V₁ = SpV of H₂O at T₁ (Cu. Ft./Lb.H₂O) 1989 ASHRAE Fundamentals, Chapter 2, Table 25 or Part 27, Properties of Air and Water

V₂ = SpV of H₂O at T₂ (Cu. Ft./Lb.H₂O) 1989 ASHRAE Fundamentals, Chapter 2, Table 26 or Part 27, Properties of Air and Water

 α = Linear Coefficient of Expansion

 $\alpha_{\text{STEEL}} = 6.5 \times 10^{-6}$

 $\alpha_{COPPER} = 9.5 \times 10^{-6}$

System Volume Estimate:

12 Gal./Ton

35 Gal./BHP

System Fill Pressure/Minimum System Pressure Estimate:

Height of System +5 to 10 Psi OR 5–10 Psi, whichever is greater.

System Operating Pressure/Maximum Operating Pressure Estimate:

150 Lb. Systems 45–125 Psi

250 Lb. Systems 125-225 Psi

5.14 Air Balance Equations

SA = Supply Air

RA = Return Air

OA = Outside Air

EA = Exhaust Air

RFA = Relief Air

SA = RA + OA = RA + EA + RFA

If minimum OA (ventilation air) is greater than EA, then

OA = EA + RFA

If EA is greater than minimum OA (ventilation air), then

OA = EA RFA = 0

For Economizer Cycle

OA = SA = EA + RFA RA = 0

5.15 Efficiencies

$$COP = \frac{BTU\ OUTPUT}{BTU\ INPUT} = \frac{EER}{3.413}$$

$$EER = \frac{BTU\ OUTPUT}{2000}$$

Turndown Ratio = Maximum Firing Rate: Minimum Firing Rate (i.e., 5:1, 10:1, 25:1)

$$OVERALL\ THERMAL\ EFF. = \frac{GROSS\ BTU\ OUTPUT}{GROSS\ BTU\ INPUT} \times 100\%$$

$$COMBUSTION\ EFF. = \frac{BTU\ INPUT-BTU\ STACK\ LOSS}{BTU\ INPUT} \times 100\%$$

Overall Thermal Efficiency Range 75%–90% Combustion Efficiency Range 85%–95%

5.16 Cooling Towers and Heat Exchangers

$$APPROACH_{CT'S} = LWT - AWB$$

$$APPROACH_{HE'S} = EWT_{HS} - LWT_{CS}$$

$$RANGE = EWT - LWT$$

EWT = Entering Water Temperature (°F) LWT = Leaving Water Temperature (°F)

AWB = Ambient Wet Bulb Temperature (Design WB, °F)

HS = Hot Side CS = Cold Side

5.17 Moisture Condensation on Glass

$$\begin{split} T_{GLASS} &= T_{ROOM} - \left[\frac{R_{IA}}{R_{GLASS}} \times (T_{ROOM} - T_{OA}) \right] \\ T_{GLASS} &= T_{ROOM} - \left[\frac{U_{GLASS}}{U_{IA}} \times (T_{ROOM} - T_{OA}) \right] \end{split}$$

If $T_{GLASS} < DP_{ROOM}$ Condensation Occurs

T = Temperature (°F.)

R = R-Value (Hr. Sq.Ft. °F./Btu.)

U = U-Value (Btu./Hr. Sq.Ft. °F.)

IA = Inside Airfilm

OA = Design Outside Air Temperature

DP = Dew Point

5.18 Electricity

$$KVA = KW + KVAR$$

KVA = Total Power (Kilovolt Amps)

KW = Real Power, Electrical Energy (Kilowatts)

KVAR = Reactive Power or "Imaginary" Power (Kilovolt Amps Reactive)

V = Voltage (Volts) A = Current (Amps)

PF = Power Factor (0.75-0.95)

BHP = Break Horsepower MHP = Motor Horsepower

EFF = Efficiency M/D = Motor Drive

A. Single Phase Power:

$$KW_{1\phi} = \frac{V \times A \times PF}{1000}$$

$$KVA_{1\phi} = \frac{V \times A}{1000}$$

$$BHP_{1\phi} = \frac{V \times A \times PF \times DEVICE_{EFE}}{746}$$

$$MHP_{1\phi} = \frac{BHP_{1\phi}}{M/D_{EFF}}$$

B. 3-Phase Power:

$$KW_{3\phi} = \frac{\sqrt{3} \times V \times A \times PF}{1000}$$

$$KVA_{3\phi} = \frac{\sqrt{3} \times V \times A}{1000}$$

$$BHP_{3\phi} = \frac{\sqrt{3} \times V \times A \times PF \times DEVICE_{EFE}}{746}$$

$$MHP_{3\phi} = \frac{BHP_{3\phi}}{M/D_{EFE}}$$

5.19 Calculating Heating Loads for Loading Docks, Heavily Used Vestibules and Similar Spaces.

- A. Find volume of space to be heated (Cu.Ft.).
- B. Determine acceptable warm-up time for space (Min.).
- C. Divide volume by time (CFM).
- D. Determine inside and outside design temperatures—assume inside space temperature has dropped to the outside design temperature because doors have been open for an extended period of time.
- E. Use sensible heat equation to determine heating requirement using CFM and inside and outside design temperatures determined above.

5.20 Ventilation of Mechanical Rooms with Refrigeration Equipment

A. For a more detailed description of ventilation requirements for mechanical rooms with refrigeration equipment see ASHRAE Standard 15 and Part 9, Ventilation Rules of Thumb.

B. Completely Enclosed Equipment Rooms:

$$CFM = 100 \times G^{0.5}$$

CFM = Exhaust Air Flow Rate Required (Cu.Ft./Minute)

G = Mass of Refrigerant of Largest System (Pounds)

C. Partially Enclosed Equipment Rooms:

$$FA = G^{0.5}$$

FA = Ventilation Free Opening Area (Sq.Ft.)

G = Mass of Refrigerant of Largest System (Pounds)

5.21 Equations for Flat Oval Ductwork

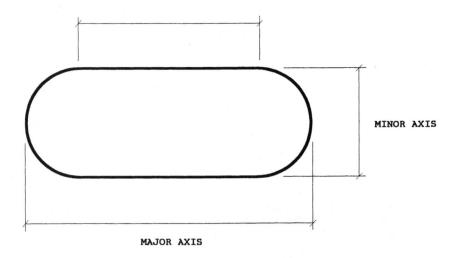

$$FS = MAJOR - MINOR$$

$$A = \frac{(FS \times MINOR) + \frac{(\pi \times MINOR^2)}{4}}{144}$$

$$P = \frac{(\pi \times MINOR) + (2 \times FS)}{12}$$

$$D_{EQ} = \frac{1.55 \times (A)^{0.625}}{(P)^{0.25}}$$

FS = Flat Span Dimension (Inches)

MAJOR = Major Axis Dimension [Inches (Larger Dimension)] MINOR = Minor Axis Dimension [Inches (Smaller Dimension)]

A = Cross-Sectional Area (Square Feet)

P = Perimeter or Surface Area (Square Feet per Lineal Feet)

 D_{EQ} = Equivalent Round Duct Diameter

5.22 Pipe Expansion Equations

A. L-Bends:

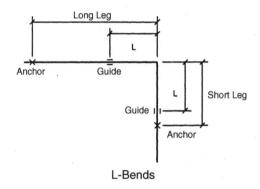

$$L = 6.225 \times \sqrt{\Delta D}$$

 $F = 500 LB./PIPE DIA. \times PIPE DIA.$

L = Length of Leg Required to Accommodate Thermal Expansion or Contraction (Feet)

 Δ = Thermal Expansion or Contraction of Long Leg (Inches)

D = Pipe Outside Diameter (Inches)

F = Force Exerted by Pipe Expansion or Contraction on Anchors and Supports (Lbs.)

See Tables in Part 32, Appendix D

B. Z-Bends:

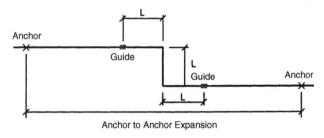

Z-Bends

$$L = 4 \times \sqrt{\Delta D}$$

 $F = 200 - 500 LB./PIPE DIA. \times PIPE DIA.$

L = Length of Offset Leg Required to Accommodate Thermal Expansion or Contraction (Feet)

 Δ = Anchor to Anchor Expansion or Contraction (Inches)

D = Pipe Outside Diameter (Inches)

F = Force Exerted by Pipe Expansion or Contraction on Anchors and Supports (Lbs.)

See Tables in Part 32, Appendix D.

C. U-Bends or Expansion Loops:

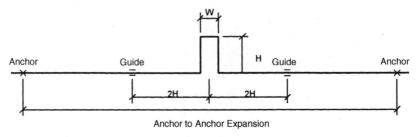

U-Bends or Loops

$$L = 6.225 \times \sqrt{\Delta D}$$

 $F = 200 LB./PIPE DIA. \times PIPE DIA.$

$$L = 2H + W$$

H = 2W

L = 5W

L = Length of Loop Required to Accommodate Thermal Expansion or Contraction (Feet)

 Δ = Anchor to Anchor Expansion or Contraction (Inches)

D = Pipe Outside Diameter (Inches)

F = Force Exerted by Pipe Expansion or Contraction on Anchors and Supports (Lbs.)

See Tables in Part 32, Appendix D.

5.23 Steam and Condensate Equations

A. General:

LBS. STM./HR. =
$$\frac{BTU/HR.}{960}$$

LB. STM. COND./HR. =
$$\frac{EDR}{4}$$

$$EDR = \frac{BTU/HR.}{240}$$

LB. STM. COND./HR. =
$$\frac{GPM \times 500 \times SP.GR. \times C_p \times \Delta T}{I}$$

LB. STM. COND./HR. =
$$\frac{CFM \times 60 \times D \times C_P \times \Delta T}{L}$$

B. Approximating Condensate Loads:

LB. STM. COND./HR. =
$$\frac{GPM(WATER) \times \Delta T}{2}$$

LB. STM. COND./HR. =
$$\frac{GPM(FUEL\ OIL) \times \Delta T}{4}$$

LB. STM. COND./HR. =
$$\frac{CFM(AIR) \times \Delta T}{900}$$

STM. = Steam

GPM = Quantity of Liquid (Gallons per Minute)

CFM = Quantity of Gas or Air (Cubic Feet per Minute)

SP.GR. = Specific Gravity

D = Density (Lbs./Cubic Feet)

C_P = Specific Heat of Gas or Liquid (Btu/Lb)

Air $C_P = 0.24$ Btu/Lb Water $C_P = 1.00$ Btu/Lb

L = Latent Heat of Steam (Btu/Lb. at Steam Design Pressure)

 ΔT = Final Temperature minus Initial Temperature

EDR = Equivalent Direct Radiation

5.24 Steam and Steam Condensate Pipe Sizing Equations

A. Steam Pipe Sizing Equations:

$$\Delta P = \frac{(0.01306) \times W^2 \times \left(1 + \frac{3.6}{1D}\right)}{3600 \times D \times 1D^5}$$

$$W = 60 \times \sqrt{\frac{\Delta P \times D \times ID^5}{0.01306 \times \left(1 + \frac{3.6}{ID}\right)}}$$

$$W = 0.41667 \times V \times A_{INCHES} \times D = 60 \times V \times A_{FEET} \times D$$

$$V = \frac{2.4 \times W}{A_{INCHES} \times D} = \frac{W}{60 \times A_{FEET} \times D}$$

ΔP Pressure Drop per 100 Feet of Pipe (Psig/100 feet)

W Steam Flow Rate (Lbs./Hour)

ID Actual Inside Diameter of Pipe (Inches)

D Average Density of Steam at System Pressure (Lbs./Cu. Ft.)

V Velocity of Steam in Pipe (Feet/Minute)

 $\begin{array}{ll} A_{INCHES} & Actual \ Cross \ Sectional \ Area \ of \ Pipe \ (Square \ Inches) \\ A_{FEET} & Actual \ Cross \ Sectional \ Area \ of \ Pipe \ (Square \ Feet) \end{array}$

B. Steam Condensate Pipe Sizing Equations:

$$FS = \frac{H_{S_{SS}} - H_{S_{CR}}}{H_{L_{CR}}} \times 100$$

$$W_{CR} = \frac{FS}{100} \times W$$

FS Flash Steam (Percentage %)

H_{SSS} Sensible Heat at Steam Supply Pressure (Btu/Lb.)

H_{SCR} Sensible Heat at Condensate Return Pressure (Btu/Lb.)

H_{LCR} Latent Heat at Condensate Return Pressure (Btu/Lb.)

W Steam Flow Rate (Lbs./Hr.)

W_{CR} Condensate Flow based on percentage of Flash Steam created during condensing process (Lbs./Hr.). Use this flow rate in steam equations above to determine condensate return pipe size.

5.25 Psychrometric Equations

$$W = 0.622 \times \frac{P_W}{P - P_W}$$

$$RH = \frac{W_{ACTUAL}}{W_{SAT}} \times 100\%$$

$$RH = \frac{P_W}{P_{SAT}} \times 100\%$$

$$H_S = m \times c_P \times \Delta T$$

$$H_L = L_V \times m \times \Delta W$$

$$H_T = m \times \Delta h$$

$$W = \frac{(2501 - 2.381 \ T_{WB})(W_{SAT \ WB}) - (T_{DB} - T_{WB})}{(2501 + 1.805 \ T_{DB} - 4.186 \ T_{WB})}$$

$$W = \frac{(1093 - 0.556 \ T_{WB})(W_{SATWB}) - (0.240)(T_{DB} - T_{WB})}{(1093 + 0.444 \ T_{DB} - T_{WB})}$$

W = Specific Humidity (Lb. $H_2O/Lb.DA$ or $Gr.H_2O/Lb.DA$)

W_{ACTUAL} = Actual Specific Humidity (Lb.H₂O/Lb.DA or Gr.H₂O/Lb.DA) W_{SAT} = Saturation Specific Humidity at the Dry Bulb Temperature

W_{SAT WB} = Saturation Specific Humidity at the Wet Bulb Temperature

P_W = Partial Pressure of Water Vapor (Lb./Sq.Ft.) P = Total Absolute Pressure of Air/Water Vapor Mixture (Lb./Sq.Ft.)

P_{SAT} = Saturation Partial Pressure of Water Vapor at the Dry Bulb Temperature

(Lb./Sq.Ft.)

 $\begin{array}{lll} RH & = & Relative \ Humidity \ (\%) \\ H_S & = & Sensible \ Heat \ (Btu/Hr.) \\ H_L & = & Latent \ Heat \ (Btu/Hr.) \\ H_T & = & Total \ Heat \ (Btu/Hr.) \end{array}$

m = Mass Flow Rate (Lb.DA/Hr. or Lb. H_2O/Hr .)

c_P = Specific Heat (Air: 0.24 Btu/Lb.DA, Water: 1.0 Btu/Lb.H₂O)

 T_{DB} = Dry Bulb Temperature (°F.) T_{WB} = Wet Bulb Temperature (°F.) ΔT = Temperature Difference (°F.)

 ΔW = Specific Humidity Difference (Lb.H₂O/Lb.DA or Gr.H₂O/Lb.DA)

 Δh = Enthalpy Difference (Btu/Lb.DA)

L_v = Latent Heat of Vaporization (Btu/Lb.H₂O)

5.26 Swimming Pools

A. Sizing Outdoor Pool Heater:

- Determine pool capacity in gallons. Obtain from Architect if available.
 Length × Width × Depth × 7.5 Gal/Cu.Ft. (If depth is not known assume an average depth 5.5 Feet)
- 2. Determine heat pick-up time in hours from Owner.
- Determine pool water temperature in degrees F. from the Owner. If Owner does not specify assume 80°F.
- 4. Determine the average air temperature on the coldest month in which the pool will be used.
- 5. Determine the average wind velocity in miles per hour. For pools less than 900 square feet and where the pool is sheltered by nearby buildings, fences, shrubs, etc., from the prevailing wind an average wind velocity of less than 3.5 mph may be assumed. The surface heat loss factor of 5.5 Btu/Hr/Sq.Ft.°F. in the equation below assumes a wind velocity of 3.5 mph. If a wind velocity of less than 3.5 mph is used, multiply equation by 0.75; for 5.0 mph multiply equation by 1.25; and for 10 mph multiply equation by 2.0.
- 6. Pool Heater Equations:

$$H_{POOL\ HEATER} = H_{HEAT-UP} + H_{SURFACE\ LOSS}$$

$$H_{\textit{HEAT-UP}} = \frac{\textit{GALS.} \times 8.34 \; \textit{LBS./GAL.} \times \Delta T_{\textit{WATER}} \times 1.0 \; \textit{BTU/LB.}^{\circ}\textit{F.}}{\textit{HEAT PICK-UP TIME}}$$

$$H_{SURFACE\ LOSS} = 5.5\ BTU/HR.\ SQ.\ FT.\ ^\circ F. \times \Delta T_{WATER/AIR} \times POOL\ AREA$$

$$\Delta T_{W\!ATER} = T_{F\!I\!N\!AL} - T_{I\!N\!I\!T\!I\!AL}$$

$$T_{FINAL} = POOL WATER TEMPERATURE$$

$$T_{INITIAL} = 50 \, ^{\circ}\text{F}$$

$$\Delta T_{WATER/AIR} = T_{FINAL} - T_{AVERAGE\,AIR}$$

H = Heating Capacity (Btu/Hr.)

 ΔT = Temperature Difference (°F.)

5.27 Domestic Water Heater Sizing

$$\begin{split} H_{OUTPUT} &= GPH \times 8.34 \; LBS./GAL. \times \Delta T \times 1.0 \\ H_{INPUT} &= \frac{GPH \times 8.34 \; LBS./GAL. \times \Delta T}{\% \; EFFICIENCY} \end{split}$$

$$GPH = \frac{H_{INPUT} \times \% \; EFFICIENCY}{\Delta T \times 8.34 \; LBS./GAL.} = \frac{KW \times 3413 \; BTU/KW}{\Delta T \times 8.34 \; LBS./GAL.}$$

$$\Delta T = \frac{H_{INPUT} \times \% \; EFFICIENCY}{GPH \times 8.34 \; LBS./GAL.} = \frac{KW \times 3413 \; BTU/KW}{GPH \times 8.34 \; LBS./GAL.}$$

$$KW = \frac{GPH \times 8.34 \; LBS./GAL. \times \Delta T \times 1.0}{3413 \; BTU/KW}$$

% COLD WATER =
$$\frac{T_{HOT} - T_{MIX}}{T_{HOT} - T_{COLD}}$$

% HOT WATER =
$$\frac{T_{MIX} - T_{COLD}}{T_{HOT} - T_{COLD}}$$

 H_{OUTPUT} = Heating Capacity, Output H_{INPUT} = Heating Capacity, Input

GPH = Recovery Rate (Gallons per Hour)

 ΔT = Temperature Rise (°F.)

KW = Kilowatts

 T_{COLD} = Temperature, Cold Water (°F.) T_{HOT} = Temperature, Hot Water (°F.) T_{MIX} = Temperature, Mixed Water (°F.)

5.28 Domestic Hot Water Recirculation Pump/Supply Sizing

- A. Determine the approximate total length of all hot water supply and return piping.
- B. Multiply this total length by 30 Btu/Ft. for insulated pipe and 60 Btu/Ft. for uninsulated pipe to obtain the approximate heat loss.
- C. Divide the total heat loss by 10,000 to obtain the total pump capacity in GPM.
- D. Select a circulating pump to provide the total required GPM and obtain the head created at this flow.
- E. Multiply the head by 100 and divide by the total length of the longest run of the hot water return piping to determine the allowable friction loss per 100 feet of pipe.
- F. Determine the required GPM in each circulating loop and size the hot water return pipe based on this GPM and the allowable friction loss as determined above.

5.29 Relief Valve Vent Line Maximum Length

$$L = \frac{9 \times P_1^2 \times D^5}{C^2} = \frac{9 \times P_2^2 \times D^5}{16 \times C^2}$$

 $P_1 = 0.25 \times [(PRESSURE\ SETTING \times 1.1) + 14.7]$

 $P_2 = [(PRESSURE\ SETTING \times 1.1) + 14.7]$

L = Maximum Length of Relief Vent Line (Feet)

D = Inside Diameter of Pipe (Inches)

C = Minimum Discharge of Air (Lbs./Min.)

5.30 Relief Valve Sizing

A. Liquid System Relief Valves and Spring Style Relief Valves:

$$A = \frac{GPM \times \sqrt{G}}{28.14 \times K_B \times K_V \times \sqrt{\Delta P}}$$

B. Liquid System Relief Valves and Pilot Operated Relief Valves:

$$A = \frac{GPM \times \sqrt{G}}{36.81 \times K_V \times \sqrt{\Delta P}}$$

C. Steam System Relief Valves:

$$A = \frac{W}{51.5 \times K \times P \times K_{SH} \times K_N \times K_R}$$

D. Gas and Vapor System Relief Valves (Lb./Hr.):

$$A = \frac{W \times \sqrt{TZ}}{C \times K \times P \times K_B \times \sqrt{M}}$$

E. Gas and Vapor System Relief Valves (SCFM):

$$A = \frac{SCFM \times \sqrt{TGZ}}{1.175 \times C \times K \times P \times K_B}$$

F. Relief Valve Equation Definitions:

- 1. A = Minimum Required Effective Relief Valve Discharge Area (Square Inches)
- 2. GPM = Required Relieving Capacity at Flow Conditions (Gallons per Minute)
- 3. W = Required Relieving Capacity at Flow Conditions (Lbs./Hr.)
- 4. SCFM = Required Relieving Capacity at Flow Conditions (Standard Cubic Feet per Minute)
- 5. G = Specific Gravity of Liquid, Gas, or Vapor at Flow Conditions Water = 1.0 for most HVAC Applications
 - Air = 1.0
- 6. C = Coefficient Determined from Expression of Ratio of Specific Heats
 C = 315 if Value is Unknown
- 7. K = Effective Coefficient of Discharge
 - K = 0.975
- 8. K_B = Capacity Correction Factor Due to Back Pressure K_B = 1.0 for Atmospheric Discharge Systems
- 9. K_V = Flow Correction Factor Due to Viscosity
 - $K_V = 0.9$ to 1.0 for most HVAC Applications with Water
- 10. K_N = Capacity Correction Factor for Dry Saturated Steam at Set Pressures above 1500 Psia and up to 3200 Psia
 - K_N = 1.0 for most HVAC Applications
 Capacity Correction Factor Due to the Degree of Superheat
- 11. K_{SH} = Capacity Correction Factor Due t K_{SH} = 1.0 for Saturated Steam
- 12. Z = Compressibility Factor
- Z = 1.0 If Value is Unknown
- 13. P = Relieving Pressure (Psia)
 P = Set Pressure (Psig) + Over Pressure (10% Psig) + Atmospheric
 Pressure (14.7 Psia)
- 14. ΔP = Differential Pressure (Psig) ΔP = Set Pressure (Psig) + Over Pressure (10% Psig) - Back Pressure (Psig)
- 15. T = Absolute Temperature (${}^{\circ}R = {}^{\circ}F. + 460$)
- 16. M = Molecular Weight of the Gas or Vapor

G. Relief Valve Sizing Notes:

1. When multiple relief valves are used, one valve shall be set at or below the maximum allowable working pressure, and the remaining valves may be set up to 5 percent over the maximum allowable working pressure.

2. When sizing multiple relief valves, the total area required is calculated on an over-pressure of 16 percent or 4 Psi, whichever is greater.

3. For superheated steam, the correction factor values listed below may be used:

a. Superheat up to 400 °F.:

0.97 (Range 0.979-0.998)

b. Superheat up to 450 °F.:

0.95 (Range 0.957–0.977)

c. Superheat up to 500 °F.:

0.93 (Range 0.930-0.968)

GAS OR VAPOR	MOLECULAR	RATIO OF	COEFFICIENT	SPECIFIC
	WEIGHT	SPECIFIC HEATS	C	GRAVITY
Acetylene	26.04	1.25	342	0.899
Air	28.97	1.40	356	1.000
Ammonia (R-717)	17.03	1.30	347	0.588
Argon	39.94	1.66	377	1.379
Benzene	78.11	1.12	329	2.696
N-Butane	58.12	1.18	335	2.006
Iso-Butane	58.12	1.19	336	2.006
Carbon Dioxide	44.01	1.29	346	1.519
Carbon Disulphide	76.13	1.21	338	2.628
Carbon Monoxide	28.01	1.40	356	0.967
Chlorine	70.90	1.35	352	2.447
Cyclohexane	84.16	1.08	325	2.905
Ethane	30.07	1.19	336	1.038
Ethyl Alcohol	46.07	1.13	330	1.590
Ethyl Chloride	64.52	1.19	336	2.227
Ethylene	28.03	1.24	341	0.968
Helium	4.02	1.66	377	0.139
N-Heptane	100.20	1.05	321	3.459
Hexane	86.17	1.06	322	2.974
Hydrochloric Acid	36.47	1.41	357	1.259
Hydrogen	2.02	1.41	357	0.070
Hydrogen Chloride	36.47	1.41	357	1.259
Hydrogen Sulphide	34.08	1.32	349	1.176
Methane	16.04	1.31	348	0.554
Methyl Alcohol	32.04	1.20	337	1.106
Methyl Butane	72.15	1.08	325	2.491
Methyl Chloride	50.49	1.20	337	1.743
Natural Gas	19.00	1.27	344	0.656
Nitric Oxide	30.00	1.40	356	1.036
Nitrogen	28.02	1.40	356	0.967
Nitrous Oxide	44.02	1.31	348	1.520
N-Octane	114.22	1.05	321	3.943
Oxygen	32.00	1.40	356	1.105
N-Pentane	72.15	1.08	325	2.491
Iso-Pentane	72.15	1.08	325	2.491
Propane	44.09	1.13	330	1.522
R-11	137.37	1.14	331	4.742
R-12	120.92	1.14	331	4.174
R-22	86.48	1.18	335	2.985
R-114	170.93	1.09	326	5.900
R-123	152.93	1.10	327	5.279
R-134a	102.03	1.20	337	3.522
Sulfur Dioxide	64.04	1.27	344	2.211
Toluene	92.13	1.09	326	3.180

d. Superheat up to 550 °F.: 0.90 (Range 0.905-0.974) e. Superheat up to 600 °F.: 0.88 (Range 0.882–0.993) f. Superheat up to 650 °F.: 0.86 (Range 0.861-0.988) g. Superheat up to 700 °F.: 0.84 (Range 0.841-0.963) h. Superheat up to 750 °F.: 0.82 (Range 0.823-0.903) i. Superheat up to 800 °F.: 0.80 (Range 0.805-0.863) j. Superheat up to 850 °F.: 0.78 (Range 0.786–0.836) k. Superheat up to 900 °F.: 0.75 (Range 0.753–0.813) 1. Superheat up to 950 °F.: 0.72 (Range 0.726-0.792) m. Superheat up to 1000 °F.: 0.70 (Range 0.704-0.774)

4. Gas and Vapor Properties are shown in the table on the preceding page:

5.31 Steel Pipe Equations

$$A = 0.785 \times ID^{2}$$

$$W_{P} = 10.6802 \times T \times (OD - T)$$

$$W_{W} = 0.3405 \times ID^{2}$$

$$OSA = 0.2618 \times OD$$

$$ISA = 0.2618 \times ID$$

$$A_{M} = 0.785 \times (OD^{2} - ID^{2})$$

 $A_{\rm M} = 0.785 \times (OD^2 - ID^2)$ A = Cross-Sectional Area (Square Inches) $W_{\rm P}$ = Weight of Pipe per Foot (Pounds) $W_{\rm W}$ = Weight of Water per Foot (Pounds) $V_{\rm T}$ = Pipe Wall Thickness (Inches) $V_{\rm T}$ = Inside Diameter (Inches)

OD = Outside Diameter (Inches)
OSA = Outside Surface Area per Foot (Square Feet)
ISA = Inside Surface Area per Foot (Square Feet)
A_M = Area of the Metal (Square Inches)

5.32 English/Metric Cooling and Heating Equations Comparison

$$\begin{split} H_{S} &= 1.08 \; \frac{Btu \; Min}{Hr \; Ft^{3} \; °F} \times CFM \times \Delta T \\ H_{SM} &= 72.42 \; \frac{KJ \; Min}{Hr \; M^{3} \; °C} \times CMM \times \Delta T_{M} \\ H_{L} &= 0.68 \; \frac{Btu \; Min \; Lb \; DA}{Hr \; Ft^{3} \; Gr \; H_{2}O} \times CFM \times \Delta W \\ H_{LM} &= 177,734.8 \; \frac{KJ \; Min \; Kg \; DA}{Hr \; M^{3} \; Kg \; H_{2}O} \times CMM \times \Delta W_{M} \\ H_{T} &= 4.5 \; \frac{Lb \; Min}{Hr \; Ft^{3}} \times CFM \times \Delta h \\ H_{TM} &= 72.09 \; \frac{Kg \; Min}{Hr \; M^{3}} \times CMM \times \Delta h_{M} \end{split}$$

$$\begin{split} H_T &= H_S + H_L \\ H_{TM} &= H_{SM} + H_{LM} \\ H &= 500 \frac{Btu\ Min}{Hr\ Gal\ ^\circ F} \times GPM \times \Delta T \\ H_M &= 250.8 \frac{KJ\ Min}{Hr\ Liters\ ^\circ C} \times LPM \times \Delta T_M \end{split}$$

$$\frac{AC}{HR} = \frac{CFM \times 60 \frac{Min}{Hr}}{VOLUME}$$

$$\frac{AC}{HR_{M}} = \frac{CMM \times 60 \frac{Min}{Hr}}{VOLUME_{M}}$$

$$^{\circ}C = \frac{^{\circ}F - 32}{1.8}$$

 $^{\circ}F = 1.8 \, ^{\circ}C + 32$

Sensible Heat (Btu/Hr.) H_s = Sensible Heat (KJ/Hr.) H_{SM} $H_{\rm I}$ = Latent Heat (Btu/Hr.) H_{IM} = Latent Heat (KJ/Hr.) H_T = Total Heat (Btu/Hr.) H_{TM} Total Heat (KJ/Hr.) Total Heat (Btu/Hr.) Η = Total Heat (KJ/Hr.) = H_{M}

 ΔT = Temperature Difference (°F.) ΔT_{M} = Temperature Difference (°C.)

 ΔW = Humidity Ratio Difference (Gr.H₂O/Lb.DA) ΔW_M = Humidity Ratio Difference (Kg.H₂O/Kg.DA)

Δh = Enthalpy Difference (Btu/Lb.DA) Δh = Enthalpy Difference (KJ/Lb.DA)

CFM = Air Flow Rate (Cubic Feet per Minute)
CMM = Air Flow Rate (Cubic Meters per Minute)
GPM = Water Flow Rate (Gallons per Minute)
LPM = Water Flow Rate (Liters per Minute)

AC/HR. = Air Change Rate per Hour, English AC/HR._M = Air Change Rate per Hour, Metric

AC/HR. = $AC/HR._{M}$

VOLUME = Space Volume (Cubic Feet) VOLUME_M = Space Volume (Cubic Meters)

KI/Hr Btu/Hr \times 1.055 = $CFM \times 0.02832$ **CMM** LPM $GPM \times 3.785$ KJ/Lb = Btu/Lb \times 2.326 = Feet \times 0.3048 Meters Sq. Meters = Sq. Feet \times 0.0929 Cu. Meters = Cu. Feet \times 0.02832 = Pounds \times 0.4536 Kg

1.0 GPM = 500 Lb. Steam/Hr.

1.0 Lb.Stm./Hr = 0.002 GPM

 $1.0 \text{ Lb.H}_2\text{O/Hr} = 1.0 \text{ Lb.Steam/Hr}.$

Kg/Cu. Meter = Pounds/Cu. Feet × 16.017 (Density)

Cu. Meters/Kg = Cu. Feet/Pound \times 0.0624 (Specific Volume) Kg H₂O/Kg DA = Gr H₂O/Lb DA/7,000 = Lb. H₂O/Lb DA

5.33 Cooling Tower Equations

$$C = \frac{(E+D+B)}{(D+B)}$$

$$B = \frac{E - [(C-1) \times D]}{(C-1)}$$

 $E = GPM_{COND.} \times R \times 0.0008$

 $D = GPM_{COND.} \times 0.0002$

R = EWT - LWT

B = Blowdown (GPM)

C = Cycles of Concentration

D = Drift (GPM)

E = Evaporation (GPM)

EWT = Entering Water Temperature (°F.) LWT = Leaving Water Temperature (°F.)

R = Range (°F.)

5.34 Motor Drive Formulas

 $D_{FP} \times RPM_{FP} = D_{MP} \times RPM_{MP}$

 $BL = [(D_{FP} + D_{MP}) \times 1.5708] + (2 \times L)$

 D_{FP} = Fan Pulley Diameter

 D_{MP} = Motor Pulley Diameter

 RPM_{FP} = Fan Pulley RPM RPM_{MP} = Motor Pulley RPM

BL = Belt Length

L = Center-to-Center Distance of Fan and Motor Pulleys

Cooling Load Rules of Thumb

6.01 Offices, Commercial

A. General:

1. Total Heat 300–400 Sq.Ft./Ton; (Range 230–520) 2. Total Heat 30–40 Btuh/Sq.Ft.; (Range 23–52) 3. Room Sens. Heat 25–28 Btuh/Sq.Ft.; (Range 19–37)

4. SHR 0.75–0.93

5. Perimeter Spaces
6. Interior Spaces
7. Building Block CFM
8. Air Change Rate
1.0–3.0 CFM/Sq.Ft.
0.5–1.5 CFM/Sq.Ft.
1.0–1.5 CFM/Sq.Ft.
4–10 AC/Hr.

B. Large, Perimeter:

Total Heat 225–275 Sq.Ft./Ton
 Total Heat 43–53 Btuh/Sq.Ft.

C. Large, Interior:

Total Heat 300–350 Sq.Ft./Ton
 Total Heat 34–40 Btuh/Sq.Ft.

D. Small:

Total Heat 325–375 Sq.Ft./Ton
 Total Heat 32–37 Btuh/Sq.Ft.

6.02 Banks, Court Houses, Municipal Buildings, Town Halls

A. Total Heat 200-250 Sq.Ft./Ton (Range 160-340)

B. Total Heat 48-60 Btuh/Sq.Ft. (Range 35-75)

C. Room Sens. Heat 28-38 Btuh/Sq.Ft. (Range 21-48)

D. SHR 0.75-0.90

E. Air Change Rate 4-10 AC/Hr.

6.03 Police Stations, Fire Stations, Post Offices

A. Total Heat 250-350 Sq.Ft./Ton (Range 200-400)

B. Total Heat 34-48 Btuh/Sq.Ft. (Range 30-60)

C. Room Sens. Heat 25-35 Btuh/Sq.Ft. (Range 20-40)

D. SHR 0.75-0.90

E. Air Change Rate 4-10 AC/Hr.

6.04 Precision Manufacturing

A. Total Heat 50-300 Sq.Ft./Ton

B. Total Heat 40-240 Btuh/Sq.Ft.

C. Room Sens. Heat 32-228 Btuh/Sq.Ft.

D. SHR 0.80-0.95

E. Air Change Rate 10-50 AC/Hr.

6.05 Computer Rooms

A. Total Heat 50-150 Sq.Ft./Ton

B. Total Heat 80-240 Btuh/Sq.Ft.

C. Room Sens. Heat 64-228 Btuh/Sq.Ft.

D. SHR 0.80-0.95

E. Air Flow 2.0-4.0 CFM/Sq.Ft.

F. Air Change Rate 15-20 AC/Hr.

6.06 Restaurants

A. Total Heat 100-250 Sq.Ft./Ton (Range 75-300)

B. Total Heat 48-120 Btuh/Sq.Ft. (Range 40-155)

C. Room Sens. Heat 21-62 Btuh/Sq.Ft. (Range 20-80)

D. SHR 0.65-0.80

E. Air Flow 1.5-4.0 CFM/Sq.Ft.

F. Air Change Rate 8-12 AC/Hr.

6.07 Kitchens (Depends Primarily on Kitchen Equipment)

A. Total Heat 150-350 Sq.Ft./Ton (At 85°F. Space)

B. Total Heat 34-80 Btuh/Sq.Ft. (At 85°F. Space)

C. Room Sens. Heat 20-56 Btuh/Sq.Ft. (At 85°F. Space)

D. SHR 0.60-0.70

E. Air Flow 1.5-2.5 CFM/Sq.Ft.

F. Air Change Rate 12-15 AC/Hr.

6.08 Cocktail Lounges, Bars, Taverns, Clubhouses, Nightclubs

A. Total Heat 150-200 Sq.Ft./Ton (Range 75-300)

B. Total Heat 60-80 Btuh/Sq.Ft. (Range 40-155)

C. Room Sens. Heat 27-40 Btuh/Sq.Ft. (Range 20-80)

D. SHR 0.65-0.80

E. Spaces 1.5-4.0 CFM/Sq.Ft.

F. Air Change Rate 15-20 AC/Hr. Cocktail Lounges, Bars, Taverns,

Clubhouses

G. Air Change Rate 20-30 AC/Hr. Night Clubs

6.09 Hospital Patient Rooms, Nursing Home Patient Rooms

A. Total Heat 250-300 Sq.Ft./Ton (Range 200-400)

B. Total Heat 40-48 Btuh/Sq.Ft. (Range 30-60)

C. Room Sens. Heat 32-46 Btuh/Sq.Ft. (Range 25-50)

D. SHR 0.75-0.85

6.10 Buildings w/100% OA Systems (i.e., Laboratories, Hospitals)

A. Total Heat 100-300 Sq.Ft./Ton

B. Total Heat 40-120 Btuh/Sq.Ft.

6.11 Medical/Dental Centers, Clinics, and Offices

A. Total Heat 250-300 Sq.Ft./Ton (Range 200-400)

B. Total Heat 40-48 Btuh/Sq.Ft. (Range 30-60)

C. Room Sens. Heat 32-46 Btuh/Sq.Ft. (Range 25-50)

D. SHR 0.75-0.85

E. Air Change Rate 8-12 AC/Hr.

6.12 Residential

A. Total Heat 500-700 Sq.Ft./Ton

B. Total Heat 17-24 Btuh/Sq.Ft.

C. Room Sens. Heat 12-20 Btuh/Sq.Ft.

D. SHR 0.80-0.95

6.13 Apartments (Eff., 1 Room, 2 Room)

A. Total Heat 350-450 Sq.Ft./Ton (Range 300-500)

B. Total Heat 27-34 Btuh/Sq.Ft. (Range 24-40)

C. Room Sens. Heat 22-30 Btuh/Sq.Ft. (Range 20-35)

D. SHR 0.80-0.95

6.14 Motel and Hotel Public Spaces

A. Total Heat 250-300 Sq.Ft./Ton (Range 160-375)

B. Total Heat 40-48 Btuh/Sq.Ft. (Range 32-74)

C. Room Sens. Heat 32-46 Btuh/Sq.Ft. (Range 25-60)

D. SHR 0.75-0.90

6.15 Motel and Hotel Guest Rooms, Dormitories

A. Total Heat 400-500 Sq.Ft./Ton (Range 300-600)

B. Total Heat 24-30 Btuh/Sq.Ft. (Range 20-40)

C. Room Sens. Heat 20-25 Btuh/Sq.Ft. (Range 15-35)

D. SHR 0.80-0.95

6.16 School Classrooms

A. Total Heat 225-275 Sq.Ft./Ton (Range 150-350)

B. Total Heat 43-53 Btuh/Sq.Ft. (Range 35-80)

C. Room Sens. Heat 25-42 Btuh/Sq.Ft. (Range 20-65)

D. SHR 0.65-0.80

E. Air Change Rate 4-12 AC/Hr.

6.17 Dining Halls, Lunch Rooms, Cafeterias, Luncheonettes

A. Total Heat 100-250 Sq.Ft./Ton (Range 75-300)

B. Total Heat 48-120 Btuh/Sq.Ft. (Range 40-155)

C. Room Sens. Heat 21-62 Btuh/Sq.Ft. (Range 20-80)

D. SHR 0.65-0.80

E. Spaces 1.5-4.0 CFM/Sq.Ft.

F. Air Change Rate 12-15 AC/Hr.

6.18 Libraries, Museums

A. Total Heat 250-350 Sq.Ft./Ton (Range 160-400)

B. Total Heat 34-48 Btuh/Sq.Ft. (Range 30-75)

C. Room Sens. Heat 22-32 Btuh/Sq.Ft. (Range 20-50)

D. SHR 0.80-0.90

E. Air Change Rate 8-12 AC/Hr.

6.19 Retail, Department Stores

A. Total Heat 200-300 Sq.Ft./Ton (Range 200-500)

B. Total Heat 40-60 Btuh/Sq.Ft. (Range 24-60)

C. Room Sens. Heat 32-43 Btuh/Sq.Ft. (Range 16-43)

D. SHR 0.65-0.90

E. Air Change Rate 6-10 AC/Hr.

6.20 Drug, Shoe, Dress, Jewelry, Beauty, Barber, and Other Shops

A. Total Heat 175-225 Sq.Ft./Ton (Range 100-350)

B. Total Heat 53-69 Btuh/Sq.Ft. (Range 35-115)

C. Room Sens. Heat 23-54 Btuh/Sq.Ft. (Range 15-90)

D. SHR 0.65-0.90

E. Air Change Rate 6-10 AC/Hr.

6.21 Supermarkets

A. Total Heat 250-350 Sq.Ft./Ton (Range 150-400)

B. Total Heat 34-48 Btuh/Sq.Ft. (Range 30-80)

C. Room Sens. Heat 25-40 Btuh/Sq.Ft. (Range 22-67)

D. SHR 0.65-0.85

E. Air Change Rate 4-10 AC/Hr.

6.22 Malls, Shopping Centers

A. Total Heat 150-350 Sq.Ft./Ton (Range 150-400)

B. Total Heat 34-80 Btuh/Sq.Ft. (Range 30-80)

C. Room Sens. Heat 25-67 Btuh/Sq.Ft. (Range 22-67)

D. SHR 0.65-0.85

E. Air Change Rate 6-10 AC/Hr.

6.23 Jails

A. Total Heat 350-450 Sq.Ft./Ton (Range 300-500)

B. Total Heat 27-34 Btuh/Sq.Ft. (Range 24-40)

C. Room Sens. Heat 22-30 Btuh/Sq.Ft. (Range 20-35)

D. SHR 0.80-0.95

6.24 Auditoriums, Theaters

A. Total Heat 0.05-0.07 Tons/Seat

B. Total Heat 600-840 Btuh/Seat

C. Room Sens. Heat 325-385 Btuh/Seat

D. SHR 0.65-0.75

E. Air Flow 15-30 CFM/Seat

F. Air Change Rate 8-15 AC/Hr.

6.25 Churches

A. Total Heat 0.04-0.06 Tons/Seat

B. Total Heat 480-720 Btuh/Seat

C. Room Sens. Heat 260-330 Btuh/Seat

D. SHR 0.65-0.75

E. Air Flow 15-30 CFM/Seat

F. Air Change Rate 8-15 AC/Hr.

6.26 Bowling Alleys

A. Total Heat 1.5-2.5 Tons/Alley

B. Total Heat 18,000-30,000 Btuh/Alley

C. Air Change Rate 10-15 AC/Hr.

6.27 All Spaces

A. Total Heat 300-500 CFM/Ton @ 20°F. ΔT

B. Total Heat 400 CFM/Ton \pm 20% @ 20°F. Δ T

C. Perimeter Spaces 1.0-3.0 CFM/Sq.Ft.

D. Interior Spaces 0.5-1.5 CFM/Sq.Ft.

E. Building Block CFM 1.0-1.5 CFM/Sq.Ft.

F. Air Change Rate 4 AC/Hr. Minimum

Total heat includes ventilation. Room sensible heat does not include ventilation.

6.28 Cooling Load Calculation Procedure

A. Obtain building characteristics:

- 1. Materials
- 2. Size
- 3. Color
- 4. Shape
- 5. Location
- 6. Orientation, N, S, E, W, NE, SE, SW, NW, etc.
- 7. External/Internal shading
- 8. Occupancy type and time of day

B. Select outdoor design weather conditions:

- 1. Temperature
- 2. Wind direction and speed
- 3. Conditions in selecting outdoor design weather conditions:
 - a. Type of structure, heavy, medium or light
 - b. Is structure insulated?
 - c. Is structure exposed to high wind?
 - d. Infiltration or ventilation load
 - e. Amount of glass
 - f. Time of building occupancy
 - g. Type of building occupancy
 - h. Length of reduced indoor temperature
 - i. What is daily temperature range, minimum/maximum?
 - j. Are there significant variations from ASHRAE weather data?
 - k. What type of heating devices will be used?
 - l. Expected cost of fuel
- See Part 16, Energy Conservation and Design Conditions, for code restrictions on selection of outdoor design conditions.
- C. Select indoor design temperature to be maintained in each space. See Part 16, Energy Conservation and Design Conditions, for code restrictions on selection of indoor design conditions.
- D. Estimate temperatures in un-conditioned spaces.
- E. Select and/or compute U-values for walls, roof, windows, doors, partitions, etc.
- F. Determine area of walls, windows, floors, doors, partitions, etc.
- G. Compute conduction heat gains for all walls, windows, floors, doors, partitions, skylights, etc.
- H. Compute solar heat gains for all walls, windows, floors, doors, partitions, skylights, etc.
- I. Infiltration heat gains are generally ignored unless space temperature and humidity tolerance are critical.
- J. Compute ventilation heat gain required.
- K. Compute internal heat gains from lights, people, and equipment.
- L. Compute sum of all heat gains indicated in items G, H, I, J, and K above
- M. Include morning cool-down for buildings with intermittent use and night set up. See Part 16, Energy Conservation and Design Conditions, for code restrictions on excess HVAC system capacity permitted for morning cool-down.
- N. Consider equipment and materials which will be brought into building above inside design temperature.
- Cooling load calculations should be conducted using industry accepted methods to determine actual cooling load requirements.

6.29 Cooling Load Peak Time Estimate

	MONTH OF PEAK ROOM COOLING LOAD FOR VARIOUS EXPOSURES											
WINDOW CHARACTERISTICS		PROBABLE MONTH OF PEAK ROOM COOLING LOAD										
% GLASS	SHADE COEF.	OVER- HANG	N	S	E	w	NE	SE	sw	NW		
25	0.4	0	JULY	SEPT.	JULY	JULY	JULY	SEPT.	SEPT.	JULY		
25	0.4	1:2	JULY	OCT.	JULY	AUG.	JULY	SEPT.	SEPT.	JULY		
25	0.4	1:1	JULY	OCT.	JULY	JULY	JULY	SEPT.	OCT.	JULY		
25	0.6	0	JULY	SEPT.	JULY	JULY	JULY	SEPT.	SEPT.	JULY		
25	0.6	1:2	JULY	OCT.	JULY	AUG.	JULY	SEPT.	SEPT.	JULY		
25	0.6	1:1	JULY	DEC.	JULY	SEPT.	JULY	SEPT.	OCT.	JULY		
50	0.4	0	JULY	SEPT.	JULY	JULY	JULY	SEPT.	SEPT.	JULY		
50	0.4	1:2	JULY	OCT.	JULY	AUG.	JULY	SEPT.	SEPT.	JULY		
50	0.4	1:1	JULY	DEC.	JULY	SEPT.	JULY	SEPT.	OCT,	JULY		
50	0.6	0	JULY	OCT.	JULY	JULY	JULY	SEPT.	SEPT.	JULY		
50	0.6	1:2	JULY	DEC.	JULY	AUG.	JULY	SEPT.	OCT.	JULY		
50	0.6	1:1	JULY	DEC.	JULY	SEPT.	JULY	SEPT.	DEC.	JULY		

Notes:

- 1. Percent glass is percentage of gross wall area for the particular exposure.
- Shading coefficient refers to the overall shading coefficient. Shading coefficient of 0.4 is approximately equal to double pane glass with heat absorbing plate out and regular plate in, combined with medium color venetian blinds.
- Although the room peak for south, southeast, and southwest exposures is September or later, the system peak will more than likely be in July.
- 4. Value for overhang is the ratio of the depth of the overhang to height of the window with the overhang at the same elevation as the top of the window.
- 5. The roof will peak in June or July.

Heating Load Rules of Thumb

7.01 All Buildings and Spaces

- A. 20-60 Btuh/Sq.Ft.
- B. 25-40 Btuh/Sq.Ft. Average

7.02 Buildings w/100% OA Systems (i.e., Laboratories, Hospitals)

A. 40-120 Btuh/Sq.Ft.

7.03 Buildings w/Ample Insulation, Few Windows

A. AC Tons \times 12,000 Btuh/Ton \times 1.2

7.04 Buildings w/Limited Insulation, Many Windows

A. AC Tons \times 12,000 Btuh/Ton \times 1.5

7.05 Walls Below Grade (Heat Loss at Outside Air Design Condition)

- A. -30°F.-6.0 Btuh/Sq.Ft.
- B. -25°F.-5.5 Btuh/Sq.Ft.
- C. -20°F.-5.0 Btuh/Sq.Ft.
- D. -15°F.-4.5 Btuh/Sq.Ft.
- E. -10°F.-4.0 Btuh/Sq.Ft.
- F. -5°F.-3.5 Btuh/Sq.Ft.
- G. 0°F.-3.0 Btuh/Sq.Ft.
- H. 5°F.-2.5 Btuh/Sq.Ft.
- I. 10°F.-2.0 Btuh/Sq.Ft.
- J. 15°F.-1.9 Btuh/Sq.Ft.
- K. 20°F.-1.8 Btuh/Sq.Ft.
- L. 25°F.-1.7 Btuh/Sq.Ft.
- M. 30°F.-1.5 Btuh/Sq.Ft.

7.06 Floors Below Grade (Heat Loss at Outside Air Design Condition)

- A. -30°F.-3.0 Btuh/Sq.Ft.
- B. -25°F.-2.8 Btuh/Sq.Ft.
- C. -20°F.-2.5 Btuh/Sq.Ft.
- D. -15°F.-2.3 Btuh/Sq.Ft.
- E. -10°F.-2.0 Btuh/Sq.Ft.
- F. -5°F.-1.8 Btuh/Sq.Ft.
- G. 0°F.-1.5 Btuh/Sq.Ft.
- H. 5°F.-1.3 Btuh/Sq.Ft.
- I. 10°F.-1.0 Btuh/Sq.Ft.
- J. 15°F.-0.9 Btuh/Sq.Ft.
- K. 20°F.-0.8 Btuh/Sq.Ft.
- L. 25°F.-1.7 Btuh/Sq.Ft.
- M. 30°F.-0.5 Btuh/Sq.Ft.

7.07 Heating System Selection Guidelines

- A. If heat loss exceeds 450 Btu/Hr. per lineal feet of wall, heat should be provided from under the window or from the base of the wall to prevent downdrafts.
- B. If heat loss is between 250 and 450 Btu/Hr. per lineal feet of wall, heat should be provided from under the window or from the base of the wall, or it may be provided from overhead diffusers, located adjacent to the perimeter wall, discharging air directly downward, blanketing the exposed wall and window areas.
- C. If heat loss is less than 250 Btu/Hr. per lineal feet of wall, heat should be provided from under the window or from the base of the wall, or it may be provided from overhead diffusers, located adjacent to or slightly away from the perimeter wall, discharging air directed at, or both directed at and directed away, from the exposed wall and window areas.

7.08 Heating Load Calculation Procedure

A. Obtain building characteristics:

- 1. Materials
- 2. Size
- 3. Color
- 4. Shape

- 5. Location
- 6. Orientation, N, S, E, W, NE, SE, SW, NW, etc.
- 7. External shading
- 8. Occupancy type and time of day

B. Select outdoor design weather conditions:

- 1. Temperature.
- 2. Wind direction and speed.
- 3. Conditions in selecting outdoor design weather conditions:
 - a. Type of structure, heavy, medium or light.
 - b. Is structure insulated?
 - c. Is structure exposed to high wind?
 - d. Infiltration or ventilation load.
 - e. Amount of glass.
 - f. Time of building occupancy.
 - g. Type of building occupancy.
 - h. Length of reduced indoor temperature.
 - i. What is daily temperature range, minimum/maximum?
 - j. Are there significant variations from ASHRAE weather data?
 - k. What type of heating devices will be used?
 - l. Expected cost of fuel.
- See Part 16, Energy Conservation and Design Conditions, for code restrictions on selection of outdoor design conditions.
- C. Select indoor design temperature to be maintained in each space. See Part 16, Energy Conservation and Design Conditions, for code restrictions on selection of indoor design conditions.
- D. Estimate temperatures in un-heated spaces.
- E. Select and/or compute U-values for walls, roof, windows, doors, partitions, etc.
- F. Determine area of walls, windows, floors, doors, partitions, etc.
- G. Compute heat transmission losses for all walls, windows, floors, doors, partitions, etc.
- H. Compute heat losses from basement and/or grade level slab floors.
- Compute infiltration heat losses.
- J. Compute ventilation heat loss required.
- K. Compute sum of all heat losses indicated in items G, H, I, and J above.
- L. For a building with sizable and steady internal heat release, a credit may be taken, but only a portion of the total. Use extreme caution!!! For most buildings, credit for heat gain should not be taken.
- M. Include morning warm-up for buildings with intermittent use and night set-back. See Part 16, Energy Conservation and Design Conditions, for code restrictions on excess HVAC system capacity permitted for morning warm-up.

- N. Consider equipment and materials which will be brought into the building below inside design temperature.
- O. Heating load calculations should be conducted using industry accepted methods to determine actual heating load requirements.

Infiltration Rules of Thumb

8.01 Heating Infiltration (15 mph wind)

A. Air Change Rate Method:

- 1. Range 0-10 AC/Hr.
- 2. Commercial Buildings
 - a. 1.0 AC/Hr. 1 Exterior Wall
 - b. 1.5 AC/Hr. 2 Exterior Walls
 - c. 2.0 AC/Hr. 3 or 4 Exterior Walls
- 3. Vestibules 3.0 AC/Hr.

B. CFM/Sq.Ft. of Wall Method:

- 1. Range 0-1.0 CFM/Sq.Ft.
- 2. Tight Buildings 0.1 CFM/Sq.Ft.
- 3. Average Buildings 0.3 CFM/Sq.Ft. 4. Leaky Building 0.6 CFM/Sq.Ft.
- C. Crack Method:
- 1. Range 0.12-2.8 CFM/Ft. of Crack
- 2. Average 1.0 CFM/Ft. of Crack

8.02 Cooling Infiltration (7.5 mph wind)

A. Cooling load infiltration is generally ignored unless close tolerances in temperature and humidity control are required. Cooling infiltration values are generally taken as ½ of the values listed above for heating infiltration.

8.03 No Infiltration Losses or Gains for Rooms **Below Grade or Interior Spaces**

8.04 Buildings Which Are Not Humidified Have No Latent **Infiltration Heating Load**

8.05 Winter Sensible Infiltration Loads Will Generally Be 1/2 to 3 Times the Conduction Heat Losses (Average 1.0–2.0 Times)

Ventilation Rules of Thumb

9.01 Outdoor Air

A. 1990 BOCA Code 5 CFM/Person Minimum

B. 1993 BOCA Code Based on ASHRAE Standard 62-1989

C. 1988 SBCCI Code 5 CFM/Person Minimum

D. 1988 UBC Code 5 CFM/Person Minimum

E. ASHRAE Standard 62-1989 (Minimum Outdoor Air):

1. Range 15–60 CFM/Person

2. Most Common Range 15–35 CFM/Person, Based on type of Occupancy

Average Range
 Smoking Lounges
 Outdoor Background Level
 ASHRAE Standard 62 Recommends
 OSHA & U.S. Air Force Proposing
 Human Discomfort Begins
 15-20 CFM/Person
 GFM/Person
 350 ppm CO₂ Avg.
 1000 ppm CO₂ max.
 650 ppm CO₂ Max.
 800-1000 ppm CO₂

9. Long-Term Health Effects >12,000 ppm CO₂

F. Outside Air Intake and Exhaust Locations:

- 1. 1990 and 1993 BOCA:
 - a. Intakes or exhausts—10 feet from lot lines, buildings on same lot or center line of street or public way
 - b. Intakes—10 feet from any hazardous or noxious contaminant (plumbing vents, chimneys, vents, stacks, alleys, streets, parking lots, loading docks). When within 10 feet, intake must be a minimum of 2 feet below any source of contaminant.
 - c. Exhausts—shall not create a nuisance or be directed onto walkways.
- 2. 1988 SBCCI:
 - a. Intakes—10 feet from any hazardous or noxious contaminant (plumbing vents, chimneys, vents, stacks, alleys, streets, parking lots, loading docks). When within 10 feet, intake must be a minimum of 2 feet below any source of contaminant.
- 3. 1988 UBC:
 - a. Intakes—10 feet from any hazardous or noxious contaminant (plumbing vents, chimneys, vents, stacks, alleys, streets, parking lots, loading docks). When within 10 feet, intake must be a minimum of 3 feet below any source of contaminant.
- 4. Guidelines for Construction and Equipment of Hospital and Medical Facilities—AIA Committee on Architecture for Health and U.S. Department of Health and Human Services:
 - a. Fresh air intakes shall be located at least 25 feet from exhaust outlets of ventilating systems, combustion equipment stacks, medical-surgical vacuum systems, plumbing vents, or areas that may collect vehicular exhaust or other noxious fumes. Prevailing winds and/or proximity to other structures may require greater clearances.
 - b. Plumbing and vacuum vents that terminate at a level above the top of the air intake may be as close as 10 feet.
 - c. The bottom of outdoor air intakes serving central systems shall be as high as practical, but at least 6 feet above ground level, or if installed above the roof, 3 feet above roof level.
 - d. Exhaust outlets from areas that may be contaminated shall be above roof level and arranged to minimize recirculation of exhaust air into the building.
- G. Outside Air Requirements—ASHRAE Standard 62-1989—are shown in the following table:

TYPE OF SPACE	OUTDOOR AIR CFM/PERSON
Offices	20
Banks, Court Houses, Municipal Buildings, Town Halls	20
Police Stations, Fire Stations, Post Offices	20
Precision Manufacturing	20
Computer Rooms	20
Restaurants	20
Kitchens	15
Cocktail Lounges, Bars, Taverns, Clubhouses, Night Clubs	30
Hospital Patient Rooms, Nursing Home Patient Rooms	25
Hospital General Areas	15
Medical Centers, Medical and Dental Clinics, Dental Offices	20
Residential (CFM/Room)	30
Apartments (CFM/Room)	30
Motel and Hotel Public Spaces	20
School Classrooms	15
Dinign Halls, Lunch Rooms, Cafeterias, Luncheonettes	20
Libraties, Museums	20
Retail, Department Stores (CFM/Sq.Ft.)	0.2 - 0.3
Beauty Shops, Barber Shops	25
Drug, Shoe, Jewelry and Other Specialty Shops	15
Supermarkets	15
Malls, Shopping Centers	15
Jails	20
Auditoriums, Theaters	15
Churches	15
Bowling Alleys	25

9.02 Indoor Air Quality (IAQ)-ASHRAE Standard 62-1989

A. Causes of Poor IAQ:

- 1. Inadequate Ventilation—50% of all IAQ problems due to lack of ventilation
- 2. Poor Intake/Exhaust Locations
- 3. Inadequate Filtration or Dirty Filters
- 4. Intermittent Airflow
- 5. Poor Air Distribution
- 6. Inadequate Operation
- 7. Inadequate Maintenance

B. IAQ Control Methods:

- 1. Control Temperature and Humidity
- 2. Ventilation—Dilution
- 3. Remove Pollution Source
- 4. Filtration

C. IAQ Factors:

- 1. Thermal Environment
- 2. Smoke
- 3. Odors
- 4. Irritants—Dust
- 5. Stress Problems (Perceptible, Non-Perceptible)
- 6. Toxic Gases—Carbon Monoxide, Carbon Dioxide
- 7. Allergens—Pollen
- 8. Biological Contaminants—Bacteria, Mold, Pathogens, Legionella, Micro-organisms, Fungi

9.03 Effects of Carbon Monoxide

A. Effects of Various Concentrations of Carbon Monoxide with Respect to Time are shown in the following table:

	CONCENTRATION OF CARBON MONOXIDE IN PPM ±					
HOURS OF EXPOSURE	BARELY SICKNESS		DEADLY			
0.5	600	1000	2000			
1.0	200	600	1600			
2	100	300	1000			
3	75	200	700			
4	50 150 400		400			
5	35	125	300			
6	25	120	200			
7	25	1,00	200			
8	25	100	150			

- B. Carbon Monoxide Concentration vs. Time vs. Symptoms are shown in the table on page 79.
- C. Carbon monoxide is lighter than air (specific gravity is 0.968).

9.04 Toilet Rooms

- A. Recommended Design Requirements:
- 1. 2.0 CFM/Sq.Ft.
- 2. 10 AC/Hr.
- 3. 100 CFM/Water Closet and Urinal
- B. ASHRAE Standard 62-1989 50 CFM/Water Closet and Urinal
- C. 1990 & 1993 BOCA Codes 75 CFM/Water Closet and Urinal

CONCENTRATION OF CO IN THE AIR	INHALATION TIME	TOXIC SYMPTOMS DEVELOPED		
9 PPM	Short Term Exposure	ASHRAE recommended maximum allowable concentration for short term exposure in living area.		
35 PPM	8 Hour	The maximum allowable concentration for a continuous exposure, in any 8 hour period, according to federal law.		
200 PPM	2 - 3 Hours	Slight headache, tiredness, dizziness, nausea, Maximum CO concentration exposure at any time as prescribed by OSHA		
400 PPM	1 - 2 Hours	Frontal headaches		
	After 3 Hours	Life Threatening		
		Maximum PPM in flue gas (on a free air basis) according to EPA and AGA		
800 PPM	45 Minutes	Dizziness, nausea, and convulsions		
	2 Hours	Unconscious		
	2 - 3 Hours	Death		
1,600 PPM	20 Minutes	Headache, dizziness, nausea		
	l Hour	Death		
3,200 PPM	5 - 10 Minutes	Headache, dizziness, nausea		
	30 Minutes	Death		
6,400 PPM	1 - 2 Minutes	Headache, dizziness, nausea		
	10 - 15 Minutes	Death		
12,800 PPM	1 - 3 Minutes	Death		

D. 1988 SBCCI Code

2.0 CFM/Sq.Ft.

E. 1988 UBC Code

5.0 AC/Hr.

F. Toilet Room Ventilation:

- For toilet rooms with high fixture densities (stadiums, auditoriums), the 75 CFM/Water Closet and Urinal dictates.
- 2. For toilet rooms with ceiling heights over 12 feet, the 10 AC/Hr dictates.
- 3. For toilet rooms ceiling heights 12 feet and under, the 2.0 CFM/Sq.Ft. dictates.
- 4. If toilet rooms are designed for 100 CFM/Water Closet and Urinal, all three major U.S. codes and the 10 AC/Hr. can be met.
- 5. Note that sometimes women's toilet rooms will contain less fixtures. If both men's and women's toilet rooms are essentially the same size, use the larger (men's) CFM for both toilet rooms when using the CFM/Water Closet and Urinal method.

9.05 Electrical Rooms

- A. 2.0 CFM/Sq.Ft.
- B. 10 AC/Hr.

C. 5 CFM/KVA of Transformer.

D. Electrical Room Design Guidelines:

- 1. Generally, electrical equipment rooms only require ventilation to keep equipment from overheating. Most electrical rooms are designed for 95°F. to 104°F; however, consult electrical engineer for equipment temperature tolerances. If space temperatures below 90°F. are required by equipment, air conditioning of the space will be required.
- 2. If outside air is used to ventilate the electrical room, the electrical room design temperature will be 10°F. to 15°F. above outside summer design temperatures.
- 3. If conditioned air from an adjacent space is used to ventilate the electrical room, the electrical room temperature can be 10°F. to 20°F. above the adjacent spaces.

9.06 Mechanical Rooms

A. 2 CFM/Sq.Ft.

B. Cleaver Brooks 10 CFM/BHP:

- 1. 8 CFM/BHP Combustion Air
- 2. 2 CFM/BHP Ventilation
- 3. 1 BHP = 34,500 Btuh

C. Mechanical Equipment Room Design Guidelines:

- 1. Generally, mechanical equipment rooms only require ventilation. Most mechanical rooms are designed for 95°F. to 104°F; however, verify mechanical equipment temperature tolerances. If space temperatures below 90°F. are required by mechanical equipment, air conditioning of the space will be required.
- 2. If outside air is used to ventilate the mechanical room, the mechanical room design temperature will be 10°F. to 15°F. above outside summer design temperatures.
- 3. If conditioned air from an adjacent space is used to ventilate the mechanical room, the mechanical room temperature can be 10°F. to 20°F. above the adjacent spaces.

D. ASHRAE Standard 15-1992:

- 1. See ASHRAE Standard 15-1992 for complete refrigeration system requirements.
- 2. Scope:
 - a. To establish safeguards of life, limb, health, and property.
 - b. Defines practices that are consistent with safety.
 - c. Prescribes safety standards.
- Application. The standard applies to all refrigerating systems and heat pumps used in institutional, public assembly, residential, commercial, industrial, and mixed use occupancies and to parts and components added after adoption of this code.
- 4. Refrigerant Classification is shown in the table on page 81.
- 5. Requirements for Refrigerant Use:
 - Requirements for refrigerant use are based on probability that refrigerant will enter occupied space and on type of occupancy (institutional, public assembly, residential, commercial, industrial, and mixed use).
 - b. The total amount of refrigerant permitted to be installed in a system is determined by the type of occupancy, the refrigerant group, and the probability that refrigerant will enter occupied space.
 - c. Refrigerant systems, piping, and associated appurtenances shall not be installed in or on stairways, stair landings, entrances, or exits.

	SAFETY GROUP					
HIGHER FLAMMABILITY	А3	В3				
LOWER FLAMMABILITY	A2	B2 Ammonia				
NO FLAME PROPAGATION	A1 R-11, R-12, R-22, R-134a	B1 R-123				
	LOWER TOXICITY	HIGHER TOXICITY				

d. Refrigeration system components shall not interfere with free passage through public hallways and limitations on size are based on refrigerant type.

6. Service Provisions:

- a. All serviceable components of refrigerating systems shall be safely accessible.
- b. Properly located stop valves, liquid transfer valves, refrigerant storage tanks, and adequate venting are required when needed for safe servicing of equipment.
- Refrigerant Systems with more than 6.6 Lbs. of Refrigerant (except Group A1) require stop valves at:
 - 1) Suction inlet of each compressor, compressor unit, or condensing unit.
 - 2) Discharge outlet of each compressor, compressor unit, or condensing unit.
 - 3) The outlet of each liquid receiver.
- d. Refrigerant Systems with more than 110 Lbs. of Refrigerant require stop valves at:
 - 1) Suction inlet of each compressor, compressor unit, or condensing unit.
 - 2) Discharge outlet of each compressor, compressor unit, or condensing unit.
 - 3) The inlet of each liquid receiver, except for self-contained systems or where the receiver is an integral part of the condenser or condensing unit.
 - 4) The outlet of each liquid receiver.
 - 5) The inlet and outlet of condensers when more than one condenser is used in parallel.

7. Installation Requirements:

- a. Air ducts passing through machinery rooms shall be of tight construction and shall have no openings in such rooms.
- b. Refrigerant piping crossing an open space that affords passageway in any building shall not be less than 7′-3″ above the floor.
- c. Passages shall not be obstructed by refrigerant piping.
- d. Refrigerant piping shall not be placed in or pass through any elevator, dumbwaiter, or other shaft containing moving objects or in any shaft that has openings to living quarters or to main exits.
- e. Refrigerant piping shall not be placed in exits, lobbies, or stairways, except that such refrigerant piping may pass across an exit if there are no joints in the section in the exit.
- f. Refrigerant piping shall not be installed vertically through floors from one story to another except as follow:

- 1) Basement to first floor, top floor to mechanical equipment penthouse or roof.
- 2) For the purpose of interconnecting separate pieces of equipment. The piping may be carried in an approved, rigid and tight, continuous fire-resistive pipe, duct, or shaft having no openings into floors not served by the refrigerating system or carried exposed on the outer wall of the building.
- 8. Refrigeration Equipment Room Requirements:
 - a. Provide proper space for service, maintenance, and operation.
 - b. Minimum clear head room shall be 7'-3".
 - c. Doors shall be outward opening, self closing, fire rated, and tight fitting. No other openings shall be permitted in equipment rooms (except doors) that will permit passage of refrigerant to other part of the building.
 - d. Group A1 refrigerants require an oxygen sensor located in the equipment room set to alarm when oxygen levels fall below 19.5 volume percent.
 - e. Group A2, A3, B1, B2, and B3 refrigerants require a refrigerant vapor detector located in the equipment room set to alarm and start the ventilation system when the level reaches the refrigerant's toxicity level.
 - f. Periodic test of alarm and sensors are required.
 - g. Mechanical rooms shall be vented to the outdoors.
 - h. Mechanical ventilation shall be capable of exhausting the air quantity determined by the formula in Part 5, Equations. The exhaust quantity is dependant on the amount of refrigerant contained in the system.
 - i. No open flames that use combustion air from the machinery room shall be installed where any refrigerant other than carbon dioxide is used.
 - j. There shall be no flame producing device or continuously operating hot surface over 800°F permanently installed in the room.
 - * k. Refrigeration compressors, piping, equipment, valves, switches, ventilation equipment, and associated appurtenances shall be labeled in accordance with ANSI/ASME A13.1.

9.07 Combustion Air

A. 1990 BOCA Code:

- 1. Inside Air: 1 Sq.In./1000 Btuh.
- 2. Outside Air:
 - a. 1 Sq.In./4000 Btuh without Horizontal Ducts.
 - b. 1 Sq.In./2000 Btuh with Horizontal Ducts.
- 1 opening high and 1 opening low for both paragraphs 1 and 2 above. Area listed is for each opening.
- 4. Mechanical Ventilation: 1 CFM/3000 Btuh.

B. 1993 BOCA Code:

- 1. Inside Air:
 - a. 40 Cu.Ft. of Room Volume/1000 Btuh.
 - b. 1 Sq.In./1000 Btuh; 100 Sq.In. Minimum.
- 2. Outside Air:
 - a. 1 Sq.In./4000 Btuh with out Horizontal Ducts.
 - b. 1 Sq.In./2000 Btuh with Horizontal Ducts.
 - c. 1 Sq.In./4000 Btuh for Floor, Ceiling, or Vertical Duct openings.
- 3. 1 opening high and 1 opening low for both paragraphs 1 and 2 above. Area listed is for each opening.
- 4. Mechanical Ventilation: 1 CFM/3000 Btuh

C. 1988 SBCCI Code:

- 1. Solid Fuels 2 Sq.In./1000 Btuh; 200 Sq.In. Min.
- 2. Liquid & Gas Fuels:
 - a. Confined Spaces:
 - 1) Inside Air: 1 Sq.In./1000 Btuh; 100 Sq.In. Min.
 - 2) Outside Air:
 - a) 1 Sq.In./4000 Btuh with out Horizontal Ducts.
 - b) 1 Sq.In./2000 Btuh with Horizontal Ducts.
 - b. Unconfined Spaces:
 - 1) Outside Air: 1 Sq.In./5000 Btuh.
- 3. 1 opening 12" above finished floor and 1 opening 12" below top of space applies to all fuels and spaces. Area listed for each opening.

D. 1988 UBC Code:

- 1. Confined Spaces:
 - a. Inside Air: 1 Sq.In./1000 Btuh Each Opening.
 - b. Outside Air:
 - 1) 1 Sq.In./4000 Btuh with out Horizontal Ducts.
 - 2) 1 Sq.In./2000 Btuh with Horizontal Ducts.
- 2. Unconfined Spaces:
 - a. Outside Air: 1 Sq.In./5000 Btuh.
- 3. 1 opening 12" above finished floor and 1 opening 12" below top of space applies to all spaces. ½ area high, ½ area low.

E. 1992 NFPA 54-National Fuel Gas Code:

- 1. Confined Spaces:
 - a. Inside Air: 1 Sq.In./1000 Btuh; 100 Sq.In. Min.
 - b. Outside Air:
 - 1) 1 Sq.In./4000 Btuh; Direct communication with outside.
 - 2) 1 Sq.In./4000 Btuh with Vertical Ducts.
 - 3) 1 Sq.In./2000 Btuh with Horizontal Ducts.
- 2. Unconfined spaces:
 - a. Tight Buildings: As specified for confined spaces.
 - b. Leaky Buildings: Infiltration may be adequate.
- 3. 1 opening 12" above finished floor and 1 opening 12" below top of space. Area listed for each opening.
- 4. Louvers and grilles—¼" mesh screens minimum; Wood louvers 20–25% free area; Metal louvers 60–75% free area.

9.08 Hazardous Locations

A. Hazardous location requirements for electrical and electronic equipment are defined in the 1996 National Electrical Code (NEC), Articles 500 through 505.

B. Hazardous Classifications:

- 1. Class I: Class I locations are spaces or areas which contain flammable gases or vapors.
 - a. Class I locations are subdivided into four groups based on type of flammable gases or vapors:
 - 1) Group A: Acetylene.

- 2) Group B: Hydrogen, Ethylene Oxide, Propylene Oxide.
- 3) Group C: Ethyl Ether, Ethylene.
- 4) Group D: Acetone, Ammonia, Butane, Gasoline, Propane.
- b. Class I locations are also subdivided into 2 divisions:
 - 1) Class I, Division 1:
 - a) Locations where ignitable concentrations of flammable gases or vapors can exist under normal operating conditions; or
 - b) Locations where ignitable concentrations of flammable gases or vapors may exist frequently because of repair or maintenance operations or because of leakage; or
 - c) Locations where breakdown or faulty operation of equipment or processes might release ignitable concentrations of flammable gases or vapors, and might cause simultaneous failure of electric equipment.

2) Class I, Division 2:

- a) Locations where volatile flammable liquids or flammable gases are handled, processed, or used, but in which the liquids, vapors, or gases will normally be confined within closed containers or closed systems where they can escape only in case of an accidental rupture or breakdown of such containers or systems; or
- Locations where ignitable concentrations of gases or vapors are normally prevented by positive mechanical ventilation, and have the potential to become hazardous through failure or abnormal operation of the ventilating equipment; or
- c) Locations that are adjacent to Class I, Division 1 locations, and to which ignitable concentrations of gases or vapors might occasionally be communicated unless such communication is prevented by adequate positive pressure ventilation from a source of clean air, and effective safeguards against ventilation failure are provided.
- 2. Class II: Class II locations are spaces or areas which contain combustible dusts.
- 3. Class III: Class II locations are spaces or areas which contain easily ignitable fibers or flyings.

C. Hazardous Location Protection Techniques:

- 1. Purged and Pressurized Systems: Spaces and equipment are pressurized at pressures above the external atmosphere with non-contaminated air or other non-flammable gas to prevent explosive gases or vapors from entering the enclosure.
- 2. Intrinsically Safe Systems: Electrical circuits are designed so that they do not release sufficient energy to ignite an explosive atmosphere.
- 3. Explosionproof Equipment: Explosionproof equipment is designed and built to withstand an internal explosion without igniting the surrounding atmosphere.
- 4. Nonicendive Circuits and Components: Circuits designed to prevent any arc or thermal effect produced, under intended operating conditions of the equipment or produced by opening, shorting, or grounding of the field wiring, is not capable, under specified test conditions, of igniting the flammable gas, vapor, or dust-air mixture.
- Oil Immersed Equipment: The arcing portions of the equipment are immersed in an oil at a depth that the arc will not set off any hazardous gases or vapors above the surface of the oil.
- 6. Hermetically Sealed Equipment: The equipment is sealed against the external atmosphere to prevent the entry of hazardous gases or vapors.
- 7. Dust-Ignitionproof Equipment: Dust-ignitionproof equipment is designed and built to exclude dusts and, where installed and protected, will not permit arcs, sparks, or heat generated or liberated inside the enclosure to cause ignition of the exterior accumulations or atmospheric suspensions of a specified dust on or in the enclosure.
- 8. Classification versus Protection Techniques is shown in the following table:

PROTECTION TECHNIQUE	CLASS I, DIVISION 1	CLASS I, DIVISION 2	CLASS II	CLASS III
PURGED AND PRESSURIZED	х	х	Х	Х
INTRINSICALLY SAFE SYSTEMS	х	х	Х	Х
EXPLOSIONPROOF EQUIPMENT	х	х	Х	Х
NONINCENDIVE CIRCUITS AND COMPONENTS	N/A	N/A X		х
HERMETICALLY SEALED EQUIPMENT	N/A	х	Х	х
OIL IMMERSED EQUIPMENT	N/A	X	Х	X
DUST-IGNITIONPROOF EQUIPMENT	N/A	N/A	х	Х

Notes:

- 1. X = Appropriate to the classification.
- 2. N/A = Not acceptable to the classification.

D. Ventilation Requirements:

- Ventilation, natural or mechanical, must be sufficient to limit the concentrations of flammable gases or vapors to a maximum level of 25% of their Lower Flammable Limit/Lower Explosive Limit (LFL/LEL).
- 2. Minimum Ventilation Required: 1.0 CFM/Sq. Ft. of floor area or 6.0 air changes per hour, whichever is greater. If a reduction in the classification is desired, the airflow must be 4 times the airflow specified above.
- 3. Recommendation: Ventilate all hazardous locations with 2.0 CFM/Sq. Ft. of floor area or 12 air changes per hour minimum with half the airflow supplied and exhausted high (within 6 inches of the ceiling or structure) and half the airflow supplied and exhausted low (within 6 inches of the floor).
- 4. Ventilation rate a minimum of 4 times the ventilation rate required to prevent the space from exceeding the maximum level of 25% LFL/LEL using fugitive emissions calculations.
- 5. Ventilate the space so that accumulation pockets for lighter than air or heavier than air gases or vapors are eliminated.
- 6. Monitoring of the space is recommended to assure that the 25% LFL/LEL is not exceeded.

E. Hazardous Location Definitions:

- 1. Boiling Point. The temperature at which the vapor pressure of a liquid equals the atmospheric pressure of 14.7 pounds per square inch absolute.
- Combustible Liquids. Liquids having flash points at or above 100 F. Combustible liquids shall be subdivided as Class II or Class III liquids as follows:
 - a. Class II. Liquids having flash points at or above 100°F. and below 140°F.
 - b. Class IIIA. Liquids having flash points at or above 140°F. and below 200°F.
 - c. Class IIIB. Liquids having flash points at or above 200°F.
- 3. Explosion. An effect produced by the sudden violent expansion of gases, which can be accompanied by a shockwave or disruption, or both, of enclosing materials or structures. An explosion might result from chemical changes such as rapid oxidation, deflagration, or detonation; decomposition of molecules, and runaway polymerization; or physical changes such as pressure tank ruptures.
- Explosive. Any chemical compound, mixture, or device, the primary or common purpose of which is to function by explosion.

- 5. Flammable. Any material capable of being ignited from common sources of heat or at a temperature of 600 F. or less.
- 6. Flammable Compressed Gas. An air/gas mixture that is flammable when the gas is 13% or less by volume or when the flammable range of the gas is wider than 12% regardless of the lower limitation determined at atmospheric temperature and pressures.
- 7. Flammable Liquids. Liquids having flash points below 100°F. and having vapor pressures not exceeding 40 pounds per square inch absolute at 100°F. Flammable liquids shall be subdivided as Class IA, IB, and IC as follows:
 - a. Class IA. Liquids having flash points below 73°F, and having boiling points below 100°F.
 - Class IB. Liquids having flash points below 73°F. and having boiling points above 100°F.
 - c. Class IC. Liquids having flash points at or above 73°F. and below 100°F.
- 8. Flammable Solids. A solid, other than a blasting agent or explosive, that is capable of causing a fire through friction, absorption of moisture, spontaneous chemical change, or retaining heat from manufacturing or processing, or which has an ignition temperature below 212°F. or which burns so vigorously and persistently when ignited as to create a serious hazard.
- 9. Flash Point. The minimum temperature in °F. at which a flammable liquid will give off sufficient vapors to form an ignitable mixture with air near the surface or in the container, but will not sustain combustion.
- 10. Noncombustible. A material that, in the form in which it is used and under the conditions anticipated, will not ignite, burn, support combustion, or release flammable vapors when subject to fire or heat.
- 11. Pyrophoric. A material that will spontaneously ignite in air at or below 130°F.

Humidification Rules of Thumb

10.01 Window Types and Space Humidity Values

A. Single Pane Windows ±10% RH Maximum

B. Double Pane Windows ±30% RH Maximum

C. Triple Pane Windows ±40% RH Maximum

D. The above numbers are based on the following:

- 1. 0°F. outside design temperature.
- 2. 72°F. inside design temperature.
- 7. Standard air at sea level
- 8. The relative humidity numbers listed above are rounded for ease of remembrance.
- The glass R-values and U-values are for average glass construction. Modern glass construction can achieve higher R-values/lower U-values.
- 10. For additional information on moisture condensation on glass see the tables at the end of this chapter.

10.02 Proper Vapor Barriers

Proper vapor barriers and moisture control must be provided to prevent moisture condensation in walls and to prevent mold, fungi, bacteria, and other plant and micro-organism growth.

10.03 Human Comfort

30-60% RH

10.04 Electrical Equipment, Computers

35-55% RH

10.05 Winter Design Relative Humidities

A. Outdoor Air Below 32°F.:

- 1. 70-80% RH
- 2. Design Wet Bulb Temperatures 2 to 4°F. below Design Dry Bulb Temperatures
- B. Outdoor Air 32-60°F: 50% RH

10.06 Energy Code Winter Design Relative Humidities

A. CABO Model Energy Code:

- 1. Winter: 30% RH Maximum
- 2. Summer: 60% RH Minimum

B. ASHRAE Standard 90A-1980:

1. Winter: 30% RH Maximum

2. Summer: 60% RH Minimum, if Humidistat is used

C. ASHRAE Standard 90A-1987:

1. Winter: 30% RH Maximum

2. Summer: 60% RH Minimum, if Humidistat is used

D. ASHRAE Standard 90.1-1989:

1. Winter: 30% RH Maximum

2. Summer: 60% RH Minimum, if Humidistat is used

10.07 Optimum Relative Humidity Ranges for Health

HEALTH ASPECT	OPTIMUM RELATIVE HUMIDITY RANGE FOR CONTROLLING HEALTH ASPECT
BACTERIA	20 - 70%
VIRUSES	40 - 78%
FUNGI	0 - 70%
MITES	0 - 60%
RESPIRATORY INFECTIONS (1)	40 - 50%
ALLERGIC RHINITIS AND ASTHMA	40 - 60%
CHEMICAL INTERACTIONS	0 - 40%
OZONE PRODUCTION	75 - 100%
COMBINED HEALTH ASPECTS	40 - 60%

Notes:

10.08 Moisture Condensation on Glass

A. The moisture condensation tables below are based on the following:

5. Standard air at sea level.

B. The glass surface temperatures, which are also the space dewpoint temperatures, listed in the moisture condensation tables that follow, were developed using the equations in Part 5.

^{1.} Insufficient data above 50% RH.

TEMP.	TEMP.	SINGLE PA	NE GLASS	DOUBLE PA	NE GLASS	TRIPLE PANE GLASS		
ROOM OUTSID °F. °F.	OUTSIDE °F.	T _{GLASS} / T _{DEWPOINT}	% R.H.	T _{GLASS} / T _{DEWPOINT}	% R.H.	T _{GLASS} / T _{DEWPOINT}	% R.H.	
	-30	-6.1	4.5	29.5	25.9	39.2	38.5	
	-25	-2.3	5.6	31.3	27.9	40.5	40.5	
	-20	1.4	6.9	33.2	30.2	41.9	42.8	
	-15	5.2	8.4	35.1	32.6	43.2	45.0	
65	-5 0 5	12.6 16.4 20.1 23.9	12.1 14.5 17.2 20.3	38.8 40.7 42.6 44.4	37.9 40.8 44.0 47.1	46.0 47.3 48.7 50.0	50.1 52.7 55.5 58.3	
	20	31.3	27.9	48.2	54.5	52.8	64.7	
	25	35.1	32.6	50.0	58.3	54.1	67.9	
	30	38.8	37.9	51.9	62.6	55.5	71.4	
	35	42.6	44.0	53.8	67.1	56.8	74.9	
	-30	-5.8	4.4	30.1	25.6	39.9	38.2	
	-25	-2.1	5.5	32.0	27.7	41.2	40.2	
	-20	1.7	6.7	33.8	29.9	42.6	42.5	
	-15	5.4	8.2	35.7	32.3	44.0	44.8	
66	-5	12.9	11.8	39.4	37.4	46.7	49.7	
	0	16.6	14.1	41.3	40.4	48.0	52.2	
	5	20.4	16.8	43.2	43.5	49.4	55.1	
	10	24.1	19.8	45.1	46.8	50.8	58.0	
	20	31.6	27.3	48.8	53.8	53.5	64.1	
	25	35.3	31.8	50.7	57.8	54.8	67.2	
	30	39.1	37.0	52.5	61.8	56.2	70.8	
	35	42.8	42.8	54.4	66.3	57.6	74.4	
	-30	-5.6	4.3	30.7	25.4	40.6	37.9	
	-25	-1.8	5.4	32.6	27.5	42.0	40.1	
	-20	1.9	6.6	34.5	29.7	43.3	42.2	
	-15	5.7	8.0	36.3	32.0	44.7	44.5	
67	-5 0 5	13.1 16.9 20.6 24.4	11.6 13.8 16.4 19.4	40.1 41.9 43.8 45.7	37.2 39.9 43.0 46.2	47.4 48.8 50.1 51.5	49.3 52.0 54.6 57.5	
	20	31.8	26.6	49.4	53.2	54.2	63.5	
	25	35.6	31.1	51.3	57.1	55.6	66.9	
	30	39.3	36.0	53.2	61.3	56.9	70.1	
	35	43.1	41.8	55.0	65.4	58.3	73.7	

TEMP. ROOM OUTSIDE °F.		SINGLE PA	NE GLASS	DOÙBLE PA	NE GLASS	TRIPLE PANE GLASS		
		T _{GLASS} / T _{DEWPOINT}	% R.H.	T _{GLASS} / T _{DEWPOINT}	% R.H.	T _{GLASS} / T _{DEWPOINT}	% R.H.	
	-30	-5.3	4.3	31.3	25.1	41.3	37.7	
	-25	-1.6	5.3	33.2	27.2	42.7	39.8	
	-20	2.2	6.5	35.1	29.4	44.1	42.0	
	-15	5.9	7.8	37.0	31.8	45.4	44.2	
68	-5	13.4	11.3	40.7	36.8	48.1	48.9	
	0	17.1	13.5	42.6	39.6	49.5	51.6	
	5	20.9	16.0	44.4	42.5	50.9	54.4	
	10	24.6	18.9	46.3	45.7	52.2	57.0	
	20	32.1	26.0	50.0	52.6	54.9	63.0	
	25	35.8	30.3	51.9	56.4	56.3	66.3	
	30	39.6	35.2	53.8	60.5	57.7	69.7	
	35	43.3	40.7	55.7	64.8	59.0	73.0	
	-30	-5.1	4.2	32.0	25.0	42.1	37.6	
	-25	-1.3	5.2	33.8	26.9	43.4	39.5	
	-20	2.4	6.3	35.7	29.1	44.8	41.7	
	-15	6.2	7.7	37.6	31.4	46.2	44.0	
69	-5	13.6	11.1	41.3	36.4	48.9	48.7	
	0	17.4	13.2	43.2	39.2	50.2	51.2	
	5	21.1	15.6	45.1	42.2	51.6	53.9	
	10	24.9	18.5	46.9	45.2	53.0	56.8	
	20	32.3	25.3	50.7	52.1	55.7	62.7	
	25	36.1	29.6	52.5	55.7	57.0	65.7	
	30	39.8	34.3	54.4	59.8	58.4	69.1	
	35	43.6	39.8	56.3	64.0	59.8	72.6	
-25 -20 -15 -5 0 70 5	-30 -25 -20 -15	-4.8 -1.1 2.7 6.4	4.1 5.0 6.2 7.5	32.6 34.5 36.3 38.2	24.8 26.8 28.8 31.1	42.8 44.2 45.5 46.9	37.3 39.4 41.4 43.7	
	0 5	13.9 17.6 21.4 25.1	10.8 12.9 15.3 18.0	41.9 43.8 45.7 47.6	36.0 38.8 41.7 44.8	49.6 51.0 52.3 53.7	48.3 51.0 53.5 56.3	
	30	32.6 36.3 40.1 43.8	24.8 28.8 33.6 38.8	51.3 53.2 55.0 56.9	51.5 55.3 59.0 63.2	56.4 57.8 59.1 60.5	62.1 65.3 68.4 71.9	

TEMP.	TEMP.	SINGLE PANE GLASS		DOUBLE PANE GLASS		TRIPLE PANE GLASS	
ROOM OUTSIDE °F.	OUTSIDE °F.	T _{GLASS} / T _{DEWPOINT}	% R.H.	T _{GLASS} / T _{DEWPOINT}	% R.H.	T _{GLASS} / T _{DEWPOINT}	% R.H.
	-30	-4.6	4.0	33.2	23.6	43.5	37.0
	-25	-0.8	5.0	35.1	26.5	44.9	39.1
	-20	2.9	6.0	37.0	28.7	46.2	41.1
	-15	6.7	7.4	38.8	30.8	47.6	43.3
71	-5	14.1	10.6	42.6	35.8	50.3	48.0
	0	17.9	12.6	44.4	38.4	51.7	50.5
	5	21.6	14.9	46.3	41.3	53.0	53.0
	10	25.4	17.6	48.2	44.3	54.4	55.8
	20	32.8	24.1	51.9	50.9	57.1	61.6
	25	36.6	28.2	53.8	54.6	58.5	64.7
	30	40.3	32.7	55.7	58.5	59.8	67.8
	35	44.1	37.9	57.5	62.5	61.2	71.3
	-30	-4.3	4.0	33.8	24.3	44.3	36.9
	-25	-0.6	4.8	35.7	26.3	45.6	38.8
	-20	3.2	5.9	37.6	28.4	47.0	41.0
	-15	6.9	7.2	39.5	30.6	48.3	43.0
72	-5	14.4	10.4	43.2	35.4	51.1	47.8
	0	18.1	12.3	45.1	38.1	52.4	50.1
	5	21.9	14.6	46.9	40.8	53.8	52.8
	10	25.6	17.2	48.8	43.8	55.1	55.3
	20	33.1	23.6	52.6	50.5	57.9	61.2
	25	36.8	27.5	54.4	54.0	59.2	64.2
	30	40.6	32.0	56.3	57.8	60.6	67.4
	35	44.3	36.9	58.2	61.9	61.9	70.6
	-30	-4.1	3.8	34.5	24.2	45.0	36.7
	-25	-0.3	4.8	36.3	26.0	46.3	38.6
	-20	3.4	5.8	38.2	28.1	47.7	40.7
	-15	7.2	7.1	40.1	30.3	49.1	42.9
73	-5	14.7	10.2	43.8	35.0	51.8	47.4
	0	18.4	12.1	45.7	37.7	53.1	49.7
	5	22.1	14.3	47.6	40.5	54.5	52.4
	10	25.9	16.9	49.4	43.3	55.9	55.1
	20	33.4	23.1	53.2	49.9	58.6	60.7
	25	37.1	26.9	55.0	53.3	59.9	63.6
	30	40.8	31.2	56.9	57.1	61.3	66.8
	35	44.6	36.1	58.8	61.2	62.7	70.2

TEMP.	TEMP.	SINGLE PA	NE GLASS	DOUBLE PA	NE GLASS	TRIPLE PA	TRIPLE PANE GLASS	
ROOM OUTSIDE °F.	OUTSIDE °F.	T _{GLASS} / T _{DEWPOINT}	% R.H.	T _{GLASS} / T _{DEWPOINT}	% R.H.	T _{GLASS} / T _{DEWPOINT}	% R.H.	
70	-30	-3.8	3.8	35.1	24.0	45.7	36.4	
	-25	-0.1	4.7	37.0	25.9	47.1	38.4	
	-20	3.7	5.7	38.8	27.8	48.4	40.4	
	-15	7.4	6.9	40.7	30.0	49.8	42.5	
74	-5	14.9	9.9	44.5	34.8	52.5	47.0	
	0	18.6	11.8	46.3	37.3	53.9	49.5	
	5	22.4	14.0	48.2	40.1	55.2	51.9	
	10	26.1	16.4	50.1	43.0	56.6	54.6	
	20	33.6	22.6	53.8	49.3	59.3	60.2	
	25	37.3	26.2	55.7	52.9	60.7	63.3	
	30	41.1	30.5	57.5	56.4	62.0	66.2	
	35	44.8	35.2	59.4	60.4	63.4	69.6	
	-30	-3.5	3.7	35.7	23.8	46.4	36.2	
	-25	0.2	4.6	37.6	25.6	47.8	38.2	
	-20	3.9	5.6	39.5	27.7	49.2	40.3	
	-15	7.7	6.8	41.3	29.7	50.5	42.2	
75	-5 0 5	15.2 18.9 22.6 26.4	9.7 11.6 13.6 16.1	45.1 46.9 48.8 50.7	34.4 36.9 39.6 42.6	53.2 54.6 56.0 57.3	46.7 49.1 51.7 54.2	
	20	33.9	22.1	54.4	48.8	60.0	59.7	
	25	37.6	25.7	56.3	52.3	61.4	62.7	
	30	41.3	29.7	58.2	56.0	62.8	65.9	
	35	45.1	34.4	60.0	59.7	64.1	69.0	
	-30	-3.3	3.6	36.4	23.6	47.2	36.1	
	-25	0.4	4.5	38.2	25.4	48.5	37.9	
	-20	4.2	5.5	40.1	27.4	49.9	39.9	
	-15	7.9	6.6	42.0	29.5	51.2	41.9	
76	-5 0 5	15.4 19.1 22.9 26.6	9.5 11.3 13.4 15.7	45.7 47.6 49.4 51.3	34.1 36.6 39.2 42.1	54.0 55.3 56.7 58.0	46.5 48.8 51.3 53.8	
	20	34.1	21.5	55.1	48.4	60.8	59.4	
	25	37.8	25.0	56.9	51.7	62.1	62.2	
	30	41.6	29.1	58.8	55.3	63.5	65.3	
	35	45.3	33.6	60.7	59.2	64.8	68.3	

LIBRARY
NSCC, STRAIT AREA CAMPUS
226 REEVES ST.
POET HAWKESBURY, NS B9A 2A2 CANADA

TEMP.	TEMP.	SINGLE PA	NE GLASS	DOUBLE PA	NE GLASS	TRIPLE PANE GLASS		
ROOM °F.	OUTSIDE °F.	T _{GLASS} / T _{DEWPOINT}	% R.H.	T _{GLASS} / T _{DEWPOINT}	% R.H.	T _{GLASS} / T _{DEWPOINT}	% R.H.	
	-30	-3.0	3.6	37.0	24.4	47.9	35.8	
	-25	0.7	4.4	38.8	25.2	49.3	37.8	
	-20	4.4	5.3	40.7	27.2	50.6	39.7	
	-15	8.2	6.5	42.6	29.3	52.0	41.8	
77	-5	15.7	9.3	46.3	33.7	54.7	46.1	
	0	19.4	11.1	48.2	36.3	56.1	48.6	
	5	23.1	13.0	50.1	38.9	57.4	50.9	
	10	26.9	15.4	51.9	41.6	58.8	53.5	
	20	34.4	21.1	55.7	47.9	61.5	58.9	
	25	38.1	24.5	57.6	51.3	62.9	61.9	
	30	41.8	28.4	59.4	54.7	64.2	64.7	
	35	45.6	32.8	61.3	58.5	65.6	68.0	
	-30	-2.8	3.5	37.6	23.2	48.6	35.6	
	-25	0.9	4.3	39.5	25.1	50.0	37.5	
	-20	4.7	5.3	41.3	26.9	51.3	39.4	
	-15	8.4	6.3	43.2	29.0	52.7	41.5	
78	-5	15.9	9.1	47.0	33.5	55.4	45.8	
	0	19.7	10.8	48.8	35.9	56.8	48.2	
	5	23.4	12.8	50.7	38.5	58.1	50.5	
	10	27.1	15.0	52.6	41.3	59.5	53.1	
	20	34.6	20.6	56.3	47.3	62.2	58.4	
	25	38.4	24.0	58.2	50.7	63.6	61.3	
	30	42.1	27.8	60.0	54.0	64.9	64.2	
	35	45.8	32.0	61.9	57.8	66.3	67.4	
	-30	-2.5	3.5	38.2	23.0	49.4	35.5	
	-25	1.2	4.2	40.1	24.8	50.7	37.3	
	-20	4.9	5.1	42.0	26.8	52.1	39.3	
	-15	8.7	6.2	43.8	28.7	53.4	41.2	
79	-5 0 5 10	16.2 19.9 23.6 27.4	8.9 10.6 12.5 14.7	47.6 49.5 51.3 53.2	33.2 35.6 38.1 40.9	56.2 57.5 58.9 60.2	45.6 47.8 50.3 52.7	
	20 25 30 35	34.9 38.6 42.3 46.1	20.2 23.4 27.1 31.3	56.9 58.8 60.7 62.5	46.8 50.1 53.6 57.1	63.0 64.3 65.7 67.0	58.1 60.8 63.9 66.8	

The second secon	TEMP.	SINGLE PANE GLASS		DOUBLE PANE GLASS		TRIPLE PANE GLASS	
ROOM °F.	OUTSIDE °F.	T_{GLASS} / T_{DEWPOINT}	% R.H.	T _{GLASS} / T _{DEWPOINT}	% R.H.	T_{GLASS} / $T_{DEWPOINT}$	% R.H.
-30 -25 -20 -15	-25 -20	-2.3 1.5 5.2 8.9	3.4 4.2 5.0 6.1	38.9 40.7 42.6 44.5	22.9 24.6 26.5 28.5	50.1 51.4 52.8 54.2	35.3 37.0 39.0 41.0
80	-5 0 5 10	16.4 20.2 23.9 27.6	8.7 10.4 12.2 14.4	48.2 50.1 51.9 53.8	32.8 35.3 37.7 40.5	56.9 58.2 59.6 61.0	45.3 47.4 49.9 52.4
	20 25 30 35	35.1 38.9 42.6 46.3	19.7 22.9 26.5 30.6	57.6 59.4 61.3 63.2	46.4 49.5 53.0 56.6	63.7 65.0 66.4 67.8	57.6 60.3 63.3 66.4

People/Occupancy Rules of Thumb

11.01 Offices, Commercial

A. General 80-150 Sq.Ft./Person

B. Private 1, 2, or 3 People

C. Private 100-150 Sq.Ft./Person

D. Conference, Meeting Rooms 20-50 Sq.Ft./Person

11.02 Banks, Court Houses, Municipal Buildings, Town Halls

50-150 Sq.Ft./Person

11.03 Police Stations, Fire Stations, Post Offices

100-500 Sq.Ft./Person

11.04 Precision Manufacturing

100-300 Sq.Ft./Person

11.05 Computer Rooms

80-150 Sq.Ft./Person

11.06 Restaurants

15-50 Sq.Ft./Person

11.07 Kitchens

50-150 Sq.Ft./Person

11.08 Cocktail Lounges, Bars, Taverns, Clubhouses, Nightclubs

15-50 Sq.Ft./Person

11.09 Hospital Patient Rooms, Nursing Home Patient Rooms

80-150 Sq.Ft./Person

11.10 Hospital General Areas

50-150 Sq.Ft./Person

11.11 Medical/Dental Centers, Clinics, and Offices

50-150 Sq.Ft./Person

11.12 Residential

200-600 Sq.Ft./Person

11.13 Apartments (Eff., 1 Room, 2 Room)

100-400 Sq.Ft./Person

11.14 Motel and Hotel Public Spaces

100-200 Sq.Ft./Person

11.15 Motel and Hotel Guest Rooms, Dormitories

100-200 Sq.Ft./Person

11.16 School Classrooms

20-30 Sq.Ft./Person

11.17 Dining Halls, Lunch Rooms, Cafeterias, Luncheonettes

10-50 Sq.Ft./Person

11.18 Libraries, Museums

30-100 Sq.Ft./Person

11.19 Retail, Department Stores

15-75 Sq.Ft./Person

11.20 Drug, Shoe, Dress, Jewelry, Beauty, Barber, and Other Shops

15-50 Sq.Ft./Person

11.21 Supermarkets

50-100 Sq.Ft./Person

11.22 Malls, Shopping Centers

50-100 Sq.Ft./Person

11.23 Jails

50-300 Sq.Ft./Person

11.24 Auditoriums, Theaters

5-20 Sq.Ft./Person

11.25 Churches

5-20 Sq.Ft./Person

11.26 Bowling Alleys

2-6 People/Lane

Note: People/Occupancy requirements should be determined from architect or client whenever possible.

Lighting Rules of Thumb

12.01 Offices, Commercial

A. General

1.5-3.0 Watts/Sq.Ft.

B. Private

2.0-5.0 Watts/Sq.Ft.

C. Conference, Meeting Rooms 2.0-6.0 Watts/Sq.Ft.

12.02 Banks, Court Houses, Municipal Buildings, Town Halls

2.0-5.0 Watts/Sq.Ft.

12.03 Police Stations, Fire Stations, Post Offices

2.0-3.0 Watts/Sq.Ft.

12.04 Precision Manufacturing

3.0-10.0 Watts/Sq.Ft.

12.05 Computer Rooms

1.5-5.0 Watts/Sq.Ft.

12.06 Restaurants

1.5-3.0 Watts/Sq.Ft.

12.07 Kitchens

1.5-2.5 Watts/Sq.Ft.

12.08 Cocktail Lounges, Bars, Taverns, Clubhouses, **Nightclubs**

1.5-2.0 Watts/Sq.Ft.

12.09 Hospital Patient Rooms, Nursing Home Patient Rooms

1.0-2.0 Watts/Sq.Ft.

12.10 Hospital General Areas

1.5-2.5 Watts/Sq.Ft.

12.11 Medical/Dental Centers, Clinics, and Offices

1.5-2.5 Watts/Sq.Ft.

12.12 Residential

1.0-4.0 Watts/Sq.Ft.

12.13 Apartments (Eff., 1 Room, 2 Room)

1.0-4.0 Watts/Sq.Ft.

12.14 Motel and Hotel Public Spaces

1.0-3.0 Watts/Sq.Ft.

12.15 Motel and Hotel Guest Rooms, Dormitories

1.0-3.0 Watts/Sq.Ft.

12.16 School Classrooms

2.0-6.0 Watts/Sq.Ft.

12.17 Dining Halls, Lunch Rooms, Cafeterias, Luncheonettes

1.5-2.5 Watts/Sq.Ft.

12.18 Libraries, Museums

1.0-3.0 Watts/Sq.Ft.

12.19 Retail, Department Stores

2.0-6.0 Watts/Sq.Ft.

12.20 Drug, Shoe, Dress, Jewelry, Beauty, Barber, and Other Shops

1.0-3.0 Watts/Sq.Ft.

12.21 Supermarkets

1.0-3.0 Watts/Sq.Ft.

12.22 Malls, Shopping Centers

1.0-2.5 Watts/Sq.Ft.

12.23 Jails

1.0-2.5 Watts/Sq.Ft.

12.24 Auditoriums, Theaters

1.0-3.0 Watts/Sq.Ft. (3)

12.25 Churches

1.0-3.0 Watts/Sq.Ft.

12.26 Bowling Alleys

1.0-2.5 Watts/Sq.Ft.

Notes:

- 1. The lighting values for most energy conscious construction will be the lower values.
- 2. Actual lighting layouts should be used for calculating lighting loads whenever available.
- 3. Does not include theatrical lighting.

Appliance/Equipment Rules of Thumb

13.01 Offices and Commercial Spaces

A. Total Appliance/Equipment Heat Gain: 0.5-5.0 Watts/Sq.Ft.

B. Computer equipment loads for office spaces range between 0.5 Watt/Sq.Ft. and 2.5 Watts/Sq.Ft. (recommend 1.5 Watts/Sq.Ft.). If actual computer equipment loads are available, they should be used in lieu of values listed here.

13.02 Computer Rooms, Data Centers, and Internet Host Facilities

2.0-300.0 Watts/Sq.Ft.

13.03 Telecommunication Rooms

50.0-120.0 Watts/Sq.Ft.

13.04 Electrical Equipment Heat Gain

A. Transformers:

1. 150 KVA and Smaller	50 Watts/KVA
2. 151-500 KVA	30 Watts/KVA
3. 501-1000 KVA	25 Watts/KVA
4. 1001-2500 KVA	20 Watts/KVA
5. Larger than 2500 KVA	15 Watts/KVA

B. Switchgear:

1.	Low Voltage Breaker 0-40 Amps	10 Watts
2.	Low Voltage Breaker 50–100 Amps	20 Watts
3.	Low Voltage Breaker 225 Amps	60 Watts
4.	Low Voltage Breaker 400 Amps	100 Watts
5.	Low Voltage Breaker 600 Amps	130 Watts
6.	Low Voltage Breaker 800 Amps	170 Watts
7.	Low Voltage Breaker 1,600 Amps	460 Watts
8.	Low Voltage Breaker 2,000 Amps	600 Watts
9.	Low Voltage Breaker 3,000 Amps	1,100 Watts
10.	Low Voltage Breaker 4,000 Amps	1,500 Watts
11.	Medium Voltage Breaker/Switch 600 Amps	1,000 Watts
12.	Medium Voltage Breaker/Switch 1,200 Amps	1,500 Watts
13.	Medium Voltage Breaker/Switch 2,000 Amps	2,000 Watts
14.	Medium Voltage Breaker/Switch 2,500 Amps	2,500 Watts

C. Panelboards:

1. 2 Watts per circuit

D. Motor Control Centers

1. 500 Watts per section—each section is approximately 20" wide × 20" deep × 84" high.

E. Starters:

 Low Voltage Starters Size 00 	50 Watts
2. Low Voltage Starters Size 0	50 Watts

3.	Low Voltage Starters Size 1	50 Watts
4.	Low Voltage Starters Size 2	100 Watts
5.	Low Voltage Starters Size 3	130 Watts
6.	Low Voltage Starters Size 4	200 Watts
7.	Low Voltage Starters Size 5	300 Watts
8.	Low Voltage Starters Size 6	650 Watts
9.	Medium Voltage Starters Size 200 Amp	400 Watts
10.	Medium Voltage Starters Size 400 Amp	1,300 Watts
11.	Medium Voltage Starters Size 700 Amp	1,700 Watts

F. Variable Frequency Drives:

1. 2 to 6 percent of the KVA rating

G. Miscellaneous Equipment:

- 1. Bus Duct 0.015 Watts/Ft/Amp
- 2. Capacitors 2 Watts/KVAR

Notes:

- Actual electrical equipment heat gain values will vary from one manufacturer to another—use actual values when available.
- 2. Generally, electrical equipment rooms only require ventilation to keep equipment from overheating. Most electrical rooms are designed for 95°F. to 104°F; however, consult electrical engineer for equipment temperature tolerances. If space temperatures below 90°F. are required by equipment, air conditioning of space will be required.
- 3. If outside air is used to ventilate the electrical room, the electrical room design temperature will be 10°F. to 15°F. above outside summer design temperatures.
- 4. If conditioned air from an adjacent space is used to ventilate the electrical room, the electrical room temperature can be 10°F. to 20°F. above the adjacent spaces.

13.05 Motor Heat Gain

A. Motors Only:

1. Motors 0 to 2 Hp	190 Watts/Hp
2. Motors 3-20 Hp	110 Watts/Hp
3. Motors 25-200 Hp	75 Watts/Hp
4. Motors 250 Hp and Larger	60 Watts/Hp

B. Motors and Driven Equipment are shown in the following table:

MOTOR	LOCATION OF MOTOR AND DRIVEN EQUIPMENT WITH RESPECT TO CONDITIONED SPACE OR AIRSTREAM		
MOTOR HORSEPOWER	MOTOR IN, DRIVEN EQUIPMENT IN BTU/HR	MOTOR OUT, DRIVEN EQUIPMENT IN BTU/HR	MOTOR IN, DRIVEN EQUIPMENT OUT BTU/HR
1/20	360	130	240
1/12	580	200	380
1/8	900	320	590
1/6	1,160	400	760
1/4	1,180	640	540
1/3	1,500	840	660
1/2	2,120	1,270	850
3/4	2,650	1,900	740
1	3,390	2,550	850
1-1/2	4,960	3,820	1,140
2	6,440	5,090	1,350
3	9,430	7,640	1,790
5	15,500	12,700	2,790
7-1/2	22,700	19,100	3,640
10	29,900	24,500	4,490
15	44,400	38,200	6,210
20	58,500	50,900	7,610
25	72,300	63,600	8,680
30	85,700	76,300	9,440
40	114,000	102,000	12,600
50	143,000	127,000	15,700
60	172,000	153,000	18,900
75	212,000	191,000	21,200
100	283,000	255,000	28,300
125	353,000	318,000	35,300
150	420,000	382,000	37,800
200	569,000	509,000	50,300
250	699,000	636,000	62,900

13.06 Miscellaneous Guidelines

- A. Actual equipment layouts and information should be used for calculating equipment loads.
- B. Movie projectors, slide projectors, overhead projectors, and similar types of equipment can generally be ignored because lights are off when being used and lighting load will normally be larger than this equipment heat gain.
- C. Items such as coffee pots, microwave ovens, refrigerators, food warmers, etc., should be considered when calculating equipment loads.
- D. Kitchen, laboratory, hospital, computer room, and process equipment should be obtained from owner, architect, engineer, or consultant due to extreme variability of equipment loads.

Cooling Load Factors

14.01 Diversity Factors

Diversity factors are an engineer's judgement applied to various people, lighting, equipment, and total loads to consider actual usage. Actual diversities may vary depending on building type and occupancy. Diversities listed here are for office buildings and similar facilities.

A. Room/Space Peak Loads:

1. People 1.0 \times Calc. Load 2. Lights 1.0 \times Calc. Load 3. Equipment 1.0 \times Calc. Load*

*Calc. Load may have diversity factor calculated with individual pieces of equipment or as a group or not at all.

B. Floor/Zone Block Loads:

People
 Lights
 Equipment
 Floor/Zone Total Loads
 People Co.90 × Sum of Peak Room/Space Lighting Loads
 Equipment
 Floor/Zone Total Loads
 People Co.90 × Sum of Peak Room/Space Equipment Loads
 Floor/Zone Total Loads

C. Building Block Loads:

People
 Lighting
 Lighting
 Equipment
 Building Total Load
 People Co.75 × Sum of Peak Room/Space Lighting Loads
 Equipment Co.75 × Sum of Peak Room/Space Equipment Loads
 Building Total Load
 People Co.75 × Sum of Peak Room/Space Equipment Loads
 Building Total Load

14.02 Safety Factors

A. Room/Space Peak Loads 1.1 × Calc. Load

B. Floor/Zone Loads (Sum of Peak) 1.0 × Calc. Load

C. Floor/Zone Loads (Block) 1.1 × Calc. Load

D. Building Loads (Sum of Peak) 1.0 × Calc. Load

E. Building Loads (Block) 1.1 × Calc. load

F. ASHRAE Standard 90.1-1989 10% Maximum Safety Factor

14.03 Cooling Load Factors

A. Lighting Load Factors:

Fluorescent Lights
 Incandescent Lights
 HID Lighting
 1.25 × Bulb Watts
 1.00 × Bulb Watts
 1.25 × Bulb Watts

B. Return Air Plenum (RAP) Factors:

1. Heat of Lights to Space with RAP 0.76 × Lighting Load

2. Heat of Lights to RAP $0.24 \times \text{Lighting Load}$

3. Heat of Roof to space with RAP $0.30 \times Roof Load$

4. Heat of Roof to RAP 0.70 × Roof Load

C. Ducted Exhaust or Return Air (DERA) Factors:

1. Heat of Lights to Space with DERA 1.00 × Lighting Load

2. Heat of Roof to Space with DERA 1.00 × Roof Load

D. Other Cooling Load Factors (CLF) are in accordance with ASHRAE Recommendations:

1. CLF × Other Loads

14.04 ASHRAE Standard 90.1-1989

A. Pick-Up Loads 10% Maximum System Capacity Allowance for Morning Cool Down Cycles

B. Safety Factor 10% Maximum

Heating Load Factors

15.01 Safety Factors

A. Room/Space Peak Loads 1.1 × Calc. Load

B. Floor/Zone Loads (Sum of Peak) 1.0 × Calc. Load

C. Floor/Zone Loads (Block) $1.1 \times$ Calc. Load

D. Building Loads (Sum of Peak) 1.0 × Calc. Load

E. Building Loads (Block) 1.1 × Calc. Load

F. Generally: Sum of Peak Loads = 1.1 × Block Loads

15.02 Heating Load Credits

A. Solar. Credit for solar gains should not be taken unless building is specifically designed for solar heating. Solar gain is not a factor at night when design temperatures generally reach their lowest point.

- B. People. Credit for people should not be taken. People gain is not a factor at night when design temperatures generally reach their lowest point because buildings are generally unoccupied at night.
- C. Lighting. Credit for lighting should not be taken. Lighting is an inefficient means to heat a building and lights are generally off at night when design temperatures generally reach their lowest point.
- D. Equipment. Credit for equipment should not be taken unless a reliable source of heat is generated 24 hours a day (i.e., Computer Facility, Industrial Process). Only a portion of this load should be considered (50%) and the building heating system should be able to keep the building from freezing if these equipment loads are shut down for extended periods of time. Consider what would happen if the system or process shut down for extended periods of time.

15.03 Heating System Selection Guidelines

- A. If heat loss exceeds 450 Btu/Hr. per lineal feet of wall, heat should be provided from under the window or from the base of the wall to prevent downdrafts.
- B. If heat loss is between 250 and 450 Btu/Hr. per lineal feet of wall, heat should be provided from under the window or from the base of the wall, or it may be provided from overhead diffusers, located adjacent to the perimeter wall, discharging air directly downward, blanketing the exposed wall and window areas.
- C. If heat loss is less than 250 Btu/Hr. per lineal feet of wall, heat should be provided from under the window or from the base of the wall, or it may be provided from overhead diffusers, located adjacent to or slightly away from the perimeter wall, discharging air directed at or both directed at and directed away from the exposed wall and window areas.

15.04 ASHRAE Standard 90.1-1989

- A. Pick-Up Loads 30% Maximum System Capacity Allowance for Morning Warm-Up Cycles
- B. Safety Factor 10% Maximum

Energy Conservation and Design Conditions

16.01 The 1989 CABO Model Energy Code

A. The 1989 CABO Model Energy Code is common to all three major U.S. codes (1990 BOCA, 1988 SBCCI, 1988 UBC) and is based on ASHRAE Standard 90A 1980, Energy Conservation in New Building Design.

B. 1990 BOCA, 1988 SBCCI, and the 1988 UBC codes also reference ASHRAE Standard 90A-1980.

C. Model Energy Code Design Conditions:

- 1. Outdoor Latest Version of ASHRAE Handbook of Fundamentals:
 - a. Heating 971/2% Values, Minimum
 - b. Cooling 21/2% Values, Maximum
- 2. Indoor:
 - a. Heating 70°F.; 30% RH Max.
 - b. Cooling 78°F.; 30 to 60% RH

D. The Model Energy Code Economizer Requirements:

- Systems 5,000 CFM and larger or 134,000 Btuh total cooling capacity and larger shall
 be designed to use up to and including 100 percent of the fan system capacity for cooling with outdoor air automatically whenever the use of outdoor air will result in lower
 usage of energy.
- 2. Exceptions (partial list):
 - a. Systems where the quality of outdoor is poor and will require extensive treatment.
 - Systems where humidification or dehumidification requires more energy than is saved by outdoor air cooling.
 - Systems where outdoor air cooling will increase the overall energy consumed by other systems.
 - d. Systems where cooling is accomplished by equipment other than refrigeration equipment (i.e., cooling towers—waterside economizer).

E. Ventilation:

 Systems shall be provided with a readily accessible means for ventilation shutoff (close OA dampers) when ventilation is not required (i.e., unoccupied periods).

F. Simultaneous Heating and Cooling:

- Systems that employ simultaneous heating and cooling in order to achieve comfort conditions shall be limited to those situations where more efficient methods of providing HVAC cannot be effectively utilized. Simultaneous heating and cooling by reheating or recooling supply air or by concurrent operations of independent HVAC systems shall be restricted as follows:
 - a. Reheat systems shall be provided with controls to automatically reset the system's cold deck supply air temperature to the highest temperature that will satisfy the zone requiring the coolest air.
 - b. Dual duct and multizone systems shall be provided with controls to automatically reset the cold deck and the hot deck supply air temperatures to the highest and lowest temperatures, respectively, that will satisfy the zones requiring the coolest and warmest air.

G. Controls:

- 1. Temperature Controls:
 - a. Heating Only 55°F.-75°F.

- b. Cooling Only 70°F.-85°F.
- c. Heating and Cooling 55°F.-85°F.
- 2. Humidity Controls:
 - a. Winter/Heating 30% Maximum.
 - b. Summer/Cooling 60% Minimum.
 - c. Note above items are values when using energy to humidify/dehumidify, respectively.
- Setback and Shutoff. Each HVAC system shall be equipped with a readily accessible means of reducing energy used for HVAC during periods of non-use or alternate uses of the building spaces or zones served by the system.
 - a. Winter. Night Setback.
 - b. Summer. Night Setup.
 - c. Occupied Periods. Time Clocks, Automatic Control Systems.
 - d. Unoccupied Periods. Manually Adjustable Automatic Timing Devices.

16.02 ASHRAE Standard 90A-1980, Energy Conservation in New Building Design

A. Purpose:

- 1. To provide design requirements which will improve utilization of energy in new buildings and to provide a means of determining the anticipated impact of that energy utilization on the depletion of energy resources.
- To provide energy efficient design of building envelopes, energy efficient design and selection of mechanical, electrical, service water heating, and illumination systems and equipment, and to provide prudent selection of fuel and energy sources.
- To encourage the use of innovative approaches and techniques to achieve effective utilization of energy.
- 4. To provide energy efficient design standards for new buildings which can be utilized during the preconstruction stage.

B. Scope:

- 1. Design of new buildings for human occupancy.
- 2. Building Envelope.
- 3. Selection of Systems and Equipment:
 - a. HVAC.
 - b. Service Water Heating.
 - c. Energy Distribution.
 - d. Illuminating Systems.
- 4. Exceptions:
 - a. Buildings whose peak energy usage is less than 3.5 Btu/Hr. Sq.Ft. of gross floor area
 - b. Buildings which are neither heated nor cooled
- 5. This standard does not include operation and maintenance criteria.

C. HVAC Systems Design:

- Heating and Cooling Load Calculation Procedures—ASHRAE Handbook & Product Directory 1977 Fundamentals or equivalent computational procedure.
- 2. Indoor Design Conditions: ANSI\ASHRAE Standard 55-1974 Thermal Environmental Conditions for Human Occupancy:
 - a. Heating (Winter)
 - 1) ASHRAE Standard 90A-1980: 72°F. Dry Bulb Recommended; 30% RH Maximum.
 - 2) Most Commonly Used Design Condition: 72°F. DB.

- b. Cooling (Summer):
 - 1) ASHRAE Standard 90A-1980: 78°F. Dry Bulb Recommended.
 - 2) Most Commonly Used Design Condition: 75°F./50% R.H.
- 3. Outdoor Design Conditions: ASHRAE Handbook & Product Directory 1977 Fundamentals or from local climate data:
 - a. Heating (Winter): 97.5% Values, Minimum.
 - b. Cooling (Summer): 2.5% Values, Maximum.
- 4. Ventilation:
 - a. Meet ASHRAE/ANSI Standard 62-1973, Natural and Mechanical Ventilation.
 - b. Air required for exhaust makeup, for source control of contaminants, or codes.

D. Controls:

- 1. System Control. At least 1 temperature control device:
 - a. Heating Only: 55°F. to 75°F.
 - b. Cooling Only: 70°F. to 85°F.
 - c. Heating and Cooling: 55°F. to 85°F. with adjustable deadband of 10°F. or more.
- 2. Humidity Control:
 - a. Humidistat is required for winter humidification, 30% maximum winter humidity level for comfort purposes.
 - b. If a humidistat is used for summer dehumidification, 60% minimum summer humidity level is required for comfort purposes.
- 3. Zone Control:
 - Residential Occupancies: Individual thermostatic controls for each system or dwelling unit.
 - b. All Other Occupancies:
 - 1) Each System.
 - 2) Each Floor.
 - 3) Each Separate Zone. A zone is a space or group of spaces with similar heating and/or cooling requirements.
- 4. Off-Hours Controls:
 - a. Provide each system with a readily accessible, manual, or automatic means of shutting off or reducing the energy used during unoccupied periods.

E. Simultaneous Heating and Cooling Systems:

- 1. The use of simultaneous heating and cooling systems will be limited to circumstances where more energy efficient systems cannot meet building design requirements.
- Reheat, Dual Duct, Multi-Zone, and Recooling Systems will employ automatic temperature reset controls for both hot and cold airstreams.

F. Economizer controls are required:

- 1. Air Side Economizers: Dry-Bulb Temperature or Enthalpy.
- 2. Exceptions:
 - a. Fans with a capacity of less than 5000 CFM or total cooling capacity of less than 134,000 Btuh
 - b. Annual heating degree days are less than 1,200.
 - c. When the system will be operated less than 30 hours per week.
 - d. Systems serving single-family or multi-family residential buildings.

G. Mechanical Ventilation:

1. Supply and exhaust systems shall be provided with a readily accessible means to shut off or reduce the ventilation air when the building is unoccupied.

H. Transport Energy:

1. All air systems, air and water systems, and water systems shall have a transport factor 5.5 or greater. Transport factors are the space sensible heat expressed in Btu/Hr. divided by the sum of the supply fan(s), return fan(s), terminal fan(s), and pump(s) input energy expressed in Btu/Hr.

I. Piping Insulation. Insulation is required on:

- 1. Heating Systems (Hot Water, Steam, Steam Condensate): 120°F. and Higher.
- 2. Cooling Systems (Chilled Water, Brine, and Refrigerant): 55°F. and Lower.
- 3. Domestic and Service Hot Water Systems: 100°F. and Higher.
- 4. Insulation not required on systems where Fluid Temperature is between 55°F. and 120°F.
- Required Insulation Thickness depends on Fluid Temperature, Insulation Type, and Pipe Size.
- 6. Insulation Thickness is given in the following table:

	FLUID	INSULATION THICKNESS FOR PIPE				PE SIZES - INCHES (1,3)			
PIPING SYSTEM	TEMP. °F.	RUNOUTS UP TO 2" (2)	1" & SMALLER	1-1/4" - 2"	2-1/2" - 4"	5" & 6"	8" & LARGER		
HEATING SYSTEM	HEATING SYSTEMS - STEAM AND HOT WATER								
HIGH PRESSURE/ TEMPERATURE	306-450	1.5	2.5	2.5	3.0	3.5	3.5		
MEDIUM PRESSURE/ TEMPERATURE	251-305	1.5	2.0	2.5	2.5	3.0	3.0		
LOW PRESSURE/ TEMPERATURE	201-250	1.0	1.5	1.5	2.0	2.0	2.0		
LOW TEMPERATURE	120-200	0.5	1.0	1.0	1.5	1.5	1.5		
STEAM CONDENSATE	ANY	1.0	1.0	1.5	2.0	2.0	2.0		
COOLING SYSTEMS									
CHILLED WATER	40-55	0.5	0.5	0.75	1.0	1.0	1.0		
REFRIGERANT OR BRINE	BELOW 40	1.0	1.0	1.5	1.5	1.5	1.5		

Notes:

- 1. Insulation thicknesses based on insulation having a thermal resistivity in the range of 4.0 to 4.6 Ft² Hr. °F./Btu. In.
- 2. Runouts to individual terminal units not exceeding 12 feet.
- 3. For piping exposed to ambient temperatures, increase insulation thickness by 0.5".

J. Air Handling System Insulation. Insulation is required on all ducts, plenums, and enclosures:

- Insulation is required when the Temperature Difference between Air Temperature and Space Temperature is Greater than 25°F.
- 2. Exceptions:

- a. Where the temperature difference is 14°F or less.
- b. Within HVAC equipment.
- c. Exhaust air ducts.
- 3. Insulation Thickness is given in the following table:

TEMPERATURE DIFFERENCE °F	R-VALUE SQ.FT. HR. °F./BTU
25	1.7
27	1.8
54	3.6
81	5.4
108	7.2
136	9.1
162	11.0

K. Duct Construction:

- SMACNA Heating and Air Conditioning Systems Installation Standards, 3rd Ed., February 1977.
- 2. SMACNA Low Pressure Duct Construction Standards, 5th Ed., 1976.
- 3. SMACNA High Pressure Duct Construction Standards, 3rd Ed., 1975.
- 4. SMACNA Fibrous Glass Duct Construction Standards, 4th Ed., 1975.
- High pressure and medium pressure ducts shall be leak tested in accordance with SMACNA Standard.

L. Balancing:

1. System design shall provide a means for balancing both air and water systems.

M. HVAC Equipment:

- 1. Minimum Equipment Efficiencies.
- 2. Equipment Rating shall be Certified by Nationally Recognized Standards.

16.03 ASHRAE Standard 90A-a-1987, Energy Conservation in New Building Design

A. HVAC Systems Design:

- Heating and Cooling Load Calculation Procedures. ASHRAE Handbook 1981 Fundamentals or similar computational procedure.
- Indoor Design Conditions: ANSI\ASHRAE Standard 55-1981 Thermal Environmental Conditions for Human Occupancy.
 - a. Satisfy 80% or More of the Occupants.
 - b. Heating (Winter):
 - 1) ASHRAE Standard 90A-a-1987: 72°F. Dry Bulb Recommended; 30% RH Maximum.

- 2) ASHRAE Standard 55: 68°F.–74°F. Dry Bulb (DB) at 60% RH; 69°F.–76°F. DB at 36°F Dew Point (DP).
- 3) Most Commonly Used Design Condition: 72°F DB.
- c. Cooling (Summer):
 - 1) ASHRAE Standard 90A-a-1987: 78°F. Dry Bulb Recommended.
 - 2) ASHRAE Standard 55: 73°F.-79°F. DB at 60% RH; 74°F.-81°F. DB at 36°F DP.
 - 3) Most Commonly Used Design Condition: 75°F/50% R.H.
- Outdoor Design Conditions: ASHRAE Handbook 1981 Fundamentals or from local climate data:
 - a. Heating (Winter): 97.5% Values, Minimum.
 - b. Cooling (Summer): 2.5% Values, Maximum.

B. Duct Construction:

- SMACNA Heating and Air Conditioning Systems Installation Standards, 3rd Ed., February 1977.
- 2. SMACNA Low Pressure Duct Construction Standards, 5th Ed., 1976.
- 3. SMACNA High Pressure Duct Construction Standards, 3rd Ed., 1975.
- 4. SMACNA Fibrous Glass Duct Construction Standards, 5th Ed., 1979.

16.04 ASHRAE Standard 90.1-1989, Energy Efficient Design of New Buildings Except Low-Rise Residential Buildings

A. Purpose:

- To set minimum requirements for the energy efficient design of new buildings so that
 they may be constructed, operated, and maintained in a manner that minimizes the use
 of energy without constraining the building function or the comfort or productivity of
 the occupants.
- To provide criteria for energy efficient design and methods for determining compliance with these criteria.
- 3. To provide sound guidance for energy efficient design.
- 4. It is estimated that as much as 40% of the energy used to heat, cool, and illuminate buildings and to provide hot water could be saved through the effective application of existing technology without reducing building performance or human comfort.

B. Scope:

- 1. Building Envelope
- 2. Distribution of Energy
- 3. Systems and Equipment:
 - a. Auxiliaries
 - b. Heating
 - c. Ventilating
 - d. Air-Conditioning
 - e. Service Water Heating
 - f. Lighting
- 4. Energy Management

C. Application:

1. To all new Buildings or Portions of Buildings that provide Facilities or Shelter for Human Occupancy and use Energy Primarily to provide Human Comfort.

- 2. Does not apply to: Areas of Buildings used for Manufacturing, Commercial or Industrial Processing.
- D. NEMA Design B; Single Speed; 1200, 1800, or 3600 RPM; Open Drip Proof (ODP) or Totally Enclosed Fan Cooled (TEFC) Motors 1 Hp and Larger that operate more than 500 hours per year must meet the following minimum nominal efficiencies:

Horsepower	Minimum Nominal Efficiency
1 - 4	78.5
5 - 9	84.0
10 - 19	85.5
20 - 49	88.5
50 - 99	90.2
100 - 124	91.7
125 or Greater	92.4

Note: Above table is based on ASHRAE Standard 90.1 prior to adoption of Addendum 90.1c by ASHRAE Board of Directors.

E. NEMA Design A and B; Open Drip Proof (ODP) or Totally Enclosed Fan Cooled (TEFC) Motors 1 Hp and Larger that operate more than 1000 hours per year must meet the following minimum nominal efficiencies; Minimum Acceptable Nominal Full-Load Motor Efficiency for Single Speed Polyphase Squirrel-Cage Induction Motors having Synchronous Speed of 3600, 1800, 1200, and 900 RPM:

Full Load Efficiencies-Open Motors

	2-P	OLE	4-P	OLE	6-POLE		8-POLE	
HP	NOMINAL EFF.	MINIMUM EFF.	NOMINAL EFF.	MINIMUM EFF.	NOMINAL EFF.	MINIMUM EFF.	NOMINAL EFF.	MINIMUM EFF.
1.0			82.5	81.5	80.0	78.5	74.0	72.0
1.5	82.5	81.5	84.0	82.5	84.0	82.5	75.5	74.0
2.0	84.0	82.5	84.0	82.5	85.5	84.0	85.5	84.0
3.0	84.0	82.5	86.5	85.5	86.5	85.5	86.5	85.5
5.0	85.5	84.0	87.5	86.5	87.5	86.5	87.5	86.0
7.5	87.5	86.5	88.5	87.5	88.5	87.5	88.5	87.5
10.0	88.5	87.5	89.5	88.5	90.2	89.5	89.5	88.5
15.0	89.5	88.5	91.0	90.2	90.2	89.5	89.5	88.5
20.0	90.2	89.5	91.0	90.2	91.0	90.2	90.2	89.5
25.0	91.0	90.2	91.7	91.0	91.7	91.0	90.2	89.5
30.0	91.0	90.2	92.4	91.7	92.4	91.7	91.0	90.2
40.0	91.7	91.0	93.0	92.4	93.0	92.4	91.0	90.2
50.0	92.4	91.7	93.0	92.4	93.0	92.4	91.7	91.0
60.0	93.0	92.4	93.6	93.0	93.6	93.0	92.4	91.7
75.0	93.0	92.4	94.1	93.6	93.6	93.0	93.6	93.0
100.0	93.0	92.4	94.1	93.6	94.1	93.6	93.6	93.0
125.0	93.6	93.0	94.5	94.1	94.1	93.6	93.6	93.0
150.0	93.6	93.0	95.0	94.5	94.5	94.1	93.6	93.0
200.0	94.5	94.1	95.0	94.5	94.5	94.1	93.6	93.0

Full Load Efficiencies-Enclosed Motors

	2-P	OLE	4-P	OLE	6-P	OLE	8-P	OLE
HP	NOMINAL EFF.	MINIMUM EFF.	NOMINAL EFF.	MINIMUM EFF.	NOMINAL EFF.	MINIMUM EFF.	NOMINAL EFF.	MINIMUM EFF.
1.0	75.5	74.0	82.5	81.5	80.0	78.5	74.0	72.0
1.5	82.5	81.5	84.0	82.5	85.5	84.0	77.0	75.5
2.0	84.0	82.5	84.0	82.5	86.5	85.5	82.5	81.5
3.0	85.5	84.0	87.5	86.5	87.5	86.5	84.0	82.5
5.0	87.5	86.5	87.5	86.5	87.5	86.5	85.5	84.0
7.5	88.5	87.5	89.5	88.5	89.5	88.5	85.5	84.0
10.0	89.5	88.5	89.5	88.5	89.5	88.5	88.5	87.5
15.0	90.2	89.5	91.0	90.2	90.2	89.5	88.5	87.5
20.0	90.2	89.5	91.0	90.2	90.2	89.5	89.5	88.5
25.0	91.0	90.2	92.4	91.7	91.7	91.0	89.5	88.5
30.0	91.0	90.2	92.4	91.7	91.7	91.0	91.0	90.2
40.0	91.7	91.0	93.0	92.4	93.0	92.4	91.0	90.2
50.0	92.4	91.7	93.0	92.4	93.0	92.4	91.7	91.0
60.0	93.0	92.4	93.6	93.0	93.6	93.0	91.7	91.0
75.0	93.0	92.4	94.1	93.6	93.6	93.0	93.0	92.4
100.0	93.6	93.0	94.5	94.1	94.1	93.6	93.0	92.4
125.0	94.5	94.1	94.5	94.1	94.1	93.6	93.6	93.0
150.0	94.5	94.1	95.0	94.5	95.0	94.5	93.6	93.0
200.0	95.0	94.5	95.0	94.5	95.0	94.5	94.1	93.6

Note: Above tables are based on ASHRAE Standard 90.1, Addendum 90.1c.

F. HVAC Systems Design:

- Heating and Cooling Load Calculation Procedures. ASHRAE Handbook 1985 Fundamentals or similar computational procedure:
 - a. Building envelope loads based on building envelope criteria of ASHRAE Standard 90.1.
 - b. Lighting loads based on actual lighting level or power budgets consistent with lighting requirements of ASHRAE Standard 90.1.
 - c. Other Loads, People and Equipment:
 - 1) Actual information based on intended use.
 - 2) Manufacturer's data.
 - 3) Technical Publications such as ASHRAE.
 - 4) Other sources.
 - 5) Designer's experience.
 - d. Safety Factor: 10% Maximum
 - e. Pick-Up Loads:
 - 1) Heating: 30% Maximum system capacity allowance for morning warm-up cycles.
 - 2) Cooling: 10% Maximum system capacity allowance for morning cool-down cycles.

- f. Areas requiring special process temperature requirements, humidity requirements, or both shall be served by separate HVAC systems.
- 2. Indoor Design Conditions: ANSI\ASHRAE Standard 55-1981 Thermal Environmental Conditions for Human Occupancy or Chapter 8, ASHRAE Handbook 1985 Fundamentals:
 - a. Satisfy 80% or More of the Occupants.
 - b. Heating (Winter):
 - 1) ASHRAE Standard 55: 68°F.–74°F. Dry Bulb (DB) at 60% RH; 69°F.–76°F. DB at 36°F Dew Point (DP).
 - 2) Most Commonly Used Design Condition: 72°F DB.
 - c. Cooling (Summer):
 - 1) ASHRAE Standard 55: 73°F.-79°F. DB at 60% RH; 74°F.-81°F. DB at 36°F DP.
 - 2) Most Commonly Used Design Condition: 75°F/50% R.H.
- Outdoor Design Conditions: ASHRAE Handbook 1985 Fundamentals or from National Climatic Center or similar recognized data source:
 - a. Heating (Winter): 99% Values, Minimum.
 - b. Cooling (Summer): 2.5% Values, Maximum.
- 4. Ventilation:
 - a. Lowest volume necessary to maintain adequate indoor air quality.
 - b. Meet ASHRAE Standard 62-1989, Ventilation for Acceptable Indoor Air Quality.
 - c. Air required for exhaust makeup for source control of contaminants.

G. Controls

- 1. System Control. At least 1 temperature control device.
- 2. Zone Control. Individual thermostatic controls within each zone.
- 3. Off-Hours Controls:
 - a. Automatic controls capable of setback temperatures or equipment shutdown.
 - b. Automatic or reduced outdoor air volume during unoccupied periods.
- 4. Humidity Control:
 - Humidistat is required for winter humidification, 30% maximum winter humidity level for comfort purposes.
 - If a humidistat is used for summer dehumidification, 60% minimum summer humidity level is required for comfort purposes.
- 5. Economizer controls are required:
 - a. Air Side Economizers: Dry-Bulb Temperature or Enthalpy.
 - b. Water Side Economizers: Direct Evaporation, Indirect Evaporation, or Both.
 - c. Exceptions:
 - Fans with a capacity of less than 3,000 CFM or total cooling capacity of less than 90,000 Btuh.
 - 2) Systems serving residential spaces or hotel or motel rooms.
- 6. Controls shall prevent:
 - a. Reheating.
 - b. Recooling.
 - c. Simultaneous mixing of hot and cold air.
 - d. Other simultaneous heating and cooling systems.
 - e. Exceptions:
 - VAV systems that reduce air flow to minimum before reheating, recooling or mixing take place.
 - Zones where pressure relationships or cross-contamination requirements are impractical—Hospitals, Laboratories.
 - 3) Heat recovery is used for reheating.
 - 4) Zones with peak supply air of 300 CFM or less.

- 7. Temperature Reset Controls:
 - a. Air Systems: Systems supplying heated or cooled air to multiple zones shall include controls that automatically reset supply air temperatures by respective building loads or outside air temperature.
 - 1) Exceptions:
 - a) VAV Systems.
 - b) Where resetting supply air temperatures can be shown to increase energy usage.
 - b. Hydronic Systems: Systems supplying heated and/or chilled water shall include controls that automatically reset supply water temperatures by respective building loads or outside air temperature.
 - 1) Exceptions:
 - a) Variable Flow Pumping Systems.
 - b) Where resetting supply water temperatures can be shown to increase energy usage.
 - c) Systems with less than 600,000 Btuh design capacity.

H. Piping Insulation. Insulation is required on:

- 1. Heating Systems (Hot Water, Steam, Steam Condensate): 105°F. and Higher.
- 2. Cooling Systems (Chilled Water, Brine, and Refrigerant): 55°F. and Lower.
- 3. Domestic and Service Hot Water Systems: 105°F. and Higher.
- 4. Insulation not required on systems where Fluid Temperature is between 55°F. and 105°F.
- Required Insulation Thickness depends on Fluid Temperature, Insulation Type, and Pipe Size.
- 6. Insulation Thickness is given in the following table:

FLUID DESIGN OPERATING	INSULA' CONDUCT		NOMINAL PIPE DIAMETER - INCHES				CHES (3)	
TEMP. RANGE °F.	RANGE (1)	MRT (2)	RUNOUTS UP TO 2" (3)	1" AND LESS	1-1/4" -	2-1/2" -	5" & 6"	8" & LARGER
HEATING SYS	STEMS - STEA	M, STEA	M CONDENSA	TE, AND H	OT WATE	R		
ABOVE 350	0.32-0.34	250	1.5	2.5	2.5	3.0	3.5	3.5
251-350	0.29-0.31	200	1.5	2.0	2.5	2.5	3.5	3.5
201-250	0.27-0.30	150	1.0	1.5	1.5	2.0	2.0	3.5
141-200	0.25-0.29	125	0.5	1.5	1.5	1.5	1.5	1.5
105-140	0.24-0.28	100	0.5	1.0	1.0	1.0	1.5	1.5
DOMESTIC AN	ND SERVICE H	OT WA	TER SYSTEMS					
105 & GREATER	0.24-0.28	100	0.5	1.0	1.0	1.5	1.5	1.5
COOLING SYS	TEMS - CHILL	ED WAT	TER, BRINE, AN	ND REFRIG	ERANT		VET	
40-55	0.23-0.27	75	0.5	0.5	0.75	1.0	1.0	1.0
BELOW 40	0.23-0.27	75	1.0	1.0	1.5	1.5	1.5	1.5

Notes:

- 1. Conductivity Range (Btu. In./Hr. Ft² °F.)
 2. MRT = Mean Rating Temperature (°F.)
 3. Runouts to individual terminal units not exceeding 12 feet.
- 4. For piping exposed to ambient temperatures, increase insulation thickness by 0.5".

I. Air Handling System Insulation. Insulation is required on:

- 1. Exterior Building Systems: Insulation Thickness is Based on CDD65 or HDD65, whichever results in greater insulation thickness and insulation type.
- Inside Building Systems: Insulation is required when the temperature difference between air temperature and space temperature is greater than 15°F. Insulation thickness is based on temperature difference and insulation type.
- 3. Insulation Thickness is given in the following table:

	COOLING (3)					
DUCT LOCATION	ANNUAL COOLING DEGREE DAYS BASE 65 °F.	INSULATION R-VALUE	INSULATION THICKNESS (2)			
EXTERIOR OF BUILDING:	BELOW 500 500 TO 1150 1151 TO 2000 ABOVE 2000	3.3 5.0 6.5 8.0	0.75 1.5 1.5 2.0			
INSIDE BUILDING OR IN UNCONDITIONED SPACES (1): $\Delta T \le 15$ $15 < \Delta T \le 40$ $\Delta T > 40$		NONE REQ'D 3.3 5.0	0.75 1.5			

	COOLING (3)				
DUCT LOCATION	ANNUAL COOLING DEGREE DAYS BASE 65 °F.	INSULATION R-VALUE	INSULATION THICKNESS (2)		
EXTERIOR OF BUILDING:	BELOW 500 500 TO 1150 1151 TO 2000 ABOVE 2000	3.3 5.0 6.5 8.0	0.75 1.5 1.5 2.0		
INSIDE BUILDING OR IN UNCONDITIONED SPACES (1): $\Delta T \le 15$ $15 < \Delta T \le 40$ $\Delta T > 40$		NONE REQ'D 3.3 5.0	 0.75 1.5		

Notes:

- 1. Δ T (Temperature difference) is the difference between space design temperature and the design air temperature in the duct.
- 2. Minimum insulation thickness required. Internally insulated (lined) ducts usually use 1" thickness. Externally insulated ducts usually use 1½" or 2" thickness.
- 3. Table based on ASHRAE Standard 90.1-1989.

J. Duct Construction:

- 1. SMACNA HVAC Duct Construction Standards—Metal and Flexible, 1985.
- 2. SMACNA Fibrous Glass Duct Construction Standard, 1979.
- 3. SMACNA HVAC Duct Leakage Test Manual, 1985.
- 4. If duct system is to operate in excess of 3 in. wc., ductwork shall be leak tested and be in conformance with SMACNA HVAC Duct Leakage Test Manual, 1985.

K. Operation and Maintenance Information:

- 1. O&M Manual shall be provided to Building Owner.
- 2. Manual to include:
 - a. Required Routine Maintenance
 - HVAC Control Information: Including schematics, diagrams, control descriptions, and maintenance and calibration information.

L. Testing, Adjusting, and Balancing shall be conducted in accordance with AABC or NEBB Standards or equivalent procedures (ASHRAE, SMACNA):

- Air System Balancing: Accomplished first to minimize Throttling Losses and then Fan Speed.
 - a. Damper throttling may be used for air systems under the following conditions:
 - 1) Fan motors of 1 Hp or less.
 - 2) If throttling results in no Greater than ½ Hp Fan Horsepower draw above that required if fan speed were adjusted.
- Hydronic System Balancing: Accomplished first to minimize Throttling Losses and then Pump Impeller shall be trimmed or Pump Speed shall be adjusted.
 - a. Valve throttling may be used for hydronic systems under the following conditions:
 - 1) Pumps with motors of 10 Hp or less.
 - 2) If throttling results in no greater than 3 Hp Pump horsepower draw above that required if the impeller were trimmed.
- 3. HVAC Control Systems shall be tested to assure that control elements are calibrated, adjusted, and in proper working order.

M. System Sizing: Systems and equipment shall be sized to provide no more than the space and system loads calculated in accordance with ASHRAE Standard 90.1:

- 1. Exceptions:
 - a. Standard equipment sizing limitations.
 - b. If oversizing does not increase energy usage.
 - Stand-by equipment with automatic change-over control only when primary equipment is not operating.
 - d. Multiple units of the same equipment (Chillers, Boilers, etc.) may be specified to operate concurrently only if optimization controls are provided.

N. Fan System Design Criteria: Supply Air, Return Air and Exhaust Fans:

- 1. Constant Volume Systems: 0.8 W/CFM of Supply Air.
- 2. Variable Air Volume (VAV) Systems: 1.25 W/CFM of Supply Air.
- 3. VAV Systems with Fan Motors 75 Hp and Larger requires controls or devices to demand no more than 50% of design wattage at 50% flow.
- 4. ASHRAE Standard 90.1 requires air handling systems to utilize either:
 - a. VAV Systems.
 - b. Supply Air Temperature Reset Systems.

O. Pumping System Design Criteria:

- 1. Maximum Piping System Design Friction Rate: 4.0 Ft./100 Ft. of Pipe.
- Variable Flow: Systems with control valves which modulate or step open and closed to meet load shall be designed for variable flow. System shall be capable of reducing flow to 50% or less using variable-speed-driven pumps, staged pumping, or pumps riding pump performance curves.

- 3. Exceptions:
 - a. Systems where a Minimum Flow greater than 50% of Design Flow is required (Chiller Systems).
 - b. Systems which include Supply Water Temperature Reset.
- 4. ASHRAE Standard 90.1 requires pumping systems to utilize either:
 - a. Variable Flow Pumping Systems.
 - b. Supply Water Temperature Reset Systems.

P. HVAC Equipment:

- 1. Minimum Equipment Efficiencies:
 - a. Full Load Efficiencies.
 - b. Part Load Efficiencies.
 - c. Includes Service Water Heating Equipment.
 - d. Includes Field Assembled Equipment: Individual Components to Meet Requirements (Coils, Fans); Sum all Component Energy Usage.
- 2. Equipment Rating shall be certified by nationally recognized standards.
- Operation and Maintenance: O&M Information shall be provided with Equipment including Mechanical Prints, Equipment Manuals, Preventive Maintenance Procedures and Schedules, and Names and Addresses of Qualified Service Agencies.

Q. Energy Management:

- 1. Each Distinct Building Energy Service shall have a Measurement System to accumulate a Record or Indicator Reading of the overall amounts of energy being delivered.
- 2. All Equipment used for Heating or Cooling and HVAC delivery of greater than 20 KVA or 60,000 Btuh energy input shall be arranged so that inputs and outputs such as Flow, Temperature, and Pressure can be individually measured to determine the equipment energy consumption, the installed performance capabilities and efficiencies, or both. Installation of measurement equipment is not required but proper access is required to permit measurements in the future.
- 3. Central Monitoring and Control Systems:
 - a. Energy Management Systems should be considered in any building exceeding 40,000
 Sq. Ft. in Gross Floor Area.
 - b. Minimum Energy Management System Capabilities:
 - 1) Readings and Daily Totals for Electrical Power and Demand.
 - 2) Readings and Daily Totals for External Energy and Fossil Fuel Use.
 - 3) Record, Summarize, and Retain Weekly Totals.
 - 4) Time Schedule HVAC Equipment and Service Water Heating Equipment.
 - 5) Reset Local Loop Control System for HVAC Equipment.
 - 6) Monitor and Verify Heating, Cooling, and Energy Delivery Systems.
 - 7) Time Schedule Lighting Systems.
 - 8) Provide Readily Accessible Override Controls.
 - 9) Provide Optimum Start/Stop Control for HVAC Systems.

16.05 Fuel Conversion Factors

A. Electric Baseboard to Hydronic Baseboard:

- 1. KWH \times 1.19 = KWH for Electric Boiler
- 2. KWH \times 0.033 = Gals. for Oil-Fired Boiler
- 3. KWH \times 0.046 = Therms for Gas-Fired Boiler

B. Electric Furnace to Hydronic Baseboard:

- 1. $KWH \times 1.0 = KWH$ for Electric Boiler
- 2. KWH \times 0.028 = Gals, for Oil-Fired Boiler
- 3. KWH \times 0.038 = Therms for Gas-Fired Boiler

C. Ceiling Cable to Hydronic Baseboard:

- 1. KWH \times 1.06 = KWH for Electric Boiler
- 2. KWH \times 0.03 = Gals. for Oil-Fired Boiler
- 3. KWH \times 0.041 = Therms for Gas-Fired Boiler

D. Heat Pump to Hydronic Baseboard:

- 1. $KWH \times 1.88 = KWH$ for Electric Boiler
- 2. $KWH \times 0.052 = Gals$. for Oil-Fired Boiler
- 3. KWH \times 0.073 = Therms for Gas-Fired Boiler

E. Electric Baseboard to Warm Air Furnace:

- 1. $KWH \times 1.19 = KWH$ for Electric Furnace
- 2. KWH \times 0.039 = Gals. for Oil-Fired Furnace
- 3. KWH \times 0.054 = Therms for Gas-Fired Furnace

F. Electric Furnace to Fuel-Fired Furnace:

- 1. KWH \times 0.032 = Gals, for Oil-Fired Furnace
- 2. KWH \times 0.045 = Therms for Gas-Fired Furnace

G. Ceiling Cable to Warm Air Furnace:

- 1. $KWH \times 1.06 = KWH$ for Electric Furnace
- 2. KWH \times 0.034 = Gals, for Oil-Fired Furnace
- 3. KWH \times 0.048 = Therms for Gas-Fired Furnace

H. Heat Pump to Warm Air Furnace:

- 1. $KWH \times 1.88 = KWH$ for Electric Furnace
- 2. $KWH \times 0.061 = Gals$. for Oil-Fired Furnace
- 3. KWH \times 0.085 = Therms for Gas-Fired Furnace

I. Warm Air Systems to Hydronic Baseboard System:

- 1. Gals. Oil for W.A. \times 0.857 = Gals. for Hydronics
- 2. Therms Gas for W.A. \times 0.857 = Therms for Hydronics
- 3. Gals. Oil for W.A. \times 1.2 = Therms for Hydronics
- 4. Therms Gas for W.A. \times 0.612 = Gals. for Hydronics

HVAC System Selection Criteria

17.01 HVAC System Selection Criteria

A. Building Type:

- 1. Institutional. Hospital, Prisons, Nursing Homes, Education
- 2. Commercial. Offices, Stores
- 3. Residential. Hotel, Motel, Apartments
- 4. Industrial, Manufacturing
- 5. Research and Development. Laboratories

B. Owner Type:

- 1. Government
- 2. Developer
- 3. Business
- 4. Private

C. Performance Requirements:

- 1. Supporting a Process. Computer Facility, Telephone Facility
- 2. Promoting an Germ Free Environment
- 3. Increasing Sales and Rental Income
- 4. System Efficiency
- 5. Increasing Property Salability
- 6. Standby and Reserve Capacity
- 7. Reliability, Life Expectancy. Frequency of Maintenance and Failure
- 8. How will Equipment Failures affect the Building? Owner Operations?

D. Capacity Requirements:

- 1. Cooling Loads. Magnitude and Characteristics
- 2. Heating Loads. Magnitude and Characteristics
- 3. Ventilation
- 4. Zoning Requirements:
 - a. Occupancy
 - b. Solar Exposure
 - c. Special Requirements
 - d. Space Temperature and Humidity Tolerances

E. Spatial Requirements:

- 1. Architectural Constraints:
 - a. Aesthetics
 - b. Structural Support
 - c. Architectural Style and Function
- 2. Space Available to House Equipment and Location
- 3. Space Available for Distribution of Ducts and Pipes
- 4. Acceptability of Components Obtruding into Occupied Space, Physically and Visually
- 5. Furniture Placement
- 6. Flexibility
- 7. Maintenance Accessibility
- 8. Roof
- 9. Available Space Constraints
- 10. Are Mechanical Rooms/Shafts Required?

F. Comfort Considerations:

- 1. Control Options
- 2. Noise and Vibration Control
- 3. Heating, Ventilating, and Air Conditioning
- 4. Filtration
- 5. Air Quality Control

G. First Cost:

- 1. System Cost. Return on Investment
- 2. Cost to Add Zones
- 3. Ability to Increase Capacity
- 4. Contribution to Life Safety Needs
- 5. Air Quality Control
- 6. Future Cost to Replace and/or Repair

H. Operating Costs:

- 1. Energy Costs
- 2. Energy Type:
 - a. Electricity. Voltage Available, Rate Schedule
 - b. Gas
 - c. Oil
 - d. District Steam
 - e. Other Sources
- 3. Energy Types Available at Project Site
- 4. Equipment Selection

I. Maintenance Cost:

- 1. Cost to Repair
- 2. Capabilities of Owners Maintenance Personnel
- 3. Cost of System Failure on Productivity
- 4. Economizer Cycle
- 5. Heat Recovery
- 6. Future Cost to Replace
- 7. Ease and Quickness of Servicing
- 8. Ease and Quickness of Adding Zones
- 9. Extent and Frequency of Maintenance

J. Codes

- 1. Codes govern HVAC and other building systems design.
- 2. Most building codes are adopted and enforced at the local level.
- 3. It is estimated that there are 13,000 building codes in the U.S.
- 4. Codes are not enforceable unless adopted by municipality, borough, county, state, etc.
- 5. Codes Regulate:
 - a. Design and Construction
 - b. Allowable Construction Types
 - c. Building Height
 - d. Egress Requirements
 - e. Structural Components
 - f. Light and Ventilation Requirements
 - g. Material Specifications

- 6. Code Approaches:
 - a. Prescriptive. Dictate specific materials and methods (ASTM A53, Steel Pipe, Welded)
 - b. Performance. Dictate desired results (HVAC system to provide and maintain design temperature of 72°F winter and 75°F/50% RH summer.)
- 7. Codes Developed Because of:
 - a. Loss of Life
 - b. Loss of Property
 - c. Pioneered by Insurance Industry
- 8. Model Codes:
 - a. Basic/National Building Code (BOCA), Northeastern U.S.
 - b. Southern Building Code (SBCCI), Southern U.S.
 - c. Uniform Building Code (ICBO), Western U.S.
 - d. Model codes are similar in their requirements, but quite different in format and technical language.

17.02 Heating System Selection Guidelines

- A. If heat loss exceeds 450 Btu/Hr. per lineal feet of wall, heat should be provided from under the window or from the base of the wall to prevent downdrafts.
- B. If heat loss is between 250 and 450 Btu/Hr. per lineal feet of wall, heat should be provided from under the window or from the base of the wall, or it may be provided from overhead diffusers, located adjacent to the perimeter wall, discharging air directly downward, blanketing the exposed wall and window areas.
- C. If heat loss is less than 250 Btu/Hr. per lineal feet of wall, heat should be provided from under the window or from the base of the wall, or it may be provided from overhead diffusers, located adjacent to or slightly away from the perimeter wall, discharging air directed at or both directed at and directed away from the exposed wall and window areas.

Air Distribution Systems

18.01 Ductwork Systems

A. Ductwork System Sizing:

0.10 (0.15) In.W.G./100 Ft.; 1. Low Pressure:

1,500-1,800 Fpm Maximum

0.20 (0.25) In.W.G./100 Ft.; 2. Medium Pressure:

2,000-2,500 Fpm Maximum

0.40 (0.45) In.W.G./100 Ft.; 3. High Pressure: 2,500-3,500 Fpm Maximum

0.03-0.05 In.WG./100 Ft.

4. Transfer Ducts: 1,000 Fpm Maximum

5. Transfer Grilles: 0.03-0.05 In.WG. pressure drop

6. Outside Air Shafts: 0.05-0.10 In. W.G./100 Ft. 1,000 Fpm Maximum

0.03-0.05 In. W.G./100 Ft. 7. Gravity Relief Air Shafts:

1,000 Fpm Maximum

8. Decrease or increase duct size whenever duct changes by 4" or more in one or two dimensions. Do NOT use fractions of an inch for duct sizes.

9. Try to change only one duct dimension at a time because it is easier to fabricate fittings and therefore generally less expensive, i.e., 36×12 to 30×12 in lieu of 36×12 to 32×10 .

10. Duct taps should be 2" smaller than main duct to properly construct and seal duct. Duct size should be 2" wider than diffusers, registers, and grilles.

11. All 90 degree square elbows should be provided with double radius turning vanes. Elbows in dishwasher, kitchen, and laundry exhaust should be unvaned smooth radius construction with radius equal to 1½ times width of duct.

12. Provide flexible connections at point of connection to equipment in all ductwork systems (supply, return, and exhaust) connected to air handling units, fans, and other equipment.

13. Provide access doors to access all fire dampers, smoke dampers, smoke detectors, volume dampers, motor operated dampers, humidifiers, coils (steam, hot water, chilled water, electric), and other items located in ductwork which require service and/or inspection.

14. All rectangular duct taps should be made with shoe (45 degree) fittings. Do NOT use splitter dampers or extractors.

15. Maximum ductwork hanger spacing:

a. SMACNA Minimum Requirements:

1) Horizontal: 8 feet maximum

2) Vertical: 16 feet and at each floor

b. Recommended:

1) Horizontal Ducts less than 4 square feet: 8 feet maximum 6 feet maximum 2) Horizontal Ducts 4 to 10 square feet: 3) Horizontal Ducts greater than 10 square feet: 4 feet maximum 12 feet maximum 4) Vertical Round Ducts: 10 feet maximum 5) Vertical Rectangular Ducts:

B. Friction Loss Estimate:

1. 1.5 × System Length (Ft./100) × Friction Rate (In.W.G./100 Ft.).

C. Ductwork Sizes:

- 1. $4'' \times 4''$ smallest rectangular size.
- 2. $8'' \times 4''$ smallest recommended size.

- 3. Rectangular ducts: Use even duct sizes, i.e., 24×12 , 10×6 , 72×36 , 48×12 .
- 4. 4:1 Maximum recommended aspect ratio.
- 5. 3" smallest round size, odd and even sizes available.
- 6. Round ducts available in 0.5 inch increments for duct sizes through 5.5 inch diameter, 1 inch increments for duct sizes 6 inches through 20 inches, and 2 inch increments for duct sizes 22 inches and greater.

18.02 Duct Construction

A. Sheet Metal and Air Conditioning Contractors' National Association (SMACNA) Duct Construction Manuals:

- SMACNA—HVAC Duct Construction Standards Metal and Flexible, First Edition, referred to herein as SMACNA-HVAC.
- SMACNA—Fibrous Glass Duct Construction Standards, Fifth Edition, referred to herein as SMACNA-FG.
- SMACNA—Rectangular Industrial Duct Construction Standard, First Edition, referred to herein as SMACNA-IDC.
- SMACNA—Round Industrial Duct Construction Standard, First Edition, referred to herein as SMACNA-RIDC.
- SMACNA—Thermoplastic Duct (PVC) Construction Manual, First Edition, referred to herein as SMACNA-PVC.

B. SMACNA-HVAC Pressure Ratings:

1. $\pm \frac{1}{2}$; $\pm \frac{1}{2}$; $\pm \frac{2}{3}$; $\pm \frac{3}{4}$; $\pm \frac{4}{3}$; $\pm \frac{6}{3}$; $\pm \frac{10}{3}$

C. SMACNA-IDC and SMACNA-RIDC Pressure Ratings:

- 1. +12'' to +100'' by multiples of 2''
- 2. -4'' to -100'' by multiples of -2''

D. Ductwork Testing:

1. -3'' W.G. and Lower: 1.5 × Pressure Rating

2. -2'' to +2'' W.G.: Generally not tested

3. +3" W.G. and Higher: 1.5 × Pressure Rating

E. SMACNA-HVAC Ductwork Leakage Classes:

- Seal Class A: 2–5% Total System Leakage (All Transverse joints, longitudinal seams, and duct penetrations).
- Seal Class B: 3–10% Total System Leakage (All Transverse joints and longitudinal seams).
- 3. Seal Class C: 5–20% Total System Leakage (All Transverse joints).
- 4. Unsealed: 10-40% Total System Leakage.
- 5. All ducts should be sealed for SMACNA Seal Class B minimum—Engineer must specify.

F. Ductwork Materials:

- Galvanized Steel: HVAC Applications; Most Common; Galvanized steel sheets meeting ASTM A90, A525, and A527, Lock Forming Quality.
- Carbon Steel: Breechings, Flues and Stacks; Carbon steel meeting ASTM A569 for stacks and breechings 24" and larger; Galvanized sheet steel meeting ASTM A527 with ANSI/ASTM A525 G90 zinc coating for stacks and breechings less than 24".

- 3. Aluminum: Moisture Laden Air Streams; Aluminum base alloy sheets meeting ASTM B209, Lock Forming Quality.
- 4. Stainless Steel: Kitchen Hood and Fume Hood Exhaust; Stacks and Breechings (Prefabricated); Type 304, 304L, 316, or 316L stainless steel sheets meeting *ASTM A167*:
 - a. 304 and 316: Non-welded applications.
 - b. 304L and 316L: Welded applications.
 - c. Kitchen Exhaust Finish:
 - 1) Concealed: None.
 - 2) Exposed: No. 2B, No 4, or Match Equipment (No. 4 preferred).
 - d. Lab Fume Exhaust Finish:
 - 1) Concealed: No 2B.
 - 2) Exposed: No 2B.
- 5. Fiberglass: HVAC Applications; 1" thick glass duct board meeting U.L. 181.
- 6. Fiberglass Reinforced: Chemical Exhaust; Plastic (FRP)
- 7. Polyvinyl Chloride (PVC): Chemical Exhaust, Underground Ducts; PVC conforming to NFPA 91, ASTM D1784, D1785, D1927, and D2241.
- 8. Concrete: Underground Ducts, Air Shafts; Reinforced concrete pipe meeting ASTM C76. Class IV.
- 9. Sheet Rock: Air Shafts (Generally Provided by Architects).
- 10. Copper: Ornamental.
- 11. Polyvinyl Steel and Stainless Steel (PVS and PVSS): Chemical Exhaust, Common Type: Halar Coated Stainless Steel.
- 12. Sheet Metal Gauges (Applies to item numbers 1, 3, 4, and 10 above):
 - a. 16, 18, 20, 22, 24, 26 SMACNA or Welded Construction.
 - b. 10, 11, 12, 13, 14 Welded Construction Only.
- 13. For ductwork system weights, see Appendix A.

G. Flexible Duct:

- 1. 5–8 Ft. Maximum recommended length.
- 2. Insulated, Uninsulated.

18.03 Kitchen Exhaust Ducts and Hoods

A. 1990 BOCA Code:

- 1. Exhaust/Makeup Air:
 - a. 1500-2200 Ft./Min Duct Velocity.
 - b. Supply shall be approximately equal to exhaust.
 - c. Δ T shall not be greater than 10°F. unless part of AC system or will not cause a decrease in comfort conditions.
 - d. Terminate 40" above the roof.
- 2. Duct Sheet Metal Gauge:
 - a. 16 ga. Galvanized Steel.
 - b. 18 ga. 304 Stainless Steel.
- 3. Cleanouts:
 - a. Base of Riser.
 - b. Every 20 feet.
- 4. Hoods:
 - a. Hood Construction 18 ga. Minimum.

- b. Hood Exhaust:
 - 1) Canopy Hoods (attached to wall): 100 CFM/Sq.Ft.
 - 2) Canopy Hoods (Exposed all sides): 150 CFM/Sq.Ft.
 - 3) Non-Canopy: 300 CFM/Lineal Ft. of cooking surface.
 - 4) As listed above or per U.L. 710.

B. 1993 BOCA Code:

- 1. Exhaust/Makeup Air:
 - a. 1500-2200 Ft./Min Duct Velocity.
 - b. Supply shall be approximately equal to exhaust.
 - c. Δ T shall not be greater than 10°F. unless part of AC system or will not cause a decrease in comfort conditions.
 - d. Terminate 40" above the roof.
- 2. Duct Sheet Metal Gauge:
 - a. 16 ga. Galvanized Steel.
 - b. 18 ga. 304 Stainless Steel.
- 3. Cleanouts:
 - a. Base of Riser.
 - b. Every 20 feet.
- 4. Hoods:
 - a. Hood Construction:
 - 1) Galvanized Steel: 18 ga. Minimum.
 - 2) Stainless Steel: 20 ga. Minimum.
 - b. Hood Exhaust:
 - 1) Canopy Hoods (attached to wall): 100 CFM/Sq.Ft.
 - 2) Canopy Hoods (exposed all sides): 150 CFM/Sq.Ft.
 - 3) Non-Canopy: 300 CFM/Lineal Ft. of cooking surface.
 - 4) As listed above or per U.L. 710.

C. 1988 SBCCI Code

- 1. Exhaust Air:
 - a. 1500 Ft./Min. Minimum Duct Velocity.
 - b. Terminate 40" above the roof.
- 2. Duct Sheet Metal Gauge:
 - a. 16 ga. Galvanized Steel.
 - b. 18 ga. 304 Stainless Steel.
- 3. Duct Slope: 1" per foot toward hood.
- 4. Hoods:
 - a. Hood Construction:
 - 1) 18 ga. Galvanized Steel.
 - 2) 20 ga. 304 Stainless Steel.
 - b. Hood Exhaust:
 - 1) Canopy Hoods (attached to wall): 100 CFM/Sq.Ft.
 - 2) Canopy Hoods (exposed all sides): 150 CFM/Sq.Ft.
 - 3) Non-Canopy: 300 CFM/Lineal Ft. of cooking surface.

D. 1988 UBC Code:

- 1. Exhaust/Makeup Air:
 - a. 1500-2500 Ft./Min Duct Velocity.
 - b. Supply shall be equal to exhaust.

- 2. Duct Sheet Metal Gauge:
 - a. 16 ga. Galvanized Steel.
 - b. 18 ga. 304 Stainless Steel.
- 3. Duct Slope:
 - a. Lengths 75 and less: ¼" per foot toward hood.
 - b. Lengths greater than 75 feet: 1" per foot toward hood.
- 4. Hoods:
 - a. Hood Construction:
 - 1) 22 ga. Galvanized Steel.
 - 2) 22 ga. 304 Stainless Steel.
 - b. Hood Exhaust:
 - 1) Canopy Hoods (attached to wall).
 - 200 CFM/Sq.Ft. over charbroilers.
 - 100 CFM/Sq.Ft. over high temperature appliances.
 - 75 CFM/Sq.Ft. over medium temperature appliances.
 - 50 CFM/Sq.Ft. over low temperature appliances.
 - 2) Canopy Hoods (exposed all sides).
 - 300 CFM/Sq.Ft. over charbroilers.
 - 150 CFM/Sq.Ft. over high temperature appliances.
 - 100 CFM/Sq.Ft. over medium temperature appliances.
 - 75 CFM/Sq.Ft. over low temperature appliances.
 - 3) Non-Canopy: 300 CFM/Lineal Ft. of cooking surface.

E. 1991 NFPA 96:

- 1. Exhaust/Makeup Air:
 - a. 1500 Ft./Min. Minimum Duct Velocity.
- 2. Duct Sheet Metal Gauge:
 - a. 16 ga. Galvanized Steel.
 - b. 18 ga. 304 Stainless Steel.
 - c. Ducts shall not pass through fire walls or partitions.
 - d. Ducts shall lead directly as possible to the outside.
 - e. Ducts shall not be connected with other ventilating or exhaust systems.
 - f. Ducts shall terminate a minimum of 40" above roof surface, 10 feet from outside air intakes and property lines, and 3 feet above any air intake within 10 feet.
- 3. Duct Slope: toward hood.
- 4. Hood Construction:
 - a. 18 ga. Galvanized Steel.
 - b. 20 ga. 304 Stainless Steel.

18.04 Louvers

- A. Louvers: Use stationary louvers only. Do not use operable louvers because they become rusty or become covered with snow and ice and may not operate:
- 1. Intake (Outdoor Air): 500 Ft./Min. Maximum Velocity through Free Area.
- 2. Exhaust or Relief: 700 Ft./Min. Maximum Velocity through Free Area.
- 3. Free Area Range:
 - a. Metal: 40-70% of Gross Area.
 - b. Wood: 20-25% of Gross Area.
- 4. Pressure Loss: 0.01-0.10" W.G.

18.05 Volume Dampers

A. Volume Dampers: Frames of duct mounted dampers shall be totally recessed out of the air stream:

- 1. Opposed Blade: Balancing, Mixing, and Modulating Control Applications.
- 2. Parallel Blade: 2 Position Applications (Open/Closed).
- 3. Pressure Loss (MOD): 0.15" W.G. @ 2000 Fpm (Full Open).
- 4. Standard Dampers: 10-15 CFM/Sq.Ft. @ 1" W.G. Differential.
- 5. Low Leakage Dampers: 10 CFM/Sq.Ft. @ 4" W.G. Differential Max.
- 6. Ultra Low Leakage Dampers: 6 CFM/Sq.Ft. @ 4" W.G. Differential Max.
- Size dampers at a flow rate of approximately 1200 to 1500 CFM/Sq.Ft. rather than on duct size.

18.06 Fire Dampers

A. Fire Dampers: Interlocking blade or expanding curtain type. Frame and damper storage should be totally recessed out of air stream.

- 1. Fire Damper Types:
 - a. Type A: Frame and damper storage are located in the airstream.
 - b. Type B: Damper storage is totally recessed out of the airstream.
 - c. Type C: Frame and damper storage are totally recessed out of the airstream.

B. Fire Damper Requirements:

- 1. 1990 BOCA Code:
 - a. 1 Hr. Construction: Fire dampers are not required if building is fully equipped with automatic sprinklers. 1 Hr. dampers required otherwise.
 - b. 2, 3, and 4 Hr. Construction: 2 and 3 Hr. dampers are required.
- 2. 1993 BOCA Code:
 - a. 1 Hr. Construction: 1 Hr. dampers are required.
 - b. 2, 3, and 4 Hr. Construction: 2 and 3 Hr. dampers are required.
 - c. Exception. Fire dampers are not required:
 - 1) In steel exhaust air subducts extending at least 22" vertically in an exhaust shaft and where there is continuous airflow upward to the outside.
 - 2) In penetrations of walls with a required 1 hour fire-resistance rating or less by a ducted HVAC system in areas of other than Use Group H where the building is equipped throughout with an automatic sprinkler system.
 - 3) In garage exhaust or supply shafts which are separated from all other building shafts by not less than a 2 hour fire-resistance rated fire separation assembly.
- 3. 1988 SBCCI Code:
 - a. 1 Hr. Construction: 1 Hr. dampers are required.
 - b. 2, 3, and 4 Hr. Construction: 2 and 3 Hr. dampers are required.
- 4. 1988 UBC Code:
 - a. 1 Hr. Construction: 1 Hr. dampers are required.
 - b. 2, 3, and 4 Hr. Construction: 2 and 3 Hr. dampers are required.
- 5. 1991 NFPA 90A:
 - a. 1 Hr. Construction: Dampers are not required.
 - b. 2, 3, and 4 Hr. Construction: 2 and 3 Hr. dampers are required.
- 6. U.L. 555:

- a. *U.L.* 555 requires fire dampers to bear an affixed label stating whether the damper is static or dynamic rated.
- b. Dynamic rated fire dampers must be U.L. tested and show airflow and maximum static pressure against which the damper will operate (fully close). Fire dampers are tested to 4" static pressure for "no duct" applications and 8" static pressure or "in duct" applications.
- c. Static rated fire dampers have not been U.L. tested against airflow and may not close under medium to high airflow conditions that may be encountered in HVAC systems which do not shut down in event of fire (i.e., smoke control systems).
- d. Recommend using dynamically rated fire dampers in all applications.

18.07 Smoke Dampers

A. Smoke Damper Requirements:

- 1. 1991 NFPA 90A:
 - a. Smoke dampers shall be installed in systems over 15,000 CFM in the supply and return. Exceptions:
 - 1) When AHU is located on the floor it serves and only serves that floor.
 - When the AHU is located on the roof and only serves the floor immediately below it.
 - b. Smoke dampers shall be installed at or adjacent (2 feet maximum distance from barrier) to the point where air ducts pass through required smoke barriers. See NFPA 90A for exceptions.

18.08 Combination Fire/Smoke Dampers

A. Operable Fire Dampers, Smoke Dampers and Combination Fire/Smoke Dampers:

1. Blowout panels should be considered for ductwork systems whenever human operation of fire, smoke, and/or combination fire/smoke dampers is required by code, by local authorities, or for smoke evacuation systems, in the event that the fire department personnel or Owner's operating personnel inadvertently close all the dampers, and system pressures exceed construction pressures of the ductwork.

18.09 Smoke Detectors

A. Smoke Detector Requirements:

- 1. 1990 BOCA:
 - a. Air distribution systems with capacity greater than 2,000 CFM shall be equipped with smoke detector in return upstream of any filters, decontamination equipment, or outside air intake.
 - b. Air distribution systems connecting two or more floors shall have smoke detectors for each return duct on each floor.
 - c. Systems that exhauşt greater 50% of the supply air shall have smoke detectors in both the return and exhaust.
 - d. Activation shall shut down fan, except smoke control equipment shall switch to smoke control mode.

2. 1993 BOCA:

- a. Supply air distribution systems with capacity greater than 2,000 CFM shall be equipped with smoke detectors downstream of any filters and ahead of any branch connections.
- b. Return air distribution systems with capacity greater than 15,000 CFM shall be equipped with smoke detectors in return air duct or plenum upstream of any filters, exhaust air connections, outdoor air connections, or decontamination equipment.
- c. Systems that exhaust greater than 50% of the supply air shall have smoke detectors in both the return and exhaust.
- d. Smoke detectors shall be installed at each story, upstream of the connection between a return riser serving two or more stories, and air ducts or plenums in return air systems with a design capacity greater than 15,000 CFM.
- e. Activation shall shut down fan, except smoke control equipment shall switch to smoke control mode.

3. 1988 SBCCI:

- a. Recirculating systems with fan capacity of 2,000 CFM and greater shall be equipped with smoke detector in return upstream of any filters, decontamination equipment, or outside air intake.
- b. Recirculating systems with fan capacity less than 2,000 CFM, but serving an area used for egress, shall be equipped with smoke detector in return upstream of any filters, decontamination equipment or outside air intake.
- c. Activation shall shut down fan. System shall not restart until manually reset.

4. 1988 UBC:

- a. Air distribution systems with capacity greater than 2,000 CFM shall be equipped with smoke detector in return upstream of any filters, decontamination equipment, or outside air intake.
- b. Activation shall shut down fan.

5. 1991 NFPA 90A:

- a. Air distribution systems with capacity greater than 2,000 CFM shall be equipped with smoke detector downstream of any filters and ahead of any branch connections in supply air system.
- b. At each story prior to the connection to a common return and prior to any recirculation or fresh air inlet connection in return systems over 15,000 CFM capacity and serving more than 1 story.
- Activation shall shut down fan, except smoke control equipment shall switch to smoke control mode.

18.10 Sound Attenuators

A. Types:

- 1. Rectangular: 3, 5, 7, and 10 foot lengths
- 2. Round: 2 or 3 times the diameter

B. Locating:

- 1. Centrifugal and Axial Fans
 - Discharge: 1 duct diameter from discharge for every 1,000 FPM Intake: 0.75 duct diameters from intake for ever 1,000 FPM
- 2. Elbows: 3 duct diameters up and down stream
- 3. Terminal Boxes: 1 duct diameter down stream

4. Mechanical Equipment Rooms: Install in or close to mechanical equipment room wall opening

18.11 Terminal Units

A. Variable Air Volume (VAV) Terminal Units:

- 1. VAV w/o Reheat:
 - a. Controls space temperature by varying the quantity of supply air.
 - b. Supply temperature is constant.
 - Energy savings is due to reduced supply air quantities and therefore reduced horsepower.
- 2. VAV w/Reheat:
 - a. Integrates heating at the VAV terminal unit to offset heating load, limit maximum humidity, provide reasonable air movement, and provide ventilation air.
- 3. Minimum CFM for VAV Boxes:
 - a. 20% of design flow: Perimeter Spaces.
 - b. 0% of design flow: Interior Spaces.
 - c. When interior spaces are occupied or lights are on, the VAV terminal unit will maintain a minimum flow to offset the heat gain. Therefore, the only time a VAV terminal unit serving an interior space will be closed is when the space is unoccupied and lights are off.

B. Fan Powered Terminal Units:

- 1. Parallel Fan Powered Terminal Units:
 - a. Primary air is modulated in response to cooling demand and fan is energized at a predetermined reduced primary airflow.
 - b. Fan is located outside the primary airstream to allow intermittent fan operation.
- 2. Series Fan Powered Terminal Units:
 - a. A constant volume fan mixes primary air with air from the ceiling plenum.
 - b. Fan is located within the primary airstream and runs continuously.

C. Induction Terminal Units:

- Reduces cooling capacity by reducing primary air and inducing room or ceiling plenum air.
- 2. Incorporates reduced supply air quantity energy savings of VAV system and air volume to space is constant to reduce effect of stagnant air.

D. Constant Volume Reheat (CVR) Terminal Units:

- CVR terminal units provide zone/space control for areas of unequal loading, simultaneous cooling/heating, and close tolerance of temperature control.
- Conditioned air is delivered to each terminal unit at a fixed temperature then reheated to control space temperature.
- 3. Energy inefficient system.

E. Constant Volume Bypass Terminal Units:

- 1. Variation of CVR system. Constant volume primary air system with VAV secondary system.
- 2. Supply air to space varied by dumping air to return air plenum.

F. Dual Duct Terminal Units:

- 1. Constant volume of supply air is delivered to the space.
- 2. Space temperature is maintained by mixing varying amounts of hot and cold air.
- 3. Energy inefficient system.

G. VAV Dual Duct Terminal Units:

- 1. Variable volume of supply air is delivered to space.
- 2. Space temperature is maintained by supplying either hot or cold air in varying amounts and limiting the amount of hot and cold air mixing.
- 3. More energy efficient the standard dual duct systems.

H. Single Zone Systems:

 Supply unit serves single temperature zone and varies supply air temperature to control space temperature.

I. Multizone Systems:

- Supply unit serves two or more temperature zones and varies supply air temperature to each zone by mixing hot and cold air with zone dampers at the unit to control space temperature.
- 2. Each zone is served by separate ductwork system.
- 3. Similar to dual duct system but mixing occurs at unit.
- Limited number of zones, inflexible system, energy inefficient, and not a recommended system.

J. Terminal Unit Types:

- 1. Pressure Independent Terminal Units: Terminal unit airflow is independent of pressure upstream of box. Recommend using pressure independant terminal units.
- Pressure Dependant Terminal Units: Terminal unit airflow is dependant on pressure upstream of box.

K. Terminal Unit Installation:

- Locate all terminal units for unobstructed access to unit access panels, controls, and valving.
- 2. Minimum straight duct length upstream of terminal units:
 - Manufacturer's generally recommend 1.5 duct diameters based on terminal unit inlet size.
 - b. 2.0 duct diameters recommended minimum.
 - c. 3.0 to 5.0 duct diameters preferred.
 - d. Best to use 3 feet of straight duct upstream of terminal units because you do not have to concern yourself with box size when producing ductwork layout (the maximum terminal unit inlet size is 16 inches with 2 duct diameters, which results in 32 inches, and most of the time you are not using 16 inches terminal units).
- 3. Duct runout to terminal unit should never be smaller than terminal units inlet size; it may be larger than inlet size. Terminal unit inlet and discharge ductwork should be sized based on ductwork sizing criteria and not the terminal unit inlet and discharge connection sizes. The transition from the inlet and discharge connection sizes to the air terminal unit should be made at the terminal unit. A minimum of 3 feet of straight duct should be provided upstream of all terminal units.

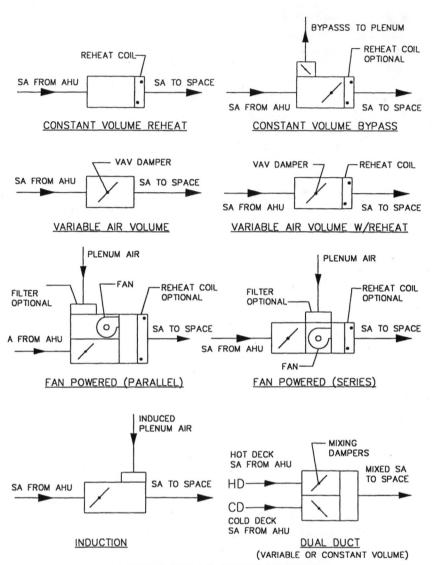

TERMINAL UNIT TYPES

L. Zoning:

- 1. Partitioned Offices:
 - a. 1, 2, 3, or 4 offices/terminal unit.
 - b. 2 or 3 offices/terminal unit most common.
 - c. 1 office/terminal unit; most desirable, also most expensive.
- 2. Open Offices:
 - a. 400-1,200 Sq.Ft./terminal Unit.
- 3. Perimeter and interior spaces should be zoned separately.

- 4. Group spaces/zones/rooms/areas of similar thermal occupancy:
 - a. Offices with offices.
 - b. Don't put offices with conference rooms or other dissimilar rooms.
 - c. Don't put east offices with south offices, etc.
 - d. Corner offices or spaces should be treated separately.

18.12 Process Exhaust Systems

- A. Ductwork material must be selected to suit the material or chemical being exhausted-carbon steel, 304 or 316 stainless steel, Teflon or Halar coated stainless steel, fiberglass reinforced plastic (FRP), and polyvinyl chloride (PVC) are some examples. Sprinklers are generally required in FRP and PVC ductwork systems in all sizes larger than 8 inch in diameter.
- B. Process exhaust ductwork cannot penetrate fire walls, fire separation assemblies, or smoke walls.
- C. Process exhaust systems should be provided with a blast gate or butterfly damper at each tap for a hood or equipment, at each lateral, and at each submain. At all fans, large laterals, and submains, a tight shutoff style butterfly damper should be provided for balancing and positive shutoff in addition to the blast gate. Blast gates should be specified with a wiper gasket, of EPDM or other suitable material, to provide as tight a seal as possible for blast gates; otherwise blast gates tend to experience high leakage rates. Wind loading on blast gates installed on the roof or outside the building need to be considered, especially in large blast gates. Blast gate blades will act as a sail in the wind and cause considerable stress on the ductwork system.
- D. Process exhaust ductwork should be sloped a minimum of 1/8 inch per foot with a drain provided at the low point. The drain should be piped to the appropriate waste system.
- E. Process exhaust systems are required, in most cases, to undergo a treatment process-scrubbing, abatement, burning, or filtering.
- F. Duct sizing must be based on capture velocities and entrainment velocities of the material or chemical being exhausted. For most chemical or fume exhaust systems, the mains, risers, submains, and large laterals should be sized for 2,000 to 3,000 feet per minute, and small laterals and branches should be sized for 1,500 to 2,500 feet per minute. Discharge stacks should be sized for 3,000 to 4,000 feet per minute discharge velocity and should terminate a minimum of 8 feet above the roof and a minimum of 10 feet from any openings or intakes. Properly locate discharge stacks and coordinate discharge height to prevent contamination of outside air intakes, CT intakes, and combustion air intakes. Clearly indicate termination heights.
- G. The connection to a fume hood or other piece of equipment will generally require between 1.0 and 3.0 inches WC negative pressure.
- H. Branches and laterals should be connected above duct centerline. If branches and laterals are connected below the duct centerline, drains will be required at the low

point. Hoods, tools, and equipment must be protected from the possibility of drainage contaminating or entering equipment when taps are connected below the centerline.

- I. Specify proper pressure class upstream and downstream of scrubbers and other abatement equipment.
- J. When ductwork is installed outside or in unconditioned spaces, verify if condensation will occur on the outside or inside this duct. Insulate duct and/or heat trace if required.
- K. Process exhaust fans are required to be on emergency power by code.
- L. Process exhaust ductwork cannot penetrate fire rated construction. Fire dampers are generally not desirable. If penetrating fire rated construction cannot be avoided, process exhaust ductwork must be enclosed in a fire rated enclosure until it exits the building or sprinkler protection in side the duct may be used if approved by authority having jurisdiction.
- M. Provide pressure ports at the end of all laterals, submains, and mains.
- N. Generally, drains are required in fan scroll, scrubber, and other abatement equipment.
- O. Provide flexible connections at fans and specify flexible connection suitable for application.
- P. If adjustable or variable frequency drives are required or used, locate and coordinated with electrical engineer. Use direct drive fans with adjustable or variable frequency drives.

Piping Systems

19.01 Water (Hydronic) Piping Systems

A. Pipe Sizing (See Appendix B):

- 1. 4 Ft./100 Ft. Maximum Pressure Drop.
- 2. 8 FPS Maximum Velocity Occupied Areas.
- 3. 10 FPS Maximum Velocity Unoccupied Areas.
- 4. Minimum pipe velocity 1.5 Fps, even under low load/flow conditions.
- 5. ASHRAE Standard 90.1: 4 Ft./100 Ft. Maximum Pressure Drop.
- 6. Standard Steel Pipe Sizes. ½", ½", 1", 1½", 1½", 2", 2½", 3", 4", 6", 8", 10", 12", 14", 16", 18", 20", 24", 30", 36", 42", 48", 54", 60", 72", 84", 96".
- 7. Standard Copper Pipe Sizes. ½", ¾", 1", 1¼", 1½", 2", 2½", 3", 4", 6", 8", 10", 12".
- 8. Standard Stainless Steel Pipe Sizes. ½", ½", 1", 1½", 1½", 2", 2½", 3", 4", 6", 8", 10", 12", 14", 16", 18", 20", 24".

B. Friction Loss Estimate

- 1. $1.5 \times \text{System Length (Ft.)} \times \text{Friction Rate (Ft./100 Ft.)}$.
- 2. Pipe Friction Estimate: 3.0-3.5 Ft./100 Ft.

C. Hydronic System Design and Piping Installation Guidelines:

- Hydronic Systems Design Principle and Goal. Provide the correct water flow at the correct water temperature to the terminal users.
- 2. Common Design Errors:
 - a. Differential pressure control valves are installed in pump discharge bypasses.
 - Control valves not selected to provide control with system design pressure differentials at maximum and minimum flows.
 - c. Control valves are selected with improper pressure drop.
 - d. Incorrect primary/secondary/tertiary system design.
 - Constant flow secondary or tertiary systems connected to variable flow primary or secondary systems, respectively.
 - f. Check valves are not provided in pump discharges when pumps are operating in parallel.
 - g. Automatic relief valves are oversized which result in quick, sudden, and sometimes violent system pressure fluctuations.
- 3. Piping System Arrangements:
 - a. When designing pumping systems for chillers, boilers, and cooling towers, provide either a unitized pumping arrangement (each pump piped directly to each piece of central plant equipment) or provide a headered system.
 - b. Unitized System:
 - A unitized system should only be used when all the equipment in the system is the same capacity (chillers, boilers, cooling towers, and associated pumps).
 - c. Headered System:
 - A true headered system is preferred especially when chillers, cooling towers, boilers, and associated pumps are of unequal capacity.
 - DO NOT USE A MODIFIED HEADERED SYSTEM. A modified headered system causes major operational problems; it does not work.
 - 3) When designing a headered system, Griswold Valves (flow control device) must be installed in the supply piping to each piece of equipment to obtain the proper flow through each piece of equipment. In addition to Griswold Valves, control valves must be installed to isolate equipment not in service if system is to be fully

- automatic. These control valves should be provided with manual means of opening and closing in case of control system malfunction or failure.
- 4) Provide adequate provisions for expansion and contraction of piping in boiler, chiller, cooling tower, and pump headered systems. Provide U-shaped header connections for all equipment to accommodate expansion and contraction (first route piping away from header, then route parallel to the header, and finally route back toward header; size of U-shape will depend on the temperature of the system).
- 4. Minimum recommended hydronic system pipe size should be ¾ inch.
- 5. In general, noise generation, in hydronic systems, indicates erosion is occurring.
- 6. Large system diversities:
 - a. Campus Heating. 80%.
 - b. Campus Cooling. 65%.
 - Constant Flow. Load is diversified only; flow is not diversified resulting in temperature changes.
 - d. Variable Flow. Load and flow are both diversified.
- 7. When designing a campus or district type heating or cooling system, the controls at the interface between the central system and the building system should be secured so that access is limited to the personnel responsible for operating the central plant and not accessible to the building operators. Building operators may not fully understand the central plant operation and may unknowingly disrupt the central plant operation with system interface tinkering.
- 8. Differential pressure control of the system pumps should never be accomplished at the pump. The pressure bypass should be provided at the end of the system or the end each of the subsystems regardless of whether the system is a bypass flow system or a variable speed pumping system. Bypass flow need not exceed 20 percent of the pump design flow.
- 9. Central plant equipment (chillers, boilers, cooling towers, and associated pumps) should be of equal size units; however, system design may include ½ size units or ½ size units with full size equipment. For example, a chiller system may be made up of 1,200 ton, 600 ton, and 400 ton chillers. However, ½ sized units have limited application. This permits providing multiple units to achieve the capacity of a single unit and having two or three pumps operate to replace the one larger pump.
- 10. Pump Discharge Check Valves:
 - a. Pump discharge check valves should be center guided, spring loaded, disc type check valves.
 - b. Pump discharge check valves should be sized so that the check valve is full open at design flow rate. Generally this will require the check valve to be one pipe size smaller than the connecting piping.
 - c. Condenser water system and other open piping system check valves should have globe style bodies to prevent flow reversal and slamming.
 - d. Install check valves with 4 to 5 pipe diameters upstream of flow disturbances is recommended by most manufacturers.
- 11. Install air vents at all high points in water systems. Install drains at all low points in water systems. All automatic air vents, manual air vents, and drains in hydronic systems should be piped to a safe location within 6 inches of the floor, preferably over a floor drain, especially heating water systems.
- 12. Thermometers should be installed in both the supply and return piping to all water coils, chillers, boilers, heat exchangers, and other similar equipment. Thermometers should also be installed at each location where major return streams mix at a location approximately 10 pipe diameters downstream of the mixing point. Placing thermometers upstream of this point is not required, but often desirable, because the other return

- thermometers located upstream will provide the water temperatures coming into this junction point. Placing thermometers in these locations will provide assistance in troubleshooting system problems. Liquid filled type thermometers are more accurate than the dial type thermometers.
- 13. Select water coils with tube velocities high enough at design flow so that tube velocities do not end up in the laminar flow region when the flow is reduced in response to low load conditions. Tube velocities become critical with units designed for 100 percent outside air at low loads near 32°F. Higher tube velocity selection results in a higher water pressure drop for the water coil. Sometimes a trade-off between pressure drop and low load flows must be evaluated.
- 14. Install manual air vent and drain on coupon rack to relieve pressure from coupon rack to facilitate removing coupons. Pipe drain to floor drain.
- 15. Install manual air vent on chemical feed tank and also pipe drain to floor drain.
- 16. Provide water meters on all makeup water and all blowdown water connections to hydronic systems (heating water, chilled water, condenser water, and steam systems). System water usage is critical in operating the systems, maintaining chemical levels, and troubleshooting the systems. If project budget permits, these meter readings should be logged and recorded at the building facilities management and control system.
- 17. Locate all valves, strainers, unions, and flanges so that they are accessible. All valves (except control valves) and strainers should be full size of pipe before reducing size to make connections to equipment and controls. Union and/or flanges should be installed at each piece of equipment, in bypasses and in long piping runs (100 feet or more) to permit disassembly for alteration and repairs.
- 18. Provide chainwheel operators for all valves in equipment rooms mounted greater than 7′-0″ above floor level, and chain should extend to 5′-0″ to 7′-0″ above floor level.
- 19. All balancing valves should be provided with position indicators and maximum adjustable stops (memory stops).
- 20. All valves should be installed so that valve remains in service when equipment or piping on equipment side of valve is removed.
- 21. Locate all flow measuring devices in accessible locations with straight section of pipe upstream (10 pipe diameters) and downstream (5 pipe diameters) of device or as recommended by manufacturer.
- 22. Provide a bypass around the water filters and water softeners. Show water filters and water softener feeding hydronic or steam systems on schematic drawings and plans.
- 23. Provide vibration isolators for all piping supports connected to and within 50 feet of isolated equipment and throughout mechanical equipment rooms, except at base elbow supports and anchor points.
- 24. Glycol systems do not use malleable iron fittings.
- 25. Water in a system should be maintained at a pH of approximately 8 to 9. A pH of 7 is neutral; below 7 is acid; above 7 is alkaline. Closed system water treatment should be 1600 to 2000 ppm Borax-Nitrite additive.
- 26. Terminal Systems:
 - a. Design for the largest possible system delta T.
 - b. Better to have terminal coils *slightly* oversized than undersized. Increasing flow rates in terminal coils to twice the design flow rate only increases coil capacity 5 to 16 percent, and tripling the flow rate only increases coil capacity 7 to 22 percent. Grossly oversized terminal unit coils can lead to serious control problems, so care must be taken in properly sizing coils.
- 27. Terminal Unit Control Methods:
 - a. Constant Supply Temperature, Variable Flow.
 - b. Variable Supply Temperature, Constant Flow.

- c. Flow Modulation to a minimum value at constant supply temperature, at minimum flow a pump or fan, is started to maintain constant minimum flow at a variable supply temperature.
- d. No primary system control, secondary system control accomplished by blending or face and bypass control.

28. Terminal Unit Design:

- a. Terminal unit design should be designed for the largest possible system delta T.
- b. Terminal unit design should be designed for the closest approach of primary return water temperature and secondary return temperature.
- c. Terminals must be selected for full load and for partial load performance.
- d. Select coils with high water velocities at full load, larger pressure drop. This will result in increased performance at partial loads.

29. Thermal Storage:

- a. Peak shaving. Constant supply with variable demand.
- b. Space heating/cooling. Variable supply with constant demand, waste heat recovery.
- c. Variable supply with variable demand.
- 30. Provide stop check valves (located closest to the boiler) and isolation valves with a drain between these valves on both the supply and return connections to all heating water boilers.
- 31. Boiler warming pumps should be piped to both the system header and to the boiler supply piping, thus allowing the boiler to be kept warm (in standby mode) from the system water flow or to warm the boiler when is has been out of service for repairs without the risk of shocking the boiler with system water temperature. Boiler warming pumps should be selected for 0.1 gpm/BHP (range 0.05 to 0.1 gpm/BHP). At 0.1 gpm/BHP, it takes 45 to 75 minutes to completely exchange the water in the boiler. This flow rate is sufficient to offset the heat loss by radiation and stack losses on boilers when in standby mode of operation. In addition, this flow rate allows the system to keep the boiler warm without firing the boiler, thus allowing for more efficient system operation. For example, it takes 8 to 16 hours to bring a bring a boiler on-line from a cold start. Therefore, the standby boiler must be kept warm to enable immediate start-up of the boiler upon failure of an operating boiler.
- 32. To provide fully automatic heating water system controls, the controls must look at and evaluate the boiler metal temperature (water temperature) and the refractory temperature prior to starting the primary pumps or enabling the boiler to fire. First, the boiler system design must circulate system water through the boilers to keep the boiler water temperature at system temperature when the boiler is in standby mode as discussed for boiler warming pump arrangements. Second, the design must look at the water temperature prior to starting the primary pumps to verify that the boiler is ready for service. And third, the design must look at refractory temperature to prevent boiler from going to high fire if the refractory is not at the appropriate temperature. However, the refractory temperature is usually handled by the boiler control package.
- 33. Heating Water System Warm-Up Procedure:
 - a. Heating water system start-up should not exceed 120°F. temperature rise per hour, but boiler or heat exchanger manufacture limitations should be consulted.
 - b. It is recommended that no more than a 25°F. temperature rise per hour be used when warming heating water systems. Slow warming of the heating water system allows for system piping, supports, hangers, and anchors to keep up with system expansion.
 - c. Low temperature heating water systems (250°F and less) should be warmed slowly at 25°F, temperature rise per hour until system design temperature is reached.

- d. Medium and high temperature heating water systems (above 250°F) should be warmed slowly at 25°F, temperature rise per hour until 250°F system temperature is reached. At this temperature the system should be permitted to settle for at least 8 hours or more (preferably overnight). The temperature and pressure maintenance time gives the system piping, hangers, supports, and anchors a chance to catch up with the system expansion. After allowing the system to settle, the system can be warmed up to 350°F or system design temperature in 25°F temperature increments and 25 psig pressure increments, semi-alternating between temperature and pressure increases, and allowing the system to settle for an hour before increasing the temperature or pressure to the next increment. When the system reaches 350°F and the design temperature is above 350°F, the system should be allowed to settle for at least 8 hours or more (preferably overnight). The temperature and pressure maintenance time gives the system piping, hangers, supports, and anchors a chance to catch up with the system expansion. After allowing the system to settle, the system can be warmed up to 455°F or system design temperature in 25°F temperature increments and 25 psig pressure increments, semialternating between temperature and pressure increases, and allowing the system to settle for an hour before increasing the temperature or pressure to the next increment.
- 34. Provide heating water systems with warm-up valves for in service startup as shown in the table on page 159. This will allow operators to warm these systems slowly and to prevent a sudden shock or catastrophic system failure when large system valves are opened. Providing warming valves also reduces wear on large system valves when they are only opened a small amount in an attempt to control system warm-up speed.
- 35. Heating Water System Warming Valve Procedure:
 - a. First, open warming return valve slowly to pressurize the equipment without flow.
 - b. Once the system pressure has stabilized, then slowly open the warming supply valve to establish flow and to warm the system.
 - c. Once the system pressure and temperature have stabilized, then proceed with the following items listed below, one at a time:
 - 1) Slowly open the main return valve.
 - 2) Close the warming return valve.
 - 3) Slowly open the main supply valve.
 - 4) Close the warming supply valve.

D. Chilled Water Systems:

- 1. Leaving Water Temperature (LWT): 40–48°F. (60°F. Maximum)
- 2. ΔT Range 10–20°F.
- 3. Chiller Start-up and Shutdown Bypass: When starting a chiller, it takes 5 to 15 minutes from the time the chiller start sequence is initiated until the time the chiller starts to provide chilled water at the design temperature. During this time the chilled water supply temperature rises above the desired set point. If chilled water temperature is critical and this deviation unacceptable, the method to correct this problem is to provide the chillers with a bypass which runs from the chiller discharge to the primary pump suction header return. The common pipe only needs to be sized for the flow of one chiller because it is unlikely that more than one chiller will be started at the same time. Chiller system operation with a bypass should be as follows:
 - a. On chiller start sequence, the primary chilled water pump is started, the bypass valve is opened, and the supply header valve is closed. When the chilled water supply temperature is reached, as sensed in the bypass, the supply header valve is slowly opened. When the supply header valve is fully opened, the bypass valve is slowly closed.

Bypass and Warming Valves

MAIN VALVE	NOMINAL PIPE SIZE		
NOMINAL PIPE	SERIES A	SERIES B	
SIZE	WARMING VALVES	BYPASS VALVES	
4	1/2	1	
5	3/4	1-1/4	
6	3/4	1-1/4	
8	3/4	1-1/2	
10	1	1-1/2	
12	1	2	
14	1	2	
16	1	3	
18	1	3	
20	1	3	
24	1	4	
30	1	4	
36	1	6	
42	1	6	
48	1	8	
54	1	8	
60	1	10	
72	1	10	
84	1	12	
96	1	12	

Notes:

- Series A covers steam service for warming up before the main line is opened and for balancing
 pressures where lines are of limited volume.
- Series B covers lines conveying gases or liquids where bypassing may facilitate the operation of the main valve through balancing the pressures on both sides of the disc or discs thereof. The valves in the larger sizes may be of the bolted on type.
 - b. On chiller stop sequence, the bypass valve is slowly opened. When the bypass valve is fully opened, the supply header valve is slowly closed. When the primary chilled water pump stops, the bypass valve is closed.
- 4. Large and campus chilled water systems should be designed for large delta T's and for variable flow secondary and tertiary systems.
- Chilled water pump energy must be accounted for in the chiller capacity because they add heat load to the system.
- 6. Methods of Maintaining Constant Chilled Water Flow:
 - a. Primary/Secondary Systems.
 - b. Bypassing-Control.
 - c. Constant volume flow only applicable to two chillers in series flow or single chiller applications.
- It is best to design chilled water and condenser water systems to pump through the chiller.
- 8. When combining independent chilled water systems into a central plant,
 - a. Create a central system concept, control scheme, and flow schematics.

- b. The system shall only have a single expansion tank connection point sized to handle entire system expansion and contraction.
- c. All systems must be altered, if necessary, to be compatible with central system concept (temperatures, pressures, flow concepts, variable or constant, control concepts).
- d. For constant flow and variable flow systems, the secondary chillers are tied into the main chiller plant return main. Chilled water is pumped from the return main through the chiller and back to the return main.
- e. District chilled water systems, due to their size, extensiveness, or both, may require that independent plants feed into the supply main at different points. If this is required, design and layout must enable isolating the plant; provide start-up and shutdown bypasses; and provide adequate flow, temperature, pressure, and other control parameter readings and indicators for proper plant operation, and other design issues which affect plant operation and optimization.
- 9. In large systems, it may be beneficial to install a steam-to-water or water-to-water heat exchanger to place an artificial load on the chilled water system to test individual chillers or groups of chillers during plant start-up, after repairs, or for troubleshooting chiller or system problems.

E. Low Temperature Chilled Water Systems (Glycol or Ice Water Systems)

- 1. Leaving Water Temperature (LWT): 20–40°F. (0°F. minimum)
- 2. ΔT Range 20–40°F.

F. Heating Water Systems General:

- 1. From a design and practical standpoint, low temperature heating water systems are often defined as systems with water temperatures 210°F. and less, and high temperature heating water systems are defined as systems with water temperatures 211°F. and higher.
- 2. Provide manual vent on top of heating water boiler to vent air from top of boiler during filling and system operation. Pipe manual vent discharge to floor drain.
- 3. Blowdown separators are not required for hot water boilers, but desirable for maintenance purposes. Install the blowdown separator so that the inlet to the separator is at or below the boiler drain to enable the use of the blowdown separator during boiler draining for emergency repairs.
- 4. Safety: High temperature hydronic systems when operated at higher system temperatures and higher system pressures will result in lower chance of water hammer and the damaging effects of pipe leaks. These high temperature heating water systems are also safer than lower temperature heating water systems because system leaks subcool to temperatures below scalding due to the sudden decrease in pressure and the production of water vapor.
- 5. Outside air temperature reset of low temperature heating water systems is recommended for energy savings and controllability of terminal units at low load conditions. However, care must be taken with boiler design to prevent thermal shock by low return water temperatures or to prevent condensation in the boiler due to low supply water temperatures and, therefore, lower combustion stack discharge temperature.
- 6. Circulating hot water through a boiler which is not operating, to keep it hot for standby purposes, creates a natural draft of heated air through the boiler and up the stack, especially in natural draft boilers. Forced draft or induced draft boilers have combustion dampers which close when not firing and therefore reduce, but not eliminate, this heat loss. Although this heat loss is undesirable for standby boilers, circulating hot water through the boiler is more energy efficient than firing the boiler. Operating a standby boiler may be in violation of air permit regulations in many jurisdictions today.

Piping Systems 161

G. Low Temperature Heating Water Systems:

Leaving Water Temperature (LWT): 180–200°F.
 ΔT Range 20–40°F.

3. Low Temperature Water 250°F. and less; 160 psig maximum

H. Medium and High Temperature Heating Water Systems:

Leaving Water Temperature (LWT): 350–450°F.
 ΔT Range 20–100°F.

Medium Temperature Water
 High Temperature Water
 251–350°F.; 160 psig maximum
 351–450°F.; 300 psig maximum

- 5. Submergence or antiflash margin is the difference between the actual system operating pressure and the vapor pressure of water at the system operating temperature. However, submergence or antiflash margin is often expressed in degrees Fahrenheit—the difference between the temperature corresponding to the vapor pressure equal to the actual system pressure and the system operating temperature.
- 6. Provide operators on valves on the discharge of the feed water pumps for medium and high temperature systems to provide positive shutoff because the check valves sometimes leak with the large pressure differential. Interlock the valves to open when the pumps operate. Verify that valve is open with an end switch or with a valve positioner.
- Provide space and racks for spare nitrogen bottles in mechanically pressurized medium and high temperature heating water systems.
- 8. Medium and High Temperature Heating Water System Design Principles:
 - a. System pressure must exceed the vapor pressure at the design temperature in all locations in the system. Verify this pressure requirement at the highest location in the system, at the pump suction, and at the control valve when at minimum flow or part load conditions. The greater the elevation difference, above the pressure source (in most cases the expansion tank), the higher the selected operating temperature in the medium and high temperature heating water system should be.
 - b. Medium and high temperature water systems are unforgiving to system design errors in capacity or flow rates.
 - c. Conversion factors in standard HVAC equations must be adjusted for specific gravity and specific heat at the design temperatures.
 - d. Thermal expansion and contraction of piping must be considered and are critical in system design.
 - e. Medium and high temperature heating water systems can be transported over essentially unlimited distances.
 - f. The greater the system delta T, the more economical the system becomes.
 - g. Use medium and high temperature heating water systems when required for process applications, because it produces precise temperature control and more uniform surface temperatures in heat transfer devices.
 - h. The net positive suction head requirements of the medium and high temperature system pumps are critical and must be checked for adequate pressure. It is best to locate and design the pumps so that cavitation does not occur as follows:
 - 1) Oversize the pump suction line to reduce resistance.
 - 2) Locate the pump at a lower level than the expansion tank to take advantage of the static pressure gain.
 - 3) Elevate the expansion tank above the pumps.
 - 4) Locate the pumps in the return piping circuit and pump through the boilers, thus reducing the system temperature at the pumps, which reduces the vapor pressure requirements.

- i. Either blending fittings or properly designed pipe fittings must be used when blending return water with supply water in large delta T systems or injecting medium and high temperature primary supply water into low temperature secondary circuits. When connecting piping to create a blending tee, the hotter water must always flow downward and the colder water must always flow upward. The blending pipe must remain vertical for a short length equal to a few pipe diameters on either side of the tee. Since turbulence is required for mixing action, it is not desirable to have straight piping for any great distance (a minimum of 10 pipe diameters is adequate).
- 9. Above approximately 300°E, the bearings and gland seals of a pump must be cooled. Consult factory representatives for all pumps for systems above 250°F, to determine specification requirements. Cooling water leaving the pump cooling jacket should not fall below 100°F. The best method for cooling seals is to provide a separate heat exchanger (one at each pump or one for a group of pumps) and circulate the water through the seal chamber. The heat exchanger should be constructed of stainless steel. Another method to cool the seals is to take a side stream flow off of the pump discharge, cool the flow, and inject it into the end face. This is not recommended because the amount of energy wasted is quite substantial.
- 10. Medium and high temperature heating water systems work well for radiant heating systems.
- 11. Control valves should be placed in the supply to heat exchangers with a check valve in the return. This practice provides a safety shutoff in case of a major leak in the heat exchanger. By placing the control valve in the supply when a leak occurs, the temperature or pressure increases on the secondary side causing the control valve to close while the check valve prevents back flow or pressure from the return. Flashing may occur with the control valve in the supply when a large pressure differential exists or when the system is operated without an antiflash margin. To correct this flashing, control must be split with one control valve in the supply and one control valve in the return.
- 12. If using medium or high temperature heating water systems to produce steam, the steam pressure dictates the delta T and thus the return water temperature.
- 13. Medium and High Temperature Heating Water Systems in Frequent Use:
 - a. Cascade Systems with integral expansion space:
 - 1) Type 1. Feedwater pump piped to steam boiler.
 - 2) Type 2. Feedwater pump piped to medium or high temperature heating water system with steam boiler feedwater provided by medium and high temperature heating water system.
 - b. Flooded generators with external expansion/pressurization provisions.
- 14. Medium and High Temperature Water System Boiler Types:
 - a. Natural Circulators, Fire Tube and Water Tube Boilers.
 - b. Controlled (Forced) Circulation.
 - c. Combustion (Natural and Forced), Corner Tube Boilers.
- 15. Design Requirements:
 - a. Settling camber to remove any foreign matter, dirt, and debris; oversized header with flanged openings for cleanout.
 - b. Generator must never be blown down. Blowdown should only be done at the expansion tank or piping system.
 - c. Boiler safety relief valves should only be tested when water content is cold; otherwise, flashing water-to-steam mixture will erode valve seat and after opening once or twice the safety relief valves will leak constantly.
 - d. Boiler safety relief valves must only be considered protection for the boilers. Another safety relief valve must be provided on the expansion tank.
 - e. Relief valves should be piped to a blowdown tank.

- 16. Medium and high temperature heating water systems may be pressurized by steam systems on the generator discharge or by pump or mechanical means on the suction side of the primary pumps pumping through the boilers.
- 17. Steam pressurized system characteristics are listed below:
 - a. Steam pressurized systems are generally continuously operated with rare shutdowns.
 - b. System expansion tank is pressurized with steam and contains a large volume of water at a high temperature, resulting in a considerable ability to absorb load fluctuations.
 - c. Steam pressurized systems improve operation of combustion control.
 - d. Steam pressurized system reduces the need to anticipate load changes.
 - e. System is closed and the entry of air or gas is prevented, thus reducing or eliminating corrosion or flow restricting accumulations.
 - f. Generally these systems can operate at a lower pressure than pump or mechanical pressurized systems.
 - g. Steam pressurized systems have a higher first cost.
 - h. These systems require greater space requirements.
 - i. The large pressurization tank must be located above and over generators.
 - j. Pipe discharges into a steam pressurized expansion tank should be vertically upward or should not exceed an angle greater than 45 degrees with respect to the vertical.
- 18. Mechanically pressurized system characteristics are listed below:
 - a. Mechanically pressurized systems have flexibility in expansion tank location.
 - Mechanically pressurized systems should be designed to pump through the generator; place the expansion and pressurization means at the pump suction inlet.
 - Mechanically pressurized systems are best suited for intermittently operated systems.
 - d. A submergence or antiflash margin must be provided.
 - e. Nitrogen supply must be kept on hand. System cannot operate without nitrogen.
 - f. Mechanically pressurized systems have a lower first cost.
 - g. Mechanically pressurized systems require less expansion tank space.
 - h. Start-up and shutdown of these systems simplified.
- 19. Pumps in medium and high temperature heating water systems should be provided with ½ to ¾ inch bypasses around the check valve and shutoff valves on the pump discharge:
 - a. To refill the pump piping after repairs have been made.
 - b. To allow for opening the system shutoff valve (often gate valve) which becomes difficult to open against the pressure differentials experienced.
 - c. To allow for a slow warming of the pump and pump seals, and for letting sealing surfaces to seat properly.
- 20. Double valves should be installed on both the supply and return side of equipment for isolation on heating water systems, above 250°F. with a drain between these valves to visually confirm isolation. The double valving of systems ensures isolation because of the large pressure differentials which occur when the system is opened for repairs. Double valve all the following:
 - a. Equipment.
 - b. Drains.
 - c. Vents.
 - d. Gauges.
 - e. Instrumentation.
 - f. Double drain and vent valve operation: Fully open the valve closest to the system piping first. Then open the second valve modulating the second valve to control

flow to the desired discharge rate. Close second valve first when finished draining or venting. Operating in this fashion keeps the valve closest to the system from being eroded and thus allowing for the valve to provide tight shutoff when needed. In addition, this operation allows for replacement of the second valve with the system in operation since this valve receives most of the wear and tear during operation.

- 21. Do not use screw fittings because high and medium temperature water is very penetrating. Use welded or flanged fittings in lieu of screwed fittings. Do not use union joints.
- 22. Use of dissimilar metals must be avoided. Use only steel pipe, fittings, valves, flanges, and other devices.
- 23. Do not use cast iron or bronze body valves.
- 24. Use valves with metal to metal seats.
- 25. Do not use lubricated plug valves.

I. Dual Temperature Water System Types:

- 1. Leaving Cooling Water Temperature 40–48°F.
- 2. Cooling ΔT Range 10–20°F.
- 3. Leaving Heating Water Temperature: 180-200°F.
- 4. Heating ΔT Range 20–40°F.
- 5. 2-Pipe Switch-over Systems provide heating or cooling but not both.
- 6. 3-Pipe Systems provide heating and cooling at the same time with a blended return water temperature causing energy waste.
- 7. 4-Pipe Systems:
 - a. Hydraulically joined at the terminal user (most common with fan coil systems with a single coil). Must design the heating and cooling systems with a common and single expansion tank connected at the generating end. At the terminal units the heating and cooling supplies should be connected and the heating and cooling returns should be connected.
 - b. Hydraulically joined at the generator end (most common with condenser water heat recovery systems).
 - c. Hydraulically joined at both ends.

J. Condenser Water Systems:

- 1. Entering Water Temperature (EWT): 85°F.
- 2. ΔT Range 10–20°F.
- 3. Normal ΔT 10°F.

K. Water Source Heat Pump Loop

- 1. Range: 60–90°F.
- 2. ΔT Range 10–15°F.

Water Equation Factors

SYSTEM TYPE	SYSTEM TEMPERATURE RANGE ° F.	EQUATION FACTOR
LOW TEMPERATURE (GLYCOL) CHILLED WATER	0 - 40	SEE NOTE 2
CHILLED WATER	40 - 60	500
CONDENSER WATER HEAT PUMP LOOP	60 - 110	500
	110 - 150	490
LOW TEMPERATURE HEATING WATER	151 - 200	485
	201 - 250	480
MEDIUM TEMPERATURE	251 - 300	475
HEATING WATER	301 - 350	470
HIGH TEMPERATURE	351 - 400	470
HEATING WATER	401 - 450	470

- Water equation corrections for temperature, density and specific heat.
 For glycol system equation factors, see paragraph 19.04, Glycol Solution Systems, below.

1.

Hydronic System Design Temperaturers and Pressures

WATER TEMPERATURE	VAPOR PRESSURE		S		ERATING FLASH MA		E	
°F.	PSIG	10 °F.	20 °F.	30 °F.	40 °F.	50 °F.	60 °F.	70 °F.
200	-3.2	-0.6	2.5	6	10	15	21	27
210	-0.6	2.5	6	10	15	21	27	35
212	0.0	3	7	11	16	22	29	36
215	0.9	4	8	13	18	24	31	39
220	2.5	6	10	15	21	27	35	43
225	4.2	8	13	18	24	30	39	48
230	6.1	10	15	21	27	35	43	52
240	10.3	15	21	27	34	43	52	63
250	15.1	21	27	34	43	52	63	75
260	20.7	27	34	43	52	63	75	88
270	27.2	34	43	52	63	75	88	103
275	30.7	39	47	58	69	81	96	111
280	34.5	43	52	63	75	88	103	120
290	42.8	52	63	75	88	103	120	138
300	52.3	63	75	88	103	120	138	159
310	62.9	75	88	103	120	138	159	181
320	74.9	88	103	120	138	159	181	206
325	81.4	96	111	129	148	170	193	219
330	88.3	103	120	138	159	181	206	232
340	103.2	120	138	159	181	206	232	262
350	119.8	138	159	181	206	232	262	294
360	138.2	159	181	206	232	262	294	329
370	158.5	181	206	232	262	294	329	367
375	169.5	193	219	247	277	311	347	387
380	180.9	206	232	262	294	329	367	407
390	205.5	232	262	294	329	367	407	452
400	232.4	262	294	329	367	407	452	500
410	261.8	294	329	367	407	452	500	551
420	293.8	329	367	407	452	500	551	606
425	310.9	347	387	429	475	524	578	635
430	328.6	367	407	452	500	551	606	665
440	366.5	407	452	500	551	606	665	729
450	407.4	452	500	551	606	665	729	797
455	429.1	475	525	578	635	697	762	832

Notes

The antiflash margin of 40°F. minimum is recommended for nitrogen or mechanically pressurized systems.

L. Piping Materials:

- 1. 125 Psi (289 Ft.) and Less:
 - a. 2" and Smaller:

•	~	and oman	
	1)	Pipe:	Black Steel Pipe, ASTM A53, Schedule 40, Type E or S, Grade B.
		Fittings:	Black Malleable Iron Screw Fittings, 150 lb. ANSI/ASME B16.3.
		Joints:	Pipe Threads, General Purpose (American) ANSI/ASME B1.20.

2) Pipe: Black Steel Pipe, ASTM A53, Schedule 40, Type E or S, Grade B.

Fittings: Cast Iron Threaded Fittings, 150 lb. *ANSI/ASME B16.4*.

Joints: Pipe Threads, General Purpose (American) ANSI/ASME B1.20.1.

Safety: High temperature hydronic systems when operated at higher system temperatures and higher system pressures will result in lower chance of water hammer and the damaging effects of pipe leaks. These high temperature heating water systems are also safer than lower temperature heating water systems because system leaks subcool to temperatures below scalding due to the sudden decrease in pressure and the production of water vapor.

3) Pipe: Type "L" Copper Tubing, ASTM B88, Hard Drawn.

Fittings: Wrought Copper Solder Joint Fittings, ANSI/ASME B16.22.

Joints: Solder Joint with 95-5 tin antimony solder, 96-4 tin silver solder, or 94-

6 tin silver solder, ASTM B32.

b. 2½" thru 10":

1) Pipe: Black Steel Pipe, ASTM A53, Schedule 40, Type E or S, Grade B.

Fittings: Steel Butt-Welding Fittings ANSI/ASME B16.9.

Joints: Welded pipe, ANSI/AWS D1.1 and ANSI/ASME Sec. 9.

2) Pipe: Black Steel Pipe, ASTM A53, Schedule 40, Type E or S, Grade B.

Fittings: Factory Grooved End Fittings equal to Victaulic Full-Flow. Tees shall

be equal to Victaulic Style 20, 25, 27, or 29.

Joints: Mechanical Couplings equal to Victaulic couplings Style 75 or 77 with

Grade H gaskets, lubricated per manufacturer's recommendation.

c. 12" and Larger:

1) Pipe: Black Steel Pipe, ASTM A53, ³/₈" wall, Type E or S, Grade B.

Fittings: Steel Butt-Welding Fittings ANSI/ASME B16.9.

Joints: Welded pipe, ANSI/AWS D1.1 and ANSI/ASME Sec. 9.

2) Pipe: Black Steel Pipe, ASTM A53, 3/8" wall, Type E or S, Grade B.

Fittings: Factory Grooved End Fittings equal to Victaulic Full-Flow. Tees shall

be equal to Victaulic Style 20, 25, 27, or 29.

Joints: Mechanical Couplings equal to Victaulic couplings Style 75 or 77 with Grade H gaskets, lubricated per manufacturer's recommendation.

2. 126-250 psig (290-578 Ft.):

a. 11/2" and Smaller:

1) Pipe: Black Steel Pipe, ASTM A53, Schedule 80, Type E or S, Grade B.

Fittings: Forged Steel Socket-Weld, 300 lb., ANSI B16.11.

Joints: Welded pipe, ANSI/AWS D1.1 and ANSI/ASME Sec. 9.

2) Pipe: Carbon Steel Pipe, ASTM A106, Schedule 80, Grade B.

Fittings: Forged Steel Socket-Weld, 300 lb., ANSI B16.11.

Joints: Welded pipe, ANSI/AWS D1.1 and ANSI/ASME Sec. 9.

b. 2" and Larger:

1) Pipe: Black Steel Pipe, ASTM A53, Schedule 80, Type E or S, Grade B.

Fittings: Steel Butt-Welding Fittings, 300 lb., ANSI/ASME B16.9.

Joints: Welded pipe, ANSI/AWS D1.1 and ANSI/ASME Sec. 9.

2) Pipe: Carbon Steel Pipe, ASTM A106, Schedule 80, Grade B.

Fittings: Steel Butt-Welding Fittings, 300 lb., ANSI/ASME B16.9.

Joints: Welded pipe, ANSI/AWS D1.1 and ANSI/ASME Sec. 9.

M. Pipe Testing:

- 1. 1.5 × System Working Pressure.
- 2. 100 Psi Minimum.
- N. Closed Piping Systems: Piping systems with no more than one point of interface with a compressible gas (generally air).
- O. Open Piping Systems: Piping systems with more than one point of interface with a compressible gas (generally air).
- P. Reverse Return Systems: Length of supply and return piping is nearly equal. Reverse return systems are nearly self-balancing.
- Q. Direct Return Systems: Length of supply and return piping is unequal. Direct return systems are more difficult to balance.

R. One-Pipe Systems:

- 1. One-pipe systems are constant volume flow systems.
- 2. All Series Flow Arrangements. Total circulation flows through every terminal user with lower inlet supply temperatures with each successive terminal device.
- 3. Diverted Series Flow Arrangements. Part of the flow goes through the terminal unit and the remainder is diverted around the terminal unit using a resistance device (balancing valve, fixed orifice, diverting tees, or flow control devices).

S. Two-Pipe Systems:

- 1. Same piping used to circulate chilled water and heating water.
- 2. Two-pipe systems are either constant volume flow or variable volume flow systems.
- 3. Direct Return Systems. Critical to provide proper balancing devices (balancing valves or flow control devices).
- 4. Reverse Return Systems. Generally limited to small systems, simplifies balancing.

T. Three-Pipe Systems (Obsolete):

1. Separate chilled water and heating water supply piping, common return piping used to circulate chilled water and heating water.

U. Four-Pipe Systems:

- 1. Separate supply and return piping (2 separate systems) used to circulate chilled water and heating water.
- 2. Four-pipe systems are either constant volume flow or variable volume flow systems.
- 3. Direct Return Systems. Critical to provide proper balancing devices (balancing valves or flow control devices).
- 4. Reverse Return Systems. Generally limited to small systems, simplifies balancing.

V. Ring or Loop Type Systems:

- 1. Piping systems which are laid out to form a loop with the supply and return mains parallel to each other.
- 2. Constant volume flow or variable volume flow systems.
- 3. Provide flexibility for future additions and provide service reliability.
- 4. Can be designed with better diversity factors.
- 5. During shutdown for emergency or scheduled repairs, maintenance, or modifications, loads, especially critical loads, can be fed from other direction or leg.
- 6. Isolation valves must be provided at critical junctions and between all major lateral connections so mains can be isolated and flow rerouted.
- 7. Flows and pressure distribution have to be estimated by trial and error or by computer.

W. Constant Volume Flow Systems:

- 1. Direct Connected Terminals. Flow created by main pump through 3-way valves.
- 2. Indirect Connected Terminals. Flow created by a separate pump with bypass and without output controls.
 - a. Permits variable volume flow systems.
 - b. Subcircuits can be operated with high pump heads without penalizing the main pump.
 - c. Requires excess flow in the main circulating system.
- 3. Constant volume flow systems are limited to:
 - a. Small systems with a single boiler or chiller.

- b. More than 1 boiler system if boilers are firetube or firebox boilers.
- c. Two chiller systems if chillers are connected in series.
- d. Small low temperature heating water systems with 10 to 20°F. delta T.
- e. Small chilled water systems with 7 to 10°F. delta T.
- f. Condenser water systems.
- g. Large chilled water and heating water systems with primary/secondary pumping systems, constant flow primary circuits.
- 4. Constant volume flow systems not suited to:
 - a. Multiple watertube boiler systems.
 - b. Parallel chiller systems.
 - c. Parallel boiler systems.
- 5. Constant volume flow systems are generally energy inefficient.

X. Variable Volume Flow Systems:

- 1. At partial load, the variable volume flow system return temperatures approach the temperature in the secondary medium.
- 2. Significantly higher pressure differentials occur at part load and must be considered during design unless variable speed pumps are provided.

Y. Primary/Secondary/Tertiary Systems (PST Systems):

- PST Systems decouple system circuits hydraulically, thereby making control, operation, and analysis of large systems less complex.
- 2. Secondary (Tertiary) pumps should always discharge into secondary (tertiary) circuits away from the common piping.
- 3. Cross-Over Bridge: Cross-over bridge is the connection between the primary (secondary) supply main and the primary (secondary) return main. Size cross-over bridge at a pressure drop of 1–4 Ft./100 Ft.
- 4. Common Piping: Common piping (sometimes called bypass piping) is the length of piping common to both the primary and secondary circuit flow paths and the secondary and tertiary circuit flow paths. Common piping is the interconnection between the primary and secondary circuits and the secondary and tertiary circuits. The common piping is purposely designed to an extremely low or negligible pressure drop and is generally only 6" to 24" long maximum. By designing for an extremely low pressure drop, the common piping ensures hydraulic isolation of the secondary circuit from the primary circuit and the tertiary circuit from the secondary circuit.
- 5. Extend common pipe size a minimum of 8 diameters upstream and a minimum of 4 diameters downstream when primary flow rate is considerably less than secondary flow rate (i.e., primary pipe size is smaller than secondary pipe size—use larger pipe size) to prevent any possibility of "jet flow." Common piping (bypass piping) in primary/secondary systems or secondary/tertiary systems should be a minimum of 10 pipe diameters in length and the same size as the larger of the two piping circuits.
- 6. A 1-Pipe Primary System uses one pipe for supply and return. The secondary circuits are in series. Therefore, this system supplies a different supply water temperature to each secondary circuit, and the secondary circuits must be designed for this temperature change.
- 7. A 2-Pipe Primary System uses two pipes, one for supply and one for return with a crossover bridge connecting the two. The secondary circuits are in parallel. Therefore, this system supplies the same supply water temperature to each secondary circuit.

19.02 Steam Piping Systems

A. Steam Pipe Sizing (See Appendix C):

- 1. Low Pressure:
 - a. Low Pressure Steam: 0-15 psig.
 - b. 0.2-3 psi Total System Pressure Drop Max.
 - c. 1/8-1/2 psi/100 Ft.
- 2. Medium Pressure:
 - a. Medium Pressure Steam: 16-100 psig.
 - b. 3-10 psi Total System Pressure Drop Max.
 - c. ½-2 psi/100 Ft.
- 3. High Pressure:
 - a. High Pressure Steam: 101-300 psig.
 - b. 10-60 psi Total System Pressure Drop Max.
 - c. 2-5 psi/100 Ft.
- 4. Steam Velocity:
 - a. 15,000 FPM Maximum.
 - b. 6,000-12,000 FPM Recommended.
 - c. Low Pressure Systems: 4,000-6,000 FPM.
 - d. Medium Pressure Systems: 6,000-8,000 FPM.
 - e. High Pressure Systems: 10,000-15,000.
- 5. Friction Loss Estimate:
 - a. 2.0 × System Length (Ft.) × Friction Rate (Ft./100 Ft.).
- 6. Standard Steel Pipe Sizes—½", ¾", 1", 1¼", 1½", 2", 2½", 3", 4", 6", 8", 10", 12", 14", 16", 18", 20", 24", 30", 36", 42", 48", 54", 60", 72", 84", 96".
- 7. Total pressure drop in the steam system should not exceed 20% of the total maximum steam pressure at the boiler.
- 8. Steam condensate liquid to steam volume ratio is 1:1600 at 0 psig.
- 9. Flash Steam. Flash steam is formed when hot steam condensate under pressure is released to a lower pressure; the temperature drops to the boiling point of the lower pressure, causing some of the condensate to evaporate forming steam. Flash steam occurs whenever steam condensate experiences a drop in pressure and thus produces steam at the lower pressure.
 - a. Low pressure steam systems flash steam is negligible and can be generally be ignored.
 - b. Medium and high pressure steam systems flash steam is important to utilize and consider when sizing condensate piping.
 - c. Flash Steam Recovery Requirements:
 - To utilize flash steam recovery the condensate must be at a reasonably high pressure (medium and high pressure steam systems) and the traps supplying the condensate must be capable of operating with the back pressure of the flash steam system.
 - 2) There must be a use or demand for the flash steam at the reduced pressure. Demand for steam at the lower pressure should be greater than the supply of flash steam. The demand for steam should occur at the same time as the flash steam supply.
 - 3) The steam equipment should be in close proximity to the flash steam source to minimize installation and radiation losses and to fully take advantage of the flash steam recovery system. Flash steam recovery systems are especially advantageous when steam is utilized at multiple pressures within the facility and the distribution systems are already in place.

Piping Systems 171

10. Saturated Steam:

a. Saturated Steam. Saturated steam is steam that is in equilibrium with the liquid at a given pressure. One pound of steam has a volume of 26.8 Cu.Ft. at atmospheric pressure (0 psig).

b. Dry Saturated Steam. Dry steam is steam which has been completely evaporated and contains no liquid water in the form of mist or small droplets. Steam systems which produce a dry steam supply are superior to systems which produce a wet steam supply.

c. Wet Saturated Steam. Wet steam is steam which has not been completely evaporated and contains water in the form of mist or small droplets. Wet steam has a heat content substantially lower than dry steam.

d. Superheated Steam. Superheated steam is dry saturated steam that is heated, which increases the temperature without increasing the system pressure.

11. Steam Types:

- a. Plant Steam. Steam produced in a conventional boiler system using softened and chemically treated water.
- Filtered Steam. Plant steam which has been filtered to remove solid particles (no chemical removal).
- c. Clean Steam. Steam produced in a clean steam generator using distilled, de-ionized, reverse-osmosis, or ultra-pure water.
- d. Pure Steam. Steam produced in a clean steam generator using distilled or de-ionized pyrogen free water, normally defined uncondensed water for injection.

12. Steam Purity versus Steam Quality:

- a. Steam Purity. A qualitative measure of steam contamination caused by dissolved solids, volatiles, or particles in vapor, or by tiny water droplets that may remain in the steam following primary separation in the boiler.
- b. Steam Quality. The ratio of the weight of dry steam to the weight of dry saturated steam and entrained water [Example: 0.95 quality refers to 95 parts steam (95%) and 5 parts water (5%)].

B. Steam Condensate Pipe Sizing (See Appendix C):

- 1. Steam Condensate Pipe Sizing Criteria Limits:
 - a. Pressure Drop: 1/6-1.0 Psig/100 Ft.
 - b. Velocity. Liquid Systems: 150 Ft./Min. Max.
 - c. Velocity. Vapor Systems: 5000 Ft./Min. Max.
- 2. Recommended Steam Condensate Pipe Sizing Criteria:
 - a. Low Pressure Systems:
 - 1) Pressure Drop: 1/8-1/4 Psig/100 Ft.
 - 2) Velocity. Vapor Systems: 2,000 to 3,000 feet per minute.
 - b. Medium Pressure Systems:
 - 1) Pressure Drop: \%-\% Psig/100 Ft.
 - 2) Velocity. Vapor Systems: 2,000 to 3,000 feet per minute.
 - c. High Pressure Systems:
 - 1) Pressure Drop: 4-4 Psig/100 Ft.
 - 2) Velocity. Vapor Systems: 3,000 to 4,000 feet per minute.
- 3. Wet Returns: Return pipes contain only liquid, no vapor. Wet condensate returns connect to the boiler below the water line so that the piping is always flooded.
- 4. Dry Returns: Return pipes contain saturated liquid and saturated vapor (most common). Dry condensate returns connect to the boiler above the waterline so that the piping is not flooded and must be pitched in the direction of flow. Dry condensate returns often carry steam, air, and condensate.

- 5. Open Returns: Return system is vented to atmosphere and condensate lines are essentially at atmospheric pressure (gravity flow lines).
- 6. Closed Returns: Return system is not vented to atmosphere.
- 7. Steam traps and steam condensate piping should be selected to discharge at 4 times the condensate rating of air handling heating coils and 3 times the condensate rating of all other equipment for system start-up.

C. Steam and Steam Condensate System Design and Pipe Installation Guidelines:

- 1. Minimum recommended steam pipe size is ¾ inch. Minimum recommended steam condensate pipe size is 1 inch.
- 2. Locate all valves, strainers, unions, and flanges so that they are accessible. All valves (except control valves) and strainers should be full size of pipe before reducing size to make connections to equipment and controls. Union and/or flanges should be installed at each piece of equipment, in bypasses and in long piping runs (100 feet or more), to permit disassembly for alteration and repairs.
- 3. Provide chainwheel operators for all valves in equipment rooms mounted greater than 7'-0" above floor level and chain should extend to 5'-0" to 7'-0" above floor level.
- 4. All valves should be installed so that valve remains in service when equipment or piping on equipment side of valve is removed.
- Locate all flow measuring devices in accessible locations with straight section of pipe upstream (10 pipe diameters) and downstream (5 pipe diameters) of device or as recommended by manufacturer.
- 6. Provide vibration isolators for all piping supports connected to and within 50 feet of isolated equipment, except at base elbow supports and anchor points, throughout mechanical equipment rooms, and for supports of steam mains within 50 feet of boiler or pressure reducing valves.
- 7. Pitch steam piping downward in direction of flow ¼" per 10 Ft. (1" per 40 Ft.) minimum.
- 8. Where length of branch lines are less than 8 feet, pitch branch lines downward toward mains ½" per foot minimum.
- 9. Connect all branch lines to the top of steam mains (45 degree preferred, 90 degree acceptable).
- 10. Steam piping should be installed with eccentric reducers (flat on bottom) to prevent accumulation of condensate in the pipe and thus increasing the risk of water hammer.
- 11. Drip leg collection points on steam piping should be the same size as the steam piping to prevent steam condensate from passing over the drip leg and increasing the risk of water hammer. The drip leg collection point should be a minimum of 12 inches long including a minimum 6 inch long dirt leg with the steam trap outlet above the dirt leg.
- 12. Pitch all steam return lines downward in the direction of condensate flow ½" per 10 Ft. minimum.
- 13. Drip legs must be installed at all low points, downfed runouts to all equipment, end of mains, bottom of risers, and ahead of all pressure regulators, control valves, isolation valves and expansion joints.
- 14. On straight runs with no natural drainage points, install drip legs at intervals not exceeding 200 feet where pipe is pitched downward in the direction of steam flow and a maximum of 100 feet where the pipe is pitched up so that condensate flow is opposite of steam flow.
- 15. Steam traps used on steam mains and branches shall be minimum ¾" size.
- 16. When elevating steam condensate to an overhead return main, it requires 1 psi to elevate condensate 2 Ft. Try to avoid elevating condensate.
- 17. Control of steam systems with more than 2 million Btuh's should be accomplished with 2 or more control valves (see steam PRVs).

- 18. Double valves should be installed on the supply side of equipment for isolating steam systems, above 40 psig, with a drain between these valves to visually confirm isolation. The reason for double valving of systems is to ensure isolation because of the large pressure differentials which occur when the system is opened for repairs. Double valve all the following:
 - a. Equipment.
 - b. Drains.
 - c. Vents.
 - d. Gauges.
 - e. Instrumentation.
- 19. Steam and steam condensate in a steam system should be maintained at a pH of approximately 8 to 9. A pH of 7 is neutral; below 7 is acid; above 7 is alkaline.
- 20. Provide stop check valve (located closest to the boiler) and isolation valve with a drain between these valves on the steam supply connections to all steam boilers.
- 21. Provide steam systems with warm-up valves for in service start-up as shown in the following table. This will allow operators to warm these systems slowly and to prevent a sudden shock or catastrophic system failure when large system valves are opened. Providing warming valves also reduces wear on large system valves when they are only opened a small amount in an attempt to control system warm-up speed.

Bypass and Warming Valves

MAIN VALVE	NOMINAL PIPE SIZE		
NOMINAL PIPE	SERIES A	SERIES B	
SIZE	WARMING VALVES	BYPASS VALVES	
4 5 6	1/2 3/4 3/4	$ \begin{array}{c} 1 \\ 1\frac{1}{4} \\ 1\frac{1}{4} \end{array} $	
8	3/4	1½	
10	1	1½	
12	1	2	
14	1	2	
16	1	3	
18	1	3	
20	1	3	
24	1	4	
30	1	4	
36 42 48	1 1 1	6 6 8	
54	1	8	
60	1	10	
72	1	10	
84 96	1	12 12	

Notes:

- Series A covers steam service for warming up before the main line is opened, and for balancing
 pressures where lines are of limited volume.
- Series B covers lines conveying gases or liquids where by-passing may facilitate the operation of the main valve through balancing the pressures on both sides of the disc or discs thereof. The valves in the larger sizes may be of the bolted on type.

- 22. Steam System Warming Valve Procedure:
 - a. Slowly open the warming supply valve to establish flow and to warm the system.
 - b. Once the system pressure and temperature have stabilized, then proceed with the following items listed below, one at a time:
 - 1) Slowly open the main supply valve.
 - 2) Close the warming supply valve.
- 23. Steam System Warm-up Procedure:
 - a. Steam system start-up should not exceed 120°F, temperature rise per hour, but boiler or heat exchanger manufacture limitations should be consulted.
 - b. It is recommended that no more than a 25°F, temperature rise per hour be used when warming steam systems. Slow warming of the steam system allows for system piping, supports, hangers, and anchors to keep up with system expansion.
 - c. Low pressure steam systems (15 psig and less) should be warmed slowly at 25°F. temperature rise per hour until system design pressure is reached.
 - d. Medium and high pressure steam systems (above 15 psig) should be warmed slowly at 25°F, temperature rise per hour until 250°F-15 psig system temperaturepressure is reached. At this temperature-pressure the system should be permitted to settle for at least 8 hours or more (preferably overnight). The temperaturepressure maintenance time gives the system piping, hangers, supports, and anchors a chance to catch up with the system expansion. After allowing the system to settle, the system can be warmed up to 120 psig or system design pressure in 25 psig pressure increments; allow the system to settle for an hour before increasing the pressure to the next increment. When the system reaches 120 psig and the design pressure is above 120 psig, the system should be allowed to settle for at least 8 hours or more (preferably overnight). The pressure maintenance time gives the system piping, hangers, supports, and anchors a chance to catch up with the system expansion. After allowing the system to settle, the system can be warmed up to 300 psig or system design pressure in 25 psig pressure increments; allow the system to settle for an hour before increasing the pressure to the next increment.

D. Low Pressure Steam Pipe Materials:

1. 2" and Smaller:

Black Steel Pipe, ASTM A53, Schedule 40, Type E or S, Grade B a. Pipe: Fittings: Black Cast Iron Screw Fittings, 125 lb., ANSI/ASME B16.4 Joints:

Pipe Threads, General Purpose (American) ANSI/ASME B1.20.1

2. 2½" thru 10":

a. Pipe: Black Steel Pipe, ASTM A53, Schedule 40, Type E or S, Grade B Steel Butt-Welding Fittings, 125 lb., ANSI/ASME B16.9 Fittings:

Welded pipe, ANSI/AWS D1.1 and ANSI/ASME Sec. 9 **Joints:**

3. 12" and Larger:

Black Steel Pipe, ASTM A53, 3/4" wall, Type E or S, Grade B a. Pipe: Fittings: Steel Butt-Welding Fittings, 125 lb., ANSI/ASME B16.9 Joints: Welded pipe, ANSI/AWS D1.1 and ANSI/ASME Sec. 9

E. Low Pressure Steam Condensate Pipe Materials:

1. 2" and Smaller:

a. Pipe: Black Steel Pipe, ASTM A53, Schedule 80, Type E or S, Grade B Black Cast Iron Screw Fittings, 250 lb., ANSI/ASME B16.4 Fittings: Pipe Threads, General Purpose (American) ANSI/ASME B1.20.1 **Joints:**

2. 2½" and Larger:

a. Pipe:

Black Steel Pipe, ASTM A53, Schedule 80, Type E or S, Grade B

Fittings: Joints:

Steel Butt-Welding Fittings, 250 lb., ANSI/ASME B16.9 Welded pipe, ANSI/AWS D1.1 and ANSI/ASME Sec. 9

F. Medium and High Pressure Steam and Steam Condensate Pipe:

1. 1½" and Smaller:

a. Pipe: Black Steel Pipe, ASTM A53, Schedule 80, Type E or S, Grade B

Fittings: Forged Steel Socket-Weld, 300 lb., ANSI B16.11

Joints: Welded pipe, ANSI/AWS D1.1 and ANSI/ASME Sec. 9

b. Pipe: Carbon Steel Pipe, ASTM A106, Schedule 80, Grade B
 Fittings: Forged Steel Socket-Weld, 300 lb., ANSI B16.11

Joints: Welded pipe, ANSI/AWS D1.1 and ANSI/ASME Sec. 9

2. 2" and Larger:

a. Pipe: Black Steel Pipe, ASTM A53, Schedule 80, Type E or S, Grade B

Fittings: Steel Butt-Welding Fittings, 300 lb., ANSI/ASME B16.9
Joints: Welded pipe, ANSI/AWS D1.1 and ANSI/ASME Sec. 9

b. Pipe: Carbon Steel Pipe, ASTM A106, Schedule 80, Grade B

Fittings: Steel Butt-Welding Fittings, 300 lb., *ANSI/ASME B16.9* Joints: Welded pipe, *ANSI/AWS D1.1* and *ANSI/ASME Sec. 9*

G. Pipe Testing:

1. 1.5 × System Working Pressure.

2. 100 Psi Minimum.

H. Steam Pressure Reducing Valves (PRV):

- 1. PRV Types:
 - a. Direct Acting:
 - 1) Low Cost.
 - 2) Limited ability to respond to changing load and pressure.
 - 3) Suitable for systems with low flow requirements.
 - 4) Suitable for systems with constant loads.
 - 5) Limited control of downstream pressure.
 - b. Pilot-Operated:
 - 1) Close control of downstream pressure over a wide range of upstream pressures.
 - 2) Suitable for systems with varying loads.
 - 3) Ability to respond to changing loads and pressures.
 - 4) Types:
 - a) Pressure-Operated-Pilot.
 - b) Temperature-Pressure-Operated-Pilot.
- 2. Use multiple stage reduction where greater than 100 psig reduction is required or where greater than 50 psig reduction is required to deliver a pressure less than 25 psig operating pressure or when intermediate steam pressure is required.
- 3. Use multiple PRVs where system steam capacity exceeds 2" PRV size, when normal operation calls for 10% of design load for sustained periods, or when there are two distinct load requirements (i.e., summer/winter). Provide number of PRV's to suit project.
 - a. If system capacity for a single PRV exceeds 2" PRV size but is not larger than 4" PRV size, use 2 PRVs with ½ and ½ capacity split.
 - b. If system capacity for a single PRV exceeds 4" PRV size, use 3 PRV's with 25%, 25%, and 50% or 15%, 35%, and 50% capacity split to suit project.

- 4. Smallest PRV to be no greater than ½ of system capacity. Maximum size PRV to be 4" (6" when 4" PRV will require more than 3 valves per stage).
- 5. PRV bypass to be 2 pipe sizes smaller than largest PRV.
- 6. Provide 10 pipe diameters from PRV inlet to upstream header.
- 7. Provide 20 pipe diameters from PRV outlet to downstream header.
- 8. Maximum Pipe Velocity Upstream and Downstream of PRV:
 - a. 8" and Smaller: 10,000 FPM.
 - b. 10" and Larger: 8,000 FPM.
 - c. Where low sound levels are required reduce velocities by 25% to 50%.
 - d. If outlet velocity exceeds those listed above, use noise suppressor.
- 9. Avoid abrupt changes in pipe size. Use concentric reducers.
- 10. Limit pipe diameter changes to two pipe sizes per stage of expansion.

I. Safety Relief Valves:

- 1. The safety relief valve must be capable of handling the volume of steam as determined by the high pressure side of the largest PRV or the bypass, whichever is greater.
- 2. Use multiple safety relief valves if the capacity of a 4" safety relief valve is exceeded. Each valve must have a separate connection to the pipeline.
- 3. Safety, Relief, and Safety Relief Valve testing is dictated by the Insurance Underwriter.

J. Steam Traps:

- 1. Steam Trap Types:
 - a. A steam trap is a self-actuated valve that closes in the presence of steam and opens in the presence of steam condensate or non-condensible gases.
 - b. Thermostatic Traps: React to differences in temperature between steam and cooled condensate. Condensate must be subcooled for the trap to operate properly. Thermostatic traps work best in drip and tracing service and where steam temperature and pressure are constant and predictable.
 - 1) Liquid Expansion Thermostatic Trap.
 - 2) Balanced Pressure Thermostatic Trap:
 - a) Balanced pressure traps change their actuation temperature automatically with changes in steam pressure. Balanced pressure traps are used in application where system pressure varies.
 - b) During start-up and operation, this trap discharges air and other noncondensibles very well. This trap is often used as a stand-alone air vent in steam systems.
 - c) The balanced pressure trap will cause condensate to back up in the system.
 - 3) Bimetal Thermostatic Trap:
 - a) Bimetal traps are rugged and resist damage from steam system events such as water hammer, freezing, superheated steam, and vibration.
 - b) Bimetal traps cannot compensate for steam system pressure changes.
 - c) Bimetal traps have a slow response time to changing process pressure and temperature conditions.
 - 4) Bellows Thermostatic Trap.
 - 5) Capsule Thermostatic Trap.
 - c. Mechanical Traps: Operate by the difference in density between steam and condensate (buoyancy operated).
 - 1) Float & Thermostatic Traps:
 - a) Process or modulating applications—will work in almost any application—heat exchangers, coils, humidifiers, etc.

- b) Simplest type of mechanical trap
- c) The F&T trap is the only trap that provides continuous, immediate, and modulating condensate discharge.
- d) A thermostat valve is open when cold or when below saturation (steam) temperature to allow air to bleed out during system start-up and operation. The valve closes when the system reaches steam temperature.
- 2) Bucket Traps.
- 3) Inverted Bucket Traps:
 - a) Work best in applications with constant load and constant pressure—drips.
 - b) When the inverted bucket is filled with steam, it rises and closes the discharge valve preventing the discharge of steam. When the inverted bucket is filled with condensate, it drops opening the valve and discharging the condensate.
 - c) Inverted bucket traps are poor at removal of air and other non-condensible gases.
- d. Kinetic Traps: Rely on the difference in flow characteristics of steam and condensate and the pressure created by flash steam.
 - 1) Thermodynamic Traps:
 - a) Thermodynamic traps work best in drip and tracing service.
 - b) Thermodynamic traps can remove air and other non-condensibles during start-up only if the system pressures are increased slowly; because of this thermodynamic traps often require a separate air vent.
 - c) These traps snap open and snap shut and the sound can be annoying if used in noise sensitive areas.
 - d) The thermodynamic trap is rugged because is has only one moving part and is resistant to water hammer, superheated steam, freezing, and vibration.
 - 2) Impulse or Piston Traps.
 - 3) Orifice Traps.

2. Steam Trap Selection:

- a. HVAC equipment steam traps should be selected to discharge three to four times the condensate rating of the equipment for system start-up.
- b. Boiler header steam traps should be selected to discharge 3 to 5 times the condensate carryover rating of the boilers (typically 10%).
- c. Steam main piping steam traps should be selected to discharge 2 to 3 times the condensate generated during the start-up mode caused by radiation losses.
- d. Steam branch piping steam traps should be selected to discharge 3 times the condensate generated during the start-up mode caused by radiation losses.
- e. Use float and thermostatic (F&T) traps for all steam supplied equipment.
 - 1) Thermostatic traps may be used for steam radiators, steam finned tube, and other non-critical equipment, in lieu of F&T traps.
 - 2) A combination of an inverted bucket trap and an F&T trap in parallel, with F&T trap installed above inverted bucket trap, may be used, in lieu of F&T traps.
- f. Use inverted bucket traps for all pipeline drips.

3. Steam Trap Functions:

- a. Steam traps allow condensate to flow from the heat exchanger or other device to minimize fouling, prevent damage, and to allow the heat transfer process to continue.
- b. Steam traps prevent steam escape from the heat exchanger or other device.
- Steam traps vent air or other non-condensible gases to prevent corrosion and allow heat transfer.

4. Common Steam Trap Problems:

a. Steam Leakage: Like all valves the steam trap seat is subject to damage, corrosion, and/or erosion. When the trap seat is damaged, the valve will not seal; thus, the steam trap will leak live steam.

- b. Air Binding: Air, carbon dioxide, hydrogen, and other non-condensible gases trapped in a steam system will reduce heat transfer and can defeat steam trap operation.
- c. Insufficient Pressure Difference: Steam traps rely on a positive pressure difference between the upstream steam pressure and the downstream condensate pressure to discharge condensate. When this is not maintained, the discharge of condensate is impeded.
 - 1) Overloading of the condensate return system is one cause: too much back pressure.
 - 2) Steam pressure that is too low is another cause.
- d. Dirt: Steam condensate often contains dirt, particles of scale and corrosion, and other impurities from the system that can erode and damage the steam traps. Strainers should always be placed upstream of the steam traps to extend life.
- e. Freezing: Freezing is normally only a problem when the steam system is shut down or idles and liquid condensate remains in the trap.
- f. Noise: Thermodynamic traps are generally the only trap that produces noise when it operates. All other traps operate relatively quietly.
- g. Maintenance: Steam traps, as with all valves, must be maintained. Most steam traps can be maintained in-line without removing the body from the connecting piping.
- 5. Steam Trap Characteristics are given in the following table.

		STEAM TRAP TYPE	
CHARACTERISTIC	INVERTED BUCKET	FLOAT & THERMOSTATIC	LIQUID EXPANSION THERMOSTATIC
Method of Operation	Intermittent, Condensate drainage is continuous, discharge is intermittent	Continuous	Intermittent
No Load	Small Dribble	No Action	No Action
Light Load	Intermittent	Usually Continuous but May Cycle at High Pressures	Continuous, Usually Dribble Action
Normal Load	Intermittent	Usually Continuous but May Cycle at High Pressures	May Blast at High Pressures
Full or Overload	Continuous	Continuous	Continuous
Energy Conservation	Excellent	Good	Fair
Resistance to Wear	Excellent	Good	Fair
Corrosion Resistance	Excellent	Good	Good
Resistance to Hydraulic Shock	Excellent	Poor	Poor
Vents Air and CO ₂ at Steam Temperature	Yes	No	No
Ability to Vent Air at Very Low Pressure (1/4 Psig)	Poor	Excellent	Good
Ability to Handle Start-up Air Loads	Fair	Excellent	Excellent
Operation Against Back Pressure	Excellent	Excellent	Excellent
Resistance to Damage from Freezing, Cast Iron Trap not Recommended	Good	Poor	Good
Ability to Purge System	Excellent	Fair	Good
Performance on Very Light Loads	Excellent	Excellent	Excellent
Responsiveness to Slugs of Condensate	Immediate	Immediate	Delayed
Ability to Handle Dirt	Excellent	Poor	Fair
Comparative Physical Size	Large	Large	Small
Ability to Handle Flash Steam	Fair	Poor	Poor

STEAM TRAP TYPE			
CHARACTERISTIC	INVERTED BUCKET	FLOAT & THERMOSTATIC	LIQUID EXPANSION THERMOSTATIC
Usual Mechanical Failure Mode	Open	Closed with Air Vent Open	Open or Closed Depending on Design
Subcooling	No	No	Yes
Venting	Fair	Excellent	Excellent
Seat Pressure Rating	Yes	Yes	N/A
	Rugged	Continuous condensate discharge	Utilizes sensible heat of condensate
Advantages	Tolerates water hammer without damage	Handles rapid pressure changes	Allows discharge of non- condensibles at startup to the set point temperature
.		High non-condensible capacity	Not affected by superheated steam, water hammer, or vibration
	12		Resists freezing
	Discharges non- condensibles slowly (additional air vent required)	Float can be damaged by water hammer	Element subject to corrosion damage
Disadvantages	Level of condensate can freeze, damaging the trap body	Level of condensate in chamber can freeze, damaging float and body	Condensate backs up into the drain line and/or process
, and the second	Must have water seal to operate - subject to loosing prime	Some thermostatic air vent designs are susceptible to corrosion	
	Pressure fluctuations and superheated steam can cause loss of water seal		
Recommended Services	Continuous operation where non-condensible venting is not critical and rugged construction is important	Heat exchangers with high and variable heat transfer rates	Ideal for tracing used for freeze protection
		When condensate pump is required	Freeze protection - water and condensate lines and traps
		Batch processes that require frequent startup of an air filled system	Non-critical temperature control of heated tanks

	STEAM TRAP TYPE		
CHARACTERISTIC	BALANCED PRESSURE THERMOSTATIC	BIMETAL THERMOSTATIC	THERMODYNAMIC
Method of Operation	Intermittent	Intermittent	Intermittent
No Load	No Action	No Action	No Action
Light Load	Continuous, Usually Dribble Action	Continuous, Usually Dribble Action	Intermittent
Normal Load	May Blast at High Pressures	May Blast at High Pressures	Intermittent
Full or Overload	Continuous	Continuous	Continuous
Energy Conservation	Fair	Fair	Poor
Resistance to Wear	Fair	Fair	Poor
Corrosion Resistance	Good	Good	Excellent
Resistance to Hydraulic Shock	Good	Good	Excellent
Vents Air and CO ₂ at Steam Temperature	No	No	No
Ability to Vent Air at Very Low Pressure (1/4 Psig)	Good	Good	Not Recommended for Low Pressure Applications
Ability to Handle Start-up Air Loads	Excellent	Excellent	Poor
Operation Against Back Pressure	Excellent	Excellent	Poor
Resistance to Damage from Freezing, Cast Iron Trap not Recommended	Good	Good	Good
Ability to Purge System	Good	Good	Excellent
Performance on Very Light Loads	Excellent	Excellent	Poor
Responsiveness to Slugs of Condensate	Delayed	Delayed	Delayed
Ability to Handle Dirt	Fair	Fair	Poor
Comparative Physical Size	Small	Small	Small
Ability to Handle Flash Steam	Poor	Poor	Poor

		STEAM TRAP TYPE	
CHARACTERISTIC	BALANCED PRESSURE THERMOSTATIC	BIMETAL THERMOSTATIC	THERMODYNAMIC
Usual Mechanical Failure Mode	Open or Closed Depending on Design	Open or Closed Depending on Design	Open, Dirt can cause to fail closed
Subcooling	Yes	Yes	No
Venting	Excellent	Excellent	Fair
Seat Pressure Rating	N/A	N/A	N/A
	Small and lightweight	Small and Lightweight	Rugged, withstands corrosion, water hammer, high pressure, and superheated steam
Alman	Maximum discharge of non-condensibles at startup	Maximum discharge of non-condensibles at startup	Handles wide pressure range
Advantages	Unlikely to freeze	Unlikely to freeze and unlikely to be damaged if it does freeze	Compact and simple
		Rugged; Withstands corrosion, water hammer, high pressure, and superheated steam	Audible operations warns when repair is needed
Disadvantages	Some types of damage by water hammer, corrosion, and superheated steam	Responds slowly to load and pressure changes	Poor operation with very low pressure steam or high back pressure
	Condensate backs up into the drain line and/or process	More condensate backup than Balance Pressure Thermostatic Trap	Requires slow pressure buildup to remove air at startup to prevent air binding
		Back pressure changes operating characteristics	Noisy operation
	Batch processing requiring rapid discharge of non-condensibles at startup	Drip legs on constant- pressure steam mains	Steam main drips, tracers
Recommended Services	Drip legs on steam mains and tracing	Installations subject to ambient conditions below freezing	Constant-pressure, constant-load applications
	Installations subject to ambient conditions below freezing		Installations subject to ambient conditions below freezing

6. Steam Trap Inspection

a. Method #1 is shown in the following table:

TRAP FAILURE RATE	STEAM TRAP INSPECTION FREQUENCY
OVER 10%	EVERY 2 MONTHS
5 TO 10%	EVERY 3 MONTHS
LESS THAN 5%	EVERY 6 MONTHS

b. Method #2 is shown in the following table:

SYSTEM PRESSURE	STEAM TRAP INSPECTION FREQUENCY
0 TO 30 PSIG	ANNUALLY
30 TO 100 PSIG	SEMI-ANNUALLY
100 TO 250 PSIG	QUARTERLY OR MONTHLY
OVER 250 PSIG	MONTHLY OR WEEKLY

19.03 Refrigerant Systems and Piping

A. Refrigeration System Design Considerations:

- 1. Refrigeration Load and System Size:
 - a. Conduction Heat Gains, Sensible.
 - b. Radiation Heat Gains, Sensible.
 - c. Convection/Infiltration Heat Gains, Sensible and Latent.
 - d. Internal Heat Gains, Lights, People, Equipment.
 - e. Product Load, Sensible and Latent.
- 2. Part Load Performance, Minimum vs Maximum Load.
- 3. Piping Layout and Design:
 - a. Assure proper refrigerant flow to feed evaporators.
 - Size piping to limit excessive pressure drop and temperature rise and to minimize first cost.
 - Assure proper lubricating oil flow to compressors and protect compressors for loss of lubricating oil flow.
 - d. To prevent liquid (oil or refrigerant) from entering the compressors.
 - e. Maintain a clean and dry system.
 - f. To prevent refrigeration system leaks.
- 4. Refrigerant type selection and refrigerant limitations.
- 5. System operation, partial year or year round regardless of ambient conditions.
- 6. Load variations during short time periods.
- 7. Evaporator frost control.
- 8. Oil management under varying load conditions.
- 9. Heat exchange method.
- 10. Secondary coolant selection.
- Installed cost, operating costs, maintenance costs, system efficiency and system simplicity.
- 12. Safe operation for building inhabitants.
- 13. Operating pressure and pressure ratios, single stage vs. two stage vs. multi-staged.
- 14. Special electrical requirements.

B. Refrigerant Pipe Design Criteria:

- 1. Halocarbon Refrigerants:
 - a. Liquid Lines (Condensers to Receivers)—100 FPM or Less.

- b. Liquid Lines (Receivers to Evaporator)—300 FPM or Less.
- c. Compressor Suction Line-900 to 4,000 FPM.
- d. Compressor Discharge Line-2,000 to 3,500 FPM.
- e. Defrost Gas Supply Lines-1,000 to 2,000 FPM.
- f. Condensate Drop Legs—150 FPM or Less.
- g. Condensate Mains-100 FPM or less.
- h. Pressure loss due to refrigerant liquid risers is 0.5 psi per foot of lift.
- i. Liquid lines should be sized to produce a pressure drop due to friction that corresponds to a 1°F. to 2°F. change in saturation temperature or less.
- j. Discharge and suction lines should be sized to produce a pressure drop due to friction that corresponds to a 2°F, change in saturation temperature or less.
- k. Pump suction pipe sizing should be 2.5 fps maximum. Oversizing of pump suction piping should be limited to one pipe size.
- 2. Standard Steel Pipe Sizes: ½", ¼", 1", 1¼", 1½", 2", 2½", 3", 4", 6", 8", 10", 12", 14", 16", 18", 20".
- 4. Ammonia Refrigerant:
 - a. Liquid lines should be sized for 2.0 Psi/100 Ft. of equivalent pipe length or less. Liquid lines should be sized for a 3:1, 4:1 or 5:1 overfeed ratio (4:1 recommended).
 - b. Suction lines should be sized for 0.25, 0.5 or 1.0°F./100 Ft. of equivalent pipe length.
 - c. Discharge lines should be sized for 1.0°F./100 Ft. of equivalent pipe length.
 - d. Pump suction pipe sizing should be 3.0 fps maximum. Oversizing of pump suction piping should be limited to one pipe size.
 - e. Cooling Water Flow Rate: 0.1 GPM/Ton.

C. Halocarbon Refrigerant Pipe Materials:

- 1. Pipe: Type "L (ACR)" Copper Tubing, ASTM B280, Hard Drawn.
 - Fittings: Wrought Copper Solder Joint Fittings, ANSI/ASME B16.22.
 - Joints: Classification BAg-1 (silver) AWS A5.8 Brazed-Silver Alloy brazing. Brazing
 - shall be conducted using a brazing flux. Do not use an acid flux.

D. Ammonia Refrigerant Pipe Materials:

- 1. Liquid Lines:
 - a. 11/2" and Smaller: Schedule 80 minimum
 - b. 2" to 6": Schedule 40 minimum
 - c. 8" and Larger: Schedule 30 minimum
- 2. Suction, Discharge, and Vapor Lines
 - a. 1½" and Smaller: Schedule 80 minimum
 - b. 2" to 6": Schedule 40 minimum
 - c. 8" and Larger: Schedule 30 minimum
- 3. Fittings:
 - a. Couplings, elbows, tees, and unions for threaded piping systems must constructed of forged steel with a pressure rating of 300 psi.
 - b. Welding fitting must match weight of pipe.
 - c. Low pressure side piping, vessels, and flanges should be designed for 150 psi.
 - d. High pressure side piping, vessels, and flanges should be designed for 250 psi if the system is water or evaporative cooled and 300 psi if the system is air cooled.
- 4. Joints:
 - a. 14" pipe and smaller may be threaded although, welded systems are superior.
 - b. 1½" pipe and larger must be welded.

5. Recommended Low Pressure Side Piping Requirements:

a. 1¼" and Smaller:

Pipe:

Black Steel Pipe, ASTM A53, Schedule 80, Type E or S, Grade B or

Carbon Steel

Pipe, ASTM A106, Schedule 80, Type S, Grade B.

Fittings:

Forged Steel Threaded Fittings, 3,000 Lb.

Joints:

Pipe Threads, General Purpose (American) ANSI/ASME B1.20.1

OR

Pipe:

Black Steel Pipe, ASTM A53, Schedule 80, Type E or S, Grade B or

Carbon Steel

Pipe, ASTM A106, Schedule 80, Type S, Grade B.

Fittings: Joints:

Forged Steel Socket Weld, 150 Lb. ANSI B16.11.

Welded Pipe, ANSI/AWS D1.1 and ANSI/ASME Sec. 9.

b. 1½":

Pipe:

Black Steel Pipe, ASTM A53, Schedule 80, Type E or S, Grade B or

Carbon Steel

Pipe, ASTM A106, Schedule 80, Type S, Grade B.

Fittings:

Forged Steel Socket Weld, 150 Lb. ANSI B16.11.

Joints:

Welded Pipe, ANSI/AWS D1.1 and ANSI/ASME Sec. 9.

c. 2" and Larger:

Pipe:

Black Steel Pipe, ASTM A53, Schedule 40, Type E or S, Grade B or

Carbon Steel

Pipe, ASTM A106, Schedule 40, Type S, Grade B.

Fittings:

Steel Butt-Welding Fittings, 150 Lb., ANSI/ASME B16.9.

Joints: We

Welded Pipe, ANSI/AWS D1.1 and ANSI/ASME Sec. 9.

6. Recommended High Pressure Side Piping Requirements:

a. 1¼" and Smaller:

Pipe:

Black Steel Pipe, ASTM A53, Schedule 80, Type E or S, Grade B or

Carbon Steel

Pipe, ASTM A106, Schedule 80, Type S, Grade B.

Fittings:

Forged Steel Threaded Fittings, 3,000 Lb.

Joints:

Pipe Threads, General Purpose (American) ANSI/ASME B1.20.1

OR

Pipe:

Black Steel Pipe, ASTM A53, Schedule 80, Type E or S, Grade B or

Carbon Steel

Pipe, ASTM A106, Schedule 80, Type S, Grade B.

Fittings:

Forged Steel Socket Weld, 300 Lb. ANSI B16.11.

Joints:

Welded Pipe, ANSI/AWS D1.1 and ANSI/ASME Sec. 9.

b. 1½":

Pipe:

Black Steel Pipe, ASTM A53, Schedule 80, Type E or S, Grade B or

Carbon Steel

Pipe, ASTM A106, Schedule 80, Type S, Grade B.

Fittings:

Forged Steel Socket Weld, 300 Lb. ANSI B16.11.

Joints:

Welded Pipe, ANSI/AWS D1.1 and ANSI/ASME Sec. 9.

c. 2" and Larger:

Pipe:

Black Steel Pipe, ASTM A53, Schedule 40, Type E or S, Grade B or

Carbon Steel

Pipe, ASTM A106, Schedule 40, Type S, Grade B.

Fittings:

Steel Butt-Welding Fittings, 300 Lb., ANSI/ASME B16.9.

Joints:

Welded Pipe, ANSI/AWS D1.1 and ANSI/ASME Sec. 9.

E. Refrigerant Piping Installation:

- 1. Slope piping 1 percent in direction of oil return.
- 2. Install horizontal hot gas discharge piping with ½" per 10 feet downward slope away from the compressor.
- 3. Install horizontal suction lines with ½" per 10 feet downward slope to the compressor, with no long traps or dead ends which may cause oil to separate from the suction gas and return to the compressor in damaging slugs.
- 4. Liquid lines may be installed level.
- 5. Provide line size liquid indicators in main liquid line leaving condenser or receiver. Install moisture-liquid indicators in liquid lines between filter dryers and thermostatic expansion valves and in liquid line to receiver.
- 6. Provide line size strainer upstream of each automatic valve. Provide shutoff valve on each side of strainer.
- 7. Provide permanent filter dryers in low temperature systems and systems using hermetic compressors.
- 8. Provide replaceable cartridge filter dryers with three valve bypass assembly for solenoid valves that is adjacent to receivers.
- Provide refrigerant charging valve connections in liquid line between receiver shutoff valve and expansion valve.
- 10. Normally only refrigerant suction lines are insulated, but liquid lines should be insulated where condensation will become a problem and hot gas lines should be insulated where personal injury from contact may pose a problem.
- 11. Refrigerant lines should be installed a minimum of 7'6" feet above the floor.

F. Refrigerant Properties:

- 1. Halocarbon refrigerants absorb 40-80 Btuhs/Lb. and ammonia absorbs 500-600 Btuhs/Lb.
- Ammonia refrigeration systems require smaller piping than halocarbon refrigeration systems for the same pressure drop and capacity.
- 3. Human or living tissue contact with many refrigerants in their liquid state can cause instant freezing, frostbite, solvent defatting or dehydration, and/or caustic or acid burns.
- 4. Leak detectors are essential for all halocarbon refrigerants because they are generally heavier than air, are odorless, and can cause suffocation due to oxygen depravation. Ammonia is lighter than air and has a distinctive and unmistakable odor.
- 5. Ammonia Properties:
 - a. Refrigerant Grade Ammonia:
 - 99.98% Ammonia Minimum.
 - 0.015% Water Maximum.
 - 3 ppm Oil Maximum.
 - 0.2 ml/g Non-Condensable Gases.
 - b. Agricultural Grade Ammonia:
 - 99.5% Ammonia Minimum.
 - 0.5% Water Maximum.
 - 0.2% Water Minimum.
 - 5 ppm Oil Maximum.

c. Ammonia Limitations are shown in the following table:

Concentration of Ammonia in the Air	Limitations/Symptoms
4 ppm	Detectable by human sense of smell.
25 ppm	Maximum ACGIH Permissible Exposure Limit (PEL). Maximum European Government Limit
30 - 35 ppm	Uncomfortable - breathing support desired or required. Common level around ammonia print machines. Maximum recommended exposure 15 minutes (ACGIH).
50 ppm	Maximum OSHA & NIOSH Permissible Exposure Limit (PEL).
100 ppm	Noticeable irritation to the eyes, throat, and mucous membranes.
400 ppm	Mucous membranes may be destroyed with prolonged contact with ammonia. No serious health threat with infrequent and less than 1 hour exposures.
500 ppm	Immediate Danger to Life and Health (IDLH) Limit.
700 ppm	Significant eye irritation.
1,700 ppm	Convulsive coughing occurs. Fatal after short exposures of less than one half hour.
2,500 ppm	Exposure in as short a time as 30 minutes is dangerous. Affects show up several days later - pulmonary edema (water in the lungs).
5,000 ppm and Above	Immediate hazard to life due to suffocation. Full face respiratory protection is required including eyes. Causes respiratory spasm, strangulation, and asphyxia - no exposure permissible.
15,000 ppm and Above	Full body protection required - ammonia reacts with body perspiration to form a caustic solution that attacks the skin causing burns and blisters.
160,000 - 270,000 ppm	Flammable in air at 68°F.
15.5% by Volume	Lower Flammability Limit (LFL) also referred to Lower Explosive Limit (LEL)

6. Refrigerant physical properties are shown in the following table:

		RE	FRIGERANT PH	YSICAL PRO	PERTIES			order Spekke
REFF	RIGERANT	ASHRAE STD 15	MOLECULAR	BOILING POINT AT	FREEZING		CRITICA	AT.
NO.	NAME	GROUP NO.	MASS	14.7 PSIA °F.	POINT °F.	TEMP. °F.	PRESS. PSIA	VOLUME FT³/LB.
R-11		A1	137.38	74.87	-168.0	388.4	639.5	0.0289
R-12		Al	120.93	-21.62	-252.0	233.6	596.9	0.0287
R-13		Al	104.47	-114.60	-294.0	83.9	561.0	0.0277
R-13B1		A1	148.93	-71.95	-270.0	152.6	575.0	0.0215
R-14		Al	88.01	-198.30	-299.0	-50.2	543.0	0.0256
R-22		Al	86.48	-41.36	-256.0	204.8	721.9	0.0305
R-40		B2	50.49	-11.60	-144.0	289.6	968.7	0.0454
R-113		A1	187.39	117.63	-31.0	417.4	498.9	0.0278
R-114		A1	170.94	38.80	-137.0	294.3	473.0	0.0275
R-115		A1	154.48	-38.40	-159.0	175.9	457.6	0.0261
R-123		B1	152.93	82.17	-160.9	362.8	532.9	
R-134a		A1	102.03	-15.08	-141.9	214.0	589.8	0.0290
R-142b		A2	100.50	14.40	-204.0	278.8	598.0	0.0368
R-152a		A2	66.05	-13.00	-178.6	236.3	652.0	0.0439
R-170	ETHANE	A3	30.07	-127.85	-297.0	90.0	709.8	0.0830
R-290	PROPANE	A3	44.10	-43.73	-305.8	206.3	617.4	0.0728
R-C318		A1	200.04	21.50	-42.5	239.6	403.6	0.0258
R-500		A1	99.31	-28.30	-254.0	221.9	641.9	0.0323
R-502		Al	111.63	-49.80		179.9	591.0	0.0286
R-503		Al	87.50	-127.60		67.1	607.0	0.0326
R-600	BUTANE	A3	58.13	31.10	-217.3	305.6	550.7	0.0702
R-600a	ISOBUTANE	A3	58.13	10.89	-255.5	275.0	529.1	0.0725
R-611		B2	60.05	89.20	-146.0	417.2	870.0	0.0459
R-717	AMMONIA	B2	17.03	-28.00	-107.9	271.4	1657.0	0.0680
R-744	CARBON DIOXIDE	A1	44.01	-109.20	-69.9	87.9	1070.0	0.0342
R-764	SULFUR DIOXIDE	BI	64.07	14.00	-103.9	315.5	1143.0	0.0306
R-1150	ETHYLENE	A3	28.05	-154.7	-272.0	48.8	742.2	0.0700
R-1270	PROPYLENE	A3	42.09	-53.86	-301.0	197.2	670.3	0.0720

REFRIGERANT TYPE	ENERGY ABSORPTION RATE BTU/LB.									
TYPE	40°F.	20°F.	0°F.	-20°F.	-40°F.					
R-11	80.863	82.507	84.126	85.732	87.335					
R-12	64.649	66.953	69.098	71.116	73.038					
R-22	86.503	90.344	93.891	97.193	100.296					
R-123	76.787	78.078	79.167	80.162	81.340					
R-134a	84.011	87.589	90.925	94.063	97.050					
R-502	61.687	65.069	68.101	70.795	73.162					
R-717 AMMONIA	535.936	552.858	568.692	583.540	597.482					

19.04 Glycol Solution Systems

A. Glycol System Design Considerations:

- 1. HVAC system glycol applications should use an industrial grade ethylene glycol (phosphate based) or propylene glycol (phosphate based) with corrosion inhibitors without fouling. Specify glycol to have ZERO silicate content.
- Automobile antifreeze solutions should NOT be used for HVAC systems because they contain silicates to protect aluminum engine parts. But these silicates found in automobile antifreeze causes fouling in HVAC systems.
- 3. Consider having the antifreeze dyed to facilitate leak detection.
- 4. Glycol systems should be filled with a high quality water, preferably distilled or deionized (deionized recommended) water, or filled with pre-diluted solutions of industrial grade glycol. Water should have less than 25 ppm of chloride and sulfate, and less than 50 ppm of hard water ions (Ca++, Mg++). City water is treated with chlorine, which is corrosive.
- 5. Automatic makeup water systems should be avoided to prevent system contamination or system dilution. A low level liquid alarm should be used in lieu of an automatic fill line
- 6. Systems should be clean with little or no corrosion.
- 7. Industrial grade glycol will last up to 20 years in a system if properly maintained.
- 8. Propylene glycol should be used where low oral toxicity is important or where incidental contact with drinking water is possible.
- Expansion tank sizing is critical to the design of glycol systems. The design should allow for a glycol level of about two-thirds full during operation. Glycol will expand about 6 percent.
- Water quality should be analyzed at each site for careful evaluation of the level of corrosion protection required.
- 11. Foaming of a glycol system is usually caused by air entrainment, improper expansion tank design, contamination by organics (oil, gas) or solids, or improper system operation. Foaming will reduce heat transfer and aggravate cavitation corrosion.
- 12. A buffering agent should be added to maintain fluid alkalinity, minimize acidic corrosive attack, and counteract fluid degradation. Proper buffering agents will reduce fluid maintenance, extend fluid life, and be less sensitive to contamination.

- 13. A non-absorbent bypass filter, of the sock or cartridge variety, should be installed in each glycol system.
- 14. An annual chemical analysis should be conducted to determine the glycol content, oxidative degradation, foaming agent concentration, inhibitor concentration, buffer concentration, freezing point, and pH, reserve alkalinity.

ETHYLENE GLYCOL CHARACTERISTICS	PROPYLENE GLYCOL CHARACTERISTICS
MORE EFFECTIVE FREEZE POINT DEPRESSION	LESS EFFECTIVE FREEZE POINT DEPRESSION
BETTER HEAT TRANSFER EFFICIENCY	LOWER HEAT TRANSFER EFFICIENCY
LOWER VISCOSITY	HIGHER VISCOSITY
LOW FLAMMABILITY	LOW FLAMMABILITY
LOW CHEMICAL OXYGEN DEMAND - MORE FRIENDLY TO THE ENVIRONMENT	HIGH CHEMICAL OXYGEN DEMAND - LESS FRIENDLY TO THE ENVIRONMENT
BIODEGRADES IN A REASONABLE PERIOD OF TIME - 10 TO 20 DAYS COMPLETELY	GREATER RESISTANCE TO COMPLETE BIODEGRADATION - MORE THAN 20 DAYS
NON-CARCINOGENIC	NON-CARCINOGENIC
HIGHER LEVEL OF ACUTE (SHORT TERM) AND CHRONIC (LONG TERM) TOXICITY TO HUMANS AND ANIMALS WHEN TAKEN ORALLY - TARGETS THE KIDNEY	LOWER LEVEL OF ACUTE (SHORT TERM) AND CHRONIC (LONG TERM) TOXICITY TO HUMANS AND ANIMALS WHEN TAKEN ORALLY
MILD EYE IRRITANT	MILD EYE IRRITANT
LESS IRRITATING TO THE SKIN	MORE IRRITATING TO THE SKIN
NO ADVERSE REPRODUCTIVE EFFECTS IN LIFETIME OR THREE GENERATION STUDIES	NO ADVERSE REPRODUCTIVE EFFECTS IN LIFETIME OR THREE GENERATION STUDIES
AT HIGH CONCENTRATIONS DURING PREGNANCY, WILL CAUSE BIRTH DEFECTS AND TOXIC TO THE FETUS	AT THE SAME CONCENTRATIONS DURING PREGNANCY, WILL NOT CAUSE BIRTH DEFECTS
RELATIVELY NON-TOXIC TO SEWAGE MICROORGANISMS NEEDED FOR BIODEGRADATION AND TO AQUATIC LIFE	RELATIVELY NON-TOXIC TO SEWAGE MICROORGANISMS NEEDED FOR BIODEGRADATION AND TO AQUATIC LIFE

Ethylene Glycol

% GLYCOL	TEMPERA	ATURE °F.	SPECIFIC	SPECIFIC	FOLIATION
SOLUTION	FREEZE POINT	BOILING POINT	HEAT	GRAVITY (1)	EQUATION FACTOR
0	+32	212	1.00	1.000	500
10	+26	214	0.97	1.012	491
20	+16	216	0.94	1.027	483
30	+4	220	0.89	1.040	463
40	-12	222	0.83	1.055	438
50	-34	225	0.78	1.067	416
60	-60	232	0.73	1.079	394
70	<-60	244	0.69	1.091	376
80	-49	258	0.64	1.101	352
90	-20	287	0.60	1.109	333
100	+10	287+	0.55	1.116	307

Propylene Glycol

% GLYCOL	TEMPER	ATURE °F.	SPECIFIC	SPECIFIC	FOLIATION
SOLUTION	FREEZE POINT	BOILING POINT	HEAT	GRAVITY (1)	EQUATION FACTOR
0	+32	212	1.000	1.000	500
10	+26	212	0.980	1.008	494
20	+19	213	0.960	1.017	488
30	+8	216	0.935	1.026	480
40	-7	219	0.895	1.034	463
50	-28	222	0.850	1.041	442
60 ·	<-60	225	0.805	1.046	421
70	<-60	230	0.750	1.048	393
80	<-60	230+	0.690	1.048	362
90	<-60 230+		0.645	1.045	337
100	<-60	230+	0.570	1.040	296

Note for ethylene and propylene glycol tables

1. Specific gravity with respect to water at 60°F.

19.05 Air Conditioning (AC) Condensate Piping

A. AC Condensate Flow:

1. Range:0.02-0.08 GPM/Ton2. Average:0.04 GPM/Ton3. Unitary Packaged AC Equipment:0.006 GPM/Ton

4. Air Handling Units (100% outside Air): 0.100 GPM/1,000 CFM5. Air Handling Units (50% Outdoor Air): 0.065 GPM/1,000 CFM

6. Air Handling Units (25% Outdoor Air): 0.048 GPM/1,000 CFM
7. Air Handling Units (15% Outdoor Air): 0.041 GPM/1,000 CFM
8. Air Handling Units (0% Outdoor Air): 0.030 GPM/1,000 CFM

B. AC Condensate Pipe Sizing

1. Minimum Pipe Sizes are given in the following table.

AC TONS	MINIMUM DRAIN SIZE
0 -20	1"
21 - 40	1-1/4"
41 - 60	1-1/2"
61 - 100	2"
101 - 250	3"
251 & LARGER	4"

2. Pipe size shall not be smaller than drain pan outlet. Minimum size below grade and below ground floor shall be 2½" (4" Allegheny Co., PA). Drain shall have slope of not less than ½" per foot.

3. Some localities require AC condensate to be discharged to storm sewers, some require AC condensate to be discharged to sanitary sewers, and some permit AC condensate to be discharged to either storm or sanitary sewers. Verify pipe sizing and discharge requirements with local authorities and codes.

19.06 Valves

A. Valve Types:

- 1. Balancing Valves:
 - a. Duty: Balancing, Shutoff (Manual or Automatic).
 - b. A valve specially designed for system balancing.
- 2. Ball Valves Full Port:
 - a. Duty: Shutoff.
 - b. A valve with a spherical shaped internal flow device which rotates open and closed to permit flow or to obstruct flow through the valve. The valve goes from full open to full close in a quarter turn. The opening in the spherical flow device is the same size or close to the same size as the pipe.
- 3. Ball Valves, Reduced Port:
 - a. Duty: Balancing, Shutoff.
 - b. A valve with a spherical shaped internal flow device which rotates open and closed to permit flow or to obstruct flow through the valve. The valve goes from full open to full close in a quarter turn. The opening in the spherical flow device is smaller than the pipe size.
- 4. Butterfly Valves:
 - a. Duty: Shutoff, Balancing.

b. A valve with a disc shaped internal flow device which rotates open and closed to permit flow or to obstruct flow through the valve. The valve goes from full open to full close in a quarter turn.

5. Check Valves:

- a. Duty: Control Flow Direction.
- b. A valve which is opened by the flow of fluid in one direction and which closes automatically to prevent flow in the reverse direction. (Types: Ball, Disc, Globe, Piston, Stop, Swing).
- 6. Gate Valves:
 - a. Duty: Shutoff.
 - b. A valve with a wedge or gate shaped internal flow device which moves on an axis perpendicular to the direction of flow.
- 7. Globe Valves:
 - a. Duty: Throttling.
 - b. A valve with a disc or plug which moves on an axis perpendicular to the valve seat.
- 8. Plug Valves:
 - a. Duty: Shutoff, Balancing.
 - b. A valve with a cylindrical or conical shaped internal flow device which rotates open and closed to permit flow or obstruct flow through the valve. The valve goes from full open to full close in a quarter turn.
- Control Valves. Control valves are mechanical devices used to control flow of steam, water, gas, and other fluids.
 - a. 2-Way. Temperature Control, Modulate Flow to Controlled Device, Variable Flow System.
 - b. 3-Way Mixing. Temperature Control, Modulate Flow to Controlled Device, Constant Flow System; 2 inlets and 1 outlet.
 - c. 3-Way Diverting. Used to Divert Flow; generally cannot modulate flow—2 position:
 1 inlet and 2 outlets.
 - d. Quick Opening Control Valves: Quick opening control valves produce wide free port area with relatively small percentage of total valve stem stroke. Maximum flow is approached as the valve begins to open.
 - e. Linear Control Valves: Linear control valves produce free port areas that are directly related to valve stem stroke. Opening and flow are related in direct proportion.
 - f. Equal Percentage Control Valves: Equal percentage control valves produce an equal percentage increase in the free port area with each equal increment of valve stem stroke. Each equal increment of opening increases flow by an equal percentage over the previous value (most common HVAC control valve).
 - g. Control valves are normally smaller than line size unless used in 2-position applications (open/closed).
 - h. Control valves should normally be sized to provide 20 to 60% of the total system pressure drop.
 - 1) Water system control valves should be selected with a pressure drop equal to 2–3 times the pressure drop of the controlled device.

OR

Water system control valves should be selected with a pressure drop equal to 10 Ft. or the pressure drop of the controlled device, whichever is greater.

OR

Water system control valves for constant flow systems should be sized to provide 25% of the total system pressure drop.

OR

- Water system control valves for variable flow systems should be sized to provide 10% of the total system pressure drop or 50% of the total available system pressure.
- 2) Steam control valves should be selected with a pressure drop equal to 75% of inlet steam pressure.

10. Specialty Valves:

Triple Duty Valves: Combination Check, Balancing, and Shutoff.

Backflow Preventer: Prevent Contamination of Domestic Water System. For HVAC applications use reduced pressure backflow preventers.

11. Valves used for balancing need not be line size. Balancing valves should be selected for midrange of its adjustment.

B. Valve Terms:

- Actuator. A mechanical, hydraulic, electric, or pneumatic device or mechanism used to operate a valve.
- 2. Adjustable Travel Stop. A mechanism used to limit the internal flow device travel.
- 3. Back Face. The side of the flange opposite the gasket.
- 4. Blind Flange. A flange with a sealed end to provide a pressure tight closure of a flanged opening.
- 5. Body. The pressure containing shell of a valve or fitting with ends for connection to the piping system.
- 6. Bonnet. A valve body component which contains an opening for the stem. The bonnet may be bolted (Bolted Bonnet), threaded (Threaded Bonnet), or a union (Union Bonnet).
- 7. Bronze Mounted. The seating surfaces of the valve are made of brass or bronze.
- 8. Butt Welding Joints. A joint made to pipes, valves, and fittings with ends adapted for welding by abutting the ends and welding them together.
- Chainwheel. A manual actuator which uses a chain-driven wheel to turn the valve flow device by turning the stem, handwheel, or gearing.
- 10. Cock. A form of a plug valve.
- 11. Cold Working Pressure. Maximum pressure at which a valve or fitting is allowed to operate at ambient temperature.
- 12. Concentric Reducer. A reducer in which both of the openings are on the same centerline.
- 13. Eccentric Reducer. A reducer with the small end off center.
- 14. Elbow, Long Radius. An elbow with a centerline turning radius of 1½ times the nominal size of the elbow.
- 15. Elbow, Short Radius. An elbow with a centerline turning radius of 1 times the nominal size of the elbow.
- 16. Face-to-Face Dimension. The dimension from the face of the inlet to the face of the outlet of the valve or fitting.
- 17. Female End. Internally threaded portion of a pipe, valve, or fitting.
- 18. Flanged Joint. A joint made with an annular collar designed to permit a bolted connection.
- 19. Grooved Joint. A joint made with a special mechanical device using a circumferential groove cut into or pressed into the pipes, valves, and fittings to retain a coupling member.
- 20. Handwheel. The valve handle shaped in the form of a wheel.
- 21. Inside Screw. The screw mechanism which moves the internal flow device is located within the valve body.
- 22. Insulating Unions (Dielectric Unions). Used in piping systems to prevent dissimilar metals from coming into direct contact with each other (See Galvanic Action Paragraph).

- 23. Male End. Externally threaded portion of pipes, valves, or fittings.
- 24. Memory Stop. A device which allows for the repeatable operation of a valve at a position other than full open or full closed, often used to set or mark a balance position.
- 25. Nipple. A short piece of pipe with boths ends externally threaded.
- 26. Nominal Pipe Size (NPS). Standard pipe size but not necessarily the actual dimension.
- 27. Non-Rising Stem. When the valve is operated, the stem does not rise through the bonnet; the internal flow device rises on the stem.
- 28. Outside Screw and Yoke (OS&Y). The valve packing is located between the stem threads and the valve body. The valve has a threaded stem which is visible.
- 29. Packing. A material that seals around the movable penetration of the valve stem.
- 30. Rising Stem. When the valve is operated, the stem rises through the bonnet and the internal flow device is moved up or down by the moving stem.
- 31. Safety-Relief Valves. A valve which automatically relieves the system pressure when the internal pressure exceeds a set value. Safety-relief valves may operate on pressure only or on a combination pressure and temperature.
 - a. Safety Valve. An automatic pressure relieving device actuated by the static pressure upstream of the valve and characterized by full opening pop action. A safety valve is used primarily for gas or vapor service.
 - b. Relief Valve. An automatic pressure relieving device actuated by the static pressure upstream of the valve which opens further with the increase in pressure over the opening pressure. A relief valve is used primarily for liquid service.
 - c. Safety Relief Valve. An automatic pressure actuated relieving device suitable for use either as a safety valve or relief valve, depending on application.
 - d. Safety, Relief, and Safety Relief Valve testing is dictated by the Insurance Underwriter.
- 32. Seat. The portion of the valve which the internal flow device presses against to form a tight seal for shutoff.
- 33. Slow Opening Valve. A valve which requires at least five 360 degree turns of the operating mechanism to change from fully closed to fully open.
- 34. Socket Welding Joint. A joint made with a socket configuration to fit the ends of the pipes, valves, or fittings and then fillet welded in place.
- 35. Soldered Joint. A joint made with pipes, valves, or fittings in which the joining is accomplished by soldering or brazing.
- 36. Stem. A device which operates the internal flow control device.
- 37. Threaded Joint. A joint made with pipes, valves, or fittings in which the joining is accomplished by threading the components.
- 38. Union. A fitting which allows the assembly or disassembly of the piping system without rotating the piping.

C. Valve Abbreviations

- TF. Threaded End FE Flanged End SE Solder End **BWE** Butt Weld End **SWE** Socket Weld End TB Threaded Bonnet
- BB **Bolted Bonnet**
- UB Union Bonnet
- TC Threaded Cap
- BC **Bolted Cap**
- UC Union Cap

Iron Body, Bronze Mounted **IBBM** Ductile Iron DI Silver Brazed SB Double Disc DD Solid Wedge Disc SW Resilient Wedge Disc **RWD** Flexible Wedge FW Handwheel HW Non-Rising Stem NRS RS Rising Stem OS&Y Outside Screw & Yoke **ISNRS** Inside Screw NRS **ISRS** Inside Screw RS Flat Face FF Raised Face RF

HF Hard Faced Mechanical Joint MI Ring Type Joint RJ

Face and Drilled Flange F&D Cold Working Pressure **CWP** Oil, Water, Gas, Pressure **OWG** Steam Working Pressure SWP Water, Oil, Gas, Pressure WOG

Water Working Pressure FTTG Fitting Flange FLG

WWP

Drainage-Wast-Vent Fitting **DWV**

Nominal Pipe Size **NPS** Iron Pipe Size IPS

National Standard Pipe Thread Taper **NPT**

19.07 Expansion Loops (See Chapter 5 and Appendix D)

- A. L-Bends. Anchor Force = 500 Lbs./Dia. Inch.
- B. Z-Bends. Anchor Force = 200-500 Lbs./Dia. Inch.
- C. U-Bends. Anchor Force = 200 Lbs./Dia. Inch.
- D. Locate anchors at beam locations, and avoid anchor locations at steel bar joists if at all possible.

19.08 Strainers

- A. Strainers shall be full line size.
- **B. Water Systems:**
- 1. Strainer Type:

"Y" Type a. 2" and Smaller: b. 2½" to 16": Basket Type

Multiple Basket Type c. 18" and Larger:

197

2. Strainer Perforation Size:

a. 4" and Smaller:

0.057" Dia. Perforations

b. 5" and Larger:

0.125" Dia. Perforations

c. Double perforation diameter for condenser water systems.

C. Steam Systems:

1. Strainer Type: "Y" Type

2. Strainer Perforation Size:

a. 2" and Smaller:

0.033" Dia. Perforations

b. 2½" and Smaller:

3/4" Dia. Perforations

D. Strainer Pressure Drops, Water Systems: Pressure drops listed below are based on the GPM and pipe sizing of 4.0 Ft./100 Ft. pressure drop or 10 Ft./Sec. velocity:

- 1. 1½" and Smaller (Y-Type & Basket Type):
 - a. Pressure Drop < 1.0 PSI, 2.31 Ft. H₂O
- 2. 2"-4" (Y-Type & Basket Type):
 - a. Pressure Drop \cong 1.0 PSI, 2.31 Ft. H₂O
- 3. 5" and Larger:
 - a. Y-Type Pressure Drop \cong 1.5 PSI, 3.46 Ft. H₂O
 - b. Basket Type Pressure Drop $\cong 1.0$ PSI, 2.31 Ft. H₂0

19.09 Expansion Tanks and Air Separators

A. Minimum (Fill) Pressure:

1. Height of System + 5 to 10 psi OR 5–10 psi, whichever is greater.

B. Maximum (System) Pressure:

1. 150 Lb. Systems: 45-125 psi

2. 250 Lb. Systems: 125-225 psi

C. System Volume Estimate:

- 1. 12 Gal./Ton
- 2. 35 Gal./BHP

D. Connection Location:

- 1. Suction Side of Pump(s).
- Suction side of Primary Pumps when used in Primary/Secondary/Tertiary Systems. An alternate location in Primary/Secondary/Tertiary Systems with a single secondary circuit may be the suction side of the secondary pumps.

E. Expansion Tank Design Considerations:

- Solubility of Air in Water. The amount of air water can absorb and hold in solution is temperature and pressure dependant. As temperature increases, maximum solubility decreases, and as pressure increases, maximum solubility increases. Therefore, expansion tanks are generally connected to the suction side of the pump (lowest pressure point).
- 2. Expansion tank sizing. If due to space or structural limitations the expansion tank must be undersized, the minimum expansion tank size should be capable of handling at least ½ of the system expansion volume. With less than this capacity, system start-up

becomes a tedious and extremely sensitive process. If the expansion tank is undersized, an automatic drain should be provided and operated by the control system in addition to the manual drain. Size both the manual and automatic drains to enable a quick dump of a water logged tank (especially critical with undersized tanks) within the limits of the nitrogen fill speed and system pressure requirements.

- 3. System Volume Changes:
 - a. System start-up and shutdown results in the largest change in system volume.
 - b. System volume expansion and contraction must be evaluated at full load and partial load. Variations caused by load changes are described below:
 - In constant flow systems, heating water return temperatures rise and chilled water temperatures drop as load decreases until at no load the return temperature is equal to the supply temperature. Heating systems expand and cooling systems contract at part load.
 - 2) In variable flow systems, heating water return temperatures drop and chilled water return temperatures rise as load decreases until at no load the return temperature equals the temperature in the secondary medium. Heating systems contract and cooling systems expand at part load.
- 4. Expansion tanks are used to accept system volume changes, and a gas cushion (usually air or nitrogen) pressure is maintained by releasing the gas from the tank and readmitting the gas into the tank as the system water expands and contracts, respectively. Expansion tanks are used where constant pressurization in the system must be maintained.
- 5. Cushion tanks are used in conjunction with expansion tanks and are limited in size. As system water expands, pressure increases in the cushion tank until reaching the relief point, at which time it discharges to a lower pressure expansion tank. As the system water contracts, pressure decreases in the cushion tank until reaching a low limit, at which time the pump starts and pumps the water from the low pressure expansion tank to the cushion tank, thus increasing the pressure. Cushion tank relief and makeup flow rates are based on the initial expansion of a heating system or the initial contraction of a cooling system during start-up, because this will be the largest change in system volume for either system.
- Compression tanks build their own pressure through the thermal expansion of the system contents. Compression tanks are not recommended on medium or high temperature heating water systems.
- 7. When expansion tank level transmitters are provided for building automation control systems, the expansion tank level should be provided from the level transmitter with local readout at the expansion tank, compression tank, or cushion tank. Also provide a sight glass or some other means of visually verifying level in tank and accuracy of transmitter.
- 8. When expansion tank pressure transmitters are provided for building automation control systems, the expansion tank pressure should be provided from the pressure transmitter with local readout at the expansion tank, compression tank, or cushion tank. Also provide pressure gauge at tank to verify transmitter.
- 9. Nitrogen relief from expansion, cushion, or compression tank must be vented to outside (noise when discharging is quite deafening). Vent can be tied into the vent off of the blowdown separator. Also need to provide nitrogen pressure monitoring and alarms and manual nitrogen relief valves.
- 10. Expansion tank sizing can be simplified using the tables and their respective corrections factors that follow. These tables can be especially helpful for preliminary sizing.
 - a. Low-temperature systems. Tables on pages 199-203.
 - b. Medium-temperature systems. Tables on pages 204-208.
 - c. High-temperature systems. Tables on pages 209–213.

F. Air Separators

1. Air separators shall be full line size.

Expansion Tank Sizing, Low Temperature Systems

TAN	K SIZED EXPRESSED	AS A PERCENTAGE	E OF SYSTEM VOLUI	ME					
MAXIMUM	EXPANSION TANK TYPE								
SYSTEM TEMPERATURE	CLOSED	OPEN -	DIAPHRA	GM TANK					
°F.	TANK	TANK	TANK VOLUME	ACCEPTANCE VOLUME					
100	2.21	1.37	1.32	0.59					
110	3.08	1.87	1.83	0.82					
120	3.71	2.24	2.21	0.99					
130	4.81	2.87	2.86	1.28					
140	5.67	3.37	3.37	1.51					
150	6.77	3.99	4.03	1.80					
160	7.87	4.61	4.68	2.10					
170	9.20	5.36	5.48	2.45					
180	10.53	6.11	6.27	2.81					
190	11.87	6.86	7.06	3.16					
200	13.20	7.61	7.86	3.52					
210	14.77		8.79	3.93					
220	16.34		9.72	4.35					
230	17.90		10.66	4.77					
240	19.71		11.73	5.25					
250	21.51		12.80	5.73					

- 1. Table based on initial temperature: 50° F.
- 2. Table based on initial pressure: 10 Psig.
- 3. Table based on maximum operating pressure: 30 Psig.
- For initial and maximum pressures different from those listed above, multiply tank size only (not Acceptance Volume) by correction factors contained in the Low Temperature System Correction Factor Tables below.

Closed Expansion Tank Sizing, Low Temperature System Correction Factors

INITIAL PRESSURE	INITI	IAL PRES	SURE + P			CREASE - SE = MAX		PERATIN	IG PRESS	URE
PSIG	5	10	15	20	25	30	35	40	45	50
5	1.76	1.06	0.83	0.71	0.64	0.59	0.56	0.53	0.51	0.50
10	2.66	1.55	1.18	1.00	0.89	0.82	0.76	0.72	0.69	0.67
15	3.73	2.14	1.60	1.34	1.18	1.07	0.99	0.94	0.89	0.86
20	4.99	2.81	2.08	1.72	1.50	1.36	1.25	1.17	1.11	1.06
25	6.43	3.57	2.62	2.15	1.86	1.67	1.53	1.43	1.35	1.29
30	8.05	4.43	3.22	2.62	2.26	2.02	1.84	1.71	1.61	1.53
35	9.85	5.37	3.88	3.14	2.69	2.39	2.18	2.02	1.89	1.80
40	11.83	6.41	4.60	3.70	3.16	2.80	2.54	2.35	2.20	2.07
45	13.99	7.54	5.39	4.31	3.66	3.23	2.93	2.70	2.52	2.37
50	16.34	8.75	6.23	4.96	4.21	3.70	3.34	3.07	2.86	2.69
55	18.86	10.06	7.13	5.66	4.78	4.20	3.78	3.46	3.22	3.02
60	21.57	11.46	8.09	6.41	5.40	4.72	4.24	3.88	3.60	3.37
65	24.46	12.95	9.11	7.20	6.05	5.28	4.73	4.32	4.00	3.75
70	27.53	14.53	10.20	8.03	6.73	5.87	5.25	4.78	4.42	4.13
75	30.77	16.20	11.34	8.91	7.45	6.48	5.79	5.27	4.86	4.54
80	34.21	17.96	12.55	9.84	8.21	7.13	6.36	5.78	5.33	4.96
85	37.82	19.81	13.81	10.81	9.01	7.81	6.95	6.31	5.81	5.41
90	41.61	21.75	15.13	11.83	9.84	8.52	7.57	6.86	6.31	5.87
95	45.59	23.79	16.52	12.89	10.71	9.25	8.22	7.44	6.83	6.35
100	49.74	25.91	17.97	13.99	11.61	10.02	8.89	8.04	7.37	6.84

- 1. Table based on initial temperature: 50°F.
- 2. Table based on initial pressure: 10 Psig.
- 3. Table based on maximum operating pressure: 30 Psig.

Closed Expansion Tank Sizing, Low Temperature System Correction Factors

INITIAL PRESSURE	INIT	AL PRES	SURE + P			CREASE -		PERATIN	IG PRESS	URE
PSIG	55	60	65	70	75	80	85	90	95	100
5	0.48	0.47	0.47	0.46	0.45	0.44	0.44	0.43	0.43	0.43
10	0.65	0.63	0.62	0.61	0.59	0.59	0.58	0.57	0.56	0.56
15	0.83	0.80	0.78	0.77	0.75	0.74	0.73	0.72	0.71	0.70
20	1.03	0.99	0.96	0.94	0.92	0.90	0.89	0.87	0.86	0.85
25	1.24	1.19	1.16	1.13	1.10	1.08	1.06	1.04	1.02	1.00
30	1.47	1.41	1.37	1.33	1.29	1.26	1.24	1.21	1.19	1.17
35	1.71	1.65	1.59	1.54	1.50	1.46	1.43	1.40	1.37	1.35
40	1.98	1.89	1.82	1.77	1.71	1.67	1.63	1.59	1.56	1.53
45	2.26	2.16	2.07	2.00	1.94	1.89	1.84	1.80	1.76	1.73
50	2.55	2.44	2.34	2.26	2.18	2.12	2.06	2.01	1.97	1.93
55	2.86	2.73	2.62	2.52	2.44	2.36	2.30	2.24	2.19	2.14
60	3.19	3.04	2.91	2.80	2.70	2.62	2.54	2.48	2.42	2.36
65	3.54	3.36	3.21	3.09	2.98	2.88	2.80	2.72	2.65	2.59
70	3.90	3.70	3.53	3.39	3.27	3.16	3.06	2.98	2.90	2.83
75	4.27	4.05	3.87	3.71	3.57	3.45	3.34	3.24	3.16	3.08
80	4.67	4.42	4.21	4.04	3.88	3.75	3.63	3.52	3.43	3.34
85	5.08	4.81	4.58	4.38	4.21	4.06	3.92	3.81	3.70	3.61
90	5.51	5.21	4.95	4.73	4.54	4.38	4.23	4.10	3.99	3.88
95	5.95	5.62	5.34	5.10	4.89	4.71	4.55	4.41	4.28	4.17
100	6.41	6.05	5.74	5.48	5.26	5.06	4.88	4.73	4.59	4.46

- 1. Table based on initial temperature: 50°F.
- 2. Table based on initial pressure: 10 Psig.
- 3. Table based on maximum operating pressure: 30 Psig.

Diaphragm Expansion Tank Sizing, Low Temperature System Correction Factors

										_
INITIAL PRESSURE	INITI	AL PRES	SURE + P			CREASE -		PERATIN	IG PRESS	URE
PSIG	5	10	15	20	25	30	35	40	45	50
5	2.21	1.33	1.04	0.89	0.80	0.74	0.70	0.67	0.64	0.62
10	2.66	1.55	1.18	1.00	0.89	0.82	0.76	0.72	0.69	0.67
15	3.11	1.78	1.33	1.11	0.98	0.89	0.83	0.78	0.74	0.71
20	3.55	2.00	1.48	1.22	1.07	0.96	0.89	0.84	0.79	0.76
25	4.00	2.22	1.63	1.34	1.16	1.04	0.95	0.89	0.84	0.80
30	4.45	2.45	1.78	1.45	1.25	1.11	1.02	0.95	0.89	0.85
35	4.89	2.67	1.93	1.56	1.34	1.19	1.08	1.00	0.94	0.89
40	5.34	2.89	2.08	1.67	1.43	1.26	1.15	1.06	0.99	0.94
45	5.79	3.12	2.23	1.78	1.52	1.34	1.21	1.12	1.04	0.98
50	6.24	3.34	2.38	1.89	1.61	1.41	1.27	1.17	1.09	1.03
55	6.68	3.57	2.53	2.01	1.69	1.49	1.34	1.23	1.14	1.07
60	7.13	3.79	2.68	2.12	1.78	1.56	1.40	1.28	1.19	1.12
65	7.58	4.01	2.82	2.23	1.87	1.64	1.47	1.34	1.24	1.16
70	8.03	4.24	2.97	2.34	1.96	1.71	1.53	1.39	1.29	1.21
75	8.47	4.46	3.12	2.45	2.05	1.79	1.59	1.45	1.34	1.25
80	8.92	4.68	3.27	2.57	2.14	1.86	1.66	1.51	1.39	1.29
85	9.37	4.91	3.42	2.68	2.23	1.93	1.72	1.56	1.44	1.34
90	9.82	5.13	3.57	2.79	2.32	2.01	1.79	1.62	1.49	1.38
95	10.26	5.36	3.72	2.90	2.41	2.08	1.85	1.67	1.54	1.43
100	10.71	5.58	3.87	3.01	2.50	2.16	1.91	1.73	1.59	1.47

- 1. Table based on initial temperature: 50° F.
- 2. Table based on initial pressure: 10 Psig.
- 3. Table based on maximum operating pressure: 30 Psig.

Diaphragm Expansion Tank Sizing, Low Temperature System Correction Factors

INITIAL PRESSURE	INIT	IAL PRES	SURE + F	PRESSUR	SSURE IN E INCREA	CREASE ASE = MA	- PSIG XIMUM (OPERATI	NG PRES	SURE
PSIG	55	60	65	70	75	80	85	90	95	100
5	0.61	0.59	0.58	0.57	0.56	0.56	0.55	0.55	0.54	0.54
10	0.65	0.63	0.62	0.61	0.59	0.59	0.58	0.57	0.56	0.56
15	0.69	0.67	0.65	0.64	0.62	0.61	0.60	0.60	0.59	0.58
20	0.73	0.71	0.69	0.67	0.65	0.64	0.63	0.62	0.61	0.60
25	0.77	0.74	0.72	0.70	0.68	0.67	0.66	0.64	0.63	0.63
30	0.81	0.78	0.76	0.73	0.71	0.70	0.68	0.67	0.66	0.65
35	0.85	0.82	0.79	0.77	0.74	0.73	0.71	0.69	0.68	0.67
40	0.89	0.86	0.82	0.80	0.77	0.75	0.74	0.72	0.71	0.69
45	0.93	0.89	0.86	0.83	0.80	0.78	0.76	0.74	0.73	0.71
50	0.97	0.93	0.89	0.86	0.83	0.81	0.79	0.77	0.75	0.74
55	1.01	.0.97	0.93	0.89	0.86	0.84	0.81	0.79	0.78	0.76
60	1.06	1.00	0.96	0.92	0.89	0.87	0.84	0.82	0.80	0.78
65	1.10	1.04	1.00	0.96	0.92	0.89	0.87	0.84	0.82	0.80
70	1.14	1.08	1.03	0.99	0.95	0.92	0.89	0.87	0.85	0.83
75	1.18	1.12	1.06	1.02	0.98	0.95	0.92	0.89	0.87	0.85
80	1.22	1.15	1.10	1.05	1.01	0.98	0.95	0.92	0.89	0.87
85	1.26	1.19	1.13	1.08	1.04	1.01	0.97	0.94	0.92	0.89
90	1.30	1.23	1.17	1.12	1.07	1.03	1.00	0.97	0.94	0.92
95	1.34	1.27	1.20	1.15	1.10	1.06	1.02	0.99	0.96	0.94
100	1.38	1.30	1.24	1.18	1.13	1.09	1.05	1.02	0.99	0.96

- Table based on initial temperature: 50°F.
 Table based on initial pressure: 10 Psig.
- 3. Table based on maximum operating pressure: 30 Psig.

Expansion Tank Sizing, Medium Temperature Systems

TAN	K SIZED EXPRESSED	AS A PERCENTAGE	OF SYSTEM VOLUM	IE .		
) (A VIII) (ET) (EXPANSION T	ANK TYPE			
MAXIMUM SYSTEM TEMPERATURE			DIAPHRAGM TANK			
°F.	CLOSED TANK	OPEN TANK	TANK VOLUME	ACCEPTANCE VOLUME		
250	263.25		18.02	5.73		
260	285.30		19.53	6.21		
270	310.23		21.24	6.75		
280	335.16		22.95	7.29		
290	360.08		24.65	7.83		
300	387.88		26.56	8.44		
310	415.67		28.46	9.04		
320	443.47		30.36	9.65		
330	474.13		32.46	10.3		
340	504.80		34.56	10.9		
350	538.33		36.86	11.7		

- 1. Table based on initial temperature: 50°F.
- 2. Table based on initial pressure: 200 Psig.
- Table based on maximum operating pressure: 300 Psig.
 For initial and maximum pressures different from those listed above, multiply tank size only (not Acceptance Volume) by correction factors contained in the Medium Temperature System Correction Factor Tables below.

Closed Expansion Tank Sizing, Medium Temperature System Correction Factors

INITIAL PRESSURE	INIT	IAL PRES	SURE + P			CREASE - SE = MA		PERATIN	IG PRESS	URE
PSIG	10	20	30	40	50	60	70	80	90	100
30	0.36	0.21	0.16	0.14	0.13	0.12	0.11	0.10	0.10	0.10
40	0.52	0.30	0.23	0.19	0.17	0.15	0.14	0.14	0.13	0.13
50	072	0.41	0.30	0.25	0.22	0.20	0.18	0.17	0.16	0.16
60	0.94	0.52	0.39	0.32	0.28	0.25	0.23	0.21	0.20	0.19
70	1.19	0.66	0.48	0.39	0.34	0.30	0.28	0.26	0.24	0.23
80	1.47	0.80	0.58	0.47	0.41	0.36	0.33	0.31	0.29	0.27
90	1.78	0.97	0.70	0.56	0.48	0.43	0.39	0.36	0.34	0.32
100	2.12	1.14	0.82	0.66	0.56	0.49	0.45	0.41	0.39	0.36
110	2.49	1.34	0.95	0.76	0.64	0.57	0.51	0.47	0.44	0.41
120	2.88	1.54	1.09	0.87	0.74	0.65	0.58	0.54	0.50	0.4
130	3.31	1.76	1.25	0.99	0.83	0.73	0.66	0.60	0.56	0.52
· 140	3.77	2.00	1.41	1.11	0.94	0.82	0.73	0.67	0.62	0.58
150	4.26	2.25	1.58	1.25	1.05	0.91	0.82	0.75	0.69	0.65
160	4.78	2.52	1.76	1.39	1.16	1.01	0.90	0.82	0.76	0.7
170	5.32	2.80	1.96	1.54	1.28	1.11	0.99	0.90	0.83	0.78
180	5.90	3.09	2.16	1.69	1.41	1.22	1.09	0.99	0.91	0.85
190	6.50	3.40	2.37	1.85	1.54	1.34	1.19	1.08	0.99	.92
200	7.14	3.73	2.59	2.02	1.68	1.45	1.29	1.17	1.08	1.00
210	7.81	4.07	2.82	2.20	1.83	1.58	1.40	1.27	1.16	1.08
220	8.50	4.42	3.06	2.39	1.98	1.71	1.51	1.37	1.25	1.16
230	9.22	4.79	3.32	2.58	2.13	1.84	1.63	1.47	1.35	1.25
240	9.98	5.18	3.58	2.78	2.30	1.98	1.75	1.58	1.44	1.34
250	10.76	5.58	3.85	2.98	2.47	2.12	1.87	1.69	1.54	1.43
260	11.57	5.99	4.13	3.20	2.64	2.27	2.00	1.80	1.65	1.52

- 1. Table based on initial temperature: 50° F.
- 2. Table based on initial pressure: 200 Psig.
- 3. Table based on maximum operating pressure: 300 Psig.

Closed Expansion Tank Sizing, Medium Temperature System Correction Factors

INITIAL PRESSURE	INITI	AL PRES	SURE + P		SURE INC E INCREA			PERATIN	G PRESS	URE
PSIG	110	120	130	140	150	160	170	180	190	200
30	0.09	0.09	0.09	0.09	0.09	0.08	0.08	0.08	0.08	0.08
40	0.12	0.12	0.12	0.11	0.11	0.11	0.11	0.11	0.10	0.10
50	0.15	0.15	0.14	0.14	0.14	0.13	0.13	0.13	0.13	0.13
60	0.19	0.18	0.17	0.17	0.17	0.16	0.16	0.16	0.15	0.15
70	0.22	0.21	0.21	0.20	0.20	0.19	0.19	0.18	0.18	0.18
80	0.26	0.25	0.24	0.23	0.23	0.22	0.22	0.21	0.21	0.21
90	0.30	0.29	0.28	0.27	0.26	0.26	0.25	0.25	0.24	0.24
100	0.35	0.33	0.32	0.31	0.30	0.29	0.28	0.28	0.27	0.27
110	0.39	0.38	0.36	0.35	0.34	0.33	0.32	0.31	0.31	0.30
120	0.44	0.42	0.41	0.39	0.38	0.37	0.36	0.35	0.34	0.33
130	0.50	0.47	0.45	0.44	0.42	0.41	0.40	0.39	0.38	0.37
140	0.55	0.52	0.50	0.48	0.47	0.45	0.44	0.43	0.42	0.4
150	0.61	0.58	0.55	0.53	0.51	0.49	0.48	0.47	0.46	0.44
160	0.67	0.63	0.61	0.58	0.56	0.54	0.52	0.51	0.50	0.48
170	0.73	0.69	0.66	0.63	0.61	0.59	0.57	0.55	0.54	0.53
180	0.80	0.76	0.72	0.69	0.66	0.64	0.62	0.60	0.58	0.5
190	0.87	0.82	0.78	0.75	0.72	0.69	0.67	0.65	0.63	0.6
200	0.94	0.89	0.84	0.81	0.77	0.74	0.72	0.70	0.68	0.66
210	1.01	0.96	0.91	0.87	0.83	0.80	0.77	0.75	0.73	0.7
220	1.09	1.03	0.97	0.93	0.89	0.86	0.83	0.80	0.78	0.7
230	1.17	1.10	1.04	1.00	0.95	0.92	0.88	0.85	0.83	0.8
240	1.25	1.18	1.12	1.06	1.02	0.98	0.94	0.91	0.88	0.80
250	1.33	1.26	1.19	1.13	1.08	1.04	1.00	0.97	0.94	0.9
260	1.42	1.34	1.27	1.20	1.15	1.10	1.06	1.03	0.99	0.90

- 1. Table based on initial temperature: 50°F.
- 2. Table based on initial pressure: 200 Psig.
- 3. Table based on maximum operating pressure: 300 Psig.

Diaphragm Expansion Tank Sizing, Medium Temperature System Correction Factors

INITIAL PRESSURE	INIT	IAL PRES	SSURE + I	PRESSUR	SSURE IN E INCRE	ICREASE ASE = MA	- PSIG	OPERATI	NG PRES	SURE
PSIG	10	20	30	40	50	60	70	80	90	100
30	1.74	1.03	0.79	0.67	0.60	0.55	0.52	0.50	0.48	0.46
40	2.06	1.19	0.90	0.75	0.67	0.61	0.57	0.54	0.51	0.49
50	2.37	1.35	1.00	0.83	0.73	0.66	0.61	0.57	0.55	0.52
60	2.69	1.50	1.11	0.91	0.79	0.71	0.66	0.61	0.58	0.56
70	3.01	1.66	1.21	0.99	0.86	0.77	0.70	0.65	0.62	0.59
80	3.33	1.82	1.32	1.07	0.92	0.82	0.75	0.69	0.65	0.62
90	3.64	1.98	1.43	1.15	0.98	0.87	0.79	0.73	0.69	0.65
100	3.96	2.14	1.53	1.23	1.05	0.93	0.84	0.77	0.72	0.68
110	4.28	2.30	1.64	1.31	1.11	0.98	0.88	0.81	0.76	0.71
120	4.60	2.46	1.74	1.39	1.17	1.03	0.93	0.85	0.79	0.75
130	4.92	2.62	1.85	1.47	1.24	1.08	0.97	0.89	0.83	0.78
140	5.23	2.78	1.96	1.55	1.30	1.14	1.02	0.93	0.86	0.81
150	5.55	2.93	2.06	1.63	1.36	1.19	1.07	0.97	0.90	0.84
160	5.87	3.09	2.17	1.71	1.43	1.24	1.11	1.01	0.93	0.87
170	6.19	3.25	2.27	1.79	1.49	1.30	1.16	1.05	0.97	0.90
180	6.50	3.41	2.38	1.86	1.56	1.35	1.20	1.09	1.01	0.94
190	6.82	3.57	2.49	1.94	1.62	1.40	1.25	1.13	1.04	0.97
200	7.14	3.73	2.59	2.02	1.68	1.45	1.29	1.17	1.08	1.00
210	7.46	3.89	2.70	2.10	1.75	1.51	1.34	1.21	1.11	1.03
220	7.78	4.05	2.80	2.18	1.81	1.56	1.38	1.25	1.15	1.06
230	8.09	4.21	2.91	2.26	1.87	1.61	1.43	1.29	1.18	1.10
240	8.41	4.36	3.02	2.34	1.94	1.67	1.47	1.33	1.22	1.13
250	8.73	4.52	3.12	2.42	2.00	1.72	1.52	1.37	1.25	1.16
260	9.05	4.68	3.23	2.50	2.06	1.77	1.56	1.41	1.29	1.19

- 1. Table based on initial temperature: 50° F.
- Table based on initial pressure: 200 Psig.
 Table based on maximum operating pressure: 300 Psig.

Diaphragm Expansion Tank Sizing, Medium Temperature System Correction Factors

INITIAL PRESSURE	INITL	AL PRESS	URE + PI	PRESS RESSURE	INCREA	REASE - SE = MAX	PSIG CIMUM O	PERATIN	G PRESS	URE
PSIG	110	120	130	140	150	160	170	180	190	200
30	0.45	0.44	0.43	0.42	0.41	0.41	0.40	0.40	0.39	0.39
40	0.48	0.46	0.45	0.44	0.43	0.43	0.42	0.41	0.41	0.40
50	0.50	0.49	0.48	0.46	0.45	0.45	0.44	0.43	0.43	0.42
60	0.53	0.52	0.50	0.49	0.48	0.47	0.46	0.45	0.44	0.44
70	0.56	0.54	0.52	0.51	0.50	0.49	0.48	0.47	0.46	0.45
80	0.59	0.57	0.55	0.53	0.52	0.51	0.49	0.48	0.48	0.47
90	0.62	0.60	0.57	0.56	0.54	0.53	0.51	0.50	0.49	0.48
100	0.65	0.62	0.60	0.58	0.56	0.55	0.53	0.52	0.51	0.50
110	0.68	0.65	0.62	0.60	0.58	0.57	0.55	0.54	0.53	0.52
120	0.71	0.67	0.65	0.62	0.60	0.59	0.57	0.56	0.54	0.53
130	0.74	0.70	0.67	0.65	0.62	0.61	0.59	0.57	0.56	0.55
140	0.76	0.73	0.70	0.67	0.65	0.63	0.61	0.59	0.58	0.56
150	0.79	0.75	0.72	0.69	0.67	0.64	0.63	0.61	0.59	0.58
160	0.82	0.78	0.74	0.71	0.69	0.66	0.64	0.63	0.61	0.60
170	0.85	0.81	0.77	0.74	0.71	0.68	0.66	0.64	0.63	0.61
180	0.88	0.83	0.79	0.76	0.73	0.70	0.68	0.66	0.64	0.63
190	0.91	0.86	0.82	0.78	0.75	0.72	0.70	0.68	0.66	0.64
200	0.94	0.89	0.84	0.81	0.77	0.74	0.72	0.70	0.68	0.66
210	0.97	0.91	0.87	0.83	0.79	0.76	0.74	0.71	0.69	0.67
220	1.00	0.94	0.89	0.85	0.81	0.78	0.76	0.73	0.71	0.69
230	1.02	0.97	0.92	0.87	0.84	0.80	0.78	0.75	0.73	0.71
240	1.05	0.99	0.94	0.90	0.86	0.82	0.79	0.77	0.74	0.72
250	1.08	1.02	0.96	0.92	0.88	0.84	0.81	0.79	0.76	0.74
260	1.11	1.05	0.99	0.94	0.90	0.86	0.83	0.80	0.78	0.75

- 1. Table based on initial temperature: 50°F.
- 2. Table based on initial pressure: 200 Psig.
- 3. Table based on maximum operating pressure: 300 Psig.

Expansion Tank Sizing, High Temperature Systems

TAN	NK SIZED EXPRESSED	AS A PERCENTAGE	E OF SYSTEM VOLU	ME			
MAXIMUM		EXPANSION '	TANK TYPE				
SYSTEM TEMPERATURE	CLOSED	OPEN -	DIAPHRAGM TANK				
°F.	TANK	TANK	TANK VOLUME	ACCEPTANCE VOLUME			
350	1,995.03		47.71	11.71			
360	2,119.30		50.68	12.44			
370	2,243.58		53.65	13.17			
380	2,378.48		56.88	13.96			
390	2,524.02		60.36	14.82			
400	2,669.56		63.84	15.67			
410	2,815.10		67.32	16.53			
420	2,981.90		71.31	17.51			
430	3,138.07		75.04	18.42			
440	3,315.51		79.29	19.46			
450	3,492.95		83.53	20.51			

- 1. Table based on initial temperature: 50°F.
- 2. Table based on initial pressure: 600 Psig.
- 3. Table based on maximum operating pressure: 800 Psig.
 4. For initial and maximum pressures different from those listed above, multiply tank size only (not Acceptance Volume) by correction factors contained in the High Temperature System Correction Factor Tables below.

Closed Expansion Tank Sizing, High Temperature System Correction Factors

INITIAL PRESSURE	INITL	AL PRESS	SURE + P	PRESS RESSURE	SURE INC E INCREA	CREASE - SE = MAX	PSIG (IMUM O	PERATIN	G PRESS	URE
PSIG	20	40	60	80	100	120	140	160	180	200
160	0.68	0.37	0.27	0.22	0.19	0.17	0.16	0.15	0.14	0.13
180	0.83	0.46	0.33	0.27	0.23	0.20	0.19	0.17	0.16	0.15
200	1.01	0.55	0.39	0.32	0.27	0.24	0.22	0.20	0.19	0.18
220	1.19	0.64	0.46	0.37	0.31	0.28	0.25	0.23	0.22	0.20
240	1.40	0.75	0.53	0.43	0.36	0.32	0.29	0.26	0.25	0.23
260	1.62	0.86	0.61	0.49	0.41	0.36	0.32	0.30	0.28	0.26
280	1.85	0.98	0.70	0.55	0.46	0.41	0.37	0.33	0.31	0.29
300	2.10	1.11	0.78	0.62	0.52	046	0.41	0.37	0.35	0.32
320	2.37	1.25	0.88	0.69	0.58	0.51	0.45	0.41	0.38	036
340	2.65	1.40	0.98	0.77	0.64	0.56	0.50	0.46	0.42	0.39
360	2.95	1.55	1.08	0.85	0.71	0.62	0.55	0.50	0.46	0.43
380	3.27	1.71	1.19	0.94	0.78	0.68	0.60	0.55	0.50	0.47
400	3.60	1.88	1.31	1.02	0.85	0.74	0.66	0.59	0.55	0.51
420	3.95	2.06	1.43	1.12	0.93	0.80	0.71	0.65	0.59	0.55
440	4.31	2.25	1.56	1.21	1.01	0.87	0.77	0.70	0.64	0.59
460	4.69	2.44	1.69	1.31	1.09	0.94	0.83	0.75	0.69	0.64
480	5.08	2.64	1.83	1.42	1.17	1.01	0.90	0.81	0.74	0.69
500	5.50	2.85	1.97	1.53	1.26	1.09	0.96	0.87	0.79	0.73
520	5.92	3.07	2.12	1.64	1.36	1.17	1.03	0.93	0.85	0.78
540	6.37	3.29	2.27	1.76	1.45	1.25	1.10	0.99	0.90	0.84
560	6.82	3.53	2.43	1.88	1.55	1.33	1.17	1.05	0.96	0.89
580	7.30	3.77	2.59	2.00	1.65	1.41	1.25	1.12	1.02	0.94
600	7.79	4.02	2.76	2.13	1.75	1.50	1.32	1.19	1.08	1.00
620	8.30	4.28	2.93	2.26	1.86	1.59	1.40	1.26	1.15	1.00
640	8.82	4.54	3.11	2.40	1.97	1.69	1.48	1.33	1.21	1.12
660	9.36	4.81	3.30	2.54	2.09	1.78	1.57	1.41	1.28	1.1
680	9.91	5.10	3.49	2.69	2.20	1.88	1.65	1.48	1.35	1.2
700	10.49	5.39	3.69	2.84	2.33	1.99	1.74	1.56	1.42	1.3

- 1. Table based on initial temperature: 50°F.
- Table based on initial pressure: 600 Psig.
 Table based on maximum operating pressure: 800 Psig.

Closed Expansion Tank Sizing, High Temperature System Correction Factors

INITIAL PRESSURE	INIT	IAL PRES	SURE + F	PRESSUR	SSURE IN E INCREA	CREASE ASE = MA	- PSIG XIMUM (OPERATI	NG PRESS	SURE
PSIG	220	240	260	280	300	320	340	360	380	400
160	0.13	0.12	0.12	0.11	0.11	0.11	0.11	0.10	0.10	0.10
180	0.15	0.14	0.14	0.13	0.13	0.13	0.12	0.12	0.12	0.12
200	0.17	0.16	0.16	0.15	0.15	0.14	0.14	0.14	0.13	0.13
220	0.19	0.19	0.18	0.17	0.17	0.16	0.16	0.15	0.15	0.15
240	0.22	0.21	0.20	0.19	0.19	0.18	0.18	0.17	0.17	0.17
260	0.25	0.24	0.23	0.22	0.21	0.20	0.20	0.19	0.19	0.19
280	0.28	0.26	0.25	0.24	0.23	0.23	0.22	0.21	0.21	0.20
300	0.31	0.29	0.28	0.27	0.26	0.25	0.24	0.24	0.23	0.22
320	0.34	0.32	0.31	0.29	0.28	0.27	0.27	0.26	0.25	0.25
340	0.37	0.35	0.33	0.32	0.31	0.30	0.29	0.28	0.27	0.27
360	0.40	0.38	0.37	0.35	0.34	0.32	0.31	0.31	0.30	0.29
380	0.44	0.42	0.40	0.38	0.37	0.35	0.34	0.33	0.32	0.31
400	0.48	0.45	0.43	0.41	0.39	0.38	0.37	0.36	0.35	0.34
420	0.52	0.49	0.46	0.44	0.43	0.41	0.40	0.38	0.37	0.36
440	0.56	0.53	0.50	0.48	0.46	0.44	0.42	0.41	0.40	0.39
460	0.60	0.56	0.54	0.51	0.49	0.47	0.45	0.44	0.43	0.41
480	0.64	0.60	0.57	0.55	0.52	0.50	0.49	0.47	0.45	0.44
500	0.69	0.65	0.61	0.58	0.56	0.54	0.52	0.50	0.48	0.47
520	0.73	0.69	0.65	0.62	0.59	0.57	0.55	0.53	0.51	0.50
540	0.78	0.73	0.69	0.66	0.63	0.61	0.58	0.56	0.54	0.53
560	0.83	0.78	0.74	0.70	0.67	0.64	0.62	0.60	0.58	0.56
580	0.88	0.83	0.78	0.74	0.71	0.68	0.65	0.63	0.61	0.59
600	0.93	0.87	0.83	0.78	0.75	0.72	0.69	0.66	0.64	0.62
620	0.98	0.92	0.87	0.83	0.79	0.76	0.73	0.70	0.68	0.66
640	1.04	0.97	0.92	0.87	0.83	0.80	0.76	0.74	0.71	0.69
660	1.10	1.03	0.97	0.92	0.88	0.84	0.80	0.77	0.75	0.72
680	1.15	1.08	1.02	0.97	0.92	0.88	0.84	0.81	0.78	0.76
700	1.21	1.14	1.07	1.01	0.87	0.92	0.89	0.85	0.82	0.80

- Table based on initial temperature: 50°F.
 Table based on initial pressure: 600 Psig.
- 3. Table based on maximum operating pressure: 800 Psig.

Diaphragm Expansion Tank Sizing, High Temperature System Correction Factors

INITIAL PRESSURE	INITIA	AL PRESS	URE + PF	PRESS	URE INC	REASE - SE = MAX	PSIG IMUM O	PERATIN	G PRESS	JRE
PSIG	20	40	60	80	100	120	140	,160	180	200
160	2.39	1.32	0.96	0.78	0.67	0.60	0.55	0.51	0.48	0.46
180	2.64	1.44	1.04	0.84	0.72	0.64	0.59	0.54	0.51	0.48
200	2.88	1.56	1.12	0.90	0.77	0.68	0.62	0.57	0.54	0.51
220	3.13	1.69	1.21	0.97	0.82	0.73	0.66	0.61	0.57	0.53
240	3.37	1.81	1.29	1.03	0.87	0.77	0.69	0.64	0.59	0.56
260	3.62	1.93	1.37	1.09	0.92	0.81	0.73	0.67	0.62	0.58
280	3.86	2.05	1.45	1.15	0.97	0.85	0.76	0.70	0.65	0.61
300	4.11	2.18	1.53	1.21	1.02	0.89	0.80	0.73	0.67	0.63
320	4.35	2.30	1.61	1.27	1.07	0.93	0.83	0.76	0.70	0.66
340	4.60	2.42	1.70	1.33	1.12	0.97	0.87	0.79	0.73	0.68
360	4.84	2.55	1.78	1.40	1.17	1.01	0.90	0.82	0.76	0.71
380	5.09	2.67	1.86	1.46	1.21	1.05	0.94	0.85	0.78	0.73
400	5.34	2.79	1.94	1.52	1.26	1.09	0.97	0.88	0.81	0.75
420	5.58	2.91	2.02	1.58	1.31	1.13	1.01	0.91	0.84	0.78
440	5.83	3.04	2.11	1.64	1.36	1.18	1.04	0.94	0.87	0.80
460	6.07	3.16	2.19	1.70	1.41	1.22	1.08	0.97	0.89	0.83
480	6.32	3.28	2.27	1.76	1.46	1.26	1.11	1.00	0.92	0.85
500	6.56	3.40	2.35	1.82	1.51	1.30	1.15	1.04	0.95	0.88
520	6.81	3.53	2.43	1.89	1.56	1.34	1.18	1.07	0.97	0.90
540	7.05	3.65	2.52	1.95	1.61	1.38	1.22	1.10	1.00	0.93
560	7.30	3.77	2.60	2.01	1.66	1.42	1.25	1.13	1.03	0.95
580	7.55	3.90	2.68	2.07	1.71	1.46	1.29	1.16	1.06	0.98
600	7.79	4.02	2.76	2.13	1.75	1.50	1.32	1.19	1.08	1.00
620	8.04	4.14	2.84	2.19	1.80	1.54	1.36	1.22	1.11	1.02
640	8.28	4.26	2.92	2.25	1.85	1.58	1.39	1.25	1.14	1.05
660	8.53	4.39	3.01	2.32	1.90	1.63	1.43	1.28	1.17	1.07
680	8.77	4.51	3.09	2.38	1.95	1.67	1.46	1.31	1.19	1.10
700	9.02	4.63	3.17	2.44	2.00	1.71	1.50	1.34	1.22	1.12

- 1. Table based on initial temperature: 50°F.
- Table based on initial pressure: 600 Psig.
 Table based on maximum operating pressure: 800 Psig.

Diaphragm Expansion Tank Sizing, High Temperature System Correction Factors

INITIAL PRESSURE	INITI	IAL PRES	SURE + F		SURE IN E INCREA		- PSIG XIMUM (PERATI	NG PRES	SURE
PSIG	220	240	260	280	300	320	340	360	380	400
160	0.44	0.42	0.41	0.40	0.39	0.38	0.37	0.36	0.36	0.35
180	0.46	0.44	0.43	0.42	0.40	0.39	0.39	0.38	0.37	0.30
200	0.49	0.47	0.45	0.43	0.42	0.41	0.40	0.39	0.38	0.38
220	0.51	0.49	0.47	0.45	0.44	0.43	0.41	0.41	0.40	0.39
240	0.53	0.51	0.49	0.47	0.45	0.44	0.43	0.42	0.41	0.40
260	0.55	0.53	0.50	0.49	0.47	0.46	0.44	0.43	0.42	0.4
280	0.57	0.55	0.52	0.50	0.49	0.47	0.46	0.45	0.44	0.43
300	0.60	0.57	0.54	0.52	0.50	0.49	0.47	0.46	0.45	0.44
320	0.62	0.59	0.56	0.54	0.52	0.50	0.49	0.47	0.46	0.45
340	0.64	0.61	0.58	0.56	0.54	0.52	0.50	0.49	0.47	0.46
360	0.66	0.63	0.60	0.57	0.55	0.53	0.52	0.50	0.49	0.48
380	0.69	0.65	0.62	0.59	0.57	0.55	0.53	0.51	0.50	0.49
400	0.71	0.67	0.64	0.61	0.58	0.56	0.54	0.53	0.51	0.50
420	0.73	0.69	0.66	0.63	0.60	0.58	0.56	0.54	0.53	0.51
440	0.75	0.71	0.67	0.64	0.62	0.59	0.57	0.56	0.54	0.52
460	0.78	0.73	0.69	0.66	0.63	0.61	0.59	0.57	0.55	0.54
480	0.80	0.75	0.71	0.68	0.65	0.63	0.60	0.58	0.57	0.55
500	0.82	0.77	0.73	0.70	0.67	0.64	0.62	0.60	0.58	0.56
520	0.84	0.79	0.75	0.71	0.68	0.66	0.63	0.61	0.59	0.57
540	0.86	0.81	0.77	0.73	0.70	0.67	0.65	0.62	0.60	0.59
560	0.89	0.83	0.79	0.75	0.72	0.69	0.66	0.64	0.62	0.60
580	0.91	0.85	0.81	0.77	0.73	0.70	0.67	0.65	0.63	0.61
600	0.93	0.87	0.73	0.78	0.75	0.72	0.69	0.66	0.64	0.62
620	0.95	0.89	0.84	0.80	0.76	0.73	0.70	0.68	0.66	0.64
640	0.98	0.92	0.86	0.82	0.78	0.75	0.72	0.69	0.67	0.65
660	1.00	0.94	0.88	0.84	0.80	0.76	0.73	0.71	0.68	0.66
680	1.02	0.96	0.90	0.85	0.81	0.78	0.75	0.72	0.69	0.67
700	1.04	0.98	0.92	0.87	0.83	0.79	0.76	0.73	0.71	0.68

- 1. Table based on initial temperature: 50°F.
- Table based on initial pressure: 600 Psig.
 Table based on maximum operating pressure: 800 Psig.

19.10 Galvanic Action

A. Galvanic action results from the electrochemical variation in the potential of metallic ions. If two metals of different potentials are placed in an electrolytic medium (i.e., water), the one with the higher potential will act as an anode and will corrode. The metal with the lower potential, being the cathode, will be unchanged. The greater the separation of the two metals on the chart below, the greater the speed and severity of the corrosion. The list below is in order of their anodic-cathodic characteristics (i.e., metals listed below will corrode those listed above, for example, copper will corrode steel).

Magnesium Alloys

Alclad 3S

Aluminum Alloys

Low-Carbon Steel

Cast Iron

Stainless Steel, Type 410

Stainless Steel, Type 430

Stainless Steel, Type 404

Stainless Steel, Type 304

Stainless Steel, Type 316

Hastelloy A

Lead-Tin Alloys

Brass

Copper

Bronze

90/10 Copper-Nickel

70/30 Copper-Nickel

Inconel

Silver

Stainless Steel (passive)

Monel

Hastelloy C

Titanium

19.11 Piping System Installation Hierarchy (Easiest to Hardest to Install)

- A. Natural Gas, Medical Gases, and Laboratory Gases, Easiest to Install.
- B. Chilled Water, Heating Water, Domestic Cold and Hot Water Systems, and other Closed HVAC and Plumbing Systems.
- C. Steam and Steam Condensate.
- D. Refrigeration Piping Systems.
- E. Sanitary Systems, Storm Water Systems, AC Condensate Systems, Hardest to Install.

ASME B31 Piping Code Comparison

	T	T	
ITEM	POWER PIPING ASME B31.1 - 1998	PROCESS PIPING ASME B31.3 - 1996	BUILDING SERVICES PIPING ASME B31.9 - 1996
Application	Power & Auxiliary Piping for Electric Generating Stations, Industrial and Institutional Plants, Central & District Heating/Cooling Plants, and Geothermal Heating Systems.	Petroleum Refineries, Chemical, Pharmaceutical, Textile, Paper, Semiconductor, and Cryogenic Plants.	Industrial, Institutional, Commercial, and Public Buildings and Multi-Unit Residences.
Services	Systems include, but are not limited to, Steam, Water, Oil, Gas, and Air.	Systems include, but are not limited to, raw, intermediate, and finished chemicals, petroleum products, gas, steam air water, fluidized solids, refrigerants, and cryogenic fluids.	Systems include, but are not limited to, water for heating and cooling, condensing water, steam or other condensate, other nontoxic liquids, steam, vacuum, other nontoxic, nonflammable gases, and combustible liquids including fuel oil.
General Limitations	This Code does not apply to building services piping within the property limits or buildings of industrial and institutional facilities which is in the scope of ASME B31.9 except that piping beyond the limitations of material, size, temperature, pressure, and service specified in ASME B31.9 shall conform to the requirements of ASME B31.1. This Code excludes power boilers in accordance with the ASME Boiler and Pressure Vessel Code (BPVC) Section I.	This code excludes piping systems for internal gauge pressures above zero but less than 15 psig provided the fluid is nonflammable, nontoxic, and not damaging to human tissue and its temperature is from -20 °F through 366 °F This Code excludes power boilers in accordance with the ASME Boiler and Pressure Vessel Code Section I and boiler external piping which is required to conform to ASME B31.1.	This Code prescribes requirements for the design, materials, fabrication, installation, inspection, examination, and testing of piping systems for building services. It includes piping systems in the building or within the property limits. This Code excludes power boilers in accordance with the ASME Boiler and Pressure Vessel Code Section I and boiler external piping which is required to conform to ASME B31.1.

ITEM	POWER PIPING ASME B31.1 - 1998	PROCESS PIPING ASME B31.3 - 1996	BUILDING SERVICES PIPING ASME B31.9 - 1996		
Pipe Size Limitations	No Limit	No Limit	Carbon Steel - 30" OD Nominal Pipe Size and 0.5" Wall (30" XS Steel Pipe)		
			Copper - 12" Nominal Pipe Size		
			Stainless Steel - 12" OD Nominal Pipe Size and 0.5" Wall		
Pressure Limitations	No Limit	No Limit	Steam & Condensate - 150 Psig		
	*		Liquids - 350 Psig		
		e .	Vacuum - 1 Atmosphere External Pressure		
			Compressed Air & Gas - 150 Psig		
Temperature Limitations	No Limit	No Limit	Steam & Condensate - 366 °F. Maximum (150 Psig)		
			Other Gases & Vapors - 200 °F Maximum		
		8	Non-Flammable Liquids 250 °F Maximum		
Ŷ			Minimum Temperature All Services - 0 °F		
Bypass Requirements	All bypasses must be in accordance with MSS-SP-45. Pipe weight shall be minimum Schedule 80.	Bypasses not addressed - recommend following B31.1	Bypasses not addressed - recommend following B31.1		

ITEM	POWER PIPING ASME B31.1 - 1998	PROCESS PIPING ASME B31.3 - 1996	BUILDING SERVICES PIPING ASME B31.9 - 1996		
Class I Boiler Systems - ASME BPVC Section I	Boiler External Piping is governed by ASME B31.1 All other piping may be governed by this Code within the limitations of the Code.	Boiler External Piping is governed by ASME B31.1 All other piping may be governed by this Code within the limitations of the Code.	Boiler External Piping is governed by ASME B31.1 All other piping may be governed by this Code within the limitations of the Code.		
Class IV Boiler Systems - ASME BPVC Section IV	All piping, including boiler external piping, may be governed by this Code within the limitations of the Code.	All piping, including boiler external piping, may be governed by this Code within the limitations of the Code.	All piping, including boiler external piping, may be governed by this Code within the limitations of the Code.		

Class I Boiler Systems

1. Class I Steam Boiler Systems are constructed for Working Pressures above 15 Psig.

 Class I Hot Water Boiler Systems are constructed for Working Pressures above 160 Psig and/or Working Temperatures above 250 °F.

Class IV Boiler Systems

Class IV Steam Boiler Systems are constructed with a maximum Working Pressure of 15 Psig.

Class IV Hot Water Boiler Systems are constructed with a maximum Working Pressure of 160
Psig and a maximum Working Temperature of 250 °F.

Class I Boiler External Piping

 Steam Boiler Piping - ASME Code piping is required from the boiler through the 1st stop check valve to the 2nd Stop Valve.

 Steam Boiler Feedwater Piping - ASME Code piping is required from the boiler through the 1st stop valve to the check valve for single boiler feedwater installations and from the boiler through the 1st stop valve and through the check valve to the 2nd stop valve at the feedwater control valve for multiple boiler installations.

 Steam Boiler Bottom Blowdown Piping - ASME Code Piping is required from the boiler through the 1st stop valve to the 2nd stop valve.

 Steam Boiler Surface Blowdown Piping - ASME Code Piping is required from the boiler to the 1st stop valve.

 Steam & Hot Water Boiler Drain Piping - ASME Code Piping is required from the boiler through the 1st stop valve to the 2nd stop valve.

 Hot Water Boiler Supply and Return Piping - ASME Code piping is required from the boiler through the 1st stop check valve to the 2nd Stop Valve on both the supply and return piping.

Class IV Boiler External Piping

All Class IV Boiler External Piping is governed by the respective piping system code.

ITEM	POWER PIPING ASME B31.1 - 1998	PROCESS PIPING ASME B31.3 - 1996	BUILDING SERVICES PIPING ASME B31.9 - 1996
Piping Classifications	No Classifications required by this Code. The Code deals with and governs all piping under its jurisdiction the same.		No Classifications required by ths Code. The Code deals with and governs all piping under its jurisdiction the same.
Low Temp Chilled Water (0 - 40 °F)		D	, ,
Chilled Water (40 - 60 °F)		D	
Condenser Water (60 - 110 °F)	X X	D	
Low Temp Heating Water (110 - 250 °F)		N	4
High Temp Heating Water (250 - 450 °F)		N - Except Boiler Ext. Piping B31.1 applicable	
Low Press. Steam (15 Psig and Less)	,	N	
High Press. Steam (Above 15 Psig)	*	N - Except Boiler Ext. Piping B31.1 applicable	
Hydrostatic Pressure Testing	Test Medium - Water, unless subject to freezing	Test Medium - Water, unless subject to freezing	Test Medium - Water, unless subject to freezing
) / d	Boiler External Piping - ASME BPVC Section I	N/A	N/A
	Nonboiler External Piping - 1.5 times the design pressure but not to exceed max. allowable system pressure for a minimum of 10 minutes.	Category D or N Fluid Service - 1.5 times the design pressure but not to exceed max. allowable system pressure for a minimum of 10 minutes.	Nonboiler External Piping - 1.5 times the design pressure but not to exceed max. allowable system pressure for a minimum of 10 minutes.
	All Other Services - 1.5 times the design pressure but not to exceed max. allowable system pressure fo a minimum of 10 minutes.		All Other Services - 1.5 times the design pressure but not to exceed max. allowable system pressure fo a minimum of 10 minutes.

ITEM	POWER PIPING ASME B31.1 - 1998	PROCESS PIPING ASME B31.3 - 1996	BUILDING SERVICES PIPING ASME B31.9 - 1996
Examination, Inspection, and Testing Requirements	The degree of examination, inspection, and testing, and the acceptance standards must be mutually agreed upon by the manufacturer, fabricator, erector, or contractor and the Owner.	The degree of examination, inspection, and testing, and the acceptance standards must be mutually agreed upon by the manufacturer, fabricator, erector, or contractor and the Owner.	The degree of examination, inspection, and testing, and the acceptance standards must be mutually agreed upon by the manufacturer, fabricator, erector, or contractor and the Owner.
	Class I Steam & Hot Water Systems - Nondestructive testing and visual examinations are required by this Code. Percentage and types of tests performed must be agreed upon. Class IV Steam & Hot Water Systems - Visual examination only.	Category D Fluid Service - Visual Examination Category N Fluid Service - Visual Examination, 5% Random Examination of components, fabrication, welds, and installation. Random radiographic or ultrasonic testing of 5% of circumferential butt welds.	All Services - Visual Examinations.
	All other Services - Visual examination only. If more rigorous examination or testing is required, it must be mutually agreed upon.	If more rigorous examination or testing is required, it must be mutually agreed upon.	If more rigorous examination or testing is required, it must be mutually agreed upon.
Nondestructive Testing	Radiographic Ultrasonic Eddy Current Liquid Penetrant Magnetic Particle Hardness Tests	Radiographic Ultrasonic Eddy Current Liquid Penetrant Magnetic Particle Hardness Tests	Radiographic Ultrasonic Eddy Current Liquid Penetrant Magnetic Particle Hardness Tests

ASME B31 Chilled Water System Decision Diagram Chilled Water Systems (0–60°F.)

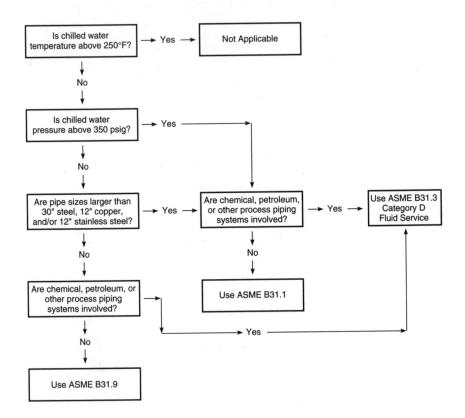

ASME B31 Condenser Water System Decision Diagram

Condenser Water Systems (60-110°F.)

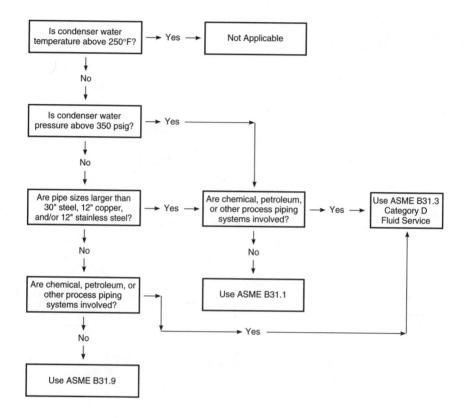

ASME B31 Heating Water System Decision Diagram Heating Water Systems (110–450°F.)

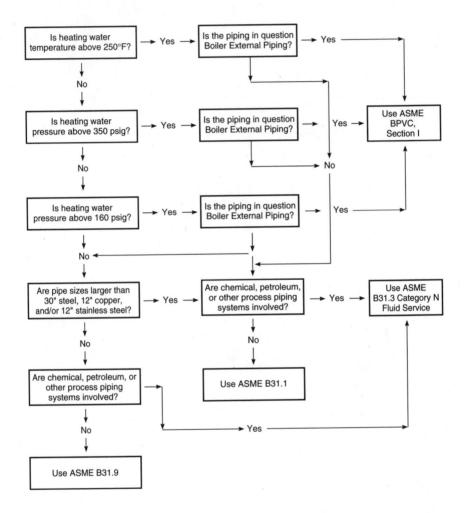

ASME B31 Steam & Condensate System Decision Diagram

Steam & Steam Condensate Systems (0-300 PSIG)

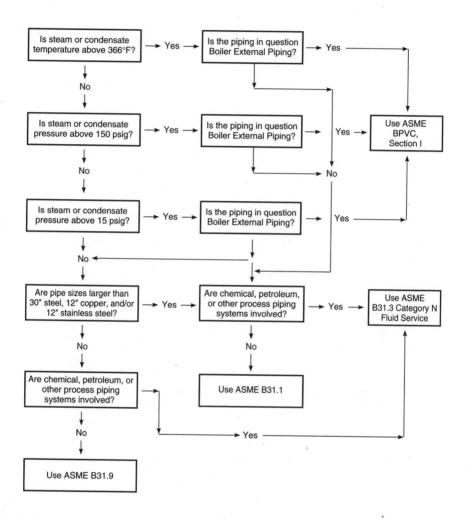

Central Plant Equipment

20.01 Air Handling Units, Air Conditioning Units, Heat Pumps

A. Definitions:

- 1. Air Handling Units (AHU): AHUs contain fans, filters, coils, and other items but do not contain refrigeration compressors.
- 2. Air Conditioning Units (ACU): ACUs are AHUs that contain refrigeration compressors.
- 3. Heat Pumps: Heat pumps are ACUs with refrigeration systems capable of providing heat to the space as well as cooling.

B. Air Handling Unit Types:

- 1. Packaged AHUs:
 - a. 800-50,000 CFM.
 - b. 0-9" SP.
 - c. 14-100 Hp.
- 2. Factory Fabricated AHUs:
 - a. 1,000-125,000 CFM.
 - b. 0-13" SP.
 - c. ¼-500 Hp.
 - d. Shipping limiting factor, 2 to 3 times more expensive than packaged AHUs.
- 3. Field Fabricated AHUs:
 - a. 10,000-804,000 CFM.
 - b. 0-14" SP.
 - c. 2-2500 Hp.
 - d. Fan size limiting factor.

C. Packaged Equipment, All Spaces:

- 1. 300-500 CFM/Ton @ 20°F. ΔT.
- 2. $400 \text{ CFM/Ton} \pm 20\% @ 20^{\circ}\text{F.} \Delta\text{T.}$

D. Water Source Heat Pumps:

- 1. Water Heat Rejection:
 - a. 2.0-3.0 GPM/Ton @ 15-10°F. ΔT.
 - b. 3.0 GPM/Ton @ 10°F. ΔT recommended.
- 2. 85-95°F. Condenser Water Temperature.
- 3. 60-90°F. Heat Pump Water Loop Temperatures:
 - a. Winter design: 60°F.
 - b. Summer design: 90°F.
- 4. Cooling Tower, Evap. Cooler Sizing:
 - a. 1.4 × Block Cooling Load.
- 5. Supplemental Heater Sizing:
 - a. 0.75 × Block Heating Load.

E. Geothermal Source Heat Pumps:

- 1. Efficiencies:

 - a. Average: 3.5-4.7 COP; 12-16 EER
- 5.3-5.9 COP; 18-20 EER
- 2. Vertical wells used for heat transfer are the most common system type in lieu of horizontal heat transfer sites.
- 3. Length of heat exchanger pipe required:
 - a. Range:
- 130 Ft/Ton-175 Ft./Ton
- b. Average: 150 Ft./Ton

- 4. 20°F.-110°F. Heat Pump Water Loop Temperatures.
- 5. If system is sized to meet cooling requirements, supplemental heat will not be required.
- 6. If system is sized to meet heating requirements, supplemental cooling tower will be required.
- 7. Pipe spacing:
 - a. Commercial: 15' × 15' Center to Center Grid
 - b. Residential: $10' \times 10'$ Center to Center Grid

F. Air Handling Unit Fans:

- 1. ½°F. temperature rise for each 1" S.P. from fan heat.
- 2. See Section on fans for more information.
- 3. Return air system with more than ½" pressure drop should have return air fan. A return air fan is also required if you intend to use an economizer and still maintain the space under a neutral or a negative pressure.

G. Economizers:

- Water side economizers take advantage of low condenser water temperature to either precool entering air, assist in mechanical cooling, or to provide total system cooling.
- 2. Air side economizers take advantage of cool outdoor air to either assist in mechanical cooling or to provide total system cooling.
 - a. Dry Bulb.
 - b. Enthalpy.

H. System Types:

- 1. VAV Systems:
 - a. Fans selected for 100% Block Airflow.
 - b. Normal Operation 60-80% Block Airflow.
 - c. Minimum Airflow 30-40% Block Airflow.
- 2. Constant Volume Reheat Systems:
 - Fans selected and operated at 100% Sum of Peak Airflow.
- 3. Dual Duct Systems:
 - a. Cold Deck designed for 100% of Sum of Peak Airflow.
 - b. Hot Deck designed for 75-90% of Sum of Peak Airflow.
 - c. Fans selected and operated at 100% of Sum of Peak Airflow.
- 4. Dual Duct VAV Systems:
 - a. Cold Deck designed for 100% of Block Airflow.
 - b. Hot Deck designed for 75-90% of Block Airflow.
 - c. Fans selected for 100% Block Airflow.
 - d. Normal Operation 60-80% Block Airflow.
 - e. Minimum Airflow 30-40% Block Airflow.
- 5. Single Zone and Multizone Systems:
 - a. Cold Deck designed for 100% of Sum of Peak Airflow.
 - b. Hot Deck designed for 75-90% of Sum of Peak Airflow.
 - c. Fans selected and operated at 100% of Sum of Peak Airflow.

I. Clearance Requirements:

 Minimum recommended clearance around air handling units and similar equipment is 24 inches on non-service side and 36 inches on service side. Maintain minimum clearance for coil pull as recommended by the equipment manufacturer; this is generally equal to the width of the air handling unit. Maintain minimum clearance as required to open access and control doors on air handling units for service, maintenance, and inspection. 2. Mechanical room locations and placement must take into account how large air handling units and similar equipment can be moved into and out of the building during initial installation and after construction for maintenance and repair and/or replacement.

20.02 Coils

A. General:

- Field erected and factory assembled air handling unit coils should be arranged for removal from upstream side without dismantling supports. Provide galvanized structural steel supports for all coils (except the lowest coil) in banks over two coils high to permit independent removal of any coil.
- 2. When air handling units are used to supply makeup air (100% OA) for smoke control/smoke management systems, water coil freeze up must be considered. Some possible solutions are listed below:
 - a. Provide preheat coil in AHU to heat the air from outside design temperature to 45–50°F.
 - b. Provide control of system to open all water coil control valves serving smoke control/smoke management systems to full open and circulate water through the coils.
 - c. Elect not to provide freeze protection with Owner concurrence in the event a fire or other emergency occurs on a cold day. Also many emergency situations are fairly short in duration. A follow-up letter should also be written.
- 3. Select water coils with tube velocities high enough at design flow so that tube velocities do not end up in the laminar flow region when the flow is reduced in response low load conditions. Tube velocities become critical with units designed for 100 percent outside air at low loads near 32°F. Higher tube velocity selection results in a higher water pressure drop for the water coil. Sometimes a trade-off between pressure drop and low load flows must be evaluated.
- It is best to use water coils with same end connections to reduce flow imbalances caused by differences in velocity head.
- 5. In horizontal water coil headers, supply water flow should be downward and return water flow should be upward for proper air venting.
- 6. Water Coil Flow Patterns:
 - a. Multiple Path, Parallel Flow, Grid Type Coil.
 - b. Series Flow, Serpentine Coil.
 - c. Series and Parallel Flow.

B. Water and Steam Coils:

- 1. Preheat:
 - a. Concurrent Air/Water or Steam Flow.
 - b. Freeze Protection:
 - 1) Face and Bypass Dampers.
 - 2) IFB Coils.
 - 3) Preheat Pumps (Primary/Secondary System).
- 2. Cooling, Heating, Reheat:
 - a. Counter Air/Water or Steam Flow.
- 3. Cooling Coil Face Velocity:
 - a. 450-550 FPM Range.
 - b. 500 FPM Recommended.
 - c. 450 FPM Preferred.
- 4. Preheat, Heating and Reheat Coil Face Velocity:
 - a. 500-900 FPM Range.

- b. 600-700 FPM Recommended.
- c. 600 FPM Preferred.
- d. Use preheat coil whenever mixed air temperature (outside air and return air) is below 40°F.

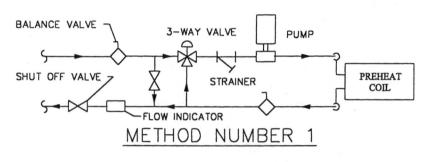

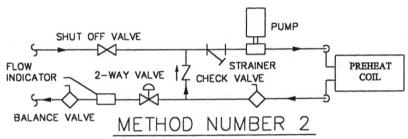

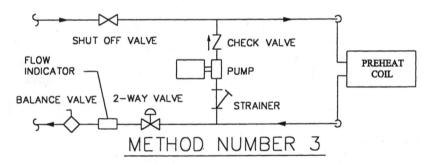

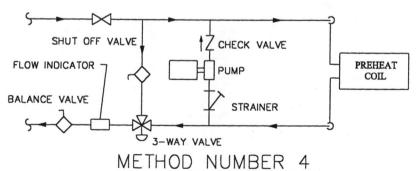

PREHEAT COIL PIPING DIAGRAMS

C. Refrigerant Coils:

- 1. Cooling:
 - a. Counter Air/Water Flow.
- 2. Cooling Coil Face Velocity:
 - a. 450-550 FPM Range.
 - b. 500 FPM Recommended.
 - c. 450 FPM Preferred.

D. Weight and Volume of Water in Standard Water Coils:

1. Weight of Water in the Tubes:

 $W_{WT} = 0.966$ Lbs./Row Sq.Ft. × No. of Rows × Face Area of Coil

2. Total Weight of Water in Coil:

$$W_{WC} = W_{WT} + W_{WH}$$

3. Total Weight of Water Coils:

$$W_T = W_C + W_{WC}$$

4. Volume of Water in Coil:

$$V = W_{WC} \times 0.12$$

W_{WT} = Water Weight in the Tubes (Pounds)

W_{WH} = Water Weight in the Headers/U-bends, from Table (Pounds)

W_{WC} = Water Weight in the Coil (Pounds)

W_C = Dry Coil Weight (Pounds)

 W_T = Total Weight of the Coil (Pounds)

V = Volume of the Coil (Gallons)

Weight of Water in Coil Heaters and U-Bends

FINNED	NUMBER OF ROWS										
WIDTH	1	2	3	4	5	6	8				
6"	0.75	1.75									
9"	1.00	2.75			244 						
12"	1.50	3.26	3.84	4.04	4.75	4.94	7.61				
18"	2.75	3.94	4.82	5.07	6.21	8.70	13.10				
24"	3.85	5.28	6.50	6.86	8.37	11.61	17.60				
30"	4.72	8.66	10.12	10.50	12.48	16.52	24.00				
33"	5.21	9.50	11.09	11.58	13.54	17.99	26.10				
36"		16.34	19.58	22.82	26.06	29.30	32.55				
42"		18.95	22.73	26.51	30.29	34.07	37.85				
48"		21.55	25.88	30.20	34.52	38.84	43.16				

E. Coil Pressure Drop

1. Air Pressure Drop (Water, Steam, Refrigerant Coils) is given in the following table:

NUMBER	FACE VELOCITY (Fpm)											
OF ROWS	450	500	550	600	700	800	900					
1	0.05-0.15	0.05-0.18	0.08-0.20	0.08-0.25	0.12-0.30	0.15-0.40	0.17-0.50					
2	0.10-0.35	0.11-0.50	0.15-0.50	0.16-0.60	0.20-0.80	0.25-0.90	0.32-0.90					
4	0.20-0.70	0.22-0.90	0.28-1.00	0.33-1.20	0.40-1.50	0.50-1.80	0.65-1.70					
6	0.30-1.10	0.35-1.30	0.45-1.50	0.50-1.70	0.65-2.30	0.75-2.80	1.00-2.70					
8	0.40-1.50	0.45-1.75	0.60-2.00	0.60-2.40	0.85-3.00	1.00-3.70	1.30-3.70					
10	0.50-1.75	0.60-2.25	0.70-2.50	0.80-3.00	1.10-3.80	1.30-4.50	1.70-4.50					

Notes for Air Pressure Drop Table:

- 1. Lower pressure drop is for 70 Fins/Ft.
- 2. Higher pressure drop is for 170 Fins/Ft.
- 3. Pressure drops in in. W.G.

2. Water Pressure Drop is given in the following table:

FINNED		FINNED LENGTH										
WIDTH	12	24	36	48	60	72	84	96	108	120	132	144
12	0.11 8.77	0.13 10.1	0.14 11.6	0.15 13.1	0.16 14.6	0.17 16.2	0.18 17.7	0.19	0.20 20.7	0.21 22.2	0.22 23.7	0.23 25.2
18	0.07 6.31	0.09 7.65	0.10 9.16	0.11	0.12 12.2	0.13 13.7	0.14 15.2	0.15 16.7	0.16 18.2	0.17 19.7	0.18 21.2	0.19 22.3
24	0.09	0.11	0.12	0.13	0.14	0.15	0.16	0.17	0.18	0.19	0.20	0.21
	8.21	9.55	11.1	12.6	14.1	15.6	17.1	18.6	20.1	21.7	23.2	24.7
30	0.12	0.14	0.15	0.16	0.17	0.18	0.19	0.20	0.21	0.22	0.23	0.24
	10.3	11.6	13.2	14.7	16.2	17.7	19.2	20.7	22.2	23.7	25.3	26.8
33	0.15	0.17	0.18	0.19	0.20	0.21	0.22	0.23	0.24	0.25	0.26	0.27
	11.4	12.7	14.2	15.7	17.2	18.7	20.2	21.8	23.3	24.8	26.3	27.8
36	0.17 13.2	0.19	0.20 16.1	0.21 17.5	0.22 19.0	0.23 20.5	0.24 22.1	0.25 23.6	0.26 25.1	0.27 26.6	0.28 28.1	0.29 29.6
42	0.20	0.22	0.23	0.24	0.25	0.26	0.27	0.28	0.29	0.30	0.31	0.32
	14.7	16.1	17.5	19.1	20.6	22.1	23.6	25.1	26.6	28.1	29.6	31.1
48	0.22	0.24	0.25	0.26	0.27	0.28	0.29	0.30	0.31	0.32	0.33	0.34
	16.4	17.8	19.3	20.8	22.3	23.8	25.3	26.8	28.3	29.8	31.3	32.9

Notes for Water Pressure Drop Table:

- 1. Pressure drops in FT H₂O/Row.
- 2. Top row is based on water velocity of 1.0 FPS.
- 3. Bottom row is based on water velocity of 8.0 FPS.
- 4. Water Velocity (FPS) = $(GPM \times 1.66)$ /Finned Width.
- 5. Based on W type coil.

F. Electric Coils:

- Open Coils: Use when personnel contact is not a concern. It is the most common type of electric coil used in HVAC applications.
 - a. Air Pressure Drops:
 - 1) 400 FPM-900 FPM 0.01-0.10 " WG

- b. Minimum Velocity:
 - 1) 400 FPM 6 KW/Sq.Ft. of Duct
 - 2) 500 FPM 8 KW/Sq.Ft. of Duct
 - 3) 600 FPM 10 KW/Sq.Ft. of Duct
 - 4) 700 FPM 12 KW/Sq.Ft. of Duct
 - 5) 800 FPM 14 KW/Sq.Ft. of Duct
 - 6) 900 FPM 16 KW/Sq.Ft. of Duct
 - 7) Manufacturer's literature should be consulted.
- 2. Finned Tubular Coils: Use when personnel contact is a concern.
 - a. Air Pressure Drops:
 - 1) 400 FPM-900 FPM 0.02-0.20" WG
 - b. Minimum Velocity:
 - 1) 400 FPM 6 KW/Sq.Ft. of Duct
 - 2) 500 FPM 9 KW/Sq.Ft. of Duct
 - 3) 600 FPM 12 KW/Sq.Ft. of Duct
 - 4) 700 FPM 15 KW/Sq.Ft. of Duct
 - 5) 800 FPM 17 KW/Sq.Ft. of Duct
 - 6) 900 FPM 20 KW/Sq.Ft. of Duct
 - 7) Manufacturer's literature should be consulted.

20.03 Filters

A. Flat or Panel Filters:

1. Efficiency: 20–35%

Face Velocity: 500 FPM
 Initial Pressure Drop: 0.25" WG

4. Final Pressure Drop: 0.50" WG

5. Nominal Sizes

a. 1" Thick: 24×24 ; 20×25 ; 20×24 ; 20×20 ; 16×25 ; 16×20

b. 2" Thick: 24×24 ; 20×25 ; 20×24 ; 20×20 ; 18×24 ; 16×25 ; 16×20 ;

 12×24

6. Test Method: ASHRAE 52-76, Atmospheric

B. Pleated Media Filters

- 1. Efficiency:
 - a. 25-35%
 - b. 60-65%
 - c. 80-85%
 - d. 90-95%
- 2. Face Velocity: 500 FPM
- 3. Initial Pressure Drop
 - a. 25-35%: 0.25-0.45" WG
 - b. 60-65%: 0.50" WG
 - c. 80-85%: 0.60" WG
 - d. 90-95%: 0.70" WG
- 4. Final Pressure Drop
 - a. 25-35%: 1.20" WG
 - b. 60-65%: 1.20" WG

- c. 80-85%: 1.20" WG
- d. 90-95%: 1.20" WG
- 5. Nominal Sizes
 - a. Thicknesses
 - 1) 25-35%: 1; 2; 4;
 - 2) 60-65%: 4; 6; 12;
 - 3) 80-85%: 4; 6; 12;
 - 4) 90-95%: 4; 6; 12;
 - b. Face Sizes
 - 1) 25–35%: 24×24 ; 20×25 ; 20×24 ; 20×20 ; 18×24 ; 16×25 ; 16×20 ; 12×24
 - 2) 60-65%: 24×24 ; 20×25 ; 20×24 ; 20×20 ; 18×24 ; 16×25 ; 16×20 ; 12×24
 - 3) 80-85%: 24×24 ; 20×25 ; 20×24 ; 20×20 ; 18×24 ; 16×25 ; 16×20 ; 12×24
 - 4) 90–95%: 24×24 ; 20×25 ; 20×24 ; 20×20 ; 18×24 ; 16×25 ; 16×20 ; 12×24
- 6. Test Method: ASHRAE 52-76, Atmospheric

C. Bag Filters:

- 1. Efficiency:
 - a. 40–45%
 - b. 50–55%
 - c. 60-65%
 - d. 80-85%
 - e. 90-95%
- 2. Face Velocity: 500 FPM
- 3. Initial Pressure Drop:
 - a. 40-45%: 0.25" WG
 - b. 50-55%: 0.35" WG
 - c. 60-65%: 0.40" WG
 - d. 80-85%: 0.50" WG
 - e. 90-95%: 0.60" WG
- 4. Final Pressure Drop
 - a. 40-45%: 1.00" WG
 - b. 50–55%: 1.00" WG
 - c. 60-65%: 1.00" WG
 - d. 80-85%: 1.00" WG
 - e. 90-95%: 1.00" WG
- 5. Nominal Sizes
 - a. Thicknesses
 - 1) 40-45%: 12; 15
 - 2) 50–55%: 21; 22; 30; 37
 - 3) 60–65%: 21; 22; 30; 37
 - 4) 80-85%: 21; 22; 30; 37
 - 5) 90-95%: 21; 22; 30; 37
 - b. Face Sizes
 - 1) 40-45%: 24×24 ; 24×20 ; 20×25 ; 20×24 ; 20×20 ; 16×25 ; 16×20 ; 12×24
 - 2) 50–55%: 24×24 ; 24×20 ; 20×24 ; 20×20 ; 12×24
 - 3) 60-65%: 24×24 ; 24×20 ; 20×24 ; 20×20 ; 12×24
 - 4) 80-85%: 24×24 ; 24×20 ; 20×24 ; 20×20 ; 12×24
 - 5) 90–95%: 24×24 ; 24×20 ; 20×24 ; 20×20 ; 12×24
- 6. Test Method: ASHRAE 52-76, Atmospheric

D. HEPA (High Efficiency Particulate Air) Filters:

1. Efficiency: 99.97% for 0.3 micron particles and larger

2. Face Velocity: 250 FPM Maximum

3. Initial Pressure Drop:

a. 95%: 0.50" WG b. 99.97–99.995%: 1.00" WG

4. Final Pressure Drop:

a. 95%: 2.00" WG b. 99.97–99.995%: 3.00" WG

5. Nominal Sizes

a. Thicknesses: 3; 5; 6; 12

b. Face Sizes: 8×8 ; 12×12 ; 12×24 ; 16×20 ; 20×20 ; 24×12 ; 24×24 ; 24×30 ;

 24×36 ; 24×48 ; 24×60 ; 24×72 ; 30×24 ; 30×30 ; 30×36 ; 30×48 ; 30×60 ; 30×72 ; 36×24 ; 36×30 ; 36×36 ; 36×48 ;

 $36 \times 60; 36 \times 72$

6. Test Method: D.O.P. or Polystyrene Latex (PSL) Spheres (PSL preferred)

E. ULPA (Ultra Low Penetrating Air) Filters:

1. Efficiency: 99.9997% for 0.12 micron particles and larger

2. Face Velocity: 250 Fpm Maximum

3. Initial Pressure Drop

a. 99.997-99.9999%: 1.00" WG

4. Final Pressure Drop

a. 99.997-99.9999%: 3.00" WG

5. Nominal Sizes

a. Thicknesses: 3; 5; 6; 12

b. Face Sizes: 8×8 ; 12×12 ; 12×24 ; 16×20 ; 20×20 ; 24×12 ; 24×24 ; 24×30 ;

 24×36 ; 24×48 ; 24×60 ; 24×72 ; 30×24 ; 30×30 ; 30×36 ; 30×48 ; 30×60 ; 30×72 ; 36×24 ; 36×30 ; 36×36 ; 36×48 ;

 36×60 ; 36×72

6. Test Method: D.O.P. or Polystyrene Latex (PSL) Spheres (PSL preferred)

F. Roll Filters:

Efficiency: 20–25%
 Face Velocity: 500 FPM

3. Initial Pressure Drop

a. 20%: 0.20" WG

4. Final Pressure Drop

a. 20%: 0.45" WG

5. Nominal Sizes

a. Thicknesses: 2

b. Face Sizes

1) Height: 5'-0" to 15'-0" by increments of 4"
2) Width: 3'-0" to 30'-0" by increments of 1'-0"

6. Test Method: ASHRAE 52-76, Atmospheric

G. Carbon Filters:

1. Front/Back Access:

a. Face Velocity: 500 FPM

1) Pressure Drop: 0.35-0.45" WG

2) Nominal Sizes

 $24 \times 24 \times 24$: 90 Lbs. of carbon per 2,000 CFM

 $24 \times 12 \times 24$: 45 Lbs. of carbon per 1,000 CFM 24×24

3) Tray Size: b. Face Velocity: 250 FPM 1) Pressure Drop: 0.30-0.40" WG

2) Nominal Sizes:

 $24 \times 24 \times 8$: 30 Lbs. of carbon per 1,000 CFM $24 \times 24 \times 8$: 15 Lbs. of carbon per 500 CFM

3) Tray Size: 24×8

2. Side Access:

a. Face Velocity: 500 FPM 1) Pressure Drop: 0.35-0.45" WG

2) Nominal Sizes

 $24 \times 24 \times 24$: 108 Lbs. of carbon per 2,000 CFM

3) Tray Size: 12×24

3.Test Method: ASHRAE 52-76, Atmospheric

H. Electronic Air Cleaners:

1. Efficiency: 30-40% 2. Face Velocity: 625 FPM

3. Initial Pressure Drop:

a. 90%: 0.26" WG

4. Final Pressure Drop:

0.50" WG a. 90%:

5. Nominal Sizes:

a. Thicknesses: 2'-0" to 4'-0" b. Face Sizes

2'-4" to 15'-8" by increments of 4" 1) Height: 2'-8" to 18'-8" by increments of 1'-0" 2) Width:

6.Test Method: ASHRAE 52-76, Atmospheric

I. Filter Removal Capabilities:

- 1. Fine Mode < 2.5 microns.
- 2. Coarse Mode ≥ 2.5 microns.
- 3. Respirable < 10.0 microns.
- 4. Nonrespirable ≥ 10.0 microns.

J. Filter Design Factors:

- 1. Degree of Air Cleanliness Required.
- 2. Particulate/Contaminate Size and Form (Solid or Aerosols).
- 3. Concentration.
- 4. Cost (Initial and Maintenance).
- 5. Space Requirements.
- 6. Pressure Loss/Energy Use.

K. Filter Characteristics

- 1. Efficiency. Ability of the filter to remove particulates/contaminates.
- 2. Airflow resistance. Static pressure drop of the filters.

3. Dust Holding Capacity. Amount of particulates/contaminates the filter will hold before efficiency drops drastically.

L. Filter Classes:

- 1. Class 1 Filters: Filters that, when clean, do not contribute fuel when attacked by flame and emit only neglible amounts of smoke.
- Class 2 Filters: Filters that, when clean, burn moderately when attacked by flame or emit moderate amounts of smoke, or both.
- However, dust, trapped by filters, will support combustion and will produce smoke more than the filter itself.

M. Filter Test Methods:

- 1. ASHRAE "Test Dust." ASHRAE test dust is composed of 72% standardized air cleaner test dust, fine; 23% powdered carbon; and 5% cotton linters.
- 2. Arrestance Test:
 - a. Uses ASHRAE Test Dust.
 - b. Tests the ability of the filter to remove the larger atmospheric dust particles.
 - c. Measures the concentration of the dust leaving the filter.
- 3. Atmospheric Dust Spot Efficiency Test:
 - a. Measures the change in light transmitted by HEPA filter media targets.
 - b. Intermittent Flow Method. Airflow upstream and downstream of the tested filter is drawn through separate target filters. Upstream airflow is intermittently drawn and the downstream airflow is continuously drawn. The test takes more time for higher efficiency filters.
 - c. Constant Flow Method. Airflow upstream and downstream of the tested filter is drawn through separate target filters at a constant flow. Test takes the same time for high and low efficiency filters.
- 4. Dust Holding Capacity Test. The amount of dust held by the filter when filter pressure drop reaches its maximum or final pressure drop or when arrestance tests drop below 85% for two consecutive readings or below 75% for one reading.
- 5. DOP (Di-Octyl Phthalate) Test:
 - a. High Efficiency Filter Tests (HEPA and ULPA).
 - b. DOP or BEP (Bis-[2-Ethylhexyl] Phthalate) Test aerosols are used.
 - c. A cloud of DOP or BEP is passed through the test filter and the amount passing through the filter is measured by light scattering photometer.
- 6. Polystyrene Latex (PSL) Spheres Test:
 - a. High Efficiency Filter Tests (HEPA and ULPA).
 - b. Filter media thickness 20 mil.
 - c. Media is tested at 10.5 feet per minute with PSL.
 - d. Filters are tested at 70 to 100 feet per minute.
 - e. PSL test material is selected to allow 90 percent of the mean size to be between 0.1 and 0.3 microns.
 - f. The minimum number of PSL particles in the filter test challenge will be a minimum of 10 million particles per cubic foot.
 - g. Particle test challenge is monitored in accordance with Institute of Environmental Sciences (IES) standards IES-RP-C001 for HEPA filters and IES-RP-C007 for ULPA filters.
- 7. Leak Scan Tests:
 - a. Used with HEPA and ULPA Filters.
 - DOP Test is used while scanning the face of the filter for air leakage through or around the filters.
- 8. Particle Size Tests. No standard exists; depends heavily on the type of aerosol used.

20.04 Chillers

A. Chiller Types:

- 1. Centrifugal:
 - a. 200 Tons and Larger.
 - b. 0.55-0.85 KW/Ton.
 - c. 4.14-6.39 COP.
 - d. Turndown Ratio, 100% to 10%.
- 2. Reciprocating:
 - a. 200 Tons and Smaller.
 - b. 0.90-1.30 KW/Ton.
 - c. 2.70-3.90 COP.
 - d. Turndown Ratio, Staged or Stepped based on number of cylinders and unloading control.
- 3. Rotary Screw:
 - a. 50-1100 Tons.
 - b. 1.00-1.50 KW/Ton.
 - c. 2.34-3.50 COP.
 - d. Turndown Ratio, 100% to 25%.
- 4. Absorption (Steam or Hot Water):
 - a. 100 Tons and Larger.
 - b. 18,750 Btuh/Ton; 0.64 COP 1-Stage.
 - c. 12,250 Btuh/Ton; 0.98 COP 2-Stage.
 - d. Turndown Ratio, 100% to 10%.
- 5. Absorption (Gas or Oil):
 - a. 100 Tons and Larger.
 - b. 11,720 Btuh/Ton; 1.02 COP Gas.
 - c. 12,440 Btuh/Ton; 0.96 COP Oil.
 - d. Turndown Ratio, 100% to 10%.

B. Chiller Motor Types:

- Hermetic Chillers/Motors:
 - a. Motors are refrigerant cooled.
 - Motor heat absorbed by the refrigerant must be removed by the condenser cooling medium (air or water).
 - c. $TONS_{COND} = TONS_{EVAP} \times 1.25$
 - = 12,000 Btu/Hr. Ton $\times 1.25 = 15,000$ Btu/Hr. Ton.

Therefore, motor heat gain is approximately 3,000 Btu/Hr. Ton.

- 2. Open Chillers/Motors:
 - a. Motors are air cooled.
 - b. Motor heat is rejected directly to the space. Therefore, the space HVAC system must remove approximately 3,000 Btu/Hr. Ton of motor heat gain.
- 3. In either case the chillers must remove the 3,000 Btu/Hr. Ton of heat generated by the motors; the only difference is the method by which it is accomplished.

C. Chiller Terms:

- Refrigeration Effect: The refrigeration effect is the amount of heat absorbed by the refrigerant in the evaporator.
- Heat of Rejection: The heat of rejection is the amount of heat rejected by the refrigerant in the condenser, which includes compressor heat.

- Subcooling: Subcooling is the cooling of the refrigerant below the temperature in which it condenses. Subcooling the liquid refrigerant will increase the refrigeration effect of the system will be increased.
- 4. Superheating: Superheating is the heating of the refrigerant above the temperature in which it evaporates. Superheating the refrigerant by the evaporator is part of the system design to prevent a slug of liquid refrigerant from entering the compressor and causing damage.
- 5. Coefficient of Performance (COP): The coefficient of performance is defined as the refrigeration effect (Btu/Hr.) divided by the work of the compressor (Btu/Hr.). Another way to define COP is Btu Output divided by Btu Input. COP is equal to EER divided by 3.413.
- 6. Energy Efficiency Ratio (EER): The energy efficiency ratio is defined as the refrigeration effect (Btu/Hr.) divided by the work of the compressor (Watts). Another way to define EER is the Btu Output divided by the Watts Input. The EER is equal to 3.413 times the COP.
- 7. pH Chart: Pressure/Enthalpy chart is a graphic representation of the properties of a specific refrigerant with the pressure on the vertical axis and the enthalpy on the horizontal axis. The graph is used and is helpful in visualizing the changes that occur in a refrigeration cycle.
- 8. Integrated Part Load Value (IPLV) ARI Specified Conditions. Acceptable tolerances for specified conditions are $\pm 5\%$.
- Application Part Load Value (APLV) Engineer Specified Conditions (Real World Conditions). Acceptable tolerances for specified conditions are ± 5%.
- 10. Rupture Disc. Relief device on low pressure machines.
- 11. Relief Valve. Relief device on high pressure machines.
- 12. Pumpdown. Refrigerant pumped to condenser for storage.
- 13. Pumpout. Refrigerant pumped to separate storage vessel. Use pumpout type storage when reasonable size and number of portable storage containers cannot be moved into the building.
- 14. Purge Unit. Removes air from the refrigeration machine, required on low pressure machines only.
- 15. Prevac. Device that prevents air from entering refrigeration machine, and it is used to leak test the refrigeration machine, required on low pressure machines only.
- 16. Factory Run Tests. 1,500 tons and smaller; most manufacturers can provide.
 - a. Certified Test. Certify Performance—Full Load and/or Part Load—IPLV, and/or APLV.
 - b. Witnessed Tests:
 - 1) Generic. Any chiller the manufacturer produces of the same size and characteristics.
 - 2) Specific. The specific chiller required by the customer.
- 17. Hot Gas Bypass. Low limit to suction pressure of compressor. Hot gas bypass is beneficial on DX systems and generally not beneficial on chilled water systems, except when tight temperature tolerances are required for a manufacturing process. Chillers specified with both hot gas bypass and low ambient temperature control will result in the hot gas bypass increasing the low ambient temperature operating point of the chiller (decrease ability for chiller to operate at low ambient conditions).

D. Basic Refrigeration Cycle Terminology:

- Compressor. Mechanical device where the refrigerant is compressed from a lower pressure and lower temperature to a higher pressure and higher temperature.
- 2. Hot Gas Piping. Refrigerant piping from the compressor discharge to the compressor suction, to the evaporator outlet, or to the evaporator inlet or from the compressor discharge and the condenser outlet to the compressor suction.
- 3. Condenser. Heat exchanger where the system heat is rejected and the refrigerant condenses into a liquid.

- 4. Liquid Piping. Refrigerant piping from the condenser outlet to the evaporator inlet.
- 5. Evaporator. Heat exchanger where the system heat is absorbed and the refrigerant evaporates into a gas.
- Suction Piping. Refrigerant piping from the evaporator outlet to the compressor suction inlet.
- 7. Thermal Expansion Valve. Pressure and temperature regulation valve, located in the liquid line, which is responsive to the superheat of the vapor leaving the evaporator coil.

E. Chiller Energy Saving Techniques:

- Constant Speed Chillers. For each 1°F. increase in chilled water temperature, chiller efficiency increases 1.0 to 2.0 percent.
- Variable Speed Chillers. For each 1°F. increase in chilled water temperature, chiller efficiency increases 2.0 to 4.0 percent.
- 3. For each 1°F. decrease in condenser water temperature, chiller efficiency increases 1.0 to 2.0 percent.

F. Evaporator / Chilled Water System:

- 1. Leaving Water Temperature (LWT): 42-46°F.
- 2. 10-20°F. ΔT.
- 3. 2.4 GPM/Ton @ 10°F. ΔT.
- 4. 2.0 GPM/Ton @ 12°F. ΔT.
- 5. 1.5 GPM/Ton @ 16°F. ΔT.
- 6. 1.2 GPM/Ton @ 20°F. ΔT.
- 7. 5,000 Btuh/GPM @ 10°F. ΔT.
- 8. 6,000 Btuh/GPM @ 12°F. ΔT.
- 9. 8,000 Btuh/GPM @ 16°F. ΔT.
- 10. 10,000 Btuh/GPM @ 20°F. ΔT.
- 11. ARI Evaporator Fouling Factor: 0.00010 Btu/Hr.Ft².°F.
- 12. Chilled Water Flow Range: Chiller Design Flow $\pm 10\%$.
- 13. Chiller Tube Velocity for Variable Flow Chilled Water:
 - a. Minimum Flow: 3.0 FPS
 - b. Maximum Flow: 12.0 FPS

G. Condenser / Condenser Water Systems:

- 1. Entering Water Temperature (EWT): 85°F.
- 2. ΔT Range: 10-20°F.
- 3. Normal ΔT: 10°F.
- 4. 3.0 GPM/Ton @ 10°F. ΔT.
- 5. 2.5 GPM/Ton @ 12°F. ΔT.
- 6. 2.0 GPM/Ton @ 15°F. ΔT.
- 7. 1.5 GPM/Ton @ 20°F. ΔT.
- 8. 5,000 Btuh/GPM @ 10°F. ΔT.
- 9. 6,000 Btuh/GPM @ 12°F. ΔT.
- 10. 7,500 Btuh/GPM @ 15°F. ΔT.
- 11. 10,000 Btuh/GPM @ 20°F. ΔT.
- 12. ARI Condenser Fouling Factor: 0.00025 Btu/Hr.Ft².°F.

H. Chilled Water Storage Systems:

- 1. 10°F. ΔT.
 - a. 19.3 Cu.FT./Ton Hr.
 - b. 623.1 Btu/Cu.Ft.; 83.3 Btu/Gal.

- 2. 12°F. ΔT:
 - a. 16.1 Cu.Ft./Ton Hr.
 - b. 747.7 Btu/Cu.Ft.; 100.0 Btu/Gal.
- 3. 16°F. ΔT:
 - a. 12.4 Cu.Ft./Ton Hr.
 - b. 996.9 Btu/Cu.Ft.: 133.3 Btu/Gal.

I. Ice Storage Systems:

- 1. 144 Btu/Lb. @ 32°F. + 0.48 Btu/Lb. for each 1°F. below 32°F.
- 2. 3.2 Cu.Ft./Ton Hr.
- 3. Only the latent heat capacity of ice should be used when designing ice storage systems.

J. Water Cooled Condensers:

- 1. Entering Water Temperature (EWT): 85°F.
- 2. Leaving Water Temperature (LWT): 95°F.
- 3. 3.0 GPM/Ton @ 10°F. ΔT.
- 4. For each 1°F. decrease in condenser water temperature, chiller efficiency increases 1 to 1.2 percent.

K. Refrigerant Estimate-Split Systems:

- 1. Total 3.0 Lbs./Ton.
- 2. Equipment 2.0 Lbs./Ton.
- 3. Piping 1.0 Lbs./Ton.
- L. Chilled Water System Makeup Connection: Minimum connection size shall be 10% of largest system pipe size or 1", whichever is greater. (20" system pipe size results in a 2" makeup water connection.)

M. Chemical Feed Systems for Chillers. Chemical feed systems are designed to control the following:

- 1. System pH, normally between 8 and 9.
- 2. Corrosion.
- 3. Scale.

N. Chiller Operating Sequence:

- Start chilled water and condenser water pumps. Verify chilled water and condenser water flow.
- 2. Start chiller and cooling tower.
- 3. Run time.
- 4. Stop chiller and cooling tower.
- Stop chilled water and condenser water pumps after 0 to 30 second delay, because some chiller manufacturers use chilled water or condenser water to cool the solid state starter circuitry.

O. Chiller Design, Layout, and Clearance Requirements/Considerations:

- 1. Design Conditions:
 - a. Chiller Load. Tons, Btu/Hr, or MBH.
 - b. Chilled Water Temperatures. Entering and Leaving or Entering and ΔT .
 - c. Condenser Water Temperatures. Entering and Leaving or Entering and ΔT .
 - d. Chilled Water Flows and Fluid Type (correct all data for fluid type).
 - e. Condenser Water Flows and Fluid Type (correct all data for fluid type).

- f. Evaporator and Condenser Pressure Drops.
- g. Fouling Factor.
- h. IPLV, Desirable.
- i. APLV, Optional.
- j. Chilled Water or Condenser Water Reset if Applicable.
- k. Ambient Operating Temperature, Dry Bulb and Wet Bulb.
- l. Electrical Data:
 - 1) Compressor or Unit KW.
 - 2) Full Load, Running Load, and Locked Rotor Amps.
 - 3) Power Factor.
 - 4) Energy Efficiency Ratio (EER).
 - 5) Voltage-Phase-Hertz.
- 2. Multiple chillers should be used to prevent complete system or building shutdown upon failure of 1 chiller in all chilled water systems over 200 tons (i.e., 2 @ 50%, 2 @ 67%, 2 @ 70%, 3 @ 34%, 3 @ 40%).
- 3. Water Boxes/Piping Connections:
 - a. Marine Type. Marine water boxes enable piping to be connected to the side of the chiller so that piping does not need to be disconnected on order to service machine. Recommend on large chillers, 500 tons and larger.
 - b. Non-Marine or Standard Type. Recommend on small chillers, less than 500 tons.
 - c. Provide victaulic or flanged connections for first 3 fittings at chiller with non-marine or standard type connections.
 - d. Locate piping connections against the wall.
 - e. Locate all piping connections opposite the tube clean/pull side of chiller.
 - f. Locate oil cooler connections.
- 4. Show tube clean/pull clearances and location.
- 5. Minimum recommended clearance around chillers is 36 inches. Maintain minimum clearances for tube pull and cleaning of tubes as recommended by the equipment manufacturer. This is generally equal to the length of the chiller. Maintain minimum clearance as required to open access and control doors on chillers for service, maintenance, and inspection.
- 6. Maintain minimum electrical clearances as required by NEC.
- Mechanical room locations and placement must take into account how chillers can be moved into and out of the building during initial installation and after construction for maintenance and repair and/or replacement.
- 8. If chiller must be disassembled for installation (chiller cannot be shipped disassembled), specify manufacturer's representative for reassembly, do not specify insulation with chiller (field insulate), and specify the chiller to come with remote mounted starter.
- 9. Show location of chiller starter, disconnect switch, and control panel.
- 10. Show chiller relief piping.
- 11. Show sanitary drain locations and chiller drain connections.
- 12. Locate refrigerant monitoring system, refrigerant sensors, and self-contained breathing apparatus (SCBA). Refrigerant detection devices and SCBA are required by code, ASHRAE Standard 15. Detection devices sound an alarm at certain level (low limit) and sound an alarm and activate ventilation system at a higher level (high limit) with levels dependent on refrigerant type.
- 13. Coordinate height of chiller with overhead clearances and obstructions. Is beam required above chiller for lifting compressor or other components?
- 14. Low Ambient Operation. Is operation of chiller required below 40°F., 0°F, etc., or will airside economizers provide cooling?

- 15. Wind Direction and Speed (Air Cooled Machines). Orient short end of chiller to wind.
- 16. If isolators are required for the chiller, has isolator height been considered in clear-ance requirements? If isolators are required for the chiller, has piping isolation been addressed?
- 17. Locate flow switches in both the evaporator and condenser water piping systems serving each chiller and flow meters as required by system design.
- 18. Locate pumpdown, pumpout, and refrigerant storage devices if they are required.
- 19. When combining independent chilled water systems into a central plant,
 - a. Create a central system concept, control scheme, and flow schematics.
 - The system shall only have a single expansion tank connection point sized to handle entire system expansion and contraction.
 - c. All systems must be altered, if necessary, to be compatible with central system concept (temperatures, pressures, flow concepts—variable or constant control concepts).
 - d. For constant flow and variable flow systems, the secondary chillers are tied into the main chiller plant return main. Chilled water is pumped from the return main through the chiller and back to the return main.
 - e. District chilled water systems, due to their size, extensiveness, or both, may require that independent plants feed into the supply main at different points. If this is required, design and layout must enable isolating the plant; provide start-up and shutdown bypasses; and provide adequate flow, temperature, pressure, and other control parameter readings and indicators for proper plant operation and other design issues which affect plant operation and optimization.
- 20. In large systems, it may be beneficial to install a steam-to-water or water-to-water heat exchanger to place an artificial load on the chilled water system to test individual chillers or groups of chillers during plant start-up, after repairs, or for troubleshooting chiller or system problems.
- 21. Large and campus chilled water systems should be designed for large delta Ts and for variable flow secondary and tertiary systems.
- 22. Chilled water pump energy must be accounted for in the chiller capacity because they add heat load to the system.
- 23. It is best to design chilled water and condenser water systems to pump through the chiller.

20.05 Cooling Towers (CTs)

A. Cooling Tower Types:

- 1. Induced Draft—Cross Flow.
 - a. 200-900 Tons Single Cell.
 - b. 400-1,800 Tons Double Cell.
- 2. Forced Draft, Counter Flow:
 - a. 200-1,300 Tons Centrifugal Fans.
 - b. 250-1,150 Tons Axial Fans.
- 3. Ejector Parallel Flow:
 - a. 5-750 Tons.

B. Definitions:

- 1. Range: Difference between entering and leaving water, system ΔT .
- 2. Approach: Difference between leaving water temperature and entering air wet bulb.
- 3. Evaporation: Method by which cooling towers cool the water.
- 4. Drift: Entrained water droplets carried off by the cooling tower. Undesirable side effect.

- 5. Blowdown or Bleed: Water intentionally discharged from the cooling tower to maintain water quality.
- 6. Plume: Hot moist air discharged from the cooling tower forming a dense fog.

C. Condenser Water:

- 1. Most Common Entering Water Temperature (EWT): 95°F.
- 2. Most Common Leaving Water Temperature (LWT): 85°F.
- 3. Range: 10–40°F. ΔT.
- 4. 3.0 GPM/Ton @ 10°F. ΔT.

D. Power: 0.035-0.040 KW/Ton

E. $TONS_{COND} = TONS_{EVAP} \times 1.25$

- = 12,000 Btu/Hr. Ton × 1.25
- = 15,000 Btu/Hr. Ton

F. Condenser Water Makeup to Cooling Tower:

1. Range:

0.0306-0.0432 GPM/Ton

2. Range:

0.0102-0.0144 GPM/Cond. GPM (1.0-1.4% Condenser GPM)

3. Centrifugal:

40 GPM/1,000 Tons

4. Reciprocating: 40 GPM/1,000 Tons

40 GPM/1,000 Tons

5. Screw: 6. Absorption:

80 GPM/1,000 Tons

G. Cooling Tower Drains: Use 2 times the makeup water rate for sizing cooling tower drains.

H. Cycles of Concentration

1. Range:

2 - 10

2. Recommend:

3 - 5

I. Evaporation

1. Range:

0.024-0.03 GPM/Ton

2. Range:

0.008-0.01 GPM/Cond. GPM (0.8-1.0% Condenser GPM)

3. Recommend:

0.01 GPM/Cond. GPM

J. Drift

1. Range:

0.0006-0.0012 GPM/Ton

2. Range:

0.0002-0.0004 GPM/Cond. GPM (0.02-0.04% Condenser GPM)

3. Recommend: 0.0002 GPM/Cond. GPM

K. Blowdown or Bleed (Based on 10°F. Range):

1. Range:

0.006-0.012 GPM/Ton

2. Range:

0.002-0.004 GPM/Cond. GPM (0.2-0.4% Condenser GPM)

3. Recommend:

0.002 GPM/Cond. GPM

4. Centrifugal:

10 GPM/1,000 Tons

5. Reciprocating: 10 GPM/1,000 Tons

6. Screw:

7. Absorption:

10 GPM/1,000 Tons 20 GPM/1,000 Tons

Blowdown GPM, % of Cond. GPM

COOLING TOWER RANGE	CYCLES OF CONCENTRATION										
	2	3	4	5	6	7	8	9	10		
10	0.80	0.40	0.30	0.20	0.10	0.10	0.10	0.10	0.10		
15	1.20	0.60	0.40	0.30	0.20	0.20	0.15	0.15	0.15		
20	1.60	0.80	0.50	0.40	0.30	0.30	0.20	0.20	0.20		
25	2.00	1.00	0.65	0.50	0.40	0.35	0.25	0.25	0.23		
30	2.40	1.20	0.80	0.60	0.50	0.40	0.30	0.30	0.25		
35	2.75	1.40	0.95	0.70	0.55	0.45	0.35	0.35	0.30		
40	3.10	1.60	1.10	0.80	0.60	0.50	0.40	0.40	0.35		

L. Cooling towers should be located at least 100 feet from the building, when located on the ground, to reduce noise and to prevent moisture from condensing on the building during the intermediate seasons (spring and fall). Cooling towers should also be located 100 feet from parking structures or parking lots to prevent staining of automobile finishes due to water treatment.

20.06 Air Cooled Condensers and Condensing Units (ACCs and ACCUs)

A. Size Range: 0.5-500 6 Tons

B. Air Flow: 600-1,200 CFM/Ton

C. Power:

Condenser Fans: 0.1–0.2 HP/Ton
 Compressors: 1.0–1.3 KW/Ton

20.07 Evaporative Condensers and Condensing Units (ECs and ECUs)

A. Type and Sizes:

1. 10-1,600 Tons Centrifugal Fans

2. 10-1,500 Tons Axial Fans

B. Drift: 0.002 GPM/Cond. GPM

C. Evaporation: 1.6-2.0 GPM/Ton

D. Bleed: 0.8-1.0 GPM/Ton

E. Total: 2.4-3.0 GPM/Ton

20.08 Installation of CTs, ACCs, ACCUs, ECs, and ECUs

A. Allow ample space to provide proper airflow to fans and units in accordance with manufacturer's recommendations.

- B. Top discharge of unit should be at the same height or higher level than adjoining building or wall to minimize recirculation caused by down drafts between unit and wall. Raise the unit or provide discharge hood to obtain proper discharge height.
- C. Elevating units may decrease space required between units and between units and walls. ONLY DECREASE SPACE IN ACCORDANCE WITH MANUFACTURER'S RECOMMENDATIONS.
- D. Decking or metal plates over units between walls and other units may decrease space required between units and between units and walls. ONLY DECREASE SPACE IN ACCORDANCE WITH MANUFACTURER'S RECOMMENDATIONS.
- E. Providing discharge hoods with units may decrease space required between units and between units and walls. ONLY DECREASE SPACE IN ACCORDANCE WITH MANUFACTURER'S RECOMMENDATIONS.
- F. Chemical Feed Systems for CTs, ECs, and ECUs. Chemical feed systems are designed to control the following:
- 1. System pH, Normally between 8 and 9.
- 2. Corrosion.
- 3. Scale.
- 4. Biological and Microbial Growth.

G. Clearance Requirements:

- 1. Minimum recommended clearance around CTs, ACCs, ACCUs, ECs, and ECUs is 36 inches. Maintain minimum clearances as recommended by the equipment manufacturer. Maintain minimum clearance as required to open access and control doors on equipment for service, maintenance, and inspection.
- 2. Mechanical room locations and placement must take into account how CTs, ACCs, ACCUs, ECs, and ECUs can be moved into and out of the building during initial installation and after construction for maintenance and repair and/or replacement.

20.09 Heat Exchangers

A. Shell and Tube:

- 1. Used where the approach of the system is greater than 15 \pm F.
- 2. Straight Tube or U-Tube Design.
- 3. Generally used in heating systems.
- 4. Water to Water:
 - a. Maximum Tube Velocity: 6 Ft./Sec.
 - b. Maximum Shell Velocity: 5 Ft./Sec.
- 5. Steam to Water:
 - a. Maximum Water Velocity: 6 Ft./Sec.
 - b. If system steam capacity exceeds 2" control valve size, provide 2 control valves with ½ and ½ capacity split.

B. Plate and Frame:

- 1. Used where the approach of the system is less than 15 \pm F.
- 2. Generally used in cooling systems.

C. Definitions:

- 1. Range: Difference between entering and leaving water, system ΔT .
- Approach: Difference between hot side entering water temperature and cold side leaving water temperature.

D. Clearance and Design Requirements:

- Minimum recommended clearance around heat exchangers is 36 inches. Maintain minimum clearances for tube pull and cleaning of tubes as recommended by the equipment manufacturer. This is generally equal to the length of the heat exchanger.
- 2. Mechanical room locations and placement must take into account how heat exchangers can be moved into and out of the building during initial installation and after construction for maintenance and repair and/or replacement.
- 3. Multiple heat exchangers should be used to prevent complete system or building shutdown upon failure of 1 heat exchanger in all water systems over 200 tons or 2,400,000 Btu/Hr. (i.e., 2 @ 50%, 2 @ 67%, 2 @ 70%, 3 @ 34%, 3 @ 40%).
- 4. Heat Transfer Factors:
 - a. Change in enthalpy on the primary side (hydronic side).
 - b. Change in enthalpy on the secondary side.
 - Heat transfer through the heat exchanger dependent on film coefficients and heat transfer surface area.
- 5. Methods of Heat Transfer:
 - a. Parallel Flow. Both mediums flow in the same direction. Least effective method of heat transfer.
 - Counter-Flow. Mediums flow in opposite directions. Most effective method of heat transfer.
 - c. Cross-Flow. Mediums flow at right angles to each other. Heat transfer effectiveness between parallel and counter flow methods.
 - d. Combination. Cross-Flow/Counter-Flow or Cross-Flow/Parallel Flow. Typical in shell and tube heat exchangers.

20.10 Boilers, General

A. Class I Boilers. ASME Boiler and Pressure Vessel Code, Section I:

- 1. Steam Boilers, Greater than 15 Psig
- 2. Hot Water Boilers:
 - a. Greater than 160 Psig
 - b. Greater than 250°F.
- 3. Common Terminology:
 - a. Process Boilers
 - b. Power Boilers
 - c. High Pressure Boilers

B. Class IV Boilers. ASME Boiler and Pressure Vessel Code, Section IV:

- 1. Steam Boilers, 15 psig and less
- 2. Hot Water Boilers:
 - a. 160 psi and less
 - b. 250°F. and less
- 3. Common Terminology:
 - a. Commercial Boilers

- b. Industrial Boilers
- c. Heating Boilers
- d. Low Pressure Boilers

C. Common Boiler Design Pressures:

- 1. 15 Psig
- 2. 30 Psig
- 3. 60 Psig
- 4. 125 Psig
- 5. 150 Psig
- 6. 200 Psig
- 7. 250 Psig
- 8. 300 Psig
- 9. 350 Psig

D. Boiler Sequence of Operation:

- 1. Prepurge
- 2. Pilot Ignition and Verification
- 3. Main Flame Ignition and Verification
- 4. Run Time
- 5. Post Purge
- 6. Boiler Operational Considerations:
 - a. Hot Water and Steam Boilers:
 - 1) Prevent hot or cold shock
 - 2) Prevent frequent cycling
 - 3) Provide proper water treatment
 - b. Hot Water Boilers Only:
 - 1) Provide continuous circulation
 - 2) Balance flow through boilers
 - 3) Provide proper over pressure
 - c. Causes of Increased Stack Temperature:
 - 1) Soot buildup
 - 2) Scale buildup
 - 3) Combustion chamber and pass sealing problems

E. Boiler Types:

- 1. Fire Tube Boilers (Scotch Marine)
- 2. Water Tube Boilers
- 3. Flexible Tube Boilers
- 4. Cast Iron Boilers
- 5. Modular Boilers
- 6. Electric Boilers
- 7. Fire Tube versus Water Tube Boiler Characteristics are shown in the following table:

Fire Tube Versus Water Tube Boilers

COMPARED ITEM	FIRE TUBE BOILERS	WATER TUBE BOILERS
STEAM QUALITY	98.5%	99.5%
STEAM PURITY	52.5 ppm	17.5 ppm can be modified to obtain 1 ppm
EFFICIENCY	85% Average	80% Average
DESIGN PRESSURE	300 psig	900 psig
DESIGN TEMPERATURE	350 °F.	455 °F.
SUPER HEATERS	None	Available to 750 °F.
LOAD SWINGS	Long Recovery Time	Short Recovery Time
WATER WEIGHT	Factor of 2.5	Factor of 1.0
LENGTH	Longer	Shorter
HEIGHT	Shorter	Higher
OVERFIRE	No	10% to 15% for Short Periods
SPACE	Door Swing and Tube Pull	3'-0" Minimum All Around
ELECTRICAL LOAD	Greater Hp Required	Lower Hp Required
WATER QUALITY	Same	Same
TURN DOWN	10:1 Gas; 8:1 Fuel Oil #2	10:1 Gas; 8:1 Fuel Oil #2
U.L. LABEL	Standard Entire Package	Not Available for Entire Package - Components Only
SOOT BLOWERS	None	Standard Option
ULTIMATE DECISION	Customer Preference	Customer Preference

F. Boiler Efficiency:

- Combustion Efficiency: Indication of the burner's ability to burn fuel measured by the unburned fuel and excess air in the exhaust.
- Thermal Efficiency: Indication of the heat exchanger's effectiveness to transfer heat from the combustion process to the water or steam in a boiler, but does not account for radiation and convection losses.
- 3. Fuel-to-Steam Efficiency: Indication of the overall efficiency of the boiler including effectiveness of the heat exchanger, radiation losses, and convection losses (output divided by input). The test to determine fuel-to-steam efficiency is defined by ASME Power Test Code, PTC 4.1:
 - a. Input-Output Method.
 - b. Heat Loss Method.
- Boiler Efficiency: Indication of either Thermal Efficiency or Fuel-to-Steam Efficiency depending on context.

G. Boiler Plant Efficiency Factors:

- 1. Boiler, 80 to 85% Efficient:
 - a. Radiation Losses.

- b. Convection Losses.
- c. Stack Losses.
- 2. Boiler Room, Steam:
 - a. Heating of Combustion Air.
 - b. Heating of Makeup Water.
 - c. Steam Condensate not returned.
 - d. Boiler Blowdown.
 - e. Radiation Losses:
 - 1) Condensate Tank.
 - 2) Condensate Pump.
 - 3) Feed Water Pump.
 - 4) Deaerator or Feedwater Tank.
- 3. Boiler Room, Hot Water:
 - a. Heating of Combustion Air.
 - b. Radiation Losses:
 - 1) Expansion Tank.
 - 2) Air Separator.
 - 3) Pumps.
- 4. Plant, System:
 - a. Steam Leaks and Bad Steam Traps.
 - b. Piping, Valves, and Equipment Radiation Losses.
 - c. Control Valve Operational Problems.
 - d. Flash Steam Losses.
 - e. Water or Condensate Leaks/Losses.

H. Steam System Energy Saving Tips:

- 1. Insulate all hot surfaces to prevent heat loss.
- 2. Isolate all steam supply piping not being used.
- 3. Repair all steam piping leaks.
- 4. Repair all steam traps not operating properly which are bypassing steam.
- 5. Stop all internal steam leaks including venting of flash steam and open bypass valves around steam traps and control valves.
- 6. Produce clean, dry steam with the use of a steam separator and proper water treatment.
- 7. Properly control steam flow at equipment.
- 8. Use and properly select steam traps.
- 9. Use flash steam for preheating and other used whenever possible.

I. Packaged Boiler Fuel Types:

- 1. Natural Gas.
- 2. Propane.
- 3. Light Fuel Oil #1 and #2.
- 4. Heavy Fuel Oil #4, #5, and #6.
- 5. Digester or Land Fill Gas.

J. Gas Trains:

- 1. U.L., Standard.
- 2. IRI.
- 3. FM.
- 4. Kemper.
- 5. CSD (ASME Control Code).
- 6. NFPA 8501.

K. Boiler Capacity Terminology:

- 1. Start-up Load. Capacity required to bring the boiler system up to temperature, pressure, or both.
- 2. Running Load. Design Capacity
- 3. Maximum Instantaneous Demand (MID). A sudden peak load requirement of unusually short duration:
 - a. MID loads are often hidden in process equipment loads.
 - b. Cold start-up or pickup loads which far exceed their normal operating demands.
 - c. Full understanding of MID loads is required to properly select boiler system capacity.
 - d. MID Shortfall Corrective Actions:
 - 1) Change load reaction time to reduce impact; slow down valve operation, reduce number of items with simultaneous start-up (staged start-up).
 - 2) Add boiler capacity.
 - 3) Add back pressure regulator downstream of deaerator or feed water tank steam supply connection.
 - 4) Add an accumulator.

L. Combustion:

- 1. Improper Combustion:
 - a. Oxygen Rich-Fuel Lean: Wastes Energy.
 - b. Oxygen Lean-Fuel Rich: Produces CO, soot, and potentially hazardous conditions.
- 2. What Affects Combustion?
 - a. Changes in Barometric Pressure.
 - b. Changes in Ambient Air Temperature:
 - 1) Oxygen Trim systems compensate for ambient air temperature changes.
 - c. Ventilation Air:
 - 1) Total:

10 CFM/BHP

3) Ventilation:

2) Combustion Air: 8 CFM/BHP 2 CFM/BHP

- d. Keep boiler room positive with respect to the stack and breeching (+0.10 inches WG maximum). to prevent the entrance of flue gases into the boiler room.
- e. Never exhaust boiler rooms; use supply air with relief air.

M. Stacks and Breeching. Provide a manual damper (lock damper in the open position) or a motorized damper (2-position damper) at the boiler outlet. A motorized damper interlocked with boiler operation is preferred:

- 1. Multiple Boilers with Common Stack and Breeching. Damper will prevent products of combustion from entering the boiler room when repairing or inspecting boilers while system is still in operation.
- 2. Multiple Boilers with Individual or Common Stack and Breeching. Damper will prevent the natural draft through the boiler when not firing, thus reducing the energy lost up the stack.

N. 1990 Clean Air Act-Focused on the reduction of the following pollutants:

- 1. Ozone (O₃).
- 2. Carbon Monoxide (CO).
- 3. Nitrogen Oxides (NO_x NO / NO₂).
- Sulfur Oxides (SO_x − SO₂ / SO₃).
- 5. Particulate Matter, 10 ppm.
- 6. Lead.

O. Standard Controls:

- 1. Steam Boiler Control and Safeties:
 - a. High Limit Pressure Control. Provides a Margin of Safety.
 - b. Operating Limit Pressure Control. Starts/Stops Burner.
 - c. Modulation Pressure Control. Varies Burner Firing Rate.
 - d. Low Limit Pressure Control.
 - e. Low Water Cutoff.
 - f. Auxiliary Low Water Cutoff.
 - g. High Water Cutoff.
- 2. Hot Water Boiler Controls and Safeties:
 - a. High Limit Pressure Control. Provides a Margin of Safety.
 - b. High Limit Temperature Control. Provides a Margin of Safety.
 - c. Operating Limit Temperature Control. Starts/Stops Burner.
 - d. Modulation Temperature Control. Varies Burner Firing Rate.
 - e. Low Limit Pressure Control.
 - f. Low Limit Temperature Control.
 - g. Low Water Flow.
 - h. High Water Flow.
- 3. Fuel System Controls and Safeties:
 - a. Low Gas Pressure Switch.
 - b. High Gas Pressure Switch.
 - c. Low Oil Pressure Switch.
 - d. High Oil Pressure Switch.
 - e. Low Oil Temperature.
- 4. Combustion Controls and Safeties:
 - a. Pilot Failure Switch.
 - b. Flame Failure Switch.
 - c. Combustion Air Proving Switch.
 - d. Oil Atomization Proving Switch.
 - e. Low Fire Hold Control.
 - f. Low Fire Switch.
 - g. High Fire Switch.

P. Safety, Relief, and Safety Relief Valve testing is dictated by the Insurance Underwriter.

20.11 Hot Water Boilers

A. Boiler Types:

- 1. Fire Tube Boilers:
 - a. 15-800 BHP.
 - b. 500-26,780 MBH.
 - c. 30-300 psig.
- 2. Water Tube Boilers:
 - a. 350-2,400 BHP.
 - b. 13,000-82,800 MBH.
 - c. 30-525 psig.
- 3. Flexible Water Tube Boilers:

- a. 30-250 BHP.
- b. 1,000-8,370 MBH.
- c. 0-150 psig.
- 4. Cast Iron Boilers:
 - a. 10-400 BHP.
 - b. 345-13,800 MBH.
 - c. 0-40 psig.
- 5. Modular Boilers:
 - a. 4-115 BHP.
 - b. 136-4,000 MBH.
 - c. 0-150 psig.
- 6. Electric Boilers:
 - a. 15-5,000 KW.
 - b. 51-17,065 MBH.
 - c. 0-300 psig.

B. Hot Water Boiler Plant Equipment:

- 1. Boilers.
- 2. Pumps.
- 3. Air Separators.
- Expansion Tanks.

C. Heating Water:

- 1. Leaving Water Temperature (LWT): 180–200°F.
- 2. 20–40°F. Δ T Most Common.
- 3. Boiler System Design Limits:
 - a. Minimum Flow through a Boiler: 0.5-1.0 GPM/BHP.
 - Maximum Flow through a Boiler: Boiler Capacity divided by the temperature difference divided by 500.
 - c. Pressure Drop through a Boiler: 3 to 5 Feet H₂O.
 - d. Minimum Supply Water Temperature: 170°F. This temperature may vary with boiler design and with manufacturer; verify the exact temperature with the manufacturer.
 - e. Minimum Return Water Temperature: 150°F. This temperature may vary with boiler design and with manufacturer; verify the exact temperature with the manufacturer.
 - f. Maximum Supply Water Temperature: Based on ASME Design Rating of the Boiler.
- 4. Heating Capacities:
 - a. 3.45 GPM/BHP @ 20°F. Δ T.
 - b. 2.30 GPM/BHP @ 30°F. Δ T.
 - c. 1.73 GPM/BHP @ 40°F. Δ T.
 - d. 10.0 GPM/Therm @ 20° F. Δ T.
 - e. 6.7 GPM/Therm @ 30°F. Δ T.
 - f. 5.0 GPM/Therm @ 40°F. Δ T.
 - g. 10,000 Btuh/GPM @ 20°F. Δ T.
 - h. 15,000 Btuh/GPM @ 30°F. Δ T.
 - i. 20,000 Btuh/GPM @ 40°F. Δ T.

D. System Types:

- 1. Low Temperature Heating Water Systems:
 - a. 250°F. and Less.
 - b. 160 psig maximum.
- 2. Medium Temperature Heating Water Systems:

- a. 251-350°F.
- b. 160 psig maximum.
- 3. High Temperature Heating Water Systems:
 - a. 351-450°F.
 - b. 300 psig maximum.

E. Heating Water Storage Systems:

- 1. 20°F. Δ T:
 - a. 0.80 Cu.Ft./MBtu.
 - b. 1246.2 Btu/Cu.Ft.
 - c. 166.6 Btu/Gal.
- 2. 30°F. Δ T:
 - a. 0.54 Cu.Ft./MBtu.
 - b. 1869.3 Btu/Cu.Ft.
 - c. 249.9 Btu/Gal.
- 3. 40°F. Δ T:
 - a. 0.40 Cu.Ft./MBtu.
 - b. 2492.3 Btu/Cu.Ft.
 - c. 333.2 Btu/Gal.
- F. Hot Water System Makeup Connection: Minimum connection size shall be 10% of largest system pipe size or 1", whichever is greater (20" system pipe size results in a 2" makeup water connection).

G. Chemical Feed Systems for Water Boilers. Chemical feed systems are designed to control the following:

- 1. System pH, normally between 8 and 9.
- 2. Corrosion.
- 3. Scale.

H. Design, Layout and Clearance Requirements/Considerations:

- 1. Design Conditions:
 - a. Boiler Load, Btu/Hr, or MBH.
 - b. Heating Water Temperatures, Entering and Leaving or Entering and Δ T.
 - c. Heating Water Flows and Fluid Type (correct all data for fluid type).
 - d. Fuel Input, Gas, Fuel Oil, Electric, etc.
 - e. Overall Boiler Efficiency.
 - f. Water Pressure Drops.
 - g. Fouling Factor.
 - h. Heating Water Reset if Applicable. Verify with boiler manufacturer that temperature limits are not exceeded.
 - i. Electrical Data:
 - 1) Unit KW, Blower Hp, Compressor Hp, and Fuel Oil Pump Hp.
 - 2) Full Load, Running Load, and Locked Rotor Amps.
 - 3) Voltage-Phase-Hertz.
- 2. Multiple hot water boilers should be used to prevent complete system or building shutdown upon failure of 1 hot water boiler in all heating water systems over 70 boiler horse-power or 2,400,000 Btu/Hr. (i.e., 2 @ 50%, 2 @ 67%, 2 @ 70%, 3 @ 34%, 3 @ 40%).
- 3. Show tube clean/pull clearances and location.
- 4. Minimum recommended clearance around boilers is 36 inches. Maintain minimum clearances for tube pull and cleaning of tubes as recommended by the equipment man-

- ufacturer. This is generally equal to the length of the boiler. Maintain minimum clearance as required to open access and control doors on boilers for service, maintenance, and inspection.
- Mechanical room locations and placement must take into account how boilers can be moved into and out of the building during initial installation and after construction for maintenance and repair and/or replacement.
- 6. Maintain minimum electrical clearances as required by NEC.
- 7. Show location of boiler starter, disconnect switch, and control panel.
- 8. Show gas train and/or fuel oil train location.
- 9. Show boiler relief piping.
- 10. Show sanitary drain locations and boiler drain connections.
- 11. Design and locate combustion air louvers and motorized dampers or engineered combustion air system. What happens if engineered combustion air system malfunctions? Is standby available? Verify that items that might freeze are not located in front of combustion air intake.
- 12. Coordinate height of boiler with overhead clearances and obstructions. Is beam required above boiler for lifting components? Is catwalk required to service boiler?
- 13. Boiler stack and breeching. Coordinate routing in boiler room, through building, and discharge height above building with architect and structural engineer.
- 14. If isolators are required for the boiler, has isolator height been considered in clearance requirements? If isolators are required for the boiler, has piping isolation been addressed?
- 15. Provide stop check valves (located closest to the boiler) and isolation valves with a drain between these valves on both the supply and return connections to all heating water boilers.
- 16. Boiler systems pumps should be located so that the pump draws water out of the boiler, because it decreases the potential for entry of air into the system, and it does not impose the pump pressure on the boiler.
- 17. Interlock the boiler and the pump so that the burner cannot operate without the pump operating.
- 18. Boiler warming pumps should be piped to both the system header and to the boiler supply piping, allowing the boiler to be kept warm (in standby mode) from the system water flow or to warm the boiler when is has been out of service for repairs without the risk of shocking the boiler with system water temperature. Boiler warming pumps should be selected for 0.1 gpm/BHP (range 0.05 to 0.1 gpm/BHP). At 0.1 gpm/BHP, it takes 45 to 75 minutes to completely exchange the water in the boiler. This flow rate is sufficient to offset the heat loss by radiation and stack losses on boilers when in standby mode of operation. In addition, this flow rate allows the system to keep the boiler warm without firing the boiler, thus allowing for more efficient system operation. For example, it takes 8 to 16 hours to bring a bring a boiler on-line from a cold start. Therefore, the standby boiler must be kept warm to enable immediate start-up of the boiler upon failure of an operating boiler.
- 19. Circulating hot water through a boiler which is not operating, to keep it hot for standby purposes, creates a natural draft of heated air through the boiler and up the stack, especially in natural draft boilers. Forced draft or induced draft boilers have combustion dampers which close when not firing and therefore reduce, but not eliminate, this heat loss. Although this heat loss is undesirable, for standby boilers, circulating hot water through the boiler is more energy efficient than firing the boiler. Operating (firing) a standby boiler may be in violation of air permit regulations in many jurisdictions today.
- 20. To provide fully automatic heating water system controls, the controls must look at and evaluate the boiler metal temperature (water temperature) and the refractory temperature prior to starting the primary pumps or enabling the boiler to fire. First, the boiler

system design must circulate system water through the boilers to keep the boiler water temperature at system temperature when the boiler is in standby mode, as discussed for boiler warming pump arrangements. Second, the design must look at the water temperature prior to starting the primary pumps to verify that the boiler is ready for service. And third, the design must look at refractory temperature to prevent boiler from going to high fire if the refractory is not at the appropriate temperature. However, the refractory temperature is usually handled by the boiler control package.

- 21. Outside air temperature reset of low temperature heating water systems is recommended for energy savings and controllability of terminal units at low load conditions. However, care must be taken with boiler design to prevent thermal shock by low return water temperatures or to prevent condensation in the boiler due to low supply water temperatures and therefore, lower combustion stack discharge temperature.
- 22. Combustion air dampers must be extra heavy duty and should be low leakage (10 cfm/sq.ft. @ 4"wc differential) or ultralow leakage (6 cfm/sq.ft. @ 4"wc differential) type.
- 23. When the system design requires the use of dual fuel boilers (natural gas, fuel oil), provide a building automation control system I/O point to determine whether the boiler is on natural gas or fuel oil. Boiler control panels generally have a fuel type switch (Gas/Off/Fuel Oil Switch) which can be connected to create this I/O point. Switching from natural gas to fuel oil (or vice versa) cannot be a fully automatic operation, because the boiler operator must first turn boiler burner to the "Off" position, then turn fuel type switch to fuel oil, then put combustion air linkage into fuel oil position, then slide fuel oil nozzle into position, then put fuel oil pump into "Hand" or "Auto" position, and then turn the boiler burner to the "On" position. Remember to interlock the fuel oil pumps with operation of the boiler on fuel oil. Do not forget to include diesel generator interlocks with fuel oil pumps when the generators are fed from the same fuel oil system.
- 24. Heating Water System Warm-Up Procedure:
 - a. Heating water system start-up should not exceed 100°F. temperature rise per hour, but boiler or heat exchanger manufacture limitations should be consulted.
 - b. It is recommended that no more than a 25°F, temperature rise per hour be used when warming heating water systems. Slow warming of the heating water system allows for system piping, supports, hangers, and anchors to keep up with system expansion.
 - c. Low temperature heating water systems (250°F and less) should be warmed slowly at 25°F, temperature rise per hour until system design temperature is reached.
 - d. Medium and high temperature heating water systems (above 250°F) should be warmed slowly at 25°F, temperature rise per hour until 250°F system temperature is reached. At this temperature the system should be permitted to settle for at least 8 hours or more (preferably overnight). The temperature and pressure maintenance time gives the system piping, hangers, supports, and anchors a chance to catch up with the system expansion. After allowing the system to settle, the system can be warmed up to 350°F or system design temperature in 25°F temperature increments and 25 psig pressure increments, semi-alternating between temperature and pressure increases, and allowing the system to settle for an hour before increasing the temperature or pressure to the next increment. When the system reaches 350°F and the design temperature is above 350°F., the system should be allowed to settle for at least 8 hours or more (preferably overnight). The temperature and pressure maintenance time gives the system piping, hangers, supports, and anchors a chance to catch up with the system expansion. After allowing the system to settle, the system can be warmed up to 455°F or system design temperature in 25°F temperature increments and 25 psig pressure increments, semialternating between temperature and pressure increases, and allow the system to settle for an hour before increasing the temperature or pressure to the next increment.

25. Provide heating water systems with warm-up valves for in service start-up as follows. This will allow operators to warm these systems slowly and to prevent a sudden shock or catastrophic system failure when large system valves are opened. Providing warming valves also reduces wear on large system valves when only opened a small amount in an attempt to control system warm-up speed.

Bypass and Warming Valves

MAIN VALVE	NOMINAL PIPE SIZE						
NOMINAL PIPE	SERIES A	SERIES B					
SIZE	WARMING VALVES	BYPASS VALVES					
5 6	1/2 3/4 3/4	1 1-1/4 1-1/4					
8	3/4	1-1/2					
10	1	1-1/2					
12	1	2					
14	1	2					
16	1	3					
18	1	3					
20	1	3					
24	1	4					
30	1	4					
36	1	6					
42	1	6					
48	1	8					
54	1	8					
60	1	10					
72	1	10					
84 96	1 1	12 12					

Notes:

- Series A covers steam service for warming up before the main line is opened and for balancing
 pressures where lines are of limited volume.
- Series B covers lines conveying gases or liquids where bypassing may facilitate the operation of the main valve through balancing the pressures on both sides of the disc or discs thereof. The valves in the larger sizes may be of the bolted on type.
- 26. Heating Water System Warming Valve Procedure:
 - a. First, open warming return valve slowly to pressurize the equipment without flow.
 - b. Once the system pressure has stabilized, then slowly open the warming supply valve to establish flow and to warm the system.
 - c. Once the system pressure and temperature have stabilized, then proceed with the following items listed below, one at a time:
 - 1) Slowly open the main return valve.
 - 2) Close the warming return valve.
 - 3) Slowly open the main supply valve.
 - 4) Close the warming supply valve.

20.12 Steam Boilers

A. Boiler Types:

- 1. Fire Tube Boilers:
 - a. 15-800 BHP.
 - b. 518-27,600 Lb./Hr.
 - c. 15-300 psig.
- 2. Water Tube Boilers:
 - a. 350-2,400 BHP.
 - b. 12,075-82,800 Lb./Hr.
 - c. 15-525 psig.
- 3. Flexible Water Tube Boilers:
 - a. 30-250 BHP.
 - b. 10,000-82,000 Lb./Hr.
 - c. 15-525 psig.
- 4. Cast Iron Boilers:
 - a. 10-400 BHP.
 - b. 1,035-8,625 Lb./Hr.
 - c. 0-150 psig.
- 5. Electric Boilers:
 - a. 15-5,000 KW.
 - b. 51-17,065 MBH.
 - c. 0-300 psig.

B. Steam Boiler Plant Equipment:

- 1. Pretreatment Systems:
 - a. Filters.
 - b. Softeners.
 - c. Dealkalizers.
 - d. RO Units.
- 2. Feed Water Systems:
 - a. Deaerator:
 - 1) Spray Type.
 - 2) Packed Column Type.
 - b. Feedwater Tank.
 - c. Feedwater Pumps.
- 3. Chemical Feed Systems:
 - a. Chemical Pumps.
 - b. Chemical Tanks.
 - c. Agitators.
- 4. Sample Coolers.
- 5. Blowdown Coolers.
- 6. Surface Blowdown/Feed Water Preheater.
- 7. Flue Gas Economizers.
- 8. Boilers.
- 9. Condensate Return Units and Pumps.
- 10. Condensate Receiver Tank.
- 11. Condensate Pumps.
- 12. Accululators:

- a. Type:
 - 1) Dry.
 - 2) Wet.
- b. Service:
 - 1) Total System.
 - 2) Dedicated Lines to Specific Equipment.
- 13. Super Heaters:
 - a. Internal.
 - b. External.

C. Steam Capacities:

- 1. Approx. 1,000 Btuh/1 Lb. Steam.
- 2. Lb. Steam/Hr. = Lb. Water/Hr.

Steam Capacity per Boiler Horsepower

FEED WATER TEMP.		POUNDS OF DRY SATURATED STEAM PER BOILER HP @ SYSTEM PRESSURE (PSIG) VERSUS FEEDWATER TEMPERATURE (°F.)																
	0	2	10	15	20	40	50	60	80	100	120	140	150	160	180	200	220	240
30	29.0	29.0	28.8	28.7	28.6	28.4	28.3	28.2	28.2	28.1	28.0	28.0	27.9	27.9	27.9	27.9	27.9	27.8
40	29.3	29.2	29.1	29.0	28.9	28.7	28.6	28.5	28.4	28.3	28.2	28.2	28.2	28.2	28.2	28.1	28.1	28.
50	29.6	29.5	29.3	29.2	29.1	28.9	28.8	28.8	28.7	28.6	28.5	28.5	28.4	28.4	28.4	28.3	28.3	28.
60	29.8	29.8	29.6	29.5	29.4	29.2	29.1	29.0	28.9	28.8	28.8	28.7	28.7	28.7	28.6	28.6	28.6	28.:
70	30.1	30.0	29.9	29.8	29.7	29.5	29.4	29.3	29.2	29.1	29.0	29.0	28.9	28.9	28.9	28.8	28.8	28.
80	30.4	30.3	30.1	30.0	30.0	29.8	29.6	29.6	29.5	29.3	29.2	29.2	29.2	29.2	29.1	29.1	29.1	29.0
90	30.6	30.6	30.4	30.3	30.2	30.0	29.9	29.8	29.7	29.6	29.5	29.5	29.4	29.4	29.4	29.3	29.3	29.
100	30.9	30.8	30.6	30.6	30.5	30.3	30.2	30.1	30.0	29.8	29.8	29.8	29.7	29.7	29.7	29.6	29.6	29.
110	31.2	31.2	30.9	30.8	30.8	30.6	30.4	30.3	30.2	30.0	30.0	30.0	30.0	30.0	29.9	29.9	29.9	29.
120	31.5	31.4	31.2	31.2	31.1	30.8	30.7	30.6	30.5	30.4	30.3	30.3	30.2	30.2	30.2	30.1	30.1	30.
130	31.8	31.7	31.5	31.4	31.4	31.1	31.0	30.9	30.8	30.7	30.6	30.6	30.5	30.5	30.4	30.4	30.4	30.
140	32.1	32.0	31.8	31.7	31.6	31.4	31.3	31.2	31.1	31.0	30.9	30.8	30.8	30.8	30.8	30.7	30.7	30.
150	32.4	32.4	32.1	32.0	31.9	31.7	31.6	31.5	31.4	31.2	31.2	31.2	31.1	31.1	31.0	31.0	30.9	30.
160	32.7	32.7	32.4	32.4	32.3	32.0	31.9	31.8	31.7	31.5	31.4	31.4	31.4	31.4	31.3	31.3	31.2	31.
170	33.0	33.0	32.7	32.6	32.6	32.3	32.2	32.1	32.0	31.8	31.7	31.7	31.7	31.7	31.6	31.6	31.5	31.
180	33.4	33.3	33.0	33.0	32.9	32.6	32.5	32.4	32.3	32.2	32.1	32.0	32.0	32.0	31.9	31.9	31.8	31.
190	33.8	33.7	33.4	33.3	33.2	32.9	32.8	32.7	32.6	32.5	32.4	32.4	32.3	32.3	32.2	32.2	32.1	32.
200	34.1	34.0	33.7	33.6	33.5	33.2	33.1	33.0	32.9	32.8	32.7	32.6	32.6	32.6	32.6	32.5	32.4	32.
212	34.5	34.4	34.2	34.1	33.9	33.6	33.5	33.4	33.3	33.2	33.1	33.0	33.0	33.0	32.9	32.9	32.8	32.
220	34.8	34.7	34.4	34.3	34.2	33.9	33.8	33.7	33.5	33.4	33.3	33.3	33.2	33.2	33.1	33.1	33.1	33.
227	35.0	34.9	34.7	34.5	34.4	34.1	34.0	33.9	33.8	33.7	33.6	33.5	33.5	33.4	33.4	33.3	33.3	33.
230	35.2	35.0	34.8	34.7	34.5	34.2	34.1	34.0	33.9	33.8	33.7	33.6	33.6	33.5	33.5	33.4	33.4	33.

D. Steam Boiler Drums:

- 1. Top Drum: Steam Drum.
- 2. Bottom Drum: Mud or Blowdown Drum.

E. System Types:

- 1. Low Pressure Steam:
- 0-15 psig

2. Medium Pressure Steam: 16-100 psig

3. High Pressure Steam: 101 psig and greater

F. Steam Carryover:

- 1. Steam carryover is the entrainment of boiler water with the steam.
- 2. Causes of Carryover:
 - a. Mechanical:
 - 1) Poor Boiler Design.
 - 2) Burner Misalignment.
 - 3) High Water Level.
 - b. Chemical:
 - 1) High Total Dissolved Solids (TDS).
 - 2) High Total Suspended Solids (TSS).
 - 3) High Alkalinity.
 - 4) High Amine Levels.
 - 5) Presence of Oils or Other Organic Materials.
- 3. Problems Caused by Carryover:
 - Deposits minerals on valves, piping, heat transfer surfaces and other steam using equipment.
 - b. Causes thermal shock to system.
 - c. Contaminates process or products which have direct steam contact.
 - d. If steam is used for humidification, a white dust is often left on air handling unit components, ductwork surfaces, and furniture and other equipment within the space.
- 4. Carryover Control:
 - a. Install steam separation devices.
 - b. Maintain proper steam space in steam drum and boiler.
 - c. Maintain proper water chemistry—TDS, TSS, alkalinity, etc.

G. Design, Layout, and Clearance Requirements/Considerations:

- 1. Design Conditions:
 - a. Boiler Load: Btu/Hr, or MBH.
 - b. Steam Pressure and Flow Rate.
 - c. Fuel Input: Gas, Fuel Oil, Electric, etc.
 - d. Overall Boiler Efficiency.
 - e. Fouling Factor.
 - f. Electrical Data:
 - 1) Unit KW, Blower Hp, Compressor Hp, and Fuel Oil Pump Hp.
 - 2) Full Load, Running Load and Locked Rotor Amps.
 - 3) Voltage-Phase-Hertz.
- 2. Multiple steam boilers should be used to prevent complete system or building shut down upon failure of 1 steam boiler in all steam systems over 70 boiler horsepower or 2,400,000 Btu/Hr. (i.e., 2 @ 50%, 2 @ 67%, 2 @ 70%, 3 @ 34%, 3 @ 40%).
- 3. Show tube clean/pull clearances and location.
- 4. Minimum recommended clearance around boilers is 36 inches. Maintain minimum clearances for tube pull and cleaning of tubes as recommended by the equipment manufacturer. This is generally equal to the length of the boiler. Maintain minimum clearance as required to open access and control doors on boilers for service, maintenance, and inspection.
- Mechanical room locations and placement must take into account how boilers can be moved into and out of the building during initial installation and after construction for maintenance and repair and/or replacement.

- 6. Maintain minimum electrical clearances as required by NEC.
- 7. Show location of boiler starter, disconnect switch, and control panel.
- 8. Show gas train and/or fuel oil train location.
- 9. Show boiler relief piping.
- 10. Show sanitary drain locations and boiler drain connections.
- 11. Design and locate combustion air louvers and motorized dampers or engineered combustion air system. What happens if engineered combustion air system malfunctions? Is standby available? Verify that items that might freeze are not located in front of combustion air intake.
- 12. Coordinate height of boiler with overhead clearances and obstructions. Is beam required above boiler for lifting components? Is catwalk required to service boiler?
- 13. Boiler stack and breeching. Coordinate routing in boiler room, through building, and discharge height above building with architect and structural engineer.
- 14. Provide stop check valve (located closest to the boiler) and isolation valve with a drain between these valves on the steam supply connections to all steam boilers.
- 15. Combustion air dampers must be extra heavy duty and should be low leakage (10 CFM/sq.ft. @ 4"wc differential) or ultralow leakage (6 CFM/sq.ft. @ 4"wc differential) type.
- 16. When the system design requires the use of dual fuel boilers (natural gas, fuel oil), provide a building automation control system I/O point to determine whether the boiler is on natural gas or fuel oil. Boiler control panels generally have a fuel type switch (Gas/Off/Fuel Oil Switch) which can be connected to create this I/O point. Switching from natural gas to fuel oil (or vice versa) cannot be a fully automatic operation, because the boiler operator must first turn boiler burner to the "Off" position, then turn fuel type switch to fuel oil, then put combustion air linkage into fuel oil position, then slide fuel oil nozzle into position, then put fuel oil pump into "Hand" or "Auto" position, and then turn the boiler burner to the "On" position. Remember to interlock the fuel oil pumps with operation of the boiler on fuel oil. Do not forget to include diesel generator interlocks with fuel oil pumps when the generators are fed from the same fuel oil system.
- 17. Steam System Warm-Up Procedure:
 - a. Steam system start-up should not exceed 100°F, temperature rise per hour (50 psig per hour); boiler or heat exchanger manufacture limitations should be consulted.
 - b. It is recommended that no more than a 25°F. temperature rise per hour (15 psig per hour) be used when warming steam systems. Slow warming of the steam system allows for system piping, supports, hangers, and anchors to keep up with system expansion.
 - c. Low pressure steam systems (15 psig and less) should be warmed slowly at 25°F. temperature rise per hour (15 psig per hour) until system design pressure is reached.
 - d. Medium and high pressure steam systems (above 15 psig) should be warmed slowly at 25°F. temperature rise per hour (15 psig per hour) until 250°F-15 psig system temperature-pressure is reached. At this temperature-pressure the system should be permitted to settle for at least 8 hours or more (preferably overnight). The temperature-pressure maintenance time gives the system piping, hangers, supports, and anchors a chance to catch up with the system expansion. After allowing the system to settle, the system can be warmed up to 120 psig or system design pressure in 25 psig pressure increments, and allow the system to settle for an hour before increasing the pressure to the next increment. When the system reaches 120 psig and the design pressure is above 120 psig, the system should be allowed to settle for at least 8 hours or more (preferably overnight). The pressure maintenance time gives the system piping, hangers, supports, and anchors a chance to catch up with the system expansion. After allowing the system to settle, the system can be warmed up to 300 psig or system design pressure in 25 psig pressure increments, and allow the system to settle for an hour before increasing the pressure to the next increment.

18. Provide steam systems with warm-up valves for in service start-up as shown in the following table. This will allow operators to warm these systems slowly and to prevent a sudden shock or catastrophic system failure when large system valves are opened. Providing warming valves also reduces wear on large system valves when only opened a small amount in an attempt to control system warm-up speed.

Bypass and Warming Valves

MAIN VALVE	NOMINAL PIPE SIZE				
NOMINAL PIPE	SERIES A	SERIES B			
SIZE	WARMING VALVES	BYPASS VALVES			
4	1/2	1			
5	3/4	1-1/4			
6	3/4	1-1/4			
8	3/4	1-1/2			
10	1	1-1/2			
12	1	2			
14	1	2			
16	1	3			
18	1	3			
20	1	3			
24	1	4			
30	1	4			
36	1	6			
42	1	6			
48	1	8			
54	1	8			
60	1	10			
72	1	10			
84	1	12			
96	1	12			

Notes:

- Series A covers steam service for warming up before the main line is opened, and for balancing
 pressures where lines are of limited volume.
- Series B covers lines conveying gases or liquids where bypassing may facilitate the operation of the main valve through balancing the pressures on both sides of the disc or discs thereof. The valves in the larger sizes may be of the bolted on type.
- 19. Steam System Warming Valve Procedure:
 - a. Slowly open the warming supply valve to establish flow and to warm the system.
 - b. Once the system pressure and temperature have stabilized, then proceed with the following items listed below, one at a time:
 - 1) Slowly open the main supply valve.
 - 2) Close the warming supply valve.
- 20. If isolators are required for the boiler, has isolator height been considered in clearance requirements? If isolators are required for the boiler, has piping isolation been addressed?

H. Low Water Cutoffs:

- 1. Primary: Float Type.
- 2. Auxiliary: Probe Type.

- 3. Low Water Cutoffs should be tested by Evaporation Test:
 - a. Take boiler to low fire.
 - b. Shut off feed water to boiler.
 - c. Operate boiler until low water cutoff shuts down boiler or water level in gauge glass falls below low water cutoff activation point, but still remains visible in glass.
 - d. Conduct evaporation test at least every 30 days; recommend once a week.
- 4. Class I Boilers. Low water cutoff is 3" above top row of tubes in fire tube boilers.
- 5. Class IV Boilers. Low water cutoff is 0" to 1/4" above top row of tubes in fire tube boilers.
- 6. WATER SHOULD ALWAYS BE VISIBLE IN GAUGE GLASS.

IF WATER IS NOT VISIBLE IN GAUGE GLASS, IMMEDIATELY FOLLOW THE TWO STEPS BELOW ONE AFTER ANOTHER IN ANY ORDER:

SHUT OFF BOILER BURNER.

SHUT OFF BOILER FEED WATER.

THEN ALLOW BOILER TO COOL AND INSPECT FOR DAMAGE.

I. Deaerator or Feedwater Tank:

- The deaerator or the feedwater tank purpose is to remove oxygen, carbon dioxide, hydrogen sulfide, and other non-condensable gases and to heat boiler feedwater.
- They also preheat the feed water prior to being pumped to the boiler. Cold feed water temperatures may cause:
 - a. Thermal Shock.
 - b. Oxygen Rich Feed Water, which causes corrosion.
- 3. This equipment should remove oxygen in the water to levels measured in parts per billion (ppb).
- 4. Steam Vent on the Deaerator or Feedwater Tank. Steam should appear 12" to 18" above top of vent. If steam appears below 12", the Deaerator or Feedwater Tank are not removing all the oxygen, carbon dioxide, hydrogen sulfide, and other non-condensable gases.
- 5. Deaerators should be used when:
 - a. System pressure is 75 psig and higher.
 - b. Steam systems with little or no standby capacity.
 - c. System depends on continuous operation.
 - d. System requires 25% or more of makeup water.

J. Sizing Boiler Feed Pumps, Condensate Return Pumps, and Condensate Receivers:

- 1. If boiler is under 50 psi, size boiler feed pumps or condensate return pumps to discharge at 5 psi above working pressure.
- 2. If boiler is over 50 psi, size boiler feed pumps or condensate return pumps to discharge at 10 psi above working pressure.
- 3. Size condensate receivers for 1 minute net capacity based on return rate.
- 4. Size boiler feedwater system receivers for system capacity (normally estimated at 10 minutes):
 - a. Deaerator Systems: 10 minute supply.
 - b. Feedwater Tank Systems: 15 minute supply.
- 5. Size condensate pumps at 3 times the condensate return rate.
- 6. Size boiler feedwater pumps and transfer pumps at:
 - a. Turbine Pumps, Intermittent Operation: 2 times boiler maximum evaporation rate or 0.14 GPM per Boiler Hp.
 - b. Centrifugal Pumps, Continuous Operation: 1.5 times boiler maximum evaporation rate or 0.104 GPM per Boiler Hp.
 - c. Boiler Feed Water and Transfer Pump Selection Criteria:

- 1) Continuous or Intermittent Operation.
- 2) Temperature of Feed Water or Condensate.
- 3) Flow Capacity (GPM).
- 4) Discharge Pressure Required: Boiler Pressure Plus Piping Friction Loss.
- 5) NPSH Requirement.
- 7. Boiler Feedwater Control Types:
 - a. On/Off feedwater control is generally used with single boiler systems or in multiple boiler systems when one feedwater pump is dedicated to each boiler and is typically accomplished with a turbine pump.
 - b. Level control is generally used with multiple boiler systems where feedwater pumps serve more than one boiler and is typically accomplished with a centrifugal pump.
- 8. Vacuum Type Steam Condensate Return Units: 0.1 GPM/1,000 Lbs./Hr. of connected load
- 9. Pumped Steam Condensate Return Units: 2.4 GPM/1,000 Lbs./Hr.

K. Boiler Blowdown Systems:

- Bottom Blowdown. Bottom blowdown, sometimes referred to as manual blowdown, functions to remove suspended solids and sediment that have settled out of the water and deposited on the bottom of the boiler. Bottom blowdown is most effective with several short discharges in lieu of one long discharge, because the solids settle out between discharges; this results in the greatest removal of suspended solids with least amount of water.
- 2. Surface Blowdown. Surface blowdown, sometimes referred to as automatic blowdown, continuous blowdown, or periodic blowdown, depending on how the blowdown is controlled, functions to remove dissolved solids, surface water scum, and foam to maintain proper conductivity levels:
 - a. Automatic:
 - 1) Conductivity Probe.
 - 2) Timer.
 - b. Continuous.
 - c. Periodic (manual) by Time.

L. Boiler Blowdown Separator Makeup:

- 1. Non-continuous blowdown (bottom blowdown): 5.0 GPM/1,000 Lbs./Hr.
- 2. Continuous blowdown (surface blowdown): 0.5 GPM/1,000 Lbs./Hr.

M. Blowdown Separator Drains: 10 GPM/1000 Lbs./Hr Boiler Output.

N. Steam Boiler Water Makeup:

- 1. Boilers: 4.0 GPM/1,000 Lbs./Hr. Each.
- 2. Deaerator/Feed Water Unit: 4.0 GPM/1,000 Lbs./Hr. Each.
- 3. Makeup water for the steam system is only required at one of the boilers or one of the feed water units at any given time, for system sizing.

O. Chemical Feed Systems for Steam Boilers. Chemical feed systems are designed to control the following:

- 1. System pH, normally between 8 and 9.
- 2. Oxygen Level, less than 0.007 PPM (7 ppb).
- 3. Water Conditioning Level.
- 4. Carbon Dioxide Level.
- 5. Scale.
- 6. Corrosion.

20.13 Makeup Water Requirements

A. Hot Water System Makeup Connection: Minimum connection size shall be 10% of largest system pipe size or 1", whichever is greater (20" system pipe size results in a 2" makeup water connection).

B. Chilled Water System Makeup Connection: Minimum connection size shall be 10% of largest system pipe size or 1", whichever is greater (20" system pipe size results in a 2" makeup water connection).

C. Condenser Water Makeup to Cooling Tower:

 1. Centrifugal:
 40 GPM/1,000 Tons

 2. Reciprocating:
 40 GPM/1,000 Tons

 3. Screw Chillers:
 40 GPM/1,000 Tons

 4. Absorption Chillers:
 80 GPM/1,000 Tons

D. Cooling Tower Blowdown and Drains:

- 1. Drains: Use 2 times the makeup water rate for sizing cooling tower drains.
- 2. Blowdown:

a. Centrifugal: 10 GPM/1,000 Tons
 b. Reciprocating: 10 GPM/1,000 Tons
 c. Screw: 10 GPM/1,000 Tons
 d. Absorption: 20 GPM/1,000 Tons

E. Steam Boiler Water Makeup:

1. Boilers: 4.0 GPM/1,000 Lbs./Hr. Each

2. Deaerator/Feed Water Unit: 4.0 GPM/1,000 Lbs./Hr. Each

Makeup water for the steam system is only required at one of the boilers or one of the feed water units at any given time, for system sizing.

F. Boiler Blowdown Separator Makeup:

Non-continuous blowdown (bottom blowdown):
 GPM/1,000 Lbs./Hr.
 GPM/1,000 Lbs./Hr.
 GPM/1,000 Lbs./Hr.

G. Blowdown Separator Drains: 10 GPM/1,000 Lbs./Hr Boiler Output.

H. Vacuum Type Steam Condensate Return Units: 0.1 GPM/1,000 Lbs./Hr.

of connected load

I. Pumped Steam Condensate Return Units: 2.4 GPM/1,000 Lbs./Hr.

J. Humidifiers:

1. Steam Humidifiers: 5.6 GPM/1,000 KW Input or 5.6 GPM/3413 MBH
2. Electric Humidifiers: 5.6 GPM/1,000 KW Input or 5.6 GPM/3413 MBH

Evaporative Humidifiers: 5.0 GPM/1,000 Lbs./Hr.
 Spray Coil Humidifiers: 5.0 GPM/1,000 Lbs./Hr.

K. Air Conditioning Condensate:

1. Unitary Packaged AC Equipment: 0.006 GPM/Ton

Air Handling Units (100% outside Air): 0.100 GPM/1,000 CFM
 Air Handling Units (50% Outdoor Air): 0.065 GPM/1,000 CFM
 Air Handling Units (25% Outdoor Air): 0.048 GPM/1,000 CFM

5. Air Handling Units (15% Outdoor Air): 0.041 GPM/1,000 CFM6. Air Handling Units (0% Outdoor Air): 0.030 GPM/1,000 CFM

20.14 Water Treatment and Chemical Feed Systems

A. General:

- 1. Water Treatment Objectives:
 - a. Prevent hard scale and soft sludge deposits.
 - b. Prevent corrosion and pitting.
 - c. Protect boiler, piping, and equipment metal chemistry.
 - d. Prevent steam carryover.
- 2. Corrosion and Scale/Deposit Control Factors:
 - a. pH Level: As the pH of the system water increases (moves toward the alkaline side of the scale), the corrosiveness of the water decreases. However, as the pH of the system water increases, the formation of scale increases. Normal pH range is 6.5 to 9. A typical pH range is 7.8 to 8.8. (Acid pH = 1; Neutral pH = 7; Alkaline pH = 14.)
 - b. Hardness: As the hardness of the system water increases, the corrosiveness of the water decreases. However, as the hardness of the system water increases, the formation of scale increases.
 - c. Temperature: As the temperature of the system water increases, the corrosiveness of the water increases. In addition, as the temperature of the system water increases, the formation of scale increases. Corrosion rates double for every 20°F increase in water temperature.
 - d. Foulants: The more scale-forming material and foulants in the system water, the greater the chances of scale and deposit formation. Foulants include calcium, magnesium, biological growth (algae, fungi, and bacteria), dirt, silt, clays, organic contaminants (oils), silica, iron, and corrosion by-products.
- 3. Water Treatment Limits:
 - a. Oxygen: Less than 0.007 ppm (7 ppb).
 - b. Hardness: Less than 5.0 ppm.
 - c. Suspended Matter: Less than 0.15 ppm.
 - d. pH: 8 to 9.
 - e. Silicas: Less than 150 ppm.
 - f. Total Alkalinity: Less than 700 ppm.
 - g. Dissolved Solids: Less than 7,000 µmho/cm.
- 4. Water Source Comparison:
 - a. Surface Water:
 - 1) High in Suspended Solids.
 - 2) High in Dissolved Gases.
 - 3) Low in Dissolved Solids.
 - b. Well Water:
 - 1) High in Dissolved Solids.
 - 2) Low in Suspended Solids.
 - 3) Low in Dissolved Gases.
- 5. Suspended Solids:
 - a. Dirt.
 - b. Silt.
 - c. Biological Growth.
 - d. Vegetation.
 - e. Insoluble Organic Matter.

- f. Undissolved Matter.
- g. Iron.
- 6. Hardness measures the amount of calcium and magnesium in the water.
- 7. Alkalinity measures the water's ability to neutralize strong acid.
- 8. Scale is the result of precipitation of hardness salts on heat exchange surfaces.
- 9. Corrosion is the dissolving or wearing away of metals:
 - a. General Corrosion. General corrosion is caused by acidic conditions.
 - Under-Deposit Corrosion. Under-deposit corrosion is caused by foreign matter resting on a metal surface.
 - c. Erosion. Erosion is caused by turbulent water flow.
 - d. Pitting Corrosion. Pitting corrosion is caused by the presence of oxygen.
 - e. Galvanic Corrosion. Galvanic corrosion is a electrochemical reaction between dissimilar metals.
- 10. Problems Caused by Poor Water Quality:
 - a. Scale and Deposits.
 - b. Decreased Efficiency/Heat Transfer.
 - c. Equipment Failure/Unscheduled Shutdowns.
 - d. Corrosion.
 - e. Tube Burnout or Fouling.
 - f. Carryover in Steam Systems.
- 11. Chemical Types:
 - a. Scale Inhibitors. Scale inhibitors prevent scale formation:
 - 1) Phosphonate.
 - 2) Polyacrylate.
 - 3) Polymethacrylate.
 - 4) Polyphosphate.
 - 5) Polymaleic Acid.
 - 6) Sulfuric Acid.
 - b. Biocides. Biocides prevent biological growth.
 - 1) Oxidizing:
 - a) Chlorine. Most Common.
 - b) Chlorine Dioxide.
 - c) Bromine. Most Common.
 - d) Ozone.
 - 2) Non-Oxidizing:
 - a) Carbamate. Most Common.
 - b) Organo-Bromide.
 - c) Methylenebis-Thiocyanate.
 - d) Isothiazoline.
 - e) Quartarnary Ammonium Salts.
 - f) Organo-Tin/Quaternary Ammonium Salts.
 - g) Glutaraldehyde.
 - h) Dodecylguanidine.
 - i) Triazine.
 - j) Thiocynates.
 - k) Quartarnary Ammonium Metalics.
 - 3) Biocide treatment program should include alternate use of oxidizing and non-oxidizing biocides for maximum effectiveness; see following table:

BIOCIDE	EFFECT	IVENESS AG	AINST	0000	
BIOCIDE	BACTERIA FUNGI		ALGAE	COMMENTS	
Oxidizing Biocides					
Chlorine (Cl ₂)	Е	G	G	Usable pH range 5 to 8 Effective at neutral pH (pH = 7) Less effective at high pH Reacts with -NH, groups	
Chlorine Dioxide (ClO ₂)	E .	G	G	Insensitive to pH levels Insensitive to presence of -NH ₂ groups	
Bromine	Е	G	P	Usable pH range 5 to 10 Effective over broad pH range Substitute for chlorine	
Ozone	Е	G	G	pH range 7 to 9	
Non-Oxidizing Biocides	4.2 %				
Carbamate	Е	Е	G	pH range of 5 to 9 Good in high suspended solids systems In-compatible with chromate treatment programs	
Organo-Bromide (DBNPA)	Е	P	P	pH range 6 to 8.5	
Methylenebis- Thiocyanate (MBT)	Е	P	P	Decomposes above a pH of 8	
Isothiazoline	Е	G	G	Insensitive to pH levels Deactivated by HS and -NH ₂ groups	
Quaternary Ammonium Salts	Е	G	G	Tendency to foam Surface active Ineffective in organic-fouled systems	
Organo-Tin/ Quaternary Ammonia Salts	Е	G	Е	Tendency to foam Functions best in alkaline pH	
Glutaraldehyde	Е	Е	G	Effective over broad pH range Deactivated by -NH ₂ groups	
Dodecylguanidine (DGH)	Е	Е	G	pH range of 6 to 9	
Triazine	N	N	Е	pH range of 6 to 9 Specific for algae control Must be used with other biocides	

Notes.

- 1. Table Abbreviations:
 - E = Excellent Biocide Control.
 - G = Good Biocide Control.
 - P = Poor Biocide Control.
 - N = No Biocide Control.
 - c. Corrosion Inhibitors. Corrosion inhibitors prevent corrosion:
 - 1) Molybdate. Most common and most effective.
 - 2) Nitrite. Most common.
 - 3) Aromatic Azoles.
 - 4) Chromate.
 - 5) Polyphosphate.
 - 6) Zinc.
 - 7) Orthophosphate.
 - 8) Benzotriazole. Copper Corrosion Inhibitor.
 - 9) Tolyltriazole. Copper Corrosion Inhibitor.
 - 10) Silicate. Copper and Steel Corrosion Inhibitor.

- d. Dispersants. Dispersants prevent suspended and dissolved solids from settling out or forming scale in the system, remove existing deposits, and enhance biocide effectiveness:
 - 1) Polyacrylate.
 - 2) Polymethacrylate.
 - 3) Polymaleic Acid.
 - 4) Surfactants.
- 12. Corrosion monitoring is recommended with the use of corrosion coupons for closed and open hydronic systems.
- 13. Side stream filtration is recommended to maintain system cleanliness. Filters should be sized to filter the entire volume of the system 3 to 5 times per day.

B. Closed System Chemical Treatment (Chilled Water Systems, Heating Water Systems):

- 1. Chemical treatment objective is to prevent and control:
 - a. Scale Formation.
 - b. Corrosion. Major concern.
 - c. System pH. Between 8 and 9.
- 2. Chemical Types Used in Closed Systems.
 - a. Scale Inhibitors.
 - b. Corrosion Inhibitors.
 - c. Dispersants.
- 3. Most Common Chemicals Used:
 - a. Molybdate.
 - b. Nitritite Based Inhibitors.
- 4. Water analysis should be conducted at least once a year, preferably semiannually or quarterly, depending on system water losses.

C. Open System Chemical Treatment (Condenser Water Systems):

- 1. Chemical treatment objective is to prevent and control:
 - a. Scale Formation.
 - b. Fouling:
 - 1) Particulate Matter.
 - 2) Biological Growth.
 - c. Corrosion.
 - d. System pH. Between 8 and 9.
- 2. Chemical Types Used in Open Systems:
 - a. Scale Inhibitors.
 - b. Biocides.
 - c. Corrosion Inhibitors.
 - d. Dispersants.
- 3. Makeup water analysis should be conducted at least twice a year, preferably quarterly.
- 4. System water analysis should be conducted at least once a week.

D. Steam Systems:

- 1. Chemical treatment objective is to prevent and control:
 - a. Scale Formation.
 - b. Corrosion. Major concern.
 - c. System pH. Between 8 and 9.
- 2. Chemical Types Used in Steam Systems:
 - a. Scale Inhibitors.

- b. Corrosion Inhibitors.
- c. Dispersants.
- 3. Steam Boiler System Water Treatment Equipment:
 - a. Pre-Treatment: Most Effective Way to Control Steam Boiler Chemical Treatment Issues:
 - 1) Softeners.
 - 2) Filters.
 - 3) Dealkalizers.
 - 4) RO Units.
 - b. Pre-Boiler: Feed Water System Treatment (Deaerator, Feed Water Tank):
 - An oxygen scavenger should be injected into the storage tank. Injection into the storage tank is the ideal location. It provides the maximum reaction time and protects feedwater tank, pumps, and piping.
 - An oxygen scavenger can be injected into the feed water line, but is not recommended.
 - 3) Oxygen Scavenger Chemicals (see following table):
 - a) Sodium Sulfite. Low and Medium Pressure Systems.
 - b) Hydrazine. Medium and High Pressure Systems.

OXYGEN SCAVENGER	FEED WATER LEVELS	BOILER LEVELS		
Sodium Sulfite	10 to 15 ppm	30 to 60 ppm		
Hydrazine	0.05 to 0.1 ppm	0.1 to 0.2 ppm		

- c. Boiler: Organic Treatment Program:
 - Scale control chemicals should be injected directly into the boiler; however, they
 may be injected into the feedwater tank or feed water line.
 - 2) Polymers. Most common.
 - 3) Phosphonate.
- d. After-Boiler: Steam and Condensate Pipe Treatment:
 - 1) Amines:
 - a) Neutralizing Amines. Neutralize carbonic acid; may be injected into the boiler or steam header.
 - b) Filming Amines. Injected into the steam header.
 - 2) Injection Location:
 - a) Steam Header. Best Location.
 - b) Boiler.
 - c) Feed Water. Worst Location; Not Recommended.
 - d) These chemical can be injected anywhere along the steam piping for better localized protection, especially in long piping runs.
- 4. Chemical Feed Methods:
 - a. Shot Feed or Batch Process. Not Recommended.
 - b. Continuous:
 - 1) Manual Control:
 - a) Continuous.
 - b) Clock Timer.
 - c) Percent Timer.

- 2) Automated Control:
 - a) Activated with Feed Water Pump.
 - b) Activated with Makeup Water Flow Control.
 - c) Activated with Burner Control.
- 5. Makeup water analysis should be conducted at least twice a year, preferably quarterly.
- 6. System water analysis should be conducted at least once a week.

20.15 Fuel Systems and Types

A. Fuel System Design Guidelines:

- 1. Natural Gas Pressure Reducing Valves (NGPRV):
 - a. Use multiple NGPRVs when system natural gas capacity exceeds 2" NGPRV size, when normal operation calls for 10% of design load for sustained periods, or when there are two distinct load requirements (i.e., summer/winter) which are substantially different. Provide the number of NGPRVs to suit the project:
 - If system capacity for a single NGPRV exceeds 2" NGPRV size but is not larger than 4" NGPRV size, use 2 NGPRVs with 33% and 67% or 50% and 50% capacity split.
 - 2) If system capacity for a single NGPRV exceeds 4" NGPRV size, use 3 NGPRVs with 25%, 25%, and 50% or 15%, 35%, and 50% capacity split to suit project.
 - b. Provide natural gas pressure regulating valves with positive shutoff ability to prevent building natural gas system from becoming equal to gas utility system pressure when the building natural gas system is not using gas.
- 2. Natural gas meters should be provided as follows:
 - a. Coordinate equipment, building, or site meter requirements with local utility company. If project budget permits, these meter readings should be logged and recorded at the building facilities management and control system.
 - Meter for a Campus or Site of Buildings. A site meter is generally provided by the utility company.
 - c. Meter for Individual Buildings on a Campus. If fed from site meter, design documents should provide a meter for each building. This meter will assist in tracking energy use at each building and for troubleshooting system problems.
 - d. Meter for Individual Buildings. A building meter will generally be provided by the utility company.
 - e. Meters for Individual Boilers. A meter should be provided by the design documents for each and every boiler; environmental air permit requirements require natural gas to be monitored at each boiler.
 - f. Meters for Other Major Users. A meter should be provided by the design documents for each major user within the building (emergency generators, gas fired AHUs, domestic water heaters, unit heaters, kitchens).
- 3. Boiler fuel oil pump flow rates and generator day tank pump flow rates are generally 2.5 to 3.0 times the boiler and generator consumption rates. Confirm with the manufacture or the electrical engineer that the information received is the consumption rate of the boiler/generator or fuel oil pumping rate of the boiler/generator. When boilers are located above the fuel oil tanks, a method of preventing back siphoning through the return line must be provided. This may be accomplished by providing the return line with a pressure regulator or with an operated valve interlocked with the fuel oil pump. Also, the fuel oil pumps must be provided with a check valve in the discharge, or if large height differentials are required, a motorized discharge isolation valve interlocked with the pump may be required because check valves will leak.
- 4. Fuel oil meters should be provided as follows:

- a. If the fuel oil system is a circulating system with a fuel oil return line, meters must be provided in both the supply and return to determine fuel oil consumed. Most manufacturers provide fuel oil meters with this capability with controls and software to automatically calculate fuel oil consumed. If project budget permits, these meter readings should be logged and recorded at the building facilities management and control system. All fuel oil meters must be shown on the design documents. Environmental regulations require the fuel oil purchased verses fuel oil consumed be recorded and tracked for determining when leaks may be occurring in the system.
- b. Meter for each Group of Site Distribution Pumps located at the pumps.
- c. Meter for individual buildings on a Campus located at each building. This meter will assist in tracking energy use at each building and for troubleshooting system problems.
- d. Meters for Individual Boilers. A meter should be provided for each and every boiler; environmental air permit requirements require fuel oil to be monitored at each boiler.
- e. Meters for Other Major Users. A meter should be provided for each major user within the building (emergency generators, gas fired AHUs, domestic water heaters, unit heaters).

B. Natural Gas:

- 1. 900-1200 Btu/Cu.Ft.
- 2. 1,000 Btu/Cu.Ft. Average.

C. Fuel Oil:

- 1. #2: 138,000 Btu/Gal.
- 2. #4: 141,000 Btu/Gal.
- 3. #5: 148,000 Btu/Gal.
- 4. #6: 152,000 Btu/Gal.

D. LP Gas:

- 1. Butane:
 - a. 21,180 Btu/Lb.
 - b. 3,200 Btu/Cu.Ft.
- 2. Propane:
 - a. 21,560 Btu/Lb.
 - b. 2,500 Btu/Cu.FT.

E. Electric:

- 1. 3,413 Btuh/KW.
- 2. 3.413 Btuh/watt.

F. Coal:

- 1. Anthracite: 14,600-14,800 Btu/Lb.
- 2. Bituminous: 13,500-15,300 Btu/Lb.

G. Wood:

1. 8,000-10,000 Btu/Lb.

H. Kerosine:

1. 135,000 Btu/Gal.

20.16 Automatic Controls

A. Control Design Guidelines:

- 2-way control valves should be installed upstream of equipment so that equipment is not subject to pump pressures.
- Proportional Band. Throttling range over which the regulating device travels from fully closed to fully open.
- 3. Drift or Offset. Difference between the set point and the actual control point.
- 4. Rangeability. Ratio of maximum free area when fully open to the minimum free area.
- 5. Bypass valves should be plug valves, ball valves, or a butterfly valves.
- Control valves in HVAC systems should be the equal percentage type for output control, because equal percentage control valve flow characteristics are opposite of coil capacity characteristics.
 - a. Do not oversize control valves; most control valves are at least one to two sizes smaller than the pipe size.
 - b. The greater the resistance at design flow the better the controllability.
 - c. Control Valve Pressure Drop:
 - 1) Minimum Control Valve Pressure Drop: 5% of total system pressure drop.
 - 2) Preferred Control Valve Pressure Drop: 10 to 15% of total system pressure drop.
 - 3) Maximum Control Valve Pressure Drop: 25% of total system pressure drop.
 - d. When specifying control valves include:
 - 1) Maximum design flow.
 - 2) Minimum design flow.
 - 3) Internal pressure.
 - 4) Pressure drop at design flow.
 - 5) Pressure drop at minimum flow.

7. 2-Way Control Valves:

a. 2-way control valves should be selected for a resistance of 20 to 25 percent of the total system resistance at the valve location. This results in selecting the control valves for the available head at each location requiring a different pressure drop for each valve in direct return systems. In reverse return systems, control valves may be selected with equal pressure drop requirements. If control valves are selected for the pressure drop at each location, balancing valves are not required for external balancing of systems unless the pressure differential at the control valve location becomes excessive. Variable volume systems will be self-balancing.

8. 3-Way Control Valves:

- a. 3-way control valves exhibit linear control characteristics which are not suited for output control at terminal units.
- b. If 3-way control action is desired to maintain minimum flow requirements, use 2 opposed-acting, equal percentage, 2-way valves. A balancing valve must be installed in the bypass adjusted to equal the coil pressure drop. Operate valves sequentially in lieu of simultaneously, because if both valves are operated simultaneously, significant flow variations may occur.
- c. The 3-way valve pressure drop should be greater than the pressure drop (up to twice the pressure drop) of the coil it serves with a balancing valve in the bypass. The bypass valve pressure drop should be adjusted to equal to the coil pressure drop. A balancing valve or flow control device should be installed in the return downstream of the 3-way valve.
- 9. Do not use On/Off type control valves, except for small line sizes (1 inch and smaller).
- 10. Provide a fine mesh strainer ahead of each control valves to protect the control valve.

B. Control Definitions: Control definitions listed below were taken from the *Honeywell Control Manual* listed in Part 2:

- Algorithm: A calculation method that produces a control output by operating on an error signal or a time series of error signals. Operational logic effected by a control system usually resident in controlled hardware or software.
- 2. Amplifiers: Amplifiers condition the control signal, including linearization, and raise it to a level adequate for transmission and use by controllers.
- 3. Analog: Continuously variable (i.e., mercury thermometer, clock, faucet controlling water from closed to open).
- 4. Authority: The effect of the secondary transmitter versus the effect of the primary transmitter.
- 5. Automatic Control System: A system that reacts to a change or imbalance in the variable it controls by adjusting other variables to restore the system to the desired balance.
- 6. Binary: A distinct variable, a noncontinuous variable (i.e., digital clock, digital thermometer, digital radio dial) also related to computer systems and the binary numbering system (base 2).
- 7. Closed Loop Control System: Sensor is directly affected by the action of the controlled device, system feedback.
- 8. Contactors: Similar to relays, but are made with much greater current carrying capacity. Used in devices with high power requirements.
- 9. Controls: As related to HVAC, three elements are necessary to govern the operation of HVAC systems:
 - a. Sensor: A device or component that measures the value of the variable (i.e., temperature, pressure, humidity).
 - b. Controller: A device that senses changes in the controlled variable, internally or remotely, and derives the proper corrective action and output to be taken (i.e., receiver/controller, DDC panel, thermostat).
 - c. Controlled Device: That portion of the HVAC system that effects the controlled variable (i.e., actuator, damper, valve).
- 10. Control Action: Affect on a control device to create a response.
- 11. Controlled Agent: The medium in which the manipulated variable exists (i.e., steam, hot water, chilled water).
- 12. Controlled Medium: The medium in which the controlled variable exists (i.e., the air within the space).
- 13. Controlled Variable: The quantity or condition that is measured and controlled (i.e., temperature, flow, pressure, humidity, three states of matter).
- 14. Control Point: Actual value of the controlled variable (set point plus or minus set point).
- 15. Corrective Action: Control action that results in a change of the manipulated variable.
- 16. Cycle: One complete execution of a repeatable process.
- 17. Cycling: A periodic change in the controlled variable from one value to another. Uncontrolled cycling is called "hunting."
- 18. Cycling Rate: The number of cycles completed per unit time, typically cycles per hour.
- 19. Dampers: Dampers are mechanical devices used to control airflow:
 - a. Quick Opening: Maximum flow is approached as the damper begins to open.
 - b. Linear: Opening and flow are related in direct proportion.
 - c. Equal Percentage: Each equal increment of opening increases flow by an equal percentage over the previous value.
 - d. Opposed Blade: Balancing, mixing, and modulating control applications. Half of the blades rotate in one direction, while the other half rotate in the other direction:
 - 1) At low pressure drops opposed blade dampers tend to be equal percentage.
 - 2) At moderate pressure drops opposed blade dampers tend to be linear.

- 3) At high pressure drops opposed blade dampers tend to be quick opening.
- e. Parallel Blade: 2-position control applications. All the blades rotate in a parallel or in the same direction:
 - 1) At low pressure drops parallel blade dampers tend to be linear.
 - 2) At high pressure drops parallel blade dampers tend to be quick opening.
- 20. Deadband: A range of the controlled variable in which no corrective action is taken by the controlled system and no energy is used.
- 21. Discriminator: A device which accepts a large number of inputs (up to twenty) and selects the appropriate output signal (averaging relay, high relay, low relay).
- 22. Deviation: The difference between the set point and the value of the controlled variable at any moment. Also called offset.
- 23. DDC: Direct Digital Control.
- 24. Differential: The difference between the turn-on signal and the turn-off signal.
- 25. Digital: Series of On and Off pulses arranged to carry messages (i.e., digital radio and TV dials, digital clock, computers).
- 26. Digital Control: A control loop in which a microprocessor based controller directly controls equipment based on sensor inputs and set point parameters. The programmed control sequence determines the output to the equipment.
- 27. Direct Acting: Controller is direct acting when an increase in the level of the sensor signal results in an increase in the level of the controller output.
- 28. Droop: A sustained deviation between the control point and the set point in a 2-position control system caused by a change in the heating or cooling.
- Dry Bulb Control: Control of the HVAC system based on outside air dry bulb temperature (sensible heat).
- 30. Electric Control: A control circuit that operates on line or low voltage and uses a mechanical means, such as temperature-sensitive bimetal or bellows, to perform control functions
- 31. Electronic Control: A control circuit that operates on low voltage and uses solid state components to amplify input signals and perform control functions.
- 32. Enthalpy Control: Control of the HVAC system based on outside air enthalpy (total heat).
- 33. Fail Closed: Position device will assume when system fails (i.e., fire dampers fail closed).
- 34. Fail Open: Position device will assume when system fails (i.e., present coil valves fail open).
- 35. Fail Last Position: Position device will assume when system fails (i.e., process coding water valve fails in last position).
- 36. Final Control Element: A device such as a valve or damper that acts to change the value of the manipulated variable (i.e., controlled device).
- 37. Floating Action: Dead spot or neutral zone in which the controller sends no signal but allows the device to float in a partly open position.
- 38. Gain: Proportion of control signal to throttling range.
- 39. In Control: Control point lies within the throttling range.
- 40. Interlocks: Devices which connect HVAC equipment so that operation is interrelated and systems function as a whole.
- 41. Lag: A delay in the effect of a changed condition at one point in the system, or some other condition to which it is related. Also, the delay in response of the sensing element of a control due to the time required for the sensing element to sense a change in the sensed variable.
- 42. Lead/Lag: A control method in which the selection of the primary and secondary piece of equipment is obtained and alternated to limit and equalize wear on the equipment.
- 43. Manipulated Variable: The quantity or condition regulated by the automatic control system to cause desired change in the controlled variable.
- 44. Measured Variable: A variable that is measured and may be controlled.

- 45. Microprocessor Based Control: A control circuit the operates on low voltage and uses a microprocessor to perform logic and control functions. Electronic devices are primarily used as sensors. The controller often furnishes flexible DDC and energy management control routines.
- 46. Modulating Action: The output of the controller can vary infinitely over the range of the controller.
- 47. Modulating Range: Amount of change in the controlled variable required to run the actuator of the controlled device from one end of its stroke to the other.
- 48. Motor Starters: Electromechanical device which utilizes the principle of electromagnetism to start and stop electric motors, often containing solenoid coil actuators, relays, and overload protective devices.
- 49. Normally Closed: The position the device will assume when the control signal is removed (position of device in box prior to installation).
- 50. Normally Open: The position the device will assume when the control signal is removed (position of device in box prior to installation).
- 51. Offset: The difference between the control point and the set point.
- 52. On/Off Control: A simple 2-position control system in which the device being controlled is either full On or full Off with no intermediate operating positions available.
- 53. Open Loop Control System: Sensor is not directly affected by the action of the controlled device; no system feedback.
- 54. Out of Control: Control point lies outside of the throttling range.
- 55. Pigtail: A loop put in a sensing device to prevent the element from experiencing temperature or pressure extremes.
- 56. Pneumatic Control: A control circuit that operates on air pressure and uses a mechanical means, such as temperature sensitive bimetal or bellows, to perform control functions.
- 57. Proportional Control: A control algorithm or method in which the final control element moves to a position proportional to the deviation of the value of the controlled variable from the set point. Cyclical control (sine/cosine).
- 58. Proportional-Integral (PI) Control: A control algorithm that combines the proportional (proportional response) and integral (reset response) control algorithms. Cyclical control but automatically narrows the band between upper and lower points. Use most common in commercial building applications.
- 59. Proportional-Integral-Derivative (PID) Control: A control algorithm than enhances the PI control algorithm by adding a component that is proportional to the rate of change (derivative) of the deviation of the controlled variable. Compensates for system dynamics and allows faster control response. Cyclical control, but automatically narrows the band between upper and lower points and also calculates time between peak high and peak low and adjusts accordingly. Use most common in industrial applications.
- 60. Relays: An electromagnetic device for remote or automatic control actuated by variation in conditions of an electric circuit and operating in turn other devices (as switches) in the same or different circuit. Carry low-level control voltages and currents.
- 61. Reverse Acting: Controller is reverse acting when an increase in the level of the sensor signal results in a decrease in the level of the controller output.
- 62. Sensing Element: A device or component that measures the value of the variable.
- 63. Sensitivity: Proportion of control signal to throttling range.
- 64. Set Point: Desired value of the controlled variable (usually in the middle of the throttling range).
- 65. Snubber: Put on a sensing device to prevent sporadic fluctuations from reaching the sensing device.
- 66. Step Control: Control method in which a multiple-switch assembly sequentially switches equipment as the controller input varies through the proportional band.

- 67. Time Delay Relays: Relays which provide a delay between the time the coil is energized and the time the contactors open and/or close.
- 68. Thermistor: A solid state device in which resistance varies with temperature.
- 69. Throttling Action: Amount of change in the controlled variable required to run the actuator of the controlled device from one end of its stroke to the other.
- 70. Throttling Range: Amount of change in the controlled variable required to run the actuator of the controlled device from one end of its stroke to the other. Also referred to as proportional band.
- 71. Transducers: Device which changes a pneumatic signal to an electric signal or vice versa. Pneumatic-Electric (PE) or Electric-Pneumatic (EP) switches (2-position transducer or analog to analog).
- 72. Turndown Ratio: The minimum flow or capacity of a piece of equipment expressed as a ratio of maximum flow/capacity to minimum flow/capacity. The higher the ratio, the better the control.
- 73. 2-Position Control: Control system in which the device being controlled is either full On or full Off with no intermediate operating positions available (On/Off; open/closed; also called On/Off control).
- 74. Valves: Valves are mechanical devices used to control flow of steam, water, gas and other fluids:
 - a. 2-Way: Temperature Control, Modulate Flow to Controlled Device, Variable Flow System.
 - b. 3-Way Mixing: Temperature Control, Modulate Flow to Controlled Device, Constant Flow System; 2 inlets and 1 outlet.
 - c. 3-Way Diverting: Used to Divert Flow; generally cannot modulate flow—2 position;
 1 inlet and 2 outlets.
 - d. Quick Opening Control Valves: Quick opening control valves produce wide free port area with relatively small percentage of total valve stem stroke. Maximum flow is approached as the valve begins to open.
 - e. Linear Control Valves: Linear control valves produce free port areas that are directly related to valve stem stroke. Opening and flow are related in direct proportion.
 - f. Equal Percentage Control Valves: Equal percentage control valves produce an equal percentage increase in the free port area with each equal increment of valve stem stroke. Each equal increment of opening increases flow by an equal percentage over the previous value (most common HVAC control valve).
 - g. Control valves are normally smaller than line size unless used in 2-position applications (open/closed).
 - h. Control valves should normally be sized to provide 20 to 60% of the total system pressure drop:
 - Water system control valves should be selected with a pressure drop equal to 2–3 times the pressure drop of the controlled device.

OR

Water system control valves should be selected with a pressure drop equal to 10 Ft. or the pressure drop of the controlled device whichever is greater.

OR

Water system control valves for constant flow systems should be sized to provide 25% of the total system pressure drop.

OR

Water system control valves for variable flow systems should be sized to provide 10% of the total system pressure drop or 50% of the total available system pressure.

2) Steam control valves should be selected with a pressure drop equal to 75% of inlet steam pressure.

C. Types of Control Systems:

- 1. Pneumatic:
 - a. Safe.
 - b. Reliable.
 - c. Proportional.
 - d. Inexpensive.
 - e. Fully modulating or 2-position in nature.
 - f. Seasonal calibration required.
 - g. If there are more than a couple dozen control devices in a building, then pneumatic controls would be less expensive than electric or electronic controls.
 - h. Widely used in commercial, institutional and industrial facilities.
 - i. Pneumatic control system pressure signals:
 - 1) Typical Heating: 0-7 psi.
 - 2) Typical Cooling: 8-15 psi.
 - 3) Max. System Pressure: 30 psi.
 - j. Compressor run time should be ½ to ½ the operating time.

2. Electric:

- a. Simple control systems.
- b. Used on small HVAC systems.
- c. Mostly used for starting and stopping equipment.
- d. Electric control system signals:
 - 1) 120 volts and less AC or DC.
 - 2) Typically 120 volts or 24 volts.

3. Electronic:

- a. Used widely in pre-packaged control systems.
- b. Fully modulating in nature.
- c. Reasonably inexpensive.
- d. Electronic control system signals:
 - 1) 24 volts or less AC or DC.
 - 2) Typical voltage signal range of 0 to 10 volts.
 - 3) Typical amperage signal range of 4 to 20 milliamps.
- 4. Direct Digital Control (DDC):
 - a. Computerized control.
 - b. Fully modulating, start/stop and staged control.
 - c. Faster and more accurate than all other control systems.
 - d. Control systems can be adapted and changed to suit field conditions. Very flexible.
 - e. Able to communicate measured, control, input and output data over a network.
 - f. Fairly expensive.
 - g. Often DDC systems use DDC Controllers and pneumatic actuators to operate valves, dampers and other devices.
 - h. DDC system signals:
 - 1) Typical voltage signal range of 0 to 10 volts DC.
 - 2) Typical amperage signal range of 4 to 20 milliamps.

D. Control System Objectives:

- 1. Define Control Functions:
 - a. Start/Stop.
 - b. Occupied/Unoccupied/Preparatory.
 - c. Fan Capacity Control:
 - 1) Variable Speed Drives.
 - 2) Inlet Vanes.

- 3) Two-Speed Motors.
- 4) Discharge Dampers.
- 5) Scroll Volume Control.
- 6) SA, RA, RFA Fan Tracking.
- d. Pump Capacity Control:
 - 1) Variable Speed Drives.
 - 2) Two-Speed Motors.
 - 3) Variable Flow Pumping Systems (2-Way Control Valves).
- e. Damper Control (OA, RA, RFA, Inlet Vanes).
- f. Valve Control (2-way, 3-way).
- g. Temperature.
- h. Humidity.
- i. Pressure.
- j. Flow.
- k. Temperature Reset (SA, Water).
- l. Terminal Unit Control (room, discharge, sub-master).
- m. Modulate, sequence, cycling.
- 2. Define Interlock Functions:
 - a. Fans/AHUs.
 - b. Pumps/Boilers/Chillers.
 - c. Smoke Control System Interlocks.
- 3. Define Safety Functions:
 - a. Fire.
 - b. Smoke.
 - c. Freeze Protection.
 - d. Low/High pressure limit.
 - e. Low/High temperature limit.
 - f. Low/High water.
 - g. Low/High flow.
 - h. Over/Under electrical current.
 - i. Vibration.
- 4. Alarm Functions (most often safety alarms).
- 5. Typical Control Algorithms:
 - a. Occupied/Unoccupied/Preparatory (Time of Day Scheduling).
 - b. Night/Weekend/Holiday (Time of Day/Week/Year Scheduling).
 - c. AHU Dry-Bulb Economizer.
 - d. AHU Enthalpy Economizer.
 - e. Boiler OA Reset.
 - f. AHU Discharge Air Control.
 - g. AHU Discharge Air Control with Room Reset.
 - h. AHU VAV Pressure Independent.
 - i. AHU VAV Pressure Dependent.
 - j. Chiller Discharge Water Reset.
 - k. Daylight Savings Time Adjustments.
 - 1. Electrical Demand Limiting.
 - m. Start/Stop Optimization.
 - n. Duty Cycle.
 - o. Enthalpy Optimization.
 - p. Smoke Control.
 - q. Trending.

- r. Alarm Instructions.
- s. Maintenance Work Order.
- t. Run Time Totalizing.

E. Types of Controls:

- Operating Controls: Operating controls are used to control a device, system, or entire facility in accordance with the needs of the device, system or facility.
- 2. Safety Controls: Safety controls are used to protect the device, system, or facility from damage should some operating characteristic get out of control; to prevent catastrophic failure of the device or system; and to prevent harm to the occupants of the facility. Most safety controls come in the form of high or low limits:
 - a. Automatic reset.
 - b. Manual reset.
- Operator Interaction Controls: Controls in which the building occupant would normally be provided with to activate various HVAC equipment devices or systems.

F. Building Automation and Control Networks (BACnet):

- BACnet is a communication protocol. A communication protocol is a set of rules governing the exchange of data between two computers. A protocol encompasses both hardware and software specifications including the following:
 - a. Physical medium.
 - b. Rules for controlling access to the medium.
 - c. Mechanics for addressing and routing messages.
 - d. Procedures for error recovery.
 - e. The specific formats for the data being exchanged.
 - f. The contents of the messages.
- The BACnet goal is to enable building automation and control devices from different manufactures to communicate.
- 3. BACnet Data Structures:
 - a. Analog Input.
 - b. Analog Output.
 - c. Analog Value.
 - d. Binary Input.
 - e. Binary Output.
 - f. Binary Value.
 - g. Calendar: Represents a list of dates that have special meaning when scheduling the operation of mechanical equipment.
 - h. Command.
 - Device: Contains general information about a particular piece of mechanical equipment (i.e., model, location).
 - j. Device Table: Shorthand reference to a list of devices.
 - k. Directory: Provide information on how to access other objects.
 - l. Event Enrollment: Provides a way to define alarms or other types of events.
 - m. File.
 - n. Group: Shorthand method to access a number of values in one request.
 - o. Loop: Represents a feedback control loop (PID).
 - p. Mailbox.
 - q. Multi-State Input.
 - r. Multi-State Output.

- s. Program.
- t. Schedule.
- 4. BACnet Object Properties:
 - a. Object Identifier.
 - b. Object Type.
 - c. Present Value.
 - d. Description.
 - e. Status Flags.
 - f. Reliability.
 - g. Override.
 - h. Out-of-Service.
 - i. Polarity.
 - j. Inadactive Text.
 - k. Active Text.
 - l. Change-of-State Time.
 - m. Elapsed Active Time.
 - n. Change-of-State Count.
 - o. Time of Reset.
- 5. BACnet Applications:
 - a. Alarm and Event Services.
 - b. File Access Services (Read, Write).
 - c. Object Access Services (Add, Create, Delete, Read, Remove, Write).
 - d. Remove Device Management Services.
 - e. Virtual Terminal Services (Open, Close, Data).
- 6. BACnet Conformance Classes:
 - a. Class 1. Class 1 devices are the lowest level in BACnet system structure and consist of smart sensors.
 - b. Class 2. Class 2 devices consist of smart actuators.
 - c. Class 3. Class 3 devices consist of unitary controllers.
 - d. Class 4. Class 4 devices consist of general purpose local controllers.
 - e. Class 5. Class 5 devices consist of operator interface controllers.
 - f. Class 6. Class 6 devices are the highest level in BACnet system structure and consist of head-end computers.
- 7. BACnet Functional Groups:
 - a. Clock.
 - b. Hand-Held Workstation.
 - c. Personal Computer Workstation.
 - d. Event Initiation.
 - e. Event Response.
 - f. Files.
 - g. Reinitialize.
 - h. Virtual Operator Interface.
 - i. Virtual Terminal.
 - j. Router.
 - k. Device Communications.
 - l. Time Master.

Auxiliary Equipment

21.01 Fans

A. Fan Types and Size Range are shown in the following table:

FAN TYPE	WHEEL\DRIVE TYPE	SP In.W.G.	WHEEL DIA.In.	CFM	Нр
Utility Sets	FC/B BI/B FC/D	0 - 3 0 - 4 0 - 2.5	8 - 36 10 - 36 6 - 12	200 - 27,500 250 - 27,500 100 - 3,500	1/6 - 30 1/6 - 30 1/6 - 3
Centrifugal	SWSI-BI/B	0 - 12	10 - 73	600 - 123,000	1/3 - 200
	DWDI-BI/B	0 - 12	12 - 73	1,300 - 225,000	1/3 - 400
	SWSI-AF/B	0 - 14	18 - 120	1,400 - 447,000	1/3 - 1500
	DWDI-AF/B	0 - 14	18 - 120	2,400 - 804,000	3/4 - 2500
Tubular Centrifugal	BI/B	0 - 9	10 - 108	450 - 332,000	1/3 - 750
Vane	/B	0 - 5	18 - 72	1,400 - 115,000	1/3 - 100
Axial	/D	0 - 4	18 - 60	1,200 - 148,000	1/3 - 150
TubeAxial	/B	0 - 1.5	12 - 60	900 - 76,000	1/3 - 25
	/D	0 - 1	18 - 48	2,600 - 48,000	1/4 - 15
Propeller	/B	0 - 1	20 - 72	400 - 80,000	1/4 - 15
	/D	0 - 1	8 - 48	50 - 49,000	1/6 - 10
Roof	BI/B	0 - 1.25	7 - 54	100 - 34,000	1/4 - 7.5
Ventilator	BI/D	0 - 1	6 - 18	75 - 3,200	1/8 - 3/4
RoofUpblast	BI/B	0 - 1.25	9 - 48	200 - 26,000	1/4 - 5
	BI/D	0 - 1.25	9 - 14	300 - 3,100	1/8 - 1
Sidewall	BI/B	0 - 1.25	14 - 24	850 - 8,200	1/4 - 2
	BI/D	0 - 1	6 - 18	80 - 4,000	1/8 - 3/4
Inline	BI/B	0 - 2.25	7 - 36	60 - 22,600	1/4 - 10
Centrifugal	BI/D	0 - 1.75	6 - 16	60 - 5,100	1/8 - 2

Notes:

FC: Forward Curved BI: Backward Inclined

B: Belt Drive D: Direct Drive

AF: Backward Inclined Airfoil DWDI: Double Width, Double Inlet SWSI: Single Width, Single Inlet

B. Fan Construction Classes are shown in the following table:

FAN CLASS	MAXIMUM TOTAL PRESSURE	
I	3-3/4" W.G.	
П	6-3/4" W.G.	
III	12-3/4" W.G.	
IV	Over 12-3/4" W.G.	

C. Fan Selection Criteria:

- Fan to be catalog rated for 15% greater static pressure (SP) than specified SP at specified volume.
- 2. Select fan so that specified volume is greater than at the apex of the fan curve.
- Select fan to provide stable operation down to 85% of design volume operating at required speed for the specified conditions.
- 4. Specified SP at specified air flow.
- 5. Consider system effects. Fans are tested with open inlets and a length of straight duct on discharge. When field conditions differ from test configuration, performance is reduced. Therefore fan must be selected at slightly higher pressure to obtain desired results.
- 6. Parallel Fan Operation: At equal static pressure, CFM is additive.
- 7. Series Fan Operation: At equal CFM, static pressure is additive.
- Every attempt should be made to have 1.0 to 1.5 diameters of straight duct on the discharge of the fan as a minimum.
- 9. There should be a minimum of 1.0 diameter of straight duct between fan inlet and an elbow. In plenum installations there should be a minimum of 0.75 of the wheel diameter between the fan inlet and the plenum wall.

D. Fan Terms:

- 1. Centrifugal: Flow within the fan is substantially radial to the shaft.
- 2. Axial: Flow within the fan is substantially parallel to the shaft.
- 3. Static Pressure: Static pressure is the compressive pressure that exists in a confined airstream. Static pressure is a measure of potential energy available to produce flow and to maintain flow against resistance. Static pressure is exerted in all directions and can be positive or negative (vacuum).
- 4. Velocity Pressure: Velocity pressure is the measure of the kinetic energy resulting from the fluid flow. Velocity pressure is exerted in the direction of fluid flow. Velocity pressure is always positive.
- Total Pressure: Total pressure is the measure of the total energy of the airstream. Total pressure is equal to static pressure plus velocity pressure. Total pressure can be either positive or negative.
- 6. Quantity of Airflow: Volume measurement expressed in Cubic Feet per Minute (CFM).
- 7. Fan Outlet Velocity: Fan airflow divided by the fan outlet area.
- 8. Fan Velocity Pressure: Fan velocity pressure is derived by converting fan velocity to velocity pressure.
- 9. Fan Total Pressure: Fan total pressure is equal to the fan's outlet total pressure minus the fan's inlet total pressure.
- 10. Fan Static Pressure: Fan static pressure is equal to fan's total pressure minus the fan's velocity pressure. Numerically it is equal to the fan's outlet static pressure minus the fan's inlet total pressure.
- 11. Fan Horsepower: Theoretical calculation of horsepower assuming there are no losses.
- 12. Break Horsepower (BHP): Break horsepower is the actual power required to drive the fan.
- 13. System Effect: System effect is the reduced fan performance of manufacturer's fan catalog data due to the difference between field installed conditions and laboratory test conditions (precisely defined inlet and outlet ductwork geometry assuring uniform entrance and exit velocities).
 - a. Maintain a minimum of 3 duct diameters of straight duct upstream and downstream of fan inlet and outlet at 2,500 feet per minute (FPM) duct velocity or less. 1 additional duct diameter should be added for each 1,000 FPM above 2,500 fpm.
 - b. Recommend maintaining a minimum of 5 duct diameters of straight duct upstream and downstream of fan inlet and outlet at 2,500 feet per minute (FPM) duct velocity

- or less. 1 additional duct diameter should be added for each 1,000 FPM above 2,500 FPM.
- c. System effect may require a range of 3 to 20 duct diameters of straight duct upstream and downstream of fan inlet and outlet.

E. AMCA Spark Resistant Construction:

- Type A. All parts of the fan in contact with the airstream must be made of non-ferrous material.
- 2. Type B. The fan shall have a non-ferrous impeller and non-ferrous ring about the opening through which the shaft passes. Ferrous hubs, shafts, and hardware are allowed if construction is such that a shift of the impeller or shaft will not permit two ferrous parts of the fan to rub or strike.
- 3. Type C. The fan must be so constructed that a shift of the wheel will not permit two ferrous part of the fan to rub or strike.

F. Centrifugal Fans:

- 1. Forward Curved Fan (FC):
 - a. FC fans have a peak static pressure curve corresponding to the region of maximum efficiency, slightly to the right. Best efficiency at low or medium pressure (0 to 5 in. w.g.)
 - b. BHP is minimum at no delivery and increases continuously with increasing flow, with maximum BHP occurring at free delivery.
 - c. They have a steep pressure volume performance curve; therefore, a slight change in pressure will not greatly effect CFM.
 - d. Fan blades curve toward direction of rotation.
 - e. Advantages:
 - 1) Low cost. Less expensive than BC, BI, or AF fans.
 - 2) Low speed (400 to 1,200 RPM) minimizes shaft and bearing sizes.
 - 3) Large operating range: 30-80% wide open CFM.
 - 4) Highest Efficiency occurs: 40-50% wide open CFM.
 - f. Disadvantages:
 - 1) Possibility of paralleling in multiple fan applications.
 - 2) Possibility of overloading.
 - Weak structurally: Not capable of high speeds necessary for developing high static pressures.
 - g. Used primarily in low to medium pressure HVAC applications: central station air handling units; rooftop units, packaged units, residential furnaces.
 - h. High CFM, Low Static Pressure.
- 2. Backward Inclined (BI) and Backward Curved (BC) Fans:
 - a. BC fans have a peak static pressure curve which occurs to the left of the maximum static efficiency. Best efficiency at medium pressure (3.5 to 5.0 in. w.g.).
 - b. BHP increases to a maximum then decreases. They are non-overloading fans.
 - c. They have a steep pressure volume performance curve; therefore, a slight change in pressure will not greatly effect CFM.
 - d. Fan operates at high speeds—1,200 to 2,400 RPM—about double that of FC fans for similar air quantity.
 - e. Blades curve away from or incline from direction of rotation.
 - f. BI fans are less expensive than BC fans but do not have as great a range of high efficiency operation.
 - g. Advantages:
 - 1) Higher Efficiencies.

- 2) Highest Efficiency occurs: 50-60% wide open CFM.
- 3) Good pressure characteristics.
- 4) Stronger structural design makes it suitable for higher static pressures.
- 5) Non-overloading power characteristics.

h. Disadvantages:

- 1) Higher speeds require larger shaft and bearings.
- 2) Has larger surge area than forward curved fan.
- 3) Operating range 40 to 80% of wide open CFM.
- 4) Can be noisier.
- 5) More expensive than FC fans.
- Used primarily in large HVAC applications where power savings are significant. Can be used in low, medium, and high pressure systems.

3. Airfoil Fans (AF):

- a. AF fans have a peak static pressure curve which occurs to the left of the maximum static efficiency.
- b. BHP increases to a maximum then decreases. They are non-overloading fans. Best efficiency at medium pressure (4.0 to 8.0 in. w.g.).
- c. They have a steep pressure volume performance curve; therefore, a slight change in pressure will not greatly effect CFM.
- d. Fan operates at high speeds—1,200 to 2,800 RPM—about double that of FC fans for similar air quantity.
- e. Blades have an aerodynamic shape similar to an airplane wing and are backwardly curved (away from direction of rotation).

f. Advantages:

- 1) Higher Efficiencies.
- 2) Highest Efficiency occurs: 50-60% wide open CFM.
- 3) Good pressure characteristics.
- 4) Stronger structural design makes it suitable for higher static pressures.
- 5) Non-overloading power characteristics.

g. Disadvantages:

- 1) Higher speeds require larger shaft and bearings.
- 2) Has larger surge area than forward curved fan.
- 3) Operating range 40 to 80% of wide open CFM.
- 4) Can be noisier.
- 5) Most expensive centrifugal fan.
- h. Used primarily in large HVAC applications where power savings are significant. Can be used in low, medium, and high pressure systems.
- Airfoil blade fans have slightly higher efficiency and surge area is slightly larger than backward inclined or backward curved fans.

4. Radial (RA) Fans:

- a. Radial fans have self-cleaning blades.
- Fan horsepower increases with increase in air quantity (overloads) while static pressure decreases.
- c. RA fans operate at high speed and pressure—2,000 to 3,000 RPM.
- d. Blades radiate from center along radius of fan.
- Used in industrial applications to transport dust, particles, or materials handling. Not commonly used in HVAC applications.

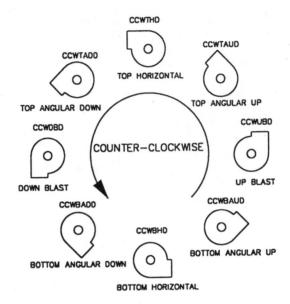

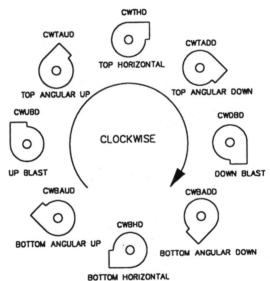

1. DIRECTION OF ROTATION IS DETERMINED FROM DRIVE SIDE OF FAN
2. ON SINGLE INLET FANS, THE DRIVE SIDE OF THE FAN IS ALWAYS CONSIDERED THE SIDE OPPOSITE THE FAN

INLET.

3. ON DOUBLE INLET FANS, WHEN THE DRIVES ARE ON BOTH SIDES OF THE FAN, THE DRIVE SIDE OF THE FAN IS THE SIDE HAVING THE HIGHER HORSEPOWER DRIVING UNIT.

4. DIRECTION OF DISCHARGE IS DETERMINED IN ACCORDANCE WITH THE DIAGRAMS. ANGULAR DISCHARGE IS REFERENCED TO THE HORIZONTAL AXIS OF THE FAN AND DESIGNATED IN DEGREES ABOVE OR BELOW THIS REFERENCE

5. FANS INVERTED FOR CEILING SUSPENSION, OR SIDE WALL MOUNTING, DIRECTION OF ROTATION AND DISCHARGE IS DETERMINED WHEN FAN IS RESTING ON THE FLOOR.

FAN ROTATION AND DISCHARGE POSITIONS

ARRANGEMENT #8 SWSI

FOR BELT DRIVE OR DIRECT DRIVE CONNECTIONS, IMPELLER OVERHUNG, TWO BEARINGS ON BASE, EXTENDED BASE FOR PRIME MOVER

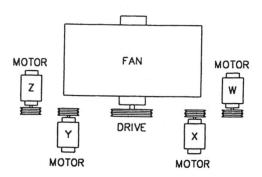

LOCATION OF MOTOR IS DETERMINED BY FACING THE DRIVE SIDE OF THE FAN OR BLOWER AND DESIGNATING THE MOTOR POSITION BY LETTERS W. X. Y. AND Z AS SHOWN ABOVE.

FAN MOTOR POSITIONS

FAN DRIVE ARRANGEMENTS

FOR BELT DRIVE CONNECTION, IMPELLER OVERHUNG, TWO BEARINGS ON BASE, PRIME MOVER OUTSIDE BASE

ARRANGEMENT #9 SWSI

ARRANGEMENT #10 SWSI

FOR BELT DRIVE CONNECTION, IMPELLER OVERHUNG, TWO BEARINGS ON BASE, PRIME MOVER INSIDE BASE

G. Axial Fans:

- 1. Propeller Fans:
 - a. Low pressure, high CFM fans.
 - b. Horsepower lowest at maximum flow.
 - c. Maximum efficiency is approximately 50% and is reached near free delivery.
 - d. No ductwork.
 - e. Blade rotation is perpendicular to direction of airflow.
 - f. Advantages:
 - 1) High volumes, low pressures.
 - 2) BHP lowest at free delivery.
 - 3) Inexpensive.
 - 4) Operates at relatively low speeds—900 to 1,800 RPM.
 - g. Disadvantages:
 - 1) Cannot handle static pressure.
 - 2) BHP increases with static pressure; could overload and shut off.
 - 3) Air delivery decreases with increase in air resistance.

2. Tubeaxial Fans:

- a. Heavy duty propeller fans arranged for duct connection. Fan blades have aerodynamic configuration.
- b. Slightly higher efficiency than propeller fans.
- Discharge air pattern is circular in shape and swirls, producing higher static losses in the discharge duct.
- d. Used primarily in low and medium pressure, high volume, ducted HVAC application where discharge side is not critical. Also used in industrial application: fume hoods, spray booths, drying ovens.
- e. Fans operate at high speeds-2,000 to 3,000 RPM.
- f. Fans are noisy.
- g. Fans may be constructed to be overloading or non-overloading. Non-overloading type fans are more common.
- h. Advantages:
 - 1) Straight through design.
 - 2) Space savings.
 - 3) Capable of higher static pressures than propeller fans.
- i. Disadvantages:
 - 1) Discharge swirl creates higher pressure drops.
 - 2) High noise level.

3. Vaneaxial:

- Vaneaxial fans are tubeaxial fans with additional vanes to increase efficiency by straightening out airflow.
- b. Vaneaxial fans are more costly than tubeaxial fans.
- c. High pressure characteristics with medium flow rate capabilities.
- d. Fans operate at high speeds—2,000 to 3,000 RPM.
- e. Fans are noisy.
- f. Fans may be constructed to be overloading or non-overloading. Non-overloading type fans are more common.
- g. Typical Selection: 65-95% wide open CFM.
- h. Used in general HVAC applications, low, medium, and high pressure where straight through flow and compact installation are required. Also used in industrial applications: usually more compact than comparable centrifugal type fans for the same duty.

- i. Advantages:
 - 1) Discharge vanes increase efficiency and reduce discharge losses.
 - 2) Reduced size and straight through design.
 - 3) Space savings.
 - 4) Capable of higher static pressures than propeller fans.
- j. Disadvantages:
 - 1) Maximum efficiency only 65%.
 - 2) Selection Range: 65-90% wide open CFM.
 - 3) High noise level.

H. Clearance Requirements:

- Minimum recommended clearance around fans is 24 inches. Maintain minimum clearance as required to open access and control doors on fans for service, maintenance, and inspection.
- Mechanical room locations and placement must take into account how fans can be move into and out of the building during initial installation and after construction for maintenance and repair and/or replacement.

21.02 Pumps

A. Available RPM:

- 1. 1,150 (1,200).
- 2. 1,750 (1,800).
- 3. 3,500 (3,600).

B. Pump Types are shown in the following table:

PUMP TYPE	GPM	HEAD FT. H₂O	HORSEPOWER
Circulators	0 - 150	0 - 60	1/4 - 5
Close Coupled, End Suction	0 - 2,000	0 - 400	1/4 - 150
Frame Mounted, End Suction	0 - 2,000	0 - 500	1/4 - 150
Horizontal Split Case	0 - 12,000	0 - 500	1 - 500
Vertical Inline	0 - 2,000	0 - 400	1/4 - 75

C. Pump Location:

- Heating Water Systems: Boilers to be on suction side of pumps; pumps to draw through boilers.
- Chilled Water Systems: Chillers to be on discharge side of pumps; pumps to pump through chillers.

D. Pump Layout and Design Criteria:

1. Pump suction piping should be kept as short and direct as possible with a minimum length of straight pipe upstream of the pump suction as recommended by the pump manufacturer. Manufacturers recommend 5 to 12 pipe diameters.

- Pump suction pipe size should be at least one pipe size larger than the pump inlet connection.
- Use flat on top, eccentric reducer to reduce pump suction piping to pump inlet connection size.
- 4. Pump suction should be kept free from air pockets.
- 5. Horizontal elbows should not be installed at the pump suction. If a horizontal elbow must be installed at the pump suction, the elbow should be installed at a lower elevation than the pump suction. A vertical elbow at the pump suction with the flow upward toward the pump is desirable.
- 6. Maintain a minimum of 5 pipe diameters of straight pipe immediately upstream of pump suction unless using suction diffuser.
- 7. Variable speed pumping cannot be used for pure lift applications, because reduced speeds will fail to provide the required lift.
- 8. Variable speed pumping is well suited for secondary and tertiary distribution loops of primary/secondary and secondary/tertiary hydronic distribution systems (chilled water and heating water systems).
- 9. Pump Discharge Check Valves:
 - a. Pump discharge check valves should be center guided, spring loaded, disc type check
 - b. Pump discharge check valves should be sized so that the check valve is full open at design flow rate. Generally this will require the check valve to be one pipe size smaller than the connecting piping.
 - c. Condenser water system and other open piping system check valves should have globe style bodies to prevent flow reversal and slamming.
 - d. Install check valves with 4 to 5 pipe diameters upstream of flow disturbances is recommended by most manufacturers.
- 10. Differential pressure control of the system pumps should never be accomplished at the pump. The pressure bypass should be provided at the end of the system or the end each of the subsystems regardless of whether the system is a bypass flow system or a variable speed pumping system. Bypass flow need not exceed 20 percent of the pump design flow.

E. Pump Selection Criteria:

- 1. Impeller size for specified duty should not exceed 85% of volute cutwater diameter.
- 2. Maximum cataloged impeller size should be rated to produce not less than 110% of specified head at specified flow.
- 3. Specified head at specified flow.
- 4. 110% of specified flow at specified head.
- 5. Parallel Pump Operation: At equal head, GPM is additive.
- 6. Series Pump Operation: At equal GPM, head is additive.
- 7. Selection Regions:
 - a. Preferred Selection—85 to 105% Design Flow.
 - b. Satisfactory Selection—66 to 115% Design Flow.
- 8. Pumps curves:
 - a. Flat. 12% rise from design point to shutoff head (0 flow). Flat curves should be used for variable flow systems with single pumps. A flat pump curve is a pump curve where the head at shutoff is approximately 25% higher than the head at the best efficiency point.
 - b. Steep. 40% rise from design point to shutoff head (0 flow). Steep curves should be used for variable speed and constant flow systems where two or more pumps are used.

- c. Hump. Developed head rises to a maximum as flow decreases and then drops to a lower value at the point of shutoff. Hump curves should be used for constant flow systems with single pumps due to increased efficiency.
- 9. Select pumps so that the design point is as close as possible or to the left of the maximum efficiency point.
- 10. Boiler warming pumps should be selected for a flow rate of 0.1 GPM/BHP (range 0.05 to 0.1 GPM/BHP).

F. Pump Seals:

- 1. Mechanical Seal: Closed Systems.
- 2. Stuffing Box Seals: Open Systems.

G. Cavitation. Net Positive Suction Head (NPSH):

1. Cavitation: "If the pressure at any point inside the pump falls below the operating vapor pressure of the fluid, the fluid flashes into a vapor and forms bubbles. These bubbles are carried along in the fluid stream until they reach a region of higher pressure. Within this region the bubbles collapse or implode with tremendous shock on the adjacent surfaces. Cavitation is accompanied by a low rumbling and/or a sharp rattling noise and even vibration causing mechanical destruction in the form of pitting and erosion."

2. Causes:

- a. Discharge heads far below the pump's calibrated head at peak efficiency.
- b. Suction lift or suction head lower than the pump rating.
- c. Speeds (RPM) higher than pump rating.
- d. Liquid temperatures higher than that for which system was designed.

3. Remedies:

- a. Increase source fluid level height.
- b. Reduce the distance and/or friction losses (larger pipe) between source and pump.
- c. Reduce temperature of the fluid.
- d. Pressurize source.
- e. Use different pump.
- f. Place balancing valve in pump discharge or trim pump impeller.
- 4. Systems most susceptible to NPSH problems:
 - a. Boiler Feed Water Systems (steam systems).
 - b. Cooling Tower and other open systems.
 - c. Medium and high temperature water systems.
- 5. Potential problems increase as:
 - a. Elevation above sea level increases.
 - Height above pump decreases.
 - c. Friction losses increase.
 - d. Fluid temperature increases.

H. Pump Terms:

- Friction Head: Friction head is the pressure expressed in psi or in feet of liquid needed to overcome the resistance to the flow in the pipe and fittings.
- Suction Lift: Suction lift exists when the source of supply is below the centerline of the pump.

¹Carrier Corporation, Carrier System Design Manuals, Part 8—Auxiliary Equipment, (Syracuse: Carrier Corporation, 1971), pp. 8–11.

- 3. Suction Head: Suction head exists when the source of supply is above the centerline of the pump.
- 4. Static Suction lift: Static suction lift is the vertical distance from the centerline of the pump down to the free level of the liquid source.
- 5. Static Suction Head: Static suction head is the vertical distance from the centerline of the pump up to the free level of the liquid source.
- Static Discharge Head: Static discharge head is the vertical elevation from the centerline of the pump to the point of free discharge.
- Dynamic Suction Lift: Dynamic suction lift includes the sum of static suction lift, friction head loss, and velocity head.
- 8. Dynamic Suction Head: Dynamic suction head includes static suction head minus the sum of friction head loss and velocity head.
- Dynamic Discharge Head: Dynamic discharge head includes the sum of static discharge head, friction head, and velocity head.
- 10. Total Dynamic Head: Total dynamic head includes the sum of the dynamic discharge head plus the dynamic suction lift or discharge head minus dynamic suction head.
- 11. Velocity Head: Velocity head is the head needed to accelerate the liquid. See the following table:

VELOCITY FT/SEC.	VELOCITY HEAD FEET	VELOCITY FT/SEC.	VELOCITY HEAD FEET	VELOCITY FT/SEC.	VELOCITY HEAD FEET
0.5	0.004	7.5	0.875	14.5	3.269
1.0	0.016	8.0	0.995	15.0	3.498
1.5	0.035	8.5	1.123	15.5	3.735
2.0	0.062	9.0	1.259	16.0	3.980
2.5	0.097	9.5	1.403	16.5	4.232
3.0	0.140	10.0	1.555	17.0	4.493
3.5	0.190	10.5	1.714	17.5	4.761
4.0	0.248	11.0	1.881	18.0	5.037
4.5	0.314	11.5	2.056	18.5	5.321
5.0	0.389	12.0	2.239	19.0	5.613
5.5	0.470	12.5	2.429	19.5	5.912
6.0	0.560	13.0	2.627	20.0	6.219
6.5	0.657	13.5	2.833	21.0	6.856
7.0	0.762	14.0	3.047	22.0	7.525

- 12. Specific Gravity: Specific gravity is the direct ratio of any liquid's weight to the weight of water at 62°F. (62.4 Lbs./Cu.Ft. or 8.33 Lbs./Gal.).
- 13. Viscosity: Viscosity is a property of a liquid that resists any force tending to produce flow. It is the evidence of cohesion between the particles of a fluid which causes a liquid to offer resistance analogous to friction. A change in the temperature may change the viscosity depending upon the liquid. Pipe friction loss increases as viscosity increases.
- 14. Static Pressure: Static pressure is the water pressure required to fill the system.

- 15. Static System Pressure: Static system pressure is the water pressure required to fill the system plus 5 psi.
- 16. Flow Pressure: Flow pressure is the pressure the pump must develop to overcome the resistance created by the flow through the system.

I. Clearance Requirements:

- 1. Minimum recommended clearance around pumps is 24 inches. Maintain minimum clearance as required to open access and control doors on pumps for service, maintenance, and inspection.
- Mechanical room locations and placement must take into account how pumps can be move into and out of the building during initial installation and after construction for maintenance and repair and/or replacement.

21.03 Motors

A. Motor Types. Items 1, 2, and 3 are the most common HVAC motor types.

- Open Drip Proof (ODP): Ventilation openings arranged to prevent liquid drops falling within an angle of 15 degrees from the vertical from affecting motor performance—use indoors and in moderately clean environments.
- Totally Enclosed Fan Cooled (TEFC): A fan on the motor shaft, outside the stator housing and within the protective shroud, blows air over the motor—use in damp, dirty, corrosive, or contaminated environments.
- 3. Explosion Proof (EXPRF): Totally enclosed with enclosure designed to withstand internal explosion of a specific gas-air or dust-air mixture to prevent escape of ignition products. Motors are approved for a specific Hazard Classification as covered by the NEC. Class I Explosion Proof and Class II Dust Ignition Resistant are the two most common type of hazardous location motors.
- 4. Open Drip Proof Air Over (ADAO): Ventilation openings arranged to prevent liquid drops falling within an angle of 15 degrees from the vertical from affecting motor performance—use indoors and in moderately clean environments. Rated for motor cooling by airflow from driven device.
- 5. Totally Enclosed Non-Ventilated (TENV): No ventilation openings in housing. Motor rated for cooling by airflow from driven device. TENV motors are usually under 5 horsepower.
- 6. Totally Enclosed Air Over (TEAO): No ventilation openings in housing. Motor rated for cooling by airflow from driven device. TEAO motors frequently have dual horsepower ratings depending on speed and cooling air temperature.

B. Motor Horsepowers, Voltage, Phase, and Operating Guidelines:

- 1. Suggested horsepower and phase:
 - a. Motors ½ Horsepower and larger: 3 Phase.
 - b. Motors less than ½ Horsepower: Single Phase.
 - c. Considering first cost economics only, it is less costly, on average, to have motors smaller than 1 Hp to be single-phase. At ¼ Hp, single-phase and 3-phase motors cost about the same, but branch circuits and control equipment for 3-phase motors are usually more expensive.
 - d. When life cycle owning and operating costs are considered, it is often more economical to provide motors as specified in a. and b. above.
- 2. Do not start and stop motors more than 6 times per hour.
- 3. Motors of 5 horsepower and larger should not be cycled; they should run continuously.
- 4. Specify energy efficient motors.

- 5. Do not use energy efficient motors with variable speed/frequency drives.
- 6. For best motor life and reliability, do not select motors to run within the service factors.
- 7. For every 50°F. (10°C.) increase in motor operating temperature, the life of the motor is cut in half. Conversely, for every 50°F. (10°C.) decrease in motor operating temperature, the life of the motor is doubled.
- 8. Energy efficient motors have a higher starting current than their standard efficiency counterparts.
- 9. The best sign of motor trouble is smoke and/or paint discoloration.
- 10. In general, motors can operate with voltages plus or minus 10% of their rated voltage.
- 11. Motors in storage should be turned by hand every six months to keep the bearings from drying out.
- 12. Available Voltages are given in the following table:

PHASE	NOMINAL VOLTAGE	NAMEPLATE VOLTAGE
	120	115
SINGLE PHASE	240	230
	277	265
	208	200
A DVI 1 OF	240	230
3 PHASE	480	460
	600	575

C. Standard Motor Sizes are given in the following table:

MOTOR SIZES (Hp)	RECOMMENDED STARTER TYPE	STANDARD SERVICE FACTORS
1/8; 1/10; 1/12; 1/15; 1/20; 1/25; 1/30; 1/60; 1/100	SPC or PSC	1.40
1/6	SPC or PSC	*
1/4; 1/3	CS	*
1/2; 3/4; 1	MS	*
1-1/2; 2	MS	*
3; 5; 7-1/2; 10; 15; 20; 25; 30; 40; 50; 60; 75; 100; 125; 150; 200; 250	MS	*
300; 350; 400; 450; 500; 600; 700; 750; 800; 900; 1000; 1250; 1500; 1750; 2000; 2250; 2500; 3000; 3500; 4000; 4500; 5000; 5500; 6000 **	MS	*

Notes:

SPC: Split Phase Capacitor Start

PSC: Permanent Split Capacitor Start

CS: Capacitor Start

*See item E.

**Motors generally not used in HVAC applications.

MS: Magnetic Start; Polyphase Induction Motors (Squirrel Cage)

½ Hp thru 50 Hp
60 Hp and Larger
Reduced-Voltage Starter

D. Standard Motor RPM: 3,600, 1,800, 1,200, 900, 720, 600, 514.

E. NEMA Motor Service Factors are given in the following table:

HP	3600 RPM	1800 RPM	1200 RPM	900 RPM
1/6 - 1/3	1.35	1.35	1.35	1.35
1/2	1.25	1.25	1.25	1.15
3/4	1.25	1.25	1.15	1.15
1	1.25	1.15	1.15	1.15
1-1/2 - 250	1.15	1.15	1.15	1.15
300 - 2500	1.15	1.15	1.15	1.15

F. Locked Rotor Indicating Code Letters are given in the following table:

	LOCKED ROTOR INDICATING CODE LETTERS						
CODE LETTER	KVA/HP	CODE LETTER	KVA/HP				
A	0 - 3.14	L	9.00 - 9.99				
В	3.15 - 3.54	М	10.00 - 11.19				
С	3.55 - 3.99	N	11.20 - 12.49				
D	4.00 - 4.49	0	NOT USED				
Е	4.50 - 4.99	P	12.50 - 13.99				
F	5.00 - 5.59	Q	NOT USED				
G	5.60 - 6.29	R"	14.00 - 15.99				
Н	6.30 - 7.09	S	16.00 - 17.99				
I	NOT USED	T	18.00 - 19.99				
J	7.10 - 7.99	U	20.00 - 22.39				
K	8.00 - 8.99	V	22.40 - AND UP				

1. Standard 3 phase motors often have these locked rotor codes:

a. 1 Horsepower and smaller: Locked Rotor Code L

b. 1½ to 2 Horsepower: Locked Rotor Code K

c. 3 Horsepower: Locked Rotor Code J

d. 5 Horsepower: Locked Rotor Code H

e. 7½ to 10 Horsepower: Locked Rotor Code G f. 15 Horsepower and Larger: Locked Rotor Code F

2. Standard single phase motors often have these locked rotor codes:

a. $\frac{1}{2}$ Horsepower and smaller: Locked Rotor Code L

Locked Rotor Code K b. 34 to 1 Horsepower: Locked Rotor Code J c. 1½ to 2 Horsepower:

Locked Rotor Code H d. 3 Horsepower: Locked Rotor Code G e. 5 Horsepower:

G. Motor Insulation Classes are given in the following table:

	MOTOR INSULATION CLASS TEMPERATURE RISE								
MOTOR TYPE	A		В		F		Н		
		°F	°C	°F	°C	°F	°C	°F	
Motors with 1.0 Service Factor(except 3 & 4 Below)	60	140	80	176	105	221	125	257	
All Motors with 1.15 Service Factor or Higher	70	158	90	194	115	239			
Totally-Enclosed Non-Ventilated Motor with 1.0 Service Factor	65	149	85	185	110	230	135	275	
Motors with Encapsulated Windings and with 1.0 Service, All Enclosures	65	149	85	185	110	230			

Notes:

1. Abnormal deterioration of insulation may be expected if the ambient temperature of 40°C/104°F is exceeded in regular operation.

2. Temperature rise based on 40°C/104°F ambient. Temperature rises are based on operation at alti-

tudes of 3,300 feet or less. 3. Class A Motors: Fractional Hp motors, Small Appliances; Maximum Operating Temperature 105°C/221°F.

4. Class B Motors: Motors for HVAC Applications, High Quality Fractional Hp Motors; Maximum Operating Temperature 130°C/266°F.

5. Class F Motors: Industrial Motors; Maximum Operating Temperature 155°C/311°F.

6. Class H Motors: High Temperature, High Reliability, High Ambient; Maximum Operating Temperature 180°C/356°F.

H. NEMA Motor Design Designations:

- 1. Design A motors are built with high pullout torque and are used on injection molding machines.
- 2. Design B motors are built with high starting torque with reasonable starting current and are used with fans, pumps, air handling units, and other HVAC equipment. They are the most common HVAC motor.
- 3. Design C motors are built with high starting torque and used with hard to start loads and are used with conveyors.
- 4. Design D motors are built with high starting torque, low starting current, and high slip and are used with cranes, hoists, and low speed presses.

I. Clearance Requirements:

- 1. Minimum recommended clearance around motors is 24 inches.
- 2. Mechanical room locations and placement must take into account how motors can be move into and out of the building during initial installation and after construction for maintenance and repair and/or replacement.

J. Motor Efficiencies: ASHRAE Standard 90.1-1989:

1. NEMA Design B; Single Speed; 1,200, 1,800, or 3,600 RPM; Open Drip Proof (ODP) or Totally Enclosed Fan Cooled (TEFC) Motors 1 Hp and Larger that operate more than 500 hours per year must meet the following minimum nominal efficiencies:

Horsepower	Minimum Nominal Efficiency
1 - 4	78.5
5 - 9	84.0
10 - 19	85.5
20 - 49	88.5
50 - 99	90.2
100 - 124	91.7
125 or Greater	92.4

Note: Above table is based on ASHRAE Standard 90.1 prior to adoption of Addendum 90.1c by ASHRAE Board of Directors.

2. NEMA Design A and B; Open Drip Proof (ODP) or Totally Enclosed Fan Cooled (TEFC) Motors 1 Hp and Larger that operate more than 1,000 hours per year must meet the following minimum nominal efficiencies; Minimum Acceptable Nominal Full-Load Motor Efficiency for Single Speed Polyphase Squirrel-Cage Induction Motors having Synchronous Speed of 3,600, 1,800, 1,200, and 900 RPM.:

Full Load Efficiencies-Open Motors

	2-P0	2-POLE 4-POLE		6-P0	OLE	8-POLE		
HP	NOMINAL EFF.	MINIMUM EFF.	NOMINAL EFF.	MINIMUM EFF.	NOMINAL EFF.	MINIMUM EFF.	NOMINAL EFF.	MINIMUM EFF.
1.0			82.5	81.5	80.0	78.5	74.0	72.0
1.5	82.5	81.5	84.0	82.5	84.0	82.5	75.5	74.0
2.0	84.0	82.5	84.0	82.5	85.5	84.0	85.5	84.0
3.0	84.0	82.5	86.5	85.5	86.5	85.5	86.5	85.5
5.0	85.5	84.0	87.5	86.5	87.5	86.5	87.5	86.0
7.5	87.5	86.5	88.5	87.5	88.5	87.5	88.5	87.5
10.0	88.5	87.5	89.5	88.5	90.2	89.5	89.5	88.5
15.0	89.5	88.5	91.0	90.2	90.2	89.5	89.5	88.5
20.0	90.2	89.5	91.0	90.2	91.0	90.2	90.2	89.5
25.0	91.0	90.2	91.7	91.0	91.7	91.0	90.2	89.5
30.0	91.0	90.2	92.4	91.7	92.4	91.7	91.0	90.2
40.0	91.7	91.0	93.0	92.4	93.0	92.4	91.0	90.2
50.0	92.4	91.7	93.0	92.4	93.0	92.4	91.7	91.0
60.0	93.0	92.4	93.6	93.0	93.6	93.0	92.4	91.7
75.0	93.0	92.4	94.1	93.6	93.6	93.0	93.6	93.0
100.0	93.0	92.4	94.1	93.6	94.1	93.6	93.6	93.0
125.0	93.6	93.0	94.5	94.1	94.1	93.6	93.6	93.0
150.0	93.6	93.0	95.0	94.5	94.5	94.1	93.6	93.0
200.0	94.5	94.1	95.0	94.5	94.5	94.1	93.6	93.0

Note: Above table is based on ASHRAE Standard 90.1, Addendum 90.1c.

Full Load Efficiencies-Enclosed Motors

	Tan 2000 Enclosed Wotols							
I III	2-P	OLE	4-P	OLE	6-P	OLE	8-1	POLE
HP	NOMINAL EFF.	MINIMUM EFF.	NOMINAL EFF.	MINIMUM EFF.	NOMINAL EFF.	MINIMUM EFF.	NOMINAL EFF.	MINIMUM EFF.
1.0	75.5	74.0	82.5	81.5	80.0	78.5	74.0	72.0
1.5	82.5	81.5	84.0	82.5	85.5	84.0	77.0	75.5
2.0	84.0	82.5	84.0	82.5	86.5	85.5	82.5	81.5
3.0	85.5	84.0	87.5	86.5	87.5	86.5	84.0	82.5
5.0	87.5	86.5	87.5	86.5	87.5	86.5	85.5	84.0
7.5	88.5	87.5	89.5	88.5	89.5	88.5	85.5	84.0
10.0	89.5	88.5	89.5	88.5	89.5	88.5	88.5	87.5
15.0	90.2	89.5	91.0	90.2	90.2	89.5	88.5	87.5
20.0	90.2	89.5	91.0	90.2	90.2	89.5	89.5	88.5
25.0	91.0	90.2	92.4	91.7	91.7	91.0	89.5	88.5
30.0	91.0	90.2	92.4	91.7	91.7	91.0	91.0	90.2
40.0	91.7	91.0	93.0	92.4	93.0	92.4	91.0	90.2
50.0	92.4	91.7	93.0	92.4	93.0	92.4	91.7	91.0
60.0	93.0	92.4	93.6	93.0	93.6	93.0	91.7	91.0
75.0	93.0	92.4	94.1	93.6	93.6	93.0	93.0	92.4
100.0	93.6	93.0	94.5	94.1	94.1	93.6	93.0	92.4
125.0	94.5	94.1	94.5	94.1	94.1	93.6	93.6	93.0
150.0	94.5	94.1	95.0	94.5	95.0	94.5	93.6	93.0
200.0	95.0	94.5	95.0	94.5	95.0	94.5	94.1	93.6

Note: Above table is based on ASHRAE Standard 90.1, Addendum 90.1c.

K. Single Phase ODP is given in the following table:

Single Phase ODP

RPM	HP	NEMA FRAME	PERCENT EFFICIENCY	PERCENT POWER
	1/6	48	41	48
	1/4	48, 56	41	51
T	1/3	48, 56	56	55
ŀ	1/2	56	62	60
1200	3/4	56, 143T	68	68
A 4"	1	184	65	62
	1-1/2	215	67	60
1	2	215	68	65
	3	215	75	80
	1/8	48	49	58
	1/6	48	49	58
	1/4	48, 56	53	52
Ì	1/3	48, 56	56	55
	1/2	48, 56	64	65
	3/4	56	63	64
1800	1	56, 143T, 182T	68	72
	1-1/2	56, 145T, 184T	70	64
	2	56, 145T, 182T	73	72
	3	184T	78	78
	5	184T, 213T	74	76
2 2	7-1/2	215T	77	85
	10	215T	84	90
	1/3	48, 56	55	68
	1/2	48, 56	57	71
	3/4	56	62	75
	1	56	63	69
	1-1/2	56, 143T	68	77
3600	2	56, 145T	71	75
	3	56, 182T	76	88
	5	184T	76	88
	7-1/2	213T	81	82
	10	215	83	86

L. Single Phase TEFC is given in the following table:

Single Phase TEFC

RPM	НР	NEMA FRAME	PERCENT EFFICIENCY	PERCENT POWER FACTOR
	1/6	48	41	48
[1/4	48, 56	44	50
	1/3	48, 56	57	56
	1/2	56	59	63
1200	3/4	56, 143T	68	68
1200	1	184	67	67
7	1-1/2	215	71	69
	2	215	82	84
	3	215	80	82
	5	256	80	82
	1/12	42	47	55
	1/8	42	47	55
	1/6	42, 48	49	58
	1/4	48, 56	53	52
	1/3	48, 56	56	55
	1/2	48, 56	63	67
	3/4	56	66	68
1800	- 1	56, 143T	68	72
İ	1-1/2	56, 145T	73	77
Ì	2	182T	75	81
İ	3	184T	78	87
İ	5	213T	82	87
	7-1/2	215T	84	87
	10	215T	84	87
	1/8	42	45	62
,	1/6	42	52	57
	1/4	42	52	57
Ì	1/3	48, 56	55	68
	1/2	48, 56	57	71
İ	3/4	56	66	74
3600	1	56	66	81
.	1-1/2	56, 143T	70	82
- 1	2	145T	74	78
ł	3	182T	76	87
İ	5	184T	84	96
ŀ	7-1/2	213T	82	89
ŀ	10	215T	86	98

M. Single Phase Explosion Proof is given in the following table:

Single Phase Explosion Proof

RPM	НР	NEMA FRAME	PERCENT EFFICIENCY	PERCENT POWER FACTOR
	1/3	56	54	56
	1/2	56	59	63
1200	3/4	56	65	67
	1	184	67	67
	1-1/2	215	71	69
	1/3	56	56	58
	1/2	56	65	65
	3/4	56	66	68
	1	56, 143T	66	67
1800	1-1/2	184	70	70
-	2	182T	75	81
Ī	3	215	79	77
	5	215	74	81
	1/2	56	55	69
	3/4	56	62	75
	1	56	66	81
3600	1-1/2	143T	70	82
İ	2	145T	74	82
	3	182T, 184T	76	87

N. Standard Efficiency 3-Phase ODP is given in the following table:

Standard Efficiency 3-Phase ODP

RPM	HP	NEMA FRAME	PERCENT EFFICIENCY	PERCENT POWER FACTOR
	1/2	56, 143T	71	57
	3/4	145T	74	56
	1	182T	71	66
000	1-1/2	184T	74	67
900	2	213T	73	63
	3	215T	76	60
	5	254T	80	60
	7-1/2	256T	85	62
	1/4	48, 56	71	58
	1/3	48, 56	71	58
22	1/2	48, 56	71	58
	3/4	56, 143T	77	67
2	1	56, 145T	77	69
	1-1/2	56, 145T, 182T	78	77
	2	184T	78	72
	3	213T	79	72
	5	215T	83	76
	7-1/2	254T	85	78
	10	256T	86	78
	15	284T	87	82
1200	20	286T	87	81
9	25	324T	88	84
	30	326T	88	80
	40	364T	91	85
	50	365T	88	87
	60	404T	90	82
	75	405T	90	83
	100	444T	91	85
	125	445T	91	85
	150	445T	91	84
	200	447T	91	84
	250	449T	91	84
	1/4	48	74	63
*	1/3	48, 56	74	63
	1/2	48, 56	74	63
	3/4	48, 56	74	60
1800	1	56, 142T, 143T	75	64
	1-1/2	56, 145T	79	69
·	2	56, 145T	80	70
390	3	56, 145T, 182T	81	77
	5	184T	84	82

Standard Efficiency 3-Phase ODP

RPM	HP	NEMA FRAME	PERCENT EFFICIENCY	PERCENT POWER
	7-1/2	213T	86	76
t	10	215T	87	78
	15	254T	87	77
	20	256T	89	86
- t	25	284T	89	83
, t	30	286T	90	86
1	40	324T	91	85
	50	326T	91	85
ŀ	60	364T	90	83
1800	75	365T	90	86
1885	100	404T	91	86
	125	405T	92	86
ŀ	150	445T	92	88
1	200	445T	92	89
ŀ	250	447T	92	90
}	300	447T	92	90
ł	350	449Z	92	90
1	400	449Z	92	90
2	450	449Z	92	90
	1/4	48, 56	74	63
	1/3	48, 56	74	63
}	1/2	48, 56	75	73
1	3/4	48, 56	67	63
1	1	56	75	64
	1-1/2	56, 143T	78	82
	2	56, 145T	80	86
	3	56, 145T	81	84
	5	56, 182T	81	88
	7-1/2	184T	84	85
	10	213T	87	89
	15	215T	87	91
3600	20	254T	89	86
	25	256T	89	87
	30	284T	87	87
	40	286T	90	87
	50	324T	88	89
	60	326T	90	88
	75	364T	90	84
	100	365T	93	83
	125	404T	89	88
	150	405T	90	89
	200	444T	91	89
	250	445T	92	90

O. Energy Efficient 3-Phase ODP is given in the following table:

Energy Efficient 3-Phase ODP

RPM	HP	NEMA FRAME	PERCENT EFFICIENCY	PERCENT POWER FACTOR
	1/2	56, 143T	71	70
	3/4	145T	74	70
*	1	182T	71	79
900	1-1/2	184T	74	79
900	2	213T	73	79
	3	215T	76	85
	5	254T	80	85
0	7-1/2	256T	85	85
	1/4	48, 56	71	70
	1/3	48, 56	71	70
	1/2	48, 56	71	70
	3/4	56, 143T	77	70
1200	1	145T	81	72
1200	1-1/2	182T	83	73
İ	2	184T	85	75
l	3	213T	86	60
	5	215T	87	65
1	7-1/2	254T	89	73
İ	10	256T	89	74
	15	284T	90	77
. 1	20	286T	90	78
1	25	324T	91	74
	30	326T	91	78
	40	364T	93	77
	50	365T	93	79
	60	404T	93	82
	75	405T	93	80
	100	444T	93	80
	125	444T	93	84
	150	445T	91	84
	200	447T	91	84
	250	449T	91	84
	1/4	48	74	63
l	1/3	48, 56	74	63
l	1/2	48, 56	74	70
l	3/4	48, 56	74	70
1800	1	143T	82	84
	1-1/2	145T	84	85
l	2	145T	84	85
	3	182T	86	86
	5	184T	87	87

Energy Efficient 3-Phase ODP

RPM	HP	NEMA FRAME	PERCENT EFFICIENCY	PERCENT POWE FACTOR
	7-1/2	213T	88	86
1	10	215T	89	85
1800	15	256T	91	85
1800	20	256T	91	86
	25	284T	91	85
Ī	30	286T	92	88
Ī	40	324T	92	83
1	50	326T	93	85
Ī	60	364T	93	88
Ī	75	365T	93	88
	100	404T	93	83
	125	405T	93	86
Ī	150	445T	93	85
	200	445T	94	85
1	250	447T	92	85
t	300	447T	92	90
Ī	350	449Z	92	90
Ì	400	449Z	92	90
- 1	450	449Z	92	90
	1/4	48, 56	74	63
	1/3	48, 56	74	63
- 1	1/2	48, 56	74	70
Ī	3/4	48, 56	75	70
	1	56	75	79
- 1	1-1/2	143T	82	85
- 1	2	145T	82	87
1	3	145T	84	85
t	5	182T	85	86
i	7-1/2	184T	86	88
1	10	213T	87	86
	15	215T	89	89
3600	20	254T	90	89
Ì	25	256T	90	92
Ì	30	284T	91	91
Ī	40	286T	92	92
1	50	324T	93	89
İ	60	326T	93	91
- 1	75	364T	93	88
İ	100	365T	92	88
1	125	404T	89	88
	150	405T	90	88
	200	444T	91	88
	250	445T	92	88

P. Standard Efficiency 3-Phase TEFC is given in the following table:

Standard Efficiency 3-Phase TEFC

RPM	HP	NEMA FRAME	PERCENT EFFICIENCY	PERCENT POWER FACTOR
	1/4	56	68	48
	1/3	56	68	48
. [1/2	56, 143T	68	48
	3/4	145T	73	57
	1	182T	68	64
	1-1/2	184T	74	65
200	2	213T	75	66
900	3	215T	75	60
Γ	5	254T	80	60
	7-1/2	256T	81	63
Г	10	284T	. 88	67
Γ	15	286T	89	66
	20	324T	90	68
	25	326T	88	69
	1/6	48	71	58
	1/4	48, 56	71	58
	1/3	56	71	58
	1/2	56	71	58
	3/4	56, 143T	76	68
	1	56, 145T	77	67
	1-1/2	56, 145T, 182T	77	71
1200	2	184T	80	73
	3	213T	79	73
	5	215T	83	73
	7-1/2	254T	85	75
	10	256T	86	82
	15	284T	88	79
	20	286T	88	81
	25	324T	90	80
	30	326T	91	81
	40	364T	90	85
F	50	365T	89	88
<u> </u>	60	404T	91 '	82
	75	405T	92	81
	100	444T	92	85
	125	445T	93	87
	150	445T	92	88
	200	447T	92	88
	250	449T	92	88
-	1/8	42	74	63
1800	1/6	42	74	63
	1/4	48	74	63

Standard Efficiency 3-Phase TEFC

RPM	HP	NEMA FRAME	PERCENT EFFICIENCY	PERCENT POWER FACTOR	
	1/3	48, 56	74	63	
- F	1/2	48, 56	74	63	
 	3/4	48, 56	74	60	
T	1	56, 143T	77	62	
H	1-1/2	56, 145T	79	66	
1800	2	56, 145T	81	74	
1800	3	182T	82	78	
F	5	184T	84	82	
ŀ	7-1/2	213T	86	79	
, t	10	215T	88	81	
F	15	254T	90	80	
ŀ	20	256T	90	83	
-	25	284T	90	84	
	30	286T	91	85	
-	40	324T	91	84	
	50	326T	92	84	
ŀ	60	364T	91	83	
1	75	365T	92	86	
	100	405T	92	89	
ŀ	125	444T	92	89	
ł	150	445T	93	89	
ł	200	445T	84	89	
ł	250	447T	84	89	
	1/6	42	67	63	
	1/4	42	67	63	
	1/3	48	67	63	
	1/2	48, 56	67	63	
ŀ	3/4	48, 56	75	73	
1	1	56	75	76	
	1-1/2	56, 143T	74	80	
	2	56, 145T	76	89	
	3	56, 145T, 182T	81	87	
	5	184T	85	94	
3600	7-1/2	184T, 213T	86	85	
5000	10	215T	87	92	
	15	215T, 254T	89	92	
	20	254T, 256T	87	89	
5.9	25	256T, 284T	88	87	
	30	286T	88	90	
	40	324T	86	90	
	50	326T	89	91	
	60	364T	89	91	
	75	365T	89	91	
	100	405T	89	91	

Q. Energy Efficient 3-Phase TEFC is given in the following table:

Energy Efficient 3-Phase TEFC

RPM	HP	NEMA FRAME	PERCENT EFFICIENCY	PERCENT POWER FACTOR
	1/4	56	68	48
1	1/3	56	68	48
	1/2	56, 143T	68	70
	3/4	145T	73	70
<i>P</i>	1	182T	68	79
İ	1-1/2	184T	74	79
	2	213T	75	79
900	3	215T	75	85
l	5	254T	80	85
	7-1/2	256T	81	85
	10	284T	88	85
	15	286T	89	85
	20	324T	90	85
İ	25	326T	88	85
	1/6	48	71	70
1	1/4	48, 56	71	70
	1/3	48, 56	71	70
- 1	1/2	56	71	70
1	3/4	56, 143T	76	70
1	1	145T	81	72
	1-1/2	182T	83	65
1200	2	184T	85	68
1	3	213T	85	63
	5	215T	86	66
ì	7-1/2	254T	89	68
	10	256T	89	75
ì	15	284T	90	72
	20	286T	90	76
	25	324T	90	71
	30	326T	91	79
	40	364T	92	78
	50	365T	92	81
	60	404T	92	83
	75	405T	92	80
	100	444T	93	83
	125	445T	93	85
	150	445T	92	85
	200	447T	91	85
	250	449T	91	85
	1/8	42	47	55
1800	1/6	42, 48	49	58
	1/4	48, 56	53	52

Energy Efficient 3-Phase TEFC

RPM	HP	NEMA FRAME	PERCENT EFFICIENCY	PERCENT POWER FACTOR
	1/3	48, 56	56	55
	1/2	48, 56	74	70
	3/4	48, 56	74	70
	1	143T	82	84
	1-1/2	145T	84	85
	2	145T	84	85
	3	182T	87	83
	5	184T	88	83
	7-1/2	213T	89	85
-	10	215T	90	84
F	15	254T	91	86
1800	20	256T	91	85
	25	284T	92	84
	30	286T	93	86
	40	324T	93	83
	50	326T	93	85
H	60	364T	93	87
	75	365T	93	87
	100	405T	94	86
ŀ	125	444T	94	87
	150	445T	94	88
-	200	447T	95	87
·	250	447T	84	85
	1/6	42	67	63
}	1/4	42	67	63
· }	1/3	48	67	63
·	1/2	48, 56	67	70
1	3/4	48, 56	75	70
· •	1	56	75	79
}	1-1/2	143T	82	85
}	2	145T	82	87
}	3	182T	82	87
+	5	184T	85	88
2600	7-1/2	213T	86	86
3600	10	215T	86	86
-		254T	88	91
}	20	256T	89	89
1	25	284T	90	92
}	30	286T	91	92
}	40	324T	91	91
}	50	324T	90	92
-		364T	91	93
	60 75	365T	91	91
	100	405T	92	92

R. 3-Phase Explosion Proof is given in the following table:

3-Phase Explosion Proof

RPM	HP	NEMA FRAME	PERCENT EFFICIENCY	PERCENT POWER FACTOR
	1/3	56	71	58
	1/2	56	71	58
	3/4	56, 143T	72	70
	1	56, 145T	77	69
	1-1/2	56, 145T, 182T	78	77
1200	2	184T	84	68
	3	213T	80	75
	. 5	215T	80	75
	7-1/2	254T	80	75
	10	256T	80	75
	15	284T	80	75
	1/3	56	74	60
	1/2	56	74	60
1800	3/4	56	76	69
1000	1	56, 143T	75	74
	1-1/2	56, 145T	78	80
	2	56, 145T	80	80
	3	182T	82	75
	5	184T	85	80
· -	7-1/2	213T	86	82
	10	215T	89	82
	15	254T	87	82
	20	256T	92	84
	25	284T	92	86
	30	286T	92	87
	40	324T	92	88
	50	326T	93	86
-	60	364T	93	86
	75	365T	93	86
	100	405T	93	86
	1/2	56	68	77
	3/4	56	72	79
	1	56	74	79
	1-1/2	143T	74	80
	2	145T	76	89
	3	145T, 182T	81	87
	5	184T	84	94
3600	7-1/2	184T, 213T	84	90
3600	10	215T	87	92
	15	254T	86	85
	20	256T	86	85
	25	284T	86	85
		286T	86	85
	30	324T	86	85
	40 50	3241 326T	86	85

21.04 Starters, Disconnect Switches, and Motor Control Centers

A. Starter Types:

- 1. Manual: (Manual Control):
 - a. Reversing/Non-reversing.
 - b. Push Button/Toggle Switch.
 - c. Available for single phase or 3-phase electrical power.
- 2. Magnetic: (Automatic Control):
 - a. Full Voltage/Across the Line.
 - b. Reversing/Non-reversing.
 - c. Reduced Voltage:
 - 1) Reactor.
 - 2) Resistance.
 - 3) Auto Transformer.
 - 4) Wye-Delta/Star Delta.
 - 5) Full Voltage Part Winding.
 - 6) Reduced Voltage Part Winding.
 - d. 2-Speed Starting:
 - 1) One Winding. Full Speed; Half Speed.
 - 2) Two Winding. Full Speed; 1/3 Speed.
 - 3) Constant Torque.
 - 4) Variable Torque.
 - 5) Constant Horsepower.
 - e. Available for single phase or 3-phase electrical power.
- 3. Combination Starter Disconnect Switch: See Magnetic Starter:
 - a. Fused.
 - b. Non-fused.
 - c. Disconnect Switches (Locking/Non-Locking—Recommend Locking Switches).
 - d. Available for 3-phase electrical power only, but 3-phase starter can be used with single phase motor (although expensive).

B. Starter Accessories:

- 1. Pilot Lights: Green, Run; Red, Off.
- 2. Switches (Locking/Non-Locking—Recommend Locking Switches).
 - a. Hand-Off-Auto (HOA).
 - b. Push Button.
 - c. Toggle Switch.
- 3. Control Transformer.
- 4. Overload Protection:
 - a. Fused.
 - b. Non-fused.
 - c. Motor Circuit Protector.
 - d. Molded Case Circuit Breaker.
 - e. Circuit Fuse Protection: Size based on circuit ampacity and wire size.
 - f. Overload Heaters: Size based on motor overload capacity.
 - g. Two Levels of Overload Protection:
 - Type 1: Considerable damage occurs to the contactor and overload relay when an overload happens but the enclosure remains externally undamaged. Parts of the starter or the entire starter may need to be replaced after an overload.

- 2) Type 2: No damage occurs to the contactor or overload relay except light contact burning is permitted when an overload happens.
- h. The choice between circuit breakers and fuses is purely a matter of user preference.
- 5. Auxiliary Contacts (No-Normally Open/NC-Normally Closed).
- 6. Relays.

C. Disconnect Switch Sizes and Accepted Fuse Sizes are given in the following table:

SAFETY SWITCH SIZE AMPS	ACCEPTABLE FUSE SIZES AMPS	SAFETY SWITCH SIZE AMPS	ACCEPTABLE FUSE SIZES AMPS
30	15, 20, 25, 30	1600	1600
60	35, 40, 45, 50, 60	2000	2000
100	70, 80, 90, 100	2500	2500
200	110, 125, 150, 175, 200	3000	3000
400	225, 250, 300, 350, 400	4000	4000
600	450, 500, 600	5000	5000
800	700, 800	6000	6000
1200	1000, 1200		

D. Standard Fuse and Circuit Breaker Sizes (Amperes): 1, 3, 6, 10, 15, 20, 25, 30, 35, 40, 45, 50, 60, 70, 80, 90, 100, 110, 125, 150, 175, 200, 225, 250, 300, 350, 400, 450, 500, 600, 700, 800, 1000, 1200, 1600, 2000, 2500, 3000, 4000, 5000, 6000.

E. Starter Types by Starting Method are given in the following table:

STARTING METHOD	INRUSH CURRENT % LRA	STARTING TORQUE % LRT
Across-the-Line	100	100
Auto-Transformer	e e e e e e e e e e e e e	
80% Tap	71	64
65% Tap	48	42
50% Tap	28	25
Primary Resistor or Reactor		
80% Applied Voltage	80	64
65% Applied Voltage	65	42
58% Applied Voltage	58	33
50% Applied Voltage	50	25
Star Delta	33	33
Part Winding	60	48
Part Winding w/Resistors	60-30	48-12
Wound Rotor (Approx.)	25	150
Solid State	· 3 x RLA	

Notes:

- 1. % LRA = Percent full voltage locked rotor current (amps).
- 2. % LRT = Percent full voltage locked rotor torque.
- 3. RLA = Rated Load Amps or Running Load Amps.

F. Motor Size, Starter and Disconnect Switch Size, and Fuse and Circuit Breaker Size are given in the following tables. The following notes are applicable to all schedules:

- Starters and/or Disconnect Switches. Fuses shall be Class RK5 Time Delay, Dual Element Fuses. Circuit breakers shall be Thermal Magnetic Circuit Breakers.
- 2. Motor data, starters, disconnect switches, and fuses based on 1993 NEC and Square D Company.

11	115 VOLT (120 VOLT) SINGLE PHASE MOTOR STARTER SCHEDULE						
MOTOR HP	NEMA STARTER SIZE	FULL LOAD AMPS PER PHASE	DISC. SWITCH SIZE	FUSE SIZE AMPERES	CIRCUIT BREAKER SIZE AMPERES		
1/8	1 1	3.0	30	4.5	15		
1/6		4.4	30	7	15		
1/4		5.8	30	9	15		
1/3	1 1 1	7.2	30	12	15		
1/2		9.8	30	15	20		
3/4		13.8	30	20	25		
1	1	16.0	30	25	30		
1.5	1	20.0	30	30	40		
2	1	24.0	30	30	50		
3	2	34.0	60	50	70		
5	3	56.0	100	80	90		
7.5	4	80.0	100	100	110		
10	-	-	-	-	-		

2:	230 VOLT (240 VOLT) SINGLE PHASE MOTOR STARTER SCHEDULE					
MOTOR HP	NEMA STARTER SIZE	FULL LOAD AMPS PER PHASE	DISC. SWITCH SIZE	FUSE SIZE AMPERES	CIRCUIT BREAKER SIZE AMPERES	
1/8	1	1.7	30	2.5	15	
1/6	1	2.2	30	3.5	15	
1/4	1	2.9	30	4.5	15	
1/3	1	3.6	30	5.6	15	
1/2	1	4.9	30	8	15	
3/4	1	6.9	30	10	15	
1	1	8.0	30	12	15	
1.5	1	10.0	30	15	20	
2	1	12.0	30	17.5	25	
3	1	17.0	30	25	35	
5	2	28.0	60	40	60	
7.5	2	40.0	60	60	80	
10	3	50.0	60	60	90	

200 Volt (208 Volt) Three-Phase Motor Starter Schedule

MOTOR HP	NEMA STARTER SIZE	FULL LOAD AMPS PER PHASE	DISC. SWITCH SIZE	FUSE SIZE AMPERES	CIRCUIT BREAKER SIZE AMPERES
1/2	1	2.3	30	3.5	15
3/4	1	3.2	30	5	15
1	1 .	4.1	30	6.25	15
1.5	1	6.0	30	10	15
2	1	7.8	30	12	15
3	1	11.0	30	17.5	20
5	1	17.5	30	25	35
7.5	1	25.3	60	40	50
10	2	32.2	60	50	60
15	3	48.3	60	60	90
20	3	62.1	100	90	100
25	3	78.2	100	100	110
30	4	92.0	200	125	125
40	4	120.0	200	175	175
50	5	150.0	200	200	200
60	5	177.0	400	250	250
75	5	221.0	400	300	300
100	6	285.0	400	400	400
125	6	359.0	600	500	600
150	6	414.0	600	600	600
200	7	552.0	•	- :	800

230 Volt (240 Volt) Three-Phase Motor Starter Schedule

		1	1	1	1
MOTOR HP	NEMA STARTER SIZE	FULL LOAD AMPS PER PHASE	DISC. SWITCH SIZE	FUSE SIZE AMPERES	CIRCUIT BREAKER SIZE AMPERES
1/2 3/4	1	2.0 2.8	30 30	3.2 4.5	15 15
1	- 1	3.6	30	5.6	15
1.5	1	5.2	30	8	15
2	1	6.8	30	10	15
3	1	9.6	30	15	20
5	1	15.2	30	25	30
7.5	1	22.0	30	30	45
10	2	28.0	60	40	60
15	2	42.0	60	60	80
20	3	54.0	100	80	90
25	3	68.0	100	100	100
30	3	80.0	100	100	110
40	4	104.0	200	150	150
50	4	130.0	200	200	200
60	5	154.0	200	200	225
75	5	192.0	400	300	250
100	5	248.0	400	350	350
125	6	312.0	400	400	450
150	6	360.0	600	500	600
200	6	480.0	600	600	800
250	7	600.0	800	800	800
300	7	720.0	1200	1000	1000
400	-	-	-	-	-

460 Volt (480 Volt) Three-Phase Motor Starter Schedule

MOTOR HP	NEMA STARTER SIZE	FULL LOAD AMPS PER PHASE	DISC. SWITCH SIZE	FUSE SIZE AMPERES	CIRCUIT BREAKER SIZE AMPERES
1/2	1	1.0	30	1.6	15
3/4	1	1.4	30	2.25	15
1	1	1.8	30	2.8	15
1.5	1	2.6	30	4	15
2	1 .	3.4	30	5.6	15
3	1	4.8	30	8	15
5	1	7.6	30	12	15
7.5	1	11.0	30	17.5	20
10	1	14.0	30	20	25
15	1	21.0	30	30	40
20	1	27.0	60	40	60
25	2	34.0	60	50	70
30	2	40.0	60	60	80
40	3	52.0	100	80	90
50	3	65.0	100	100	100
60	3	77.0	100	100	110
75	4	96.0	200	150	125
100	4	124.0	200	175	200
125	5	156.0	200	200	225
150	5	180.0	400	250	250
200	5	240.0	400	350	350
250	6	300.0	600	500	500
300	6	360.0	600	600	600
400	6	480.0	800	700	700
500	7	540.0	1200	800	800

575 Volt (600 Volt) Three-Phase Motor Starter Schedule

To tolk (000 tolk) fill 00 f liuso lilotor otartor onioualo					
MOTOR HP	NEMA STARTER SIZE	FULL LOAD AMPS PER PHASE	DISC. SWITCH SIZE	FUSE SIZE AMPERES	CIRCUIT BREAKER SIZE AMPERES
1/2	1	0.8	30	1.25	15
3/4	1	1.1	30	1.6	15
1	1	1.4	30	2.25	15
1.5	1	2.1	30	3.5	15
2	1	2.7	30	4.5	15
3	1	3.9	30	6.25	15
5	1	6.1	30	10	15
7.5	1	9.0	30	15	15
10	1	11.0	30	17.5	20
15	2	17.0	30	25	35
20	2	22.0	30	30	45
25	2	27.0	60	40	60
30	3	32.0	60	50	60
40	3	41.0	60	60	80
50	3	52.0	100	80	90
60	4	62.0	100	90	100
75	4	77.0	100	110	110
100	4	99.0	200	150	150
125	5	125.0	200	175	200
150	5	144.0	200	200	200
200	5	192.0	400	300	250
250	6	240.0	600	350	350
300	6	290.0	600	400	400
400	6	385.0	600	500	500
500	7	480.0	800	800	700

G. Motor Control Centers (MCC's):

- 1. NEMA Class I, Type A:
 - a. No Terminal boards for load or control connections are provided.
 - Numbered terminals for field wired power and control connections are provided on starter.
 - c. Starter unit mounted pilot devices are internally wired to starter.
- 2. NEMA Class I, Type B:
 - a. Terminal boards for load connections are provided for Size 3 and smaller controllers. For controllers larger than Size 3, numbered terminals for field wired power connections are provided on starter.
 - Unit control terminal boards for each combination motor controller are provided for field wiring.
 - c. Both terminal boards are factory wired and mounted on, or adjacent to, unit.
 - d. No load terminal boards for feeder tap units are provided.
 - e. Starter unit mounted pilot devices internally wired to starter.
 - f. NEMA Class I, Type B will be suitable for most HVAC applications.
- 3. NEMA Class I, Type C:
 - Factory wired master section terminal board, mounted on the stationary structure, is provided for each section.
 - b. Terminal boards for load connections, are provided for Size 3 and smaller controllers. For controllers larger than Size 3, numbered terminals for field wired power connections are provided on starter.
 - Unit control terminal boards for each combination motor controller are provided for field wiring.
 - d. Complete wiring between combination controllers or control assemblies and their master terminal boards are factory installed. No wiring between sections or between master terminals is provided. No interconnections between combination controllers and control assemblies.
 - e. No load terminal boards for feeder tap units are provided.
- 4. NEMA Class II, Type B:
 - a. Terminal boards for load connections are provided for Size 3 and smaller controllers. For controllers larger than Size 3, numbered terminals for field wired power connections are provided on starter.
 - b. Unit control terminal boards for each combination motor controller are provided for field wiring.
 - c. Both terminal boards are factory wired and mounted on, or adjacent to, unit.
 - d. Complete wiring between combination controllers or control assemblies in the same and other sections are factory wired.
 - e. No load terminal boards for feeder tap units are provided.
- 5. NEMA Class II, Type C:
 - Factory wired master section terminal board, mounted on the stationary structure, is provided for each section.
 - b. Terminal boards for load connections are provided for Size 3 and smaller controllers. For controllers larger than Size 3, numbered terminals for field wired power connections are provided on starter.
 - Unit control terminal boards for each combination motor controller are provided for field wiring.
 - d. Complete wiring between combination controllers or control assemblies and their master terminal boards in the same section and other sections are factory wired.
 - e. No load terminal boards for feeder tap units are provided.
- 6. MCCs are available in NEMA enclosure types 1, 2, 3R, and 12.

21.05 Adjustable (Variable) Frequency Drives (AFDs or VFDs)

A. AFD Components (from power side to load side):

- 1. Rectifier Section: Silicon controlled rectifiers (SCRs) or diodes change single or 3-phase AC power to DC power.
- DC Bus Section: Capacitors and an inductor smooth the rippled DC power supplied by the rectifier.
- 3. Inverter Section: An inverter converts the DC bus power to 3-phase variable frequency power.
- 4. Controller Section: The controller turns the inverter on and off to control the output frequency and voltage.

B. AFD Types:

- Variable Voltage Inverters (VVI) use a silicon controlled rectifier (SCR) to convert incoming AC power to a varying DC power and then they use an inverter to convert the DC power to 3 phase variable voltage and variable frequency power. The disadvantages of VVIs are:
 - a. Incoming line notching, which requires isolation transformers.
 - Power factor is proportional to speed, which may require power factor correction capacitors.
 - c. Torque pulsations are experienced at low speeds.
 - d. Non-sinusoidal current waveform produce additional heating in the motor.
- 2. Current Source Inverters (CSI) use SCRs in the rectifier and inverter sections and only and inductor in the DC bus section. The disadvantages of CSIs are:
 - a. Incoming line notching, which requires isolation transformers.
 - b. Power factor is proportional to speed, which may require power factor correction capacitors.
 - c. Motor drive matching is critical to proper operation.
 - d. Non-sinusoidal current waveform produce additional heating in the motor.
- 3. Pulse Width Modulated (PWM) Drives use a full wave diode bridge rectifier to convert the incoming AC power to DC power. Most PWM drives use a 6-pulse converter and some offer a 12-pulse converter in the rectifier section. The DC bus section consists of capacitors and in some cases an inductor. The inverter section uses Insulated Gate Bipolar Transistors (IGBTs), Bipolar Junction Transistors (BJTs), or Gate Turn off Thyristors (GTOs) to convert the DC bus power to a 3-phase variable voltage and variable frequency power. PWM drives are the most common AFD in use in the HVAC industry today despite the fact that it can punish motors electrically, especially 460 and 575 volt motors. The advantages of PWM drives are:
 - a. Minimal line notching.
 - b. Better efficiency.
 - c. Higher power factor.
 - d. Larger speed ranges.
 - e. Lower motor heating.

The disadvantages of the PWM drives are:

- a. Higher initial cost.
- b. Regenerative braking is caused because power is allowed to flow in both directions and can act as a drive or a brake.

C. AFD Design Guidelines:

1. For best motor life and reliability, do not operate motors run by AFDs into their service factor and do not select motors to run within the service factors.

- 2. Do not run motors below 25% of their rated speed or capacity.
- 3. Use inverter duty motors whenever possible. Inverter duty motors are built with winding thermostats that shut down the motor when elevated temperatures are sensed inside the motor. In addition, these motors are built with oversized frames and external blowers to cool the motor through the full range of speeds.
- 4. Motors which are operated with AFDs should be specified with phase insulation, should operate at a relatively low temperature rise (most high efficiency motors fit this category), and should use a high class of insulation (either insulation class F or H).
- 5. Generally, AFDs do not include disconnect switches; therefore the engineer must include a disconnect switch in the project design. The disconnect switch should be fused with the fuse rated for the drive input current rating.
- 6. Multiple motors can be driven with one AFD.
- 7. All control wiring should be run separate from AFD wiring.
- 8. Most AFDs include the following features as standard:
 - a. Overload protection devices.
 - b. Short Circuit Protection.
 - c. Ground Fault Protection.
- 9. Provide AFDs with a manual bypass in the event the drive fails.

D. AFDs produce non-linear loads, which cause the following unwanted effects:

- AC system circuits containing excessive currents and unexpectedly higher or lower voltages.
- 2. Conductor, connector, and component heating which is unsafe.
- 3. Loss of torque on motors.
- 4. Weaker contactor, relay, and solenoid action.
- 5. High heat production in transformers and motors which can be destructive.
- 6. Poor power factor.

21.06 NEMA Enclosures

A. NEMA Type 1: Indoor General Purpose, Standard

B. NEMA Type 2: Indoor Dripproof

C. NEMA Type 3R: Outdoor, Rain Tight, Water Tight, Dust Tight

D. NEMA Type 4, 4X, 5: Outdoor Rain Tight, Water Tight, Dust Tight, Corrosion

Resistant

E. NEMA Type 7X: Explosionproof

F. NEMA Type 12: Indoor Oil and Dust Tight

21.07 Humidifiers

A. Number of Humidifier Manifolds required is given in the following table:

DUCT HEIGHT	NUMBER OF MANIFOLDS
Less than 37"	1
37" - 58"	2
59" - 80"	3
81" - 100"	4
101" and Over	5

B. Humidifier Installation Requirements:

- 1. Humidifiers shall be installed a minimum of 3'-0" from any duct transformation, elbow, fitting, or outlet.
- Consideration must be given to length of vapor trail and air handling unit and ductwork design must provide sufficient length to prevent vapor trail from coming in contact with items downstream of humidifier before vapor has had time to completely evaporate.

C. Humidifier Makeup Requirements:

1. Steam or Electric Humidifiers: 5.6 GPM/1000 KW Input or

5.6 GPM/3413 MBH

2. Evaporative and Spray Coil Humidifiers: 5.0 GPM/1000 Lbs./Hr.

21.08 Insulation

A. Materials:

1. Calcium Silicate Temperature Range:	0-+1200°F.
2. Fiberglass Temperature Range:	-20-+1000°F.
3. Mineral Wool Temperature Range:	+200-+1900°F.
4 11 41 0	-350-+250°F.
	-450-+850°F.
6. Ceramic Fiber Temperature Range:	0-+3000°F.
7. Flexible Tubing and Sheets Temperature Range	-40-+250°F

B. General:

- 1. Insulation, adhesives, mastics, sealants, and coverings shall have a flame spread rating of 25 or less and a smoke developed rating of 50 or less as determined by an independent testing laboratory in accordance with NFPA 255 and UL 728 as required by ASHRAE 90A and 90B. Coatings and adhesives applied in the field shall be non-flammable in the wet state.
- Hangers on chilled water and other cold piping systems should be installed on the outside of the insulation to prevent hangers from sweating.

C. Pipe Insulation:

1. Insulation shall be sectional molded glass fiber, minimum 3.0 lb. per cubic foot density, thermal conductivity not greater than 0.24 Btu-in/sq.ft./°F./hour at a mean temperature

- difference of 75°F. and factory applied jacket of white, flame retardant vapor barrier jacket of 0.001" aluminum foil laminated to kraft paper reinforced with glass fibers, or all service jacket.
- 2. Insulation shall be flexible foamed plastic, minimum 5.0 lb. per cubic foot density, thermal conductivity not greater than 0.28 Btu-in/sq.ft./°F./Hour at a mean temperature difference of 75°F.
- 3. Insulation shall be cellular glass, thermal conductivity not greater than 0.40 Btu-in/sq.ft./°F./hour at a mean temperature difference of 75°F.
- 4. Insulation shall be foamglass, minimum 8.5 lb. per cubic foot density, thermal conductivity not greater than 0.35 Btu-in/sq.ft./°F./hour at a mean temperature difference of 75°F.
- 5. Insulation Thickness is given in the following table:

PIPING SYSTEM	PIPE SIZES	INSULATION THICKNESS VS TYPE(1,8)			
(7)		A	В	С	D
CHILLED WATER - 40 °F TO 60 °F (3)	6" & SMALLER 8" & LARGER	1.0 1.5	1.5 2.0	2.0 2.5	1.5 2.5
CHILLED WATER - 32 °F TO 40 °F (3)	1" & SMALLER 1-1/4" - 6" 8" & LARGER	1.0 1.5 2.0	1.5 2.0 2.5	2.0 2.5 3.5	1.5 2.5 3.0
CHILLED WATER - BELOW 32 °F (3)	2" & SMALLER 2-1/2" - 6" 8" & LARGER	1.5 2.0 2.5	2.0 2.5 3.0	2.5 3.5 4.5	2.5 3.0 4.0
CONDENSER WATER	ALL SIZES	(2)	(2)	(2)	(2)
HEATING WATER - LOW TEMPERATURE 100 °F TO 140 °F (4)	4" & SMALLER 5" & LARGER	1.0 1.5	1.5 2.0	2.0 2.5	1.5 2.5
HEATING WATER - LOW TEMPERATURE 141 °F TO 200 °F (4)	ALL SIZES	1.5	2.0	2.5	2.5
HEATING WATER - LOW TEMPERATURE 201 °F TO 250 °F (4)	2" & SMALLER 2-1/2" - 6" 8" & LARGER	1.5 2.0 3.5	2.0 2.5 4.5	2.5 3.5 6.0	2.5 3.0 5.5
HEATING WATER - MEDIUM TEMPERATURE 251 °F TO 350 °F (4)	1" & SMALLER 1-1/4" - 4" 5" & LARGER	2.0 2.5 3.5	(10)	3.5 4.5 6.0	3.0 4.0 5.5
HEATING WATER - HIGH TEMPERATURE 351 °F TO 450 °F (4)	2" & SMALLER 2-1/2" - 4" 5" & LARGER	2.5 3.0 3.5	(10)	4.5 5.0 6.0	4.0 4.5 5.5
DUAL TEMPERATURE	ALL SIZES	(9)	(9)	(9)	(9)
HEAT PUMP LOOP	ALL SIZES	(2)	(2)	(2)	(2)
STEAM AND STEAM CONDENSATE - LOW PRESSURE (5)	2" & SMALLER 2-1/2" - 6" 8" & LARGER	1.5 2.0 3.5	2.0 2.5 4.5	2.5 3.5 6.0	2.5 3.0 5.5
STEAM AND STEAM CONDENSATE - MEDIUM PRESSURE (5)	1" & SMALLER 1-1/4" - 4" 5" & LARGER	2.0 2.5 3.5	(10)	3.5 4.5 6.0	3.0 4.0 5.5
STEAM AND STEAM CONDENSATE - HIGH PRESSURE (5)	2" & SMALLER 2-1/2" - 4" 5" & LARGER	2.5 3.0 3.5	(10)	4.5 5.0 6.0	4.0 4.5 5.5
REFRIGERANT SUCTION AND LIQUID LINES (6)	1" & SMALLER 1-1/4" - 6" 8" & LARGER	1.0 1.5 2.0	1.5 2.0 2.5	2.0 2.5 3.5	1.5 2.5 3.0
REFRIGERANT HOT GAS (6)	ALL SIZES	0.75	1.0	1.5	1.0
AIR CONDITIONING CONDENSATE	ALL SIZES	0.5	0.5	1.0	0.75

Notes:

- 1. Type A: Fiberglass Insulation.
 - Type B: Flexible Foamed Plastic Insulation.
 - Type C: Cellular Glass Insulation.
 - Type D: Foamglass Insulation.
- Insulation not required on systems with temperatures between 55°F and 105°F, unless insulating
 pipe for freeze protection; then use chilled water (40°F, and above) thicknesses.
- Chilled water system piping is often insulated with fiberglass insulation; however, cellular glass and flexible foamed plastic may be more appropriate for moisture condensation protection. Other types of insulation may be used.
- Heating water system piping is generally insulated with fiberglass pipe insulation. Other types of insulation may be used.
- Steam system piping and steam condensate system piping are generally insulated with fiberglass pipe insulation. Other types of insulation may be used.
- 6. Refrigerant system piping is generally insulated with flexible foamed plastic. Other types of insulation may be used. Normally only refrigerant suction lines are insulated, but liquid lines should be insulated where condensation will become a problem and hot gas lines should be insulated where personal injury from contact may pose a problem.
- 7. Table meets or exceeds ASHRAE Standard 90.1-1989.
- 8. For piping exposed to ambient temperatures increase insulation thickness by 1.0 inch.
- For dual temperature systems use insulation thickness for more stringent system, usually the heating system.
- 10. System temperature exceeds temperature rating of insulation.

D. Duct Insulation

- 1. Internal Duct Liner:
 - a. 1" thick, 1½ pounds per cubic foot density amber color glass fiber blanket with smooth coated matte facing to conform to TIMA Standard AHC-101, NFPA 90A, NFPA 90B, NFPA 255, UL 181, and UL 723. Duct lining shall have a thermal conductance (k) not greater then 0.26 Btu/sq.ft./°F./hour at a mean temperature difference of 75°F. Vinyl spray face shall not be permitted.
 - b. Thicknesses: 1", 11/2", 2".
- 2. External Duct Insulation:
 - a. Duct Wrap: Insulation shall be flexible glass fiber blanket, 2" thick, minimum ¼ lb. per cubic foot density, thermal conductivity not greater than 0.31 Btu-in./sq.ft./°F./ hour at a mean temperature difference of 75°F and factory applied jacket of minimum 0.001" aluminum foil reinforced with glass fiber bonded to flame resistant kraft paper vapor barrier. Thicknesses: 1", 1½", 2".
 - b. Duct Board: Insulation shall be glass fiber, 2" thick, minimum 3.0 lb. per cubic foot density, thermal conductivity not greater than 0.24 Btu-in./sq.ft./°F./hour at a mean temperature difference of 75°F and factory applied jacket of white, flame retardant vapor barrier jacket of 0.001" aluminum foil reinforced with glass fibers bonded to flame resistant kraft paper. Thicknesses: 1", 1½", 2", 3", 4".
 - c. Duct Board: Insulation shall be rigid glass fiber board, 2" thick, minimum 6.0 lb. per cubic foot density, thermal conductivity not greater than 0.22 Btu-in./sq.ft./°F./hour at a mean temperature difference of 75°F and factory applied jacket of white, flame retardant vapor barrier jacket of 0.001" aluminum foil reinforced with glass fibers bonded to flame resistant kraft paper. Thicknesses: 1", 1½", 2".

3. Insulation Thickness is given in the following table:

	COOLING (3)				
DUCT LOCATION	ANNUAL COOLING DEGREE DAYS BASE 65 °F.	INSULATION R-VALUE	INSULTION THICKNESS (2)		
EXTERIOR OF BUILDING:	BELOW 500 500 TO 1150 1151 TO 2000 ABOVE 2000	3.3 5.0 6.5 8.0	0.75 1.5 1.5 2.0		
INSIDE BUILDING OR IN UNCONDITIONED SPACES (1): Δ T \leq 15 15 $<$ Δ T \leq 40 Δ T $>$ 40		NONE REQ'D 3.3 5.0	0.75 1.5		

	HEATING (3)				
DUCT LOCATION	ANNUAL HEATING DEGREE DAYS BASE 65 °F.	INSULATION R-VALUE	INSULTION THICKNESS		
EXTERIOR OF BUILDING:	BELOW 1500 1500 TO 4500 4501 TO 7500 ABOVE 7500	3.3 5.0 6.5 8.0	0.75 1.5 1.5 2.0		
INSIDE BUILDING OR IN UNCONDITIONED SPACES (1): Δ T \leq 15 15 $<$ Δ T \leq 40 Δ T $>$ 40		NONE REQ'D 3.3 5.0	0.75 1.5		

Notes:

- 1. Δ T (Temperature difference) is the difference between space design temperature and the design air temperature in the duct.
- 2. Minimum insulation thickness required. Internally insulated (lined) ducts usually use 1" thickness. Externally insulated ducts usually use 1½" or 2" thickness.
- 3. Table based on ASHRAE Standard 90.1-1989.

E. Insulation Protection:

- Aluminum roll jacketing and fitting covers produced from 0.016 inch thickness, H-14 temper with a smooth finish or approved equal. Install in accordance with manufacturer's recommendations.
- Prefabricated PVC fitting covers and jacketing with the same insulation and thickness as specified. Install in accordance with manufacturer's recommendations.

21.09 Firestopping and Through-Penetration Protection Systems

A. All openings in fire-rated and smoke-rated building construction must be protected from fire and smoke by systems that seal these openings to resist the pas-

sage of fire, heat, smoke, flames, and gases. These openings include passages for mechanical and electrical systems, expansion joints, seismic joints, construction joints, control joints, curtain wall gaps, the space between the edge of floor slab and the exterior curtain wall and columns, and other openings or cracks.

B. Terms:

- Firestopping. Firestopping is non-combustible building materials or a system of lumber pieces which are installed to prevent the movement of fire, heat, smoke, flames, and gases to other areas of the building through small concealed spaces. The term *firestopping* is used with all types of building construction except with non-combustible and fireresistive construction.
- 2. Through-Penetration Protection Systems (TPPS). TPPS are building materials or assemblies of materials specifically designed and manufactured to form a system designed to prevent the movement of fire, heat, smoke, flames, and gases to other areas of the building through openings made in fire-rated floors and walls to accommodate the passage of combustible and non-combustible items. The term TPPS is used with non-combustible and fire-resistive building construction.
- Combustible Penetrating Items. Combustible penetrating items are materials such as plastic pipe and conduit, electrical cables, and combustible pipe insulation.
- 4. Non-Combustible Penetrating Items. Non-combustible penetrating items are materials such as copper, iron, or steel pipe; steel conduit; EMT; electrical cable with steel jackets; and other non-combustible items.
- 5. Annular Space Protection. Annular space protection is the building materials or assembly of materials which protect the space between non-combustible penetrating items and the rated assembly. In concrete or masonry assemblies, the materials generally used for annular space protection are concrete, grout, or mortar. In all other assemblies, the materials must be tested and meet ASTM E119 standard under positive pressure.
- 6. Single-Membrane Protection. Single-membrane protection is the building materials or assembly of materials which protect the opening through one side, or a single membrane of a fire-resistive wall, roof/ceiling, or floor/ceiling to accommodate passage of combustible or non-combustible items. Materials protecting single membranes are annular space protection systems or TPPS.
- 7. Shaft Alternatives. A fire-rated shaft or enclosure is not required if a TPPS system with an F-Rating and a T-Rating equal to the rating of the assembly is used to protect openings made in fire-rated floors and walls to accommodate the passage of combustible and non-combustible items.

C. System Ratings:

- F-Ratings (Flame Ratings) define the period of time for which the firestopping or TPPS system prevents the passage of flames and hot gases to the unexposed side of the assembly, in accordance with ASTM E814. To receive an F-Rating, the system must also pass the hose stream test. F-Ratings are needed for all applications. F-Ratings must be equal to the rating of the assembly.
- 2. T-Ratings (Thermal Ratings) define the period of time for which the firestopping or TPPS system prevents the passage of flames and hot gases to the unexposed side of the assembly (F-Rating), and must also restrict the temperature rise on the unexposed surface to 325°F. in accordance with *ASTM E814*. T-Ratings must be equal to the rating of the assembly and at least 1 hour. T-Ratings are rarely applied because most penetrations in commercial structures tend to be in non-combustible concealed spaces and are generally only applied where codes require open protectives.

D. TPPS Materials:

- 1. Intumescent materials expand to form an insulating char.
- 2. Subliming materials pass from solid to vapor when heated without passing through the liquid phase.
- 3. Ablative materials char, melt, or vaporize when heated.
- 4. Endothermic materials, such as concrete and gypsum, absorb heat using chemically bounded water of the material.
- 5. Ceramic fibers are high temperature refractory materials.

E. Material Forms:

- 1. Caulks.
- 2. Putties.
- 3. Mixes.
- 4. Sheets, strips or collars.
- 5. Kits.
- 6. Devices.

Equipment Schedules

22.01 General

A. The equipment requirements listed in this section are general in nature and should be edited to the suit the project. The items listed for a particular piece of equipment are generally not all required. For example, a variable volume terminal unit will have either a hot water coil or steam coil, but not both. Also some Clients and Authorities Having Jurisdiction may not permit some of this information to be included on the drawings (i.e., Manufacturer's Name and Model No.).

B. Abbreviations

1. CFM = Air Flow Rate (Cubic Feet per Minute) 2. GPM = Water Flow Rate (Gallons per Minute) 3. MBH $= 1.000 \, \text{Btu/Hr}.$ 4. Hp = Horsepower = Dry Bulb Temperature (°F.) 5. DB = Wet Bulb Temperature (°F.) 6. WB 7. RH = Relative Humidity (%) 8. EAT = Entering Air Temperature (°F.) 9. LAT = Leaving Air Temperature (°F.) = Entering Water Temperature (°F.) 10. EWT = Leaving Water Temperature (°F.) 11. LWT 12. SP = Static Pressure (In. WG) = External Static Pressure (In. WG) 13. ESP 14. Total SP = Total Static Pressure (In. WG) 15. FLA = Full Load Amps 16. LRA = Locked Rotor Amps = Feet per Minute 17. FPM 18. Air PD = Air Pressure Drop (In. WG) 19. Water PD = Water Pressure Drop (Ft. H_2O) = Pressure Reducing Valve (Psig) 20. PRV 21. RV = Relief Valve (Psig) 22. Psig = Pounds per Square Inch 23. SA = Supply Air CFM 24. RA = Return Air CFM Outside Air CFM 25. OA 26. EXH = Exhaust Air CFM 27. RFA = Relief Air CFM 28. CC = Cooling Coil 29. HC Heating Coil 30. PHC = Preheat Coil Reheat Coil 31. RHC

22.02 Air Balance Schedule

Room Number Room Name Source Number of Occupants Code Requirements: OA CFM

SA CFM

Supply CFM

Return CFM

Relief CFM

Exhaust CFM

Outdoor CFM

Transfer Air:

CFM

To Room

From Room

Remarks

22.03 Air Compressors

Designation

Location

Service

Type (Reciprocating, Rotary Screw, Duplex, Simplex)

CFM

Pressure Psig

Receiver Size:

Gallons

Diameter

Length

Motor:

Hp

RPM

Volts-Phase-Hertz

Operating Weight Lbs.

Manufacturers: Name and Model No.

Remarks

22.04 Air Cooled Condensers

Designation

Location

Service

Type

Tons or MBH

Refrigerant Type

Saturated Condenser Temperature

Condenser EAT °F.DB/°F.WB

Minimum OA Temperature

Fans:

Number

Hp

Volts-Phase-Hertz

Operating Weight Lbs.

Manufacturers: Name and Model No.

Remarks

22.05 Air Cooled Condensing Units

Designation

Location

Service

Type

Tons or MBH

Refrigerant Type

Saturated Condenser Temperature

Condenser EAT °F.DB/°F.WB

Minimum OA Temperature

Compressor:

Number

KW

Volts-Phase-Hertz

Fans:

Number

Hp

Volts-Phase-Hertz

Operating Weight Lbs.

Manufacturers: Name and Model No.

Remarks

22.06 Air Conditioning Units

Designation

Location

Service

Min. OA CFM

Fan:

CFM

ESP

Number of Wheels

Wheel Diameter In.

Motor Hp

Filters:

Type

Efficiency

Cooling Coil:

Refrigerant Type

Sensible MBH

Total MBH

EAT °F.DB/°F.WB

LAT °F.DB/°F.WB

Compressor:

Number

KW

Condenser:

EAT

Motor Hp

Exhaust Fan Motor Hp

Electric Heat:

KW

EAT

LAT

Gas Heater:

Output MBH

Input MBH

EAT

LAT

Hot Water Coil:

MBH

EAT

LAT

EWT

LWT

GPM

Steam Coil:

MBH

EAT

LAT

Steam/Hr.

Steam Pressure Psig

Electric, Volts-Phase-Hertz

Operating Weight Lbs.

Manufacturers: Name and Model No.

Remarks

22.07 Air Filters (Pre-Filters, Filters, Final-Filters)

Designation

Location

Equipment Served

Number

Type

Width

Height

Depth

Efficiency %

Initial Air PD

Final Air PD

Remarks

22.08 Air Handling Units-Custom, Factory Assembled, Factory Packaged, or Field Fabricated

Designation Location Service Min. OA CFM Fan: **CFM** Type (AF, BI, FC, DWDI, SWSI) Class (I, II, III, IV) Number of Wheels Wheel Diameter **ESP** Total SP Motor Hp Volts-Phase-Hertz Filters (See Air Filters) Coils (See Coils—DX, Electric, Steam, Water) Operating Weight Lbs. Manufacturers: Name and Model No. Remarks

22.09 Air Handling Units-Packaged

Designation Location Service Min. OA CFM Fan: **CFM** Type (AF, BI, FC, DWDI, SWSI) No. of Wheels Wheel Diameter In. **ESP Total SP** Motor Hp Volts-Phase-Hertz Filters (See Air Filters) Coils (See Coils—DX, Electric, Steam, Water) Operating Weight Lbs. Manufacturers: Name and Model No. Remarks

22.10 Boilers, Hot Water

Designation Location Service Output MBH Water: **GPM EWT** LWT Water PD Heater: Gas Input MBH Oil Input GPH Electric: KW Volts-Phase-Hertz **RV** Setting Accessories: HP KW Volts-Phase-Hertz

22.11 Boilers, Steam

Operating Weight Lbs.

Remarks

Manufacturers: Name and Model No.

Designation Location Service Output # Steam/Hr. Steam Pressure Psig Feed Water Temperature Heating Surface Sq. Ft. Steam Drum Diameter Lower Drum Diameter Gas Input MBH Oil Input GPH Electric: KW Volts-Phase-Hertz **RV** Setting Operating Weight Lbs. Manufacturers: Name and Model No. Remarks

22.12 Cabinet Unit Heaters

Designation Location

Type (Recessed, Semi-recessed, Exposed, Concealed, Ceiling, Floor, Up Discharge, Down Discharge, Hot Water, Steam, Electric, etc.)

Fan:

CFM

RPM

Motor Hp

Volts-Phase-Hertz

Hot Water Coil:

Capacity MBH

EAT

GPM

EWT

Steam Coil:

Capacity MBH

EAT

Steam/Hr.

Steam Pressure Psig

Electric Coil:

KW

Volts-Phase-Hertz

Runouts:

Supply

Return

Manufacturers: Name and Model No.

Remarks

22.13 Chemical Feed Systems

Designation

Location

Service

Pump:

Type (Positive Displacement)

GPH

PSI

HP

Volts-Phase-Hertz

Tank Gallons

Agitator:

HP

RPM

Volts-Phase-Hertz

Remarks

22.14 Chillers, Absorption

Designation

Location

Service

Type

Refrigerant Type Capacity **Tons Cooling** MBH Heating Evaporator **EWT** LWT **GPM** Water PD Condenser **EWT** LWT **GPM** Water PD Absorber Steam Pressure Psig # Steam/Hr. Gas Pressure In. W.G. Gas Input MBH Oil Input GPH Heating: **EWT** LWT **GPM** Water PD Electrical: Hp KW Volts-Phase-Hertz

22.15 Chillers, Air Cooled

Manufacturers: Name and Model No.

Operating Weight Lbs.

Remarks

Designation

Location
Service
Type
Refrigerant Type
Capacity Tons
Evaporator:
 EWT
 LWT
 GPM
 Water PD
Condenser Temperature
Condenser:
 EAT

Fans:

Number

Hp

Compressor

Number

KW

Volts-Phase-Hertz

Operating Weight Lbs.

Manufacturers: Name and Model No.

Remarks

22.16 Chillers, Water Cooled

Designation

Location

Service

Type

Refrigerant Type

Capacity Tons

Evaporator:

EWT

LWT

GPM

Water PD

Condenser:

EWT

LWT

GPM

Water PD

Heating (Heat Recovery Type):

EWT

LWT

GPM

Water PD

Compressor:

Number

KW

Volts-Phase-Hertz

Evaporator Temperature

Operating Weight Lbs.

Manufacturers: Name and Model No.

Remarks

22.17 Coils, Direct Expansion (DX)

Designation

Location

Equipment Served

Service (CC, Heat Recovery)

Refrigerant Type

MBH

CFM

EAT °F.DB/°F.WB

LAT °F.DB/°F.WB

Maximum Face Velocity FPM

Air PD

Remarks

22.18 Coils, Electric

Designation

Location

Equipment Served

Service (PHC, HC, RHC)

MBH

CFM

EAT

LAT

Maximum Face Velocity FPM

Air PD

KW

Volts-Phase-Hertz

Number of Control Steps

Manufacturers: Name and Model No.

Remarks

22.19 Coils, Steam

Designation

Location

Equipment Served

Service (HC, PHC, RHC)

MBH

CFM

EAT

LAT

Maximum Face Velocity FPM

Air PD

Steam/Hr.

Steam Pressure Psig

Runout Sizes

Supply

Return

Remarks

22.20 Coils, Water

Designation

Location

Equipment Served

Service (PHC, CC, HC, RHC)

MBH

CFM

EAT °F.DB/°F.WB

LAT °F.DB/°F.WB

Max. Face Velocity FPM

GPM

EWT

LWT

Air PD Water PD

Runout Size:

Supply

Return

Remarks

22.21 Condensate Pump and Receiver Sets

Designation

Location

Service

Type (Simplex, Duplex)

GPM

Heat Ft. H₂O

Motor Hp

Volts-Phase-Hertz

Tank Capacity Gallons

Operating Weight Lbs.

Manufacturers: Name and Model No.

Remarks

22.22 Convectors

Designation

Location

Type (Recessed, Semi-recessed, Exposed, Concealed, Ceiling, Floor, etc.)

Capacity MBH

EAT

GPM

EWT

Steam/Hr.

Steam Pressure Psig

KW

Volts-Phase-Hertz

Runout Size

Supply

Return

Manufacturers: Name and Model No.

Remarks

22.23 Cooling Towers

Designation

Location

Service

Type

GPM

EWT

LWT

Ambient Air °F.WB

Fan

Number

CFM

No. of Motors

Hp

ESP In. W.G.

Volts-Phase-Hertz

Nozzle PD

Height Difference

Operating Weight Lbs.

Manufacturers: Name and Model No.

Remarks

22.24 Deaerators

Designation

Location

Service

Type

Number of Stages

Outlet Capacity Lb./Hr.

Storage Capacity:

Pounds

Minutes

Steam:

Lbs./Hr.

Psig

Size (Length × Diameter)

Operating Weight Lbs.

Manufacturers: Name and Model No.

Remarks

22.25 Design Conditions

Room Number

Room Name

Summer:

Outside °F.DB/°F.WB

Inside °F.DB/%RH

Winter:

Outside °F.DB/°F.WB Inside °F.DB/%RH

Remarks

22.26 Electric Baseboard Radiation

Designation

Type (See Specification for Type Designation)

Style (Wall Mounted, Floor Mounted, Flat Top, Sloped Top, Etc.)

Number of Elements

Electric:

KW

Volts-Phase-Hertz

Manufacturers: Name and Model No.

Remarks

22.27 Electric Radiant Heaters

Designation

Type (See Specification for Type Designation)

Style

Number of Elements

Length of Unit

Electric:

KW

Volts-Phase-Hertz

Manufacturers: Name and Model No.

Remarks

22.28 Evaporative Condensers

Designation

Location

Service

Type

Tons or MBH

Refrigerant Type

Saturated Condenser Temperature

Condenser EAT °F.DB/°F.WB

Minimum OA Temperature

Fans:

Number

ESP

Hp

Volts-Phase-Hertz

Pump:

Hp

Head Ft.H2O

Number

Volts-Phase-Hertz

Operating Weight Lbs.

Manufacturers: Name and Model No.

Remarks

22.29 Expansion Tanks

Designation

Location

Service (Hot Water, Chilled Water, Condenser Water, Etc.)

Type (Closed, Open, Diaphragm)

Capacity Gallons

Size Diameter × Length

PRV Setting Psig

RV Setting Psig

Connection Size:

Fill

System

Operating Weight Lbs.

Manufacturers: Name and Model No.

Remarks

22.30 Fans

Designation

Location

Service (SA, RA, EA)

CFM

RPM

Drive (Belt, Direct)

Type (BI, AF, FC, Roof, Propeller, Etc.)

Class (I, II, III, IV)

Wheel Diameter Inches

SP

Motor Hp

Volts-Phase-Hertz

Operating Weight Lbs.

Manufacturers: Name and Model No.

Remarks

22.31 Fan Coil Units

Designation

Nominal CFM

Type (2-Pipe, 4-Pipe, 2-Pipe with Electric Heat)

 $Style\ (Recessed, Semi-recessed, Exposed, Concealed, Cabinet, Hi-Rise, Ceiling, Floor, etc.)$

Cooling:

Sensible MBH

Total MBH **GPM EWT** LWT EAT °F.DB/°F.WB Water PD Runout Size: Supply Return Drain Size Heating: **MBH GPM** Water PD **EWT** LWT EAT °F.DB/°F.WB Runout Size: Supply Return KW Volts-Phase-Hertz Number of Control Steps Fan: **CFM** Motor Hp **ESP** Volts-Phase-Hertz Manufacturers: Name and Model No. Remarks

22.32 Finned Tube Radiation

EAT

Designation Type (See Specification for Type Designation) Style (Wall Mounted, Floor Mounted, Flat Top, Sloped Top, etc.) Number of Elements Element Size: Fins Tube Water: Capacity MBH **EWT** LWT **EAT GPM** Water PD Steam: Capacity MBH

Steam/Hr.

Steam Pressure

Manufacturers: Name and Model No.

Remarks

22.33 Flash Tanks

Designation

Location

Service

Type

Discharge Steam Pressure Psig

Tanks Size (Diameter × Height)

Operating Weight Lbs.

Manufacturers: Name and Model No.

Remarks

22.34 Fluid Coolers/Closed Circuit Evaporative Coolers

Designation

Location

Service

Type

Fluid Type

GPM

EWT

LWT

Ambient Air °F.WB

Fan:

Number

CFM

Number of Motors

Hp

ESP

Volts-Phase-Hertz

Pump:

Hp

Head Ft.H2O

Number

Volts-Phase-Hertz

Operating Weight Lbs.

Manufacturers: Name and Model No.

Remarks

22.35 Fuel Oil Tanks

Designation

Location

Fuel Type
Tank Type (Double Wall, Steel, Fiberglass)
Capacity Gallons
Size:
 Length
 Diameter
Approximate Weight
Connection Sizes:
 Supply
 Return
 Fill
 Vent
 Gauge

Sounding Drop (Tank, Storage) Pad Size ($L \times W \times Th$)

Heating Supply and Return

Manhole Size

Manufacturers: Name and Model No.

Remarks

22.36 Gas Pressure Regulators

Designation

Location

Capacity Cu.Ft./Hr.

Inlet:

Psig

Pipe Size

Outlet:

Psig

Pipe Size

Manufacturers: Name and Model No.

Remarks

22.37 Gravity Ventilators

Designation

Location

Service

Type Dome, Louvered, Filters, No Filters)

Throat Size (L×W)

Physical Size $(L \times W \times H)$

Manufacturers: Name and Model No.

Remarks

22.38 Heat Exchangers, Plate and Frame

Designation Location Service

Capacity MBH

Cold Side:

GPM

EWT

LWT

Water PD

Hot Side:

GPM

EWT

LWT

Water PD

Operating Weight Lbs.

Manufacturers: Name and Model No.

Remarks

22.39 Heat Exchangers, Shell and Tube, Steam to Water (Converter)

Designation

Location

Service

Capacity MBH

Shell:

Steam/Hr.

Steam Pressure Psig

Tubes:

GPM

EWT

LWT

Water PD

Minimum Surface Area Sq. Ft.

Number of Passes

Approximate Length Ft.

Operating Weight Lbs.

Manufacturers: Name and Model No.

Remarks

22.40 Heat Exchangers, Shell and Tube, Water to Water

Designation

Location

Service

Capacity MBH

Shell:

GPM

EWT

LWT

Water PD

Tubes:

GPM

EWT

LWT

Water PD

Minimum Surface Area Sq. Ft.

Number of Passes

Approximate Length Ft.

Operating Weight Lbs.

Manufacturers: Name and Model No.

Remarks

22.41 Heat Pumps, Air Source

Designation

Location

Service

Type (Recessed, Semi-recessed, Exposed, Concealed, Ceiling, Floor, etc.)

Fan:

Total CFM

OA CFM

ESP

Cooling:

Sensible MBH

Total MBH

EAT °F.DB/°F.WB

LAT °F.DB/°F.WB

Sink Air Temperature

Heating Capacity:

Compressor MBH

Total MBH

Source Air Temperature

Electrical:

Evaporator Fan Hp

Condenser Fan Hp

Compressor KW

Heater KW

Volts-Phase-Hertz

Operating Weight Lbs.

Manufacturers: Name and Model No.

Remarks

22.42 Heat Pumps, Water Source

Designation

Location

Service

Type (Recessed, Semi-recessed, Exposed, Concealed, Ceiling, Floor, etc.)

Fan:

Total CFM

OA CFM

ESP

Cooling:

Sensible MBH

Total MBH

EAT °F.DB/°F.WB

LAT °F.DB/°F.WB

EWT

Heating Capacity:

Compressor MBH

Total MBH

EWT

Source Water:

GPM

Water PD

Runout Size:

Supply

Return

Electrical:

Fan Hp

Compressor KW

Heater KW

Volts-Phase-Hertz

Operating Weight Lbs.

Manufacturers: Name and Model No.

Remarks

22.43 Humidifiers

Designation

Location

Service

Capacity:

Steam/Hr.

Steam Pressure Psig

Electric:

KW

Volts-Phase-Hertz

Duct/Air Handling Unit Size

Number of Manifolds

Runout Size:

Supply

Return

Drain

Manufacturers: Name and Model No.

Remarks

22.44 Motor Control Centers

Item Number

Hp/KW

FLA

Starter Size

Circuit Breaker Size

Auxiliary Equipment (Specifications)

Nameplate Designation

Operating Weight Lbs.

Manufacturers: Name and Model No.

Remarks

22.45 Packaged Terminal AC Systems

Designation

Location

Service

Minimum OA CFM

Fan:

CFM

ESP

Number Of Wheels

Motor Hp

Filters:

Type

Efficiency %

DX Cooling:

Sensible MBH

Total MBH

EAT °F.DB/°F.WB

LAT °F.DB/°F.WB

Compressors:

Number

KW

Condenser:

EAT

Motor Hp

Electric Heat:

KW

EAT

LAT

Electric Volts-Phase-Hertz

Hot Water:

MBH

EAT

LAT

EWT

LWT

GPM

Water PD

Steam Heat:

MBH

EAT

LAT

Steam/Hr.

Steam Pressure Psig

Operating Weight Lbs.

Manufacturers: Name and Model No.

Remarks

22.46 Pumps

Designation

Location

Service (Chilled, Heating, Condenser Water, etc.)

Type (End Suction, Horizontal Split Case, In-Line, etc.)

GPM

Head Ft.

RPM

Motor Hp

NPSH

Volts-Phase-Hertz

Operating Weight Lbs.

Manufacturers: Name and Model No.

Remarks

22.47 Radiant Heaters

Designation

Output Capacity MBH

Gas Input MBH

Burner:

FLA

LRA

Volts-Phase-Hertz

Vacuum Pump:

Motor Hp

Volts-Phase-Hertz

Length of Reflector

Manufacturers: Name and Model No.

Remarks

22.48 Steam Pressure Reducing Valves

Designation

Location

Capacity # Steam/Hr.

Inlet:

Pressure Psig

Pipe Size

Outlet:

Pressure Psig

Pipe Size

Manufacturers: Name and Model No.

Remarks

22.49 Steam Pressure Relief Valve

Designation

Location

Capacity # Steam/Hr.

Relief Valve Setting Psig

Discharge Pipe Size

Manufacturers: Name and Model No.

Remarks

22.50 Sound Attenuators (Duct Silencers)

Designation

Location

Service

Type

CFM

Noise Reduction:

63 HZ

125 HZ

250 HZ

500 HZ

1,000 HZ

2,000 HZ

4,000 HZ

8,000 HZ

Face Velocity FPM

Maximum Air PD

Length Ft.

Manufacturers: Name and Model No.

Remarks

22.51 Terminal Units, Constant Volume Reheat

Designation

CFM Range

Inlet Duct Size

Hot Water Coil:

Capacity MBH

EAT

Number of Rows

GPM

EWT

Water PD

Steam Coil:

Capacity MBH

EAT

Number of Rows

#Steam/Hr.

Steam Pressure Psig

Runout Size:

Supply

Return

Electric Coil:

KW

Volts-Phase-Hertz

No. of Control Steps

Manufacturers: Name and Model No.

Remarks

22.52 Terminal Units, Dual Duct Mixing Box

Designation

CFM Range

Minimum/Maximum CFM:

Cold Deck

Hot Deck

Inlet Duct Size:

Cold

Hot

Manufacturers: Name and Model No.

Remarks

22.53 Terminal Units, Fan Powered

Designation

CFM Range

Minimum CFM Setting

Inlet Duct Size

Fan:

Type (Series, Parallel)

CFM

ESP

Motor Hp

Volts-Phase-Hertz

Hot Water Coil:

Capacity MBH

EAT

Number of Rows

GPM

EWT

Water PD

Steam Coil:

Capacity MBH

EAT

Number of Rows

Steam/Hr.

Steam Pressure Psig

Runout Size:

Supply

Return

Electric Coil:

KW

Volts-Phase-Hertz

Number of Control Steps

Manufacturers: Name and Model No.

Remarks

22.54 Terminal Units, Variable Air Volume (VAV)

Designation

CFM Range

Minimum CFM Setting

Inlet Duct Size

Hot Water Coil:

Capacity MBH

EAT

Number of Rows

GPM

EWT

Water PD

Steam Coil:

Capacity MBH

EAT

Number of Rows

Steam/Hr.

Steam Pressure Psig

Runout Size:

Supply

Return

Electric Coil:

KW

Volts-Phase-Hertz

Number of Control Steps

Manufacturers: Name and Model No.

Remarks

22.55 Unit Heaters

Designation

Location

Type (Horizontal Discharge, Vertical Discharge, Hot Water, Steam, Electric, Gas Fired, Oil Fired, etc.)

Fan:

CFM

RPM

Motor Hp

Volts-Phase-Hertz

Hot Water Coil

Capacity MBH

EAT

GPM

EWT

Steam Coil

Capacity MBH

EAT

Steam/Hr.

Steam Pressure Psig

Gas Heater:

Output Capacity MBH

Input MBH

EAT

Oil Heater:

Output Capacity MBH

Input GPH

EAT

Electric Coil:

KW

Volts-Phase-Hertz

Runouts:

Supply

Return

Manufacturers: Name and Model No.

Remarks

22.56 Water Softeners

Designation

Location

Service

Number of Tanks

Capacity:

Minimum Grains

Maximum Grains

GPM

Tank Size (Diameter × Height)

Brine Tank (Diameter × Height) Electrical Volts-Phase-Hertz Operating Weight Lbs. Manufacturers: Name and Model No. Remarks

Equipment Manufacturers

23.01 Central Plant Equipment

- A. Air Cooled Condensers and Condensing Units: Trane; Carrier; York; McQuay
- B. Boilers, Cast Iron: H.B. Smith; Weil McClain; Burnham
- C. Boilers, Copper Tube: Triad; Raypak; Hydrotherm
- D. Boilers, Electric: Brasch; Indeeco; Cemline
- E. Boilers, Fire Tube: Cleaver Brooks; York-Shipley; Kewaunee; Johnston
- F. Boilers, Water Tube: Cleaver Brooks; Babcock & Wilcox; Keeler
- G. Chillers, Absorption: Trane; Carrier; York
- H. Chillers, Centrifugal: Trane; Carrier; York; McQuay
- I. Chillers, Reciprocating: Trane; Carrier; York; McQuay; Bohn; Dunham-Bush
- J. Chillers, Rotary Screw: Trane; McQuay; Bohn; Dunham-Bush
- K. Cooling Towers: Baltimore Air Coil; Marley; Evapco, Tower Tech
- L. Evaporative Condensers and Fluid Coolers: Baltimore Air Coil; Marley; Evapco, Tower Tech
- M. Fans, Cabinet Centrifugal: Trane; Buffalo; Carrier; York; McQuay
- N. Fans, Ceiling Type: Greenheck; Penn; Cook
- O. Fans, Centrifugal, Utility Sets: Greenheck; Barry; Buffalo; Trane; York; Peerless; Twin City; Pace; Ilg; New York Blower; Hartzell Fan, Inc.; Cincinnatti Fan and Ventilator Company, Inc.
- P. Fans, Power Roof and Wall Ventilators: Greenheck; Penn; Cook; Jenn-Air; Acme; Powerline; Ilg; Hartzell Fan, Inc.; Cincinnatti Fan and Ventilator Company, Inc.
- Q. Fans, Power Roof and Wall Ventilators, Upblast: Greenheck; Penn; Cook; Jenn-Air; Acme; Powerline; Ilg; Hartzell Fan, Inc.; Cincinnatti Fan and Ventilator Company, Inc.
- R. Fans, Propeller: Greenheck; ACME; Buffalo; Trane; Powerline; Ilg; American Coolaire; Hartzell Fan, Inc.; Cincinnatti Fan and Ventilator Company, Inc.
- S. Fans, Tubular Centrifugal: Greenheck; Barry; Peerless; Twin City; Ilg; New York Blower
- T. Fans, Vane Axial: Peerless; Greenheck; Joy; Woods Fan Company; Hartzell Fan, Inc.
- U. Heat Exchangers, Plate and Frame: Bell and Gossett; Tranter; Baltimore Air Coil; Alfa-Laval Thermal, Inc.; Paul Mueller
- V. Heat Exchangers, Shell and Tube: Bell and Gossett; Taco; Amtrol; Patterson-Kelley; Sims; Dominion; Whitlock

- W. Heat Pumps: McQuay; American Air Filter; International Environmental; Friedrich; General Electric
- X. Ice Storage Systems: Baltimore Air Coil; Calmac; Turbo; Marley
- Y. Pumps, Centrifugal, End Suction, Horizontal Split Case, Close Coupled: Bell and Gossett; Taco; Worthington; Weinman; Allis Chalmers; Amtrol; Aurora; Buffalo; Goulds; Ingersall Rand
- Z. Pumps, Centrifugal, Inline: Bell and Gossett; Taco; Amtrol; Goulds; Thrush
- AA. Steam Generators, Unfired: Cemline; Ketema

23.02 Air System Equipment and Specialties

- A. Air Conditioners, Window and Split Systems: Friedrich; Mitsubishi; Comfortmaker; Eubank; National Comfort Products; Trane; Carrier; York; McQuay
- B. Air Filters: American Air Filter; Farr; Cambridge; Continental; Mine Safety Appliances
- C. Air Filter Gauges: Dwyer
- D. Air Flow Monitors: Air Monitor Corporation; Cambridge Air Sentinel
- E. Air Handling Units, Custom Built: Miller-Picking; Buffalo; Air Enterprises; Gamewell; Semco; Mammoth; Racan; Pace; Hunt Air; Acousti Flo; M&I; Gaylord Industries; Governair; York; Industrial Sheet Metal & Mechanical Corp (ISM)
- F. Air Handling Units, Direct or Indirect Gas Fired: Weatherite; Reznor; Absolut Aire; Rapid; Concept Designs, Inc.; Sterling; Cambridge Engineering
- G. Air Handling Units, Packaged: Trane; Carrier; York; McQuay; Buffalo; Bohn; Dunham-Bush; Magic Aire; Mammoth; Governair
- H. Air Purification Systems: Bioclimatic, Inc.
- I. Coils, Heating and Cooling: Trane; Carrier; York; McQuay; Aerofin; Bohn; Dunham-Bush
- J. Dampers, Fire, Smoke, Combination, Motor Operated: Ruskin; Air Balance, Inc.; American Warming and Ventilating, Inc.; Arrow Louver and Damper; Penn Ventilator Co.; Phillips-Aire; United Air/Safe Air
- K. Diffusers, Register and Grilles: Krueger, Anemostat, Agitair; Barber-Colman; Titus; Carnes
- L. Ductwork, FRP: Beverly-Pacific; Corrosion Products; Environmental Corrections; Fiber Dyne; Harrington; Viron
- M. Ductwork, FRP Resins: Atlac Type 711-05 AS; Dion Corres 9300FR; Hetron FR992; Derakane 510A; Interplastics VE8440
- N. Ductwork, Halar Coated Stainless Steel: Fab Tech Incorporated; GDS Manufacturing Company; Viron; PSI

- O. Fans, Cabinet Centrifugal: Trane; Buffalo; Carrier; York; McQuay
- P. Fans, Ceiling Type: Greenheck; Penn; Cook
- Q. Fans, Centrifugal, Utility Sets: Greenheck; Barry; Buffalo; Trane; York; Peerless; Twin City; Pace; Ilg; New York Blower; Hartzell Fan, Inc.; Cincinnatti Fan and Ventilator Company, Inc.
- R. Fans, Power Roof and Wall Ventilators: Greenheck; Penn; Cook; Jenn-Air; Acme; Powerline; Ilg; Hartzell Fan, Inc.; Cincinnatti Fan and Ventilator Company, Inc.
- S. Fans, Power Roof and Wall Ventilators, Upblast: Greenheck; Penn; Cook; Jenn-Air; Acme; Powerline; Ilg; Hartzell Fan, Inc.; Cincinnatti Fan and Ventilator Company, Inc.
- T. Fans, Propeller: Greenheck; ACME; Buffalo; Trane; Powerline; Ilg; American Coolaire; Hartzell Fan, Inc.; Cincinnatti Fan and Ventilator Company, Inc.
- U. Fans, Tubular Centrifugal: Greenheck; Barry; Peerless; Twin City; Ilg; New York Blower
- V. Fans, Vane Axial: Peerless; Greenheck; Joy; Woods Fan Company; Hartzell Fan, Inc.
- W. Flexible Duct: Thermaflex; Genflex; Wiremold
- X. Gravity Ventilators: Greenheck; Penn; Acme; Cook; Jenn; Powerline
- Y. Heat Pumps: McQuay; American Air Filter; International Environmental; Friedrich; General Electric
- Z. Humidifiers: Armstrong; Herrmidifier; Dryomatic; Industrial Humidifier Co.; Carnes; Nortec; Hygromatik; Dri-Steam Humidifier Co.
- AA. Louvers: American Warming and Ventilating, Inc.; Air Balance, Inc.; Ruskin; Airline Products; Airstream Products; Penn Ventilator Co.; Phillips Industries, Inc.; Arrow United Industries; Construction Specialties, Inc.
- BB. Prefabricated Panels: United Sheet Metal Co.; Industrial Acoustics Co.; Gale Corp.
- CC. Sound Attenuators (Active Noise Control): Digisonix
- DD. Sound Attenuators (Duct Silencers): Industrial Acoustics Co. (IAC); Koppers; Gale; Semco; Vibro Acoustics; Commercial Acoustics; Vibration Mountings, Inc.; Aero-Sonics
- EE. Thermometers: Ashcroft; Marsh; Weiss; Marshalltown; Moeller; Taylor Tel-Tru; Trerice; Weksler; Weston

23.03 Water System Equipment and Specialties

- A. Air Separators and Air Control Devices: Bell and Gossett; Taco; Amtrol; Thrush
- B. Air Vents, Automatic: Bell and Gossett; Taco; Amtrol; Armstrong

- C. Backflow Preventers and Pressure Reducing Valves: Watts Regulator; Cobraco Industries
- D. Expansion Joints: Metraflex; Keflex; Hyspan; Kopperman; Anaconda; Aeroquip
- E. Expansion Tanks: Bell and Gossett; Taco; Amtrol; Woods
- F. Filters/Separators: Lakos Solids Separators; 3M Filtration Products; Filterite; Ametek; Puro Flux
- G. Flow Measuring Systems, Portable and Permanent: Rockwell International Inc.; Taco; Bell and Gossett; Barton; Fisher and Porter; Girand; Barco; Dietrich Standard
- H. Coils, Heating and Cooling: Trane; Carrier; York; McQuay; Aerofin; Bohn; Dunham-Bush
- I. Pressure Gauges: Ashcroft; Marsh; Weiss; Marshalltown; Moeller; Trerice; Weksler; Weston; U.S. Gauge
- J. Pumps, Centrifugal, End Suction, Horizontal Split Case, Close Coupled: Bell and Gossett; Taco; Worthington; Weinman; Allis Chalmers; Amtrol; Aurora; Buffalo; Paco; Dean; Goulds; Ingersall Rand
- K. Pumps, Centrifugal, Inline: Bell and Gossett; Taco; Amtrol; Goulds; Thrush; Paco
- L. Relief Valves: Crosby; Farris; Lonnergan; Kunkle
- M. Strainers: Mueller; Spence; Sarco; Metraflex; McAlear; Tate Tempco; Boylston; Nicholson
- N. Thermometers: Ashcroft; Marsh; Weiss; Marshalltown; Moeller; Taylor Tel-Tru; Trerice; Weksler; Weston
- O. Valves, Balancing: Bell and Gossett; Taco; Torr & Anderson (TA)
- P. Valves, Ball: Nibco; Hammond; Fairbanks; Worchester; Itt Grinnell; Apollo; Crane; Powell; Contromatics; Dynaquip
- Q. Valves, Butterfly: Dezurik; Allis-Chalmers; Centerline; Conoflow; Walworth; Trw Mission; Crane-Monark; Demco; Continental; Milliken Valve Co.; Mueller
- R. Valves, Check: Jenkins; Crane; Lunkenheimer; Nibco; Hammond; Powell; Stockham; Walworth; Fairbanks; Kennedy; Milwaukee; RP & C Valve
- S. Valves, Silent Check: Miller Valve Co.
- T. Valves, Gate: Jenkins; Crane; Lunkenheimer; Nibco; Hammond; Powell; Stockham; Walworth; Fairbanks; Kennedy; Milwaukee; RP & C Valve
- U. Valves, Globe: Jenkins; Crane; Lunkenheimer; Nibco; Hammond; Powell; Stockham; Walworth; Fairbanks; Kennedy; Milwaukee; RP & C Valve
- V. Valves, Plug: Dezurik; Milliken Valve Co.; Mueller
- W. Water Treatment Systems: Betz Dearborn, Inc.; Nalco; Diversey Water Technologies, Inc.; Ashland Chemical Company; Chem Treat, Inc.; Coastline; Tricon Chemical Corporation; Cleaver Brooks Water Management Group; Mogul; Olin; ARC; Culligan

- X. Water Heaters, Electric: Cemline; A.O. Smith; PVI; State; Bradford White; Lochinvar: Ruud
- Y. Water Heaters, Gas: A.O. Smith; PVI; State; Bradford White; Lochinvar
- Z. Water Heaters, Instantaneous, Undersink: In Sink Erator; Eemax
- AA. Water Heaters, Oil: A.O. Smith; PVI; State
- BB. Water Heaters, Steam: Cemline, A.O. Smith; Bell & Gossett; Patterson & Kelley

23.04 Steam System Equipment and Specialties

- A. Coils, Heating and Cooling: Trane; Carrier; York; McQuay; Aerofin; Bohn; Dunham-Bush
- B. Condensate Pump and Receiver Units: Federal; Chicago; Domestic Pump; Skidmore; Weinman
- C. Condensate Storage Units: Cleaver Brooks; Trane; Crane-Cochrane Buffalo Tank; Adamson
- D. Deaerator Feedwater Systems: Cleaver Brooks; Permutit; Chicago; Trane; Crane-Cochrane
- E. Steam Control Valves and Regulators: Leslie; Spirax Sarco
- F. Steam Generators, Unfired: Cemline, Ketema
- G. Steam Pressure Reducing Valves: Spence Regulators; Fisher; Masoneilan
- H. Steam Relief Valves: Crosby; Farris; Lonnergan; Kunkle
- I. Steam Traps: Armstrong; Sarco; Trane; Anderson; Dunham-Bush
- J. Strainers: Mueller; Spence; Sarco; Metraflex; McAlear; Tate Tempco; Boylston; Nicholson
- K. Thermometers: Ashcroft; Marsh; Weiss; Marshalltown; Moeller; Taylor Tel-Tru; Trerice; Weksler; Weston
- L. Valves, Ball: Nibco; Hammond; Fairbanks; Worchester; Itt Grinnell; Apollo; Crane; Powell; Contromatics; Dynaquip
- M. Valves, Butterfly: Dezurik; Allis-Chalmers; Centerline; Conoflow; Walworth; Trw Mission; Crane-Monark; Demco; Continental; Milliken Valve Co.; Mueller
- N. Valves, Check: Jenkins; Crane; Lunkenheimer; Nibco; Hammond; Powell; Stockham; Walworth; Fairbanks; Kennedy; Milwaukee; RP & C Valve
- O. Valves, Silent Check: Miller Valve Co.
- P. Valves, Gate: Jenkins; Crane; Lunkenheimer; Nibco; Hammond; Powell; Stockham; Walworth; Fairbanks; Kennedy; Milwaukee; RP & C Valve

- Q. Valves, Globe: Jenkins; Crane; Lunkenheimer; Nibco; Hammond; Powell; Stockham; Walworth; Fairbanks; Kennedy; Milwaukee; RP & C Valve
- R. Valves, Plug: Dezurik; Milliken Valve Co.; Mueller
- S. Water Softeners: Cleaver Brooks; Cochran; Elgin; Culligan
- T. Water Treatment Systems: Betz Dearborn, Inc.; Nalco; Diversey Water Technologies, Inc.; Ashland Chemical Company; Chem Treat, Inc.; Coastline; Tricon Chemical Corporation; Cleaver Brooks Water Management Group; Mogul; Olin; ARC; Culligan

23.05 Terminal Equipment

- A. Air Terminal Units (VAV, CV, DD, Fan Powered, etc.): Krueger; Titus; Anemostat; Carnes; Barber-Colman; Buensod
- B. Cabinet Unit Heaters: Vulcan; Trane; Ted-Reed; McQuay; Modine; Emerson-Chromalox; Brasch; Berko; Dunham-Bush
- C. Coils, Heating and Cooling: Trane; Carrier; York; McQuay; Aerofin; Bohn; Dunham-Bush
- D. Computer Room Air Conditioning Units: Liebert; Edpac; Airflow
- E. Convectors: Trane; Ted-Reed; Sterling; Dunham-Bush
- F. Duct Heater, Electric: Indeeco; Chromalox; Brasch
- G. Electric Baseboard Radiation: Vulcan; Chromalox; Trane
- H. Fan Coil Units: Trane; Carrier; American Air Filter; McQuay; International Environmental; Nesbitt; Sterling; Dunham-Bush
- I. Finned Tube Radiation: Vulcan; Trane; Ted-Reed; Sterling; Dunham-Bush
- J. Gravity Ventilators: Greenheck; Penn; Acme; Cook; Jenn; Powerline
- K. Heat Pumps: McQuay; American Air Filter; International Environmental; Friedrich; General Electric
- L. Humidifiers: Armstrong; Herrmidifier; Dryomatic; Industrial Humidifier Co.; Carnes; Nortec; Hygromatik; Dri-Steam Humidifier Co.
- M. Unit Heaters: Vulcan; Trane; Ted-Reed; McQuay; Modine; Emerson-Chromalox; Brasch; Berko; Dunham-Bush; King Electrical Manufacturing; Ruffneck; Reznor; Markel

23.06 Miscellaneous Equipment

A. Automatic Control Systems: Johnson Controls; Honeywell; Barber-Colman; Landis-Gyr Powers; Robertshaw

- B. Breechings, Chimneys and Stacks, Double Wall Sheet Metal: Metalbestos; Van Packer; Industrial Chimney; Heat Fab, Inc.
- C. Expansion Joints & Flexible Metal Hoses: Mason Industries; Mercer Rubber Co.; Twin City Hose; Garlock; Pathway Bellows Inc.; Proco Products; Flexible Metal Hose; Advanced Thermal Systems Inc.; Vibration Mountings, Inc.; Uni-Source; ATCO Rubber Products; General Rubber
- D. Breechings, Chimneys and Stacks, Refractory Lined: Van Packer; Power-Pac
- E. Identification: Seton Name Plate Corp.; W.H. Brady Co.; Industrial Safety Supply Co., Inc.; Bunting
- F. Insulation Adhesives, Mastics, and Coatings: Fosters
- G. Insulation, Calcium Silicate: Atlas; Owens Corning; Johns-Manville
- H. Insulation, Ductwork External: Owens Corning, Certainteed, Johns-Manville, Knauf
- I. Insulation, Ductwork Lining: Owens Corning; Aeroflex; Johns-Manville; CGS Ultraliner
- J. Insulation, Flexible Foamed Plasic: Armstrong; Rubatex; Halstead
- K. Insulation, Piping Fiberglass: Owens Corning, Certainteed, Johns-Manville, Knauf
- L. Motors: General Electric; Lincoln; Reliance; Louis Allis; Toshiba; Marathon
- M. Refrigeration System Specialties: Parker Hannifin; Sporlan Valve; Henry Valve; Alco Controls
- N. Variable Frequency Drives: Toshiba Corporation Tosvert; Reliance Electric; Cutler Hammer; Louis Allis Magnetek; ABB; Robicon Corporation; Saftronics
- O. Vibration Isolation: Mason Industries; Industrial Acoustics Co. (IAC); Amber/Booth; Korfund; Vibration Eliminator; Vibration Mountings Inc.; Peabody Noise Control Inc.; Metroflex

Building Construction Business Fundamentals

24.01 Engineering/Construction Contracts

A. Methods of Obtaining Contracts:

 Competitive Bidding Contracts. Contracts in which Engineers/Contractors are selected on the basis of their competitive bids.

Negotiated Contracts. Contracts in which Engineers/Contractors are selected on the basis of ability, reputation, past experience with the owner, or type of project, etc., and fees are then negotiated.

B. Contract Types:

1. Lump Sum Contract. A contract in which the Engineer/Contractor agrees to carry out the stipulated project for a fixed sum of money.

2. Unit Price Contract. A contract based on estimated quantities of adequately specified items of work and the costs for these items of work are expressed in dollars per unit of work. For example, the unit of work may be dollars per foot of caisson drilled, dollars per cubic yard of rock excavated, or dollars per cubic yard of soil removed.

This contract is generally only applicable to construction contracts.

Unit price contracts are usually used when quantities of work cannot be accurately defined by the construction documents (driving piles, foundation excavation, rock excavation, contaminated soil removal, etc.). Unit prices may be included in part of a lump sum or other type of contract.

3. Cost Plus Contracts. A contract in which the owner reimburses the Engineer/Contractor for all costs incurred and compensates them for services rendered. Cost plus contracts are always negotiated. Compensation may be based on the following:

a. Fixed Percentage of the Cost of the Work (Cost Plus Fixed Percentage Contract). Compensation is based on an agreed percentage of the cost.

b. Sliding-Scale Percentage of the Cost of the Work (Cost Plus Sliding-Scale Percentage Contract). Compensation is based on an agreed sliding-scale percentage of the cost (federal income taxes are paid on an increasing sliding scale).

c. Fixed Fee (Cost Plus Fixed Fee Contract). Compensation is based on an agreed fixed sum of money.

d. Fixed Fee with Guaranteed Maximum Price (Cost Plus Fixed Fee with Guaranteed Maximum Price Contract). Compensation is based on an agreed fixed sum of money and the total cost will not exceed an agreed upon total project cost.

e. Fixed Fee with Bonus (Cost Plus Fixed Fee with Bonus Contract). Compensation is based on an agreed fixed sum of money and an agreed upon bonus is established for completing the project ahead of schedule, under budget, superior performance, etc.

f. Fixed Fee with Guaranteed Maximum Price and Bonus (Cost Plus Fixed Fee with Guaranteed Maximum Price and Bonus Contract). Compensation is based on an agreed fixed sum of money, a guaranteed maximum price, and an agreed upon bonus is established for completing the project ahead of schedule, under budget, superior performance, etc.

g. Fixed Fee with Agreement for Sharing Any Cost Savings (Cost Plus Fixed Fee with Agreement for Sharing Any Cost Savings Contract). Compensation is based on an agreed upon fixed sum of money and an agreed upon method of sharing any cost savings.

h. Other fixed fee contracts can be generated using variations on those listed above or by negotiating certain aspects particular to the project into a cost plus fixed fee contract with the owner.

- 4. Incentive Contracts. A contract in which the owner awards or penalizes the Engineer/Contractor for performance of work in accordance with an agreed upon target. The target is often project cost or project schedule.
- 5. Liquidated Damages Contracts. A contract in which the Engineer/Contractor is required to pay the owner an agreed upon sum of money in accordance with an agreed upon target. The target is often for each calendar day of delay in completion of the project.

Liquidated damages, when included in the contract, must be a reasonable measure of the damages suffered by the owner due to delay in completion of the project to be enforceble in a court of law. The owner must also be able to demonstrate and prove the damages suffered due to delay in completion of the project. Weather, strikes, contract changes, natural disasters, and other events beyond the control of the contractor can void the claim for liquidated damages.

- 6. Percentage of Construction Fee Contracts. A contract in which the Engineer's fee is based on an agreed upon percentage of the project's construction cost.
- 7. Scope of Work. The scope of work is part of the Engineer's contract defining the Engineer's responsibilities and work required to produce the Contract Documents required by the owner to get the project built. The Engineer's scope of work can be compared to the Contract Documents defining a construction contract.

24.02 Building Construction Business Players

- A. Owner. The individual or individuals who initiates the building design process (May be a business, corporation, developer, hospital, local government, municipality, state government, or federal government).
- B. Architect. Design team member responsible for internal and external space planning, space sizes, relative location and interconnection of spaces, emergency egress, internal and external circulation, aesthetics, life safety, etc. Generally the architect is the lead and the driving force behind the project.
- C. Civil Engineers. Design team member responsible for site drainage, roadways, parking, site grading, site circulation, retaining walls, site utilities (sometimes done by the mechanical and electrical engineers), etc.
- D. Structural Engineers. Design team member responsible for building structure (design of beams, columns, foundations, floors, roof). Responsible for making the building stand.
- E. Interior Designers. Design team member responsible for building finishes (wall coverings, floor coverings, ceilings); often assists with or is responsible for space planning. Often this is also done by the architect.
- F. Landscape Architect. Design team member responsible for interior as well as external plantings (grass, shrubs, trees, flowers,) etc.
- G. Surveyors. Design team member responsible for establishing contours and site boundaries and locating existing benchmarks, trees, roads, water lines, sanitary and storm sewers, electric and telephone utilities, etc.

- H. Geologists/Soils Analysts. Design team member responsible for establishing soil characteristics for foundation analysis, potential ground water problems, rock formations, etc.
- I. Transportation Engineer. Design team member responsible for elevators, escalators, dumbwaiters, and other modes of vertical and/or horizontal transportation.
- J. Electrical Engineer. Design team member responsible for design of electrical distribution systems, lighting, powering mechanical and other equipment, receptacles, communication systems (telephone, intercom, paging), fire alarm and detection systems, site lighting, site electrical (or civil engineer), emergency power systems, uninterruptable power systems, security systems, etc.

K. Mechanical Engineers:

- 1. Plumbing Engineer. Design team member responsible for water supply and distribution systems; sanitary, vent, and storm water systems; natural gas systems; medical and laboratory gas and drainage systems; underground storage tanks; plumbing fixtures; etc.
- Fire Protection Engineer. Design team member responsible for sprinkler and other fire protection systems, standpipe and hose systems, fire pumps, site fire mains, fire extinguishers (or architect), etc.
- 3. HVAC Engineer. Design team member responsible for the design of the heating, ventilating, and air conditioning systems; ductwork and piping systems; automatic temperature control systems; industrial ventilation systems; environmental control; indoor air quality; heat loss and heat gain within the building; human comfort, etc.

L. Contractors:

- 1. General Contractor. Also referred to as prime contractor in single contract construction projects. The general contractor is the construction team member responsible for construction of the building structure and foundations, building envelope, interior partitions, building finishes, roofing, site work, elevators, project schedule, project coordination, project management, etc. The general contractor may sub some or all of the work to other contractors. In single contract projects, the general contractor is also responsible for mechanical and electrical work as well, but this work is most often done by sub-contractors.
- 2. Mechanical Contractor. Also referred to as sub-contractor in single contract construction projects. The mechanical contractor is the construction team member responsible for construction of the building HVAC, plumbing, and fire protection systems. The mechanical contractor may be broken into one, two, or three sub-contracts HVAC and Plumbing and/or Fire Protection. The mechanical contractor may sub some or all of the work to other contractors (plumbing, sheet metal, fire protection, automatic controls, etc.).
- 3. Electrical Contractor. Also referred to as sub-contractor in single contract construction projects. The electrical contractor is the construction team member responsible for construction of the building electrical systems, fire alarm systems, communication systems, security systems, lighting systems, etc. The electrical contractor may sub some or all of the work to other contractors (communication, security fire alarm, etc.).
- Prime Contractor. The contractor who signs a contract with the owner to perform the work.
- 5. Multiple Prime Contractors. When more than one contractor signs a contract with the owner to perform the work. Often this is accomplished with four prime contracts as follows, but may be done with any number of contracts:
 - a. General Contract
 - b. Mechanical (HVAC) Contract

- c. Plumbing/Fire Protection Contract
- d. Electrical Contract
- 6. Sub-Contractor. The contractor or contractors who sign a contract with the general or prime contractor to perform a particular portion of the prime contractor's work.
- 7. Sub-Sub-Contractor. The contractor or contractors who sign a contract with the sub-contractor to perform a particular portion of the sub-contractor's work.

Architectural, Structural, and Electrical Information

25.01 Building Structural Systems

A. Standard Nominal Structural Steel Depths:

- 1. W-Shapes (Wide Flange Beams): 4, 5, 6, 8, 10, 12, 14, 16, 18, 21, 24, 27, 30, 33, 36, 40, 44.
- 2. S-Shapes (I beams): 3, 4, 5, 6, 7, 8, 10, 12, 15, 18, 20, 24.
- 3. C-Shapes (Channels): 3, 4, 5, 6, 7, 8, 9, 10, 12, 15.

B. Standard Nominal Joist Depths as Manufactured by Vulcraft:

- 1. K-Series: 8, 10, 12, 14, 16, 18, 20, 22, 24, 26, 28, 30.
- 2. LH-Series & DLH-Series: 18, 20, 24, 28, 32, 36, 40, 44, 48, 52, 56, 60, 64, 68, 72, 84.
- C. Building mechanical equipment support points should not deflect more than 0.33 inch for cooling towers and no more than 0.25 inch for all other mechanical equipment.

D. Maximum Duct and Pipe Sizes that may pass through steel joists are given in the following table:

JOIST DEPTH	ROUND DUCT OR PIPE SIZE	SQUARE DUCT SIZE	RECTANGLE DUCT SIZE
8"	5"	4 X 4	3 X 8
10"	6"	5 X 5	3 X 8
12"	7"	6 X 6	4 X 9
14"	8"	6 X 6	5 X 9
16"	9"	7 X 7	6 X 10
18"	11"	8 X 8	7 X 11
20"	11"	9 X 9	7 X 12
22"	12"	9 X 9	8 X 12
24"	13"	10 X 10	8 X 13
26"	15"	12 X 12	9 X 18
28"	16"	13 X 13	9 X 18
30"	17"	14 X 14	10 X 18

- 1. Table based on Vulcraft K Series Joists. For LH or DLH Series Joists consult with Vulcraft.
- 2. Above values are maximum sizes; designer must consider duct insulation or duct liner thickness.
- Do not run ductwork through joists or between joists because it generally becomes a problem in the field. If you must run ductwork through joists or between joists, notify structural engineer and verify locations of joist bridging.

E. Floor Span vs. Structural Member Depths is given in the following table:

Floor-Structural Member Depth (1)

,	STI	RUCTURA	L STEEL SH	IAPES	STRUCTURAL STEEL JOISTS			
STRUCTURAL	BE	AMS	GIRDERS		JOISTS (9)		JOISTS GIRDERS	
MEMBER SPAN	MIN. (2,4)	MAX. (3,4,8)	MIN. (2,5,7)	MAX. (3,5,8)	MIN. (2,4,6)	MAX. (3,6)	MIN. (2,5)	MAX. (3,5)
20 Ft.	10"	14"	16"	24"	12"	14"	18"	28"
30 Ft.	16"	18"	21"	33"	16"	24"	20"	40"
40 Ft.	21"	24"	24"	36"	20"	24"	24"	52"
50 Ft.	N/A	N/A	N/A	N/A	N/A	N/A	N/A	N/A
60 Ft.	N/A	N/A	N/A	N/A	N/A	N/A	N/A	N/A

Notes:

- 1. Floor spans generally do not exceed 40 feet.
- 2. Assumed Floor Dead Load (DL) = 50 psf; Live Load (LL) = 50 psf.
- 3. Assumed Floor Dead Load (DL) = 50 psf; Live Load (LL) = 150 psf.
- 4. Assumed Spacing = $\pm 5'$ -0".
- 5. Assumed Spacing = $\pm 30'$ -0".
- 6. Assumed Spacing = $\pm 2'$ -0".
- 7. Assumed Steel Grade 50 ksi.
- 8. Assumed Steel Grade 36 ksi.
- 9. K Series Joists for 20' and 30' spans; LH Series for 40' spans.

F. Roof Span vs. Structural Member Depths is given in the following table:

Roof-Structural Member Depth

	STI	RUCTURA	L STEEL SH	IAPES	STRUCTURAL STEEL JOISTS			
STRUCTURAL	BEAMS		GIRDERS		JOISTS (7)		JOISTS GIRDERS	
MEMBER SPAN	MIN. (1,3)	MAX. (2,3)	MIN. (1,4,5)	MAX. (2,4,6)	MIN. (1,3)	MAX. (2,3)	MIN. (1,4)	MAX. (2,4)
20 Ft.	8"	10"	10"	18"	12"	14"	18"	28"
30 Ft.	14"	16"	16"	24"	16"	20"	20"	40"
40 Ft.	18"	21"	21"	30"	20"	24"	24"	52"
50 Ft.	N/A	N/A	27"	36"	28"	32"	32"	64"
60 Ft.	N/A	N/A	30"	36"	32"	36"	44"	84"

Notes:

- 1. Assumed Roof Dead Load (DL) = 20 psf; Live Load (LL) = 20 psf.
- 2. Assumed Roof Dead Load (DL) = 35 psf; Live Load (LL) = 50 psf.
- 3. Assumed Spacing = $\pm 5'$ -0".
- 4. Assumed Spacing = $\pm 30'$ -0".
- 5. Assumed Steel Grade 50 ksi.
- 6. Assumed Steel Grade 36 ksi.
- 7. K Series Joists for 20' and 30' spans; LH Series for 40', 50', and 60' spans.

25.02 Architectural and Structural Information

A. Equipment Weights. Provide equipment weights, sizes, and locations to Architect and Structural Engineer. Architect does not normally need the weights of equipment, but information is needed by Structural Engineer. Obtain weights and sizes from

Manufacturer's catalogs or Manufacturer's Representative. Equipment weights should include the following information as a minimum:

- 1. Item designation.
- 2. Location.
- 3. Size—length, width, height—include curb height if required.
- 4. Weight. Operating weight if substantially different from installed weight.
- 5. Floor/Roof openings. Wall openings if load bearing or shear walls are used.
- 6. Special remarks.
- B. Ductwork Weight. Coordinate all ductwork with Structural Engineer, especially when ductwork weight is 20 Lbs./Lf. or more. Provide ductwork weight and drawings showing location of ductwork and sizes. See Appendix A for ductwork weight information.
- C. Piping Weight. Coordinate all piping with Structural Engineer especially pipe sizes 6 inches and larger. Provide piping weight, location of anchors and forces and drawings showing location of piping and pipe sizes. See Appendix for pipe weight information.

25.03 Electrical Information

- A. Provide electrical information for all mechanical equipment requiring electrical power to the Electrical Engineer. Electrical information should include the following information as a minimum:
- 1. Item designation.
- 2. Location.
- 3. Voltage-Phase-Hertz.
- 4. Horsepower, Full Load Amps, Locked Rotor Amps, KW, Minimum Circuit Amps: Provide 1 or more.
- 5. Is equipment to be on emergency power?
- 6. Who provides starter? Who provides disconnect switch?
- 7. Control Type, HOA, Manual, etc.
- 8. Special Requirements?

25.04 Mechanical/Electrical Equipment Space Requirements

A. Commercial Buildings:

- 8 to 20% of Gross Floor Area. Most of the mechanical equipment is located indoors (i.e., no rooftop AHUs).
- ½ to ½ of Total Building Volume. This includes the ceiling plenum as mechanical/electrical space.

B. Hospital and Laboratory Buildings:

- 1. 15 to 50% of Gross Floor Area. Most of the mechanical equipment is located indoors (i.e., no rooftop AHUs).
- ½ to ½ of Total Building Volume. This includes the ceiling plenum as mechanical/electrical space.
- C. The original building design should allow from 10 to 15 percent additional shaft space for future expansion and modification of the facility. This additional shaft space will also reduce the initial installation cost.

- D. Minimum recommended clearance around boiler and chillers is 36 inches. Minimum recommended clearance around all other mechanical equipment is 24 inches. Maintain minimum clearances for coil pull, tube pull, and cleaning of tubes as recommended by the equipment manufacturer. This is generally equal to the length or width of the tubes or piece of equipment. Maintain minimum clearance as required to open access and control doors on equipment for service, maintenance, and inspection.
- E. Minimum recommended clearance between top of lights and deepest structural member is 24 inches.
- F. Mechanical and electrical rooms should be centrally located to minimize ductwork, pipe, and conduit runs (size and length). Centrally locating mechanical and electrical spaces will minimize construction, maintenance, and operating costs. Additional space is quite often required when mechanical and electrical equipment rooms cannot be centrally located or when space requirements are fragmented throughout the building. In addition, centrally located equipment rooms will simplify distribution systems and will in some cases decrease above ceiling space requirements.
- G. Mechanical rooms with fans and air handling equipment should have at least 10 to 15 square feet of floor area for each 1,000 CFM of equipment air flow.
- H. Mechanical rooms with refrigeration equipment must have an exit door which opens directly to the outside or through a vestibule type exit equipped with self-closing, tight-fitting doors.
- Mechanical rooms must be clear of electrical rooms, elevators, and stairs on at least two sides, preferably on three sides.
- J. Electrical rooms must be clear of elevators and stairs on at least two sides, preferably on three sides.
- K. In general, mechanical equipment rooms require from 12 to 20 feet clear from floor to underside of structure.
- L. Mechanical and electrical shafts must be clear of elevators and stairs on at least two sides. Rectangular shafts with aspect ratios of 2:1 to 4:1 are easier to work mechanical and electrical distribution systems in and out of the shafts than square shafts.
- M. The main electrical switchgear room should be located as close as possible to the incoming electrical service. If an emergency generator is required, the emergency generator room should be located adjacent to the main switchgear room to minimize electrical costs and interconnection problems. The emergency generator room should be located on an outside wall, preferably a corner location to enable proper ventilation, combustion air, and venting of engine exhaust.
- N. A mechanical equipment room should be located on the first floor or basement floor to accommodate the incoming domestic water service main, the fire protection service mains, and the gas service. These service mains may include meter and regulator assemblies if these assemblies are not installed in meter vaults or outside the building. Consult you local utility company for service and meter/regulator assembly requirements.

O. The locations and placement of mechanical and electrical rooms must take into account how large pieces of equipment (chillers, boilers, cooling towers, transformers, and other large pieces of equipment) can be moved into and out of the building during initial installation and after construction for maintenance and repair and/or replacement.

25.05 Americans with Disabilities Act (ADA)

A. ADA Titles:

- 1. Title I—Equal Employment Opportunity.
- 2. Title II—State and Local Governments.
- 3. Title III—New and Existing Public Accommodations and new Commercial Facilities.
- 4. Title IV—Telecommunications.
- 5. Title V—Miscellaneous Provisions.

B. Drinking Fountains:

- 1. Where only one drinking fountain is provided on a floor, a drinking fountain with two bowls, one high bowl and one low bowl, is required.
- 2. Where more than one drinking fountain is provided on a floor, 50% shall be handicapped accessible and shall be on an accessible route.
- 3. Spouts shall be no higher than 36 inches above finished floor or grade.
- 4. Spouts shall be located at the front of the unit and shall direct the water flow parallel or nearly parallel to the front of the unit.
- 5. Controls shall be mounted on the front or side of the unit.
- 6. Clearances:
 - a. Knee space below unit 27 inches high, 30 inches wide, and 17 to 9 inches deep and a minimum front clear floor space of 30 inch \times 48 inch.
 - b. Units without clear space below: 30 inch \times 48 inch clearance suitable for parallel approach.

C. Water Closets:

- 1. Height of water closet shall be 17 to 19 inches to the top of the toilet seat.
- 2. Flush controls shall be hand operated or automatic. Controls shall be mounted on the wide side of toilet areas no more than 44 inches above the floor.
- 3. At least one toilet shall be handicapped accessible.

D. Urinals:

- Urinals shall be stall-type or wall hung with and elongated rim at a maximum of 17 inches above the floor.
- 2. Flush controls shall be hand operated or automatic. Controls shall be mounted no more than 44 inches above the floor.
- 3. If urinals are provided, at least one shall be handicapped accessible.

E. Lavatories:

- 1. Lavatories shall be mounted with the rim or counter surface no higher than 34 inches above the finished floor with a clearance of at least 29 inches to the bottom of the apron.
- 2. Hot water and drain pipe under lavatories shall be insulated or otherwise configured to protect against contact.
- 3. Faucets shall be lever operated, push-type, and electronically controlled. Self-closing valves are acceptable provided they remain open for a minimum of 10 seconds.

F. Bathtubs:

- 1. Bathtub controls shall be located toward the front half of the bathtub.
- Shower unit shall be provided with a hose at least 60 inches long that can be used both as a fixed shower head and a hand-held shower head.

G. Shower Stalls:

- 1. The shower controls shall be opposite the seat in a 36 inch × 36 inch shower stall and adjacent to the seat in a 30 inch × 60 inch shower stall.
- Shower unit shall be provided with a hose at least 60 inches long that can be used both as a fixed shower head and a hand-held shower head.

H. Forward Reach:

- 1. Maximum High Forward Reach: 48 inches.
- 2. Minimum Low Forward Reach: 15 inches.

I. Side Reach:

- 1. Maximum High Side Reach: 54 inches.
- 2. Minimum Low Side Reach: 9 inches.

J. Areas of Rescue Assistance:

- 1. A portion of a stairway landing within a smokeproof enclosure.
- 2. A portion of an exterior exit balcony located immediately adjacent to an exit stairway.
- A portion of a one-hour fire-resistive corridor located immediately adjacent to an exit enclosure.
- 4. A portion of a stairway landing within an exit enclosure which is vented to the exterior and is separated from the interior of the building with not less than one-hour fireresistive doors.
- A vestibule located immediately adjacent to an exit enclosure and constructed to the same fire-resistive standards as required for corridors.
- 6. When approved by the authorities having jurisdiction, an area or room which is separated from other portions of the building by a smoke barrier.
- 7. An elevator lobby when elevator shafts and adjacent lobbies are pressurized as required for a smokeproof enclosures by local regulations and when complying with the requirements herein for size, communication and signage.
- 8. Size:
 - a. Each Area of Rescue Assistance shall have at least two accessible areas $30'' \times 48''$ minimum.
 - b. Area shall not encroach on the exit width.
 - c. The total number of areas per floor shall be one for every 200 persons. If the occupancy per floor is less than 200, the authorities having jurisdiction may reduce the number of areas to one.
- 9. A method of two-way communication, with both visible and audible signals, is required between the primary fire entry and the areas of rescue assistance.
- 10. Each area must be identified.

K. Stairway Width, 48 inches between handrails minimum.

L. Protruding Objects:

 Objects protruding from wall with their leading edges between 27 and 80 inches above the finished floor shall protrude no more than 4 inches into walks, halls, corridors, passageways, or aisles.

- 2. Objects mounted with their leading edges at or below 27 inches above the finished floor may protrude any amount.
- 3. Protruding objects shall not reduce the clear width of an accessible route or maneuvering space.
- Walks, halls, corridors, passageways, aisles, or other circulation spaces shall have 80 inch minimum clear head room.

M. Controls and Operating Mechanisms:

- 1. The highest operable part of controls, dispensers, receptacles, and other operable equipment shall be placed within at least one of the reach ranges.
- Electrical and communication system receptacles on walls shall be mounted no less than 15 inches above the floor.
- 3. Controls and operating mechanisms shall be operable with one hand and shall not require tight grasping, pinching, or twisting of the wrist. The force required to activate shall be no greater than 5 lbf.

Conversion Factors

26.01 Length

- 1 Mile = 1760 Yds = 5,280 Ft. = 63,360 In. = 1.609 Km
- 1 Ft. = 0.3048 M = 30.48 Cm = 304.8 Mm
- 1 In. = 2.54 Cm = 25.4 Mm
- 1 Cm = 0.3937 In.
- 1 M = 39.37 In. = 3.2808 Ft. = 1.094 Yds.
- 1 Km = 3281 Ft. = 0.6214 Miles = 1094 Yds.
- 1 Fathom = 6 Feet = 1.828804 Meters
- 1 Furlong = 660 Feet

26.02 Weight

- 1 Gal. $H_2O = 8.33 \text{ Lbs.} H_2O$
- 1 Lb. = 16 oz. = 7000 grains = 0.4536 Kg
- 1 Ton = 2000 Lbs. = 907 Kg
- 1 Kg = 2.205 lbs.
- 1 Lb. Steam = 1 Lb. H_2O

26.03 Area

- 1 Sq. Ft. = 144 Sq.In.
- 1 Acre = 43,560 Sq.Ft. = 4840 Sq.Yds. = 0.4047 Hectares
- 1 Sq. Mile = 640 Acres
- 1 Sq. Yd. = 9 Sq.Ft. = 1296 Sq.In.
- 1 Hectare = 2.417 acres
- 1 Sq. M = 1,550 Sq. In. = 0.0929 Sq.Ft. = 1.1968 Sq.Yds.

26.04 Volume

- 1 Cu.Yd. = 27 Cu.Ft. = 46,656 Cu.In. = 1616 Pints = 807.9 Quarts = 764.6 Liters
- 1 Cu.Ft. = 1,728 Cu.In
- 1 Liter = 0.2642 Gallons = 1.057 Quarts = 2.113 Pints
- 1 Gallon = 4 Quarts = 8 Pints = 3.785 Liters
- 1 Cu. Meter = 61,023 Cu.In. = 0.02832 Cu.Ft. = 1.3093 Cu.Yds.
- 1 Barrel Oil = 42 Gallons Oil
- 1 Barrel Beer = 31.5 Gallons Beer
- 1 Barrel Wine = 31.0 Gallons Wine
- 1 Bushel = 1.2445 Cu.Ft. = 32 Quarts (Dry) = 64 Pints (Dry) = 4 Pecks
- 1 Hogshead = 63 Gallon = 8.42184 Cu.Ft.

26.05 Velocity

- 1 MPH = 5280 Ft./Hr. = 88 Ft./Min. = 1.467 Ft./Sec. = 0.8684 Knots
- 1 Knot = 1.1515 Mph = 1.8532 Km/Hr. = 1.0 Nautical Miles/Hr.
- 1 League = 3.0 Miles (Approx.)

Conversion Factors 381

26.06 Speed of Sound in Air

1128.5 Ft./Sec. = 769.4 MPH

26.07 Pressure

14.7 psi = 33.95 Ft. H_2O = 29.92 In. Hg = 407.2 In. W.G. = 2116.8 Lbs./Sq.Ft. 1 psi = 2.307 Ft. H_2O = 2.036 In. Hg = 16 ounces = 27.7 In. WC 1 Ft. H_2O = 0.4335 psi = 62.43 Lbs./Sq.Ft. 1 Ounce = 1.73 In. WC

26.08 Density

A. Water:

62.43 Lbs./Cu.Ft. = 8.33 Lbs./Gal. = 0.1337 Cu.Ft./Gal. 1 Cu.Ft. = 7.48052 Gallons = 29.92 Quarts = 62.43 Lbs. H₂O

B. Standard Air @ 60°F., 14.7 psi:

13.329 Cu.Ft./Lb. = 0.0750 Lbs./Cu.Ft.

1 Lb./Cu.Ft. = 177.72 Cu.Ft./Lbs.

1 Cu. Ft./Lb. = 0.00563 Lbs./Cu.Ft.

1 Kg/Cu M = 16.017 Lbs./Cu.Ft.

1 Cu M/Kg = 0.0624 Cu.Ft./Lb

26.09 Energy

- $1 \text{ Hp} = 0.746 \text{ KW} = 746 \text{ Watts} = 2,545 \text{ Btuh} \approx 1.0 \text{ KVA}$
- 1 KW = 1,000 Watts = 3,413 Btuh = 1.341 Hp
- 1 Watt = 3.413 Btuh
- 1 Ton Ac = 12,000 Btuh Cooling = 15,000 Btuh Heat Rejection
- 1 Btuh = 1 Btu/Hr.
- 1 BHP = 34,500 Btuh (33,472 Btuh) = 34.5 Lb.Stm/Hr. = 34.5 Lb.H₂O/Hr. = 0.069 GPM = 4.14 GPH = 140 EDR (Sq.Ft. of Equivalent Radiation)
- 1 Therm = 100,000 Btuh
- 1 MBH = 1,000 Btuh
- 1 Lb.Stm/Hr. = 0.002 GPM
- 1 GPM = 500 Lbs.Stm/Hr.
- EDR = Equivalent Direct Radiation
- 1 EDR = 0.000496 GPM = 0.25 Lbs.Stm.Cond./Hr.
- 1000 EDR = 0.496 GPM
- 1 EDR Hot Water = 150 Btu/Hr.
- 1 EDR Steam = 240 Btu/Hr.
- 1 EDR = 240 Btu/Hr. (Up to 1,000 Ft. Above Sea Level)
- 1 EDR = 230 Btu/Hr. (1,000 Ft.-3,000 Ft. Above Sea Level)
- 1 EDR = 223 Btu/Hr. (3,000 Ft.-5,000 Ft. Above Sea Level)

```
1 EDR = 216 Btu/Hr. (5,000 Ft.-7,000 Ft. Above Sea Level)
1 EDR = 209 Btu/Hr. (7,000 Ft.-10,000 Ft. Above Sea Level)
```

26.10 Flow

1 mgd (million gal./day) = 1.547 Cu.Ft./Sec. = 694.4 GPM 1 Cu.Ft./Min. = 62.43 Lbs. H₂O/Min. = 448.8 GPH

26.11 HVAC Metric Conversions

KI/Hr Btu/Hr \times 1.055 CFM × 0.02832 **CMM** $GPM \times 3.785$ LPM Btu/Lb. \times 2.326 KI/Lb. Meters Feet \times 0.3048 Sq. Meters Sq. Feet \times 0.0929 = Cu. Meters Cu. Feet \times 0.02832 Pounds \times 0.4536 Kg 500 Lb Steam/Hr 1.0 GPM 1.0 Lb.Stm/Hr = 0.002 GPM $1.0 \text{ Lb.H}_2\text{O/Hr} = 1.0 \text{ Lbs. Steam/Hr}$ Kg/Cu. Meter = Pounds/Cu.Ft. × 16.017 (Density)

Cu. Meters/Kg = Cu.Ft./Pound \times 0.0624 (Specific Volume) Kg H₂O/Kg DA = Gr H₂O/Lb. DA/7,000 = Lb.H₂O/Lb DA

Properties of Air and Water

27.01 Properties of Air/Water Vapor Mixtures

A. Psychrometric Definitions:

- 1. Dry Bulb Temperature. The temperature of air read on a standard thermometer. Units: $^{\circ}$ F.DB. Symbol: T_{DB} or DB.
- 2. Wet Bulb Temperature. The wet bulb temperature is the temperature indicated by a thermometer whose bulb is covered by a wet wick and exposed to air moving at a velocity of 1,000 feet per minute. Units: $^{\circ}$ F.WB. Symbol: T_{WB} or WB.
- 3. Humidity Ratio. The weight of water vapor in each pound of dry air; also known as specific humidity. Units: Lb.H₂O/Lb.DA or Gr.H₂O/Lb.DA. Symbol: W.
- 4. Enthalpy. A thermodynamic property which serves as a measure of the heat content above some datum temperature (Air 0 °F.DB and Water 32 °F.). Units: Btu/Lb.DA or Btu/Lb.H₂O. Symbol: h.
- 5. Specific Volume. The cubic feet of air/water mixture per pound of dry air. Units: Cu.Ft./Lb.DA. Symbol: SpV.
- 6. Dew Point Temperature. The temperature at which moisture will start to condense from the air. Units: °F.DP. Symbol: T_{DP} or DP.
- 7. Relative Humidity. The ratio of water vapor in the air/water mixture to the water vapor in saturated air/water mixture. Units: %RH. Symbol: RH.
- 8. Sensible Heat. Heat that causes a rise in temperature. Units: Btu/Hr. Symbol: Hs.
- 9. Latent Heat. Heat that causes a change in state (i.e., liquid water to gaseous water). Units: Btu/Hr. Symbol: H_L .
- 10. Total Heat. Sum of sensible heat and latent heat. Units: Btu/Hr. Symbol: H_T.
- 11. Sensible Heat Ratio. The ratio of the sensible heat to the total heat. Units: None. Symbol: SHR.
- 12. Vapor Pressure. Pressure exerted by water vapor in the air. Units: In.Hg. Symbol: Pw.
- 13. Standard Barometric Pressure. Pressure at Sea Level (29.921 InHg. = 14.7 Psi).

B. Thermodynamic Properties of Air/Water Mixtures are given in the following tables:

TEMPERATURE RANGE ° F.	SPECIFIC HEAT BTU/LB °F.
-80 TO 129	0.240
130 TO 215	0.241
216 TO 280	0.242
281 TO 330	0.243
331 TO 370	0.244
371 TO 400	0.245
401 TO 440	0.246
441 TO 460	0.247
461 TO 470	0.248
471 TO 500	0.249

TEMP	HUMID	ITY RATIO	SPE	CIFIC VOLU FT.3/LB DA	ME		ENTHALPY BTU/LB DA	
°F.	GRAINS/ LB DA	POUNDS/ LB DA	ν,	Vas	ν,	. h,	h _{as}	h,
-80	0.0343	0.0000049	9.553	0.000	9.553	-19.221	0.005	-19.215
-79	0.0371	0.0000053	9.579	0.000	9.579	-18.980	0.005	-18.975
-78	0.0399	0.0000057	9.604	0.000	9.604	-18.740	0.006	-18.734
-77	0.0434	0.0000062	9.629	0.000	9.629	-18.500	0.007	-18.493
-76	0.0469	0.0000067	9.655	0.000	9.655	-18.259	0.007	-18.252
-75	0.0504	0.0000072	9.680	0.000	9.680	-18.019	0.007	-18.011
-74	0.0546	0.0000078	9.705	0.000	9.705	-17.778	0.008	-17.770
-73	0.0588	0.0000084	9.731	0.000	9.731	-17.538	0.009	-17.529
-72	0.0630	0.0000090	9.756	0.000	9.756	-17.298	0.010	-17.288
-71	0.0679	0.0000097	9.781	0.000	9.781	-17.057	0.010	-17.047
-70	0.0728	0.0000104	9.807	0.000	9.807	-16.806	0.011	-16.817
-69	0.0784	0.0000112	9.832	0.000	9.832	-16.577	0.012	-16.565
-68	0.0840	0.0000120	9.858	0.000	9.858	-16.336	0.013	-16.324
-67	0.0903	0.0000129	9.883	0.000	9.883	-16.096	0.013	-16.083
-66	0.0973	0.0000139	9.908	0.000	9.908	-15.856	0.015	-15.841
-65	0.1043	0.0000149	9.934	0.000	9.934	-15.616	0.015	-15.600
-64	0.1120	0.0000160	9.959	0.000	9.959	-15.375	0.017	-15.359
-63	0.1204	0.0000172	9.984	0.000	9.984	-15.117	0.018	-15.135
-62	0.1288	0.0000184	10.010	0.000	10.010	-14.895	0.019	-14.876
-61	0.1386	0.0000198	10.035	0.000	10.035	-14.654	0.021	-14.634
-60	0.1484	0.0000212	10.060	0.000	10.060	-14.414	0.022	-14.392
-59	0.1590	0.0000227	10.085	0.000	10.085	-14.174	0.024	-14.150
-58	0.1701	0.0000243	10.111	0.000	10.111	-13.933	0.025	-13.908
-57	0.1820	0.0000260	10.136	0.000	10.136	-13.693	0.027	-13.666
-56	0.1953	0.0000279	10.161	0.000	10.161	-13.453	0.029	-13.424
-55	0.2086	0.0000298	10.187	0.000	10.187	-13.213	0.031	-13.182
-54	0.2233	0.0000319	10.212	0.001	10.213	-12.972	0.033	-12.939
-53	0.2387	0.0000341	10.237	0.001	10.238	-12.732	0.035	-12.697
-52	0.2555	0.0000365	10.263	0.001	10.263	-12.492	0.038	-12.454
-51	0.2730	0.0000390	10.288	0.001	10.289	-12.251	0.041	-12.211
-50	0.2912	0.0000416	10.313	0.001	10.314	-12.011	0.043	-11.968
-49	0.3115	0.0000445	10.339	0.001	10.340	-11.771	0.046	-11.725
-48	0.3325	0.0000475	10.364	0.001	10.365	-11.531	0.050	-11.481
-47	0.3549	0.0000507	10.389	0.001	10.390	-11.290	0.053	-11.237
-46	0.3787	0.0000541	10.415	0.001	10.416	-11.050	0.056	-10.994
-45	0.4039	0.0000577	10.440	0.001	10.441	-10.810	0.060	-10.750
-44	0.4305	0.0000615	10.465	0.001	10.466	-10.570	0.064	-10.505
-43	0.4592	0.0000656	10.491	0.001	10.492	-10.329	0.068	-10.261
-42	0.4893	0.0000699	10.516	0.001	10.517	-10.089	0.073	-10.016
-41	0.5208	0.0000744	10.541	0.001	10.543	-9.849	0.078	-9.771

TEMP	HUMIDI	TY RATIO		CIFIC VOLU FT.³/LB DA	ME		ENTHALPY BTU/LB DA	
°F.	GRAINS/ LB DA	POUNDS/ LB DA	ν,	V _{as}	ν,	h,	h,	h,
-40	0.5551	0.0000793	10.567	0.001	10.568	-9.609	0.083	-9.526
-39	0.5908	0.0000844	10.592	0.001	10.593	-9.368	0.088	-9.280
-38	0.6286	0.0000898	10.617	0.002	10.619	-9.128	0.094	-9.034
-37	0.6692	0.0000956	10.643	0.002	10.644	-8.888	0.100	-8.788
-36	0.7119	0.0001017	10.668	0.002	10.670	-8.648	0.106	-8.541
-35	0.7567	0.0001081	10.693	0.002	10.695	-8.407	0.113	-8.294
-34	0.8050	0.0001150	10.719	0.002	10.721	-8.167	0.120	-8.047
-33	0.8554	0.0001222	10.744	0.002	10.746	-7.927	0.128	-7.799
-32	0.9086	0.0001298	10.769	0.002	10.772	-7.687	0.136	-7.551
-31	0.9653	0.0001379	10.795	0.002	10.797	-7.447	0.145	-7.302
-30	1.0255	0.0001465	10.820	0.003	10.822	-7.206	0.154	-7.053
-29	1.0885	0.0001555	10.845	0.003	10.848	-6.966	0.163	-6.803
-28	1.1550	0.0001650	10.871	0.003	10.873	-6.726	0.173	-6.553
-27	1.2257	0.0001751	10.896	0.003	10.899	-6.486	0.184	-6.302
-26	1.3006	0.0001858	10.921	0.003	10.924	-6.245	0.195	-6.051
-25	1.3790	0.0001970	10.947	0.003	10.950	-6.005	0.207	-5.798
-24	1.4616	0.0002088	10.972	0.004	10.976	-5.765	0.220	-5.545
-23	1.5498	0.0002214	10.997	0.004	11.001	-5.525	0.233	-5.292
-22	1.6422	0.0002346	11.022	0.004	11.027	-5.284	0.247	-5.038
-21	1.7395	0.0002485	11.048	0.004	11.052	-5.044	0.261	-4.783
-20	1.8424	0.0002632	11.073	0.005	11.078	-4.804	0.277	-4.527
-19	1.9502	0.0002786	11.098	0.005	11.103	-4.564	0.293	-4.271
-18	2.0650	0.0002950	11.124	0.005	11.129	-4.324	0.311	-4.013
-17	2.1847	0.0003121	11.149	0.006	11.155	-4.084	0.329	-3.754
-16	2.3121	0.0003303	11.174	0.006	11.180	-3.843	0.348	-3.495
-15	2.4451	0.0003493	11.200	0.006	11.206	-3.603	0.368	-3.235
-14	2.5858	0.0003694	11.225	0.007	11.232	-3.363	0.390	-2.973
-13	2.7335	0.0003905	11.250	0.007	11.257	-3.123	0.412	-2.710
-12	2.8896	0.0004128	11.276	0.007	11.283	-2.882	0.436	-2.447
-11	3.0534	0.0004362	11.301	0.008	11.309	-2.642	0.460	-2.182
-10	3.2256	0.0004608	11.326	0.008	11.335	-2.402	0.487	-1.915
-9	3.4069	0.0004867	11.351	0.009	11.360	-2.162	0.514	-1.647
-8	3.5973	0.0005139	11.377	0.009	11.386	-1.922	0.543	-1.378
-7	3.7975	0.0005425	11.402	0.010	11.412	-1.681	0.574	-1.108
-6	4.0082	0.0005726	11.427	0.010	11.438	-1.441	0.606	-0.835
-5	4.2287	0.0006041	11.453	0.011	11.464	-1.201	0.640	-0.561
-4	4.4611	0.0006373	11.478	0.012	11.490	-0.961	0.675	-0.286
-3	4.7054	0.0006722	11.503	0.012	11.516	-0.721	0.712	-0.008
-2	4.9616	0.0007088	11.529	0.013	11.542	-0.480	0.751	0.271
-1	5.2304	0.0007472	11.554	0.014	11.568	-0.240	0.792	0.552

TEMP	HUMID	ITY RATIO	SPE	CIFIC VOLU FT.³/LB DA	ME		ENTHALPY BTU/LB DA	
°F.	GRAINS/ LB DA	POUNDS/ LB DA	V _a	Vas	ν,	h _a	h _{as}	h,
0	5.5125	0.0007875	11.579	0.015	11.594	0.000	0.835	0.835
1	5.8086	0.0008298	11.604	0.015	11.620	0.240	0.880	1.121
2	6.1194	0.0008742	11.630	0.016	11.646	0.480	0.928	1.408
3	6.4449	0.0009207	11.655	0.017	11.672	0.721	0.978	1.699
4	6.7865	0.0009695	11.680	0.018	11.699	0.961	1.030	1.991
5	7.1449	0.0010207	11.706	0.019	11.725	1.201	1.085	2.286
6	7.5201	0.0010743	11.731	0.020	11.751	1.441	1.143	2.584
7	7.9142	0.0011306	11.756	0.021	11.778	1.681	1.203	2.884
8	8.3265	0.0011895	11.782	0.022	11.804	1.922	1.266	3.188
9	8.7584	0.0012512	11.807	0.024	11.831	2.162	1.332	3.494
10	9.2106	0.0013158	11.832	0.025	11.857	2.402	1.402	3.804
11	9.6845	0.0013835	11.857	0.026	11.884	2.642	1.474	4.117
12	10.1808	0.0014544	11.883	0.028	11.910	2.882	1.550	4.433
13	10.7002	0.0015286	11.908	0.029	11.937	3.123	1.630	4.753
14	11.2434	0.0016062	11.933	0.031	11.964	3.363	1.714	5.077
15	11.8118	0.0016874	11.959	0.032	11.991	3.603	1.801	5.404
16	12.4068	0.0017724	11.984	0.034	12.018	3.843	1.892	5.736
17	13.0291	0.0018613	12.009	0.036	12.045	4.084	1.988	6.072
18	13.6801	0.0019543	12.035	0.038	12.072	4.324	2.088	6.412
19	14.3605	0.0020515	12.060	0.040	12.099	4.564	2.193	6.757
20	15.0717	0.0021531	12.085	0.042	12.127	4.804	2.303	7.107
21	15.8144	0.0022592	12.110	0.044	12.154	5.044	2.417	7.462
22	16.5921	0.0023703	12.136	0.046	12.182	5.285	2.537	7.822
23	17.4041	0.0024863	12.161	0.048	12.209	5.525	2.662	8.187
24	18.2511	0.0026073	12.186	0.051	12.237	5.765	2.793	8.558
25	19.1373	0.0027339	12.212	0.054	12.265	6.005	2.930	8.935
26	20.0620	0.0028660	12.237	0.056	12.293	6.246	3.073	9.318
27	21.0273	0.0030039	12.262	0.059	12.321	6.486	3.222	9.708
28	22.0360	0.0031480	12.287	0.062	12.349	6.726	3.378	10.104
29	23.0888	0.0032984	12.313	0.065	12.378	6.966	3.541	10.507
30	24.1864	0.0034552	12.338	0.068	12.406	7.206	3.711	10.917
31	25.3330	0.0036190	12.363	0.072	12.435	7.447	3.888	11.335
32	26.5265	0.0037895	12.389	0.075	12.464	7.687	4.073	11.760
33	27.6290	0.0039470	12.414	0.079	12.492	7.927	4.243	12.170
34	28.7630	0.0041090	12.439	0.082	12.521	8.167	4.420	12.587
35	29.939	0.004277	12.464	0.085	12.550	8.408	4.603	13.010
36	31.164	0.004452	12.490	0.089	12.579	8.648	4.793	13.441
37	32.431	0.004633	12.515	0.093	12.608	8.888	4.990	13.878
38	33.740	0.004820	12.540	0.097	12.637	9.128	5.194	14.322
39	35.098	0.005014	12.566	0.101	12.667	9.369	5.405	14.773

TEMP	HUMIDI	TY RATIO		TIFIC VOLUM	Œ		NTHALPY STU/LB DA	
°F.	GRAINS/ LB DA	POUNDS/ LB DA	ν,	٧	ν,	h,	h	h,
40	36.512	0.005216	12.591	0.105	12.696	9.609	5.624	15.233
41	37.968	0.005424	12.616	0.110	12.726	9.849	5.851	15.700
42	39.480	0.005640	12.641	0.114	12.756	10.089	6.086	16.175
43	41.041	0.005863	12.667	0.119	12.786	10.330	6.330	16.660
44	42.658	0.006094	12.692	0.124	12.816	10.570	6.582	17.152
45	44.338	0.006334	12.717	0.129	12.846	10.810	6.843	17.653
46	46.067	0.006581	12.743	0.134	12.877	11.050	7.114	18.164
47	47.866	0.006838	12.768	0.140	12.908	11.291	7.394	18.685
48	49.721	0.007103	12.793	0.146	12.939	11.531	7.684	19.215
49	51.646	0.007378	12.818	0.152	12.970	11.771	7.984	19.756
50	53.627	0.007661	12.844	0.158	13.001	12.012	8.295	20.306
51	55.685	0.007955	12.869	0.164	13.033	12.252	8.616	20.868
52	57.813	0.008259	12.894	0.171	13.065	12.492	8.949	21.441
53	60.011	0.008573	12.920	0.178	13.097	12.732	9.293	22.025
54	62.279	0.008897	12.945	0.185	13.129	12.973	9.648	22.621
55	64.631	0.009233	12.970	0.192	13.162	13.213	10.016	23.229
56	67.060	0.009580	12.995	0.200	13.195	13.453	10.397	23.850
57	69.566	0.009938	13.021	0.207	13.228	13.694	10.790	24.484
58	72.163	0.010309	13.046	0.216	13.262	13.934	11.197	25.131
59	74.844	0.010692	13.071	0.224	13.295	14.174	11.618	25.792
60	77.609	0.011087	13.096	0.233	13.329	14.415	12.052	26.467
61	80.472	0.011496	13.122	0.242	13.364	14.655	12.502	27.157
62	83.433	0.011919	13.147	0.251	13.398	14.895	12.966	27.862
63	86.485	0.012355	13.172	0.261	13.433	15.135	13.446	28.582
64	89.635	0.012805	13.198	0.271	13.468	15.376	13.942	29.318
65	92.890	0.013270	13.223	0.281	13.504	15.616	14.454	30.071
66	96.250	0.013750	13.248	0.292	13.540	15.856	14.983	30.840
67	99.722	0.014246	13.273	0.303	13.577	16.097	15.530	31.626
68	103.306	0.014758	13.299	0.315	13.613	16.337	16.094	32.431
69	107.002	0.015286	13.324	0.326	13.650	16.577	16.677	33.254
70	110.824	0.015832	13.349	0.339	13.688	16.818	17.279	34.097
71	114.765	0.016395	13.375	0.351	13.726	17.058	17.901	34.959
72	118.832	0.016976	13.400	0.365	13.764	17.299	18.543	35.841
73	123.025	0.017575	13.425	0.378	13.803	17.539	19.204	36.743
74	127.358	0.018194	13.450	0.392	13.843	17.779	19.889	37.668
75	131.831	0.018833	13.476	0.407	13.882	18.020	20.595	38.615
76	136.437	0.019491	13.501	0.422	13.923	18.260	21.323	39.583
77	141.190	0.020170	13.526	0.437	13.963	18.500	22.075	40.576
78	146.097	0.020871	13.551	0.453	14.005	18.741	22.851	41.592
79	151.158	0.021594	13.577	0.470	14.046	18.981	23.652	42.633

TEMP	HUMID	ITY RATIO	SPE	CIFIC VOLU FT.3/LB DA	ME		ENTHALPY BTU/LB DA	
°F.	GRAINS/ LB DA	POUNDS/ LB DA	Va	ν_{as}	ν,	h	h	h,
80	156.380	0.022340	13.602	0.487	14.089	19.222	24.479	43.701
81	162.330	0.023109	13.627	0.505	14.132	19.462	25.332	44.794
82	167.314	0.023902	13.653	0.523	14.175	19.702	26.211	45.913
83	173.040	0.024720	13.678	0.542	14.220	19.943	27.120	47.062
84	178.941	0.025563	13.703	0.561	14.264	20.183	28.055	48.238
85	185.031	0.026433	13.728	0.581	14.310	20.424	29.021	49.445
86	191.303	0.027329	13.754	0.602	14.356	20.664	30.017	50.681
87	197.778	0.028254	13.779	0.624	14.403	20.905	31.045	51.949
88	204.456	0.029208	13.804	0.646	14.450	21.145	32.105	53.250
89	211.323	0.030189	13.829	0.669	14.498	21.385	33.197	54.582
90	218.421	0.031203	13.855	0.692	14.547	21.626	34.325	55.951
91	225.729	0.032247	13.880	0.717	14.597	21.866	35.489	57.355
92	233.261	0.033323	13.905	0.742	14.647	22.107	36.687	58.794
93	241.031	0.034433	13.930	0.768	14.699	22.347	37.924	60.271
94	249.039	0.035577	13.956	0.795	14.751	22.588	39.199	61.787
95	257.299	0.036757	13.981	0.823	14.804	22.828	40.515	63.343
96	265.804	0.037972	14.006	0.852	14.858	23.069	41.871	64.940
97	274.575	0.039225	14.032	0.881	14.913	23.309	43.269	66.578
98	283.612	0.040516	14.057	0.912	14.969	23.550	44.711	68.260
99	292.936	0.041848	14.082	0.944	15.026	23.790	46.198	69.988
100	302.533	0.043219	14.107	0.976	15.084	24.031	47.730	71.761
101	312.438	0.044634	14.133	1.010	15.143	24.271	49.312	73.583
102	322.630	0.046090	14.158	1.045	15.203	24.512	50.940	75.452
103	333.144	0.047592	14.183	1.081	15.264	24.752	52.621	77.373
104	343.980	0.049140	14.208	1.118	15.326	24.993	54.354	79.346
105	355.159	0.050737	14.234	1.156	15.390	25.233	56.142	81.375
106	366.681	0.052383	14.259	1.196	15.455	25.474	57.986	83.460
107	378.539	0.054077	14.284	1.236	15.521	25.714	59.884	85.599
108	390.782	0.055826	14.309	1.279	15.588	25.955	61.844	87.799
109	403.396	0.057628	14.335	1.322	15.657	26.195	63.866	90.061
110	416.402	0.059486	14.360	1.367	15.727	26.436	65.950	92.386
111	429.807	0.061401	14.385	1.414	15.799	26.677	68.099	94.776
112	443.646	0.063378	14.411	1.462	15.872	26.917	70.319	97.237
113	457.877	0.065411	14.436	1.511	15.947	27.158	72.603	99.760
114	472.584	0.067512	14.461	1.562	16.023	27.398	74.964	102.362
115	487.732	0.069676	14.486	1.615	16.101	27.639	77.396	105.035
116	503.356	0.071908	14.512	1.670	16.181	27.879	79.906	107.786
117	519.477	0.074211	14.537	1.726	16.263	28.120	82.497	110.617
118	536.102	0.076586	14.562	1.784	16.346	28.361	85.169	113.530
119	553.252	0.079036	14.587	1.844	16.432	28.601	87.927	116.528

TEMP	HUMIDIT	Y RATIO		CIFIC VOLUI FT.3/LB DA	ME		ENTHALPY BTU/LB DA	
°F.	GRAINS/L B DA	POUNDS/ LB DA	ν	ν _{ss}	ν,	h _a	h _{as}	h,
120	570.920	0.081560	14.613	1.906	16.519	28.842	90.770	119.612
121	589.183	0.084169	14.638	1.971	16.609	29.083	93.709	122.792
122	608.020	0.086860	14.663	2.037	16.700	29.323	96.742	126.065
123	627.431	0.089633	14.688	2.106	16.794	29.564	99.868	129.432
124	647.500	0.092500	14.714	2.176	16.890	29.805	103.102	132.907
125	668.192	0.095456	14.739	2.250	16.989	30.045	106.437	136.482
126	689.528	0.098504	14.764	2.325	17.090	30.286	109.877	140.163
127	711.599	0.101657	14.789	2.404	17.193	30.527	113.438	143.965
128	734.370	0.104910	14.815	2.485	17.299	30.767	117.111	147.878
129	757.890	0.108270	14.840	2.569	17.409	31.008	120.908	151.916
130	782.166	0.111738	14.865	2.655	17.520	31.249	124.828	156.076
131	807.254	0.115322	14.891	2.745	17.635	31.489	128.880	160.370
132	833.161	0.119023	14.916	2.837	17.753	31.730	133.066	164.796
133	859.985	0.122855	14.941	2.934	17.875	31.971	137.403	169.374
134	887.628	0.126804	14.966	3.033	17.999	32.212	141.873	174.084
135	916.265	0.130895	14.992	3.136	18.127	32.452	146.504	178.957
136	945.868	0.135124	15.017	3.242	18.259	32.693	151.294	183.987
137	976.458	0.139494	15.042	3.352	18.394	32.934	156.245	189.179
138	1008.133	0.144019	15.067	3.467	18.534	33.175	161.374	194.548
139	1040.872	0.148696	15.093	3.585	18.678	33.415	166.677	200.092
140	1074.766	0.153538	15.118	3.708	18.825	33.656	172.168	205.824
141	1110.501	0.158643	15.143	3.835	18.978	33.897	177.857	211.754
142	1146.236	0.163748	15.168	3.967	19.135	34.138	183.754	217.892
143	1173.854	0.169122	15.194	4.103	19.297	34.379	189.855	244.233
144	1222.858	0.174694	15.219	4.245	19.464	34.620	196.183	230.802
145	1263.269	0.180467	15.244	4.392	19.637	34.860	202.740	237.600
146	1305.220	0.186460	15.269	4.545	19.815	35.101	209.550	244.651
147	1348.676	0.192668	15.295	4.704	19.999	35.342	216.607	251.949
148	1393.770	0.199110	15.320	4.869	20.189	35.583	223.932	259.514
149	1440.544	0.205792	15.345	5.040	20.385	35.824	231.533	267.356
150	1489.110	0.212730	15.370	5.218	20.585	36.064	239.426	275.490
151	1539.615	0.219945	15.396	5.404	20.799	36.305	247.638	283.943
152	1592.003	0.227429	15.421	5.596	21.017	36.546	256.158	292.705
153	1646.526	0.235218	15.446	5.797	21.243	36.787	265.028	301.816
154	1703.163	0.243309	15.471	6.005	21.477	37.028	274.245	311.273
155	1762.166	0.251738	15.497	6.223	21.720	37.269	283.849	321.118
156	1823.584	0.260512	15.522	6.450	21.972	37.510	293.849	331.359
157	1887.508	0.269644	15.547	6.686	22.233	37.751	304.261	342.012
158	1954.162	0.279166	15.572	6.933	22.505	37.992	315.120	353.112
159	2023.707	0.289101	15.598	7.190	22.788	38.233	326.452	364.685

TEMP	HUMIDIT	Y RATIO	SPE	CIFIC VOLU FT.³/LB DA	ME		ENTHALPY BTU/LB DA	
°F.	GRAINS/ LB DA	POUNDS/ LB DA	ν _z	Vas	ν,	h,	h	h,
160	2096.15	0.29945	15.623	7.459	23.082	38.474	338.263	376.737
161	2171.89	0.31027	15.648	7.740	23.388	38.715	350.610	389.325
162	2250.92	0.32156	15.673	8.034	23.707	38.956	363.501	402.457
163	2333.52	0.33336	15.699	8.341	24.040	39.197	376.979	416.175
164	2420.04	0.34572	15.724	8.664	24.388	39.438	391.095	430.533
165	2510.55	0.35865	15.749	9.001	24.750	39.679	405.865	445.544
166	2605.40	0.37220	15.774	9.355	25.129	39.920	421.352	461.271
167	2685.83	0.38639	15.800	9.726	25.526	40.161	437.578	477.739
168	2809.17	0.40131	15.825	10.117	25.942	40.402	454.630	495.032
169	2918.86	0.41698	15.850	10.527	26.377	40.643	472.554	513.197
170	3034.01	0.43343	15.875	10.959	26.834	40.884	491.372	532.256
171	3155.53	0.45079	15.901	11.414	27.315	41.125	511.231	552.356
172	3283.35	0.46905	15.926	11.894	27.820	41.366	532.138	573.504
173	3418.03	0.48829	15.951	12.400	28.352	41.607	554.160	595.767
174	3560.69	0.50867	15.976	12.937	28.913	41.848	577.489	619.337
175	3711.33	0.53019	16.002	13.504	29.505	42.089	602.139	644.229
176	3870.58	0.55294	16.027	14.103	30.130	42.331	628.197	670.528
177	4039.70	0.57710	16.052	14.741	30.793	42.572	655.876	698.448
178	4219.18	0.60274	16.078	15.418	31.496	42.813	685.260	728.073
179	4410.14	0.63002	16.103	16.138	32.242	43.054	716.524	759.579
180	4613.77	0.65911	16.128	16.909	33.037	43.295	749.871	793.166
181	4830.84	0.69012	16.153	17.730	33.883	43.536	785.426	828.962
182	5063.17	0.72331	16.178	18.609	34.787	43.778	823.487	867.265
183	5311.95	0.75885	16.204	19.551	35.755	44.019	864.259	908.278
184	5579.21	0.79703	16.229	20.564	36.793	44.260	908.061	952.321
185	5867.19	0.83817	16.254	21.656	37.910	44.501	955.261	999.763
186	6177.57	0.88251	16.280	22.834	39.113	44.742	1006.149	1050.892
187	6513.99	0.93057	16.305	24.111	40.416	44.984	1061.314	1106.298
188	6879.04	0.98272	16.330	25.498	41.828	45.225	1121.174	1166.399
189	7276.57	1.03951	16.355	27.010	43.365	45.466	1186.382	1231.848
190	7710.78	1.10154	16.381	28.661	45.042	45.707	1257.614	1303.321
191	8187.55	1.16965	16.406	30.476	46.882	45.949	1335.834	1381.783
192	8712.97	1.24471	16.431	32.477	48.908	46.190	1422.047	1468.238
193	9295.16	1.32788	16.456	34.695	51.151	46.431	1517.581	1564.013
194	9942.03	1.42029	16.481	37.161	53.642	46.673	1623.758	1670.430
195	10667.72	1.52396	16.507	39.928	56.435	46.914	1742.879	1789.793
196	11484.90	1.64070	16.532	43.046	59.578	47.155	1877.032	1924.188
197	12410.93	1.77299	16.557	46.580	63.137	47.397	2029.069	2076.466
198	13473.04	1.92472	16.583	50.636	67.218	47.638	2203.464	2251.102
199	14698.25	2.09975	16.608	55.316	71.923	47.879	2404.668	2452.547
200	16131.78	2.30454	16.663	60.793	77.426	48.121	2640.084	2688.205

27.02 Properties of Air

Barometric Pressures at Various Altitudes at 70°F.

ALTITUDE	BA	ROMETER (ABSO	LUTE PRESSURE	5)	RELATIVE
FEET	IN. HG.	PSI	FT. H₂O	IN.WG.	DENSITY
60,000	2:14	1.05	2.43	29.1	0.07
50,000	3.44	1.69	3.90	46.8	0.11
40,000	5.56	2.73	6.31	75.7	0.18
30,000	8.90	4.37	10.10	121.1	0.30
20,000	13.76	6.76	15.61	187.2	0.46
15,000	16.88	8.29	19.15	229.7	0.56
10,000	20.57	10.11	23.34	280.0	0.69
9,000	21.34	10.49	24.22	290.5	0.71
8,000	22.12	10.87	25.10	301.0	0.74
7,000	23.09	11.34	26.20	314.2	0.77
6,000	23.98	11.78	27.21	326.4	0.80
5,000	24.89	12.23	28.24	338.8	0.83
4,000	25.84	12.70	29.32	351.7	0.86
3,500	26.33	12.94	29.88	358.3	0.88
3,000	26.81	13.17	30.42	364.8	0.90
2,500	27.31	13.42	30.99	371.7	0.91
2,000	27.82	13.67	31.57	378.6	0.93
1,500	28.33	13.92	32.15	385.6	0.95
1,000	28.85	14.17	32.74	392.6	0.96
500	29.38	14.43	33.33	399.9	0.98
SEA LEVEL	29.92	14.70	33.95	407.2	1.00
-500	30.47	14.97	34.57	414.7	1.02
-1000	31.02	15.24	35.20	422.2	1.04
-2,000	32.15	15.80	36.48	437.5	1.07
-3,000	33.31	32.16	37.80	453.3	1.11
-4,000	34.51	16.96	39.16	469.7	1.15
-5,000	35.74	17.56	40.55	486.4	1.19

Air Equation Constants for Altitude

ALTITUDE	SENSIBLE HEAT	LATEN	T HEAT	TOTAL HEAT
FEET	(1)	Gr.H ₂ O (2)	Lb.H ₂ O (3)	(4)
60,000	0.08	0.048	339	0.315
50,000	0.12	0.075	532	0.495
40,000	0.19	0.123	871	0.810
30,000	0.32	0.204	1452	1.350
20,000	0.49	0.306	2178	2.025
15,000	0.56	0.382	2710	2.520
10,000	0.69	0.470	3340	3.105
9,000	0.77	0.483	3436	3.195
8,000	0.74	0.504	3582	3.330
7,000	0.77	0.525	3727	3.465
6,000	0.80	0.545	3872	3.600
5,000	0.83	0.566	4017	3.735
4,000	0.86	0.586	4162	3.870
3,500	0.88	0.600	4259	3.960
3,000	0.90	0.613	4356	4.050
2,500	0.91	0.620	4404	4.095
2,000	0.93	0.634	4501	4.185
1,500	0.95	0.647	4598	4.275
1,000	0.96	0.654	4646	4.320
500	0.98	0.668	4743	4.410
SEA LEVEL	1.08	0.681	4840	4.500
-500	1.19	0.695	4937	4.590
-1,000	1.12	0.708	5034	4.680
-2,000	1.16	0.729	5179	4.815
-3,000	1.20	0.756	5372	4.995
-4,000	1.24	0.783	5566	5.175
-5,000	1.29	0.810	5760	5.335

- 1. Equation Constants Units: BTU/Hr. CFM °F.
- 2. Equation Constants Units: BTU LbDA/Hr. Gr.H₂O CFM.
- 3. Equation Constants Units: BTU LbDA/Hr. Lb.H₂O CFM.
- 4. Equation Constants Units: Lb.DA/Hr. CFM.
- 5. Use table values in lieu of constants in equations in Part 5, Equations.

Air Equation Constants for Temperature

TEMPERATURE °F.	SENSIBLE HEAT	LATEN	TOTAL HEAT	
	(1)	Gr.H ₂ O (2)	Lb.H ₂ O (3)	(4)
0	1.204	0.759	5397	5.018
50	1.102	0.695	4937	4.590
60	1.080	0.681	4840	4.500
100	1.015	0.640	4550	4.230
150	0.950	0.599	4259	3.960
200	0.896	0.565	4017	3.735
250	0.842	0.531	3775	3.510
300	0.799	0.504	3582	3.330
350	0.756	0.477	3388	3.150
400	0.724	0.456	3243	3.015
450	0.691	0.436	3098	2.880
500	0.659	0.415	2952	2.745
550	0.626	0.395	2807	2.610
600	0.610	0.385	2735	2.543
650	0.583	0.368	2614	2.430
700	0.567	0.358	2541	2.363
750	0.551	0.347	2468	2.295
800	0.529	0.334	2372	2.205
850	0.513	0.323	2299	2.138
900	0.497	0.313	2226	2.070
950	0.486	0.306	2178	2.025
1000	0.470	0.296	2105	1.958

- 1. Equation Constants Units: BTU/Hr. CFM °F.
- 2. Equation Constants Units: BTU LbDA/Hr. Gr.H₂O CFM.
- 3. Equation Constants Units: BTU LbDA/Hr. Lb.H₂O CFM.
- 4. Equation Constants Units: Lb.DA/Hr. CFM.
- 5. Use table values in lieu of constants in equations in Part 5, Equations.

Air Equation Factors for Density

	TEMPERATURE °F						
ALTITUDE FEET	-40	0	40	70	100	150	200
60,000	0.90	0.08	0.08	0.07	0.07	0.06	0.06
50,000	0.14	0.13	0.12	0.11	0.11	0.10	0.09
40,000	0.23	0.21	0.20	0.19	0.18	0.16	0.15
30,000	0.37	0.34	0.32	0.30	0.28	0.26	0.24
20,000	0.58	0.53	0.49	0.46	0.44	0.40	0.37
15,000	0.71	0.65	0.60	0.56	0.54	0.49	0.45
10,000	0.87	0.79	0.73	0.69	0.65	0.60	0.55
9,000	0.90	0.82	0.76	0.71	0.68	0.62	0.57
8,000	0.93	0.85	0.79	0.74	0.70	0.65	0.60
7,000	0.97	0.89	0.82	0.77	0.73	0.67	0.62
6,000	1.01	0.91	0.85	0.80	0.75	0.69	0.64
5,000	1.05	0.95	0.88	0.83	0.78	0.72	0.66
4,000	1.09	0.99	0.92	0.86	0.81	0.75	0.69
3,500	1.11	1.01	0.94	0.87	0.83	0.77	0.70
3,000	1.13	1.03	0.95	0.89	0.85	0.78	0.71
2,500	1.15	1.05	0.97	0.91	0.87	0.80	0.73
2,000	1.17	1.07	0.99	0.93	0.88	0.81	0.74
1,500	1.20	1.09	1.01	0.95	0.90	0.83	0.76
1,000	1.22	1.11	1.02	0.96	0.92	0.84	0.77
500	1.24	1.13	1.04	0.98	0.94	0.86	0.79
SEA LEVEL	1.26	1.15	1.06	1.00	0.95	0.87	0.80
-500	1.28	1.17	1.08	1.02	0.97	0.89	0.81
-1,000	1.31	1.19	1.10	1.04	0.98	0.90	0.83
-2,000	1.35	1.24	1.14	1.07	1.02	0.93	0.86
-3,000	1.40	1.28	1.18	1.11	1.06	0.97	0.89
-4,000	1.45	1.33	1.22	1.15	1.10	1.00	0.92
-5,000	1.51	1.37	1.27	1.19	1.13	1.04	0.96

^{1.} Multiply constants in equations in Part 5, Equations, by values in the table.

Air Equation Factors for Density

	TEMPERATURE °F								
ALTITUDE FEET	250	300	350	400	450	500	550		
60,000	0.05	0.05	0.05	0.04	0.04	0.04	0.04		
50,000	0.09	0.08	0.07	0.07	0.07	0.06	0.06		
40,000	0.14	0.13	0.12	0.12	0.11	0.10	0.10		
30,000	0.22	0.21	0.19	0.18	0.17	0.16	0.16		
20,000	0.34	0.32	0.30	0.29	0.27	0.26	0.24		
15,000	0.42	0.39	0.37	0.35	0.33	0.31	0.30		
10,000	0.51	0.48	0.45	0.42	0.40	0.38	0.36		
9,000	0.53	0.50	0.47	0.44	0.42	0.39	0.38		
8,000	0.56	0.52	0.49	0.46	0.43	0.41	0.39		
7,000	0.58	0.54	0.51	0.48	0.45	0.43	0.41		
6,000	0.60	0.56	0.52	0.49	0.46	0.44	0.42		
5,000	0.62	0.58	0.54	0.51	0.48	0.45	0.44		
4,000	0.64	0.60	0.56	0.53	0.50	0.47	0.45		
3,500	0.66	0.61	0.57	0.54	0.51	0.48	0.46		
3,000	0.67	0.62	0.58	0.55	0.52	0.49	0.47		
2,500	0.69	0.64	0.59	0.56	0.53	0.50	0.48		
2,000	0.70	0.65	0.60	0.57	0.54	0.51	0.49		
1,500	0.71	0.66	0.61	0.59	0.55	0.52	0.50		
1,000	0.72	0.67	0.62	0.60	0.56	0.53	0.51		
500	0.74	0.69	0.64	0.61	0.57	0.54	0.52		
SEA LEVEL	0.75	0.70	0.65	0.62	0.58	0.55	0.53		
-500	0.76	0.71	0.66	0.63	0.59	0.56	0.54		
-1,000	0.78	0.73	0.67	0.64	0.60	0.57	0.55		
-2,000	0.81	0.75	0.70	0.67	0.62	0.59	0.57		
-3,000	0.83	0.78	0.72	0.69	0.65	0.61	0.59		
-4,000	0.87	0.81	0.75	0.72	0.67	0.63	0.61		
-5,000	0.90	0.84	0.78	0.74	0.69	0.66	0.63		

^{1.} Multiply constants in equations in Part 5, Equations, by values in the table.

Air Equation Factors for Density

	TEMPERATURE °F							
ALTITUDE - FEET	600	650	700	750	800	900	1000	
60,000	0.04	0.03	0.03	0.03	0.03	0.03	0.03	
50,000 40,000	0.06 0.09	0.06	0.05 0.09	0.05	0.05 0.08	0.04 0.07	0.04 0.07	
30,000	0.15	0.14	0.14	0.13	0.12	0.12	0.11	
20,000 15,000	0.23 0.28	0.22 0.27	0.21 0.26	0.20 0.25	0.19 0.24	0.18 0.22	0.17 0.20	
10,000	0.34	0.33	0.32	0.31	0.29	0.27	0.25	
9,000 8,000	0.35 0.37	0.34 0.36	0.33	0.32 0.33	0.30 0.31	0.28 0.29	0.26 0.27	
7,000	0.39	0.37	0.35	0.33	0.32	0.30	0.28	
6,000 5,000	0.40 0.41	0.38 0.40	0.37 0.38	0.35 0.37	0.33 0.35	0.31 0.32	0.29 0.30	
4,000	0.43	0.41	0.39	0.38	0.36	0.33	0.31	
3,500 3,000	0.44 0.45	0.42 0.43	0.40 0.41	0.39 0.39	0.37 0.37	0.34	0.32 0.32	
2,500	0.46	0.44	0.42	0.40	0.38	0.36	0.33	
2,000 1,500	0.46 0.47	0.45 0.46	0.43 0.44	0.41 0.42	0.39 0.40	0.36 0.37	0.33 0.34	
1,000	0.48	0.46	0.44	0.42	0.40	0.37	0.35	
SEA LEVEL	0.49 0.50	0.47 0.48	0.45 0.46	0.43 0.44	0.41 0.42	0.38 0.39	0.36 0.36	
-500	0.51	0.49	0.47	0.45	0.43	0.40	0.37	
-1,000 -2,000	0.52 0.54	0.50 0.52	0.48 0.49	0.46 0.47	0.44 0.45	0.41 0.42	0.38 0.39	
-3,000	0.56	0.53	0.51	0.49	0.47	0.43	0.40	
-4,000 -5,000	0.58 0.60	0.55 0.57	0.53 0.55	0.51 0.55	0.48 0.50	0.45 0.47	0.42 0.43	

^{1.} Multiply constants in equations in Part 5, Equations, by values in the table.

Physical Properties of Gases

SUBSTANCE	FORMULA	MOLECULAR WEIGHT	PHASE	SPECIFIC VOLUME Cu.Ft./Lbm	DENSITY Lbm/Cu.Ft.	SPECIFIC GRAVITY
GASES						
AIR		28.996	GAS	13.333	0.075	1.000
CARBON	С	12.01	SOLID			
HYDROGEN	H ₂	2.016	GAS	187.723	0.005	0.067
AMMONIA	NH ₃	17.031	GAS	21.914	0.046	0.613
SULFUR	S	32.06	GAS	7.407	0.135	1.800
HYDROGEN SULFIDE	H ₂ S	34.076	GAS	10.979	0.091	1.213
NITROUS OXIDE	N₂O	44.013	GAS	8.772	0.114	1.520
OZONE	O ₃	48.0	GAS	8.032	0.125	1.660
ARGON	Ar	39.948	GAS	9.662	0.104	1.380
CHLORINE	Cl2	70.906	GAS	5.442	0.184	2.450
HELIUM	Не	4.002	GAS	96.618	0.010	0.138
NEON	Ne	20.179	GAS	19.130	0.052	0.697
PRODUCTS OF COMBU	STION - COMP	LETE				
CARBON DIOXIDE	CO ₂	44.01	GAS	8.548	0.117	1.560
WATER VAPOR	H ₂ O	18.016	GAS	21.017	0.048	0.640
OXYGEN	O ₂	32.000	GAS	11.819	0.085	1.133
NITROGEN	N ₂	28.016	GAS	13.443	0.074	0.987
PRODUCTS OF COMBU	STION - INCO	MPLETE				
CARBON MONOXIDE	СО	28.01	GAS	13.699	0.073	0.967
NITRIC OXIDE	NO	30.006	GAS	12.821	0.078	1.040
NITROGEN DIOXIDE	NO ₂	46.006	GAS			
NITROUS TRIOXIDE	NO ₃	62.005	GAS			
NOX	NO _x		GAS			
SULFURIC OXIDE	SO	48.063	GAS			
SULFUR DIOXIDE	SO ₂	64.06	GAS	5.770	0.173	2.307
SULFUR TRIOXIDE	SO ₃	80.062	GAS			
SOX	SO _x		GAS			

27.03 Properties of Water

Boiling Points of Water

PSIA	BOILING POINT °F.	PSIA	BOILING POINT °F.	PSIA	BOILING POINT °F.
0.5	79.6	44	273.1	150	358.5
1	101.7	46	275.8	175	371.8
2	126.0	48	278.5	200	381.9
3	141.4	50	281.0	225	391.9
4	152.9	52	283.5	250	401.0
5	162.2	54	285.9	275	409.5
6	170.0	56	288.3	300	417.4
7	176.8	58	290.5	325	424.8
8	182.8	60	292.7	350	431.8
9	188.3	62	294.9	375	438.4
10	193.2	64	297.0	400	444.7
11	197.7	66	299.0	425	450.7
12	201.9	68	301.0	450	456.4
13	205.9	70	303.0	475	461.9
14	209.6	72	304.9	500	467.1
14.69	212.0	74	306.7	525	472.2
15	213.0	76	308.5	550	477.1
16	216.3	78	310.3	575	481.8
17	219.4	80	312.1	600	486.3
18	222.4	82	313.8	625	490.7
19	225.2	84	315.5	650	495.0
20	228.0	86	317.1	675	499.2
22	233.0	88	318.7	700	503.2
24	237.8	90	320.3	725	507.2
26	242.3	92	321.9	750	511.0
28	246.4	94	323.4	775	514.7
30	250.3	96	324.9	800	518.4
32	254.1	98	326.4	825	521.9
34	257.6	100	327.9	850	525.4
36	261.0	105	331.4	875	528.8
38	264.2	110	334.8	900	532.1
40	267.3	115	338.1	950	538.6
42	270.2	120	341.3	1000	544.8

Thermodynamic Properties of Water

TEMP	PRESS	SPECIFIC VOLUME FT³/LB.		ENTHALPY BTU/LB			
°F.	PSIA	ν_1	v_{lg}	ν _g	h	h_{lg}	h _g
-80	0.000116	0.01732	1953234	1953234	-193.50	1219.19	1025.69
-79	0.000125	0.01732	1814052	1814052	-193.11	1219.24	1026.13
-78	0.000135	0.01732	1685445	1685445	-192.71	1219.28	1026.57
-77	0.000145	0.01732	1566663	1566663	-192.31	1219.33	1027.02
-76	0.000157	0.01732	1456752	1456752	-191.92	1219.38	1027.46
-75	0.000169	0.01733	1355059	1355059	-191.52	1219.42	1027.90
-74	0.000182	0.01733	1260977	1260977	-191.12	1219.47	1028.34
-73	0.000196	0.01733	1173848	1173848	-190.72	1219.51	1028.79
-72	0.000211	0.01733	1093149	1093149	-190.32	1219.55	1029.23
-71	0.000227	0.01733	1018381	1018381	-189.92	1219.59	1029.67
-70	0.000245	0.01733	949067	949067	-189.52	1219.63	1030.11
-69	0.000263	0.01733	884803	884803	-189.11	1219.67	1030.55
-68	0.000283	0.01733	825187	825187	-188.71	1219.71	1031.00
-67	0.000304	0.01734	769864	769864	-188.30	1219.74	1031.44
-66	0.000326	0.01734	718508	718508	-187.90	1219.78	1031.88
-65	0.000350	0.01734	670800	670800	-187.49	1219.82	1032.32
-64	0.000376	0.01734	626503	626503	-187.08	1219.85	1032.77
-63	0.000404	0.01734	585316	585316	-186.67	1219.88	1033.21
-62	0.000433	0.01734	548041	548041	-186.26	1219.91	1033.65
-61	0.000464	0.01734	511446	511446	-185.85	1219.95	1034.09
-60	0.000498	0.01734	478317	478317	-185.44	1219.98	1034.54
-59	0.000533	0.01735	447495	447495	-185.03	1220.01	1034.98
-58	0.000571	0.01735	418803	418803	-184.61	1220.03	1035.42
-57	0.000612	0.01735	392068	392068	-184.20	1220.06	1035.86
-56	0.000655	0.01735	367172	367172	-183.78	1220.09	1036.30
-55	0.000701	0.01735	343970	343970	-183.37	1220.11	1036.75
-54	0.000750	0.01735	322336	322336	-182.95	1220.14	1037.19
-53	0.000802	0.01735	302157	302157	-182.53	1220.16	1037.63
-52	0.000857	0.01735	283335	283335	-182.11	1220.18	1038.07
-51	0.000916	0.01736	265773	265773	-181.69	1220.21	1038.52
-50	0.000979	0.01736	249381	249381	-181.27	1220.23	1038.96
-49	0.001045	0.01736	234067	234067	-180.85	1220.25	1039.40
-48	0.001116	0.01736	219766	219766	-180.42	1220.26	1039.84
-47	0.001191	0.01736	206398	206398	-181.00	1220.28	1040.28
-46	0.001271	0.01736	193909	193909	-179.57	1220.30	1040.73
-45	0.001355	0.01736	182231	182231	-179.14	1220.31	1041.17
-44	0.001445	0.01736	171304	171304	-178.72	1220.33	1041.61
-43	0.001541	0.01737	161084	161084	-178.29	1220.34	1042.05
-42	0.001642	0.01737	151518	151518	-177.86	1220.36	1042.50
-41	0.001749	0.01737	142566	142566	-177.43	1220.37	1042.94

TEMP	PRESS	SPE	ECIFIC VOLU FT³/LB.	ME		ENTHALPY BTU/LB	
°F.	PSIA	ν_1	v_{lg}	ν _g	h _t	h _{lg}	h _g
-40	0.001863	0.01737	134176	134176	-177.00	1220.38	1043.38
-39	0.001984	0.01737	126322	126322	-176.57	1220.39	1043.82
-38	0.002111	0.01737	118959	118959	-176.13	1220.40	1044.27
-37	0.002247	0.01737	112058	112058	-175.70	1220.40	1044.71
-36	0.002390	0.01738	105592	105592	-175.26	1220.41	1045.15
-35	0.002542	0.01738	99522	99522	-174.83	1220.42	1045.59
-34	0.002702	0.01738	93828	93828	-174.39	1220.42	1046.03
-33	0.002872	0.01738	88489	88489	-173.95	1220.43	1046.48
-32	0.003052	0.01738	83474	83474	-173.51	1220.43	1046.92
-31	0.003242	0.01738	78763	78763	-173.07	1220.43	1047.36
-30	0.003443	0.01738	74341	74341	-172.63	1220.43	1047.80
-29	0.003655	0.01738	70187	70187	-172.19	1220.43	1048.25
-28	0.003879	0.01739	66282	66282	-171.74	1220.43	1048.69
-27	0.004116	0.01739	62613	62613	-171.30	1220.43	1049.13
-26	0.004366	0.01739	59161	59161	-170.86	1220.43	1049.57
-25	0.004630	0.01739	55915	55915	-170.41	1220.42	1050.01
-24	0.004909	0.01739	52861	52861	-169.96	1220.42	1050.46
-23	0.005203	0.01739	49986	49986	-169.51	1220.41	1050.90
-22	0.005514	0.01739	47281	47281	-169.07	1220.41	1051.34
-21	0.005841	0.01740	44733	44733	-168.62	1220.40	1051.78
-20	0.006186	0.01740	42333	42333	-168.16	1220.39	1052.22
-19	0.006550	0.01740	40073	40073	-167.71	1220.38	1052.67
-18	0.006933	0.01740	37943	37943	-167.26	1220.37	1053.11
-17	0.007337	0.01740	35934	35934	-166.81	1220.36	1053.55
-16	0.007763	0.01740	34041	34041	-166.35	1220.34	1053.99
-15	0.008211	0.01740	32256	32256	-165.90	1220.33	1054.43
-14	0.008683	0.01741	30572	30572	-165.44	1220.31	1054.87
-13	0.009179	0.01741	28983	28983	-164.98	1220.30	1055.32
-12	0.009702	0.01741	27483	27483	-164.52	1220.28	1055.76
-11	0.010252	0.01741	26067	26067	-164.06	1220.26	1056.20
-10	0.010830	0.01741	24730	24730	-163.60	1220.24	1056.64
-9	0.011438	0.01741	23467	23467	-163.14	1220.22	1057.08
-8	0.012077	0.01741	22274	22274	-162.68	1220.20	1057.53
-7	0.012749	0.01742	21147	21147	-162.21	1220.18	1057.97
-6	0.013456	0.01742	20081	20081	-162.75	1220.16	1058.41
-5	0.014197	0.01742	19074	19074	-161.28	1220.13	1058.85
-4	0.014977	0.01742	18121	18121	-160.82	1220.11	1059.29
-3	0.015795	0.01742	17220	17220	-160.35	1220.08	1059.73
-2	0.016654	0.01742	16367	16367	-159.88	1220.05	1060.17
-1	0.017556	0.01742	15561	15561	-159.41	1220.02	1060.62

TEMP	PRESS	SPE	ECIFIC VOLU	ME		ENTHALPY BTU/LB	7
°F.	PSIA	ν ₁	v_{lg}	ν _g	h	h _{lg}	h _g
0	0.018502	0.01743	14797	14797	-158.94	1220.00	1061.06
	0.019495	0.01743	14073	14073	-158.47	1219.96	1061.50
2	0.020537	0.01743	13388	13388	-157.99	1219.93	1061.94
3	0.021629	0.01743	12740	12740	-157.52	1219.90	1062.38
4	0.022774	0.01743	12125	12125	-157.05	1219.87	1062.82
5	0.023975	0.01743	11543	11543	-156.57	1219.83	1063.26
6	0.025233	0.01743	10991	10991	-156.09	1219.80	1063.70
7	0.026552	0.01744	10468	10468	-155.62	1219.76	1064.14
8 9	0.027933 0.029379	0.01744 0.01744 0.01744	9971 9500	9971 9500	-155.14 -154.66	1219.72 1219.68	1064.58 1065.03
10	0.030894	0.01744	9054	9054	-154.18	1219.64	1065.47
11	0.032480	0.01744	8630	8630	-153.70	1219.60	1065.91
12	0.034140	0.01744	8228	8228	-153.21	1219.56	1066.35
13	0.035878	0.01745	7846	7846	-152.73	1219.52	1066.79
14	0.037696	0.01745	7483	7483	-152.24	1219.47	1067.23
15 16 17 18	0.039597 0.041586 0.043666 0.045841 0.048113	0.01745 0.01745 0.01745 0.01745 0.01745	7139 6811 6501 6205 5924	7139 6811 6501 6205 5924	-151.76 -151.27 -150.78 -150.30 -149.81	1219.43 1219.38 1219.33 1219.28 1219.23	1067.67 1068.11 1068.55 1068.99 1069.43
20	0.050489	0.01746	5657	5657	-149.32	1219.18	1069.87
21	0.052970	0.01746	5404	5404	-148.82	1219.13	1070.31
22	0.055563	0.01746	5162	5162	-148.33	1219.08	1070.75
23	0.058271	0.01746	4932	4932	-147.84	1219.02	1071.19
24	0.061099	0.01746	4714	4714	-147.34	1218.97	1071.63
25	0.064051	0.01746	4506	4506	-146.85	1218.91	1072.07
26	0.067133	0.01747	4308	4308	-146.35	1218.85	1072.50
27	0.07034P	0.01747	4119	4119	-145.85	1218.80	1072.94
28	0.073706	0.01747	3940	3940	-145.35	1218.74	1073.38
29	0.077207	0.01747	3769	3769	-144.85	1218.68	1073.82
30	0.080860	0.01747	3606	3606	-144.35	1218.61	1074.26
31	0.084669	0.01747	3450	3450	-143.85	1218.55	1074.70
32	0.08865	0.01602	3302.07	3302.09	-0.02	1075.15	1075.14
33	0.09229	0.01602	3178.15	3178.16	0.99	1074.59	1075.58
34	0.09607	0.01602	3059.47	3059.49	2.00	1074.02	1076.01
35	0.09998	0.01602	2945.66	2945.68	3.00	1073.45	1076.45
36	0.10403	0.01602	2836.60	2836.61	4.01	1072.88	1076.89
37	0.10822	0.01602	2732.13	2732.15	5.02	1072.32	1077.33
38	0.11257	0.01602	2631.88	2631.89	6.02	1071.75	1077.77
39	0.11707	0.01602	2535.86	2535.88	7.03	1071.18	1078.21

TEMP	PRESS	SP	ECIFIC VOLU FT³/LB.	ME		ENTHALPY BTU/LB	
°F.	PSIA	ν ₁	$\nu_{ m lg}$	ν _g	h	h _{lg}	h _g
40 41	0.12172 0.12654	0.01602 0.01602	2443.67 2355.22	2443.69 2355.24	8.03 9.04	1070.62	1078.65
42	0.13153	0.01602	2270.42	2270.43	10.04	1070.05 1069.48	1079.09
43	0.13669	0.01602	2189.02	2189.04	11.04	1069.48	1079.52 1079.96
44	0.14203	0.01602	2110.92	2110.94	12.05	1068.35	1079.90
45	0.14755	0.01602	2035.91	2035.92	13.05	1067.79	1080.84
46	0.15326	0.01602	1963.85	1963.87	14.05	1067.22	1081.28
47	0.15917	0.01602	1894.71	1894.73	15.06	1066.66	1081.71
48	0.16527	0.01602	1828.28	1828.30	16.06	1066.09	1082.15
49	0.17158	0.01602	1764.44	1764.46	17.06	1065.53	1082.59
50	0.17811	0.01602	1703.18	1703.20	18.06	1064.96	1083.03
51 52	0.18484	0.01602	1644.25	1644.26	19.06	1064.40	1083.46
	0.19181	0.01603	1587.64	1587.65	20.07	1063.83	1083.90
53 54	0.19900	0.01603	1533.22	1533.24	21.07	1063.27	1084.34
	0.20643	0.01603	1480.89	1480.91	22.07	1062.71	1084.77
55	0.21410	0.01603	1430.61	1430.62	23.07	1062.14	1085.21
56	0.22202	0.01603	1382.19	1382.21	24.07	1061.58	1085.65
57	0.23020	0.01603	1335.65	1335.67	25.07	1061.01	1086.08
58	0.23864	0.01603	1290.85	1290.87	26.07	1060.45	1086.52
59	0.24735	0.01603	1247.76	1247.78	27.07	1059.89	1086.96
60	0.25635	0.01604	1206.30	1206.32	28.07	1059.32	1087.39
61 62	0.26562	0.01604	1166.38	1166.40	29.07	1058.76	1087.83
63	0.27519	0.01604	1127.93	1127.95	30.07	1058.19	1088.27
64	0.28506 0.29524	0.01604	1090.94	1090.96	31.07	1057.63	1088.70
		0.01604	1055.32	1055.33	32.07	1057.07	1089.14
65	0.30574	0.01604	1020.98	1021.00	33.07	1056.50	1089.57
66	0.31656	0.01604	987.95	987.97	34.07	1055.94	1090.01
67 68	0.32772	0.01605	956.11	956.12	35.07	1055.37	1090.44
69	0.33921	0.01605	925.44	925.45	36.07	1054.81	1090.88
	0.35107	0.01605	895.86	895.87	37.07	1054.24	1091.31
70	0.36328	0.01605	867.34	867.36	38.07	1053.68	1091.75
71	0.37586	0.01605	839.87	839.88	39.07	1053.11	1092.18
72 73	0.38882	0.01606	813.37	813.39	40.07	1052.55	1092.61
73	0.40217	0.01606	787.85	787.87	41.07	1051.98	1093.05
	0.41592	0.01606	763.19	763.21	42.06	1051.42	1093.48
75	0.43008	0.01606	739.42	739.44	43.06	1050.85	1093.92
76 77	0.44465	0.01606	716.51	716.53	44.06	1050.29	1094.35
78	0.45966	0.01607	694.38	694.40	45.06	1049.72	1094.78
78 79	0.47510	0.01607	673.05	673.06	46.06	1049.16	1095.22
17	0.49100	0.01607	652.44	652.46	47.06	1048.59	1095.65

TEMP	PRESS	SPE	SPECIFIC VOLUME FT³/LB.			ENTHALPY BTU/LB	
°F.	PSIA	ν ₁	ν_{lg}	Vg	h _i	h_{lg}	h _g
80	0.50736	0.01607	632.54	632.56	48.06	1048.03	1096.08
81	0.52419	0.01608	613.35	613.37	49.06	1047.46	1096.51
82	0.54150	0.01608	594.82	594.84	50.05	1046.89	1096.95
83	0.55931	0.01608	576.90	576.92	51.05	1046.33	1097.38
84	0.57763	0.01608	559.63	559.65	52.05	1045.76	1097.81
85	0.59647	0.01609	542.93	542.94	53.05	1045.19	1098.24
86	0.61584	0.01609	526.80	526.81	54.05	1044.63	1098.67
87	0.63575	0.01609	511.21	511.22	55.05	1044.06	1099.11
88	0.65622	0.01609	496.14	496.15	56.05	1043.49	1099.54
89	0.67726	0.01610	481.60	481.61	57.04	1042.92	1099.97
90	0.69889	0.01610	467.52	467.53	58.04	1042.36	1100.40
91	0.72111	0.01610	453.91	453.93	59.04	1041.79	1100.83
92	0.74394	0.01611	440.76	440.78	60.04	1041.22	1101.26
93	0.76740	0.01611	428.04	428.06	61.04	1040.65	1101.69
94	0.79150	0.01611	415.74	415.76	62.04	1040.08	1102.12
95	0.81625	0.01612	403.84	403.86	63.03	1039.51	1102.55
96	0.84166	0.01612	392.33	392.34	64.03	1038.95	1102.98
97	0.86776	0.01612	381.20	381.21	65.03	1038.38	1103.41
98	0.89456	0.01612	370.42	370.44	66.03	1037.81	1103.84
99	0.92207	0.01613	359.99	360.01	67.03	1037.24	1104.26
100	0.95031	0.01613	349.91	349.92	68.03	1036.67	1104.69
101	0.97930	0.01613	340.14	340.15	69.03	1036.10	1105.12
102	1.00904	0.01614	330.69	330.71	70.02	1035.53	1105.55
103	1.03956	0.01614	321.53	321.55	71.02	1034.95	1105.98
104	1.07088	0.01614	312.67	312.69	72.02	1034.38	1106.40
105	1.10301	0.01615	304.08	304.10	73.02	1033.81	1106.83
106	1.13597	0.01615	295.76	295.77	74.02	1033.24	1107.26
107	1.16977	0.01616	287.71	287.73	75.01	1032.67	1107.68
108	1.20444	0.01616	279.91	279.92	76.01	1032.10	1108.11
109	1.23999	0.01616	272.34	272.36	77.01	1031.52	1108.54
110	1.27644	0.01617	265.02	265.03	78.01	1030.95	1108.96
111	1.31381	0.01617	257.91	257.93	79.01	1030.38	1109.39
112	1.35212	0.01617	251.02	251.04	80.01	1029.80	1109.81
113	1.39138	0.01618	244.36	244.38	81.01	1029.23	1110.24
114	1.43162	0.01618	237.89	237.90	82.00	1028.66	1110.66
115	1.47286	0.01619	231.62	231.63	83.00	1028.08	1111.09
116	1.51512	0.01619	225.53	225.55	84.00	1027.51	1111.51
117	1.55842	0.01619	219.63	219.65	85.00	1026.93	1111.93
118	1.60277	0.01620	213.91	213.93	86.00	1026.36	1112.36
119	1.64820	0.01620	208.36	208.37	87.00	1025.78	1112.78

TEMP	PRESS	SPI	ECIFIC VOLU	ME		ENTHALPY BTU/LB	
°F.	PSIA	ν ₁	v_{lg}	ν _g	h	h _{lg}	h _g
120	1.69474	0.01620	202.98	202.99	88.00	1025.20	1113.20
121	1.74240	0.01621	197.76	197.76	89.00	1023.62	1113.62
122	1.79117	0.01621	192.69	192.69	90.00	1024.05	1114.05
123	1.84117	0.01622	187.78	187.78	90.99	1024.47	1114.47
124	1.89233	0.01622	182.98	182.99	91.99	1022.90	1114.89
125	1.94470	0.01623	178.34	178.36	92.99	1022.32	1115.31
126	1.99831	0.01623	173.85	173.86	93.99	1021.74	1115.73
127	2.05318	0.01623	169.47	169.49	94.99	1021.16	1116.15
128	2.10934	0.01624	165.23	165.25	95.99	1020.58	1116.57
129	2.16680	0.01624	161.11	161.12	96.99	1020.00	1116.99
130	2.22560	0.01625	157.11	157.12	97.99	1019.42	1117.41
131	2.28576	0.01625	153.22	153.23	98.99	1018.84	1117.83
132	2.34730	0.01626	149.44	149.46	99.99	1018.26	1118.25
133	2.41025	0.01626	145.77	145.78	100.99	1017.68	1118.67
134	2.47463	0.01627	142.21	142.23	101.99	1017.10	1119.08
135	2.54048	0.01627	138.74	138.76	102.99	1016.52	1119.50
136	2.60782	0.01627	135.37	135.39	103.98	1015.93	1119.92
137	2.67667	0.01628	132.10	132.12	104.98	1015.35	1120.34
138	2.74707	0.01628	128.92	128.94	105.98	1014.77	1120.75
139	2.81903	0.01629	125.83	125.85	106.98	1014.18	1121.17
140	2.89260	0.01629	122.82	122.84	107.98	1013.60	1121.58
141	2.96780	0.01630	119.90	119.92	108.98	1013.01	1122.00
142	3.04465	0.01630	117.05	117.07	109.98	1012.43	1122.41
143	3.12320	0.01631	114.29	114.31	110.98	1011.84	1122.83
144	3.20345	0.01631	111.60	111.62	111.98	1011.26	1123.24
145	3.28546	0.01632	108.99	109.00	112.98	1010.67	1123.66
146	3.36924	0.01632	106.44	106.45	113.98	1010.09	1124.07
147	3.45483	0.01633	103.96	103.98	114.98	1009.50	1124.48
148	3.54226	0.01633	101.55	101.57	115.98	1008.91	1124.89
149	3.63156	0.01634	99.21	99.22	116.98	1008.32	1125.31
150	3.72277	0.01634	96.93	96.94	117.98	1007.73	1125.72
151	3.81591	0.01635	94.70	94.72	118.99	1007.14	1126.13
152	3.91101	0.01635	92.54	92.56	119.99	1006.55	1126.54
153	4.00812	0.01636	90.44	90.46	120.99	1005.96	1126.95
154	4.10727	0.01636	88.39	88.41	121.99	1005.37	1127.36
155	4.20848	0.01637	86.40	86.41	122.99	1004.78	1127.77
156	4.31180	0.01637	84.45	84.47	123.99	1004.19	1128.18
157	4.41725	0.01638	82.56	82.58	124.99	1003.60	1128.59
158	4.52488	0.01638	80.72	80.73	125.99	1003.00	1128.99
159	4.63472	0.01639	78.92	78.94	126.99	1002.41	1129.40

TEMP	PRESS	SPE	SPECIFIC VOLUME FT³/LB.		p	ENTHALPY BTU/LB	
°F.	PSIA	νι	ν_{lg}	ν _g	h	h _{lg}	h _g
160	4.7468	0.01639	77.175	77.192	127.99	1001.82	1129.81
161	4.8612	0.01640	75.471	75.488	128.99	1001.22	1130.22
162	4.9778	0.01640	73.812	73.829	130.00	1000.63	1130.62
163	5.0969	0.01641	72.196	72.213	131.00	1000.03	1131.03
164	5.2183	0.01642	70.619	70.636	132.00	999.43	1131.43
165	5.3422	0.01642	69.084	69.101	133.00	998.84	1131.8
166	5.4685	0.01643	67.587	67.604	134.00	998.24	1132.2
167	5.5974	0.01643	66.130	66.146	135.00	997.64	1132.6
168	5.7287	0.01644	64.707	64.723	136.01	997.04	1133.0
169	5.8627	0.01644	63.320	63.336	137.01	996.44	1133.4
170	5.9993	0.01645	61.969	61.989	138.01	995.84	1133.8
171	6.1386	0.01646	60.649	60.666	139.01	995.24	1134.2
172	6.2806	0.01646	59.363	59.380	140.01	994.64	1134.6
173	6.4253	0.01647	58.112	58.128	141.02	994.04	1135.0
174	6.5729	0.01647	56.887	56.904	142.02	993.44	1135.4
175	6.7232	0.01648	55.694	55.711	143.02	992.83	1135.8
176	6.8765	0.01648	54.532	54.549	144.03	992.23	1136.2
177	7.0327	0.01649	53.397	53.414	145.03	991.63	1136.6
178	7.1918	0.01650	52.290	52.307	146.03	991.02	1137.0
179	7.3539	0.01650	51.210	51.226	147.03	990.42	1137.4
180	7.5191	0.01651	50.155	50.171	148.04	989.81	1137.8
181	7.6874	0.01651	49.126	49.143	149.04	989.20	1138.2
182	7.8589	0.01652	48.122	48.138	150.04	988.60	1138.6
183	8.0335	0.01653	47.142	47.158	151.05	987.99	1139.0
184	8.2114	0.01653	46.185	46.202	152.05	987.38	1139.4
185	8.3926	0.01654	45.251	45.267	153.05	986.77	1139.
186	8.5770	0.01654	44.339	44.356	154.06	986.16	1140.
187	8.7649	0.01655	43.448	43.465	155.06	985.55	1140.
188	8.9562	0.01656	42.579	42.595	156.07	984.94	1141.0
189	9.1510	0.01656	41.730	41.746	157.07	984.32	1141.
190	9.3493	0.01657	40.901	40.918	158.07	983.71	1141.
191	9.5512	0.01658	40.092	40.108	159.08	983.10	1142.
192	9.7567	0.01658	39.301	39.317	160.08	982.48	1142. 1142.
193	9.9659	0.01659	38.528	38.544	161.09	981.87	
194	10.1788	0.01659	37.774	37.790	162.09	981.25	1143.
195	10.3955	0.01660	37.035	37.052	163.10	980.63	1143.
196	10.6160	0.01661	36.314	36.331	164.10	980.02	1144.
197	10.8404	0.01661	35.611	35.628	165.11	979.40	1144.
198	11.0687	0.01662	34.923	34.940	166.11	978.78	1144.
199	11.3010	0.01663	34.251	34.268	167.12	978.16	1145.

		SPE	CIFIC VOLUI	ME		ENTHALPY	-
TEMP	PRESS		FT³/LB.			BTU/LB	
°F.	PSIA	v_1	ν_{lg}	ν _g	h	h_{lg}	h _g
200	11.5374	0.01663	33.594	33.610	168.13	977.54	1145.66
201	11.7779	0.01664	32.951	32.968	169.13	976.92	1146.05
202	12.0225	0.01665	32.324	32.340	170.14	976.29	1146.43
203	12.2713	0.01665	31.710	31.726	171.14	975.67	1146.81
204	12.5244	0.01666	31.110	31.127	172.15	975.05	1147.20
205	12.7819	0.01667	30.523	30.540	173.16	974.42	1147.58
206	13.0436	0.01667	29.949	29.965	174.16	973.80	1147.96
207	13.3099	0.01668	29.388	29.404	175.17	973.17	1148.34
208	13.5806	0.01669	28.839	28.856	176.18	972.54	1148.72
209	13.8558	0.01669	28.303	28.319	177.18	971.92	1149.10
210	14.1357	0.01670	27.778	27.795	178.19	971.29	1149.48
212	14.7096	0.01671	26.763	26.780	180.20	970.03	1150.23
214	15.3025	0.01673	25.790	25.807	182.22	968.76	1150.98
216	15.9152	0.01674	24.861	24.878	184.24	967.50	1151.73
218	16.5479	0.01676	23.970	23.987	186.25	966.23	1152.48
220	17.2013	0.01677	23.118	23.134	188.27	964.95	1153.22
222	17.8759	0.01679	22.299	22.316	190.29	963.67	1153.96
224	18.5721	0.01680	21.516	21.533	192.31	962.39	1154.70
226	19.2905	0.01682	20.765	20.782	194.33	961.11	1155.43
228	20.0316	0.01683	20.045	20.062	196.35	959.82	1156.16
230	20.7961	0.01684	19.355	19.372	198.37	958.52	1156.89
232	21.5843	0.01686	18.692	18.709	200.39	957.22	1157.62
234	22.3970	0.01688	18.056	18.073	202.41	955.92	1158.34
236	23.2345	0.01689	17.466	17.463	204.44	954.62	1159.06
238	24.0977	0.01691	16.860	16.877	206.46	953.31	1159.77
240	24.9869	0.01692	16.298	16.314	208.49	952.00	1160.48
242	25.9028	0.01694	15.757	15.774	210.51	950.68	1161.19
244	26.8461	0.01695	15.238	15.255	212.54	948.35	1161.90
246	27.8172	0.01697	14.739	14.756	214.57	948.03	1162.60
248	28.8169	0.01698	14.259	14.276	216.60	946.70	1163.29
250	29.8457	0.01700	13.798	13.815	218.63	945.36	1163.99
252	30.9043	0.01702	13.355	13.372	220.66	944.02	1164.68
254	31.9934	0.01703	12.928	12.945	222.69	942.68	1165.37
256	33.1135	0.01705	12.526	12.147	224.73	939.99	1166.72
258	34.2653	0.01707	12.123	12.140	226.76	939.97	1166.73
260	35.4496	0.01708	11.742	11.759	228.79	938.61	1167.40
262	36.6669	0.01710	11.376	11.393	230.83	937.25	1168.08
264	37.9180	0.01712	11.024	11.041	232.87	935.88	1168.74
266	39.2035	0.01714	10.684	10.701	234.90	934.50	1169.41
268	40.5241	0.01715	10.357	10.374	236.94	933.12	1170.07

TEMP	PRESS	SPE	ECIFIC VOLU FT³/LB.	ME		ENTHALPY BTU/LB	
°F.	PSIA	ν_1	ν_{lg}	ν _g	h	h_{lg}	h _g
270	41.8806	0.01717	10.042	10.059	238.98	931.74	1170.72
272	43.2736	0.01719	9.737	9.755	241.03	930.35	1171.38
274	44.7040	0.01721	9.445	9.462	243.07	928.95	1172.02
276	46.1723	0.01722	9.162	9.179	245.11	927.55	1172.67
278	47.6794	0.01724	8.890	8.907	247.16	926.15	1173.31
280	49.2260	0.01726	8.627	8.644	249.20	924.74	1173.94
282	50.8128	0.01728	8.373	8.390	251.25	923.32	1174.57
284	52.4406	0.01730	8.128	8.146	253.30	921.90	1175.20
286	54.1103	0.01731	7.892	7.910	255.35	920.47	1175.82
288	55.8225	0.01733	7.664	7.681	257.40	919.03	1176.44
290	57.5780	0.01735	7.444	7.461	259.45	917.59	1177.05
292	59.3777	0.01737	7.231	7.248	261.51	916.15	1177.66
294	61.2224	0.01739	7.026	7.043	263.56	914.69	1178.26
296	63.1128	0.01741	6.827	6.844	265.62	913.24	1178.86
298	65.0498	0.01743	6.635	6.652	267.68	911.77	1179.45
300	67.03	0.01745	6.450	6.467	269.74	910.3	1180.04
302	69.01	0.01747	6.275	6.292	271.79	909.0	1180.79
304	71.09	0.01749	6.102	6.119	273.86	907.5	1181.36
306	73.22	0.01751	5.933	5.951	275.93	906.0	1181.93
308	75.40	0.01753	5.771	5.789	278.00	904.5	1182.50
310	77.64	0.01755	5.614	5.632	280.06	903.0	1183.06
312	79.92	0.01757	5.462	5.480	282.13	901.5	1183.63
314	82.26	0.01759	5.315	5.333	284.21	899.9	1184.11
316	84.65	0.01761	5.172	5.190	286.28	898.4	1184.68
318	87.10	0.01763	5.034	5.052	288.36	896.9	1185.26
320	89.60	0.01765	4.901	4.919	290.43	895.3	1185.73
322	92.16	0.01767	4.772	4.790	292.51	893.8	1186.31
324	94.78	0.01770	4.647	4.665	294.59	892.2	1186.79
326	97.46	0.01772	4.525	4.543	296.67	890.7	1187.37
328	100.20	0.01774	4.408	4.426	298.76	889.1	1187.86
330	103.00	0.01776	4.294	4.312	300.84	887.5	1188.34
332	105.86	0.01778	4.183	4.201	302.93	885.9	1188.83
334	108.78	0.01780	4.076	4.094	305.02	884.3	1189.32
336	111.76	0.01783	3.973	3.991	307.11	882.7	1189.81
338	114.82	0.01785	3.872	3.890	309.21	881.1	1190.31
340	117.93	0.01787	3.774	3.792	311.30	879.5	1190.80
342	121.11	0.01789	3.680	3.698	313.39	877.9	1191.29
344	124.36	0.01792	3.588	3.606	315.49	876.3	1191.79
346	127.68	0.01794	3.499	3.517	317.59	874.6	1192.19
348	131.07	0.01796	3.412	3.430	319.70	873.0	1192.70

TEMP	PRESS	SPE	CIFIC VOLUM FT³/LB.	ИE		ENTHALPY BTU/LB	
°F.	PSIA	ν_1	v_{lg}	ν _g	h _i	h_{lg}	h _g
350	134.53	0.01799	3.328	3.346	321.80	871.3	1193.10
352	138.06	0.01801	3.247	3.265	323.91	869.6	1193.51
354	141.66	0.01804	3.167	3.185	326.02	868.0	1194.02
356	145.34	0.01806	3.091	3.109	328.13	866.3	1194.43
358	149.09	0.01808	3.286	3.304	330.24	864.6	1194.84
360	152.92	0.01811	2.943	2.961	332.35	862.9	1195.25
362	156.82	0.01813	2.873	2.891	334.47	861.2	1195.67
364	160.80	0.01816	2.804	2.822	336.59	859.5	1196.09
366	164.87	0.01818	2.738	2.756	338.71	857.7	1196.41
368	169.01	0.01821	2.673	2.691	340.83	856.0	1196.83
370	173.23	0.01823	5.283	2.628	342.96	854.2	1197.16
372	177.53	0.01826	2.549	2.567	345.08	852.5	1197.58
374	181.92	0.01828	2.325	2.508	347.21	850.7	1197.91
376	186.39	0.01831	2.432	2.450	349.35	848.9	1198.25
378	190.95	0.01834	2.376	2.394	351.48	847.2	1198.68
380	195.60	0.01836	2.321	2.339	353.62	845.4	1199.02
382	200.33	0.01839	2.268	2.286	355.76	843.6	1199.36
384	205.15	0.01842	2.216	2.234	357.90	841.7	1199.60
386	210.06	0.01844	2.165	2.183	360.04	839.9	1199.94
388	215.06	0.01847	2.116	2.134	362.19	838.1	1200.29
390	220.2	0.01850	2.069	2.087	364.34	836.2	1200.54
392	225.3	0.01853	2.021	2.040	366.49	834.4	1200.89
394	230.6	0.01855	1.976	1.995	368.64	832.5	1201.14
396	236.0	0.01858	1.932	1.951	370.80	830.6	1204.40
398	241.5	0.01861	1.889	1.908	372.96	828.7	1201.66
400	247.1	0.01864	1.847	1.866	375.12	826.8	1201.92
405	261.4	0.01871	1.747	1.766	380.53	822.0	1202.53
410	276.5	0.01878	1.654	1.673	385.97	817.2	1203.17
415	292.1	0.01886	1.566	1.585	391.42	812.2	1203.62
420	308.5	0.01894	1.483	1.502	396.89	807.2	1204.09
425	325.6	0.01901	1.406	1.425	402.38	802.1	1204.48
430	343.3	0.01909	1.333	1.352	407.89	796.9	1204.79
435	361.9	0.01918	1.265	1.284	413.42	791.7	1205.12
440	381.2	0.01926	1.200	1.219	418.98	786.3	1205.28
445	401.2	0.01935	1.139	1.158	424.55	780.9	1205.45
450	422.1	0.01943	1.082	1.101	430.20	775.4	1205.60
455	443.8	0.01952	1.027	1.047	435.80	769.8	1205.60
460	466.3	0.01961	0.976	0.996	441.40	764.1	1205.50
465	489.8	0.01971	0.928	0.948	447.10	758.3	1205.40
470	514.1	0.01980	0.883	0.903	452.80	752.4	1205.20

TEMP	PRESS	SPEC	SPECIFIC VOLUME FT³/LB.		ENTHALPY BTU/LB		
°F.	PSIA	v ₁	v_{lg}	ν _g	h	h _{lg}	h _g
475	539.3	0.01990	0.840	0.8594	458.5	746.4	1204.9
480	565.5	0.02000	0.799	0.8187	464.3	740.3	1204.6
485	592.6	0.02011	0.760	0.7801	470.1	734.1	1204.2
490	620.7	0.02021	0.723	0.7436	475.9	727.8	1203.7
495	649.8	0.02032	0.689	0.7090	481.8	721.3	1203.1
500	680.0	0.02043	0.656	0.6761	487.7	714.8	1202.5
525	847.1	0.02104	0.514	0.5350	517.8	680.0	1197.8
550	1044.0	0.02175	0.406	0.4249	549.1	641.6	1190.6
575	1274.0	0.02259	0.315	0.3378	581.9	598.6	1180.4
600	1541.0	0.02363	0.244	0.2677	616.7	549.7	1166.4

Properties of Water

TEMPERATURE °F.	SPECIFIC HEAT BTU/LB °F.	DENSITY LB/FT³	SPECIFIC GRAVITY
32 - 100	1.00	62.40	1.000
101 - 150	1.00	61.15	0.980
151 - 200	1.01	59.90	0.960
201 - 250	1.02	58.66	0.940
251 - 300	1.03	57.41	0.920
301 - 350	1.05	55.85	0.895
351 - 400	1.08	53.98	0.865
401 - 450	1.13	51.79	0.830

Water Equation Factors

SYSTEM TYPE	SYSTEM TEMPERATURE RANGE ° F.	EQUATION FACTOR
LOW TEMPERATURE (GLYCOL) CHILLED WATER	0 - 40	SEE NOTE 2
CHILLED WATER	40 - 60	500
CONDENSER WATER HEAT PUMP LOOP	60 - 110	500
	110 - 150	490
LOW TEMPERATURE HEATING WATER	151 - 200	485
	201 - 250	480
MEDIUM TEMPERATURE	251 - 300	475
HEATING WATER	301 - 350	470
HIGH TEMPERATURE	351 - 400	470
HEATING WATER	401 - 450	470

Notes:

- 1. Water equation corrections for temperature, density, and specific heat.
- 2. For glycol system equation factors, see Section 27.04, Glycol Systems, below.

27.04 Glycol Systems

Ethylene Glycol

% GLYCOL	TEMPERA	ATURE °F.	SPECIFIC	SPECIFIC	EQUATION
SOLUTION	FREEZE POINT	BOILING POINT	HEAT	GRAVITY (1)	FACTOR
0	+32	212	1.00	1.000	500
10	+26	214	0.97	1.012	491
20	+16	216	0.94	1.027	483
30	+4	220	0.89	1.040	463
40	-12	222	0.83	1.055	438
50	-34	225	0.78	1.067	416
60	-60	232	0.73	1.079	394
70	<-60	244	0.69	1.091	376
80	-49	258	0.64	1.101	352
90	-20	287	0.60	1.109	333
100	+10	287+	0.55	1.116	307

Propylene Glycol

% GLYCOL	TEMPERA	ATURE °F.	SPECIFIC	SPECIFIC	EQUATION
SOLUTION	FREEZE POINT	BOILING POINT	HEAT	GRAVITY (1)	FACTOR
0	+32	212	1.000	1.000	500
10	+26	212	0.980	1.008	494
20	+19	213	0.960	1.017	488
30	+8	216	0.935	1.026	480
40	-7	219	0.895	1.034	463
50	-28	222	0.850	1.041	442
60	<-60	225	0.805	1.046	421
70	<-60	230	0.750	1.048	393
80	<-60	230+	0.690	1.048	362
90	<-60	230+	0.645	1.045	337
100	<-60	230+	0.570	1.040	296

Note:

1. Specific gravity with respect to water at 60°F.

General Notes

28.01 General

- A. Provide all materials and equipment and perform all labor required to install complete and operable mechanical systems as indicated on the drawings, as specified and as required by code.
- B. Contract document drawings for mechanical work (HVAC, plumbing, and fire protection) are diagrammatic and are intended to convey scope and general arrangement only.
- C. Install all mechanical equipment and appurtenances in accordance with manufacturers' recommendations, contract documents, and applicable codes and regulations.
- D. Provide vibration isolation for all mechanical equipment to prevent transmission of vibration to building structure.
- E. Provide vibration isolators for all piping supports connected to and within 50 feet of isolated equipment (except at base elbow supports and anchor points) throughout mechanical equipment rooms. Do the same for supports of steam mains within 50 feet of boiler or pressure reducing valves.
- F. Provide vibration isolators for all piping supports of steam mains within 50 feet of boilers and pressure reducing valves.
- G. The location of existing underground utilities is shown in an approximate way only. The contractor shall determine the exact location of all existing utilities before commencing work. The contractor shall pay for and repair all damages caused by failure to exactly locate and preserve any and all underground utilities unless otherwise indicated.
- H. Coordinate construction of all mechanical work with architectural, structural, civil, electrical work, etc., shown on other contract document drawings.
- I. Maintain a minimum of 6'-8" clearance to underside of pipes, ducts, conduits, suspended equipment, etc., throughout access routes in mechanical rooms.
- J. All tests shall be completed before any mechanical equipment or piping insulation is applied.
- K. Locate all temperature, pressure, and flow measuring devices in accessible locations with straight section of pipe or duct up- and downstream as recommended by the manufacturer for good accuracy.
- L. Testing, adjusting, and balancing agency shall be a member of the Associated Air Balance Council (AABC) or the National Environmental Balancing Bureau (NEBB). Testing, adjusting, and balancing shall be performed in accordance with the AABC Standards.
- M. Where two or more items of the same type of equipment are required, the product of one manufacturer shall be used.
- N. Reinforcement, detailing, and placement of concrete shall conform to ASTM 315 and ACI 318. Concrete shall conform to ASTM C94. Concrete work shall conform to

ACI 318, part entitled "Construction Requirements." Compressive strength in 28 days shall be 3,000 psi. Total air content of exterior concrete shall be between 5 and 7 percent by volume. Slump shall be between 3 and 4 inches. Concrete shall be cured for 7 days after placement.

- O. Coordinate all equipment connections with manufacturers' certified drawings. Coordinate and provide all duct and piping transitions required for final equipment connections to furnished equipment. Field verify and coordinate all duct and piping dimensions before fabrication.
- P. All control wire and conduit shall comply with the National Electric Code and Division 16 of the specification.
- Q. Concrete housekeeping pads to suit mechanical equipment shall be sized and located by the mechanical contractor. Minimum concrete pad thickness shall be 6 inches. Pad shall extend beyond the equipment a minimum of 6 inches on each side. Concrete housekeeping pads shall be provided by the general contractor. It shall be the responsibility of the mechanical contractor to coordinate size and location of concrete housekeeping pads with general contractor.
 - R. All mechanical room doors shall be a minimum of 4'-0" wide.
- S. Where beams are indicated to be penetrated with ductwork or piping, coordinate ductwork and piping layout with beam opening size and opening locations. Coordination shall be done prior to fabrication of ductwork, cutting of piping, or fabrication of beams.
- T. When mechanical work (HVAC, plumbing, sheet metal, fire protection, etc.) is subcontracted, it shall be the mechanical contractor's responsibility to coordinate subcontractors and the associated contracts. When discrepancies arise pertaining to which contractor provides a particular item of the mechanical contract or which contractor provides final connections for a particular item of the mechanical contract, it shall be brought to the attention of the mechanical contractor, whose decision shall be final.
- U. The locations of all items shown on the drawings or called for in the specifications that are not definitely fixed by dimensions are approximate only. The exact locations necessary to secure the best conditions and results must be determined by the project site conditions and shall have the approval of the engineer before being installed. Do not scale drawings.
- V. All miscellaneous steel required to ensure proper installation and as shown in details for piping, ductwork, and equipment (unless otherwise noted) shall be furnished and installed by the mechanical contractor.
- W. Provide access panels for installation in walls and ceilings, where required, to service dampers, valves, smoke detectors, and other concealed mechanical equipment.
 Access panels shall be turned over to general contractor for installation.
- X. All equipment, piping, ductwork, etc., shall be supported as detailed, specified, and required to provide a vibration free installation.
- Y. All ductwork, piping and equipment supported from structural steel shall be coordinated with general contractor. All attachments to steel bar joists, trusses, or joist girders shall be at panel points. Provide beam clamps meeting mss standards.

Welding to structural members shall not be permitted. The use of C-clamps shall not be permitted.

- Z. Mechanical equipment, ductwork, and piping shall not be supported from metal deck.
- AA. All roof mounted equipment curbs for equipment provided by the mechanical contractor shall be furnished by the mechanical contractor and installed by the general contractor.
- BB. Locations and sizes of all floor, wall, and roof openings shall be coordinated with all other trades involved.
- CC. All openings in fire walls due to ductwork, piping, conduit, etc., shall be fire stopped with a product similar to 3M or approved equal.
- DD. All air conditioning condensate drain lines from each air handling unit and rooftop unit shall be piped full size of the unit drain outlet, with "P" trap, and piped to nearest drain. See details shown on the drawings or the contract specifications for depth of air conditioning condensate trap.
- EE. Refer to typical details for ductwork, piping, and equipment installation.

28.02 Piping

- A. Provide all materials and equipment and perform all labor required to install complete and operable piping systems as indicated on the drawings, as specified and as required by code.
- B. Elevations as shown on the drawings are to the centerline of all pressure piping and to the invert of all gravity piping.
- C. Maintain a minimum of 3'6" of ground cover over all underground HVAC piping (edit depth of ground cover to suit frost line depth and project requirements).
- D. Unless otherwise noted, all chilled water and heating water piping shall be % inch size (edit system type or pipe size to suit project requirements).
- E. Provide an air vent at the high point of each drop in the heating water, chilled water, and other closed water piping systems (edit system types to suit project requirements). All piping shall grade to low points. Provide hose end drain valves at the bottom of all risers and low points.
- F. Unless otherwise noted, all piping is overhead, tight to underside of structure or slab, with space for insulation if required.
- G. Install piping so that all valves, strainers, unions, traps, flanges, and other appurtenances requiring access are accessible.
- H. All valves shall be installed so that valve remains in service when equipment or piping on equipment side of valve is removed.
- I. All balancing valves and butterfly valves shall be provided with position indicators and maximum adjustable stops (memory stops).

- J. Provide chainwheel operators for all valves in equipment rooms mounted greater than 7'-0" above floor level; Chain shall extend to 7'-0" above floor level.
- K. All valves (except control valves) and strainers shall be full size of pipe before reducing size to make connections to equipment and controls.
- L. Unions and/or flanges shall be installed at each piece of equipment, in bypasses, and in long piping runs (100 feet or more) to permit disassembly for alteration and repairs.
- M. Pitch steam piping downward in the direction of flow $\frac{1}{3}$ inch in 10 feet (1 inch in 40 feet) minimum. Pitch all steam return lines downward in the direction of condensate flow $\frac{1}{3}$ inch per 10 feet (1 inch in 20 feet) minimum. Where length of branch lines are less than 8 feet, pitch branch lines toward mains $\frac{1}{3}$ inch per foot minimum.
- N. Pitch up all steam and condensate runouts to risers and equipment ½ inch per foot. Where this pitch cannot be obtained, runouts over 8 feet in length shall be one size larger than noted.
- O. Tap all branch lines from top of steam mains (45 degrees preferred, 90 degrees acceptable).
- P. Provide an end of main drip at each rise in the steam main. Provide condensate drips at the bottom of all steam risers, downfed runouts to equipment, radiators, etc., at end of mains and low points, and ahead of all pressure regulators, control valves, isolation valves, and expansion joints.
- Q. On straight steam piping runs with no natural drainage points, install drip legs at intervals not exceeding 200 feet where pipe is pitched downward in the direction of steam flow and a maximum of 100 feet where the pipe is pitched up so that condensate flow is opposite of steam flow.
 - R. Steam traps shall be minimum \" size.
 - S. Install all piping without forcing or springing.
 - T. All piping shall clear doors and windows.
 - U. All valves shall be adjusted for smooth and easy operation.
- V. All piping work shall be coordinated with all trades involved. Offsets in piping around obstructions shall be provided at no additional cost to the owner.
- W. Provide flexible connections in all piping systems connected to pumps, chillers, cooling towers, and other equipment which require vibration isolation except water coils. Flexible connections shall be provided as close to the equipment as possible or as indicated on the drawings.
- X. Slope refrigerant piping one percent in the direction of oil return. Liquid lines may be installed level.
- Y. Install horizontal refrigerant hot gas discharge piping With ½" per 10 feet downward slope away from the compressor.

- C. In corridors where ceiling speakers and air diffusers are indicated between the same light fixtures, install both devices at the quarter points between the same fixture.
- D. Unless otherwise shown, locate all room thermostats and humidistats 4'-0'' (centerline) above finished floor. Notify the engineer of any rooms where the above location cannot be maintained or where there is a question on location.
- E. All ductwork shall clear doors and windows.
- F. All ductwork dimensions, as shown on the drawings, are internal clear dimensions and duct size shall be increased to compensate for duct lining thickness.
- G. Provide all 90 degree square elbows with double radius turning vanes unless otherwise indicated. Elbows in dishwasher, kitchen, and laundry exhaust shall be unvaned smooth radius construction with a radius equal to 1½ times the width of the duct. Provide access doors upstream of all elbows with turning vanes.
- H. Coordinate diffuser, register, and grille locations with architectural reflected ceiling plans, lighting, and other ceiling items and make minor duct modifications to suit.
- I. Field erected and factory assembled air handling unit coils shall be arranged for removal from the upstream side without dismantling supports. Provide galvanized structural steel supports for all coils (except lowest coil) in banks over two coils high to permit independent removal of any coil.
- J. All air handling units shall operate without moisture carryover.
- K. Locate all mechanical equipment (single duct, dual duct, variable volume, constant volume and fan powered boxes, fan coil units, cabinet heaters, unit heaters, unit ventilators, coils, steam humidifiers, etc.) for unobstructed access to unit access panels, controls and valving.
- L. Finned tube radiation enclosures shall be wall to wall unless otherwise indicated.
- M. Provide flexible connections in all ductwork systems (supply, return, and exhaust) connected to air handling units, fans, and other equipment which require vibration isolation. Flexible connections shall be provided at the point of connection to the equipment unless otherwise indicated.
- N. Unless otherwise noted, all ductwork is overhead, tight to the underside of the structure, with space for insulation if required.
- O. Runs of flexible duct shall not exceed 5 feet (edit maximum length of flexible duct to suit project; 5 feet maximum recommended length, 8 feet maximum length).
- P. All ductwork shall be coordinated with all trades involved. Offsets in ducts, including divided ducts and transitions around obstructions, shall be provided at no additional cost to the owner.
- Q. Provide access doors in ductwork to provide access for all smoke detectors, fire dampers, smoke dampers, volume dampers, humidifiers, coils, and other items located in the ductwork which require service and/or inspection.
- R. Provide access doors in ductwork for operation, adjustment, and maintenance of all fans, valves, and mechanical equipment.

- S. All ducts shall be grounded across flexible connections with flexible copper grounding straps. Grounding straps shall be bolted or soldered to both the equipment and the duct.
- T. Smoke detectors shall be furnished and wired by the electrical contractor. The mechanical contractor shall be responsible for mounting the smoke detector in ductwork as shown on the drawings and in accordance with manufacturer's printed instructions.
- U. Terminate gas vents for unit heaters, water heaters, high pressure parts washer, high pressure cleaner, and other gas appliances a minimum of 3'0" above roof with rain cap (edit appliances and height above roof to meet code and to suit project requirements).
- V. See specifications for ductwork gauges, bracing, hangers, and other requirements.
- W. Exterior louvers are indicated for information only. Detailed descriptions are provided in the architectural specifications.
- X. Exterior louvers are indicated for information only. Louver sizes, locations, and details shall be coordinated with general contractor.
- Y. Exterior louvers are indicated for information only. Louver sizes, locations, mounting, and details shall be coordinated with other trades involved.

28.05 Fire Protection

- A. Provide all materials and equipment and perform all labor required to install complete and operable fire protection systems as indicated on the drawings, as specified and complying with the standards of the National Fire Protection Association, Industrial Risk Insurers, Factory Mutual, and all state and local regulations.
- B. The entire building sprinkler system shall be hydraulically designed unless otherwise noted on the drawings. Head spacing in general and water quantity shall be based on Light Hazard Occupancy (edit occupancy classification to suit project requriements; see NFPA 13-Light Hazard Occupancy, Ordinary Hazard Group I Occupancy, Extra Hazard Group I Occupancy, Extra Hazard Group II Occupancy).
- C. The entire building sprinkler system shall be pipe schedule designed unless otherwise noted on the drawings. Head spacing in general and water quantity shall be based on Light Hazard Occupancy (edit occupancy classification to suit project requirements. See NFPA 13-Light Hazard Occupancy, Ordinary Hazard Group I Occupancy, Ordinary Hazard Group II Occupancy, Extra Hazard Group II Occupancy).
- D. Provide an automatic wet pipe sprinkler system throughout the entire building, complete in all respects and ready for operation including all test and drain lines, pressure gauges, hangers and supports, signs, and other standard appurtenances. Wiring shall be provided under the electrical division.

- E. Provide an automatic dry pipe sprinkler system throughout the entire building, complete in all respects and ready for operation including all test and drain lines, pressure gauges, dry pipe valves, air compressors, hangers and supports, signs, and other standard appurtenances. Wiring shall be provided under the electrical division.
- F. See architectural drawings for exact location of fire extinguisher cabinets, fire hose cabinets, and Siamese connections.
- G. All shutoff valves in sprinkler, standpipe, and combined systems shall be approved indicating type.
- H. Coordinate sprinkler head locations with the architectural reflected ceiling plans, lighting, and other ceiling items and make minor modifications to suit.
- I. Sprinklers installed in ceilings of finished areas shall be symmetrical in relation to ceiling system components and centered in the ceiling tile.

Appendix A: Ductwork

Friction Loss Correction Factors for Ducts

				MATI	ERIAL			
VELOCITY Fpm	GALV. STEEL STAINLESS STEEL	DUCT LINER	ALUMINUM	CARBON STEEL	FIBEROUS GLASS (2)	PVC	CONCRETE OR CONC. BLOCK (1)	DRYWALL
500	1.00	1.25	0.98	0.93	1.25	0.93	1.5-1.9	1.25
600	1.00	1.28	0.98	0.92	1.27	0.92	1.5-1.9	1.27
700	1.00	1.30	0.98	0.92	1.30	0.92	1.5-2.0	1.30
800	1.00	1.31	0.97	0.91	1.31	0.91	1.5-2.0	1.31
900	1.00	1.32	0.97	0.90	1.31	0.90	1.5-2.0	1.31
1000	1.00	1.33	0.97	0.90	1.32	0.90	1.6-2.1	1.32
1200	1.00	1.36	0.97	0.89	1.34	0.89	1.6-2.1	1.34
1400	1.00	1.38	0.96	0.88	1.36	0.88	1.6-2.1	1.36
1600	1.00	1.40	0.96	0.87	1.38	0.87	1.6-2.2	1.38
1800	1.00	1.41	0.96	0.86	1.39	0.86	1.6-2.3	1.39
2000	1.00	1.42	0.96	0.85	1.40	0.85	1.7-2.3	1.40
2500	1.00	1.45	0.95	0.84	1.42	0.84	1.7-2.3	1.42
3000	1.00	1.47	0.95	0.83	1.43	0.83	1.7-2.3	1.43
3500	1.00	1.49	0.95	0.83	1.44	0.83	1.8-2.4	1.44
4000	1.00	1.50	0.94	0.82	1.45	0.82	1.8-2.4	1.45
4500	1.00	1.52	0.94	0.81	1.46	0.81	1.8-2.4	1.46
5000	1.00	1.54	0.94	0.80	1.48	0.80	1.8-2.4	1.48
5500	1.00	1.55	0.93	0.79	1.49	0.79	1.8-2.4	1.49
6000	1.00	1.56	0.93	0.78	1.50	0.78	1.8-2.4	1.50

Notes:

- 1. First number indicated is for smooth concrete; second number indicated is for rough concrete.
- 2. Flexible ductwork has a friction loss correction factor of 1.5 to 2.0 times the value read from friction loss tables, ductulators, etc.

Velocities vs. Velocity Pressures

VELOCITY Fpm	VELOCITY PRESSURE In.WG.	VELOCITY Fpm	VELOCITY PRESSURE In.WG.	VELOCITY Fpm	VELOCITY PRESSURE In.WG.
50	0.0002	2,050	0.262	4,050	1.023
100	0.0006	2,100	0.275	4,100	1.048
150	0.001	2,150	0.288	4,150	1.074
200	0.002	2,200	0.302	4,200	1.100
250	0.004	2,250	0.316	4,250	1.126
300	0.006	2,300	0.330	4,300	1.153
350	0.008	2,350	0.344	4,350	1.180
400	0.010	2,400	0.359	4,400	1.207
450	0.013	2,450	0.374	4,450	1.235
500	0.016	2,500	0.390	4,500	1.262
550	0.019	2,550	0.405	4,550	1.291
600	0.022	2,600	0.421	4,600	1.319
650	0.026	2,650	0.438	4,650	1.348
700	0.031	2,700	0.454	4,700	1.377
750	0.035	2,750	0.471	4,750	1.407
800	0.040	2,800	0.489	4,800	1.436
850	0.045	2,850	0.506	4,850	1.466
900	0.050	2,900	0.524	4,900	1.497
950	0.056	2,950	0.543	4,950	1.528
1,000	0.062	3,000	0.561	5,000	1.559
1,050	0.069	3,050	0.580	5,050	1.590
1,100	0.075	3,100	0.599	5,100	1.622
1,150	0.082	3,150	0.619	5,150	1.654
1,200	0.090	3,200	0.638	5,200	1.686
1,250	0.097	3,250	0.659	5,250	1.718
1,300	0.105	3,300	0.679	5,300	1.751
1,350	0.114	3,350	0.700	5,350	1.784
1,400	0.122	3,400	0.721	5,400	1.818
1,450	0.131	3,450	0.742	5,450	1.852
1,500	0.140	3,500	0.764	5,500	1.886
1,550	0.150	3,550	0.786	5,550	1.920
1,600	0.160	3,600	0.808	5,600	1.955
1,650	0.170	3,650	0.831	5,650	1.990
1,700	0.180	3,700	0.853	5,700	2.026
1,750	0.191	3,750	0.877	5,750	2.061
1,800	0.202	3,800	0.900	5,800	2.097
1,850	0.213	3,850	0.924	5,850	2.134
1,900	0.225	3,900	0.948	5,900	2.170
1,950	0.237	3,950	0.973	5,950	2.207
2,000	0.249	4,000	0.998	6,000	2.244

Sheet Metal Gauges and Weights

	MATERIAL WEIGHT, Lb./Sq.Ft.						
SHEET METAL	GALVANIZED	300 SERIES	ALUMINUM				
GAUGE	STEEL	STAINLESS STEEL					
26	0.906	0.748	0.224				
24	1.156	0.987	0.282				
22	1.406	1.231	0.352				
20	1.656	1.491	0.451				
18	2.156	2.016	0.563				
16	2.656	2.499	0.718				
14	3.281	3.154	0.901				
12	4.531	4.427	1.141				
10	5.781	5.670	1.436				

SMACNA HVAC Ductwork Sheet Metal Gauges

MAXIMUM DUCT		SMACNA PRESSURE CLASS							
DIMENSION	±1/2	±1	±2	±3	+4	+6	+10		
To 12 13 - 18 19 - 24 25 - 30	26 26 26 26	26 26 26 26	26 26 26 24	24 24 24 22	24 24 24 22	24 24 22 20	24 24 20 18		
31 - 36 37 - 42 43 - 48 49 - 54	26 26 26 26	26 24 24 22	22 22 20 18	20 20 18 18	20 18 18 18	18 18 18	18 18 18 18		
55 - 60 61 - 66 67 - 72 73 - 78	24 22 22 22 22	22 18 18 18	18 18 18 18	18 18 18 18	18 18 18 18	18 18 18 18	18 18 18 16		
79 - 84 85 - 90 91 - 96 97+	22 22 22 18	18 18 18 18	18 18 18 18	18 18 18 18	18 18 18 18	18 18 18 18	16 16 16 16		

Notes

- 1. Table is based on 5 feet maximum reinforcing spacing.
- 2. Lighter sheet metal gauges may be used with additional reinforcing and heavier gauges may be used with less reinforcing (See SMACNA manuals).
- 3. Commercial installations recommend 24 gauge minimum.

WIDTH +			SHEET ME	ETAL GAUGE	3		SURFACE AREA
DEPTH	26	24	22	20	18	16	Sq.Ft./
Inches	(12")	(24")	(48")	(60")	(60+")		Lin.Ft.
8	1.51	1.93	2.34	2.76	3.59	4.43	1.33
9	1.70	2.17	2.64	3.11	4.04	4.98	1.50
10	1.89	2.41	2.93	3.45	4.49	5.53	1.67
11	2.08	2.65	3.22	3.80	4.94	6.09	1.83
12	2.27	2.89	3.52	4.14	5.39	6.64	2.00
13	2.45	3.13	3.81	4.49	5.84	7.19	2.17
14	2.64	3.37	4.10	4.83	6.29	7.75	2.34
15	2.83	3.61	4.39	5.18	6.74	8.30	2.50
16	3.02	3.85	4.69	5.52	7.19	8.85	2.67
17	3.21	4.09	4.98	5.87	7.64	9.41	2.83
18	3.40	4.34	5.27	6.21	8.09	9.96	3.00
19	3.59	4.58	5.57	6.56	8.53	10.51	3.17
20	3.78	4.82	5.86	6.90	8.98	11.07	3.34
21	3.96	5.06	6.15	7.25	9.43	11.62	3.50
22	4.15	5.30	6.44	7.59	9.88	12.17	3.67
23 24 25 26 27	4.34 4.53 4.72 4.91	5.54 5.78 6.02 6.26 6.50	6.74 7.03 7.32 7.62 7.91	7.94 8.28 8.63 8.97 9.32	10.33 10.78 11.23 11.68 12.13	12.73 13.28 13.83 14.39 14.94	3.83 4.00 4.17 4.34 4.50
28	-	6.74	8.20	9.66	12.58	15.49	4.67
29		6.98	8.49	10.01	13.03	16.05	4.83
30		7.23	8.79	10.35	13.48	16.60	5.00
31		7.47	9.08	10.70	13.92	17.15	5.17
32		7.71	9.37	11.04	14.37	17.71	5.34
33	-	7.95	9.67	11.39	14.82	18.26	5.50
34		8.20	9.96	11.73	15.27	18.81	5.67
35		8.43	10.25	12.08	15.72	19.37	5.83
36		8.67	10.55	12.42	16.17	19.92	6.00
37		8.91	10.84	12.77	16.62	20.47	6.17
38	-	9.15	11.13	13.11	17.07	21.03	6.34
39		9.39	11.42	13.46	17.52	21.58	6.50
40		9.63	11.72	13.80	17.97	22.13	6.67
41		9.87	12.01	14.15	18.42	22.69	6.83
42		10.12	12.30	14.49	18.87	23.24	7.00
43	-	10.36	12.60	14.84	19.31	23.79	7.17
44		10.60	12.89	15.18	19.76	24.35	7.34
45		10.84	13.18	15.53	20.21	24.90	7.50
46		11.08	13.47	15.87	20.66	25.45	7.67
47		11.32	13.77	16.22	21.11	26.00	7.83

WIDTH +			SHEET M	ETAL GAUG	E		SURFACE AREA		
DEPTH Inches	26 (12")	24 (24")	22 (48")	20 (60")	18 (60+")	16	Sq.Ft./ Lin.Ft.		
128 129 130 131 132		; ; ;	37.49 37.79 38.08 38.37 38.67	44.16 44.51 44.85 45.20 45.54	57.49 57.94 58.39 58.84 59.29	70.83 71.38 71.93 72.49 73.04	21.34 21.50 21.67 21.83 22.00		
133 134 135 136 137		-	38.96 39.25 39.54 39.84 40.13	45.89 46.23 46.58 46.92 47.27	59.74 60.19 60.64 61.09 61.54	73.59 74.15 74.70 75.25 75.81	22.17 22.34 22.50 22.67 22.83		
138 139 140 141 142	-	-	40.42 40.72 41.01 41.30 41.59	47.61 47.96 48.30 48.65 48.99	61.99 62.43 62.88 63.33 63.78	76.36 76.91 77.46 78.02 78.57	23.00 23.17 23.34 23.50 23.67		
143 144 145 146 147	- - - - -	-	41.88 42.18 42.47 42.77 43.06	49.34 49.68 50.03 50.37 50.72	64.23 64.68 65.13 65.58 66.03	79.13 79.68 80.23 80.79 81.34	23.83 24.00 24.17 24.34 24.50		
148 149 150 151 152	-	-	43.35 43.64 43.94 44.23 44.52	51.06 51.41 51.75 52.10 52.44	66.48 66.93 67.38 67.82 68.27	81.89 82.45 83.00 83.55 84.11	24.67 24.83 25.00 25.17 25.34		
153 154 155 156 157	:	-	44.82 45.11 45.40 45.70 45.99	52.79 53.13 53.48 53.82 54.17	68.72 69.17 69.62 70.07 70.52	84.66 85.21 85.77 86.32 86.87	25.50 25.67 25.83 26.00 26.17		
158 159 160 161 162	-	-	46.28 46.57 46.87 47.16 47.45	54.51 54.86 55.20 55.55 55.89	70.97 71.42 71.87 72.32 72.77	87.43 87.98 88.53 89.09 89.64	26.34 26.50 26.67 26.83 27.00		
163 164 165 166 167	- - - -	- - - -	47.75 48.04 48.33 48.62 48.92	56.24 56.58 56.93 57.27 57.62	73.21 73.66 74.11 74.56 75.01	90.19 90.75 91.30 91.85 92.41	27.17 17.34 27.50 27.67 27.83		

WIDTH +			SHEET M	ETAL GAUG	E		SURFACE AREA
DEPTH Inches	26 (12")	24 (24")	22 (48")	20 (60")	18 (60+")	16	Sq.Ft./ Lin.Ft.
168 169 170 171 172	- - - -	- - - -	49.21 49.50 49.80 50.09 50.38	57.96 58.31 58.65 59.00 59.34	75.46 75.91 76.36 76.81 77.26	92.96 93.51 94.07 94.62 95.17	28.00 28.17 28.34 28.50 28.67
173 174 175 176 177	-	-	50.67 50.97 51.26 51.55 51.85	59.69 60.03 60.38 60.72 61.07	77.71 78.16 78.60 79.05 79.50	95.73 96.28 96.83 97.39 97.94	28.83 29.00 29.17 29.34 29.50
178 179 180 181 182	-	-	52.14 52.43 52.73 53.02 53.31	61.41 61.76 62.10 62.45 62.79	79.95 80.40 80.85 81.30 81.75	98.49 99.05 99.60 100.15 100.71	29.67 29.83 30.00 30.17 30.34
183 184 185 186 187	-	-	53.60 53.90 54.19 54.48 54.78	63.14 63.48 63.83 64.17 64.52	82.20 82.65 83.10 83.55 83.99	101.26 101.81 102.37 102.92 103.47	30.50 30.67 30.83 31.00 31.17
188 189 190 191 192	-	-	55.07 55.36 55.65 55.95 56.24	64.86 65.21 65.55 65.90 66.24	84.44 84.89 85.34 85.79 86.24	104.03 104.58 105.13 105.69 106.24	31.34 31.50 31.67 31.83 32.00
193 194 195 196 197	-	- - -	56.53 56.83 57.12 57.41 57.70	66.59 66.93 67.28 67.62 67.97	86.69 87.14 87.59 88.04 88.49	106.79 107.35 107.90 108.45 109.01	32.17 32.34 32.50 32.67 32.83
198 199 200 201 202		- - - -	58.00 58.29 58.58 58.88 59.17	68.31 68.66 69.00 69.35 69.69	88.94 89.38 89.83 90.28 90.73	109.56 110.11 110.67 111.22 111.77	33.00 33.17 33.34 33.50 33.67
203 204 205 206 207	- - - -	-	59.46 59.76 60.05 60.34 60.63	70.04 70.38 70.73 71.07 71.42	91.18 91.63 92.08 92.53 92.98	112.33 112.88 113.43 113.99 114.54	33.83 34.00 34.17 34.34 34.50

WIDTH			at EDE 1 o				SURFACE
+			SHEET M	ETAL GAUG	E		AREA
DEPTH Inches	26 (12")	24 (24")	22 (48")	20 (60")	18 (60+")	16	Sq.Ft./ Lin.Ft.
208 209 210 211 212	- - - -	- - - -	60.93 61.22 61.51 61.81 62.10	71.76 72.11 72.45 72.80 73.14	93.43 93.88 94.33 94.77 95.22	115.09 115.65 116.20 116.75 117.31	34.67 34.83 35.00 35.17 35.34
213 214 215 216 217			62.39 62.68 62.98 63.27 63.56	73.49 73.83 74.18 74.52 74.87	95.67 96.12 96.57 97.02 97.47	117.86 118.41 118.97 119.52 120.07	35.50 35.67 35.83 36.00 36.17
218 219 220 221 222	: : :	- - - -	63.86 64.15 64.44 64.73 65.03	75.21 75.56 75.90 76.25 76.59	97.92 98.37 98.82 99.27 99.72	120.63 121.18 121.73 122.29 122.84	36.34 36.50 36.67 36.83 37.00
223 224 225 226 227	-	- - - -	65.32 65.61 65.91 66.20 66.49	76.94 77.28 77.63 77.97 78.32	100.16 100.61 101.06 101.51 101.96	123.39 123.95 124.50 125.05 125.61	37.17 37.34 37.50 37.67 37.83
228 229 230 231 232	-		66.79 67.08 67.37 67.66 67.96	78.66 79.01 79.35 79.70 80.04	102.41 102.86 103.31 103.76 104.21	126.16 126.71 127.27 127.82 128.37	38.00 38.17 38.34 38.50 38.67
233 234 235 236 237	- - - -	-	68.25 68.54 68.84 69.13 69.42	80.39 80.73 81.08 81.42 81.77	104.66 105.11 105.55 106.00 106.45	128.93 129.48 130.03 130.59 131.14	38.83 39.00 39.17 39.34 39.50
238 239 240	-	-	69.71 70.01 70.30	82.11 82.46 82.80	106.90 107.35 107.80	131.69 132.25 132.80	39.67 39.83 40.00

Notes:

- 1. Table includes 25% allowance for bracing, hangers, reinforcing, joints and seams. Add 10% for insulated ductwork systems.
- 2. The first column is the sum of the width and depth of the duct (i.e., a 20×10 duct equals 30 inches).
- 3. Columns 2 through 7 give weight of galvanized steel ducts in pounds per lineal foot.
- 4. Column 8 gives the ductwork surface area used for estimating insulation.
- Numbers in parenthesis below sheet metal gauges indicate maximum duct dimension for the indicated gauge.

Galvanized Round Duct Weight

DILL CONTR			G	AUGE			SURFACE AREA		
DIAMETER	26	24	22	20	18	16	Sq.Ft./		
						L	Lin.Ft.		
3	0.89	1.13	1.38	1.63	2.12	2.61	0.79		
4	1.19	1.51	1.84	2.17	2.82	3.48	1.05		
5	1.48	1.89	2.30	2.71	3.53	4.35 5.22	1.31		
7	1.78 2.08	2.27 2.65	2.76 3.22	3.25 3.79	4.23 4.94	6.08	1.57 1.83		
8	2.37	3.03	3.68	4.34	5.64	6.95	2.09		
9	2.67	3.40	4.14	4.88	6.35	7.82	2.36		
10	2.96	3.78	4.60	5.42	7.06	8.69	2.62		
11	326	4.16	5.06	5.96	7.76	9.56	2.88		
12	3.56	4.54	5.52	6.50	8.47	10.43	3.14		
14	4.15	5.30	6.44	7.59	9.88	12.17	3.67		
16	4.74	6.05	7.36	8.67	11.29	13.91	4.19		
18	5.34	6.81	8.28	9.75	12.70	15.65	4.71		
20	5.93	7.57	9.20	10.84	14.11	17.38	5.24		
22	6.52	8.32	10.12	11.92	15.52	19.12	5.76		
24	7.12	9.08	11.04	13.01	16.93	20.86	6.28		
26	7.71	9.84	11.96	14.09	18.34	22.60	6.81		
28	8.30	10.59	12.88	15.17	19.76	24.34	7.33		
30	8.89	11.35	13.80	16.26	21.17	26.08	7.85		
32	9.49	12.11	14.72	17.34	22.58	27.81	8.38		
34	10.08	12.86	15.64	18.43	23.99	29.55	8.90		
36	10.67	13.62	16.56	19.51	25.40	31.29	9.42		
38	11.27	14.38	17.48	20.59	26.81	33.03	9.95		
40	11.86	15.13	18.40	21.68	28.22	34.77	10.47		
42	12.45	15.89	19.32	22.76	29.63	36.51	11.00		
44	13.05	16.65	20.24	23.84	31.04	38.24	11.52		
46	13.64	17.40	21.17	24.93	32.46	39.98	12.04		
48	14.23	18.16	22.09	26.01	33.87	41.72	12.57		
50		18.92	23.01	27.10	35.28 36.69	43.46 45.20	13.09 13.61		
52		19.67	23.93	28.18					
54		20.43	24.85	29.26	38.10	46.94	14.14 14.66		
56		21.18	25.77	30.35	39.51 40.92	48.67 50.41	15.18		
58 60		21.94 22.70	26.69 27.61	31.43 32.52	40.92	52.15	15.18		
62		23.45	28.53	32.52	42.33	53.89	16.23		
64		24.21	29.45	34.68	45.16	55.63	16.76		
66		24.97	30.37	35.77	46.57	57.37	17.28		
68		25.72	31.29	36.85	47.98	59.10	17.80		
70		26.48	32.21	37.93	49.39	60.84	18.33		
72		27.24	33.13	39.02	50.80	62.58	18.85		

Galvanized Round Duct Weight

DIAMETER			G	AUGE			SURFACE AREA	
DIAWETER	26	24	22	20	18	16	Sq.Ft./ Lin.Ft.	
74 76 78 80 82		27.99 28.75 29.51 30.26 31.02	34.05 34.97 35.89 36.81 37.73	40.10 41.19 42.27 43.35 44.44	52.21 53.62 55.03 56.44 57.86	64.32 66.06 67.80 69.53 71.27	19.37 19.90 20.42 20.94 21.47	
84 86 88 90 92		31.78 32.53 33.29 34.05 34.80	38.65 39.57 40.49 41.41 42.33	45.52 46.61 47.69 48.77 49.86	59.27 60.68 62.09 63.50 64.91	73.01 74.75 76.49 78.23 79.96	21.99 22.51 23.04 23.56 24.09	
94 96 98 100 102		35.56 36.32 37.07 37.83 38.59	43.25 44.17 45.09 46.01 46.93	50.94 52.02 53.11 54.19 55.28	66.32 66.73 69.14 70.55 71.97	81.70 83.44 85.18 86.92 88.66	24.61 25.13 25.66 26.18 26.70	
104 106 108 110	 	39.34 40.10 40.86 41.61 42.37	47.85 48.77 49.69 50.61 51.53	56.36 57.44 58.53 59.61 60.70	73.38 74.79 76.20 77.61 79.02	90.39 92.13 93.87 95.61 97.35	27.23 27.75 28.27 28.80 29.32	
114 116 118 120 122		43.13 43.88 44.64 45.40 46.15	52.45 53.37 54.29 55.21 56.13	61.78 62.86 63.95 65.03 66.11	80.43 81.84 83.25 84.67 86.08	99.09 100.82 102.56 104.30 106.04	29.85 30.37 30.89 31.42 31.94	
124 126 128 130 132	 	46.91 47.67 48.42 49.18 49.94	57.05 57.97 58.89 59.81 60.73	67.20 68.28 69.37 70.45 71.53	8749 88.90 90.31 91.72 93.13	107.78 109.52 111.25 112.99 114.73	32.46 32.99 33.51 34.03 34.56	
134 136 138 140 142	 	50.69 51.45 52.21 52.96 53.72 54.48	61.66 62.58 63.50 64.42 65.34 66.26	72.62 73.70 74.79 75.87 76.95 78.04	94.54 95.95 97.37 98.78 100.19 101.60	116.47 118.21 119.95 121.68 123.42 125.16	35.08 35.60 36.12 36.65 37.18 37.70	

Notes:

1. Table includes 25% allowance for bracing, hangers, reinforcing, joints, and seams. Add 10% for insulated ductwork systems.

2. Table gives weight of galvanized steel ducts in pounds per lineal foot.

NOMINAL FLAT OVAL SIZE	EQUIV. ROUND	CROSS SECTIONAL AREA SQ.FT.	SURFACE AREA SQ.FT./ LN.FT.	GAUGE	WEIGHT LBS./ LN.FT.	
3 x 8	5.1	0.15	1.57	24	2.3	
3 x 9	5.6	0.18	1.83	24	2.6	
3 x 11	6.0	0.22	2.09	24	3.1	
3 x 12	6.4	0.25	2.36	24	3.4	
3 x 14	6.7	0.29	2.62	24	3.8	
3 x 15	7.0	0.32	2.88	24	4.2	
3 x 17	7.3	0.36	3.14	24	4.5	
3 x 19	7.5	0.39	3.40	24	4.9	
3 x 22	8.0	0.46	3.93	24	5.7	
4 x 7	5.7	0.18	1.57	24	2.3	
4 x 9	6.2	0.22	1.83	24	2.6	
4 x 10	6.7	0.26	2.09	24	3.1	
4 x 12	7.2	0.31	2.36	24	3.4	
4 x 13	7.6	0.35	2.62	24	3.8	
4 x 15	8.0	0.40	2.88	24	4.2	
4 x 17	8.4	0.44	3.14	24	4.5	
4 x 18	8.5	0.48	3.40	24	4.9	
4 x 20	9.0	0.52	3.68	24	5.3	
4 x 21	9.5	0.57	3.93	24	5.7	
5 x 8	6.6	0.25	1.83	24	2.6	
5 x 10	7.3	0.30	2.09	24	3.0	
5 x 11	7.9	0.35	2.36	24	3.4	
5 x 13	8.4	0.41	2.62	24	3.8	
5 x 14	8.8	0.46	2.88	24	4.2	
5 x 16	9.3	0.52	3.14	24	4.5	
5 x 18	9.5	0.57	3.40	24	4.9	
5 x 19	10.0	0.63	3.66	24	5.3	
5 x 21	10.5	0.68	3.93	24	5.7	
6 x 8	6.9	0.26	1.83	24	2.6	
6 x 9	7.7	0.33	2.09	24	3.0	
6 x 11	8.4	0.39	2.36	24	3.4	
6 x 12	8.9	0.46	2.62	24	3.8	
6 x 14	9.6	0.53	2.88	24	4.2	
6 x 15	10.1	0.59	3.14	24	4.5	
6 x 17	10.5	0.65	3.40	24	4.9	
6 x 19	11.0	0.72	3.66	24	5.3	
6 x 20	11.5	0.79	3.93	24	5.7	

•						
NOMINAL FLAT OVAL SIZE	EQUIV. ROUND	CROSS SECTIONAL AREA SQ.FT.	SURFACE AREA SQ.FT./ LN.FT.	GAUGE	WEIGHT LBS./ LN.FT.	
6 x 22	11.8	0.85	4.18	24	6.0	
6 x 23	12.0	0.92	4.45	24	6.4	
6 x 25	12.5	0.98	4.71	22	8.3	
6 x 28	13.2	1.11	5.23	22	9.2	
6 x 30	13.5	1.18	5.50	22	9.7	
6 x 31	13.8	1.24	5.76	22	10.1	
6 x 33	14.0	1.31	6.02	22	10.6	
6 x 34	14.3	1.38	6.28	22	11.0	
6 x 36	14.5	1.44	6.54	22	11.5	
6 x 37	14.9	1.50	6.80	22	12.0	
6 x 39	15.0	1.57	7.07	22	12.4	
6 x 41	15.4	1.64	7.33	22	12.9	
6 x 44	15.9	1.77	7.85	22	13.8	
6 x 45	16.0	1.83	8.12	22	14.3	
6 x 52	17.0	2.09	9.16	20	19.0	
6 x 59	18.0	2.42	10.47	20	21.7	
7 x 10	8.7	0.42	2.36	24	3.4	
7 x 12	9.4	0.50	2.62	24	3.8	
7 x 13	10.1	0.57	2.88	24	4.2	
7 x 15	10.7	0.65	3.14	24	4.5	
7 x 16	11.0	0.73	3.40	24	4.9	
7 x 18	11.7	0.80	3.67	24	5.3	
7 x 20	12.0	0.88	3.93	24	5.7	
7 x 21	12.5	0.95	4.19	24	6.1	
7 x 23	13.0	1.03	4.45	24	6.4	
8 x 10	9.0	0.44	2.36	24	3.4	
8 x 11	9.8	0.53	2.62	24	3.8	
8 x 13	10.6	0.62	2.88	24	4.2	
8 x 14	11.2	0.70	3.14	24	4.5	
8 x 16	11.5	0.79	3.40	24	4.9	
8 x 17	12.0	0.87	3.67	24	5.3	
8 x 18	12.4	0.90	3.80	24	5.5	
8 x 19	13.0	0.96	3.93	24	5.7	
8 x 21	13.5	1.05	4.18	24	6.1	
8 x 22	14.0	1.13	4.45	24	6.4	
8 x 24	14.4	1.23	4.71	24	6.8	
8 x 27	15.2	1.40	5.23	22	9.2	
8 x 30	15.9	1.57	5.76	22	10.2	
8 x 33	16.6	1.74	6.28	22	11.0	
8 x 35	17.0	1.83	6.54	22	11.5	

	The state of the s					
NOMINAL FLAT OVAL SIZE	EQUIV. ROUND	CROSS SECTIONAL AREA SQ.FT.	SURFACE AREA SQ.FT./ LN.FT.	GAUGE	WEIGHT LBS./ LN.FT.	
8 x 36	17.3	1.92	6.80	22	12.0	
8 x 39	17.9	2.09	7.33	22	12.9	
8 x 43	18.6	2.27	7.85	22	13.8	
8 x 46	19.1	2.44	8.37	22	14.7	
8 x 49	19.6	2.62	8.89	20	18.4	
8 x 50	20.0	2.71	9.16	20	19.0	
8 x 52	20.2	2.80	9.42	20	19.5	
8 x 58	21.0	3.14	10.47	20	21.7	
8 x 65	22.0	3.49	11.52	20	23.8	
8 x 71	23.0	3.84	12.57	18	33.9	
8 x 77	24.0	4.19	13.61	18	36.7	
9 x 12	10.8	0.64	2.88	24	4.2	
9 x 14	11.5	0.74	3.14	24	4.6	
9 x 15	12.0	0.83	3.40	24	4.9	
9 x 17	12.9	0.93	3.67	24	5.3	
9 x 18	13.5	1.03	3.93	24	5.7	
9 x 20	14.0	1.13	4.19	24	6.1	
9 x 22	14.5	1.23	4.45	24	6.4	
9 x 23	15.0	1.33	4.71	24	6.8	
10 x 12	11.0	0.66	2.88	24	4.2	
10 x 13	11.9	0.77	3.14	24	4.5	
10 x 15	12.5	0.87	3.40	24	4.9	
10 x 16	13.4	1.00	3.66	24	5.3	
10 x 18	14.0	1.09	3.93	24	5.7	
10 x 19	14.5	1.20	4.19	24	6.1	
10 x 20	14.7	1.25	4.18	24	6.1	
10 x 21	15.0	1.31	4.45	24	6.4	
10 x 23	15.7	1.42	4.71	24	6.8	
10 x 24	16.0	1.53	4.97	24	7.2	
10 x 26	16.7	1.63	5.23	22	9.2	
10 x 27	17.0	1.75	5.50	22	9.7	
10 x 29 10 x 30 10 x 32	17.7 18.0 18.5	1.86 1.96 2.07	5.76 6.02 6.28	22 22 22 22	10.2 10.6 11.1	
10 x 34 10 x 35 10 x 38	19.0 19.3 20.1	2.18 2.29 2.51	6.54 6.80 7.33	22 22 22 22	11.5 12.0 12.9	
10 x 41	20.8	2.73	7.85	22	13.8	
10 x 43	21.0	2.84	8.12	22	14.3	
10 x 45	21.5	2.95	8.37	22	14.7	

NOMINAL FLAT OVAL SIZE	EQUIV. ROUND	CROSS SECTIONAL AREA SQ.FT.	SURFACE AREA SQ.FT./ LN.FT.	GAUGE	WEIGHT LBS./ LN.FT.
10 x 48	22.1	3.16	8.89	22	15.6
10 x 51	22.8	3.39	9.42	20	19.5
10 x 52	23.0	3.49	9.69	20	20.1
10 x 54	23.3	3.60	9.95	20	20.6
10 x 57	23.8	3.82	10.56	20	21.9
10 x 60	24.4	4.04	11.00	20	22.8
10 x 63	25.0	4.25	11.52	20	23.8
10 x 67	25.5	4.47	12.05	20	24.9
10 x 70	26.0	4.69	12.51	20	25.9
10 x 73	26.4	4.91	13.10	18	35.3
10 x 76	27.0	5.13	13.61	18	36.7
11 x 14	13.0	0.90	3.40	24	4.9
11 x 16	13.6	1.02	3.67	24	5.3
11 x 17	14.0	1.14	3.93	24	5.7
11 x 19	15.0	1.26	4.19	24	6.1
11 x 22	16.3	1.50	4.71	24	6.8
11 x 24	17.0	1.62	4.97	24	7.2
12 x 14	13.0	0.92	3.40	24	4.9
12 x 15	13.8	1.05	3.67	24	5.3
12 x 17	14.5	1.18	3.93	24	5.7
12 x 18	15.3	1.31	4.19	24	6.1
12 x 20	16.0	1.44	4.45	24	6.4
12 x 21	16.7	1.57	4.71	24	6.8
12 x 25 12 x 28 12 x 31	18.0 19.1 20.1	1.83 2.09 2.36	5.24 5.76 6.28	22 22 22 22	9.2 10.1 11.1
12 x 34	20.9	2.62	6.81	22	12.0
12 x 37	21.9	2.88	7.33	22	12.9
12 x 40	22.7	3.14	7.85	22	13.8
12 x 42 12 x 43 12 x 45	23.0 23.5 24.0	3.27 3.40 3.53	8.12 8.37 8.64	22 22 22 22	14.3 14.7 15.2
12 x 47	24.3	3.67	8.89	22	15.6
12 x 50	25.0	3.93	9.42	20	19.5
12 x 53	25.7	4.19	9.95	20	20.6
12 x 56	26.3	4.45	10.56	20	21.9
12 x 59	26.9	4.71	11.00	20	22.8
12 x 62	27.5	4.98	11.52	20	23.8

FT.					
NOMINAL FLAT OVAL SIZE	EQUIV. ROUND	CROSS SECTIONAL AREA SQ.FT.	SURFACE AREA SQ.FT./ LN.FT.	GAUGE	WEIGHT LBS./ LN.FT.
12 x 65	28.1	5.23	12.05	20	24.9
12 x 69	28.7	5.51	12.57	20	26.0
12 x 72	29.2	5.76	13.10	18	35.3
12 x 78	30.0	6.28	14.14	18	38.1
12 x 81	31.0	6.54	14.66	18	39.5
14 x 17	16.0	1.37	4.19	24	6.1
14 x 19	17.0	1.53	4.45	24	6.4
14 x 20	17.5	1.68	4.71	24	6.8
14 x 22	18.0	1.83	4.97	24	7.2
14 x 23	18.9	1.98	5.23	24	7.6
14 x 27	20.2	2.30	5.76	22	10.1
14 x 28	21.0	2.44	6.02	22	10.6
14 x 30	21.3	2.60	6.28	22	11.0
14 x 31	22.0	2.75	6.54	22	11.5
14 x 33	22.4	2.91	6.80	22	12.0
14 x 34	23.0	3.05	7.07	22	12.4
14 x 36	23.4	3.21	7.33	22	12.9
14 x 38	24.0	3.36	7.59	22	13.3
14 x 39	24.4	3.51	7.85	22	13.8
14 x 41	25.0	3.67	8.12	22	14.3
14 x 42	25.3	3.84	8.37	22	14.7
14 x 45	26.1	4.12	8.89	22	15.6
14 x 49	26.9	4.43	9.42	20	19.5
14 x 52	27.7	4.74	9.95	20	20.6
14 x 55	28.4	5.04	10.56	20	21.9
14 x 58	29.1	5.35	11.00	20	22.8
14 x 61	29.8	5.65	11.52	20	23.9
14 x 64	30.5	5.96	12.05	20	24.9
14 x 67	31.1	6.27	12.57	20	26.0
14 x 71	31.7	6.57	13.10	18	35.9
14 x 77	33.0	7.18	14.14	18	38.1
16 x 19	18.0	1.75	4.71	24	6.8
16 x 21	19.0	1.92	4.97	24	7.2
16 x 22	19.5	2.08	5.23	24	7.6
16 x 24	20.0	2.27	5.50	24	7.9
16 x 25	20.9	2.44	5.76	22	10.2
16 x 29	22.3	2.79	6.28	22	11.0
16 x 30	23.0	2.97	6.54	22	11.5
16 x 32	23.5	3.13	6.80	22	12.0
16 x 33	24.0	3.32	7.07	22	12.4

3						
NOMINAL FLAT OVAL SIZE	EQUIV. ROUND	CROSS SECTIONAL AREA SQ.FT.	SURFACE AREA SQ.FT./ LN.FT.	GAUGE	WEIGHT LBS./ LN.FT.	
16 x 35	24.7	3.48	7.33	22	12.9	
16 x 36	25.0	3.67	7.59	22	13.3	
16 x 38	25.7	3.84	7.85	22	13.8	
16 x 41	26.8	4.19	8.38	22	14.7	
16 x 44	27.7	4.53	8.89	22	15.6	
16 x 46	28.0	4.71	9.16	22	16.1	
16 x 47	28.6	4.88	9.42	22	16.6	
16 x 49	29.0	5.06	9.69	20	20.1	
16 x 51	29.4	5.23	9.95	20	20.6	
16 x 54	30.2	5.59	10.47	20	21.7	
16 x 57	31.0	5.93	11.00	20	22.8	
16 x 60	31.8	6.28	11.52	20	23.8	
16 x 63	32.5	6.61	12.05	20	24.9	
16 x 66	33.3	6.98	12.57	20	26.0	
16 x 69	34.0	7.33	13.09	20	27.1	
16 x 76	35.0	8.03	14.14	18	38.1	
16 x 79	36.0	8.38	14.66	18	39.5	
18 x 21	19.9	2.16	5.23	24	7.6	
18 x 23	21.0	2.36	5.50	24	7.9	
18 x 24	21.6	2.56	5.76	24	8.3	
18 x 26	22.0	2.75	6.02	22	10.6	
18 x 27	23.1	2.95	6.28	22	11.0	
18 x 29	24.0	3.14	6.54	22	11.5	
18 x 31	24.5	3.35	6.80	22	12.0	
18 x 32	25.0	3.53	7.07	22	12.4	
18 x 34	25.7	3.73	7.33	22	12.9	
18 x 37	27.0	4.13	7.85	22	13.8	
18 x 40	28.1	4.53	8.37	22	14.7	
18 x 43	29.1	4.92	8.89	22	15.6	
18 x 46	30.2	5.31	9.42	22	16.6	
18 x 49	31.1	5.70	9.95	20	20.6	
18 x 53	32.0	6.10	10.56	20	21.9	
18 x 56	32.9	6.49	11.00	20	22.8	
18 x 59	33.7	6.88	11.52	20	23.8	
18 x 62	34.5	7.26	12.05	20	24.9	
18 x 65	35.3	7.67	12.51	20	25.9	
18 x 68	36.0	8.07	13.10	20	27.1	
18 x 71	37.0	8.44	13.61	18	36.7	
18 x 78	38.0	9.23	14.66	18	39.5	

Galvanized Flat Oval Ductwork Weight

NOMINAL FLAT OVAL SIZE	EQUIV. ROUND	CROSS SECTIONAL AREA SQ.FT.	SURFACE AREA SQ.FT./ LN.FT.	GAUGE	WEIGHT LBS./ LN.FT.
20 x 26 20 x 29 20 x 31	23.6 25.2 26.0	3.05 3.49 3.71	6.28 6.81 7.07	22 22 22 22	11.0 12.0 12.4
20 x 33	26.6	3.93	7.33	22	12.9
20 x 34	27.0	4.15	7.59	22	13.3
20 x 36	28.0	4.36	7.85	22	13.8
20 x 39	29.2	4.81	8.37	22	14.7
20 x 40	30.0	5.02	8.64	22	15.2
20 x 42	30.3	5.23	8.89	22	15.6
20 x 44	31.0	5.45	9.16	22	16.1
20 x 45	31.4	5.67	9.42	22	16.6
20 x 47	32.0	5.89	9.69	22	17.0
20 x 48	32.5	6.11	9.95	22	17.5
20 x 51	33.4	6.55	10.56	20	21.9
20 x 55	34.4	6.98	11.00	20	22.8
20 x 58	35.3	7.41	11.52	20	23.8
20 x 61	36.2	7.86	12.05	20	24.9
20 x 64	37.1	8.29	12.57	20	26.0
20 x 67	37.9	8.71	13.10	20	27.1
20 x 77	40.0	10.04	14.66	18	39.5
22 x 25	23.9	3.12	6.28	22	11.0
22 x 28	25.6	3.60	6.81	22	12.0
22 x 31	27.2	4.08	7.33	22	12.9
22 x 35	28.7	4.56	7.85	22	13.8
22 x 38	30.0	5.04	8.38	22	14.7
22 x 39	31.0	5.28	8.64	22	15.2
22 x 41	31.3	5.52	8.90	22	15.6
22 x 42	32.0	5.76	9.16	22	16.1
22 x 44	32.5	6.00	9.42	22	16.6
22 x 46	33.0	6.24	9.69	22	17.0
22 x 47	33.7	6.48	9.95	22	17.5
22 x 50	34.8	6.96	10.47	20	21.7
22 x 53	35.8	7.44	11.00	20	22.8
22 x 57	36.7	7.92	11.52	20	23.8
22 x 60	37.8	8.40	12.04	20	24.9
22 x 63	38.7	8.88	12.57	20	26.0
22 x 66	39.6	9.36	13.09	20	27.1
22 x 69	40.4	9.84	13.61	20	28.2
22 x 75	42.0	10.80	14.66	18	39.5
22 x 82	44.0	11.76	15.71	18	42.3

Galvanized Flat Oval Ductwork Weight

NOMINAL FLAT OVAL SIZE	EQUIV. ROUND	CROSS SECTIONAL AREA SQ.FT.	SURFACE AREA SQ.FT./ LN.FT.	GAUGE	WEIGHT LBS./ LN.FT.					
34 x 65	49.3	13.72	14.14	20	29.3					
34 x 69	50.5	14.46	14.66	20	30.3					
34 x 72	51.6	15.20	15.18	18	31.4					
36 x 39	38.0	7.85	9.95	22	17.5					
36 x 42	39.8	8.64	10.47	22	18.4					
36 x 45	41.5	9.42	11.00	22	19.4					
36 x 49	43.1	10.21	11.52	20	23.8					
36 x 52	44.7	11.00	12.04	20	24.9					
36 x 55	46.2	11.78	12.57	20	26.0					
36 x 58	47.6	12.57	13.09	20	27.1					
36 x 61	48.9	13.35	13.61	20	28.2					
36 x 64	50.2	14.14	14.14	20	29.3					
36 x 67	51.1	14.92	14.66	20	30.3					
36 x 71	52.7	15.71	15.18	18	40.9					
38 x 41	40.0	8.70	10.47	22	18.4					
38 x 44	41.8	9.53	11.00	22	19.3					
38 x 47	43.5	10.36	11.52	22	20.3					
38 x 51	45.2	11.19	12.04	20	24.9					
38 x 54	46.7	12.02	12.57	20	26.0					
38 x 57	48.2	12.85	13.09	20	27.1					
38 x 60	49.7	13.68	13.61	20	28.2					
38 x 63	51.0	14.51	14.14	20	29.3					
38 x 66	52.4	15.34	14.66	20	30.3					
38 x 69	53.7	16.16	15.18	20	31.4					
40 x 43	42.0	9.60	11.00	22	19.3					
40 x 46	43.8	10.47	11.52	22	20.3					
40 x 49	45.6	11.34	12.04	20	24.9					
40 x 53	47.2	12.21	12.57	20	26.0					
40 x 56	48.8	13.09	13.09	20	27.1					
40 x 59	50.4	13.96	13.61	20	28.2					
40 x 62	51.8	14.83	14.14	20	29.3					
40 x 65	53.2	15.71	14.66	20	30.3					
40 x 68	54.5	16.58	15.18	20	31.4					
40 x 71	55.8	17.45	15.71	18	42.3					

- 1. Equivalent round is the diameter of the round duct which will have the capacity and friction equivalent to the flat oval duct size.
- 2. To obtain the rectangular duct size, use the Trane Ductulator and equivalent round duct size.
- Table includes 25% allowance for bracing, hangers, reinforcing, joints, and seams. Add 10% for insulated ductwork systems.
- 4. Table lists standard sizes as manufactured by United Sheet Metal, a Division of United McGill Corporation.

Equivalent Rectangular Duct Dimensions

DUCT	RECT.	ASPECT RATIO									
DIA.	SIZE				ASPEC	KATIO					
IN.	IN.	1.00	1.25	1.50	1.75	2.00	2.25	2.50	2.75		
6	WIDTH HEIGHT	_	6 5								
7	WIDTH HEIGHT	6	8 6								
8	WIDTH HEIGHT	7 7	9 7	9	11 6						
9	WIDTH HEIGHT	8	9	11 7	11 6	12 6	14 6				
10	WIDTH HEIGHT	9	10 8	12 8	12 7	14 7	14 6	15 6	17 6		
11	WIDTH	10	11	12	14	14	16	18	17		
	HEIGHT	10	9	8	8	7	7	7	6		
12	WIDTH	11	13	14	14	16	16	18	19		
	HEIGHT	11	10	9	8	8	7	7	7		
13	WIDTH	12	14	15	16	18	18	20	19		
	HEIGHT	12	11	10	9	9	8	8	7		
14	WIDTH	13	14	17	18	18	20	20	22		
	HEIGHT	13	11	11	10	9	9	8	8		
15	WIDTH	14	15	17	18	20	20	23	25		
	HEIGHT	14	12	11	10	10	9	9	9		
16	WIDTH HEIGHT	15 15	16 13	18 12	19 11	20 10	23 10	23	25 9		
17	WIDTH	16	18	20	21	22	25	25	28		
	HEIGHT	16	14	13	12	11	11	10	10		
18	WIDTH	16	19	21	23	24	25	28	28		
	HEIGHT	16	15	14	13	12	11	11	10		
19	WIDTH	17	20	21	23	24	27	28	30		
	HEIGHT	17	16	14	13	12	12	11	11		
20	WIDTH	18	20	23	25	26	27	30	30		
	HEIGHT	18	16	15	14	13	12	12	11		
21	WIDTH	19	21	24	26	28	29	30	33		
	HEIGHT	19	17	16	15	14	13	12	12		
22	WIDTH	20	23	26	26	28	32	33	36		
	HEIGHT	20	18	17	15	14	14	13	13		
23	WIDTH	21	24	26	28	30	32	35	36		
	HEIGHT	21	19	17	16	15	14	14	13		
24	WIDTH	22	25	27	30	32	34	35	39		
	HEIGHT	22	20	18	17	16	15	14	14		
25	WIDTH	23	25	29	30	32	36	38	39		
	HEIGHT	23	20	19	17	16	16	15	14		
26	WIDTH	24	26	30	32	34	36	38	41		
	HEIGHT	24	21	20	18	17	16	15	15		
27	WIDTH	25	28	30	33	36	38	40	41		
	HEIGHT	25	22	20	19	18	17	16	15		

Equivalent Rectangular Duct Dimensions

DUCT	RECT.				SPECT RATIO)		
DIA.	SIZE			AS	T LCT KATI			
IN.	IN.	3.00	3.50	4.00	5.00	6.00	7.00	8.00
6	WIDTH HEIGHT							
7	WIDTH HEIGHT							
8	WIDTH HEIGHT							
9	WIDTH HEIGHT							
10	WIDTH HEIGHT							
- 11	WIDTH HEIGHT	18 6	21 6				1.01	
12	WIDTH HEIGHT	21 7	21 6	24 6				
13	WIDTH HEIGHT	21 7	25 7	24 6	30 6			
14	WIDTH HEIGHT	24 8	25 7	28 7	30 6	36 6		
15	WIDTH HEIGHT	24 8	28 8	28 7	35 7	36 6	42 6	
16	WIDTH HEIGHT	27 9	28 8	32 8	35 7	42 7	42 6	48 6
17	WIDTH HEIGHT	27 9	32 9	32 8	35 7	42 7	49 7	48 6
18	WIDTH HEIGHT	30 10	32 9	36 9	40 8	42 7	49 7	56 7
19	WIDTH HEIGHT	30 10	35 10	36 9	40 8	48 8	49 7	56 7
20	WIDTH HEIGHT	33 11	35 10	40 10	45 9	48 8	56 8	56 7
21	WIDTH HEIGHT	33 11	39 11	40 10	45 9	54 9	56 8	64 8
22	WIDTH HEIGHT	36 12	39 11	44 11	50 10	54 9	56 8	64 8
23	WIDTH HEIGHT	39 13	42 12	44 11	50 10	54 9	63 8	64 8
24	WIDTH HEIGHT	39 13	42 12	48 12	55 11	60 10	63 9	72 9
25	WIDTH HEIGHT	42 14	46 13	48 12	55 11	60 10	70 10	72 9
26	WIDTH HEIGHT	42 14	46 13	52 13	55 11	66 11	70 10	72 9
27	WIDTH HEIGHT	45 15	49 14	52 13	60 12	66 11	70 10	80 10

Equivalent Rectangular Duct Dimensions

DUCT	RECT.	Ī —		A	SPECT RATIO)		
DIA. IN.	SIZE IN.	3.00	3.50	4.00	5.00	6.00	7.00	8.00
28	WIDTH HEIGHT	45 15	49 14	56 14	60 12	66	77 11	80 10
29	WIDTH HEIGHT	48 16	53 15	56 14	65 13	72 12	77	88 11
30	WIDTH	48	53	60	65	72	77	88
	HEIGHT	16	15	15	13	12	11	11
31	WIDTH	51	56	60	70	78	84	88
	HEIGHT	17	16	15	14	13	12	11
32	WIDTH	54	56	60	70	78	84	96
	HEIGHT	18	16	15	14	13	12	12
33	WIDTH	54	60	64	75	78	91	96
	HEIGHT	18	17	16	15	13	13	12
34	WIDTH	57	60	64	75	84	91	96
	HEIGHT	19	17	16	15	14	13	12
35	WIDTH	57	63	68	75	84	91	104
	HEIGHT	19	18	17	15	14	13	13
36	WIDTH	60	63	68	80	90	98	104
	HEIGHT	20	18	17	16	15	14	13
38	WIDTH	63	67	72	85	96	105	112
	HEIGHT	21	19	18	17	16	15	14
40	WIDTH	66	70	76	90	96	105	120
	HEIGHT	22	20	19	18	16	15	15
42	WIDTH	69	74	80	90	102	112	120
	HEIGHT	23	21	20	18	17	16	15
44	WIDTH HEIGHT	72 24	81 23	84 21	95 19	108	119 17	128 16
46	WIDTH	75	84	88	100	114	126	136
	HEIGHT	25	24	22	20	19	18	17
48	WIDTH	78	88	92	105	120	126	136
	HEIGHT	26	25	23	21	20	18	17
50	WIDTH	81	91	96	110	120	133	144
	HEIGHT	27	26	24	22	20	19	18
52	WIDTH	84	95	100	115	126	140	152
	HEIGHT	28	27	25	23	21	20	19
54	WIDTH	90	98	104	120	132	147	160
	HEIGHT	30	28	26	24	22	21	20
56	WIDTH	93	102	108	125	138	147	160
	HEIGHT	31	29	27	25	23	21	20
58	WIDTH	96	105	112	130	144	154	168
	HEIGHT	32	30	28	26	24	22	21
60	WIDTH HEIGHT	99 33	109 31	116 29	130 26	144 24	161 23	W. W. Co.
62	WIDTH HEIGHT	102 34	112 32	120 30	135 27	150 25	168 24	1797

Round/Rectangular Duct Equivalents

A/B	52	54	56	58	60	62	64	66	68	70	72	74
50												
52	56.8											
54	57.9	59.0										
56	59.0	60.1	61.2									
58	60.0	61.2	62.3	63.4							,	
60	61.0	62.2	63.4	64.5	65.6							
62	62.0	63.2	64.4	65.5	66.7	67.8						
64	63.0	64.2	65.4	66.6	67.7	69.9	70.0					
66	63.9	65.2	66.4	67.6	68.8	69.9	71.0	72.1				(1)
68	64.9	66.2	67.4	68.6	69.8	71.0	72.1	73.2	74.3		-	
70	65.8	67.1	68.3	69.6	70.8	72.0	73.2	74.3	75.4	76.5		
72	66.7	68.0	69.3	70.6	71.8	73.0	74.2	75.4	76.5	77.6	78.7	
74	67.5	68.9	70.2	71.5	72.7	74.0	75.2	76.4	77.5	78.7	79.8	80.9
76	68.4	69.8	71.1	72.4	73.7	75.0	76.2	77.4	78.6	79.7	80.9	82.0
78	69.3	70.6	72.0	73.3	74.6	75.9	77.1	78.4	79.6	80.7	81.9	83.0
80	70.1	71.6	72.9	74.2	75.4	76.9	78.1	79.4	80.6	81.8	82.9	84.1
82	70.9	72.3	73.7	75.1	76.4	77.8	79.0	80.3	81.5	82.8	84.0	85.1
84	71.7	72.6	74.6	76.0	77.3	78.7	80.0	81.3	82.5	83.8	85.0	86.1
86	72.5	73.3	75.4	76.8	78.2	79.6	80.9	82.2	83.5	84.7	85.9	87.1
88	73.3	74.0	76.3	77.7	79.1	80.5	81.8	83.1	84.4	85.7	86.9	88.1
90	74.1	75.6	77.1	78.5	79.9	81.3	82.7	84.0	85.3	86.6	87.9	89.1
92	74.9	76.4	77.9	79.3	80.8	82.2	83.5	85.4	86.2	87.5	88.8	90.1
94	75.6	77.2	78.7	80.1	81.6	83.0	84.4	86.0	87.1	88.4	89.7	91.0
96	76.3	77.9	79.4	80.9	82.4	83.8	85.3	86.6	88.0	89.3	90.7	91.9
98	77.1	78.7	80.2	81.7	83.2	84.7	86.1	87.5	88.9	90.2	91.6	92.9
100	77.8	79.4	81	82.5	84	85.5	86.9	88.3	89.7	91.1	92.4	93.8

Round/Rectangular Duct Equivalents

A/B	76	78	80	82	84	86	88	90	92	94	96	98
70												
72									-			
74												
76	83.1											
78	84.2	85.3										
80	85.2	86.4	87.5									
82	86.3	87.4	88.5	89.6								
84	87.3	88.5	89.6	90.7	91.8							
86	88.3	89.5	90.7	91.8	92.9	94.0						
-88	89.3	90.5	91.7	92.9	94.0	95.1	96.2					
90	90.3	91.5	92.7	93.9	95.0	96.2	97.3	98.4				
92	91.3	92.5	93.7	94.9	96.1	97.2	98.4	99.5	100.6			
94	92.3	93.5	94.7	95.9	97.1	98.3	99.4	100.6	101.1	102.8		
96	93.2	94.5	95.7	96.9	98.1	99.3	100.5	101.6	102.7	103.8	104.9	
98	94.2	95.5	96.7	97.9	99.1	100.3	101.5	102.7	103.8	104.9	106.0	107.1
100	95.1	96.4	97.6	98.9	100.1	101.3	102.5	103.7	104.8	106	107.1	108.2

Notes:

1. Shaded areas and bold numbers exceed the recommended maximum 4:1 aspect ratio.

Appendix B: Hydronic Piping Systems

30.01 Hydronic Piping Systems

A. Table Notes: Hydronic Piping Systems-Copper, Steel, and Stainless Steel Pipe:

- 1. Maximum Recommended Pressure Drop: 4 Ft./100 Ft.
- 2. Maximum Recommended Velocity (Occupied Areas): 8 Fps.
- 3. Maximum Recommended Velocity (Unoccupied Areas, Shafts, Tunnels, etc.): 10 FPS.
- Standard steel pipe and Type L copper pipe are the most common pipe materials used in HVAC applications.
- 5. Tables are applicable to closed and open hydronic piping systems.
- 6. Pipe Sizes 5", 22", 26", 28", 32", and 34" are not standard sizes and not readily available in all locations.
- 7. Types K, L, and M copper pipe are available in sizes through 12 inch.
- 8. Standard and XS steel pipe are available in sizes through 96 inch.
- 9. XXS steel pipe is available in sizes through 12 inch.
- 10. Schedule 40 steel pipe is available in sizes through 96 inch.
- 11. Schedule 80 and 160 steel pipe are available in sizes through 24 inch.
- 12. Schedule 5 and 10 stainless steel pipe are available in sizes through 24 inch.
- 13. Standard and Schedule 40 steel pipe have the same dimensions and flow for 10 inch and smaller.
- 14. XS and Schedule 80 steel pipe have the same dimensions and flow for 8 inch and smaller.
- 15. XXS and Schedule 160 have no relationship for dimensions or flow.

Hydronic Piping Systems-Type K Copper Pipe

				WATER FL	OW - GPM					
PIPE SIZE	FRICTION RATE - FT/100 FT				VELOCITY - FT/SEC.					
	2.0	3.0	4.0	4.0	5.0	6.0	8.0	10.0		
1/2 3/4 1	1.0 2.4 5.2	1.2 3.0 6.4	1.4 3.5 7.4		Pressure with these	Drop Pipe	Governs Sizes			
1-1/4 1-1/2 2	9 15 31	12 18 38	13 21 44	21 38						
2-1/2 3 4	55 87 183	67 107 224	78 123 258	58 83 146	73 103 182	124 219				
5 6 8	324 515 1,064	397 631 1,304	458 729	226 323 563	283 403 704	339 484 845	452 645 1,126	1,408		
10 12	1,887 3,015	Velocity with these	Governs Pipe Sizes	874 1,254	1,093 1,567	1,311 1,880	1,749 2,507	2,186 3,134		

Hydronic Piping Systems-Type L Copper Pipe

				WATED EI	OW - GPM		-		
PIPE				WAIERFI	COW - GFIVI				
SIZE	FRICTI	ON RATE - F	T/100 FT	VELOCITY - FT/SEC.					
	2.0	3.0	4.0	4.0	5.0	6.0	8.0	10.0	
1/2 3/4 1	1.1 2.8 5.7	1.3 3.4 6.9	1.5 4.0 8.0		Pressure with these	Drop Pipe	Governs Sizes		
1-1/4 1-1/2 2	10 16 32	12 19 39	14 22 45	22 39					
2-1/2 3 4	57 90 189	69 111 231	80 128 267	59 85 149	74 106 187	127 224	2		
5 6 8	337 540 1,117	412 662 1,368	476 764	233 335 584	291 418 730	349 502 877	465 669 1,169	1,461	
10 12	1,980 3,191	Velocity with these	Governs Pipe Sizes	907 1,310	1,134 1,637	1,361 1,965	1,814 2,619	2,268 3,274	

Hydronic Piping Systems—Type M Copper Pipe

				WATER FL	OW - GPM					
PIPE SIZE	FRICTIO	ON RATE - F	T/100 FT		VELOCITY - FT/SEC.					
	2.0	3.0	4.0	4.0	5.0	6.0	8.0	10.0		
1/2 3/4 1	1.2 3.1 6.1	1.5 3.7 7.5	1.7 4.3 8.6		Pressure with these	Drop Pipe	Governs Sizes			
1-1/4 1-1/2 2	10 16 33	13 20 41	15 23 47	16 23 40		5		ė.		
2-1/2 3 4	58 93 192	72 114 236	83 132 272	61 87 152	76 109 190	131 227				
5 6 8	342 549 1,140	419 672 1,396	484 776	236 339 593	295 423 742	354 508 890	472 677 1,187	1,484		
10 12	2,020 3,228	Velocity with these	Governs Pipe Sizes	922 1,321	1,152 1,652	1,382 1,982	1,843 2,643	2,304 3,304		

Hydronic Piping Systems-Standard Steel Pipe

				WATER FI	OW - GPM			
PIPE	EDICTIO	N RATE - FT	T/100 FT	- ATENTE		OCITY - FT/S	SEC	
SIZE								10.0
	2.0	3.0	4.0	4.0	5.0	6.0	8.0	10.0
1/2 3/4 1	1.5 3.2 6.0	1.9 3.9 7.4	2.1 4.5 8.5		Pressure with these	Drop Pipe	Governs Sizes	
1-1/4 1-1/2 2	12 19 36	15 23 44	18 26 51	19 25 42	52			
2-1/2 3 4	57 100 204	70 123 250	80 142 289	60 92 159	75 115 198	138 238	i i	
5 6 8	368 595 1,216	451 729 1,489	521 841	249 360 .624	312 450 780	374 540 936	499 720 1,247	1,559
10 12 14	2,198 3,512			983 1,410 1,719	1,229 1,763 2,149	1,475 2,115 2,579	1,966 2,820 3,438	2,458 3,525 4,298
16 18 20		·		2,277 2,914 3,629	2,847 3,642 4,536	3,416 4,371 5,443	4,554 5,827 7,257	5,693 7,284 9,071
22 24 26				4,422 5,293 6,243	5,527 6,616 7,804	6,633 7,940 9,364	8,843 10,586 12,486	11,054 13,233 15,607
28 30 32		en S		7,271 8,378 9,562	9,089 10,472 11,953	10,907 12,566 14,344	14,542 16,755 19,125	18,178 20,944 23,906
34 36 42	Velocity these	Governs Pipe	with Sizes	10,826 12,167 16,662	13,532 15,209 20,827	16,238 18,251 24,992	21,651 24,334 33,323	27,064 30,418 41,654
48 54 ,60	,			21,861 27,766 34,375	27,327 34,707 42,969	32,792 41,649 51,563	43,722 55,532 68,751	54,653 69,414 85,938
72 84 96	. }	7,7		49,710 67,864 88,838	62,137 84,830 111,048	74,564 101,796 133,257	99,419 135,728 177,677	124,274 169,660 222,096

Hydronic Piping Systems—XS Steel Pipe

			mo r ipin		OW - GPM			
PIPE SIZE	FRICTIO	N RATE - F	Γ/100 FT		VEL	OCITY - FT/	SEC.	
SIZE	2.0	3.0	4.0	4.0	5.0	6.0	8.0	10.0
1/2 3/4 1	1.1 2.4 4.7	1.3 3.0 5.8	1.5 3.4 6.7		Pressure with these	Drop Pipe	Governs Sizes	1
1-1/4 1-1/2 2	10 15 30	12 19 37	14 22 43	22 37				
2-1/2 3 4	48 87 179	59 106 219	69 123 253	53 82 143	66 103 179	124 215		
5 6 8	325 520 1,080	399 637 1,322	460 736	227 325 569	284 406 712	340 487 854	454 650 1,139	1,423
10 12 14	2,047 3,325			931 1,352 1,655	1,164 1,690 2,069	1,396 2,028 2,482	1,862 2,704 3,310	2,327 3,380 4,137
16 18 20				2,203 2,830 3,535	2,754 3,537 4,419	3,305 4,245 5,302	4,406 5,660 7,070	5,508 7,075 8,837
22 24 26		-		4,318 5,180 6,120	5,398 6,475 7,650	6,477 7,770 9,180	8,637 10,360 12,240	10,796 12,950 15,300
28 30 32				7,138 8,235 9,410	8,923 10,294 11,763	10,708 12,353 14,115	14,277 16,470 18,820	17,846 20,588 23,525
34 36 42	Velocity these	Governs Pipe	with Sizes	10,663 11,995 16,460	13,329 14,994 20,575	15,995 17,993 24,690	21,327 23,990 32,921	26,659 29,988 41,151
48 54 60				21,630 27,506 34,086	27,038 34,382 42,607	32,446 41,258 51,129	43,261 55,011 68,172	54,076 68,764 85,215
72 84 96		,		49,361 67,457 88,373	61,702 84,321 110,466	74,042 101,185 132,559	98,723 134,914 176,745	123,403 168,642 220,931

Hydronic Piping Systems-Schedule 80 Steel Pipe

				WATER FL	OW - GPM			
PIPE SIZE	FRICTIO	N RATE - FT	7/100 FT		VEL	OCITY - FT/S	SEC.	
	2.0	3.0	4.0	4.0	5.0	6.0	8.0	10.0
1/2 3/4 1	1.1 2.4 4.7	1.3 3.0 5.8	1.5 3.4 6.7		Pressure with these	Drop Pipe	Governs Sizes	
1-1/4 1-1/2 2	10 15 30	12 19 37	14 22 43	22 37				
2-1/2 3 4	48 87 179	59 106 219	69 123 253	53 82 143	66 103 179	124 215		
5 6 8	325 520 1,080	399 637 1,322	460 736	227 325 569	284 406 712	340 487 854	454 650 1,139	1,423
10 12 14	1,947 3,057			896 1,267 1,530	1,120 1,584 1,912	1,344 1,901 2,295	1,791 2,534 3,060	2,239 3,168 3,825
16 18 20	Velocity	Governs	with	2,006 2,546 3,151	2,508 3,183 3,938	3,009 3,820 4,726	4,013 5,093 6,302	5,016 6,366 7,877
22 24	these	Pipe	Sizes	3,819 4,553	4,774 5,692	5,729 6,830	7,639 9,107	9,549 11,383

Hydronic Piping Systems—Schedule 160 Steel Pipe

				WATER FL	OW - GPM			
PIPE SIZE	FRICTIO	N RATE - FT	7/100 FT		VEL	OCITY - FT/	SEC.	
J J	2.0	3.0	4.0	4.0	5.0	6.0	8.0	10.0
1/2 3/4 1	0.7 1.5 3.1	0.9 1.8 3.8	1.0 2.1 4.4		Pressure with these	Drop Pipe	Governs Sizes	
1-1/4 1-1/2 2	8 11 21	10 14 26	11 16 30	28				1 , 21
2-1/2 3 4	38 67 135	47 82 166	54 95 191	44 68 116	55 84 145	174		
5 6 8	244 396 805	299 485 986	346 560	182 264 455	228 330 568	273 395 682	527 909	1,136
10 12 14	1,433 2,259 2,928	1,755		707 1,004 1,226	884 1,255 1,532	1,061 1,506 1,839	1,415 2,008 2,451	1,769 2,510 3,064
16 18 20	Volonite	Governs	with	1,608 2,041 2,527	2,010 2,551 3,159	2,412 3,062 3,790	3,216 4,082 5,054	4,020 5,103 6,317
22 24	Velocity these	Pipe	Sizes	3,085 3,653	3,856 4,566	4,628 5,479	6,170 7,305	7,713 9,132

Hydronic Piping Systems-Schedule 5 Stainless Steel Pipe

				WATER FL	OW - GPM		-	
PIPE SIZE	FRICTIC	N RATE - F	T/100 FT		VEL	OCITY - FT/	SEC.	
	2.0	3.0	4.0	4.0	5.0	6.0	8.0	10.0
1/2 3/4 1	2.2 4.3 8.3	2.6 5.2 10.2	3.0 6.0 11.7		Pressure with these	Drop Pipe	Governs Sizes	
1-1/4 1-1/2 2	16 24 44	20 29 54	23 34 63	23 31 49	62			
2-1/2 3 4	73 125 248	89 153 303	103 176 350	72 109 184	90 136 230	163 276		a
5 6 8	428 686 1,392	524 840 1,705	605 970	280 402 692	350 502 865	420 603 1,038	559 804 1,384	1,730
10 12 14	2,471			1,076 1,515 1,835	1,345 1,894 2,293	1,614 2,272 2,752	2,152 3,030 3,669	2,690 3,787 4,587
16 18 20	Velocity	Governs	with	2,404 3,057 3,771	3,006 3,822 4,714	3,607 4,586 5,656	4,809 6,115 7,542	6,011 7,643 9,427
22 24	these	Pipe	Sizes	4,579 5,437	5,723 6,796	6,868 8,156	9,157 10,874	11,447 13,593

Hydronic Piping Systems-Schedule 10 Stainless Steel Pipe

				WATER FL	OW - GPM			
PIPE SIZE	FRICTIO	ON RATE - F	T/100 FT		VEL	OCITY - FT/	SEC.	
	2.0	3.0	4.0	4.0	5.0	6.0	8.0	10.0
1/2 3/4 1	1.9 3.8 6.8	2.3 4.7 8.3	2.7 5.4 9.6		Pressure with these	Drop Pipe	Governs Sizes	,
1-1/4 1-1/2 2	14 21 40	17 25 49	20 29 56	20 28 46	57		,	2.
2-1/2 3 4	67 118 237	83 144 290	95 166 335	68 104 178	85 130 222	156 267		
5 6 8	417 672 1,359	511 823 1,664	590 951	275 396 679	343 495 849	412 594 1,019	549 791 1,359	1,698
10 12 14	2,433			1,063 1,503 1,818	1,329 1,879 2,272	1,595 2,255 2,726	2,126 3,006 3,635	2,658 3,758 4,544
16 18 20	Velocity these	Governs Pipe	with Sizes	2,390 3,041 3,748	2,988 3,802 4,685	3,585 4,562 5,622	4,781 6,083 7,496	5,976 7,604 9,370
22 24	uiese	ripe	SIZES	4,553 5,408	5,692 6,760	6,830 8,111	9,107 10,815	11,383 13,519

the second of th

AND THE STREET AND TH

And the date of the control of the con

The Committee of the Co

the strength of the strength o

the state of the second of the second of the state of the second of the

Appendix C: Steam Piping Systems

Steam Tables

STEAM	STEAM	SATURATION	SPECIFIC	HEAT CONT	ENT (ABOVE 3	2°F) BTU/LB
PRESSURE PSIG	PRESSURE PSIA	TEMPERATURE °F	VOLUME CU.FT./LB.	SENSIBLE	LATENT	TOTAL
200	214.7	387.9	2.138	362.1	838.2	1,200.3
201	215.7	388.2	2.128	362.5	837.8	1,200.3
202	216.7	388.6	2.119	362.9	837.5	1,200.4
203	217.7	389.0	2.110	363.3	837.1	1,200.4
204	218.7	389.4 389.8	2.100	363.8 364.2	836.8 836.4	1,200.6
206	220.7	390.2	2.082	364.6	836.0	1,200.6
207	221.7	390.6	2.073	365.0	835.7	1,200.7
208	222.7	391.0	2.064	365.4	835.3	1,200.7
209	223.7	391.4	2.055	365.8	835.0	1,200.8
210	224.7	391.8	2.046	366.2	834.6	1,200.8
211	225.7	392.1	2.037	366.6	834.2	1,200.8
212	226.7	392.5	2.028	367.0	833.9	1,200.9
213	227.7	392.9	2.020	367.5	833.5	1,201.0
214	228.7	393.3	2.011	367.9	833.2	1,201.1
215	229.7	393.6	2.003	368.3	832.8	1,201.1
216	230.7	394.0	1.994	368.7	832.5	1,201.2
217	231.7	394.4	1.986	369.1	832.1	1,201.2
218	232.7	394.8	1.978	369.5	831.8	1,201.3
219	233.7	395.2	1.970	369.9	831.4	1,201.3
220	234.7	395.5	1.961	370.3	831.1	1,201.4
221	235.7	395.9	1.953	370.7	830.8	1,201.5
222	236.7	396.3	1.945	371.1	830.4	1,201.5
223	237.7	396.6	1.937	371.5	830.1	1,201.6
224	238.7	397.0	1.929	371.9	829.7	1,201.6
225	239.7	397.4	1.921	372.3	829.4	1,201.7
226	240.7	397.7	1.914	372.7	829.0	1,201.7
227	241.7	398.1	1.906	373.0	828.7	1,201.7
228	242.7	398.4	1.898	373.4	828.3	1,201.7
229	243.7	398.8	1.891	373.8	828.0	1,201.8
230 231 232 233 234	244.7 245.7 246.7 247.7 248.7	399.2 399.5 399.9 400.2 400.6	1.883 1.876 1.869 1.862 1.854	374.2 374.6 375.0 375.3 375.7	827.6 827.3 826.9 826.6 826.2	1,201.8 1,201.9 1,201.9 1,201.9
235	249.7	400.9	1.847	376.1	825.9	1,202.0
236	250.7	401.3	1.840	376.5	825.6	1,202.1
237	251.7	401.6	1.833	376.8	825.3	1,202.1
238	252.7	402.0	1.826	377.2	824.9	1,202.1
239	253.7	402.3	1.819	377.6	824.6	1,202.2

Steam Tables

STEAM PRESSURE	STEAM PRESSURE	SATURATION	SPECIFIC	HEAT CONT	ENT (ABOVE 3	2°F) BTU/LB
PSIG	PSIA	TEMPERATURE °F	VOLUME CU.FT./LB.	SENSIBLE	LATENT	TOTAL
240	254.7	402.7	1.812	378.0	824.3	1,202.3
241	255.7	403.0	1.805	378.4	824.0	1,202.4
242	256.7	403.4	1.798	378.7	823.7	1,202.4
243	257.7	403.7	1.791	379.1	823.3	1,202.4
244	258.7	404.1	1.785	379.5	822.9	1,202.4
245	259.7	404.4	1.778	379.9	822.6	1,202.5
246	260.7	404.7	1.771	380.3	822.3	1,202.6
247	261.7	405.1	1.765	380.6	822.0	1,202.6
248	262.7	405.4	1.758	381.0	821.6	1,202.6
249 250 251 252 253 254	263.7 264.7 265.7 266.7 267.7 268.7	405.8 406.1 406.4 406.8 407.1 407.4	1.752 1.745 1.739 1.733 1.726 1.720	381.7 382.1 382.4 382.8 383.2	821.0 820.7 820.4 820.0 819.6	1,202.6 1,202.7 1,202.8 1,202.8 1,202.8 1,202.8
255	269.7	407.8	1.714	383.6	819.3	1,202.9
256	270.7	408.1	1.707	383.9	819.0	1,202.9
257	271.7	408.4	1.701	384.3	818.7	1,203.0
258	272.7	408.8	1.695	384.6	818.4	1,203.0
259	273.7	409.1	1.689	385.0	818.0	1,203.0
260	274.7	409.4	1.683	385.3	817.7	1,203.0
261	275.7	409.7	1.677	385.7	817.4	1,203.1
262	276.7	410.1	1.671	386.0	817.1	1,203.1
263	277.7	410.4	1.666	386.4	816.7	1,203.1
264	278.7	410.7	1.660	386.7	816.4	1,203.1
265 266 267 268 269	279.7 280.7 281.7 282.7 283.7	411.1 411.4 411.7 412.0 412.3	1.654 1.648 1.642 1.637 1.631	387.1 387.5 387.8 388.2 388.5	816.1 815.8 815.5 815.2 814.9	1,203.2 1,203.3 1,203.4 1,203.4
270	284.7	412.7	1.625	388.9	814.6	1,203.5
271	285.7	413.0	1.620	389.2	814.3	1,203.5
272	286.7	413.3	1.614	389.5	814.0	1,203.5
273	287.7	413.6	1.609	389.9	813.6	1,203.5
274	288.7	413.9	1.603	390.3	813.3	1,203.6
275 276 277 278 279	289.7 290.7 291.7 292.7 293.7	414.2 414.5 414.9 415.2 415.5	1.598 1.593 1.587 1.582 1.577	390.6 390.9 391.3 391.6 392.0	813.0 812.7 812.3 812.0 811.7	1,203.6 1,203.6 1,203.6 1,203.7

Steam Tables

STEAM	STEAM	SATURATION	SPECIFIC	HEAT CONT	ENT (ABOVE 3	2°F) BTU/LB
PRESSURE PSIG	PRESSURE PSIA	TEMPERATURE °F	VOLUME CU.FT./LB.	SENSIBLE	LATENT	TOTAL
900	914.7	534.0	0.492	529.0	666.6 664.7	1,195.6
910	924.7	535.3	0.486	530.6		1,195.3
920	934.7	536.6	0.481	532.2	662.7	1,194.9
930 940	944.7 954.7	537.9 539.1	0.475 0.470	533.8 535.4	660.7 658.7	1,194.5 1,194.1
950	964.7	540.4	0.464	536.9	656.8	1,193.7
960	974.7	541.6	0.459	538.5	654.9	1,193.4
970	984.7	542.9	0.454	540.0	653.0	1,193.0
980	994.7	544.1	0.449	541.6	651.0	1,192.6
990	1,004.7	545.3	0.444	543.1	649.1	1,192.2
1,000	1,014.7	546.5	0.439	544.6	647.2	1,191.8
1,050	1,064.7	552.4	0.416	552.2	637.6	1,189.8
1,100	1,114.7	558.1	0.395	559.5	628.2	1,187.7
1,150	1,164.7	563.6	0.375	566.7	618.9	1,185.6
1,200	1,214.7	568.9	0.357	573.7	609.6	1,183.3
1,250	1,264.7	574.0	0.341	580.6	600.3	1,180.9
1,300	1,314.7	579.0	0.325	587.4	591.1	1,178.5
1,350	1,364.7	583.9	0.311	594.0	581.9	1,175.9
1,400	1,414.7	588.6	0.298	600.5	572.8	1,173.3
1,450	1,464.7	593.2	0.285	607.0	563.6	1,170.6
1,500	1,514.7	597.7	0.274	613.4	554.5	1,167.9
1,550	1,564.7	602.0	0.263	619.6	545.4	1,165.0
1,600	1,614.7	606.3	0.252	625.8	536.2	1,162.0
1,650	1,664.7	610.4	0.242	632.0	527.1	1,159.1
1,700	1,714.7	614.5	0.233	638.0	517.9	1,155.9
1,750	1,764.7	618.5	0.224	644.1	508.7	1,152.8
1,800	1,814.7	622.3	0.216	650.0	499.4	1,149.4
1,850	1,864.7	626.1	0.208	655.9	490.0	1,145.9
1,900	1,914.7	629.8	0.200	661.8	480.6	1,142.4
1,950	1,964.7	633.5	0.193	667.7	471.2	1,138.9
2,000	2,014.7	637.0	0.187	673.6	461.5	1,135.1
2,050	2,064.7	640.5	0.179	679.4	451.8	1,131.3
2,100	2,114.7	643.9	0.173	685.3	442.1	1,127.2
2,150	2,164.7	647.3	0.167	691.1	432.1	1,123.2
2,200	2,214.7	650.6	0.161	697.0	422.0	1,119.0
2,250	2,264.7	653.8	0.155	702.8	411.7	1,114.5
2,300	2,314.7	657.0	0.150	708.7	401.3	1,110.0
2,350	2,364.7	660.1	0.144	714.6	390.6	1,105.2
2,400	2,414.7	663.2	0.139	720.6	379.7	1,100.3
2,450	2,464.7	666.2	0.134	726.6	368.5	1,095.1
2,500	2,514.7	669.2	0.129	732.7	357.1	1,089.8

Steam Flow Through Orifices

	STEAM FLOW - LBS/HR.												
ORIFICE DIA. INCHES					5	STEAM	PRESSI	URE - P	SIG				
INCILS	2	5	10	15	25	50	75	100	125	150	200	250	300
1/32	0.3	0.5	0.6	0.7	0.9	1.5	2.1	2.7	3.3	3.9	5.1	6.3	7.4
1/16	1.3	1.9	2.3	2.8	3.8	6.1	8.5	10.8	13.2	15.6	20.3	25.1	29.8
3/32	2.8	4.2	5.3	6.3	8.5	13.8	19.1	24.4	29.7	35.1	45.7	56.4	67.0
1/8	4.5	7.5	9.4	11.2	15.0	24.5	34.0	43.4	52.9	62.4	81.3	100	119
5/32	7.8	11.7	14.6	17.6	23.5	38.3	53.1	67.9	82.7	97.4	127	156	186
3/16	11.2	16.7	21.0	25.3	33.8	55.1	76.4	97.7	119	140	183	226	268
7/32	15.3	22.9	28.7	34.4	46.0	75.0	104	133	162	191	249	307	365
1/4	20.0	29.8	37.4	45.0	60.1	98.0	136	173	212	250	325	401	477
9/32	25.2	37.8	47.4	56.9	76.1	124	172	220	268	316	412	507	603
5/16	31.2	46.6	58.5	70.3	94.0	153	212	272	331	390	508	627	745
11/32	37.7	56.4	70.7	85.1	114	185	257	329	400	472	615	758	901
3/8	44.9	67.1	84.2	101	135	221	306	391	476	561	732	902	1073
13/32	52.7	78.8	98.8	119	159	259	359	459	559	659	859	1059	1259
7/16	61.1	91.4	115	138	184	300	416	532	648	764	996	1228	1460
15/32	70.2	105	131	158	211	344	478	611	744	877	1144	1410	1676
1/2	79.8	119	150	180	241	392	544	695	847	998	1301	1604	1907

^{1.} Steam Leaks and Energy Wasted. A ¼" diameter hole in a steam pipe can discharge 62.4 Lb.Stm./Hr. at 150 psig, resulting in 30 tons of coal, 4,800 gallons of oil, or 7,500 therms of gas to be wasted each year (assuming 8,400 hour per year operation).

Medium Pressure Steam Piping Warm-Up Loads

			POUNI	OS OF STE	AM PER 10	O FEET OF	PIPE		
PIPE SIZE				STEAM	PRESSUR	E PSIG			
	20	25	30	40	50	60	75	85	100
1/2"	2	2	2	2	2	3	3	3	3
3/4"	3	3	3	3	3	3	4	4	4
1"	4	4	4	5	5	5	5	6	6
1-1/4"	5	6	6	6	7	7	7	8	8
1-1/2"	6	7	7	7	8	8	9	9	10
2"	8	9	9	10	11	11	12	12	13
2-1/2"	13	14	15	16	17	17	19	19	20
3"	18	18	19	21	22	23	24	25	27
4"	25	26	27	29	31	32	35	36	38
5"	34	35	37	40	42	44	47	49	51
6"	44	46	48	51	55	57	61	63	66
8"	66	69	72	77	82	86	92	95	100
10"	94	98	102	110	116	122	130	135	142
12"	115	120	125	134	142	149	159	165	173
14"	126	132	138	148	157	164	175	182	191
16"	145	152	158	170	180	188	201	209	219
18"	163	171	178	191	203	213	227	235	247
20"	182	191	198	213	226	237	252	262	275
22"	201	211	220	236	250	262	279	290	304
24"	219	229	239	257	272	285	304	316	331
26"	238	250	260	279	296	310	331	344	360
28"	257	269	280	301	319	334	356	370	388
30"	275	289	300	323	342	358	382	397	416
32"	294	308	321	344	365	382	408	424	444
34"	312	327	341	366	388	407	434	450	472
36"	331	347	361	388	411	431	459	477	500
42"	386	405	422	453	480	503	536	557	584
48"	441	463	482	517	548	574	612	636	667
54"	497	521	542	583	617	647	690	717	751
60"	552	579	603	648	686	719	767	797	835
72"	664	696	724	778	825	864	921	957	1,003
84"	775	812	846	908	963	1,009	1,075	1,117	1,171
96"	886	929	967	1,039	1,101	1,153	1,230	1,278	1,340
CORR. FACTOR	1.37	1.36	1.35	1.32	1.31	1.29	1.28	1.27	1.26

Notes:

1. Table based on 70°F. ambient temperature, standard weight steel pipe to 250 psig, and extrastrong weight steel pipe above 250 psig.

2. For ambient temperatures of 0°F., multiply table values by correction factor.

High Pressure Steam Piping Warm-Up Loads

	_		Doin						
DIDE CIZE			POUN			100 FEET C	OF PIPE		
PIPE SIZE				STEAN	A PRESSU	RE PSIG			
	120	125	150	175	200	225	250	275	300
1/2" 3/4" 1"	3 4 6	3 4 6	3 4 7	5 7	4 5 7	4 5 8	5 8	6 8	5 7 11
1-1/4"	8	9	9	9	10	10	11	11	15
1-1/2"	10	10	11	11	12	12	13	13	18
2"	14	14	14	15	16	17	17	18	25
2-1/2"	21	22	23	24	25	26	27	28	39
3"	28	28	30	32	33	34	36	37	52
4"	40	40	43	45	47	49	51	53	75
5"	54	55	58	61	64	66	69	71	104
6"	70	71	75	79	83	86	89	92	144
8"	106	107	113	119	125	129	134	139	218
10"	150	152	161	169	177	184	191	197	275
12"	183	186	197	206	216	225	233	241	329
14"	202	204	217	227	238	247	257	266	362
16"	231	234	248	261	273	284	295	305	416
18"	261	264	280	294	308	320	332	343	470
20"	290	294	312	327	343	356	370	382	523
22"	322	326	345	362	380	394	409	423	578
24"	350	354	375	394	413	429	445	460	631
26"	381	386	409	429	449	467	485	501	384
28"	410	416	440	462	484	503	522	540	739
30"	440	446	472	496	519	540	560	579	794
32"	469	476	504	529	554	576	598	618	844
34"	499	506	536	562	589	612	635	657	900
36"	528	536	567	596	624	648	673	696	955
42"	617	626	663	696	729	757	786	813	1,116
48"	705	714	757	794	832	865	898	928	1,275
54"	794	805	852	895	937	974	1,011	1,045	1,436
60"	883	894	948	995	1,042	1,083	1,124	1,162	1,597
72"	1,060	1,075	1,139	1,195	1,252	1,301	1,350	1,396	1,946
84"	1,238	1,254	1,329	1,395	1,461	1,518	1,576	1,630	2,241
96"	1,415	1,435	1,520	1,595	1,671	1,737	1,803	1,864	2,510
CORR. FACTOR	1.25	1.25	1.24	1.23	1.22	1.22	1.21	1.21	1.20

Notes:

 Table based on 70°F. ambient temperature, standard weight steel pipe to 250 psig, and extrastrong weight steel pipe above 250 psig.

2. For ambient temperatures of 0°F, multiply table values by correction factor.

High Pressure Steam Piping Operating Loads

		POI	INIDS OF S	STEAM PE	R HOUR P	ER 100 FEI	ET OF PIPE		
PIPE SIZE		100	DINDS OF S		PRESSURE				
FIFE SIZE	120	125	150	175	200	225	250	275	300
1/2"	6 7 9	6	7	7	8	8	8	9	9
3/4"		7	8	9	9	10	10	11	11
1"		9	10	10	11	12	12	13	14
1-1/4"	11	11	12	13	14	14	15	16	17
1-1/2"	12	12	13	14	15	16	17	18	19
2"	15	15	16	18	19	20	21	22	23
2-1/2"	18	18	19	21	22	23	25	26	27
3"	21	21	23	25	26	28	29	31	32
4"	26	27	29	31	33	35	37	38	40
5"	31	32	35	37	40	42	44	46	49
6"	37	38	41	44	46	49	52	54	57
8"	47	48	52	55	59	62	66	69	72
10"	57	58	63	67	72	76	80	84	88
12"	66	68	73	79	84	89	93	98	103
14"	72	74	80	85	91	96	102	107	112
16"	81	83	90	96	103	109	115	121	126
18"	91	92	100	107	115	121	128	134	141
20"	100	102	110	118	126	134	141	148	155
22"	109	111	120	129	138	146	154	161	169
24"	118	120	130	140	149	158	167	175	183
26"	127	129	140	150	161	170	179	188	197
28"	149	152	165	177	189	182	192	201	211
30"	160	163	177	190	203	214	226	237	249
32"	170	174	189	202	216	229	241	253	265
34"	181	185	200	215	230	243	256	269	282
36"	192	195	212	228	243	257	271	285	299
42"	224	228	248	265	284	300	317	332	348
48"	256	261	283	303	324	343	362	380	398
54"	287	293	318	341	365	386	407	427	448
60"	319	326	354	379	406	429	452	475	498
72"	383	391	425	455	487	514	543	570	597
84"	447	456	495	531	568	600	633	665	697
96"	511	521	566	607	649	686	724	760	796
CORR. FACTOR	1.39	1.39	1.39	1.38	1.37	1.37	1.36	1.36	1.35

- 1. Table based on 70°F. ambient temperature, standard weight steel pipe to 250 psig, and extrastrong weight steel pipe above 250 psig.
- 2. For ambient temperatures of 0°F., multiply table values by correction factor.
- 3. Table values include convection and radiation loads with 80% efficient insulation.

Boiling Points of Water

PSIA	BOILING POINT °F.	PSIA	BOILING POINT °F.	PSIA	BOILING POINT °F.
0.5	79.6	44	273.1	150	358.5
1	101.7	46	275.8	175	371.8
2	126.0	48	278.5	200	381.9
3	141.4	50	281.0	225	391.9
4	152.9	52	283.5	250	401.0
5	162.2	54	285.9	275	409.5
6	170.0	56	288.3	300	417.4
7	176.8	58	290.5	325	424.8
8	182.8	60	292.7	350	431.8
9	188.3	62	294.9	375	438.4
10	193.2	64	297.0	400	444.7
11	197.7	66	299.0	425	450.7
12	201.9	68	301.0	450	456.4
13	205.9	70	303.0	475	461.9
14	209.6	72	304.9	500	467.1
14.69	212.0	74	306.7	525	472,2
15	213.0	76	308.5	550	477.1
16	216.3	78	310.3	575	481.8
17	219.4	80	312.1	600	486.3
18	222.4	82	313.8	625	490.7
19	225.2	84	315.5	650	495.0
20	228.0	86	317.1	675	499.2
22	233.0	88	318.7	700	503.2
24	237.8	90	320.3	725	507.2
26	242.3	92	321.9	750	511.0
28	246.4	94	323.4	775	514.7
30	250.3	96	324.9	800	518.4
32	254.1	98	326.4	825	521.9
34	257.6	100	327.9	850	525.4
36	261.0	105	331.4	875	528.8
38	264.2	110	334.8	900	532.1
40	267.3	115	338.1	950	538.6
42	270.2	120	341.3	1000	544.8

				STEAN	FLOW LE	SS./HR.			
PIPE SIZE		ESSURE DR PSIG/100 FT.			1	VELOCITY	FPM (MPH)	
	0.125	0.25	0.5	2,000 (23)	4,000 (45)	6,000 (68)	8,000 (91)	10,000 (114)	12,000 (136)
1/2 3/4 1	5 10 21	6 15 30	9 21 42	20 32	Pressure these	Drop Pipe	Governs Sizes	with	
1-1/4 1-1/2 2	46 72 145	65 101 205	92 143 290	55 75 124	248				
2-1/2 3 4	239 437 924	338 619 1,307	478 870 1,849	177 274 471	354 547 942	821 1,413			
5 6 8	1,701 2,807 5,843	2,405 3,969 8,263	3,402 5,614	737 1,069 1,851	1,475 2,138 3,702	2,212 3,207 5,553	2,949 4,276 7,404	5,345 9,255	11,106
10 12 14	10,662 17,112 22,165	15,078 24,200		2,918 4,185 5,102	5,835 8,369 10,204	8,753 12,554 15,305	11,670 16,738 20,407	14,588 20,923 25,509	17,506 25,108 30,611
16 18 20	31,951 43,968 58,368			6,758 8,647 10,768	13,516 17,294 21,537	20,275 25,941 32,305	27,033 34,588 43,074	33,791 43,235 53,842	40,549 51,883 64,611
22 24 26	75,290			13,122 15,709 18,527	26,245 31,417 37,055	39,367 47,126 55,582	52,489 62,834 74,110	65,611 78,543 92,637	78,734 94,252 111,164
28 30 32				21,579 24,862 28,379	43,157 49,725 56,757	64,736 74,587 85,136	86,315 99,450 113,515	107,893 124,312 141,893	129,472 149,175 170,272
34 36 42				32,127 36,109 49,447	64,255 72,217 98,894	96,382 108,326 148,341	128,509 144,434 197,788	160,637 180,543 247,235	192,764 216,651 296,682
48 54 60	Velocity	Governs	with	64,878 82,401 102,016	129,755 164,801 204,032	194,633 247,202 306,048	259,511 329,603 408,064	324,388 412,003 510,080	389,266 494,404 612,096
72 84 96	these	Pipe	Sizes	147,524 201,400 263,646	295,047 402,801 527,292	442,571 604,201 790,939	590,094 805,601 1,054,585	737,618 1,007,001 1,318,231	885,141 1,208,402 1,581,877

- 1. Maximum recommended pressure drop / velocity: 0.125 Psig/100 Ft. / 4,000 Fpm.
- 2. Table based on Standard Weight Steel Pipe using Steam Equations in Part 5.

-				STEAN	I FLOW LE	BS./HR.			
PIPE SIZE		ESSURE DR PSIG/100 FT				VELOCITY	FPM (MPH)	
	0.125	0.25	0.5	2,000 (23)	4,000 (45)	6,000 (68)	8,000 (91)	10,000 (114)	12,000 (136)
1/2 3/4 1	5 11 22	7 15 31	10 22 44	22 35	Pressure these	Drop Pipe	Governs Sizes	with	
1-1/4 1-1/2 2	48 75 153	69 106 216	97 150 305	61 83 137	275		14		
2-1/2 3 4	251 460 972	355 651 1,375	503 914 1,944	196 302 521	392 605 1,042	907 1,563			# "
5 6 8	1,789 2,952 6,144	2,529 4,174 8,689	3,577 5,903	815 1,182 2,047	1,631 2,364 4,094	2,446 3,546 6,141	3,261 4,728 8,188	10,235	12,282
10 12 14	11,212 17,995 23,309	15,856 25,449 32,964		3,226 4,628 5,642	6,453 9,255 11,284	9,679 13,883 16,926	12,906 18,510 22,567	16,132 23,138 28,209	19,359 27,765 33,851
16 18 20	33,599 46,237 61,380			7,474 9,562 11,908	14,947 19,125 23,817	22,421 28,687 35,725	29,894 38,250 47,633	37,368 47,812 59,542	44,842 57,375 71,450
22 24 26	79,175 99,764		A	14,511 17,371 20,489	29,023 34,743 40,977	43,534 52,114 61,466	58,045 69,486 81,955	72,557 86,857 102,443	87,068 104,229 122,932
28 30 32				23,863 27,494 31,383	47,726 54,988 62,765	71,589 82,483 94,148	95,452 109,977 125,531	119,314 137,471 156,913	143,177 164,965 188,296
34 36 42				35,528 39,931 54,681	71,056 79,862 109,362	106,585 119,792 164,044	142,113 159,723 218,725	177,641 199,654 273,406	213,169 239,585 328,087
48 54 60	Velocity	Governs	with	71,745 91,123 112,815	143,491 182,247 225,630	215,236 273,370 338,445	286,981 364,493 451,260	358,727 455,616 564,075	430,472 546,740 676,890
72 84 96	these	Pipe	Sizes	163,140 222,720 291,555	326,280 445,439 583,109	489,419 668,159 874,664	652,559 890,879 1,166,219	815,699 1,113,598 1,457,774	978,839 1,336,318 1,749,328

- Maximum recommended pressure drop / velocity: 0.25 Psig/100 Ft. / 6,000 Fpm.
 Table based on Standard Weight Steel Pipe using Steam Equations in Part 5.

T				STEAM	FLOW LBS	S./HR.			
PIPE SIZE		SSURE DRO	OP		v	ELOCITY F	PM (MPH)		
SIZE	0.125	0.25	0.5	2,000 (23)	4,000 (45)	6,000 (68)	8,000 (91)	10,000 (114)	12,000 (136)
1/2 3/4 1	5 11 23	7 16 33	10 23 46	39	Pressure these	Drop Pipe	Governs Sizes	with	
1-1/4 1-1/2 2	51 79 160	72 111 226	101 157 319	67 91 150	300				
2-1/2 3 4	263 481 1,016	372 680 1,438	526 956 2,033	214 331 570	429 662 1,139	1,709			
5 6 8	1,870 3,087 6,426	2,645 4,365 9,087	3,741 6,174 12,851	892 1,293 2,239	1,783 2,586 4,477	2,675 3,879 6,716	3,567 5,171 8,955	11,194	
10 12 14	11,726 18,819 24,376	16,583 26,614 34,473		3,529 5,061 6,170	7,057 10,122 12,341	10,586 15,183 18,511	14,115 20,244 24,682	17,644 25,306 30,852	21,172 30,367 37,023
16 18 20	35,138 48,354 64,191			8,174 10,458 13,024	16,348 20,917 26,048	24,521 31,375 39,072	32,695 41,833 52,096	40,869 52,292 65,120	49,043 62,750 78,144
22 24 26	82,801 104,332 128,924	0.1	44	15,871 18,999 22,408	31,742 37,998 44,816	47,613 56,997 67,224	63,483 75,996 89,633	79,354 94,995 112,041	95,225 113,993 134,449
28 30 32				26,099 30,070 34,323	52,197 60,140 68,646	78,296 90,210 102,968	104,394 120,280 137,291	130,493 150,350 171,614	156,591 180,421 205,937
34 36 42				38,857 43,672 59,804	77,713 87,344 119,608	116,570 131,015 179,412	155,427 174,687 239,216	194,284 218,359 299,020	233,140 262,031 358,824
48 54 60				78,467 99,660 123,384		235,401 298,981 370,153	313,868 398,641 493,537	392,335 498,301 616,921	470,801 597,962 740,305
72 84 96	Velocity these	Governs Pipe	with Sizes	178,424 243,585 318,869	487,171	535,271 730,756 956,608	713,695 974,342 1,275,478	892,119 1,217,927 1,594,347	1,070,542 1,461,513 1,913,217

Notes

1. Maximum recommended pressure drop / velocity: 0.25 Psig/100 Ft. / 6,000 Fpm.

2. Table based on Standard Weight Steel Pipe using Steam Equations in Part 5.

	_			STEAN	FLOW LE	BS./HR.	-		
PIPE SIZE		ESSURE DR PSIG/100 FT				VELOCITY	FPM (MPH)	
	0.25	0.5	1	2,000 (23)	4,000 (45)	6,000 (68)	8,000 (91)	10,000 (114)	12,000 (136)
1/2 3/4 1	8 17 35	11 24 49	15 34 69	15 27 44	Pressure these	Drop Pipe	Goverms Sizes	with	
1-1/4 1-1/2 2	76 118 240	108 167 339	152 236 479	76 103 169	151 206 339			8	
2-1/2 3 4	395 723 1,527	558 1,016 2,160	790 1,445 3,054	242 373 643	484 747 1,286	725 1,120 1,929	2,572		
5 6 8	2,810 4,637 9,654	3,974 6,558 13,652	5,620	1,006 1,459 2,526	2,013 2,918 5,053	3,019 4,377 7,579	4,025 5,836 10,105	5,031 7,295 12,632	8,754 15,158
10 12 14	17,616 28,273 36,621	24,912		3,982 5,711 6,963	7,964 11,423 13,927	11,946 17,134 20,890	15,929 22,846 27,853	19,911 28,557 34,816	23,893 34,268 41,780
16 18 20	52,789			9,224 11,802 14,697	18,448 23,604 29,395	27,672 35,406 44,092	36,896 47,208 58,790	46,120 59,011 73,487	55,344 70,813 88,185
22 24 26				17,910 21,440 25,287	35,820 42,880 50,575	53,730 64,320 75,862	71,641 85,760 101,150	89,551 107,201 126,437	107,461 128,641 151,724
28 30 32		a de la composição de l		29,452 33,934 38,733	58,904 67,868 77,466	88,356 101,802 116,199	117,808 135,735 154,932	147,260 169,669 193,665	176,712 203,603 232,398
34 36 42		5		43,849 49,283 67,488	87,699 98,567 134,977	131,548 147,850 202,465	175,398 197,133 269,954	219,247 246,416 337,442	263,097 295,700 404,930
48 54 60	Velocity	Governs	with	88,549 112,466 139,238	177,098 224,932 278,476	265,648 337,397 417,714	354,197 449,863 556,952	442,746 562,329 696,190	531,295 674,795 835,428
72 84 96	these	Pipe	Sizes	201,350 274,884 359,841	402,699 549,768 719,683	604,049 824,653 1,079,524	805,399 1,099,537 1,439,366	1,006,749 1,374,421 1,799,207	1,208,098 1,649,305 2,159,049

- 1. Maximum recommended pressure drop / velocity: 0.5 Psig/100 Ft. / 6,000 Fpm.
- 2. Table based on Standard Weight Steel Pipe using Steam Equations in Part 5.

				STEAN	FLOW LE	BS./HR.			
PIPE SIZE		ESSURE DR PSIG/100 FT.			,	VELOCITY	FPM (MPH)		
SILL	0.25	0.5	1	4,000 (45)	6,000 (68)	8,000 (91)	10,000 (114)	12,000 (136)	15,000 (170)
1/2 3/4 1	9 20 41	13 29 57	18 40 81		Pressure these	Drop Pipe	Governs Sizes	with	
1-1/4 1-1/2 2	89 139 281	126 196 397	178 277 562	466	2				
2-1/2 3 4	463 847 1,790	655 1,191 2,532	926 1,695 3,581	665 1,026 1,767	1,540 2,651	3,535			
5 6 8	3,295 5,437 11,318	4,659 7,689 16,006	6,589 10,874 22,636	2,766 4,011 6,945	4,150 6,016 10,418	5,533 8,022 13,891	10,027 17,364	20,836	
10 12 14	20,653 33,148 42,936	29,208 46,878 60,720		10,948 15,702 19,143	16,421 23,553 28,715	21,895 31,403 38,286	27,369 39,254 47,858	32,843 47,105 57,430	41,054 58,881 71,787
16 18 20	61,891 85,170 113,063	87,527 120,449		25,358 32,446 40,406	38,038 48,669 60,609	50,717 64,892 80,812	63,396 81,115 101,015	76,075 97,338 121,218	95,094 121,673 151,522
22 24 26	145,843 183,768 227,082			49,238 58,943 69,519	73,857 88,414 104,279	98,476 117,885 139,039	123,095 147,357 173,799	147,714 176,828 208,558	184,643 221,035 260,698
28 30 32	276,022 330,813 397,670			80,969 93,290 106,484	121,453 139,935 159,726	161,937 186,580 212,968	202,422 233,225 266,210	242,906 279,870 319,451	303,632 349,838 399,314
34 36 42	,			120,550 135,488 185,537	180,825 203,232 278,306	241,100 270,977 371,075	301,375 338,721 463,844	361,650 406,465 556,612	452,062 508,081 695,765
48 54 60	`Velocity	Governs	with	243,437 309,188 382,790	365,156 463,782 574,185	486,875 618,376 765,580	608,593 772,970 956,974	730,312 927,564 1,148,369	912,890 1,159,456 1,435,462
72 84 96	these	Pipe	Sizes	553,546 755,705 989,267	830,318 1,133,557 1,483,901	1,107,091 1,511,409 1,978,534	1,383,864 1,889,262 2,473,168	1,660,637 2,267,114 2,967,802	2,075,796 1,833,893 3,709,752

- Maximum recommended pressure drop / velocity: 0.5 Psig/100 Ft. / 8,000 Fpm.
 Table based on Standard Weight Steel Pipe using Steam Equations in Part 5.

				STEAN	FLOW LE	BS./HR.			
PIPE SIZE		ESSURE DR PSIG/100 FT			,	VELOCITY	FPM (MPH)	
	0.25	0.5	1	4,000 (45)	6,000 (68)	8,000 (91)	10,000 (114)	12,000 (136)	15,000 (170)
1/2 3/4 1	9 21 43	13 30 61	19 43 86		Pressure these	Drop Pipe	Governs Sizes	with	
1-1/4 1-1/2 2	95 148 299	134 209 423	190 295 599	529				,	
2-1/2 3 4	493 902 1,907	697 1,269 2,697	986 1,805 3,814	754 1,164 2,005	1,747 3,008			5	
5 6 8	3,509 5,791 12,055	4,963 8,190 17,048	7,018 11,582 24,110	3,138 4,550 7,879	4,708 6,825 11,819	6,277 9,100 15,759	11,376 19,698	23,638	
10 12 14	21,998 35,306 45,731	31,110 49,930 64,674	43,996	12,420 17,813 21,717	18,629 26,719 32,576	24,839 35,626 43,434	31,049 44,532 54,293	37,259 53,438 65,151	66,798 81,439
16 18 20	65,920 90,715 120,424	93,225 128,291 170,306		28,768 36,809 45,839	43,152 55,213 68,758	52,536 73,617 91,677	71,920 92,021 114,597	86,304 110,426 137,516	107,880 138,032 171,895
22 24 26	155,339 195,732 241,867		20	55,858 66,868 78,867	83,788 100,302 118,300	111,717 133,735 157,733	139,646 167,169 197,167	167,575 200,603 236,600	209,469 250,754 295,750
28 30 32	293,993 352,351 417,171			91,855 105,833 120,801	137,783 158,750 181,201	183,710 211,667 241,602	229,638 264,583 302,002	275,565 317,500 362,403	344,457 396,875 453,004
34 36 42	488,677 567,084			136,758 153,705 210,484	205,137 230,558 315,725	273,517 307,410 420,967	341,896 384,263 526,209	410,275 461,116 631,451	512,844 576,395 789,314
48 54 60	Velocity	Governs	with	276,168 350,760 434,257	414,253 526,140 651,386	552,337 701,519 868,515	690,421 876,899 1,085,643	828,505 1,052,279 1,302,772	1,035,632 1,315,349 1,628,465
72 84 96	these	Pipe	Sizes	627,972 857,312 1,122,278	941,958 1,285,968 1,683,417	1,255,944 1,714,624 2,244,556	1,569,930 2,143,280 2,805,695	1,882,916 2,571,936 3,366,834	2,354,984 3,214,920 4,208,542

- 1. Maximum recommended pressure drop / velocity: 0.5 Psig/100 Ft. / 8,000 Fpm.
- 2. Table based on Standard Weight Steel Pipe using Steam Equations in Part 5.

				STEAN	I FLOW LE	BS./HR.			
PIPE SIZE		ESSURE DR PSIG/100 FT			1 20	VELOCITY	FPM (MPH)	
	0.25	0.5	1	4,000 (45)	6,000 (68)	8,000 (91)	10,000 (114)	12,000 (136)	15,000 (170)
1/2 3/4 1	, 10 23 46	14 32 65	20 45 91		Pressure these	Drop Pipe	Governs Sizes	with	
1-1/4 1-1/2 2	101 156 317	142 221 448	201 312 633	591					
2-1/2 3 4	521 954 2,017	737 1,342 2,852	1,043 1,909 4,034	843 1,302 2,243	3,364				
5 6 8	3,711 6,125 12,749	5,249 8,662 18,030	7,423 12,249 25,499	3,510 5,090 8,813	5,266 7,634 13,220	7,021 10,179 17,626	22,033		
10 12 14	23,265 37,340 48,365	32,902 52,806 68,399	46,530 74,679	13,891 19,924 24,291	20,837 29,886 36,436	27,783 39,848 48,582	34,729 49,810 60,727	41,674 59,772 72,873	91,091
16 18 20	69,717 95,940 127,361	98,595 135,680 180,116		32,178 41,171 51,271	48,266 61,757 76,907	64,355 82,342 102,543	80,444 102,928 128,178	96,533 123,513 153,814	120,666 154,391 192,268
22 24 26	164,286 207,006 255,799	232,336	7	62,479 74,793 88,214	93,718 112,189 132,321	124,957 149,586 176,428	156,197 186,982 220,534	187,436 224,378 264,641	234,295 280,473 330,802
28 30 32	310,927 372,647 441,200			102,742 118,376 135,118	154,113 177,565 202,677	205,483 236,753 270,236	256,854 295,941 337,795	308,225 355,129 405,354	385,281 443,912 506,693
34 36 42	516,825 599,748			152,967 171,922 235,430	229,450 257,883 353,145	305,933 343,844 470,860	382,417 429,805 588,575	458,900 515,766 706,290	573,625 644,708 882,862
48 54 60	Velocity	Governs	with	308,900 392,331 485,725	463,349 588,497 728,587	617,799 784,662 971,450	772,249 980,828 1,214,312	926,699 1,176,994 1,457,175	1,158,373 1,471,242 1,821,468
72 84 96	these	Pipe	Sizes	702,398 958,919 1,255,289	1,053,597 1,438,379 1,882,933	1,404,796 1,917,839 2,510,577	1,755,995 2,397,398 3,138,222	2,107,194 2,876,758 3,765,866	2,633,993 3,595,948 4,707,332

- Maximum recommended pressure drop / velocity: 0.5 Psig/100 Ft. / 8,000 Fpm.
 Table based on Standard Weight Steel Pipe using Steam Equations in Part 5.

				STEAN	I FLOW LE	BS./HR.			
PIPE SIZE	II	ESSURE DR PSIG/100 FT			,	VELOCITY	FPM (MPH)	
	0.5	1	2	4,000 (45)	6,000 (68)	8,000 (91)	10,000 (114)	12,000 (136)	15,000 (170)
1/2 3/4 1	16 35 71	22 50 100	31 71 142		Pressure these	Drop Pipe	Governs Sizes	with	
1-1/4 1-1/2 2	156 242 492	221 343 695	312 485 984	433 713					
2-1/2 3 4	810 1,473 3,133	1,145 2,097 4,430	1,620 2,965 6,265	1,017 1,571 2,705	1,526 2,356 4,058	5,410			
5 6 8	5,764 9,513 19,802	8,152 13,453 28,005	11,529 19,026 39,605	4,234 6,139 10,631	6,352 9,209 15,946	8,469 12,278 21,261	10,586 15,348 26,577	18,418 31,892	
10 12 14	36,136 57,996 75,122	51,103 82,019 106,239		16,757 24,033 29,301	25,135 36,050 43,951	33,513 48,066 58,602	41,891 60,083 73,252	50,270 72,100 87,903	62,837 90,124 109,878
16 18 20	108,286 149,016 197,819			38,814 49,662 61,846	58,221 74,493 92,769	77,628 99,325 123,692	97,035 124,156 154,615	116,442 148,987 185,537	145,553 186,234 231,922
22 24 26	255,172 321,526 397,311			75,364 90,218 106,407	113,047 135,327 159,611	150,729 180,437 212,815	188,411 225,546 266,018	226,093 270,655 319,222	282,617 338,319 399,028
28 30 32				123,932 142,791 162,985	185,897 214,186 244,478	247,863 285,582 325,971	309,829 356,977 407,464	371,795 428,373 488,956	464,743 535,466 611,195
34 36 42				184,515 207,380 283,986	276,773 311,070 425,979	369,030 414,760 567,972	461,288 518,450 709,965	553,546 622,140 851,958	691,932 777,675 1,064,947
48 54 60	Velocity	Governs	with	372,608 473,247 585,903	558,912 709,871 878,854	745,216 946,494 1,171,805	931,521 1,183,118 1,464,757	1,117,825 1,419,742 1,757,708	1,397,281 1,774,677 2,197,135
72 84 96	these	Pipe	Sizes	847,264 1,156,691 1,514,184	1,270,895 1,735,036 2,271,277	1,694,527 2,313,382 3,028,369	2,118,159 2,891,727 3,785,461	2,541,791 3,470,073 4,542,553	3,177,239 4,337,591 5,678,192

- 1. Maximum recommended pressure drop / velocity: 1.0 Psig/100 Ft. / 10,000 Fpm.
- 2. Table based on Standard Weight Steel Pipe using Steam Equations in Part 5.

				STEAN	I FLOW LE	SS./HR.			
PIPE SIZE		ESSURE DR PSIG/100 FT.			,	VELOCITY	FPM (MPH))	
	0.5	. 1	2	4,000 (45)	6,000 (68)	8,000 , (91)	10,000 (114)	12,000 (136)	15,000 (170)
1/2 3/4 1	20 45 90	28 63 127	39 89 179		Pressure these	Drop Pipe	Governs Sizes	with	
1-1/4 1-1/2 2	197 306 621	279 433 879	394 612 1,243	1,138	e e		v v	J*	
2-1/2 3 4	1,023 1,862 3,957	1,447 2,649 5,597	2,046 3,746 7,915	1,624 2,507 4,318	6,477		11		
5 6 8	7,283 12,018 25,018	10,299 16,997 35,380	14,565 24,036 50,035	6,758 9,799 16,967	10,138 14,698 25,451	13,517 19,597 33,935	42,419		
10 12 14	45,652 73,270 94,906	64,562 103,620 134,218	91,304	26,745 38,359 46,766	40,117 57,538 70,150	53,489 76,718 93,533	66,862 95,897 116,916	80,234 115,077 140,299	143,846 175,374
16 18 20	136,805 188,261 249,917	193,471 266,242 353,436		61,950 79,265 98,711	92,925 118,897 148,066	123,900 158,530 197,422	154,876 198,162 246,777	185,851 237,795 296,132	232,313 297,244 370,165
22 24 26	322,374 406,203 501,947			120,288 143,996 169,834	180,431 215,993 254,752	240,575 287,991 339,669	300,719 359,989 424,586	360,863 431,987 509,503	451,079 539,983 636,879
28 30 32	610,125 731,235 865,756	2		197,804 227,905 260,138	296,707 341,858 390,206	395,609 455,811 520,275	494,511 569,764 650,344	593,413 683,716 780,413	741,767 854,646 975,516
34 36 42	1,014,152 1,176,871	8		294,501 330,995 453,264	441,751 496,492 679,896	589,001 661,990 906,527	736,252 827,487 1,133,159	883,502 992,985 1,359,791	1,104,378 1,241,231 1,699,739
48 54 60	Velocity	Governs	with	594,712 755,340 935,147	892,068 1,133,009 1,402,720	1,189,424 1,510,679 1,870,293	1,486,780 1,888,349 2,337,867	1,784,136 2,266,019 2,805,440	2,230,170 2,832,524 3,506,800
72 84 96	these	Pipe	Sizes	1,352,299 1,846,169 2,416,757	2,028,449 2,769,254 3,625,136	2,704,598 3,692,339 4,833,514	3,380,748 4,615,423 6,041,893	4,056,898 5,538,508 7,250,271	5,071,122 6,923,135 9,062,839

- 1. Maximum recommended pressure drop / velocity: 1.0 Psig/100 Ft. / 12,000 Fpm.
- 2. Table based on Standard Weight Steel Pipe using Steam Equations in Part 5.

				STEAM	M FLOW LI	BS./HR.			
PIPE SIZE	11	ESSURE DR PSIG/100 FT				VELOCITY	FPM (MPH	D)	
	0.5	1	2	4,000 (45)	6,000 (68)	8,000 (91)	10,000 (114)	12,000 (136)	15,000 (170)
1/2 3/4 1	21 47 94	29 66 133	41 94 188		Pressure these	Drop Pipe	Governs Sizes	with	
1-1/4 1-1/2 2	207 322 653	293 455 924	415 644 1,306	1,258					
2-1/2 3 4	1,076 1,957 4,160	1,521 2,784 5,883	2,151 3,938 8,320	1,794 2,771 4,771	7,157	4			e ·
5 6 8	7,655 12,633 26,298	10,826 17,866 37,192	15,311 25,267 52,597	7,468 10,828 18,749	11,202 16,241 28,124	14,936 21,655 37,499	46,873		
10 12 14	47,989 77,021 99,765	67,867 108,925 141,089	95,979 154,043	29,553 42,387 51,678	44,330 63,580 77,516	59,107 84,774 103,355	73,883 105,967 129,194	88,660 127,161 155,033	193,791
16 18 20	143,808 197,899 262,712	203,376 279,872 371,531		68,456 87,589 109,077	102,684 131,383 163,615	136,911 175,178 218,153	171,139 218,972 272,692	205,367 262,766 327,230	256,709 328,458 409,037
22 24 26	338,879 426,999 527,645	479,247		132,919 159,117 187,669	199,379 238,675 281,504	265,839 318,234 375,338	332,298 397,792 469,173	398,758 477,350 563,007	498,447 596,688 703,759
28 30 32	641,361 768,671 910,079			218,576 251,838 287,455	327,865 377,758 431,183	437,153 503,677 574,910	546,441 629,596 718,638	655,729 755,515 862,366	819,661 944,394 1,077,957
34 36 42	1,066,072 1,237,121 1,845,105			325,427 365,753 500,862	488,140 548,630 751,293	650,854 731,507 1,001,724	813,567 914,384 1,252,155	976,281 1,097,260 1,502,586	1,220,351 1,371,575 1,878,232
48 54 60	Velocity	Governs	with	657,164 834,660 1,033,349	985,746 1,251,989 1,550,023	1,314,328 1,669,319 2,066,697	1,642,910 2,086,649 2,583,372	1,971,492 2,503,979 3,100,046	2,464,365 3,129,973 3,875,057
72 84 96	these	Pipe	Sizes	1,494,307 2,040,040 2,670,546	2,241,461 3,060,060 4,005,820	2,988,614 4,080,080 5,341,093	3,735,768 5,100,099 6,676,366	4,482,922 6,120,119 8,011,639	5,603,652 7,650,149 10,014,549

- 1. Maximum recommended pressure drop / velocity: 1.0 Psig/100 Ft. / 12,000 Fpm.
- 2. Table based on Standard Weight Steel Pipe using Steam Equations in Part 5.

				STEAN	IFLOW LB	S./HR.			
PIPE SIZE		ESSURE DR PSIG/100 FT.			,	VELOCITY	FPM (MPH))	
	1	2	5	4,000 (45)	6,000 (68)	8,000 (91)	10,000 (114)	12,000 (136)	15,000 (170)
1/2 3/4 1	34 78 156	48 110 221	77 174 350		Pressure these	Drop Pipe	Governs Sizes	with	
1-1/4 1-1/2 2	344 534 1,084	487 756 1,533	770 1,195 2,424	1,051 1,733					
2-1/2 3 4	1,785 3,268 6,905	2,525 4,622 9,766	3,992 7,308 15,441	2,472 3,817 6,573	3,708 5,726 9,860	13,146			
5 6 8	12,707 20,971 43,654	17,971 29,657 61,735	28,414 46,892	10,289 14,917 25,831	15,433 22,376 38,746	20,578 29,834 51,661	25,722 37,293 64,577	44,751 77,492	96,865
10 12 14	79,659 127,850 165,603	112,655 180,808 234,198		40,715 58,396 71,195	61,073 87,594 106,793	81,430 116,792 142,391	101,788 145,990 177,988	122,145 175,188 213,586	152,682 218,985 266,983
16 18 20	238,712 328,499 436,083	337,590		94,310 120,670 150,273	141,466 181,005 225,410	188,621 241,339 300,546	235,776 301,674 375,683	282,931 362,009 450,820	353,664 452,511 563,524
22 24 26	562,515 708,789 875,854			183,121 219,213 258,549	274,681 328,819 387,823	366,242 438,426 517,098	457,802 548,032 646,372	549,363 657,638 775,647	686,703 822,048 969,559
28 30 32	1,064,614 1,275,940			301,129 346,954 396,023	451,694 520,431 594,034	602,259 693,908 792,045	752,823 867,385 990,057	903,388 1,040,862 1,188,068	1,129,235 1,301,077 1,485,085
34 36 42				448,336 503,893 690,030	672,504 755,839 1,035,045	896,671 1,007,786 1,380,060	1,120,839 1,259,732 1,725,075	1,345,007 1,511,679 2,070,090	1,681,259 1,889,599 2,587,612
48 54 60	Velocity	Governs	with	905,365 1,149,898 1,423,629	1,358,047 1,724,847 2,135,443	1,810,730 2,299,796 2,847,258	2,263,412 2,874,745 3,559,072	2,716,095 3,449,694 4,270,886	3,395,119 4,312,117 5,338,608
72 84 96	these	Pipe	Sizes	2,058,684 2,810,532 3,679,171	3,088,027 4,215,798 5,518,757	4,117,369 5,621,064 7,358,343	5,146,711 7,026,330 9,197,928		7,720,067 10,539,495 13,796,893

- Maximum recommended pressure drop / velocity: 2.0 Psig/100 Ft. / 15,000 Fpm.
 Table based on Standard Weight Steel Pipe using Steam Equations in Part 5.

				STEAM	M FLOW LE	BS./HR.	-		
PIPE SIZE		ESSURE DR PSIG/100 FT			,	VELOCITY	FPM (MPH)	
	1	2	5	4,000 (45)	6,000 (68)	8,000 (91)	10,000 (114)	12,000 (136)	15,000 (170)
1/2 3/4 1	37 84 169	52 119 239	83 188 378		Pressure these	Drop Pipe	Governs Sizes	with	
1-1/4 1-1/2 2	372 578 1,173	526 817 1,658	832 1,292 2,622	1,230 2,027					
2-1/2 3 4	1,931 3,535 7,470	2,731 4,999 10,564	4,318 7,905 16,703	2,893 4,466 7,691	6,700 11,537	15,382			
5 6 8	13,746 22,684 47,221	19,439 32,080 66,780	30,736 50,724 105,589	12,039 17,455 30,225	18,059 26,182 45,337	24,078 34,909 60,449	30,098 43,636 75,562	90,674	
10 12 14	86,168 138,298 179,135	121,861 195,583 253,336		47,641 68,330 83,306	71,462 102,494 124,960	95,282 136,659 166,613	119,103 170,824 208,266	142,923 204,989 249,919	
16 18 20	258,219 355,343 471,718	365,176 502,531		110,354 141,197 175,836	165,530 211,795 263,754	220,707 282,394 351,672	275,884 352,992 439,590	331,061 423,590 527,508	
22 24 26	608,481 766,709 947,425			214,272 256,503 302,531	321,407 384,755 453,796	428,543 513,006 605,061	535,679 641,258 756,327	642,815 769,509 907,592	803,518 961,886 1,134,490
28 30 32	1,151,610 1,380,205 1,634,114			352,354 405,974 463,390	528,532 608,961 695,085	704,709 811,948 926,780	880,886 1,014,935 1,158,475	1,057,063 1,217,922 1,390,170	1,321,329 1,522,403 1,737,713
34 36 42	1,914,211			524,602 589,610 807,411	786,903 884,415 1,211,116	1,049,204 1,179,220 1,614,822	1,311,505 1,474,025 2,018,527	1,573,806 1,768,830 2,422,232	1,967,257 2,211,038 3,027,790
48 54 60	Velocity	Governs	with	1,059,376 1,345,507 1,665,802	1,589,065 2,018,260 2,498,703	2,118,753 2,691,013 3,331,604	2,648,441 3,363,767 4,164,505	3,178,129 4,036,520 4,997,406	3,972,661 5,045,650 6,246,757
72 84 96	these	Pipe	Sizes	2,408,887 3,288,631 4,305,034	3,613,330 4,932,946 6,457,551	4,817,773 6,577,262 8,610,068	6,022,217 8,221,577 10,762,586		9,033,325 12,332,366 16,143,878

- 1. Maximum recommended pressure drop / velocity: 2.0 Psig/100 Ft. / 15,000 Fpm.
- 2. Table based on Standard Weight Steel Pipe using Steam Equations in Part 5.

STEAM FLOW LBS./HR.									
PIPE SIZE	PRESSURE DROP PSIG/100 FT.			VELOCITY FPM (MPH)					
I SIZIC	1	2	5	4,000 (45)	6,000 (68)	8,000 (91)	10,000 (114)	12,000 (136)	15,000 (170)
1/2 3/4 1	44 101 203	63 143 287	99 225 453		Pressure these	Drop Pipe	Governs Sizes	with	
1-1/4 1-1/2 2	446 693 1,405	631 980 1,987	998 1,549 3,142	2,912		9) (j
2-1/2 3 4	2,314 4,236 8,952	3,273 5,991 12,660	5,175 9,473 20,017	4,154 6,414 11,046	16,568		,		
5 6 8	16,473 27,185 56,589	23,296 38,445 80,029	36,834 60,787 126,536	17,290 25,067 43,407	25,935 37,601 65,110	34,579 50,134 86,814	108,517		
10 12 14	103,263 165,735 214,674	146,036 234,384 303,595	230,904	68,419 98,131 119,639	102,629 147,196 179,459	136,838 196,262 239,279	171,048 245,327 299,099	205,258 294,392 358,918	367,990 448,648
16 18 20	309,447 425,840 565,302	437,623 602,228 799,458		158,483 202,778 252,525	237,724 304,167 378,787	316,966 405,556 505,050	396,207 506,945 631,312	475,449 608,334 757,575	594,311 760,418 946,968
22 24 26	729,198 918,816 1,135,385	1,031,241 1,299,402 1,605,676		307,724 368,374 434,476	461,585 552,561 651,714	615,447 736,748 868,952	769,309 920,934 1,086,189	923,171 1,105,121 1,303,427	1,153,963 1,381,402 1,629,284
28 30 32	1,380,078 1,654,023 1,958,305			506,029 583,035 665,492	759,044 874,552 998,238	1,012,059 1,166,070 1,330,984	1,265,074 1,457,587 1,663,730	1,518,088 1,749,105 1,996,476	
34 36 42	2,293,971 2,662,034 3,970,291			753,401 846,761 1,159,553	1,130,101 1,270,142 1,739,330	1,506,802 1,693,523 2,319,107	1,883,502 2,116,903 2,898,883	2,260,202 2,540,284 3,478,660	2,825,253 3,175,355 4,348,325
48 54 60	5,603,917			1,521,411 1,932,333 2,392,321	2,282,116 2,898,500 3,588,482	3,042,821 3,864,666 4,784,643	3,803,526 4,830,833 5,980,803	4,564,232 5,797,000 7,176,964	7,246,250
72 84 96	Velocity these	Governs Pipe	with Sizes	3,459,494 4,722,928 6,182,623	5,189,240 7,084,391 9,273,934	6,918,987 9,445,855 12,365,246	8,648,734 11,807,319 15,456,557		17,710,978

- 1. Maximum recommended pressure drop / velocity: 5.0 Psig/100 Ft. / 15,000 Fpm.
- 2. Table based on Standard Weight Steel Pipe using Steam Equations in Part 5.

250 Psig Steam Piping Systems-Steel Pipe

				STEAT	MELOW	ре дій					
PIPE SIZE		ESSURE DE		SIEA	STEAM FLOW LBS./HR. VELOCITY FPM (MPH)						
	1	2	5	4,000 (45)	6,000 (68)	8,000 (91)	10,000 (114)	12,000 (136)	15,000 (170)		
1/2 3/4 1	47 106 213	66 150 301	104 236 476		Pressure these	Drop Pipe	Governs Sizes	with			
1-1/4 1-1/2 2	468 727 1,474	662 1,028 2,085	1,047 1,625 3,297	3,205							
2-1/2 3 4	2,428 4,445 9,392	3,434 6,286 13,283	5,430 9,939 21,002	4,573 7,061 12,160	18,239						
5 6 8	17,283 28,522 59,374	24,442 40,337 83,967	38,647 63,778 132,764	19,033 27,595 47,784	28,550 41,393 71,676	55,190					
10 12 14	108,345 173,891 225,238	153,223 245,919 318,535	242,267 388,831	75,319 108,027 131,705	112,978 162,040 197,557		270,067	324,080			
16 18 20	324,675 446,796 593,122	459,160 631,865 838,801		174,465 223,227 277,991	261,698 334,841 416,986	348,930 446,455 555,982	558,068	669,682	837,102		
22 24 26	765,083 964,032 1,191,259	1,081,991 1,363,348 1,684,694		338,756 405,522 478,291	508,134 608,284 717,436	677,512 811,045 956,581	846,890 1,013,806 1,195,726	1,216,567	1,520,709		
28 30 32	1,447,994 1,735,421 2,054,677	2,047,773		557,060 641,831 732,604	835,590 962,747 1,098,905	1,114,120 1,283,662 1,465,207	1,392,650 1,604,578 1,831,509	1,925,493			
34 36 42	2,406,861 2,793,037 4,165,676			829,378 932,153 1,276,489	1,244,067 1,398,230 1,914,733	1,658,755 1,864,306 2,552,977	2,073,444 2,330,383 3,191,222	2,488,133 2,796,460 3,829,466	3,495,574		
48 54 60	5,879,695 7,959,549			1,674,837 2,127,200 2,633,575	2,512,256 3,190,800 3,950,363	3,349,675 4,254,399 5,267,151	4,187,094 5,317,999 6,583,938	5,024,512 6,381,599 7,900,726			
72 84 96	Velocity these	Governs Pipe	with Sizes	3,808,367 5,199,212 6,806,111	5,712,550 7,798,818 10,209,166	7,616,734 10,398,424 13,612,221		15,597,636	14,281,376 19,497,045 25,522,915		

- Maximum recommended pressure drop / velocity: 5.0 Psig/100 Ft. / 15,000 Fpm.
 Table based on Standard Weight Steel Pipe using Steam Equations in Part 5.

31.02 Steam Condensate Systems

Steam Condensate System Design Criteria

			0	
SYSTEM TYPE	INITIAL STEAM PRESSURE PSIG	MAXIMUM SYSTEM BACK PRESSURE PSIG	MAXIMUM PRESSURE DROP PSIG/100 FT.	MAXIMUM VELOCITY FPM
	1	0	1/8	2,000
	3	0	1/8	2,000
	5	0	1/8	2,000
LOW PRESSURE	7 10 12 15	0 3 4 5	1/8 1/4 1/4 1/4	2,000 3,000 3,000 3,000
	20	6	1/4	3,000
	25	8	1/4	3,000
	30	10	1/4	3,000
MEDIUM PRESSURE	40 50 60	13 16 20	1/4 1/4 1/4	3,000 3,000 3,000
	75	25	1/4	3,000
	85	28	1/4	3,000
	100	33	1/4	3,000
	120	40	1/4	3,000
	125	41	1/4	3,000
	150	50	1/4	4,000
HIGH PRESSURE	175 200 225	58 66 75	1/4 1/2 1/2	4,000 4,000 4,000
	250	83	1/2	4,000
	275	91	1/2	4,000
	300	100	1/2	4,000

			STEAM CON	DENICATE EL	OW LBS./HR.		
				G BACK PRES			
PIPE SIZE	Pl	RESSURE DRO PSIG/100 FT.	OP		VELOCITY	FPM (MPH)	
	0.125	0.25	0.5	2,000 (23)	3,000 (34)	4,000 (45)	5,000 (57)
1/2 3/4 1	843 2,067 4,329	1,192 2,923 6,122	1,686 4,134 8,658	3,954 6,577	Pressure with these	Drop Pipe	Governs with
1-1/4 1-1/2 2	9,965 15,758 32,660	14,093 22,285 46,189	19,930 31,515 65,321	11,729 16,158 27,000	17,594 24,237 40,500	54,000	
2-1/2 3 4	54,310 100,865 216,701	76,806 142,645		38,753 60,396 105,124	58,130 90,594 157,686	77,507 120,792 210,247	96,883 150,989 262,809
5 6 8	405,300			166,358 238,345 417,533	249,536 357,518 626,299	332,715 476,690 835,065	415,894 595,863 1,043,831
10 12 14				682,684 991,486 1,213,661	1,024,026 1,487,228 1,820,491	1,365,369 1,982,971 2,427,322	1,706,711 2,478,714 3,034,152
16 18 20				1,615,821 2,075,432 2,592,495	2,423,731 3,113,148 3,888,742	3,231,642 4,150,864 5,184,990	4,039,552 5,188,580 6,481,237
22 24 26				3,167,009 3,798,974 4,488,391	4,750,513 5,698,462 6,732,587	6,334,018 7,597,949 8,976,782	7,917,522 9,497,436 11,220,978
28 30 32				5,235,260 6,039,579 6,901,350	7,852,889 9,059,369 10,352,026	10,470,519 12,079,159 13,802,701	13,088,149 15,098,948 17,253,376
34 36 42	Velocity	Governs	with	7,820,573 8,797,247 12,071,977	11,730,859 13,195,870 18,107,966	15,641,146 17,594,494 24,143,954	19,551,432 21,993,117 30,179,943
48 54 60	these	Pipe	Sizes	15,863,770 20,172,626 24,998,544	23,795,655 30,258,938 37,497,816	31,727,540 40,345,251 49,997,088	39,659,425 50,431,564 62,496,360
72 84 96				36,201,568 49,472,844 64,812,370	54,302,353 74,209,266 97,218,554	72,403,137 98,945,687 129,624,739	90,503,921 123,682,109 162,030,924

- 1. Maximum recommended pressure drop / velocity: 0.125 Psig/100 Ft. / 2,000 Fpm.
- 2. Table based on Heavy Weight Steel Pipe using Steam Equations in Part 5.

			STEAM CON	DENISATE EL	OW LBS./HR.		
				G BACK PRES			
PIPE SIZE	PF	RESSURE DRO PSIG/100 FT.	P		VELOCITY	FPM (MPH)	
	0.125	0.25	0.5	2,000 (23)	3,000 (34)	4,000 (45)	5,000 (57)
1/2 3/4 1	183 449 940	259 635 1,329	366 898 1,880	858 1,428	Pressure with these	Drop Pipe	Governs Sizes
1-1/4 1-1/2 2	2,163 3,421 7,091	3,060 4,838 10,028	4,327 6,842 14,182	2,546 3,508 5,862	3,820 5,262 8,793	11,724	
2-1/2 3 4	11,791 21,898 47,047	16,675 30,969		8,414 13,112 22,823	12,620 19,668 34,234	16,827 26,224 45,646	21,034 32,781 57,057
5 6 8	87,993	1		36,117 51,746 90,649	54,176 77,619 135,973	72,234 103,492 181,297	90,293 129,365 226,621
10 12 14		*		148,214 215,257 263,492	222,322 322,885 395,238	296,429 430,513 526,984	370,536 538,142 658,730
16 18 20				350,803 450,587 562,844	526,205 675,881 844,266	701,606 901,174 1,125,689	877,008 1,126,468 1,407,111
22 24 26	7		ı	687,574 824,777 974,453	1,031,361 1,237,166 1,461,680	1,375,149 1,649,555 1,948,907	1,718,936 2,061,943 2,436,133
28 30 32				1,136,602 1,311,224 1,498,319	1,704,904 1,966,837 2,247,479	2,273,205 2,622,449 2,996,639	2,841,506 3,278,061 3,745,799
34 36 42	Velocity	Governs	with	1,697,888 1,909,929 2,620,890	2,546,831 2,864,893 3,931,335	3,395,775 3,819,857 5,241,780	4,244,719 4,774,821 6,552,224
48 54 60	these	Pipe	Sizes	3,444,108 4,379,583 5,427,315	5,166,162 6,569,375 8,140,973	6,888,216 8,759,166 10,854,631	8,610,270 10,948,958 13,568,289
72 84 96				7,859,551 10,740,815 14,071,107	11,789,327 16,111,222 21,106,660	15,719,102 21,481,629 28,142,213	19,648,878 26,852,037 35,177,766

- 1. Maximum recommended pressure drop / velocity: 0.125 Psig/100 Ft. / 2,000 Fpm.
- 2. Table based on Heavy Weight Steel Pipe using Steam Equations in Part 5.

				IDENSATE FL IG BACKPRES	OW LBS./HR SURE		
PIPE SIZE	Pl	RESSURE DRO PSIG/100 FT.)P		VELOCITY	FPM (MPH)	
	0.125	0.25	0.5	2,000 (23)	3,000 (34)	4,000 (45)	5,000 (57)
1/2 3/4 1	240 590 1,235	340 834 1,746	481 1,179 2,470	1,163 1,934	Pressure with these	Drop Pipe	Governs Sizes
1-1/4 1-1/2 2	2,843 4,495 9,317	4,020 6,357 13,176	5,685 8,990 18,634	3,450 4,752 7,941	5,175 7,128 11,911	15,882	
2-1/2 3 4	15,493 28,773 61,817	21,910 40,691		11,398 17,763 30,918	17,097 26,644 46,377	22,795 35,526 61,836	28,494 44,407 77,295
5 6 8	115,617			48,927 70,100 122,800	73,391 105,149 184,200	97,855 140,199 245,600	122,318 175,249 307,001
10 12 14				200,784 291,605 356,949	301,176 437,408 535,423	401,568 583,210 713,898	501,960 729,013 892,372
16 18 20	7			475,228 610,404 762,477	712,842 915,606 1,143,715	950,456 1,220,808 1,524,954	1,188,070 1,526,010 1,906,192
22 24 26				931,447 1,117,314 1,320,078	1,397,170 1,675,971 1,980,116	1,862,894 2,234,627 2,640,155	2,328,617 2,793,284 3,300,194
28 30 32		×		1,539,739 1,776,296 2,029,751	2,309,608 2,664,445 3,044,627	3,079,477 3,552,593 4,059,503	3,849,346 4,440,741 5,074,378
34 36 42	Velocity	Governs	with	2,300,103 2,587,352 3,550,481	3,450,155 3,881,028 5,325,721	4,600,207 5,174,704 7,100,962	5,750,258 6,468,380 8,876,202
48 54 60	these	Pipe	Sizes	4,665,682 5,932,957 7,352,304	6,998,524 8,899,435 11,028,457	9,331,365 11,865,914 14,704,609	11,664,206 14,832,392 18,380,761
72 84 96				10,647,218 14,550,424 19,061,921	15,970,827 21,825,635 28,592,881	21,294,436 29,100,847 38,123,842	26,618,045 36,376,059 47,654,802

- 1. Maximum recommended pressure drop / velocity: 0.25 Psig/100 Ft. / 3,000 Fpm.
- 2. Table based on Heavy Weight Steel Pipe using Steam Equations in Part 5.

				DENSATE FLO G BACK PRES			
PIPE SIZE	PF	RESSURE DRO	P		VELOCITY	FPM (MPH)	7 77 1
	0.125	0.25	0.5	2,000 (23)	3,000 (34)	4,000 (45)	5,000 (57)
1/2 3/4 1	167 408 855	236 578 1,210	333 817 1,711	1,417	Pressure with these	Drop Pipe	Governs Sizes
1-1/4 1-1/2 2	1,969 3,113 6,453	2,784 4,403 9,126	3,938 6,227 12,906	2,527 3,481 5,817	3,791 5,222 8,726	11,635	
2-1/2 3 4	10,730 19,928 42,814	15,175 28,183		8,350 13,013 22,649	12,524 19,519 33,974	16,699 26,025 45,299	20,874 32,531 56,623
5 6 8	80,076			35,842 51,352 89,959	53,764 77,029 134,939	71,685 102,705 179,918	89,606 128,381 224,898
10 12 14				147,087 213,620 261,488	220,631 320,429 392,232	294,174 427,239 522,976	367,718 534,049 653,721
16 18 20				348,135 447,160 558,564	522,203 670,740 837,845	696,270 894,321 1,117,127	870,338 1,117,901 1,396,409
22 24 26	0			682,345 818,504 967,042	1,023,517 1,227,757 1,450,563	1,364,690 1,637,009 1,934,084	1,705,862 2,046,261 2,417,605
28 30 32			el .	1,127,958 1,301,252 1,486,924	1,691,937 1,951,878 2,230,386	2,255,916 2,602,504 2,973,848	2,819,895 3,253,130 3,717,310
34 36 42	Velocity	Governs	with	1,684,974 1,895,403 2,600,957	2,527,461 2,843,104 3,901,435	3,369,949 3,790,805 5,201,913	4,212,436 4,738,507 6,502,392
48 54 60	these	Pipe	Sizes	3,417,914 4,346,274 5,386,038	5,126,871 6,519,411 8,079,057	6,835,828 8,692,549 10,772,076	8,544,785 10,865,686 13,465,095
72 84 96				7,799,775 10,659,126 13,964,089	11,699,663 15,988,688 20,946,133	15,599,551 21,318,251 27,928,178	19,499,438 26,647,814 34,910,222

^{1.} Maximum recommended pressure drop / velocity: 0.25 Psig/100 Ft. / 3,000 Fpm.

^{2.} Table based on Heavy Weight Steel Pipe using Steam Equations in Part 5.

	-			NDENSATE FI	LOW LBS./HR		
PIPE SIZE	P	PRESSURE DR		I DACK I KE		FPM (MPH)	
	0.125	0.25	0.5	2,000 (23)	3,000 (34)	4,000 (45)	5,000 (57)
1/2 3/4 1	87 213 446	123 301 631	174 426 893	408 678	Pressure with these	Drop Pipe	Governs Sizes
1-1/4 1-1/2 2	1,028 1,625 3,368	1,453 2,298 4,763	2,055 3,250 6,736	1,210 1,666 2,784	1,814 2,499 4,177	5,569	
2-1/2 3 4	5,601 10,402 22,347	7,921 14,710		3,996 6,228 10,841	5,995 9,342 16,261	7,993 12,457 21,682	9,991 15,571 27,102
5 6 8	41,797			17,156 24,579 43,058	25,733 36,869 64,587	34,311 49,159 86,116	42,889 61,448 107,645
10 12 14				70,402 102,247 125,159	105,603 153,370 187,738	140,804 204,494 250,318	176,005 255,617 312,897
16 18 20				166,632 214,029 267,351	249,947 321,043 401,027	333,263 428,058 534,702	416,579 535,072 668,378
22 24 26		2		326,598 391,769 462,865	489,897 587,654 694,298	653,196 783,538 925,731	816,494 979,423 1,157,163
28 30 32				539,886 622,832 711,702	809,829 934,247 1,067,553	1,079,772 1,245,663 1,423,404	1,349,715 1,557,079 1,779,254
34 36 42	Velocity	Governs	with	806,497 907,216 1,244,923	1,209,745 1,360,824 1,867,384	1,612,993 1,814,432 2,489,845	2,016,241 2,268,040 3,112,307
48 54 60	these	Pipe	Sizes	1,635,951 2,080,302 2,577,975	2,453,927 3,120,453 3,866,962	3,271,903 4,160,604 5,155,950	4,089,878 5,200,755 6,444,937
72 84 96				3,733,287 5,101,887 6,683,776	5,599,930 7,652,831 10,025,663	7,466,573 10,203,774 13,367,551	9,333,217 12,754,718 16,709,439

Notes:

1. Maximum recommended pressure drop / velocity: 0.25 Psig/100 Ft. / 3,000 Fpm.

2. Table based on Heavy Weight Steel Pipe using Steam Equations in Part 5.

				IDENSATE FLO			
PIPE SIZE	P	RESSURE DRO PSIG/100 FT.				FPM (MPH)	
	0.125	0.25	0.5	2,000 (23)	3,000 (34)	4,000 (45)	5,000 (57)
1/2 3/4 1	73 179 375	103 253 530	146 358 750	342 570	Pressure with these	Drop Pipe	Governs Sizes
1-1/4 1-1/2 2	863 1,365 2,829	1,221 1,930 4,001	1,726 2,730 5,658	1,016 1,400 2,339	1,524 2,099 3,508	4,677	
2-1/2 3 4	4,704 8,736 18,769	6,652 12,355	9 30 42	3,357 5,231 9,105	5,035 7,847 13,658	6,713 10,462 18,210	8,391 13,078 22,763
5 6 8	35,105		200	14,409 20,644 36,164	21,613 30,966 54,246	28,818 41,288 72,328	36,022 51,610 90,411
10 12 14				59,130 85,877 105,120	88,695 128,815 157,680	118,260 171,753 210,240	147,825 214,692 262,801
16 18 20				139,953 179,762 224,547	209,929 269,643 336,820	279,906 359,524 449,094	349,882 449,405 561,367
22 24 26				274,308 329,045 388,758	411,462 493,568 583,137	548,616 658,090 777,517	685,770 822,613 971,896
28 30 32				453,448 523,113 597,755	680,172 784,670 896,632	906,895 1,046,226 1,195,510	1,133,619 1,307,783 1,494,387
34 36 42	Velocity	Governs	with	677,372 761,966 1,045,604	1,016,059 1,142,949 1,568,406	1,354,745 1,523,933 2,091,209	1,693,431 1,904,916 2,614,011
48 54 60	these	Pipe	Sizes	1,374,027 1,747,235 2,165,228	2,061,041 2,620,853 3,247,842	2,748,055 3,494,471 4,330,456	3,435,068 4,368,088 5,413,071
72 84 96		*		3,135,569 4,285,049 5,613,670	4,703,353 6,427,574 8,420,505	6,271,138 8,570,099 11,227,340	7,838,922 10,712,624 14,034,175

- 1. Maximum recommended pressure drop / velocity: 0.25 Psig/100 Ft. / 3,000 Fpm.
- 2. Table based on Heavy Weight Steel Pipe using Steam Equations in Part 5.

				NDENSATE FLOW LBS./HR IG BACKPRESSURE					
PIPE SIZE	PF	RESSURE DRO PSIG/100 FT.	P		VELOCITY	FPM (MPH)			
	0.125	0.25	0.5	2,000 (23)	3,000 (34)	4,000 (45)	5,000 (57)		
1/2 3/4 1	82 202 422	116 285 597	164 403 845	398 661	Pressure with these	Drop Pipe	Governs Sizes		
1-1/4 1-1/2 2	972 1,537 3,186	1,375 2,174 4,506	1,944 3,074 6,372	1,180 1,625 2,715	1,769 2,438 4,073	5,431			
2-1/2 3 4	5,298 9,839 21,139	7,492 13,915		3,897 6,074 10,572	5,846 9,111 15,859	7,795 12,148 21,145	9,744 15,185 26,431		
5 6 8	39,536		2	16,731 23,971 41,992	25,096 35,956 62,988	33,462 47,942 83,984	41,827 59,927 104,980		
10 12 14		-		68,659 99,716 122,060	102,988 149,573 183,090	137,318 199,431 244,120	171,647 249,289 305,150		
16 18 20				162,506 208,730 260,732	243,759 313,095 391,098	325,012 417,460 521,464	406,265 521,825 651,830		
22 24 26			ě	318,512 382,070 451,406	477,768 573,105 677,109	637,024 764,140 902,812	796,280 955,175 1,128,515		
28 30 32				526,520 607,412 694,082	789,780 911,118 1,041,122	1,053,040 1,214,823 1,388,163	1,316,299 1,518,529 1,735,204		
34 36 42	Velocity	Governs	with	786,530 884,755 1,214,101	1,179,794 1,327,133 1,821,152	1,573,059 1,769,511 2,428,202	1,966,324 2,211,889 3,035,253		
48 54 60	these	Pipe	Sizes	1,595,449 2,028,798 2,514,150	2,393,173 3,043,198 3,771,225	3,190,898 4,057,597 5,028,300	3,988,622 5,071,996 6,285,375		
72 84 96				3,640,859 4,975,576 6,518,301	5,461,289 7,463,364 9,777,451	7,281,718 9,951,152 13,036,601	9,102,148 12,438,940 16,295,751		

- $1. \ \ Maximum\ recommended\ pressure\ drop\ /\ velocity: 0.25\ Psig/100\ Ft.\ /\ 3,000\ Fpm.$
- 2. Table based on Heavy Weight Steel Pipe using Steam Equations in Part 5.

			STEAM CON	DENSATE FL	OW LBS./HR				
			7 PSI	IG BACKPRESSURE					
PIPE SIZE	Pl	RESSURE DRO PSIG/100 FT.)P		VELOCITY	FPM (MPH)			
	0.125	0.25	0.5	2,000 (23)	3,000 (34)	4,000 (45)	5,000 (57)		
1/2 3/4 1	123 301 631	174 426 892	246 602 1,262	1,150	Pressure with these	Drop Pipe	Governs Sizes		
1-1/4 1-1/2 2	1,452 2,296 4,759	2,053 3,247 6,730	2,904 4,592 9,518	2,050 2,824 4,719	4,236 7,079	9,438			
2-1/2 3 4	7,913 14,697 31,575	11,191 20,785 44,654	15,827	6,773 10,556 18,374	10,160 15,834 27,560	13,547 21,112 36,747	26,390 45,934		
5 6 8	59,055 96,011			29,076 41,658 72,976	43,614 62,487 109,464	58,152 83,316 145,953	72,690 104,145 182,441		
10 12 14		8	a 2	119,320 173,292 212,124	178,979 259,938 318,185	238,639 346,584 424,247	298,299 433,230 530,309		
16 18 20				282,413 362,744 453,116	423,620 544,116 679,674	564,826 725,488 906,232	706,033 906,860 1,132,790		
22 24 26			-	553,530 663,985 784,481	830,294 995,977 1,176,721	1,107,059 1,327,969 1,568,962	1,383,824 1,659,961 1,961,202		
28 30 32				915,018 1,055,597 1,206,218	1,372,528 1,583,396 1,809,327	1,830,037 2,111,195 2,412,435	2,287,546 2,638,993 3,015,544		
34 36 42	Velocity	Governs	with	1,366,879 1,537,582 2,109,940	2,050,319 2,306,374 3,164,909	2,733,759 3,075,165 4,219,879	3,417,198 3,843,956 5,274,849		
48 54 60	these	Pipe	Sizes	2,772,669 3,525,771 4,369,244	4,159,003 5,288,656 6,553,866	5,545,338 7,051,541 8,738,489	6,931,672 8,814,426 10,923,111		
72 84 96				6,327,308 8,646,861 11,327,903	9,490,963 12,970,292 16,991,854	12,654,617 17,293,722 22,655,806	15,818,271 21,617,153 28,319,757		

- $1.\ Maximum\ recommended\ pressure\ drop\ /\ velocity:\ 0.25\ Psig/100\ Ft.\ /\ 3,000\ Fpm.$ $2.\ Table\ based\ on\ Heavy\ Weight\ Steel\ Pipe\ using\ Steam\ Equations\ in\ Part\ 5.$

			OTTE AN ACCOUNT		-				
I				NDENSATE FLOW LBS./HR. SIG BACK PRESSURE					
PIPE SIZE	P.	RESSURE DRO PSIG/100 FT.	OP		VELOCITY	FPM (MPH)			
	0.125	0.25	0.5	2,000 (23)	3,000 (34)	4,000 (45)	5,000 (57)		
1/2 3/4 1	50 123 257	71 174 364	100 246 515	235 391	Pressure with these	Drop Pipe	Governs Sizes		
1-1/4 1-1/2 2	593 937 1,942	838 1,325 2,746	1,185 1,874 3,884	697 961 1,605	1,046 1,441 2,408	3,211			
2-1/2 3 4	3,229 5,997 12,885	4,567 8,482		2,304 3,591 6,251	3,456 5,387 9,376	4,609 7,182 12,501	5,761 8,978 15,626		
5 6 8	24,099			9,892 14,172 24,826	14,837 21,258 37,239	19,783 28,344 49,653	24,729 35,430 62,066		
10 12 14				40,592 58,953 72,164	60,888 88,430 108,245	81,184 117,906 144,327	101,480 147,383 180,409		
16 18 20				96,076 123,404 154,148	144,114 185,106 231,223	192,152 246,808 308,297	240,190 308,510 385,371		
22 24 26				188,309 225,885 266,877	282,463 338,827 400,316	376,617 451,770 533,755	470,772 564,712 667,193		
28 30 32				311,286 359,110 410,351	466,929 538,665 615,526	622,571 718,220 820,701	778,214 897,775 1,025,876		
34 36 42	Velocity	Governs	with	465,007 523,080 717,793	697,511 784,619 1,076,690	930,014 1,046,159 1,435,586	1,162,518 1,307,699 1,794,483		
48 54 60	these	Pipe	Sizes	943,251 1,199,453 1,486,400	1,414,877 1,799,180 2,229,600	1,886,502 2,398,907 2,972,800	2,358,128 2,998,634 3,716,000		
72 84 96				2,152,526 2,941,629 3,853,708	3,228,789 4,412,443 5,780,563	4,305,051 5,883,257 7,707,417	5,381,314 7,354,071 9,634,271		

Notes:

Maximum recommended pressure drop / velocity: 0.25 Psig/100 Ft. / 3,000 Fpm.
 Table based on Heavy Weight Steel Pipe using Steam Equations in Part 5.

				DENSATE FLO	OW LBS./HR.		
PIPE SIZE	PI	RESSURE DRO PSIG/100 FT.				FPM (MPH)	
	0.125	0.25	0.5	2,000 (23)	3,000 (34)	4,000 (45)	5,000 (57)
1/2 3/4 1	44 108 227	63 153 321	88 217 454	207 345	Pressure with these	Drop Pipe	Governs Sizes
1-1/4 1-1/2 2	523 827 1,714	739 1,169 2,423	1,046 1,653 3,427	615 848 1,417	923 1,272 2,125	2,833	
2-1/2 3 4	2,849 5,292 11,369	4,030 7,484	9	2,033 3,169 5,515	3,050 4,753 8,273	4,066 6,337 11,030	5,083 7,922 13,788
5 6 8	21,264			8,728 12,505 21,906	13,092 18,757 32,858	17,456 25,009 43,811	21,820 31,261 54,764
10 12 14				35,817 52,018 63,674	53,725 78,026 95,511	71,633 104,035 127,348	89,541 130,044 159,184
16 18 20		9		84,773 108,886 136,013	127,159 163,329 204,020	169,546 217,772 272,026	211,932 272,215 340,033
22 24 26				166,155 199,310 235,480	249,232 298,965 353,220	332,309 398,621 470,960	415,387 498,276 588,700
28 30 32				274,664 316,862 362,074	411,996 475,293 543,111	549,328 633,724 724,148	686,660 792,155 905,185
34 36 42	Velocity	Governs	with	410,300 461,541 633,347	615,450 692,311 950,020	820,601 923,082 1,266,694	1,025,751 1,153,852 1,583,367
48 54 60	these	Pipe	Sizes	832,280 1,058,341 1,311,529	1,248,421 1,587,512 1,967,294	1,664,561 2,116,682 2,623,059	2,080,701 2,645,853 3,278,823
72 84 96				1,899,287 2,595,555 3,400,331	2,848,931 3,893,332 5,100,496	3,798,575 5,191,109 6,800,662	4,748,218 6,488,886 8,500,827

- 1. Maximum recommended pressure drop / velocity: 0.25 Psig/100 Ft. / 3,000 Fpm.
- 2. Table based on Heavy Weight Steel Pipe using Steam Equations in Part 5.

	1		CTEANCO	IDENIGATE	OW 1 DO			
				VDENSATE FLOW LBS./HR. IG BACK PRESSURE				
PIPE SIZE	P	RESSURE DRO PSIG/100 FT.	OP		VELOCITY	FPM (MPH)		
	0.125	0.25	0.5	2,000 (23)	3,000 (34)	4,000 (45)	5,000 (57)	
1/2 3/4 1	66 162 340	94 230 481	132 325 680	592	Pressure with these	Drop Pipe	Governs Sizes	
1-1/4 1-1/2 2	782 1,237 2,564	1,107 1,750 3,627	1,565 2,475 5,129	1,056 1,455 2,431	2,182 3,646	4,861		
2-1/2 3 4	4,264 7,920 17,015	6,031 11,200	8,529	3,489 5,437 9,464	5,233 8,156 14,196	6,978 10,874 18,928	13,593 23,660	
5 6 8	31,824 51,739			14,977 21,457 37,589	22,465 32,186 56,383	29,953 42,915 75,178	37,441 53,643 93,972	
10 12 14				61,459 89,260 109,261	92,189 133,889 163,892	122,919 178,519 218,523	153,649 223,149 273,153	
16 18 20				145,466 186,843 233,392	218,199 280,265 350,089	290,932 373,686 466,785	363,665 467,108 583,481	
22 24 26				285,114 342,007 404,073	427,671 513,011 606,109	570,227 684,014 808,145	712,784 855,018 1,010,182	
28 30 32				471,310 543,720 621,302	706,966 815,580 931,953	942,621 1,087,441 1,242,604	1,178,276 1,359,301 1,553,256	
34 36 42	Velocity	Governs	with	704,056 791,983 1,086,794	1,056,084 1,187,974 1,630,191	1,408,113 1,583,965 2,173,588	1,760,141 1,979,956 2,716,985	
48 54 60	these	Pipe	Sizes	1,428,155 1,816,064 2,250,523	2,142,232 2,724,097 3,375,785	2,856,309 3,632,129 4,501,047	3,570,387 4,540,161 5,626,309	
72 84 96				3,259,089 4,453,851 5,834,810	4,888,633 6,680,777 8,752,215	6,518,178 8,907,702 11,669,620	8,147,722 11,134,628 14,587,025	

 $^{1. \ \} Maximum\ recommended\ pressure\ drop\ /\ velocity; 0.25\ Psig/100\ Ft.\ /\ 3,000\ Fpm.$

^{2.} Table based on Heavy Weight Steel Pipe using Steam Equations in Part 5.

				DENSATE FLO					
PIPE SIZE	PF	PRESSURE DROP PSIG/100 FT.			VELOCITY FPM (MPH)				
	0.125	0.25	0.5	2,000 (23)	3,000 (34)	4,000 (45)	5,000 (57)		
1/2 3/4 1	59 146 305	84 206 432	119 291 610	556	Pressure with these	Drop Pipe	Governs Sizes		
1-1/4 1-1/2 2	702 1,111 2,302	993 1,571 3,256	1,405 2,221 4,604	992 1,366 2,283	2,049 3,424	4,566			
2-1/2 3 4	3,828 7,110 15,275	5,414 10,055 21,602	7,656	3,277 5,106 8,888	4,915 7,660 13,332	6,553 10,213 17,777	12,766 22,221		
5 6 8	28,568 46,446			14,066 20,152 35,303	21,098 30,228 52,954	28,131 40,304 70,605	35,164 50,381 88,257		
10 12 14				57,721 83,831 102,616	86,582 125,746 153,924	115,443 167,661 205,232	144,303 209,577 256,539		
16 18 20				136,619 175,479 219,197	204,928 263,219 328,795	273,237 350,958 438,394	341,547 438,698 547,992		
22 24 26		٨		267,772 321,206 379,496	401,659 481,808 569,244	535,545 642,411 758,992	669,431 803,014 948,740		
28 30 32				442,644 510,650 583,513	663,966 765,975 875,270	885,289 1,021,300 1,167,026	1,106,611 1,276,625 1,458,783		
34 36 42	Velocity	Governs	with	661,234 743,812 1,020,693	991,851 1,115,719 1,531,039	1,322,468 1,487,625 2,041,386	1,653,085 1,859,531 2,551,732		
48 54 60	these	Pipe	Sizes	1,341,291 1,705,607 2,113,642	2,011,937 2,558,411 3,170,462	2,682,582 3,411,215 4,227,283	3,353,228 4,264,018 5,284,104		
72 84 96			7	3,060,864 4,182,958 5,479,924	4,591,296 6,274,437 8,219,886	6,121,728 8,365,916 10,959,848	7,652,160 10,457,395 13,699,810		

- 1. Maximum recommended pressure drop / velocity: 0.25 Psig/100 Ft. / 3,000 Fpm.
- 2. Table based on Heavy Weight Steel Pipe using Steam Equations in Part 5.

			CTEANCO	IDENIG AME					
			STEAM COL	NDENSATE FI SIG BACK PRE	NDENSATE FLOW LBS./HR. SIG BACK PRESSURE				
PIPE SIZE	P	RESSURE DRO PSIG/100 FT.	OP		VELOCITY	FPM (MPH)			
	0.125	0.25	0.5	2,000 (23)	3,000 (34)	4,000 (45)	5,000 (57)		
1/2 3/4 1	72 177 370	102 250 523	144 353 740	717	Pressure with these	Drop Pipe	Governs Sizes		
1-1/4 1-1/2 2	852 1,347 2,792	1,205 1,905 3,949	1,704 2,694 5,585	1,278 1,761 2,942	2,641 4,414				
2-1/2 3 4	4,643 8,624 18,527	6,567 12,196 26,202	9,287	4,223 6,582 11,456	6,335 9,872 17,184	8,446 13,163 22,912	16,454 28,640		
5 6 8	34,652 56,336			18,129 25,974 45,501	27,193 38,961 68,251	36,258 51,948 91,002	45,322 64,934 113,752		
10 12 14				74,396 108,048 132,259	111,594 162,071 198,389	148,792 216,095 264,518	185,989 270,119 330,648		
16 18 20	10 a 1			176,085 226,171 282,518	264,127 339,256 423,777	352,169 452,342 565,036	440,212 565,427 706,295		
22 24 26			=	345,126 413,995 489,124	517,689 620,992 733,686	690,252 827,989 978,248	862,815 1,034,987 1,222,810		
28 30 32	-			570,514 658,165 752,077	855,771 987,248 1,128,116	1,141,029 1,316,331 1,504,154	1,426,286 1,645,413 1,880,193		
34 36 42	Velocity these	Governs	with	852,250 958,683 1,315,548	1,278,375 1,438,025 1,973,322	1,704,500 1,917,366 2,631,096	2,130,624 2,396,708 3,288,870		
48 54 60	uiese	Pipe	Sizes	1,728,760 2,198,319 2,724,225	2,593,140 3,297,479 4,086,338	3,457,520 4,396,638 5,448,451	4,321,900 5,495,798 6,810,564		
72 84 96				3,945,079 5,391,321 7,062,952	5,917,619 8,086,982 10,594,427	7,890,158 10,782,642 14,125,903	9,862,698 13,478,303 17,657,379		

Maximum recommended pressure drop / velocity: 0.25 Psig/100 Ft. / 3,000 Fpm.
 Table based on Heavy Weight Steel Pipe using Steam Equations in Part 5.

				DENSATE FLO					
PIPE SIZE		PRESSURE DROP PSIG/100 FT.			VELOCITY FPM (MPH)				
	0.125	0.25	0.5	2,000 (23)	3,000 (34)	4,000 (45)	5,000 (57)		
1/2 3/4 1	. 82 201 421	116 284 595	164 402 842		Pressure with these	Drop Pipe	Governs Sizes		
1-1/4 1-1/2 2	969 1,533 3,177	1,371 2,167 4,492	1,938 3,065 6,353	1,508 2,077 3,471	5,207				
2-1/2 3 4	5,282 9,810 21,076	7,470 13,873 29,806	10,564	4,982 7,765 13,515	7,474 11,647 20,273	9,965 15,530 27,031	19,412 33,788		
5 6 8	39,419 64,086			21,388 30,643 53,680	32,082 45,965 80,521	42,776 61,286 107,361	53,470 76,608 134,201		
10 12 14				87,770 127,471 156,035	131,655 191,207 234,053	175,540 254,942 312,070	219,424 318,678 390,088		
16 18 20				207,739 266,829 333,306	311,609 400,244 499,959	415,478 533,659 666,612	519,348 667,074 833,265		
22 24 26				407,169 488,418 577,053	610,753 732,627 865,580	814,338 976,836 1,154,106	1,017,922 1,221,045 1,442,633		
28 30 32				673,075 776,483 887,277	1,009,612 1,164,724 1,330,916	1,346,150 1,552,966 1,774,554	1,682,687 1,941,207 2,218,193		
34 36 42	Velocity	Governs	with	1,005,458 1,131,024 1,552,042	1,508,186 1,696,537 2,328,064	2,010,915 2,262,049 3,104,085	2,513,644 2,827,561 3,880,106		
48 54 60	these	Pipe	Sizes	2,039,537 2,593,508 3,213,956	3,059,305 3,890,262 4,820,934	4,079,074 5,187,016 6,427,911	5,098,842 6,483,770 8,034,889		
72 84 96				4,654,281 6,360,512 8,332,649	6,981,421 9,540,767 12,498,973	9,308,561 12,721,023 16,665,297	11,635,701 15,901,279 20,831,622		

- Maximum recommended pressure drop / velocity: 0.25 Psig/100 Ft. / 3,000 Fpm.
 Table based on Heavy Weight Steel Pipe using Steam Equations in Part 5.

			CTEAN CON	IDENIGATE ET	OW IDO 5TO		
				G BACK PRES	OW LBS./HR. SSURE		
PIPE SIZE	Pl	RESSURE DRO PSIG/100 FT.)P		VELOCITY	FPM (MPH)	
	0.125	0.25	0.5	2,000 (23)	3,000 (34)	4,000 (45)	5,000 (57)
1/2 3/4 1	32 78 164	45 111 232	64 156 328	150 249	Pressure with these	Drop Pipe	Governs Sizes
1-1/4 1-1/2 2	377 596 1,236	533 843 1,748	754 1,193 2,472	444 611 1,022	666 917 1,533	2,044	
2-1/2 3 4	2,055 3,817 8,201	2,907 5,398		1,467 2,286 3,978	2,200 3,428 5,967	2,933 4,571 7,957	3,666 5,714 9,946
5 6 8	15,338			6,296 9,020 15,801	9,443 13,530 23,702	12,591 18,040 31,602	15,739 22,550 39,503
10 12 14				25,836 37,522 45,930	38,753 56,283 68,895	51,671 75,044 91,860	64,589 93,805 114,825
16 18 20				61,149 78,543 98,110	91,724 117,814 147,166	122,298 157,085 196,221	152,873 196,357 245,276
22 24 26				119,852 143,769 169,859	179,779 215,653 254,788	239,705 287,537 339,718	299,631 359,421 424,647
28 30 32				198,123 228,562 261,175	297,185 342,843 391,762	396,247 457,124 522,350	495,308 571,405 652,937
34 36 42	Velocity	Governs	with	295,962 332,923 456,852	443,943 499,385 685,279	591,924 665,847 913,705	739,905 832,308 1,142,131
48 54 60	these	Pipe	Sizes	600,349 763,414 946,046	900,524 1,145,120 1,419,069	1,200,698 1,526,827 1,892,092	1,500,873 1,908,534 2,365,115
72 84 96		, ,		1,370,013 1,872,252 2,452,762	2,055,020 2,808,378 3,679,143	2,740,027 3,744,504 4,905,523	3,425,034 4,680,630 6,131,904

- 1. Maximum recommended pressure drop / velocity: 0.25 Psig/100 Ft. / 3,000 Fpm.
- 2. Table based on Heavy Weight Steel Pipe using Steam Equations in Part 5.

				DENSATE FLO G BACK PRES					
PIPE SIZE	PR	PRESSURE DROP PSIG/100 FT.			VELOCITY FPM (MPH)				
	0.125	0.25	0.5	2,000 (23)	3,000 (34)	4,000 (45)	5,000 (57)		
1/2 3/4 1	44 108 225	62 152 318	88 215 450	392	Pressure with these	Drop Pipe	Governs Sizes		
1-1/4 1-1/2 2	518 820 1,699	733 1,159 2,403	1,037 1,639 3,398	700 964 1,610	1,446 2,416	3,221			
2-1/2 3 4	2,825 5,247 11,273	3,995 7,420	5,650	2,311 3,602 6,270	3,467 5,403 9,405	4,623 7,204 12,540	9,005 15,675		
5 6 8	21,083 34,277			9,922 14,215 24,903	14,883 21,323 37,354	19,844 28,431 49,805	24,805 35,539 62,257		
10 12 14				40,717 59,135 72,386	61,075 88,702 108,578	81,434 118,269 144,771	101,792 147,836 180,964		
16 18 20				96,371 123,784 154,622	144,557 185,675 231,934	192,743 247,567 309,245	240,928 309,459 386,556		
22 24 26				188,888 226,580 267,698	283,332 339,870 401,547	377,776 453,159 535,396	472,220 566,449 669,245		
28 30 32	9			312,243 360,215 411,613	468,365 540,322 617,419	624,486 720,429 823,225	780,608 900,537 1,029,032		
34 36 42	Velocity	Governs	with	466,437 524,688 720,001	699,656 787,033 1,080,002	932,875 1,049,377 1,440,002	1,166,093 1,311,721 1,800,003		
48 54 60	these	Pipe	Sizes	946,152 1,203,143 1,490,972	1,419,229 1,804,714 2,236,458	1,892,305 2,406,285 2,981,944	2,365,381 3,007,857 3,727,429		
72 84 96				2,159,146 2,950,676 3,865,562	3,238,720 4,426,015 5,798,343	4,318,293 5,901,353 7,731,123	5,397,866 7,376,691 9,663,904		

- 1. Maximum recommended pressure drop / velocity: 0.25 Psig/100 Ft. / 3,000 Fpm.
- 2. Table based on Heavy Weight Steel Pipe using Steam Equations in Part 5.

				NDENSATE FLOW LBS./HR SIG BACKPRESSURE				
PIPE SIZE	PF	RESSURE DRO PSIG/100 FT.)P		VELOCITY	FPM (MPH)		
	0.125	0.25	0.5	2,000 (23)	3,000 (34)	4,000 (45)	5,000 (57)	
1/2 3/4 1	49 121 253	70 171 358	99 242 507	462	Pressure with these	Drop Pipe	Governs Sizes	
1-1/4 1-1/2 2	583 923 1,912	825 1,305 2,704	1,167 1,845 3,824	824 1,135 1,896	1,702 2,844	3,792		
2-1/2 3 4	3,180 5,905 12,687	4,497 8,351 17,942	6,359	2,722 4,241 7,382	4,082 6,362 11,074	5,443 8,483 14,765	10,603 18,456	
5 6 8	23,728 38,577			11,683 16,738 29,322	17,524 25,107 43,983	23,365 33,476 58,644	29,207 41,845 73,305	
10 12 14			e.	47,942 69,628 85,231	71,914 104,443 127,847	95,885 139,257 170,462	119,856 174,071 213,078	
16 18 20				113,473 145,750 182,062	170,210 218,625 273,092	226,947 291,500 364,123	283,683 364,375 455,154	
22 24 26			£	222,408 266,788 315,204	333,612 400,183 472,806	444,815 533,577 630,407	556,019 666,971 788,009	
28 30 32				367,654 424,138 484,657	551,480 636,207 726,986	735,307 848,276 969,314	919,134 1,060,345 1,211,643	
34 36 42	Velocity	Governs	with	549,211 617,799 847,772	823,816 926,699 1,271,658	1,098,422 1,235,598 1,695,544	1,373,027 1,544,498 2,119,430	
48 54 60	these	Pipe	Sizes	1,114,056 1,416,651 1,755,558	1,671,084 2,124,977 2,633,338	2,228,112 2,833,303 3,511,117	2,785,140 3,541,629 4,388,896	
72 84 96	-			2,542,307 3,474,301 4,551,541	3,813,460 5,211,452 6,827,312	5,084,614 6,948,602 9,103,082	6,355,767 8,685,753 11,378,853	

- 1. Maximum recommended pressure drop / velocity: 0.25 Psig/100 Ft. / 3,000 Fpm.
- 2. Table based on Heavy Weight Steel Pipe using Steam Equations in Part 5.

				DENSATE FLOW LBS./HR. G BACK PRESSURE				
PIPE SIZE		PRESSURE DROP PSIG/100 FT.			VELOCITY I	FPM (MPH)		
	0.125	0.25	0.5	2,000 (23)	3,000 (34)	4,000 (45)	5,000 (57)	
1/2 3/4 1	58 143 300	83 203 424	117 286 600	581	Pressure with these	Drop Pipe	Governs Sizes	
1-1/4 1-1/2 2	690 1,092 2,263	976 1,544 3,200	1,381 2,184 4,526	1,036 1,427 2,384	2,140 3,577			
2-1/2 3 4	3,763 6,989 15,015	5,322 9,883 21,234	7,526	3,422 5,334 9,284	5,134 8,001 13,926	6,845 10,668 18,568	13,334 23,210	
5 6 8	28,082 45,655			14,692 21,049 36,874	22,038 31,574 55,311	29,383 42,098 73,748	36,729 52,623 92,185	
10 12 14				60,291 87,562 107,183	90,436 131,343 160,775	120,581 175,124 214,366	150,726 218,905 267,958	
16 18 20				142,699 183,290 228,953	214,049 274,934 343,430	285,399 366,579 457,907	356,749 458,224 572,383	
22 24 26				279,691 335,502 396,387	419,536 503,254 594,581	559,382 671,005 792,775	699,227 838,756 990,969	
28 30 32				462,346 533,379 609,485	693,520 800,068 914,228	924,693 1,066,758 1,218,971	1,155,866 1,333,447 1,523,713	
34 36 42	Velocity	Governs	with	690,666 776,919 1,066,124	1,035,998 1,165,379 1,599,186	1,381,331 1,553,839 2,132,247	1,726,664 1,942,299 2,665,309	
48 54 60	these	Pipe	Sizes	1,400,992 1,781,524 2,207,720	2,101,488 2,672,286 3,311,579	2,801,984 3,563,048 4,415,439	3,502,480 4,453,810 5,519,299	
72 84 96				3,197,103 4,369,141 5,723,835	4,795,654 6,553,712 8,585,752	6,394,205 8,738,282 11,447,670	7,992,757 10,922,853 14,309,587	

 $1. \ \ Maximum\ recommended\ pressure\ drop\ /\ velocity: 0.25\ Psig/100\ Ft.\ /\ 3,000\ Fpm.$

^{2.} Table based on Heavy Weight Steel Pipe using Steam Equations in Part 5.

				IDENSATE FLOW LBS./HR IG BACKPRESSURE				
PIPE SIZE	PI	RESSURE DRO PSIG/100 FT.)P		VELOCITY	FPM (MPH)		
	0.125	0.25	0.5	2,000 (23)	3,000 (34)	4,000 (45)	5,000 (57)	
1/2 3/4 1	65 160 335	92 226 474	130 320 670		Pressure with these	Drop Pipe	Governs Sizes	
1-1/4 1-1/2 2	771 1,219 2,526	1,090 1,724 3,573	1,542 2,438 5,052	1,199 1,652 2,761	4,141			
2-1/2 3 4	4,201 7,802 16,762	5,941 11,033 23,704	8,402	3,962 6,175 10,749	5,944 9,263 16,123	7,925 12,351 21,497	15,438 26,871	
5 6 8	31,349 50,967			17,010 24,370 42,691	25,514 36,555 64,037	34,019 48,740 85,383	42,524 60,925 106,729	
10 12 14		ē		69,802 101,376 124,093	104,704 152,065 186,140	139,605 202,753 248,186	174,506 253,441 310,233	
16 18 20	,		a .	165,213 212,207 265,075	247,819 318,310 397,612	330,426 424,413 530,150	413,032 530,517 662,687	
22 24 26	×			323,817 388,434 458,925	485,726 582,651 688,387	647,634 776,868 917,849	809,543 971,084 1,147,311	
28 30 32	-			535,290 617,529 705,642	802,934 926,293 1,058,464	1,070,579 1,235,058 1,411,285	1,338,224 1,543,822 1,764,106	
34 36 42	Velocity	Governs	with	799,630 899,492 1,234,324	1,199,445 1,349,238 1,851,485	1,599,260 1,798,984 2,468,647	1,999,075 2,248,730 3,085,809	
48 54 60	these	Pipe	Sizes	1,622,023 2,062,591 2,556,026	2,433,035 3,093,886 3,834,040	3,244,046 4,125,181 5,112,053	4,055,058 5,156,477 6,390,066	
72 84 96				3,701,502 5,058,450 6,626,871	5,552,253 7,587,675 9,940,306	7,403,004 10,116,901 13,253,742	9,253,755 12,646,126 16,567,177	

- 1. Maximum recommended pressure drop / velocity: 0.25 Psig/100 Ft. / 3,000 Fpm.
- 2. Table based on Heavy Weight Steel Pipe using Steam Equations in Part 5.

			CTEAN CON	DENSATE FLO	out the am		
				G BACK PRES			
PIPE SIZE	PI	RESSURE DRO PSIG/100 FT.	P		VELOCITY	FPM (MPH)	
	0.125	0.25	0.5	2,000 (23)	3,000 (34)	4,000 (45)	5,000 (57)
1/2 3/4 1	50 123 257	71 174 364	100 246 514	498	Pressure with these	Drop Pipe	Governs Sizes
1-1/4 1-1/2 2	592 936 1,941	837 1,324 2,744	1,184 1,873 3,881	888 1,224 2,045	1,836 3,067		
2-1/2 3 4	3,227 5,993 12,876	4,564 8,476 18,209	6,454	2,935 4,574 7,961	4,402 6,861 11,942	5,870 9,148 15,923	11,435 19,904
5 6 8	24,082 39,152			12,599 18,051 31,621	18,898 27,076 47,432	25,198 36,102 63,243	31,497 45,127 79,053
10 12 14	1			51,702 75,089 91,915	77,554 112,634 137,873	103,405 150,178 183,831	129,256 187,723 229,788
16 18 20				122,373 157,181 196,340	183,559 235,771 294,510	244,745 314,361 392,680	305,931 392,952 490,850
22 24 26	7			239,850 287,711 339,924	359,775 431,567 509,885	479,700 575,423 679,847	599,625 719,278 849,809
28 30 32	1 9 7			396,487 457,401 522,667	594,730 686,102 784,000	792,974 914,802 1,045,333	991,217 1,143,503 1,306,666
34 36 42	Velocity	Governs	with	592,283 666,250 914,259	888,424 999,375 1,371,388	1,184,566 1,332,501 1,828,517	1,480,707 1,665,626 2,285,647
48 54 60	these	Pipe	Sizes	1,201,426 1,527,753 1,893,239	1,802,139 2,291,629 2,839,858	2,402,852 3,055,506 3,786,477	3,003,565 3,819,382 4,733,097
72 84 96	-			2,741,688 3,746,774 4,908,497	4,112,532 5,620,161 7,362,746	5,483,376 7,493,549 9,816,995	6,854,220 9,366,936 12,271,243

- 1. Maximum recommended pressure drop / velocity: 0.25 Psig/100 Ft. / 3,000 Fpm.
- 2. Table based on Heavy Weight Steel Pipe using Steam Equations in Part 5.

				DENSATE FL					
PIPE SIZE	PF	PRESSURE DROP			IG BACKPRESSURE VELOCITY FPM (MPH)				
SIZE	0.125	PSIG/100 FT.	0.5	2,000 (23)	3,000 (34)	4,000 (45)	5,000 (57)		
1/2 3/4 1	55 136 284	78 192 402	111 271 568		Pressure with these	Drop Pipe	Governs Sizes		
1-1/4 1-1/2 2	654 1,033 2,142	924 1,462 3,029	1,307 2,067 4,284	1,017 1,401 2,341	3,511				
2-1/2 3 4	3,562 6,615 14,213	5,037 9,356 20,100	7,124	3,360 5,236 9,114	5,040 7,854 13,671	6,720 10,472 18,228	13,090 22,785		
5 6 8	26,582 43,216			14,423 20,664 36,199	21,634 30,996 54,299	28,846 41,328 72,398	36,057 51,660 90,498		
10 12 14				59,187 85,960 105,222	88,781 128,940 157,833	118,375 171,919 210,444	147,968 214,899 263,055		
16 18 20				140,088 179,936 224,764	210,132 269,903 337,146	280,177 359,871 449,528	350,221 449,839 561,910		
22 24 26				274,573 329,363 389,134	411,860 494,045 583,701	549,146 658,726 778,268	686,433 823,408 972,836		
28 30 32				453,886 523,619 598,333	680,829 785,428 897,499	907,772 1,047,238 1,196,666	1,134,715 1,309,047 1,495,832		
34 36 42	Velocity	Governs	with	678,027 762,703 1,046,615	1,017,041 1,144,055 1,569,923	1,356,055 1,525,406 2,093,231	1,695,069 1,906,758 2,616,538		
48 54 60	these	Pipe	Sizes	1,375,356 1,748,925 2,167,322	2,063,034 2,623,387 3,250,983	2,750,712 3,497,850 4,334,644	3,438,390 4,372,312 5,418,305		
72 84 96				3,138,601 4,289,193 5,619,098	4,707,901 6,433,789 8,428,647	6,277,202 8,578,386 11,238,196	7,846,502 10,722,982 14,047,745		

- Maximum recommended pressure drop / velocity: 0.25 Psig/100 Ft. / 3,000 Fpm.
 Table based on Heavy Weight Steel Pipe using Steam Equations in Part 5.

		STEAM CONDENSATE FLOW LBS./HR. 20 PSIG BACK PRESSURE										
PIPE SIZE	PI	PRESSURE DROP PSIG/100 FT.			VELOCITY	FPM (MPH)						
	0.125	0.25	0.5	2,000 (23)	3,000 (34)	4,000 (45)	5,000 (57)					
1/2 3/4 1	64 157 328	90 222 464	128 313 656		Pressure with these	Drop Pipe	Governs Sizes					
1-1/4 1-1/2 2	755 1,195 2,476	1,068 1,689 3,502	1,511 2,389 4,952	1,329 1,831 3,059	4,589	-						
2-1/2 3 4	4,117 7,647 16,428	5,823 10,814 23,233	8,234 15,293	4,391 6,843 11,911	6,586 10,264 17,866	13,686 23,821	29,777					
5 6 8	30,726 49,953 105,768	43,453		18,849 27,005 47,307	28,273 40,508 70,961	37,697 54,010 94,615	47,122 67,513 118,268					
10 12 14				77,350 112,337 137,510	116,024 168,506 206,265	154,699 224,675 275,021	193,374 280,843 343,776					
16 18 20				183,076 235,151 293,735	274,614 352,726 440,602	366,152 470,301 587,470	457,690 587,877 734,337					
22 24 26			*	358,829 430,432 508,544	538,243 645,647 762,816	717,657 860,863 1,017,088	897,071 1,076,079 1,271,360					
28 30 32				593,166 684,297 781,937	889,748 1,026,445 1,172,906	1,186,331 1,368,593 1,563,874	1,482,914 1,710,742 1,954,843					
34 36 42	Velocity	Governs	with	886,087 996,746 1,367,780	1,329,130 1,495,119 2,051,670	1,772,174 1,993,492 2,735,559	2,215,217 2,491,865 3,419,449					
48 54 60	these	Pipe	Sizes	1,797,398 2,285,600 2,832,386	2,696,096 3,428,400 4,248,579	3,594,795 4,571,200 5,664,773	4,493,494 5,714,000 7,080,966					
72 84 96	4			4,101,712 5,605,375 7,343,374	6,152,568 8,408,062 11,015,061	8,203,424 11,210,749 14,686,749	10,254,280 14,013,436 18,358,436					

- $1. \ \ Maximum\ recommended\ pressure\ drop\ /\ velocity:\ 0.25\ Psig/100\ Ft.\ /\ 3,000\ Fpm.$ $2. \ \ Table\ based\ on\ Heavy\ Weight\ Steel\ Pipe\ using\ Steam\ Equations\ in\ Part\ 5.$

		STEAM CONDENSATE FLOW LBS./HR. 25 PSIG BACK PRESSURE								
PIPE SIZE	PI	RESSURE DRO PSIG/100 FT.)P		VELOCITY	FPM (MPH)				
	0.125	0.25	0.5	2,000 (23)	3,000 (34)	4,000 (45)	5,000 (57)			
1/2 3/4 1	78 191 399	110 270 565	156 381 799		Pressure with these	Drop Pipe	Governs Sizes			
1-1/4 1-1/2 2	919 1,454 3,014	1,300 2,056 4,262	1,839 2,908 6,027	1,723 2,373 3,966	5,948					
2-1/2 3 4	5,011 9,307 19,995	7,087 13,162 28,277	10,022 18,614	5,692 8,871 15,440	8,538 13,306 23,160	17,741 30,880	38,600			
5 6 8	37,397 60,799 128,734	52,888 85,983		24,434 35,007 61,325	36,651 52,510 91,988	48,868 70,014 122,650	61,084 87,517 153,313			
10 12 14	246,797			100,269 145,625 178,257	150,404 218,437 267,385	200,539 291,249 356,513	250,673 364,061 445,642			
16 18 20			i. v	237,324 304,829 380,773	355,986 457,244 571,160	474,648 609,659 761,546	593,310 762,073 951,933			
22 24 26			, (465,155 557,975 659,233	697,732 836,962 988,850	930,310 1,115,950 1,318,466	1,162,887 1,394,937 1,648,083			
28 30 32				768,929 887,064 1,013,637	1,153,394 1,330,596 1,520,455	1,537,859 1,774,128 2,027,273	1,922,324 2,217,660 2,534,092			
34 36 42	Velocity	Governs	with	1,148,648 1,292,097 1,773,073	1,722,971 1,938,145 2,659,610	2,297,295 2,584,193 3,546,146	2,871,619 3,230,242 4,432,683			
48 54 60	these	Pipe	Sizes	2,329,993 2,962,857 3,671,664	3,494,990 4,444,285 5,507,496	4,659,986 5,925,714 7,343,329	5,824,983 7,407,142 9,179,161			
72 84 96				5,317,110 7,266,330 9,519,325	7,975,665 10,899,495 14,278,988	10,634,220 14,532,660 19,038,650	13,292,775 18,165,825 23,798,313			

- 1. Maximum recommended pressure drop / velocity: 0.25 Psig/100 Ft. / 3,000 Fpm.
- 2. Table based on Heavy Weight Steel Pipe using Steam Equations in Part 5.

		-	STEAM CON	DENSATE FLO	OW LBS./HR.						
		20 PSIG BACK PRESSURE									
PIPE SIZE	PI	RESSURE DRO PSIG/100 FT.)P		VELOCITY	FPM (MPH)					
	0.125	0.25	0.5	2,000 (23)	3,000 (34)	4,000 (45)	5,000 (57)				
1/2 3/4 1	57 139 292	80 197 412	114 278 583		Pressure with these	Drop Pipe	Governs Sizes				
1-1/4 1-1/2 2	671 1,061 2,200	949 1,501 3,111	1,343 2,123 4,400	1,181 1,627 2,718	4,077						
2-1/2 3 4	3,658 6,795 14,598	5,174 9,609 20,644	7,317 13,589	3,902 6,080 10,584	5,852 9,121 15,875	12,161 21,167	26,459				
5 6 8	27,302 44,387 93,983	38,611		16,748 23,996 42,036	25,123 35,994 63,054	33,497 47,992 84,072	41,871 59,990 105,090				
10 12 14				68,731 99,820 122,188	103,096 149,730 183,282	137,462 199,640 244,377	171,827 249,551 305,471				
16 18 20				162,677 208,949 261,006	244,015 313,424 391,509	325,353 417,898 522,011	406,692 522,373 652,514				
22 24 26		s		318,846 382,471 451,880	478,269 573,706 677,819	637,693 764,942 903,759	797,116 956,177 1,129,699				
28 30 32				527,072 608,049 694,810	790,609 912,074 1,042,215	1,054,145 1,216,099 1,389,620	1,317,681 1,520,123 1,737,025				
34 36 42	Velocity	Governs	with	787,355 885,684 1,215,376	1,181,033 1,328,526 1,823,063	1,574,710 1,771,368 2,430,751	1,968,388 2,214,210 3,038,439				
48 54 60	these	Pipe	Sizes	1,597,123 2,030,928 2,516,789	2,395,685 3,046,392 3,775,183	3,194,247 4,061,856 5,033,578	3,992,809 5,077,320 6,291,972				
72 84 96				3,644,681 4,980,798 6,525,142	5,467,021 7,471,197 9,787,713	7,289,361 9,961,597 13,050,284	9,111,701 12,451,996 16,312,855				

- 1. Maximum recommended pressure drop / velocity: 0.25 Psig/100 Ft. / 3,000 Fpm.
- 2. Table based on Heavy Weight Steel Pipe using Steam Equations in Part 5.

			OTE AN (CC)	TO TO LOW					
				ONDENSATE FLOW LBS./HR. PSIG BACK PRESSURE					
PIPE SIZE	P	PRESSURE DRO PSIG/100 FT.	OP		VELOCITY	FPM (MPH)			
	0.125	0.25	0.5	2,000 (23)	3,000 (34)	4,000 (45)	5,000 (57)		
1/2 3/4 1	68 167 349	96 236 494	136 333 698		Pressure with these	Drop Pipe	Governs Sizes		
1-1/4 1-1/2 2	804 1,271 2,634	1,136 1,797 3,725	1,607 2,542 5,268	1,506 2,074 3,466	5,199				
2-1/2 3 4	4,380 8,134 17,476	6,194 11,504 24,714	8,760 16,268	4,975 7,753 13,495	7,462 11,629 20,242	15,506 26,989	33,737		
5 6 8	32,685 53,139 112,514	46,224 75,150		21,355 30,596 53,598	32,033 45,894 80,398	42,710 61,192 107,197	53,388 76,491 133,996		
10 12 14	215,701			87,636 127,276 155,797	131,454 190,915 233,695	175,271 254,553 311,594	219,089 318,191 389,492		
16 18 20	9			207,422 266,422 332,797	311,133 399,633 499,195	414,844 532,844 665,594	518,555 666,055 831,992		
22 24 26				406,547 487,672 576,172	609,820 731,508 864,258	813,094 975,344 1,152,344	1,016,367 1,219,179 1,440,429		
28 30 32				672,047 775,297 885,922	1,008,070 1,162,945 1,328,883	1,344,094 1,550,593 1,771,843	1,680,117 1,938,242 2,214,804		
34 36 42	Velocity	Governs	with	1,003,922 1,129,297 1,549,672	1,505,883 1,693,945 2,324,507	2,007,843 2,258,593 3,099,343	2,509,804 2,823,242 3,874,179		
48 54 60	these	Pipe	Sizes	2,036,422 2,589,546 3,209,046	3,054,632 3,884,320 4,813,569	4,072,843 5,179,093 6,418,093	5,091,054 6,473,866 8,022,616		
72 84 96				4,647,171 6,350,796 8,319,920	6,970,757 9,526,194 12,479,881	9,294,342 12,701,592 16,639,841	11,617,928 15,876,989 20,799,801		

^{1.} Maximum recommended pressure drop / velocity: 0.25 Psig/100 Ft. / 3,000 Fpm.

^{2.} Table based on Heavy Weight Steel Pipe using Steam Equations in Part 5.

				DENSATE FLO				
PIPE SIZE		PRESSURE DROP PSIG/100 FT.			VELOCITY FPM (MPH)			
	0.125	0.25	0.5	2,000 (23)	3,000 (34)	4,000 (45)	5,000 (57)	
1/2 3/4 1	37 91 191	53 129 270	74 182 382		Pressure with these	Drop Pipe	Governs Sizes	
1-1/4 1-1/2 2	439 694 1,439	621 982 2,035	878 1,389 2,878	683 941 1,573	2,359			
2-1/2 3 4	2,393 4,444 9,548	3,384 6,285 13,503	4,786	2,257 3,518 6,123	3,386 5,277 9,185	4,514 7,036 12,246	8,795 15,308	
5 6 8	17,859 29,034			9,690 13,883 24,320	14,534 20,824 36,479	19,379 27,765 48,639	24,224 34,707 60,799	
10 12 14				39,764 57,750 70,691	59,645 86,625 106,036	79,527 115,500 141,382	99,409 144,375 176,727	
16 18 20			٥	94,115 120,886 151,002	141,173 181,328 226,504	188,230 241,771 302,005	235,288 302,214 377,506	
22 24 26				184,466 221,275 261,431	276,698 331,912 392,146	368,931 442,550 522,861	461,164 553,187 653,577	
28 30 32				304,933 351,781 401,976	457,399 527,672 602,964	609,866 703,562 803,952	762,332 879,453 1,004,940	
34 36 42	Velocity	Governs	with	455,517 512,404 703,144	683,275 768,606 1,054,716	911,034 1,024,808 1,406,288	1,138,792 1,281,011 1,757,860	
48 54 60	these	Pipe	Sizes	924,001 1,174,974 1,456,065	1,386,001 1,762,461 2,184,097	1,848,001 2,349,948 2,912,129	2,310,002 2,937,436 3,640,161	
72 84 96				2,108,596 2,881,594 3,775,060	3,162,893 4,322,391 5,662,589	4,217,191 5,763,188 7,550,119	5,271,489 7,203,985 9,437,649	

^{1.} Maximum recommended pressure drop / velocity: 0.25 Psig/100 Ft. / 3,000 Fpm.

^{2.} Table based on Heavy Weight Steel Pipe using Steam Equations in Part 5.

						-			
				NDENSATE FLOW LBS./HR. SIG BACK PRESSURE					
PIPE SIZE	P	RESSURE DRO PSIG/100 FT.				FPM (MPH)			
	0.125	0.25	0.5	2,000 (23)	3,000 (34)	4,000 (45)	5,000 (57)		
1/2 3/4 1	41 102 213	59 144 301	83 203 426		Pressure with these	Drop Pipe	Governs Sizes		
1-1/4 1-1/2 2	490 776 1,608	694 1,097 2,273	981 1,551 3,215	802 1,105 1,847	2,770				
2-1/2 3 4	2,673 4,964 10,666	3,780 7,021 15,084	5,346 9,929	2,650 4,130 7,189	3,975 6,196 10,784	5,301 8,261 14,379	17,973		
5 6 8	19,948 32,432 68,670	28,211		11,377 16,300 28,555	17,066 24,451 42,832	22,754 32,601 57,110	28,443 40,751 71,387		
10 12 14				46,689 67,807 83,002	70,033 101,711 124,503	93,377 135,615 166,004	116,721 169,518 207,505		
16 18 20				110,505 141,938 177,300	165,758 212,907 265,950	221,011 283,876 354,600	276,264 354,845 443,250		
22 24 26				216,591 259,811 306,960	324,886 389,716 460,440	433,182 519,621 613,919	541,477 649,527 767,399		
28 30 32				358,038 413,045 471,981	537,057 619,567 707,972	716,076 826,090 943,962	895,094 1,032,612 1,179,953		
34 36 42	Velocity	Governs	with	534,847 601,641 825,599	802,270 902,462 1,238,398	1,069,693 1,203,282 1,651,198	1,337,116 1,504,103 2,063,997		
48 54 60	these	Pipe	Sizes	1,084,918 1,379,600 1,709,643	1,627,378 2,069,400 2,564,464	2,169,837 2,759,199 3,419,285	2,712,296 3,448,999 4,274,107		
72 84 96				2,475,814 3,383,433 4,432,498	3,713,721 5,075,149 6,648,747	4,951,628 6,766,865 8,864,996	6,189,535 8,458,581 11,081,245		

Notes:

1. Maximum recommended pressure drop / velocity: 0.25 Psig/100 Ft. / 3,000 Fpm.

2. Table based on Heavy Weight Steel Pipe using Steam Equations in Part 5.

	STEAM CONDENSATE FLOW LBS./HR. 30 PSIG BACK PRESSURE								
PIPE SIZE	PRESSURE DROP PSIG/100 FT.				VELOCITY FPM (MPH)				
	0.125	0.25	0.5	2,000 (23)	3,000 (34)	4,000 (45)	5,000 (57)		
1/2 3/4 1	68 167 349	96 236 493	136 333 698		Pressure with these	Drop Pipe	Governs Sizes		
1-1/4 1-1/2 2	803 1,269 2,631	1,135 1,795 3,721	1,606 2,539 5,262	1,590 2,191 3,661					
2-1/2 3 4	4,375 8,126 17,458	6,188 11,492 24,689	8,751 16,252 34,916	5,254 8,188 14,252	7,881 12,282 21,379	28,505			
5 6 8	32,652 53,085 112,400	46,177 75,073	10	22,554 32,314 56,608	33,832 48,471 84,912	45,109 64,628 113,216	56,386 80,786 141,520		
10 12 14	215,482			92,557 134,423 164,545	138,835 201,635 246,818	185,113 268,846 329,090	231,392 336,058 411,363		
16 18 20	,			219,069 281,382 351,484	328,603 422,073 527,226	438,138 562,764 702,968	547,672 703,455 878,710		
22 24 26				429,375 515,055 608,525	644,063 772,583 912,787	858,750 1,030,111 1,217,050	1,073,438 1,287,639 1,521,312		
28 30 32		7		709,783 818,831 935,668	1,064,675 1,228,247 1,403,502	1,419,567 1,637,662 1,871,336	1,774,459 2,047,078 2,339,170		
34 36 42	Velocity	Governs	with	1,060,294 1,192,709 1,636,689	1,590,441 1,789,063 2,455,033	2,120,587 2,385,418 3,273,377	2,650,734 2,981,772 4,091,721		
48 54 60	these	Pipe	Sizes	2,150,770 2,734,954 3,389,240	3,226,155 4,102,431 5,083,860	4,301,541 5,469,908 6,778,480	5,376,926 6,837,386 8,473,100		
72 84 96				4,908,118 6,707,405 8,787,099	7,362,177 10,061,107 13,180,649	9,816,236 13,414,809 17,574,198	12,270,296 16,768,512 21,967,748		

 $^{1. \ \} Maximum\ recommended\ pressure\ drop\ /\ velocity: 0.25\ Psig/100\ Ft.\ /\ 3,000\ Fpm.$

^{2.} Table based on Heavy Weight Steel Pipe using Steam Equations in Part 5.

			STEAM CON	DENSATEEL	OW LBS./HR.		
				G BACK PRES			
PIPE SIZE	PF	RESSURE DRO PSIG/100 FT.	P		VELOCITY	FPM (MPH)	2
	0.125	0.25	0.5	2,000 (23)	3,000 (34)	4,000 (45)	5,000 (57)
1/2 3/4 1	20 48 101	28 68 143	39 96 202	92 153	Pressure with these	Drop Pipe	Governs Sizes
1-1/4 1-1/2 2	232 367 761	328 519 1,076	464 734 1,521	273 376 629	410 564 943	1,258	
2-1/2 3 4	1,265 2,349 5,047	1,789 3,322		903 1,407 2,448	1,354 2,110 3,672	1,805 2,813 4,896	2,256 3,516 6,120
5 .6 8	9,439	-		3,874 5,551 9,724	5,811 8,326 14,586	7,748 11,101 19,448	9,686 13,877 24,309
10 12 14	-			15,899 23,090 28,265	23,848 34,636 42,397	31,798 46,181 56,529	39,747 57,726 70,661
16 18 20				37,630 48,334 60,376	56,445 72,501 90,564	75,261 96,668 120,751	94,076 120,835 150,939
22 24 26				73,755 88,473 104,529	110,633 132,709 156,793	147,511 176,946 209,057	184,388 221,182 261,321
28 30 32	a .			121,922 140,654 160,723	182,883 210,980 241,085	243,844 281,307 321,446	304,805 351,634 401,808
34 36 42	Velocity	Governs	with	182,130 204,876 281,140	273,196 307,314 421,710	364,261 409,752 562,280	455,326 512,190 702,850
48 54 60	these	Pipe	Sizes	369,446 469,793 582,182	554,168 704,689 873,273	738,891 939,586 1,164,364	923,614 1,174,482 1,455,455
72 84 96				843,085 1,152,155 1,509,392	1,264,628 1,728,233 2,264,088	1,686,170 2,304,310 3,018,784	2,107,713 2,880,388 3,773,480

- 1. Maximum recommended pressure drop / velocity: 0.25 Psig/100 Ft../ 3,000 Fpm.
- 2. Table based on Heavy Weight Steel Pipe using Steam Equations in Part 5.

				DENSATE FLO	OW LBS./HR.		
PIPE SIZE	PI	RESSURE DRO PSIG/100 FT.)P		VELOCITY	FPM (MPH)	
	0.125	0.25	0.5	2,000 (23)	3,000 (34)	4,000 (45)	5,000 (57)
1/2 3/4 1	31 75 157	43 106 222	61 150 313	303	Pressure with these	Drop Pipe	Governs Sizes
1-1/4 1-1/2 2	361 570 1,182	510 807 1,672	721 1,141 2,364	541 745 1,246	1,118 1,868	. 25	
2-1/2 3 4	1,966 3,651 7,843	2,780 5,163 11,091	3,931	1,788 2,786 4,849	2,682 4,179 7,274	3,575 5,572 9,699	6,965 12,124
5 6 8	14,669 23,848			7,674 10,995 19,261	11,511 16,493 28,892	15,348 21,990 38,522	19,185 27,488 48,153
10 12 14				31,493 45,738 55,987	47,239 68,607 83,981	62,985 91,476 111,974	78,732 114,345 139,968
16 18 20				74,539 95,741 119,594	111,808 143,612 179,390	149,078 191,482 239,187	186,347 239,353 298,984
22 24 26				146,096 175,249 207,053	219,144 262,874 310,579	292,193 350,499 414,105	365,241 438,123 517,631
28 30 32		·		241,506 278,610 318,364	362,259 417,915 477,546	483,012 557,220 636,728	603,765 696,525 795,910
34 36 42	Velocity	Governs	with	360,768 405,823 556,888	541,152 608,734 835,333	721,537 811,646 1,113,777	901,921 1,014,557 1,392,221
48 54 60	these	Pipe	Sizes	731,806 930,577 1,153,200	1,097,710 1,395,865 1,729,800	1,463,613 1,861,154 2,306,399	1,829,516 2,326,442 2,882,999
72 84 96		a i a fab		1,670,003 2,282,216 2,989,838	2,505,004 3,423,324 4,484,758	3,340,006 4,564,431 5,979,677	4,175,007 5,705,539 7,474,596

- 1. Maximum recommended pressure drop / velocity: 0.25 Psig/100 Ft. / 3,000 Fpm.
- 2. Table based on Heavy Weight Steel Pipe using Steam Equations in Part 5.

			STEAM CO	NIDENISATE EI	LOW LBS./HF		
			12 P	SIG BACKPRE	SSURE		
PIPE SIZE	P	PRESSURE DRO PSIG/100 FT.	OP		VELOCIT	Y FPM (MPH)	
	0.125	0.25	0.5	2,000 (23)	3,000 (34)	4,000 (45)	5,000 (57)
1/2 3/4 1	33 80 168	46 114 238	66 161 337		Pressure with these	Drop Pipe	Governs Sizes
1-1/4 1-1/2 2	388 613 1,271	549 867 1,798	776 1,227 2,542	603 831 1,389	2,084		
2-1/2 3 4	2,114 3,926 8,434	2,989 5,552 11,928	4,228	1,994 3,107 5,409	2,991 4,661 8,113	3,988 6,215 10,817	7,768 13,521
5 6 8	15,775 25,646	1 2 2 2	,	8,559 12,263 21,482	12,839 18,394 32,223	17,118 24,526 42,964	21,398 30,657 53,705
10 12 14				35,124 51,012 62,443	52,686 76,517 93,664	70,248 102,023 124,885	87,810 127,529 156,106
16 18 20	7			83,134 106,780 133,383	124,700 160,171 200,075	166,267 213,561 266,766	207,834 266,951 333,458
22 24 26				162,942 195,456 230,926	244,413 293,184 346,390	325,883 390,912 461,853	407,354 488,640 577,316
28 30 32				269,353 310,735 355,073	404,029 466,102 532,609	538,705 621,469 710,145	673,382 776,837 887,681
34 36 42	Velocity these	Governs	with	402,366 452,616 621,100	603,549 678,924 931,650	804,733 905,232 1,242,200	1,005,916 1,131,540 1,552,750
48 54 60	uiese	Pipe	Sizes	816,187 1,037,876 1,286,168	1,224,280 1,556,814 1,929,252	1,632,373 2,075,752 2,572,336	2,040,467 2,594,690 3,215,421
72 84 96				1,862,561 2,545,364 3,334,579	2,793,841 3,818,046 5,001,868	3,725,122 5,090,729 6,669,157	4,656,402 6,363,411 8,336,447

- 1. Maximum recommended pressure drop / velocity: 0.25 Psig/100 Ft. / 3,000 Fpm.
- 2. Table based on Heavy Weight Steel Pipe using Steam Equations in Part 5.

				DENSATE FLO	OW LBS./HR.		
PIPE SIZE	PI	RESSURE DRO PSIG/100 FT.				FPM (MPH)	
	0.125	0.25	0.5	2,000 (23)	3,000 (34)	4,000 (45)	5,000 (57)
1/2 3/4 1	49 121 254	70 171 359	99 243 508		Pressure with these	Drop Pipe	Governs Sizes
1-1/4 1-1/2 2	585 924 1,916	827 1,307 2,709	1,169 1,849 3,832	1,095 1,509 2,521	3,782		
2-1/2 3 4	3,186 5,917 12,712	4,505 8,367 17,977	6,372 11,833	3,619 5,639 9,816	5,428 8,459 14,724	11,279 19,631	24,539
5 6 8	23,775 38,652 81,840	33,622 54,662		15,533 22,255 38,986	23,300 33,383 58,479	31,067 44,510 77,973	38,833 55,638 97,466
10 12 14	156,896		9 V	63,744 92,578 113,323	95,616 138,867 169,985	127,489 185,156 226,646	159,361 231,445 283,308
16 18 20				150,874 193,789 242,069	226,311 290,684 363,104	301,748 387,579 484,138	377,185 484,474 605,173
22 24 26				295,713 354,722 419,095	443,570 532,083 628,642	591,427 709,444 838,190	739,283 886,805 1,047,737
28 30 32	į.			488,832 563,934 644,400	733,248 845,901 966,600	977,664 1,127,868 1,288,800	1,222,080 1,409,835 1,611,000
34 36 42	Velocity	Governs	with	730,231 821,426 1,127,197	1,095,346 1,232,139 1,690,796	1,460,461 1,642,852 2,254,395	1,825,577 2,053,564 2,817,993
48 54 60	these	Pipe	Sizes	1,481,249 1,883,580 2,334,190	2,221,873 2,825,369 3,501,285	2,962,497 3,767,159 4,668,381	3,703,122 4,708,949 5,835,476
72 84 96				3,380,251 4,619,430 6,051,729	5,070,376 6,929,146 9,077,593	6,760,502 9,238,861 12,103,457	8,450,627 11,548,576 15,129,322

- Maximum recommended pressure drop / velocity: 0.25 Psig/100 Ft. / 3,000 Fpm.
 Table based on Heavy Weight Steel Pipe using Steam Equations in Part 5.

				DENSATE FLO				
PIPE SIZE		RESSURE DRO PSIG/100 FT.		VELOCITY FPM (MPH)				
	0.125	0.25	0.5	2,000 (23)	3,000 (34)	4,000 (45)	5,000 (57)	
1/2 3/4 1	57 139 292	80 197 413	114 279 584		Pressure with these	Drop Pipe	Governs Sizes	
1-1/4 1-1/2 2	672 1,063 2,204	951 1,504 3,117	1,345 2,127 4,408	1,332 1,835 3,066				
2-1/2 3 4	3,665 6,806 14,622	5,183 9,625 20,679	7,329 13,612 29,244	4,401 6,858 11,937	6,601 10,287 17,906	23,875	;	
5 6 8	27,348 44,462 94,142	38,676 62,879		18,891 27,065 47,413	28,336 40,598 71,119	37,781 54,130 94,826	47,227 67,663 118,532	
10 12 14	180,480			77,522 112,588 137,817	116,283 168,882 206,725	155,044 225,176 275,634	193,805 281,470 344,542	
16 18 20				183,484 235,675 294,390	275,226 353,513 441,585	366,968 471,350 588,780	458,710 589,188 735,975	
22 24 26				359,629 431,392 509,678	539,443 647,087 764,517	719,258 862,783 1,019,356	899,072 1,078,479 1,274,195	
28 30 32				594,489 685,823 783,681	891,733 1,028,734 1,175,522	1,188,977 1,371,646 1,567,362	1,486,222 1,714,557 1,959,203	
34 36 42	Velocity	Governs	with	888,063 998,969 1,370,830	1,332,095 1,498,454 2,056,246	1,776,127 1,997,939 2,741,661	2,220,158 2,497,423 3,427,076	
48 54 60	these	Pipe	Sizes	1,801,407 2,290,698 2,838,704	2,702,110 3,436,047 4,258,056	3,602,813 4,581,395 5,677,407	4,503,517 5,726,744 7,096,759	
72 84 96				4,110,860 5,617,877 7,359,753	6,166,291 8,426,815 11,039,630	8,221,721 11,235,754 14,719,506	10,277,151 14,044,692 18,399,383	

- 1. Maximum recommended pressure drop / velocity: 0.25 Psig/100 Ft. / 3,000 Fpm.
- 2. Table based on Heavy Weight Steel Pipe using Steam Equations in Part 5.

			STEAM CON	DENSATE FLO	OW LBS./HR.		-			
	40 PSIG BACK PRESSURE									
PIPE SIZE	PI	RESSURE DRO PSIG/100 FT.)P		VELOCITY	FPM (MPH)				
	0.125	0.25	0.5	2,000 (23)	3,000 (34)	4,000 (45)	5,000 (57)			
1/2 3/4 1	74 182 381	105 257 538	148 363 761		Pressure with these	Drop Pipe	Governs Sizes			
1-1/4 1-1/2 2	876 1,385 2,871	1,239 1,959 4,060	1,752 2,770 5,742	2,626 4,387	135					
2-1/2 3 4	4,774 8,866 19,048	6,751 12,539 26,939	9,548 17,733 38,097	6,297 9,814 17,081	9,446 14,721 25,622	34,163				
5 6 8	35,627 57,921 122,639	50,384 81,913		27,031 38,729 67,845	40,547 58,093 101,767	54,063 77,457 135,689	67,578 96,821 169,611			
10 12 14	235,113 383,762			110,929 161,106 197,207	166,393 241,659 295,810	221,858 322,212 394,414	277,322 402,765 493,017			
16 18 20				262,554 337,236 421,253	393,830 505,853 631,879	525,107 674,471 842,506	656,384 843,089 1,053,132			
22 24 26				514,605 617,293 729,316	771,908 925,939 1,093,974	1,029,210 1,234,586 1,458,631	1,286,513 1,543,232 1,823,289			
28 30 32				850,674 981,367 1,121,396	1,276,011 1,472,051 1,682,094	1,701,348 1,962,734 2,242,792	2,126,685 2,453,418 2,803,490			
34 36 42	Velocity	Governs	with	1,270,760 1,429,459 1,961,568	1,906,140 2,144,188 2,942,351	2,541,519 2,858,918 3,923,135	3,176,899 3,573,647 4,903,919			
48 54 60	these	Pipe	Sizes	2,577,693 3,277,837 4,061,997	3,866,540 4,916,755 6,092,995	5,155,387 6,555,673 8,123,994	6,444,234 8,194,591 10,154,992			
72 84 96				5,882,369 8,038,810 10,531,319	8,823,553 12,058,214 15,796,979	11,764,738 16,077,619 21,062,638	14,705,922 20,097,024 26,328,298			

- 1. Maximum recommended pressure drop / velocity: 0.25 Psig/100 Ft. / 3,000 Fpm.
- 2. Table based on Heavy Weight Steel Pipe using Steam Equations in Part 5.

			STEAM CON	DENSATE FLO	OW LBS./HR.			
				IG BACK PRESSURE				
PIPE SIZE	PI	RESSURE DRO PSIG/100 FT.)P		VELOCITY	FPM (MPH)		
	0.125	0.25	0.5	2,000 (23)	3,000 (34)	4,000 (45)	5,000 (57)	
1/2 3/4 1	19 47 99	27 67 140	38 94 197	90 150	Pressure with these	Drop Pipe	Governs Sizes	
1-1/4 1-1/2 2	227 359 745	321 508 1,053	455 719 1,490	267 369 616	401 553 924	1,232		
2-1/2 3 4	1,239 2,300 4,942	1,752 3,253		884 1,377 2,397	1,326 2,066 3,596	1,768 2,755 4,795	2,210 3,443 5,994	
5 6 8	9,243			3,794 5,436 9,522	5,691 8,153 14,283	7,588 10,871 19,044	9,485 13,589 23,805	
10 12 14				15,569 22,612 27,679	23,354 33,917 41,518	31,138 45,223 55,357	38,923 56,529 69,196	
16 18 20			۰	36,850 47,332 59,124	55,275 70,998 88,686	73,700 94,664 118,248	92,125 118,330 147,810	
22 24 26				72,226 86,639 102,361	108,339 129,958 153,542	144,452 173,277 204,723	180,565 216,597 255,903	
28 30 32				119,394 137,737 157,391	179,091 206,606 236,086	238,789 275,475 314,782	298,486 344,344 393,477	
34 36 42	Velocity	Governs	with	178,354 200,628 275,311	267,532 300,942 412,967	356,709 401,257 550,622	445,886 501,571 688,278	
48 54 60	these	Pipe	Sizes	361,786 460,053 570,112	542,679 690,079 855,168	723,572 920,106 1,140,224	904,465 1,150,132 1,425,280	
72 84 96				825,606 1,128,268 1,478,098	1,238,409 1,692,402 2,217,147	1,651,212 2,256,536 2,956,197	2,064,015 2,820,670 3,695,246	

- 1. Maximum recommended pressure drop / velocity: 0.25 Psig/100 Ft. / 3,000 Fpm.
- 2. Table based on Heavy Weight Steel Pipe using Steam Equations in Part 5.

			STEAM CON	DENSATE EL	W IRS/LID						
		STEAM CONDENSATE FLOW LBS./HR. 10 PSIG BACK PRESSURE									
PIPE SIZE	PI	RESSURE DRO PSIG/100 FT.	P	VELOCITY FPM (MPH)							
	0.125	0.25	0.5	2,000 (23)	3,000 (34)	4,000 (45)	5,000 (57)				
1/2 3/4 1	30 73 153	42 103 216	59 146 305	296	Pressure with these	Drop Pipe	Governs Sizes				
1-1/4 1-1/2 2	351 556 1,152	497 786 1,629	703 1,111 2,304	527 726 1,214	1,089 1,820						
2-1/2 3 4	1,915 3,557 7,642	2,709 5,030 10,807	3,830	1,742 2,715 4,725	2,613 4,072 7,088	3,484 5,429 9,450	6,787 11,813				
5 6 8	14,293 23,237			7,478 10,713 18,768	11,216 16,070 28,151	14,955 21,427 37,535	18,694 26,783 46,919				
10 12 14				30,686 44,566 54,553	46,029 66,849 81,829	61,372 89,132 109,105	76,715 111,415 136,382				
16 18 20				72,629 93,288 116,530	108,944 139,932 174,794	145,259 186,577 233,059	181,573 233,221 291,324				
22 24 26				142,353 170,760 201,748	213,530 256,139 302,622	284,707 341,519 403,496	355,884 426,899 504,370				
28 30 32				235,319 271,472 310,208	352,978 407,208 465,312	470,638 542,944 620,416	588,297 678,680 775,519				
34 36 42	Velocity	Governs	with	351,526 395,426 542,621	527,289 593,139 813,932	703,051 790,852 1,085,243	878,814 988,565 1,356,554				
48 54 60	these	Pipe	Sizes	713,058 906,736 1,123,656	1,069,587 1,360,104 1,685,484	1,426,116 1,813,473 2,247,312	1,782,645 2,266,841 2,809,139				
72 84 96				1,627,219 2,223,747 2,913,241	2,440,828 3,335,621 4,369,862	3,254,438 4,447,495 5,826,483	4,068,047 5,559,368 7,283,103				

- 1. Maximum recommended pressure drop / velocity: 0.25 Psig/100 Ft. / 3,000 Fpm.
- 2. Table based on Heavy Weight Steel Pipe using Steam Equations in Part 5.

	STEAM CONDENSATE FLOW LBS./HR 12 PSIG BACKPRESSURE								
PIPE SIZE	PI	RESSURE DRO PSIG/100 FT.)P	VELOCITY FPM (MPH)					
	0.125	0.25	0.5	2,000 (23)	3,000 (34)	4,000 (45)	5,000 (57)		
1/2 3/4 1	32 78 164	45 111 232	64 157 328		Pressure with these	Drop Pipe	Governs Sizes		
1-1/4 1-1/2 2	378 597 1,237	534 844 1,750	755 1,194 2,475	587 809 1,352	2,028				
2-1/2 3 4	2,058 3,821 8,210	2,910 5,404 11,610	4,115	1,941 3,025 5,265	2,911 4,537 7,897	3,882 6,049 10,529	7,562 13,162		
5 6 8	15,355 24,963			8,331 11,936 20,910	12,497 17,905 31,365	16,662 23,873 41,820	20,828 29,841 52,275		
10 12 14				34,189 49,654 60,780	51,283 74,481 91,171	68,378 99,308 121,561	85,472 124,134 151,951		
16 18 20	-			80,921 103,938 129,833	121,381 155,907 194,749	161,841 207,876 259,665	202,301 259,845 324,581		
22 24 26				158,604 190,253 224,779	237,907 285,380 337,169	317,209 380,507 449,559	396,511 475,633 561,948		
28 30 32				262,183 302,463 345,621	393,274 453,695 518,431	524,365 604,926 691,242	655,457 756,158 864,052		
34 36 42	Velocity	Governs	with	391,656 440,568 604,567	587,483 660,851 906,850	783,311 881,135 1,209,133	979,139 1,101,419 1,511,417		
48 54 60	these	Pipe	Sizes	794,460 1,010,248 1,251,931	1,191,690 1,515,373 1,877,897	1,588,921 2,020,497 2,503,863	1,986,151 2,525,621 3,129,828		
72 84 96				1,812,981 2,477,608 3,245,814	2,719,471 3,716,412 4,868,722	3,625,961 4,955,217 6,491,629	4,532,452 6,194,021 8,114,536		

- 1. Maximum recommended pressure drop / velocity: 0.25 Psig/100 Ft. / 3,000 Fpm.
- 2. Table based on Heavy Weight Steel Pipe using Steam Equations in Part 5.

			OTE AM CON	DENGATE OF	OW IDE #TD						
		STEAM CONDENSATE FLOW LBS./HR. 25 PSIG BACK PRESSURE									
PIPE SIZE	PI	PRESSURE DROP PSIG/100 FT.			VELOCITY FPM (MPH)						
	0.125	0.25	0.5	2,000 (23)	3,000 (34)	4,000 (45)	5,000 (57)				
1/2 3/4 1	48 117 245	68 166 347	96 234 491		Pressure with these	Drop Pipe	Governs Sizes				
1-1/4 1-1/2 2	565 893 1,851	799 1,263 2,618	1,130 1,786 3,703	1,058 1,458 2,436	3,654		14-				
2-1/2 3 4	3,079 5,718 12,284	4,354 8,086 17,372	6,157 11,435	3,497 5,450 9,486	5,245 8,175 14,228	10,899 18,971	23,714				
5 6 8	22,975 37,352 79,088	32,491 52,824		15,011 21,507 37,675	22,516 32,260 56,513	30,022 43,013 75,350	37,527 53,766 94,188				
10 12 14	151,620			61,600 89,464 109,512	92,401 134,197 164,268	123,201 178,929 219,024	154,001 223,661 273,780				
16 18 20			11/	145,800 187,272 233,928	218,700 280,908 350,892	291,600 374,544 467,856	364,500 468,180 584,820				
22 24 26			*	285,768 342,792 405,000	428,652 514,188 607,500	571,536 685,583 809,999	714,419 856,979 1,012,499				
28 30 32				472,392 544,968 622,727	708,587 817,451 934,091	944,783 1,089,935 1,245,455	1,180,979 1,362,419 1,556,819				
34 36 42	Velocity	Governs	with	705,671 793,799 1,089,287	1,058,507 1,190,699 1,633,931	1,411,343 1,587,599 2,178,574	1,764,179 1,984,498 2,723,218				
48 54 60	these	Pipe	Sizes	1,431,431 1,820,231 2,255,686	2,147,146 2,730,346 3,383,529	2,862,862 3,640,461 4,511,372	3,578,577 4,550,576 5,639,215				
72 84 96				3,266,565 4,464,068 5,848,195	4,899,848 6,696,102 8,772,293	6,533,131 8,928,137 11,696,390	8,166,413 11,160,171 14,620,488				

- 1. Maximum recommended pressure drop / velocity: 0.25 Psig/100 Ft. / 3,000 Fpm.
- 2. Table based on Heavy Weight Steel Pipe using Steam Equations in Part 5.

					OW LBS./HR.			
				G BACK PRESSURE				
PIPE SIZE	PF	RESSURE DRO PSIG/100 FT.)P		VELOCITY	FPM (MPH)		
	0.125	0.25	0.5	2,000 (23)	3,000 (34)	4,000 (45)	5,000 (57)	
1/2 3/4 1	55 134 281	77 190 398	110 269 563		Pressure with these	Drop Pipe	Governs Sizes	
1-1/4 1-1/2 2	648 1,024 2,123	916 1,449 3,002	1,295 2,049 4,246	1,283 1,768 2,954				
2-1/2 3 4	3,530 6,556 14,086	4,993 9,272 19,921	7,061 13,113 28,172	4,239 6,607 11,499	6,359 9,910 17,249	22,999		
5 6 8	26,345 42,831 90,689	37,258 60,573		18,198 26,073 45,674	27,297 39,109 68,511	36,396 52,145 91,348	45,495 65,182 114,185	
10 12 14	173,861			74,679 108,459 132,763	112,018 162,688 199,144	149,358 216,918 265,525	186,697 271,147 331,906	
16 18 20				176,755 227,032 283,593	265,132 340,548 425,390	353,510 454,064 567,187	441,887 567,580 708,984	
22 24 26				346,440 415,570 490,986	519,659 623,356 736,479	692,879 831,141 981,972	866,099 1,038,926 1,227,465	
28 30 32			4	572,686 660,671 754,940	859,029 991,006 1,132,410	1,145,372 1,321,341 1,509,880	1,431,715 1,651,676 1,887,350	
34 36 42	Velocity	Governs	with	855,494 962,332 1,320,556	1,283,241 1,443,498 1,980,833	1,710,987 1,924,665 2,641,111	2,138,734 2,405,831 3,301,389	
48 54 60	these	Pipe	Sizes	1,735,340 2,206,687 2,734,595	2,603,011 3,310,030 4,101,892	3,470,681 4,413,374 5,469,189	4,338,351 5,516,717 6,836,487	
72 84 96				3,960,095 5,411,842 7,089,836	5,940,143 8,117,764 10,634,753	7,920,191 10,823,685 14,179,671	9,900,239 13,529,606 17,724,589	

- 1. Maximum recommended pressure drop / velocity: 0.25 Psig/100 Ft. / 3,000 Fpm.
- 2. Table based on Heavy Weight Steel Pipe using Steam Equations in Part 5.

			STEAM CON	DENSATE FLO	OW I BS/HR			
				G BACK PRES				
PIPE SIZE	PRESSURE DROP PSIG/100 FT.			VELOCITY FPM (MPH)				
	0.125	0.25	0.5	2,000 (23)	3,000 (34)	4,000 (45)	5,000 (57)	
1/2 3/4 1	22 54 113	31 76 160	44 108 226	197	Pressure with these	Drop Pipe	Governs Sizes	
1-1/4 1-1/2 2	261 412 854	369 583 1,208	521 824 1,708	352 485 810	727 1,215	1,619		
2-1/2 3 4	1,420 2,638 5,668	2,009 3,731	2,841	1,162 1,811 3,152	1,743 2,717 4,729	2,324 3,622 6,305	4,528 7,881	
5 6 8	10,601 17,234			4,989 7,147 12,521	7,483 10,721 18,781	9,977 14,295 25,042	12,472 17,869 31,302	
10 12 14				20,472 29,732 36,395	30,708 44,599 54,592	40,944 59,465 72,790	51,180 74,331 90,987	
16 18 20				48,455 62,238 77,743	72,682 93,356 116,615	96,910 124,475 155,486	121,137 155,594 194,358	
22 24 26				94,972 113,923 134,597	142,457 170,884 201,895	189,943 227,846 269,194	237,429 284,807 336,492	
28 30 32				156,994 181,114 206,956	235,491 271,670 310,434	313,988 362,227 413,912	392,484 452,784 517,390	
34 36 42	Velocity	Governs	with	234,522 263,810 362,012	351,782 395,715 543,018	469,043 527,620 724,023	586,304 659,525 905,029	
48 54 60	these	Pipe	Sizes	475,719 604,932 749,651	713,579 907,398 1,124,476	951,438 1,209,864 1,499,301	1,189,298 1,512,330 1,874,127	
72 84 96				1,085,604 1,483,580 1,943,579	1,628,407 2,225,370 2,915,368	2,171,209 2,967,161 3,887,157	2,714,011 3,708,951 4,858,946	

- 1. Maximum recommended pressure drop / velocity: $0.25 \, Psig/100 \, Ft. / 4,000 \, Fpm.$ 2. Table based on Heavy Weight Steel Pipe using Steam Equations in Part 5.

	1		STEAM CON	IDENICATE TO	OW I DO TO		
				NDENSATE FI SIG BACKPRES		L ₁	
PIPE SIZE	P	PRESSURE DRO PSIG/100 FT.	OP		VELOCITY	Y FPM (MPH)	
	0.125	0.25	0.5	2,000 (23)	3,000 (34)	4,000 (45)	5,000 (57)
1/2 3/4 1	24 59 123	34 83 173	48 117 245	223	Pressure with these	Drop Pipe	Governs Sizes
1-1/4 1-1/2 2	282 446 925	399 631 1,308	564 892 1,850	398 549 917	823 1,376	1,834	
2-1/2 3 4	1,538 2,856 6,136	2,175 4,039 8,678	3,076	1,316 2,051 3,571	1,975 3,077 5,356	2,633 4,103 7,142	5,129 8,927
5 6 8	11,477 18,659			5,651 8,096 14,182	8,476 12,144 21,274	11,301 16,192 28,365	14,127 20,240 35,456
10 12 14				23,189 33,678 41,225	34,784 50,517 61,837	46,378 67,356 82,450	57,973 84,195 103,062
16 18 20				54,885 70,497 88,060	82,328 105,746 132,090	109,770 140,994 176,121	137,213 176,243 220,151
22 24 26				107,575 129,041 152,459	161,363 193,562 228,688	215,150 258,082 304,918	268,938 322,603 381,147
28 30 32				177,828 205,149 234,421	266,742 307,723 351,631	355,656 410,297 468,842	444,570 512,872 586,052
34 36 42	Velocity	Governs	with	265,644 298,819 410,054	398,467 448,229 615,080	531,289 597,639 820,107	664,111 747,049 1,025,134
48 54 60	these	Pipe	Sizes	538,851 685,211 849,135	808,276 1,027,817 1,273,703	1,077,702 1,370,423 1,698,270	1,347,127 1,713,028 2,122,838
72 84 96				1,229,673 1,680,463 2,201,507	1,844,509 2,520,695 3,302,260	2,459,345 3,360,926 4,403,014	3,074,182 4,201,158 5,503,767

Maximum recommended pressure drop / velocity: 0.25 Psig/100 Ft. / 4,000 Fpm.
 Table based on Heavy Weight Steel Pipe using Steam Equations in Part 5.

			STEAM COND	ENSATE FLO	W LBS./HR.			
				BACK PRESSURE				
PIPE SIZE	PRESSURE DROP PSIG/100 FT.				VELOCITY I	PM (MPH)		
	0.125	0.25	0.5	2,000 (23)	3,000 (34)	4,000 (45)	5,000 (57)	
1/2 3/4 1	27 65 137	38 92 193	53 131 273	265	Pressure with these	Drop Pipe	Governs Sizes	
1-1/4 1-1/2 2	315 497 1,031	445 704 1,458	629 995 2,062	472 650 1,087	975 1,630			
2-1/2 3 4	1,715 3,184 6,841	2,425 4,503 9,675	3,429	1,559 2,430 4,230	2,339 3,646 6,345	3,119 4,861 8,461	6,076 10,576	
5 6 8	12,796 20,803			6,694 9,591 16,802	10,042 14,387 25,203	13,389 19,182 33,604	16,736 23,978 42,005	
10 12 14				27,472 39,898 48,839	41,208 59,847 73,258	54,944 79,797 97,678	68,680 99,746 122,097	
16 18 20				65,022 83,517 104,324	97,533 125,276 156,486	130,044 167,035 208,649	162,555 208,793 260,811	
22 24 26				127,443 152,874 180,617	191,165 229,311 270,925	254,887 305,748 361,234	318,608 382,185 451,542	
28 30 32				210,672 243,038 277,717	316,007 364,557 416,575	421,343 486,076 555,433	526,679 607,595 694,291	
34 36 42	Velocity	Governs	with	314,707 354,009 485,787	472,060 531,014 728,681	629,414 708,018 971,575	786,767 885,023 1,214,468	
48 54 60	these	Pipe	Sizes	638,372 811,765 1,005,964	957,559 1,217,647 1,508,946	1,276,745 1,623,529 2,011,928	1,595,931 2,029,412 2,514,910	
72 84 96				1,456,784 1,990,832 2,608,108	2,185,176 2,986,248 3,912,162	2,913,568 3,981,664 5,216,217	3,641,960 4,977,080 6,520,271	

- 1. Maximum recommended pressure drop / velocity: 0.25 Psig/100 Ft. / 4,000 Fpm.
- 2. Table based on Heavy Weight Steel Pipe using Steam Equations in Part 5.

			STEAM CON	IDENSATE FL	OW LBS./HR			
	24	ñ.		G BACKPRESSURE				
PIPE SIZE	PF	RESSURE DRO PSIG/100 FT.)P		VELOCITY	FPM (MPH)		
	0.125	0.25	0.5	2,000 (23)	3,000 (34)	4,000 (45)	5,000 (57)	
1/2 3/4 1	28 70 146	40 99 207	57 140 292		Pressure with these	Drop Pipe	Governs Sizes	
1-1/4 1-1/2 2	337 532 1,103	476 753 1,560	673 1,065 2,206	524 721 1,206	1,808	æ		
2-1/2 3 4	1,835 3,407 7,320	2,594 4,818 10,352	3,669	1,730 2,697 4,694	2,596 4,045 7,041	3,461 5,394 9,388	6,742 11,735	
5 6 8	13,691 22,258		2 22	7,428 10,643 18,644	11,142 15,964 27,966	14,856 21,285 37,287	18,571 26,607 46,609	
10 12 14				30,483 44,272 54,193	45,725 66,408 81,289	60,967 88,544 108,385	76,208 110,680 135,482	
16 18 20				72,150 92,673 115,761	108,225 139,009 173,641	144,300 185,345 231,521	180,375 231,681 289,401	
22 24 26		-		141,414 169,632 200,416	212,121 254,449 300,625	282,828 339,265 400,833	353,535 424,081 501,041	
28 30 32			_	233,766 269,680 308,160	350,649 404,521 462,240	467,531 539,361 616,321	584,414 674,201 770,401	
34 36 42	Velocity	Governs	with	349,206 392,816 539,040	523,808 589,224 808,560	698,411 785,632 1,078,080	873,014 982,041 1,347,600	
48 54 60	these	Pipe	Sizes	708,352 900,752 1,116,239	1,062,528 1,351,127 1,674,359	1,416,704 1,801,503 2,232,479	1,770,880 2,251,879 2,790,598	
72 84 96				1,616,479 2,209,070 2,894,013	2,424,718 3,313,605 4,341,020	3,232,958 4,418,140 5,788,027	4,041,197 5,522,675 7,235,033	

- 1. Maximum recommended pressure drop / velocity: 0.25 Psig/100 Ft. / 4,000 Fpm.
- 2. Table based on Heavy Weight Steel Pipe using Steam Equations in Part 5.

				DENSATE FLO					
PIPE SIZE	PI	PRESSURE DROP PSIG/100 FT.			VELOCITY FPM (MPH)				
	0.125	0.25	0.5	2,000 (23)	3,000 (34)	4,000 (45)	5,000 (57)		
1/2 3/4 1	31 77 161	44 109 227	63 154 322		Pressure with these	Drop Pipe	Governs Sizes		
1-1/4 1-1/2 2	370 585 1,213	524 828 1,716	740 1,171 2,427	605 834 1,394	2,091	10 m			
2-1/2 3 4	2,018 3,747 8,050	2,853 5,299 11,385	4,035 7,494	2,000 3,118 5,426	3,001 4,676 8,140	4,001 6,235 10,853	13,566		
5 6 8	15,057 24,479 51,830	21,293		8,587 12,303 21,553	12,881 18,455 32,329	17,174 24,606 43,105	21,468 30,758 53,882		
10 12 14				35,240 51,180 62,648	52,859 76,769 93,972	70,479 102,359 125,296	88,099 127,949 156,620		
16 18 20				83,407 107,132 133,822	125,111 160,698 200,734	166,815 214,264 267,645	208,518 267,830 334,556		
22 24 26				163,478 196,100 231,687	245,217 294,150 347,530	326,957 392,200 463,374	408,696 490,250 579,217		
28 30 32	25			270,240 311,758 356,242	405,359 467,637 534,363	540,479 623,516 712,484	675,599 779,395 890,605		
34 36 42	Velocity	Governs	with	403,691 454,106 623,145	605,537 681,160 934,718	807,383 908,213 1,246,290	1,009,228 1,135,266 1,557,863		
48 54 60	these	Pipe	Sizes	818,874 1,041,294 1,290,404	1,228,312 1,561,941 1,935,605	1,637,749 2,082,588 2,580,807	2,047,186 2,603,235 3,226,009		
72 84 96		* .		1,868,694 2,553,746 3,345,560	2,803,041 3,830,619 5,018,339	3,737,389 5,107,493 6,691,119	4,671,736 6,384,366 8,363,899		

- Maximum recommended pressure drop / velocity: 0.25 Psig/100 Ft. / 4,000 Fpm.
 Table based on Heavy Weight Steel Pipe using Steam Equations in Part 5.

	STEAM CONDENSATE FLOW LBS./HR.								
				IG BACK PRESSURE					
PIPE SIZE	PI	PRESSURE DROP PSIG/100 FT.			VELOCITY FPM (MPH)				
	0.125	0.25	0.5	2,000 (23)	3,000 (34)	4,000 (45)	5,000 (57)		
1/2 3/4 1	36 89 186	51 126 263	72 178 372		Pressure with these	Drop Pipe	Governs Sizes		
1-1/4 1-1/2 2	428 677 1,404	606 958 1,986	857 1,355 2,808	754 1,038 1,735	2,602				
2-1/2 3 4	2,335 4,336 9,316	3,302 6,132 13,174	4,669 8,672	2,490 3,880 6,754	3,735 5,821 10,131	7,761 13,508	16,885		
5 6 8	17,423 28,326 59,977	24,640		10,688 15,313 26,826	16,032 22,970 40,239	21,377 30,627 53,652	26,721 38,283 67,065		
10 12 14		5		43,862 63,702 77,976	65,792 95,552 116,964	87,723 127,403 155,952	109,654 159,254 194,940		
16 18 20				103,814 133,344 166,564	155,722 200,016 249,847	207,629 266,688 333,129	259,536 333,359 416,411		
22 24 26				203,476 244,079 288,373	305,214 366,119 432,560	406,952 488,158 576,746	508,690 610,198 720,933		
28 30 32		2		336,359 388,035 443,403	504,538 582,053 665,104	672,717 776,070 886,805	840,896 970,088 1,108,507		
34 36 42	Velocity	Governs	with	502,462 565,212 775,609	753,692 847,817 1,163,413	1,004,923 1,130,423 1,551,217	1,256,154 1,413,029 1,939,022		
48 54 60	these	Pipe	Sizes	1,019,226 1,296,065 1,606,124	1,528,840 1,944,097 2,409,185	2,038,453 2,592,129 3,212,247	2,548,066 3,240,162 4,015,309		
72 84 96				2,325,903 3,178,565 4,164,110	3,488,855 4,767,848 6,246,164	4,651,806 6,357,130 8,328,219	5,814,758 7,946,413 10,410,274		

- 1. Maximum recommended pressure drop / velocity: 0.25 Psig/100 Ft. / 4,000 Fpm.
- 2. Table based on Heavy Weight Steel Pipe using Steam Equations in Part 5.

			STEAM CON	DENSATE FLO	OW I DS /UD				
				IG BACK PRESSURE					
PIPE SIZE	PI	PRESSURE DROP PSIG/100 FT.			VELOCITY FPM (MPH)				
	0.125	0.25	0.5	2,000 (23)	3,000 (34)	4,000 (45)	5,000 (57)		
1/2 3/4 1	41 102 213	59 144 301	83 203 425		Pressure with these	Drop Pipe	Governs Sizes		
1-1/4 1-1/2 2	490 774 1,605	692 1,095 2,270	979 1,549 3,210	917 1,264 2,112	3,168				
2-1/2 3 4	2,669 4,956 10,649	3,774 7,009 15,059	5,338 9,913	3,031 4,724 8,223	4,547 7,086 12,334	9,448 16,445	20,557		
5 6 8	19,916 32,379 68,558	28,166 45,791		13,012 18,643 32,659	19,519 27,965 48,989	26,025 37,286 65,318	32,531 46,608 81,648		
10 12 14	131,433			53,399 77,553 94,932	80,099 116,330 142,397	106,798 155,106 189,863	133,498 193,883 237,329		
16 18 20				126,388 162,339 202,783	189,582 243,508 304,174	252,776 324,677 405,566	315,971 405,847 506,957		
22 24 26				247,721 297,153 351,078	371,581 445,729 526,618	495,442 594,306 702,157	619,302 742,882 877,696		
28 30 32				409,498 472,411 539,818	614,247 708,617 809,727	818,996 944,822 1,079,636	1,023,745 1,181,028 1,349,545		
34 36 42	Velocity	Governs	with	611,719 688,114 944,261	917,579 1,032,171 1,416,391	1,223,438 1,376,227 1,888,521	1,529,298 1,720,284 2,360,651		
48 54 60	these	Pipe	Sizes	1,240,852 1,577,887 1,955,366	1,861,277 2,366,830 2,933,050	2,481,703 3,155,774 3,910,733	3,102,129 3,944,717 4,888,416		
72 84 96				2,831,658 3,869,727 5,069,573	4,247,487 5,804,590 7,604,359	5,663,316 7,739,454 10,139,145	7,079,145 9,674,317 12,673,931		

- 1. Maximum recommended pressure drop / velocity: 0.25 Psig/100 Ft. / 4,000 Fpm.
- 2. Table based on Heavy Weight Steel Pipe using Steam Equations in Part 5.

			STEAM CON	DENSATE FI	OW LBS./HR.			
				IG BACK PRESSURE				
PIPE SIZE	PI	RESSURE DRO PSIG/100 FT.)P		VELOCITY	FPM (MPH)		
	0.125	0.25	0.5	2,000 (23)	3,000 (34)	4,000 (45)	5,000 (57)	
1/2 3/4 1	47 115 241	66 163 341	94 230 482		Pressure with these	Drop Pipe	Governs Sizes	
1-1/4 1-1/2 2	555 877 1,818	785 1,241 2,572	1,110 1,755 3,637	1,099 1,514 2,530	-			
2-1/2 3 4	3,024 5,616 12,065	4,276 7,942 17,063	6,048 11,232 24,131	3,631 5,659 9,850	5,447 8,488 14,775	19,700		
5 6 8	22,566 36,687 77,679	31,913 51,883		15,587 22,332 39,122	23,381 33,499 58,683	31,175 44,665 78,244	38,968 55,831 97,804	
10 12 14	148,920			63,966 92,900 113,717	95,949 139,350 170,576	127,932 185,800 227,434	159,915 232,249 284,293	
16 18 20				151,398 194,463 242,910	227,098 291,694 364,366	302,797 388,926 485,821	378,496 486,157 607,276	
22 24 26				296,741 355,955 420,551	445,111 533,932 630,827	593,482 711,909 841,102	741,852 889,886 1,051,378	
28 30 32	÷	,		490,531 565,894 646,640	735,796 848,841 969,959	981,062 1,131,787 1,293,279	1,226,327 1,414,734 1,616,599	
34 36 42	Velocity	Governs	with	732,768 824,280 1,131,115	1,099,153 1,236,421 1,696,672	1,465,537 1,648,561 2,262,229	1,831,921 2,060,701 2,827,786	
48 54 60	these	Pipe	Sizes	1,486,396 1,890,125 2,342,302	2,229,594 2,835,188 3,513,453	2,972,792 3,780,251 4,684,604	3,715,991 4,725,314 5,855,755	
72 84 96				3,391,998 4,635,484 6,072,760	5,087,997 6,953,226 9,109,140	6,783,996 9,270,968 12,145,519	8,479,995 11,588,710 15,181,899	

- 1. Maximum recommended pressure drop / velocity: 0.25 Psig/100 Ft. / 4,000 Fpm.
- 2. Table based on Heavy Weight Steel Pipe using Steam Equations in Part 5.

	STEAM CONDENSATE FLOW LBS./HR. 40 PSIG BACK PRESSURE									
PIPE SIZE	PF	PRESSURE DROP PSIG/100 FT.			VELOCITY FPM (MPH)					
	0.125	0.25	0.5	2,000 (23)	3,000 (34)	4,000 (45)	5,000 (57)			
1/2 3/4 1	59 145 304	84 205 429	118 290 607		Pressure with these	Drop Pipe	Governs Sizes			
1-1/4 1-1/2 2	699 1,105 2,290	988 1,562 3,238	1,397 2,209 4,580	2,094 3,499						
2-1/2 3 4	3,808 7,072 15,193	5,385 10,001 21,486	7,615 14,143 30,385	5,022 7,827 13,624	7,534 11,741 20,436	27,248				
5 6 8	28,415 46,196 97,814	40,185 65,331		21,560 30,889 54,111	32,339 46,333 81,167	43,119 61,778 108,222	53,899 77,222 135,278			
10 12 14	187,520 306,079			88,474 128,494 157,287	132,711 192,741 235,931	176,948 256,988 314,575	221,186 321,235 393,219			
16 18 20				209,406 268,971 335,981	314,110 403,456 503,971	418,813 537,942 671,962	523,516 672,427 839,952			
22 24 26				410,437 492,338 581,685	615,655 738,507 872,527	820,873 984,676 1,163,369	1,026,092 1,230,844 1,454,211			
28 30 32				678,477 782,715 894,398	1,017,715 1,174,072 1,341,597	1,356,954 1,565,429 1,788,796	1,696,192 1,956,787 2,235,995			
34 36 42	Velocity	Governs	with	1,013,527 1,140,102 1,564,499	1,520,291 1,710,153 2,346,748	2,027,054 2,280,203 3,128,997	2,533,818 2,850,254 3,911,247			
48 54 60	these	Pipe	Sizes	2,055,906 2,614,323 3,239,750	3,083,859 3,921,484 4,859,625	4,111,812 5,228,646 6,479,500	5,139,765 6,535,807 8,099,376			
72 84 96				4,691,635 6,411,560 8,399,525	7,037,452 9,617,339 12,599,287	9,383,270 12,823,119 16,799,049	11,729,087 16,028,899 20,998,812			

- 1. Maximum recommended pressure drop / velocity: 0.25 Psig/100 Ft. / 4,000 Fpm.
- 2. Table based on Heavy Weight Steel Pipe using Steam Equations in Part 5.

			STEAM CON	DENSATE EL	OW LBS./HR.			
				IG BACK PRESSURE				
PIPE SIZE	PI	RESSURE DRO PSIG/100 FT.)P	F A	VELOCITY	FPM (MPH)		
	0.125	0.25	0.5	2,000 (23)	3,000 (34)	4,000 (45)	5,000 (57)	
1/2 3/4 1	74 180 378	104 255 534	147 361 755		Pressure with these	Drop Pipe	Governs Sizes	
1-1/4 1-1/2 2	869 1,374 2,849	1,229 1,944 4,029	1,738 2,749 5,697	4,715				
2-1/2 3 4	4,737 8,797 18,900	6,699 12,441 26,729	9,474 17,595 37,801	6,767 10,546 18,357	15,819 27,535	36,713		
5 6 8	35,350 57,471 121,686	49,992 81,276 172,090	70,699	29,049 41,620 72,910	43,574 62,430 109,364	58,099 83,240 145,819	104,050 182,274	
10 12 14	233,285 380,779 495,895			119,210 173,133 211,930	178,816 259,700 317,894	238,421 346,266 423,859	298,026 432,833 529,824	
16 18 20		20 20		282,155 362,412 452,701	423,232 543,618 679,052	564,309 724,824 905,403	705,387 906,030 1,131,754	
22 24 26				553,023 663,377 783,763	829,535 995,065 1,175,644	1,106,046 1,326,754 1,567,526	1,382,558 1,658,442 1,959,407	
28 30 32				914,181 1,054,631 1,205,114	1,371,272 1,581,947 1,807,671	1,828,362 2,109,263 2,410,228	2,285,453 2,636,579 3,012,785	
34 36 42	Velocity	Governs	with	1,365,629 1,536,175 2,108,009	2,048,443 2,304,263 3,162,013	2,731,257 3,072,351 4,216,018	3,414,072 3,840,439 5,270,022	
48 54 60	these	Pipe	Sizes	2,770,132 3,522,544 4,365,246	4,155,198 5,283,816 6,547,869	5,540,264 7,045,089 8,730,493	6,925,330 8,806,361 10,913,116	
72 84 96				6,321,519 8,638,949 11,317,537	9,482,278 12,958,423 16,976,306	12,643,037 17,277,898 22,635,075	15,803,797 21,597,372 28,293,843	

- 1. Maximum recommended pressure drop / velocity: 0.25 Psig/100 Ft. / 4,000 Fpm.
- 2. Table based on Heavy Weight Steel Pipe using Steam Equations in Part 5.

	STEAM CONDENSATE FLOW LBS./HR. 0 PSIG BACK PRESSURE								
PIPE SIZE	PF	PRESSURE DROP PSIG/100 FT.			VELOCITY FPM (MPH)				
	0.125	0.25	0.5	2,000 (23)	3,000 (34)	4,000 (45)	5,000 (57)		
1/2 3/4 1	16 40 84	23 57 118	33 80 167	76 127	Pressure with these	Drop Pipe	Governs Sizes		
1-1/4 1-1/2 2	193 305 631	272 431 893	385 609 1,263	227 312 522	340 469 783	1,044			
2-1/2 3 4	1,050 1,950 4,189	1,485 2,758		749 1,168 2,032	1,124 1,751 3,048	1,498 2,335 4,065	1,873 2,919 5,081		
5 6 8	7,835			3,216 4,608 8,072	4,824 6,912 12,108	6,432 9,215 16,144	8,040 11,519 20,180		
10 12 14			4.1	13,198 19,168 23,463	19,797 28,751 35,194	26,396 38,335 46,925	32,994 47,919 58,657		
16 18 20				31,237 40,123 50,119	46,856 60,184 75,178	62,475 80,245 100,237	78,093 100,306 125,296		
22 24 26	-			61,225 73,442 86,770	91,838 110,164 130,155	122,450 146,885 173,541	153,063 183,606 216,926		
28 30 32				101,209 116,758 133,418	151,813 175,137 200,127	202,418 233,516 266,836	253,022 291,895 333,545		
34 36 42	Velocity	Governs	with	151,189 170,070 233,377	226,783 255,105 350,066	302,377 340,140 466,755	377,971 425,174 583,444		
48 54 60	these	Pipe	Sizes	306,681 389,980 483,276	460,021 584,971 724,914	613,362 779,961 966,552	766,702 974,951 1,208,190		
72 84 96				699,855 956,417 1,252,963	1,049,782 1,434,626 1,879,445	1,399,709 1,912,834 2,505,926	1,749,636 2,391,043 3,132,408		

- 1. Maximum recommended pressure drop / velocity: 0.25 Psig/100 Ft. / 4,000 Fpm.
- 2. Table based on Heavy Weight Steel Pipe using Steam Equations in Part 5.

			STEAM CON	DENSATE FLO	OW LBS./HR.		
			5 PSI	G BACK PRES	SURE		
PIPE SIZE	PF	RESSURE DRO PSIG/100 FT.)P		VELOCITY	FPM (MPH)	
	0.125	0.25	0.5	2,000 (23)	3,000 (34)	4,000 (45)	5,000 (57)
1/2 3/4 1	20 50 104	29 70 147	41 100 209	182	Pressure with these	Drop Pipe	Governs Sizes
1-1/4 1-1/2 2	240 380 787	339 537 1,113	480 759 1,573	324 446 746	669 1,118	1,491	
2-1/2 3 4	1,308 2,429 5,219	1,850 3,436	2,616	1,070 1,668 2,903	1,605 2,502 4,355	2,140 3,336 5,806	4,170 7,258
5 6 8	9,762 15,871			4,594 6,582 11,530	6,891 9,873 17,296	9,188 13,164 23,061	11,485 16,455 28,826
10 12 14				18,853 27,381 33,516	28,279 41,071 50,274	37,706 54,761 67,032	47,132 68,452 83,790
16 18 20				44,622 57,315 71,594	66,933 85,972 107,391	89,244 114,629 143,187	111,555 143,287 178,984
22 24 26				87,459 104,912 123,950	131,189 157,367 185,925	174,919 209,823 247,901	218,648 262,279 309,876
28 30 32				144,576 166,787 190,586	216,863 250,181 285,879	289,151 333,575 381,172	361,439 416,969 476,465
34 36 42	Velocity	Governs	with	215,971 242,943 333,377	323,956 364,414 500,065	431,942 485,885 666,753	539,927 607,356 833,442
48 54 60	these	Pipe	Sizes	438,090 557,082 690,353	657,135 835,623 1,035,530	876,180 1,114,164 1,380,707	1,095,225 1,392,705 1,725,884
72 84 96			5 V	999,733 1,366,230 1,789,842	1,499,600 2,049,344 2,684,763	1,999,467 2,732,459 3,579,684	2,499,333 3,415,574 4,474,605

- 1. Maximum recommended pressure drop / velocity: 0.25 Psig/100 Ft. / 4,000 Fpm.
- 2. Table based on Heavy Weight Steel Pipe using Steam Equations in Part 5.

			CTT 11 (CO)	DESTRUCTION OF THE	OW I DO ME							
		STEAM CONDENSATE FLOW LBS./HR 12 PSIG BACKPRESSURE										
PIPE SIZE	PI	PRESSURE DROP PSIG/100 FT.			VELOCITY FPM (MPH)							
	0.125	0.25	0.5	2,000 (23)	3,000 (34)	4,000 (45)	5,000 (57)					
1/2 3/4 1	26 64 133	37 90 188	52 127 267		Pressure with these	Drop Pipe	Governs Sizes					
1-1/4 1-1/2 2	307 485 1,005	434 686 1,422	614 970 2,011	477 658 1,099	1,648							
2-1/2 3 4	1,672 3,105 6,671	2,364 4,391 9,434	3,344	1,577 2,458 4,278	2,365 3,686 6,417	3,154 4,915 8,555	6,144 10,694					
5 6 8	12,476 20,284			6,769 9,699 16,990	10,154 14,548 25,486	13,539 19,398 33,981	16,924 24,247 42,476					
10 12 14				27,780 40,346 49,387	41,670 60,519 74,080	55,560 80,692 98,774	69,450 100,865 123,467					
16 18 20				65,752 84,454 105,495	98,627 126,681 158,242	131,503 168,909 210,990	164,379 211,136 263,737					
22 24 26		,		128,873 154,589 182,643	193,310 231,884 273,965	257,746 309,179 365,287	322,183 386,473 456,608					
28 30 32		9		213,035 245,765 280,832	319,553 368,647 421,249	426,070 491,530 561,665	532,588 614,412 702,081					
34 36 42	Velocity	Governs	with	318,238 357,981 491,238	477,357 536,972 736,856	636,476 715,962 982,475	795,595 894,953 1,228,094					
48 54 60	these	Pipe	Sizes	645,535 820,872 1,017,251	968,302 1,231,309 1,525,876	1,291,070 1,641,745 2,034,501	1,613,837 2,052,181 2,543,126					
72 84 96	2		2	1,473,128 2,013,168 2,637,370	2,209,693 3,019,753 3,956,056	2,946,257 4,026,337 5,274,741	3,682,821 5,032,921 6,593,426					

- 1. Maximum recommended pressure drop / velocity: 0.25 Psig/100 Ft. / 4,000 Fpm.
- 2. Table based on Heavy Weight Steel Pipe using Steam Equations in Part 5.

			STEAMCON	IDENIGATE EL	OW IDE AD		
				IG BACK PRE	OW LBS./HR. SSURE		
PIPE SIZE	PI	RESSURE DRO PSIG/100 FT.)P		VELOCITY	FPM (MPH)	
	0.125	0.25	0.5	2,000 (23)	3,000 (34)	4,000 (45)	5,000 (57)
1/2 3/4 1	28 70 146	40 99 206	57 139 292		Pressure with these	Drop Pipe	Governs Sizes
1-1/4 1-1/2 2	336 531 1,101	475 751 1,557	672 1,062 2,202	549 757 1,264	1,897		
2-1/2 3 4	1,830 3,400 7,304	2,589 4,808 10,329	3,661 6,799	1,815 2,828 4,923	2,722 4,243 7,385	3,630 5,657 9,846	12,308
5 6 8	13,660 22,208 47,023	19,318		7,791 11,162 19,553	11,686 16,743 29,330	15,581 22,324 39,107	19,477 27,905 48,884
10 12 14	9			31,971 46,432 56,837	47,956 69,648 85,255	63,942 92,864 113,674	79,927 116,081 142,092
16 18 20				75,670 97,194 121,409	113,506 145,792 182,113	151,341 194,389 242,818	189,176 242,986 303,522
22 24 26				148,314 177,910 210,196	222,471 266,864 315,293	296,628 355,819 420,391	370,785 444,774 525,489
28 30 32				245,172 282,839 323,197	367,758 424,259 484,795	490,344 565,678 646,394	612,930 707,098 807,992
34 36 42	Velocity	Governs	with	366,245 411,983 565,342	549,367 617,975 848,013	732,490 823,967 1,130,684	915,612 1,029,959 1,413,355
48 54 60	these	Pipe	Sizes	742,915 944,703 1,170,706	1,114,373 1,417,055 1,756,058	1,485,831 1,889,406 2,341,411	1,857,289 2,361,758 2,926,764
72 84 96				1,695,354 2,316,860 3,035,225	2,543,031 3,475,290 4,552,837	3,390,708 4,633,721 6,070,450	4,238,385 5,792,151 7,588,062

- $1. \ \ Maximum\ recommended\ pressure\ drop\ /\ velocity: 0.25\ Psig/100\ Ft.\ /\ 4,000\ Fpm.$
- 2. Table based on Heavy Weight Steel Pipe using Steam Equations in Part 5.

				DENSATE FLOW LBS./HR. IG BACK PRESSURE					
PIPE SIZE		ESSURE DRO PSIG/100 FT.	P		VELOCITY	FPM (MPH)			
	0.125	0.25	0.5	2,000 (23)	3,000 (34)	4,000 (45)	5,000 (57)		
1/2 3/4 1	23 55 116	32 78 164	45 111 232	224	Pressure with these	Drop Pipe	Governs Sizes		
1-1/4 1-1/2 2	267 422 874	377 596 1,236	533 843 1,748	400 . 551 921	827 1,382				
2-1/2 3 4	1,453 2,699 5,800	2,056 3,818 8,202	2,907	1,322 2,060 3,586	1,983 3,090 5,379	2,644 4,120 7,172	5,151 8,965		
5 6 8	10,847 17,635			5,675 8,130 14,243	8,512 12,196 21,364	11,350 16,261 28,486	14,187 20,326 35,607		
10 12 14				23,288 33,822 41,401	34,932 50,733 62,101	46,576 67,643 82,801	58,220 84,554 103,502		
16 18 20		2		55,119 70,798 88,436	82,679 106,196 132,653	110,238 141,595 176,871	137,798 176,994 221,089		
22 24 26			2	108,034 129,591 153,109	162,050 194,387 229,663	216,067 259,183 306,218	270,084 323,978 382,772		
28 30 32			160	178,586 206,023 235,420	267,879 309,035 353,130	357,172 412,046 470,840	446,465 515,058 588,550		
34 36 42	Velocity	Governs	with	266,777 300,093 411,802	400,165 450,140 617,702	533,554 600,187 823,603	666,942 750,233 1,029,504		
48 54 60	these	Pipe	Sizes	541,148 688,132 852,755	811,722 1,032,199 1,279,132	1,082,296 1,376,265 1,705,510	1,352,870 1,720,331 2,131,887		
72 84 96				1,234,915 1,687,627 2,210,892	1,852,372 2,531,440 3,316,337	2,469,829 3,375,254 4,421,783	3,087,286 4,219,067 5,527,229		

- $1. \ \ Maximum\ recommended\ pressure\ drop\ /\ velocity: 0.25\ Psig/100\ Ft.\ /\ 4,000\ Fpm.$
- 2. Table based on Heavy Weight Steel Pipe using Steam Equations in Part 5.

			STEAMCON	DENGATEEL	OW I DS /LID			
				DENSATE FLOW LBS./HR IG BACKPRESSURE				
PIPE SIZE	PI	RESSURE DRO PSIG/100 FT.)P	VELOCITY FPM (MPH)				
	0.125	0.25	0.5	2,000 (23)	3,000 (34)	4,000 (45)	5,000 (57)	
1/2 3/4 1	24 59 123	34 83 174	48 118 247		Pressure with these	Drop Pipe	Governs Sizes	
1-1/4 1-1/2 2	284 449 930	401 635 1,316	568 898 1,861	442 608 1,017	1,525			
2-1/2 3 4	1,547 2,873 6,172	2,188 4,063 8,729	3,094	1,459 2,274 3,958	2,189 3,411 5,937	2,918 4,548 7,916	5,685 9,895	
5 6 8	11,544 18,768		*	6,264 8,974 15,721	9,396 13,461 23,581	12,527 17,948 31,442	15,659 22,435 39,302	
10 12 14				25,704 37,331 45,697	38,557 55,997 68,545	51,409 74,663 91,394	64,261 93,329 114,242	
16 18 20	z			60,839 78,144 97,613	91,258 117,216 146,419	121,678 156,288 195,225	152,097 195,360 244,032	
22 24 26			,	119,244 143,039 168,997	178,866 214,558 253,495	238,488 286,078 337,994	298,111 357,597 422,492	
28 30 32				197,118 227,402 259,850	295,677 341,103 389,774	394,236 454,804 519,699	492,795 568,506 649,624	
34 36 42	Velocity	Governs	with	294,460 331,234 454,534	441,690 496,851 681,801	588,920 662,468 909,068	736,151 828,085 1,136,335	
48 54 60	these	Pipe	Sizes	597,303 759,540 941,245	895,954 1,139,310 1,411,868	1,194,605 1,519,079 1,882,490	1,493,257 1,898,849 2,353,113	
72 84 96				1,363,061 1,862,752 2,440,315	2,044,592 2,794,127 3,660,473	2,726,123 3,725,503 4,880,631	3,407,654 4,656,879 6,100,789	

- 1. Maximum recommended pressure drop / velocity: 0.25 Psig/100 Ft. / 4,000 Fpm.
- 2. Table based on Heavy Weight Steel Pipe using Steam Equations in Part 5.

				DENSATE FLO			,	
PIPE SIZE	PF	RESSURE DRO PSIG/100 FT.		VELOCITY FPM (MPH)				
	0.125	0.25	0.5	2,000 (23)	3,000 (34)	4,000 (45)	5,000 (57)	
1/2 3/4 1	34 83 173	48 117 245	67 165 346		Pressure with these	Drop Pipe	Governs Sizes	
1-1/4 1-1/2 2	399 630 1,307	564 891 1,848	797 1,261 2,613	747 1,029 1,719	2,579	-		
2-1/2 3 4	2,173 4,035 8,669	3,072 5,706 12,259	4,345 8,070	2,468 3,846 6,694	3,702 5,769 10,041	7,692 13,388	16,735	
5 6 8	16,213 26,359 55,812	22,929 37,278		10,593 15,177 26,587	15,890 22,766 39,881	21,186 30,354 53,174	26,483 37,943 66,468	
10 12 14	106,997	-		43,471 63,135 77,282	65,207 94,702 115,923	86,942 126,269 154,564	108,678 157,837 193,205	
16 18 20		·		102,890 132,157 165,082	154,336 198,236 247,623	205,781 264,314 330,164	257,226 330,393 412,705	
22 24 26				201,665 241,907 285,807	302,498 362,860 428,710	403,330 483,814 571,613	504,163 604,767 714,517	
28 30 32		D		333,365 384,582 439,456	500,047 576,872 659,185	666,730 769,163 878,913	833,412 961,454 1,098,641	
34 36 42	Velocity	Governs	with	497,990 560,181 768,706	746,984 840,272 1,153,059	995,979 1,120,362 1,537,412	1,244,974 1,400,453 1,921,764	
48 54 60	these	Pipe	Sizes	1,010,155 1,284,530 1,591,829	1,515,233 1,926,795 2,387,744	2,020,311 2,569,060 3,183,658	2,525,388 3,211,324 3,979,573	
72 84 96				2,305,203 3,150,276 4,127,049	3,457,804 4,725,414 6,190,574	4,610,405 6,300,552 8,254,098	5,763,007 7,875,690 10,317,623	

- $1. \ \ Maximum\ recommended\ pressure\ drop\ /\ velocity:\ 0.25\ Psig/100\ Ft.\ /\ 4,000\ Fpm.$
- 2. Table based on Heavy Weight Steel Pipe using Steam Equations in Part 5.

			STEAM CON	DENSATE FI	OW LBS./HR.				
				IG BACK PRE					
PIPE SIZE	P	RESSURE DRO PSIG/100 FT.)P	VELOCITY FPM (MPH)					
	0.125	0.25	0.5	2,000 (23)	3,000 (34)	4,000 (45)	5,000 (57)		
1/2 3/4 1	38 92 193	53 131 274	75 185 387		Pressure with these	Drop Pipe	Governs Sizes		
1-1/4 1-1/2 2	445 704 1,459	630 996 2,064	891 1,408 2,919	882 1,215 2,030					
2-1/2 3 4	2,427 4,507 9,683	3,432 6,374 13,693	4,853 9,014 19,365	2,914 4,541 7,905	4,371 6,812 11,857	15,809			
5 6 8	18,110 29,442 62,339	25,611 41,637	¥	12,509 17,922 31,396	18,764 26,883 47,094	25,018 35,844 62,792	31,273 44,805 78,490		
10 12 14	119,511			51,334 74,554 91,260	77,001 111,831 136,890	102,668 149,108 182,521	128,335 186,385 228,151		
16 18 20				121,500 156,061 194,941	182,251 234,091 292,411	243,001 312,121 389,881	303,751 390,151 487,352		
22 24 26	1 10			238,141 285,661 337,501	357,211 428,492 506,252	476,282 571,322 675,002	595,352 714,153 843,753		
28 30 32				393,661 454,142 518,942	590,492 681,212 778,413	787,323 908,283 1,037,884	984,153 1,135,354 1,297,355		
34 36 42	Velocity	Governs	with	588,062 661,502 907,743	882,093 992,254 1,361,615	1,176,124 1,323,005 1,815,486	1,470,155 1,653,756 2,269,358		
48 54 60	these	Pipe	Sizes	1,192,864 1,516,865 1,879,747	1,789,296 2,275,298 2,819,620	2,385,728 3,033,731 3,759,493	2,982,161 3,792,163 4,699,367		
72 84 96				2,722,150 3,720,073 4,873,517	4,083,224 5,580,110 7,310,276	5,444,299 7,440,146 9,747,034	6,805,374 9,300,183 12,183,793		

- 1. Maximum recommended pressure drop / velocity: 0.25 Psig/100 Ft. / 4,000 Fpm.
- 2. Table based on Heavy Weight Steel Pipe using Steam Equations in Part 5.

	STEAM CONDENSATE FLOW LBS./HR. 40 PSIG BACK PRESSURE										
PIPE SIZE		PRESSURE DROP PSIG/100 FT.			VELOCITY FPM (MPH)						
	0.125	0.25	0.5	2,000 (23)	3,000 (34)	4,000 (45)	5,000 (57)				
1/2 3/4 1	46 113 236	65 160 334	92 226 472		Pressure with these	Drop Pipe	Governs Sizes				
1-1/4 1-1/2 2	544 860 1,782	769 1,216 2,520	1,087 1,720 3,564	1,630 2,723							
2-1/2 3 4	2,963 5,504 11,824	4,191 7,784 16,722	5,927 11,008 23,649	3,909 6,092 10,603	5,863 9,138 15,905	21,207					
5 6 8	22,115 35,955 76,129	31,276 50,848		16,780 24,041 42,115	25,170 36,061 63,172	33,560 48,082 84,230	41,950 60,102 105,287				
10 12 14	145,947 238,222			68,860 100,007 122,417	103,289 150,011 183,626	137,719 200,014 244,834	172,149 250,018 306,043				
16 18 20				162,981 209,341 261,495	244,472 314,011 392,242	325,963 418,681 522,989	407,454 523,351 653,737				
22 24 26				319,444 383,187 452,726	479,165 574,781 679,089	638,887 766,375 905,452	798,609 957,969 1,131,815				
28 30 32				528,060 609,188 696,112	792,090 913,783 1,044,168	1,056,120 1,218,377 1,392,224	1,320,150 1,522,971 1,740,279				
34 36 42	Velocity	Governs	with	788,830 887,343 1,217,652	1,183,245 1,331,015 1,826,478	1,577,660 1,774,687 2,435,305	1,972,075 2,218,358 3,044,131				
48 54 60	these	Pipe	Sizes	1,600,115 2,034,733 2,521,504	2,400,173 3,052,099 3,782,256	3,200,231 4,069,465 5,043,007	4,000,288 5,086,831 6,303,759				
72 84 96	5 S	,		3,651,508 4,990,129 6,537,366	5,477,262 7,485,193 9,806,049	7,303,016 9,980,258 13,074,732	9,128,771 12,475,322 16,343,415				

- Maximum recommended pressure drop / velocity: 0.25 Psig/100 Ft. / 4,000 Fpm.
 Table based on Heavy Weight Steel Pipe using Steam Equations in Part 5.

				ONDENSATE FLOW LBS./HR. PSIG BACK PRESSURE				
PIPE SIZE	PI	RESSURE DRO PSIG/100 FT.)P		VELOCITY	FPM (MPH)	7 1	
	0.125	0.25	0.5	2,000 (23)	3,000 (34)	4,000 (45)	5,000 (57)	
1/2 3/4 1	55 136 284	78 192 401	111 271 568		Pressure with these	Drop Pipe	Governs Sizes	
1-1/4 1-1/2 2	653 1,033 2,142	924 1,461 3,029	1,307 2,067 4,283	3,545				
2-1/2 3 4	3,561 6,614 14,210	5,037 9,354 20,096	7,123 13,229 28,420	5,088 7,929 13,801	11,894 20,702	27,603		
5 6 8	26,578 43,209 91,489	37,586 61,107 129,385	53,155	21,841 31,292 54,817	32,761 46,938 82,225	43,681 62,584 109,634	78,229 137,042	
10 12 14	175,395 286,288 372,838			89,628 130,170 159,339	134,442 195,255 239,008	179,256 260,340 318,678	224,070 325,425 398,347	
16 18 20				212,137 272,479 340,363	318,206 408,718 510,544	424,275 544,957 680,725	530,344 681,197 850,907	
22 24 26			a	415,789 498,759 589,271	623,684 748,138 883,906	831,579 997,517 1,178,541	1,039,473 1,246,897 1,473,176	
28 30 32	8 5 3			687,325 792,922 906,062	1,030,988 1,189,384 1,359,094	1,374,650 1,585,845 1,812,125	1,718,313 1,982,306 2,265,156	
34 36 42	Velocity	Governs	with	1,026,745 1,154,970 1,584,902	1,540,118 1,732,455 2,377,353	2,053,490 2,309,941 3,169,804	2,566,863 2,887,426 3,962,255	
48 54 60	these	Pipe	Sizes	2,082,718 2,648,418 3,282,001	3,124,077 3,972,627 4,923,002	4,165,436 5,296,835 6,564,003	5,206,795 6,621,044 8,205,004	
72 84 96				4,752,821 6,495,176 8,509,067	7,129,231 9,742,764 12,763,601	9,505,642 12,990,352 17,018,134	11,882,052 16,237,940 21,272,668	

- 1. Maximum recommended pressure drop / velocity: 0.25 Psig/100 Ft. / 4,000 Fpm.
- 2. Table based on Heavy Weight Steel Pipe using Steam Equations in Part 5.

				DENSATE FLO					
PIPE SIZE	PI	PRESSURE DROP PSIG/100 FT.			VELOCITY FPM (MPH)				
	0.125	0.25	0.5	2,000 (23)	3,000 (34)	4,000 (45)	5,000 (57)		
1/2 3/4 1	66 161 337	93 227 476	131 321 673		Pressure with these	Drop Pipe	Governs Sizes		
1-1/4 1-1/2 2	775 1,225 2,539	1,096 1,733 3,591	1,549 2,450 5,078	4,497		14			
2-1/2 3 4	4,222 7,842 16,848	5,971 11,090 23,826	8,445 15,684 33,695	6,454 10,059 17,508	15,088 26,262				
5 6 8	31,510 51,229 108,469	44,562 72,448 153,399	63,021	27,706 39,696 69,539	41,560 59,544 104,308	55,413 79,392 139,078	99,239 173,847		
10 12 14	207,948 339,422 442,035			113,699 165,129 202,132	170,549 247,694 303,198	227,399 330,259 404,264	284,248 412,823 505,330		
16 18 20	- F 1 g		4.1	269,111 345,658 431,773	403,666 518,487 647,660	538,221 691,316 863,546	672,777 864,144 1,079,433		
22 24 26	-		*	527,457 632,709 747,530	791,186 949,064 1,121,295	1,054,914 1,265,419 1,495,060	1,318,643 1,581,773 1,868,825		
28 30 32				871,919 1,005,876 1,149,402	1,307,878 1,508,814 1,724,103	1,743,838 2,011,752 2,298,804	2,179,797 2,514,690 2,873,505		
34 36 42	Velocity	Governs	with	1,302,496 1,465,158 2,010,556	1,953,744 2,197,738 3,015,834	2,604,992 2,930,317 4,021,113	3,256,240 3,662,896 5,026,391		
48 54 60	these	Pipe	Sizes	2,642,069 3,359,698 4,163,442	3,963,104 5,039,547 6,245,163	5,284,139 6,719,396 8,326,884	6,605,174 8,399,245 10,408,605		
72 84 96	180		, ,	6,029,277 8,239,573 10,794,331	9,043,915 12,359,359 16,191,496	12,058,553 16,479,146 21,588,662	15,073,192 20,598,932 26,985,827		

Maximum recommended pressure drop / velocity: 0.25 Psig/100 Ft. / 4,000 Fpm.
 Table based on Heavy Weight Steel Pipe using Steam Equations in Part 5.

	2			IDENSATE FLOW LBS./HR. IG BACK PRESSURE				
PIPE SIZE	PI	RESSURE DRO PSIG/100 FT.)P		VELOCITY	FPM (MPH)		
	0.125	0.25	0.5	2,000 (23)	3,000 (34)	4,000 (45)	5,000 (57)	
1/2 3/4 1	14 36 74	20 50 105	29 71 149	68 113	Pressure with these	Drop Pipe	Governs Sizes	
1-1/4 1-1/2 2	171 271 561	242 383 793	342 541 1,122	201 278 464	302 416 696	928		
2-1/2 3 4	933 1,733 3,723	1,319 2,450		666 1,038 1,806	999 1,556 2,709	1,331 2,075 3,612	1,664 2,594 4,515	
5 6 8	6,962			2,858 4,094 7,173	4,287 6,142 10,759	5,716 8,189 14,345	7,144 10,236 17,932	
10 12 14				11,728 17,032 20,849	17,591 25,548 31,273	23,455 34,065 41,698	29,319 42,581 52,122	
16 18 20				27,757 35,653 44,535	41,636 53,479 66,803	55,515 71,306 89,071	69,394 89,132 111,338	
22 24 26				54,405 65,261 77,104	81,607 97,891 115,656	108,809 130,522 154,208	136,012 163,152 192,760	
28 30 32			,	89,934 103,751 118,555	134,901 155,627 177,833	179,868 207,502 237,110	224,835 259,378 296,388	
34 36 42	Velocity	Governs	with	134,346 151,124 207,379	201,519 226,686 311,069	268,692 302,248 414,758	335,865 377,810 518,448	
48 54 60	these	Pipe	Sizes	272,517 346,537 429,439	408,775 519,805 644,158	545,033 693,073 858,878	681,292 866,341 1,073,597	
72 84 96				621,891 849,872 1,113,383	932,836 1,274,808 1,670,074	1,243,781 1,699,744 2,226,765	1,554,726 2,124,680 2,783,457	

- 1. Maximum recommended pressure drop / velocity: 0.25 Psig/100 Ft. / 4,000 Fpm.
- 2. Table based on Heavy Weight Steel Pipe using Steam Equations in Part 5.

				DENSATE FLO					
			10 PSI	G BACK PRESSURE					
PIPE SIZE		ESSURE DRO PSIG/100 FT.	P	21	VELOCITY	FPM (MPH)			
	0.125	0.25	0.5	2,000 (23)	3,000 (34)	4,000 (45)	5,000 (57)		
1/2 3/4 1	21 52 109	30 73 154	42 104 217	210	Pressure with these	Drop Pipe	Governs Sizes		
1-1/4 1-1/2 2	250 396 820	354 559 1,159	500 791 1,640	375 517 864	776 1,296	-			
2-1/2 3 4	1,363 2,532 5,440	1,928 3,581 7,693	2,727	1,240 1,932 3,364	1,860 2,899 5,045	2,480 3,865 6,727	4,831 8,409		
5 6 8	10,174 16,541			5,323 7,626 13,360	7,984 11,440 20,040	10,646 15,253 26,720	13,307 19,066 33,399		
10 12 14				21,844 31,725 38,834	32,766 47,587 58,250	43,688 63,449 77,667	54,610 79,311 97,084		
16 18 20	-			51,701 66,408 82,952	77,552 99,611 124,428	103,403 132,815 165,904	129,254 166,019 207,380		
22 24 26			,	101,335 121,556 143,615	152,002 182,334 215,423	202,670 243,112 287,230	253,337 303,890 359,038		
28 30 32				167,513 193,249 220,823	251,269 289,873 331,234	335,025 386,497 441,645	418,782 483,121 552,057		
34 36 42	Velocity	Governs	with	250,235 281,486 386,267	375,353 422,229 579,401	500,470 562,971 772,535	625,588 703,714 965,668		
48 54 60	these	Pipe	Sizes	507,593 645,464 799,879	761,390 968,196 1,199,818	1,015,187 1,290,928 1,599,758	1,268,983 1,613,660 1,999,697		
72 84 96				1,158,342 1,582,984 2,073,803	1,737,514 2,374,476 3,110,704	2,316,685 3,165,967 4,147,606	2,895,856 3,957,459 5,184,507		

- 1. Maximum recommended pressure drop / velocity: 0.25 Psig/100 Ft. / 4,000 Fpm.
- 2. Table based on Heavy Weight Steel Pipe using Steam Equations in Part 5.

			OTT IN COS	DE 10 1 ME	OW I DO ST		
				IDENSATE FL IG BACKPRES	OW LBS./HR SSURE		
PIPE SIZE	PI	RESSURE DRO PSIG/100 FT.)P		VELOCITY	FPM (MPH)	
	0.125	0.25	0.5	2,000 (23)	3,000 (34)	4,000 (45)	5,000 (57)
1/2 3/4 1	22 55 115	32 78 163	45 110 231		Pressure with these	Drop Pipe	Governs Sizes
1-1/4 1-1/2 2	266 420 871	376 594 1,232	532 840 1,742	413 570 952	1,428		7
2-1/2 3 4	1,448 2,690 5,779	2,048 3,804 8,173	2,897	1,366 2,129 3,706	2,049 3,194 5,559	2,732 4,258 7,412	5,323 9,265
5 6 8	10,809 17,573			5,865 8,402 14,719	8,797 12,604 22,079	11,729 16,805 29,439	14,662 21,006 36,798
10 12 14				24,067 34,953 42,785	36,100 52,430 64,178	48,134 69,906 85,571	60,167 87,383 106,964
16 18 20		4 8		56,963 73,166 91,394	85,444 109,748 137,091	113,926 146,331 182,787	142,407 182,914 228,484
22 24 26	, 1			111,647 133,926 158,230	167,471 200,889 237,345	223,294 267,852 316,460	279,118 334,815 395,575
28 30 32			2	184,560 212,914 243,295	276,839 319,372 364,942	369,119 425,829 486,589	461,399 532,286 608,236
34 36 42	Velocity	Governs	with	275,700 310,131 425,576	413,550 465,196 638,363	551,400 620,262 851,151	689,250 775,327 1,063,939
48 54 60	these	Pipe	Sizes	559,248 711,149 881,278	838,873 1,066,724 1,321,917	1,118,497 1,422,299 1,762,557	1,398,121 1,777,873 2,203,196
72 84 96				1,276,221 1,744,075 2,284,842	1,914,331 2,616,113 3,427,264	2,552,441 3,488,151 4,569,685	3,190,551 4,360,188 5,712,106

- 1. Maximum recommended pressure drop / velocity: 0.25 Psig/100 Ft. / 4,000 Fpm.
- 2. Table based on Heavy Weight Steel Pipe using Steam Equations in Part 5.

				DENSATE FLO					
PIPE SIZE	PF	PRESSURE DROP PSIG/100 FT.			VELOCITY FPM (MPH)				
	0.125	0.25	0.5	2,000 (23)	3,000 (34)	4,000 (45)	5,000 (57)		
1/2 3/4 1	24 60 126	35 85 178	49 120 251		Pressure with these	Drop Pipe	Governs Sizes		
1-1/4 1-1/2 2	289 457 948	409 647 1,340	578 915 1,896	473 652 1,089	1,633				
2-1/2 3 4	1,576 2,927 6,289	2,229 4,140 8,894	3,152 5,854	1,563 2,435 4,239	2,344 3,653 6,358	3,125 4,871 8,478	10,597		
5 6 8	11,762 19,122 40,488	16,634		6,708 9,611 16,836	10,062 14,416 25,254	13,416 19,222 33,673	16,770 24,027 42,091		
10 12 14				27,528 39,980 48,939	41,292 59,970 73,408	55,056 79,960 97,878	68,820 99,950 122,347		
16 18 20				65,155 83,688 104,538	97,733 125,532 156,807	130,310 167,376 209,076	162,888 209,221 261,345		
22 24 26				127,704 153,187 180,987	191,556 229,781 271,480	255,408 306,374 361,973	319,260 382,968 452,467		
28 30 32	a e			211,103 243,536 278,285	316,654 365,303 417,428	422,206 487,071 556,570	527,757 608,839 695,713		
34 36 42	Velocity	Governs	with	315,351 354,734 486,782	473,027 532,101 730,172	630,702 709,468 973,563	788,378 886,834 1,216,954		
48 54 60	these	Pipe	Sizes	639,679 813,426 1,008,023	959,519 1,220,139 1,512,035	1,279,358 1,626,853 2,016,046	1,599,198 2,033,566 2,520,058		
72 84 96				1,459,766 1,994,907 2,613,447	2,189,649 2,992,361 3,920,170	2,919,531 3,989,814 5,226,894	3,649,414 4,987,268 6,533,617		

- Maximum recommended pressure drop / velocity: 0.25 Psig/100 Ft. / 4,000 Fpm.
 Table based on Heavy Weight Steel Pipe using Steam Equations in Part 5.

				DENSATE FLO			
PIPE SIZE	PF	RESSURE DRO PSIG/100 FT.		IG BACK PRES		FPM (MPH)	
	0.125	0.25	0.5	2,000 (23)	3,000 (34)	4,000 (45)	5,000 (57)
1/2 3/4 1	28 68 143	39 96 202	56 136 286		Pressure with these	Drop Pipe	Governs Sizes
1-1/4 1-1/2 2	329 520 1,077	465 735 1,523	657 1,039 2,155	578 797 1,331	1,996		
2-1/2 3 4	1,791 3,327 7,148	2,533 4,705 10,108	3,583 6,654	1,910 2,977 5,182	2,866 4,466 7,773	5,955 10,364	12,955
5 6 8	13,368 21,734 46,018	18,905		8,201 11,749 20,583	12,301 17,624 30,874	16,401 23,499 41,165	20,502 29,374 51,456
10 12 14				33,653 48,876 59,828	50,480 73,314 89,743	67,307 97,752 119,657	84,134 122,190 149,571
16 18 20		."		79,653 102,310 127,799	119,480 153,465 191,699	159,306 204,620 255,598	199,133 255,775 319,498
22 24 26				156,120 187,273 221,259	234,180 280,910 331,888	312,240 374,547 442,518	390,300 468,184 553,147
28 30 32	,	e e		258,076 297,726 340,207	387,114 446,589 510,311	516,152 595,452 680,415	645,191 744,314 850,519
34 36 42	Velocity	Governs	with	385,521 433,667 595,098	578,282 650,501 892,646	771,043 867,334 1,190,195	963,803 1,084,168 1,487,744
48 54 60	these	Pipe	Sizes	782,017 994,425 1,232,323	1,173,025 1,491,638 1,848,484	1,564,034 1,988,851 2,464,645	1,955,042 2,486,063 3,080,807
72 84 96				1,784,585 2,438,802 3,194,976	2,676,877 3,658,204 4,792,465	3,569,169 4,877,605 6,389,953	4,461,461 6,097,006 7,987,441

- $1.\ \ Maximum\ recommended\ pressure\ drop\ /\ velocity:\ 0.25\ Psig/100\ Ft.\ /\ 4,000\ Fpm.$ $2.\ \ Table\ based\ on\ Heavy\ Weight\ Steel\ Pipe\ using\ Steam\ Equations\ in\ Part\ 5.$

				DENSATE FLO	OW LBS./HR.		
PIPE SIZE	PF	RESSURE DRO PSIG/100 FT.	P		VELOCITY	FPM (MPH)	
	0.125	0.25	0.5	2,000 (23)	3,000 (34)	4,000 (45)	5,000 (57)
1/2 3/4 1	58 143 300	83 203 425	117 287 601		Pressure with these	Drop Pipe	Governs Sizes
1-1/4 1-1/2 2	692 1,094 2,267	978 1,547 3,205	1,383 2,187 4,533	4,014			
2-1/2 3 4	3,769 7,000 15,039	5,330 9,899 21,268	7,538 14,000 30,077	5,761 8,979 15,628	13,468 23,442		
5 6 8	28,127 45,728 96,823	39,778 64,670 136,929	56,254	24,732 35,434 62,073	37,097 53,151 93,109	49,463 70,867 124,145	88,584 155,182
10 12 14	185,621 302,979 394,575			101,492 147,400 180,429	152,237 221,099 270,644	202,983 294,799 360,859	253,729 368,499 451,074
16 18 20	572,625	1		240,217 308,545 385,414	360,325 462,818 578,122	480,433 617,090 770,829	600,542 771,363 963,536
22 24 26		,		470,825 564,776 667,269	706,237 847,164 1,000,903	941,650 1,129,553 1,334,537	1,177,062 1,411,941 1,668,172
28 30 32				778,302 897,877 1,025,992	1,167,453 1,346,815 1,538,989	1,556,605 1,795,754 2,051,985	1,945,756 2,244,692 2,564,981
34 36 42	Velocity	Governs	with	1,162,649 1,307,847 1,794,686	1,743,974 1,961,770 2,692,029	2,325,298 2,615,693 3,589,372	2,906,623 3,269,617 4,486,715
48 54 60	these	Pipe	Sizes	2,358,395 2,998,973 3,716,420	3,537,592 4,498,459 5,574,630	4,716,789 5,997,945 7,432,840	5,895,987 7,497,432 9,291,050
72 84 96		1		5,381,923 7,354,903 9,635,361	8,072,884 11,032,354 14,453,041	10,763,845 14,709,806 19,270,721	13,454,807 18,387,257 24,088,402

- 1. Maximum recommended pressure drop / velocity: 0.25 Psig/100 Ft. / 4,000 Fpm.
- 2. Table based on Heavy Weight Steel Pipe using Steam Equations in Part 5.

			CTEAM CON	DENICATE EL	OW IDE #TD		
				IG BACK PRES	OW LBS./HR. SSURE		
PIPE SIZE	PI	RESSURE DRO PSIG/100 FT.)P		VELOCITY	FPM (MPH)	
	0.125	0.25	0.5	2,000 (23)	3,000 (34)	4,000 (45)	5,000 (57)
1/2 3/4 1	73 180 376	104 254 532	147 359 753		Pressure with these	Drop Pipe	Governs Sizes
1-1/4 1-1/2 2	866 1,370 2,839	1,225 1,937 4,015	1,732 2,739 5,678	5,481			
2-1/2 3 4	4,721 8,767 18,836	6,676 12,399 26,638	9,441 17,535 37,672	7,867 12,260 21,339	32,009		
5 6 8	35,229 57,275 121,271	49,822 80,999 171,504	70,459 114,550	33,769 48,382 84,756	50,654 72,573 127,133	67,538 96,764 169,511	211,889
10 12 14	232,491 379,483 494,206	328,792		138,579 201,263 246,363	207,869 301,895 369,544	277,158 402,527 492,726	346,448 503,158 615,907
16 18 20	717,216 992,077	, v		327,998 421,295 526,255	491,997 631,943 789,382	655,996 842,591 1,052,509	819,995 1,053,238 1,315,637
22 24 26				642,876 771,160 911,106	964,314 1,156,740 1,366,659	1,285,752 1,542,320 1,822,211	1,607,191 1,927,900 2,277,764
28 30 32				1,062,714 1,225,984 1,400,916	1,594,071 1,838,976 2,101,374	2,125,427 2,451,968 2,801,832	2,656,784 3,064,960 3,502,290
34 36 42	Velocity	Governs	with	1,587,511 1,785,767 2,450,510	2,381,266 2,678,651 3,675,765	3,175,021 3,571,534 4,901,020	3,968,777 4,464,418 6,126,275
48 54 60	these	Pipe	Sizes	3,220,212 4,094,874 5,074,495	4,830,318 6,142,310 7,611,742	6,440,424 8,189,747 10,148,989	8,050,530 10,237,184 12,686,236
72 84 96				7,348,614 10,042,572 13,156,367	11,022,922 15,063,858 19,734,550	14,697,229 20,085,144 26,312,734	18,371,536 25,106,430 32,890,917

^{1.} Maximum recommended pressure drop / velocity: 0.25 Psig/100 Ft. / 4,000 Fpm.

^{2.} Table based on Heavy Weight Steel Pipe using Steam Equations in Part 5.

				DENSATE FLO G BACK PRES			-		
PIPE SIZE	PF	PRESSURE DROP PSIG/100 FT.			VELOCITY FPM (MPH)				
	0.125	0.25	0.5	2,000 (23)	3,000 (34)	4,000 (45)	5,000 (57)		
1/2 3/4 1	14 34 71	20 48 100	28 68 142	65 108	Pressure with these	Drop Pipe	Governs Sizes		
1-1/4 1-1/2 2	163 258 535	231 365 756	326 516 1,070	192 265 442	288 397 663	884			
2-1/2 3 4	889 1,652 3,549	1,258 2,336		635 989 1,722	952 1,484 2,582	1,269 1,978 3,443	1,587 2,473 4,304		
5 6 8	6,638			2,724 3,903 6,838	4,087 5,855 10,257	5,449 7,807 13,676	6,811 9,759 17,095		
10 12 14				11,180 16,238 19,876	16,771 24,357 29,815	22,361 32,475 39,753	27,951 40,594 49,691		
16 18 20		2		26,463 33,990 42,458	39,694 50,985 63,687	52,925 67,979 84,915	66,156 84,974 106,144		
22 24 26				51,867 62,216 73,507	77,800 93,325 110,261	103,733 124,433 147,014	129,667 155,541 183,768		
28 30 32				85,739 98,911 113,025	128,608 148,367 169,537	171,477 197,822 226,049	214,347 247,278 282,561		
34 36 42	Velocity	Governs	with	128,079 144,074 197,705	192,118 216,111 296,557	256,158 288,148 395,410	320,197 360,185 494,262		
48 54 60	these	Pipe	Sizes	259,804 330,371 409,405	389,706 495,556 614,108	519,607 660,741 818,811	649,509 825,926 1,023,514		
72 84 96				592,879 810,225 1,061,443	889,319 1,215,338 1,592,165	1,185,759 1,620,450 2,122,887	1,482,198 2,025,563 2,653,608		

- 1. Maximum recommended pressure drop / velocity: 0.25 Psig/100 Ft. / 4,000 Fpm.
- 2. Table based on Heavy Weight Steel Pipe using Steam Equations in Part 5.

			STEAM CON	DENSATE FL	OW LBS./HR.			
			5 PSI	G BACK PRESSURE				
PIPE SIZE	PI	RESSURE DRO PSIG/100 FT.)P		VELOCITY	FPM (MPH)		
	0.125	0.25	0.5	2,000 (23)	3,000 (34)	4,000 (45)	5,000 (57)	
1/2 3/4 1	17 42 87	24 59 123	34 83 174	152	Pressure with these	Drop Pipe	Governs Sizes	
1-1/4 1-1/2 2	200 317 657	283 448 929	401 634 1,313	270 372 622	559 934	1,245		
2-1/2 3 4	1,092 2,028 4,357	1,544 2,868	2,184	893 1,392 2,423	1,340 2,088 3,635	1,787 2,784 4,846	3,480 6,058	
5 6 8	8,148 13,247			3,835 5,494 9,624	5,752 8,241 14,436	7,669 10,988 19,248	9,586 13,735 24,061	
10 12 14			-	15,736 22,854 27,975	23,604 34,281 41,963	31,472 45,708 55,950	39,340 57,135 69,938	
16 18 20	٥			37,245 47,839 59,757	55,867 71,759 89,636	74,490 95,678 119,515	93,112 119,598 149,394	
22 24 26				73,000 87,567 103,458	109,500 131,351 155,187	146,000 175,134 206,916	182,500 218,918 258,646	
28 30 32			ū.	120,674 139,213 159,077	181,011 208,820 238,616	241,347 278,427 318,155	301,684 348,033 397,693	
34 36 42	Velocity	Governs	with	180,266 202,778 278,261	270,398 304,167 417,392	360,531 405,556 556,523	450,664 506,945 695,653	
48 54 60	these	Pipe	Sizes	365,663 464,983 576,221	548,494 697,474 864,331	731,326 929,965 1,152,442	914,157 1,162,457 1,440,552	
72 84 96				834,453 1,140,358 1,493,937	1,251,679 1,710,537 2,240,905	1,668,905 2,280,716 2,987,874	2,086,132 2,850,895 3,734,842	

- 1. Maximum recommended pressure drop / velocity: 0.25 Psig/100 Ft. / 4,000 Fpm.
- 2. Table based on Heavy Weight Steel Pipe using Steam Equations in Part 5.

				DENSATE FLO G BACK PRES			
PIPE SIZE		RESSURE DRO PSIG/100 FT.	P		VELOCITY	FPM (MPH)	4
	0.125	0.25	0.5	2,000 (23)	3,000 (34)	4,000 (45)	5,000 (57)
1/2 3/4 1	26 64 134	37 91 190	52 128 268		Pressure with these	Drop Pipe	Governs Sizes
1-1/4 1-1/2 2	309 488 1,012	436 690 1,431	617 976 2,023	543 748 1,250	1,875		
2-1/2 3 4	1,682 3,124 6,712	2,379 4,418 9,492	3,364 6,248	1,794 2,796 4,866	2,691 4,194 7,299	5,592 9,733	12,166
5 6 8	12,553 20,409 43,213	17,753		7,701 11,033 19,328	11,551 16,550 28,992	15,402 22,066 38,656	19,252 27,583 48,320
10 12 14				31,602 45,897 56,181	47,403 68,845 84,272	63,204 91,793 112,362	79,005 114,741 140,453
16 18 20				74,798 96,073 120,008	112,196 144,110 180,013	149,595 192,146 240,017	186,994 240,183 300,021
22 24 26		,		146,603 175,857 207,771	219,905 263,786 311,656	293,206 351,715 415,542	366,508 439,643 519,427
28 30 32				242,344 279,576 319,468	363,516 419,365 479,203	484,688 559,153 638,937	605,860 698,941 798,671
34 36 42	Velocity	Governs	with	362,020 407,231 558,821	543,030 610,846 838,231	724,040 814,462 1,117,641	905,050 1,018,077 1,397,051
48 54 60	these	Pipe	Sizes	734,345 933,805 1,157,201	1,101,518 1,400,708 1,735,801	1,468,691 1,867,611 2,314,401	1,835,863 2,334,513 2,893,002
72 84 96				1,675,797 2,290,134 3,000,211	2,513,695 3,435,200 4,500,317	3,351,593 4,580,267 6,000,423	4,189,492 5,725,334 7,500,528

 $^{1. \ \} Maximum\ recommended\ pressure\ drop\ /\ velocity: 0.25\ Psig/100\ Ft.\ /\ 4,000\ Fpm.$

^{2.} Table based on Heavy Weight Steel Pipe using Steam Equations in Part 5.

			OTE AM CONT	DENIGATE EL	M IDCAD			
				DENSATE FLOW LBS./HR. IG BACK PRESSURE				
PIPE SIZE	PF	RESSURE DRO PSIG/100 FT.	P		VELOCITY	FPM (MPH)		
	0.125	0.25	0.5	2,000 (23)	3,000 (34)	4,000 (45)	5,000 (57)	
1/2 3/4 1	29 72 150	41 101 212	58 143 300		Pressure with these	Drop Pipe	Governs Sizes	
1-1/4 1-1/2 2	345 546 1,131	488 772 1,600	690 1,091 2,262	647 891 1,488	2,233			
2-1/2 3 4	1,881 3,493 7,505	2,660 4,940 10,614	3,762 6,987	2,136 3,330 5,795	3,205 4,994 8,693	6,659 11,591	14,488	
5 6 8	14,037 22,821 48,319	19,851 32,273		9,171 13,140 23,018	13,757 19,709 34,527	18,342 26,279 46,036	22,928 32,849 57,545	
10 12 14	92,633		e e	37,635 54,659 66,907	56,453 81,989 100,361	75,271 109,318 133,815	94,088 136,648 167,268	
16 18 20				89,078 114,415 142,920	133,617 171,623 214,380	178,155 228,831 285,841	222,694 286,039 357,301	
22 24 26				174,592 209,432 247,438	261,889 314,147 371,157	349,185 418,863 494,876	436,481 523,579 618,595	
28 30 32				288,612 332,953 380,461	432,918 499,429 570,691	577,224 665,906 760,922	721,530 832,382 951,152	
34 36 42	Velocity	Governs	with	431,136 484,979 665,510	646,704 727,468 998,264	862,272 969,958 1,331,019	1,077,841 1,212,447 1,663,774	
48 54 60	these	Pipe	Sizes	874,545 1,112,086 1,378,132	1,311,818 1,668,129 2,067,197	1,749,091 2,224,172 2,756,263	2,186,364 2,780,215 3,445,329	
72 84 96				1,995,737 2,727,362 3,573,007	2,993,606 4,091,043 5,359,510	3,991,474 5,454,725 7,146,014	4,989,343 6,818,406 8,932,517	

- 1. Maximum recommended pressure drop / velocity: 0.25 Psig/100 Ft. / 4,000 Fpm.
- 2. Table based on Heavy Weight Steel Pipe using Steam Equations in Part 5.

					OW LBS./HR.			
				IG BACK PRESSURE				
PIPE SIZE	PI	RESSURE DRO PSIG/100 FT.)P	V	VELOCITY	FPM (MPH)		
	0.125	0.25	0.5	2,000 (23)	3,000 (34)	4,000 (45)	5,000 (57)	
1/2 3/4 1	66 161 338	93 228 477	131 322 675		Pressure with these	Drop Pipe	Governs Sizes	
1-1/4 1-1/2 2	777 1,229 2,546	1,099 1,737 3,601	1,554 2,457 5,093	4,916			-	
2-1/2 3 4	4,234 7,864 16,895	5,988 11,121 23,893	8,468 15,727 33,789	7,056 10,996 19,140	28,710			
5 6 8	31,598 51,372 108,772	44,687 72,650 153,827	63,196 102,743	30,289 43,395 76,020	45,433 65,093 114,030	60,577 86,791 152,040	190,050	
10 12 14	208,528 340,369 443,268	294,903		124,296 180,519 220,970	186,444 270,779 331,455	248,592 361,038 441,941	310,740 451,298 552,426	
16 18 20	643,292 889,824	-		294,191 377,872 472,014	441,287 566,808 708,020	588,382 755,745 944,027	735,478 944,681 1,180,034	
22 24 26				576,615 691,676 817,198	864,922 1,037,514 1,225,797	1,153,230 1,383,353 1,634,396	1,441,537 1,729,191 2,042,995	
28 30 32				953,180 1,099,622 1,256,524	1,429,769 1,649,432 1,884,785	1,906,359 2,199,243 2,513,047	2,382,949 2,749,054 3,141,309	
34 36 42	Velocity	Governs	with	1,423,886 1,601,708 2,197,935	2,135,828 2,402,562 3,296,903	2,847,771 3,203,416 4,395,871	3,559,714 4,004,270 5,494,839	
48 54 60	these	Pipe	Sizes	2,888,304 3,672,814 4,551,465	4,332,456 5,509,221 6,827,198	5,776,609 7,345,629 9,102,931	7,220,761 9,182,036 11,378,664	
72 84 96				6,591,191 9,007,482 11,800,338	9,886,787 13,511,223 17,700,507	13,182,383 18,014,964 23,600,676	16,477,979 22,518,706 29,500,845	

- Maximum recommended pressure drop / velocity: 0.25 Psig/100 Ft. / 4,000 Fpm.
 Table based on Heavy Weight Steel Pipe using Steam Equations in Part 5.

			STEAM CON	DENSATE FLO	OW IDEAD		
				G BACK PRES			
PIPE SIZE	PF	RESSURE DRO PSIG/100 FT.	P		VELOCITY	FPM (MPH)	
	0.125	0.25	0.5	2,000 (23)	3,000 (34)	4,000 (45)	5,000 (57)
1/2 3/4 1	13 32 68	19 46 96	26 65 136	62 103	Pressure with these	Drop Pipe	Governs Sizes
1-1/4 1-1/2 2	156 247 512	221 350 724	313 494 1,025	184 253 423	276 380 635	847	1
2-1/2 3 4	852 1,582 3,399	1,205 2,237		608 947 1,649	912 1,421 2,473	1,216 1,895 3,298	1,520 2,368 4,122
5 6 8	6,357			2,609 3,738 6,549	3,914 5,607 9,823	5,218 7,477 13,098	6,523 9,346 16,372
10 12 14		17 a 21	e o	10,708 15,551 19,036	16,061 23,326 28,553	21,415 31,102 38,071	26,769 38,877 47,589
16 18 20				25,343 32,552 40,662	38,015 48,828 60,993	50,686 65,104 81,324	63,358 81,380 101,654
22 24 26				49,673 59,585 70,398	74,509 89,377 105,597	99,345 119,169 140,796	124,182 148,962 175,994
28 30 32				82,112 94,727 108,244	123,168 142,091 162,365	164,224 189,454 216,487	205,280 236,818 270,609
34 36 42	Velocity	Governs	with	122,661 137,980 189,342	183,992 206,969 284,013	245,322 275,959 378,684	306,653 344,949 473,355
48 54 60	these	Pipe	Sizes	248,814 316,396 392,087	373,221 474,594 588,131	497,628 632,791 784,175	622,035 790,989 980,219
72 84 96				567,800 775,952 1,016,544	851,700 1,163,929 1,524,816	1,135,601 1,551,905 2,033,088	1,419,501 1,939,881 2,541,360

- Maximum recommended pressure drop / velocity: 0.25 Psig/100 Ft. / 4,000 Fpm.
 Table based on Heavy Weight Steel Pipe using Steam Equations in Part 5.

				DENSATE FLO			
PIPE SIZE	PF	RESSURE DRO PSIG/100 FT.				FPM (MPH)	
	0.125	0.25	0.5	2,000 (23)	3,000 (34)	4,000 (45)	5,000 (57)
1/2 3/4 1	22 54 112	31 76 159	44 107 225		Pressure with these	Drop Pipe	Governs Sizes
1-1/4 1-1/2 2	258 409 847	366 578 1,198	517 817 1,694	423 582 973	1,460		
2-1/2 3 4	1,409 2,616 5,621	1,992 3,700 7,949	2,817 5,232	1,397 2,177 3,789	2,095 3,265 5,683	2,793 4,353 7,577	9,472
5 6 8	10,513 17,091 36,188	14,867		5,996 8,590 15,048	8,993 12,885 22,572	11,991 17,180 30,096	14,989 21,475 37,620
10 12 14				24,604 35,734 43,741	36,906 53,601 65,611	49,209 71,467 87,482	61,511 89,334 109,352
16 18 20		2 2		58,235 74,800 93,435	87,353 112,200 140,152	116,470 149,599 186,870	145,588 186,999 233,587
22 24 26				114,141 136,917 161,764	171,211 205,376 242,646	228,281 273,834 323,528	285,352 342,293 404,410
28 30 32				188,682 217,670 248,728	283,022 326,504 373,093	377,363 435,339 497,457	471,704 544,174 621,821
34 36 42	Velocity	Governs	with	281,858 317,057 435,081	422,786 475,586 652,621	563,715 634,115 870,161	704,644 792,644 1,087,701
48 54 60	these	Pipe	Sizes	571,739 727,032 900,961	857,608 1,090,548 1,351,441	1,143,478 1,454,064 1,801,922	1,429,347 1,817,581 2,252,402
72 84 96				1,304,724 1,783,028 2,335,872	1,957,086 2,674,542 3,503,809	2,609,448 3,566,055 4,671,745	3,261,810 4,457,569 5,839,681

- Maximum recommended pressure drop / velocity: 0.25 Psig/100 Ft. / 4,000 Fpm.
 Table based on Heavy Weight Steel Pipe using Steam Equations in Part 5.

			CTEAN CON	DENIGATE ET	OW I DO AT			
				DENSATE FLOW LBS./HR. IG BACK PRESSURE				
PIPE SIZE	PI	RESSURE DRO PSIG/100 FT.)P		VELOCITY	FPM (MPH)		
	0.125	0.25	0.5	2,000 (23)	3,000 (34)	4,000 (45)	5,000 (57)	
1/2 3/4 1	25 61 127	35 86 179	49 121 254		Pressure with these	Drop Pipe	Governs Sizes	
1-1/4 1-1/2 2	292 461 956	413 653 1,353	584 923 1,913	513 707 1,182	1,772			
2-1/2 3 4	1,590 2,954 6,346	2,249 4,177 8,974	3,181 5,907	1,696 2,643 4,601	2,544 3,965 6,901	5,286 9,201	11,502	
5 6 8	11,868 19,295 40,855	16,784		7,281 10,431 18,273	10,921 15,647 27,410	14,561 20,862 36,546	18,201 26,078 45,683	
10 12 14		V ₃		29,878 43,392 53,116	44,816 65,088 79,673	59,755 86,784 106,231	74,694 108,480 132,789	
16 18 20	, '			70,716 90,831 113,460	106,074 136,246 170,190	141,432 181,661 226,920	176,790 227,077 283,650	
22 24 26				138,603 166,261 196,433	207,905 249,392 294,650	277,207 332,522 392,867	346,508 415,653 491,083	
28 30 32				229,120 264,321 302,036	343,680 396,481 453,054	458,240 528,641 604,072	572,799 660,802 755,090	
34 36 42	Velocity	Governs	with	342,265 385,009 528,327	513,398 577,514 792,490	684,531 770,018 1,056,654	855,663 962,523 1,320,817	
48 54 60	these	Pipe	Sizes	694,274 882,850 1,094,055	1,041,411 1,324,275 1,641,082	1,388,548 1,765,699 2,188,110	1,735,684 2,207,124 2,735,137	
72 84 96				1,584,352 2,165,166 2,836,497	2,376,528 3,247,749 4,254,745	3,168,704 4,330,332 5,672,993	3,960,881 5,412,915 7,091,241	

- 1. Maximum recommended pressure drop / velocity: 0.25 Psig/100 Ft. / 4,000 Fpm.
- 2. Table based on Heavy Weight Steel Pipe using Steam Equations in Part 5.

				DENSATE FLO					
PIPE SIZE	PF	PRESSURE DROP PSIG/100 FT.			VELOCITY FPM (MPH)				
	0.125	0.25	0.5	2,000 (23)	3,000 (34)	4,000 (45)	5,000 (57)		
1/2 3/4 1	28 67 141	39 95 200	55 135 283		Pressure with these	Drop Pipe	Governs Sizes		
1-1/4 1-1/2 2	325 514 1,066	460 727 1,508	651 1,029 2,132	609 840 1,403	2,104				
2-1/2 3 4	1,773 3,293 7,074	2,507 4,656 10,004	3,546 6,585	2,014 3,138 5,462	3,020 4,707 8,193	6,276 10,925	13,656		
5 6 8	13,230 21,509 45,543	18,710 30,419		8,644 12,385 21,695	12,966 18,577 32,543	17,288 24,769 43,391	21,610 30,962 54,239		
10 12 14	87,311		XI.	35,473 51,519 63,063	53,209 77,278 94,595	70,946 103,037 126,126	88,682 128,796 157,658		
16 18 20				83,960 107,842 134,709	125,939 161,762 202,063	167,919 215,683 269,417	209,899 269,604 336,771		
22 24 26			n 18	164,561 197,398 233,221	246,841 296,098 349,832	329,122 394,797 466,442	411,402 493,496 583,053		
28 30 32				272,029 313,823 358,601	408,044 470,734 537,901	544,059 627,645 717,202	680,073 784,556 896,502		
34 36 42	Velocity	Governs	with	406,365 457,114 627,272	609,547 685,670 940,908	812,729 914,227 1,254,544	1,015,912 1,142,784 1,568,180		
48 54 60	these	Pipe	Sizes	824,297 1,048,190 1,298,949	1,236,446 1,572,284 1,948,424	1,648,594 2,096,379 2,597,898	2,060,743 2,620,474 3,247,373		
72 84 96				1,881,069 2,570,658 3,367,715	2,821,604 3,855,987 5,051,572	3,762,138 5,141,316 6,735,429	4,702,673 6,426,645 8,419,287		

- Maximum recommended pressure drop / velocity: 0.25 Psig/100 Ft. / 4,000 Fpm.
 Table based on Heavy Weight Steel Pipe using Steam Equations in Part 5.

				DENSATE FLO				
				G BACK PRESSURE				
PIPE SIZE	PF	PSIG/100 FT.)P		VELOCITY	FPM (MPH)		
	0.125	0.25	0.5	2,000 (23)	3,000 (34)	4,000 (45)	5,000 (57)	
1/2 3/4	30 75	43 105	61 149		Pressure	Drop	Governs	
1	156	221	312		with these	Pipe	Sizes	
1-1/4	359	508	718	712				
1-1/2	568 1,177	803 1,665	1,136 2,355	980 1,638	843	1 6		
2-1/2	1,958	2,769	3,916	2,351	3,526			
3 4	3,636 7,812	5,142 11,047	7,272 15,623	3,664 6,377	5,496 9,566	12,755		
5	14,610	20,662	15,025	10,092	15,138	20,184	25,230	
6	23,753	33,592		14,459	21,689	28,919	36,148	
8	50,294			25,330	37,995	50,659	63,324	
10 12	96,419			41,415 60,149	62,123 90,223	82,830 120,297	103,538 150,372	
14			2.0	73,627	110,440	147,254	184,067	
16				98,024	147,036	196,048	245,060	
18 20				125,906 157,274	188,860 235,911	251,813 314,548	314,766 393,185	
22				192,127	288,191	384,254	480,318	
24 26				230,465 272,289	345,698 408,434	460,931 544,578	576,164 680,723	
28				317,598	476,397	635,196	793,995	
30				366,392	549,588	732,784	915,981	
32				418,672	628,008	837,343	1,046,679	
34 36				474,437 533,687	711,655 800,530	948,873 1,067,373	1,186,091 1,334,217	
42	Velocity	Governs	with	732,349	1,098,523	1,464,698	1,830,872	
48	these	Pipe	Sizes	962,379	1,443,568	1,924,757	2,405,946	
54 60		,		1,223,776 1,516,541	1,835,664 2,274,812	2,447,552 3,033,083	3,059,440 3,791,353	
72			s	2,196,175	3,294,262	4,392,350	5,490,437	
84		u u		3,001,279	4,501,919	6,002,559	7,503,198	
96				3,931,855	5,897,782	7,863,709	9,829,636	

- 1. Maximum recommended pressure drop / velocity: 0.25 Psig/100 Ft. / 4,000 Fpm.
- 2. Table based on Heavy Weight Steel Pipe using Steam Equations in Part 5.

				DENSATE FLO					
PIPE SIZE	PF	PRESSURE DROP PSIG/100 FT.			VELOCITY FPM (MPH)				
	0.125	0.25	0.5	2,000 (23)	3,000 (34)	4,000 (45)	5,000 (57)		
1/2 3/4 1	36 89 186	51 126 263	72 178 372		Pressure with these	Drop Pipe	Governs Sizes		
1-1/4 1-1/2 2	429 678 1,405	606 958 1,986	857 1,355 2,809	1,284 2,146		77			
2-1/2 3 4	2,336 4,338 9,319	3,303 6,134 13,179	4,671 8,675 18,638	3,081 4,801 8,357	4,621 7,202 12,535	16,713			
5 6 8	17,429 28,336 59,997	24,649 40,073		13,224 18,947 33,191	19,836 28,420 49,786	26,448 37,894 66,382	33,061 47,367 82,977		
10 12 14	115,022 187,744			54,269 78,816 96,477	81,403 118,224 144,716	108,537 157,632 192,955	135,671 197,040 241,194		
16 18 20				128,446 164,982 206,085	192,669 247,473 309,127	256,893 329,964 412,170	321,116 412,455 515,212		
22 24 26				251,755 301,992 356,795	377,632 452,987 535,193	503,510 603,983 713,591	629,387 754,979 891,988		
28 30 32				416,166 480,104 548,609	624,249 720,156 822,913	832,332 960,208 1,097,217	1,040,415 1,200,260 1,371,521		
34 36 42	Velocity	Governs	with	621,680 699,319 959,637	932,520 1,048,978 1,439,455	1,243,360 1,398,638 1,919,274	1,554,201 1,748,297 2,399,092		
48 54 60	these	Pipe	Sizes	1,261,057 1,603,581 1,987,207	1,891,586 2,405,372 2,980,811	2,522,115 3,207,162 3,974,415	3,152,644 4,008,953 4,968,018		
72 84 96			7	2,877,769 3,932,741 5,152,125	4,316,653 5,899,112 7,728,187	5,755,537 7,865,482 10,304,250	7,194,421 9,831,853 12,880,312		

- 1. Maximum recommended pressure drop / velocity: 0.25 Psig/100 Ft. / 4,000 Fpm.
- 2. Table based on Heavy Weight Steel Pipe using Steam Equations in Part 5.

			OTT IN CONT	DELTA . ME	ow the se		
				IDENSATE FL IG BACK PRE:	OW LBS./HR. SSURE		
PIPE SIZE	PI	RESSURE DRO PSIG/100 FT.	OP		VELOCITY	FPM (MPH)	
	0.125	0.25	0.5	2,000 (23)	3,000 (34)	4,000 (45)	5,000 (57)
1/2 3/4 1	42 104 218	60 147 309	85 208 436		Pressure with these	Drop Pipe	Governs Sizes
1-1/4 1-1/2 2	502 794 1,646	710 1,123 2,328	1,005 1,589 3,293	2,725	10	,	
2-1/2 3 4	2,738 5,084 10,923	3,871 7,190 15,447	5,475 10,168 21,846	3,911 6,095 10,609	9,142 15,913	21,217	
5 6 8	20,429 33,214 70,325	28,892 46,971 99,455	40,859	16,788 24,053 42,136	25,182 36,080 63,204	33,577 48,106 84,272	60,133 105,340
10 12 14	134,821 220,061 286,589			68,894 100,058 122,479	103,341 150,086 183,718	137,789 200,115 244,957	172,236 250,144 306,197
16 18 20				163,063 209,446 261,626	244,595 314,169 392,439	326,127 418,892 523,252	407,659 523,615 654,065
22 24 26	9			319,604 383,380 452,954	479,406 575,070 679,431	639,209 766,760 905,908	799,011 958,451 1,132,385
28 30 32				528,325 609,495 696,462	792,488 914,242 1,044,693	1,056,651 1,218,990 1,392,924	1,320,814 1,523,737 1,741,155
34 36 42	Velocity	Governs	with	789,227 887,790 1,218,265	1,183,840 1,331,685 1,827,397	1,578,454 1,775,579 2,436,530	1,973,067 2,219,474 3,045,662
48 54 60	these	Pipe	Sizes	1,600,920 2,035,756 2,522,772	2,401,381 3,053,634 3,784,158	3,201,841 4,071,512 5,045,544	4,002,301 5,089,390 6,306,930
72 84 96				3,653,345 4,992,639 6,540,655	5,480,018 7,488,959 9,810,982	7,306,690 9,985,279 13,081,309	9,133,363 12,481,598 16,351,637

- 1. Maximum recommended pressure drop / velocity: 0.25 Psig/100 Ft. / 4,000 Fpm.
- 2. Table based on Heavy Weight Steel Pipe using Steam Equations in Part 5.

			STEAM CON	DENSATE FL	OW LBS./HR.				
	60 PSIC			IG BACK PRE	G BACK PRESSURE				
PIPE SIZE	PI	RESSURE DRO PSIG/100 FT.)P		VELOCITY	FPM (MPH)			
	0.125	0.25	0.5	2,000 (23)	3,000 (34)	4,000 (45)	5,000 (57)		
1/2 3/4 1	49 120 252	69 170 356	98 241 504		Pressure with these	Drop Pipe	Governs Sizes		
1-1/4 1-1/2 2	580 917 1,900	820 1,297 2,688	1,160 1,834 3,801	3,366	- E				
2-1/2 3 4	3,160 5,869 12,610	4,469 8,300 17,833	6,321 11,739 25,219	4,831 7,529 13,104	11,293 19,656				
5 6 8	23,584 38,342 81,185	33,353 54,224 114,812	47,168	20,737 29,711 52,047	31,106 44,566 78,070	41,474 59,421 104,094	74,276 130,117		
10 12 14	155,640 254,042 330,844			85,099 123,592 151,287	127,648 185,388 226,930	170,198 247,184 302,574	212,747 308,980 378,217		
16 18 20	480,136	20 1	, a	201,417 258,709 323,163	302,126 388,064 484,745	402,835 517,419 646,326	503,543 646,774 807,908		
22 24 26		,		394,778 473,555 559,493	592,167 710,332 839,239	789,556 947,109 1,118,986	986,945 1,183,887 1,398,732		
28 30 32		÷		652,592 752,853 860,276	978,889 1,129,280 1,290,414	1,305,185 1,505,707 1,720,552	1,631,481 1,882,134 2,150,690		
34 36 42	Velocity	Governs	with	974,860 1,096,606 1,504,812	1,462,290 1,644,909 2,257,218	1,949,720 2,193,212 3,009,623	2,437,150 2,741,515 3,762,029		
48 54 60	these	Pipe	Sizes	1,977,471 2,514,584 3,116,151	2,966,207 3,771,876 4,674,226	3,954,942 5,029,169 6,232,302	4,943,678 6,286,461 7,790,377		
72 84 96				4,512,645 6,166,953 8,079,076	6,768,967 9,250,430 12,118,613	9,025,290 12,333,906 16,158,151	11,281,612 15,417,383 20,197,689		

- Maximum recommended pressure drop / velocity: 0.25 Psig/100 Ft. / 4,000 Fpm.
 Table based on Heavy Weight Steel Pipe using Steam Equations in Part 5.

			STEAM CON	DENSATE FL	OW LBS./HR.			
				IG BACK PRESSURE				
PIPE SIZE	PI	RESSURE DRO PSIG/100 FT.)P		VELOCITY	FPM (MPH)		
	0.125	0.25	0.5	2,000 (23)	3,000 (34)	4,000 (45)	5,000 (57)	
1/2 3/4 1	60 147 308	85 208 435	120 294 615		Pressure with these	Drop Pipe	Governs Sizes	
1-1/4 1-1/2 2	708 1,119 2,320	1,001 1,583 3,281	1,416 2,239 4,640	4,479				
2-1/2 3 4	3,858 7,165 15,392	5,456 10,132 21,768	7,715 14,329 30,785	6,428 10,019 17,438	26,157		10	
5 6 8	28,789 46,804 99,101	40,714 66,191 140,150	57,578 93,608	27,596 39,537 69,261	41,393 59,306 103,891	55,191 79,074 138,522	173,152	
10 12 14	189,987 310,107 403,857	268,683		113,245 164,469 201,324	169,867 246,703 301,985	226,489 328,938 402,647	283,111 411,172 503,309	
16 18 20	586,096 810,709			268,034 344,275 430,046	402,052 516,413 645,069	536,069 688,551 860,093	670,086 860,688 1,075,116	
22 24 26	7			525,347 630,179 744,540	788,021 945,268 1,116,810	1,050,695 1,260,357 1,489,080	1,313,368 1,575,447 1,861,350	
28 30 32				868,431 1,001,853 1,144,805	1,302,647 1,502,779 1,717,207	1,736,863 2,003,706 2,289,609	2,171,079 2,504,632 2,862,012	
34 36 42	Velocity	Governs	with	1,297,286 1,459,298 2,002,515	1,945,930 2,188,947 3,003,772	2,594,573 2,918,597 4,005,029	3,243,216 3,648,246 5,006,287	
48 54 60	these	Pipe	Sizes	2,631,502 3,346,260 4,146,790	3,947,253 5,019,391 6,220,185	5,263,004 6,692,521 8,293,579	6,578,755 8,365,651 10,366,974	
72 84 96				6,005,161 8,206,617 10,751,157	9,007,742 12,309,926 16,126,735	12,010,323 16,413,234 21,502,314	15,012,904 20,516,543 26,877,892	

- Maximum recommended pressure drop / velocity: 0.25 Psig/100 Ft. / 4,000 Fpm.
 Table-based on Heavy Weight Steel Pipe using Steam Equations in Part 5.

			STEAM CON	DENSATE FLO	OW LBS./HR.			
				G BACK PRESSURE				
PIPE SIZE	PF	RESSURE DRO PSIG/100 FT.)P		VELOCITY	FPM (MPH)		
	0.125	0.25	0.5	2,000 (23)	3,000 (34)	4,000 (45)	5,000 (57)	
1/2 3/4 1	68 166 349	96 235 493	136 333 697		Pressure with these	Drop Pipe	Governs Sizes	
1-1/4 1-1/2 2	802 1,269 2,630	1,135 1,795 3,720	1,605 2,538 5,260	ee 19	22 ji			
2-1/2 3 4	4,374 8,123 17,451	6,185 11,487 24,680	8,747 16,246 34,902	7,661 11,940 20,782	31,174			
5 6 8	32,639 53,064 112,355	46,159 75,044 158,894	65,278 106,128	32,888 47,120 82,544	49,332 70,680 123,817	94,240 165,089	206,361	
10 12 14	215,397 351,582 457,871	304,618		134,964 196,012 239,935	202,446 294,019 359,903	269,927 392,025 479,871	337,409 490,031 599,839	
16 18 20	664,484 919,137 1,225,107			319,441 410,304 512,525	479,161 615,456 768,787	638,881 820,608 1,025,050	798,602 1,025,760 1,281,312	
22 24 26				626,104 751,041 887,335	939,156 1,126,561 1,331,003	1,252,207 1,502,081 1,774,670	1,565,259 1,877,601 2,218,338	
28 30 32		a		1,034,988 1,193,998 1,364,367	1,552,482 1,790,997 2,046,550	2,069,976 2,387,997 2,728,733	2,587,470 2,984,996 3,410,917	
34 36 42	Velocity	Governs	with	1,546,093 1,739,177 2,386,577	2,319,139 2,608,766 3,579,865	3,092,186 3,478,354 4,773,154	3,865,232 4,347,943 5,966,442	
48 54 60	these	Pipe	Sizes	3,136,198 3,988,039 4,942,102	4,704,296 5,982,059 7,413,153	6,272,395 7,976,079 9,884,205	7,840,494 9,970,099 12,355,256	
72 84 96				7,156,891 9,780,564 12,813,121	10,735,337 14,670,846 19,219,681	14,313,782 19,561,128 25,626,242	17,892,228 24,451,410 32,032,802	

- Maximum recommended pressure drop / velocity: 0.25 Psig/100 Ft. / 4,000 Fpm.
 Table based on Heavy Weight Steel Pipe using Steam Equations in Part 5.

			STEAM CON	DENSATE FLO	W IRS/HR			
	20			IG BACK PRESSURE				
PIPE SIZE	PF	RESSURE DRO PSIG/100 FT.	P		VELOCITY	FPM (MPH)		
	0.125	0.25	0.5	2,000 (23)	3,000 (34)	4,000 (45)	5,000 (57)	
1/2 3/4 1	13 31 65	18 44 92	25 62 131	60 99	Pressure with these	Drop Pipe	Governs Sizes	
1-1/4 1-1/2 2	150 238 493	213 336 697	301 476 986	177 244 407	265 366 611	815		
2-1/2 3 4	819 1,522 3,270	1,159 2,152		585 911 1,586	877 1,367 2,379	1,170 1,823 3,172	1,462 2,278 3,966	
5 6 8	6,116	,		2,510 3,596 6,300	3,765 5,395 9,450	5,020 7,193 12,600	6,275 8,991 15,751	
10 12 14				10,301 14,961 18,313	15,452 22,441 27,470	20,602 29,921 36,626	25,753 37,402 45,783	
16 18 20				24,381 31,317 39,119	36,572 46,975 58,678	48,763 62,633 78,237	60,953 78,291 97,796	
22 24 26			9	47,788 57,323 67,726	71,681 85,985 101,589	95,575 114,647 135,452	119,469 143,308 169,315	
28 30 32				78,996 91,132 104,136	118,494 136,698 156,203	157,991 182,264 208,271	197,489 227,830 260,339	
34 36 42	Velocity	Governs	with	118,006 132,743 182,156	177,009 199,115 273,234	236,012 265,486 364,312	295,015 331,858 455,390	
48 54 60	these	Pipe	Sizes	239,371 304,388 377,207	359,057 456,582 565,811	478,742 608,776 754,414	598,428 760,970 943,018	
72 84 96				546,251 746,504 977,964	819,377 1,119,756 1,466,947	1,092,503 1,493,008 1,955,929	1,365,628 1,866,260 2,444,911	

Notes:

1. Maximum recommended pressure drop / velocity: 0.25 Psig/100 Ft. / 4,000 Fpm.

^{2.} Table based on Heavy Weight Steel Pipe using Steam Equations in Part 5.

				DENSATE FLO	OW LBS./HR. SURE				
PIPE SIZE	PR	PRESSURE DROP PSIG/100 FT.			VELOCITY FPM (MPH)				
	0.125	0.25	0.5	2,000 (23)	3,000 (34)	4,000 (45)	5,000 (57)		
1/2 3/4 1	16 38 80	22 54 113	31 76 159	139	Pressure with these	Drop Pipe	Governs Sizes		
1-1/4 1-1/2 2	183 290 601	259 410 850	367 580 1,202	248 341 570	511 855	1,140			
2-1/2 3 4	1,000 1,856 3,988	1,414 2,625	1,999	818 1,274 2,218	1,227 1,912 3,327	1,636 2,549 4,437	3,186 5,546		
5 6 8	7,459 12,127			3,510 5,030 8,811	5,266 7,544 13,216	7,021 10,059 17,622	8,776 12,574 22,027		
10 12 14				14,406 20,922 25,611	21,609 31,383 38,416	28,812 41,845 51,221	36,015 52,306 64,027		
16 18 20				34,097 43,796 54,707	51,145 65,694 82,060	68,194 87,591 109,413	85,242 109,489 136,767		
22 24 26				66,830 80,166 94,714	100,245 120,249 142,071	133,660 160,332 189,428	167,075 200,415 236,785		
28 30 32				110,474 127,447 145,632	165,711 191,170 218,448	220,948 254,894 291,264	276,186 318,617 364,080		
34 36 42	Velocity	Governs	with	165,029 185,639 254,742	247,544 278,459 382,114	330,059 371,278 509,485	412,574 464,098 636,856		
48 54 60	these	Pipe	Sizes	334,757 425,682 527,518	502,135 638,523 791,277	669,513 851,364 1,055,037	836,892 1,064,205 1,318,796		
72 84 96				763,924 1,043,974 1,367,668	1,145,886 1,565,961 2,051,502	1,527,848 2,087,948 2,735,336	1,909,810 2,609,935 3,419,170		

- 1. Maximum recommended pressure drop / velocity: 0.25 Psig/100 Ft. / 4,000 Fpm.
- 2. Table based on Heavy Weight Steel Pipe using Steam Equations in Part 5.

				IDENSATE FL			
PIPE SIZE	PF	RESSURE DRO PSIG/100 FT.		G BACKPRES		FPM (MPH)	
	0.125	0.25	0.5	2,000 (23)	3,000 (34)	4,000 (45)	5,000 (57)
1/2 3/4 1	17 41 85	23 58 121	33 81 171	155	Pressure with these	Drop Pipe	Governs Sizes
1-1/4 1-1/2 2	196 310 643	278 439 910	393 621 1,287	277 382 638	573 957	1,276	KI
2-1/2 3 4	1,070 1,987 4,269	1,513 2,810 6,038	2,140	916 1,427 2,484	1,374 2,141 3,727	1,832 2,855 4,969	3,568 6,211
5 6 8	7,985 12,982	0		3,932 5,633 9,868	5,897 8,449 14,801	7,863 11,266 19,735	9,829 14,082 24,669
10 12 14		7 1 970		16,134 23,432 28,683	24,201 35,148 43,024	32,268 46,864 57,365	40,335 58,580 71,707
16 18 20				38,187 49,049 61,269	57,281 73,574 91,903	76,374 98,098 122,538	95,468 122,623 153,172
22 24 26	1		-	74,847 89,782 106,075	112,270 134,673 159,113	149,693 179,564 212,150	187,116 224,455 265,188
28 30 32				123,726 142,735 163,101	185,589 214,102 244,652	247,452 285,469 326,202	309,315 356,837 407,753
34 36 42	Velocity	Governs	with	184,825 207,907 285,300	277,238 311,861 427,949	369,651 415,814 570,599	462,063 519,768 713,249
48 54 60	these	Pipe	Sizes	374,912 476,744 590,796	562,368 715,116 886,194	749,824 953,488 1,181,592	937,280 1,191,860 1,476,990
72 84 96				855,559 1,169,202 1,531,724	1,283,339 1,753,803 2,297,587	1,711,119 2,338,404 3,063,449	2,138,898 2,923,006 3,829,311

- 1. Maximum recommended pressure drop / velocity: 0.25 Psig/100 Ft. / 4,000 Fpm.
- 2. Table based on Heavy Weight Steel Pipe using Steam Equations in Part 5.

				DENSATE FLO			
PIPE SIZE	PI	RESSURE DRO PSIG/100 FT.		IO BACKT RE		FPM (MPH)	
	0.125	0.25	0.5	2,000 (23)	3,000 (34)	4,000 (45)	5,000 (57)
1/2 3/4 1	18 45 94	26 63 132	36 89 187	181	Pressure with these	Drop Pipe	Governs Sizes
1-1/4 1-1/2 2	215 341 706	305 482 998	431 681 1,412	323 445 744	668 1,116		
2-1/2 3 4	1,174 2,180 4,683	1,660 3,082 6,622	2,347	1,067 1,663 2,895	1,601 2,495 4,343	2,135 3,327 5,791	4,159 7,239
5 6 8	8,758 14,239			4,582 6,565 11,500	6,873 9,847 17,250	9,164 13,130 23,000	11,455 16,412 28,750
10 12 14		,	5 30	18,803 27,309 33,428	28,205 40,963 50,142	37,607 54,617 66,856	47,008 68,272 83,570
16 18 20		,		44,505 57,164 71,406	66,757 85,746 107,108	89,010 114,328 142,811	111,262 142,910 178,514
22 24 26				87,230 104,636 123,625	130,844 156,954 185,437	174,459 209,272 247,250	218,074 261,590 309,062
28 30 32				144,196 166,349 190,085	216,294 249,524 285,128	288,392 332,699 380,171	360,490 415,874 475,214
34 36 42	Velocity	Governs	with	215,404 242,305 332,501	323,106 363,457 498,752	430,808 484,609 665,002	538,509 605,761 831,253
48 54 60	these	Pipe	Sizes	436,939 555,619 688,540	655,409 833,429 1,032,811	873,879 1,111,238 1,377,081	1,092,348 1,389,048 1,721,351
72 84 96				997,108 1,362,642 1,785,142	1,495,662 2,043,962 2,677,712	1,994,216 2,725,283 3,570,283	2,492,770 3,406,604 4,462,854

- Maximum recommended pressure drop / velocity: 0.25 Psig/100 Ft. / 4,000 Fpm.
 Table based on Heavy Weight Steel Pipe using Steam Equations in Part 5.

				IDENSATE FL			
PIPE SIZE	PI	RESSURE DRO PSIG/100 FT.)P		VELOCITY	FPM (MPH)	
	0.125	0.25	0.5	2,000 (23)	3,000 (34)	4,000 (45)	5,000 (57)
1/2 3/4 1	19 47 99	27 67 140	39 95 198		Pressure with these	Drop Pipe	Governs Sizes
1-1/4 1-1/2 2	228 360 747	322 510 1,056	456 721 1,494	355 488 816	1,224		
2-1/2 3 4	1,242 2,307 4,956	1,756 3,262 7,008	2,484	1,172 1,826 3,178	1,757 2,739 4,767	2,343 3,652 6,356	4,564 7,945
5 6 8	9,269 15,069	,		5,029 7,205 12,622	7,544 10,808 18,933	10,058 14,411 25,244	12,573 18,013 31,556
10 12 14				20,638 29,973 36,690	30,957 44,960 55,034	41,276 59,946 73,379	51,595 74,933 91,724
16 18 20		0		48,847 62,741 78,372	73,271 94,112 117,559	97,694 125,483 156,745	122,118 156,853 195,931
22 24 26	e e	×		95,740 114,845 135,686	143,610 172,267 203,529	191,481 229,690 271,373	239,351 287,112 339,216
28 30 32				158,265 182,580 208,631	237,397 273,869 312,947	316,529 365,159 417,263	395,661 456,449 521,578
34 36 42	Velocity	Governs	with	236,420 265,945 364,942	354,630 398,918 547,413	472,840 531,890 729,884	591,050 664,863 912,355
48 54 60	these	Pipe	Sizes	479,570 609,829 755,719	719,355 914,743 1,133,578	959,139 1,219,657 1,511,437	1,198,924 1,524,572 1,889,296
72 84 96				1,094,392 1,495,589 1,959,311	1,641,587 2,243,383 2,938,966	2,188,783 2,991,178 3,918,621	2,735,979 3,738,972 4,898,276

- 1. Maximum recommended pressure drop / velocity: 0.25 Psig/100 Ft. / 4,000 Fpm.
- 2. Table based on Heavy Weight Steel Pipe using Steam Equations in Part 5.

	STEAM CONDENSATE FLOW LBS./HR. 15 PSIG BACK PRESSURE										
PIPE SIZE		PRESSURE DROP PSIG/100 FT.			VELOCITY FPM (MPH)						
	0.125	0.25	0.5	2,000 (23)	3,000 (34)	4,000 (45)	5,000 (57)				
1/2 3/4 1	21 51 107	29 72 152	42 102 214		Pressure with these	Drop Pipe	Governs Sizes				
1-1/4 1-1/2 2	247 390 808	349 551 1,143	493 780 1,616	403 556 928	1,393						
2-1/2 3 4	1,344 2,496 5,362	1,901 3,530 7,584	2,688 4,992	1,333 2,077 3,615	1,999 3,115 5,422	2,665 4,153 7,229	9,036				
5 6 8	10,029 16,306 34,525	14,184		5,720 8,195 14,357	8,580 12,293 21,535	11,440 16,391 28,713	14,300 20,488 35,89				
10 12 14				23,474 34,091 41,731	35,210 51,137 62,596	46,947 68,183 83,461	58,684 85,229 104,327				
16 18 20				55,559 71,362 89,141	83,338 107,043 133,711	111,117 142,724 178,282	138,89° 178,40° 222,85°				
22 24 26				108,895 130,625 154,330	163,343 195,937 231,495	217,790 261,249 308,659	272,233 326,565 385,82				
28 30 32				180,010 207,666 237,297	270,015 311,499 355,946	360,020 415,332 474,595	450,02 519,16 593,24				
34 36 42	Velocity	Governs	with	268,904 302,486 415,085	403,356 453,729 622,628	537,808 604,972 830,170	672,260 756,21: 1,037,71:				
48 54 60	these	Pipe	Sizes	545,463 693,619 859,555	818,194 1,040,429 1,289,332	1,090,926 1,387,239 1,719,109	1,363,65 1,734,04 2,148,88				
72 84 96	8.4 (1,244,761 1,701,083 2,228,521	1,867,142 2,551,625 3,342,781	2,489,523 3,402,167 4,457,041	3,111,90 4,252,70 5,571,30				

- 1. Maximum recommended pressure drop / velocity: 0.25 Psig/100 Ft. / 4,000 Fpm.
- 2. Table based on Heavy Weight Steel Pipe using Steam Equations in Part 5.

	-			DENSATE FLO	OW LBS./HR.	-	
PIPE SIZE	PI	RESSURE DRO PSIG/100 FT.		IO BACK FRES		FPM (MPH)	
	0.125	0.25	0.5	2,000 (23)	3,000 (34)	4,000 (45)	5,000 (57)
1/2 3/4 1	23 58 121	33 81 171	47 115 241		Pressure with these	Drop Pipe	Governs Sizes
1-1/4 1-1/2 2	278 439 910	393 621 1,287	555 878 1,820	488 673 1,124	1,687		
2-1/2 3 4	1,513 2,811 6,038	2,140 3,975 8,539	3,027 5,621	1,614 2,515 4,378	2,421 3,773 6,567	5,030 8,756	10,945
5 6 8	11,294 18,361 38,876	15,972		6,928 9,926 17,388	10,392 14,889 26,082	13,856 19,852 34,777	17,320 24,815 43,471
10 12 14				28,431 41,291 50,543	42,646 61,936 75,815	56,861 82,582 101,087	71,077 103,227 126,359
16 18 20			20	67,292 86,432 107,966	100,937 129,648 161,948	134,583 172,865 215,931	168,229 216,081 269,914
22 24 26	ě		2	131,891 158,210 186,921	197,837 237,315 280,382	263,783 316,420 373,842	329,729 395,525 467,303
28 30 32		-		218,025 251,521 287,410	327,037 377,281 431,115	436,049 503,042 574,820	545,062 628,802 718,525
34 36 42	Velocity	Governs	with	325,691 366,365 502,743	488,537 549,548 754,114	651,382 732,731 1,005,486	814,228 915,913 1,256,857
48 54 60	these	Pipe	Sizes	660,654 840,098 1,041,075	990,981 1,260,147 1,561,613	1,321,307 1,680,196 2,082,151	1,651,634 2,100,245 2,602,689
72 84 96				1,507,630 2,060,319 2,699,140	2,261,446 3,090,478 4,048,710	3,015,261 4,120,637 5,398,280	3,769,076 5,150,796 6,747,850

- 1. Maximum recommended pressure drop / velocity: 0.25 Psig/100 Ft. / 4,000 Fpm.
- 2. Table based on Heavy Weight Steel Pipe using Steam Equations in Part 5.

				DENSATE FLO G BACK PRES				
PIPE SIZE		ESSURE DRO		VELOCITY FPM (MPH)				
	0.125	0.25	0.5	2,000 (23)	3,000 (34)	4,000 (45)	5,000 (57)	
1/2 3/4 1	26 64 134	37 91 190	52 128 268		Pressure with these	Drop Pipe	Governs Sizes	
1-1/4 1-1/2 2	309 488 1,012	437 690 1,431	617 976 2,024	578 797 1,332	1,997			
2-1/2 3 4	1,683 3,125 6,714	2,380 4,420 9,495	3,365 6,250	1,911 2,979 5,185	2,867 4,468 7,777	5,957 10,369	12,961	
5 6 8	12,557 20,415 43,227	17,759 28,872		8,204 11,755 20,592	12,307 17,632 30,888	16,409 23,510 41,184	20,511 29,387 51,480	
10 12 14	82,870			33,669 48,898 59,856	50,503 73,348 89,784	67,338 97,797 119,712	84,172 122,246 149,639	
16 18 20				79,690 102,357 127,858	119,534 153,535 191,786	159,379 204,714 255,715	199,224 255,892 319,644	
22 24 26				156,192 187,359 221,360	234,288 281,039 332,040	312,383 374,718 442,720	390,479 468,398 553,400	
28 30 32				258,194 297,862 340,363	387,292 446,793 510,545	516,389 595,724 680,727	645,486 744,655 850,908	
34 36 42	Velocity	Governs	with	385,698 433,866 595,370	578,547 650,799 893,055	771,396 867,732 1,190,740	964,245 1,084,665 1,488,425	
48 54 60	these	Pipe	Sizes	782,375 994,881 1,232,887	1,173,563 1,492,321 1,849,331	1,564,750 1,989,762 2,465,775	1,955,938 2,487,202 3,082,218	
72 84 96				1,785,402 2,439,920 3,196,440	2,678,103 3,659,880 4,794,660	3,570,804 4,879,839 6,392,880	4,463,505 6,099,799 7,991,100	

- 1. Maximum recommended pressure drop / velocity: 0.25 Psig/100 Ft. / 4,000 Fpm.
- 2. Table based on Heavy Weight Steel Pipe using Steam Equations in Part 5.

			STEAM CONT	DENICATE ET	TDS /IDS			
				DENSATE FLOW LBS./HR. G BACK PRESSURE				
PIPE SIZE		RESSURE DRO PSIG/100 FT.	P		VELOCITY	FPM (MPH)		
	0.125	0.25	0.5	2,000 (23)	3,000 (34)	4,000 (45)	5,000 (57)	
1/2 3/4 1	29 71 148	41 100 209	58 141 295		Pressure with these	Drop Pipe	Governs Sizes	
1-1/4 1-1/2 2	340 538 1,115	481 761 1,576	680 1,076 2,229	674 928 1,551				
2-1/2 3 4	1,853 3,442 7,396	2,621 4,868 10,459	3,707 6,885 14,791	2,226 3,469 6,038	3,339 5,203 9,056	12,075		
5 6 8	13,832 22,488 47,615	19,562 31,803		9,554 13,689 23,980	14,332 20,533 35,970	19,109 27,378 47,961	23,886 34,222 59,951	
10 12 14	91,283			39,209 56,944 69,705	58,813 85,417 104,557	78,418 113,889 139,409	98,022 142,361 174,262	
16 18 20				92,802 119,199 148,896	139,203 178,799 223,343	185,604 238,398 297,791	232,005 297,998 372,239	
22 24 26			÷	181,892 218,188 257,783	272,838 327,282 386,675	363,784 436,376 515,567	454,730 545,470 644,458	
28 30 32				300,678 346,873 396,368	451,018 520,310 594,551	601,357 693,746 792,735	751,696 867,183 990,919	
34 36 42	Velocity	Governs	with	449,162 505,255 693,334	673,742 757,883 1,040,001	898,323 1,010,511 1,386,668	1,122,904 1,263,138 1,733,335	
48 54 60	these	Pipe	Sizes	911,109 1,158,581 1,435,750	1,366,664 1,737,872 2,153,625	1,822,219 2,317,163 2,871,500	2,277,773 2,896,453 3,589,375	
72 84 96				2,079,177 2,841,391 3,722,391	3,118,766 4,262,086 5,583,587	4,158,354 5,682,782 7,444,782	5,197,943 7,103,477 9,305,978	

Notes:

1. Maximum recommended pressure drop / velocity: 0.25 Psig/100 Ft. / 4,000 Fpm.

^{2.} Table based on Heavy Weight Steel Pipe using Steam Equations in Part 5.

	STEAM CONDENSATE FLOW LBS /HR. 40 PSIG BACK PRESSURE									
PIPE SIZE		PRESSURE DROP PSIG/100 FT.			VELOCITY FPM (MPH)					
	0.125	0.25	0.5	2,000 (23)	3,000 (34)	4,000 (45)	5,000 (57)			
1/2 3/4 1	34 84 175	48 118 248	68 167 351		Pressure with these	Drop Pipe	Governs Sizes			
1-1/4 1-1/2 2	404 638 1,323	571 903 1,871	807 1,276 2,646	1,210 2,022						
2-1/2 3 4	2,200 4,085 8,777	3,111 5,778 12,413	4,400 8,171 17,554	2,902 4,522 7,871	4,352 6,783 11,806	15,742				
5 6 8	16,416 26,689 56,510	23,216 37,744		12,456 17,846 31,262	18,683 26,768 46,893	24,911 35,691 62,523	31,139 44,614 78,154			
10 12 14	108,336 176,832		8	51,114 74,235 90,870	76,671 111,353 136,305	102,229 148,470 181,740	127,786 185,588 227,175			
16 18 20		2		120,981 155,393 194,107	181,471 233,089 291,160	241,961 310,786 388,213	302,452 388,482 485,267			
22 24 26				237,122 284,439 336,057	355,683 426,658 504,086	474,244 568,878 672,114	592,805 711,097 840,143			
28 30 32				391,977 452,199 516,722	587,966 678,298 775,082	783,954 904,397 1,033,443	979,943 1,130,497 1,291,804			
34 36 42	Velocity	Governs	with	585,546 658,672 903,860	878,319 988,008 1,355,789	1,171,092 1,317,344 1,807,719	1,463,865 1,646,680 2,259,649			
48 54 60	these	Pipe	Sizes	1,187,761 1,510,376 1,871,704	1,781,641 2,265,564 2,807,557	2,375,521 3,020,751 3,743,409	2,969,402 3,775,939 4,679,261			
72 84 96				2,710,503 3,704,157 4,852,667	4,065,755 5,556,236 7,279,000	5,421,007 7,408,315 9,705,333	6,776,258 9,260,393 12,131,666			

- 1. Maximum recommended pressure drop / velocity: 0.25 Psig/100 Ft. / 4,000 Fpm.
- 2. Table based on Heavy Weight Steel Pipe using Steam Equations in Part 5.

	STEAM CONDENSATE FLOW LBS./HR. 50 PSIG BACK PRESSURE										
PIPE SIZE		PRESSURE DROP PSIG/100 FT.			VELOCITY FPM (MPH)						
	0.125	0.25	0.5	2,000 (23)	3,000 (34)	4,000 (45)	5,000 (57)				
1/2 3/4 1	40 98 204	56 138 289	80 195 409		Pressure with these	Drop Pipe	Governs Sizes				
1-1/4 1-1/2 2	471 744 1,542	666 1,052 2,181	941 1,488 3,085	2,553		***					
2-1/2 3 4	2,565 4,763 10,234	3,627 6,736 14,472	5,129 9,527 20,467	3,664 5,710 9,939	8,565 14,909	19,878					
5 6 8	19,140 31,117 65,886	27,068 44,006 93,177	38,280	15,729 22,535 39,477	23,593 33,802 59,215	31,457 45,070 78,953	56,337 98,691				
10 12 14	126,311 206,171 268,500			64,546 93,742 114,748	96,819 140,613 172,122	129,092 187,484 229,496	161,365 234,355 286,870				
16 18 20				152,771 196,226 245,113	229,157 294,339 367,669	305,542 392,452 490,226	381,928 490,565 612,782				
22 24 26	,		,	299,432 359,182 424,364	449,147 538,773 636,547	598,863 718,364 848,729	748,579 897,955 1,060,911				
28 30 32				494,979 571,025 652,503	742,468 856,537 978,754	989,957 1,142,050 1,305,006	1,237,447 1,427,562 1,631,257				
34 36 42	Velocity	Governs	with	739,413 831,754 1,141,371	1,109,119 1,247,631 1,712,056	1,478,825 1,663,509 2,282,741	1,848,531 2,079,386 2,853,426				
48 54 60	these	Pipe	Sizes	1,499,874 1,907,264 2,363,540	2,249,811 2,860,895 3,545,310	2,999,747 3,814,527 4,727,080	3,749,684 4,768,159 5,908,850				
72 84 96				3,422,754 4,677,515 6,127,822	5,134,131 7,016,272 9,191,734	6,845,508 9,355,029 12,255,645	8,556,885 11,693,786 15,319,556				

Notes:

1. Maximum recommended pressure drop / velocity: 0.25 Psig/100 Ft. / 4,000 Fpm.

^{2.} Table based on Heavy Weight Steel Pipe using Steam Equations in Part 5.

				IDENSATE FL IG BACK PRE	OW LBS./HR				
PIPE SIZE	P	PRESSURE DROP PSIG/100 FT.			VELOCITY FPM (MPH)				
	0.125	0.25	0.5	2,000 (23)	3,000 (34)	4,000 (45)	5,000 (57)		
1/2 3/4 1	46 112 235	65 158 332	91 224 469		Pressure with these	Drop Pipe	Governs Sizes		
1-1/4 1-1/2 2	540 854 1,771	764 1,208 2,504	1,081 1,709 3,542	3,136					
2-1/2 3 4	2,945 5,469 11,749	4,164 7,734 16,616	5,889 10,937 23,498	4,501 7,015 12,210	10,522 18,314				
5 6 8	21,974 35,725 75,643	31,076 50,523 106,976	43,949	19,322 27,683 48,494	28,982 41,524 72,741	38,643 55,365 96,989	69,206 121,236		
10 12 14	145,016 236,702 308,261		n n	79,290 115,156 140,961	118,935 172,734 211,441	158,581 230,312 281,921	198,226 287,890 352,401		
16 18 20	447,364			187,669 241,051 301,105	281,504 361,576 451,658	375,339 482,102 602,210	469,173 602,627 752,763		
22 24 26				367,832 441,231 521,304	551,748 661,847 781,956	735,664 882,463 1,042,607	919,580 1,103,079 1,303,259		
28 30 32				608,049 701,466 801,557	912,073 1,052,199 1,202,335	1,216,097 1,402,933 1,603,113	1,520,122 1,753,666 2,003,891		
34 36 42	Velocity	Governs	with	908,320 1,021,755 1,402,098	1,362,479 1,532,633 2,103,148	1,816,639 2,043,511 2,804,197	2,270,799 2,554,388 3,505,246		
48 54 60	these	Pipe	Sizes	1,842,496 2,342,947 2,903,453	2,763,744 3,514,421 4,355,180	3,684,992 4,685,895 5,806,906	4,606,240 5,857,368 7,258,633		
72 84 96		s		4,204,627 5,746,018 7,527,625	6,306,941 8,619,027 11,291,438	8,409,254 11,492,036 15,055,251	10,511,568 14,365,045 18,819,064		

Notes:

Maximum recommended pressure drop / velocity: 0.25 Psig/100 Ft. / 4,000 Fpm.
 Table based on Heavy Weight Steel Pipe using Steam Equations in Part 5.

				DENSATE FLO			
PIPE SIZE	PF	RESSURE DRO PSIG/100 FT.		G BACK PRES		FPM (MPH)	
	0.125	0.25	0.5	2,000 (23)	3,000 (34)	4,000 (45)	5,000 (57)
1/2 3/4 1	55 136 284	78 192 402	111 271 568		Pressure with these	Drop Pipe	Governs Sizes
1-1/4 1-1/2 2	654 1,034 2,142	924 1,462 3,030	1,307 2,067 4,285	4,136		9	
2-1/2 3 4	3,562 6,616 14,214	5,038 9,356 20,102	7,125 13,232 28,428	5,936 9,251 16,103	24,154		
5 6 8	26,585 43,220 91,513	37,596 61,123 129,419	53,169 86,441	25,483 36,510 63,958	38,224 54,765 95,936	50,965 73,019 127,915	159,894
10 12 14	175,440 286,362 372,934	248,110		104,574 151,876 185,909	156,860 227,814 278,863	209,147 303,752 371,817	261,434 379,689 464,772
16 18 20	541,220 748,634		9	247,511 317,915 397,118	371,267 476,872 595,678	495,023 635,829 794,237	618,779 794,787 992,796
22 24 26				485,122 581,927 687,532	727,684 872,890 1,031,298	970,245 1,163,854 1,375,064	1,212,806 1,454,817 1,718,830
28 30 32	* 1			801,937 925,143 1,057,149	1,202,906 1,387,714 1,585,723	1,603,874 1,850,286 2,114,298	2,004,843 2,312,857 2,642,872
34 36 42	Velocity	Governs	with	1,197,955 1,347,562 1,849,186	1,796,933 2,021,344 2,773,778	2,395,911 2,695,125 3,698,371	2,994,889 3,368,906 4,622,964
48 54 60	these	Pipe	Sizes	2,430,012 3,090,043 3,829,277	3,645,019 4,635,065 5,743,916	4,860,025 6,180,086 7,658,554	6,075,031 7,725,108 9,573,193
72 84 96				5,545,357 7,578,251 9,927,959	8,318,035 11,367,376 14,891,939	11,090,713 15,156,501 19,855,919	13,863,392 18,945,627 24,819,899

^{1.} Maximum recommended pressure drop / velocity: 0.25 Psig/100 Ft. / 4,000 Fpm.

^{2.} Table based on Heavy Weight Steel Pipe using Steam Equations in Part 5.

				DENSATE FL	OW LBS./HR.		
PIPE SIZE	Pl	RESSURE DRO PSIG/100 FT.		IO BACK FRE		FPM (MPH)	
	0.125	0.25	0.5	2,000 (23)	3,000 (34)	4,000 (45)	5,000 (57)
1/2 3/4 1	62 153 320	88 216 452	125 305 640		Pressure with these	Drop Pipe	Governs Sizes
1-1/4 1-1/2 2	736 1,164 2,413	1,041 1,646 3,412	1,472 2,328 4,826	* .			
2-1/2 3 4	4,012 7,452 16,010	5,674 10,539 22,641	8,025 14,904 32,020	7,029 10,954 19,066	28,599		
5 6 8	29,944 48,682 103,076	42,347 68,846 145,772	59,887 97,363	30,172 43,228 75,727	45,258 64,842 113,591	86,457 151,455	189,318
10 12 14	197,608 322,546 420,057	279,460	,	123,817 179,824 220,120	185,726 269,736 330,180	247,635 359,649 440,240	309,544 449,561 550,300
16 18 20	609,606 843,229 1,123,929			293,059 376,418 470,197	439,589 564,627 705,295	586,118 752,836 940,394	732,648 941,045 1,175,492
22 24 26				574,396 689,014 814,053	861,594 1,033,521 1,221,079	1,148,791 1,378,029 1,628,106	1,435,989 1,722,536 2,035,132
28 30 32				949,511 1,095,389 1,251,688	1,424,267 1,643,084 1,877,531	1,899,022 2,190,779 2,503,375	2,373,778 2,738,474 3,129,219
34 36 42	Velocity	Governs	with	1,418,406 1,595,544 2,189,476	2,127,608 2,393,315 3,284,215	2,836,811 3,191,087 4,378,953	3,546,014 3,988,859 5,473,691
48 54 60	these	Pipe	Sizes	2,877,188 3,658,679 4,533,949	4,315,782 5,488,019 6,800,923	5,754,377 7,317,358 9,067,897	7,192,971 9,146,698 11,334,872
72 84 96				6,565,824 8,972,816 11,754,923	9,848,737 13,459,224 17,632,384	13,131,649 17,945,632 23,509,846	16,414,561 22,432,040 29,387,307

- 1. Maximum recommended pressure drop / velocity: 0.25 Psig/100 Ft. / 4,000 Fpm.
- 2. Table based on Heavy Weight Steel Pipe using Steam Equations in Part 5.

				DENSATE FLO					
PIPE SIZE		RESSURE DRO PSIG/100 FT.		IO BACK FRE		VELOCITY FPM (MPH)			
	0.125	0.25	0.5	2,000 (23)	3,000 (34)	4,000 (45)	5,000 (57)		
1/2 3/4 1	74 181 379	104 256 536	148 362 758		Pressure with these	Drop Pipe	Governs Sizes		
1-1/4 1-1/2 2	872 1,380 2,859	1,234 1,951 4,044	1,745 2,759 5,719						
2-1/2 3 4	4,755 8,830 18,971	6,724 12,488 26,829	9,509 17,660 37,942	8,900 13,871 24,144	36,215				
5 6 8	35,482 57,686 122,141	50,179 81,580 172,733	70,964 115,371	38,207 54,740 95,894	57,310 82,110 143,841	109,480 191,788	239,735		
10 12 14	234,157 382,203 497,750	331,149 540,517		156,791 227,712 278,739	235,186 341,569 418,108	313,581 455,425 557,478	391,977 569,281 696,847		
16 18 20	722,357 999,190 1,331,807			371,102 476,660 595,413	556,653 714,990 893,119	742,204 953,320 1,190,825	927,755 1,191,650 1,488,532		
22 24 26	1,723,555 2,177,597	,	a v	727,360 872,502 1,030,839	1,091,040 1,308,753 1,546,259	1,454,720 1,745,004 2,061,678	1,818,400 2,181,255 2,577,098		
28 30 32		a - :		1,202,371 1,387,097 1,585,018	1,803,556 2,080,646 2,377,527	2,404,741 2,774,194 3,170,036	3,005,927 3,467,743 3,962,545		
34 36 42	Velocity	Governs	with	1,796,134 2,020,445 2,772,545	2,694,201 3,030,667 4,158,817	3,592,268 4,040,889 5,545,089	4,490,335 5,051,111 6,931,362		
48 54 60	these	Pipe	Sizes	3,643,397 4,633,003 5,741,361	5,465,096 6,949,504 8,612,042	7,286,795 9,266,006 11,482,722	9,108,494 11,582,507 14,353,403		
72 84 96	,			8,314,335 11,362,320 14,885,316	12,471,503 17,043,480 22,327,974	16,628,671 22,724,640 29,770,631	20,785,838 28,405,801 37,213,289		

- Maximum recommended pressure drop / velocity: 0.25 Psig/100 Ft. / 4,000 Fpm.
 Table based on Heavy Weight Steel Pipe using Steam Equations in Part 5.

Appendix D: Pipe Materials, Expansion, and Support

PIPE	I		INSIDE	WALL	OUTSIDE		7	WEIGHT (1)	WATER
SIZE	SCHE	DULE	DIA.	THICK	DIA.	AREA	PIPE	WATER	TOTAL	VOLUME
In.			In.	In.	In.	Sq.In.	Lb/Ft	Lb/Ft	Lb/Ft	Gal/Ft
	10		0.674	0.083	0.840	0.357	0.671	0.155	0.826	0.019
	40	STD	0.622	0.109	0.840	0.304	0.851	0.132	0.983	0.015
1/2	80	XS	0.546	0.147	0.840	0.234	1.088	0.101	1.189	0.012
	160		0.466	0.187	0.840	0.171	1.304	0.074	1.378	0.009
		xxs	0.252	0.294	0.840	0.050	1.714	0.022	1.736	0.003
	10		0.884	0.083	1.050	0.614	0.857	0.266	1.123	0.032
	40	STD	0.824	0.113	1.050	0.533	1.131	0.231	1.362	0.032
3/4	80	XS	0.742	0.154	1.050	0.432	1.474	0.187	1.661	0.022
57.	160		0.614	0.218	1.050	0.296	1.937	0.128	2.065	0.015
		xxs	0.434	0.308	1.050	0.148	2.441	0.064	2.505	0.008
	10		1.097	0.109	1.315	0.945	1.404	0.409	1.813	0.049
	40	STD	1.049	0.133	1.315	0.864	1.679	0.374	2.053	0.045
1	80	XS	0.957	0.179	1.315	0.719	2.172	0.312	2.483	0.037
	160		0.815	0.250	1.315	0.522	2.844	0.226	3.070	0.027
		XXS	0.599	0.358	1.315	0.282	3.659	0.122	3.781	0.015
	10		1.442	0.109	1.660	1.633	1.806	0.708	2.513	0.085
	40	STD	1.380	0.140	1.660	1.496	2.273	0.648	2.921	0.078
1-1/4	80	XS	1.278	0.191	1.660	1.283	2.997	0.556	3.552	0.067
	160		1.160	0.250	1.660	1.057	3.765	0.458	4.223	0.055
		xxs	0.896	0.382	1.660	0.631	5.214	0.273	5.487	0.033
	10		1.682	0.109	1.900	2.222	2.085	0.963	3.048	0.115
	40	STD	1.610	0.145	1.900	2.036	2.718	0.882	3.600	0.106
1-1/2	80	XS	1.500	0.200	1.900	1.767	3.631	0.766	4.397	0.092
	160		1.338	0.281	1.900	1.406	4.859	0.609	5.468	0.073
		XXS	1.100	0.400	1.900	0.950	6.408	0.412	6.820	0.049
	10		2.157	0.109	2.375	3.654	2.638	1.583	4.221	0.190
	40	STD	2.067	0.154	2.375	3.356	3.653	1.454	5.107	0.174
2	80	XS	1.939	0.218	2.375	2.953	5.022	1.279	6.301	0.153
	160		1.689	0.343	2.375	2.241	7.444	0.971	8.415	0.116
		XXS	1.503	0.436	2.375	1.774	9.029	0.769	9.798	0.092
	10		2.635	0.120	2.875	5.453	3.531	2.363	5.893	0.283
	40	STD	2.469	0.203	2.875	4.788	5.793	2.074	7.867	0.249
2-1/2	80	XS	2.323	0.276	2.875	4.238	7.661	1.836	9.497	0.220
	160		2.125	0.375	2.875	3.547	10.013	1.537	11.549	0.184
		XXS	1.771	0.552	2.875	2.463	13.695	1.067	14.762	0.128
	10		3.260	0.120	3.500	8.347	4.332	3.616	7.948	0.434
	40	STD	3.068	0.216	3.500	7.393	7.576	3.203	10.779	0.384
3	80	XS	2.900	0.300	3.500	6.605	10.253	2.862	13.115	0.343
	160		2.626	0.437	3.500	5.416	14.296	2.346	16.642	0.281
		XXS	2.300	0.600	3.500	4.155	18.584	1.800	20.384	0.216
	10		4.260	0.120	4.500	14.253	5.614	6.175	11.789	0.740
	40	STD	4.026	0.237	4.500	12.730	10.791	5.515	16.306	0.661
4	80	XS	3.826	0.337	4.500	11.497	14.984	4.981	19.965	0.597
	160		3.438	0.531	4.500	9.283	22.509	4.022	26.531	0.482
9		XXS	3.152	0.674	4.500	7.803	27.541	3.381	30.922	0.405

PIPE			INSIDE WALL OUTSID			4054	V	WATER		
SIZE	SCHE	DULE	DIA.	THICK	DIA.	AREA	PIPE	WATER	TOTAL	VOLUME
In.			In.	In.	In.	Sq.In.	Lb/Ft	Lb/Ft	Lb/Ft	Gal/Ft
	10 1		5.295	0.134	5.563	22.020	7.770	9.540	17.310	1.144
	40	STD	5.047	0.258	5.563	20.006	14.618	8.667	23.285	1.039
5	80	XS	4.813	0.375	5.563	18.194	20.778	7.882	28.661	0.945
	160		4.313	0.625	5.563	14.610	32.962	6.330	39.291	0.759
		XXS	4.063	0.750	5.563	12.965	38.553	5.617	44.170	0.674
	10		6.357	0.134	6.625	31.739	9.290	13.751	23.040	1.649
	40	STD	6.065	0.280	6.625	28.890	18.974	12.517	31.491	1.501
6	80	XS	5.761	0.432	6.625	26.067	28.574	11.293	39.867	1.354
	160		5.189	0.718	6.625	21.147	45.297	9.162	54.459	1.099
		XXS	4.897	0.864	6.625	18.834	53.161	8.160	61.321	0.978
	10		8.329	0.148	8.625	54.485	13.399	23.605	37.005	2.830
	20		8.125	0.250	8.625	51.849	22.362	22.463	44.825	2.693
	30		8.071	0.277	8.625	51.162	24.697	22.166	46.862	2.658
8	40	STD	7.981	0.322	8.625	50.027	28.554	21.674	50.228	2.599
	80	XS	7.625	0.500	8.625	45.664	43.388	19.784	63.172	2.372
		XXS	6.875	0.875	8.625	37.122	72.425	16.083	88.508	1.928
	160		6.813	0.906	8.625	36.456	74.691	15.794	90.485	1.894
	10		10.420	0.165	10.750	85.276	18.653	36.945	55.599	4.430
	20		10.250	0.250	10.750	82.516	28.036	35.750	63.785	4.287
	30		10.136	0.307	10.750	80.691	34.241	34.959	69.200	4.192
10	40	STD	10.020	0.365	10.750	78.854	40.484	34.163	74.647	4.096
10	60	XS	9.750	0.500	10.750	74.662	54.736	32.347	87.083	3.879
	80		9.564	0.593	10.750	71.840	64.328	31.125	95.453	3.732
1 1	140	XXS	8.750	1.000	10.750	60.132	104.132	26.052	130.184	3.124
	160		8.500	1.125	10.750	56.745	115.647	24.585	140.231	2.948
	10		12.390	0.180	12.750	120.568	24.165	52.236	76.401	6.263
	20		12.250	0.250	12.750	117.859	33.376	51.062	84.438	6.123
	30		12.090	0.330	12.750	114.800	43.774	49.737	93.511	5.964
1		STD	12.000	0.375	12.750	113.097	49.563	48.999	98.562	5.875 5.815
12	40		11.938	0.406	12.750	111.932	53.526	48.494	102.020	5.633
		XS	11.750	0.500	12.750	108.434	65.416	46.979	112.395 132.545	5.280
	80		11.376	0.687	12.750	101.641	88.510	44.036 39.323	164.815	4.715
1 1	120	XXS	10.750	1.000	12.750	90.763 80.531	125.492 160.274	34.890	195.164	4.713
-	160		10.126	1.312 0.250	12.750	143.139	36.713	62.014	98.728	7.436
	10		13.500		14.000		45.611	60.880	106.492	7.300
	20		13.376	0.312	14.000	140.521	54.569	59.739	114.308	7.163
1,,	30	STD	13.250 13.126	0.375 0.437	14.000 14.000	137.886 135.318	63.302	58.626	121.928	7.029
14	40	XS		0.437	14.000	132.732	72.091	57.506	129.597	6.895
			13.000	0.300	14.000	122.718	106.134	53.167	159.302	6.375
	80 160		12.500 11.188	1.406	14.000	98.309	189.116	42.592	231.708	5.107
 	100		15.500	0.250	16.000	188.692	42.053	81.750	123.803	9.802
1 1	20		15.376	0.230	16.000	185.685	52.276	80.447	132.723	9.646
	30	STD	15.250	0.312	16.000	182.654	62.579	79.134	141.714	9.489
16	40	XS	15.000	0.500	16.000	176.715	82.772	76.561	159.333	9.180
1 1	80	7.5	14.314	0.843	16.000	160.921	136.465	69.718	206.183	8.360
	160		12.814	1.593	16.000	128.961	245.114	55.872	300.986	6.699

PIPE			INSIDE	WALL	OUTSIDE	AREA	7	WEIGHT (1)	WATER
SIZE	SCHE	DULE	DIA.	THICK	DIA.	Sq.In.	PIPE	WATER	TOTAL	VOLUME
In.			In.	In.	In.	•	Lb/Ft	Lb/Ft	Lb/Ft	Gal/Ft
	10		17.500	0.250	18.000	240.528	47.393	104.208	151.601	12.495
	20		17.376	0.312	18.000	237.132	58.940	102.737	161.677	12.319
		STD	17.250	0.375	18.000	233.705	70.589	101.252	171.841	12.141
18	30		17.126	0.437	18.000	230.357	81.971	99.802	181.772	11.967
		XS	17.000	0.500	18.000	226.980	93.452	98.338	191.790	11.791
	40		16.876	0.562	18.000	223.681	104.668	96.909	201.577	11.620
	80		16.126	0.937	18.000	204.241	170.755	88.487	259.242	10.610
	160		14.438	1.781	18.000	163.721	308.509	70.932	379.440	8.505
	10		19.500	0.250	20.000	298.648	52.733	129.388	182.122	15.514
	20	STD	19.250	0.375	20.000	291.039	78.600	126.092	204.691	15.119
20	30	XS	19.000	0.500	20.000	283.529	104.132	122.838	226.970	14.729
	40		18.814	0.593	20.000	278.005	122.911	120.445	243.356	14.442
	80		17.938	1.031	20.000	252.719	208.873	109.490	318.363	13.128
	160		16.064	1.968	20.000	202.674	379.008	87.808	466.816	10.529
	10		21.500	0.250	22.000	363.050	58.074	157.290	215.364	18.860
	20	STD	21.250	0.375	22.000	354.656	86.610	153.654	240.263	18.424
22	30	XS	21.000	0.500	22.000	346.361	114.812	150.060	264.872	17.993
	80		19.750	1.125	22.000	306.354	250.818	132.727	383.545	15.915
	160		17.750	2.125	22.000	247.450	451.072	107.207	558.278	12.855
	10		23.500	0.250	24.000	433.736	63.414	187.915	251.328	22.532
1	20	STD	23.250	0.375	24.000	424.557	94.620	183.938	278.558	22.055
		XS	23.000	0.500	24.000	415.476	125.492	180.003	305.496	21.583
24	30		22.876	0.562	24.000	411.008	140.681	178.068	318.749	21.351
	40		22.626	0.687	24.000	402.073	171.054	174.197	345.251	20.887
	80		21.564	1.218	24.000	365.215	296.359	158.228	454.587	18.972
	160		19.314	2.343	24.000	292.978	541.938	126.932	668.870	15.220
	10		25.376	0.312	26.000	505.750	85.598	219.115	304.713	26.273
26		STD	25.250	0.375	26.000	500.740	102.630	216.944	319.574	26.012
	20	XS	25.000	0.500	26.000	490.874	136.173	212.670	348.842	25.500
	10		27.376	0.312	28.000	588.613	92.263	255.015	347.277	30.577
28		STD	27.250	0.375	28.000	583.207	110.640	252.673	363.313	30.296
28	20	XS	27.000	0.500	28.000	572.555	146.853	248.058	394.910	29.743
	30		26.750	0.625	28.000	562.001	182.732	243.485	426.217	29.195
	10		29.376	0.312	30.000	677.759	98.927	293.637	392.564	35.208
		STD	29.250	0.375	30.000	671.957	118.650	291.123	409.774	34.907
30	20	XS	29.000	0.500	30.000	660.520	157.533	286.168	443.701	34.313
	30		28.750	0.625	30.000	649.181	196.082	281.255	477.337	33.724
	40		28.500	0.688	29.876	637.940	214.473	276.385	490.858	33.140
	10		31.376	0.312	32.000	773.188	105.591	334.981	440.573	40.166
1 1		STD	31.250	0.375	32.000	766.990	126.660	332.296	458.957	39.844
32	20	XS	31.000	0.500	32.000	754.768	168.213	327.001	495.214	39.209
	30		30.750	0.625	32.000	742.643	209.432	321.748	531.180	38.579
	40		30.624	0.688	32.000	736.569	230.080	319.116	549.196	38.263

PIPE			INSIDE	WALL	OUTSIDE	AREA	7	WEIGHT (1)	WATER
SIZE	SCHE	DULE	DIA.	THICK	DIA.	Sq.In.	PIPE	WATER	TOTAL	VOLUME
In.			In.	In.	In.		Lb/Ft	Lb/Ft	Lb/Ft	Gal/Ft
	10		33.376	0.312	34.000	874.900	112.256	379.048	491.304	45.449
		STD	33.250	0.375	34.000	868.307	134.671	376.191	510.862	45.107
34	20	XS	33.000	0.500	34.000	855.299	178.893	370.555	549.449	44.431
	30		32.750	0.625	34.000	842.389	222.782	364.962	587.744	43.760
	40		32.624	0.688	34.000	835.919	244.776	362.159	606.935	43.424
	10		35.376	0.312	36.000	982.895	118.920	425.836	544.757	51.060
		STD	35.250	0.375	36.000	975.906	142.681	422.808	565.489	50.696
36	20	XS	35.000	0.500	36.000	962.113	189.574	416.832	606.406	49.980
, .	30		34.750	0.625	36.000	948.417	236.133	410.899	647.031	49.268
	40		34.500	0.750	36.000	934.820	282.358	405.008	687.366	48.562
		STD	41.250	0.375	42.000	1336.404	166.711	578.993	745.704	69.424
40	20	XS	41.000	0.500	42.000	1320.254	221.614	571.996	793.610	68.585
42	30		40.750	0.625	42.000	1304.203	276.183	565.042	841.225	67.751
	40		40.500	0.750	42.000	1288.249	330.419	558.130	888.549	66.922
		STD	47.250	0.375	48.000	1753.450	190.742	759.677	950.418	91.088
48	20	XS	47.000	0.500	48.000	1734.945	253.655	751.659	1005.314	90.127
48	30		46.750	0.625	48.000	1716.537	316.234	743.684	1059.918	89.171
	40		46.500	0.750	48.000	1698.227	378.480	735.751	1114.231	88.220
		STD	53.250	0.375	54.000	2227.046	214.772	964.860	1179.632	115.691
	20	XS	53.000	0.500	54.000	2206.183	285.695	955.822	1241.517	114.607
54	30		52.750	0.625	54.000	2185.419	356.285	946.826	1303.111	113.528
	40		52.500	0.750	54.000	2164.754	426.540	937.873	1364.413	112.455
		STD	59.250	0.375	60.000	2757.189	238.803	1194.543	1433.346	143.231
	20	XS	59.000	0.500	60.000	2733.971	317.736	1184.484	1502.220	142.024
60	30		58.750	0.625	60.000	2710.851	396.336	1174.467	1570.803	140.823
-	40		58.500	0.750	60.000	2687.829	474.601	1164.493	1639.095	139.627
		STD	71.250	0.375	72.000	3987.123	286.863	1727.408	2014.272	207.123
	20	XS	71.000	0.500	72.000	3959.192	381.817	1715.307	2097.124	205.672
72	30		70.750	0.625	72.000	3931.360	476.437	1703.249	2179.686	204.226
	40		70.500	0.750	72.000	3903.625	570.723	1691.233	2261.956	202.786
_		STD	83.250	0.375	84.000	5443.251	334.924	2358.271	2693.195	282,766
	20	XS	83.000	0.500	84.000	5410.608	445.898	2344.128	2790.027	281.071
84	30		82.750	0.625	84.000	5378.063	556.539	2330.029	2886.567	279.380
	40		82.500	0.750	84.000	5345.616	666.845	2315.971	2982.816	277.694
		STD	95.250	0.375	96.000	7125.574	382.985	3087.132	3470.117	370.160
	20	XS	95.000	0.500	96.000	7088.218	509.980	3070.948	3580.927	368.219
96	30		94.750	0.625	96.000	7050.961	636.640	3054.806	3691.446	366.284
	40		94.500	0.750	96.000	7013.802	762.967	3038.707	3801.674	364.353
	40		74.500	0.730	70.000	7013,002	102.701	5050.707	3001.074	501.555

Properties of Stainless Steel Pipe

PIPE			INSIDE	WALL	OUTSIDE	AREA	V	VEIGHT (1)	WATER
SIZE In.	SCHE	DULE	DIA. In.	THICK In.	DIA. In.	Sq.In.	PIPE Lb/Ft	WATER Lb/Ft	TOTAL Lb/Ft	VOLUME Gal/Ft
1/2	5 10		0.710 0.674	0.065 0.083	0.840 0.840	0.396 0.357	0.549 0.684	0.172 0.155	0.720 0.839	0.021 0.019
3/4	5 10		0.920 0.884	0.065 0.083	1.050 1.050	0.665 0.614	0.697 0.874	0.288 0.266	0.985 1.140	0.035 0.032
1	5 10		1.185 1.097	0.065 0.109	1.315 1.315	1.103 0.945	0.885 1.432	0.478 0.409	1.363 1.842	0.057 0.049
1-1/4	5 10		1.530 1.442	0.065 0.109	1.660 1.660	1.839 1.633	1.129 1.842	0.797 0.708	1.926 2.549	0.096 0.085
1-1/2	5		1.770 1.682	0.065 0.109	1.900 1.900	2.461 2.222	1.299 2.127	1.066 0.963	2.365 3.089	0.128 0:115
2	5		2.245 2.157	0.065 0.109	2.375 2.375	3.958 3.654	1.636 2.691	1.715 1.583	3.351 4.274	0.206 0.190
2-1/2	5		2.709 2.635	0.083 0.120	2.875 2.875	5.764 5.453	2.524 3.601	2.497 2.363	5.022 5.964	0.299 0.283
3	5		3.334 3.260	0.083 0.120	3.500 3.500	8.730 8.347	3.090 4.419	3.782 3.616	6.872 8.035	0.454 0.434
4	5		4.334 4.260	0.083	4.500 4.500	14.753 14.253	3.994 5.726	6.392 6.175	10.385 11.901	0.766 0.740
5	5		5.345 5.295	0.109 0.134	5.563 5.563	22.438 22.020	6.476 7.925	9.721 9.540	16.197 17.465	1.166 1.144
6	5		6.407 6.357	0.109 0.134	6.625 6.625	32.240 31.739	7.737 9.475	13.968 13.751	21.705 23.226	1.675 1.649
8	5		8.407 8.329	0.109 0.148	8.625 8.625	55.510 54.485	10.112 13.667	24.050 23.605	34.162 37.273	2.884 2.830
10	5		10.482 10.420	0.134 0.165	10.750 10.750	86.294 85.276	15.497 19.026	37.386 36.945	52.883 55.972	4.483 4.430
12	5		12.438 12.390	0.156 0.180	12.750° 12.750	121.504 120.568	21.403 24.648	52.641 52.236	74.044 76.884	6.312 6.263
14	5		13.688 13.624	0.156 0.188	14.000 14.000	147.153 145.780	23.527 28.287	63.754 63.159	87.281 91.446	7.644 7.573
16	5		15.670 15.624	0.165 0.188	16.000 16.000	192.854 191.723	28.463 32.384	83.553 83.063	112.016 115.447	10.018 9.960
18	5		17.670 17.624	0.165 0.188	18.000 18.000	245.224 243.949	32.058 36.480	106.243 105.690	138.301 142.170	12.739 12.673
20	5		19.624 19.564	0.188	20.000	302.458 300.611	40.576 46.979	131.039 130.239	171.615 177.218	15.712 15.616
22	5		21.624 21.564	0.188 0.218	22.000 22.000	367.250 365.215	44.672 51.729	159.110 158.228	203.782 209.957	19.078 18.972
24	5		23.564 23.500	0.218 0.250	24.000 24.000	436.102 433.736	56.479 64.682	188.940 187.915	245.418 252.597	22.655 22.532

32.02 Pipe Expansion

Thermal Expansion of Metal Pipe

r							
SATURATED STEAM	TEMPERATURE	LINEAR THERMAL EXPANSION INCHES/100 FEET					
PRESSURE PSIG	°F	CARBON STEEL	STAINLESS STEEL	COPPER			
	-30 -20	-0.19 -0.12	-0.30 -0.20	-0.32			
-	-20	-0.12	-0.20	-0.21 -0.11			
	0	0	0	0			
	10	0.08	0.11	0.12			
-14.6	20 32	0.15 0.24	0.22 0.36	0.24 0.37			
-14.6	40	0.30	0.45	0.45			
-14.5	50	0.38	0.56	0.57			
-14.4 -14.3	60 70	0.46 0.53	0.67 0.78	0.68 0.79			
-14.3	80	0.61	0.78	0.79			
-14.0	90	0.68	1.01	1.02			
-13.7	100	0.76	1.12	1.13			
-13.0 -11.8	120 140	0.91 1.06	1.35 1.57	1.37 1.59			
-10.0	160	1.22	1.79	1.80			
-7.2 -3.2	180 200	1.37 1.52	2.02 2.24	2.05 2.30			
0	212	1.62	2.38	2.43			
2.5	220	1.69	2.48	2.52			
10.3 20.7	240 260	1.85 2.02	2.71 2.94	2.76 2.99			
34.6	280	2.02	3.17	3.22			
52.3	300	2.35	3.40	3.46			
75.0 103.3	320 340	2.53 2.70	3.64 3.88	3.70 3.94			
138.3	360	2.70	4.11	4.18			
181.1	380	3.05	4.35	4.42			
232.6	400	3.23	4.59	4.87			
366.9	440	3.60	5.07	5.15			
294.1	420	. 3.41	4.83	4.91			

Pipe Expansion U-Bends or Loops

			ANCH	OR TO ANO	HOR EXPA	NSION		
PIPE SIZE	3	3"	4"		5"			5"
	w	Н	W	Н	w	Н	w	Н
1/2	2'-0"	4'-0"	2'-4"	4'-8"	2'-8"	5'-4"	2'-10"	5'-8"
3/4	2'-4"	4'-8"	2'-8"	5'-4"	3'-0"	6'-0"	3'-3"	6'-6"
1	2'-6"	5'-0"	3'-0"	6'-0"	3'-4"	6'-8"	3'-6"	7'-0"
1-1/4	2'-10"	5'-8"	3'-3"	6'-6"	3'-8"	7'-4"	4'-0"	8'-0"
1-1/2	3'-0"	6'-0"	3'-6"	7'-0"	3'-10"	7'-8"	4'-3"	8'-6"
2	3'-4"	6'-8"	4'-0"	8'-0"	4'-4"	8'-8"	4'-9"	9'-6"
2-1/2	3'-8"	7'-4"	4'-3"	8'-6"	4'-10"	9'-10"	5'-2"	10'-4"
3	4'-1"	8'-2"	4'-8"	9'-4"	5'-4"	10'-8"	5'-9"	11'-8"
4	4'-7"	9'-2"	5'-4"	10'-8"	5'-10"	11'-8"	6'-6"	13'-0"
5	5'-2"	10'-4"	6'-0"	12'-0"	6'-8"	13'-4"	7'-3"	14'-6"
6	5'-7"	11'-2"	6'-6"	13'-0"	7'-2"	14'-4"	8'-0"	16'-0"
8	6'-4"	12'-8"	7'-4"	14'-8"	8'-4"	16'-8"	9'-0"	18'-0"
10	7'-1"	14'-2"	8'-2"	16'-4"	9'-2"	18'-4"	10'-0"	20'-0"
12	7'-9"	15'-6"	9'-0"	18'-0"	10'-0"	20'-0"	11'-0"	22'-0"
14	8'-1"	16'-2"	9'-4"	18'-8"	10'-6"	21'-0"	11'-6"	23'-0"
16	8'-8"	17'-4"	10'-0"	20'-0"	11'-2"	22'-4"	12'-3"	24'-6"
18	9'-2"	18'-4"	10'-8"	21'-4"	11'-10"	23'-8"	13'-0"	26'-0"
20	9'-8"	19'-4"	11'-2"	22'-4"	12'-6"	25'-0"	13'-8"	27'-4"
22	10'-2"	20'-4"	11'-8"	23'-4"	13'-2"	26'-4"	14'-4"	28'-8"
24	10'-8"	21'-4"	12'-3"	24'-6"	13'-8"	27'-4"	15'-0"	30'-0"
26	11'-0"	22'-0"	12'-9"	25'-6"	14'-4"	28'-8"	15'-7"	31'-2"
28	11'-6"	23'-0"	13'-2"	26'-4"	14'-10"	29'-8"	16'-2"	32'-4"
30	12'-0"	23'-8"	13'-8"	27'-4"	15'-4"	30'-8"	16'-9"	33'-6"
32	12'-3"	24'-6"	14'-2"	28'-4"	15'-10"	31'-8"	17'-3"	34'-6"
34	12'-8"	25'-4"	14'-6"	29'-0"	16'-4"	32'-8"	18'-0"	36'-0"
36	13'-0"	26'-0"	15'-0"	30'-0"	16'-10"	33'-8"	18'-4"	36'-8"
42	14'-0"	28'-0"	16'-2"	32'-4"	18'-2"	36'-4"	20'-0"	40'-0"
48	15'-0"	30'-0"	17'-4"	34'-8"	19'-4"	38'-8"	21'-2"	42'-4"
54	15'-11"	31'-10"	18'-4"	36'-8"	20'-6"	41'-0"	22'-5"	44'-10"
60	16'-9"	33'-6"	19'-4"	38'-8"	21'-7"	43'-2"	23'-8"	47'-4"
72	18'-4"	36'-8"	21'-2"	42'-4"	23'-8"	47'-4"	25'-11"	51'-10"
84	19'-10"	39'-8"	22'-10"	45'-8"	25'-7"	51'-2"	28'-0"	56'-0"
96	21'-2"	42'-4"	24'-5"	48'-10"	27'-4"	54'-8"	29'-11"	59'-10

Pipe Expansion U-Bends or Loops

		ANCHOR TO ANCHOR EXPANSION							
PIPE SIZE	7	, "	8	3"	1	0"	1	2"	
	w	Н	w	Н	W	Н	W	Н	
1/2	3'-2"	6'-4"	3'-3"	6'-6"	3'-8"	7'-4"	4'-0"	8'-0"	
3/4	3'-6"	7'-0"	3'-8"	7'-4"	4'-2"	8'-4"	4'-6"	9'-0"	
1	3'-10"	7'-8"	4'-0"	8'-0"	4'-7"	9'-2"	5'-0"	10'-0"	
1-1/4	4'-4"	8'-8"	4'-7"	9'-2"	5'-1"	10'-2"	5'-7"	11'-2"	
1-1/2	4'-8"	9'-4"	5'-0"	10'-0"	5'-6"	11'-0"	6'-0"	12'-0"	
2	5'-2"	10'-4"	5'-6"	11'-0"	6'-1"	12'-2"	6'-8"	13'-4"	
2-1/2	5'-8"	11'-4"	6'-0"	12'-0"	6'-8"	13'-4"	7'-4"	14'-8"	
3	6'-2"	12'-4"	6'-8"	13'-4"	7'-6"	15'-0"	8'-1"	16'-2"	
4	7'-0"	14'-0"	7'-6"	15'-0"	8'-6"	17'-0"	9'-2"	18'-4"	
5	7'-10"	15'-8"	8'-4"	16'-8"	9'-4"	18'-8"	10'-2"	20'-4"	
6	8'-6"	17'-0"	9'-2"	18'-4"	10'-2"	20'-4"	11'-2"	22'-4"	
8	9'-8"	19'-4"	10'-4"	20'-8"	11'-7"	23'-2"	12'-8"	25'-4"	
10	10'-10"	21'-8"	11'-7"	23'-2"	13'-0"	26'-0"	14'-2"	28'-4"	
12	11'-10"	23'-8"	12'-7"	25'-2"	14'-0"	28'-0"	15'-6"	31'-0"	
14	12'-4"	24'-8"	13'-3"	26'-6"	14'-9"	29'-6"	16'-2"	32'-4"	
16	13'-2"	26'-4"	14'-2"	28'-4"	15'-9"	31'-6"	17'-3"	34'-6"	
18	14'-0"	28'-0"	15'-0"	30'-0"	16'-9"	33'-6"	18'-4"	36'-8"	
20	14'-10"	29'-8"	15'-9"	31'-6"	17'-8"	35'-4"	19'-4"	38'-8"	
22	15'-6"	31'-0"	16'-7"	33'-2"	18'-6"	37'-0"	20'-3"	40'-6"	
24	16'-2"	32'-4"	17'-4"	34'-8"	19'-4"	38'-8"	21'-2"	42'-4"	
26	16'-10"	33'-8"	18'-0"	36'-0"	20'-0"	40'-0"	22'-0"	44'-0"	
28	17'-6"	35'-0"	18'-8"	37'-4"	21'-0"	42'-0"	23'-0"	46'-0"	
30	18'-2"	36'-4"	19'-4"	38'-8"	21'-7"	43'-2"	23'-8"	47'-4"	
32	18'-8"	37'-4"	20'-0"	40'-0"	22'-4"	44'-8"	24'-6"	49'-0"	
34	19'-4"	38'-8"	20'-8"	41'-4"	23'-0"	46'-0"	25'-2"	50'-4"	
36	19'-10"	39'-8"	21'-2"	42'-4"	23'-8"	47'-4"	26'-0"	52'-0"	
42	21'-6"	43'-0"	23'-0"	46'-0"	25'-6"	51'-0"	28'-0"	56'-0"	
48	22'-10"	45'-8"	24'-5"	48'-10"	27'-4"	54'-8"	30'-0"	60'-0"	
54	24'-3"	48'-6"	25'-11"	51'-10"	29'-0"	58'-0"	31'-9"	63'-6"	
60	25'-7"	51'-2"	27'-4"	54'-8"	30'-6"	61'-0"	33'-6"	67'-0"	
72	23'-8"	47'-4"	29'-11"	59'-10"	33'-5"	66'-10"	36'-8"	73'-4"	
84	30'-3"	60'-6"	32'-4"	64'-8"	36'-1"	72'-2"	39'-7"	69'-2"	
96	32'-4"	64'-8"	34'-7"	69'-2"	38'-8"	77'-4"	42'-4"	84'-8"	

32.03 Pipe Support

Horizontal Pipe Support Spacing

		MAXIMUI		TAL HANGER SPA	ACING		MINIMUM
PIPE SIZE		STEEL			ROD SIZE		
	RECOMMEND	WATER SYSTEMS	VAPOR SYSTEMS	RECOMMEND	WATER SYSTEMS	VAPOR SYSTEMS	INCHES
1/2 3/4 1	6 6 6	7 7 7	8 9 9	5 5 6	5 5 6	6 7 8	3/8 3/8 3/8
1-1/4 1-1/2 2	6 6 7	7 9 10	9 12 13	6 6 7	7 8 8	9 10 11	3/8 3/8 3/8
2-1/2 3 4	10 10 10	11 12 14	14 15 17	8 10 10	9 10 12	13 14 16	1/2 1/2 5/8
5 6 8	10 10 12	16 17 19	19 21 24	10 10 10	13 14 16	18 20 23	5/8 3/4 7/8
10 12 14	12 12 12	22 23 25	26 30 32	10 10 	18 19 	25 28 	7/8 7/8 1
16 18 20	12 12 12	27 28 30	35 37 39		 		1 1-1/4 1-1/4
22 24 26	12 12 12	30 32 32	39 42 42				1-1/2 1-1/2 1-1/2
28 30 32	12 12 12	32 33 33	42 44 44		 		1-1/2 1-1/2 1-1/2
34 36 42	12 12 12	33 33 33	44 44 44		 		1-1/2 1-1/2 1-1/2
48 54 60	12 12 12	32 33 33	42 44 44				1-3/4 1-3/4 2
72 84 96	12 12 12	33 33 33	44 44 44				2 2-1/2 2-1/2

Vertical Pipe Support Spacing

PIPE SIZE		L SUPPORT SPACING ET	SUPPORT
SIZE	STEEL	COPPER	
8" AND SMALLER	EVERY OTHER FLOOR AND BASE OF TALL PIPE RISERS	EVERY FLOOR AND BASE OF TALL PIPE RISERS	STEEL EXTENSION PIPE CLAMPS
10" - 12"	EVERY OTHER FLOOR AND BASE OF ALL PIPE RISERS	EVERY FLOOR AND BASE OF ALL PIPE RISERS	STEEL EXTENSION PIPE CLAMPS
14" - 24"	EVERY OTHER FLOOR AND BASE OF ALL PIPE RISERS	NOT APPLICABLE	STEEL EXTENSION PIPE CLAMPS
26" - 96".	EVERY FLOOR AND BASE OF ALL PIPE RISERS	NOT APPLICABLE	STEEL EXTENSION PIPE CLAMPS

Appendix E: Space Requirements

33.01 Space Requirements

Ceiling Plenum Space

1				9					-		
		CLE	AR DIS	TANCE -	LIGHT	TO BEAN	M IN INC	HES			
FLOOR TO	CLG.					BEAM	DEPTH				
FLOOR	HEIGHT	12"	14"	16"	18"	21"	24"	27"	30"	33"	36"
	7"-0" 7'-6"	*	*	*	*	*	*	*	*	*	*
9'-0"	8"-0" 8'-6" 9'-0"	* *	*	*	* *	* *	* * *	*	* *	*	* *
10"-0"	7"-0" 7'-6" 8"-0" 8'-6" 9'-0"	10.5 4.5 * *	8.5 2.5 * *	6.5	4.5	1.5	* * * * *	* * * *	* * * *	* * * * *	* * * * *
11'-0"	8'-0" 8'-6" 9'-0" 9'-6" 10'-0"	10.5 4.5 * * *	8.5 2.5 * * *	6.5	4.5 * * * *	1.5 * * * *	* * * * *	* * * * *	* * * *	* * * * * *	* * * * *
12'-0"	8'-0" 8'-6" 9'-0" 9'-6" 10'-0"	22.5 16.5 10.5 4.5 *	20.5 14.5 8.5 2.5 *	18.5 12.5 6.5 0.5	16.5 10.5 4.5 *	13.5 7.5 1.5 *	10.5 4.5 * *	7.5 1.5 * *	4.5 * * * *	1.5	* * * * * *

Ceiling Plenum Space

CLEAR DISTANCE - LIGHT TO BEAM IN INCHES												
		CLE	AK DIS	ANCE -	LIGHT	OBEAN	NI IN INC	TIES				
FLOOR	CLG.					BEAM	DEPTH					
TO FLOOR	HEIGHT	12"	14"	16"	18"	21"	24"	27"	30"	33"	36"	
13'-0"	8'-0" 8'-6" 9'-0" 9'-6" 10'-0"	34.5 28.5 22.5 16.5 10.5 4.5	32.5 26.5 20.5 14.5 8.5 2.5	30.5 24.5 18.5 12.5 6.5 0.5	28.5 22.5 16.5 10.5 4.5 *	25.5 19.5 13.5 7.5 1.5	22.5 16.5 10.5 4.5 *	19.5 13.5 7.5 1.5 *	16.5 10.5 4.5 * *	13.5 7.5 1.5 *	10.5 4.5 * * *	
14'-0"	8'-0" 8'-6" 9'-0" 9'-6" 10'-6" 11'-0" 11'-6"	46.5 40.5 34.5 28.5 22.5 16.5 10.5 4.5	44.5 38.5 32.5 26.5 20.5 14.5 8.5 2.5	42.5 36.5 30.5 24.5 18.5 12.5 6.5 0.5	40.5 34.5 28.5 22.5 16.5 10.5 4.5	37.5 31.5 25.5 19.5 13.5 7.5 1.5	34.5 28.5 22.5 16.5 10.5 4.5 *	31.5 25.5 19.5 13.5 7.5 1.5 *	28.5 22.5 16.5 10.5 4.5 *	25.5 19.5 13.5 7.5 1.5 *	22.5 16.5 10.5 4.5 * *	
15'-0"	8'-0" 8'-6" 9'-0" 9'-6" 10'-0" 10'-6" 11'-0" 11'-6" 12'-0"	58.5 52.5 46.5 40.5 34.5 28.5 22.5 16.5 10.5	56.5 50.5 44.5 38.5 32.5 26.5 20.5 14.5 8.5	54.5 48.5 42.5 36.5 30.5 24.5 18.5 12.5 6.5	52.5 46.5 40.5 34.5 28.5 22.5 16.5 10.5 4.5	49.5 43.5 37.5 31.5 25.5 19.5 13.5 7.5 1.5	46.5 40.5 34.5 28.5 22.5 16.5 10.5 4.5	43.5 37.5 31.5 25.5 19.5 13.5 7.5 1.5	40.5 34.5 28.5 22.5 16.5 10.5 4.5 *	37.5 31.5 25.5 19.5 13.5 7.5 1.5 *	34.5 28.5 22.5 16.5 10.5 4.5 *	
20'-0"	9'-0" 9'-6" 10'-0" 10'-6" 11'-0" 11'-6" 12'-0"	106 100 94.5 88.5 82.5 76.5 70.5	104 98.5 92.5 86.5 80.5 74.5 68.5	102 96.5 90.5 84.5 78.5 72.5 66.5	100 94.5 88.5 82.5 76.5 70.5 64.5	97.5 91.5 85.5 79.5 73.5 67.5 61.5	94.5 88.5 62.5 76.5 70.5 64.5 58.5	91.5 85.5 79.5 73.5 67.5 61.5 55.5	88.5 82.5 76.5 70.5 64.5 58.5 52.5	85.5 79.5 73.5 67.5 61.5 55.5 49.5	82.5 76.5 70.5 64.5 58.5 52.5 46.5	

Notes for Ceiling Plenum Space Tables:

- Assumptions: 2" fire proofing on beam, 6" fluorescent light depth, 5\" floor slab thickness, 2" suspended ceiling thickness.
- 2. For depth from beam to ceiling, add 4" to above figures.
- 3. For depth from underside of slab to light, add depth of beam plus 2".
- 4. * indicates beam protruding through ceiling.

Pipe Spacing on Racks

		MINIM	UM CEN	TERLINE	-TO-CEN	ITERLINI	E DIMEN	SIONS, IN	NCHES		
PIPE					I	PIPE SIZE					1
SIZE	1/2	3/4	1	1-1/4	1-1/2	2	2-1/2	3	4	5	6
1/2 3/4 1	7.5 8.0 8.0	8.0 8.5	 8.5					-	=		
1-1/4 1-1/2 2	8.5 8.5 9.0	8.5 8.5 9.0	8.5 9.0 9.5	9.0 9.0 9.5	9.0 9.5	10.0	111		=		
2-1/2 3 4	10.0 10.0 11.5	10.0 10.5 11.5	10.5 10.5 12.0	10.5 11.0 12.0	10.5 11.0 12.0	11.0 11.5 12.5	12.0 12.5 13.5	12.5 14.0	 15.0	==	
5 6 8	12.0 12.5 13.5	12.0 12.5 14.0	12.5 13.0 14.0	12.5 13.0 14.5	12.5 13.0 14.5	13.0 13.5 15.0	14.0 14.5 16.0	14.5 14.5 16.0	15.5 16.0 17.5	16.0 16.5 18.0	17.0 18.5
10	15.0	15.0	15.5	15.5	15.5	16.0	17.0	17.5	18.5	19.0	19.5
12	16.5	16.5	17.0	17.5	17.0	17.5	18.5	19.0	20.0	20.5	21.0
14	17.5	17.5	18.0	18.0	18.0	18.5	19.5	20.0	21.0	21.5	22.0
16	18.5	19.0	19.0	19.0	19.5	20.0	21.0	21.0	22.5	23.0	23.5
18	19.5	19.5	20.0	20.0	20.0	20.5	21.5	22.0	23.0	23.5	24.0
20	20.5	21.0	21.0	21.0	21.5	22.0	23.0	23.0	24.5	25.0	25.5
22	22.0	22.0	22.0	22.0	22.5	23.0	24.0	24.0	25.5	26.0	26.5
24	23.0	23.5	23.5	23.5	23.5	24.0	25.0	25.5	26.5	27.0	27.5
26	24.0	24.5	24.5	24.5	25.0	25.0	26.0	26.5	28.0	28.0	29.0
28	25.0	25.5	25.5	25.5	26.0	26.5	27.5	27.5	29.0	29.5	30.0
30	26.5	27.0	27.0	27.0	27.0	27.5	28.5	29.0	30.0	30.5	31.0
32	28.0	28.0	28.0	28.0	28.5	29.0	29.5	30.0	31.5	32.0	32.5
34	29.0	29.0	29.0	29.0	29.5	30.0	31.0	31.0	32.5	33.0	33.5
36	30.0	30.5	30.5	30.5	30.5	31.0	32.0	32.5	33.5	34.0	34.5
42	33.5	34.0	34.0	34.0	34.0	34.5	35.5	36.0	37.0	37.5	38.0
48	36.5	37.0	37.0	37.5	37.5	38.0	39.0	39.0	40.5	41.0	41.5
54	40.0	40.0	40.5	40.5	41.0	41.5	42.5	42.5	44.0	44.5	45.0
60	43.5	43.5	44.0	44.0	44.0	44.5	45.5	46.0	47.0	47.5	48.0
72	50.0	50.5	50.5	51.0	51.0	51.5	52.5	52.5	54.0	54.5	55.0
84	57.0	57.0	57.5	57.5	57.5	58.0	59.0	59.5	60.5	61.0	61.5
96	63.5	64.0	64.0	64.5	64.5	65.0	66.0	66.0	67.5	68.0	68.5

Notes for Pipe Spacing on Racks Tables:

- 1. Table based on Schedule 40 pipe and includes the outside dimensions for flanges, fittings, etc.; insulation over flanges, fittings, etc.; and space between fittings as follows:
 - a. Pipe sizes: 2" and smaller: 11/2" Insulation.
 - Pipe sizes: 2½" and larger: 2" Insulation. b. Space between two pipes 3" and smaller: 1".
 - c. Space between one pipe 3" and smaller and one pipe 4" and larger: 11/2".
 - d. Space between two pipes 4" and larger: 2".
- 2. For Schedule 80 and 160 pipe and 300 lb. fittings add the following:
 - a. Pipe sizes 4" and smaller: 1".
 - b. Pipe sizes 5" to 12": 11/2".
 - c. Pipe sizes 14" and larger: 2".
- 3. Tables do not include space for valve handles and stems, expansion joints, expansion loops, and pipe guides.

Pipe Spacing on Racks

MINIMUM CENTERLINE-TO-CENTERLINE DIMENSIONS, INCHES											
PIPE				1		PIPE SIZE	Ξ				
SIZE	8	10	12	14	16	18	20	22	24	26	28
1/2 3/4 1							=				
1-1/4 1-1/2 2			 	 						,	
2-1/2 3 4			 								
5 6 8	19.5										
10 12 14	21.0 22.5 23.5	22.0 23.5 24.5	25.0 26.0	 27.0							
16 18 20	24.5 25.5 26.5	26.0 26.5 28.0	27.5 28.0 29.5	28.5 29.0 30.5	30.0 30.5 31.5	31.0 32.5	33.5				
22 24 26	27.5 29.0 30.0	29.0 30.0 31.0	30.5 31.5 33.0	31.5 32.5 34.0	32.5 34.0 35.0	33.5 34.5 36.0	34.5 36.0 37.0	35.5 37.0 38.0	38.0 39.5	40.5	
28 30 32	31.0 32.5 34.0	32.5 33.5 35.0	34.0 35.0 36.5	35.0 36.0 37.4	36.0 37.5 39.0	37.0 38.0 39.5	38.0 39.5 41.0	39.0 40.5 42.0	40.5 41.5 43.0	41.5 42.5 44.0	42.5 44.0 45.5
34 36 42	35.0 36.0 39.5	36.0 37.0 40.5	37.5 38.5 42.0	38.5 39.5 41.0	40.0 41.0 44.5	40.5 41.5 45.0	42.0 43.0 46.5	43.0 44.0 47.5	44.0 45.0 48.5	45.0 46.5 50.0	46.5 47.5 51.0
48 54 60	42.5 46.0 49.5	44.0 47.5 50.5	45.5 49.0 52.0	46.5 50.0 53.0	47.5 51.0 54.5	48.5 52.0 55.0	49.5 53.0 56.5	51.0 54.0 57.5	52.0 55.5 58.5	53.0 56.5 60.0	54.0 57.5 61.0
72 84 96	56.0 63.0 69.5	57.5 64.0 71.0	59.0 65.5 72.5	60.0 66.5 73.5	61.0 68.0 74.5	62.0 68.5 75.5	63.0 70.0 76.5	64.5 71.0 78.0	65.5 72.0 79.0	66.5 73.5 80.0	67.5 74.5 81.0

Notes for Pipe Spacing on Racks Tables:

- 1. Table based on Schedule 40 pipe and includes the outside dimensions for flanges, fittings, etc.; insulation over flanges, fittings, etc.; and space between fittings as follows:
 - a. Pipe sizes: 2" and smaller: 11/2" Insulation. Pipe sizes: 2½" and larger: 2" Insulation.
 - b. Space between two pipes 3" and smaller: 1".
 - c. Space between one pipe 3" and smaller and one pipe 4" and larger: 11/2".
 - d. Space between two pipes 4" and larger: 2".
- 2. For Schedule 80 and 160 pipe and 300 lb. fittings add the following:
 - a. Pipe sizes 4" and smaller: 1".b. Pipe sizes 5" to 12": 1½".

 - c. Pipe sizes 14" and larger: 2".
- 3. Tables do not include space for valve handles and stems, expansion joints, expansion loops, and pipe guides.

Pipe Spacing on Racks

	MINIMUM CENTERLINE-TO-CENTERLINE DIMENSIONS, INCHES											
PIPE						PIPE SIZI	Е			W.		
SIZE	30	32	34	36	42	48	54	60	. 72	84	96	
1/2 3/4 1			=	=	=	=		=	=		=	
1-1/4 1-1/2 2					=			=	=			
2-1/2 3 4						-		==	=	=	=	
5 6 8										==		
10 12 14												
16 18 20												
22 24 26												
28 30 32	45.0 46.5	48.0										
34 36 42	47.5 48.5 52.0	49.0 50.0 53.5	50.0 51.0 54.5	52.0 55.5	 59.0							
48 54 60	55.5 58.5 62.0	57.0 60.0 63.5	58.0 61.0 64.5	59.0 62.5 65.5	62.5 66.0 69.0	65.5 69.0 72.5	72.5 76.0	 79.0				
72 84 96	69.0 75.4 82.5	70.5 77.0 84.0	71.5 78.0 85.0	72.5 79.0 86.0	76.0 82.5 89.5	79.0 86.0 92.5	82.5 89.5 96.0	86.0 92.5 99.5	92.5 99.5 106.0	106.0 113.0	 119.5	

Notes for Pipe Spacing on Racks Tables:

- 1. Table based on Schedule 40 pipe and includes the outside dimensions for flanges, fittings, etc.; insulation over flanges, fittings, etc.; and space between fittings as follows:
 - a. Pipe sizes: 2" and smaller: 11/4" Insulation. Pipe sizes: 21/2" and larger: 2" Insulation.
 - b. Space between two pipes 3" and smaller: 1".
 - c. Space between one pipe 3" and smaller and one pipe 4" and larger: 11/2".
 - d. Space between two pipes 4" and larger: 2".
- 2. For Schedule 80 and 160 pipe and 300 lb. fittings add the following:
 - a. Pipe sizes 4" and smaller: 1". b. Pipe sizes 5" to 12": 1½".

 - c. Pipe sizes 14" and larger: 2".
- 3. Tables do not include space for valve handles and stems, expansion joints, expansion loops, and pipe guides.

Appendix F: Miscellaneous

34.01 Airborne Contaminants

A. Particle Classifications:

1. Fine <2.5 microns
2. Course ≥2.5 microns
3. Respirable <10.0 microns
4. Nonrespirable ≥10.0 microns

2. Visible to the Naked Eye

B. Relative Sizes:

1. Micron = 1 millionth of a meter (0.000001 meter) = 39 millionths of an inch (0.000039 inch)

25 microns

Human Hair
 Dust
 Optical Microscope
 Scanning Electron Microscope
 Macro Particle Range
 Micro Particle Range
 Molecular Macro Range
 100 microns
 0.25 micron
 25 microns and larger
 1.0 to 25 microns
 0.085 to 1.0 micron

10. Molecular Range 0.002 to 0.085 micron 11. Ionic Range 0.002 microns and smaller

C. Airborne Particle Sizes are given in the following table:

PARTICLE	PARTICLE SIZE MICRONS	PARTICLE	PARTICLE SIZE MICRONS
PLANT			
POLLEN	10 - 100	TEA DUST	8 - 300
SPANISH MOSS POLLEN	150 - 750	GRAIN DUSTS	5 - 1000+
MOLD	3 - 12	SAW DUST	30 - 600
SPORES	3 - 40	CORN STARCH PUDDING MIX CAYENNE PEPPER	0.09 - 0.75
STARCHES	3 - 100		3 - 160
MILLED FLOUR	1 - 100		15 - 1000
MILLED CORN	1 - 100	SNUFF	3 - 30
MUSTARD	6 - 10	TEXTILE FIBERS	8 - 1000+
GINGER	25 - 40	CORN COBB CHAFF	30 - 100
COFFEE COFFEE ROAST SOOT	5 - 400	CARBON BLACK	0.2 - 10
	0.6 - 3.5	CHANNEL BLACK	0.2 - 100
ANIMAL			
BACTERIA	0.3 - 60	HUMAN HAIR	60 - 600
VIRUSES	0.005 - 0.1	HAIR	5 - 200
DUST MITES	100 - 300	RED BLOOD CELLS	5 - 10
SPIDER WEB	2.5	LIQUID DROPLETS,	0.5 - 5
DISINTEGRATED FECES	0.8 - 1.5	SNEEZED	
FECES	10 - 45	BONE DUST	3 - 350

PARTICLE	PARTICLE SIZE MICRONS	PARTICLE	PARTICLE SIZE MICRONS
COMBUSTION			
COMBUSTION TOBACCO SMOKE BURNING WOOD	0.01 - 0.1 0.01 - 4.5 0.2 - 3	SMOKE PARTICLES: NATURAL MATLS. SYNTHETIC MATLS.	0.01 - 0.1 1 - 50
ROSIN SMOKE COAL FLUE GAS OIL SMOKE	0.01 - 1 0.08 - 0.2 0.03 - 1	SMOLDERING COOKING OIL FLAMING COOKING OIL AUTO EMISSIONS	0.3 - 0.9 0.3 - 0.9 1 - 150
FLY ASH	0.9 - 1000		
MINERAL		<u> </u>	
ASBESTOS CEMENT DUST COAL DUST	0.7 - 90 3 - 100 1 - 100	CARBON DUST CARBON DUST- GRAPHITE FERTILIZER	0.25 - 5 0.02 - 2 10 - 1000
SEA SALT TEXTILES CLAY	0.035 - 0.5 6 - 20 0.1 - 50	GROUND LIMESTONE LEAD BROMINE	10 - 1000 0.1 - 0.7 0.1 - 0.7
CALCIUM, ZINC IRON LEAD DUST	0.7 - 20 4 - 20 2	GLASS WOOL FIBERGLASS INSULATION	1000 8 1 - 1000
TALC NH ₂ CL FUMES	0.5 - 50 0.1 - 3	METALLURGICAL DUST METALLURGICAL FUMES	0.1 - 1000 0.1 - 1000
OTHER			
ATMOSPHERIC DUST LUNG DAMAGING DUST MIST	0.001 - 40 0.6 - 7 70 - 350	YEAST CELLS SUGARS GELATIN	2 - 75 0.0008 - 0.005 5 - 90
OXYGEN CARBON DIOXIDE ATOMIC RADII	0.00050 0.00065 0.0001 - 0.001	BEACH SAND COPIER TONER FABRIC PROTECTOR	100 - 10,000 0.5 - 15 2.5 - 5
AIR FRESHENER HAIR SPRAY SPRAY PAINT	0.2 - 2 3 - 7 8 - 10	FACE POWDER LINT HUMIDIFIER	0.1 - 30 10 - 90 0.9 - 3
ANTIPERSPIRANT DUSTING AID PAINT PIGMENTS	6 - 10 6 - 15 0.1 - 5	ARTIFICIAL TEXTILE FIBERS INSECTICIDE DUSTS	10 - 30 0.5 - 10

D. Airborne Particulate Cleanliness Classes: FED-STD-209E-1992:

- 1. A Clean Zone is a defined space in which the concentration of airborne particles is controlled to meet a specified airborne particulate cleanliness class.
- 2. A Cleanroom is a room in which the concentration of airborne particles is controlled and which contains one or more clean zones:
 - a. As-built Cleanroom is a cleanroom complete and ready for operation, certifiable, with all services connected and functional, but without equipment or operating personnel in the facility.
 - b. At-rest Cleanroom is a cleanroom that is complete, with all services functioning and with equipment installed and operable or operating, as specified, but without operating personnel in the facility.

c. Operational Cleanroom is a cleanroom in normal operation, with all services functioning and with equipment and personnel, if applicable, present and performing their normal work functions in the facility.

						CLAS	SLIMITS				
CLAS	SS NAME	0.1 MI	CRON	0.2 MI	CRON	0.3 MI	CRON	0.5 MIC	5 MICRON		
		VOL		VOLUME UNITS			UME ITS	VOLUME	UNITS	VOL UN	
SI	ENGLISH	M³	FT³	M³	FT³	M³	FT³	M³	FT³	M³	FT³
M1		350	9.91	75.7	2.14	30.9	0.875	10.0	0.283	_	-
M1.5	1	1,240	35.0	265	7.50	106	3.00	35.3	1.00		_
M2		3,500	99.1	757	21.4	. 309	8.75	100	2.83	_	-
M2.5	10	12,400	350	2,650	75.0	1,060	30.0	353	10.0		-
МЗ		35,000	991	7,570	214	3,090	87.5	1,000	28.3	-	
M3.5	100	-	-	26,500	750	10,600	300	3,530	100		
M4			-	75,700	2,140	30,900	875	10,000	283		-
M4.5	1,000		-	-	-	-	-	35,300	1,000	247	7.00
M5		-	-	-	-	-		100,000	2,830	618	17.5
M5.5	10,000		-		-	-		353,000	10,000	2,470	70.0
M6		-	_	-	_	_		1,000,000	28,300	6,180	175
M6.5	100,000	-		_			-	3,530,000	100,000	24,700	700
М7	nože = 1	-	-	-	_		-	10,000,000	283,000	61,800	1,750

Cleanroom Design Criteria

CLEANROOM	3	FEDERAL		209E CLASSIF /METRIC	FICATIONS	
DESIGN CRITERIA	1	10	100	1,000	10,000	100,000
	M1.5	M2.5	M3.5	M4.5	M5.5	M6.5
CIRCULATION RATE AC/HR (8)	360 - 540	360 - 540	210 - 540	120 - 300	30 - 120	12 - 60
ROOM AIR VELOCITY FT./MIN.	60 - 90	60 - 90	35 - 90 (1)	20 - 50	5 - 20	2 - 10
% FILTER COVERAGE	100	100	50 - 100 (1)	25 - 60	10 - 40	5 - 20
ROOM CHARACTERISTICS	LAMINAR	LAMINAR	LAMINAR / NON- LAMINAR	NON- LAMINAR	NON- LAMINAR	NON- LAMINAR
UNIDIRECTIONAL FLOW	YES	YES	YES/NO	NO	NO	NO
PARALLELISM DEGREES (2)	10 - 35	10 - 35	10 - 35 N/A	N/A	N/A	N/A

Notes:

- 1. Velocity and filter coverage could be reduced possibly as low as 35 fpm and 50% coverage if parallelism requirements are relaxed by the client.
- 2. Parallelism requirements are often driven by a client's standard facility criteria.
- 3. Makeup Air: 1-6 CFM/SQ.FT.
- 4. Pressurization Requirement: 1/4-1/2 CFM/SQ.FT.
- 5. Temperature:
 - a. Range: 68–74°F.
 - b. Tolerance: $\pm 0.1-\pm 2.0^{\circ}F$.
 - c. Change Rate: 0.75-2.0°F./Hour
 - d. Example: $72^{\circ}F$, $\pm 2.0^{\circ}F$.
- 6. Relative Humidity:
 - a. Range: 30-50%RH
 - b. Tolerance: ±1.0-±5.0%RH

 Change Rate: 1.0-5.0%RH/Hour
 - c. Change Rate: 1.0–5.0%RH/Hour d. Example: 45% RH, ±5.0%RH
- 7. Fire Protection/Smoke Purge Exhaust: 3-5 CFM/SQ.FT.
- 8. Air change rate is based on 10'-0" ceiling height.

Areas and Circumferences of Circles

DIAMETER IN	ARE	EA	CIRCUMFER	ENCE
INCHES	SQUARE INCHES	SQUARE FEET	INCHES	FEET
0.5	0.20	0.0014	1.57	0.1309
0.75	0.44	0.0031	2.36	0.1963
1	0.79	0.0055	3.14	0.2618
1.25	1.23	0.0085	3.93	0.3272
1.5	1.77	0.0123	4.17	0.3927
2	3.14	0.0218	6.28	0.5236
2.5	4.91	0.0341	7.85	0.6545
3	7.07	0.0491	9.42	0.7854 0.9163
3.5	9.62	0.0668	11.00	0.9163
4	12.57	0.0873	12.57	1.0472
4.5	15.90	0.1104	14.14	1.1781
5.0	19.63	0.1364	15.71	1.3090
5.5	23.76	0.1650	17.28	1.4399
6	28.27	0.1963	18.85	1.5708
6.5	33.18	0.2304	20.42	1.7017
7	38.48	0.2673	21.99	1.8326
7.5	44.18	0.3068	23.56	1.9635
8	50.27	0.3491	25.13	2.0944
8.5	56.75	0.3941	26.70	2.2253
9	63.62	0.4418	28.27	2.3562
9.5	70.88	0.4922	29.85	2.4871
10	78.54	0.5454	31.42	2.6180
10.5	86.59	0.6013	32.99	2.7489
11	95.03	0.6600	34.56	2.8798
11.5	103.87	0.7213	36.13	3.0107
12	113.10	0.7854	37.70	3.1416
13	132.73	0.9218	40.84	3.4034
14	153.94	1.0690	43.98	3.6652
15	176.71	1.2272	47.12	3.9270
16	201.06	1.3963	50.27	4.1888
17	226.98	1.5763	53.41	4.4506
18	254.47	1.7671	56.55	4.7124
19	283.53	1.9689	59.69	4.9742
20	314.16	2.1817	62.83	5.2360
21	346.36	2.4053	65.97	5.4978
22	380.13	2.6398	69.12	5.7596
23	415.48	2.8852	72.26	6.0214
24	452.39	3.1416	75.40	6.2832
25	490.87	3.4088	78.54	6.5450
26	530.93	3.6870	81.68	6.8068
27	572.56	3.9761	84.82	7.0686
28	615.75	4.2761	87.96	7.3304

Areas and Circumferences of Circles

DIAMETER IN	ARI	EA	CIRCUMFE	RENCE
INCHES	SQUARE INCHES	SQUARE FEET	INCHES	FEET
29	660.52	4.5869	91.11	7.5922
30	706.86	4.9087	94.25	7.8540
31	754.77	5.2414	97.39	8.1158
32 33	804.25 855.30	5.5851 5.9396	100.53 103.67	8.3776 8.6394
33	907.92	6.3050	106.81	8.9012
35	962.11	6.6813	109.96	9.1630
36	1017.88	7.0686	113.10	9.4248
37	1075.21	7.4667	116.24	9.6866
38	1134.11	7.8758	119.38	9.9484
39	1194.59	8.2958	122.52	10.2102
40	1256.64	8.7266	125.66	10.4720
41	1320.25	9.1684	128.81	10.7338
42 43	1385.44 1452.20	9.6211 10.0847	131.95 135.09	10.9956 11.2574
43	1432.20	10.0847	133.09	11.25/4
44	1520.53	10.5592	138.23	11.5192
45	1590.43	11.0447	141.37	11.7810
46	1661.90	11.5410	144.51	12.0428
47	1734.94	12.0482	147.65	12.3046
48	1809.55	12.5663	150.80	12.5663
49	1885.74	13.0954	153.94	12.8282
50	1963.50	13.6354	157.08	13.0900
52	2123.72	14.7480	163.36	13.6136
54	2290.22	15.9043	169.65	14.1372
56	2463.01	17.1042	175.93	14.6608
58	2642.08	18.3478	182.21 188.50	15.1844 15.7080
60	2827.43	19.6350	188.50	15.7080
62	3019.07	20.9658	194.78	16.2316
64	3216.99	22.3402	201.06	16.7552
66	3421.19	23.7583	207.35	17.2788
68	3631.68	25.2200	213.63	17.8024
70	3848.45	26.7254	219.91	18.3260
72	4071.50	28.2743	226.19	18.8496
74	4300.84	29.8669	232.48	19.3732
76	4536.46	31.5032	238.76	19.8968
78	4778.36	33.1831	245.04	20.4204
80	5026.55	34.9066	251.33	20.9440
82	5281.02	36.6737	257.61	21.4675
84	5541.77	38.4845	263.89	21.9911
86	5808.80	40.3389	270.18	22.5147
88	6082.12	42.2370	276.46	23.0383
90	6361.73	44.1786	282.74	23.5619

Fraction-Decimal Equivalents

64 ^{THS}	32 ^{NDS}	16 ^{THS}	8 ^{THS}	4 ^{THS}	HALF	WHOLE	DECIMAL
1/64 2/64 3/64 4/64	1/32 - 2/32	- - - 1/16	- - - -	:	-		0.0156 0.0313 0.0469 0.0625
5/64 6/64 7/64 8/64	3/32 - 4/32	- - 2/16	1/8	:	:	-	0.0781 0.0938 0.1094 0.1250
9/64 10/64 11/64 12/64	5/32 - 6/32	3/16	-	:	:	:	0.1406 0.1563 0.1719 0.1875
13/64 14/64 15/64 16/64	7/32 - 8/32	- - - 4/16	- - - 2/8	- - - 1/4	-	:	0.2031 0.2188 0.2344 0.2500
17/64 18/64 19/64 20/64	9/32 - 10/32	- - - 5/16	-	:	:	:	0.2656 0.2813 0.2969 0.3125
21/64 22/64 23/64 24/64	11/32 - 12/32	- - - 6/16	3/8	, .	-	- - -	0.3281 0.3438 0.3594 0.3750
25/64 26/64 27/64 28/64	13/32 - 14/32	7/16	- - -	-	- - -	:	0.3906 0.4063 0.4219 0.4375
29/64 30/64 31/64 32/64	15/32 16/32	- - 8/16	- - - 4/8	- - 2/4	- - 1/2		0.4531 0.4688 0.4844 0.5000

Fraction-Decimal Equivalents

64 ^{THS}	32 ^{NDS}	16 ^{THS}	8 ^{THS}	4 ^{THS}	HALF	WHOLE	DECIMAL
33/64 34/64 35/64 36/64	17/32 - 18/32	- - - 9/16	- - -	-	-	-	0.5156 0.5312 0.5469 0.5625
37/64 38/64 39/64 40/64	19/32 - 20/32	- - 10/16	- - - 5/8		-		0.5781 0.5938 0.6094 0.6250
41/64 42/64 43/64 44/64	21/32	- - - 11/16	- - - -	-		- - - -	0.6406 0.6563 0.6719 0.6875
45/64 46/64 47/64 48/64	23/32 - 24/32	- - 12/16	- - - 6/8	3/4	- - -	:	0.7031 0.7188 0.7343 0.7500
49/64 50/64 51/64 52/64	25/32	- - - 13/16	- - -		-	-	0.7656 0.7813 0.7969 0.8125
53/64 54/64 55/64 56/64	27/32 - 28/32	- - - 14/16	- - - 7/8			:	0.8281 0.8438 0.8594 0.8750
57/64 58/64 59/64 60/64	29/32 - 30/32	15/16	- - -	-	-	-	0.8906 0.9063 0.9219 0.9375
61/64 62/64 63/64 64/64	31/32	- - 16/16	8/8	- - - 4/4	- - - 2/2	1	0.9531 0.9688 0.9844 1.0000

SUBSTANCE	FORMULA	MOLECULAR WEIGHT	PHASE	SPECIFIC VOLUME Cu.Ft./Lbm	DENSITY Lbm/Cu.Ft.	SPECIFIC GRAVITY
FUELS						
GASOLINE	_	113.0	LIQ.	0.0223	44.9	0.72
KEROSINE	-	154.0	LIQ.	0.0200	49.9	0.80
DIESEL FUEL (1-D)	_	170.0	LIQ.	0.0183	54.6	0.875
DIESEL FUEL (2-D)	-	184.0	LIQ.	0.0174	57.4	0.920
DIESEL FUEL (4-D)	-	198.0	LIQ.	0.0167	59.9	0.960
FUEL OIL No.1	-	_	LIQ.	0.0183	54.6	0.875
FUEL OIL No.2	_		LIQ.	0.0174	57.4	0.920
FUEL OIL No.4		198.0	LIQ.	0.0167	59.8	0.959
FUEL OIL No.5 Lt	_	_	LIQ.	0.0167	59.9	0.960
FUEL OIL No.5 Hv		-	LIQ.	0.0167	59.9	0.960
FUEL OIL No.6	_		LIQ.	0.0167	59.9	0.960
PARAFIN OR ALKANE SE	RIES					
METHANE (NAT.GAS)	CH,	16.041	GAS	24.0963	0.0415	0.553
ETHANE	C₂H₄	30.067	GAS	12.9032	0.0775	1.033
PROPANE	C₃H₄	44.092	GAS	8.7719	0.114	1.520
n-BUTANE	C ₄ H ₁₀	58.118	GAS	0.0276	36.14	481.9
ISOBUTANE	C ₄ H ₁₀	58.118	GAS	0.0288	34.77	463.6
n-PENTANE	C,H12	72.144	LIQ.	0.0256	39.08	0.626
ISOPENTANE	C3H12	72.144	LIQ.	0.0258	38.77	0.621
NEOPENTANE	C ₅ H ₁₂	72.144	GAS	0.0261	38.27	510.3
n-HEXANE	C ₆ H ₁₄	86.178	LIQ	0.0243	41.14	0.659
NEOHEXANE	C ₆ H ₁₄	86.178	LIQ.	0.0247	40.51	0.649
n-HEPTANE	C,H16	100.206	LIQ.	0.0239	41.70	0.668
TRIPTANE	C,H16	100.206	LIQ.	0.0232	43.07	0.690
n-OCTANE	C _s H ₁₈	114.223	LIQ.	0.0227	44.14	0.707
ISO-OCTANE	C _s H _{1s}	114.223	LIQ.	0.0228	43.82	0.702

SUBSTANCE	FORMULA	MOLECULA R WEIGHT	PHASE	SPECIFIC VOLUME Cu.Ft./Lbm	DENSITY Lbm/Cu.Ft.	SPECIFIC GRAVITY
OLEFIN OR ALKENE SER	IES					
ETHYLENE	C ₂ H ₄	28.054	GAS	13.6426	0.0733	0.977
PROPYLENE	C ₃ H ₆	42.081	GAS	7.5187	0.113	1.507
BUTYLENE	C ₄ H ₈	56.108	GAS	0.0269	37.12	494.9
ISOBUTENE	C ₄ H ₈	56.108	GAS	0.0272	36.83	491.1
n-PENTENE	C,H10	70.135	LIQ.	0.0250	40.02	0.641
AROMATIC SERIES						
BENZENE	C ₆ H ₆	78.114	LIQ.	0.0172	58.18	0.932
TOLULENE	C,H	92.141	LIQ.	0.0181	55.31	0.886
XYLENE	C _t H ₁₀	106.169	LIQ.	0.0186	53.75	0.861
OTHER HYDROCARBON	S					
ACETYLENE	C ₂ H ₂	26.038	GAS	14.8148	0.0675	0.900
NAPHTHALENE	C ₁₀ H ₈	128.175	SOLID	-	71.48	-
METHYL ALCOHOL	СН,ОН	32.041	LIQ.	0.0204	49.10	0.789
EHTYL ALCOHOL	C ₂ H ₅ OH	46.067	LIQ.	0.0204	49.01	0.787
MOTOR OILS						
5W		_	LIQ.	0.0176	54.9-58.7	0.88-0.94
10W		-	LIQ.	0.0176	54.9-58.7	0.88-0.94
20W		_	LIQ.	0.0176	54.9-58.7	0.88-0.94
30W		-	LIQ.	0.0176	54.9-58.7	0.88-0.94
40W	-	-	LIQ.	0.0176	54.9-58.7	0.88-0.94
50W		- 7	LIQ.	0.0176	54.9-58.7	0.88-0.94
GEAR OILS						
75W		-	LIQ.	0.0176	54.9-58.7	0.88-0.94
80W		-	LIQ.	0.0176	54.9-58.7	0.88-0.94
85W			LIQ.	0.0176	54.9-58.7	0.88-0.94
90		_	LIQ.	0.0176	54.9-58.7	0.88-0.94
120		_	LIQ.	0.0176	54.9-58.7	0.88-0.94
140			LIQ.	0.0176	54.9-58.7	0.88-0.94
150			LIQ.	0.0176	54.9-58.7	0.88-0.94

SUBSTANCE	BOILING PT. F.	IGNITION TEMP. F.	FLASH POINT	FLAMMABILITY LIMITS (IN AIR) % BY VOLUME
FUELS				
GASOLINE	100 - 400	536	-45	1.4 - 7.6
KEROSINE	304 - 574	410	100 - 162	0.7 - 5.0
DIESEL FUEL (1-D)	-	_	100	-
DIESEL FUEL (2-D)	-	-	125	-
DIESEL FUEL (4-D)	_	-	130	-
FUEL OILS No.1	304 - 574	410	100 - 162	0.7 - 5.0
FUEL OILS No.2		494	126 - 204	-
FUEL OILS No.4	_	505	142 - 240	-
FUEL OILS No.5 Lt	-	-	156 - 336	-
FUEL OILS No.5 Hv	_	-	160 - 250	
FUEL OILS No.6	-		150	
PARAFIN OR ALKANE SER	IES		9 9	
METHANE (NAT.GAS)	-258.7	900 - 1170	GAS	5.0 - 15.0
ETHANE	-127.5	959	GAS	3.0 - 12.5
PROPANE	-43.8	842	GAS	2.1 - 10.1
n-BUTANE	31.1	761	-76	1.86 - 8.41
ISOBUTANE	10.9	864	-117	1.80 - 8.44
n-PENTANE	97.0	500	<-40	1.40 - 7.80
ISOPENTANE	82.2	788	<-60	1.32 - 9.16
NEOPENTANE	49.1	842	GAS	1.38 - 7.22
n-HEXANE	155.7	437	-7	1.25 - 7.0
NEOHEXANE	121.5	797	-54	1.19 - 7.58
n-HEPTANE	209.1	419	25	1.00 - 6.00
TRIPTANE	177.6	849		1.08 - 6.69
n-OCTANE	258.3	428	56	0.95 - 3.20
ISO-OCTANE	243.9	837	10	0.79 - 5.94

SUBSTANCE	BOILING	IGNITION	FLASH	FLAMMABILITY LIMITS
SUBSTANCE	PT. F.	TEMP. F.	POINT	(IN AIR) % BY VOLUME
OLEFIN OR ALKENE SERIE	ES	The state of the s		
ETHYLENE	-154.7	914	GAS	2.75 - 28.6
PROPYLENE	-53.9	856	GAS	2.00 - 11.1
BUTYLENE	21.2	829	GAS	1.98 - 9.65
n-BUTENE			_	_
ISOBUTENE	19.6	869	GAS	1.8 - 9.0
n-PENTENE	86.0	569	_	1.65 - 7.70
AROMATIC SERIES				
BENZENE	176.2	1040	12	1.35 - 6.65
TOLULENE	321.1	992	40	1.27 - 6.75
XYLENE	281.1	867	63	1.00 - 6.00
OTHER HYDROCARBONS				
ACETYLENE	-119.2	581	GAS	2.50 - 100
NAPHTHALENE	424.4	959	174	0.90 - 5.90
METHYL ALCOHOL	151	725	_	6.7 - 36.0
EHTYL ALCOHOL	172	689		3.3 - 19.0
MOTOR OILS				(a)
5W		_	420	
10W	_	_	425	-
20W	-		465	
30W	_		450	-
40W	-	_	475	-
50W		_	485	
GEAR OILS				
75W	-	_	375	
80W	-	_	425	
85W		_	435	
90	-		425	
120			425	
140	-		580	
150			580	

Velocity of Sound in Various Media

) (EDIII) (VELC	OCITY
MEDIUM	FEET PER SECOND	MILES PER HOUR
RUBBER	310	211
AIR	1,130	770
WATER VAPOR	1,328	905
CORK	1,640	1,118
LEAD	4,026	2,745
WATER	4,625	3,153
WOOD	10,825	7,380
BRASS	11,480	7,827
COPPER	11,670	7,957
BRICK	11,800	8,045
CONCRETE	12,100	8,250
WOOD	12,500	8,523
STEEL & IRON	16,000	10,909
GLASS	16,400	11,181
ALUMINUM	19,000	12,955

Voice Level Comparison at Various Distances

DISTANCE FEET	NORMAL VOICE LEVEL dB	RAISED VOICE LEVEL dB	VERY LOUD VOICE dB	SHOUTING VOICE dB
1	70	76	82	88
3	60	66	72	78
6	54	60	66	72
12	48	54	60	66
24	42	48	54	60

Directional Effect on Sound

DIRECTION OF SOUND SOURCE WITH RESPECT TO LISTENER	DECREASE IN SPEACH ENERGY
FACE TO FACE	0 dB
30 DEGREE ROTATION AWAY	1.5
60 DEGREE ROTATION AWAY	3.0
90 DEGREE ROTATION AWAY	4.5
120 DEGREE ROTATION AWAY	6.0
150 DEGREE ROTATION AWAY	7.5
180 DEGREE ROTATION AWAY SOURCE TURNED AWAY FROM LISTENER	9.0

Typical Sound Levels

PRESSURE LEVEL dB	TYPICAL SOUND	SUBJECTIVE IMPRESSION
150	Jet Plane Take-off	Short exposure can cause hearing loss
140	Military Jet Takeoff at 100 Ft.	Short exposure can cause hearing loss.
130	Artillery Fire at 10 Ft. Machine Gun	
120	Siren at 100 Feet Jet Plane (Passenger Ramp) Thunder Sonic Boom	Deafening (Threshold of Pain)
110	Wood Working Shop Accelerating Motorcycle Hard Rock Band 75 Piece Orchestra	Threshold of Discomfort
100	Subway (Steel Wheels) Propeller Plane, Outboard Motor Loud Street Noise Power Lawn Mower	
90	Truck Unmuffled Train Whistle Kitchen Blender Pneumatic Jackhammer Shouting at 5 Feet	Very Loud
80	Printing Press Subway (Rubber Wheels) Noisy Office Computer Printout Room Average Factory	Loud Intolerable for Phone Use
70	Average Street Noise Quiet Typewriter Freight Train at 100 Feet Average Radio Speech at 3 Feet	Loud
60	Noisy Home Average Office Normal Conversation at 3 Ft.	Loud Unusual Background
50	General Office Quiet Office Quiet Radio, Window AC Unit Average Home Quiet Street	Moderate
40	Private Office Quiet Home/Residential Area	Moderate
30	Quiet Conversation Broadcast Studio	Noticeably Quiet
20	Empty Auditorium Whisper Watch Ticking Buzzing Inset at 3 Ft. Rural Ambient	Very Quiet
10	Rustling Leaves Soundproof Room	Very Faint Threshod of Good Hearing
0	Human Breathing	Intolerbly Quiet Threshold of Audibility (Youthful Hearing)

Typical Noise Levels

EQUIPMENT	dBA
Saturn Rocket	200
Turbo Jet Engine	170
Jet Plane/Aircraft at Take-off, Inside Jet Engine Test Cell	150
Turbo Popeller Plane at Takeoff, Military Jet Takeoff at 100 Ft.	140
Large Pipe Organ, Artillery Fire at 10 Ft., Machine Gun	130
Jolt Squeeze Hammer	122
Small Aircraft Engine, Siren at 100 Feet, Jet Plane (Passenger Ramp), Thunder, Sonic Boom, Threshold of Feeling (Pain)	120
Blaring Radio, Wood Working Shop, Accelerating Motorcycle, Hard Rock Band, 75 Piece Orchestra, Chain Saw	110
Vacuum Pump, Large Air Compressor	108
Positive Displacement Blower, Air Hammer	107
Magnetic Drill Press, Air Chisel, High Pressure Gas Leak	106
Banging of Steel Plate, Wood Planer	104
Air Compressor, Automobile at Highway Speed, Subway (Steel Wheels), Propeller Plane, Outboard Motor, Loud Street Noise, Power Lawn Mower, Helicopter	100
Turbine Condenser, Welder, Punch Press, Riveter, Power Saws, Plastic Chipper	98
Small Air Compressor, Airplane Cabin Normal Flight	94
Heavy Duty Grinder	93
Heavy Diesel Powered Vehicle, Spinning Machines - Looms, Noisy Street	92
Voice, Shouting, Truck Unmuffled, Train Whistle, Kitchen Blender, Pneumatic Jackhammer, Shouting at 5 Feet, Noisy Factory, Blender	90
Printing Press, Inside Average Rail Road Car, Toilet Flushing	86
Garbage Disposal, Printing Press, Subway (Rubber Wheels), Noisy Office, Computer Printout Room, Average Factory, Lathe, Police Whistle, Telephone Ring, Clothes Washer, Dish Washer, TV - Loud	80
Voice - Conversational Level, Average Street Noise, Quiet Typewriter, Freight Train at 100 Feet, Average Radio, Speech at 3 Feet, Inside Average Automobile, Clothes Dryer, Vacuum Cleaner, TV - Soft	70
Electronic Equipment Ventilation Fan, Noisy Home, Average Office, Normal Conversation at 3 Ft., Hair Dryer	60
Office Air Diffuser, General Office, Quiet Office, Quiet Radio, Window AC Unit, Average Home, Quiet Street	50
Small Electric Clock, Private Office, Quiet Home/Residential Area, Refrigerator, Bird Singing, Wilderness Ambient, Agricultural Land	40
Voice, Soft Whisper, Quiet Conversation, Broadcast Studio	30
Rustling Leaves, Empty Auditorium, Whisper, Watch Ticking, Buzzing Inset at 3 Ft., Rural Ambient	20
Human Breath, Sound Proof Room, Rustling Leaves	10
Threshold of Hearing	0

Subjective Effect of Changes in Sound Characteristics

CHANGE IN SOUND PRESSURE LEVEL	CHANGE IN APPARENT LOUDNESS	
1 dB	Insignificant	
3 dB	Just Perceptible	
5 dB	Clearly Noticeable	
10 dB	Twice or Half as Loud	
15 dB	Significant Change	
20 dB	Much Louder or Quieter	

Decibel Addition

DIFFERENCE BETWEEN TWO LEVELS dB	ADD TO HIGHER LEVEL dB	
0	3	
1	2.5	
2	2	
3	2	
4	1.5	
5	1	
6	1	
7	1	
8	0.5	
9	0.5	
10	0.5	
More than 10	0	

Acceptable HVAC Noise Levels

SPACE TYPE	RECOMMENDED NC LEVEL	RECOMMENDED RC LEVEL	EQUIVALENT SOUND LEVEL METER READINGS (A SCALE) dB
Apartments	NC 25-35	RC 25-35	35-45
Assembly Halls	NC 25-30	RC 25-30	35-40
Churches	NC 30-35	RC 30-35	40-45
Concert and Recital Halls	NC 15-20	RC 15-20	25-30
Courtrooms	NC 30-40.	RC 30-40	40-50
Factories	NC 40-65	RC 40-65	50-75
Hospitals and Clinics Private Rooms Wards Operating Rooms Laboratories Corridors Public Areas	NC 25-30 NC 30-35 NC 25-30 NC 35-40 NC 30-35 NC 35-40	RC 25-30 RC 30-35 RC 25-30 RC 35-40 RC 30-35 RC 35-40	35-40 40-45 35-40 45-50 40-45 45-50
Hotels/Motels Individual Rooms/Suites Meeting/Banquet Rooms Halls,Corridors,Lobbies Service/Support Areas	NC 25-35 NC 25-35 NC 35-40 NC 40-45	RC 25-35 RC 25-35 RC 35-40 RC 40-45	35-45 35-45 45-50 50-55
Ligitimate Theaters	NC 20-25	RC 20-25	30-35
Libraries	NC 30-40	RC 30-40	40-50
Music Rooms	NC 20-25	RC 20-25	30-35
Movie/Motion Picture Theaters	NC 30-35	RC 30-35	40-45
Offices Executive Conference Rooms Private Open-Plan Offices/Areas Business Mach/Computers Public Circulation	NC 25-30 NC 25-30 NC 30-35 NC 35-40 NC 40-45 NC 40-45	RC 25-30 RC 25-30 RC 30-35 RC 35-40 RC 40-45 RC 40-45	35-40 35-40 40-45 45-50 50-55 50-55
Private Residences	NC 25-35	. RC 25-35	35-45
Recording Studios	NC 15-20	RC 15-20	25-30
Restaurants	NC 40-45	RC 40-45	50-55
Retail Stores	NC 40-45	RC 40-45	50-55
Schools Lecture and Classrooms Open-Plan Classrooms	NC 25-30 NC 35-40	RC 25-30 RC 35-40	35-40 45-50
Sports Coliseums	NC 45-55	RC 45-55	55-65
TV/Broadcast Studios	NC 15-25	RC 15-25	25-35

U.S. Postal Service Abbreviations

UNITED STATE	S POSTAL SERV	TCE STANDARD ABBREVIAT	TIONS
STATE	ABBREV.	STATE	ABBREV.
ALABAMA	AL	MONTANA	MT
ALASKA	AK	NEBRASKA	NE
ARIZONA	AZ	NEVADA	NV
ARKANSAS	AR	NEW HAMPSHIRE	NH
CALIFORNIA	CA	NEW JERSEY	NJ
COLORADO	СО	NEW MEXICO	NM
CONNECTICUT	СТ	NEW YORK	NY
DELAWARE	DE	NORTH CAROLINA	NC
DISTRICT OF COLUMBIA	DC	NORTH DAKOTA	ND
FLORIDA	FL	ОНІО	ОН
GEORGIA	GA	OKLAHOMA	OK
HAWAII	НІ	OREGON	OR
IDAHO	ID	PENNSYLVANIA	PA
ILLINOIS	IL	PUERTO RICO	PR
INDIANA	IN	RHODE ISLAND	RI
IOWA	IA	SOUTH CAROLINA	SC
KANSAS	KS	SOUTH DAKOTA	SD
KENTUCKY	KY	TENNESSEE	TN
LOUISIANA	LA	TEXAS	TX
MAINE	ME	UTAH	UT
MARYLAND	MD	VERMONT	VT
MASSACHUSETTS	MA	VIRGINIA	VA
MICHIGAN	МІ	WASHINGTON	WA
MINNESOTA	MN	WEST VIRGINIA	wv
MISSISSIPPI	MS	WISCONSIN	WI
MISSOURI	МО	WYOMING	WY

Appendix G: Designer's Checklist

35.01 Boilers, Chillers, Cooling Towers, Heat Exchangers, and Other Central Plant Equipment

- A. Have Owner redundancy requirements been met? Has future equipment space been clearly indicated on the drawings? Has move-in route and replacement access been determined?
- B. Have multiple pieces of central plant equipment been provided to prevent system shutdown in the event of equipment failure? Has low load been evaluated and is equipment selected capable of operating at this low load condition?
- C. Has proper service access been provided? Has tube pull or clean space been provided?
- D. Have final loads been calculated and final equipment selection been made? Has equipment been specified and capacity scheduled?
- E. Has chemical treatment of hydronic and steam systems been properly addressed? Have flushing and passivation of hydronic and steam systems been adequately covered, in particular waste treatment handling of spent flushing water and chemicals?
- F. Does central plant equipment need to be on emergency power?
- G. When multiple pieces of equipment are headered together, have adequate provisions for expansion and contraction been provided, especially boiler systems? Recommendation: Multiple boiler connections to header, from boiler nozzles to header main, should be U-shaped (first traveling away from header, then traveling parallel to header, and finally traveling back toward header) to accommodate expansion and contraction of piping to prevent excess stress on the boiler nozzles.
- H. When specifying boiler control and oxygen trim systems, chillers with remote starters and remote control panels, cooling tower basin heaters, and other electrical or control systems associated with central plant equipment, has field wiring required for these systems been coordinated with the electrical and I&C engineers? This includes panel installation, interconnecting power and control wiring, instrument air, and mounting of devices.
- I. Have starter, disconnect switch, adjustable frequency drive, and/or motor control center space been coordinated and/or located?
- J. When specifying dual fuel boilers, does the Owner want a dual fuel pilot (natural gas and fuel oil) or is a tee connection preferred for connection to portable propane bottle?

35.02 Air Handling Equipment-Makeup, Recirculation, and General Air Handling Equipment

- A. Have Owner redundancy requirements been met? Has future equipment space been clearly indicated on the drawings? Has move-in route and replacement access been determined?
- B. Have multiple pieces of air handling equipment been provided to prevent system shutdown in the event of equipment failure?

- C. Has adequate coil pull space and service space been provided? Recommendation: The service access space should be a minimum of the unit width plus 2 feet on at least one side and a minimum of 2 feet on the other side.
- D. Have unit components and capacities been properly specified, detailed, and scheduled-coils, filters, fans, motors, humidifiers, outside air and return air dampers, smoke detectors, smoke dampers, access section, service vestibules, access doors, interior lighting (incandescent, fluorescent), etc? Have coil and filter air pressure drops been scheduled? Have coil water pressure drops been scheduled?
- E. Have outside air and return air been mixed prior to entering any air handling unit filters or coils?
- F. Has proper length downstream of humidifiers been provided to absorb humidification vapor trail? The first air handling unit section downstream of the humidifier should be stainless steel, including coil frames, especially with DI, RO, or UPW water.
- G. Have cooling coils been locked out during the air handling unit preheat and humidification operation?
- H. Has piping in service vestibules been checked for adequate space? Recommendation: A minimum of 6'-0" wide and minimum of 9'-0" high clearance should be maintained to allow for pipe installation for full length of unit.
- I. Are access doors of adequate size to remove fans, motors, filters, dampers, actuators, inlet guide vanes or other variable flow device, and other devices requiring service and/or replacement?
- J. Do all air handling unit preheat coils with a design mixed air temperature below 40°F, have preheat pumps? To reduce the risk of freezing, preheat pumps are recommended for all preheat coils with a design mixed air temperature below 40°F.
- K. Have coil selections been made so that low water flows, in direct response to low loads, do not fall into laminar flow region?
- L. Have air conditioning condensate drains been piped to appropriate drainage system? Have drains been provided for storm water and sanitary?
- M. Have receptacles been provided for roof mounted equipment in accordance with the NEC?
- N. Have starter, disconnect switch, adjustable frequency drive, and/or motor control center space been coordinated and/or located?
- O. Does air handling equipment need to be on emergency power?

35.03 Piping Systems-General

- A. Expansion Tank: Has size, location, adequate space, support, makeup water pressure and makeup water location with been coordinated with Plumbing Engineer?
- B. Are there provisions for piping expansion and contraction, anchors, guides, loops vs. joints? Have anchor locations and forces been coordinated with Structural Engi-

- neer? Locate anchors at steel beams and avoid joists if possible. Is piping coordinated with building expansion joints?
- C. Do the drawings clearly indicate where ASME code piping and valves are required at the boilers in accordance with ASME Code requirements for high temperature (over 250°F.) and high pressure boilers (over 15 psig)?
- D. Does the boiler layout and design have enough expansion and flexibility in the boiler connection piping to prevent overstressing the boiler nozzle? It is best to use U-shaped layout to header.
- E. Have flexible connections been clearly shown on the drawings and have they been properly detailed? Have the appropriate flexible connections been specified for the application?
- F. Is there structural support for large water risers?
- G. Are there drains and air vents on water systems and adequate space for service?
- H. Are balancing valves required on parallel piping loops?
- I. Is adequate space available for pitching of pipes?
- J. Is there space for coil and tube removal or cleaning (i.e., AHUs, Chillers, Boilers, etc.) and is it clearly shown on the drawings where it is required?
- K. Is coil piped for counterflow or parallel flow as indicated by detail (parallel flow for preheat coils only; all others counter flow)?
- L. Condensate drains from room terminals with chilled, dual temperature water and packaged cooling units: Do local authorities require condensate drains to be piped to sanitary or to storm? Can condensate drains be discharged onto roof? onto grade?
- M. Are relief valve settings noted on drawings or schedules?
- N. Is there adequate straight pipe up- and downstream of flow meter orifices?
- O. Have all required equipment valves not covered by standard details been indicated? Avoid duplications.
- P. Do not run horizontal piping in solid masonry walls or in narrow stud partitions.
- Q. Has all piping been eliminated from electrical switchgear, transformer, motor control center, and emergency generator rooms? If not, have drain troughs or enclosures been provided?
- R. Are shutoff valves provided at base of all risers?
- S. Are all systems compatible with flow requirements established by control diagrams?
- T. Is cathodic protection required for buried piping?
- U. Has required heat tracing been included, coordinated, and insulated?
- V. Will large mains or risers transmit noise to occupied spaces? Are isolators required in supply and return at pump?

- W. Is present and future duty for pumps, boilers, chillers, cooling towers, heat exchangers, terminal units, coils, AHUs, etc. specified? Scheduled?
- X. Are air conditioning and steam condensate (when wasted) piped to storm water or sanitary? Is steam condensate cooled?

35.04 Steam and Condensate Piping

- A. See Piping Systems-General for additional requirements.
- B. Are end of main drips shown, detailed, and specified?
- C. Will condensate drain? Are pipes oversized for opposing flow?
- D. Will humidifier arms add excessive sensible heat to air stream (likely on small flat ducts and some AHUs)? Insulate where needed. Provide motor operated shutoff valve if steam is live during mechanical cooling season.
- E. Are riser drips shown, detailed, and specified?
- F. Flash tank for medium and high pressure condensate. Vent flash tanks either to low pressure steam or outdoors.
- G. Are relief valves piped to outside? Have they been sized?
- H. Has steam consumption for humidification been considered in establishing water makeup quantity for boiler?
- I. Has adequate space been allowed for pressure reducing stations? Have standard details been edited?
- J. Are water sampling connections provided?
- K. Are steam injectors piped to floor drains?
- L. Avoid cross-connections between gravity condensate returns and pumped condensate return lines.
- M. Is there adequate height between condensate receiver and/or feedwater heater and pump to prevent flashing at pump, particularly with condensate above 200°F.?
- N. Has bypass around boiler feedwater heater been provided for maintenance?
- O. Are there drip runouts to equipment such as sterilizers and glassware washers?
- P. Are end of main drips piped?
- Q. Are condensate return systems compatible?
- R. Have noise suppressors been provided on reduced pressure side of PRVs? Will radiated noise be a problem? Are there adequate numbers of stages of pressure reduction for quiet operation and an adequate number of valves for capacity control?
- S. Are steam and/or condensate flow meters and recorders required?
- T. Is there adequate access to components requiring service on boilers? Is catwalk required?

- U. Are boilers piped in accordance with ASME code? Is there nonreturn plus shutoff valve on HP boiler?
- V. Is condensate tank vented to outside?
- W. Are chemicals used in treatment system suitable for humidification? Are chemical feed systems shown, detailed, and specified?
- X. Is feedwater heater required or is deaerator required?
- Y. Are water softeners required on makeup? Are they shown, detailed, and specified?
- Z. Are bottom blowdown and continuous blowdown shown, detailed, and specified?
- AA. Avoid lifting steam condensate, if possible.
- BB. Are proper traps being used? Have they been specified and scheduled?
- CC. Are air conditioning and steam condensate (when wasted) piped to storm water or to sanitary? Is steam condensate cooled?

35.05 Low Temperature Hot Water and Dual Temperature Systems

- A. See Piping Systems-General for additional requirements.
- B. Are balancing valves indicated? Are flow measuring stations needed and indicated?
- C. Is pressure regulation needed?
- D. Is a bypass filter required? Is GPM included in pump capacity?
- E. Is standby pump needed?
- F. Converter support: Are details needed? Is elevation indicated?
- G. Are service valves shown?
- H. Will branch piping and ducts fit in allotted space or enclosure?
- I. Are riser shutoff valves shown?
- J. Are riser drains and vents shown?
- K. Is there adequate space for installation and use of riser valves?
- L. Will minimum allowable circulation be maintained through hot water boiler?
- M. Is distribution system reverse return? If not, will balancing problems result?

35.06 Chilled Water and Condenser Water Systems

- A. See Piping Systems-General for additional requirements.
- B. Are balancing valves indicated? Are flow measuring stations needed? Have they been indicated?

- C. Is pressure regulation needed?
- D. Is bypass filter required? Is GPM included in pump capacity?
- E. Is standby pump needed?
- F. Are service valves shown?
- G. Will branch piping and ducts fit in allotted space or enclosure?
- H. Are riser shutoff valves shown?
- I. Are riser drains and vents shown?
- J. Is there adequate space for installation and use of riser valves?
- K. Will minimum allowable circulation be maintained through chiller?
- L. Is distribution system reverse return? If not, will balancing problems result?
- M. Condenser water piping: Loop traps to avoid excessive drainage, submerged impeller. Has available NPSH been calculated? Is NPSH indicated in pump schedule?
- N. For cooling tower makeup, overflow, and drain splash blocks, are there balancing valves in branch lines to tower cells? Coordinate makeup with Plumbing Engineer.

35.07 Air Systems

- A. Are adequate balancing dampers provided to prevent noise at outlets due to excessive pressure, or to avoid complicated balancing procedures on extensive low pressure systems or exhaust systems (i.e., each zone of a multizone system; to limit flow variation due to stack effect in vertical low pressure and exhaust systems)?
- B. Are fire damper locations, type, and flow restrictions indicated? Is there adequate height for damper recess pocket at shaft wall? Is breakaway ductwork at fire damper wall sleeve detailed or specified?
- C. Are smoke damper locations, type, and flow restrictions indicated? Is there adequate height for damper at shaft wall? Is breakaway ductwork at smoke damper wall sleeve detailed or specified? Is smoke damper operator located on supported duct and not on breakaway duct?
- D. Are access doors at fire dampers, smoke dampers, turning vanes, humidifiers, coils, etc., properly specified and included in general notes?
- E. Are proper relief air provisions provided?
- F. Is return air fan needed? Is outside air fan needed?
- G. Are condensate drains provided? Are outside air intake drains provided?
- H. Are flexible connections shown and specified?
- I. Is sound lining required? Is it properly located and specified?

- J. Will duct arrangement permit transfer of excessive noise between offices, toilet rooms and rooms of a different function?
- K. Are there objectionable fan noise from intakes or exhaust points to nearby buildings?
- L. Are outlets located in supply mains? Are there noisy conditions?
- M. Do trunk ducts pass above quiet rooms? Will noise be a problem?
- N. Have fan class, bearing arrangement, motor location, etc., been shown, scheduled, or specified?
- O. Are air intakes on party walls?
- P. Will outlets blow at lights, beams, sprinkler heads, smoke detectors? Sprinkler head and smoke detector locations must meet code requirements. Locate in accordance with code.
- Q. Have outlet and return grille elevations been coordinated with architect and indicated?
- R. Adjust outlet air quantities for duct heat gain and duct leakage.
- S. Are isotope and chemical exhaust ducts accessible?
- T. Is there interference between sill grille discharge and drapes or blinds? Beware of annoying movement of vertical blinds or light drapes caused by sill air discharge nearby.
- U. Are present and future duty for air terminal units, AHUs, fans, etc., specified and scheduled?
- V. Is exhaust or relief discharge or plumbing stack effluent near intakes. Maintain a minimum of 10 feet clear.
- W. Is there anti-stratification provision at intakes, large mixing box outlets, downstream of steam coils or water coils? Are air blenders indicated on all AHUs?
- X. Are there aluminum grilles on shower, sterilizer, etc., exhaust? Is stainless steel ductwork or aluminum ductwork required? Is it clearly indicated on drawings as to extent? Has it been specified?
- Y. Are there sealing and sloping of shower, cage washer, etc., exhaust ducts? When more than one type of duct material is used, is extent and location clearly defined?
- Z. Has adequate relief from rooms been provided? Are there door louvers, undercut doors, transfer grilles and direct exhaust? Have they been coordinated?
- AA. Will door louvers defeat needed acoustical privacy (i.e., conference rooms, private offices, VP office)? Will door louvers defeat needed door fire rating? Are door louvers located in accordance with code?
- BB. Are the types of branch takeoffs and duct splits shown? Are details included on drawings?

- CC. Are there intermediate drip pans on cooling coil banks? Are they piped to floor drain? Include detail.
- DD. Are there drains for kitchen exhaust duct risers?
- EE. Is there excessive duct heat gain from nearby steam pipes and other heat sources?
- FF. Are there combustion air intakes for boilers, water heaters, etc. Are vents, stacks, breeching, and chimneys shown, specified, and detailed? Are termination heights clearly indicated?
- GG. Locate exhaust grilles near floor in operating rooms, flammable storage rooms, chlorine storage rooms, battery rooms (high and low), etc.
- HH. Do not use corridors as return air plenums in hospitals, nursing homes, offices, and other facilities.
- II. Have insulated louver blank-off panels or sheets been included where required?
- JJ. Are filters provided in makeup air to elevator equipment rooms? Are filters provided for air cooled condensers and condensing units located indoors?
- KK. Are there motor operated dampers in wall louvers? Do not use operable louvers. Use stationary louvers with motor operated dampers behind when required.
- LL. Are casings adequately described as prefabricated or field fabricated? Is extent of sound paneling clear? Has adequate pressure rating been specified?
- MM. Has Architect provided adequate framing for linear diffuser in metal lath and plaster or dry wall bulkheads? Do not dimension diffuser lengths for wall to wall installations—note dimension as "wall to wall."
- NN. Have fan systems been checked for excessive sound transmission?
- OO. Is there adequate space for servicing fans, motors, belts etc.
- PP. Has sufficient space been provided between coils of AHUs to accommodate thermostats?
- QQ. Are adequate service space or equipment size access panels noted on drawings to equipment installed above ceilings? Coordinate with Architect who furnishes, installs, provides.
- RR. Are there adequate straight duct branch length or straightening vanes between main duct and diffuser?
- SS. Do ducts pierce partitions at 90 degree angle wherever possible?
- TT. Are wash down systems or fire protection systems required for fume hoods or kitchen hoods?
- UU. Are fume hood exhaust systems balanceable? Are orifice plates required?
- VV. Are correct outside air quantities and pressurization included?
- WW. Is smoke control system required?

- XX. Avoid contamination of air intake from exhaust air, contaminated vents, vehicle exhaust, etc. Are locations in accordance with code?
- YY. Are static pressure sensors indicated or specified?
- ZZ. Are fire and smoke dampers coordinated with fire and smoke walls? Are fire rated floor/ceiling assemblies used? Will diffusers, registers, and grilles require fire dampers? Are smoke dampers required for air handling units or fans?
- AAA. Is floor suitable for "built-up" air handling units?
- BBB. Have ventilation systems been provided for equipment rooms and other nonair conditioned spaces?
- CCC. Are flow measuring devices located? Is there adequate straight run?
- DDD. Is there adequate straight duct upstream of terminal units? VAV, constant volume reheat, dual duct, fan powered, and other air terminal unit runouts should be sized based on the ductwork criteria established for sizing the ductwork upstream of the air terminal unit, and not on the terminal unit connection size. The transition from the runout size to the air terminal unit connection size should be made at the terminal unit. A minimum of 3 feet of straight duct should be provided upstream of all air terminal units.
- EEE. Is system compatible with architectural floor/ceiling assemblies?
- FFF. Do toilet rooms have code required minimum exhaust (BOCA-75 CFM per WC and Urinal; SBCCI-2.0 CFM/Sq.Ft.; UBC-5 AC/Hr.)?
- GGG. Locate exterior wall louvers, especially intake louvers, a minimum of 2'0" above roof, finished grade, etc.
- HHH. Locate gravity roof ventilators, especially intake ventilators, a minimum of 1'0" from finished roof to top of roof curb.
- III. Are air conditioning condensate drains piped to storm water or sanitary?

35.08 Process Exhaust Systems

- A. Branches and laterals should be connected above duct centerline. If branches and laterals are connected below, the duct centerline drains will be required at the low point.
- B. Provide blast gates or butterfly dampers at each branch, at each submain, and at each equipment or tool connection. Wind loading on blast gates needs to be considered when installed on the roof or outside the building, especially those blast gates which are normally open.
- C. Blast gate blades for process exhaust systems should be specified with an EPDM wiper gasket to provide a tight seal. For blast gates installed for future use, it is rec-

ommended that the blade be removed and a gasketed blind flange be provided where the blade goes in the duct to reduce leakage.

- D. Does duct pitch to low points and drains? Are drains provided at all low points?
- E. Has correct duct material been specified? Is it Stainless Steel, Halar Coated Stainless Steel, FRP or PVC? PVC is not recommended and maximum size is 8" round.
- F. Has proper pressure class been specified upstream and downstream of scrubbers and other abatement equipment?
- G. Is ductwork installed outside or in unconditioned spaces and will condensation occur on the outside or inside this duct? Is duct insulation or heat tracing required?
- H. Are adequate butterfly balancing dampers shown for system balancing?
- I. Are process exhaust fans on emergency power as required by code?
- J. Process exhaust ductwork cannot penetrate fire rated construction. Fire dampers are generally not desirable. If penetrating fire rated construction cannot be avoided, process exhaust ductwork must be enclosed in a fire rated enclosure until it exits the building, or sprinkler protection in side the duct may be used if approved by authority having jurisdiction.
- K. Are pressure ports provided at the ends of all laterals, submains, and mains?
- L. Are drains required in fan scroll, scrubber, or other abatement equipment?
- M. Are flexible connections provided at fans and are flexible connection specified suitable for application?
- N. Are stacks properly located and is discharge height adequate to prevent contamination of outside air intakes, CT intakes, combustion air intakes? Are termination heights clearly indicated?
- O. Have redundancy requirements been met?
- P. Are adjustable or variable frequency drives required, located, and coordinated with electrical engineer?

35.09 Refrigeration

- A. See Piping Systems-General for additional requirements.
- B. Is future machine space indicated on drawings?
- C. Is space for servicing indicated on drawings?
- D. Are there rigging supports for large water boxes and compressor shell?
- E. Is noise transmission likely to occupied spaces?
- F. Is there adequate control of chilled water temperature?

- G. Are sprinklers required for wood fill towers? NFPA 214.
- H. Is refrigerant relief piping shown on drawings? Is it piped to outside?
- I. Is noise from cooling towers likely to be a problem?
- J. Will cooling tower discharge air pocket or recirculate?
- K. Should cooling tower be winterized?
- L. Have cooling tower support locations been cleared with Structural Engineer. When determining cooling tower enclosure height, has height of vibration isolators been considered (8"-12" high) and has height of safety rail been considered?
- M. Are cooling tower discharge duct connections necessary?
- N. Are flow diagrams required? Have they been coordinated?
- O. Are present and ultimate duties noted where applicable and coordinated with pumps and coils, etc.?
- P. Is Ethylene or propylene glycol required? Has it been specified and equipment capacities de-rated?
- Q. Has additional insulation been included for low temperature systems?
- R. Has split single-phase protection been included for packaged (single and/or split systems) air conditioning and heat pump compressor motors?

35.10 Controls

- A. Are all panels located? Have they been coordinated with Electrical Engineer? Are they local or central?
- B. Are flow meter locations an adequate distance up- and downstream of orifice?
- C. Are thermostat and humidistat locations indicated? Do not mount stats on glass panels and door frames. Avoid middle of wall locations.
- D. Are control settings, schedules, and diagrams indicated or specified?
- E. Are temperature tolerances in lab areas clearly specified?
- F. Are power and control wiring diagrams shown? Is interlocking wiring included?
- G. Have reheat coils requiring full capacity in summer been supplied from a constant temperature hot water supply?
- H. Are low-leak dampers specified on intakes and elsewhere as required?
- I. Have compressor location and motor size been coordinated with Electrical Engineer?
- J. Are all AHUs and systems accounted for on control design?
- K. Coordinate purchase and installation of duct smoke detectors and duct fire stat locations with electrical department for connection to building fire detection system.

- L. Are direct digital controls appropriate?
- M. Are valve positions (open or closed) indicated where applicable?
- N. Is compressor size for ultimate duty?

35.11 Sanitary and Storm Water Systems

- A. See Piping Systems-General for additional requirements.
- B. Adjust sewer inverts to keep tops of pipe in line (note this on the drawings).
- C. Maintain at least minimum cover on sewers for entire run.
- D. Has sewer authority been contacted for the following:
- 1. Are sewer authority mains capable of handling additional discharge?
- 2. Location, size, and depth of sanitary and storm sewer mains?
- 3. Connection requirements?
- 4. Requirements for grease traps, oil/water interceptors, etc.?
- 5. Has DER or EPA been contacted?
- 6. Have storm water management requirements been determined?
- E. Sewer profiles are usually required where contours vary extensively or where possible interference with other lines exists. Indicate contours where required.
- F. Indicate sewer inverts at points of connection to public sewers, at building walls, at crossover points, and at points of possible interference. Are all underground utilities coordinated with foundations and grade beams?
- G. Indicate foundation drain tile inverts. Provide back water valves (BWVs) at connection to storm water system. Check accessibility; is manhole required?
- H. Is there a dry manhole for BWVs outside building or deep BWVs inside building?
- Provide headwall and rip rap for storm water discharge to drainage ditch, storm water retention pond/tank, or stream.
- J. Size site storm sewers large enough to prevent stoppage by leaves, paper, silt, etc. Except for light duty sewers, use 8" or 10" pipe minimum.
- K. Are all plumbing fixtures designated and scheduled?
- L. Coordinate fixture locations with final architectural plans. Check ADA requirements. Are handicapped fixtures identified?
- M. Provide BWVs for drains and groups of drains connected to storm water below grade or where backflow is possible above grade.
- N. Vent sumps for sanitary and storm water drainage.
- O. Is elevation of mains selected to be above footings? Advise Structural Engineer if mains must run below footings or through footings.

- P. Is there adequate ceiling space for AHU floor drain traps on upper floors? Are deep seal traps required? Are they indicated?
- Q. Are drains for overflows piped?
- R. Are there separate vapor vents for sterilizer and bed pan washers?
- S. Are grease traps required for commercial kitchens? Are sand interceptors and/or oil/water separators required for garages and parking areas? Is oil and/or water collected by oil/water separator to be treated as hazardous waste?
- T. If oil filled transformer is located inside building, provide transformer room with drain and pipe to accessible storage tank.
- U. Provide floor drains for air handling units, boilers, chemical feed equipment, air compressors, pumps, generators, etc., especially for relief valve discharge and pump stuffing box discharge.
- V. Are disposals directly connected to heavy flow mains? Do not connect to grease interceptor.
- W. Provide floor drain to create indirect waste connection for commercial dishwashers, kitchen sinks, and kitchen equipment processing food.
- X. Is plumbing fixture connection schedule included?
- Y. Does general piping or equipment interfere with overhead door's travel?
- Z. Do not run horizontal piping in solid masonry walls.
- AA. Is there adequate AHU pad height to allow condensate drain from pan to be properly trapped. Are condensate drains piped to storm or sanitary made with indirect connections? Do local authorities require condensate drains to be piped to sanitary or to storm? Can condensate drains be discharged onto roof or grade?
- BB. Are floor drains, roof drains, and trench drains coordinated with structural system? Are drains coordinated with building expansion joints?
- CC. Are air conditioning and steam condensate (when wasted) piped to storm water or sanitary? Is steam condensate cooled?
- DD. Are automatic trap priming systems required?
- EE. Are floor drain, roof drain, and trench drain types suitable for duty and traffic rating?
- FF. Are flow or riser diagrams required by plumbing authorities? Are fixture units clearly indicated on riser diagrams when required?
- GG. Is minimum size of vent through roof indicated (i.e., recommend 3")? Has minimum size pipe below floor been coordinated with local codes (i.e., Allegheny Co. 4" minimum pipe size below floor)?
- HH. Are fixtures and drains trapped and vented in accordance with applicable code?
- II. Will drainage to grade freeze and create slippery condition?

- JJ. Is tub overflow assembly accessible? Use solid connection, if not.
- KK. Are cooling tower and evaporative cooler overflows, bleeds, and drains piped to sanitary?
- LL. Do not use cleanouts on Washington, D.C. projects. Verify requirements.
- MM. Are acid waste and vent systems clearly indicated on the drawings and specified?
- NN. Site drainage: Are adequate manholes, catch basins, and other items shown on the drawings and specified?
- OO. Are future connections and/or expansions considered in slope of piping, size of piping, and sewer connection sizing?
- PP. Provide manways for septic and sewage holding tanks. Manholes and covers should be waterproof/watertight.

35.12 Domestic Water Systems

- A. See Piping Systems-General for additional requirements.
- B. Has water authority been contacted to obtain the following:
- 1. Water static and residual pressures and flows at water main? Are these pressures and flows adequate?
- 2. Location and size of water mains?
- 3. Water hardness and corrosiveness of water?
- 4. Backflow prevention requirements?
- 5. Water meter location requirements and meter pit requirements if necessary?
- C. Are pressure regulating valves required? Do pressures exceed 60 psi; if so, pressure reducing valves should be provided.
- D. Are there submain section valves?
- E. Are there provisions for piping and building expansion?
- F. Have all wall, box, and yard hydrants been provided and specified?
- G. Are water softeners for laundry and boiler makeup required?
- H. Is makeup water connected to boiler, heating, chilled, condenser, and other HVAC water systems? Is freeze protection required? Is sufficient pressure available to overcome static head?
- I. Provide hose bibbs at cooling towers and in boiler rooms, mechanical rooms, large toilet rooms, dormitory toilet rooms, and kitchens.
- J. In boiler and chiller rooms, provide service sink and water sampling connections.
- K. Are flow or riser diagrams required by plumbing authorities? Are fixture units clearly indicated on riser diagrams when required?
- L. Is a hot water recirculating pump required, located, scheduled, and specified?

- M. Are all hospital, laboratory, kitchen, and other special equipment connections shown on the drawings? Are hospital, laboratory, kitchen, and other special equipment connection schedules required and included?
- N. Are backflow preventers provided at service entrance, at fire protection service, and at connection to HVAC water systems fill connections? Use reduced pressure backflow preventers on all HVAC systems and double-check backflow preventers on domestic water and fire protection service.
- O. Is pressure boosting system required?
- P. Is a main shutoff valve provided? Are shutoff valves shown at each toilet room and groups of two or more plumbing fixtures?
- Q. Are all plumbing fixtures shown on the drawings and specified?
- R. Is a water meter required? Is Sub-metering required?
- S. Are balancing valves on hot water recirculation system shown?
- T. Use ¾" cold water connection to eye wash units.
- U. Are water heater connections shown (gas, water, vents, etc.)?
- V. Is dishwasher booster heater connected?
- W. Are future connections and/or expansions considered in size of piping and service entrance?
- X. Are all underground utilities coordinated with foundations?

35.13 Fire Protection

- A. See Piping Systems-General for additional requirements.
- B. Are Siamese connections shown and coordinated with Architect?
- C. Are check valves and shutoff valves shown on drawings?
- D. Have fire extinguishers and/or cabinets been specified by Architect or Engineer? Have fire hoses and/or cabinets been specified by Architect or Engineer?
- E. Is fire protection for kitchen hoods required?
- F. Is there adequate space for sprinkler mains?
- G. Are dry systems provided for areas subject to freezing?
- H. Is there a sprinkler for trash and linen chutes?
- I. Are there drains for ball drips of Siamese connections?
- J. Are pressures noted for hydraulically calculated systems?
- K. Is the extent of sprinklered area indicated? If more than one type of sprinkler system is required (wet, dry, pre-action, deluge, etc.), are they clearly indicated on the drawings?

- L. Are fire department valves clearly indicated on the drawings?
- M. Are special fire protection systems included?
- N. Are standpipes and fire department valve shown?
- O. Is sprinkler zoning compatible with fire alarm zoning?
- P. Are all test connections shown and locations coordinated with Architect? Are drains for test connection provided?
- Q. Has water authority been contacted to obtain the following:
- 1. Water static and residual pressures and flows at water main? Are these pressures and flows adequate or is fire pump required?
- 2. Location and size of water mains?
- 3. Water hardness and corrosiveness of water?
- 4. Backflow prevention requirements?
- 5. Water meter location requirements and meter pit requirements if necessary?
- 6. Street or on site fire hydrant requirements?
- 7. Fire hydrant and fire department connection size, thread type, etc.?
- R. Have electrical requirements for fire pump, tamper switches, flow switches, etc., been coordinated with Electrical Department?
- S. Have fire pump requirements been coordinated between spec and drawings?
- T. Have fire hose and fire extinguisher locations been coordinated with Electrical Department for wiring of blue indicator light?
- U. Who paints fire protection piping and what color (red)?

35.14 Natural Gas Systems

- A. See Piping Systems-General for additional requirements.
- B. Determine minimum gas pressure required. Is gas company pressure available at street adequate for equipment? Has gas company been contacted to obtain the following:
- 1. Pressures and flows at gas main? Are these pressures and flows adequate?
- 2. Location and size of gas mains?
- 3. Gas meter location requirements and meter pit requirements if necessary?
- C. Has gas meter size been coordinated with gas company? Has capacity requirement and site location been given to gas company? Is meter required to be located inside or outside? Who provides gas meter and regulator assembly? Does gas company? Who provides gas piping from main to curb box, from curb box to meter assembly, from meter assembly to building, and inside building?
- D. Have gas pressure regulators been evaluated for low load conditions and during start-up? It is recommended that multiple gas pressure regulators be used, especially on large central utility plant natural gas systems, not only for low load conditions but for replacement of regulators without shutdown of the entire plant. For instance, the natural gas system design may use two regulators sized at 50%-50%,

- 33%-67%, or 40%-60%, or it may use three regulators sized at 15%-35%-50% or 25%-25%-50%.
- E. Is there gas meter access and room ventilation (when required)?
- F. Are there drip pockets if gas lines cannot drain back to meter and adequate space for pitch?
- G. Are there submain section gas cocks?
- H. Are gas vent valves and vents from pressure regulating valves piped to outside?
- I. Do not locate natural draft burners in room under "negative" pressure.
- J. Coordinate gas train with gas pressure available and with Owner's insurance carrier.
- K. Are stacks, vents, and breeching shown on the drawings and properly sized and specified? Coordinate with design team other equipment requiring gas vents (i.e., water heaters, shop equipment, kitchen equipment, lab equipment, hospital equipment).
- L. Is combustion air for fuel fired equipment properly designed in accordance with code? Watch for water heaters in janitor closets.
- M. What pressures are permitted to be run inside the building?
- N. Is piping run in plenum? If so, valves cannot be located in plenum, including walls.
- O. Check with local gas company for welded and screwed pipe requirements (concealed, exposed, etc.). Screwed pipe and fittings may only be used if gas service is less than 1 psig and vertical runs are less than four stories. Otherwise use welded pipe.
- P. Plastic pipe can only be used for underground service. Require contractor to install #14 insulated tracer wire 4 to 6 inches above all underground plastic lines.

35.15 Fuel Oil Systems

- A. See Piping Systems-General for additional requirements.
- B. Do not locate natural draft burners in room under "negative" pressure.
- C. Is suction lift within allowable limits of fuel oil pump?
- D. Is underground fuel oil tank location coordinated with site plan. Does it have adequate cover? Has truck traffic been considered? Are leak detection systems and double wall piping systems shown on the drawings and specified?
- E. Are tank vent and fill indicated and away from air intakes? Are vents properly sized?
- F. Are fuel oil heaters required (#4, #5, #6 fuel oils)?
- G. Is a tank heater required (they are not permitted with fiberglass tanks)?
- H. Is a compressed air for tank gauge provided?

- I. Is specified tank suitable for installation? Has it been coordinated with Owner? Is future conversion to heavy oil a consideration?
- J. Are leak detection, double wall piping, spill containment, double wall tanks, etc., properly specified and shown on the drawings?
- K. Are stacks, vents, and breeching shown on the drawings and properly sized and specified? Coordinate with design team other equipment requiring vents (i.e., water heaters, shop equipment, lab equipment, hospital equipment).
- L. Is combustion air for fuel fired equipment properly designed in accordance with code? Watch for water heaters in janitor closets.
- M. Are DER tank requirements met? Have Pennsylvania state police requirements been met?
- N. Are emergency vents properly sized for indoor tanks?
- O. Are manholes and covers for fill and access openings specified and/or detailed to be waterproof/watertight?

35.16 Laboratory and Medical Gas Systems

- A. Is separate zone valve required?
- B. Are medical gas alarm panels required?
- C. Is air intake for hospital compressor indicated? Is it outside? Does it provide clean air?
- D. Vacuum pump discharge should not be at rubber membrane roofs, due to adverse reaction of oil with membrane materials.
- E. Are NFPA 99 requirements met?

35.17 General

- A. Are all mechanical items specified and coordinated with other disciplines as to who provides, furnishes, and/or installs? Have all items on specification coordination list been coordinated? Do all disciplines have the most current drawings showing mechanical equipment?
- B. Are there a north arrow, title blocks, and engineer's stamp with signature?
- C. Are scales noted on plans? Does project or client require graphic scales?
- D. Are there client and project numbers on all projects, and company name, logo, address, etc., on all drawings?
- E. Check for completeness of general notes, legend, abbreviations, and title blocks.
- F. Check column numbers and grids.

- G. Check room names and numbers.
- H. Is extent of demolition clearly defined? Is what is to remain clearly defined? Are points of connection between new and old clearly defined?
- I. Check coordination and contrast of new and existing work.
- J. Coordinate the following with architectural, structural, and electrical departments:
- 1. Clearances between lighting fixtures, structure, and ducts and pipes.
- Clearances between conduits out of electrical panels and pull boxes, structure, and ducts and pipes.
- 3. Wiring of filters (roll filters and air purification systems).
- K. Does electrical department have the final motor list and heater list?
- L. Have existing mechanical/electrical services and available space for new work been adequately field checked?
- M. Advise electrical department of relocated mechanical equipment having electrical components.
- N. Has division of work between Architectural, Structural, Mechanical, and Electrical disciplines been coordinated (as to who furnishes, install and/or provides) on such items as:
 - 1. Starters and disconnect switches?
 - 2. Line and low voltage control wiring and power wiring to control panels?
 - 3. Access panels?
 - 4. Fire extinguishers, fire hoses, and/or cabinets?
 - 5. Catwalks and ladders?
 - 6. Under-window unit discharge grilles on built in cabinets?
 - 7. Louvers?
 - 8. Door grilles, undercut doors?
 - Generators, muffler, fuel oil piping, engine exhaust, engine cooling air ductwork, and accessories?
- 10. Painting and priming?
- 11. Mechanical equipment screens?
- 12. Equipment supports and concrete housekeeping pads?
- 13. Roof curbs (equipment, ductwork, and piping), flashing, and counter flashing?
- 14. Site work/building utility design termination (5'0" outside of foundation wall)?
- 15. Foundation drains?
- 16. Excavation?
- 17. Kitchenette units?
- 18. Bus washer, vehicle lifts, hydraulic piping and accessories, and paint booths and accessories?
- 19. Countertop plumbing fixtures; built in showers?
- 20. Kitchen hoods?
- 21. Laboratory fume hoods?
- O. Where ceiling height and door or window head heights provide no leeway to lower ceiling, have mechanical and electrical work space above ceiling been closely checked?

- P. Check framing of holes in existing structures.
- Q. Is structure adequate for new mechanical equipment in existing buildings?
- R. Is there adequate clearance for removal of ceiling systems for access to equipment. Tee bar system requires 3" minimum from underside of ceiling to equipment.
- S. Have heating and ventilation of bathrooms and toilet rooms been provided?
- T. Is there equipment room, PRV room, electrical room, and electrical closet ventilation?
- U. Has insulation or ventilation been provided to overcome radiant heat from boiler or incinerator stacks?
- V. Has specified equipment been properly described by current model designation?
- W. Have all items specified "As indicated on the drawings" been coordinated? Coordinate references between drawings, details, sections, risers, and specifications.
- X. Is there any material or equipment for which there is no catalog data in the office library?
- Y. Have details been coordinated?
- Z. Has space for future ducts, pipes, fans, pumps, chillers, boilers, cooling towers, water heaters, and other equipment been clearly indicated?
- AA. Are "floating floors" required for noise control? Have they been specified and detailed?
- BB. Has existing area been adequately field checked?
- CC. Are elevator machine rooms free of piping, ductwork, and equipment except elevator machine equipment? Is elevator machine room ventilated? Does elevator machine room need to be air conditioned?
- DD. Have chemical treatment systems been included?
- EE. Have handwash sinks been included in mechanical equipment rooms?
- FF. Have chain operators for valves more than 7'-0" above finished floor been specified?
- GG. Are General Notes, drawing notes, and Keyed Notes included?
- HH. Is key plan needed?
- II. Are applicable standard details included and coordinated?
- JJ. Have applicable codes been researched?
- KK. Should smoke and fire walls be indicated?
- LL. Are present and ultimate duties included in schedules where applicable and coordinated with Electrical Engineer? Are future flows accounted for in duct and pipe sizing and appropriate provision made?

- MM. Have authorities having jurisdiction been consulted regarding fire detection and protection systems, applicable codes, etc.?
- NN. Is minimum head room (6'-8") maintained in equipment rooms?
- OO. Is verification that building meets ASHRAE Standard 90 or other Energy Conservation Code required?
- PP. Is access to equipment with electrical connections (such as ceiling mounted heat pumps) adequate to satisfy NEC?
- QQ. Have all equipment housekeeping pads been indicated, specified, and coordinated?
- RR. Is asbestos present in existing building? Is preparation of removal documents part of Contract?

35.18 Architect and/or Owner Coordination

- A. Have all shafts/chases been coordinated? Are they large enough?
- B. Do shafts/chases line up floor to floor? Are structural members located in shaft space?
- C. Have pipe or duct chases been provided where required?
- D. Will partitions accommodate piping and plumbing fixtures?
- E. Has suitable type stationary louver been specified?
- F. Are bird screens (not insect screens) specified? Are bird screens located on the inside or outside of louver? Outside of louver easier to clean but appearance is undesirable.
- G. Have louver locations and sizes been coordinated? Who provides, furnishes, and/or installs louvers?
- H. Have plumbing fixtures as required been specified under the architectural section?
- I. Have all plumbing fixtures been coordinated?
- J. Has all special equipment been coordinated?
- K. Have NIC or future items requiring "stub-up" services been identified?
- L. Have masonry air shafts been avoided? If not, are they specified to be airtight?
- M. Has access to roof mounted equipment been provided?
- N. Have provisions for equipment replacement been made?
- O. Have supply air ceiling plenums been coordinated? Are partitions floor to floor where required? Is supply air plenum area sealed where required?
- P. Have return air ceiling plenums been coordinated? Are partitions floor to floor? If so, have provisions been provided to return air from these spaces?

- Q. Have trenches, sumps, and covers been coordinated?
- R. Have under-window units been coordinated?
- S. Have air outlet types been coordinated?
- T. Have thermostat types been selected and approved by Owner?
- U. Have plumbing fixtures and types been approved? Have countertop fixtures been coordinated? Who provides, furnishes, and/or installs countertop fixtures?
- V. Include vibration isolators, grillage, and cooling tower safety rail when dimensioning height of cooling tower for architectural screen.
- W. Have all skylights, roof hatches, bulkheads, and multiple height ceilings been coordinated with ductwork, piping, and other mechanical equipment?
- X. Who provides, furnishes, and/or installs roof curbs for mechanical equipment?
- Y. Who provides, furnishes and/or installs flashing and counterflashing?
- Z. Who provides cutting and patching?

35.19 Structural Engineer Coordination

- A. Have equipment locations, sizes, and weights been given to the Structural Engineer? Have equipment housekeeping pad locations and sizes been coordinated? Has final and complete structural list been given to Structural Engineer?
- B. Have all floor, roof, and wall openings been coordinated?
- C. Have pipes 6 inches and larger been located and coordinated with structural engineer?
- D. Have all sleeved beams, grade beams, and foundations been coordinated? Have pipes and ducts been coordinated?
- E. Has structural framing in shafts been considered?
- F. Has mechanical layout been coordinated with structural system, especially in post tensioned concrete structural systems (penetrations at columns and column lines are not normally possible)?
- G. Is structural system adequate for future equipment?
- H. Where equipment must be "rolled" into place, is the structure over which equipment will be rolled adequate?
- I. Have catwalks been coordinated?
- J. Have pipe risers been coordinated?
- K. Do structural openings allow for insulation and ductwork reinforcing?
- L. Have anchor locations and associated forces been given to Structural Engineer? Avoid locating anchors at joist or joist girder locations.
- M. Have louver openings, sizes, and framing been coordinated with Structural Engineer?